2008

Photographer's Market®

Donna Poehner, **Editor**

WRITER'S DIGEST BOOKS
CINCINNATI, OH

If you are an editor, art director, creative director, art publisher or gallery director and would like to be considered for a listing in the next edition of *Photographer's Market*, send your request for a questionnaire to *Photographer's Market*, 4700 East Galbraith Road, Cincinnati, Ohio 45236, or e-mail photomarket@fwp ubs.com.

Editorial Director, Writer's Digest Books: Jane Friedman
Managing Editor, Writer's Digest Market Books: Alice Pope

Photographer's Market Web page: www.photographersmarket.com
Writer's Market Web site: www.writersmarket.com
Writer's Digest Web site: www.writersdigest.com
F+W Publications Bookstore: http://fwpublications.com

Distributed in Canada by Fraser Direct
100 Armstrong Ave.
Georgetown, ON, Canada L7G 5S4
Tel: (905) 877-4411

Distributed in the U.K. and Europe by David & Charles
Brunel House, Newton Abbot, Devon, TQ12 4PU, England
Tel: (+44) 1626 323200, Fax: (+44) 1626 323319
E-mail: postmaster@davidandcharles.co.uk

Distributed in Australia by Capricorn Link
P.O. Box 704, Windsor, NSW 2756, Australia
Tel: (02) 4577-3555

Distributed in New Zealand by David Bateman Ltd.
P.O. Box 100-242, N.S.M.C., Auckland 1330, New Zealand
Tel: (09) 415-7664, Fax: (09) 415-8892

Distributed in South Africa by Real Books
P.O. Box 1040, Auckland Park 2006, Johannesburg, South Africa
Tel: (011) 837-0643, Fax: (011) 837-0645
E-mail: realbook@global.co.za

ISSN: 0147-247X
ISBN-13: 978-1-58297-501-6
ISBN-10: 1-58297-501-9

Cover design by Josh Roflow
Cover photograph © Digital Vision/Digital Zoo/Getty Images
Interior design by Clare Finney
Production coordinated by Kristen Heller and Greg Nock

fw

F+W PUBLICATIONS, INC.

Attention Booksellers: This is an annual directory of F+W Publications. Return deadline for this edition is December 31, 2008.

Contents

© Ralph Lee Hopkins

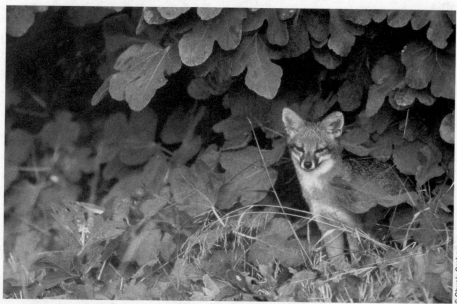

© Chuck Graham

© Dawn Norris

MARKETS

© Stephanie Carson

© Ralph Lee Hopkins

RESOURCES

INDEXES

© 2000 Robert J. Hurt

From the Editor

It's an exciting time to be a photographer. The evolution of digital technology continues to change not only how photographers make pictures but also how they promote themselves and deliver the end product to their clients. Photographers have more tools to aid their creativity as well as their business productivity than ever before.

The way I see at it, photography is going through not just an evolution, but a revolution. New business models are replacing old ones at a staggering pace, especially in stock photography. So not only is this an exciting time to be a photographer, it's also a challenging one. Today, photographers need a variety of resources to help them succeed.

Many of those resources are available here in *Photographer's Market*. I've called on some of the best photographers and industry experts for their advice. Outdoor photographer Ralph Lee Hopkins told me in an interview that photographers should try to find several income streams in today's competitive market (page 30). "Do whatever it takes to get your work out there," he says. Paul H. Henning of Stock Answers presents compelling recommendations for today's stock photographers, enlightening them about recent changes, including microstock (page 37). Blogging has become a favorite (and sometimes profitable) pastime for many. The article on page 44 explains how photographers can make blogging work for them and their businesses, using the blog as a self-promotion "pull" (rather than a "push").

A new section on portrait and wedding photography rounds out this edition of *Photographer's Market*. This sector of the photography business has experienced a revolution of its own, thanks to digital technology and fresh, updated styles. Three top photographers share their advice on family portraiture, wedding photography, and pet photography.

Challenging times call for daring action: Join the revolution.

Donna Poehner

Donna Poehner
photomarket@fwpubs.com
www.photographersmarket.com

2008 Reader Survey:
Tell us about yourself!

1. How often do you purchase *Photographer's Market?*

○ every year
○ every other year
○ This is my first edition

2. What type of photography do you do?

3. Do you have suggestions for improving *Photographer's Market?*

4. Would you like to see an online version of *Photographer's Market?*

○ Yes
○ No

Name: _____
Address: _____
City: _____ State: _____ Zip: _____
Phone: _____ E-mail: _____
Web site: _____

Fax to Donna Poehner: (513)531-2686; mail to Photographer's Market, 4700 East Galbraith Road, Cincinnati, OH 45236; or e-mail photomarket@fwpubs.com.

How to Use This Book

The first thing you'll notice about most of the listings in this book is the group of symbols that appears before the name of each company. Scanning the listings for symbols can help you quickly locate markets that meet certain criteria. (You'll find a quick-reference key to the symbols on the front and back inside covers of the book.) Here's what each symbol stands for:

- **N** This photo buyer is new to this edition of the book.
- **↔** This photo buyer is located in Canada.
- **⊕** This photo buyer is located outside the U.S. and Canada.
- **A** This photo buyer uses only images created on assignment.
- **S** This photo buyer uses only stock images.
- **□** This photo buyer accepts submissions in digital format.
- **▣** This photo buyer uses film or other audiovisual media.
- **▽** This art fair is a juried event; a juror or committee of jurors views applicants' work and selects those whose work fits within the guidelines of the event.

Complaint Procedure

If you feel you have not been treated fairly by a company listed in *Photographer's Market*, we advise you to take the following steps:

Important

- First, try to contact the listing. Sometimes one phone call, e-mail or letter can quickly clear up the matter.

- Document all your correspondence with the listing. If you write to us with a complaint, provide the details of your submission, the date of your first contact with the listing, and the nature of your subsequent correspondence.

- We will enter your letter into our files.

- The number and severity of complaints will be considered in our decision whether to delete the listing from the next edition.

PAY SCALE

We asked photo buyers to indicate their general pay scale based on what they typically pay for a single image. Their answers are signified by a series of dollar signs before each listing. Scanning for dollar signs can help you quickly identify which markets pay at the top of the scale. However, not every photo buyer answered this question, so don't mistake a missing dollar sign as an indication of low pay rates. Also keep in mind that many photo buyers are willing to negotiate.

$ Pays $1-150

$ $ Pays $151-750

$ $ $ Pays $751-1,500

$ $ $ $ Pays more than $1,500

OPENNESS

We also asked photo buyers to indicate their level of openness to freelance photography. Looking for these symbols can help you identify buyers who are willing to work with newcomers, as well as prestigious buyers who only publish top-notch photography.

◻ Encourages beginning or unpublished photographers to submit work for consideration; publishes new photographers. May pay only in copies or have a low pay rate.

◓ Accepts outstanding work from beginning and established photographers; expects a high level of professionalism from all photographers who make contact.

◔ Hard to break into; publishes mostly previously published photographers. May pay at the top of the scale.

⊘ Closed to unsolicited submissions.

SUBHEADS

Each listing is broken down into sections to make it easier to locate specific information. In the first section of each listing you'll find mailing addresses, phone numbers, e-mail and Web site addresses, and the name of the person you should contact. You'll also find general information about photo buyers, including when their business was established and their publishing philosophy. Each listing will include one or more of the following subheads:

Needs. Here you'll find specific subjects each photo buyer is seeking. (You can find an index of these subjects starting on page 503 to help you narrow your search.) You'll also find the average number of freelance photos a buyer uses each year, which will help you gauge your chances of publication.

Audiovisual Needs. If you create images for media such as filmstrips or overhead transparencies, or you shoot videotape or motion picture film, look here for photo buyers' specific needs in these areas.

Specs. Look here to see in what format the photo buyer prefers to receive accepted images. Many photo buyers will accept both digital and film (slides, transparencies, prints) formats. However, many photo buyers are reporting that they accept digital images only, so make sure you can provide the format the photo buyer requires before you send samples.

Exhibits. This subhead appears only in the Galleries section of the book. Like the Needs subhead, you'll find information here about the specific subjects and types of photography a gallery shows.

Making Contact & Terms. When you're ready to make contact with a photo buyer, look

Frequently Asked Questions

1 How do companies get listed in the book?

No company pays to be included—all listings are free. Every company has to fill out a detailed questionnaire about their photo needs. All questionnaires are screened to make sure the companies meet our requirements. Each year we contact every company in the book and ask them to update their information.

2 Why aren't other companies I know about listed in this book?

We may have sent these companies a questionnaire, but they never returned it. Or if they did return a questionnaire, we may have decided not to include them based on our requirements.

3 Some publishers say they accept photos with or without a manuscript. What does that mean?

Essentially, the word manuscript means a written article that will be published by a magazine. Some magazines will only consider publishing your photos if they accompany a written article. Other publishers will consider publishing your photos alone, without a manuscript. In previous editions, the word manuscript was abbreviated to ms. In this edition, we spell out the word manuscript whenever it occurs.

4 I sent a CD with large digital files to a photo buyer who said she wanted to see my work. I have not heard from her, and I am afraid that my photos will be used without my permission and without payment. What should I do?

Do not send large, printable files (300 dpi or larger) unless you are sure the photo buyer is going to use them, and you know what you will be paid for their usage and what rights the photo buyer is requesting. If a photo buyer shows interest in seeing your work in digital format, send small JPEGs at first so they can "review" them—i.e., determine if the subject matter and technical quality of your photos meet their requirements. Until you know for sure that the photo buyer is going to license your photos and you have some kind of agreement, do not send high-resolution files. The exception to this rule would be if you have dealt with the photo buyer before or perhaps know someone who has. Some companies receive a large volume of submissions, so sometimes you must be patient. It's a good idea to give any company listed in this book a call before you submit anything and be sure nothing has changed since we contacted them to gather or update information. This is true whether you submit slides, prints or digital images.

5 A company says they want to publish my photographs, but first they will need a fee from me. Is this a standard business practice?

No, it is not a standard business practice. You should never have to pay to have your photos reviewed or to have your photos accepted for publication. If you suspect that a company may not be reputable, do some research before you submit anything or pay their fees. The exception to this rule is contests. It is not unusual for some contests listed in this book to have entry fees (usually minimal—between five and 20 dollars).

here to find out exactly what they want to see in your submission. You'll also find what the buyer usually pays and what rights they expect in exchange. In the Stock section, this subhead is divided into two parts, Payment & Terms and Making Contact, because this information is often lengthy and complicated.

Handles. This subhead appears only in the Photo Representatives section. Some reps also represent illustrators, fine artists, stylists, make-up artists, etc., in addition to photographers. The term "handles" refers to the various types of "talent" they represent.

Tips. Look here for advice and information directly from photo buyers in their own words.

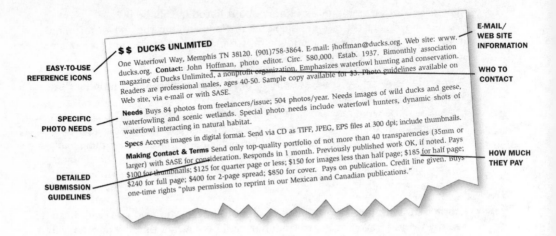

EASY-TO-USE
REFERENCE ICONS

SPECIFIC
PHOTO NEEDS

DETAILED
SUBMISSION
GUIDELINES

E-MAIL/
WEB SITE
INFORMATION

WHO TO
CONTACT

HOW MUCH
THEY PAY

$ $ DUCKS UNLIMITED
One Waterfowl Way, Memphis TN 38120. (901)758-3864. E-mail: jhoffman@ducks.org. Web site: www. ducks.org. **Contact:** John Hoffman, photo editor. Circ. 580,000. Estab. 1937. Bimonthly association magazine of Ducks Unlimited, a nonprofit organization. Emphasizes waterfowl hunting and conservation. Readers are professional males, ages 40-50. Sample copy available for $3. Photo guidelines available on Web site, via e-mail or with SASE.

Needs Buys 84 photos from freelancers/issue; 504 photos/year. Needs images of wild ducks and geese, waterfowling and scenic wetlands. Special photo needs include waterfowl hunters, dynamic shots of waterfowl interacting in natural habitat.

Specs Accepts images in digital format. Send via CD as TIFF, JPEG, EPS files at 300 dpi; include thumbnails.

Making Contact & Terms Send only top-quality portfolio of not more than 40 transparencies (35mm or larger) with SASE for consideration. Responds in 1 month. Previously published work OK, if noted. Pays $100 for thumbnails; $125 for quarter page or less; $150 for images less than half page; $185 for half page; $240 for full page; $400 for 2-page spread; $850 for cover. Pays on publication. Credit line given. Buys one-time rights "plus permission to reprint in our Mexican and Canadian publications."

How to Start Selling Your Work

I f this is your first edition of *Photographer's Market*, you're probably feeling a little overwhelmed by all the information in this book. Before you start flipping through the listings, read the 11 steps below to learn how to get the most out of this book and your selling efforts.

1. Be honest with yourself. Are the photographs you make of the same quality as those you see published in magazines and newspapers? If the answer is yes, you may be able to sell your photos.

2. Get someone else to be honest with you. Do you know a professional photographer who would critique your work for you? Other ways to get opinions about your work: join a local camera club or other photo organization; attend a stock seminar led by a professional photographer; attend a regional or national photo conference or a workshop where they offer daily critiques.

- You'll find workshop and seminar listings beginning on page 433.
- You'll find a list of photographic organizations on page 462.
- Check your local camera store for information about camera clubs in your area.

3. Get Organized. Create a list of subjects you have photographed and organize your images into subject groups. Make sure you can quickly find specific images and keep track of any sample images you send out. You can use database software on your home computer to help you keep track of your images. (See page 26 for more information.)

Other Resources:

- *Photo Portfolio Success* by John Kaplan, Writer's Digest Books.
- *Sell and Re-Sell Your Photos* by Rohn Engh, Writer's Digest Books.
- *Sellphotos.com* by Rohn Engh, Writer's Digest Books.
- *The Photographer's Travel Guide* by William Manning, Writer's Digest Books.

4. Consider the format. Are your pictures color snapshots, black & white prints, color slides or digital captures? The format of your work will determine, in part, which markets you can approach. Below are some general guidelines for where you can market various photo formats. Always check the listings in this book for specific format information.

- **black & white prints**—galleries, art fairs, private collectors, literary/art magazines, trade magazines, newspapers, some book publishers
- **color prints**—newsletters, very small trade or club magazines
- **large color prints**—galleries, art fairs, private collectors
- **color slides** (35mm)—most magazines, newspapers, some greeting card and calendar publishers, some book publishers, textbook publishers, stock agencies
- **color transparencies** ($2^{1}/_{4} \times 2^{1}/_{4}$ and 4×5)—magazines, book publishers, calendar publishers, ad agencies, stock agencies. Many of these photo buyers have begun to accept only digital photos, especially stock agencies.

- **digital**—newspapers, magazines, stock agencies, ad agencies, book and greeting card publishers. (All listings that accept digital work are marked with a ■ symbol.)

5. Do you want to sell stock images or accept assignments? A stock image is any photograph you create on your own and then sell to a publisher. An assignment is a photograph created at the request of a specific buyer. Many of the listings in *Photographer's Market* are interested in both stock and assignment work.

- Listings that are only interested in stock photography are marked with a ⟨S⟩ symbol.
- Listings that are only interested in assignment photography are marked with a ⟨A⟩ symbol.

6. Start researching. Generate a list of the publishers that might buy your images— check the newsstand, go to the library, search the Web, read the listings in this book. Don't forget to look at greeting cards, stationery, calendars and CD covers. Anything you see with a photograph on it, from a billboard advertisement to a cereal box, is a potential market.

- See page 5 for instructions about how to read the listings in this book.
- If you shoot a specific subject, check the Subject Index on page 503 to simplify your search.

7. Check the publisher's guidelines. Do you know exactly how the publisher you choose wants to be approached? Check the listings in this book first. If you don't know the format, subject and number of images a publisher wants in a submission, you should check their Web site first. Often, guidelines are posted there. Or you can send a short letter with a self-addressed, stamped envelope (SASE) or e-mail asking those questions. A quick call to the receptionist might also yield you the answers.

8. Check out the market. Get in the habit of reading industry magazines.

- You'll find a list of useful magazines on page 465.

9. Prepare yourself. Before you send your first submission, make sure you know how to respond when a publisher agrees to buy your work.

Pay Rates:

Most magazines and newspapers will tell you what they pay, and you can accept or decline. However, you should become familiar with typical pay rates. Ask other photographers what they charge—preferably ones you know well or who are not in direct competition with you. Many will be willing to tell you to prevent you from devaluing the market by undercharging. (See page 17 for more information.)

Other Resources:

- *Pricing Photography: The Complete Guide to Assignment and Stock Prices* by Michal Heron and David MacTavish, Allworth Press.
- *fotoQuote*, a software package that is updated each year to list typical stock photo and assignment prices, (800)679-0202, www.cradoc.com.
- *Negotiating Stock Photo Prices* by Jim Pickerell, 110 Frederick Ave., Suite A, Rockville MD 20850, (301)251-0720.

Copyright:

You should always include a copyright notice on any slide, print or digital image you send out. While you automatically own the copyright to your work the instant it is created, the notice affords extra protection. The proper format for a copyright notice includes the word or symbol for copyright, the date and your name: © 2008 Donna Poehner. To fully protect your copyright and recover damages from infringers, you must register your copyright with the Copyright Office in Washington. (See page 26 for more information.)

Rights:

In most cases, you will not actually be selling your photographs, but rather, the rights to publish them. If a publisher wants to buy your images outright, you will lose the right to resell those images in any form or even display them in your portfolio. Most publishers will buy one-time rights and/or first rights. (See page 27 for more information.)

Other Resources:

- *Legal Guide for the Visual Artist* by Tad Crawford, Allworth Press.

Contracts:

Formal contract or not, you should always agree to any terms of sale in writing. This could be as simple as sending a follow-up letter restating the agreement and asking for confirmation, once you agree to terms over the phone. You should always keep copies of any correspondence in case of a future dispute or misunderstanding. (See page 15 for more information.)

Other Resources:

- *Business and Legal Forms for Photographers* by Tad Crawford, Allworth Press.

10. Prepare your submission. The number one rule when mailing submissions is: "Follow the directions." Always address letters to specific photo buyers. Always include a SASE of sufficient size and with sufficient postage for your work to be safely returned to you. Never send originals when you are first approaching a potential buyer. Try to include something in your submission that the potential buyer can keep on file, such as a tearsheet and your résumé. In fact, photo buyers prefer that you send something they don't have to return to you. Plus, it saves you the time and expense of preparing a SASE. (See page 12 for more information.)

Other Resources:

- *Photo Portfolio Success* by John Kaplan, Writer's Digest Books.

11. Continue to promote yourself and your work. After you've made that first sale (and even before), it is important to promote yourself. Success in selling your work depends in part on how well and how often you let photo buyers know what you have to offer. This is known as self-promotion. There are several ways to promote yourself and your work. You can send postcards or other printed material through the mail; send an e-mail with an image and a link to your Web site if you have one; and upload your images to a Web site that is dedicated to showcasing your work and your photographic services. (See page 24 for more information.)

Getting Started

Running Your Business

Photography is an art that requires a host of skills, some which can be learned and some which are innate. To make money from your photography, the one skill you can't do without is a knowledge of business. Thankfully, this skill can be learned. What you'll find on the following pages are the basics of running a photography business. We'll cover:

SUBMITTING YOUR WORK

Editors, art directors and other photo buyers are busy people. Many only spend 10 percent of their work time actually choosing photographs for publication. The rest of their time is spent making and returning phone calls, arranging shoots, coordinating production and a host of other unglamorous tasks that make publication possible. They want to discover new talent, and you may even have the exact image they're looking for, but if you don't follow a market's submission instructions to the letter, you have little chance of acceptance.

To learn the dos and don'ts of photography submissions, read each market's listing carefully and make sure to send only what they ask for. Don't send prints if they only want slides. Don't send color if they only want black & white. Check their Web site or send for guidelines whenever they are available to get the most complete and up-to-date submission advice. When in doubt, follow these 10 rules when sending your work to a potential buyer:

1. Don't forget your SASE—Always include a self-addressed, stamped envelope whether you want your submission back or not. Make sure your SASE is big enough, has enough packaging, and has enough postage to ensure the safe return of your work.

2. Don't over-package—Never make a submission difficult to open and file. Don't tape down all the loose corners. Don't send anything too large to fit in a standard file.

3. Don't send originals—Try not to send things you must have back. Never, ever send originals unsolicited.

4. Label everything—Put a label directly on the slide mount or print you are submitting. Include your name, address and phone number, as well as the name or number of the image. Your slides and prints will almost certainly get separated from your letter.

5. Do your research—Always research the places to which you want to sell your work. Request sample issues of magazines, visit galleries, examine ads, look at Web sites, etc. Make sure your work is appropriate before you send it out. A blind mailing is a waste of postage and a waste of time for both you and the art buyer.

6. Follow directions—Always request submission guidelines. Include a SASE for reply. Follow *all* the directions exactly, even if you think they're silly.

7. Include a business letter—Always include a cover letter, no more than one page, that lets the potential buyer know you are familiar with their company, what your photography background is (briefly), and where you've sold work before (if it pertains to what you're trying to do now). If you send an e-mail, follow the same protocol as you would for a business cover letter and include the same information.

8. Send to a person, not a title—Send submissions to a specific person at a company. When you address a cover letter to Dear Sir or Madam, it shows you know nothing about the company you want to buy your work.

9. Don't forget to follow through—Follow up major submissions with postcard samples several times a year.

10. Have something to leave behind—If you're lucky enough to score a portfolio review, always have a sample of your work to leave with the art director. Make it small enough to fit in a file but big enough not to get lost. Always include your contact information directly on the leave-behind.

DIGITAL SUBMISSION GUIDELINES

Digital images can come from scanned slides, negatives or prints, or from digital cameras. Today, almost every publisher of photographs will accept digital images. Some still accept "analog" images (slides and prints) as well as digital images, but some accept *only* digital images. And, of course, there are those who still do not accept digital images at all, but their number is decreasing.

Previews

Photo buyers need to see a preview of an image before they can decide if it will fit their needs. In the past, photographers mailed slides or prints to prospective photo buyers so they could review them, determine their quality, and decide whether or not the subject matter was something they could use. Or photographers sent a self-promotion mailer, often a post-card with one or more representative images of the their work. Today, preview images can be e-mailed to prospective photo buyers, or they can be viewed on a photographer's Web site. This eliminates the hassle and expense of sending slides through the mail and wondering if you'll ever get them back.

The important thing about digital preview images is size. They should be no larger than 3 by 5 inches at 72 dpi. E-mailing larger files to someone who just wants a peek at your work could greatly inconvenience them if they have to wait a long time for the files to open or if their e-mail system cannot handle larger files. If photo buyers are interested in using your photographs, they will definitely want a larger, high-resolution file later, but don't overload their systems and their patience in the beginning with large files. Another option is sending a CD with preview images. This is not as efficient as e-mail or a Web site since the photo buyer has to put the CD in the computer and view the images one by one. If you send a CD, be sure to include a printout of thumbnail images: If the photo buyer does not have time to put the CD in the computer and view the images, she can at least glance at the printed thumbnails. CDs and DVDs are probably best reserved for high-resolution photos you know the photo buyer wants and has requested from you.

Starting a Business

For More Info

To learn more about starting a business:

- Take a course at a local college. Many community colleges offer short-term evening and weekend courses on topics like creating a business plan or finding financial assistance to start a small business.

- Contact the Small Business Administration at (800)827-5722 or check out their Web site at www.sba.gov. "The U.S. Small Business Administration was created by Congress in 1953 to help America's entrepreneurs form successful small enterprises. Today, SBA's program offices in every state offer financing, training and advocacy for small firms."

- Contact the Small Business Development Center at (202)205-6766. The SBDC offers free or low-cost advice, seminars and workshops for small business owners.

- Read a book. Try *The Business of Commercial Photography* by Ira Wexler (Amphoto Books) or *The Business of Studio Photography* by Edward R. Lilley (Allworth Press). The business section of your local library will also have many general books about starting a small business.

Size and Quality

Size and quality might be the two most important aspects of your digital submission. If the quality is not there, photo buyers will not be interested in buying your image regardless of its subject matter. Find out what the photo buyer needs. If you scan your slides or prints, make sure your scanning quality is excellent: no dirt, dust or scratches. If the file size is too small, they will not be able to do much with it either. A resolution of 72 dpi is fine for previews, but if a photo buyer wants to publish your images, they will want larger, high-resolution files. While each photo buyer may have different needs, there are some general guidelines to follow. Often digital images that are destined for print media need to be 300 dpi and the same size as the final, printed image will be (or preferably a little larger). For example, for a full-page photo in a magazine, the digital file might be 8 by 10 inches at 300 dpi. However, always check with the photo buyer who will ultimately be publishing the photo. Many magazines, book publishers, and stock photo agencies post digital submission guidelines on their Web sites or will provide copies to photographers if they ask. Photo buyers are usually happy to inform photographers of their digital guidelines since they don't want to receive images they won't be able to use due to poor quality.

Note: Many of the listings in this book that accept digital images state the dpi they require for final submissions. They may also state the size they need in terms of megabytes (MB). See subhead "Specs" in each listing.

Formats

When you know that a photo buyer is definitely going to use your photos, you will then need to submit a high-resolution digital file (as opposed to the low-resolution 72-dpi JPEGs used for previews). Photo buyers often ask for digital images to be saved as JPEGs or TIFFs. Again,

make sure you know what format they prefer. Some photo buyers will want you to send them a CD or DVD with the high-resolution images saved on it. Most photo buyers appreciate having a printout of thumbnail images to review in addition to the CD. Some may allow you to e-mail images directly to them, but keep in mind that anything larger than 9 megabytes is usually too large to e-mail. Get the permission of the photo buyer before you attempt to send anything that large via e-mail.

Another option is FTP (file transfer protocol). It allows files to be transferred over the Internet from one computer to another. This option is becoming more prevalent.

Note: Most of the listings in this book that accept digital images state the format they require for final digital submissions. See subhead "Specs" in each listing.

Color space

Another thing you'll need to find out from the photo buyer is what color space they want photos to be saved in. RGB (red, green, blue) is a very common one. You might also encounter CMYK (cyan, magenta, yellow and black). Grayscale is for photos that will be printed without any color (black & white). Again, check with the photo buyer to find out what color space they require.

USING ESSENTIAL BUSINESS FORMS

Using carefully crafted business forms will not only make you look more professional in the eyes of your clients; it will make bills easier to collect while protecting your copyright. Forms from delivery memos to invoices can be created on a home computer with minimal design skills and printed in duplicate at most quick-print centers. When producing detailed contracts, remember that proper wording is imperative. You want to protect your copyright and, at the

<div style="text-align: right">*Articles & Information*</div>

Forms for Photographers

For More Info

To learn more about forms for photographers, try the following:

- EP (Editorial Photographers), www.editorialphoto.com.

- *Business and Legal Forms for Photographers* by Tad Crawford (Allworth Press).

- *Legal Guide for the Visual Artist* by Tad Crawford (Allworth Press).

- *ASMP Professional Business Practices in Photography* (Allworth Press).

- The American Society of Media Photographers offers traveling business seminars that cover issues from forms to pricing to collecting unpaid bills. Write to them at 14 Washington Rd., Suite 502, Princeton Junction NJ 08550, for a schedule of upcoming business seminars, or visit www.asmp.org.

- The Volunteer Lawyers for the Arts, 1 E. 53rd St., 6th Floor, New York NY 10022, (212)319-2910. The VLA is a nonprofit organization, based in New York City, dedicated to providing all artists, including photographers, with sound legal advice.

same time, be fair to clients. Therefore, it's a good idea to have a lawyer examine your forms before using them.

The following forms are useful when selling stock photography, as well as when shooting on assignment:

Delivery Memo

This document should be mailed to potential clients along with a cover letter when any submission is made. A delivery memo provides an accurate count of the images that are enclosed, and it provides rules for usage. The front of the form should include a description of the images or assignment, the kind of media in which the images can be used, the price for such usage, and the terms and conditions of paying for that usage. Ask clients to sign and return a copy of this form if they agree to the terms you've spelled out.

Terms & Conditions

This form often appears on the back of the delivery memo, but be aware that conditions on the front of a form have more legal weight than those on the back. Your terms and conditions should outline in detail all aspects of usage for an assignment or stock image. Include copyright information, client liability, and a sales agreement. Also be sure to include conditions covering the alteration of your images, transfer of rights, and digital storage. The more specific your terms and conditions are to the individual client, the more legally binding they will be. If you create your forms on your computer, seriously consider altering your standard contract to suit each assignment or other photography sale.

Invoice

This is the form you want to send more than any of the others, because mailing it means you have made a sale. The invoice should provide clients with your mailing address, an explanation of usage, and the amount due. Be sure to include a reasonable due date for payment, usually 30 days. You should also include your business tax identification number or social security number.

Model/Property Releases

Get into the habit of obtaining releases from anyone you photograph. They increase the sales potential for images and can protect you from liability. A model release is a short form, signed by the person(s) in a photo, that allows you to sell the image for commercial purposes. The property release does the same thing for photos of personal property. When photographing children, remember that a parent or guardian must sign before the release is legally binding. In exchange for signed releases, some photographers give their subjects copies of the photos; others pay the models. You may choose the system that works best for you, but keep in mind that a legally binding contract must involve consideration, the exchange of something of value. Once you obtain a release, keep it in a permanent file. (You'll find a sample property release on page 17 and a sample model release on page 18.)

You do not need a release if the image is being sold editorially. However, magazines now require such forms in order to protect themselves, especially when an image is used as a photo illustration instead of as a straight documentary shot. You always need a release for advertising purposes or for purposes of trade and promotion. In works of art, you only need a release if the subject is recognizable. When traveling in a foreign country, it is a good idea to carry releases written in that country's language. To translate releases into a foreign language, check with an embassy or a college language professor.

PROPERTY RELEASE

In consideration of $_____$ and/or $_____$
$_____$, receipt of which is acknowledged, I being the legal owner of or having the right to permit the taking and use of photographs of certain property designated as $_____$, do hereby give $_____$, his/her assigns, licensees, and legal representatives the irrevocable right to use this image in all forms and media and in all manners, including composite or distorted representations, for advertising, trade, or any other lawful purposes, and I waive any rights to inspect or approve the finished product, including written copy that may be created in connection therewith.

Short description of photographs: $_____$
$_____$
$_____$

Additional information: $_____$

I am of full age. I have read this release and fully understand its contents.

Please Print:

Name $_____$

Address $_____$

City $_____$ State $_____$ Zip Code $_____$

Sample property release

Articles & Information

STOCK LIST

Some market listings in this book ask for a stock list, so it is a good idea to have one on hand. Your stock list should be as detailed and specific as possible. Include all the subjects you have in your photo files, breaking them into logical categories and subcategories. On page 19 is a sample stock list that shows how you might categorize your stock images to create a list that will be easy for photo buyers to skim. This sample list only hints at what a stock list might include. Create a list that reflects your unique collection of images.

CHARGING FOR YOUR WORK

No matter how many books you read about what photos are worth and how much you should charge, no one can set your fees for you. If you let someone try, you'll be setting yourself up for financial ruin. Figuring out what to charge for your work is a complex task that will require a lot of time and effort. But the more time you spend finding out how much you need to charge, the more successful you'll be at targeting your work to the right markets and getting the money you need to keep your business, and your life, going.

Keep in mind that what you charge for an image may be completely different from what

MODEL RELEASE

In consideration of $ _____ and/or _____,
receipt of which is acknowledged, I, _____, do
hereby give _____, his/her assigns, licensees, and
legal representatives the irrevocable right to use my image in all forms and
media and in all manners, including composite or distorted representations, for
advertising, trade, or any other lawful purposes, and I waive any rights to in-
spect or approve the finished product, including written copy that may be cre-
ated in connection therewith. The following name may be used in reference to
these photographs:

My real name, or _____

Short description of photographs: _____

Additional information: _____

Please print:

Name _____

Address _____

City _____ State _____ Zip code _____

Country _____

CONSENT

(If model is under the age of 18) I am the parent or guardian of the minor named
above and have the legal authority to execute the above release. I approve the
foregoing and waive any rights in the premises.

Please print:

Name _____

Address _____

City _____ State _____ Zip code _____

Country _____

Signature _____

Witness _____ Date _____

Sample model release

STOCK LIST

INSECTS

Ants

Aphids

Bees

Beetles

Butterflies

Grasshoppers

Moths

Termites

Wasps

PROFESSIONS

Bee Keeper

Biologist

Firefighter

Nurse

Police Officer

Truck Driver

Waitress

Welder

LANDMARKS

Asia

Angkor Wat

Great Wall of China

Europe

Big Ben

Eiffel Tower

Louvre

Stonehenge

United States

Empire State Building

Grand Canyon

Liberty Bell

Mt. Rushmore

Statue of Liberty

TRANSPORTATION

Airplanes and helicopters

Roads

Country roads

Dirt roads

Interstate highways

Two-lane highways

WEATHER

Clouds

Cumulus

Cirrus

Nimbus

Stratus

Flooding

Lightning

Snow and Blizzards

Storm Chasers

Rainbows

Tornadoes

Tornado Damage

Articles & Information

Sample stock list

a photographer down the street charges. There is nothing wrong with this if you've calculated your prices carefully. Perhaps the photographer works in a basement on old equipment and you have a brand new, state-of-the-art studio. You'd better be charging more. Why the disparity? For one thing, you've got a much higher overhead, the continuing costs of running your business. You're also probably delivering a higher-quality product and are more able to meet client requests quickly. So how do you determine just how much you need to charge in order to make ends meet?

Setting your break-even rate

All photographers, before negotiating assignments, should consider their break-even rate—the amount of money they need to make in order to keep their studios open. To arrive at the actual price you'll quote to a client, you should add onto your base rate things like usage, your experience, how quickly you can deliver the image, and what kind of prices the market will bear.

Start by estimating your business expenses. These expenses may include rent (office, studio), gas and electric, insurance (equipment), phone, fax, Internet service, office supplies, postage, stationery, self-promotions/portfolio, photo equipment, computer, staff salaries, taxes. Expenses like film and processing will be charged to your clients.

Next, figure your personal expenses, which will include food, clothing, medical, car and home insurance, gas, repairs and other car expenses, entertainment, retirement savings and investments, etc.

Before you divide your annual expenses by the 365 days in the year, remember you won't be shooting billable assignments every day. A better way to calculate your base fee is by billable weeks. Assume that at least one day a week is going to be spent conducting office business and marketing your work. This amounts to approximately 10 weeks. Add in days for vacation and sick time, perhaps three weeks, and add another week for workshops and seminars. This totals 14 weeks of nonbillable time and 38 billable weeks throughout the year.

Now estimate the number of assignments/sales you expect to complete each week and multiply that number by 38. This will give you a total for your yearly assignments/sales. Finally, divide the total overhead and administrative expenses by the total number of assignments. This will give you an average price per assignment, your break-even or base rate.

As an example, let's say your expenses come to $65,000 per year (this includes $35,000 of personal expenses). If you complete two assignments each week for 38 weeks, your average price per assignment must be about $855. This is what you should charge to break even on each job. But, don't forget, you want to make money.

Establishing usage fees

Too often, photographers shortchange themselves in negotiations because they do not understand how the images in question will be used. Instead, they allow clients to set prices and prefer to accept lower fees rather than lose sales. Unfortunately, those photographers who shortchange themselves are actually bringing down prices throughout the industry. Clients realize if they shop around they can find photographers willing to shoot assignments at very low rates.

There are ways to combat low prices, however. First, educate yourself about a client's line of work. This type of professionalism helps during negotiations because it shows buyers that you are serious about your work. The added knowledge also gives you an advantage when negotiating fees because photographers are not expected to understand a client's profession.

For example, if most of your clients are in the advertising field, acquire advertising rate cards for magazines so you know what a client pays for ad space. You can also find print ad rates in the Standard Rate and Data Service directory at the library. Knowing what a client is willing to pay for ad space and considering the importance of your image to the ad will give you a better idea of what the image is really worth to the client.

For editorial assignments, fees may be more difficult to negotiate because most magazines have set page rates. They may make exceptions, however, if you have experience or if the assignment is particularly difficult or time-consuming. If a magazine's page rate is still too low to meet your break-even price, consider asking for extra tearsheets and copies of the issue in which your work appears. These pieces can be used in your portfolio and as mailers, and the savings they represent in printing costs may make up for the discrepancy between the page rate and your break-even price.

There are still more ways to negotiate sales. Some clients, such as gift and paper product manufacturers, prefer to pay royalties each time a product is sold. Special markets, such as galleries and stock agencies, typically charge photographers a commission of 20 to 50 percent for displaying or representing their images. In these markets, payment on sales comes from the purchase of prints by gallery patrons, or from fees on the "rental" of photos by clients of stock agencies. Pricing formulas should be developed by looking at your costs and the current price levels in those markets, as well as on the basis of submission fees, commissions and other administrative costs charged to you.

Bidding for jobs

As you build your business, you will likely encounter another aspect of pricing and negotiating that can be very difficult. Like it or not, clients often ask photographers to supply bids for jobs. In some cases, the bidding process is merely procedural and the assignment will go to the photographer who can best complete it. In other instances, the photographer who submits the lowest bid will earn the job. When asked to submit a bid, it is imperative that you find out which bidding process is being used. Putting together an accurate estimate takes time, and you do not want to waste your efforts if your bid is being sought merely to meet some budget quota.

If you decide to bid on a job, it's important to consider your costs carefully. You do not want to bid too much on projects and repeatedly get turned down, but you also don't want to bid too low and forfeit income. When a potential client calls to ask for a bid, consider these dos and don'ts:

1. Always keep a list of questions by the telephone so you can refer to it when bids are requested. The answers to the questions should give you a solid understanding of the project and help you reach a price estimate.

2. Never quote a price during the initial conversation, even if the caller pushes for a "ballpark figure." An on-the-spot estimate can only hurt you in the negotiating process.

3. Immediately find out what the client intends to do with the photos, and ask who will own copyrights to the images after they are produced. It is important to note that many clients believe if they hire you for a job they'll own all the rights to the images you create. If they insist on buying all rights, make sure the price they pay is worth the complete loss of the images.

4. If it is an annual project, ask who completed the job last time, then contact that photographer to see what he or she charged.

5. Find out who you are bidding against and contact those people to make sure you received the same information about the job. While agreeing to charge the same price is illegal, sharing information about reaching a price is not.

6. Talk to photographers not bidding on the project and ask them what they would charge.

7. Finally, consider all aspects of the shoot, including preparation time, fees for assistants and stylists, rental equipment, and other materials costs. Don't leave anything out.

Pricing Information

For More Info

Where to find more information about pricing:

- *Pricing Photography: The Complete Guide to Assignment and Stock Prices* by Michal Heron and David MacTavish (Allworth Press).

- *ASMP Professional Business Practices in Photography* (Allworth Press).

- *fotoQuote*, a software package produced by the Cradoc Corporation, is a customizable, annually updated database of stock photo prices for markets from ad agencies to calendar companies. The software also includes negotiating advice and scripted telephone conversations. Call (800)679-0202, or visit www.fotoquote.com for ordering information.

- Stock Photo Price Calculator, a Web site that suggests fees for advertising, corporate and editorial stock, http://photographersindex.com/stockprice.htm.

- EP (Editorial Photographers), www.editorialphoto.com.

FIGURING SMALL BUSINESS TAXES

Whether you make occasional sales from your work or you derive your entire income from your photography skills, it's a good idea to consult with a tax professional. If you are just starting out, an accountant can give you solid advice about organizing your financial records. If you are an established professional, an accountant can double-check your system and maybe find a few extra deductions. When consulting with a tax professional, it is best to see someone who is familiar with the needs and concerns of small business people, particularly photographers. You can also conduct your own tax research by contacting the Internal Revenue Service.

Self-employment tax

As a freelancer it's important to be aware of tax rates on self-employment income. All income you receive over $400 without taxes being taken out by an employer qualifies as self-employment income. Normally, when you are employed by someone else, the employer shares responsibility for the taxes due. However, when you are self-employed, you must pay the entire amount yourself.

Freelancers frequently overlook self-employment taxes and fail to set aside a sufficient amount of money. They also tend to forget state and local taxes. If the volume of your photo sales reaches a point where it becomes a substantial percentage of your income, then you are required to pay estimated tax on a quarterly basis. This requires you to project the amount of money you expect to generate in a three-month period. However burdensome this may be in the short run, it works to your advantage in that you plan for and stay current with the various taxes you are required to pay. Read IRS publication #505 (Tax Withholding and Estimated Tax).

Deductions

Many deductions can be claimed by self-employed photographers. It's in your best interest to be aware of them. Examples of 100-percent-deductible claims include production costs of résumé, business cards and brochures; photographer's rep commissions; membership dues; costs of purchasing portfolio materials; education/business-related magazines and books; insurance; and legal and professional services.

Additional deductions can be taken if your office or studio is home-based. The catch here is that your work area must be used only on a professional basis; your office can't double as a family room after hours. The IRS also wants to see evidence that you use the work space on a regular basis via established business hours and proof that you've actively marketed your work. If you can satisfy these criteria, then a percentage of mortgage interests, real estate taxes, rent, maintenance costs, utilities and homeowner's insurance, plus office furniture and equipment, can be claimed on your tax form at year's end.

In the past, to qualify for a home-office deduction, the space you worked in had to be "the most important, consequential, or influential location" you used to conduct your business. This meant that if you had a separate studio location for shooting but did scheduling, billing and record keeping in your home office, you could not claim a deduction. However, as of 1999, your home office will qualify for a deduction if you "use it exclusively and regularly for administrative or management activities of your trade or business and you have no other fixed location where you conduct substantial administrative or management activities of your trade or business." Read IRS publication #587, Business Use of Your Home, for more details.

If you are working out of your home, keep separate records and bank accounts for personal and business finances, as well as a separate business phone. Since the IRS can audit tax records as far back as seven years, it's vital to keep all paperwork related to your business. This includes invoices, vouchers, expenditures and sales receipts, canceled checks, deposit slips, register tapes and business ledger entries for this period. The burden of proof will be on you if the IRS questions any deductions claimed. To maintain professional status in the eyes of the IRS, you will need to show a profit for three years out of a five-year period.

Tax Information

For More Info

To learn more about taxes, contact the IRS. There are free booklets available that provide specific information, such as allowable deductions and tax rate structure:

- Tax Guide for Small Businesses, #334
- Travel, Entertainment, Gift and Car Expenses, #463
- Tax Withholding and Estimated Tax, #505
- Business Expenses, #535
- Accounting Periods and Methods, #538
- Business Use of Your Home, #587

To order any of these booklets, phone the IRS at (800)829-3676. IRS forms and publications, as well as answers to questions and links to help, are available on the Internet at www.irs.gov.

Sales tax

Sales taxes are complicated and need special consideration. For instance, if you work in more than one state, use models or work with reps in one or more states, or work in one state and store equipment in another, you may be required to pay sales tax in each of the states that apply. In particular, if you work with an out-of-state stock photo agency that has clients over a wide geographic area, you should explore your tax liability with a tax professional.

As with all taxes, sales taxes must be reported and paid on a timely basis to avoid audits and/or penalties. In regard to sales tax, you should:

- Always register your business at the tax offices with jurisdiction in your city and state.
- Always charge and collect sales tax on the full amount of the invoice, unless an exemption applies.
- If an exemption applies because of resale, you must provide a copy of the customer's resale certificate.
- If an exemption applies because of other conditions, such as selling one-time reproduction rights or working for a tax-exempt, nonprofit organization, you must also provide documentation.

SELF-PROMOTION

There are basically three ways to acquaint photo buyers with your work: through the mail, over the Internet, or in person. No one way is better or more effective than another. They each serve an individual function and should be used in concert to increase your visibility and, with a little luck, your sales.

Self-promotion mailers

When you are just starting to get your name out there and want to begin generating assignments and stock sales, it's time to design a self-promotion campaign. This is your chance to do your best, most creative work and package it in an unforgettable way to get the attention of busy photo buyers. Self-promotions traditionally are sample images printed on card stock and sent through the mail to potential clients. If the image you choose is strong and you carefully target your mailing, a traditional self-promotion can work.

But don't be afraid to go out on a limb here. You want to show just how amazing and creative you are, and you want the photo buyer to hang onto your sample for as long as

Ideas for Great Self-Promotions

For More Info

Where to find ideas for great self-promotions:

- *HOW* magazine's self-promotion annual (October issue).
- *Self-Promotion Online* by Ilise Benun (North Light Books).
- *Photo District News* magazine's self-promotion issue (April).
- *The Photographer's Guide to Marketing & Self-Promotion* by Maria Piscopo (Allworth Press).
- *Marketing Guidebook for Photographers* by Mary Virginia Swanson, available at www.mvswanson.com or by calling (520)742-6311.

possible. Why not make it impossible to throw away? Instead of a simple postcard, maybe you could send a small, usable notepad with one of your images at the top, or a calendar the photo buyer can hang up and use all year. If you target your mailing carefully, this kind of special promotion needn't be expensive.

If you're worried that a single image can't do justice to your unique style, you have two options. One way to get multiple images in front of photo buyers without sending an overwhelming package is to design a campaign of promotions that builds from a single image to a small group of related photos. Make the images tell a story and indicate that there are more to follow. If you are computer savvy, the other way to showcase a sampling of your work is to point photo buyers to an online portfolio of your best work. Send a single sample that includes your Internet address, and ask buyers to take a look.

Web sites

Web sites are steadily becoming more important in the photographer's self-promotion repertory. If you have a good collection of digital photographs—whether they have been scanned from film or are from a digital camera—you should consider creating a Web site to showcase samples of your work, provide information about the type of work you do, and display your contact information. The Web site does not have to be elaborate or contain every photograph you've ever taken. In fact, it is best if you edit your work very carefully and choose only the best images to display on your Web site. The benefit of having a Web site is that it makes it so easy for photo buyers to see your work. You can send e-mails to targeted photo buyers and include a link to your Web site. Many photo buyers report that this is how they prefer to be contacted. Of course, your URL should also be included on any print materials, such as postcards, brochures, your business cards and stationery. Some photographers even include their URL in their credit line.

Portfolio presentations

Once you've actually made contact with potential buyers and piqued their interest, they'll want to see a larger selection of your work—your portfolio. Once again, there's more than one way to get this sampling of images in front of buyers. Portfolios can be digital—stored on a disk or CD-ROM, or posted on the Internet. They can take the form of a large box or binder and require a special visit and presentation by you. Or they can come in a small binder and be sent through the mail. Whichever way(s) you choose to showcase your best work, you should always have more than one portfolio, and each should be customized for potential clients.

Keep in mind that your portfolios should contain your best work (dupes only). Never put originals in anything that will be out of your hands for more than a few minutes. Also, don't include more than 20 images. If you try to show too many pieces you'll overwhelm the buyer, and any image that is less than your best will detract from the impact of your strongest work. Finally, be sure to show only work a buyer is likely to use. It won't do any good to show a shoe manufacturer your shots of farm animals or a clothing company your food pictures. For more detailed information on the various types of portfolios and how to select which photos to include and which ones to leave out, see *Photo Portfolio Success* by John Kaplan (Writer's Digest Books).

Do you need a résumé?

Some of the listings in this book say to submit a résumé with samples. If you are a freelancer, a résumé may not always be necessary. Sometimes a stock list or a list of your clients may suffice, and may be all the photo buyer is really looking for. If you do include a résumé, limit the details to your photographic experience and credits. If you are applying for a position teaching photography or for a full-time photography position at a studio, corporation, newspaper, etc.,

you will need the résumé. Galleries that want to show your work may also want to see a résumé, but, again, confine the details of your life to significant photographic achievements.

ORGANIZING AND LABELING YOUR IMAGES

It will be very difficult for you to make sales of your work if you aren't able to locate a particular image in your files when a buyer needs it. It is imperative that you find a way to organize your images—a way that can adapt to a growing file of images. There are probably as many ways to catalog photographs as there are photographers. However, most photographers begin by placing their photographs into large, general categories such as landscapes, wildlife, countries, cities, etc. They then break these down further into subcategories. If you specialize in a particular subject—birds, for instance—you may want to break the bird category down further into cardinal, eagle, robin, osprey, etc. Find a coding system that works for your particular set of photographs. For example, nature and travel photographer William Manning says, "I might have slide pages for Washington, DC (WDC), Kentucky (KY), or Italy (ITY). I divide my mammal subcategory into African wildlife (AWL), North American wildlife (NAW), zoo animals (ZOO)."

After you figure out a coding system that works for you, find a method for captioning your slides. Captions with complete information often prompt sales: Photo editors appreciate having as much information as possible. Always remember to include your name and copyright symbol © on each photo. Computer software can make this job a lot easier. Programs such as Emblazon (www.planettools.com), formerly CaptionWriter, allow photographers to easily create and print labels for their slides.

The computer also makes managing your photo files much easier. Programs such as FotoBiz (www.fotobiz.net) and StockView (www.hindsightltd.com) are popular with freelance assignment and stock photographers. FotoBiz has an image log and is capable of creating labels. FotoBiz can also track your images and allows you to create documents such as delivery memos, invoices, etc. StockView (www.hindsightltd.com/stockview/stockview.ht ml) also tracks your images, has labeling options, and can create business documents.

Image Organization and Storage

For More Info

To learn more about selecting, organizing, labeling and storing images, see:

- *The Photographer's Travel Guide* by William Manning (Writer's Digest Books).

- *Photo Portfolio Success* by John Kaplan (Writer's Digest Books).

- *Sell & Re-Sell Your Photos* by Rohn Engh, 5th edition (Writer's Digest Books).

PROTECTING YOUR COPYRIGHT

There is one major misconception about copyright: Many photographers don't realize that once you create a photo it becomes yours. You (or your heirs) own the copyright, regardless of whether you register it for the duration of your lifetime plus 70 years.

The fact that an image is automatically copyrighted does not mean that it shouldn't be

registered. Quite the contrary. You cannot even file a copyright infringement suit until you've registered your work. Also, without timely registration of your images, you can only recover actual damages—money lost as a result of sales by the infringer plus any profits the infringer earned. For example, recovering $2,000 for an ad sale can be minimal when weighed against the expense of hiring a copyright attorney. Often this deters photographers from filing lawsuits if they haven't registered their work. They know that the attorney's fees will be more than the actual damages recovered, and, therefore, infringers go unpunished.

Registration allows you to recover certain damages to which you otherwise would not be legally entitled. For instance, attorney fees and court costs can be recovered. So too can statutory damages—awards based on how deliberate and harmful the infringement was. Statutory damages can run as high as $100,000. These are the fees that make registration so important.

In order to recover these fees, there are rules regarding registration that you must follow. The rules have to do with the timeliness of your registration in relation to the infringement:

- **Unpublished images** must be registered before the infringement takes place.
- **Published images** must be registered within three months of the first date of publication or before the infringement began.

The process of registering your work is simple. Contact the Register of Copyrights, Library of Congress, Washington, DC 20559, (202)707-9100, and ask for Form VA (works of visual art). Registration costs $30, but you can register photographs in large quantities for that fee. For bulk registration, your images must be organized under one title, for example, "The works of John Photographer, 1990-1995."

The copyright notice

Another way to protect your copyright is to mark each image with a copyright notice. This informs everyone reviewing your work that you own the copyright. It may seem basic, but in court this can be very important. In a lawsuit, one avenue of defense for an infringer is "innocent infringement"—basically the "I-didn't-know" argument. By placing a copyright notice on your images, you negate this defense for an infringer.

The copyright notice basically consists of three elements: the symbol, the year of first publication, and the copyright holder's name. Here's an example of a copyright notice for an image published in 1999: © 1999 John Q. Photographer. Instead of the symbol ©, you can use the word "Copyright" or simply "Copr." However, most foreign countries prefer © as a common designation.

Also consider adding the notation "All rights reserved" after your copyright notice. This phrase is not necessary in the U.S. since all rights are automatically reserved, but it is recommended in other parts of the world.

Know your rights

The digital era is making copyright protection more difficult. As this technology grows, more and more clients will want digital versions of your photos. Don't be alarmed, just be careful. Your clients don't want to steal your work. When you negotiate the usage of your work, consider adding a phrase to your contract that limits the rights of buyers who want digital versions of your photos. You might want them to guarantee that images will be removed from their computer files once the work appears in print. You might say it's okay to perform limited digital manipulation, and then specify what can be done. The important thing is to discuss what the client intends to do and spell it out in writing.

It's essential not only to know your rights under the Copyright Law, but also to make sure

that every photo buyer you deal with understands them. The following list of typical image rights should help you in your dealings with clients:

- **One-time rights.** These photos are "leased" or "licensed" on a one-time basis; one fee is paid for one use.
- **First rights.** This is generally the same as purchase of one-time rights, though the photo buyer is paying a bit more for the privilege of being the first to use the image. He may use it only once unless other rights are negotiated.
- **Serial rights.** The photographer has sold the right to use the photo in a periodical. This shouldn't be confused with using the photo in "installments." Most magazines will want to be sure the photo won't be running in a competing publication.
- **Exclusive rights.** Exclusive rights guarantee the buyer's exclusive right to use the photo in his particular market or for a particular product. A greeting card company, for example, may purchase these rights to an image with the stipulation that it not be sold to a competing company for a certain time period. The photographer, however, may retain rights to sell the image to other markets. Conditions should always be put in writing to avoid any misunderstandings.
- **Electronic rights.** These rights allow a buyer to place your work on electronic media such as CD-ROMs or Web sites. Often these rights are requested with print rights.
- **Promotion rights.** Such rights allow a publisher to use a photo for promotion of a publication in which the photo appears. The photographer should be paid for promotional use in addition to the rights first sold to reproduce the image. Another form of this—agency promotion rights—is common among stock photo agencies. Likewise, the terms of this need to be negotiated separately.
- **Work for hire.** Under the Copyright Act of 1976, section 101, a "work for hire" is defined as: "(1) a work prepared by an employee within the scope of his or her employment; or (2) a work . . . specially ordered or commissioned for use as a contribution to a collective, as part of a motion picture or audiovisual work or as a supplementary work . . . if the parties expressly agree in a written instrument signed by them that the work shall be considered a work made for hire."

Protecting Your Copyright

For More Info

How to learn more about protecting your copyright:

- Call the Copyright Office at (202)707-3000 or check out their Web site, http://lcweb.loc.gov/copyright, for forms and answers to frequently asked questions.
- ASMP (American Society of Media Photographers), www.asmp.org/commerce/legal/copyright.
- EP (Editorial Photographers), www.editorialphoto.com.
- *Legal Guide for the Visual Artist* by Tad Crawford, Allworth Press.
- *SPAR* (Society of Photographers and Artists Representatives), (212)779-7464.

- **All rights.** This involves selling or assigning all rights to a photo for a specified period of time. This differs from work for hire, which always means the photographer permanently surrenders all rights to a photo and any claims to royalties or other future compensation. Terms for all rights—including time period of usage and compensation—should only be negotiated and confirmed in a written agreement with the client.

It is understandable for a client not to want a photo to appear in a competitor's ad. Skillful negotiation usually can result in an agreement between the photographer and the client that says the image(s) will not be sold to a competitor, but could be sold to other industries, possibly offering regional exclusivity for a stated time period.

Ralph Lee Hopkins

Capturing the Beauty of Wild Places

© Mindy Say

by Donna Poehner

With a graduate degree in geology, photographer Ralph Lee Hopkins turns his well-trained eye on nature and wildlife, producing beautifully simple images that convey emotion. From the Colorado Rockies to Antarctica, he's traveled to some of the best locations for photographing the beauty of the wilderness and has built a successful photography career with his winning style. Hopkins' work has been published in *National Geographic*, *Arizona Highways*, *Audubon*, *Outside*, and many other national publications. His photos have also found their way into several books and calendars. However, Hopkins does not contain his marketing efforts to editorial clients. He also leads photo expeditions and teaches workshops and has begun selling his photographs as fine art prints. His photographs are also represented by a variety of stock agencies, including Getty Images, Lonely Planet Images, and the National Geographic Image Collection. Here, this seasoned photographer shares what he's learned about photographing in the wild and reveals how photographers can stay afloat by creating multiple income streams from their work.

How did you get started in photography? Did your study of geology (especially in the Grand Canyon) influence your photography? What else has contributed to your development as a photographer?

I didn't set out to be a photographer. Instead, photography found me when I first saw the red-rock landscapes of Utah. Right out of college I worked as a field geologist in remote places across the West. I was seeing things every day that I had never seen in a photograph. Next thing I knew I had an old Graflex Crown Graphic 4×5 view camera. I taught myself about light and composition lugging my 4×5 camera around, even when backpacking. Film was expensive for me back then. Sometimes I would head out for a week with just 10 sheets of film. I had to learn to be very selective before clicking the shutter. But it wasn't until working on my master's degree that I came into my own as a photographer. I attended Northern Arizona University in Flagstaff so that I could study in the Grand Canyon. Many of the photos I made while in graduate school were later published in *Arizona Highways* magazine. If it weren't for my geology background I probably would not be a photographer. The more you know about the landscape—the kinds of landforms and how they evolved—the more you see out there to photograph. For me, it's an endless cycle. It's like I have to photograph to live. I can't drive around the block without seeing a potential photo.

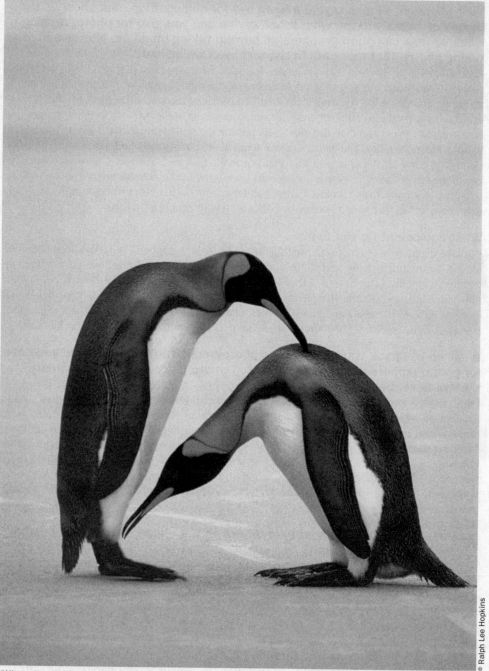

© Ralph Lee Hopkins

"When there are hundreds of penguins around, it's challenging to find simple compositions, and animal behavior may only last a couple seconds. This is one of my bestselling images because of the symmetry and pleasing white background," says Hopkins of this image of two penguins making a courtship bow.

Your photos of wildlife reveal a keen eye for composition, and show us the beauty of animals in the wild. What advice can you give for photographing wildlife? How can photographers go beyond taking mundane photos and start taking photos that more are lively, and even whimsical?

Photographing wildlife is a real challenge. You must be a naturalist first and learn about your subjects. This helps put you in good situations at the right time of year. Knowing something about the animals helps you anticipate their behavior and recognize the special moments. My eye is drawn to simple compositions with strong elements of design. I try to make images that have a visual impact and that also effectively portray the soul of the animal. I like to use motion to bring life to the image and also a shallow depth of field to make the animals jump out against clean backgrounds. But it is also important to make images that show a sense of place and reveal the environment in which the animals live. Many of the animals we are photographing today are in trouble, from climate change, habitat loss, or both. I believe photography may help save many of the threatened species by connecting with people who care.

What equipment do you use?

With the digital revolution, it's an exciting time to be a photographer. Digital has been liberating for me. I experiment more and shoot in difficult lighting situations that I would not have attempted with film. I still have a Linhof 4×5 camera and a medium-format Pentax, but my last film order has been in the freezer for several years. I work mostly with Canon digital SLR cameras now, from the 5D up to the 1D series. I carry a range of lenses, including a 15mm fish-eye, 16-35mm, 24-70mm, 70-200mm and 300mm, plus a couple of flash units for fill flash.

What do you pack when going on a photography trip? What tips do you have for photographers planning to travel to remote places, or to somewhere they've never been before?

I tend to be a minimalist when it comes to equipment. I work with two camera bodies and a range of lenses from wide-angle to telephoto. I also carry a laptop and portable hard drives for storing images. Too many photographers get bogged down with their equipment and miss the key moments messing with their gear. For travel photography, take only what you can carry and work from a belt pack or shoulder bag to protect your gear where there are people. For wildlife photography, work from a compartmentalized backpack so that you can bring the arsenal, and be sure to have an umbrella and camera hoods for working in bad weather.

It seems you've been almost everywhere on the planet. To what places have you traveled to photograph?

Actually, I've been to relatively few places around the world, but I've been there many times. I've been fortunate over the last 18 years to work with Lindblad Expeditions, and more recently National Geographic. I've carved a niche developing the photography programs on the Lindblad ships and have been lucky to travel to some of the wildest places on earth: Arctic Norway, the Antarctic, Baja California and the Galápagos Islands. I've also taken many trips to southeast Alaska and the British Isles, and each year I lead a photo workshop on the Colorado River through the Grand Canyon with *Arizona Highways*. I'm writing this interview on board the National Geographic Endeavour on the way to South Georgia and Antarctica. There is no place on earth as wild and remote as Antarctica, and the island of South Georgia is one of the last best places on earth for wildlife photography.

What do you think makes a good nature photograph?

Like any image, a good nature photograph should combine three basic elements: a strong composition; dramatic or interesting light; and, perhaps most importantly, it must capture

the uniqueness of the moment. It takes hard work and patience to combine all three of these elements in a single image, but this is what it's all about.

How did you start your association with National Geographic? What specifically have you done for them? Do you think things have changed since you first started working for them? Would it be harder today for a photographer to break into that market?

My association started years ago with a National Geographic book project on the Grand Canyon for which I contributed a number of images. More recently I've been teaching workshops and seminars around the country and leading photo expeditions with the Lindblad Expeditions/National Geographic alliance. My images are also represented by the National Geographic Image Collection, which is their stock library. I also tour with *National Geographic Traveler* magazine presenting the seminar "Travel Photography in the Digital World" with Bob Krist. With digital there are more opportunities for photographers than ever before, but there is also more competition, so it's getting harder and harder to break in. However, if you have unique coverage or a fresh look at the familiar, you have a fighting chance.

You've also photographed for *Arizona Highways*, *Outside* and other publications. How did assignments with these magazines come about?

Actually, I don't do that many assignments. Most of my work with these and other magazines has been on a freelance basis where I have submitted a body of work that caught the editor's eye. I like to call them "self-assignments," which is a great way to work because you can set your own deadlines.

© Ralph Lee Hopkins

Hopkins loves photographing polar bears and travels to Arctic Norway each summer to do so. "To capture special moments or interesting behavior, it helps to know something about the animal. Polar bears test the ice before jumping, a signal to get ready. It helps to use motor-drive, or what is called continuous or burst mode in digital, to capture the action," says Hopkins.

Tell me about one of your favorite assignments. Who was it for, and why did you like it?

My first book assignment for Mountaineers Books in Seattle stands out. The title of the book was *Hiking Colorado's Geology*, which I photographed and co-authored with my wife, Lindy. This project tested me both conceptually (How do you summarize billions of years?) and physically (Colorado has a lot of mountains!). Since I am both a geologist and a photographer, this was a dream project for me. And all the hiking got me in the best shape of my life.

Do you consider yourself primarily a stock photographer?

My business model is one of multiple revenue streams, of which stock plays a big part, as does the photo expedition work with Lindblad and National Geographic. My work is primarily represented by National Geographic, Lonely Planet Images, Photo Researchers and Getty Images. But I also enjoy writing and teaching workshops. The key is to always have a lot of irons in the fire.

Do you also try to sell your stock on your own?

For years, selling stock on my own was the bread and butter of my business. But over the last few years I have transitioned away from this to focus on specific projects I am interested in. However, I still make direct sales to a handful of clients that I built a relationship with, and this will always be an important part of my business.

What changes have you seen in the stock industry in recent years, especially for nature photography?

This is a depressing question, actually. The market is being saturated with images, and digital technology is a major reason for this. True, the playing field may be more level in some respects, but, sadly, many hungry photographers are hurting the industry by giving away their work for pennies to royalty-free or microstock agencies. Research any animal or nature concept online with Getty or Corbis, and you will see what I mean.

Do you think stock is still a viable way to make a living as a photographer?

Hopefully, stock will always be an important income stream for photographers, but it's crucial to have images online with the large agencies. Like it or not, royalty-free is a force in the business and is driving prices down. More and more it's one-stop shopping, and no one knows what the future holds. The hope is that there are more and more buyers out there, so that the volume of sales will increase over time and offset the lower prices. I strongly recommend that photographers diversify their business as soon as possible.

What are some of your best-selling images, and why do you think they sell well?

"Courtship Bow," my image of king penguins in the Falkland Islands is a top seller because of its emotional impact, symmetry, and clean, white background. But many of my best-selling images are not necessarily what I consider to be my best images. Classic landscape scenes from the Galápagos and Grand Canyon sell over and over, but not because they are great or unique images. Simple and iconic images seem to sell best as stock.

Do you think the market has become overloaded with nature photos? What can nature photographers do to set themselves apart?

True, in the digital and online world there is a glut of nature images. To survive, photographers need to work hard and develop a unique body of work. But you don't have to go to the ends of the earth—start by photographing your own back yard in a new way.

What are some other ways photographers can make money with their nature photos?

Start small, maybe with a local project and create a niche for yourself. It's much easier to market yourself if you can write a story or article to accompany your images. For example, produce a story about a local conservation project and query local or regional magazines. Or work directly with a local conservation organization. Once you are published, no matter what the scale, you'll be amazed at the kind of connections you will make and the other opportunities that will come your way. Another idea is to self-publish your own book. Self-publishing is becoming a more viable option with all the online book publishers out there. This way you can produce one copy at a time and build your market over time, instead of incurring the big upfront costs of traditional publishing. Do whatever it takes to get your work out there. Unless it's for a good cause or nonprofit organization, never ever give your work away with a promise of a photo credit. If you produce good work, it will be worth something to someone.

What is the main thing you try to get across in your workshops? What do budding photographers need to learn about the craft?

Photography is a creative and important medium for self-discovery and personal expression. But with the digital revolution there's so much talk about the technical side of photography. In my workshops I try to bring aspiring photographers back to thinking about the creative side. In the end it's not about the kind of camera you use: It all comes down to your own unique vision. Learn to explore your vision and see where it takes you.

© Ralph Lee Hopkins

"The downside of digital is that many people think this is a composite image. It's not. The image was made at dawn on a sub-zero morning along the Chilkat River near Haines, Alaska. The moon actually moves pretty fast, so I had to continually move the tripod slightly to keep the eagle framed by the moon," says Hopkins.

Do you have any other advice for outdoor/travel photographers?

If you are serious about photography, give in to your passion and live life as a photographer. That doesn't mean you must quit your real job. You can still be a photographer without making it your profession. If you think of photography as a means of making a lot of money, think again. Start with weekend trips. Get out in bad weather and dramatic light. Shoot the seasons. To be good at anything you must practice. Make images that are simple but have an emotional impact. Adopt a personal project and see it through. Hopefully, your friends and family will share, or at least understand, your passion. It's more about a way of life and a different way of seeing the world. But, like anything, photography can become an obsession. Seek balance in your life and let creativity have its place. If that leads to travel to wild and exotic places, be thankful and show gratitude.

Paul H. Henning

How to Thrive in the Ever-Changing
Stock Photo Business

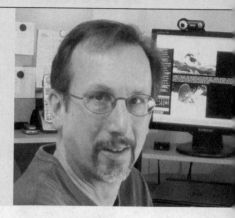

by Donna Poehner

Because I've been down so many roads in the stock business, I can save photographers a lot of wasted time, effort and expense by pointing them in the right direction," says Paul H. Henning, owner of Stock Answers LLC, a consultancy dedicated to helping stock photographers and stock photo agencies improve their businesses.

In more than two decades of working in the stock photo industry, Henning has been a photographer, stock agency owner, and manager of European operations for a large, global stock agency. In his current role as consultant, he helps photographers and stock agencies of all sizes with a wide array of issues and needs. In this interview Henning discusses the challenges facing stock photographers today and offers advice on how to be successful in a changing business environment.

The stock photo industry is changing at such a rapid pace. What do you think are the biggest changes that have affected photographers recently?

The trend of mergers and acquisitions by stock agencies is perhaps the thing that has affected photographers the most. This trend started over a decade ago and continues right up through today. The result of this massive change in the stock industry is that many formerly independent stock agencies have simply disappeared, either swallowed up by "larger fish" in the sea of stock or put out of business by The Big Boys (Getty Images, Corbis, and Jupiter Images). This has given some shooters a wonderful opportunity to capitalize upon the increased global reach of whatever new entity their work may reside at as a result of such mergers. However, for far more photographers it has resulted in declining revenue (due to increased in-house competition) and far fewer new images being accepted and thus making it into the market-place. For photographers who were not already with an agency, their opportunities for agency representation have shrunk considerably, while simultaneously the chances of getting into one of The Big Boys have declined to somewhere between slim and none.

That doesn't mean all is doom and gloom, of course: Photographers have far more options for marketing their images today than they've ever had in the past. But the method of working through traditional stock agencies has changed dramatically and is no longer the golden goose that it once was. I think the trend of mergers and acquisitions will continue as well as the introduction of new licensing models (subscription, micropayment, no payment, etc.). It will be fascinating not only to observe how the business continues to change, but also to see how photographers respond to those changes.

© Jerry and Marcy Monkman/EcoPhotography.com

Images of outdoor recreation, adventure and sports are consistent top-selling subjects in stock. Notice how photographer Jerry Monkman deliberately composed the picture so that it could run as a double-trucked illustration across two pages. Also note the "empty" space at the top and bottom of the left side, which can be used by art directors and designers for a headline, text or even to drop in another photo.

Microstock is emerging as a real contender in the stock photo industry. Do you think it is a viable business model for the photographer?

The introduction of "microstock" (cheap stock photos, available for anywhere from $1 to $5 per image) is reminiscent of the debut of royalty-free imagery just over a decade ago. From a buyer's perspective, obviously, the price is right! The question for those same buyers, though, is: Can you really find what you want? For photographers, the jury is definitely out on whether or not it's a viable model. I truly do not believe that photographers can survive when their pictures are being sold for a buck a piece (and, don't forget, the microstock agency is taking their cut of that, too!). At a rate of five or ten bucks, though, *if* a microsite generates really high-volume sales, maybe a photographer can make a living from that.

But let's not forget that there is a wide disparity between the costs of image production for photographers, depending upon the type of work they do. A photographer who shoots nature images, for example, will probably have radically lower costs of doing business compared to the shooter who specializes in people and lifestyles, which often require stylists, models, location fees, etc. So, whether or not microstock will "work" for a photographer has a lot to do with his particular business plan, his area of specialization, and his costs of doing business. High-overhead shooters probably won't want to go the microstock route, while those with very low costs of doing business may find microstock a viable channel for getting their pictures into the marketplace, perhaps as a supplement to other forms of image marketing rather than as an exclusive distribution model.

Whenever somebody comes along with a radical new idea, they're generally greeted with skepticism (at best) or the desire on the part of the established interests to string 'em up (at worst). Why? Because the established entities see a potential threat, whether real or imagined. For a long time many professional photographers stuck their heads in the sand, wishing

royalty-free would just go away. They pretended that RF was a moral issue and that by shooting RF, their brethren (who kept a very low profile, by the way, for fear of being ostracized) had crossed some invisible line and gone over to the dark side. Well, guess what? Royalty free isn't a moral issue, and neither is microstock. They are *business* issues, and decisions should be made after a dispassionate re-evaluation of one's business model and business plan. If, after careful analysis, participating in royalty-free production, or selling through a micropayment site, makes good business sense, then a photographer would be a pretty poor businessperson not to jump on board. Hopefully, most of the photographers out there have learned from the RF experience and this time won't wait until the train has already pulled far away from the station before they climb on board.

Can smaller stock agencies be successful competing against the giants like Getty, Corbis and Jupiter? What advice do you have for these small agencies to succeed?

My clients ask me this question often: Do we have a future? And the answer is . . . maybe. Now, that might sound like a cop-out, but it's not. The truth is that today's small niche agencies that are extremely focused and do what they do better than anyone else within that niche have a great opportunity to succeed—depending, of course, upon how you define ''success.'' On the other hand, any agency that doesn't have a very well-thought-out identity, or isn't the best at what they do, or lacks expertise in dealing with down-and-dirty business issues like marketing, personnel and finances, will die a slow and painful death.

This is the era of the specialist, not the generalist; narrowcasting, not broadcasting; customized solutions, not one-size-fits-all. There's a great opening for niche players, but they have to be really smart about what they do and how they do it. Sure, the Wal-Marts of stock are doing great, and there's a sizable place for them in the stock universe. But don't forget, there's a negative reaction to Wal-Mart in some quarters; and don't think that it's any different in our business.

Can photographers be successful targeting individual photo buyers and photo researchers? Or are these photo buyers simply getting their stock photos from the big agencies? Any advice on how individual photographers can reach these buyers and persuade them to buy their stock?

Corbis and Getty are well established; they often have ''deals'' with the big publishers; and they are habit-forming. But I think picture buyers are extremely schizophrenic. On the one hand, they like the Web sites of the Big Boys, and they like the ease of making purchases with them. At the same time, I have also heard them say that they are bored with seeing the same images time after time. They don't feel the Big Boys have a sufficient depth of material (at least in the editorial sector), and they are turned off by their methods of doing business.

Further, don't forget that art buyers are under constant pressure to come up with something new, different and more creative than their competitors. How creative and different can you be if you're always using the same two picture sources as everybody else? That is a huge issue that I don't think gets nearly enough recognition, including by The Big Boys' competitors!

Can individual photographers exploit this and market directly to these image buyers? Sure, if they have the time, energy and smarts to do it right. It takes real work to market directly to picture buyers on a consistent basis, and some shooters just don't have the skills to do it. In other cases, it's not even a good use of a photographer's time: Perhaps she is far happier and far more profitable concentrating on *making* images rather than *marketing* them. But that's where a photographer has to analyze what they do and how they do it to determine what works best for their specific scenario.

What are some trends in stock photography today? How can photographers keep up with the trends?

One of the jobs of a stock photographer is to stay tuned into the needs of the marketplace. In other words, what are the trends, both in terms of subject matter and photographic style? And, of course, the really successful photographers are the ones who *set* the trends, not just follow them. Spend time at the magazine stand looking at images, watch what's being broadcast on cable or satellite television, read the Wall Street Journal, read books or rent books-on-disc about the changes taking place in business and society in general. For example: What's the fastest growing ethnic minority in the United States? Answer: Hispanics. One of my clients focuses on people and lifestyle images for stock. He makes sure that at least 50 percent of everything he shoots includes Latin American models, and he's making a killing because the demand is rising so dramatically for these sorts of images. Remember: Stock has to mirror the world around us, so any photographer who wants to be successful has to produce images that are representative of what the world looks like at the moment, not several moments ago.

How have styles of stock photographs changed over the years? Is there a "shelf life" for a typical stock image?

Styles change much faster now in stock photography. Stock has to be very trendy, very "of the moment" and reflect current fashions, hairstyles, accessories, etc. Today, anything goes as far as technique: black & white, tilted horizon lines, soft focus, extremely shallow depth of field, in-your-face close-ups, and action. There seems to be a place for just about anything and everything. But if there are people in the image, then obviously there is a definite shelf life to a stock shot.

What types of images are most in demand today?

The same ones that were in demand 10 or 20 years ago: fresh interpretations of timeless concepts (love, family, patriotism, success, effort, etc.). The concepts behind successful stock shots don't change a whole lot as the years pass by; what does change is the visual interpretation of them. The best-selling images of all, of course, have people in them, and usually fall into the categories of lifestyles, business, families, healthcare, and sports and recreation.

For stock photographers just starting out in the business, is it better for them to approach one of the big agencies like Getty or Corbis, or should they try one of the smaller agencies first? Or does it depend on their collection of images?

I often work with photographers who are "newbies" to stock, and it is extremely rare that I recommend that any of them approach the big agencies. Let me compare it to sports. First-round draft picks have a fairly decent (though not guaranteed) chance of getting a job in the NFL. Second-round picks have a good chance of making a team's roster, though not as good a chance as a first-rounder. And then, once you get down into the third, forth and fifth rounds of the draft, newcomers have to fight really hard, and perhaps have some tremendously good luck, in order to make it onto a professional team. Lots of these guys will be out on the street after training camp. That doesn't mean they have no future: they may very well play on a pro team's practice squad, or join an NFL-Europe team, or find some other way to gain more experience and thus work their way up to the NFL someday.

In stock photography, if you have something really different, really special, or something that really plugs a hole in the files of the Big Boys, then like the first round-draft pick, you have a chance at making it onto one of those teams. What I'm saying is that everybody wants to play for the Super Bowl champs, and every photographer wants his images sold by Getty,

© 2007 Tetra Images

The stock marketplace has a voracious appetite for clean, contemporary images of people and lifestyles. Nobody shoots that genre better than Tom Grill, who spent almost three decades at Comstock as co-owner and chief photographer. Grill now sells his images primarily through his own royalty-free stock photo production company, Tetra Images.

but what are the odds of that happening? So, photographers may very well have to toil in the minor leagues (smaller agencies) for a period of time and upgrade their game before trying the Big Boys. And, even after some "seasoning," they may never make it into one of the biggest agencies. That's not necessarily a bad thing because lots of photographers like the "big fish in a small pond" model and do very well at it. Big agencies certainly have their attractions and advantages, but photographers should not make the mistake of thinking that if they aren't with Corbis or Jupiter or Getty that they can't make a very good living from stock.

Keywords are important to a successful stock image search. On your Web site you say, "If they can't find it, they can't buy it!" Can you tell us more about keywording?

A few quick points: 1) I see keywording as the Achilles' heel of stock photography. Photographers go to all this expense and trouble to plan and shoot these terrific images, and then they invest even more time and energy making them perfect in Photoshop, only to blow it in the final step, which is the keywording! It doesn't matter how great your pictures are: If you do a bum job of keywording them, you're potentially giving up a sizable portion of the revenue those images could earn for you. 2) Most photographers don't have the expertise, desire or time to do keywording right. 3) Keywording needs to be done by people who can keyword not only the obvious, literal content of an image but also the concepts and messages that the image conveys. 4) When in doubt, hire out. There is no excuse for not having great, comprehensive keywording for your images, because there is a number of outsourcing services around that you can use.

What are some of the suggestions you might give to a photographer on a limited budget looking to sell her stock without an agency?

That depends on a complex array of factors, such as: What type of subject matter do you create? Who is your target market for this material? What are the financial goals for your business? What percentage of your revenue are you willing to allocate to marketing? Are you new to selling stock or fairly well established? Coming up with an effective marketing plan requires a good deal of analysis and preparation, but without marketing of some sort, you don't stand a chance of being competitive.

Marketing can be as simple and cheap as phone calls and e-mails. It can also be as complex and expensive as 4-color ads in design magazines and custom-produced books sent to targeted art buyers. Obviously, if you're at the low-end of the budget scale then you need to figure out how to get the most bang for your buck, because you're probably not going to be able to afford to have a very diverse marketing program.

Direct mail is still relatively cheap, but you really have to work hard at making your mailers different and appealing, and that can be expensive. Great design isn't cheap, so try to work out a trade with a talented designer: You shoot pictures for the designer and she designs your promo piece—win-win!

E-mail is also inexpensive but not free. But, even more so than with direct mail, you have to work hard at getting your message read (and let's not even get started on spam filters that block your e-mail blast).

If you have good phone presence, nothing beats direct contact, but first you have to get past voicemail—good luck with that! Probably the best advice I can give is to keep it simple: Start with a small, targeted list of potential buyers and work that list mercilessly, with lots of repeat contacts, until you convert a decent percentage of them from prospects to buyers. Then slowly expand your prospects list in manageable increments and keep hitting them as often as you can without becoming a pest.

Are many photographers still culling stock images from their assignments? Or do you think most stock photographers these days are creating images for stock? Do you have any opinions on which photographer might be more successful?

The really successful photographers who sell to the commercial markets (ad agencies, designers, corporate in-house art departments) shoot stock as stock. But in the editorial markets, of course, it's a very different deal: Shooters who do assignments for magazines or book publishers generally maintain the copyright to their work and move it into stock sales once the original use of the images has been made. So, as a generality that I think holds up in most but not all cases, commercial stock shooters create images with stock specifically in mind while the number-one priority for editorial shooters is to satisfy their clients first and the stock marketplace second.

Outdoor/nature photography is a popular genre for photographers, but is the market already glutted with this type of image? How would you advise outdoor/nature photographers to market their stock?

There is no question in my mind that the outdoor/nature market is oversaturated, which puts a premium on making your work better and different than everybody else's. Part of the problem is this sort of material has a much longer shelf life than images with people, so there's not the necessity for a turnover of material like you have with lifestyle photography. The only solutions are to have a distinct style, specialization in subjects that aren't the *most* crowded, and a really well-crafted, consistent marketing program to get your imagery in front of buyers. This may sound a bit discouraging, but it's also reality. If you're shooting nature and outdoor subjects, your images can't be just "OK."

Do you think portals such as Digital Railroad help photographers? Do you see them as the wave of the future for photographers who are trying to sell their stock themselves (as opposed to through an agency)?

I definitely see a trend in which more photographers will find it easier to sell their work directly to customers. Digital Railroad (for infrastructure), Alamy (for an online marketer of images), and a number of other services are changing the landscape of how stock pictures are sold. As a result, photographers see direct selling as a more attractive option than at any time in the past. Years ago, of course, the big impediment was that it was expensive and difficult to bring your images into the marketplace. Now, there are all kinds of new and innovative ways to do it. If you decide to plunge ahead and sell directly, the tools to help you do it just keep getting better and better.

© Jason Krav

Photoblogs

The New Self-Promotion Tool

by Lynn Haller

Just a few years ago, the question all photographers were asking themselves was "Do I go digital?" The fact that so many photographers have, making it easier to share photos on the Internet than ever before, has led to a new question: "Should I have a photoblog?"

A photoblog (also known as a fotolog or fotoblog) is the visual equivalent of a blog—a Web site devoted to postings of an (often daily) off-the-cuff picture, sometimes open for comments and sometimes not, sometimes accompanied by captions or technical information and sometimes not. Some photoblogs are part of a larger community (www.flickr.com and www.fotolog.com are two of the most popular), and some are completely freestanding. Some photographers use their photoblog as a sort of visual diary, while others use it as a place to share their latest photographic experiments. And just as blogs are not strictly the province of professional writers, photoblogs are not strictly the province of professional photographers—in fact, some of the most successful photobloggers in the world aren't professional photographers.

Take Sam Javanrouh. An immigrant to Canada from Iran in 1999, he started his photoblog, Daily Dose of Imagery (wvs.topleftpixel.com) in July 2003 to share his visual diary of his daily life in his new country with his friends back home. Excited by the promise of the new technology of digital photography, he challenged himself to post a new photo every day. He posted a link to his site on www.photoblogs.org, a popular resource and directory for photobloggers, and it was discovered by connoisseurs of the genre, quickly making it to the site's "Hot Photoblog" list. After his site was named one of the top photoblogs of 2004 by *Forbes* magazine, it was picked up by the rest of the media, and its popularity quickly grew. References to his photoblog on well-known blogs like Boing-Boing and Fark brought additional visitors. Now, Daily Dose of Imagery is one of the most popular—and honored—photoblogs on the Web. It was named Photoblog of the Year for 2006 by Photoblogawards.com, and his photoblog is now visited by an average of one million unique visitors per month.

Despite this success, Javanrouh was not a professional photographer when he started his photoblog; he was a creative director at Optix digital pictures, and digital photography was a hobby for him. "The fact that I really love photography and digital arts in general was the passion behind the whole thing, and the reason that I took it this far," says Javanrouh. The

LYNN HALLER is a literary agent for Studio B Productions, an agency specializing in working with authors of computer books. As former acquisitions editor for HOW Design Books, she acquired and edited a wide variety of graphic design books, and featured the work of, or collaborated with, hundreds of designers around the world. She is author or coauthor of six books about design, the latest of which is *Design Secrets: Products 2* (Rockport). She is also an amateur photographer who goes by the moniker carrienation on Flickr.

popularity of and acclaim for his site has led to numerous photo commissions and several art exhibitions, and Javanrouh is now selling prints on his Web site, as well as a self-published book of his photos.

WHY PHOTOBLOG?

Javanrouh's experience may not be typical, but it is inspirational—clearly, for some, their photoblog has opened up opportunities they'd never dreamed of. Says Javanrouh, "It's priceless, the way I can show my work to pretty much anyone in the world. That's how I'm getting all these requests from all over the world." Exposure, however, is only one reason to photoblog. Here are some others:

● **Education.** Having other photographers comment on your work can be a great way to learn new techniques or to see things in a different way. Likewise, returning the favor by viewing and commenting on other photobloggers' works (a netiquette must, especially if you hope for the same for yourself) will keep you up on the latest digital photography tricks and techniques. As Jason Kravitz of Jason Kravitz Photography (http://jason.aminus3.com) says, "Seeing other people's images and getting comments on my own has helped me improve and provides inspiration to keep posting and trying new things."

● **Discipline.** Many photobloggers find that knowing that they have a hungry audience for their work keeps them on their toes, and keeps them producing. Knowing that your work will be seen is a great motivator to keep shooting.

● **Creativity.** Many photographers consider photoblogs a way of demonstrating what kind of photographs they themselves like to take. "You have to follow very strict rules when you're making a portfolio," says Javanrouh. "Photoblogging has no rules whatsoever, so you can include very experimental and very personal work."

● **Community.** Many photobloggers cite the ability to see what other photographers are doing, to network, and to talk with them about their work as a major incentive to photoblog.

Sam Javanrouh's blog, Daily Dose of Imagery, reflects his day-to-day life in Toronto. He decided to mix it up with this unique angle of view: He placed his camera on the floor of a streetcar with the lens pointing up slightly.

Some even take these relationships further by participating in get-togethers with other photo-bloggers through Flickr or meetup.com.

PLANNING FOR SUCCESS

Convinced? If you're ready to take the plunge, it's time to start planning your photoblog. If you've created a self-promotional Web site, you already know that before you create any Web site (or photoblog), you'll need to ask yourself a number of questions before beginning. Chief among them are:

- What is your purpose in starting a photoblog? Is it to explore creatively, to make a name for yourself, to motivate yourself to take photos every day, to network with other photographers, to get new business? Your goals should inform the rest of your planning.

- Will you be creating the photoblog yourself from scratch, hiring someone to help with it, or using a software package? Be honest about your own technical limitations—if you've been planning a self-promotional Web site for four years but still have ''Under Construction'' on your Web site, hire help or start with one of the leading user-friendly photoblogging software packages. Photoblogs.org features an excellent and comprehensive chart of software and hosting services that you should review thoroughly before making a decision.

- If you already have a self-promotional Web site, will it link to your photoblog, or will it be free standing? Some photoblogs contain links to the photographer's self-promotional Web site, but the Web site doesn't contain a link to their photoblog—the thought being that the photoblog contains experimental work that might put off the existing market for their photos.

- How often will you post photos? Make sure to pick a schedule you can stick to. Javanrouh attributes some of the success of his photoblog to his consistency: ''I still haven't missed a day; there are not a lot of photobloggers who can say that.''

- Will you enable comments on your site? If you do, make sure to respond to comments promptly, and be gracious in answering technical questions and responding to criticism.

GETTING STARTED

Now that you've finished your planning, it's time to get down to the nuts and bolts of setting up a photoblog. Since advice varies so widely, depending upon the path you plan to take and the software you're using, we won't go into too much detail here (see the Resources sidebar for a list of helpful books and Web sites), but following are some words of advice that apply to all situations.

- Keep the design simple. Remember, you want visitors to your photoblog to admire your photos, not your site design, so make sure your site design doesn't distract from your pictures.

- Pick an interface that works for you. If you have to struggle every time you upload an image, that's a strong disincentive to post frequently.

- Prepare for success. ''Choose one of the strongest photoblogging tools in the market, like WordPress or Movable Type and start it from the ground up, thinking that it will be very big, that it will be thousands of pages soon, and be prepared to carry a lot of traffic. A lot of people start with very cheap hosting companies and then struggle,'' says Javanrouh. ''Right now I get so much traffic that if my hosting company wasn't good enough, I would have to switch. Good ones aren't cheap. Take it seriously.''

ATTRACTING VISITORS

Now that you have a photoblog, how do you promote it? ''Don't,'' says Colleen Wainwright (www.communicatrix.com), marketer of creative services and blogger. ''I think a blog should be a 'pull' rather than a 'push.' Promotion via a link in a newsletter or on a business card is great. 'Promotion' via meaningful comments left on other blogs is probably best of all. Blogs are conversations, not ads.'' Wainwright notes that the worst mistake you can make when

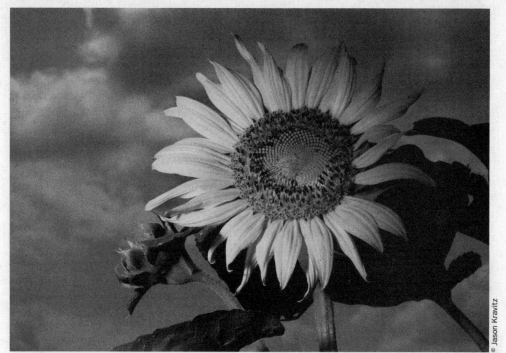

Jason Kravitz believes photoblogging inspires him to keep improving his photography through innovation and creativity. He had posted this sunflower as a color image, but then decided to post it as a black & white conversion. Most people preferred the black & white version. "It was a good example of the way a photoblog can confirm (or negate) creative experimentation," says Kravitz.

promoting your photoblog is "trying too hard. It's the kiss of death, and immediately obvious in a transparent medium like the Web."

Javanrouh adds that traditional advertising methods won't work for photoblogs. "You can put ads here and there, but people today are much smarter than this," he says. "If they click on an ad and they don't like the content, they're not going to click again. What's important about the blog is coming back. It's not important to have 2000 visitors in one day; it's important how many of those are going to come back tomorrow."

Still, you need to make people aware that your photoblog is out there; following are some of the best ways to do so:

• Submit your photoblog for inclusion in popular directories. Photoblogs.org, coolphotoblogs.com, www.vfxy.com are good places to start. Keep in mind, though, that the second and third sites mentioned are curated, meaning your photoblog might be rejected if the site editors feel it's not up to snuff. For those sites, you may want to wait until you're confident and consistent about your content before applying.

• Post at least some of your photos in a photoblogging community, even if you build a freestanding site. Jason Kravitz is one of the creators of the photoblog community at www.am inus3.com. He says, "Photoblog communities are set up to encourage members to look at each other's images. Members are more likely to see what else is out there, and at Aminus3 we feature the best of the community images on the front page." Comment on other's photos, and if you're on Flickr, make sure to join photo pools that are of interest, to expose your photos to a new audience.

• Make it easy for people to see your photos—even if they don't visit your Web site. Javanrouh offers a daily e-mail subscription list, allowing subscribers to have his images

delivered straight to his Web site. Setting up an RSS feed is another way to allow your audience to see your photos without coming to your Web site. If, however, you're using your photoblog to drive traffic to your Web site, you may not want to do this.

● Don't forget search engines. "A lot of my hits also come from Google Images and other image crawling services," says Kravitz. "The site is optimized to feed keywords to crawlers so I come up higher in image searches." Remember this, and upload photos with keywords in their names, not photos named "photo5853"—and don't forget to title them.

● Update frequently. Ilise Benun, founder of Marketing Mentor (www.marketing-mentor.com) and author of *Self-Promotion Online*, says, "The more often you post, the better your search engine rankings. So carve out some time each day, if possible (or once a week at a minimum), and just keep adding to it. Consistency is key."

● Keep up to date on what other photobloggers are doing. Kravitz says, "Find other people with a similar style as your own and watch what they do, where they list their site, what is successful for them and what does not work so well."

● Last, but not least: Take good pictures. "That's one thing that a lot of people tend to forget. You can get lost in the technical aspects [of setting up a photoblog] and forget that you're doing it because of the photos," says Javanrouh. "Shoot whatever you like, take the photographs you're interested in, and the world will follow." It's worked for Javanrouh; only time (and a lot of hard work) will tell whether it will work for you too.

Resources for Photobloggers

BOOKS

Create Your Own Photo Blog, by Catherine Jamieson (Wiley)

WordPress Complete: Set Up, Customize, and Market Your Blog, by Hayder Hasen (Packt)

How to Use Flickr: The Digital Photography Revolution, by Richard Giles (Course)

Buzz Marketing with Blogs for Dummies, by Suzannah Gardner (Wiley)

Blog Marketing, by Jeremy Wright (McGraw-Hill)

WEB SITES

www.photoblogs.org

The leading directory of photoblogs, it currently lists over 21,000 photoblogs (though only ones with RSS feeds—something most leading blog software provides). Learn the latest tips and techniques for photobloggers, check out what other photographers are doing, and get your own photoblog listed—all for free. The site also maintains an updated and comprehensive chart of leading software and hosting packages, so it should be one of the first sites photographers visit when planning their photoblogs. This vibrant community allows photographers to ask fellow photobloggers questions if they get stuck when putting up their sites.

http://www.lightstalkers.org/

Sort of a LinkedIn or MySpace for photographers, this free resource gives you an opportunity to see what other photographers are doing, to list your photoblog to increase viewership, and to network.

Portrait and Wedding Photography

Portrait and wedding photography comprises a large sector of the photography business. If you're interested in serving a retail customer rather than providing photographs for editorial and commercial clients, the portrait and wedding photography business can provide you with a part- or full-time income. Unlike the other markets in this book, your clients will be retail customers, not photo editors, art directors and art buyers. You still need to find clients who want your services, but you'll be looking in different places and perhaps presenting yourself and your services differently.

Portraits created for retail clients are different than the portraits made for the editorial and commercial markets. Portraits for the commercial client are often not made to please the subject, but to convey a concept or impart information about the business or promote the image of the business. Portraits created for retail clients must please them—or they won't buy any prints! Photographers should still try various angles, lighting set ups, poses, settings and backgrounds, and be as creative as ever, all the while keeping in mind that the end product must please the subject.

If you're new to the portrait and wedding photography profession, you can find help with both the technical and the business aspects of this sector by joining professional organizations and attending seminars and workshops. There are also excellent publications and educational DVDs available for those who want to learn at their own pace. If you're already an experienced portrait or wedding photographer, you too can benefit from ongoing training and networking with other professionals. The Professional Photographers of America (PPA) offers education to its members. In addition to conferences where photographers can learn the latest techniques as well as how to maximize profits, PPA is the leading certifying body for imaging professionals. Visit their Web site at www.ppa.com for more information. Wedding & Portrait Photographers International (WPPI) presents a weeklong conference annually in Las Vegas where dozens of professional portrait and wedding photographers offer business seminars and live demonstrations. PhotoVision offers educational DVDs featuring portrait and wedding photographers demonstrating how they conduct their portrait sessions or wedding shoots. They also offer advice on how to run a profitable business. Visit their Web site at www.photovisionvideo.com or call (888)880-1441 for more information. *Professional Photographer* magazine (PPA's official publication) and *Rangefinder* magazine both offer articles of interest to portrait and wedding photographers, covering the latest information on running a business as well as inspiration for becoming a better photographer. See the Workshops section of this book for workshops that offer training for portrait and wedding photographers.

Much of the advice given on how to run a successful commercial photo business also applies to running a portrait or wedding photography business: have a business plan, know

your cost of doing business, be organized, and promote yourself. Digital imaging has affected this segment of the photography business as well as the commercial segment. As prices keep falling on digital SLR cameras, more and more people try their hand at wedding and portrait photography. As with other professional photography, however, there is more to the equation than having the latest camera. Clients must realize they get what they pay for: The skill that goes into posing, composition and lighting adds value to the final product. Photographers must be savvy about pricing and marketing. Understanding your cost of doing business will help you figure out how much you should be charging to make a profit (see page 17).

PORTRAIT PHOTOGRAPHY

Portrait photographers can be generalists, but many specialize in one area, such as babies and children, families, high school seniors, school photography, pets or weddings. Sometimes wedding photographers will also do portraits of babies, children and families because being a wedding photographer is a good way to start a lifelong relationship with a client.

Generally, there are two business models for portrait studios: the high-volume studio and the high-end studio. The high-volume studio aims to serve as many clients as possible. Clients are often attracted to them because of the reasonable or low prices for prints, or because of a promotion or special offer. Because of the high volume, the photographer cannot spend as much time with each client nor do much to customize the portrait sitting. The high-end studio takes more time with each client and produces heirloom-quality portraits at a premium price. They often don't offer packages, discounts or special promotions. They usually don't have as many clients as the high-volume studio, but they make more profit from each client. Either type of studio could be operated from a home or from a retail location.

There are many methods and styles for producing portraits, and photographers should decide for themselves what works best for them, given their budget for equipment, availability of studio space, and personal photographic style. If they do not like working with strobes, they should try creating only natural-light portraits and cultivate a clientele that prefers that style. For photographers who are adept at using studio strobes and have room for an in-home studio or a can rent studio space, many options will be available to them as far as style.

Marketing and sales

Promoting a portrait photography business is somewhat different than promoting a stock photography or commercial photography business. Some of the same tactics apply, such as contacting clients and potential clients frequently through various self-promotion efforts. One big difference in marketing styles is that when marketing to your retail clients, your sales tactics should appeal to your clients' emotions, not their logic. The experience of the portrait session—not just the end product—will usually matter greatly to your clients. The way the photographer presents the proofs to the client makes a difference too. Smart photographers see this as another opportunity for creating an unforgettable impact. One of the most moving—and profitable—ways to show clients their proofs is by projecting them on a screen or monitor accompanied by music. Many photographers are also using a variety of products, including albums, framing and special packaging, to enhance their profit margins.

There are many avenues portrait photographers can take to reach their clients. Photographers of children, for example, can ask to have their children's portraits displayed in a children's clothing boutique, or a toy shop—anywhere mothers will be shopping for goods for their children. ''Watch Me Grow'' programs provide an excellent incentive for repeat business for the children's portrait photographer, as the photographer offers a discount on a number of portrait sittings during the child's first few years. Seasonal and holiday promotional campaigns are also a natural for targeting families. Pet photographers can ask owners of businesses catering to pet owners if they can display a sampling of their pet portraits. For more ideas on how

Portrait/Wedding Photography Resources

PROFESSIONAL ASSOCIATIONS

Children and Family Photographers of America
http://cfpamerica.com/index.html
(512)218-9947 (press 2)

Professional Photographers of America
www.ppa.com; (800)786-6277

Wedding and Portrait Photographers International
www.wppionline.com; (310)451-0090

BACKGROUNDS, LIGHTING AND PROPS

Artistic Backgrounds
www.artisticbackgrounds.com
(208)535-1323

Backdrop Outlet
www.backdropoutlet.com; (312)842-6550

Calumet Photographic
www.calumetphoto.com; (800)225-8638

Denny Manufacturing
www.dennymfg.com; (251)457-2388

Knowledge Backgrounds
www.handpaintedbackgrounds.com
(888)849-7352

Larson Enterprises
www.larson-ent.com; (800)351-2158

La-vie Album
www.la-viealbum.com; (310)395-4000

Studio Dynamics
www.studiodynamics.com; (562)531-6700

Virtual Backgrounds
www.virtualbackgrounds.net
(512)805-4844

F. J. Westcott Co.
www.fjwestcott.com/fjw.com
(419)243-7311

Wicker by Design
www.wickerbydesign.com; (919)383-6212

ALBUMS

Albums Inc.
www.albumsinc.com; (800)662-1000

Albums Unlimited
www.albumsunlimited.com; (800)625-2867

Art Hands
www.arthandsalbum.com; (213)688-8886

Art Leather Manufacturing Co.
www.artleather.com
(718)699-6300

AsukaBook
asukabook.com; (866)330-1530

General Products LLC
www.gpalbums.com; (800)888-1934

Show Off Albums
www.showoffalbumsusa.com
(714)537-3737

Zookbinders
www.zookbinders.com
(800)810-5745

ONLINE PROOFING AND PRINTING

Collages.net
www.collages.net; (877)638-7468

Eventpix.com
www.eventpix.com

Pictage, Inc.
www.trust.pictage.com
(877)PICTAGE

Printroom.com
www.printroom.com; (888)868-4157

MARKETING AND SELF-PROMOTION

Blossom Publishing
www.blossom-publishing.com
(800)583-5370

The Knot
www.theknot.com

Marathon Press
www.marathonpress.com
(800)228-0629

PUBLICATIONS AND EDUCATIONAL DVDs

PhotoVision
www.photovisionvideo.com
888-880-1441

Professional Photographer
www.ppmag.com; (800)742-7468

Rangefinder
www.rangerfindermag.com
(310)451-8506
(Subscriptions are free)

to run a successful portrait business, see the article about family portrait photographer Sarah Petty on page 53, and the article about pet photographer Dawn Norris on page 59.

WEDDING PHOTOGRAPHY

The style of wedding photography has changed in the past few years. The new style—often called photojournalism or, simply, journalism—is more casual, more candid, more emotional, and perhaps better at telling the story of the wedding day than the traditional style practiced for so many years. While there is still a place for the more formal and posed wedding shots, most couples today want a fair amount of photojournalism in their wedding albums.

One way to learn the craft of wedding photography is to work as a "contract" photographer for an established photographer. If you choose this route, however, you might have to sign an agreement stating that if you leave their employment before a specified date, you may not start your own wedding photography business in the same geographic area for a period of time. Some wedding photographers may let you work as an assistant or second shooter without requiring a contract. If you want to start your own business without going the route of shooting for an established studio, the learning curve may be steeper, but there are many resources to help you. Professional Photographers of American and Wedding and Portrait Photographers International are two good places to start. See the list of resources on page 51 for information on products and services for wedding photographers.

Marketing and sales

Many wedding photographers report that their best advertising is word of mouth. There are, however, other means to get the word out about your wedding photography business. It's certainly a good idea to have your own Web site dedicated to showcasing your wedding photography so that potential clients can see your style. Some wedding photographers also advertise on The Knot (www.theknot.com), a wedding planning Web site.

Like many portrait photographers, wedding photographers are finding they can maximize profits by offering their clients special products and services. Designing and selling wedding albums is one way wedding photographers help their bottom line. Some photographers see it as part of their customer service. Many clients are overwhelmed by the sheer number of photos that can be taken digitally during a wedding (sometimes 800-1,000), and they're glad to have the photographer edit them into a beautiful layout that tells the story of the day.

Another way wedding photographers are seeing more profits is by employing an online proofing service. Some sites allow the photographer to set up a storefront Web site that handles all fulfillment, including collecting the money, sales tax, shipping and handling, while the photographer retains his brand identity. With online proofing, photographers no longer have to deal with clients who keep their (paper) proofs for months before deciding on a final print order. The online proofing system also makes it easy for friends and family of the bride and groom to order prints, thus boosting the photographer's sales even more.

To keep up with the latest trends, study modern portraiture, especially weddings shot in the photojournalistic style. Also study the latest fashion magazines and visit the mall—immerse yourself in the world of your potential client, the bride. For more information on how to run a successful wedding photography business, see the article about wedding photographer Stephanie Carson on page 64.

Sarah Petty

Attracting High-end Clients Through Creative Marketing

by Deb Heneghan

'd always loved photography, but when I took a photography class in college I was hooked,'' says Sarah Petty, owner of Sarah Petty Photography (http:// sarahpetty.com), a studio catering to families in Springfield, Illinois. After college she begin photographing the nieces and nephews of her husband-to-be and discovered her passion for capturing the personalities of children and their relationship with their parents. Petty worked in Coca-Cola's marketing department, spent six years as marketing director at a top advertising agency, and completed her MBA—all in preparation to operate her own photography studio. "After giving birth to twins in 2000, I was ready to take the leap, and in August of 2001—two weeks before 9/11—I opened my studio." Although that might not have been the best time to launch a fledgling portrait business, Petty has been successful. Because of her creativity in the studio and in her marketing techniques, Petty has developed a high-end clientele and continues to expand her business. In this interview, she shares her marketing wisdom and her secrets for success in the studio.

Describe your workflow for a portrait session, from your first consultation with the client to delivering prints.

We insist clients come in for a consultation. This is critical because with children, the magic often occurs in the first few minutes of the photo session. I want to make sure they show up in the right clothing and that we are completely prepared for them. The consultation is important for the high bchool seniors because we want to begin building a relationship.

A typical photo session lasts 45 to 90 minutes, usually within a week of the consultation. It is important that sessions with children not have time limits. If a new mom needs to stop and nurse, I want her to be able to without feeling rushed.

About two weeks after the session, the clients return for their image presentation. Unless the client lives out of town, we insist they come in for their image presentation of 25 to 30 of our favorite images set to music. This takes about an hour, and I truly believe the clients are impressed and appreciate the extra attention. Plus, we want them to order when they are excited about their images. They place the order that day. It is crucial to have all decisions makers there. When clients take proofs home, they often receive input that can be confusing. Sometimes clients give up and put the proofs in a drawer to look at later, and sometimes later never comes. Our process helps them eliminate the photos they can live without and narrow it down to their favorites.

DEB HENEGHAN is a freelance writer and photographer based in Wisconsin.

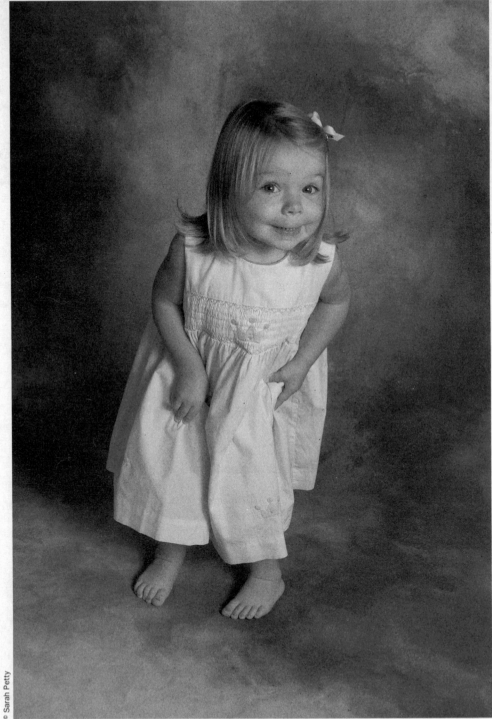

© Sarah Petty

In her portraiture, Sarah Petty tries to capture the magic of each child, so she has everything ready before the child arrives in the studio. Her camera room caters to children: lights are mounted to the ceiling so there is nothing to knock over.

About four to six weeks later, the client returns to select their frames. All of our wall portraits (11×14 and larger) include frames. The client can select from several frames that are included in the portrait price, or they can upgrade to something fully custom. All framing materials are archival including UV glass and 100 percent rag mats. This drives up our prices, but it is important to me that this artwork is preserved.

Describe a portrait session with a child. What are some of your techniques for getting the best results?

Our camera room caters to children. Our lights mount to the ceiling so there is nothing to knock over. We can also move lights quickly. Because we have a consultation prior to the session, we are prepared when the client arrives. Lights are set up and metered. Backgrounds are in place and the camera is loaded. We don't want to miss the magic when the child arrives.

I want to capture the shyness when the child enters. I talk softly and typically don't even look directly at the child while I ask the parent to move to the background. I always warn parents during the consultation that their legs, arms or feet may be in any given image and advise them to dress appropriately. I love a pensive image of a child peeking around his parent's legs. I usually start with soft music playing and move into more fun, playful music.

If I start to lose the child's attention, I pull out my mini trampoline. If the child is under three, I can at least keep her in one spot. If she is over four, she can jump on the trampoline. Those images typically sell. I also have a chair that spins. I call it my magic chair. I have the parent spin the chair and stop it each time it comes around. If I have a group of kids, and I need one of them to cooperate for a few more shots, as a last resort, my assistant brings out our treasure chest with toys. We've learned that parents can try all day long to bribe their kids unsuccessfully. However, when we pull out the promise of a surprise present (albeit short lived and only once during the session), we get full cooperation long enough to get the shot we need.

What techniques do you use for getting good portraits of families?

My favorite technique is to focus the family members on each other instead of on me. I tell them to snuggle and interact as if they were playing at home. I want them to forget about me completely. I also ask them to tell me their favorite thing about the other. When parents start talking about their children or vice versa, they get a certain glow. It's very honest.

What are some of the most common problems that arise during a session and how do you deal with them?

It is very challenging to photograph 12-20 month-old children. Since they're unable to take direction very well, we ask the parents to swing them, dip them, spin them on our chair, or do whatever they can to engage them. The mini-trampoline is great with the five-to-ten-year-olds, even if it's just to loosen up a nervous child.

It is also challenging when people bring others (such as grandparents) who aren't in the portraits. I let them know they are welcome, but they will need to stand in the shadows. I explain that I must be the only person the child sees so that I can connect with him.

What equipment do you use?

We use the Canon Mark II 1DN, 70-200mm 2.8 and 28-135mm 4.5 lenses, Photogenic strobes with Larson soft boxes and reflectors. We usually use one 4 ft.×6 ft. soft box with reflectors. We add a second light on the background to keep the background bright white for our high-key images.

How do you find clients? Describe your marketing efforts.

I have as much passion for business and marketing as I do for photography. I am constantly thinking about new ways to attract clients. We send a super creative (and super expensive) mailing to new parents. This piece is designed to evoke emotion and attract clients who like our style. This kind of marketing has affected my business positively.

I also mail Christmas cards to my entire client list. Our cards are always fun. They include a Dr. Suess-type 9×12 book with a card that unfolds into a circle. My philosophy is that you can't tell people you are creative; you must show them, which is why we hire a professional graphic designer.

We do a lot of advertising to promote our image, including an emotional television spot targeting the Mom audience that aired during *Oprah*. We communicate with our clients, especially our senior high school audience, through our Web site. We're currently adding blogs. We also compile mailing lists of high school juniors and market directly to them with professionally designed marketing pieces.

Do you have different marketing strategies for each of your client groups (babies/children and seniors)?

Yes, we market completely differently for both groups. Although our logo doesn't change, we have a look and a feel for each target market. I feel strongly that each target market should be treated as if they are our only clients. For seniors, our marketing campaigns have a completely different look, feel and message than our children's campaigns. For children, our look is playful and whimsical. For seniors, our look is more earthy and natural and all about them! From our price list, to our direct marketing pieces, to the way we package our images, everything has a consistent look and feel that speaks to that target market. Even the bag we package our images in is customized to coordinate with each marketing campaign. Our bags have a see-through pocket on the front where we insert an image from the client's session. We then add colored tissue paper inside the bag and tags on the outside that match the feel of each marketing campaign. It is more time consuming to create these individualized campaigns, but it is critical to make everyone feel special.

What advice can you give photographers on pricing their services and products?

I offer two recommendations on pricing: keep it simple and don't offer discounts!

You want consumers to make decisions with their emotions, and if they have to spend an hour deciphering the products, they are making logical decisions instead of emotional ones. We only have about 10 products on our rate card.

Discounting sacrifices the long-term value of a brand for short-term income. Not only does this strategy attract price-conscious consumers, it trains consumers to wait for lower prices.

Do you do much touching up in Photoshop for your portrait clients? If so, how does this affect your bottom line?

Yes, when we retouch our images we do it in-house. We like to increase the contrast and saturation. We also have specific actions we run on our black & white images to make them more vibrant. For children, the images don't need a lot of retouching. We invest more time retouching seniors as they typically have skin issues. This time is figured in our rate structure, ensuring our costs are covered.

Are senior portraits a very big part of your business, and are they very profitable?

Seniors account for about 20 percent of our business. This is the area where we see the most growth potential now that we have an additional production person. We are projecting that

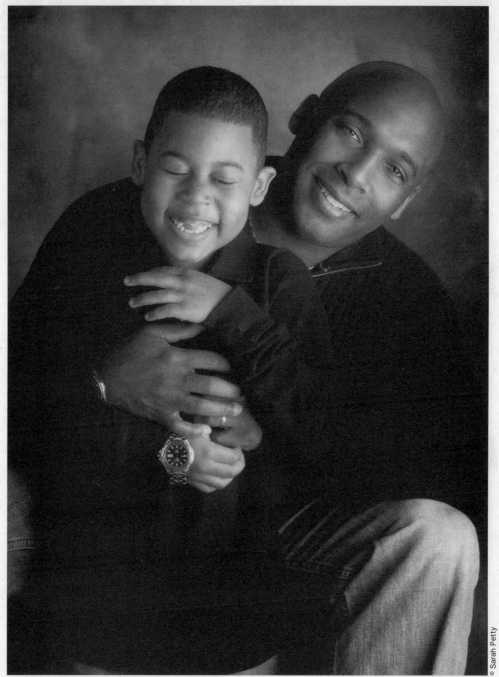

© Sarah Petty

Petty tells families to snuggle and interact with each other as she photographs them, which helps create portraits that are more natural and spontaneous.

seniors will be 35 to 40 percent of our business in the next two years. To ensure that these sessions are profitable, our product and pricing mix is very different from our children and family structure. Because we spend more time with the seniors during their session, and after the session retouching their images, we require minimum orders associated with our larger sessions. If a session includes out-of-studio locations, we need our pricing structure to ensure that they are ordering lots of these images.

As a member of the Professional Photographers of America (PPA), you give talks and workshops at their conferences. What are some of the most important aspects of marketing that photographers need to learn?

Photographers want to know how to attract clients. Usually, when consulting on this issue, I start by looking at the photographer's logo and identity. When they aren't achieving results from their promotional efforts, I often find it's because they don't have a strong identity. To build a strong brand, a company must start with a strong logo and not change it. Colors, studio design, signage, etc., must be consistent, or it confuses the consumer.

I also find that photographers are often looking for a magic "how to be successful in business" kit. When I teach, I want to educate photographers about how to create their own business and marketing plan based on their strengths and weaknesses, not on what others are doing.

Creating highly personal portraits that reveal the spirit of the child is one of the hallmarks of Sarah Petty's photographic style.

© Sarah Petty

Dawn Norris

*A Genuine Love of Animals Helps
Photographer Create Engaging Pet Portraits*

by Patricia Bruno

When Dawn Norris was in law school, she was quite certain that her goal was to someday become a judge. A series of events caused her to take a break from her studies, and she found herself spending time walking dogs with a dog-trainer friend. Because of Norris's love of animals and photography, it was only natural for her to take along her camera and document the actions of the dogs to later share with their owners. People would often ask Norris if the photos were available for sale. Norris found she had a knack for capturing the unique personalities of the dogs, and that her love of the animals helped her connect with her canine subjects. Today Norris runs a successful pet photography business, Absolutely Canine Photography, in New Hampshire. Here Norris shares her perspective on the burgeoning pet photography business as well as some tips on the best ways to approach this challenging yet rewarding photographic niche.

What is it about pet photography that appeals to your personality and style of shooting?

I invest so much of myself into my work. I feel that the connection between the photographer and the subject definitely shows in the final image. I like to focus on one source of energy at a time and not be over-stimulated by too many forces at once, as there are in wedding photography, for example. Similar to wildlife photography, pet photography requires a lot of patience and anticipation of that perfect moment.

Does there seem to be more demand for dog portraits rather than those of other pets?

I do feel that there is a growing demand for dog portraits as the role of pets, especially dogs, continues to change in our society. Catering to our pets has become a multibillion-dollar industry. From gourmet foods and designer furniture to specialty training classes and consulting, pet products and services continue to be in great demand.

Are there vastly different approaches to photographing different types of animals?

Cats and dogs are such very different subjects. Most canines thrive on social interaction and have an innate desire to please, so they're often easy to 'dial in' to. Cats, on the other hand,

PATRICIA BRUNO is a photographer and writer, and owner of Positive Images stock photo agency. She has contributed articles to the *Picture Professional* magazine, and is a member of the Garden Writers Association of America. Her photographs have appeared in magazines, books, greeting cards, calendars and advertising.

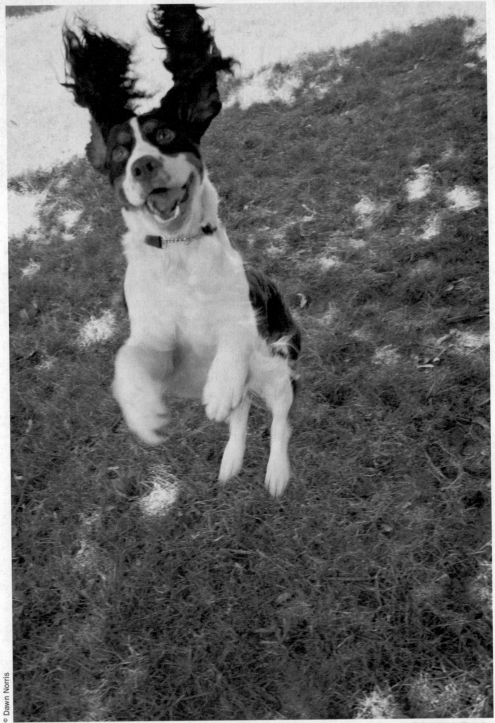

© Dawn Norris

''This English springer spaniel is true to the breed—she's a jumper and full of joie de vivre,'' says Dawn Norris, whose knowledge of canine behavior helps her make better portraits of dogs.

are very independent. I have found the best way to photograph most cats is to completely ignore them; don't make eye contact; and simply wait for the moment to capture them doing something cat-like, such as lounging on the back of a couch.

Horses obviously require different equipment, since they are so large. I often use a wide-angle lens to photograph up close in tight environments, such as stalls, and to get a contextual image, such as a horse in a field or corral. Horses are unpredictable, and often respond by moving suddenly when fearful. Because they are so large, these unpredictable movements when reacting to the noise of a shutter, for example, can be more dangerous than a dog or cat reacting in a similar manner. These factors combine to make photographing horses a bit of a challenge.

How do you first approach the pets to make them comfortable for the session? What techniques do you use to capture expressive portraits?

I initially greet my subjects just as I would a person. I am not overzealous when we first meet. I allow the pet to examine me and my equipment as I talk to the owner. If treats are allowed, I'll provide one.

I always ask if there are any health issues, such as joint pain, that might make the pet uncomfortable in certain positions or situations. I let the pet relax, and only then do I begin shooting. I spend a lot of time at their level, on my stomach, on the floor.

I often ask the owner to step aside so that I can interact with the pet. With dogs there is often a trigger word that the owner can use such as "treat" or "car" that will elicit a response and a great expression. I sometimes use treats and/or a clicker, which is a device often used in training. There are breed-specific items that I might use, such as Frisbees, tennis balls, or sticks that can be tossed. If we are outdoors, I might have the owner play fetch or simply walk with the animal. In those cases I become more of an observer, a director of sorts.

Should a pet photographer consider special training before starting a business in this field?

I am equipped with training in canine CPR, first aid and canine behavior. I also have a genuine love of animals and care for the well being of each and every subject. I often notice behavior issues that I can then point out to the owners. I often refer my clients to specialists in the field if they need assistance. It is not enough to be a good photographer in this profession. I need to be well informed on a variety of levels concerning animals.

Do you use a studio, or are all of your photos taken in natural surroundings?

I have used a studio, but mostly I have a portable studio using available light with supplemental portable studio flash and diffusers. I carry reflectors, which I will use sometimes if I have an assistant. I use a tripod or monopod most of the time.

I prefer a natural setting, yet the biggest challenge when photographing animals outdoors is the possibility of outside interference, such as other dogs, which can pose a danger to me and to my client's pet.

I never foster an environment in which the pet would not be content. I will not go outside of the scope of the comfort zone for that particular animal. If the owner requests an image of his poodle swimming, I'll ask, "Does your poodle ordinarily swim?" I refuse to ask my subjects to do anything beyond their natural repertoire.

What type of equipment do you use?

I shoot with a Canon 20D and a Canon 5D, which is the camera I use the most. I use Canon lenses, usually a 70-200mm and a 70-300mm. I seldom use a fixed-length lens; if I need one, I rent it. I always shoot in full manual mode. I prefer a narrow depth of field with the sole

focal point on the subject, so that the eye is drawn to the subject while the background is soft and blurred.

I shoot at the beginning or end of the day, when the light is less harsh, and I prefer not to use flash. I will shoot in any weather that is comfortable for my subjects and me. When the temperature goes below 30 degrees, fingers and paws get frozen!

I always use a UV haze filter to protect the lens from dust, sand and licks, and I often use a polarizing filter as well as a neutral density filter.

Do your clients often ask to be included in the photograph? Do you charge extra for a second subject in the session?

Despite the fact that I do ask, most owners do not wish to be included in the photos. My fee always includes up to two subjects. I do get lots of requests for children to be in the portraits, which is another challenge entirely. In those cases, I ask that the child understand in advance that she is going to be photographed, because kids can be the toughest negotiators when it comes to sitting for a photograph. In addition to pet treats, I will bring along something for the child.

How do you determine pricing for your sessions and prints?

This is an ongoing process. I do a lot of competitive analysis of the marketplace. I look at industry standards as well as my own overhead and what it will take to come out in the black. Clients understand the value of a great portrait. Anyone can call himself a pet photographer, but the love of the work and the knowledge of the craft come through in the final print.

How do you deliver prints to your clients?

This depends on the client. Some people do not have Internet access or simply prefer to look at a book of proofs, for which I charge a fee. For those who wish to see their proofs online,

© Dawn Norris

Many dog owners can probably relate to this quintessential image. Norris captured this portrait of her own dog as she shook out her wet fur.

I provide a password-protected online proofing gallery at no charge, from which they can then choose prints.

How do you promote your business?

Word of mouth is hands-down the best marketing tool in my business, but that comes with time. To get the word out initially, I send seasonal postcards to my ever-growing list of possible clients. I also display my business cards in local animal hospitals and pet stores. I try to make connections with people in the business, such as pet trainers and groomers, who allow me to leave literature in their facilities.

Have you explored other outlets for marketing your services and images?

One never knows what opportunities will arise in this niche. I have been asked to photograph several canine demonstrations and events. Once you become well known in the field of pet photography, the door opens in a variety of directions.

My pet photography has been sold as wall art for veterinary facilities, animal sanctuaries and rescue leagues, and has been reproduced in fund-raising calendars.

What advice do you have for photographers wanting to start out in this business?

Practice. A lot. Take advantage of opportunities that are often right in front of you. Immerse yourself in pet-friendly environments. Talk to other photographers about the business end of photography. If you have no head for business, hire someone who does. Continue to educate yourself in both photography and in animal behavior. Find a mentor if you can. Most important, you have to love your subjects and have respect and a genuine concern for their well-being. Communicating with animals is an art.

© Dawn Norris

This is not a typical shot for Norris. She was working in the studio to photograph a litter of puppies for a breeder, and could not resist posing them in this bowl.

Articles & Information

Stephanie Carson

Not Your Mother's Wedding Photographer

© Chris Co

by Donna Poehner

Stephanie Carson's style of wedding photography might be considered a little left of center. The Web site for her business StephCarson Photography claims: "Our style is photojournalistic, with just enough traditional shots to make your mother happy." Fun and humor are a big part of Carson's style. "I like to make people laugh, and I like to photograph them while they're laughing. With digital, I just snap away and lay on the shutter whenever I hear laughter," she says.

When she finished photography school in 1989, Carson's goal was to be a commercial photographer—not a wedding photographer. She pursued a career as a commercial photographer, and in 1997 started teaching studio classes, including portraiture and wedding photography. "It was then I noticed that wedding photography had a new style—something I wanted to try. It wasn't until digital SLRs came along that I finally had the courage to give it a try on an actual wedding!"

Carson echoes what many event photographers know: Digital photography has taken the guesswork (and a lot of the stress) out of shooting events. "With film, event photographers needed to be careful," says Carson. "It was a shot in the dark (pun intended) whenever they tried to experiment with their flash. Digital allows us to see before we commit," she says. Of course, having the ability to take hundreds of photos during a wedding without the expense of film and processing also makes the digital photographer's job sweeter.

Carson shoots weddings with a second photographer she refers to as her "journalist" (the photographer taking the candid shots). However, there are no hard and fast rules about how Carson and the journalist work together. "Each wedding is different and so there is no set way that my journalist and I shoot it. Sometimes the journalist will end up shooting the formals while I shoot journalism. Sometimes we switch in the middle. When the formals are done, we are both in journalistic mode," she says. Carson has found that most clients still want some formal shots, although they may not be as formal as they once were. Group shots can be fun and casual. She and her journalist try not to set up any shots or give direction on how people interact with each other (aside from the formals). "We have learned to anticipate actions and to shoot not only with our eyes, but with our ears as well. Expressions make the photograph real; the background becomes secondary to a marvelous expression," she says.

An important component of Carson's business is her signature style, so she hires second shooters whose styles are similar to hers. Carson says her style is still developing, and she owes much of her inspiration not to other wedding photographers, but to commercial photographers. Two photographers in particular in her hometown of Cincinnati, Ohio, Todd Joyce (www.joycephotography.com) and Tony Arrasmith (www.tonyarrasmith.com), have influ-

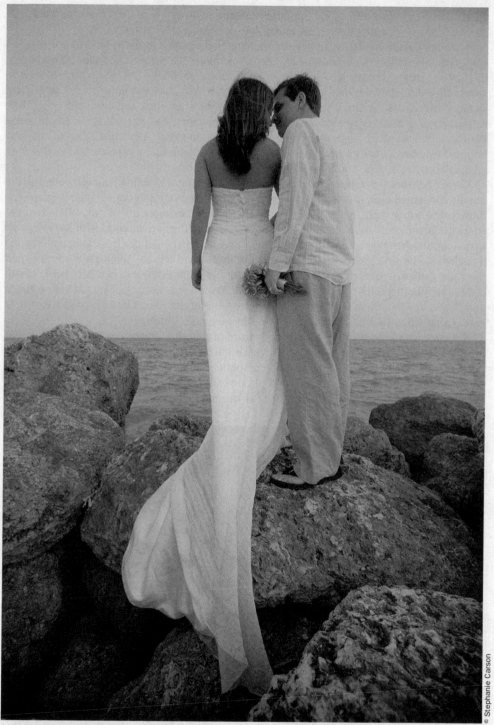

© Stephanie Carson

Although most couples still want some formal shots for their wedding album, the shots are not nearly as formal as they used to be. Stephanie Carson traveled to the Bahamas to photograph this couple's wedding.

enced Carson's humorous style. "I also believe your style develops from the equipment you use. I allow my lenses to work their magic and go from there," she says.

Although Carson has been running her wedding photography business for only a few years, she's found her share of clients. In 2006, her second year in business, she shot 56 weddings. In 2007 she planned to book 36 weddings, but accidentally booked 39. She's learned how to attract clients (mainly through word of mouth and her Web site) and how to work with them to meet their needs. In fact, she's been very successful in meeting and even exceeding their expectations. In a survey conducted by the wedding planning Web site, the Knot, StephCarson Photography was voted the best wedding photographer in greater Cincinnati. Carson also was honored by *Photo District News* when one of her photos won in the candids category of their competition, Top Knots: The New School of Wedding Photography.

Carson believes that when a couple first starts looking for a wedding photographer, they're mainly concerned with prices and packages. But once they start interviewing photographers, finding one whose personality meshes with theirs becomes more important. When couples come to Carson, they have already seen her Web site, so they are familiar with her style and casual approach. "I try to find out a little bit about their personalities by asking open-ended questions," she says. "This gives them the opportunity to tell me about themselves—their likes and dislikes." Carson has an office space for her business, but says it is possible to run a wedding photography business from home. "I started out meeting clients at coffee shops and diners to show them my photos. I converted one of my rooms into office space only to realize that when I work from home, I never leave home," she says.

Carson's best advertising comes through word of mouth. "The best way to promote your business is good customer service," she says. Deadlines are just as important for the wedding photographer as they are for the commercial photographer. "When you tell a client it will be ready, get it done. Return e-mails and phone calls by the end of the day. Be flexible but not to the point where it hurts your business or your bottom line. My biggest challenge is

© Stephanie Carson

Carson tries to capture the fun and excitement of the wedding day without posing or directing her subjects. In this photo she's captured a very real moment, as the bride gets ready for her wedding.

© Stephanie Carson

Carson's photojournalistic approach allows her to catch wedding guests having fun, such as this girl dancing at the reception.

how to deal with things that go wrong. Sometimes I take it personally when I shouldn't. It's important to remember that for most of my clients, they have gone over their budget to hire me. This is a huge investment for them. If they are unhappy, then I need to do what I can to fix the situation,'' she says.

Although Carson advertises on the Knot (www.theknot.com), she also has her own Web site (www.stephcarson.com). Before Carson had a site for her business, she used her personal Web site to showcase a gallery of her photographs and sent prospective clients there to view her work. Her personal Web site also contained accounts of her rock climbing adventures and stories about her black Labrador, Lucky Duck. ''I just assumed clients would go to the photo gallery and leave it at that. But when I met with brides, they would mention how much they enjoyed my stories about rock climbing and my dog,'' she says. When Carson put a blog on her business site, she decided to continue making these personal posts. Such posts help clients relate to her as a person not just a photographer they've hired. If she doesn't post something for a week or so, she gets e-mails from clients asking if she is okay. In some posts she shares humorous incidents that her clients can relate to. Carson wrote of one bride: ''One of her biggest concerns was looking good in her wedding dress. Even though this bride is rather slim, it's tough to wear a strapless dress and not have the problem she referred to as 'back fat.' I've heard this term quite often in the past two years—usually from frustrated brides on their wedding day. It's something that brides usually don't think about until it's too late. My bride, who knows that I'm an active person, asked what sort of exercise I would suggest for toning up the back muscles. Of course, rock climbing!''

To make wedding day photo shoots run as smoothly as possible, Carson likes to make sure that she and the couple are on the same page before the big day arrives. A few days before each wedding, Carson meets with the bride to discuss the photo list and to get a better understanding of what the bride considers to be the important details of her wedding day. ''I like to use this meeting to get a sense of how the bride is feeling. It gives me a better idea

of what to expect on the wedding day. It is important for the client to understand the wedding-day time frame. For example, time should be set aside for formal shots if they need to be taken.'' says Carson. She also makes sure to spell out important details in the contract. For instance, she never assumes that her clients understand the copyright laws, so she makes it clear in her contract that the only rights they have to the photos are for printing. They may not sell the photographs, enter them in a contest, or publish them without Carson's written consent.

Carson doesn't feel a great need to keep tabs on what her competitors are doing, but she will sneak a peek at the Web sites of her favorite photographers. ''These sites are mostly from other areas in the world, so it helps me keep up with everything,'' she says. True to her roots in commercial photography, Carson is a member of ASMP (American Society of Media Photographers), which is primarily for commercial photographers, not wedding photographers. She finds camaraderie and advice in her local chapter. ''I like the community they've created. They aren't competitive with each other, and they really try to help you with your business,'' she says.

As most photographers know, wedding photography can be stressful and a lot of hard work, with its demands to get it right the first time, 10-hour days, and hundreds of images to post-process. But who knew wedding photography could also be fun?

Consumer Publications

Research is the key to selling any kind of photography. If you want your work to appear in a consumer publication, you're in luck. Magazines are the easiest market to research because they're available on newsstands and at the library and at your doctor's office and . . . you get the picture. So, do your homework. Before you send your query or cover letter and samples, and before you drop off your portfolio on the prescribed day, look at a copy of the magazine. The library is a good place to see sample copies because they're free, and there will be at least a year's worth of back issues right on the shelf.

Once you've read a few issues and feel confident your work is appropriate for a particular magazine, it's time to hit the keyboard. Most first submissions take the form of a query or cover letter and samples. So what kind of letter do you send? That depends on what kind of work you're selling. If you simply want to let an editor know you're available for assignments or have a list of stock images appropriate for the publication, send a cover letter, a short business letter that introduces you and your work and tells the editor why your photos are right for the magazine. If you have an idea for a photo essay or plan to provide the text and photos for an article, you should send a query letter, a 1-to 1½-page letter explaining your story or essay idea and why you're qualified to shoot it. You can send your query letter through the U.S. postal system, or you can e-mail it along with a few JPEG samples of your work. Check the listing for the magazine to see how they prefer to be contacted initially. (You'll find a sample query letter on the next page.)

Both kinds of letters can include a brief list of publication credits and any other relevant information about yourself. Both also should include a sample of your work—a tearsheet, a slide or a printed piece, but never an original negative. Be sure your sample photo is of something the magazine might publish. It will be difficult for the editor of a biking magazine to appreciate your skills if you send a sample of your fashion work.

If your letter piques the interest of an editor, he or she may want to see more. If you live near the editorial office, you might be able to schedule an appointment to show your portfolio in person. Or you can inquire about the drop-off policy—many magazines have a day or two each week when artists can leave their portfolios for art directors to review. If you're in Wichita and the magazine is in New York, you'll have to send your portfolio through the mail. Consider using FedEx or UPS; both have tracking services that can locate your book if it gets waylaid on its journey. If the publication accepts images in a digital format (most do these days), you can send more samples of your work via e-mail or on a CD—whatever the publication prefers. Make sure you ask first. Better yet, if you have a Web site, you can provide the photo buyer with the link.

To make your search for markets easier, consult the Subject Index on page 503. The index is divided into topics, and markets are listed according to the types of photographs they want to see.

Sample Query Letter

February 6, 2008

You may also include your Web site in your contact information.

Alicia Pope
2984 Hall Avenue
Cincinnati, OH 45206
e-mail: amp@shoot.net

Make sure to address letter to the current photo contact.

Connie Albright
Coastal Life
1234 Main Street
Cape Hatteras, NC 27954

Dear Ms. Albright:

Show that you are familiar with the magazine.

I enjoy reading *Coastal Life*, and I'm always impressed with the originality of the articles and photography. The feature on restored lighthouses in the June 2007 edition was spectacular.

Briefly explain your reason for querying.

Enclose copies of relevant work or direct them to your Web site. Never send originals.

I have traveled to many regions along the eastern seaboard and have photographed in several locations along the coast. I have enclosed samples of my work, including 20 slides of lighthouses, sea gulls, sand castles, as well as people enjoying the seaside at all times of the year. I have included vertical shots that would lend themselves to use on the cover. I have also included tearsheets from past assignments with *Nature Photographer*. You may keep the tearsheets on file, but I have enclosed a SASE for the return of the slides when you are done reviewing them.

If you feel any of these images would be appropriate for an upcoming issue of *Coastal Life*, please contact me by phone or e-mail. If you would like to see more of my coast life images, I will be happy to send more.

Always include a self-addressed, stamped envelope for the magazine's reply.

I look forward to hearing from you in the near future.

Sincerely,

Alicia Pope

$ ✐ ⑤ ▣ AAA MIDWEST TRAVELER

Auto Club of Missouri, 12901 N. Forty Dr., St. Louis MO 63141. (314)523-7350. Fax: (314)523-6982. E-mail: dreinhardt@aaamissouri.com. Web site: www.aaa.com/traveler. **Contact:** Deborah Reinhardt, managing editor. Circ. 500,000. Bimonthly. Emphasizes travel and driving safety. Readers are members of the Auto Club of Missouri. Sample copy and photo guidelines free with SASE (use large manila envelope) or on Web site.

Needs Buys 3-5 photos/issue. "We use four-color photos inside to accompany specific articles. Our magazine covers topics of general interest, historical (of Midwest regional interest), profile, travel, car care and driving tips. Our covers are full-color photos mainly corresponding to an article inside. Except for cover shots, we use freelance photos only to accompany specific articles." Model release preferred. Photo captions required.

Specs Accepts images in digital format. Send via Zip as TIFF files at minimum of 300 dpi.

Making Contact & Terms Send query letter with résumé of credits and list of stock photo subjects. Does not keep samples on file; include SASE for return of material. Responds in 1 month. Simultaneous submissions and previously published work OK. Pays $400 for color cover; $75-200 for color inside. **Pays on acceptance.** Credit line given. Buys first, second and electronic rights.

Tips "Send an 8½×11 SASE for sample copies and study the type of covers and inside work we use. Photo needs driven by an editoral calendar/schedule. Write to request a copy and include SASE."

$ ✐ ▣ ADIRONDACK LIFE

P.O. Box 410, Jay NY 12941-0410. (518)946-2191. Fax: (518)946-7461. E-mail: khofscheider@adirondackl ife.com. Web site: www.adirondacklife.com. **Contact:** Kelly Hofscheider, photo editor. Circ. 50,000. Consumer magazine. "Emphasizes the Adirondack region and the North Country of New York State in articles covering outdoor activities, history, and natural history directly related to the Adirondacks. *Adirondack Life* attempts to capture the unique flavor and ethos of the Adirondack mountains and North Country region through feature articles directly pertaining to the qualities of the area." Photo guidelines available on Web site.

Needs Wants photos of environmental, landscapes/scenics, wildlife. "All photos must be taken in the Adirondacks." Reviews photos with or without a manuscript.

Specs Accepts color transparencies of any size; b&w prints no larger than 8×10. Digital images output to paper may be submitted.

Making Contact & Terms Pays $400 maximum for color cover. Pays $150 maximum for b&w or color inside. Credit line given. **Prefers to work with local freelance photographers.**

ADVENTURE CYCLIST

P.O. Box 8308, Missoula MT 59807. (406)721-1776, ext. 222. Fax: (406)721-8754. E-mail: editor@adventu recycling.org. Web site: www.adventurecycling.org/mag. **Contact:** Mike Deme, editor. Circ. 43,000. Estab. 1974. Publication of Adventure Cycling Association. Magazine published 9 times/year. Emphasizes bicycle touring. Sample copy and photo guidelines free with 9×12 SAE and 4 first-class stamps. Guidelines also available on Web site.

Needs Cover photos. Model release preferred. Photo captions required.

Making Contact & Terms Query first by e-mail to obtain permission to submit samples or portfolio for review. Responds in 6-9 weeks. Simultaneous submissions and previously published work OK. Payment negotiable. Pays on publication. Credit line given. Buys one-time rights.

Ⓝ ◯ ▣ AFRICAN AMERICAN GOLFER'S DIGEST

139 Fulton St., Suite 209, New York NY 10038. (212)571-6559. E-mail: debertcook@aol.com. Web site: www.africanamericangolfersdigest.com. **Contact:** Debert Cook, managing editor. Circ. 20,000. Estab. 2003. Quarterly consumer magazine emphasizes golf lifestyle, health, travel destinations, golfer profiles, golf equipment reviews. Editorial content focuses on the "interests of our market demographic of African Americans and categories of high interest to them—historical, artistic, musical, educational (higher learning), automotive, sports, fashion, entertainment. Sample copy available for $4.50.

Needs Needs photos of golf, golfers, automobiles, entertainment, health/fitness/beauty, sports. Interested in lifestyle. Reviews photos with or without a manuscript. Model release required. Captions required: include identification of subjects.

Specs Accepts images in digital format. Send JPEG or GIF files, 4×6 inches at 300 dpi.
Making Contact & Terms Payment negotiated. Credit line given. Buys all rights.

$AIM MAGAZINE

P.O. Box 390, Milton WA 98354. E-mail: aim-72@comcast.net. Web site: www.aimmagazine.org. **Contact:** Ruth Apilado, owner and founder. Editor: Kathleen Leatham; associate editors: Ray Leatham and Myron Apilado. Circ. 7,000. Estab. 1974. Quarterly magazine dedicated to promoting racial harmony and peace. Readers are high school and college students, as well as those interested in social change. Sample copy available for $5 with 9×12 SAE and 6 first-class stamps.
Needs Uses 10 photos/issue; 40 photos/year. Needs "ghetto pictures, pictures of people deserving recognition, etc." Needs photos of "integrated schools with high achievement." Model release required.
Specs Uses b&w prints.
Making Contact & Terms Send unsolicited photos by mail for consideration; include SASE. Responds in 1 month. Simultaneous submissions OK. Pays $25-50 for b&w cover; $5-10 for b&w inside. **Pays on acceptance.** Credit line given. Buys one-time rights.
Tips Looks for "positive contributions and social and educational development."

$ $▣ ALASKA: Exploring Life on The Last Frontier

301 Arctic Slope Ave., Suite 300, Anchorage AK 99518. (907)272-6070. Web site: www.alaskamagazine.com. **Contact:** Tim Blum, art director. Circ. 140,000. Estab. 1935. Monthly magazine. Readers are people interested in Alaska. Sample copy available for $4. Photo guidelines free with SASE or on Web site.
Needs Buys 500 photos/year, supplied mainly by freelancers. Photo captions required.
Making Contact & Terms Send carefully edited, captioned submission of 35mm, 2¼×2¼ or 4×5 transparencies. Include SASE for return of material. Also accepts images in digital format; check guidelines before submitting. Responds in 1 month. Pays $50 maximum for b&w photos; $75-500 for color photos; $300 maximum/day; $2,000 maximum/complete job; $300 maximum/full page; $500 maximum/cover. Buys limited rights, first North American serial rights and electronic rights.
Tips "Each issue of *Alaska* features a 4- to 6-page photo feature. We're looking for themes and photos to show the best of Alaska. We want sharp, artistically composed pictures. Cover photo always relates to stories inside the issue."

▣ ⬚ ALTERNATIVES JOURNAL: Canadian Environmental Ideas & Action

Faculty of Environmental Studies, University of Waterloo, Waterloo ON N2L 3G1 Canada. (519)888-4545. Fax: (519)746-0292. E-mail: mruby@fes.uwaterloo.ca. Web site: www.alternativesjournal.ca. **Contact:** Marcia Ruby, production coordinator. Circ. 5,000. Estab. 1971. Bimonthly magazine. Emphasizes environmental issues. Readers are activists, academics, professionals, policy makers. Sample copy free with 9×12 SAE and 2 first-class stamps.
● "*Alternatives* is a nonprofit organization whose contributors are all volunteer. We are able to give a small honorarium to artists and photographers. This in no way should reflect the value of the work. It symbolizes our thanks for their contribution to *Alternatives*."
Needs Buys 4-8 photos from freelancers/issue; 48-96 photos/year. Subjects vary widely depending on theme of each issue. "We need action shots of people involved in environmental issues." Upcoming themes: climate change, waste, aid and art. Reviews photos with or without a manuscript. Photo captions preferred; include who, when, where, environmental significance of shot.
Specs Accepts images in digital format. Send via CD, e-mail as JPEG files at 300 dpi.
Making Contact & Terms "E-mail your Web address/electronic portfolio." Simultaneous submissions and previously published work OK. Pays on publication. Buys one-time rights; negotiable.
Tips "*Alternatives* covers Canadian and global environmental issues. Strong action photos or topical environmental issues are needed—preferably with people. We also print animal shots. We look for positive solutions to problems and prefer to illustrate the solutions rather than the problems. Freelancers need a good background understanding of environmental issues. You need to know the significance of your subject before you can powerfully present its visual perspective."

$ $▣ AMERICAN ANGLER, The Magazine of Fly Fishing and Fly Tying

Morris Communications, 160 Benmont Ave., Bennington VT 05201. (802)447-1518. Fax: (802)447-2471. E-mail: americanangler@flyfishingmagazines.com. Web site: www.americanangler.com. **Contact:** Phil Monahan, editor. Circ. 63,500. Estab. 1978. Bimonthly consumer magazine covering "fly fishing only.

More how-to than where-to, but we need shots from all over. More domestic than foreign. More trout, salmon and steelhead than bass or saltwater.'' Sample copy available for $6 and 9×12 SAE with Priority Mail Flat Rate Envelope with $4.05. Photo guidelines available on Web site.

Needs Buys 10 photos from freelancers/issue; 60 photos/year. "Most of our photos come from writers of articles." Wants photos that convey "the spirit, essence and exhilaration of fly fishing. Always need good fish-behavioral stuff—spawning, rising, riseforms, etc." Photo captions required.

Specs Prefers slides or digital images via CD or e-mail at 300 dpi; must be very sharp with good contrast.

Making Contact & Terms Send query letter with samples, brochure, stock photo list, tearsheets. Provide résumé, business card, self-promotion piece or tearsheets to be kept on file for possible future assignments. Portfolio review by prior arrangement. Query deadline: 6-10 months prior to cover date. Submission deadline: 5 months prior to cover date. Responds in 6 weeks to queries; 1 month to samples. Simultaneous submissions and previously published work OK—"but only for inside 'editorial' use—not for covers, prominent feature openers, etc." Pays $600 for color cover; $30-350 for color inside. Pays on publication. Credit line given. Buys one-time rights, first rights for covers.

Tips "We are sick of the same old shots: grip and grin, angler casting, angler with bent rod, fish being released. Sure, we need them, but there's a lot more to fly fishing. Don't send us photos that look exactly like the ones you see in most fishing magazines. Think like a storyteller. Let me know where the photos were taken, at what time of year, and anything else that's pertinent to a fly fisher."

▣ AMERICAN ARCHAEOLOGY

The Archaeological Conservancy, 5301 Central NE #902, Albuquerque NM 87108. (505)266-9668. Fax: (505)266-0311. E-mail: tacmag@nm.net. Web site: www.americanarchaeology.org. **Contact:** Vicki Singer, art director. Circ. 35,000. Estab. 1997. Quarterly consumer magazine. Sample copies available.

Specs Uses 35mm, 2¼×2¼, 4×5 transparencies. Accepts images in digital format. Send via CD at 300 dpi or higher.

Making Contact & Terms Send query letter with résumé, photocopies and tearsheets. Provide résumé, business card, self-promotion piece to be kept on file for possible future assignments. Responds in 2 months to queries. Previously published work OK. Pays $50 and up for occasional stock images; assigns work by project (pay varies); negotiable. **Pays on acceptance.** Credit line given. Buys one-time rights.

Tips "Read our magazine. Include accurate and detailed captions."

Ⓝ $AMERICAN FITNESS

15250 Ventura Blvd., Suite 200, Sherman Oaks CA 91403. (818)905-0040, ext. 200. E-mail: americanfitnes s@afaa.com. Web site: www.americanfitness.com. **Contact:** Meg Jordan, editor. Circ. 42,000. Estab. 1983. Bimonthly publication of the Aerobics and Fitness Association of America. Emphasizes exercise, fitness, health, sports nutrition, aerobic sports. Readers are fitness professionals, 75% college educated, 66% female, majority between ages 20-45. Sample copy available for $3.50.

Needs Buys 20-40 photos from freelancers/issue; 120-240 photos/year. Assigns 90% of work. Needs action photography of runners, aerobic classes, swimmers, bicyclists, speedwalkers, in-liners, volleyball players, etc. Also needs food choices, babies/children/teens, celebrities, couples, multicultural, families, parents, senior fitness, people enjoying recreation, cities/urban, rural, adventure, entertainment, events, hobbies, humor, performing arts, sports, travel, medicine, product shots/still life, science. Interested in alternative process, fashion/glamour, seasonal. Model release required.

Specs Uses b&w prints; 35mm, 2¼×2¼ transparencies.

Making Contact & Terms Send query letter with samples, list of stock photo subjects; include SASE for return of material. Responds in 2 weeks. Simultaneous submissions and previously published work OK. Pays $10-35 for b&w or color photo; $50 for text/photo package. Pays 4-6 weeks after publication. Credit line given. Buys first North American serial rights.

Tips Over-40 sports leagues, youth fitness, family fitness and senior fitness are hot trends. Wants high-quality, professional photos of people participating in high-energy activities—anything that conveys the essence of a fabulous fitness lifestyle. Also accepts highly stylized studio shots to run as lead artwork for feature stories. "Since we don't have a big art budget, freelancers usually submit spin-off projects from their larger photo assignments."

$ $◨ ▣ AMERICAN FORESTS MAGAZINE

734 15th St. NW, 8th Floor, Washington DC 20005. (202)737-1944, ext. 203. Fax: (202)737-2457. E-mail: mrobbins@amfor.org. Web site: www.americanforests.org. **Contact:** Michelle Robbins, editor. Circ.

25,000. Estab. 1895. Quarterly publication of American Forests. Emphasizes use, enjoyment and management of forests and other natural resources. Readers are "people from all walks of life, from rural to urban settings, whose main common denominator is an abiding love for trees, forests or forestry." Sample copy and photo guidelines free with magazine-sized envelope and 7 first-class stamps.

Needs Buys 32 photos from freelancers/issue; 128 photos/year. Needs woods scenics, wildlife, woods use/management, and urban forestry shots. "Also shots of national champion trees; contact editor for details." Photo captions required; include who, what, where, when and why.

Specs Uses 35mm or larger. Accepts images in digital format. Send link to viewing platform, or send via CD or FTP as TIFF files at 300 dpi.

Making Contact & Terms "We regularly review portfolios from photographers to look for potential images for upcoming issues or to find new photographers to work with." Send query letter with résumé of credits. Include SASE for return of material. Responds in 4 months. Pays $400 for color cover; $90-200 for color inside; $75-100 for b&w inside; $250-2,000 for text/photo package. **Pays on acceptance.** Credit line given. Buys one-time rights and rights for use in online version of magazine.

Tips "Please identify species in tree shots if possible."

$ ⑤ ▣ THE AMERICAN GARDENER

American Horticultural Society, 7931 E. Boulevard Dr., Alexandria VA 22308-1300. (703)768-5700. Fax: (703)768-7533. E-mail: editor@ahs.org. Web site: www.ahs.org. **Contact:** Mary Yee, art director/managing editor. Circ. 30,000. Estab. 1922. Bimonthly magazine. Sample copy available for $5. Photo guidelines free with SASE or via e-mail request.

Needs Uses 35-50 photos/issue. Needs photos of plants, gardens, landscapes. Reviews photos with or without a manuscript. Photo captions required; include complete botanical names of plants including genus, species and botanical variety or cultivar.

Specs Prefers color, 35mm slides and larger transparencies or high-res JPEG or TIFF files with a minimum size of 5×7 inches at 300 dpi. Digital images should be submitted on a CD.

Making Contact & Terms Send query letter with samples, stock list. Photographer will be contacted for portfolio review if interested. Does not keep samples on file; include SASE for return of material. Pays $300 maximum for color cover; $40-125 for color inside. Pays on publication. Credit line given. Buys one-time North American and nonexclusive rights.

Tips "Lists of plant species for which photographs are needed are sent out to a selected list of photographers approximately 10 weeks before publication. We currently have about 20 photographers on that list. Most of them have photo libraries representing thousands of species. Before adding photographers to our list, we need to determine both the quality and quantity of their collections. Therefore, we ask all photographers to submit both some samples of their slides (these will be returned immediately if sent with a SASE) and a list indicating the types and number of plants in their collection. After reviewing both, we may decide to add the photographer to our photo call for a trial period of 6 issues (1 year)."

$ $ ▣ AMERICAN HUNTER

NRA, 11250 Waples Mill Rd., Fairfax VA 22030. (703)267-1336. Fax: (703)267-3971. E-mail: publications @nrahq.org. Web site: www.nrapublications.org. **Contact:** J. Scott Olmsted, editor-in-chief. Circ. 1 million. Monthly magazine of the National Rifle Association. Sample copy and photo guidelines free with 9×12 SAE.

Needs Uses wildlife shots and hunting action scenes. Photos purchased with or without accompanying manuscript. Seeks general hunting stories on North American game. Model release required "for every recognizable human face in a photo." Photo captions preferred.

Specs Uses 35mm color transparencies. Accepts images in digital format. Send via CD as TIFF, GIF, JPEG files at 300 dpi. Vertical format required for cover.

Making Contact & Terms Send material by mail for consideration; include SASE for return of material. Responds in 3 months. Pays $75-450/transparency; $450-600 for color cover; $300-800 for text/photo package. Pays on publication. Credit line given. Buys one-time rights.

Tips "Most successful photographers maintain a file in our offices so editors can select photos to fill holes when needed. We keep files on most North American big game, small game, waterfowl, upland birds, and some exotics. We need live hunting shots as well as profiles and portraits in all settings. Many times there is not enough time to call photographers for special needs. This practice puts your name in front of the editors more often and increases the chances of sales."

$ ▣ AMERICAN MOTORCYCLIST

13515 Yarmouth Dr., Pickerington OH 43147. (614)856-1900. Fax: (614)856-1935. E-mail: ama@ama-cycle.org. Web site: www.amadirectlink.com. **Contact:** Bill Wood, director of communications. Managing Editor: Grant Parsons. Circ. 245,000. Monthly magazine of the American Motorcyclist Association. Emphasizes people involved in, and events dealing with, all aspects of motorcycling. Readers are "enthusiastic motorcyclists, investing considerable time in road riding or all aspects of the sport." Sample copy available for $1.50.

Needs Buys 10-20 photos/issue. Subjects include: travel, technical, sports, humorous, photo essay/feature and celebrity/personality. Photo captions preferred.

Specs Prefers images in digital format. Send via CD as TIFF, GIF, JPEG files at 300 dpi.

Making Contact & Terms Send query letter with samples to be kept on file for possible future assignments. Responds in 3 weeks. Pays $50-150/photo; $250 minimum for cover. Also buys photos in photo/text packages according to same rate; pays $8/column inch minimum for story. Pays on publication. Buys first North American serial rights.

Tips "The cover shot is tied in with the main story or theme of that issue and generally needs to be submitted with accompanying manuscript. Show us experience in motorcycling photography, and suggest your ability to meet our editorial needs and complement our philosophy."

$ ◪ ⑤ ▣ AMERICAN TURF MONTHLY

747 Middle Neck Rd., Suite 103, Great Neck NY 11024. (516)773-4075. Fax: (516)773-2944. E-mail: editor@americanturf.com. Web site: www.americanturf.com. **Contact:** James Corbett, editor-in-chief. Circ. 30,000. Estab. 1946. Monthly magazine covering Thoroughbred horse racing, especially aimed at horseplayers and handicappers.

Needs Buys 10 photos from freelancers/issue; 120 photos/year. Needs photos of celebrities, racing action, horses, owners, trainers, jockeys. Reviews photos with or without a manuscript. Photo captions preferred; include who, what, where.

Specs Uses glossy color prints. Accepts images in digital format. Send via CD, floppy disk, Zip as TIFF, JPEG files at 300 dpi.

Making Contact & Terms Send query letter with CD, prints. Provide business card to be kept on file for possible future assignments. Responds only if interested; send nonreturnable samples. Pays $150 minimum for color cover; $25 minimum for b&w or color inside. Pays on publication. Credit line given. Buys all rights.

Tips "Like horses and horse racing."

ⓝ $ ⑤ AMERICANPHOTOGUIDE.COM

E-mail: info@americanphotoguide.com. Web site: www.americanphotoguide.com. **Contact:** Joe Baker. Online consumer magazine whose mission is to bring excellence to the photography field while working to bring responsible conservation to the planet. Request photo guildelines via e-mail.

Needs Buys 2-5 photos from freelancers/issue. Needs photos of babies/children/teens, couples, families, parents, senior citizens, environmental, landscapes/scenics, wildlife, adventure. Reviews photos with or without a manuscript. "Manuscripts are not required but are encouraged. We primarily only accept images accompanied by an article. So for the best chance of getting published, send your photos along with an article explaining how to acheive the look/process in your photo, or an article that relates to the subject of the image." Model/property release preferred. Photo captions required; include date, place taken, any informaton about the area or subject, camera equipment used."

Specs Accepts images in digital format. Send via e-mail as JPEG files. Uses 4×6 and 5×7 prints.

Making Contact & Terms Does not keep samples on file. Responds in 24-72 hours. Simultaneous submissions and previously published work OK. Pays $1-150 for images and accompanying article. Pays on publication. Buys first rights and occasionally buys all rights.

▣ ANCHOR NEWS

75 Maritime Dr., Manitowoc WI 54220. (920)684-0218. Fax: (920)684-0219. E-mail: museum@Wisconsin Maritime.org. Web site: www.WisconsinMaritime.org. **Contact:** Curator. Circ. 1,100. Quarterly publication of the Wisconsin Maritime Museum. Emphasizes Great Lakes maritime history. Readers include learned and lay readers interested in Great Lakes history. Sample copy available for 9×12 SAE and $1 postage. Photo guidelines free with SASE.

Needs Uses 8-10 photos/issue; infrequently supplied by freelance photographers. Needs historic/nostal-

gic; personal experience; Great Lakes environmental issues, including aquatic invasive species and other topics of intereset to environmental educators; and general interest articles on Great Lakes maritime topics. How-to and technical pieces and model ships and shipbuilding are OK. Special needs include historic photography or photos that show current historic trends of the Great Lakes; photos of waterfront development, bulk carriers, sailors, recreational boating, etc. Model release required. Photo captions required.

Specs Accepts images in digital format. Send via CD, e-mail as JPEG files at 300 dpi minimum.

Making Contact & Terms Send 4×5 or 8×10 glossy b&w prints by mail for consideration; include SASE for return of material. Simultaneous submissions and previously published work OK. Pays in copies on publication. Credit line given. Buys first North American serial rights.

Tips "Besides historic photographs, I see a growing interest in underwater archaeology, especially on the Great Lakes, and underwater exploration—also on the Great Lakes. Sharp, clear photographs are a must. Our publication deals with a wide variety of subjects; however, we take a historical slant with our publication. Therefore photos should be related to a historical topic in some respect. Also, there are current trends in Great Lakes shipping. A query is most helpful. This will let the photographer know exactly what we are looking for and will help save a lot of time and wasted effort."

ANIMAL TRAILS

2660 Petersborough St., Herndon VA 20171. E-mail: animaltrails@yahoo.com. Quarterly publication.

Needs Needs photos of environmental, landscapes/scenics, wildlife, architecture, cities/urban, gardening, interiors/decorating, pets, religious, rural, performing arts, agriculture, product shots/still life—as related to animals. Interested in alternative process, avant garde, documentary, fashion/glamour, fine art, historical/vintage, seasonal. Reviews photos with or without a manuscript. Model/property release preferred.

Specs Uses glossy or matte color and/or b&w prints.

Making Contact & Terms Send query letter via e-mail. Provide résumé, business card, self-promotion piece to be kept on file for possible future assignments. "A photograph or two is requested but not required. Illustrations and artwork are also accepted." Responds within 1 month to queries; 1 week to portfolios. Simultaneous submissions and previously published work OK. **Pays on acceptance.** Credit line given. Buys one-time rights, first rights; negotiable.

$ ☑ ▣ APPALACHIAN TRAIL JOURNEYS

P.O. Box 807, Harpers Ferry WV 25425. (304)535-6331. Fax: (304)535-2667. E-mail: mbartels@appalachi antrail.org. Web site: www.appalachiantrail.org. **Contact:** Marty Bartels, director of marketing & communications. Circ. 38,000. Estab. 2005. Bimonthly publication of the Appalachian Trail Conservancy. Uses only photos related to the Appalachian Trail. Readers are conservationists, hikers. Photo guidelines available on Web site.

Needs Buys 4-5 photos from freelancers/issue in addition to 2- to 4-page "Vistas" spread each issue; 50-60 photos/year. Most frequent need is for candids of hikers enjoying the trail. Photo captions and release required.

Specs Accepts high-res digital images (300 dpi). Uses 35mm transparencies.

Making Contact & Terms Send query letter with ideas by mail, e-mail. Duplicate slides preferred over originals for query. Responds in 3 weeks. Simultaneous submissions and previously published work OK. Pays on publication. Pays $300 for cover; variable for inside. Credit line given. Rights negotiable.

$ ☑ ▣ AQUARIUM FISH INTERNATIONAL

(formerly *Aquarium Fish Magazine*), P.O. Box 6050, Mission Viejo CA 92690. Fax: (949)855-3045. E-mail: aquariumfish@bowtieinc.com. Web site: www.aquariumfish.com. **Contact:** Patricia Knight, managing editor. Estab. 1988. Monthly magazine. Emphasizes aquarium fish. Readers are both genders, all ages. Photo guidelines free with SASE, via e-mail or on Web site.

Needs Buys 30 photos from freelancers/issue; 360 photos/year. Needs photos of aquariums and fish, freshwater and saltwater; ponds.

Specs Uses 35mm slides, transparencies; original prints are preferred. Accepts digital images—"but digital image guidelines must be strictly followed for submissions to be considered."

Making Contact & Terms Send slides, transparencies, original prints (no laser printouts) or CDs (no DVDs) by mail for consideration; include SASE for return of material. Pays $200 for color cover; $15-150 for color inside. Pays on publication. Credit line given. Buys first North American serial rights.

N $ $ ☺ ▣ ARIZONA WILDLIFE VIEWS

Arizona Game and Fish Department, IEPB, 2221 W. Greenway Rd., Phoenix AZ. E-mail: awv@azfgd.gov. Web site: www.azgfd.gov **Contact:** Julie Hammonds, associate editor. Estab. 1953. Circ. 22,000. Bimonthly official magazine of the Arizona Game & Fish Department. "*Arizona Wildlife Views* is a general interest magazine about Arizona wildlife, wildlife management and outdoor recreation (specifically hunting, fishing, wildlife watching, boating and off-highway vehicle recreation). We publish material that conforms to the mission and policies of the Arizona Game and Fish Department. In addition to Arizona wildlife management, topics include habitat issues, outdoor recreation involving wildlife, boating, fishing, hunting, bird-watching, animal observation, off-highway vehicle use, and historical articles about wildlife and wildlife management."

Needs Needs photos of sports, environmental, landscapes/scenics, wildlife in Arizona. Reviews photos with or without a manuscript. Model release required only if the subject matter is of a delicate or sensitive nature. Captions required.

Specs "We prefer and primarily use professional-quality 35mm and larger color transparencies. Submitted transparencies must be numbered, identified by artist, and an inventory list must accompany each shipment. The highest resolution digital images are occasionally used." Send JPEG or GIF files.

Making Contact & Terms "The magazine does not accept responsibility for any submissions. It is the artist's responsibility to insure his or her work." Pays $400 for front cover; $350 for back cover; $250 for inside half-page or larger; $150 for inside smaller than half-page. Pays following publication. Credit line given. Buys one-time rights.

Tips "Unsolicited material without proper identification will be returned immediately."

$ $ ◨ ▣ ⬙ ASCENT MAGAZINE: yoga for an inspired life

837 Rue Gilford, Montreal QC H2J 1P1 Canada. (514)499-3999. Fax: (514)499-3904. E-mail: design@ascentmagazine.com. Web site: www.ascentmagazine.com. **Contact:** Rocket Day Arts. Circ. 11,000. Estab. 1999. "A quarterly magazine that presents unique perspectives on yoga and spirituality; explores what it means to be truly human, think deeply and live a meaningful life in today's world. The writing is intimate and literary." Sample copy available for $11. Photo guidelines available via e-mail or on Web site.

Needs Buys 12 photos from freelancers/issue; 48 photos/year. Specific photo needs: yoga, meditation; "artwork that is abstract, quirky and unique." Interested in alternative process, avant garde, documentary, fine art. Reviews photos with or without a manuscript. Model release required; property release preferred. Photo captions preferred; include title, artist, date.

Specs Uses glossy color and/or b&w prints. Accepts images in digital format. Send via CD, e-mail as TIFF, JPEG files at 300 dpi.

Making Contact & Terms E-mail query letter with attached résumé, Web site link, and/or self-promotion piece. Place "Ascent" in the subject line of the e-mail. Responds in 2 months to queries and portfolios. Previously published work OK. Pays $300-500 for color cover; $50-350 for b&w inside. Pays on publication. Credit line given. Buys first rights; negotiable.

Tips "Connect with the simplicity of the magazine's design, and be willing to work with content. Please review artist guidelines and themes on Web site."

$ ▣ ASTRONOMY

21027 Crossroads Circle, Waukesha WI 53187. (262)796-8776. Fax: (262)798-6468. E-mail: mbakich@astronomy.com. Web site: www.astronomy.com. **Contact:** Michael Bakich, photo editor. Circ. 133,000. Estab. 1973. Monthly magazine. Emphasizes astronomy, science and hobby. Median reader: 52 years old, 86% male, income approximately $75,000/year. Sample copy available for $3. Photo guidelines free with SASE or via Web site.

Needs Buys 70 photos from freelancers/issue; 840 photos/year. Needs photos of astronomical images. Model/property release preferred. Photo captions required.

Specs Accepts images in high-resolution digital format ("RAW preferred, but JPEG is acceptable"). Also can accept conventional photos in most formats ("the larger the better").

Making Contact & Terms Send duplicate images by mail for consideration. Keeps samples on file. Responds in 1 month. Pays $100 for cover; $25 for routine uses. Pays on publication. Credit line given.

$ $ ◨ Ⓐ ▣ ATLANTA HOMES & LIFESTYLES

1100 Johnson Ferry Rd. NE, Suite 595, Atlanta GA 30342. (404)252-6670. Web site: www.atlantahomesmag.com. **Contact:** Rachel Cardina, creative director. Editor: Clinton Ross Smith. Circ. 34,000. Estab. 1983.

Monthly magazine. Covers residential design (home and garden); food, wine and entertaining; people, lifestyle subjects in the metro Atlanta area. Sample copy available for $3.95.
Needs Needs photos of homes (interior/exterior), people, decorating ideas, products, gardens. Model/property release required. Photo captions preferred.
Specs Uses 35mm, $2\frac{1}{4} \times 2\frac{1}{4}$, 4×5 transparencies. Accepts images in digital format.
Making Contact & Terms Contact creative director to review portfolio. Provide résumé, business card, brochure, flier or tearsheets to be kept on file for possible future assignments. Responds in 2 months. Simultaneous submissions and previously published work OK. Pays $150-750/job. **Pays on acceptance.** Credit line given. Buys one-time rights.

N ⬚ ⬚ ATLANTA LIFE MAGAZINE
2500 Hospital Blvd., Roswell GA 30076. (707)664-6466. Fax: (707)664-6465. E-mail: nzieky@atlantalifemag.com. Web site: www.atlantalifemag.com. **Contact:** Natalie Zieky. Estab. 2006. Monthly consumer magazine. ''We are an upscale lifestyle magazine covering the northern part of Atlanta. We cover a variety of topics, including sports, fashion, travel, health, finances, home design.''
Needs Needs photos of architecture, cities/urban, gardening, interiors/decorating, entertainment, food/drink, health/fitness/beauty, performing arts, sports, travel. Interested in lifestyle. Reviews photos with or without a manuscript. Model release required. Captions required: include identification of subjects.
Specs Accepts images in digital format. Send JPEG or GIF files.
Making Contact & Terms Payment negotiated. Pays on publication. Credit line given. Buys one-time rights, Web usage rights.
Tips ''Have high-resolution photo support if you are also submitting a manuscript.''

$ ⬚ ATLANTA PARENT
2346 Perimeter Park Dr., Atlanta GA 30341. (770)454-7599. Fax: (770)454-7699. E-mail: rmintz@atlantaparent.com. Web site: www.atlantaparent.com. **Contact:** Robin Mintz, associate publisher. Circ. 120,000. Estab. 1983. Monthly magazine. Emphasizes parents, families, children, babies. Readers are parents with children ages 0-18. Sample copy available for $3.
Needs Needs professional-quality photos of babies, children involved in seasonal activities, parents with kids and teenagers. Also needs photos showing racial diversity. Model/property release required.
Specs Accepts images in digital format. E-mail as TIFF, EPS, JPEG, PDF files at 300 dpi.
Making Contact & Terms Send query letter with samples via e-mail. Keeps samples on file for future consideration. Simultaneous submissions and previously published work OK. Pays after publication. Credit line given.

$ ⬚ ⬚ AUTO RESTORER
P.O. Box 6050, Mission Viejo CA 92690. (949)855-8822, ext. 3412. Fax: (949)855-3045. E-mail: tkade@bowtieinc.com. Web site: www.autorestorermagazine.com. **Contact:** Ted Kade, editor. Circ. 60,000. Estab. 1989. Monthly magazine. Emphasizes restoration of collector cars and trucks. Readers are 98% male, professional/technical/managerial, ages 35-65.
Needs Buys 47 photos from freelancers/issue; 564 photos/year. Needs photos of auto restoration projects and restored cars. Reviews photos with accompanying manuscript only. Model/property release preferred. Photo captions required; include year, make and model of car; identification of people in photo.
Specs Prefers images in high-resolution digital format. Send via CD at 240 dpi with minimum width of 5 inches. Uses transparencies, mostly 35mm, $2\frac{1}{4} \times 2\frac{1}{4}$.
Making Contact & Terms Submit inquiry and portfolio for review. Provide résumé, business card, brochure, flier or tearsheets to be kept on file for possible future assignments. Responds in 1 month. Simultaneous submissions OK. Pays $50 for b&w cover; $35 for b&w inside. Pays on publication. Credit line given. Buys first North American serial rights.
Tips Looks for ''technically proficient or dramatic photos of various automotive subjects, auto portraits, detail shots, action photos, good angles, composition and lighting. We're also looking for photos to illustrate how-to articles such as how to repair a damaged fender or how to repair a carburetor.''

⬚ BABYTALK
135 W. 50th St., 3rd Floor, New York NY 10020. (212)522-6242. Fax: (212)467-1747. E-mail: nancy_smith @timeinc.com. Web site: www.babytalk.com. **Contact:** Nancy Smith, art director. Estab. 1937. Monthly magazine with a non-newstand circulation of 2 million; distributed via subscription and through physi-

cians' offices and retail outlets. Readers are new mothers and pregnant women. Sample copies available upon request.

Making Contact & Terms Send query letter and printed samples; include URL for your Web site. After introductory mailing, send follow-up postcard every 3 months. Samples are kept on file. Responds only if interested. Portfolios not required. **Pays on acceptance.** Buys one-time rights, reprint rights, all rights, electronic rights. Finds freelancers through agents, artists' submissions, word of mouth and sourcebooks.

Tips "Please, no calls or e-mails. Postcards or mailers are best. We don't look at portfolios unless we request them. Web sites listed on mailers are great."

☑ ▣ BASEBALL

2660 Petersborough St., Herndon VA 20171. E-mail: shannonaswriter@yahoo.com. Quarterly magazine covering baseball. Photo guidelines available by e-mail request.

Needs Wants photos of baseball scenes featuring children and teens; photos of celebrities, couples, multicultural, families, parents, environmental, landscapes/scenics, wildlife, agriculture—as related to the sport of baseball. Interested in alternative process, avant garde, documentary, fine art, historical/vintage, seasonal. Reviews photos with or without a manuscript.

Specs Uses glossy or matte color and/or b&w prints.

Making Contact & Terms Send query letter via e-mail. "If possible, please do not include photographs in files if they are sent through e-mail. A disk with your photographs is acceptable. If you plan to send a disk, photographs or portfolio, please send an e-mail stating this." Provide résumé, business card, self-promotion piece to be kept on file for possible future assignments. "Photographs sent with CDs are requested but not required. Illustrations and artwork are also accepted." Responds within 1 month to queries; 1 week to portfolios. Simultaneous submissions and previously published work OK. **Pays on acceptance.** Credit line given. Buys one-time, first rights; negotiable.

▣ ▩ BC OUTDOORS: HUNTING & SHOOTING

OP Publishing Ltd., 1080 Howe St., Suite 900, Vancouver BC V6Z 2T1 Canada. (604)606-4644. Fax: (604)687-1925. E-mail: cdawson@oppublishing.com. Web site: www.oppublishing.com. **Contact:** Chelsea Whitteker, managing editor. Art Director: Cory Dawson. Circ. 35,000. Estab. 1945. Biannual magazine emphasizing hunting, RV camping, wildlife and management issues in British Columbia only. Sample copy available for $4.95 Canadian.

Needs Buys 30-35 photos from freelancers/issue; 60-70 photos/year. "Hunting, canoeing and camping. Family oriented. By far, most photos accompany manuscripts. We are always on the lookout for good covers—wildlife, recreational activities, people in the outdoors—of British Columbia, vertical and square format. Photos with manuscripts must, of course, illustrate the story. There should, as far as possible, be something happening. Photos generally dominate lead spread of each story. They are used in everything from double-page bleeds to thumbnails. Column needs basically supplied in-house." Model/property release preferred. Photo captions or at least full identification required.

Specs Prefers images in digital format. Send via e-mail at 300 dpi.

Making Contact & Terms Send by mail for consideration actual 5×7 or 8×10 color prints; 35mm, 2¼×2¼, 4×5 or 8×10 color transparencies; color contact sheet. If color negative, send jumbo prints, then negatives only on request. E-mail high-resolution electronic images. Send query letter with list of stock photo subjects. Include SASE or IRC. Pays in Canadian currency. Simultaneous submissions not acceptable if competitor. Editor determines payments. Pays on publication. Credit line given. Buys one-time rights for inside shots; for covers, "we retain the right for subsequent promotional use."

▣ ▩ BC OUTDOORS: SPORT FISHING & OUTDOOR ADVENTURE

OP Publishing Ltd., 1080 Howe St., Suite 900, Vancouver BC V6Z 2T1 Canada. (604)606-4644. Fax: (604)687-1925. E-mail: cdawson@oppublishing.com. Web site: www.bcosportfishing.com. **Contact:** Chelsea Whitteker, managing editor. Art Director: Cory Dawson. Circ. 35,000. Estab. 1945. Magazine published 7 times/year. Emphasizes fishing, both fresh and salt water. Sample copy available for $4.95 Canadian.

Needs Buys 30-35 photos from freelancers/issue; 180-210 photos/year. "Fishing (in our territory) is a big need—people in the act of catching or releasing fish. Family oriented. By far, most photos accompany manuscripts. We are always on the lookout for good covers—fishing, wildlife, recreational activities, people in the outdoors—of British Columbia, vertical and square format. Photos with manuscripts must, of course, illustrate the story. There should, as far as possible, be something happening. Photos generally

dominate lead spread of each story. They are used in everything from double-page bleeds to thumbnails. Column needs basically supplied in-house.'' Model/property release preferred. Photo captions or at least full identification required.

Specs Prefers images in digital format. Send via e-mail at 300 dpi.

Making Contact & Terms Send by mail for consideration actual 5×7 or 8×10 color prints; 35mm, 2¼×2¼, 4×5 or 8×10 color transparencies; color contact sheet. If color negative, send jumbo prints, then negatives only on request. E-mail high-resolution electronic images. Send query letter with list of stock photo subjects. Include SASE or IRC. Pays in Canadian currency. Simultaneous submissions not acceptable if competitor. Editor determines payments. Pays on publication. Credit line given. Buys one-time rights for inside shots; for covers, ''we retain the right for subsequent promotional use.''

$ ☑ ▣ THE BEAR DELUXE MAGAZINE

Orlo, P.O. Box 10342, Portland OR 97296. (503)242-1047. E-mail: bear@orlo.org. Web site: www.orlo.org. **Contact:** Kristen Rogers, art director. Circ. 20,000. Estab. 1993. Quarterly magazine. ''We use the arts to focus on environmental themes.'' Sample copy available for $3. Photo guidelines available for SASE.

Needs Buys 10 photos from freelancers/issue; 40 photos/year. Needs photos of environmental, landscapes/scenics, wildlife, adventure, political. Reviews photos with or without a manuscript. Model release required (as needed); property release preferred. Photo captions preferred; include place, year, photographer, names of subjects.

Specs Uses 8×10 matte b&w prints. Accepts images in digital format. Send via CD, Zip, or low-res e-mail files.

Making Contact & Terms Send query letter with résumé, slides, prints, photocopies. Portfolio may be dropped off by appointment. Provide résumé, self-promotion piece to be kept on file for possible future assignments. Responds in 6 months to queries; 2 months to portfolios. Only returns materials if appropriate SASE included. Not liable for submitted materials. Simultaneous submissions and previously published work OK as long as it is noted as such. Pays $200 for b&w cover; $30-50 for b&w inside. Pays approximately 3 weeks after publication. Credit line given. Buys one-time rights; negotiable.

Tips ''Read the magazine. We want unique and unexpected photos, not your traditional nature or landscape stuff.''

ℕ $◯ ▣ BIBLE ADVOCATE

P.O. Box 33677, Denver CO 80233. E-mail: bibleadvocate@cog7.org. Web site: www.cog7.org/BA/. **Contact:** Sherri Langton. Circ. 13,500. Estab. 1863. Publication of the Church of God (Seventh Day). Magazine published 8 times/year. Gives a voice for the Bible and represents the Church of God. Sample copy free with 9×12 SAE and 3 first-class stamps.

Needs Needs photos of people, especially Hispanics and other ethnic groups, social issues, churches, congregations worshiping in church and being involved in church activities, Israel. Photo captions preferred; include name, place.

Specs Accepts images in digital format. Send via CD, Zip, e-mail as TIFF, JPEG files at 300 dpi.

Making Contact & Terms Submit portfolio for review or ''refer us to your Web site''; include SASE for return of material. ''Digital work is easiest for us to access. E-mail is preferred.'' Responds as needed. Simultaneous submissions and previously published work OK. ''We normally purchase CDs from stock companies. We rarely purchase individual photos by freelancers.'' Rights negotiable.

Tips ''Because of our limited budget, we usuually buy CDs from stock companies, but would consider CDs of photographers' work. Please, *no scenics*. We really need people shots.''

$ ☑ Ⓢ BIRD WATCHER'S DIGEST

149 Acme St., Marietta OH 45750. (740)373-5285. E-mail: editor@birdwatchersdigest.com. Web site: www.birdwatchersdigest.com. **Contact:** Bill Thompson III, editor. Circ. 99,000. Bimonthly; digest size. Emphasizes birds and bird watchers. Readers are bird watchers/birders (backyard and field, veterans and novices). Sample copy available for $3.99. Photo guidelines available on Web site.

Needs Buys 25-35 photos from freelancers/issue; 150-210 photos/year. Needs photos of North American species.

Specs Accepts high-resolution (300 dpi) digital images via CD or DVD. ''We appreciate quality thumbnails to accompany digital images.''

Making Contact & Terms Send query letter with list of stock photo subjects, samples, SASE. Responds

in 2 months. *Work previously published in other bird publications should not be submitted.*Pays $75 for color inside. Pays on publication. Credit line given. Buys one-time rights.

Tips "Query with slides to be considered for photograph want list. Send a sample of at least 20 slides for consideration. Sample will be reviewed and responded to in 8 weeks."

$ $ ☺ ▣ BIRDER'S WORLD

Kalmbach Publishing Co., 21027 Crossroads Circle, Waukesha WI 53187-1612. (262)796-8776, ext. 426. E-mail: emastroianni@birdersworld.com. Web site: www.birdersworld.com. **Contact:** Ernie Mastroianni, photo editor. Circ. 40,000. Estab. 1987. Bimonthly consumer magazine. Readers are avid birdwatchers, ornithologists and those interested in wildlife. Sample copy available for SAE with first-class postage. Photo guidelines available on Web site.

Needs Buys 30 photos from freelancers/issue; 180 photos/year. Needs photos of birds. Also interested in landscapes/scenics, other wildlife, travel. Reviews photos with or without a manuscript. Photo captions should include species of bird, date and place.

Specs Accepts images in "film or digital format. Send digital images via CD as TIFF or high-quality JPEG files at a size of at least 2,000 by 3,000 pixels."

Making Contact & Terms Send query letter with transparencies or full-resolution digital images on CD. Responds in 1 month to queries and portfolios. Previously published work OK. Pays $250 for color cover; $50 minimum for color inside; $125 for full page; $200 for spread. Pays on publication. Credit line given. Buys one-time rights.

Tips "Our contributors are well-established wildlife photographers who submit photographs in response to an e-mail want list. To be considered for placement on the want list, submit a portfolio of 40 transparencies or full-resolution digital images on a CD with complete captions. The field is extremely competitive, so your portfolio must show more than common backyard birds and should demonstrate a fresh approach to wildlife photography. Captions and photographer's name must be included in the digital file metadata. We need images of birds in their natural habitat. We do not publish pictures of birds in captivity. If an image is digitally altered, please tell us. We also publish our readers' best photos in our "Your View" section, but we do not pay for these images."

$ $ ◑ ⑤ ▣ BIRDS & BLOOMS

Reiman Media Group, Inc., 5400 S. 60th St., Greendale WI 53129. Fax: (414)423-8463. E-mail: photocoord inator@reimanpub.com. Web site: www.birdsandblooms.com. **Contact:** Trudi Bellin, photo coordinator. Estab. 1994. Bimonthly magazine. Celebrates "the beauty in your own backyard." Readers are male and female, ages 40-70 (majority), who prefer to spend their spare time in their "outdoor living room." Heavy interest in "amateur" gardening, backyard bird-watching and bird-feeding. Sample copy available for $2.

- *Birds & Blooms EXTRA* is published in the months between regular issues. Content and guidelines are the same.

Needs Buys 60 photos from freelancers/issue; 720 photos/year. Needs photos of gardening, backyard birds, landscapes, outdoor hobbies and seasonal.

Specs Prefers color transparencies, all sizes. Accepts images in digital format: TIFF or high-quality JPEG files at 300 dpi for up to 9×11 reproduction. Embedded metadata is recommended. Send via lightboxes or on removable media. Or send CD/DVD with printed thumbnails and caption sheet. E-mail if first review selection is small (12 images or less).

Making Contact & Terms Send query letter with résumé of credits, stock list. Send unsolicited photos by mail for consideration. Keeps samples on file (tearsheets; no dupes); include SASE for return of material. Responds in 3 months for first review. Simultaneous submissions and previously published work OK. Buys stock only. Pays $100-300 for inside; $300 for cover; $200 for color back cover. Pays on publication. Credit line given. Buys one-time rights to stock photos; all rights to assignments. "Magazine generates an annual book; you can count on most images appearing again in the annual at a re-use rate."

Tips "Technical quality is extremely important; focus must be sharp (no soft focus), and colors must be vivid so they 'pop off the page.' Study our magazine thoroughly—we have a continuing need for sharp, colorful images, and those who can supply what we need can expect to be regular contributors. Very interested in photos of people involved in typical backyard activities."

$ ◑ ▣ BLUE RIDGE COUNTRY

P.O. Box 21535, Roanoke VA 24018. (540)989-6138. Fax: (540)989-7603. E-mail: photos@leisurepublishi ng.com. Web site: www.blueridgecountry.com. **Contact:** Cara Ellen Modisett, editor. Circ. 60,000. Estab.

1988. Bimonthly magazine. Emphasizes outdoor scenics, recreation, travel destinations in 9-state Blue Ridge Mountain region. Photo guidelines available for SASE or on Web site.

Needs Buys 20-40 photos from freelancers/issue; 100-300 photos/year. Needs photos of travel, scenics and wildlife. Seeking more scenics with people in them. Model release preferred. Photo captions required.

Specs Uses 35mm, $2\frac{1}{4} \times 2\frac{1}{4}$, 4×5 transparencies. Accepts images in digital format. Send via CD at 300 dpi; low-res images okay for initial review, but accepted images must be high-res.

Making Contact & Terms Send query letter with list of stock photo subjects, samples with caption info and SASE. Responds in 2 months. Pays $100-150 for color cover; $40-100 for color inside. Pays on publication. Credit line given. Buys one-time rights.

$◻ ⑤ ▣ BOROUGH NEWS MAGAZINE

2941 N. Front St., Harrisburg PA 17110. (717)236-9526. Fax: (717)236-8164. E-mail: caccurti@boroughs.org. Web site: www.boroughs.org. **Contact:** Courtney Accurti, editor. Circ. 6,000. Estab. 2001. Monthly magazine of Pennsylvania State Association of Boroughs. Emphasizes borough government in Pennsylvania. Readers are officials in municipalities in Pennsylvania. Sample copy free with 9×12 SAE and 5 first-class stamps.

Needs Number of photos/issue varies with inside copy. Needs ''color photos of scenics (Pennsylvania), local government activities, Pennsylvania landmarks, ecology—for cover photos only; authors of articles supply their own photos.'' Special photo needs include street and road maintenance work; wetlands scenic. Model release preferred. Photo captions preferred; include identification of place and/or subject.

Specs Uses color prints and 35mm transparencies. Accepts images in digital format. Send via CD, Zip, e-mail as TIFF, EPS, JPEG, PSD files at 300 dpi.

Making Contact & Terms Send query letter with résumé of credits and list of stock photo subjects. Send unsolicited photos by mail for consideration; include SASE for return of material. Provide résumé, business card, brochure, flier or tearsheets to be kept on file for possible future assignments. Responds in 1 month. Pays $30 for color cover. Pays on publication. Buys one-time rights.

Tips ''We're looking for a variety of scenic shots of Pennsylvania for front covers of the magazine, especially special issues such as engineering, street/road maintenance, downtown revitalization, technology, tourism and historic preservation, public safety and economic development, and recreation.''

$ $ BOWHUNTER

6405 Flank Dr., Harrisburg PA 17112. (717)657-9555. E-mail: bowhunter@cowles.com. Web site: www.bowhunter.com. **Contact:** Mark Olszewski, art director. Editor: Dwight Schuh. Publisher: Jeff Waring. Circ. 180,067. Estab. 1971. Published 9 times/year. Emphasizes bow and arrow hunting. Sample copy available for $2. Submission guidelines free with SASE.

Needs Buys 50-75 photos/year. Wants scenic (showing bowhunting) and wildlife (big and small game of North America) photos. ''No cute animal shots or poses. We want informative, entertaining bowhunting adventure, how-to and where-to-go articles.'' Reviews photos with or without a manuscript.

Specs Uses 5×7, 8×10 glossy b&w and/or color prints, both vertical and horizontal format; 35mm and $2\frac{1}{4} \times 2\frac{1}{4}$ transparencies; vertical format preferred for cover.

Making Contact & Terms Send query letter with samples, SASE. Responds in 2 weeks to queries; 6 weeks to samples. Pays $50-125 for b&w inside; $75-300 for color inside; $600 for cover, ''occasionally more if photo warrants it.'' **Pays on acceptance.** Credit line given. Buys one-time publication rights.

Tips ''Know bowhunting and/or wildlife and study several copies of our magazine before submitting any material. We're looking for better quality, and we're using more color on inside pages. Most purchased photos are of big game animals. Hunting scenes are second. In b&w we look for sharp, realistic light, good contrast. Color must be sharp; early or late light is best. We avoid anything that looks staged; we want natural settings, quality animals. Send only your best, and, if at all possible, let us hold those we indicate interest in. Very little is taken on assignment; most comes from our files or is part of the manuscript package. If your work is in our files, it will probably be used. Some digital photography may be accepted—inquire by phone before submitting!''

◪ ▣ BRENTWOOD MAGAZINE

2118 Wilshire Blvd., #590, Santa Monica CA 90403. (310)395-5209. Fax: (310)390-0261. E-mail: jenny@brentwoodmagazine.com. Web site: www.brentwoodmagazine.com. **Contact:** Jenny Peters, editor-in-chief. Circ. 70,000. Bimonthly lifestyle magazine for an affluent California audience.

Needs Buys 10 photos from freelancers/issue; 60 photos/year. Needs photos of celebrities, wildlife,

architecture, interiors/decorating, adventure, automobiles, entertainment, health/fitness, sports, travel. Interested in avant garde, fashion/glamour, historical/vintage, seasonal.
Specs Accepts images in digital format. Send via Zip as TIFF files at high-res dpi.
Making Contact & Terms Send query letter with résumé. Simultaneous submissions and previously published work OK. Payment varies. Pays on publication. Credit line given. Rights negotiable.

☐ ☒ BRIARPATCH

2138 McIntyre St., Regina SK S4P 2R7 Canada. (306)525-2949. E-mail: editor@briarpatchmagazine.com. Web site: www.briarpatchmagazine.com. **Contact:** Dave Mitchell, editor. Circ. 2,000. Estab. 1973. Magazine published 8 times/year. Emphasizes Canadian and international politics, labor, environment, women, peace. Readers are left-wing political activists. Sample copy available for $3.99 plus shipping.
Needs Buys 15-30 photos from freelancers/issue; 150-300 photos/year. Needs photos of Canadian and international politics, labor, environment, women, peace and personalities. Model/property release preferred. Photo captions preferred; include name of person(s) in photo, etc.
Specs Minimum 3×5 color or b&w prints.
Making Contact & Terms Send query letter with stock list. Send unsolicited photos by mail for consideration. "Do not send slides!" Provide résumé, business card, brochure, flier or tearsheets to be kept on file for possible future assignments. Keeps samples on file; include SASE for return of material. Responds in 1 month. Simultaneous submissions and previously published work OK. "We cannot pay photographers for their work since we do not pay any of our contributors (writers, illustrators). We rely on volunteer submissions. When we publish photos, etc., we send photographer 5 free copies of magazine." Credit line given. Buys one-time rights.
Tips "We keep photos on file and send free magazines when they are published."

$ ☑ ◲ BRIDAL GUIDES

2660 Petersborough St., Herndon VA 20171. E-mail: BridalGuides@yahoo.com. Estab. 1998. Quarterly. Photo guidelines available by e-mail request.
Needs Buys 12 photos from freelancers/issue; 48-72 photos/year. Needs photos of babies/children/teens, celebrities, couples, multicultural, families, parents, cities/urban, environmental, landscapes/scenics, wildlife, architecture, gardening, interiors/decorating, pets, religious, rural, adventure, entertainment, events, food/drink, health/fitness, performing arts, travel, agriculture—as related to weddings. Interested in alternative process, avant garde, documentary, fashion/glamour, fine art, historical/vintage, seasonal. Also wants photos of weddings "and those who make it all happen, both behind and in front of the scene." Reviews photos with or without a manuscript. Model/property release preferred.
Specs Uses glossy or matte color and/or b&w prints.
Making Contact & Terms Send query letter via e-mail. "If possible, please do not include photographs in files if they are sent through e-mail. A disk with your photographs is acceptable. If you plan to send a disk, photographs or portfolio, please send an e-mail stating this." Provide résumé, business card or self-promotion piece to be kept on file for possible future assignments. "A photograph or two sent with CD is requested but not required. Illustrations and artwork are also accepted." Responds within 1 month to queries; 1 week to portfolios. Simultaneous submissions and previously published work OK. **Pays on acceptance.** Credit line given. Buys one-time rights, first rights; negotiable.

$ ◲ THE BRIDGE BULLETIN

American Contract Bridge League, 2990 Airways Blvd., Memphis TN 38116-3847. (901)332-5586. Fax: (901)398-7754. E-mail: editor@acbl.org. Web site: www.acbl.org. Circ. 154,000. Estab. 1937. Monthly association magazine for tournament/duplicate bridge players. Sample copies available.
Needs Buys 4-5 photos/year. Reviews photos with or without a manuscript.
Specs Prefers high-res digital images, color only.
Making Contact & Terms Query by phone. Responds only if interested; send nonreturnable samples. Previously published work OK. Pays $100 or more for suitable work. Pays on publication. Credit line given. Buys all rights.
Tips Photos must relate to bridge. Call first.

Ⓝ ☑ ◲ BVM: Beach Volleyball Magazine

STN Media Co., 700 Torrance Blvd. Suite C, Redondo Beach CA 90277. (310)792-2226. Fax: (310)792-2231. E-mail: vince@bvmag.com, ryan@bvmag.com. Web site: www.bvmag.com. **Contact:** Vince Rios,

art director. Circ. 30,000. Estab. 2006. Consumer magazine published 6 times/year focusing on the life-style of beach volleyball; features news about the beach volleyball community nationwide, including exclusive interviews with top AVP players, major association news, junior volleyball coverage, and major tournament coverage.
Needs Needs lifestyle photos of beach volleyball, travel. Reviews photos with or without manuscript. Model release required. Captions required, including identification of subjects.
Specs Accepts images in digital format. Send JPEG or GIF files. Also reviews contact sheets.
Making Contact & Terms Payment negotiated. Pays on publication. Credit line given. Buys all rights.

$ ⊘ Ⓐ 🔀 CANADIAN HOMES & COTTAGES

2650 Meadowvale Blvd., Unit 4, Mississauga ON L5N 6M5 Canada. (905)567-1440. Fax: (905)567-1442. E-mail: editorial@homesandcottages.com. Web site: www.homesandcottages.com. **Contact:** Steven Chester, managing editor. Circ. 79,099. Bimonthly. Canada's largest building, renovation and home improvement magazine. Photo guidelines free with SASE.
Needs Needs photos of landscapes/scenics, architecture, interiors/decorating.
Making Contact & Terms Does not keep samples on file; cannot return material. Responds only if interested; send nonreturnable samples. **Pays on acceptance.** Credit line given.

Ⓝ 🖻 🔀 THE CANADIAN ORGANIC GROWER

Canadian Organic Growers, 129 Beech Hill Rd., Weldon NB E4H 4N5. E-mail: janet@cog.ca. Web site: www.cog.ca. **Contact:** Janet Wallace, managing editor. Circ. 4,000. Estab. 1975. Quarterly consumer magazine for organic gardeners, farmers and consumers in Canada.
Needs Needs photos of gardening, rural, agriculture, organic gardening and farming in Canada. Reviews photos with or without accompanying manuscript. Captions required; include identification of subjects.
Specs Accepts images in digital format. Send JPEG or GIF files.
Making Contact & Terms Pays on publication. Credit line given. Buys one-time rights.

$ ⊘ Ⓐ 🖻 🔀 CANADIAN RODEO NEWS

2116 27th Ave. NE, #223, Calgary AB T2E 7A6 Canada. (403)250-7292. Fax: (403)250-6926. E-mail: editor@rodeocanada.com. Web site: www.rodeocanada.com. **Contact:** Darell Hartlen, editor. Circ. 4,000. Estab. 1964. Monthly tabloid. Promotes professional rodeo in Canada. Readers are male and female rodeo contestants and fans—all ages.
Needs Wants photos of professional rodeo action or profiles.
Specs Uses color and/or b&w prints. Accepts images in digital format. Send via CD or e-mail as JPEG or TIFF files at 300 dpi.
Making Contact & Terms Send low-resolution unsolicited photos by e-mail for consideration. Phone to confirm if photos are usable. Keeps samples on file. Simultaneous submissions and previously published work OK. Pays $25 for color cover; $15 for b&w or color inside. Pays on publication. Credit line given. Rights negotiable.
Tips "Photos must be from or pertain to professional rodeo in Canada. Phone to confirm if subject/material is suitable before submitting. *CRN* is very specific in subject."

$ $ ⊘ Ⓢ 🖻 CANOE & KAYAK

P.O. Box 3146, Kirkland WA 98083-3146. (425)827-6363. Fax: (425)827-1893. E-mail: photos@canoekayak.com. Web site: www.canoekayak.com. **Contact:** Art Director. Circ. 63,000. Estab. 1973. Bimonthly magazine. Emphasizes a variety of paddle sports, as well as how-to material and articles about equipment. For upscale canoe and kayak enthusiasts at all levels of ability. Also publishes special projects. Sample copy free with 9×12 SASE.
Needs Buys 25 photos from freelancers/issue; 150 photos/year. Needs photos of canoeing, kayaking, ocean touring, canoe sailing, fishing when compatible to the main activity, canoe camping but not rafting. No photos showing disregard for the environment, be it river or land; no photos showing gasoline-powered, multi-hp engines; no photos showing unskilled persons taking extraordinary risks to life, etc. Accompanying manuscripts for "editorial coverage striving for balanced representation of all interests in today's paddling activity. Those interests include paddling adventures (both close to home and far away), camping, fishing, flatwater, whitewater, ocean kayaking, poling, sailing, outdoor photography, how-to projects, instruction and historical perspective. Regular columns feature paddling techniques, conservation topics, safety, interviews, equipment reviews, book/movie reviews, new products and

letters from readers." Photos only occasionally purchased without accompanying manuscript. Model release preferred "when potential for litigation." Property release required. Photo captions preferred.
Specs Uses 5×7, 8×10 glossy b&w prints; 35mm, 2¼×2¼, 4×5 transparencies; color transparencies for cover; vertical format preferred. Accepts images in digital format. Send via CD, Zip as TIFF, EPS, JPEG files at 300 dpi.
Making Contact & Terms Interested in reviewing work from newer, lesser-known photographers. Query or send material. "Let me know those areas in which you have particularly strong expertise and/or photo file material. Send best samples only and make sure they relate to the magazine's emphasis and/or focus. (If you don't know what that is, pick up a recent issue before sending me unusable material.) We will review dupes for consideration only. Originals required for publication. Also, if you have something in the works or extraordinary photo subject matter of interest to our audience, let me know! It would be helpful to me if those with substantial reserves would supply indexes by subject matter." Include SASE for return of material. Responds in 1 month. Simultaneous submissions and previously published work OK, in noncompeting publications. Pays $500-700 for color cover; $75-200 for b&w inside; $75-350 for color inside. Pays on publication. Credit line given. Buys one-time rights, first serial rights and exclusive rights.
Tips "We have a highly specialized subject, and readers don't want just any photo of the activity. We're particularly interested in photos showing paddlers' *faces*; the faces of people having a good time. We're after anything that highlights the paddling activity as a lifestyle and the urge to be outdoors." All photos should be "as natural as possible with authentic subjects. We receive a lot of submissions from photographers to whom canoeing and kayaking are quite novel activities. These photos are often clichéd and uninteresting. So consider the quality of your work carefully before submission if you are not familiar with the sport. We are always in search of fresh ways of looking at our sport. All paddlers must be wearing life vests/PFDs."

$THE CAPE ROCK

Southeast Missouri State University, Cape Girardeau MO 63701. (573)651-2500. E-mail: hhecht@semo.edu. Web site: http://cstl-cla.semo.edu/hhecht/caperock.htm. **Contact:** Harvey Hecht, editor-in-chief. Circ. 1,000. Estab. 1964. Semiannual. Emphasizes poetry and poets for libraries and interested persons. Photo guidelines available on Web site.
Needs Uses 11 photos/issue (at least 10 must be "portrait format"); 24 photos/year. "We feature a single photographer each issue. Submit 25-30 thematically organized black-and-white glossies (at least 5×7), or send 5 pictures with plan for complete issue. We favor a series that conveys a sense of place. Seasons are a consideration, too: we have spring and fall issues. Photos must have a sense of place; e.g., an issue featuring Chicago might show buildings or other landmarks, people of the city (no nudes), travel or scenic. No how-to or products. Sample issues and guidelines provide all information a photographer needs to decide whether to submit to us." Model release not required, "but photographer is liable." Photo captions not required, "but photographer should indicate where series was shot."
Making Contact & Terms Send query letter with list of stock photo subjects, actual b&w photos, or submit portfolio by mail for review; include SASE for return of material. Response time varies. Pays $100 and 10 copies of publication. Credit line given. Buys all rights, but will release rights to photographer on request.
Tips "We don't give assignments, but we look for a unified package put together by the photographer. We may request additional or alternative photos when accepting a package."

$ $ $CAREERS AND COLLEGES MAGAZINE

2 Lan Dr., Suite 100, Westford MA 01886. (978)842-2774. Fax: (978)692-4174. E-mail: msummer@alloyeducation.com. Web site: www.careersandcolleges.com. **Contact:** Matt Summer, vice president of sales and marketing. Circ. 750,000. Estab. 1980. Magazine published once during school term and twice during summer. Emphasizes college and career choices for teens. Readers are high school juniors and seniors, male and female, ages 16-19. Sample copy available for $2.50 with 9×12 SAE and 5 first-class stamps.
Needs Buys 12+ photos/year from freelancers. Uses minimum 4 photos/issue; 40% supplied by freelancers. Photo subjects: teen situations, study or career related; some profiles. Model release preferred; property release required. Photo captions preferred.
Making Contact & Terms Send tearsheets and promo cards. Submit URL. "Please call for appointment." Keeps samples on file. Responds within 3 weeks. Pays $800-1,000 for color cover; $350-450 for color

inside; $600-800/color page rate. Work-for-hire basis. **Pays on acceptance.** Credit line given. Buys one-time rights; negotiable.

Tips "Must work well with teen subjects and understand the teen market. Promo cards or packets work best; business cards are not needed unless they contain your photography."

$ $CARIBBEAN TRAVEL & LIFE

Bonnier Corporation, 460 N. Orlando Ave., Suite 200, Winter Park FL 32789. (407)571-4704. E-mail: zach.stovall@bonniercorp.com. Web site: www.caribbeantravelmag.com. **Contact:** Zach Stovall, photo services. Circ. 150,000. Estab. 1985. Published 9 times/year. Emphasizes travel, culture and recreation in islands of Caribbean, Bahamas and Bermuda. Readers are male and female frequent Caribbean travelers, ages 32-52. Sample copy available for $4.95. Photo guidelines free with SASE.

Needs Uses about 100 photos/issue; 90% supplied by freelance photographers: 10% assignment and 90% freelance stock. "We combine scenics with people shots. Where applicable, we show interiors, food shots, resorts, water sports, cultural events, shopping and wildlife/underwater shots. We want images that show intimacy between people and place. Provide thorough caption information. Don't submit stock that is mediocre."

Specs Uses 4-color photography.

Making Contact & Terms Query by mail or e-mail with list of stock photo subjects and tearsheets. Responds in 3 weeks. Pays $1,000 for color cover; $450/spread; $325/full+ page; $275/full page; $200/$\frac{1}{2}$+ page; $150/$\frac{1}{2}$ page; $120 /$\frac{1}{3}$ page; $90/$\frac{1}{4}$ page or less. Pays after publication. Buys one-time rights. Does not pay shipping, research or holding fees.

Tips Seeing trend toward "fewer but larger photos with more impact and drama. We are looking for particularly strong images of color and style, beautiful island scenics and people shots—images that are powerful enough to make the reader want to travel to the region; photos that show people doing things in the destinations we cover; originality in approach, composition, subject matter. Good composition, lighting and creative flair. Images that are evocative of a place, creating story mood. Good use of people. Submit stock photography for specific story needs; if good enough can lead to possible assignments. Let us know exactly what coverage you have on a stock list so we can contact you when certain photo needs arise."

▣ CARLSBAD MAGAZINE

Wheelhouse Media, 2911 State St., Suite I, Carlsbad CA 92008. (760)729-9010. Fax: (760)729-9011. E-mail: carly@carlsbadmagazine.com. Web site: www.clickoncarlsbad.com; www.carlsbadmagazine.com. **Contact:** Carly Bartkiewicz, managing editor. Circ. 37,000. Estab. 2004. Bimonthly consumer magazine covering the people, places, events and arts in Carlsbad, California. "We are a regional magazine highlighting all things pertaining specifically to Carlsbad. We focus on history, events, people and places that make Carlsbad interesting and unique. Our audience is both Carlsbad residents and visitors or anyone interested in learning more about Carlsbad." Sample copy available for $2.31.

Needs Needs photos of gardening, entertainment, events, performing arts. Interested in historical/vintage, lifestyle. "People, places, events, arts in Carlsbad, California."

Specs Accepts images in digital format. Send as GIF or JPEG files.

Making Contact & Terms Pays $15-400/photo. Pays on publication. Credit line given. Buys one-time rights.

Tips "E-mail is the preferred method for queries."

$▣ ▣ CAT FANCY

Fancy Publications, a division of BowTie Inc., P.O. Box 6050, Mission Viejo CA 92690.(949)855-8822. Fax: (949)855-3045. E-mail: slogan@bowtieinc.com. Web site: www.catchannel.com. **Contact:** Susan Logan, managing editor. Estab. 1965. Monthly magazine. Readers are men and women of all ages interested in all aspects of cat ownership. Photo guidelines and needs free with SASE or on Web site.

Needs Buys 20-30 photos from freelancers/issue; 240-360 photos/year. Wants editorial "lifestyle" shots of cats in beautiful, modern homes; cats with attractive people (infant to middle-age, variety of ethnicities); cat behavior (good and bad, single and in groups); cat and kitten care (grooming, vet visits, feeding, etc.); household shots of CFA- or TICA-registered cats and kittens. Model release required.

Specs Accepts images in digital format. Send via CD as TIFF or JPEG files at 300 dpi minimum; include contact sheet (thumbnails with image names). Also accepts 35mm slides and 2$\frac{1}{4}$ color transparencies; include SASE.

Making Contact & Terms Obtain photo guidelines before submitting photos. Pays $200 maximum for color cover; $25-200 for inside. Credit line given. Buys first North American serial rights.

Tips "Sharp, focused images only (no prints). Lifestyle focus. Indoor cats preferred. Send SASE for list of specific photo needs."

$ $▣ CHESAPEAKE BAY MAGAZINE: Boating At Its Best

Chesapeake Bay Communications, Inc., 1819 Bay Ridge Ave., Annapolis MD 21403. (410)263-2662, ext. 15. Fax: (410)267-6924. E-mail: kashley@cbmmag.net. Web site: www.cbmmag.net. **Contact:** Karen Ashley, art director. Circ. 45,000. Estab. 1972. Monthly. Emphasizes boating—Chesapeake Bay only. Readers are "people who use Chesapeake Bay for recreation." Sample copy available with SASE.

• *Chesapeake Bay* is CD-ROM-equipped and does corrections and manipulates photos in-house.

Needs Buys 27 photos from freelancers/issue; 324 photos/year. Needs photos that are Chesapeake Bay related (must); "vertical powerboat shots are badly needed (color)." Special needs include "vertical 4-color slides showing boats and people on Bay."

Specs Uses 35mm, $2^{1}/_{4} \times 2^{1}/_{4}$, 4×5, 8×10 transparencies. Accepts images in digital format. Send via CD as TIFF files at 300 dpi, at least 8×10 (16×10 for spreads). "A proof sheet would be helpful."

Making Contact & Terms Interested in reviewing work from newer, lesser-known photographers. Send query letter with samples or list of stock photo subjects. Responds only if interested. Simultaneous submissions OK. Pays $400 for color cover; $75-250 for color *stock* inside, depending on size; $200-1,200 for *assigned* photo package. Pays on publication. Credit line given. Buys one-time rights.

Tips "We prefer Kodachrome over Ektachrome. Looking for boating, bay and water-oriented subject matter. Qualities and abilities include fresh ideas, clarity, exciting angles and true color. We're using larger photos—more double-page spreads. Photos should be able to hold up to that degree of enlargement. When photographing boats on the Bay, keep safety in mind. People hanging off the boat, drinking, women 'perched' on the bow are a no-no! Children must be wearing life jackets on moving boats. We must have IDs for *all* people in close-up to medium-view images."

$▣ CHESS LIFE

USCF, P.O. Box 3967, Crossville TN 38557-3967. (931)787-1234. Fax: (931)787-1200. E-mail: fbutler@uschess.org. Web site: www.uschess.org. **Contact:** Frankie Butler, art director. Circ. 70,000. Estab. 1939. Monthly publication of the U.S. Chess Federation. Emphasizes news of all major national and international tournaments; includes historical articles, personality profiles, columns of instruction, occasional fiction, humor for the devoted fan of chess. Sample copy and photo guidelines free with SASE or on Web site.

• *"Chess Life* underwent a redesign as of the June 2006 issue. Please see current issue for new photographic philosophy."

Needs Uses about 15 photos/issue; 7-8 supplied by freelancers. Needs "news photos from events around the country; shots for personality profiles." Special needs include "Spot Light" section. Model release preferred. Photo captions preferred.

Specs Accepts prints or high-resolution digital images. Send digital images as JPEG or TIFF files at 300 dpi—via CD for multiple-image submissions; e-mail for single-shot submission.

Making Contact & Terms Query with samples. Provide business card and tearsheets to be kept on file for possible future assignments. Responds in 1 month, "depending on when the deadline crunch occurs." Simultaneous submissions and previously published work OK. Pays $25-100 for b&w inside; cover payment negotiable. Pays on publication. Buys one-time rights; "we occasionally purchase all rights for stock mug shots." Credit line given.

Tips Using "more color, and more illustrative photography. The photographer's name, address and date of the shoot should appear on the back of all photos. Also, name of person(s) in photograph and event should be identified." Looks for "clear images, good composition and contrast with a fresh approach to interest the viewer. Increasing emphasis on strong portraits of chess personalities, especially Americans. Tournament photographs of winning players and key games are in high demand."

ⓝ $▣ CHESS LIFE FOR KIDS

U.S. Chess Federation, P.O. Box 3967, Crossville TN 38557. (732)252-8388. E-mail: gpetersen@uschess.org. Web site: www.uschess.org. **Contact:** Glenn Petersen, editor. Estab. 2006. Circ. 28,000. Bimonthly association magazine geared for the young reader, age 12 and under, interested in chess; fellow chess

players; tournament results; and instruction. Sample copy available with SAE and first-class postage. Photo guidelines available via e-mail.

Needs Wants photos of babies/children/teens, celebrities, multicultural, families, senior citizens, events, humor. Some aspect of chess must be present: playing, watching, young/old contrast. Reviews photos with or without a manuscript. Property release is required. Captions required.

Specs Accepts images in digital format. Send via Zip or e-mail. Contact Frankie Butler at fbutler@uschess. org for more information on digital specs. Uses glossy color prints.

Making Contact & Terms E-mail query letter with link to photographer's Web site. Provide self-promotion piece to be kept on file. Responds in 1 week to queries and portfolios. Simultaneous submissions and previously published work OK. Pays $150 minimum/$300 maximum for color cover. Pays $35 for color inside. Pays on publication. Credit line given. Rights are negotiable. Will negotiate with a photographer unwilling to sell all rights.

Tips "Read the magazine. What would appeal to *your* 10-year-old? Be original. We have plenty of people to shoot headshots and award ceremonies. And remember, you're competing against proud parents as well."

◪ ▣ ▧ CHICKADEE MAGAZINE

10 Lower Spadina Ave., Suite 400, Toronto ON M5V 2Z2 Canada. (416)340-2700. Fax: (416)340-9769. E-mail: deb@owlkids.com. Web site: www.owlkids.com. **Contact:** Debbie Yea, photo researcher. Circ. 92,000. Estab. 1979. Published 10 times/year. A discovery magazine for children ages 6-9. Sample copy available for $4.95 with 9 × 12 SAE and $1.50 money order to cover postage. Photo guidelines available for SAE or via e-mail.

• *chickaDEE* has received Magazine of the Year, Parents' Choice, Silver Honor, Canadian Children's Book Centre Choice and several Distinguished Achievement awards from the Association of Educational Publishers.

Needs Buys 1-2 photos from freelancers/issue; 10-20 photos/year. Needs "crisp, bright shots" of children, multicultural, environmental, wildlife, pets, adventure, events, hobbies, humor, performing arts, sports, travel, science, technology, animals in their natural habitats. Interested in documentary, seasonal. Model/property release required. Photo captions required.

Specs Uses images in any hard-copy format. Accepts images in digital format. Send via CD, e-mail as TIFF, JPEG files at 72 dpi; 300 dpi required for publication.

Making Contact & Terms Request photo package before sending photos for review. Responds in 3 months. Previously published work OK. Credit line given. Buys one-time rights.

$▣ CHILDREN'S DIGEST

P.O. Box 567, Indianapolis IN 46206. (317)634-1100. Fax: (317)637-0126. Web site: www.childrensdigest mag.org or www.cbhi.org. **Contact:** Daniel Lee, editor. Circ. 75,000. Estab. 1950. Magazine published 6 times/year. Emphasizes health and fitness. Readers are preteens—kids ages 10-13. Sample copy available for $1.25.

Needs "We have featured photos of health and fitness, wildlife, children in other countries, adults in different jobs, how-to projects." Reviews photos with accompanying manuscript, but seldom purchases manuscript/photo packages. Model release preferred.

Specs Uses 35mm transparencies. "We prefer images in digital format. Send via e-mail or CD at minimum 300 dpi."

Making Contact & Terms Send complete manuscript and photos on speculation. Include SASE. Responds in 10 weeks. Pays $70-275 for color cover; $35-70 for b&w inside; $70-155 for color inside. Pays on publication. Buys North American serial rights.

◪ ▣ ▧ CHIRP MAGAZINE

10 Lower Spadina Ave., Suite 400, Toronto ON M5V 2Z2 Canada. (416)340-2700. Fax: (416)340-9769. E-mail: deb@owlkids.com. Web site: www.owlkids.com. **Contact:** Debbi Yea, photo researcher. Circ. 85,000. Estab. 1997. Published 10 times/year. A discovery magazine for children ages 3-6. Sample copy available for $4.95 with 9 × 12 SAE and $1.50 money order to cover postage. Photo guidelines available for SAE or via e-mail.

• *Chirp* has received Best New Magazine of the Year, Parents' Choice, Canadian Children's Book Centre Choice and Distinguished Achievement awards from the Association of Educational Publishers.

Needs Buys at least 2 photos from freelancers/issue; 10-20 photos/year. Needs "crisp, bright shots" of

children ages 5-7, multicultural, environmental, wildlife, adventure, events, hobbies, humor, animals in their natural habitats. Interested in documentary, seasonal. Model/property release required. Photo captions required.

Specs Prefers images in digital format. Send via CD, e-mail as TIFF, JPEG files at 72 dpi; 300 dpi required for publication.

Making Contact & Terms Request photo package before sending photos for review. Responds in 3 months. Previously published work OK. Credit line given. Buys one-time rights.

$ ☑ ▣ CHRONOGRAM

Luminary Publishing, 314 Wall St., Kingston NY 12401. (845)334-8600. Fax: (845)334-8610. E-mail: dperry@chronogram.com. Web site: www.chronogram.com. **Contact:** David Perry, art director. Circ. 50,000. Estab. 1993. Monthly arts, events, philosophy, literary magazine. Sample copy available for $5. Photo guidelines available on Web site.

Needs Buys 16 photos from regional freelancers/issue; 192 photos/year. Interested in alternative process, avant garde, fashion/glamour, fine art, historical/vintage, artistic representations of anything. "Striking, minimalistic and good! Great covers!" Reviews photos with or without a manuscript. Model/property release preferred. Photo captions required; include title, date, artist, medium.

Specs Prefers images in digital format. Send via CD as TIFF files at 300 dpi or larger at printed size.

Making Contact & Terms Send query letter with résumé and digital images or prints. Provide self-promotion piece to be kept on file for possible future assignments. Responds only if interested; send nonreturnable samples. Pays $250 maximum for b&w inside. Pays 1 month after publication. Credit line given. Buys one-time rights; negotiable.

Tips "Colorful, edgy, great art! See our Web site—look at the back issues and our covers, then submit one for consideration!"

$ $ ☑ ▣ CLEVELAND MAGAZINE

Great Lakes Publishing, 1422 Euclid Ave., #730, Cleveland OH 44115. (216)771-2833. Fax: (216)781-6318. E-mail: sluzewski@clevelandmagazine.com. Web site: www.clevelandmagazine.com. **Contact:** Gary Sluzewski, design director. Circ. 50,000. Estab. 1972. Monthly consumer magazine emphasizing Cleveland, Ohio. General interest to upscale audience.

Needs Buys 50 photos from freelancers/issue; 600 photos/year. Needs photos of people (babies/children/teens, celebrities, couples, multicultural, parents, families, senior citizens), environmental, landscapes/scenics, architecture, education, gardening, interiors/decorating, adventure, entertainment, events, food/drink, health/fitness, hobbies, humor, performing arts, sports, travel, business concepts, industry, medicine, political, product shots/still life, technology/computers. Interested in documentary, fashion/glamour, seasonal. Reviews photos with or without a manuscript. Model release required for portraits; property release required for individual homes. Photo captions required; include names, date, location, event, phone.

Specs Prefers images in digital format. Send via CD, e-mail as TIFF, JPEG files at 300 dpi. Also uses color and b&w prints; 35mm, 2¼×2¼, 4×5, 8×10 transparencies.

Making Contact & Terms Provide business card, self-promotion piece or tearsheets to be kept on file for possible future assignments. To show portfolio, photographer should follow up with call. Portfolio should include "only your best, favorite work." Keeps samples on file. Responds only if interested; send nonreturnable samples. Simultaneous submissions and previously published work OK. Pays $300-700 for color cover; $100-600 for color inside; $100-300 for b&w inside. Pays on publication. Credit line given. Buys one-time publication, electronic and promotional rights.

Tips "Eighty percent of our work is people. Send sample. Follow up with phone call. Make appointment for portfolio review. Arrange the work you want to show me ahead of time and be professional, instead of telling me you just threw this together."

$ ☑ ▣ COBBLESTONE: Discover American History

Cobblestone Publishing, 30 Grove St., Suite C, Peterborough NH 03458. (603)924-7209. Fax: (603)924-7380. Web site: www.cobblestonepub.com. **Contact:** Meg Chorlian, editor. Circ. 29,000. Estab. 1980. Published 9 times/year, September-May. Emphasizes American history; each issue covers a specific theme. Readers are children ages 8-14, parents, teachers. Sample copy available for $4.95 and 9×12 SAE with 5 first-class stamps. Photo guidelines free with SASE.

Needs Buys 10-20 photos from freelancers/issue; 90-180 photos/year. Needs photos of children, multicul-

tural, landscapes/scenics, architecture, cities/urban, agriculture, industry, military. Interested in fine art, historical/vintage, reenacters. "We need photographs related to our specific themes (each issue is theme-related) and urge photographers to request our themes list." Model release required. Photo captions preferred.

Specs Uses 8×10 glossy prints; 35mm, $2\frac{1}{4} \times 2\frac{1}{4}$ transparencies. Accepts images in digital format. Send via CD, SyQuest, Zip as TIFF files at 300 dpi, saved at 8×10 size.

Making Contact & Terms Send query letter with samples or list of stock photo subjects; include SASE for return of material. "Photos must pertain to themes, and reporting dates depend on how far ahead of the issue the photographer submits photos. We work on issues 6 months ahead of publication." Simultaneous submissions and previously published work OK. Pays $150-300 for color cover; $10-100 for color inside (payment depends on size of photo). Pays on publication. Credit line given. Buys one-time rights.

Tips "Most photos are of historical subjects, but contemporary color images of, for example, a Civil War battlefield, are great to balance with historical images. However, the amount varies with each monthly theme. Please review our theme list and submit related images."

$ ☑ ▣ COLLECTIBLE AUTOMOBILE

Publications International Ltd., 7373 N. Cicero Ave., Lincolnwood IL 60712. (847)583-4525. E-mail: lrich man@pubint.com. Web site: http://consumerguideauto.howstuffworks.com. **Contact:** Lynne E. Rich-man, automotive acquisitions and research editor. Estab. 1984. Bimonthly magazine. "*CA* features pro-files of collectible automobiles and their designers as well as articles on literature, scale models, and other topics of interest to automotive enthusiasts." Sample copy available for $8 and $10\frac{1}{2} \times 14$ SAE with $3.50 first-class postage. Photo guidelines available for #10 SASE.

Needs "We require full photo shoots for any auto photo assignment. This requires 2-3 rolls of 35mm, 2-3 rolls of $2\frac{1}{4} \times 2\frac{1}{4}$, and/or 4-8 4×5 exposures. Complete exterior views, interior and engine views, and close-up detail shots of the subject vehicle are required."

Specs Uses 35mm, $2\frac{1}{4} \times 2\frac{1}{4}$, 4×5 transparencies. Accepts images in digital format (discuss file parame-ters with the acquisitions editor).

Making Contact & Terms Send query letter with transparencies and stock list. Provide business card to be kept on file for possible future assignments. Responds only if interested; send nonreturnable samples. Previously published work OK. Pays bonus if image is used as cover photo; $250-275 plus mileage and film costs for standard auto shoot. **Pays on acceptance**. Photography is credited on an article-by-article basis in an "Acknowledgments" section at the front of the magazine. Buys all intellectual and digital property rights.

Tips "Read our magazine for good examples of the types of backgrounds, shot angles and overall quality that we are looking for."

$ COLLECTOR CAR MARKET REVIEW

P.O. Box 607, North Grafton MA 01536-1559. (508)839-6707. Fax: (508)839-6266. E-mail: vmr@vmrintl.c om. Web site: www.collectorcarmarket.com. **Contact:** Kelly Hulitzky, production director. Circ. 30,000. Estab. 1994. Bimonthly magazine. Emphasizes old cars and trucks. Readers are primarily males, ages 30-60.

Needs Buys 3 photos from freelancers/issue; 18 photos/year. Needs photos of old cars and trucks. Model/property release required. Photo captions required; include year, make and model.

Making Contact & Terms Provide résumé, business card, brochure, flier or tearsheets to be kept on file for possible future assignments. Responds in 1 month. Previously published work OK. Pays $100 for color cover. Pays net 30 days. Buys one-time rights.

$ COLLEGE PREVIEW MAGAZINE

CPG Publications, 7300 W. 110th St., 7th Floor, Overland Park KS 66210. (913)317-2888. E-mail: jwolf@c pgcommunications.com. Web site: www.CollegePreviewMagazine.com. **Contact:** Jennifer Wolf, associ-ate editor. Circ. 600,000. Quarterly magazine. Emphasizes college and college-bound African-American and Hispanic students. Readers are African-American, Hispanic, ages 16-24. Sample copy free with 9×12 SAE and 4 first-class stamps.

Needs Uses 30 photos/issue. Needs photos of students in class, at work, in interesting careers, on campus. Special photo needs include computers, military, law and law enforcement, business, aerospace and aviation, health care. Model/property release required. Photo captions required; include name, age, location, subject.

Making Contact & Terms Send query letter with résumé of credits. Simultaneous submissions and previously published work OK. Pays $10-50 for color photos; $5-25 for b&w inside. Pays on publication. Buys first North American serial rights.

▣ COMMUNITY OBSERVER

Ann Arbor Observer Co., 201 Catherine St., Ann Arbor MI 48104. (734)769-3175. Fax:(734)769-3375. E-mail: michael@aaobserver.com. Web site: www.washtenawguide.com. **Contact:** Michael Betzold, managing editor. Circ. 21,000. Quarterly consumer magazine. "The *Community Observer* serves four historic communities facing rapid change. We provide an intelligent, informed perspective on the most important news and events in the communities we cover." Sample copy available for $2.

Specs Uses contact sheets, negatives, transparencies, prints. Accepts images in digital format; GIF or JPEG files.

Making Contact & Terms Negotiates payment individually. Pays on publication. Buys one-time rights.

$▣ ▣ COMPANY MAGAZINE

P.O. Box 60790, Chicago IL 60660-0790. (773)761-9432. Fax: (773)761-9443. E-mail: editor@companyma gazine.org. Web site: www.companymagazine.org. **Contact:** Martin McHugh, editor. Circ. 114,000. Estab. 1983. Quarterly magazine published by the Jesuits (Society of Jesus). Emphasizes Jesuit works/ministries and the people involved in them. Sample copy available for 9×12 SAE.

Needs Needs photos and photo-stories of Jesuit and allied ministries and projects. Reviews photos with or without manuscript. Photo captions required.

Specs Accepts images in digital format. Send via CD, Zip, e-mail "at screen resolution as long as higher-res is available."

Making Contact & Terms Query with samples; include SASE for return of material. Provide résumé, business card, brochure, flier or tearsheets to be kept on file for possible future assignments. Responds in 1 month. Pays $50-100 for individual photos; $300 for color cover; up to $750 for photo story. Pays on publication. Credit line given. Buys one-time rights; negotiable.

Tips "Avoid large-group, 'smile-at-camera' photos. We are interested in people/activity photographs that tell a story about Jesuit ministries."

$ $▣ THE CONFERENCE BOARD REVIEW

(formerly *Across the Board Magazine*), The Conference Board, 845 Third Ave., New York NY 10022-6679. (212)339-0455. E-mail: spiezio@tcbreview.com. Web site: www.tcbreview.com. **Contact:** Serena Spiezio, creative director. Circ. 30,000. Estab. 1976. General interest business magazine published bimonthly. Readers are senior executives in large corporations.

Needs Uses 10-15 photos/issue; some supplied by freelancers. Wide range of needs, including location portraits, industrial, workplace, social topics, environmental topics, government and corporate projects, foreign business (especially East and West Europe and Asia).

Specs Accepts digital images.

Making Contact and Terms Query *by e-mail only*; place the word "Photo" in the subject line. "No phone queries, please." Cannot return material. Pays $250-500 for inside; up to $2,000 for cover; $450/day for assignments. Buys one-time rights.

Tips "Our style is journalistic, and we are assigning photographers who are able to deliver high-quality photographs with an inimitable style. We are interested in running full photo features with business topics from the U.S. or worldwide. If you are working on a project, e-mail us. Interested in any business-related stories."

$▣ CONFRONTATION MAGAZINE

English Dept., C.W. Post Campus of Long Island University, 720 Northern Blvd., Brookville NY 11548. (516)299-2391. Fax: (516)299-2735. E-mail: martin.tucker@liu.edu. **Contact:** Martin Tucker, editor. Circ. 2,000. Estab. 1968. Semiannual literary magazine. Readers are college-educated lay people interested in literature. Sample copy available for $3.

Needs Reviews photos with or without manuscript. Photo captions preferred.

Making Contact & Terms Send query letter with résumé of credits, stock list. Responds in 1 month. Simultaneous submissions OK. Pays $100-300 for b&w or color cover; $40-100 for b&w inside; $50-100 for color inside. Pays on publication. Credit line given. Buys first North American serial rights; negotiable.

$ □ ⑤ ▣ CONSCIENCE

1436 U St. NW, #301, Washington DC 20009. (202)986-6093. E-mail: conscience@catholicsforchoice.org. Web site: www.catholicsforchoice.org. **Contact:** David Nolan, editor. Circ. 12,500. Quarterly news journal of Catholic opinion. Sample copies available.

Needs Buys up to 25 photos/year. Needs photos of multicultural, religious, Catholic-related news. Reviews photos with or without a manuscript. Model/property release preferred. Photo captions preferred; include title, subject, photographer's name.

Specs Uses glossy color and/or b&w prints. Accepts high-res digital images. Send as TIFF, JPEG files.

Making Contact & Terms Send query letter with tearsheets. Responds only if interested; send nonreturnable samples. Simultaneous submissions and previously published work OK. Pays $300 maximum for color cover; $50 maximum for b&w inside. Pays on publication. Credit line given.

▣ CONTEMPORARY BRIDE MAGAZINE

216 Stelton Rd., Unit D-1, Piscataway NJ 08854. (732)968-0123. Fax: (732)968-0220. E-mail: gary@contemporarybride.com. Web site: www.contemporarybride.com. **Contact:** Gary Paris, publisher. Circ. 120,000. Estab. 1994. Biannual bridal magazine with wedding planner; 4-color publication with editorial, calendars, check-off lists and advertisers. Sample copy available for first-class postage.

Needs Needs photos of travel destinations, fashion, bridal events. Reviews photos with accompanying manuscript only. Model/property release preferred. Photo captions preferred; include photo credits.

Specs Accepts images in digital format. Send as high-res files at 300 dpi.

Making Contact & Terms Send query letter with samples. Art director will contact photographer for portfolio review if interested. Provide b&w and/or color prints, disc. Keeps samples on file; cannot return material. Responds only if interested; send nonreturnable samples. Simultaneous submissions and previously published work OK. Payment negotiable. Buys all rights, electronic rights.

Tips "Digital images preferred with a creative eye for all wedding-related photos. Give us the *best* presentation."

$ □ ⑤ CONTINENTAL NEWSTIME

501 W. Broadway, Plaza A, PMB #265, San Diego CA 92101-3802. (858)492-8696. E-mail: ContinentalNewsService@yahoo.com. Web site: www.ContinentalNewsService.com. **Contact:** Gary P. Salamone, editor-in-chief. Estab. 1987. Semimonthly general interest magazine of news and commentary on U.S. national and world news, with travel columns, entertainment features, humor pieces, comic strips, general humor panels, and editorial cartoons. Covers the unreported and under-reported national (U.S.) and international news. Sample copy available for $6.

Needs Buys variable number of photos from freelancers. Needs photos of celebrities, public figures, multicultural, disasters, environmental, wildlife, architecture, cities/urban, adventure, entertainment, events, performing arts, sports, travel, agriculture, industry, medicine, military, political, science, technology; U.S. and foreign government officials/cabinet ministers and newsworthy events, breaking/unreported/under-reported news. Interested in documentary, historical/vintage, seasonal. Reviews photos with or without a manuscript. Model/property release required. Photo captions required.

Specs Uses 8×10 color and/or b&w prints.

Making Contact & Terms Send query letter with résumé, photocopies, tearsheets, stock list. Provide résumé to be kept on file for possible future assignments. Responds only if interested; send nonreturnable samples. Simultaneous submissions OK. Pays $10 minimum for b&w cover. Pays on publication. Credit line given. Buys one-time rights.

Tips "Read our magazine to develop a better feel for our photo applications/uses and to satisfy our stated photo needs."

$ $ □ ⑤ ▣ COUNTRY

Reiman Media Group, Inc., 5400 S. 60th St., Greendale WI 53129. Fax: (414)423-8463. E-mail: photocoordinator@reimanpub.com. Web site: www.country-magazine.com. **Contact:** Trudi Bellin, photo coordinator. Estab. 1987. Bimonthly magazine. "For those who live in or long for the country." Readers are rural-oriented, male and female. "*Country* is supported entirely by subscriptions and accepts no outside advertising." Sample copy available for $2. Photo guidelines free with SASE.

● *Country EXTRA* is published in the months between regular issues. Content and guidelines are the same.

Needs Buys 40 photos from freelancers/issue; 480 photos/year. Needs photos of families, senior citizens,

gardening, travel, agriculture, country scenics, animals, rural and small-town folk at work or wholesome play. Interested in historical/vintage, seasonal. Photo captions preferred; include season, location.

Specs Prefers color transparencies, all sizes. Accepts images in digital format: TIFF or high-quality JPEG files at 300 dpi for up to 9×11 reproduction. Embedded metadata is recommended. Send via lightboxes or on removable media. Or send CD/DVD with printed thumbnails and caption sheet. E-mail if first review selection is small (12 images or less).

Making Contact & Terms Send query letter with résumé of credits, stock list. Send unsolicited photos by mail for consideration. Keeps samples on file (tearsheets, no dupes); include SASE for return of material. Responds in 3 months. Previously published work OK. Buys stock only. Pays $300 for color cover; $200 for color back cover; $100-300 for color inside. Pays on publication. Credit line given. Buys one-time rights to stock photos; all rights to assignment.

Tips "Technical quality is extremely important; focus must be sharp (no soft focus), and colors must be vivid so they 'pop off the page.' Study our magazine thoroughly—we have a continuing need for sharp, colorful images, especially those taken along the backroads of rural North America. Photographers who can supply what we need can expect to be regular contributors. Submissions are on spec and should cover only one season."

N $ $ COUNTRY WOMAN

Reiman Media Group, Inc., 5400 S. 60th St., Greendale WI 53129. E-mail: editors@countrywomanmagazine.com. Web site: www.countrywomanmagazine.com. **Contact:** Marilyn Kruse, managing editor. Bimonthly consumer magazine. Supported entirely by subscriptions and accepts no outside advertising. Emphasizes rural life and a special quality of living to which country women can relate; at work or play, in sharing problems, etc. Sample copy available for $2. Photo guidelines free with SASE.

Needs Uses 75-100 photos/issue; most supplied by readers, rather than freelance photographers. "Covers are usually supplied by professional photographers; they are often seasonal in nature and generaly feature a good-looking country woman (mid-range to close up, shown within her business setting or with a hobby, craft or others; static pose or active)." Photos purchased with or without accompanying manuscript. Also interested in unique or well-designed country homes and interiors. Some work assigned for interiors. Works 6 months in advance. "No poor-quality color prints, posed photos, etc." Photo captions required.

Specs Prefers color transparencies, all sizes. Accepts images in digital format. Send via lightboxes, CD/DVD with printed thumbnails and caption sheet, or e-mail if first review selection is small (12 or less).

Making Contact & Terms Send material by mail for consideration; include SASE. Provide brochure, calling card, letter of inquiry, price list, résumé and samples to be kept on file for possible future assignments. Responds in 3 months. Previously published work OK. Pays $300-800 for text/photo package depending on quality of photos and number used; $300 minimum for front cover; $200 minimum for back cover; $100-300 for partial page inside, depending on size. No b&w photos used. **Pays on acceptance.** Buys one-time rights.

Tips Prefers to see "rural scenics, in various seasons; include a variety of country women—from traditional farm and ranch women to the new baby-boomer, rural retiree; slides appropriately simple for use with poems or as accents to inspirational, reflective essays, etc."

$ $ CRC PRODUCT SERVICES

2850 Kalamazoo Ave. SE, Grand Rapids MI 49560. (616)246-0780. Web site: www.crcna.org/proservices. **Contact:** Dean Heetderks, art acquisition. Publishes numerous magazines with various formats. Emphasizes living the Christian life. Readers are Christians, ages 35-85. Photo guidelines available on Web site.

Needs Buys 6-8 photos from freelancers/issue. Needs photos of people, holidays and concepts. Reviews photos with or without manuscript. Special photo needs include real people doing real activities: couples, families. Model/property release required. Photo captions preferred.

Specs Uses any color or b&w prints; 35mm, $2\frac{1}{4} \times 2\frac{1}{4}$, 4×5, 8×10 transparencies. Accepts images in digital format.

Making Contact & Terms Provide résumé, business card, brochure, flier or tearsheets to be kept on file for possible future assignments. Cannot return material. Simultaneous submissions and previously published work OK. Pays $300-600 for color cover; $200-400 for b&w cover; $200-300 for b&w or color inside. **Pays on acceptance.** Buys one-time and electronic rights.

$ $◻ ▣ CRUISING WORLD

Bonnier Corp., 55 Hammarlund Way, Middletown RI 02842. (401)845-5100. Fax: (401)845-5180. E-mail: bill.roche@bonniercorp.com. Web site: www.cruisingworld.com. **Contact:** William Roche, art director. Circ. 156,000. Estab. 1974. Emphasizes sailboat maintenance, sailing instruction and personal experience. For people interested in cruising under sail. Sample copy free for 9×12 SAE.

Needs Buys 25 photos/year. Needs ''shots of cruising sailboats and their crews anywhere in the world. Shots of ideal cruising scenes. No identifiable racing shots, please.'' Also wants exotic images of cruising sailboats, people enjoying sailing, tropical images, different perspectives of sailing, good composition, bright colors. For covers, photos ''must be of a cruising sailboat with strong human interest, and can be located anywhere in the world.'' Prefers vertical format. Allow space at top of photo for insertion of logo. Model release preferred; property release required. Photo captions required; include location, body of water, make and model of boat.

Specs Prefers images in digital format via CD. Accepts 35mm color slides.

Making Contact & Terms ''Submit original 35mm slides—*no* duplicates —or digital images. Most of our editorial is supplied by author. We look for good color balance, very sharp focus, the ability to capture sailing, good composition and action. Always looking for *cover shots*.'' Responds in 2 months. Pays $600 for color cover; $50-300 for color inside. Pays on publication. Credit line given. Buys all rights, but may reassign to photographer after publication; first North American serial rights; or one-time rights.

$◻ ▣ CYCLE CALIFORNIA! MAGAZINE

1702-L Meridian Ave., #289, San Jose CA 95125. (888)292-5323. Fax: (408)292-3005. E-mail: bmack@cyclecalifornia.com. Web site: www.cyclecalifornia.com. **Contact:** Bob Mack, publisher. Circ. 30,000. Estab. 1995. Monthly magazine providing readers with a comprehensive source of bicycling information, emphasizing the bicycling life in northern California and Nevada; promotes bicycling in all its facets. Sample copy available for 9×12 SAE with $1.11 first-class postage. Photo guidelines available for 37¢ SASE.

Needs Buys 3-5 photos from freelancers/issue; 45 photos/year. Needs photos of recreational bicycling, bicycle racing, triathalons, bicycle touring and adventure racing. Cover photos must be vertical format, color. All cyclists must be wearing a helmet if riding. Reviews photos with or without manuscript. Model release required; property release preferred. Photo captions preferred; include when and where photo is taken; if an event, include name, date and location of event; for nonevent photos, location is important.

Specs High-resolution TIFF images preferred (2000×3000 pixel minimum). Uses 4×6 matte color and/or b&w prints; 35mm transparencies.

Making Contact & Terms Send query letter with slides, prints or CD/disk. Keeps usable images on file; include SASE for return of material. Responds in 3 weeks. Simultaneous submissions OK. Pays $125 for color cover; $25 for b&w inside; $50 for color inside. Pays on publication.

Tips ''We are looking for photographic images that depict the fun of bicycle riding. Your submissions should show people enjoying the sport. Read the magazine to get a feel for what we do. Label images so we can tell what description goes with which image.''

$ CYCLE WORLD MAGAZINE

1499 Monrovia Ave., Newport Beach CA 92663. (949)720-5300. E-mail: dedwards@hfmus.com. Web site: www.cycleworld.com. **Contact:** David Edwards, editor-in-chief. Vice President/Senior Editor: Paul Dean. Monthly magazine. Circ. 335,000. Readers are active motorcyclists who are ''young, affluent, educated and very perceptive.''

Needs Buys 10 photos/issue. Wants ''outstanding'' photos relating to motorcycling. Prefers to buy photos with manuscripts. For Slipstream column, see instructions in a recent issue.

Specs Prefers high-res digital images at 300 dpi or quality 35mm color transparencies.

Making Contact & Terms Send photos for consideration; include SASE for return of material. Responds in 6 weeks. ''Cover shots are generally done by the staff or on assignment.'' Pays $50-200/photo. Pays on publication. Buys first publication rights.

◻ ▣ DANCE

2660 Petersborough St., Herndon VA 20171. E-mail: shannonaswriter@yahoo.com. Quarterly publication featuring international dancers.

Needs Needs photos of babies/children/teens, celebrities, couples, multicultural, families, parents, senior citizens, environmental, landscapes/scenics, wildlife, architecture, cities/urban, gardening, interiors/decorating, pets, religious, rural, performing arts, agriculture, product shots/still life—as related to inter-

national dance for children and teens. Interested in alternative process, avant garde, documentary, fashion/glamour, fine art, historical/vintage, seasonal. Reviews photos with or without a manuscript. Model/property release preferred.

Specs Uses glossy or matte color and/or b&w prints.

Making Contact & Terms Send query letter via e-mail. Provide résumé, business card, self-promotion piece to be kept on file for possible future assignments. "Photographs sent along with CDs are requested but not required. Artwork and illustrations also accepted." Responds within 1 month to queries; 1 week to portfolios. Simultaneous submissions and previously published work OK. **Pays on acceptance.** Credit line given. Buys one-time rights, first rights; negotiable.

$ $▣ DEER & DEER HUNTING

F+W Publications, 700 E. State St., Iola WI 54990. (715)445-2214. E-mail: dan.schmidt@fwpubs.com. Web site: www.deeranddeerhunting.com. **Contact:** Daniel Schmidt, editor. Circ. 200,000. Estab. 1977. Magazine published 9 times/year. Emphasizes white-tailed deer and deer hunting. Readers are "a cross-section of American deer hunters—bow, gun, camera." Sample copy and photo guidelines free with 9×12 SAE with 7 first-class stamps. Photo guidelines also available on Web site.

Needs Buys 20 photos from freelancers/issue; 180 photos/year. Needs photos of deer in natural settings. Model release preferred. Photo captions preferred.

Specs Accepts images in digital format. Send contact sheet.

Making Contact & Terms Send query letter with résumé of credits and samples. "If we judge your photos as being usable, we like to hold them in our file. Send originals—include SASE if you want them returned." Responds in 2-4 weeks. Pays $800 for color cover; $75-250 for color inside; $50 for b&w inside. Pays net 30 days of publication. Credit line given. Buys one-time rights.

Tips Prefers to see "adequate selection of 35mm color transparencies; action shots of whitetail deer only, as opposed to portraits. We also need photos of deer hunters in action. We are currently using almost all color—very little black & white. Submit a limited number of quality photos rather than a multitude of marginal photos. Include your name on all entries. Cover shots must have room for masthead."

$▨ ▣ ⊕ DIGITAL PHOTO

Emap Active, Bretton Court, Bretton, Peterborough PE3 8DZ United Kingdom. (44)(173)326-4666. Fax: (44)(173)346-5246. E-mail: dp@emap.com. Circ. 50,000. Estab. 1997. Monthly consumer magazine. "The practical guide to creative digital imaging for anyone with a camera who wants to use a computer to enhance pictures or learn photo manipulation techniques."

Needs Stunning, digitally manipulated images of any subject and Photoshop, Elements, or Paint Shop Pro step-by-step tutorials of any subject. Reviews photos with or without a manuscript. Model/property release preferred. Photo captions preferred.

Specs Uses up to A4 glossy color and/or b&w prints. Accepts images in digital format. Send via CD as PSD, TIFF, JPEG files at 300 dpi.

Making Contact & Terms Send query letter with résumé, tearsheets, contact prints and CD with high-res files. Provide SAE for eventual return. Responds in 1 month to queries. Rates negotiable. Pays on publication. Credit line given. Buys first rights.

Tips "Read magazine to check the type of images we use, and send a sample of images you think would be suitable. The broader your style, the better for general acceptance, while individual styles appeal to our Gallery section. Step-by-step technique pieces must be formatted to house style, so check magazine before submitting. Supply a contact sheet or thumbnail of all the images supplied in electronic form to make it easier for us to make a quick decision on the work."

$▨ ▣ DOG FANCY

Fancy Publications, a division of BowTie, Inc., P.O. Box 6050, Mission Viejo CA 92690. (949)855-8822. Fax: (949)855-3045. E-mail: ashirreffs@bowtieinc.com. Web site: www.dogfancy.com. **Contact:** Annie Shirreffs, associate editor. Circ. 268,000. Estab. 1970. Monthly magazine. Readers are "men and women of all ages interested in all aspects of dog ownership." Sample copy available for $5.50. Photo guidelines free with SASE or on Web site.

Needs Buys 40-60 photos from freelancers/issue; 490-720 photos/year. Three specific breeds featured in each issue. Prefers "photographs that show the various physical and mental attributes of the breed. Include both environmental and action photographs. Dogs must be well groomed and, if purebred, good examples of their breed. By good example, we mean a dog that has achieved some recognition on the

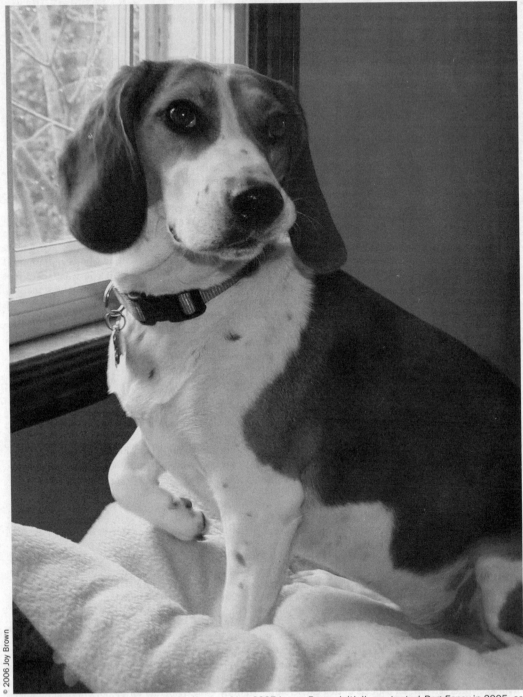

© 2006 Joy Brown

Dog Fancy used this image by Joy Brown in their May 2007 issue. Brown initially contacted *Dog Fancy* in 2005, so she was surprised to hear from them two years later when they wanted to publish this photo of a beagle. "They obviously kept my work on file," she says. She has since sent them many more photos.

show circuit and is owned by a serious breeder or exhibitor. We also have a need for good-quality, interesting photographs of any breed or mixed breed in any and all canine situations (dogs with veterinarians; dogs eating, drinking, playing, swimming, etc.) for use with feature articles.'' Shots should have natural background, style and setting, avoiding stylized studio backgrounds. Model release required. ''Slides should be labeled with photographer's name and breed of dog.''

Specs Uses high-density 35mm slides for inside. Accepts images in digital format. Send via CD, Jaz, Zip as TIFF, EPS files at 300 dpi, 5 inches minimum size.

Making Contact & Terms Send by mail for consideration actual 35mm photos or slides. Address submission to ''Photo Editors.'' Present a professional package: 35mm slides in sleeves, labeled, numbered or otherwise identified. Pays $300 for color cover; $25-100 for color inside; $200 for 4-color centerspreads. Credit line given. Buys first North American print rights and non-exclusive rights to use in electronic media.

Tips ''Nothing but sharp, high-contrast shots. Send SASE for list of photography needs. We're looking more and more for good-quality photo/text packages that present an interesting subject both editorially and visually. Bad writing can be fixed, but we can't do a thing with bad photos. Subjects should be in interesting poses or settings with good lighting, good backgrounds and foregrounds, etc. We are very concerned with sharpness and reproducibility; the best shot in the world won't work if it's fuzzy, and it's amazing how many are. Submit a variety of subjects—there's always a chance we'll find something special we like.''

$☐ ⑤ ▣ DOVETAIL, A Journal by and for Jewish/Christian Families

Dovetail Institute for Interfaith Family Resources, 775 Simon Greenwell Lane, Boston KY 40107-8524. (502)549-5499 or (800)530-1596. Fax: (502)549-3543. E-mail: di-ifr@bardstown.com. Web site: www.do vetailinstitute.org. **Contact:** Mary Rosenbaum, editor. Circ. 800. Estab. 1992. Quarterly association magazine for Jews and Christians who are intermarried. Covers all positive interfaith options. (Occasionally treats other religious mixes, e.g., Christian/Muslim.) Suspending print version; PDF sample version available online.

Needs Very seldom buys photos from freelancers. Needs photos of babies/children/teens, couples, multicultural, families, parents, religious. Interested in seasonal. Reviews photos with or without a manuscript. Model/property release required. Photo captions preferred; include names, place, date, occasion.

Specs Uses maximum 4×5 b&w and color prints. Accepts images in digital format. Send via CD, Zip, e-mail as TIFF files at 1,200 dpi.

Making Contact & Terms Send query letter with photocopies, stock list. Does not keep samples on file; cannot return material. Responds only if interested; send nonreturnable samples. Simultaneous submissions and previously published work OK. Pays $25-50 /photo. Pays on publication. Credit line given. Buys one-time rights.

Tips ''Pictures must relate to interfaith theme. We have no use for generic single-faith religious scenes, objects or people. Take a look at our publication first. Also, we need photo illustrations for children's story books with Jewish/Christian Thanksgiving, Christmas/Hanukkah themes.''

▣ DOWN BEAT MAGAZINE

102 N. Haven Rd., Elmhurst IL 60126. (630)941-2030. Fax: (630)941-3210. E-mail: jasonk@downbeat.c om. Web site: www.downbeat.com. **Contact:** Jason Koransky, editor. Circ. 90,000. Estab. 1934. Monthly. Emphasizes jazz musicians. Sample copy available for SASE.

Needs Buys 20 photos from freelancers/issue; 240 photos/year. Needs photos of live music performers/posed musicians/equipment, primarily jazz and blues. Photo captions preferred.

Specs Accepts images in digital format. ''Do NOT send unsolicited high-resolution images via e-mail!'' Making Contact & Terms Send 8×10 b&w prints; 35mm, 2¼×2¼, 4×5, 8×10 transparencies; b&w or color contact sheets by mail. Unsolicited samples will not be returned unless accompanied by SASE. Provide résumé, business card, brochure, flier or tearsheets to be kept on file for possible future assignments. Responds only when needed. Simultaneous submissions and previously published work OK. Pay rates vary by size. Credit line given. Buys one-time rights.

Tips ''We prefer live shots and interesting candids to studio work.''

$ $▣ DUCKS UNLIMITED

One Waterfowl Way, Memphis TN 38120. (901)758-3864. E-mail: jhoffman@ducks.org. Web site: www.d ucks.org. **Contact:** John Hoffman, photo editor. Circ. 580,000. Estab. 1937. Bimonthly association maga-

zine of Ducks Unlimited, a nonprofit organization. Emphasizes waterfowl hunting and conservation. Readers are professional males, ages 40-50. Sample copy available for $3. Photo guidelines available on Web site, via e-mail or with SASE.

Needs Buys 84 photos from freelancers/issue; 504 photos/year. Needs images of wild ducks and geese, waterfowling and scenic wetlands. Special photo needs include waterfowl hunters, dynamic shots of waterfowl interacting in natural habitat.

Specs Accepts images in digital format. Send via CD as TIFF, JPEG, EPS files at 300 dpi; include thumbnails.

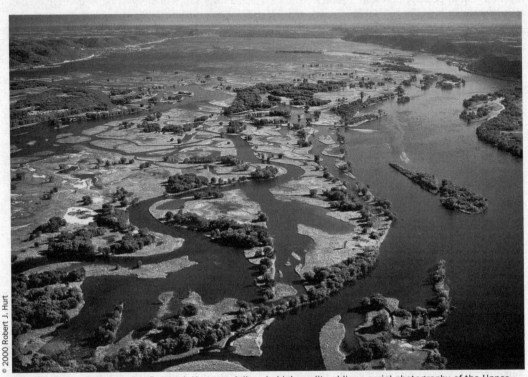

© 2000 Robert J. Hurt

Architect-turned-photographer Robert J. Hurt specializes in high-quality oblique aerial photography of the Upper Mississippi River Basin. "I meet the needs of a specialized market—nonprofit, environmental, conservation and government organizations. With cutbacks in government spending, it helps to love what you're doing, maintain high-quality standards, build a respected track record, and be persistent at promoting yourself," he says. Hurt was paid $510 for this image, which was published in *Ducks Unlimited*.

Making Contact & Terms Send only top-quality portfolio of not more than 40 transparencies (35mm or larger) with SASE for consideration. Responds in 1 month. Previously published work OK, if noted. Pays $100 for thumbnails; $125 for quarter page or less; $150 for images less than half page; $185 for half page; $240 for full page; $400 for 2-page spread; $850 for cover. Pays on publication. Credit line given. Buys one-time rights "plus permission to reprint in our Mexican and Canadian publications."

$ $⊘ ⑤ ▣ E/THE ENVIRONMENTAL MAGAZINE

28 Knight St., Norwalk CT 06851. (203)854-5559. Fax: (203)866-0602. E-mail: bbelli@emagazine.com. Web site: www.emagazine.com. **Contact:** Brita Belli, managing editor/photo editor. Circ. 60,000. Estab. 1988. Nonprofit consumer magazine. Emphasizes environmental issues. Readers are environmental activists, people concerned about the environment. Sample copy available for 9×12 SAE and $5. Photo guidelines free with SASE or via e-mail.

Needs Buys 20 photos from freelancers/issue. Needs photos of threatened landscapes, environmental leaders, people and the environment, pollution, transportation, energy, wildlife and activism. Photo captions required; include location, identities of people in photograph, date, action in photograph.

Specs Accepts images in digital format. Send via CD, Zip, e-mail as TIFF, EPS, JPEG files at 300 dpi and at least 3×4 print size.

Making Contact & Terms Send query letter with résumé of credits and list of stock photo subjects, specialties or accompanying story ideas. Keeps printed samples on file. Responds in 6 weeks. Simultaneous submissions and previously published work OK. Pays up to $500 for color cover; up to $250 for color inside. Pays several weeks after publication. Credit line given. Buys print and Web version rights.

Tips Wants to see "straightforward, journalistic images. Abstract or art photography or landscape photography is not used." In addition, "please do not send manuscripts with photographs. These can be addressed as queries to the managing editor."

$ $⊘ Ⓢ ▣ THE ELKS MAGAZINE

425 W. Diversey Pkwy., Chicago IL 60614-6196. (773)755-4894. Fax: (773)755-4792. E-mail: cheryls@elks.org. Web site: www.elks.org/elksmag. **Contact:** Cheryl T. Stachura, editor/publisher. Circ. 1 million. Estab. 1922. Magazine published 10 times/year. Mission is to provide news of Elks to all 1 million members. "In addition, we have general interest articles. Themes: Americana; history; wholesome, family info; sports; industries; adventure; technology. We do not cover religion, politics, controversial issues." Sample copy free.

Needs Buys 7 cover photos/year; approximately 20 photos/month for interior use. "Photographs of Elks in action are particularly welcome." Reviews photos with or without a manuscript. Photo captions required; include location.

Specs Accepts high-resolution digital images. Uses 35mm, 2¼×2¼, 4×5, 8×10 transparencies.

Making Contact & Terms Send query letter with samples. Does not keep samples on file; include SASE for return of material. Responds in 2 months to queries. Simultaneous submissions OK. Pays $475 for color cover. Pays on publication. Credit line given. Buys one-time rights.

Tips "Artistry and technical excellence are as important as subject matter. We are now purchasing 90 percent of our photographs from photographic stock houses."

Ⓝ $⊘ ▣ ENTREPRENEUR

2445 McCabe Way, Suite 400, Irvine CA 92614. (949)261-2325. E-mail: rolson@entrepreneur.com. Web site: www.entrepreneur.com. **Contact:** Richard R. Olson, design director. Circ. 600,000. Estab. 1977. Monthly magazine emphasizing business. Readers are existing and aspiring small business owners.

Needs Uses about 30 photos/issue; about 30% supplied by freelance photographers; 60% on assignment; 10% from stock. Needs "people at work: home office, business situations. I want to see colorful shots in all formats and styles." Model/property release preferred. Photo captions required; include names of subjects.

Specs Accepts images in digital format and film. Send via Zip, CD, e-mail as TIFF, EPS, JPEG files at 300 dpi.

Making Contact & Terms Provide résumé, business card, brochure, flier or tearsheets to be kept on file for possible future assignments; "follow up for response." Pays $425-700 for b&w cover; $800-1,200 for color cover; $150-275 for b&w inside; $150-600 for color inside. Pays "depending on photo shoot, per hour or per day. We pay $450 per day plus up to $250 for expenses for assignments." **Pays on acceptance.** Credit line given. Buys one-time North American rights; negotiable.

Tips "I am looking for photographers who use the environment creatively; I do not like blank walls for backgrounds. Lighting is also important. I prefer medium-format for most shoots. I think photographers are going back to the basics—a good, clean shot, different angles and bright colors. I also like gelled lighting. I prefer examples of your work—promo cards and tearsheets—along with business cards and résumés."

$☐ ▣ ⊕ EOS MAGAZINE

Robert Scott Publishing Ltd., The Old Barn, Ball Lane, Tackley, Kidlington, Oxfordshire OX5 3AG United Kingdom. (44)(186)933-1741. Fax: (44)(186)933-1641. E-mail: editorial@eos-magazine.com. Web site: www.eos-magazine.com. **Contact:** Angela August, editor. Circ. 20,000. Estab. 1993. Quarterly consumer magazine for all users of Canon EOS cameras. Photo guidelines free.

Needs Looking for quality stand-alone images as well as photos showing specific photographic techniques and comparison pictures. All images must be taken with EOS cameras but not necessarily with Canon lenses. Model release preferred. Photo captions required; include technical details of photo equipment and techniques used.

Specs Accepts images in digital format exclusively.

Making Contact & Terms E-mail for further information on how to submit images, current requirements and rates of payment. Pays on publication. Credit line given. Buys one-time rights.

Tips "We are more likely to use images from photographers who submit a wide selection of top-quality images (40-60 images)."

$☑ ⒮ FACES: People, Places, and Cultures

Cobblestone Publishing, 30 Grove St., Suite C, Peterborough NH 03458. (603)924-7209. Fax: (603)924-7380. Web site: www.cobblestonepub.com. **Contact:** Peg Lopata, assistant editor. Circ. 13,500. Estab. 1984. Magazine published 9 times/year, September-May. Emphasizes cultural anthropology for young people ages 8-14. Sample copies available; see Web site. Photo guidelines and themes available on Web site or free with SASE.

Needs Uses about 30-35 photos/issue; about 75% supplied by freelancers. "Photos (color) for text must relate to themes; cover photos (color) should also relate to themes." Send SASE for themes. Photos purchased with or without accompanying manuscript. Model release preferred. Photo captions preferred.

Making Contact & Terms Query with stock photo list and/or samples. Responds in 1 month. Simultaneous submissions and previously published work OK. Pays $200-350 for color cover; $25-100 color inside. Pays on publication. Buys one-time rights. Credit line given.

Tips "Photographers should request our theme list. Most of the photographs we use are of people from other cultures. We look for an ability to capture people in action—at work or play. We primarily need photos showing people, young and old, taking part in ceremonies, rituals, customs and with artifacts and architecture particular to a given culture. Appropriate scenics and animal pictures are also needed. All submissions must relate to a specific future theme."

Ⓝ ◻ ⒮ ▣ ⦂ FAITH & FRIENDS

The Salvation Army, 2 Overlea Blvd., Toronto ON M4H 1P4. (416)422-6226. Fax: (416)422-6120. E-mail: faithandfriends@can.salvationarmy.org. Web site: www.faithandfriends.ca. **Contact:** Geoff Moulton, senior editor. Circ. 43,000. Monthly consumer magazine. "Our mission: To show Jesus Christ at work in the lives of real people, and to provide spiritual resources for those who are new to the Christian faith."

Needs Needs photos of religion.

Specs Accepts images in digital format. Send JPEG or GIF files. Uses prints.

Making Contact & Terms Payment negotiated. Captions required. Buys one-time rights.

$ $☑ ▣ ⦂ FAITH TODAY

Evangelical Fellowship of Canada, MIP Box 3745, Markham ON L3R 0Y4 Canada. (905)479-6071, ext 241. Fax: (905)479-4742. E-mail: FTeditor@efc-canada.com. Web site: www.faithtoday.ca. **Contact:** Bill Fledderus, senior editor. Circ. 18,000. Estab. 1983. Bimonthly consumer publication. Sample copy free for SAE.

Needs Buys 3 photos from freelancers/issue; 18 photos/year. Needs photojournalism of Canadian religious events and photos of multicultural, families, senior citizens, education, religious. Interested in religious historical/vintage. Also looking for scenes of church life: people praying, singing, etc. Reviews photos with or without a manuscript. Model/property release preferred. Photo captions required.

Specs Uses color prints. Accepts images in digital format. Send via e-mail as TIFF, EPS, JPEG files at 266 dpi.

Making Contact & Terms Send query letter with photocopies, stock list. Does not keep samples on file; include SASE for return of material. Responds only if interested; send nonreturnable samples. Simultaneous submissions and previously published work OK. Pays $25-400 for color cover; $25-150 for color inside. Pays on publication. Credit line given "if requested." Buys one-time rights.

Tips "We emphasize Canada and so generally use photos that are clearly Canadian. Our Web site does not adequately represent our use of photos but does list sample articles, so you can see the kind of topics we cover. We also commission illustrations and welcome queries on that."

$▣ FAMILY MOTOR COACHING

8291 Clough Pike, Cincinnati OH 45244. (513)474-3622. Fax: (513)388-5286. E-mail: magazine@fmca.com. Web site: www.fmca.com. **Contact:** Robbin Gould, editor. Art Director: Guy Kasselmann. Circ. 140,000. Estab. 1963. Monthly publication of the Family Motor Coach Association. Emphasizes motor

homes. Readers are members of national association of motor home owners. Sample copy available for $3.99 ($5 if paying by credit card). Writer's/photographer's guidelines free with SASE or via e-mail.

Needs Buys 55-60 photos from freelancers/issue; 660-720 photos/year. Each issue includes varied subject matter—primarily needs photos depicting motorhome travel, travel with scenic shots, couples, families, senior citizens, hobbies and how-to material. Photos purchased with accompanying manuscript only. Model release preferred. Photo captions required.

Specs Accepts images in digital format. Send via CD as EPS, TIFF files at 300 dpi.

Making Contact & Terms Send query letter with résumé of credits, samples, contact sheets; include SASE for return of material. Responds in 3 months. Pays $100 for color cover; $25-100 for b&w and color inside. $125-500 for text/photo package. **Pays on acceptance.** Credit line given if requested. Prefers first North American rights, but will consider one-time rights on photos *only.*

Tips Photographers are "welcome to submit brochures or copies of their work. We'll keep them in mind should a freelance photography need arise."

$ $◫ ⑤ ▣ FARM & RANCH LIVING

Reiman Media Group, Inc., 5400 S. 60th St., Greendale WI 53129. Fax: (414)423-8463. E-mail: photocoord inator@reimanpub.com. Web site: www.farmandranchliving.com. **Contact:** Trudi Bellin, photo coordinator. Estab. 1978. Bimonthly magazine. "Concentrates on farming and ranching as a way of life." Readers are full-time farmers and ranchers. "*Farm & Ranch Living* is supported entirely by subscriptions and accepts no outside advertising." Sample copy available for $2. Photo guidelines free with SASE.

Needs Buys 15 photos from freelancers/issue; 90 photos/year. Needs photos of beautiful or warmhearted agricultural scenes, lifestyle images of farmers and ranchers (riding, gardening, restoring tractors, handling livestock, hobbies, pets, etc.). Looks for everything from colorful close-ups of produce to panoramic vistas of crops and pastures in a scenic environment. Especially interested in great seasonal shots of agriculture: harvests, feeding cattle in winter, planting, mowing hay. "Shots that are creative, pretty, idyllic or have a warmhearted human interest quality have the best chance of being used." Photo captions preferred; include season and location, and identify subject (type of crop, livestock, etc.).

Specs Prefers color transparencies, all sizes. Accepts images in digital format: TIFF or high-quality JPEG files at 300 dpi for up to 9×11 reproduction. Embedded metadata is recommended. Send via lightboxes or on removable media. Or send CD/DVD with printed thumbnails and caption sheet. E-mail if first review selection is small (12 images or less).

Making Contact & Terms Send query letter with samples or list of stock photo subjects; include SASE for return of material. "We review one season at a time; we work one season in advance." Responds in 3 months. Previously published work OK. Buys stock only. Pays $300 for color cover; $200 for color back cover; $100-300 for inside. Pays on publication. Buys one-time rights to stock photos; all rights to assignments.

Tips "Technical quality is extremely important; focus must be sharp (no soft focus), and colors must be vivid so they 'pop off the page.' Study our magazine thoroughly. We have a continuing need for sharp, colorful images. Those who supply what we need can expect to be regular contributors."

$□ FELLOWSHIP

P.O. Box 271, Nyack NY 10960. (845)358-4601, ext. 42. Fax: (845)358-3278. E-mail: editor@forusa.org. Web site: www.forusa.org. **Contact:** Ethan Vesely-Flad, editor. Circ. 7,000. Estab. 1935. Publication of the Fellowship of Reconciliation; quarterly magazine (36-52 pages) published 6 times/year. Emphasizes peace-making, social justice, nonviolent social change. Readers are interested in peace, justice, nonviolence and spirituality. Sample copy available for $7.50.

Needs Buys 3-5 photos from freelancers/issue; 10-20 photos/year. Needs stock photos of people, civil disobedience, demonstrations—Middle East, Latin America, Caribbean, prisons, anti-nuclear, children, gay/lesbian, human rights issues, the former Soviet Union. Other needs include landscapes/scenics, disasters, environmental, wildlife, religious, humor. Interested in fine art; b&w only. Captions required.

Making Contact & Terms Provide résumé, business card, brochure, flier or tearsheets to be kept on file for possible future assignments. "Call on specs." Responds in 3 weeks. Simultaneous submissions and previously published work OK. Pays $100 for color cover; $35 for b&w inside. Pays on publication. Credit line given. Buys one-time rights.

Tips "You must want to make a contribution to peace movements. Money is simply token."

$ ☐ ▣ FENCERS QUARTERLY MAGAZINE

P.O. Box 1686, Springfield MO 65801. (417)866-4370. E-mail: editor@fencersquarterly.com. Web site: www.fencersquarterly.com. **Contact:** Anita Evangelista, managing editor. Circ. 5,000. Estab. 1996. Quarterly specialty magazine "devoted to all aspects of fencing—its history, traditions, sport, personalities, conflicts and controversies. While our preference is for a 'classical' approach, we publish all viewpoints and well-thought-out opinions." Sample copy available for 9×12 SAE with 3 1st-class stamps.

Needs Buys 10 photos from freelancers/issue; 40-60 photos/year. Needs photos related to fencing—"can include unique, unusual images; prefer clear action shots over static shots." Interested in avant garde, documentary, fine art, historical/vintage, seasonal. Reviews photos with or without a manuscript. Model release required if person is identifiable; property release required. Photo captions preferred; include when, where, who (if fencers are identifiable), and circumstances (if unusual).

Specs Uses 4×5 to 8×10 glossy or matte color and/or b&w prints. No transparencies. Accepts images in digital format. Send via e-mail as BMP, GIF, JPEG files (less than 1 MB).

Making Contact & Terms Send query letter with résumé. Provide self-promotion piece to be kept on file for possible future assignments. Send SASE for return of materials. Responds in 2 weeks. Simultaneous submissions and previously published work OK; "Please indicate if they are!" Pays $25-50 for b&w cover; $5-10 for b&w or color inside. **Pays on acceptance**, before or at publication. Credit line sometimes given depending upon wishes of photographer. Buys one-time rights, first rights, all rights.

Tips "Our ideal photos show either how stylish, graceful, athletic, and complex good fencing can be, or how distorted, tangled and confused modern fencing can be. Contributors should have an understanding of fencing and be familiar with our slant. We're a magazine for the grass-roots, for people who love the sword—many 'ordinary' and 'olympic' fencers subscribe. If we don't buy your work, we'll tell you why. Be realistic about your own work. Just because two people are holding weapons, that doesn't necessarily make a good photo for our magazine."

$ ☐ ▣ FIELD & STREAM

2 Park Ave., New York NY 10016. (212)779-5238. Fax: (212)779-5114. Web site: www.fieldandstream.com. **Contact:** Amy Berkley, photo editor. Circ. 1.5 million. Broad-based service magazine published 11 times/year. Editorial content ranges from very basic "how it's done" filler stories that tell in pictures and words how an outdoor technique is accomplished or device is made, to feature articles of penetrating depth about national conservation, game management and resource management issues; also recreational hunting, fishing, travel, nature and outdoor equipment. Photo guidelines available.

Needs Photos using action and a variety of subjects and angles in color and occasionally b&w. "We are always looking for cover photographs, in color, vertical or horizontal. Remember: a cover picture must have room for cover lines." Also looking for interesting photo essay ideas related to hunting and fishing. Query photo editor by mail. Needs photo information regarding subjects, the area, the nature of the activity and the point the picture makes. First Shots: these photos appear every month (2/issue). Prime space, 2-page spread. One of a kind, dramatic, impactful images, capturing the action and excitement of hunting and fishing. Great beauty shots. Unique wildlife images. See recent issues. "Please do not submit images without reviewing past issues and having a strong understanding of our audience."

Specs Uses 35mm slides. Will also consider large-format photography. Accepts images in digital format. Send via CD, e-mail as JPEG files at 300 dpi.

Making Contact & Terms Submit photos by registered mail. Send slides in 8½×11 plastic sheets, and pack slides and/or prints between cardboard. Include SASE for return of material. Drop portfolios at receptionist's desk, ninth floor. Buys first North American serial rights.

$ ☐ ▣ FIFTY SOMETHING MAGAZINE

1168 Beachview Dr., Willoughby OH 44094. (440)951-2468. Fax: (440)951-1015. E-mail: linde@apk.net. **Contact:** Linda Lindeman-DeCarlo, publisher. Circ. 10,000. Estab. 1990. Quarterly consumer magazine targeted to the 50-and-better reader. Sample copy available for 9×12 SAE with $1.35 first-class postage. Photo guidelines available for #10 SASE.

Needs Buys 2 photos from freelancers/issue; 8 photos/year. Needs photos of celebrities, couples, families, parents, senior citizens, disasters, environmental, landscapes/scenics, architecture, gardening, interiors/decorating, pets, rural, medicine, military, political, product shots/still life, adventure, entertainment, events, health/fitness/beauty, hobbies, humor, sports, travel. Interested in alternative process, avant garde, documentary, fashion/glamour, fine art, historical/vintage, seasonal. Reviews photos with or without a manuscript. Model/property release preferred. Photo captions preferred.

Specs Uses 4×6 glossy color and/or b&w prints; 35mm, 8×10 transparencies. Accepts images in digital format. Send via CD as TIFF, EPS, JPEG files at 300 dpi.

Making Contact & Terms Send query letter with résumé, slides, prints, photocopies, tearsheets, transparencies, stock list. Or direct us to your Web site. Provide résumé, business card, self-promotion piece to be kept on file for possible future assignments. Responds in 2 months. Simultaneous submissions and previously published work OK. Pays $10-100. Pays on publication. Credit line given. Buys one-time rights.

Tips "Looking for photos that are clear and colorful. Need material for historical and nostalgic features. Anything that is directed toward the over-50 reader."

$☑ 🖿 540 RIDER

TMB Publications, P.O. Box 1156, Lake Oswego OR 97035. (503)236-2524. Fax: (503)620-3800. E-mail: dank@aracnet.com. Web site: www.540rider.com. **Contact:** Dan Kesterson, publisher. Circ. 100,000. Estab. 2002. Quarterly magazine. Emphasizes action sports for youth: snowboarding, skateboarding and other board sports. Features high school teams, results, events, training, "and kids that just like to ride." Sample copy available for 8×10 SAE and 75¢ first-class postage. Photo guidelines available by e-mail request or on Web site.

Needs Buys 10-20 photos from freelancers/issue; 40-80 photos/year. Needs photos of sports. Reviews photos with or without a manuscript. Model/property release preferred. Photo captions preferred.

Specs Accepts images in digital format only. Send via CD as TIFF files at 300 dpi.

Making Contact & Terms Send query via e-mail. Provide self-promotion piece to be kept on file for possible future assignments. Responds only if interested; send nonreturnable samples. Simultaneous submissions OK. Pays $25 minimum for b&w and color covers and inside photos. Pays on publication. Credit line given. Buys all rights.

Tips "Send an e-mail ahead of time to discuss. Send us stuff that even you don't like, because we just might like it."

🄽 🖿 FLAUNT MAGAZINE

1422 N. Highland Ave., Los Angeles CA 90028. (323)836-1000. E-mail: info@flauntmagazine.com. Web site: www.flaunt.com. **Contact:** Todd Tourso, art director. Estab. 1998. Circ. 110,000. Monthly consumer magazine covering culture, arts, entertainment, literature. "*Flaunt* features the bold work of emerging photographers, writers, artists and musicians. The quality of the content is mirrored in the sophisticated, interactive format of the magazine, using advanced printing techniques, fold-out articles, beautiful papers, and inserts to create a visually stimulating, surprisingly readable and intelligent book that pushes the magazine format into the realm of art object."

Needs Needs photos of celebrities, architecture, cities/urban, entertainment, performing arts, avant garde, lifestyle. Reviews photos with or without a manuscript. Model release required. Captions required; include identification of subjects.

Specs Accepts images in digital format. Send JPEG or GIF files. Reviews contact sheets, any size transparencies and prints.

Making Contact & Terms E-mail query letter with link to photographer's Web site. Credit line given. Buys one-time rights.

🖿 FLY FISHERMAN

Intermedia Outdoors, Inc., 6385 Flank Dr., Harrisburg PA 17112. (717)657-9555. Fax: (717)657-9552. Web site: www.flyfisherman.com. **Contact:** Geoff Mueller, managing editor: Editor/publisher: John Randolph. Circ. 130,000. Magazine published 6 times/year. Emphasizes all types of fly fishing for readers who are "97.8% male, 83% college-educated, 98% married; average household income is $138,000, and 49% are managers or professionals; 68% keep their copies for future reference and spend 33 days/year fishing." Sample copy available via Web site or for $4.95 with 9×12 SAE and 4 first-class stamps. Photo guidelines available on Web site or free with SASE.

Needs Buys 36 photos from freelancers/issue; 216 photos/year. Needs shots of "fly fishing and all related areas—scenics, fish, insects, how-to." Photo captions required.

Making Contact & Terms Send 35mm, 2¼×2¼, 4×5 or 8×10 color transparencies by mail with SASE for consideration. Accepts color digital images on CD or via e-mail for submissions. Responds in 6 weeks. Payment negotiable. Pays on publication. Credit line given. Buys one-time or all rights.

$ $⌀ Ⓢ FLY ROD & REEL: The Excitement of Fly-Fishing

P.O. Box 370, Camden ME 04843. (207)594-9544. Fax: (207)594-5144. E-mail: pguernsey@flyrodreel.com. Web site: www.flyrodreel.com. **Contact:** Paul Guernsey, editor-in-chief. Circ. 61,941. Bimonthly magazine. Emphasizes fly-fishing. Readers are primarily fly-fishers ages 30-60. Estab. 1979. Sample copy and photo guidelines free with SASE ; photo guidelines also available via e-mail.

Needs Buys 15-20 photos from freelancers/issue; 90-120 photos/year. Needs ''photos of fish, scenics (preferrably with anglers in shot), equipment.'' Photo captions preferred; include location, name of model (if applicable).

Specs Uses 35mm slides; $2^1/_4 \times 2^1/_4$, 4×5 transparencies.

Making Contact & Terms Send query letter with list of stock photo subjects. Send unsolicited photos by mail for consideration; include SASE for return of material. Provide résumé, business card, brochure, flier or tearsheets to be kept on file for possible future assignments. Responds in 1 month. Pays $600-800 for color cover photo; $75 for b&w inside (seldom needed); $75-200 for color inside. Pays on publication. Credit line given. Buys one-time rights.

Tips ''Photos should avoid appearance of being too 'staged.' We look for bright color (especially on covers), and unusual, visually appealing settings. Trout and salmon are preferred for covers. Also looking for saltwater fly-fishing subjects. Ask for guidelines, then send 20 to 40 shots showing breadth of work.''

$ $ FOOD & WINE

American Express Publishing Corporation, 1120 Avenue of the Americas, New York NY 10036. (212)382-5600. Web site: www.foodandwine.com. **Contact:** Fredrika Stjarne, director o f photography. Circ. 950,000. Estab. 1978. Monthly magazine. Emphasizes food and wine. Readers are ''upscale people who cook, entertain, dine out and travel stylishly.''

Needs Uses about 25-30 photos/issue; 85% freelance photography on assignment basis; 15% freelance stock. ''We look for editorial reportage specialists who do restaurants, food on location, and travel photography.'' Model release required. Photo captions required.

Making Contact & Terms Drop off portfolio on Wednesday (attn: Rebecca Jacobs). Call for pickup. Submit fliers, tearsheets, etc., to be kept on file for possible future assignments and stock usage. Pays $450/color page; $100-450 for color photos. **Pays on acceptance.**Credit line given. Buys one-time world rights.

$ $Ⓐ FORTUNE

Rockefeller Center, Time-Life Bldg., 1271 Avenue of the Americas, New York NY 10020. (212)522-8021. Fax: (212)467-1213. E-mail: scott_thode@fortunemail.com. Web site: www.fortune.com. **Contact:** Scott Thode, deputy picture editor. Emphasizes analysis of news in the business world for management personnel.

Making Contact & Terms Picture Editor reviews photographers' portfolios on an overnight drop-off basis. Photos purchased on assignment only. Day rate on assignment (against space rate): $500; page rate for space: $400; minimum for b&w or color usage: $200.

Ⓝ $○ ▣ 4-WHEEL ATV ACTION

Hi-Torque Publications, 25233 Anza Dr., Valencia CA 91355. (661)295-1910. Fax: (661)295-1278. E-mail: atv@hi-torque.com. Web site: www.4wheelatv.com. **Contact:** Joe Kosch, editor. Circ. 65,000. Estab. 1986. Monthly consumer magazine emphasizing all-terrain vehicles and anything closely related to them.

Needs Buys 4 photos from freelancers/issue; 50 photos/year. Needs photos of adventure, events, hobbies, sports. ''We are interested only in ATVs and very closely related ride-on machines with more than two wheels—no cars, trucks, buggies or motocycles. We're looking for scenic riding areas with ATVs in every shot, plus unusual or great looking ATVs.'' Reviews photos with or without a manuscript. Model/property release preferred. Photo captions preferred; include location, names.

Specs Uses 8×10 glossy color prints; 35mm transparencies. Accepts images in digital format. Send via Zip, e-mail as JPEG files at 300 dpi.

Making Contact & Terms Send query letter with photocopies or e-mail JPEGs. Does not keep samples on file; cannot return material. Responds only if interested; send nonreturnable samples. Simultaneous submissions and previously published work OK. Pays $50-100 for color cover; $15-25 for color inside. Credit line given. Buys one-time rights, first rights; negotiable.

Tips ''*4-Wheel ATV Action* offers a good opportunity for amateur but serious photographers to get a credit line in a national publication.''

◻ Ⓢ FREEFALL

Undead Poets Press, 15735 Kerstyn St., Taylor MI 48180-4891. E-mail: mauruspoet@yahoo.com. **Contact:** Marc Maurus, publisher. Estab. 1997. Circ. 250. Poetry journal "that uses standard snapshot-sized photos, one on the front cover and one on the back." Photo guidelines available with #10 SASE.

Needs Buys 1 or 2 photos from freelancers/issue; 6 photos/year. Needs photos of babies/children/teens, couples, multicultural, families, parents, senior citizens, architecture, cities/urban, gardening, interiors/decorating, rural, agriculture, industry, medicine, product shots/still life, science, landscapes/scenics, wildlife, hobbies, humor, performing arts, travel. Interested in fine art, seasonal. Model/property release required.

Specs Uses 4×6 glossy or matte color or b&w pritns.

Making Contact & Terms Send query letter with prints. Does not keep samples on file; include SASE for return of material. Credit line given.

Tips "We look for quality composition in artistic work. Our magazine is edgy as often as it is pondering, and we like our photos to be varied as well."

$◻ ▣ FT. MYERS MAGAZINE

15880 Summerlin Rd., Suite 189, Ft. Myers FL 33908. E-mail: ftmyers@optonline.net. **Contact:** Andrew Elias, director. Circ. 20,000. Estab. 2002. Magazine published every 2 months for southwest Florida, focusing on local and national arts and lifestyle. *Ft. Myers Magazine* is targeted at successful, educated and active residents of southwest Florida, ages 20-60, as well as guests at the best hotels and resorts on the Gulf Coast. Media columns and features include: books, music, video, films, theater, Internet, software (news, previews, reviews, interviews, profiles). Lifestyle columns and features include: art & design, house & garden, food & drink, sports & recreation, health & fitness, travel & leisure, science & technology (news, previews, reviews, interviews, profiles). Sample copy available for $3 including postage & handling.

Needs Buys 3-6 photos from freelancers/year. Needs photos of celebrities, architecture, gardening, interiors/decorating, medicine, product shots/still life, environmental, landscapes/scenics, wildlife, entertainment, events, food & drink, health/fitness/beauty, performing arts, sports, travel. Interested in alternative process, avant garde, documentary, fashion/glamour, fine art, historical/vintage. Also needs beaches, beach scenes/sunsets over beaches, boating/fishing, palm trees. Reviews photos with or without a manuscript. Model release required. Photo captions preferred; include description of image and photo credit.

Specs Uses 4×5, 8×10 glossy or matte color and/or b&w prints; 35mm, 2×2, 4×5, 8×10 transparencies ("all are acceptable, but we prefer prints or digital"). Accepts images in digital format. Send via CD, floppy disk, Zip, e-mail (preferred) as TIFF, EPS, PICT, JPEG, PDF files (prefers TIFF or JPEG) at 300-600 dpi.

Making Contact & Terms Send query letter via e-mail with digital images and stock list. Provide résumé, business card, self-promotion piece to be kept on file. Responds only if interested; send nonreturnable samples. Simultaneous submissions and previously published work OK. Pays $100 for b&w or color cover; $25-100 for b&w or color inside. Pays on publication. Credit line given. Buys one-time rights.

$▢ ▣ GAME & FISH MAGAZINES

2250 Newmarket Pkwy., Suite 110, Marietta GA 30067. (770)953-9222, ext. 2029. Fax: (770)933-9510. E-mail: ronald.sinfelt@intermediaoutdoors.com. Web site: www.gameandfish.about.com. **Contact:** Ron Sinfelt, photo editor. Editorial Director: Ken Dunwoody. Combined circ. 576,000. Estab. 1975. Publishes 31 different monthly outdoors magazines: *Alabama Game & Fish, Arkansas Sportsman, California Game & Fish, Florida Game & Fish, Georgia Sportsman, Great Plains Game & Fish, Illinois Game & Fish, Indiana Game & Fish, Iowa Game & Fish, Kentucky Game & Fish, Louisiana Game & Fish, Michigan Sportsman, Mid-Atlantic Game & Fish, Minnesota Sportsman, Mississippi Game & Fish, Missouri Game & Fish, New England Game & Fish, New York Game & Fish, North Carolina Game & Fish, Ohio Game & Fish, Oklahoma Game & Fish, Pennsylvania Game & Fish, Rocky Mountain Game & Fish, South Carolina Game & Fish, Tennessee Sportsman, Texas Sportsman, Virginia Game & Fish, Washington-Oregon Game & Fish, West Virginia Game & Fish, Wisconsin Sportsman,* and *North American Whitetail*. All magazines (except *Whitetail*) are for experienced hunters and fishermen and provide information about where, when and how to enjoy the best hunting and fishing in their particular state or region, as well as articles about game and fish management, conservation and environmental issues. Sample copies available for $3.50 with 10×12 SAE. Photo guidelines and current needs list free with SASE.

Needs Fifty percent of photos supplied by freelance photographers; 5% assigned. Needs photos of live

game animals/birds in natural environments and hunting scenes; also underwater game fish photos and fishing scenes. Photo captions required; include species identification and location. Number slides/prints. **Specs** Accepts images in digital format. Send via CD at 300 dpi with output of 8×12 inches.

Making Contact & Terms Send 5×7, 8×10 glossy b&w prints or 35mm transparencies (preferably Fujichrome, Kodachrome) with SASE for consideration. Responds in 1 month. Simultaneous submissions not accepted. Pays $250 for color cover; $25 for b&w inside; $75 for color inside. Pays 60 days prior to publication. Tearsheet provided. Credit line given. Buys one-time rights.

Tips ''Send separate CD and proof sheet for each species, with digital submissions. We'll return photos we don't expect to use and hold remainder in-house so they're available for monthly photo selections. Please do not send dupes. Photos will be returned upon publication or at photographer's request.''

Ⓝ $☐ ▣ GERMAN LIFE MAGAZINE

1068 National Hwy., LaVale MD 21502. (301)729-6190. Fax: (301)729-1720. E-mail: mslider@germanlife. com. Web site: www.germanlife.com. **Contact:** Mark Slider, editor. Circ. 40,000. Estab. 1994. Bimonthly magazine focusing on history, culture, and travel relating to German-speaking Europe and German-American heritage. Sample copy available for $5.95.

Needs Limited number of photos purchased separate from text articles.

Specs Queries welcome for specs.

Making Contact & Terms Payment varies. Pays on publication. Credit line given. Buys one-time rights.

▣ GHOST TOWN

2660 Petersborough St., Herndon VA 20171. E-mail: shannonaswriter@yahoo.com. Estab. 1998. Quarterly magazine. Photo guidelines available by e-mail request.

Needs Buys 12 photos from freelancers/issue; 48-72 photos/year. Needs photos of babies/children/teens, celebrities, couples, multicultural, families, parents, disasters, environmental, landscapes/scenics, wildlife, architecture, cities/urban, education, gardening, interiors/decorating, pets, religious, rural, adventure, events, food/drink, sports, travel, agriculture, medicine, military, political, product shots/still life, science, technology—as related to archaeology and ghost towns. Interested in alternative process, avant garde, documentary, fashion/glamour, fine art, historical/vintage, seasonal. Wants photos of archaeology sites and excavations in progress of American ghost towns. ''Would like photographs of artifacts and Paleobiology.'' Reviews photos with or without a manuscript. Model/property release preferred.

Specs Uses glossy or matte color and/or b&w prints.

Making Contact & Terms Send query letter via e-mail. ''If possible, please do not include photographs in files if they are sent through e-mail. A CD sent with your photographs is acceptable.'' Provide résumé, business card or self-promotion piece to be kept on file for possible future assignments. ''Photographs sent with CDs are requested but not required. Illustrations and artwork are also accepted.'' Responds within 1 month to queries; 1 week to portfolios. Simultaneous submissions and previously published work OK. **Pays on acceptance.** Credit line given. Buys one-time rights, first rights; negotiable.

Ⓝ $☑ ▣ GOLF TIPS

12121 Wilshire Blvd., #1200, Los Angeles CA 90025. (310)820-1500. Fax: (310)826-5008. E-mail: wkeating @wernerpublishing.com. Web site: www.golftipsmag.com. **Contact:** Warren Keating, art director. Circ. 300,000. Estab. 1986. Magazine published 9 times/year. Readers are ''hardcore golf enthusiasts.'' Sample copy free with SASE.

Needs Buys 40 photos from freelancers/issue; 360 photos/year. Needs photos of golf instruction (usually pre-arranged, on-course), equipment; health/fitness, travel. Interested in alternative process, documentary, fashion/glamour. Reviews photos with accompanying manuscript only. Model/property release preferred. Photo captions required.

Specs Uses prints; 35mm, $2\frac{1}{4} \times 2\frac{1}{4}$, 4×5, 8×10 transparencies. Accepts images in digital format. Send via Zip as TIFF files at 300 dpi.

Making Contact & Terms Send query letter with résumé of credits. Submit portfolio for review. Cannot return material. Responds in 1 month. Pays $500-1,000 for b&w or color cover; $100-300 for b&w inside; $150-450 for color inside. Pays on publication. Buys one-time rights; negotiable.

☐ ▣ ⚡ GOSPEL HERALD

4904 King St., Beamsville ON L0R 1B6 Canada. (905)563-7503. E-mail: editorial@gospelherald.org. Web site: www.gospelherald.org. **Contact:** Wayne Turner, co-editor. Managing Editor: Max Craddock. Circ.

1,300. Estab. 1936. Monthly consumer magazine. Emphasizes Christianity. Readers are primarily members of the Churches of Christ. Sample copy free with SASE.

Needs Uses 2-3 photos/issue. Needs photos of babies/children/teens, families, parents, landscapes/scenics, wildlife, seasonal, especially those relating to readership—moral, religious and nature themes.

Specs Uses b&w, any size and any format. Accepts images in digital format. Send via CD, Zip, e-mail as JPEG files.

Making Contact & Terms Send unsolicited photos by mail for consideration. Payment not given, but photographer receives credit line.

Tips "We have never paid for photos. Because of the purpose of our magazine, both photos and stories are accepted on a volunteer basis."

$ $🗓 🆂 🖳 GRIT MAGAZINE

1503 SW 42nd St., Topeka KS 66609. (785)274-4300. Fax: (785)274-4305. E-mail: grit@grit.com. Web site: www.grit.com. **Contact:** Hank Will, editor. Circ. 150,000. Estab. 1882. Bimonthly magazine. Emphasizes country lifestyle or "hobby" farm-oriented material. Readership is national. Sample copy available for $4.

Needs Buys 24+ photos/year with accompanying stories or articles; 90% from freelancers. Needs, on a regular basis, photos of small-farm livestock, animals, farm labor, gardening, produce and related images. "Be certain pictures are well composed, properly exposed and pin sharp. Must be *shot* at high resolution (no less than 300 dpi). No cheesecake. No pictures that cannot be shown to any member of the family. No pictures that are out of focus or over- or under-exposed. No ribbon-cutting, check-passing or hand-shaking pictures. Story subjects include all aspects of the hobby or country lifestyle farm, such as livestock, farm dogs, barn cats, sowing and hoeing, small tractors, fences, etc." Photo captions required. "Any image that stands alone must be accompanied by 50-100 words of meaningful caption information."

Specs Uses 35mm, slides and high-resolution digital images. Send digital images via CD, Zip as JPEG files at 300 dpi.

Making Contact & Terms Study the magazine. Send material by mail with SASE for consideration. Responds ASAP. Pay is negotiable up to $1,000 for color cover; $35-200 for color inside; $25-100 for b&w inside. Rarely uses b&w, and only if "irresistibly atmospheric." Pays on publication. Buys shared rights; negotiable.

Tips "This is a relaunch of an old title. You must study the new publication to make sure your submissions are appropriate to *Grit*'s new direction."

$ $🗓 🖳 GUIDEPOSTS

16 E. 34th St., 21st Floor, New York NY 10016. (212)251-8124. Fax: (212)684-1311. Web site: www.guideposts.com. **Contact:** Candice Smilow, photo editor. Circ. 2.6 million. Estab. 1945. Monthly magazine. Emphasizes tested methods for developing courage, strength and positive attitudes through faith in God. Free sample copy and photo guidelines with 6×9 SASE.

Needs Uses 90% assignment, 10% stock on a story-by-story basis. Photos are mostly environmental portraiture, editorial reportage. Stock can be scenic, sports, fine art, mixed variety. Model release required.

Specs Uses 35mm, 2¼×2¼ transparencies; vertical for cover, horizontal or vertical for inside. Accepts images in digital format. Send via CD at 300 dpi.

Making Contact & Terms Send photos or arrange a personal interview. Responds in 1 month. Simultaneous submissions OK. Pays by job or on a per-photo basis; $800 minimum for color cover; $150-400 for color inside; negotiable. **Pays on acceptance.**Credit line given. Buys one-time rights.

Tips "I'm looking for photographs that show people in their environment; straight portraiture and people interacting. We're trying to appear more contemporary. We want to attract a younger audience and yet maintain a homey feel. For stock—scenics; graphic images in color. *Guideposts* is an 'inspirational' magazine. NO violence, nudity, sex. No more than 20 images at a time. Write first and ask for a sample issue; this will give you a better idea of what we're looking for."

$ $🗓 🖳 HADASSAH MAGAZINE

50 W. 58th St., New York NY 10019. (212)451-6284. Fax: (212)451-6257. E-mail: rfyman@hadassah.org. Web site: www.hadassah.org. **Contact:** Rachel Fyman, editorial assistant. Circ. 300,000. Monthly publication of the Hadassah Women's Zionist Organization of America. Emphasizes Jewish life, Israel. Readers

are 85% females who travel and are interested in Jewish affairs, average age 59. Photo guidelines free with SASE.

Needs Uses 10 photos/issue; most supplied by freelancers. Needs photos of travel, Israel and general Jewish life. Photo captions preferred; include where, when, who and credit line.

Specs Accepts images in digital format. Send via CD as JPEG files at 300 dpi.

Making Contact & Terms Submit portfolio for review. Send unsolicited photos by mail for consideration. Keeps samples on file; include SASE for return of material. Responds in 3 months. Pays $450 for color cover; $125-175 for ¼ page color inside. Pays on publication. Credit line given. Buys one-time rights.

Tips "We frequently need travel photos, especially of places of Jewish interest."

N ▣ ▧ HAMILTON MAGAZINE

Town Media, a division of Osprey Media LP, 1074 Cooke Blvd., Burlington ON L7T 4A8. Phone/fax: (905)634-8003. E-mail: john@townmedia.ca. Web site: www.hamiltonmagazine.com. **Contact:** John Bullock, art director. Estab. 1978. Consumer magazine. "Our mandate: to entertain and inform by spotlighting the best of what our city and region has to offer. We invite readers to take part in a vibrant community by supplying them with authoritative and dynamic coverage of local culture, food, fashion and design."

Needs Needs photos of cities/urban, entertainment, food/drink, health/fitness/beauty, fashion/glamour, lifestyle. Reviews photos with or without a manuscript. Captions required; include identification of subjects.

Specs Accepts images in digital format. Send JPEG files at 8×10 inches at 300 dpi. Uses 8×10 prints.

Making Contact & Terms Pays on publication. Credit line given.

$ $▣ HARPER'S MAGAZINE

Harper's Magazine Foundation, 666 Broadway, 11th Floor, New York NY 10012. (212)420-5720. Fax: (212)228-5889. E-mail: alyssa@harpers.org. Web site: www.harpers.org. **Contact:** Alyssa Coppelman, assistant art director. Circ. 250,000. Estab. 1850. Monthly literary magazine. "The nation's oldest continually published magazine providing fiction, satire, political criticism, social criticism, essays."

Needs Buys 8-10 photos from freelancers/issue; 120 photos/year. Needs photos of human rights issues, environmental, political. Interested in alternative process, avant garde, documentary, fine art, historical/vintage. Model/property release preferred.

Specs Uses any format. Accepts images in digital format. Send via CD, Zip, e-mail as TIFF, EPS, JPEG files at 300 dpi.

Making Contact & Terms Send query letter with résumé, slides, prints, photocopies, tearsheets, transparencies. Portfolio may be dropped off last Wednesday of the month. Provide self-promotion piece to be kept on file for possible future assignments. Responds in 1 week. Pays $200-800 for b&w/color cover; $250-400 for b&w/color inside. Pays on publication. Credit line given. Buys one-time rights; negotiable.

Tips "Harper's is geared more toward fine art photos or artist's portfolios than to 'traditional' photo usages. For instance, we never do fashion, food, travel (unless it's for political commentary), lifestyles or celebrity profiles. A good understanding of the magazine is crucial for photo submissions. We consider all styles and like experimental or nontraditional work. Please don't confuse us with Harper's Bazaar!"

$▣ HIGHLIGHTS FOR CHILDREN

803 Church St., Honesdale PA 18431. (570)253-1080. Web site: www.highlights.com. **Contact:** Cindy Faber Smith, art director. Circ. around 2.5 million. Monthly magazine for children ages 2-12. Sample copy free.

• Highlights is currently expanding photographic needs.

Needs Buys 100 or more photos/year. "We will consider outstanding photo essays on subjects of high interest to children." Reviews photos with accompanying manuscript only. Wants no single photos without captions or accompanying manuscript.

Specs Accepts images in digital format. Send via CD at 300 dpi. Also accepts transparencies of all sizes.

Making Contact & Terms Send photo essays with SASE for consideration. Responds in 7 weeks. Pays $30 minimum for b&w photos; $50 minimum for color photos; $100 minimum for manuscript. Buys all rights.

Tips "Tell a story that is exciting to children. We also need mystery photos, puzzles that use photography/collage, special effects, anything unusual that will visually and mentally challenge children."

$ $☑ ⑤ ▣ HIGHWAYS, The Official Publication of The Good Sam Club

Affinity Group Inc., 2575 Vista Del Mar Dr., Ventura CA 93001-3920. (805)667-4003. Fax: (805)667-4122. E-mail: sfrankel@affinitygroup.com. Web site: www.goodsamclub.com/highways. **Contact:** Stacy Frankel, art director. Circ. 975,000. Estab. 1966. Monthly consumer magazine. "Your authoritative source for information on issues of concern to all RVers, as well as your link to the RV community." Sample copy free with 8½×11 SAE.

Specs Accepts images in digital format. Send via CD or e-mail at 300 dpi.

Making Contact & Terms Art director will contact photographer for portfolio review if interested. Pays $500 for cover; $75-350 for inside. Buys one-time rights.

$ HOOF BEATS

750 Michigan Ave., Columbus OH 43215. (614)224-2291. Fax: (614)222-6791. E-mail: hoofbeats@ustrotting.com. Web site: www.ustrotting.com. **Contact:** Nicole Kraft, executive editor. Art Director/Production Manager: Gena Gallagher. Circ. 13,500. Estab. 1933. Monthly publication of the U.S. Trotting Association. Emphasizes harness racing. Readers are participants in the sport of harness racing. Sample copy free.

Needs Buys 6 photos from freelancers/issue; 72 photos/year. Needs "artistic or striking photos that feature harness horses for covers; other photos on specific horses and drivers by assignment only."

Making Contact & Terms Send query letter with samples; include SASE for return of material. Responds in 3 weeks. Simultaneous submissions OK. Pays $150 minimum for color cover; $25-150 for b&w inside; $50-200 for color inside; freelance assignments negotiable. Pays on publication. Credit line given if requested. Buys one-time rights.

Tips "We look for photos with unique perspective and that display unusual techniques or use of light. Send query letter first. Know the publication and its needs before submitting. Be sure to shoot pictures of harness horses only, not thoroughbred or riding horses. We always need good night racing action or creative photography."

$ $ HORSE ILLUSTRATED

Fancy Publications, BowTie Magazines, P.O. Box 6050, Mission Viejo CA 92690. (949)855-8822. Fax: (949)855-3045. E-mail: horseillustrated@bowtieinc.com. Web site: www.horseillustrated.com. **Contact:** Elizabeth Moyer, editor. Circ. 192,000. Readers are "primarily adult horsewomen, ages 18-40, who ride and show mostly for pleasure, and who are very concerned about the well being of their horses." Sample copy available for $4.50. Photo guidelines free with SASE.

Needs Buys 30-50 photos from freelancers/issue. Needs stock photos of riding and horse care. "Photos must reflect safe, responsible horsekeeping practices. We prefer all riders to wear protective helmets; prefer people to be shown only in action shots (riding, grooming, treating, etc.). We like all riders—especially those jumping—to be wearing protective headgear."

Specs "We generally use color transparencies." Prefers 35mm, 2¼×2¼ color transparencies.

Making Contact & Terms Send by mail for consideration. Responds in 2 months. Pays $200 for color cover; $60-200 for color inside; $100-350 for text/photo package. Credit line given. Buys one-time rights.

Tips "Nothing but sharp, high-contrast shots. Looks for clear, sharp color shots of horse care and training. Healthy horses, safe riding and care atmosphere is standard in our publication. Send SASE for a list of photography needs, photo guidelines and to submit work. Photo guidelines are also available on our Web site."

$☑ ⑤ IDEALS MAGAZINE

Ideals Publications, 535 Metroplex Dr., Suite 250, Nashville TN 37211. (615)333-0478. Fax: (615)781-1447. Web site: www.idealsbooks.com. **Contact:** Melinda Rathjen, editor. Circ. 200,000. Estab. 1944. Magazine published 4 times/year. Emphasizes an idealized, nostalgic look at America through poetry and short prose, using seasonal themes. Average reader has a college degree. Sample copy available for $4. Photo guidelines free with SASE or available on Web site.

Needs Buys 30 photos from freelancers/issue; 120 photos/year. Needs photos of "bright, colorful flowers, scenics, still life, children, pets, home interiors; subject-related shots depending on issue." Model/property release required. No research fees.

Specs Prefers medium- to large-format transparencies; no 35mm.

Making Contact & Terms Submit tearsheets to be kept on file. No color copies. Will send photo needs list if interested. Do not submit unsolicited photos or transparencies. Keeps samples on file. Simultaneous

submissions and previously published work OK. Payment negotiable. Pays on publication. Credit line given. Buys one-time rights.

Tips "We want to see *sharp* shots. No mood shots, please. No filters. We suggest the photographer study several recent issues of *Ideals* for a better understanding of our requirements."

N ◯ S ILLOGICAL MUSE

P.O. Box 63, Buchanan MI 49107-1424. E-mail: illogicalmuse@yahoo.com. Web site: www.geocities. com/illogicalmuse. **Contact:** Amber Rothrock, editor. Estab. 2004. Quarterly literary magazine. Online journal publishing fiction, poetry, reviews, essays and artwork. Photo guidelines available on Web site.

Needs Wants photos of babies/children/teens, couples, multicultural, parents, senior citizens, architecture, cities/urban, gardening, pets, religious, rural, agriculture, disasters, environmental, wildlife, hobbies, performing arts; interested in avant garde, historical/vintage, seasonal. Does not want to see anything pornographic; mild erotica is fine. "I am open to all schools and styles but tend to lean toward the more experimental and avant garde." Reviews photos with or without a manuscript. Model release preferred. Property release preferred. Photo captions preferred.

Specs Accepts images in digital format only. Send JPEG or GIF files via CD or e-mail.

Making Contact & Terms E-mail query letter with link to photographer's Web site, JPEG samples at 72 dpi. "Send a cover letter with a brief, publishable bio. An exceptionally long list of prior achievements is not necessary. Tell me a little bit about yourself and the work you do." Does not keep samples on file; include SASE for return of material. Responds in 1 month to queries; 6 months to portfolios. Simultaneous submissions and previously published work OK. All rights remain with the photographer.

Tips "Visit the Web site to see if it appeals to you. It's hard to say what I am specifically looking for as I try to keep an open mind with every submission. Just send your best."

⊞ IMMIGRANT ANCESTORS

2660 Petersborough St., Herndon VA 20171. E-mail: tiedbylove@yahoo.com. Estab. 2005. Quarterly magazine, "searching for immigrants and immigrant ancestors." Photo guidelines available by e-mail request.

Needs Buys 12-24 photos/year. Needs photos of babies/children/teens, multicultural, families, parents, disasters, environmental, landscapes/scenics, wildlife, cities/urban, education, religious, rural, adventure, events, food/drink, sports, travel, agriculture, medicine, military, political, product shots/still life, science, technology-as related to early immigration and those who made its history. Interested in alternative process, avant garde, documentary, fashion/glamour, fine art, historical/vintage, seasonal. Reviews photos with or without manuscript. Model/property release preferred.

Specs Uses glossy or matte color and/or b&w prints.

Making Contact & Terms Send query letter via e-mail. "If possible, please do not include photographs in files if they are sent through e-mail. A disk with your photographs is acceptable." Provide résumé, business card or self-promotion piece to be kept on file for possible future assignments. Responds within 1 month to queries; 1 week to portfolios. Simultaneous submissions and previously published work OK. **Pays on acceptance.** Credit line given. Buys one-time rights, first rights; negotiable.

$ $⊟ INDIANAPOLIS MONTHLY

40 Monument Circle, Suite 100, Indianapolis IN 46204. (317)237-9288. Web site: www.indianapolismont hly.com. **Contact:** Art Director. Monthly regional magazine. Readers are upscale, well-educated. Circ. 50,000. Sample copy available for $4.95 and 9×12 SASE.

Needs Buys 10-12 photos from freelancers/issue; 120-144 photos/year. Needs seasonal, human interest, humorous, regional; subjects must be Indiana- or Indianapolis-related. Model release preferred. Photo captions preferred.

Specs Uses 5×7 or 8×10 glossy b&w prints; 35mm, 2¼×2¼ transparencies. Accepts images in digital format. Send via CD, e-mail as TIFF, EPS, JPEG files at 300 dpi at actual size.

Making Contact & Terms Send query letter with samples, SASE. Responds in 1 month. Previously published work on occasion OK, if different market. Pays $300-1,200 for color cover; $75-300 for b&w inside; $75-350 for color inside. Pays on publication. Credit line given. Buys first North American serial rights.

Tips "Read publication. Send photos similar to those you see published. If you see nothing like what you are considering submitting, it's unlikely we will be interested. We are always interested in photo essay queries if they are Indiana-specific."

$ $◔ INSIGHT MAGAZINE

Review and Herald Publishing Association, 55 W. Oak Ridge Dr., Hagerstown MD 21740-7390. (301)393-3000. Fax: (301)393-4055. E-mail: insight@rhpa.org. Web site: www.insightmagazine.org. **Contact:** Jason Diggs, art director. Circ. 20,000. Estab. 1970. Weekly Seventh-Day Adventist teen magazine. "We print teens' true stories about God's involvement in their lives. All stories, if illustrated by a photo, must uphold moral and church organization standards while capturing a hip, teen style." Sample copy free.
Needs "Send query letter with photo samples so we can evaluate style." Model/property release required. Photo captions preferred; include who, what, where, when.
Making Contact & Terms Send query letter with samples. Provide résumé, business card, self-promotion piece or tearsheets to be kept on file for possible future assignments. Responds only if interested; send nonreturnable samples. Simultaneous submissions and previously published work OK. Pays $200-300 for color cover; $200-400 for color inside. Pays 30-45 days after receiving invoice and contract. Credit line given. Buys first rights.

$ INTELLIGENCE TODAY

1576 E. Cottonwood Lane #1129, Casa Grande AZ 85222. (520)423-2137. E-mail: laroger0@yahoo.com. Web site: www.laroger.com. **Contact:** Roger Jewell, publisher. Estab. 2006. Monthly consumer magazine. "We publish articles and photos regarding national and international intelligence agencies and security."
Needs Buys 2 photos from freelancers/issue; 24 photos/year. Needs photos of military, political, documentary. Reviews photos with or without a manuscript. Model/property release required. Photo captions required; include names, dates.
Specs Uses 4×5 (at least) color and b&w prints; 35mm transparencies.
Making Contact & Terms E-mail query letter with link to photographer's Web site. Send query letter with prints, transparencies. Keeps samples on file; provide self-promotion piece to be kept on file for possible future assignments. Responds in 2 weeks to queries; 4 weeks to portfolios. Pays $15 minimum/$150 maximum for b&w or color cover. Pays $15 minimum/$80 maximum for b&w or color inside. **Pays on acceptance**. Credit line given.

$ ◔ ▤ THE IOWAN MAGAZINE

218 Sixth Ave., Suite 610, Des Moines IA 50309. (515)246-0402. Fax: (515)282-0125. E-mail: editor@iowan.com or artdirector@iowan.com. Web site: www.iowan.com. **Contact:** Beth Wilson, editor; Bobbie Russie, art director. Circ. 22,000. Estab. 1952. Bimonthly magazine. Emphasizes "Iowa—its people, places, events, nature and history." Readers are over age 40, college-educated, middle-to-upper income. Sample copy available for $4.50 + shipping/handling; call the Distribution Center toll-free at (877)899-9977. Photo guidelines available on Web site or via e-mail.
Needs Iowa-related residents, towns, environmental, landscape/scenics, wildlife, architecture, rural, entertainment, events, performing arts, travel. Interested in historical/vintage, seasonal. Accepts unsolicited stock photos related to above. Editorial stock photo needs available on Web site or via e-mail. Model/property release preferred. Photo captions required.
Specs Digital format preferred on clearly labeled CD/DVD with submission form, printed contact sheet, and image reference. See Web site for details. Press resolution is 300 dpi at 8×10. Digital materials will not be returned. Uses 35mm, 2¼×2¼, 4×5 color transparencies, which will be returned following press deadline.
Making Contact & Terms Pays $25-200 for stock photo one-time use, depending on size printed; pays on publication. Contract rates run $200-500/day for assigned editorials; pays within 60 days of receipt of invoice.

Ⓝ $ $◔ ▤ ISLANDS, The Leading Guide to Island Travel

460 N. Orlando Ave., Suite 200, Winter Park FL 32789. (407)571-4930. Fax: (407)628-7061. E-mail: loribarbely@bonniercorp.com. Web site: www.islands.com. **Contact:** Lori Barbely, photography editor. Circ. 200,000. Bimonthly. Emphasizes travel.
Needs Buys 50 photos from freelancers/issue; 400 photos/year. Needs photos of travel. Reviews photos with or without manuscript. Model/property release preferred. Detailed captions required; include name, phone, address, subject information.
Specs Prefers images in digital format. Send via CD, e-mail, Web gallery, FTP site as JPEG files at 300 dpi. Uses color 35mm, 2¼×2¼, 4×5, 8×10 transparencies.
Making Contact & Terms Send query letter with tearsheets. Provide résumé, business card, self-promo-

tion piece or tearsheets to be kept on file for possible future assignments. To show portfolio, photographer should follow up with call. Portfolio should include b&w and/or color prints, slides, tearsheets, transparencies. Keeps samples on file. Simultaneous submissions OK. Pays $600-1,000 for color cover; $100-350 for inside. Pays 30 days after publication. Credit line given. Buys one-time rights.

$ $☑ 🖾 ITALIAN AMERICA

219 E St. NE, Washington DC 20002. (202)547-2900. Fax: (202)547-0121. E-mail: kcafiero@osia.org. Web site: www.osia.org. **Contact:** Kylie Cafiero, director of communications. Circ. 65,000. Estab. 1996. Quarterly. *"Italian America* is the official publication of the Order Sons of Italy in America, the nation's oldest and largest organization of American men and women of Italian heritage. *Italian America* strives to provide timely information about OSIA, while reporting on individuals, institutions, issues and events of current or historical significance in the Italian American community." Sample copy and photo guidelines free.

Needs Buys 5-10 photos from freelancers/issue; 25 photos/year. Needs photos of travel, history, personalities; anything Italian or Italian-American. Reviews photos with or without a manuscript. Special photo needs include travel in Italy. Model release preferred. Photo captions required.

Specs Accepts images in digital format. Send via CD, e-mail as TIFF, EPS, PICT, BMP, GIF, JPEG files at 400 dpi.

Making Contact & Terms Send query letter with tearsheets. Provide résumé, business card, self-promotion piece or tearsheets to be kept on file for possible future assignments. Art director will contact photographer for portfolio review if interested. Portfolio should include color tearsheets. Responds only if interested; send nonreturnable samples. Simultaneous submissions OK. Pays $250 for b&w or color cover; $50-250 for b&w or color inside. Pays on publication. Credit line given. Buys one-time rights.

$ $🖾 JEWISH ACTION, The Magazine of the Orthodox Union

11 Broadway, 14th Floor, New York NY 10004. (212)613-8146. Fax: (212)613-0646. E-mail: ja@ou.org. Web site: www.ou.org/publications/ja. **Contact:** Nechama Carmel, editor. Circ. 20,000. Estab. 1986. Quarterly magazine with adult Orthodox Jewish readership. Sample copy available for $5 or on Web site.

Needs Buys 30 photos/year. Needs photos of Jewish lifestyle, landscapes and travel photos of Israel , and occasional photo essays of Jewish life. Reviews photos with or without a manuscript. Model/property release preferred. Photo captions required; include description of activity, where taken, when.

Specs Uses color and/or b&w prints. Accepts images in digital format. Send CD, Jaz, Zip as TIFF, GIF, JPEG files.

Making Contact & Terms Send query letter with samples, brochure or stock photo list. Keeps samples on file. Responds in 2 months. Simultaneous submissions OK. Pays $250 maximum for b&w cover; $400 maximum for color cover; $100 maximum for b&w inside; $150 maximum for color inside. Pays within 6 weeks of publication. Credit line given. Buys one-time rights.

Tips "Be aware that models must be clothed in keeping with Orthodox laws of modesty. Make sure to include identifying details. Don't send work depicting religion in general. We are specifically Orthodox Jewish."

$ $ JUNIOR SCHOLASTIC

557 Broadway, New York NY 10012. (212)343-6924. Fax: (212)343-6333. Web site: www.juniorscholastic .com. **Contact:** Richard Serviss, photo editor. Circ. 500,000. Biweekly educational school magazine. Emphasizes middle school social studies (grades 6-8): world and national news, U.S. and world history, geography, how people live around the world. Sample copy available for $1.75 with 9×12 SAE.

Needs Uses 20 photos/issue. Needs photos of young people ages 11-14; nontravel photos of life in other countries; U.S. news events. Reviews photos with accompanying manuscript only. Photo captions required.

Making Contact & Terms Arrange a personal interview to show portfolio. "Please do not send samples— only stock list or photocopies of photos. No calls, please." Simultaneous submissions OK. Pays $500-750 for color cover depending on size; $185-400 for b&w or color inside depending on size. Pays on publication. Credit line given. Buys one-time rights.

Tips Prefers to see young teenagers, in U.S. and foreign countries; especially interested in "personal interviews with teenagers worldwide with photos."

$ $◙ JUVENILE DIABETES RESEARCH FOUNDATION INTERNATIONAL

120 Wall St., New York NY 10005. (800)533-2873. Fax: (212)785-9595. E-mail: info@jdrf.org. Web site: www.jdrf.org. **Contact:** Jason Dineen. Estab. 1970. Produces 4-color, 48-page quarterly magazine to deliver research information to a lay audience.

Needs Buys 60 photos/year; offers 20 freelance assignments/year. Needs photos of babies/children/teens, families, events, food/drink, health/fitness, medicine, product shots/still life, science. Needs "mostly portraits of people, but always with some environmental aspect." Reviews stock photos. Model release preferred. Photo captions preferred.

Specs Uses $2\frac{1}{4} \times 2\frac{1}{4}$ transparencies. Accepts images in digital format. Send via CD, Zip as TIFF, EPS, JPEG files at 300 dpi.

Making Contact & Terms Send query letter with samples. Provide résumé, business card, brochure, flier or tearsheets to be kept on file for possible future assignments. Cannot return material. Responds as needed. Pays $500 for color photos; $500-700 per day. Also pays by the job—payment "depends on how many days, shots, cities, etc." Credit line given. Buys nonexclusive perpetual rights.

Tips Looks for "a style consistent with commercial magazine photography—upbeat, warm, personal, but with a sophisticated edge. Call and ask for samples of our publications before submitting any of your own samples so you will have an idea of what we are looking for in photography. Nonprofit groups have seemingly come to depend more and more on photography to get their messages across. The business seems to be using a variety of freelancers, as opposed to a single in-house photographer."

$ $◙ KANSAS!

1000 SW Jackson St., Suite 100, Topeka KS 66612-1354. (785)296-3479. Fax: (785)296-6988. Web site: www.kansmag.com. **Contact:** Cara Sloan, editor. Circ. 40,000. Estab. 1945. Quarterly magazine published by the Travel & Tourism Development Division of the Kansas Department of Commerce. Emphasizes Kansas travel, scenery, arts, recreation and people. Photo guidelines available on Web site.

Needs Buys 60-80 photos from freelancers/year. Subjects include animal, human interest, nature, seasonal, rural, scenic, sport, travel, wildlife, photo essay/photo feature, all from Kansas. No b&w, nudes, still life or fashion photos. Reviews photos with or without a manuscript. Model/property release preferred. Photo captions required; include subject and specific location.

Specs Uses 35mm, $2\frac{1}{4} \times 2\frac{1}{4}$ or 4×5 transparencies.

Making Contact & Terms Send material by mail for consideration. Previously published work OK. **Pays on acceptance.** Credit line given. Buys one-time or limited universal rights.

Tips Kansas-oriented material only. Prefers Kansas photographers. "Follow guidelines, submission dates specifically. Shoot a lot of seasonal scenics."

$◙ KASHRUS MAGAZINE, The Guide for the Kosher Consumer

P.O. Box 204, Parkville Station, Brooklyn NY 11204. (718)336-8544. Web site: www.kashrusmagazine.com. **Contact:** Rabbi Yosef Wikler, editor. Circ. 10,000. Bimonthly. Emphasizes kosher food and food technology, travel (Israel-desirable), catering, weddings, remodeling, humor. Readers are kosher food consumers, vegetarians and food producers. Sample copy available for $2.

Needs Buys 3-5 photos from freelancers/issue; 18-30 photos/year. Needs photos of babies/children/teens, environmental, landscapes, interiors, Jewish, rural, food/drink, humor, travel, product shots, technology/computers. Interested in seasonal, nature photos and Jewish holidays. Model release preferred. Photo captions preferred.

Specs Uses $2\frac{1}{4} \times 2\frac{1}{4}$, $3\frac{1}{2} \times 3\frac{1}{2}$ or $7\frac{1}{2} \times 7\frac{1}{2}$ matte b&w and color prints.

Making Contact & Terms Send unsolicited photos by mail with SASE for consideration. Provide business card, brochure, flier or tearsheets to be kept on file for possible future assignments. Responds in 1 week. Simultaneous submissions and previously published work OK. Pays $40-75 for b&w cover; $50-100 for color cover; $25-50 for b&w inside; $75-200/job; $50-200 for text for photo package. Pays part on acceptance, part on publication. Buys one-time rights, first North American serial rights, all rights; negotiable.

Tips "Seriously in need of new photo sources, but *call first* to see if your work is appropriate before submitting samples."

$□ ◙ KENTUCKY MONTHLY

213 St. Clair St., P.O. Box 559, Frankfort KY 40601-0559. (502)227-0053. Fax: (502)227-5009. E-mail: steve@kentuckymonthly.com. Web site: www.kentuckymonthly.com. **Contact:** Stephen Vest, editor.

Circ. 40,000. Estab. 1998. Monthly magazine focusing on Kentucky and/or Kentucky-related stories. Sample copy available for $3.

Needs Buys 10 photos from freelancers/issue; 120 photos/year. Needs photos of celebrities, wildlife, entertainment, landscapes. Reviews photos with or without a manuscript. Model release required. Photo captions preferred.

Specs Uses glossy prints; 35mm transparencies. Accepts images in digital format. Send via CD, e-mail at 300 dpi.

Making Contact & Terms Send query letter. Provide self-promotion piece to be kept on file for possible future assignments. Responds in 1 month. Simultaneous submissions OK. Pays $25 minimum for inside photos. Pays the 15th of the following month. Credit line given. Buys one-time rights.

$ $ ◙ ▣ KNOWATLANTA, The Premier Relocation Guide

New South Publishing, 1303 Hightower Trail, Suite 101, Atlanta GA 30350. (770)650-1102. Fax: (770)650-2848. E-mail: editor1@knowatlanta.com. Web site: www.knowatlanta.com. **Contact:** Judy Putnam, editor-in-chief. Circ. 48,000. Estab. 1986. Quarterly magazine serving as a relocation guide to the Atlanta metro area with a corporate audience. Photography reflects regional and local material as well as corporate-style imagery.

Needs Buys more than 10 photos from freelancers/issue; more than 40 photos/year. Needs photos of cities/urban, events, performing arts, business concepts, medicine, technology/computers. Reviews photos with or without a manuscript. Model release required; property release preferred. Photo captions preferred.

Specs Uses 8×10 glossy color prints; 35mm, 2¼×2¼ transparencies. Accepts images in digital format. Send via CD, Zip, e-mail as TIFF, EPS, JPEG files at 300 dpi.

Making Contact & Terms Send query letter with photocopies. Provide résumé, business card, self-promotion piece to be kept on file for possible future assignments. Responds only if interested; send nonreturnable samples. Pays $600 maximum for color cover; $300 maximum for color inside. Pays on publication. Credit line given. Buys first rights.

Tips "Think like our readers. What would they want to know about or see in this magazine? Try to represent the relocated person if using subjects in photography."

$ ◙ ▣ LAKE COUNTRY JOURNAL

Evergreen Press, P.O. Box 465, Brainerd MN 56401. (218)828-6424. Fax: (218)825-7816. E-mail: andrea@lakecountryjournal.com. Web site: www.lakecountryjournal.com. **Contact:** Andrea Baumann, art director. Estab. 1996. Bimonthly regional consumer magazine focused on north-central area of Minnesota. Sample copy and photo guidelines available for $5 and 9×12 SAE.

Needs Buys 35 photos from freelancers/issue; 210 photos/year. Needs photos of babies/children/teens, couples, multicultural, families, senior citizens, environmental, landscapes, wildlife, architecture, gardening, decorating, rural, entertainment, events, food/drink, health/fitness/beauty, hobbies, humor, sports, agriculture, medicine. Interested in documentary, fine art, historical/vintage, seasonal; Minnesota outdoors. Reviews photos with or without a manuscript. Model release preferred. Photo captions preferred; include who, where, when.

Specs Prefers images in digital format. Send via CD, DVD as TIFF, EPS files at 300 dpi. Also uses 35mm, 2¼×2¼, 4×5, 8×10 transparencies.

Making Contact & Terms Send query letter with résumé, slides, prints, tearsheets, transparencies, stock list. Provide résumé, business card or self-promotion piece to be kept on file for possible future assignments. Responds in 3 weeks to queries. Previously published work OK. Pays $180 for cover; $35-150 for inside. Pays on publication. Credit line given. Buys one-time rights; negotiable.

$ ◙ ▣ LAKE SUPERIOR MAGAZINE

Lake Superior Port Cities, Inc., P.O. Box 16417, Duluth MN 55816-0417. (218)722-5002. Fax: (218)722-4096. E-mail: edit@lakesuperior.com. Web site: www.lakesuperior.com. **Contact:** Konnie LeMay, editor. Circ. 20,000. Estab. 1979. Bimonthly magazine. "Beautiful picture magazine about Lake Superior." Readers are male and female, ages 35-55, highly educated, upper-middle and upper-management level through working. Sample copy available for $3.95 with 9×12 SAE and 5 first-class stamps. Photo guidelines free with SASE or via Web site.

Needs Buys 21 photos from freelancers/issue; 126 photos/year. Also buys photos for calendars and

books. Needs photos of landscapes/scenics, travel, wildlife, personalities, boats, underwater—all Lake Superior-related. Photo captions preferred.

Specs Uses 5×7, 8×10 glossy b&w and color-corrected prints; 35mm, 2¼×2¼, 4×5, 8×10 transparencies. Accepts images in digital format. Send via CD with at least thumbnails on a printout.

Making Contact & Terms Send unsolicited photos by mail with SASE for consideration. Provide résumé, business card, brochure, flier or tearsheets to be kept on file for possible future assignments. Responds in 2 months. Simultaneous submissions OK. Pays $150 for color cover; $50 for b&w or color inside. Pays on publication. Credit line given. Buys first North American serial rights; reserves second rights for future use.

Tips "Be aware of the focus of our publication—Lake Superior. Photo features concern only that. Features with text can be related. We are known for our fine color photography and reproduction. It has to be 'tops.' We try to use images large; therefore, detail quality and resolution must be good. We look for unique outlook on subject, not just snapshots. Must communicate emotionally. Some photographers send material we can keep in-house and refer to, and these will often get used."

⦑N⦒ $⬚ ▣ LAKESTYLE: celebrating life on the water

Bayside Publications, Inc., Lakestyle Submissions, P.O. Box 170, Excelsior MN 55331. (888)774-7060. Fax: (952)470-1389. E-mail: editor@lakestyle.com. Web site: www.lakestyle.com. **Contact:** Tom Henke, publisher. Circ. 30,000. Estab. 1999. Quarterly magazine for lake home and cabin owners who seek to celebrate life on the water. Sample copy available for $5.

Needs Buys 5-10 photos from freelancers/issue; 50 photos/year. Needs photos of landscapes/scenics, wildlife, architecture, gardening, interiors/decorating, adventure, entertainment, hobbies, sports, travel—anything that connotes the lake lifestyle. Reviews photos with or without a manuscript. Model/property release required. Photo captions preferred.

Specs Any traditional formats are OK. Prefers digital. Send via CD, Zip, e-mail as TIFF, JPEG files at 300 dpi.

Making Contact & Terms Send query letter. Does not keep samples on file; cannot return material. Responds only if interested; send nonreturnable samples. Simultaneous submissions and previously published work OK. Pays $250 minimum for color cover; $25 minimum for color inside. Pays on publication. Credit line given. Buys all rights; negotiable.

Tips "*Lakestyle* is published for an upscale audience. We do not publish 'folksy' artwork. We prefer photos that clearly support our mission of 'celebrating life on the water.' "

$ $⬚ ▣ ▣ THE LION

Lions Clubs International, 300 W. 22nd St., Oak Brook IL 60523-8842. (630)571-5466. Fax: (630)571-1685. E-mail: jay.copp@lionsclubs.org. Web site: www.lionsclubs.org. **Contact:** Jay Copp, senior editor. Circ. 490,000. Estab. 1918. Monthly magazine for members of the Lions Club and their families. Emphasizes Lions Club activities and membership. Sample copy and photo guidelines free.

Needs Uses 50-60 photos/issue. Needs photos of Lions Club service or fundraising projects. "All photos must be as candid as possible, showing an activity in progress. Please, no award presentations, meetings, speeches, etc. Generally, photos are purchased with manuscript (300-1,500 words) and used as a photo story. We seldom purchase photos separately." Model release preferred for young or disabled children. Photo captions required.

Specs Uses 5×7, 8×10 glossy color prints; 35mm transparencies; also accepts digital images via e-mail at 300 dpi or larger.

Making Contact & Terms Works with freelancers on assignment only. Provide résumé to be kept on file for possible future assignments. Query first with résumé of credits or story idea. Pays $150-600 for text/photo package. "Must accompany story on the service or fundraising project of the The Lions Club." **Pays on acceptance**. Buys all rights; negotiable.

Tips "Query on specific project and photos to accompany manuscript."

$ $ $ $⬚ LOG HOME LIVING

4125 Lafayette Center Dr., Suite 100, Chantilly VA 20151. (703)222-9411. Fax: (703)222-3209. E-mail: emann@homebuyerpubs.com. Web site: www.loghomeliving.com. **Contact:** Edie Mann, art director. Circ. 120,000. Estab. 1989. Monthly magazine. Emphasizes planning, building and buying a log home. Sample copy available for $4. Photo guidelines available on Web site.

Needs Buys 90 photos from freelancers/issue; 120 photos/year. Needs photos of homes—living room,

dining room, kitchen, bedroom, bathroom, exterior, portrait of owners, design/decor—tile sunrooms, furniture, fireplaces, lighting, porch and deck, doors. Close-up shots of details (roof trusses, log stairs, railings, dormers, porches, window/door treatments) are appreciated. Model release required.

Specs Prefers to use digital images or 4×5 color transparencies/Kodachrome or Ektachrome color slides; smaller color transparencies and 35mm color prints also acceptable.

Making Contact & Terms Send unsolicited photos by mail for consideration. Keeps samples on file. Responds only if interested. Previously published work OK. Pays $2,000 maximum for color feature. Cover shot submissions also accepted; fee varies, negotiable. **Pays on acceptance.** Credit line given. Buys first World-one-time stock serial rights; negotiable.

Tips "Send photos of log homes, both interiors and exteriors."

$ $⊡ LOYOLA MAGAZINE

820 N. Michigan, 14th Floor, Chicago IL 60611. (312)915-6930. Fax: (312)915-6185. Web site: www.luc. edu/loyolamagazine. **Contact:** Anastasia Busiek, editor. Circ. 120,000. Estab. 1971. Loyola University Alumni magazine. Quarterly magazine emphasizing issues related to Loyola University Chicago. Readers are Loyola University Chicago alumni—professionals, ages 22 and up. Sample copy available for 9×12 SAE and 3 first-class stamps.

Needs Buys 20 photos from freelancers/issue; 60 photos/year. Needs Loyola-related or Loyola alumni-related photos only. Model release preferred. Photo captions preferred.

Specs Uses 8×10 b&w and/or color prints; 35mm, $2^{1}/_{4} \times 2^{1}/_{4}$ transparencies. Accepts high-resolution digital images. Query before submitting.

Making Contact & Terms Best to query by mail before making any submissions. If interested, will ask for résumé, business card, brochure, flier or tearsheets to be kept on file for possible future assignments. Responds in 3 months. Simultaneous submissions and previously published work OK. Pays $250/assignment; $400 half-day rate; $800-full day rate. **Pays on acceptance.** Credit line given.

Tips "Send us information, but don't call."

$LUTHERAN FORUM

P.O. Box 327, Delhi NY 13753. (607)746-7511. Web site: www.alpb.org. **Contact:** Paul Saner, editor. Circ. 3,500. Quarterly magazine. Emphasizes "Lutheran concerns, both within the church and in relation to the wider society, for the leadership of Lutheran churches in North America."

Needs Uses cover photos occasionally. "While subject matter varies, we are generally looking for photos that include people, and that have a symbolic dimension. We use *few* purely 'scenic' photos. Photos of religious activities, such as worship, are often useful, but should not be 'cliches'—types of photos that are seen again and again." Photo captions "may be helpful."

Making Contact & Terms Send query letter with list of stock photo subjects. Responds in 2 months. Simultaneous submissions and previously published work OK. Pays $15-25 for b&w photos. Pays on publication. Credit line given. Buys one-time rights.

Ⓝ $ $⊘ ⊡ THE LUTHERAN

8765 W. Higgins Rd., Chicago IL 60631. (773)380-2540. Fax: (773)380-2751. E-mail: michael.watson@the lutheran.org. Web site: www.thelutheran.org. **Contact:** Michael Watson, art director. Circ. 300,000. Estab. 1988. Monthly publication of Evangelical Lutheran Church in America.

Needs Buys 10-15 photos from freelancers/issue; 120-180 photos/year. Needs current news, mood shots. Subjects include babies/children/teens, couples, multicultural, families, parents, senior citizens, disasters, landscapes/scenics, cities/urban, education, religious. Interested in fine art, seasonal. "We usually assign work with exception of 'Reflections' section." Model release required. Photo captions preferred.

Specs Accepts images in digital format. Send via CD or e-mail as TIFF or JPEG files at 300 dpi.

Making Contact & Terms Send query letter with list of stock photo subjects. Provide résumé, brochure, flier or tearsheets to be kept on file for possible future assignments. Pays $300-500 for color cover; $175-300 for color inside; $300 for half day; $600 for full day. Pays on publication. Credit line given. Buys one-time rights.

Tips Trend toward "more dramatic lighting; careful composition." In portfolio or samples, wants to see "candid shots of people active in church life, preferably Lutheran. Church-only photos have little chance of publication. Submit sharp, well-composed photos with borders for cropping. Send printed or duplicate samples to be kept on file; no originals. If we like your style, we will call you when we have a job in your area."

◼ THE MAGAZINE ANTIQUES

575 Broadway, New York NY 10012. (212)941-2800. Fax: (212)941-2819. Web site: www.themagazineant iques.com. **Contact:** Allison E. Ledes, editor. Circ. 60,000. Estab. 1922. Monthly magazine. Emphasizes art, antiques, architecture. Readers are male and female collectors, curators, academics, interior design ers, ages 40-70. Sample copy available for $10.50.

Needs Buys 24-48 photos from freelancers/issue; 288-576 photos/year. Needs photos of interiors, archi tectural exteriors, objects. Reviews photos with or without a manuscript.

Specs Uses 8×10 glossy prints; 4×5 transparencies; JPEGs at 300 dpi.

Making Contact & Terms Submit portfolio for review; phone ahead to arrange drop-off. Does not keep samples on file; include SASE for return of material. Responds in 6 weeks. Previously published work OK. Payment negotiable. Pays on publication. Credit line given. Buys one-time rights; negotiable.

$ $ $◼ MARLIN: The International Sportfishing Magazine

Bonnier Corporation, 460 N. Orlando Ave., Suite 200, Winter Park FL 32789. (407)628-4802. Fax: (407)628-7061. E-mail: dave.ferrell@bonniercorp.com. Web site: www.marlinmag.com. **Contact:** David Ferrell, editor. Circ. 45,000 (paid). Estab. 1981. Published 8 times/year. Emphasizes offshore big game fishing for billfish, tuna and other large pelagics. Readers are 94% male, 75% married, average age 43, very affluent businessmen. Sample copy free with 8×10 SASE. Photo guidelines free with SASE or on Web site.

Needs Buys 45 photos from freelancers/issue; 270 photos/year. Needs photos of fish/action shots, scenics and how-to. Special photo needs include big game fishing action and scenics (marinas, landmarks, etc.). Model release preferred. Photo captions preferred.

Specs Uses 35mm transparencies. Also accepts high-resolution images on CD or via FTP.

Making Contact & Terms Contract required. Send unsolicited photos by mail with SASE for consideration. Responds in 1 month. Simultaneous submissions OK with notification. Pays $1,200 for color cover; $100-300 for color inside. Pays on publication. Buys first North American rights.

Tips "Send sample material with SASE. No phone call necessary."

$ $◻ ◼ METROSOURCE MAGAZINE

Metrosource Publishing, 180 Varick St., #504, New York NY 10014. (212)691-5127. Fax: (212)741-2978. E-mail: sburke@metrosource.com. Web site: www.metrosource.com. **Contact:** Sara Burke, art director. Circ. 125,000. Estab. 1990. Upscale, gay men's luxury lifestyle magazine published 6 times/year. Empha sizes fashion, travel, profiles, interiors, film, art. Sample copies free.

Needs Buys 10-15 photos from freelancers/issue; 50 photos/year. Needs photos of celebrities, architec ture, interiors/decorating, adventure, food/drink, health/fitness, travel, product shots/still life. Interested in erotic, fashion/glamour, seasonal. Also needs still life drink shots for spirits section. Reviews photos with or without a manuscript. Model/property release preferred. Photo captions preferred.

Specs Uses 8×10 glossy or matte color and/or b&w prints; $2^1/_4 \times 2^1/_4$, 4×5 transparencies. Prefers images in digital format. Send via CD, Zip, e-mail as TIFF, EPS, JPEG files at 300 dpi.

Making Contact & Terms Send query letter with self-promo cards. "Please call first for portfolio drop-off." Provide self-promotion piece to be kept on file for possible future assignments. Responds only if interested; send nonreturnable samples. Simultaneous submissions and previously published work OK. Pays $500-800 for cover; $0-300 for inside. Pays on publication. Credit line given. Buys one-time rights.

Tips "We work with creative established and newly-established photographers. Our budgets vary depend ing on the importance of story. Have an e-mail address on card so we can see more photos or whole portfolio online."

◼ ◻ ◼ MGW NEWSMAGAZINE

Guess What Media, LLC, 1123 21st St., Suite 200, Sacramento CA 95814. (916)441-6397. Fax: (916)441-6422. E-mail: editor@mgwnews.com. Web site: www.mgwnews.com. **Contact:** Jeffry Davis, publisher. Circ. 21,000. Estab. 1978. Monthly magazine. Emphasizes gay/lesbian issues, including news, politics, entertainment, etc. Readers are gay and straight people. Sample copy available for $1. Photo guidelines free with SASE.

Needs Buys 8-10 photos from freelancers/issue; 416-520 photos/year. Photo subjects include events, personalities, culture, entertainment, fashion, food, travel. Model release required. Photo captions re quired.

Specs Accepts images in digital format. Send via CD, e-mail preferred as TIFF, EPS, JPEG, PDF files at 300 dpi.

Making Contact & Terms Arrange a personal interview to show portfolio. Send 8×10 glossy color or b&w prints by mail for consideration; include SASE for return of material. Previously published work OK. ''Currently only using volunteer/pro bono freelance photographers but will consider all serious inquiries from local professionals.'' Credit line given.

Tips In portfolios, prefers to see gay/lesbian-related stories, human/civil rights, some ''artsy'' photos; *no* nudes or sexually explicit photos. ''E-mail is always the best way to contact us.'' Uses photographers as interns (contact editor for details).

$☑ Ⓐ ▦ MINNESOTA GOLFER

Minnesota Golf Association, 6550 York Ave. S., Suite 211, Edina MN 55435. (952)927-4643. Fax: (952)927-9642. E-mail: editor@mngolf.org. Web site: www.mngolf.org. **Contact:** W.P. Ryan, editor. Circ. 60,000. Estab. 1970. Bimonthly association magazine covering Minnesota golf scene. Sample copies available.

Needs Works on assignment only. Buys 25 photos from freelancers/issue; 150 photos/year. Needs photos of golf, golfers, and golf courses only. Will accept exceptional photography that tells a story or takes specific point of view. Reviews photos with or without manuscript. Model/property release required. Photo captions required; include date, location, names and hometowns of all subjects.

Specs Accepts images in digital format. Send via DVD or CD, e-mail as TIFF files.

Making Contact & Terms Send query letter with digital medium. Portfolios may be dropped off every Monday. Provide business card or self-promotion piece to be kept on file for possible future assignments. Responds only if interested; send nonreturnable samples. Pays on publication. Credit line given. Buys one-time rights. Will negotiate one-time or all rights, depending on needs of the magazine and the MGA.

Tips ''We use beautiful golf course photography to promote the game and Minnesota courses to our readers. We expect all submissions to be technically correct in terms of lighting, exposure and color. We are interested in photos that portray the game and golf courses in new, unexpected ways. For assignments, submit work with invoice and all expenses. For unsolicited work, please include contact, fee, and rights terms submitted with photos; include captions where necessary. Artist agreement available upon request.''

$◻ ▦ MISSOURI LIFE

Missouri Life, Inc., 515 E. Morgan St., Boonville MO 65233. (660)882-98989. Fax: (660)882-9899. E-mail: info@missourilife.com. Web site: www.missourilife.com. **Contact:** Shea Bryant, art dirtcor. Circ. 20,000. Estab. 1973. Bimonthly consumer magazine. ''*Missouri Life* celebrates Missouri people and places, past and present, and the unique qualities of our great state with interesting stories and bold, colorful photography.'' Sample copy available for $4.50 and SASE with $2.44 first-class postage. Photo guidelines available on Web site.

Needs Buys 80 photos from freelancers/issue; more than 500 photos/year. Needs photos of environmental, seasonal, landscapes/scenics, wildlife, architecture, cities/urban, rural, adventure, historical sites, entertainment, events, hobbies, performing arts, travel. Reviews photos with or without manuscript. Model/property release required. Photo captions required; include location, names and detailed identification (including any title and hometown) of subjects.

Specs Prefers images in high-res digital format (minimum 300 ppi at 8×10). Send via e-mail, CD, Zip as EPS, JPEG, TIFF files.

Making Contact & Terms Send query letter with résumé, stock list. Provide self-promotion piece to be kept on file for possible future assignments. Responds in 1 month. Pays $100-150 for color cover; $50 for color inside. Pays on publication. Credit line given. Buys first rights, nonexclusive rights, limited rights.

Tips ''Be familiar with our magazine and the state of Missouri. Provide well-labeled images with detailed caption and credit information.''

$▦ MONTANA MAGAZINE

P.O. Box 5630, Helena MT 59604. (406)444-5110. Fax: (406)443-5480. E-mail: photos@montanamagazine.com (queries only). Web site: www.montanamagazine.com. **Contact:** Mary Alice Chester, photo librarian. Circ. 120,000. Bimonthly consumer magazine. Subscribers include lifelong residents, first-time visitors, and ''wanna-be'' Montanans from around the nation and the world. Publishes articles on Montana recreation, contemporary issues, people, natural history, cities, small towns, humor, wildlife, real-life

adventure, nostalgia, geography, history, byways and infrequently explored countryside, made-in-Montana products, local businesses and environment. Photo guidelines available for SASE or on Web site.

Needs Buys majority of photos from freelancers. Needs photos of wildlife, cities/urban. Interested in seasonal; community scenes, scenic panoramas and intimate close-ups that showcase Montana; humorous or nostalgic images for ''Glimpses'' page. Subject matter is limited to Montana and Yellowstone National Park. Model/property release preferred. Photo captions required.

Specs Uses transparencies and high-resolution digital files.

Making Contact & Terms Send query letter with slides. Does not keep samples on file; include SASE for return of material. Pays $250 maximum for color cover. Pays $50-175 for color inside. Credit line given. Buys one-time rights.

Tips ''Editorial calendar available on request with SASE.''

◻ Ⓢ ▣ ⊕ MOTORING & LEISURE

CSMA, Britannia House, 21 Station St., Brighton BN1 4DE United Kingdom. (44)(127)374-4757. Fax: (44)(127)374-4761. E-mail: sarah.harvey@csma.uk.com. Web site: www.csma.uk.com. **Contact:** Sarah Harvey, picture editor and researcher. Circ. 300,000. In-house magazine of csma (Civil Service Motoring Association); 144 pages printed 10 times/year (double issue July/August and November/December). Covers car reviews, worldwide travel features, lifestyle and leisure, gardening. Sample copy available.

Needs Needs innovative photos of cars and motorbikes, old and new, to give greater choice than usual stock shots; motoring components (tires, steering wheels, windscreens); car manufacturer logos; UK traffic signs, road markings, general traffic, minor roads and motorways; worldwide travel images; UK villages, towns and cities; families on UK outdoor holidays; caravans, motor homes, camping, picnics sites. Reviews photos with or without manuscript. Photo captions preferred; include location.

Specs Prefers images in digital format. Send JPEG files via e-mail at 300 dpi where possible or 72 dpi at the largest possible image size. Maximum limit per e-mail is 8MB so may need to send images in separate e-mails or compress byte size in Photoshop. Most file formats (EPS, TIFF, PDF, PSD) accepted for PC use. Unable to open Mac files. TIFFs and very large files should be sent on a CD.

Making Contact & Terms Prefers to be contacted via e-mail. Simultaneous submissions and previously published work OK. Payment negotiated with individual photographers and image libraries. Credit line sometimes given if asked. Buys one-time rights.

$ $▣ MOUNTAIN LIVING

1777 S. Harrison St., Suite 1200, Denver CO 80210. (303)248-2052. Fax: (303)248-2064. E-mail: lshowell@ mountainliving.com. Web site: www.mountainliving.com. **Contact:** Loneta Showell, art director. Circ. 45,000. Estab. 1994. Bimonthly magazine. Emphasizes shelter, lifestyle.

Needs Buys 10 photos from freelancers/issue; 120 photos/year. Needs photos of home interiors, architecture. Reviews photos with accompanying manuscript only. Model/property release required. Photo captions preferred.

Specs Prefers images in digital format. Send via CD as TIFF files at 300 dpi. Also uses 35mm, $2\frac{1}{4} \times 2\frac{1}{4}$, 4×5 transparencies.

Making Contact & Terms Submit portfolio for review. Send query letter with stock list. Provide résumé, business card, brochure, flier or tearsheets to be kept on file for possible future assignments. Responds in 6 weeks. Pays $500-600/day; $0-600 for color inside. **Pays on acceptance.** Credit line given. Buys one-time and first North American serial rights as well as rights to use photos on the *Mountain Living* Web site and in promotional materials; negotiable.

$ $◪ ▧ MUSCLEMAG INTERNATIONAL

Canusa Group, 5775 McLaughlin Rd., Mississauga ON L5R 3P7 Canada. (888)254-0767. E-mail: rramsay@ emusclemag.com. Web site: www.emusclemag.com. **Contact:** Art Director. Circ. 300,000. Estab. 1974. Monthly magazine. Emphasizes hardcore bodybuilding for men and women. Sample copy available for $6.

Needs Buys 3,000 photos/year; 50% assigned; 50% stock. Needs celebrity/personality, fashion/beauty, glamour, swimsuit, how-to, human interest, humorous, special effects/experimental and spot news. ''We require action exercise photos of bodybuilders and fitness enthusiasts training with sweat and strain.'' Wants on a regular basis ''different'' pics of top names, bodybuilders or film stars famous for their physiques (i.e., Schwarzenegger, The Hulk, etc.). No photos of mediocre bodybuilders. ''They have to

be among the top 100 in the world or top film stars exercising.'' Photos purchased with accompanying manuscript. Photo captions preferred.

Specs Uses 8×10 glossy b&w prints; 35mm, 2¼×2¼ or 4×5 transparencies; high-resolution digital thumbnails; vertical format preferred for cover.

Making Contact & Terms Send material by mail for consideration; send $3 for return postage. Send query letter with contact sheet. Responds in 1 month. Pays $20-50/b&w photo; $25-500/color photo; $500-1,000/cover photo. Pays on publication. Credit line given. Buys all rights.

Tips ''We would like to see photographers take up the challenge of making exercise photos look like exercise motion. In samples we want to see sharp, color-balanced, attractive subjects, no grain, artistic eye. Someone who can glamorize bodybuilding on film. To break in get serious: read, ask questions, learn, experiment and try, try again. Keep trying for improvement—don't kid yourself that you are a good photographer when you don't even understand half the attachments on your camera. Immerse yourself in photography. Study the best; study how they use light, props, backgrounds, angles. Current biggest demand is for swimsuit-type photos of fitness men and women (splashing in waves, playing/ posing in sand, etc.). Shots must be sexually attractive.''

$ ⬛ Ⓢ ▣ MUSHING: The Magazine of Dog-Powered Adventure

3875 Geist Rd., Suite E #246, Fairbanks AK 99709. (917)929-6118. E-mail: editor@mushing.com. Web site: www.mushing.com. **Contact:** Amanda Byrd, managing editor. Circ. 6,000. Estab. 1987. Bimonthly magazine. Readers are dog drivers, mushing enthusiasts, dog lovers, outdoor specialists, innovators, and sled dog history lovers. Sample copy available for $5 in U.S. Photo guidelines free with SASE or on Web site.

Needs Uses 50 photos/issue; most supplied by freelancers. Needs action photos: all-season and wilderness; still and close-up photos: specific focus (sledding, carting, dog care, equipment, etc). Special photo needs include skijoring, feeding, caring for dogs, summer carting or packing, 1- to 3 -dog-sledding, and kids mushing. Model release preferred. Photo captions preferred.

Specs Accepts images in digital format. Send via CD, Zip, e-mail as JPEG files at 300 dpi.

Making Contact & Terms Send unsolicited photos by mail for consideration. Responds in 6 months. Pays $175 maximum for color cover; $15-40 for b&w inside; $40-50 for color inside. Pays $10 extra for 1 year of electronic use rights on the Web. Pays within 60 days after publication. Credit line given. Buys first serial rights and second reprint rights.

Tips Wants to see work that shows ''the total mushing adventure/lifestyle from environment to dog house.'' To break in, one's work must show ''simplicity, balance and harmony. Strive for unique, provocative shots that lure readers and publishers. Send 10-40 images for review. Allow for 2-6 months' review time for at least a screened selection of these.''

$ ⬛ Ⓢ ▣ MUZZLE BLASTS

P.O. Box 67, Friendship IN 47021. (812)667-5131. Fax: (812)667-5137. E-mail: mblastdop@seidata.com. Web site: www.nmlra.org. **Contact:** Terri Trowbridge, director of publications. Circ. 20,000. Estab. 1939. Publication of the National Muzzle Loading Rifle Association. Monthly magazine emphasizing muzzle-loading. Sample copy free. Photo guidelines free with SASE.

Needs Interested in muzzleloading, muzzleloading hunting, primitive camping. ''Ours is a specialized association magazine. We buy some big-game wildlife photos but are more interested in photos featuring muzzleloaders, hunting, powder horns and accoutrements.'' Model/property release required. Photo captions preferred.

Specs Prefers to use 3×5 color transparencies; sharply contrasting 35mm color slides acceptable. Accepts images in digital format. Send via CD, floppy disk, Zip as TIFF, EPS files at 300 dpi.

Making Contact & Terms Send query letter with stock list. Keeps samples on file; include SASE for return of material. Responds in 2 weeks. Simultaneous submissions OK. Pays $300 for color cover; $25-50 for b&w inside. Pays on publication. Credit line given. Buys one-time rights.

$ ◨ ▣ NA'AMAT WOMAN

350 Fifth Ave., Suite 4700, New York NY 10118. (212)563-5222. Fax: (212)563-5710. E-mail: judith@naa mat.org. Web site: www.naamat.org. **Contact:** Judith A. Sokoloff, editor. Circ. 20,000. Estab. 1926. Quarterly organization magazine focusing on issues of concern to contemporary Jewish families and women. Sample copy free with SAE and $1.35 first-class postage.

Needs Buys 5-10 photos from freelancers/issue; 50 photos/year. Needs photos of Jewish themes, Israel,

women, babies/children/teens, families, parents, senior citizens, landscapes/scenics, architecture, religious, travel. Interested in documentary, fine art, historical/vintage, seasonal. Reviews photos with or without manuscript. Photo captions preferred.

Specs Uses color and/or b&w prints. "Can use color prints, but magazine is black & white except for cover." Accepts images in digital format. Contact editor before sending.

Making Contact & Terms Provide résumé, business card, self-promotion piece or tearsheets to be kept on file for possible future assignments. Art director will contact photographer for portfolio review if interested. Keeps samples on file; include SASE for return of material. Responds in 6 weeks. Pays $250 maximum for b&w cover; $35-75 for b&w inside. Pays on publication. Credit line given. Buys one-time, first rights.

⊘ ⬛ NATIONAL GEOGRAPHIC

National Geographic Society, 1145 17th St. NW, Washington DC 20036. Web site: www.nationalgeograph ic.com. **Contact:** Susan Smith, deputy director of photography. Director of Photography: David Griffin. Circ. 7 million. Monthly publication of the National Geographic Society.

- This is a premiere market that demands photographic excellence. *National Geographic* does not accept unsolicited work from freelance photographers. Photography internships and faculty fellowships are available. Contact Susan Smith, deputy director of photography, for application information.

$ $⊘ ⑤ NATIONAL PARKS MAGAZINE

National Parks Conservation Association, 1300 19th St. NW, Suite 300, Washington DC 20036. (800)628-7275. E-mail: nyin@npca.org. Web site: www.npca.org/magazine. **Contact:** Nicole Yin, communications coordinator. Circ. 300,000. Estab. 1919. Quarterly magazine. Emphasizes the preservation of national parks and wildlife. Sample copy available for $3 and 8½×11 or larger SASE. Photo guidelines available on Web site.

Making Contact & Terms "We are not currently accepting unsolicited photographs from freelancers. We only accept images from our established corps of photographers. Less than 1 percent of our image needs are generated from unsolicited photographs, yet we receive dozens of submissions every week. Our limited staffing and even more limited time make it incredibly difficult to keep up with the inflow of images. Hopefully, as we continue to grow, we will eventually be able to lift this moratorium. Photographers are welcome to send postcards or other simple promotional materials that we do not have to return or respond to." Pays within 30 days after publication. Buys one-time rights.

Tips "When searching for photos, we frequently use www.AGPix.com to find photographers who fit our needs. If you're interested in breaking into the magazine, we suggest setting up a profile and posting your absolute best parks images there."

$⊘ ⬛ NATIVE PEOPLES MAGAZINE

5333 N. Seventh St., Suite C-224, Phoenix AZ 85014. (602)265-4855. Fax: (602)265-3113. E-mail: hwallace @nativepeoples.com. Web site: www.nativepeoples.com. **Contact:** Hilary Wallace, art director. Circ. 50,000. Estab. 1987. Bimonthly magazine. "Dedicated to the sensitive portrayal of the arts and lifeways of the Native peoples of the Americas." Photo guidelines free with SASE or on Web site.

Needs Buys 20-50 photos from freelancers/issue; 120-300 photos/year. Needs Native American lifeways photos (babies/children/teens, celebrities, couples, multicultural, families, parents, senior citizens, events). Also uses photos of entertainment, performing arts, travel. Interested in fine art. Model/property release preferred. Photo captions preferred; include names, location and circumstances.

Specs Uses transparencies, all formats. Accepts images in digital format. Send via CD, Zip, e-mail as TIFF, JPEG, EPS files at 300 dpi.

Making Contact & Terms Submit portfolio for review. Send unsolicited photos by mail for consideration; include SASE for return of material. Responds in 1 month. Pays $250 for color cover; $45-150 for color or b&w inside. Pays on publication. Buys one-time rights.

Tips "Send samples, or, if in the area, arrange a visit with the editors."

$ $⬛ NATURAL HISTORY MAGAZINE

36 W. 25th St., 5th Floor, New York NY 10010. (646)356-6500. Fax: (646)356-6511. E-mail: nhmag@nhma g.com. Web site: www.nhmag.com. **Contact:** Steve Black, art director. Circ. 250,000. Magazine printed 10 times/year. Readers are primarily well-educated people with interests in the sciences. Free photo guidelines.

Needs Buys 400-450 photos/year. Subjects include animal behavior, photo essay, documentary, plant and landscape. "We are interested in photo essays that give an in-depth look at plants, animals, or people and that are visually superior. We are also looking for photos for our photographic feature, 'The Natural Moment.' This feature focuses on images that are both visually arresting and behaviorally interesting." Photos used must relate to the social or natural sciences with an ecological framework. Accurate, detailed captions required.

Specs Uses 35mm, $2\frac{1}{4} \times 2\frac{1}{4}$, 4×5, 6×7, 8×10 color transparencies; high-res digital images. Covers are always related to an article in the issue.

Making Contact & Terms Send query letter with résumé of credits. "We prefer that you come in and show us your portfolio, if and when you are in New York. Please don't send us any photographs without a query first, describing the work you would like to send. No submission should exceed 30 original transparencies or negatives. However, please let us know if you have additional images that we might consider. Potential liability for submissions that exceed 30 originals shall be no more than $100 per slide." Responds in 2 weeks. Previously published work OK but must be indicated on delivery memo. Pays (for color and b&w) $400-600 for cover; $350-500 for spread; $300-400 for oversize; $250-350 for full-page; $200-300 for $\frac{1}{4}$ page; $175-250 for less than $\frac{1}{4}$ page. Pays $50 for usage on contents page. Pays on publication. Credit line given. Buys one-time rights.

Tips "Study the magazine—we are more interested in ideas than individual photos."

$ ◨ Ⓢ ▣ NATURE FRIEND, Helping Children Explore the Wonders of God's Creation

4253 Woodcock Lane, Dayton VA 22821. (540)867-0764. Fax: (540)867-9516. **Contact:** Kevin Shank, editor. Circ. 10,000. Estab. 1982. Monthly children's magazine. Sample copy available for $3 plus $2 first-class postage.

Needs Buys 5-10 photos from freelancers/issue; 100 photos/year. Needs photos of wildlife, wildlife interacting with each other, humorous wildlife, all natural habitat appearance. Reviews photos with or without manuscript. Model/property release preferred. Photo captions preferred.

Specs Prefers images in digital format. Send via CD or DVD as TIFF files at 300 dpi at 8×10 size; provide color thumbnails when submitting photos. "Transparencies are handled and stored carefully; however, we do not accept liability for them so discourage submissions of them."

Making Contact & Terms Send query letter with thumbnail contact sheets and photos. "Label contact prints and digital media with your name, address and phone number so we can easily know how to contact you if we select your photo for use." Responds in 1 month to queries; 2 weeks to portfolios. Simultaneous submissions and previously published work OK. Pays $75 for front cover; $50 for back cover. Pays on publication. Credit line given. Buys one-time rights.

Tips "We're always looking for photos of wild animals doing something unusual or humorous. Please label every sheet of paper or digital media with name, address and phone number. We may need to contact you on short notice, and you do not want to miss a sale. Also, photos are selected on a monthly basis, after the articles. What this means to a photographer is that photos are secondary to writings and cannot be selected far in advance. High-resolution photos in our files the day we are making selections will stand the greatest chance of being published."

$ ▣ NATURE PHOTOGRAPHER

P.O. Box 220, Lubec ME 04652. (207)733-4201. Fax: (207)733-4202. E-mail: nature_photographer@yahoo.com. Web site: www.naturephotographermag.com. **Contact:** Helen Longest-Saccone, editor-in-chief/photo editor. Circ. 35,000. Estab. 1990. Quarterly 4-color, high-quality magazine. Emphasizes "conservation-oriented, low-impact nature photography" with strong how-to focus. Readers are male and female nature photographers of all ages. Sample copy available for 10×13 SAE with 6 first-class stamps.

● *Nature Photographer* charges $79/year to be a "field contributor."

Needs Buys 90-120 photos from freelancers/issue; 400 photos/year. Needs nature shots of "all types—abstracts, animals/wildlife, flowers, plants, scenics, environmental images, etc. Shots must be in natural settings; no set-ups, zoo or captive animal shots accepted." Reviews photos (slides or digital images on CD) with or without ms 4 times/year: May (for fall issue); August (for winter issue); November (for spring issue); and January (for summer issue). Photo captions required; include description of subject, location, type of equipment, how photographed. "This information published with photos."

Making Contact & Terms Contact by e-mail or with SASE for guidelines before submitting images. Prefers to see 35mm transparencies or CD of digital images. "Send digital images via CD; please do not e-mail digital images." Does not keep samples on file; include SASE for return of material. Responds within 4

months, according to deadline. Simultaneous submissions and previously published work OK. Pays $100 for color cover; $20 for b&w inside; $25-40 for color inside; $75-150 for photo/text package. Pays on publication. Credit line given. Buys one-time rights.

Tips Recommends working with "the best lens you can afford and slow-speed slide film; or, if shooting digital, using the RAW mode." Suggests editing with a 4× or 8× loupe (magnifier) on a light board to check for sharpness, color saturation, etc. "Color prints are not normally used for publication in our magazine."

$☐ ▣ NATURIST LIFE INTERNATIONAL

P.O. Box 969, Winnisquam NH 03289. (603)455-7368. E-mail: info@naturistlifemag.com or editor@naturistlifemag.com. Web sites:www.naturistlife.com and www.naturistlifemag.com. **Contact:** Tom Caldwell, editor-in-chief. Estab. 1987. Quarterly electronic magazine. Emphasizes nudism. Readers are male and female nudists, ages 20-80. Sample copy available on CD for $5. Photo guidelines free with SASE.

• *Naturist Life* holds yearly Vermont Naturist Photo Safaris organized to shoot nudes in nature.

Needs Buys 36 photos from freelancers/issue; 144 photos/year. Needs photos depicting family-oriented nudist/naturist work, recreational activity and travel. Reviews photos with or without a manuscript. Model release required (including Internet use) for recognizable nude subjects. Photo captions preferred.

Specs Prefers digital images submitted on CD; 8×10 glossy color and/or b&w prints; 35mm, 2¼×2¼, 4×5, 8×10 (preferred) transparencies.

Making Contact & Terms Send query letter with résumé of credits. Send unsolicited photos by mail or e-mail for consideration; include SASE for return of material. Provide résumé, business card, brochure, flier or tearsheets to be kept on file for possible future assignments. Responds in 2 weeks. Pays $50 for color cover; $10-25 for others. Pays on publication. Credit line given. "Prefer to own all rights but sometimes agree to one-time publication rights."

Tips "The ideal *NLI* photo shows ordinary-looking people of all ages doing everyday activities, in the joy of nudism. We do not want 'cheesecake' glamour images or anything that emphasizes the erotic."

N $☐ ⊘ S NECROLOGY MAGAZINE

Isis International, P.O. Box 510232, St. Louis MO 63151. (314)315-5200. E-mail: editor@necrologymag.com. Web site: www.necrologymag.com. **Contact:** John Ferguson, editor. Circ. 1,000. Estab. 2006. Quarterly consumer magazine. "Necrology is a publication of science fiction, fantasy, horror, and Lovecraftian-type fiction." Sample copy available for $5. Photo guidelines available with #10 SASE. Request photo guidelines via e-mail.

Needs Buys 1-2 photos from freelancers/issue; 4-8 photos/year. Needs photos of architecture, cities/urban, religious, landscapes/scenics; interested in alternative process, avant garde, fine art, historical/vintage, seasonal. Cemeteries, crypts, and anything that might relate to the magazine. Reviews photos with or without a manuscript. Model release required. Property release preferred. Photo captions preferred; include subject, location.

Specs Uses b&w prints. Accepts images in digital format. E-mail query letter with link to photographer's Web site. Send via CD, Zip or e-mail as JPEG, GIF or Photoshop files, grayscale. File size must be under 100k.

Making Contact & Terms Does not keep samples on file; include SASE for return of material. Responds in 2 weeks to queries and portfolios. Pays $1-20 for b&w cover or inside. **Pays on acceptance.** Credit line given. Buys one-time rights.

Tips "Read our magazine. We publish horror and fantasy. Photos should have something dark, edgy, and relate to our fiction. Follow guidelines. We prefer e-mail or CD submissions; other types of submissions may not be reviewed."

$ $▣ NEW MEXICO MAGAZINE

495 Old Santa Fe Trail, Santa Fe NM 87501. (505)827-7447. Fax: (505)827-6496. E-mail: photos@nmmagazine.com. Web site: www.nmmagazine.com. **Contact:** Steve Larese, photo editor. Circ. 123,000. Monthly magazine for affluent people ages 35-65 interested in the Southwest or who have lived in or visited New Mexico. Sample copy available for $3.95 with 9×12 SAE and 3 first-class stamps. Photo guidelines available on Web site.

Needs Buys 10 photos from freelancers/issue; 120 photos/year. Needs New Mexico photos only—landscapes, people, events, architecture, etc. "Most work is done on assignment in relation to a story, but we welcome photo essay suggestions from photographers. Cover photos usually relate to the main feature

in the magazine." Model release preferred. Photo captions required; include who, what, where.

Specs Uses transparencies. "We prefer transparencies submitted in plastic pocketed sheets and accept high-resolution, unmanipulated digital files with good proof sheets."

Making Contact & Terms Submit portfolio to Steve Larese; include SASE for return of material. Pays $450/day; $300 for color or b&w cover; $60-100 for color or b&w stock. Pays on publication. Credit line given. Buys one-time rights.

Tips *"New Mexico Magazine* is the official magazine for the state of New Mexico. Photographers should know New Mexico. We are interested in the less common stock of the state. The magazine is editorial driven, and all photos run directly related to a story in the magazine."

$□ 回 NEW YORK STATE CONSERVATIONIST MAGAZINE

NYSDEC Editorial Office, 625 Broadway, 2nd Floor, Albany NY 12233-4502. (518)402-8047. Fax: (518)402-8050. E-mail: magazine@gw.dec.state.ny.us. Web site: www.theconservationist.org and www. dec.state.ny.us. **Contact:** Photo Editor. Circ. 100,000. Estab. 1946. Bimonthly nonprofit, New York State government publication. Emphasizes natural history, environmental and outdoor interests pertinent to New York State. Sample copy available for $3.50. Photo guidelines free with SASE or on Web site.

Needs Uses 40 photos/issue; 80% supplied by freelancers. Needs wildlife shots, people in the environment, outdoor recreation, forest and land management, fisheries and fisheries management, environmental subjects. Also needs landscapes/scenics, cities, travel, historical/vintage, seasonal. Model release preferred. Photo captions required.

Specs Accepts images in digital format. Send via CD as TIFF files at 300 dpi. Also uses 35mm, $2\frac{1}{4} \times 2\frac{1}{4}$, 4×5, 8×10 transparencies.

Making Contact & Terms Send material by mail for consideration, or submit portfolio for review. Provide résumé, bio, business card, brochure, flier or tearsheets to be kept on file for possible future assignments. Responds in 3 weeks. Simultaneous submissions and previously published work OK. Pays $50 for cover photos; $15 for b&w or color inside. Pays on publication. Buys one-time rights.

Tips Looks for "artistic interpretation of nature and the environment; unusual ways of picturing environmental subjects (even pollution, oil spills, trash, air pollution, etc.); wildlife and fishing subjects at all seasons. Try for unique composition, lighting. Technical excellence a must."

⦾ NEWSWEEK

251 W. 57th St., New York NY 10019-6999. (212)445-4000. Web site: www.newsweek.com. Circ. 3,180,000. *Newsweek* reports the week's developments on the newsfront of the world and the nation through news, commentary and analysis. News is divided into National Affairs; International; Business; Society; Science & Technology; and Arts & Entertainment. Relevant visuals, including photos, accompany most of the articles. *Query before submitting.*

$□ 回 NEWWITCH, not your mother's broomstick

BBI Media, Inc., P.O. Box 641, Point Arena CA 95468-0641. (707)882-2052. Fax: (707)882-2793. E-mail: meditor@newwitch.com. Web site: www.newwitch.com. **Contact:** Anne Niven, editor-in-chief. Circ. 15,000. Estab. 2002. Quarterly consumer magazine. *"newWitch* aims to break the stereotypes about wicca being boring—we are hip, active and irreverent." Sample copy and photo guidelines available for SAE.

Needs Buys 10 photos from freelancers/issue; 40 photos/year. Interested in alternative process, avant garde, seasonal. Reviews photos with or without a manuscript. Model release preferred.

Specs Uses 5×7 or larger matte color or b&w prints. Accepts images in digital format. Send via CD, Zip, e-mail as TIFF, JPEG files at 400 dpi.

Making Contact & Terms "Request a sample copy (we send them free!) first, to see if our style and subject matter meet your interests." Provide self-promotion piece to be kept on file for possible future assignments. Responds in 10 weeks to queries; 1 month to portfolios. Responds only if interested; send nonreturnable samples. Simultaneous submissions and previously published work OK. Pays $100-200 for color cover; $10-100 for b&w inside. Pays on publication. Credit line given. Buys one-time rights, all rights; negotiable.

Tips "You should be aware of pagan/wiccan culture (you do *not* need to be a witch). We like contemporary, edgy work and extreme closeups, mostly of people ages 18-34."

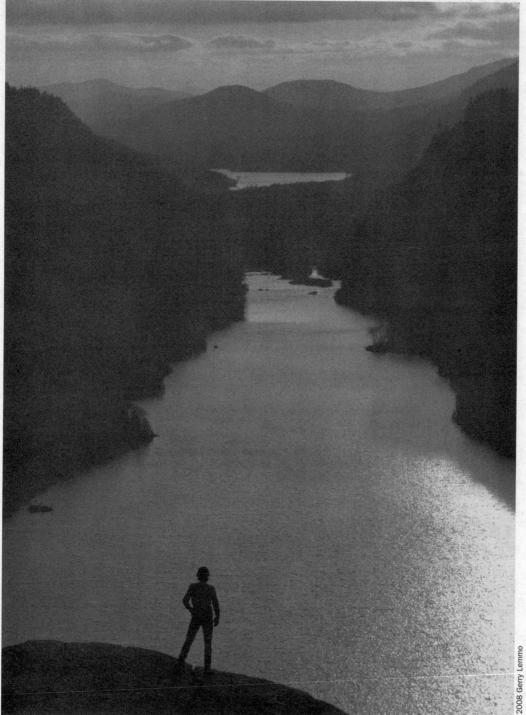

Gerry Lemmo submitted several photographs to *New York State Conservationist Magazine*, and this photo of the Ausable Lakes in the Adirondack Mountains was chosen for a special issue celebrating the one-hundredth anniversary of the New York State Forest Preserve.

$ ◨ ▣ NORTH AMERICAN WHITETAIL MAGAZINE

P.O. Box 741, Marietta GA 30061. (770)953-9222. Fax: (770)933-9510. E-mail: ronald.sinfelt@intermedia outdoors.com. Web site: www.northamericanwhitetail.com. **Contact:** Ron Sinfelt, photo editor. Circ. 130,000. Estab. 1982. Published 8 times/year (July-February) by Primedia. Emphasizes trophy whitetail deer hunting. Sample copy available for $3. Photo guidelines free with SASE.

Needs Buys 8 photos from freelancers/issue; 64 photos/year. Needs photos of large, live whitetail deer, hunter posing with or approaching downed trophy deer, or hunter posing with mounted head. Also uses photos of deer habitats and signs. Model release preferred. Photo captions preferred; include when and where scene was photographed.

Specs Accepts images in digital format. Send via CD at 300 dpi with output of 8×12 inches. Also uses 8×10 b&w prints; 35mm transparencies.

Making Contact & Terms Send query letter with résumé of credits and list of stock photo subjects. Will return unsolicited material in 1 month if accompanied by SASE. Simultaneous submissions not accepted. Pays $400 for color cover; $75 for color inside; $25 for b&w inside. Tearsheets provided. Pays 60 days prior to publication. Credit line given. Buys one-time rights.

Tips "In samples we look for extremely sharp, well-composed photos of whitetailed deer in natural settings. We also use photos depicting deer hunting scenes. Please study the photos we are using before making submission. We'll return photos we don't expect to use and hold the remainder for potential use. Please do not send dupes. Use an 8×10 envelope to ensure sharpness of images, and put name and identifying number on all slides and prints. Photos returned at time of publication or at photographer's request."

$ ▣ NORTH CAROLINA LITERARY REVIEW

East Carolina University, Greenville NC 27858-4353. (252)328-1537. Fax: (252)328-4889. E-mail: BauerM @ecu.edu. Web site: www.ecu.edu/nclr. **Contact:** Margaret Bauer, editor. Circ. 750. Estab. 1992. Annual literary magazine with North Carolina focus. *NCLR* publishes poetry, fiction and nonfiction by and inter- views with NC writers, and articles and essays about NC literature, literary history and culture. Photo- graphs must be NC-related. Sample copy available for $15. Photo guidelines available for SASE or on Web site.

Needs Buys 3-6 photos from freelancers/issue. Model/property release preferred. Photo captions pre- ferred.

Specs Uses b&w prints; 4×5 transparencies. Accepts images in digital format. Inqure first; request, submit TIFF, GIF files at 300 dpi to nclruser@ecu.edu.

Making Contact & Terms Send query letter with Web site address to show sample of work. Portfolios may be dropped off. Provide résumé, business card, self-promotion piece to be kept on file for possible future assignments. Send nonreturnable samples or include SASE for return of material. Responds in 2 months to queries. Pays $50-200 for cover; $5-100 for b&w inside. Pays on publication. Credit line given. Buys first rights.

Tips "Look at our publication—1998-present back issues. See our Web site."

$ $ ◨ ▣ NORTHEAST BOATING MAGAZINE

(formerly *Offshore*), Offshore Communications, Inc., 500 Victory Rd., Marina Bay, North Quincy MA 02171. (617)221-1400. Fax: (617)847-1871. E-mail: dauerd@northeastboating.net. Web site: www.northe astboating.net. **Contact:** Dave Dauer, director of creative services. Monthly magazine. Focuses on recre- ational boating in the Northeast region of U.S., from Maine to New Jersey. Sample copy free with 9×12 SASE.

Needs Buys 35-50 photos from freelancers/issue; 420-600 photos/year. Needs photos of recreational boats and boating activities. "Boats covered are mostly 20-50 feet; mostly power, but some sail, too." Photo captions required; include location.

Specs Accepts slides or digital images only. "Cover photos should be vertical format and have strong graphics and/or color."

Making Contact & Terms "Please call before sending photos." Simlultaneous submissions and previously published work OK. Pays $400 for color cover; $75-250 for color inside. Pays on publication. Credit line given. Buys one-time rights.

$ ▣ NORTHERN WOODLANDS: A New Way of Looking at the Forest

P.O. Box 471, Corinth VT 05039-9900. (802)439-6292. Fax: (802)439-6296. E-mail: anne@northernwoodl ands.org. Web site: www.northernwoodlands.org. **Contact:** Anne Margolis, managing editor. Circ.

17,000. Estab. 1994. Quarterly consumer magazine "created to inspire landowners' sense of stewardship by increasing their awareness of the natural history and the principles of conservation and forestry that are directly related to their land; to encourage loggers, foresters, and purchasers of raw materials to continually raise the standards by which they utilize the forest's resources; to increase the public's awareness and appreciation of the social, economic and environmental benefits of a working forest; to raise the level of discussion about environmental and natural resource issues; and to educate a new generation of forest stewards." Sample copies available for $5. Photo guidelines available on Web site.

Needs Buys 10-50 photos from freelancers/year. Needs photos of forestry, environmental, landscapes/scenics, wildlife, rural, adventure, travel, agriculture, science. Interested in historical/vintage, seasonal. Other specific photo needs: vertical format, photos specific to assignments in northern New England and upstate New York. Reviews photos with or without a manuscript. Model release preferred. Photo captions required.

Specs Uses glossy or matte color and b&w prints; 35mm, $2\frac{1}{4} \times 2\frac{1}{4}$ transparencies. Prefers images in digital format. Send via CD, Zip, e-mail as TIFF, EPS files at 300 dpi minimum. No e-mails larger than 1 MB.

Making Contact & Terms Send query letter with slides. Provide self-promotion piece to be kept on file for possible future assignments. Responds only if interested; send nonreturnable samples. Previously published work OK. Pays $150 for color cover; $25-75 for b&w inside. "We might pay upon receipt or as late as publication." Credit line given. Buys one-time rights.

Tips "Read our magazine or go to our Web site for samples of the current issue. We're always looking for high-quality cover photos on a seasonal theme. Vertical format for covers is essential. Also, note that our title goes up top, so photos with some blank space up top are best. Please remember that not all good photographs make good covers—we like to have a subject, lots of color, and we don't mind people. Anything covering the woods and people of Vermont, New Hampshire, Maine, northern Massachusetts or northern New York is great. Unusual subjects, and ones we haven't run before (we've run lots of birds, moose, large mammals, and horse-loggers), get our attention. For inside photos we already have stories and are usually looking for regional photographers willing to shoot a subject theme."

$ NORTHWEST TRAVEL MAGAZINE

4969 Hwy. 101, Suite 2, Florence OR 97439. (800)348-8401. Fax: (541)997-1124. E-mail: barb@ohwy.com. Web site: www.northwestmagazines.com. **Contact:** Barbara Grano, photo editor. Circ. 50,000. Estab. 1991. Bimonthly consumer magazine emphasizing travel in Oregon, Washington, Idaho, western Montana, and British Columbia, Canada. Readers are middle-class, middle-age. Sample copy available for $6. Photo guidelines free with SASE or on Web site.

Needs Buys 3-5 photos from freelancers/issue; 18-30 photos/year. Wants seasonal scenics. Model release required. Photo captions required; include specific location and description. "Label all slides and transparencies with captions and photographer's name."

Specs Uses 35mm, $2\frac{1}{4} \times 2\frac{1}{4}$, 4×5 positive transparencies. "Do not e-mail images."

Making Contact & Terms Send query letter with transparencies. Does not keep samples on file; include SASE for return of material. Responds in 1 month. Pays $425 for color cover; $100 for calendar usage; $25-50 for b&w inside; $25-100 for color inside; $100-250 for photo/text package. Credit line given. Buys one-time rights.

Tips "Send slide film that can be enlarged without graininess (50-100 ASA). We don't use color filters. Send 20-40 slides. Protect slides with sleeves put in plastic holders. Don't send in little boxes. We work about 3 months ahead, so send spring images in winter, summer images in spring, etc."

$ ☑ ⑤ ▣ NORTHWOODS JOURNAL, a magazine for working writers

Conservatory of American Letters, P.O. Box 298, Thomaston ME 04861. (207) 226-7528. E-mail: cal@americanletters.org. Web site: www.americanletters.org. **Contact:** Robert Olmsted, editor. Circ. 100-200. Estab. 1992. Quarterly literary magazine. "We are a magazine for writers—a showcase, not a how-to." Sample copy available for $6.50 and 6×9 SAE with $1.04 postage.

Needs Sometimes buys 1 photo from freelancers/issue; at least 4 photos/year. Needs photos of landscapes/scenics, wildlife, rural. Reviews photos with or without a manuscript. Model release required.

Specs Uses 5×7 glossy color and/or b&w prints. No digital images. Send via mail.

Making Contact & Terms Send query letter with prints. Does not keep samples on file; include SASE for return of material. Responds in 1 week to queries. Pays $5-20 for b&w cover; $20-50 for color cover. **Pays on acceptance.** Credit line given. Buys one-time rights.

Tips "We're a small, tough market. We buy a seasonal color cover photo for each issue of the magazine, and occasional color covers for books. Our subject matter usually does not suggest interior photos."

$ 🖉 🖥 NOW & THEN: The Appalachian Magazine

Center for Appalachian Studies & Services, Box 70556 ETSU, 807 University Pkwy., Johnson City TN 37614-1707. (423)439-7 994. Fax: (423)439-7870. E-mail: sandersr@etsu.edu. Web site: www.etsu.edu/cass. **Contact:** Randy Sanders, managing editor. Circ. 1,000. Estab. 1984. Literary magazine published twice/year. *Now & Then* tells the story of Appalachia, the mountain region that extends from northern Mississippi to southern New York state. The magazine presents a fresh, revealing picture of life in Appalachia, past and present, with engaging articles, personal essays, fiction, poetry and photography. Sample copy available for $8 plus $2 shipping. Photo guidelines free with SASE or visit Web site.

Needs Needs photos of environmental, landscapes/scenics, architecture, cities/urban, rural, adventure, performing arts, travel, agriculture, political, disasters. Interested in documentary, fine art, historical/vintage. Photographs must relate to theme of issue. Themes are posted on the Web site or available with guidelines. "We publish photo essays based on the magazine's theme." Reviews photos with or without a manuscript. Model/property release preferred. Photo captions preferred; include where the photo was taken, identify places/people.

Specs Require images in digital format sent as e-mail attachments as JPEG or TIFF files at 300 dpi minimum.

Making Contact & Terms Send query letter with résumé, photocopies. Provide self-promotion piece to be kept on file for possible future assignments. Responds only if interested; send nonreturnable samples. Simultaneous submissions OK. Pays $100 maximum for color cover; $25 for b&w inside. Pays on publication. Credit line given. Buys one-time rights; negotiable.

Tips "Know what our upcoming themes are. Keep in mind we cover only the Appalachian region. (See the Web site for a definition of the region)."

$ $ 🖉 🖥 OKLAHOMA TODAY

120 N. Robinson, Suite 600, Oklahoma City OK 73102. (405)230-8450. E-mail: megan@oklahomatoday.com. Web site: www.oklahomatoday.com. **Contact:** Megan Rossman, associate editor. Circ. 45,000. Estab. 1956. Bimonthly magazine. "We cover all aspects of Oklahoma, from history to people profiles, but we emphasize travel." Readers are "Oklahomans, whether they live in-state or are exiles; studies show them to be above average in education and income." Sample copy available for $4.95. Photo guidelines free with SASE or on Web site.

Needs Buys 45 photos from freelancers/issue; 270 photos/year. Needs photos of "Oklahoma subjects only; the greatest number are used to illustrate a specific story on a person, place or thing in the state. We are also interested in stock scenics of the state." Other areas of focus are adventure—sport/travel, reenactment, historical and cultural activities. Model release required. Photo captions required.

Specs Uses 8×10 glossy b&w prints; 35mm, 2¼×2¼, 4×5, 8×10 transparencies. Accepts images in digital format. Send via CD or e-mail.

Making Contact & Terms Send query letter with samples; include SASE for return of material. Responds in 2 months. Simultaneous submissions and previously published work OK (on occasion). Pays $50-150 for b&w photos; $50-250 for color photos; $125-1,000/job. Pays on publication. Buys one-time rights with a 4-month from publication exclusive, plus right to reproduce photo in promotions for magazine without additional payment with credit line.

Tips To break in, "read the magazine. Subjects are normally activities or scenics (mostly the latter). I would like good composition and very good lighting. I look for photographs that evoke a sense of place, look extraordinary and say something only a good photographer could say about the image. Look at what Ansel Adams and Eliot Porter did and what Muench and others are producing, and send me that kind of quality. We want the best photographs available, and we give them the space and play such quality warrants."

🖉 🖥 ONBOARD MEDIA

1691 Michigan Ave,, Suite 600, Miami Beach FL 33139. (305)673-0400. Fax: (305)674-9396. E-mail: beth@onboard.com; sirena@onboard.com. Web site: www.onboard.com. **Contact:** Beth Wood and Sirena Andras, co-art directors. Circ. 792,184. Estab. 1990. Ninety annual and quarterly publications. Emphasize travel in the Caribbean, Europe, Mexican Riviera, Bahamas, Alaska, Bermuda, Las Vegas. Custom publications reach cruise vacationers and vacation/resort audience. Photo guidelines free with SASE.

Needs Needs photos of scenics, nature, prominent landmarks based in Caribbean, Mexican Riviera, Bahamas, Alaska, Europe and Las Vegas. Model/property release required. Photo captions required; include where the photo was taken and explain the subject matter. Credit line information requested.
Specs Uses 35mm, $2\frac{1}{4} \times 2\frac{1}{4}$, 4×5, 8×10 transparencies. Prefers images in digital format RAW data. Send via CD at 300 dpi.
Making Contact & Terms Send query letter with stock list. Provide résumé, business card, brochure, flier or tearsheets to be kept on file for possible future assignments. Keeps samples on file. Responds in 3 weeks. Previously published work OK. Rates negotiable per project. Pays on publication. Credit line given.

$OREGON COAST MAGAZINE

4969 Hwy. 101, Suite 2, Florence OR 97439. (800)348-8401. Fax: (541)997-1124. E-mail: barb@ohwy.com. Web site: www.northwestmagazines.com. **Contact:** Barbara Grano, photo editor. Circ. 50,000. Estab. 1982. Bimonthly magazine. Emphasizes Oregon coast life. Readers are middle-class, middle-aged. Sample copy available for $6, including postage. Photo guidelines available with SASE or on Web site.
Needs Buys 3-5 photos from freelancers/issue; 18-30 photos/year. Needs scenics. Especially needs photos of typical subjects—waves, beaches, lighthouses—with a fresh perspective. Needs mostly vertical format. Model release required. Photo captions required; include specific location and description. "Label all slides and transparencies with captions and photographer's name."
Making Contact & Terms Send unsolicited 35mm, 2×2, 4×5 positive transparencies by mail for consideration; SASE or return postage required. "Do not e-mail images." Responds in 1 month. Pays $425 for color cover; $100 for calendar usage; $25-50 for b&w inside; $25-100 for color inside; $100-250 for photo/text package. Credit line given. Buys one-time rights.
Tips "Send only the very best. Use only slide film that can be enlarged without graininess. Don't use color filters. An appropriate submission would be 20-40 slides. Protect slides with sleeves—put in plastic holders. Don't send in little boxes."

$ $ 🖊 🖳 ☑ OUTDOOR CANADA

25 Sheppard Ave. W., Suite 100, Toronto ON M2N 6S7 Canada. (416)218-3697. Fax: (416)227-8296. E-mail: scheung@outdoorcanada.ca. Web site: www.outdoorcanada.ca. **Contact:** Sandra Cheung, associate art director. Art Director: Robert Biron. Circ. 100,000. Estab. 1972. Magazine published 8 times/year. Photo guidelines free with SASE (or SAE and IRC), via e-mail or on Web site.
Needs Buys 200-300 photos/year. Needs photos of wildlife; fishing, hunting, ice-fishing; action shots. "**Canadian content only.**" Photo captions required; include identification of fish, bird or animal.
Specs Accepts images in digital format.
Making Contact & Terms "Send a well edited selection of transparencies with return postage for consideration. E-mail/CD portfolios also accepted." Responds in 1 month. Pays $550 for cover; $75-400 for color inside, depending on size used (all payable in Canadian funds). Pays on invoice. Buys one-time rights.

$🖳 OVER THE BACK FENCE

Long Point Media, LLC, 2947 Interstate Pkwy., Brunswick OH 44212. (330)220-2483. Fax: (330)220-3083. E-mail: RockyA@LongPointMedia.com. Web site: www.backfencemagazine.com. **Contact:** Rocky Alten, creative director. Estab. 1994. Quarterly magazine. "*Over the Back Fence* is a regional magazine serving southern and central Ohio. We are looking for photos of interesting people, events and history of our area." Sample copy available for $5. Photo guidelines available on Web site.
Needs Buys 50 photos from freelancers/issue; 200 photos/year. Needs photos of scenics, attractions, food (specific to each issue), historical locations in region (call for specific counties). Model release required for identifiable people. Photo captions preferred; include location, description, names, date of photo (year), and if previously published, where and when.
Specs Prefers images in digital format. Review guidelines before submitting.
Making Contact & Terms Send query letter with stock list and résumé of credits. Provide résumé, business card, brochure, flier or tearsheets to be kept on file for possible future assignments. Responds in 3 months. Simultaneous submissions and previously published work OK, "but you must identify photos used in other publications." Pays $100 for cover; $25-100 for inside. "We pay mileage fees to photographers on assignments. See our photographer's rates and guidelines for specifics." Pays on publication. Credit line given "except in the case of ads, where it may or may not appear." Buys one-time rights.

Tips "We are looking for sharp, colorful images and prefer using digital files or color transparencies over color prints when possible. Nostalgic and historical photos are usually in black and white."

◨ ▣ ↕ OWL MAGAZINE

10 Lower Spadina Ave., Suite 400, Toronto ON M5V 2Z2 Canada. (416)340-2700. Fax: (416)340-9769. E-mail: deb@owlkids.com. Web site: www.owlkids.com. **Contact:** Debbie Yea, photo researcher. Circ. 80,000. Estab. 1976. Published 10 times/year. A discovery magazine for children ages 9-13. Sample copy available for $4.95 and 9×12 SAE with $1.50 money order for postage. Photo guidelines free with SAE or via e-mail.

Needs Buys 5 photos from freelancers/issue; 40 photos/year. Needs photos of children ages 12-14, extreme weather, wildlife, science, technology, environmental, pop culture, multicultural, events, adventure, hobbies, humor, sports and extreme sports. Interested in documentary, seasonal. Model/property release required. Photo captions required. Will buy story packages.

Specs Uses images in any hard-copy format. Accepts images in digital format. Send via CD, e-mail as TIFF, JPEG files at 72 dpi. "For publication, we require 300 dpi."

Making Contact & Terms Request photo guidelines package before sending photos for review. "We accept no responsibility for unsolicited material." Keeps samples on file. Responds in 3 months. Previously published work OK. Credit line given. Buys one-time rights.

Tips "Photos should be sharply focused with good lighting, and engaging for kids. We are always on the lookout for humorous, action-packed shots; eye-catching, sports, animals, bloopers, etc. Photos with a 'wow' impact."

$ $ $↕ OXYGEN

Robert Kennedy Publishing, 5775 McLaughlin Rd., Mississauga ON L5R 3P7 Canada. (905)507-3545. Fax: (905)507-2372. E-mail: editorial@oxygenmag.com. Web site: www.oxygenmag.com. **Contact:** Robert Kennedy, publisher. Circ. 250,000. Estab. 1997. Monthly magazine. Emphasizes exercise and nutrition for women. Readers are women ages 20-39. Sample copy available for $5.

Needs Buys 720 photos from freelancers/issue. Needs photos of women weight training and exercising aerobically. Model release required. Photo captions preferred; include names of subjects.

Specs Accepts high-res digital images. Uses 35mm, 2¼×2¼ transparencies. Prints occasionally acceptable.

Making Contact & Terms Send unsolicited photos by mail for consideration. Does not keep samples on file; include SASE for return of material. Responds in 3 weeks. Pays $200-400/hour; $800-1,500/day; $500-1,500/job; $500-2,000 for color cover; $50-100 for color or b&w inside. **Pays on acceptance.** Credit line given. Buys all rights.

Tips "We are looking for attractive, fit women working out on step machines, joggers, rowers, treadmills, ellipticals; with free weights; running for fitness; jumping, climbing. Professional pictures only, please. We particularly welcome photos of female celebrities who are into fitness; higher payments are made for these."

$◨ ▣ ↕ PACIFIC YACHTING MAGAZINE

1080 Howe St., Vancouver BC V6Z 2T1 Canada. (604)606-4644. Fax: (604)687-1925. E-mail: editorial@pacificyachting.com. Web site: www.pacificyachting.com. **Contact:** Peter A. Robson, editor. Circ. 20,000. Estab. 1968. Monthly magazine. Emphasizes boating on West Coast. Readers are ages 35-60; boaters, power and sail. Sample copy available for $6.95 Canadian plus postage.

Needs Buys 75 photos from freelancers/issue; 900 photos/year. Needs photos of landscapes/scenics, adventure, sports. Interested in historical/vintage, seasonal. "All should be boating related." Reviews photos with accompanying manuscript only. "Always looking for covers; must be shot in British Columbia."

Making Contact & Terms Keeps samples on file. Simultaneous submissions and previously published work OK. Pays $400 Canadian for color cover. Payment negotiable. Credit line given. Buys one-time rights.

$ $◨ ▣ PADDLER MAGAZINE

Paddlesport Publishing, Inc., 12040 98th Ave. NE, Suite 205, Kirkland WA 98033. (425)814-4140. Fax: 425)814-4042. E-mail: mike@paddlermagazine.com. Web site: www.paddlermagazine.com. **Contact:** Mike Kord, editor. Circ. 65,000. Estab. 1990. Bimonthly magazine. Emphasizes kayaking, rafting, canoe-

ing and sea kayaking. Sample copy available for $3.50. Photo guidelines free with SASE.

Needs Buys 27-45 photos from freelancers/issue; 162-270 photos/year. Needs photos of scenics and action. Model/property release preferred. Photo captions preferred; include location.

Specs Prefers images in digital format. Send via CD, Zip, e-mail as TIFF, EPS, JPEG files at 300 dpi. Digital submissions should be accompanied by a printed proof sheet. Also accepts 35mm transparencies.

Making Contact & Terms Send query letter with stock list. Send unsolicited photos by mail with SASE for consideration. Keeps samples on file. Responds in 2 months. Pays $250-350 for color cover; $50 for inset color cover; $125 for color full page inside. Pays on publication. Credit line given. Buys first North American serial rights; negotiable.

Tips "Send innovative photos of canoeing, kayaking and rafting, and let us keep them on file."

$ $ ▣ PENNSYLVANIA

P.O. Box 755, Camp Hill PA 17011. (717)697-4660. E-mail: PaMag@aol.com. Web site: www.pa-mag.c om. **Contact:** Matthew K. Holliday, editor. Circ. 30,000. Bimonthly. Emphasizes history, travel and contemporary topics. Readers are 40-70 years old, professional and retired; average income is $59,000. Sample copy available for $2.95. Photo guidelines free with SASE or via e-mail.

Needs Uses about 40 photos/issue; most supplied by freelancers. Needs include travel, wildlife and scenic. All photos must be taken in Pennsylvania. Reviews photos with or without accompanying manuscript. Photo captions required.

Making Contact & Terms Send query letter with samples. Send digital submissions of 3.1 MP or higher (OK on CD-ROM with accompanying printout with image file references); 5×7 and larger color prints; 35mm and 2¼×2¼ transparencies (duplicates only, in camera or otherwise, no originals) by mail for consideration; include SASE for return of material. Responds in 1 month. Simultaneous submissions and previously published work OK with notification. Pays $100-150 for color cover; $25 for color inside; $50-500 for text/photo package. Credit line given. Buys one-time, first rights or other rights as arranged.

Tips Look at several past issues and review guidelines before submitting.

$ ▣ PENNSYLVANIA GAME NEWS

2001 Elmerton Ave., Harrisburg PA 17110-9797. (717)787-3745. Web site : www.pgc.state.pa.us. **Contact:** Bob Mitchell, editor. Circ. 75,000. Monthly magazine published by the Pennsylvania Game Commission. Readers are people interested in hunting, wildlife management and conservation in Pennsylvania. Sample copy available for 9×12 SASE. Editorial guidelines free.

Needs Considers photos of "any outdoor subject (Pennsylvania locale), except fishing and boating." Reviews photos with accompanying manuscript only.

Making Contact & Terms Send prints or slides. "No negatives, please." Include SASE for return of material. Will accept electronic images via CD only (no e-mail). Will also view photographer's Web site if available. Responds in 2 months. Pays $40-300. **Pays on acceptance**.

$ ▣ ⊕ PERIOD IDEAS

Aceville Publications Ltd., 25 Phoenix Court, Hawkins Rd., Colchester, Essex CO2 8JY United Kingdom. (44)(1206)505991. Fax: (44)(1206)505985. E-mail: rebecca.winward@aceville.co.uk. Web site: www.per iodideas.com. **Contact:** Rebecca Winward, editor. Circ. 38,000. Monthly home interest magazine for readers with period properties which they wish to renovate sympathetically.

Needs Needs photos of architecture, interiors/decorating, gardens, events. Reviews photos with or without ms.

Specs Uses glossy color prints; 35mm transparencies. Accepts images in digital format. Send via CD as TIFF, JPEG files at 300 dpi.

Making Contact & Terms Send query letter with prints, transparencies. Does not keep samples on file; include SASE for return of material. Responds only if interested; send nonreturnable samples. Previously published work OK. Prices for covers/packages/single shots negotiated one-on-one (please indicate expectations. Pays at the end of the cover-dated publication date. Credit line sometimes given. Buys one-time rights.

Tips "Label each image with what it is, name and contact address/telephone number of photographer."

$ $ ▨ ▣ PERSIMMON HILL MAGAZINE

1700 NE 63rd St., Oklahoma City OK 73111. (405)478-6404. Fax: (405)478-4714. E-mail: editor@nationalc owboymuseum.org. Web site: www.nationalcowboymuseum.org. **Contact:** M.J. Van Deventer, editor.

Circ. 15,000. Estab. 1970. Quarterly publication of the National Cowboy and Western Heritage Museum. Emphasizes the West, both historical and contemporary views. Has diverse international audience with an interest in preservation of the West. Sample copy available for $10.50 and 9×12 SAE with 10 first-class stamps. Photo guidelines free with SASE or on Web site.

- This magazine has received Outstanding Publication honors from the Oklahoma Museums Association, the International Association of Business Communicators, Ad Club and Public Relations Society of America.

Needs Buys 65 photos from freelancers/issue; 260 photos/year. "Photos must pertain to specific articles unless it is a photo essay on the West." Western subjects include celebrities, couples, families, landscapes, wildlife, architecture, interiors/decorating, rural, adventure, entertainment, events, hobbies, travel. Interested in documentary, fine art, historical/vintage, seasonal. Model release required for children's photos. Photo captions required; include location, names of people, action. Proper credit is required if photos are historic.

Specs Accepts images in digital format. Send via CD.

Making Contact & Terms Submit portfolio for review by mail, directly to the editor, or with a personal visit to the editor. Responds in 6 weeks. Pays $150-500 for color cover; $100-150 for b&w cover; $50-150 for color inside; $25-100 for b&w inside. Credit line given. Buys first North American serial rights.

Tips "Make certain your photographs are high quality and have a story to tell. We are using more contemporary portraits of things that are currently happening in the West and using fewer historical photographs. Work must be high quality, original, innovative. Photographers can best present their work in a portfolio format and should keep in mind that we like to feature photo essays on the West in each issue. Study the magazine to understand its purpose. Show only the work that would be beneficial to us or pertain to the traditional Western subjects we cover."

N $ S ▣ PHI DELTA KAPPA

408 N. Union St., P.O. Box 789, Bloomington IN 47402. Web site: www.pdkintl.org/kappan.htm. **Contact:** Carol Bucheri, design director. Estab. 1915. Produces *Phi Delta Kappa* magazine and supporting materials. Photos used in magazine, fliers and subscription cards. Photo guidelines available online at www.pdkintl.org/kappan/khpsubmi.htm.

Needs Uses high-quality royalty-free, model-released stock phots on education topics. Especially interested in photos of educators and students at all levels, pre-D through university depicting a variety of people in different educational settings; teacher-to-teacher interactions with or without students (e.g., teachers' meetings, in-service, professional development settings). Reviews stock photos. Model release required. Photo caption required; include who, what, when, where.

Specs Uses 8×10 b&w and color prints; occasionally uses color. Accepts images in digital format. Send e-mail inquiries to cbucheri@pdkintl.org.

Making Contact & Terms Send query letter with list of education-related stock photo subjects before sending samples, or send URL for online portfolio. Provide photocopies, brochure or flier to be kept on file for possible future assignments. Responds in 3 weeks. Credit line and tearsheets given. Buys one-time rights.

Tips "We will definitely consider purchasing collections of royalty-free, copyright-free, model-released stock work if the majority of the photos are relevant."

N $ ◐ A ▣ ⇄ PHOTO LIFE

Apex Publications, One Dundas St. W., Suite 2500, P.O. Box 84, Toronto ON M5G 1Z3 Canada. (800)905-7468. Fax: (800)664-2739. Web site: www.photolife.com. **Contact:** Anita Dammer, editor. Circ. 60,000. Magazine published 6 times/year. Readers are amateur, advanced amateur and professional photographers. Sample copy free with SASE. Photo guidelines available on Web site.

Needs Buys 70 photos from freelancers/issue; 420 photos/year. Needs landscape/wildlife shots, fashion, scenics, b&w images and so on. Priority is given to Canadian photographers.

Specs Accepts images in digital format. Send via CD at 300 dpi.

Making Contact & Terms Send query letter with résumé of credits, SASE. Pays on publication. Buys first North American serial rights and one-time rights.

Tips "Looking for good writers to cover any subject of interest to the amateur and advanced photographer. Fine art photos should be striking, innovative. General stock and outdoor photos should be presented with a strong technical theme."

$ $⊘ ▣ PHOTO TECHNIQUES

Preston Publications, 6600 W. Touhy Ave., Niles IL 60714. (847)647-2900. Fax: (847)647-1155. E-mail: slewis@phototechmag.com. Web site: www.phototechmag.com. **Contact:** Scott Lewis, editor. Circ. 25,000. Estab. 1979. Bimonthly magazine for advanced traditional and digital photographers. Sample copy available for $5. Photo guidelines free with SAE or available on Web site.

Needs Publishes expert technical articles about photography. Needs photos of rural, landscapes/scenics, ''but if extensively photographed by others, ask yourself if your photo is sufficiently different.'' Also ''some urban or portrait if it fits theme of article.'' Especially needs digital ink system testing and coloring and alternative processes articles. Reviews photos with or without a manuscript. Photo captions required; include technical data.

Specs Uses any and all formats.

Making Contact & Terms ''E-mail queries work best.'' Send article or portfolio for review. Portfolio should include b&w and/or color prints, slides or transparencies. Keeps samples on file; include SASE for return of material. ''Prefer that work not have been previously published in any competing photography magazine; small, scholarly, or local publication OK.'' Pays $300 for color cover; $100-150/page. Pays on publication. Credit line given. Buys one-time rights.

Tips ''We need people to be familiar with our magazine before submitting/querying. Include return postage/packaging. Also, we much prefer complete, finished submissions. When people ask, 'Would you be interested in . . .?', often the answer is simply, 'We don't know! Let us see it.' Most of our articles are written by practicing photographers and use their work as illustrations.''

PHOTOGRAPHER'S FORUM MAGAZINE

Serbin Communications, Inc., 813 Reddick St., Santa Barbara CA 93103. (805)963-0439 or (800)876-6425. Fax: (805)965-0496. E-mail: julie@serbin.com. Web site: www.serbin.com. **Contact:** Julie Simpson, managing editor. Quarterly magazine for the serious student and emerging professional photographer. Includes feature articles on historic and contemporary photographers, interviews, book reviews, workshop listings, new products. (See separate listings for annual photography contests in the Contests section.)

▣ PLAYBOY'S SPECIAL EDITIONS

680 N. Lake Shore Dr., Suite 1500, Chicago IL 60611. (312)373-2273. Fax: (312)751-2818. E-mail: specialeditions@playboy.com. Web site: www.playboyse.com. Circ. 300,000. Estab. 1984. Bimonthly magazine and 18 newsstand specials for male sophisticates (25 issues/year). Photo guidelines available on Web site.

Needs Needs photos of beautiful women. Model/property release required. Models must be 18 years or older with two forms of valid ID. Photo captions required.

Specs Uses 35mm color transparencies or high-resolution digital. Accepts images in digital format. Send via e-mail to sesubmissions@playboy.com.

Making Contact & Terms Send query letter with samples. Does not keep samples on file; include SASE for return of material. Responds in 4-6 weeks. **Pays on accpetance.** Credit line given. Buys all rights.

▣ POETS & WRITERS MAGAZINE

72 Spring St., New York NY 10012. (212)226-3586. Fax: (212)226-3963. E-mail: editor@pw.org. Web site: www.pw.org/mag. Circ. 60,000. Estab. 1987. Bimonthly literary trade magazine. ''Designed for poets, fiction writers and creative nonfiction writers. We supply our readers with information about the publishing industry, conferences and workshop opportunities, grants and awards available to writers, as well as interviews with contemporary authors.''

Needs Needs photos of contemporary writers: poets, fiction writers, writers of creative nonfiction. Photo captions required.

Specs Uses b&w prints. Accepts images in digital format.

Making Contact & Terms Provide résumé, business card, self-promotion piece or tearsheets to be kept on file for possible future assignments. Managing editor will contact photographer for portfolio review if interested. Pays on publication. Credit line given.

Tips ''We seek black-and-white photographs to accompany articles and profiles. We'd be pleased to have photographers' lists of author photos.''

☑ ▣ POPULAR PHOTOGRAPHY & IMAGING

Hachette Fillipacchi Media, 1633 Broadway, New York NY 10019. (212)767-6000. E-mail: popeditor@hfm us.com. Web site: www.popularphotography.com. **Contact:** John Owens, editor-in-chief. Circ. 450,000. Estab. 1937. Monthly magazine. Readers are male and female photographers, amateurs to professionals of all ages. Photo guidelines free with SASE.

Needs "We are primarily interested in articles on new or unusual phases of photography which we have not covered recently or in recent years. We do not want general articles on photography which could just as easily be written by our staff. We reserve the right to rewrite, edit, or revise any material we are interested in publishing."

Making Contact & Terms "Queries should be accompanied by a sampling of how-to pictures (particularly when equipment is to be constructed or a process is involved), or by photographs which support the text. Please send duplicates only; do not send negatives or original slides. We are not responsible for the loss of original work. The sender's name and address should be clearly written on the back of each print, on the mount of each slide, watermarked on digitally sent sample images, and on the first and last pages of all written material, including the accompanying letter. Technical data should accompany all pictures, including the camera used, lens, film (or image format if digital), shutter speed, aperture, lighting, and any other points of special interest on how the picture was made. Material mailed to us should be carefully wrapped or packaged to avoid damage. All submissions must be accompanied by a stamped, self-addressed return envelope. We assume no responsibility for safe return, but will make every effort to handle and return it with care. The rate of payment depends upon the importance of the feature, quality of the photographs, and our presentation of it. Upon acceptance, fees will be negotiated by the author/photographer and the editors of the magazine. We are unable to accept individual portfolios for review. However, we do welcome samples of your work in the form of promotional mailers, press kits, or tear sheets for our files. These shoud be sent to the attention of Miriam Leuchter, Managing Editor, at the above address or via e-mail at mleuchter@hfmus.com"

Tips The Annnual Reader's Picture Contest gives photographers the opportunity to have their work recognized in the largest photo magazine in the world, as well as on PopPhoto.com. See Web site for submission guidelines, or e-mail acooper@hfmus.com.

● See the magazine's monthly photo contest, Your Best Shot, in the Contests section.

$ $ $ ☑ ▣ ☑ POZ MAGAZINE

Smart + Strong, 500 Fifth Ave., Suite 320, New York NY 10110-0303. (212)242-2163. Fax: (212)675-8505. E-mail: webmaster@poz.com. Web site: www.poz.com. **Contact:** Michael Halliday, art director. Circ. 100,000. Monthly magazine focusing exclusively on HIV/AIDS news, research and treatment.

Needs Buys 10-25 photos from freelancers/issue; 120-300 photos/year. Reviews photos with or without a manuscript. Model release preferred. Photo captions required.

Specs Prefers online portfolios.

Making Contact & Terms Send query letter with nonreturnable samples. Provide self-promotion piece to be kept on file for possible future assignments. Responds only if interested; send nonreturnable samples. Simultaneous submissions and previously published work OK. Pays $400-1,000 for color cover; $100-500 for color inside. Pays on publication. Credit line given.

$ ☐ ⑤ ▣ ☑ THE PRAIRIE JOURNAL, A Magazine of Canadian Literature

P.O. Box 61203, Brentwood PO, Calgary AB T2L 2K6 Canada. E-mail: prairiejournal@yahoo.com. Web site: www.geocities.com/prairiejournal. Circ. 600. Estab. 1983. Literary magazine published twice/year. Features mainly poetry and artwork. Sample copy available for $6 and 7×8½ SAE. Photo guidelines available for SAE and IRC.

Needs Buys 4 photos/year. Needs literary only, artistic.

Specs Uses b&w prints. Accepts images in digital format. Send via e-mail "if your query is successful."

Making Contact & Terms Send query letter with photocopies only (no originals) by mail. Provide self-promotion piece to be kept on file. Responds in 6 months, only if interested; send nonreturnable samples. Pays $10-50 for b&w cover or inside. Pays on publication. Credit line given. Buys first rights.

Tips "Black & white literary, artistic work preferred; not commercial. We especially like newcomers. Read our publication or check out our Web site. You need to own copyright for your work and have permission to reproduce it. We are open to subjects that would be suitable for a literary arts magazine containing poetry, fiction, reviews, interviews. We do not commission but choose from your samples."

Ⓝ ▣ PRAKN TREGER

National Yiddish Book Center, 1021 West St., Amherst MA 01002. E-mail: bwolfson@bikher.org. Web site: www.yiddishbookcenter.org. **Contact:** Betsey Wolfson, designer. Circ. 30,000. Estab. 1980. Literary magazine published 3 times/year; focuses on modern and contemporary Jewish and Yiddish culture.

Needs Needs photos of families, parents, senior citizens, education, religious, humor, historical/vintage, Jewish and Yiddish culture. Reviews photos with or without a manuscript. Captions required; include identification of subjects.

Specs Accepts images in digital format. Send JPEG or GIF files.

Making Contact & Terms Negotiates payment. Pays on publication. Credit line given. Buys one-time rights.

☑ PRIMAVERA

Box 37-7547, Chicago IL 60637. **Contact:** Editor. Annual literary/visual arts magazine. "We publish original fiction, poetry, drawings, paintings and photographs that deal with women's experiences." Sample copy available for $5. Photo guidelines free with SASE.

Needs Buys 2-12 photos from freelancers/issue. Needs photos of babies/children/teens, couples, multi-cultural, families, parents, senior citizens, environmental, landscapes/scenics, wildlife, architecture, gardening, interiors/decorating, rural.

Specs Uses b&w prints.

Making Contact & Terms Send unsolicited photos or photocopies by mail for consideration; include SASE for return of material. Responds in 1 month. Payment is 2 contributor's copies (issue in which photography appears). Pays on publication. Credit line given. Buys one-time rights.

PRINCETON ALUMNI WEEKLY

194 Nassau St., Princeton NJ 08542. (609)258-4722. Web site: www.princeton.edu/paw. **Contact:** Marianne Nelson, art director. Circ. 60,000. Magazine published 15 times/year. Emphasizes Princeton University and higher education. Readers are alumni, faculty, students, staff and friends of Princeton University. Sample copy available for $2 with 9×12 SAE and 2 first-class stamps.

Needs Assigns local and out-of-state photographers and purchases stock. Needs photos of "people, campus scenes; subjects vary greatly with content of each issue."

Making Contact & Terms Arrange a personal interview to show portfolio. Provide sample card to be kept on file for possible future assignments. Payment varies according to usage, size, etc. Pays on publication. Buys one-time rights.

$☐ Ⓐ ▣ THE PROGRESSIVE

409 E. Main St., Madison WI 53703. (608)257-4626. E-mail: photos@progressive.org. Web site: www.progressive.org. **Contact:** Nick Jehlen, art director. Circ. 68,000. Estab. 1909. Monthly political magazine. "Grassroots publication from a left perspective, interested in foreign and domestic issues of peace and social justice." Photo guidelines free and on Web site.

Needs Buys 5-10 photos from freelancers/issue; 50-100 photos/year. Looking for images documenting the human condition and the social/political environments of contemporary society. Special photo needs include "labor activities, environmental issues and political movements." Photo captions required; include name, place, date, credit information.

Specs Accepts low-resolution JPEGs via e-mail.

Making Contact & Terms Send query letter with photocopies; include SASE. Provide stock list to be kept on file for possible future assignments. Art director will contact photographer for portfolio review if interested. Responds once every month. Simultaneous submissions and previously published work OK. Pays $50-150 for b&w inside. Pays on publication. Credit line given. Buys one-time rights. All material returned with SASE.

Tips "Most of the photos we publish are of political actions. Interesting and well-composed photos of creative actions are the most likely to be published. We also use 2-3 short photo essays on political or social subjects per year." For detailed photo information, see Web site at www.art.progressive.org.

$☑ Ⓐ ▣ RACQUETBALL MAGAZINE

1685 W. Uintah, Colorado Springs CO 80904-2906. (719)635-5396. Fax: (719)635-0685. E-mail: jhiser@usra.org. Web site: www.usaracquetball.com. **Contact:** Jim Hiser, executive director. Circ. 30,000. Estab.

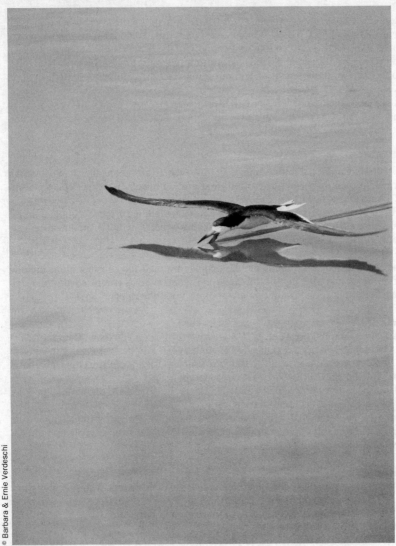

© Barbara & Ernie Verdeschi

Barbara and Ernie Verdeschi contacted the editor at Primavera and told her about their photographs of wild birds. The editor requested samples and published this photo of a black skimmer on the cover of the magazine.

1990. Bimonthly magazine of USA Racquetball. Emphasizes racquetball. Sample copy available for $4.50. Photo guidelines available.

Needs Buys 6-12 photos from freelancers/issue; 36-72 photos/year. Needs photos of action racquetball. Model/property release preferred. Photo captions required.

Specs Accepts images in digital format. Send via CD as EPS files at 900 dpi.

Making Contact & Terms Provide résumé, business card, brochure, flier or tearsheets to be kept on file for possible future assignments. Responds in 1 month. Previously published work OK. Pays $200 for color cover; $3-5 for b&w inside; $25-75 for color inside. Pays on publication. Credit line given. Buys all rights; negotiable.

$ ⊘ Ⓐ ▣ RAILMODEL JOURNAL

Golden Bell Press, Inc., 2403 Champa St., Denver CO 80205. (303)296-1600. Web site: www.railmodeljour
nal.com. **Contact:** Robert Schleicher, editor. Circ. 15,000. Estab. 1989. Monthly magazine for experienced
model railroaders who wish to recreate specific locomotives, cars, structures and complete scenes. Sample
copy available for $7.45.

Needs Buys 50 photos from freelancers/issue; 600 photos/year. Needs how-to photos. Interested in
documentary, historical/vintage. Reviews photos with accompanying manuscript only. Model release
required. Photo captions required.

Specs Uses 5×7 prints; 35mm transparencies. Accepts images in digital format. Send via CD as TIFF
files at 300 dpi.

Making Contact & Terms Send query letter with prints, transparencies, contact sheets. Does not keep
samples on file; include SASE for return of material. Responds in 2 months to queries. Pays $100 minimum
for cover; $10 minimum for b&w inside; $60 minimum for color inside. Pays on publication. Credit line
given. Buys one-time rights.

Tips "Depth of field is critical. Models must look real. Need step-by-step how-to sequences. ID each
image."

Ⓝ $ ⊘ ▣ THE RAMBLER

Rambler Publications, LLC, P.O. Box 5070, Chapel Hill NC 27514-5001. (919)545-9789. Fax: (919)545-
0921. E-mail: editor@ramblermagazine.com. Web site: www.ramblermagazine.com. **Contact:** Elizabeth
Oliver, editor. Circ. 4,000. Bimonthly literary magazine. Sample copy available. Photo guidelines are free
with an SASE or on the Web site.

Needs Buys 12 freelance photos/month; 75/year. Needs photos of cities/urban, environmental. Interested
in avant garde, documentary, fine art. Reviews photos with or without a manuscript. Model/property
release preferred.

Specs Uses 8×10 prints. Accepts images in digital format. Send TIFF files at 300 dpi via CD or e-mail.

Making Contact & Terms E-mail query letter with link to photographer's Web site, JPEG samples at 72
dpi. Does not keep samples on file; include SASE for return of material. Simultaneous submissions and
previously published work OK. Pays $100 maximum for b&w cover; $100 maximum for color cover. Pays
$25 maximum for b&w inside; $25 maximum for color inside. Pays on publication. Credit line given.
Buys one-time rights.

$ $ ⊠ RANGER RICK

11100 Wildlife Center Dr., Reston VA 20190-5362. (703)438-6525. Fax: (703)438-6094. E-mail: mcelhinne
y@nwf.org. Web site: www.nwf.org/rangerrick. **Contact:** Susan McElhinney, photo editor. Circ. 500,000.
Estab. 1967. Monthly educational magazine published by the National Wildlife Federation for children
ages 8-12. Photo guidelines free with SASE.

Needs Needs photos of children, multicultural, environmental, wildlife, adventure, science.

Specs Uses transparencies or digital capture; dupes or lightboxes OK for first edit.

Making Contact & Terms Send nonreturnable printed samples or Web site address. *Ranger Rick* space
rates: $300 (quarter page) to $1,000 (cover).

Tips "Seeking experienced photographers with substantial publishing history only."

REFORM JUDAISM

633 Third Ave., 7th Floor, New York NY 10017-6778. (212)650-4240. E-mail: rjmagazine@urj.org. Web
site: www.reformjudaismmag.org. **Contact:** Joy Weinberg, managing editor. Circ. 305,000. Estab. 1972.
Quarterly publication of the Union for Reform Judaism. Offers insightful, incisive coverage of the chal-
lenges faced by contemporary Jews. Readers are members of Reform congregations in North America.
Sample copy available for $3.50. Photo guidelines available via e-mail or on Web site.

Needs Buys 3 photos from freelancers/issue; 12 photos/year. Needs photos relating to Jewish life or
Jewish issues, Israel, politics. Model release required. Photo captions required.

Making Contact & Terms Provide résumé, business card, brochure, flier or tearsheets to be kept on file
for possible future assignments. Responds in 1 month. Simultaneous submissions and previously pub-
lished work OK. Include self-addressed, stamped postcard for response. Pays on publication. Credit line
given. Buys one-time rights, first North American serial rights.

Tips Wants to see "excellent photography: artistic, creative, evocative pictures that involve the reader."

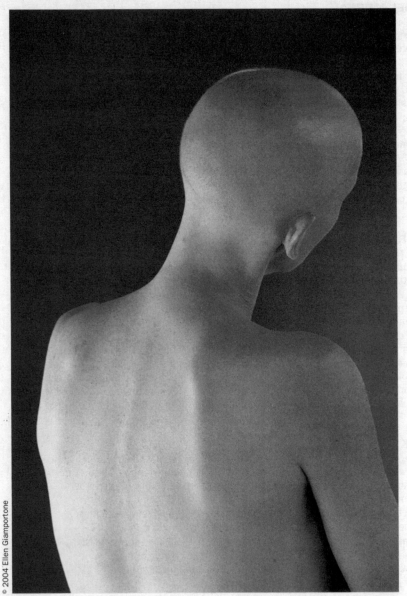

© 2004 Ellen Giamportone

A few years ago Ellen Giamportone contacted the editor at *The Rambler* and developed a working relationship with her. "She visits my Web site for images, and I also let her know when I have new work she might find interesting," says Giamportone. This image, published in *The Rambler*, was part of a series Giamportone made of a friend as she went through treatment for cancer.

$ ⬛ Ⓢ ▣ REMINISCE

Reiman Media Group, Inc., 5400 S. 60th St., Greendale WI 53129. Fax: (414)423-8463. E-mail: photocoord inator@reimanpub.com. Web site: www.reminisce.com. **Contact:** Trudi Bellin, photo coordinator. Estab. 1990. Bimonthly magazine. "The magazine that brings back the good times." Readers are males and females interested in nostalgia, ages 55 and over. "*Reminisce* is supported entirely by subscriptions and accepts no outside advertising." Sample copy available for $2. Photo guidelines free with SASE.

• *Reminisce EXTRA* is published in the months between regular issues. Content and guidelines are the same.

Needs Buys 17 photos from freelancers/issue; 200 photos/year. Needs good-quality b&w and color vintage photography; has occasional use for high-quality color shots of memorabilia. Photo captions preferred; include season, location.

Specs Accepts images in digital format: TIFF or high-quality JPEG files at 300 dpi for up to 9 × 11 reproduction. Embedded metadata is recommended. Send via lightboxes or on removable media. Or send CD/DVD with printed thumbnails and caption sheet. E-mail if first review selection is small (12 images or less). Will preview sharp photocopies to judge possible use; or color transparencies/b&w prints.

Making Contact & Terms Send query letter with list of stock photo subjects. Send unsolicited photos by mail for consideration. Submit seasonally. Keeps samples on file (tearsheets, no dupes); include SASE for return of material. Responds in 3 months. Previously published work OK. Buys stock only. Pays $150-300 for cover; $50-150 for inside. Pays on publication. Credit line given. Buys one-time rights, occasionally needs nonprint electronic rights.

Tips "We are continually in need of authentic color taken in the 1940s, 1950s and 1960s, and black & white stock photos. Technical quality is extremely important; focus must be sharp (no soft focus); we can work with shifted color on vintage photos. Study our magazine thoroughly—we have a continuing need for vintage color and black &white images, and those who can supply what we need can expect to be regular contributors."

▣ REVOLUTIONARY WAR TRACKS

2660 Petersborough St., Herndon VA 20171. E-mail: tiedbylove@yahoo.com. Estab. 2005. Quarterly magazine, "bringing Revolutionary War history alive for children and teens." Photo guidelines available by e-mail request.

Needs Buys 12-24 photos/year. Needs photos of babies/children/teens, multicultural, families, parents, disasters, environmental, landscapes/scenics, wildlife, cities/urban, education, religious, rural, adventure, events, food/drink, sports, travel, agriculture, medicine, military, political, product shots/still life, science, technology—as related to Revolutionary War history. Interested in alternative process, avant garde, documentary, fashion/glamour, fine art, historical/vintage, seasonal. Reviews photos with or without a manuscript. Model/property release preferred.

Specs Uses glossy or matte color and/or b&w prints.

Making Contact & Terms Send query letter via e-mail. "If possible, please do not include photographs in files if they are sent through e-mail. A disk with your photographs is acceptable." Provide résumé, business card or self-promotion piece to be kept on file for possible future assignments. "Photographs sent with CDs are requested but not required." Responds within 1 month to queries; 1 week to portfolios. Simultaneous submissions and previously published work OK. **Pays on acceptance.** Credit line given. Buys one-time rights, first rights; negotiable.

▣ ▣ RHODE ISLAND MONTHLY

Rhode Island Monthly Communications, Inc., 280 Kinsley Ave., Providence RI 02903-1017. (401)277-8174. Fax: (401)277-8080. Web site: www.rimonthly.com. **Contact:** Ellen Dessloch, art director. Circ. 40,000. Estab. 1988. Monthly regional publication for and about Rhode Island.

Needs Buys 15 photos from freelancers/issue; 200 photos/year. "Almost all photos have a local slant: portraits, photo essays, food, lifestyle, home, issues."

Specs Uses glossy b&w prints; 35 mm, 2¼ × 2¼, 4 × 5 transparencies. Accepts images in digital format.

Making Contact & Terms Send query letter with tearsheets, transparencies. Portfolio may be dropped off. Provide self-promotion piece to be kept on file for possible future assignments. Will return anything with SASE. Responds in 2 weeks. Pays "about a month after invoice is submitted." Credit line given. Buys one-time rights.

Tips "Freelancers should be familiar with *Rhode Island Monthly* and should be able to demonstrate their proficiency in the medium before any work is assigned."

$ ▣ Ⓐ ▣ THE ROANOKER

P.O. Box 21535, Roanoke VA 24018. (540)989-6138. Fax: (540)989-7603. E-mail: jwood@leisurepublishing.com. Web site: www.theroanoker.com. **Contact:** Jeffrey K. Wood, associate editor. Circ. 14,000. Estab. 1974. Bimonthly. Emphasizes Roanoke region and western Virginia. Readers are upper-income, educated people interested in their community. Sample copy available for $3.

Needs Buys 30 photos from freelancers/issue; 180 photos/year. Needs photos of couples, multicultural, families, parents, senior citizens, architecture, cities/urban, education, interiors/decorating, entertainment, events, food/drink, health/fitness/beauty, performing arts, sports, travel, business concepts, medicine, technology/computers, seasonal. Needs "travel and scenic photos in western Virginia; color photo essays on life in western Virginia." Model/property release preferred. Photo captions required.
Making Contact & Terms Send any size glossy color prints and transparencies (preferred) by mail with SASE for consideration. Accepts images in digital format. Send via CD, Zip, e-mail as TIFF, EPS, GIF, JPEG files at 300 dpi, minimum print size 4×6 with cutlines and thumbnails. Responds in 1 month. Simultaneous submissions and previously published work OK. Pays $100-150 for color cover; $15-25 for b&w inside; $25-100 for color inside; $100/day. Pays on publication. Credit line given. Rights purchased vary; negotiable.

ROCKFORD REVIEW

P.O. Box 858, Rockford IL 61105. Web site: http://writersguild1.tripod.com. **Contact:** David Ross, editor. Circ. 750. Estab. 1982. Association publication of Rockford Writers' Guild. Published twice/year (summer and winter). Emphasizes poetry and prose of all types. Readers are of all stages and ages who share an interest in quality writing and art. Sample copy available for $9.

• This publication is literary in nature and publishes very few photographs. However, the photos on the cover tend to be experimental (e.g., solarized images, photograms, etc.).

Needs Uses 1-5 photos/issue; all supplied by freelancers. Needs photos of scenics and personalities. Model/property release preferred. Photo captions preferred; include when and where, and biography.
Specs Uses 8×10 or 5×7 glossy b&w prints.
Making Contact & Terms Send unsolicited photos by mail for consideration. Does not keep samples on file; include SASE for return of material. Responds in 6 weeks. Simultaneous submissions OK. Payment is one copy of magazine, but work is eligible for *Review*'s $25 Editor's Choice prize. Pays on publication. Credit line given. Buys first North American serial rights.
Tips "Experimental work with a literary magazine in mind will be carefully considered. Avoid the 'news' approach."

ⓝ ☑ ▣ ROCKY MOUNTAIN SPORTS MAGAZINE

Windy City Publishing, Inc., 2525 15th St., #1A, Denver CO 80211. (303)477-9770. Fax: (303)477-9747. E-mail: rheaton@rockymountainsports.com. Web site: www.rockymountainsports.com. **Contact:** Rebecca Heaton. Estab. 1986. Circ. 95,000. Monthly consumer magazine covering running, mountain biking, road racing, snowboarding, both alpine and Nordic skiing, kayaking, hiking, climbing, mountaineering, and other individual sports.
Needs Needs photos of adventure, running, mountain biking, road racing, snowboarding, both alpine and Nordic skiing, kayaking, hiking, climbing, mountaineering, and other individual sports. Interested in lifestyle. Editorial calendar: March: running; April: adventure; May: triathlon; June: climbing/paddling/mountain biking; July: summer travel; August: organic; September: women; October: gym/fitness; November: snow sports; December: snow sports. Reviews photos with or without a manuscript. Model release required. Captions required; include identification of subjects.
Specs Accepts images in digital format. Send JPEG or TIFF files at 300 dpi minimum.
Making Contact & Terms Payment negotiated. Pays on publication. Credit line given. Buys one-time rights.
Tips "Think fun. Don't be afraid to try something new. We like new."

☑ ▣ ROLLING STONE

1290 Avenue of the Americas, 2nd Floor, New York NY 10104. (212)484-1616. Fax: (212)767-8203. Web site: www.rollingstone.com. **Contact:** Jodi Peckman, director of photography. Circ. 1,254,148. Estab. 1967. Biweekly consumer magazine. Emphasizes film, CD reviews, music groups, celebrities, fashion. Readers are young adults interested in news of popular music, politics and culture.
Needs Needs photos of celebrities, political, entertainment, events. Interested in alternative process, avant garde, documentary, fashion/glamour.
Specs Accepts images in digital format. Send as TIFF, JPEG files at 300 dpi.
Making Contact & Terms Portfolio may be dropped off every Wednesday and picked up on Friday afternoon. Provide business card, self-promotion piece to be kept on file for possible future assignments. Responds only if interested; send nonreturnable samples.

Tips "It's not about a photographer's experience, it's about a photographer's talent and eye. Lots of photographers have years of professional experience but their work isn't for us. Others might not have years of experience, but they have this amazing eye."

N $ ROMANTIC HOMES

APG Meida, 265 S. Anita Dr., Suite 120, Orange CA 92868-3310. (714)939-9991. Fax: (714)939-9909. E-mail: editorial@romantichomes.com. Web site: www.romantichomes.com. **Contact:** Jacqueline Demontravel, editor. Circ. 140,000. Estab. 1983. Monthly magazine for women who want to create a warm, intimate and casually elegant home. Provides how-to advice, along with information on furniture, home decorating ideas, floor and window coverings, artwork, travel, etc. Sample copy available for SASE.
Needs Buys 20-30 photos from freelancers/issue; 240-360 photos/year. Needs photos of gardening, interiors/decorating, travel. Reviews photos with accompanying manuscript only. Model/property release required. Photo captions preferred.
Specs Uses $2^{1}/_{4} \times 2^{1}/_{4}$ transparencies.
Making Contact & Terms Send query letter with transparencies, stock list. Provide self-promotion piece to be kept on file for possible future assignments. Responds in 3 weeks. Simultaneous submissions OK. Pays net 30 days for images and on publication for articles. Credit line/byline given. Buys all rights; negotiable.

THE ROTARIAN

1560 Sherman Ave., Evanston IL 60201. (847)866-3000. Fax: (847)866-9732. E-mail: lawrende@rotaryintl .org. Web site: www.rotary.org. **Contact:** Deborah Lawrence, creative director, or Alyce Henson, photo editor. Circ. 500,000. Estab. 1911. Monthly organization magazine for Rotarian business and professional men and women and their families. "Dedicated to business and professional ethics, community life, and international understanding and goodwill." Sample copy and photo guidelines free with SASE.
Needs Buys 5 photos from freelancers/issue; 60 photos/year. "Our greatest needs are for assigned location photography that is specific to Rotary, i.e., humanitarian projects, fundraisers, conventions. Photo captions essential."
Specs Uses 35mm, $2^{1}/_{4} \times 2^{1}/_{4}$, 4×5 transparencies. Prefers digital images at 300 dpi, 24MB files.
Making Contact & Terms Send query e-mail, fee schedule and link to online portfolio. Creative director will contact photographer for portfolio review if interested. Keeps e-mail, promotion samples on file. Do not send unsolicited originals. Responds in 3 weeks. Simultaneous submissions and previously published work OK. Payment negotiable. **Pays on acceptance**. Credit line given. Buys one-time rights; occasionally all rights; negotiable.
Tips "We prefer high-resolution digital images in most cases. The key words for the freelance photographer to keep in mind are *internationality* and *variety*. Study the magazine. Read the kinds of articles we publish. Think how your photographs could illustrate such articles in a dramatic, storytelling way."

$ A RUGBY MAGAZINE

33 Kings Highway, Orangeburg, NY 10962. (212)787-1160. Fax: (212)787-1161. E-mail: rugbymag@aol.c om. Web site: www.rugbymag.com. **Contact:** Ed Hagerty, editor/publisher. Circ. 10,000. Estab. 1975. Monthly magazine emphasizing rugby matches. Readers are male and female, wealthy, well-educated, ages 16-60. Sample copy available for $4 with $1.25 postage.
Needs Uses 20 photos/issue; most supplied by freelancers. Needs rugby action shots. Reviews photos with accompanying manuscript only.
Specs Uses color or b&w prints. Accepts images in digital format. Send as high-res JPEG or TIFF files at 300 dpi.
Making Contact & Terms Send unsolicited photos by mail with SASE for consideration. Provide résumé, business card, brochure, flier or tearsheets to be kept on file for possible future assignments. Responds in 2 weeks. Simultaneous submissions and previously published work OK. "We only pay when we assign a photographer. Rates are very low, but our magazine is a good place to get some exposure." Pays on publication. Credit line given. Buys one-time rights.

$ RURAL HERITAGE

281 Dean Ridge Lane, Gainesboro TN 38562-5039. (931)268-0655. E-mail: editor@ruralheritage.com. Web site: www.ruralheritage.com. **Contact:** Gail Damerow, editor. Circ. 8,500. Estab. 1976. Bimonthly journal in support of modern-day farming and logging with draft animals (horses, mules, oxen). Sample

copy available for $8 ($10 outside the U.S.). Photo guidelines available on Web site or via e-mail.

Needs "Quality photographs of draft animals working in harness."

Specs "For interior pages we use glossy color prints, high-quality slides, or high-resolution images (300 dpi or greater) shot with a quality digital camera. For covers we use 5×7 glossy color prints, large-format transparencies, or high-resolution images shot with a quality digital camera. Digital images must be original (not resized, cropped, etc.) files from a digital camera; scans unacceptable."

Making Contact & Terms Send query letter with samples. "Please include SASE for the return of your material, and put your name and address on the back of each piece." Pays $100 for color cover; $10-25 for b&w inside. Also provides 2 copies of issue in which work appears. Pays on publication.

Tips "Animals usually look better from the side than from the front. We like to see all the animal's body parts, including hooves, ears and tail. For animals in harness, we want to see the entire implement or vehicle. We prefer action shots (plowing, harvesting hay, etc.). Watch out for shadows across animals and people. Please include the name of any human handlers involved, the farm, the town (or county), state, and the animals' names (if possible) and breeds. You'll find current guidelines in the 'Business Office' of our Web site."

$ ▣ RUSSIAN LIFE MAGAZINE

P.O. Box 567, Montpelier VT 05601. (802)223-4955. E-mail: editors@russianlife.net. Web site: www.russi anlife.net. **Contact:** Paul Richardson, publisher. Estab. 1956. Bimonthly magazine.

Needs Uses 25-35 photos/issue. Offers 10-15 freelance assignments/year. Needs photojournalism related to Russian culture, art and history. Model/property release preferred.

Making Contact & Terms Works with local freelancers only. Send query letter with samples. Send 35mm, 2¼×2¼, 4×5, 8×10 transparencies; 35mm film; digital format. Include SASE "or material will not be returned." Responds in 1 month. Pays $20-50 (color photo with accompanying story), depending on placement in magazine. Pays on publication. Credit line given. Buys one-time and electronic rights.

$ $☑ ▣ SAIL MAGAZINE

98 N. Washington St., 2nd Floor, Boston MA 02114. (617)720-8600. Fax: (617)723-0912. E-mail: kate.berr y@primedia.com. Web site: www.sailmagazine.com. **Contact:** Kate Berry, photo editor. Circ. 200,000. Estab. 1970. Monthly magazine. Emphasizes all aspects of sailing. Readers are managers and professionals, average age 44. Photo guidelines free with SASE and on Web site.

Needs Buys 50-100 images/issue. "Particularly interested in photos for cover and 'pure sail' sections. Ideally, these photos would be digital files @300 dpi with a run size of approximately 9×12 for cover, 9×16 for 'pure sail'." Also accepts 35mm transparencies. Vertical cover shots also needed. Photo captions required.

Specs Accepts images in digital format. Send high-resolution JPEG, TIFF and RAW files via CD, DVD or FTP (contact for FTP log-in info). Also accepts all forms of transparencies and prints with negatives.

Making Contact Terms Send unsolicited 35mm and 2¼×2¼ transparencies by mail with SASE for consideration. Pays $1,000 for color cover; $50-800 for color inside; also negotiates prices on a per day, per hour and per job basis. Pays on publication. Credit line given. Buys one-time North American rights. Photo shoots commissioned using half- or full-day rates.

$ $ $☑ ▣ SALT WATER SPORTSMAN

2 Park Ave., New York NY 10016. (212)779-5179. Fax: (212)779-5999. E-mail: editor@saltwatersportsma n.com. Web site: www.saltwatersportsman.com. **Contact:** David Dibenedetto, editor. Circ. 175,000. Estab. 1939. Monthly magazine. Emphasizes all phases of saltwater sport fishing for the avid beginner-to-professional saltwater angler. "Number-one monthly marine sport fishing magazine in the U.S." Sample copy free with 9×12 SAE and 7 first-class stamps. Photo guidelines free.

Needs Buys photos (including covers) without manuscript; 20-30 photos/issue with manuscript. Needs saltwater fishing photos. "Think fishing action, scenery, mood, storytelling close-ups of anglers in action. Make it come alive—and don't bother us with the obviously posed 'dead fish and stupid fisherman' back at the dock." Wants, on a regular basis, cover shots (clean verticals depicting saltwater fishing action). For accompanying manuscript, needs fact/feature articles dealing with marine sport fishing in the U.S., Canada, Caribbean, Central and South America. Emphasis on how-to.

Specs Uses 35mm or 2¼×2¼ transparencies; vertical format preferred for covers. Accepts images in digital format. Send via CD, Zip; format as 8-bit, unconverted, 300 dpi, RGB TIFF. A confirming laser or

proof of each image must accompany the media. A printed disk directory with each new name written next to each original name must be provided.

Making Contact & Terms Send material by mail for consideration, or query with samples. Provide résumé or tearsheets to be kept on file for possible future assignments. Holds slides for 1 year and will pay as used; include SASE for return of material. Responds in 1 month. Pays $2,500 maximum for cover; $100-500 for color inside; $500 minimum for text-photo package. **Pays on acceptance.**

Tips "Prefer to see a selection of fishing action and mood; must be sport fishing-oriented. Read the magazine! No horizontal cover slides with suggestions it can be cropped, etc. Don't send Ektachrome. We're using more 'outside' photography—that is, photos not submitted with manuscript package. Take lots of verticals and experiment with lighting."

$◩▣ SANDLAPPER MAGAZINE

P.O. Box 1108, Lexington SC 29071. Fax: (803)359-0629. E-mail: aida@sandlapper.org. Web site: www.sa ndlapper.org. **Contact:** Aida Rogers, editor. Estab. 1989. Quarterly magazine. Emphasizes South Carolina topics *only*.

Needs Uses about 10 photographers/issue. Needs photos of anything related to South Carolina in any style, "as long as they're not in bad taste." Model release preferred. Photo captions required; include places and people.

Specs Uses 8×10 color and b&w prints; 35mm, $2^{1}/_{4} \times 2^{1}/_{4}$, 4×5, 8×10 transparencies. Accepts images in digital format. Send via CD, Zip as TIFF, JPEG files at 300 dpi. "Do not format exclusively for PC. RGB preferred. Submit low-resolution and high-resolution files, and label them as such. Please call or e-mail Elaine Gillespie with any questions" about digital submissions: (803)779-2126; elaine@thegillespieagen-cy.com.

Making Contact & Terms Send query letter with samples. Keeps samples on file; include SASE for return of material. Responds in 1 month. Pays $100 for color cover; $50-100 for color inside. Pays 1 month *after* publication. Credit line given. Buys first rights plus right to reprint.

Tips "Looking for any South Carolina topic—scenics, people, action, mood, etc."

$ SANTA BARBARA MAGAZINE

25 E. De La Guerra St, Santa Barbara CA 93101. (805)965-5999. Fax: (805)965-7627. E-mail: editorial@sb mag.com. Web site: www.sbmag.com. **Contact:** Jennifer Smith Hale, publisher. Art Director: Alisa Baur. Editor: Gina Tolleson. Circ. 40,000. Estab. 1975. Bimonthly magazine. Emphasizes Santa Barbara community and culture. Sample copy available for $4.95 with 9×12 SASE.

Needs Buys 64-80 photos from freelancers/issue; 384-480 photos/year. Needs portrait, environmental, architectural, travel, celebrity, etc. Reviews photos with accompanying manuscript only. Model release required. Photo captions preferred.

Making Contact & Terms Provide résumé, business card, brochure, flier or tearsheets to be kept on file for possible future assignments; "portfolio drop-off 24 hours." Cannot return unsolicited material. Pays $75-250 for b&w or color. Pays on publication. Credit line given. Buys first North American serial rights.

Tips Prefers to see strong personal style and excellent technical ability. "Work needs to be oriented to our market. Know our magazine and its orientation before contacting me."

$▣ SCHOLASTIC MAGAZINES

568 Broadway, New York NY 10012. (212)343-7147. Fax: (212)343-7799. E-mail: sdiamond@scholastic.c om. Web site: www.scholastic.com. **Contact:** Steven Diamond, executive director of photography. Estab. 1920. Publication of magazines varies from weekly to monthly. "We publish 27 titles on topics from current events, science, math, fine art, literature and social studies. Interested in featuring high-quality, well-composed images of students of all ages and all ethnic backgrounds."

Needs Needs photos of various subjects depending upon educational topics planned for academic year. Model release required. Photo captions required. "Images must be interesting, bright and lively!"

Specs Accepts images in digital format. Send via CD, e-mail.

Making Contact & Terms Send query letter with résumé, business card, brochure, flier or tearsheets to be kept on file for possible future assignments. Material cannot be returned. Previously published work OK. Pays on publication.

Tips Especially interested in good photography of all ages of student population.

$ $ $ SCIENTIFIC AMERICAN

415 Madison Ave., New York NY 10017. (212)451-8891. Fax: (212)755-1976. E-mail: eharrison@sciam.com. Web site: www.sciam.com. **Contact:** Emily Harrison, photography editor. Circ. one million. Estab. 1854. Emphasizes science, policy, technology and people involved in science. Seeking to broaden our 20-40 year-old readership.

Needs Buys 100 photos from freelancers/issue. Needs all kinds of photos. Model release required; property release preferred. Photo captions required.

Making Contact & Terms Arrange a personal interview to show portfolio. "Do not send unsolicited photos." Provide résumé, business card, brochure, flier or tearsheets to be kept on file for possible future assignments and note photo Web site. Cannot return material. Responds in 1 month. Pays $600/day; $1,000 for color cover. Pays on publication. Credit line given. Buys one-time rights and world rights. Frequently leads to re-use buying and develops relationships with scientists and writers needing photo work.

Tips Wants to see strong natural and artificial lighting, location portraits and location shooting. Intelligent artistic photography and photo-illustration welcomed. Send business cards and promotional pieces frequently when dealing with magazine editors. Find a niche.

$ ☐ ◻ SEA, America's Western Boating Magazine

17782 Cowan, Suite A, Irvine CA 92614. (949)660-6150. Fax: (949)660-6172. E-mail: editorial@goboating.com. Web site: www.goboating.com. **Contact:** Mike Telleria, managing editor. Associate Editor and Publisher: Jeff Fleming. Circ. 50,000. Monthly magazine. Emphasizes "recreational boating in 13 Western states (including some coverage of Mexico and British Columbia) for owners of recreational power boats." Sample copy and photo guidelines free with 10×13 SAE.

Needs Uses about 50-75 photos/issue; most supplied by freelancers; 10% assignment; 75% requested from freelancers, existing photo files, or submitted unsolicited. Needs "people enjoying boating activity (families, parents, senior citizens) and scenic shots (travel, regional); shots that include parts or all of a boat are preferred." Photos should have West Coast angle. Model release required. Photo captions required.

Specs Accepts images in digital format. Send via CD, SyQuest, Zip, e-mail as TIFF, EPS, JPEG files at 266 dpi. Call managing editor for FTP instructions.

Making Contact & Terms Send query letter with samples; include SASE for return of material. Responds in 1 month. Pay rate varies according to size published (range is $50-200 for color). Pays on publication. Credit line given. Buys one-time North American rights and retains reprint rights via print and electronic media.

Tips "We are looking for sharp color transparencies with good composition showing pleasure boats in action, and people having fun aboard boats in a West Coast location. Digital shots are preferred; they must be at least 5 inches wide and a minimum of 300 dpi. We also use studio shots of marine products and do personality profiles. Send samples of work with a query letter and a résumé or clips of previously published photos. *Sea* does not pay for shipping; will hold photos up to 6 weeks."

Ⓝ $ $ ☑ Ⓐ ◻ SEATTLE HOMES AND LIFESTYLES

Network Communications, Inc., 1221 E. Pike St., Suite 305, Seattle WA 98122. (206)322-6699. Fax: (206)322-2799. E-mail: swilliams@seattlehomesmag.com. Web site: www.seattlehomesmag.com. **Contact:** Shawn Williams, art director. Circ. 30,000. Estab. 1996. Magazine published 10 times/year. Emphasizes home design, gardens, architecture, lifestyles (profiles, food, wine). Sample copy available for $3.95 and SAE.

Needs Buys 35-60 photos from freelancers/issue; 200 photos/year. Needs photos of architecture, interior design, gardening, entertainment, events, food/drink. Interested in fine art, seasonal. All work is commissioned specifically for magazine. Model release required. Photo captions required. "Do not send photos without querying first."

Specs Uses 35mm, 2¼×2¼, 4×5 transparencies. Accepts images in digital format.

Making Contact & Terms No phone calls, please. Send query letter with résumé, photocopies, tearsheets. Provide self-promotion piece to be kept on file for possible future assignments. Responds only if interested; send nonreturnable samples. Payment varies by assignment, $140-750, depending on number of photos and complexity of project. **Pays on acceptance.** Credit line given. Buys exclusive one-time rights, first rights for one year; includes Web usage for one year.

Tips "We primarily use experienced architectural and interior photographers for home-design stories;

garden photographers and portrait photographers for profiles and occasional celebrity profiles. Photographers must be in Seattle area.''

⊘ Ⓐ SEVENTEEN MAGAZINE

Hearst Communications, Inc., 300 W 57th St., New York NY 10019-3741. (917)934-6500. Web site: www.seventeen.com. *Seventeen* is a young women's fashion and beauty magazine. Tailored to young women in their teens and early 20s, *Seventeen* covers fashion, beauty, health, fitness, food, cars, college, careers, talent, entertainment, fiction, plus crucial personal and global issues. Photos purchased on assignment only. *Query before submitting.*

$⊘ ▣ SHARING THE VICTORY

Fellowship of Christian Athletes, 8701 Leeds Rd., Kansas City MO 64129. (816)921-0909. Fax: (816)921-8755. E-mail: stv@fca.org. Web site: www.sharingthevictory.com. **Contact:** Jill Ewert, managing editor. Circ. 80,000. Estab. 1982. Monthly association magazine featuring stories and testimonials of prominent athletes and coaches in sports who proclaim a relationship with Jesus Christ. Sample copy available for $1 and 9×12 SAE. No photo guidelines available.

Needs Needs photos of sports. ''We buy photos of persons being featured in our magazine. We don't buy photos without story being suggested first.'' Reviews photos with accompanying manuscript only. ''All submitted stories must be connected to the FCA Ministry.'' Model release preferred; property release required. Photo captions preferred.

Specs Uses glossy or matte color prints; 35mm, $2\frac{1}{4} \times 2\frac{1}{4}$ transparencies. Accepts images in digital format. Send via CD, Zip, e-mail as TIFF, JPEG files at 300 dpi.

Making Contact & Terms Contact through e-mail with a list of types of sports photographs in stock. Do not send samples. Simultaneous submissions OK. Pays $150 maximum for color cover; $100 maximum for color inside. Pays on publication. Credit line given. Buys one-time rights.

Tips ''We would like to increase our supply of photographers who can do contract work.''

$⊘ ▣ SHINE BRIGHTLY

P.O. Box 7259, Grand Rapids MI 49510. (616)241-5616. Fax: (616)241-5558. E-mail: sara@gemsgc.org. Web site: www.gemsgc.org. **Contact:** Sara Hilton, senior editor. Circ. 15,500. Estab. 1970. Monthly publication of GEMS Girls' Club. Emphasizes ''girls ages 9-14 in action. The magazine is a Christian girls' publication geared to the needs and activities of girls in the above age group.'' Sample copy and photo guidelines available for $1 with 9×12 SASE.

Needs Uses about 5-6 photos/issue. Needs ''photos suitable for illustrating stories and articles: photos of babies/children/teens, multicultural, religious, girls aged 9-14 from multicultural backgrounds, close-up shots with eye contact.'' Model/property release preferred.

Specs Uses 5×7 glossy color prints. Accepts images in digital format. Send via Zip, CD as TIFF, BMP files at 300 dpi.

Making Contact & Terms Send 5×7 glossy color prints by mail (include SASE), electronic images by CD only (no e-mail) for consideration. Will view photographer's Web site if available. Responds in 2 months. Simultaneous submissions OK. Pays $50-75 for cover; $35 for color inside. Pays on publication. Credit line given. Buys one-time rights.

Tips ''Make the photos simple. We prefer to get a spec sheet or CDs rather than photos, and we'd really like to hold photos sent to us on speculation until publication. We select those we might use and send others back. Freelancers should write for our annual theme update and try to get photos to fit the theme of each issue.'' Recommends that photographers ''be concerned about current trends in fashions, hair styles, and realize that all girls don't belong to 'families.' Please, no slides, no negatives and no e-mail submissions.''

$ $⊘ ▣ SHOOTING SPORTS USA

NRA, 11250 Waples Mill Rd., Fairfax VA 22030. (703)267-1310. E-mail: shootingsportsusa@nrahq.org. Web site: www.nrapublications.org. **Contact:** Tes Salb, editor. Circ. 25,000. Monthly publication of the National Rifle Association of America. Emphasizes competitive shooting sports (rifle, pistol and shotgun). Readers are mostly NRA-classified competitive shooters, including Olympic-level shooters. Sample copy free with 9×12 SAE and $1 postage. Editorial guidelines free with SASE.

Needs Buys 15-25 photos from freelancers/issue; 180-300 photos/year. Needs photos of how-to, shooting

positions, specific shooters. Quality photos preferred with accompanying manuscript. Model release required. Photo captions preferred.

Specs Uses 8×10 glossy color prints; 35mm and medium-format tranparencies. Accepts images in digital format. Send via CD as TIFF files at 300 dpi.

Making Contact & Terms Send query letter with photo and editorial ideas by mail. Include SASE. Responds in 2 weeks. Previously published work OK when cleared with editor. Pays $150-400 for color cover; $50-150 for color inside; $250-500 for photo/text package; amount varies for photos alone. Pays on publication. Credit line given. Buys first North American serial rights.

Tips Looks for "generic photos of shooters shooting, obeying all safety rules and using proper eye protection and hearing protection. If text concerns certain how-to advice, photos are needed to illuminate this. Always query first. We are in search of quality photos to interest both beginning and experienced shooters."

☑ 🖥 SHOTS

P.O. Box 27755, Minneapolis MN 55427-0755. E-mail: shotsmag@juno.com. Web site: www.shotsmag.com. **Contact:** Russell Joslin, editor/publisher. Circ. 2,000. Quarterly fine art photography magazine. "We publish black-and-white fine art photography by photographers with an innate passion for personal, creative work." Sample copy available for $5. Photo guidelines free with SASE or on Web site.

Needs Fine art photography of all types accepted for consideration (but not bought). Reviews photos with or without a manuscript. Model/property release preferred. Photo captions preferred.

Specs Uses 8×10 b&w prints. Accepts images in digital format. Send via CD as TIFF files at 300 dpi. "See Web site for further specifications."

Making Contact & Terms Send query letter with prints. There is a **$15 submission fee for nonsubscribers** (free for subscribers). Include SASE for return of material. Responds in 3 months. Credit line given. Does not buy photographs/rights.

Ⓝ $🖥 ⬛ SKI CANADA

117 Indian Rd., Toronto ON M6R 2V5 Canada. (416)538-2293. Fax: (416)538-2475. E-mail: design@skicanadamag.com. Web site: skicanadamag.com. **Contact:** Iain MacMillan, editor. Magazine published monthly, September-February. Readership is 65% male, ages 25-44, with high income. Circ. 50,000. Sample copy free with SASE.

Needs Buys 80 photos from freelancers/issue; 480 photos/year. Needs photos of skiing—travel (within Canada and abroad), new school, competition, equipment, instruction, news and trends. Photo captions preferred.

Specs Uses 35mm color transparencies. Accepts images in digital format. Send via e-mail.

Making Contact & Terms Send unsolicited photos by mail for consideration; include SASE for return of material. Provide résumé, business card, brochure, flier or tearsheets to be kept on file for possible future assignments. Responds in 1 month. Simultaneous submissions OK. Pays $400 for cover; $50-200 for inside. Pays within 30 days of publication. Credit line given.

Tips "Please see http://travel.canoe.ca/SkiCanada/mediakit.html#editorial for the annual editorial lineup."

◐ 🖥 SKIPPING STONES: A Multicultural Children's Magazine

P.O. Box 3939, Eugene OR 97403. (541)342-4956. E-mail: editor@ SkippingStone.org. Web site: www.skippingstones.org. **Contact:** Arun N. Toké, managing editor. Circ. 2,000 and electronic readership. Estab. 1988. Nonprofit, noncommercial magazine published 5 times/year. Emphasizes multicultural and ecological issues. Readers are youth ages 8-16, their parents and teachers, schools and libraries. Sample copy available for $6 (including postage). Photo guidelines free with SASE.

Needs Buys 10-15 photos from freelancers/issue; 50 photos/year. Needs photos of nature (animals, wildlife), children and youth, cultural celebrations, international travel, school/home life in other countries or cultures. Model release preferred. Photo captions preferred; include site, year, names of people in photo.

Specs Uses 4×6, 5×7 glossy color and/or b&w prints. Accepts images in digital format. Send via CD as TIFF, JPEG files at 300 dpi.

Making Contact & Terms Send unsolicited photos by mail for consideration. Keeps samples on file; include SASE for return of material. Responds in 4 months. Simultaneous submission s OK. Pays in contributor's copies; "we're a labor of love." For photo essays, "we provide 5-10 copies to contributors.

Additional copies at a 25% discount.'' Credit line given. Buys first North American serial rights and nonexclusive reprint rights; negotiable.

Tips ''We publish black & white inside; color on cover. Should you send color photos, choose the ones with good contrast that can translate well into black & white photos. We are seeking meaningful, humanistic and realistic photographs.''

◙ SMITHSONIAN

MRC 513, P.O. Box 37012, Washington DC 20013-7012. (202)633-6090. Fax: (202)633-6095. Web site: www.smithsonianmagazine.com. **Contact:** Jeff Campagna, art department administrator. Monthly magazine. *Smithsonian* chronicles the arts, environment, sciences and popular culture of the times for today's well-rounded individuals with diverse, general interests, providing its readers with information and knowledge in an entertaining way. Visit Web site for photo submission guidelines. *Does not accept unsolicited photos or portfolios. Call or query before submitting.*

$ ▣ SOUTHCOMM PUBLISHING COMPANY, INC.

2600 Abbey Court, Alpharetta GA 30004. (678)624-1075. Fax: (678)624-1079. E-mail: cwwalker@southcomm.com. Web site: www.southcomm.com. **Contact:** Carolyn Williams-Walker, managing editor. Estab. 1985. ''We publish approximately 35 publications throughout the year. They are primarily for chambers of commerce throughout the Southeast (Georgia, Tennesee, South Carolina, North Carolina, Alabama, Virgina, Florida). We are expanding to the Northeast (Pennsylvania) and Texas. Our publications are used for tourism, economic development and marketing purposes. We also are a custom publishing company, offering brochures and other types of printed material.''

Needs Needs photos of babies/children/teens, celebrities, couples, multicultural, families, parents, senior citizens, architecture, cities/urban, education, gardening, interiors/decorating, pets, religious, rural, agriculture, business concepts, industry, medicine, military, polictical, science/technology/computers, environmental, landscapes/scenics, wildlife, automobiles, entertainment, events, food/drink, health/fitness/beauty, hobbies, performing arts, sports. Interested in lifestyle and seasonal. ''We are only looking for photographers who can travel to the communities with which we're working as we need shots that are specific to those locations. We will not consider generic stock-type photos. Images are generally for editorial purposes; however, advertising shots sometimes are required.'' Reviews photos with or without a manuscript. Model/property release preferred. Photo captions required. Indentify people, buildings and as many specifics as possible.''

Specs Prefers images in digital format. Send via CD, saved as TIFF, GIF or JPEG files for Mac at no less than 300 dpi. Uses matte color prints. ''We prefer digital photography for all our publications.''

Making Contact & Terms Send query letter with résumé and photocopies. Keeps samples on file; provide résumé, business card. Responds only if interested; send nonreturnable samples. Considers previously published work. Pays $40 minimum; $60 maximum for color inside. ''Payment per photo varies per project. However, rates are mainly toward the minimum end of the range. We pay the same rates for cover images as for interior shots because, at times, images identified for the cover cannot be used as such. They are then used in the interior instead.'' **Pays on acceptance**. Credit line given. ''Photos that are shot on assignment become the property of SouthComm Publishing Company, Inc. They cannot be released to our clients or another third party. We will purchase one-time rights to use images from photographers should the need arise.'' Will negotiate with a photographer unwilling to sell all rights.

Tips ''We are looking for photograpehrs who enjoy traveling and are highly organized and can communicate well with our clients as well as with us. Digital photographers *must* turn in contact sheets of all images shot in the community, clearly identifying the subjects.''

$ $ ⑤ ▣ SOUTHERN BOATING

Southern Boating & Yachting, Inc., 330 N. Andrews Ave., Ft. Lauderdale FL 33301. (954)522-5515. Fax: (954)522-2260. E-mail: marilyn@southernboating.com. Web site: www.southernboating.com. **Contact:** Marilyn Mower, editor. Circ. 40,000. Estab. 1972. Monthly magazine. Emphasizes ''powerboating and cruising in the southeastern U.S., Bahamas and the Caribbean.'' Readers are ''concentrated in 30-60 age group, mostly male, affluent, very experienced boat owners.'' Sample copy available for $7.

Needs Number of photos/issue varies; many supplied by freelancers. Seeks ''boating lifestyle'' cover shots. Buys stock only. No ''assigned covers.'' Model release required. Photo captions required.

Specs Accepts images in digital format. Send via CD, floppy disk, e-mail as JPEG, TIFF files, minimum 4×6 in. at 300 dpi.

Consumer Publications

Making Contact & Terms Send query letter with list of stock photo subjects, SASE. Response time varies. Simultaneous submissions and previously published work OK. Pays $500 minimum for color cover; $70 minimum for color inside; photo/text package negotiable. Pays within 30 days of publication. Credit line given. Buys one-time print and electronic/Web site rights.

Tips "We want lifestyle shots of saltwater cruising, fishing or just relaxing on the water. Lifestyle or family boating shots shots are actively sought."

$ ⑤ ▣ SPECIALIVING

P.O. Box 1000, Bloomington IL 61702. (309)661-9277. E-mail: gareeb@aol.com. Web site: www.speciaLiving.com. **Contact:** Betty Garee, publisher. Circ. 12,000. Estab. 2001. Quarterly consumer magazine for physically disabled people. Emphasizes travel, home modifications, products, info, inspiration. Sample copy available for $5.

Needs Any events/settings that involve physically disabled people (who use wheelchairs), not developmentally disabled. Reviews photos with or without a manuscript. Model release preferred. Photo captions required.

Specs Uses glossy or matte color and/or b&w prints. Accepts images in digital format. Send via CD, Zip, e-mail as TIFF, JPEG files at 300 dpi.

Making Contact & Terms Send query letter with prints. Does not keep samples on file; include SASE for return of material. Responds in 3 weeks. Simultaneous submissions and previously published work OK. Pays $50 minimum for b&w cover; $100 maximum for color cover; $10 minimum for b&w or color inside. Pays on publication. Credit line given. Buys one-time rights.

Tips "Need good-quality photos of someone in a wheelchair involved in an activity. Need caption and where I can contact subject to get story if wanted."

$ ◪ ▣ SPEEDWAY ILLUSTRATED

Performance Media LLC, 107 Elm St., Salisbury MA 01952. (978)465-9099. Fax: (978)465-9033. E-mail: editorial@speedwayillustrated.com. Web site: www.speedwayillustrated.com. **Contact:** Kimberly McGraw, managing editor. Circ. 125,000. Estab. 2000. Monthly auto racing magazine that specializes in stock cars. Sample copies available.

Needs Buys 75 photos from freelancers/issue; 1,000 photos/year. Needs photos of automobiles, entertainment, events, humor, sports. Reviews photos with or without a manuscript. Model release required. Photo captions required.

Specs Prefers images in digital format. Send via CD-ROM at high resolution.

Making Contact & Terms Send query letter and CD-ROM with photos and captions. Provide business card to be kept on file for possible future assignments. Responds in 1 week to queries. Pays $250 minimum for color cover; $40 for inside. Pays on publication. Credit line given. Buys first rights.

Tips "Send only your best stuff."

$ ▢ ▣ SPFX: SPECIAL EFFECTS MAGAZINE

181 Robinson St., Teaneck NJ 07666. (201)391-8788. E-mail: thedeadlyspawn@aol.com. Web site: www.deadlyspawn.net/spfxmagazine.html. **Contact:** Ted A. Bohus, editor. Circ. 6,000-10,000. Estab. 1978. Biannual film magazine emphasizing science fiction, fantasy and horror films of the past, present and future. Includes feature articles, interviews and rare photos. Sample copy available for $5. Photo guidelines free.

- The magazine is currently on hiatus.

Needs Needs film stills and film personalities. Reviews photos with or without a manuscript. Special photo needs include rare film photos. Model/property release preferred. Photo captions preferred.

Specs Uses any size prints. Accepts images in digital format. Send via CD, Zip, e-mail as TIFF, EPS files at 300 dpi.

Making Contact & Terms Send query letter with samples. Provide résumé, business card, self-promotion piece or tearsheets to be kept on file for possible future assignments. To show portfolio, photographer should follow up with letter after initial query. Art director will contact photographer for portfolio review if interested. Portfolio should include b&w and/or color, prints, tearsheets, slides, transparencies or thumbnails. Responds only if interested; send nonreturnable samples. Previously published work OK. Pays $150-200 for color cover; $10-50 for b&w and color inside. Pays on publication. Credit line given.

$ $ $⊘ ▣ SPORT FISHING

World Publications, LLC, 460 N. Orlando Ave., Suite 200, Winter Park FL 32789. (407)628-5662. Fax: (407)628-7061. E-mail: editor@sportfishingmag.com or mike.mazur@wordpub.net. Web site: www.sportfishingmag.com. **Contact:** John N. Felsher, managing editor. Circ. 150,000 (paid). Estab. 1986. Publishes 9 issues/year. Emphasizes saltwater sport fishing. Readers are upscale boat owners and affluent fishermen. Sample copy available for $2.50, 9×12 SAE and 6 first-class stamps. Photo guidelines available on Web site, via e-mail or with SASE.

Needs Buys 50% or more photos from freelancers/issue. Needs photos of saltwater fish and fishing—especially good action shots. "We are working more from stock—good opportunities for extra sales on any given assignment." Model release not generally required; releases needed for subjects (under "unusual" circumstances) in photo.

Specs Uses 35mm, 2¼×2¼, 4×5 transparencies. "Fuji Velvia 50 or Fuji Provia 100 preferred." Accepts images in digital format. All guidelines, rates, suggestions available on Web site; click on tiny "editorial" button at bottom of home page.

Making Contact & Terms Send query letter with samples. Send unsolicited photos by mail or low resolution digitals by e-mail for consideration. Provide business card, brochure, flier or tearsheets to be kept on file for possible future assignments. Responds in 3 weeks. Pays $1,000 for cover; $75-400 for inside. Buys one-time rights unless otherwise agreed upon.

Tips "Tack-sharp focus critical; avoid 'kill' shots of big game fish, sharks; avoid bloody fish in/at the boat. The best guideline is the magazine itself. Know your market. Get used to shooting on, in or under water. Most of our needs are found there. If you have first-rate photos and questions, e-mail us."

⊘ SPORTS ILLUSTRATED

AOL/Time Warner, Time Life Building, 135 W. 50th St., New York NY 10020. (212)522-1212. Web site: www.si.com. **Contact:** James Colton, photography editor. *Sports Illustrated* reports and interprets the world of sports, recreation and active leisure. It previews, analyzes and comments on major games and events, as well as those noteworthy for character and spirit alone. In addition, the magazine has articles on such subjects as fashion, physical fitness and conservation. *Query before submitting.*

$ $▣ SPORTSCAR

16842 Von Karman Ave., Suite 125, Irvine CA 92606. (949)417-6700. Fax: (949)417-6116. E-mail: sportscar@haymarketworldwide.com. Web site: www.sportscarmag.com. **Contact:** Philip Royle, editor. Circ. 50,000. Estab. 1944. Monthly magazine of the Sports Car Club of America. Emphasizes sports car racing and competition activities. Sample copy available for $3.95.

Needs Uses 75-100 photos/issue; 75% from assignment and 25% from freelance stock. Needs action photos from competitive events, personality portraits and technical photos.

Making Contact & Terms Prefers electronic submissions on CD with query letter. Provide résumé, business card, brochure or flier to be kept on file for possible future assignments. Responds in 1 month. Simultaneous submissions OK. Pays $250-400 for color cover; $25-100 for color inside; negotiates all other rates. Pays on publication. Credit line given. Buys first North American serial rights.

Tips To break in with this or any magazine, "always send only your absolute best work; try to accommodate the specific needs of your clients. Have a relevant subject, strong action, crystal-sharp focus, proper contrast and exposure. We need good candid personality photos of key competitors and officials."

$⊙ Ⓐ ▣ SPRINGFIELD! MAGAZINE

P.O. Box 4749, Springfield MO 65808. (417)831-1600. E-mail: production@sgfmag.com. Web site: www.sgfmag.com. **Contact:** David White, art director. Circ. 10,000. Estab. 1979. Monthly consumer magazine. "We concentrate on the glorious past, exciting future and thrilling present of the Queen City of the Ozarks—Springfield, Missouri." Sample copy available for $5 plus $4.50 shipping.

Needs Buys 20-25 photos from freelancers/issue; 300 photos/year. Needs photos of babies/children/teens, couples, families, parents, landscapes/scenics, wildlife, education, gardening, humor, travel, computers, medicine, science. Interested in documentary, erotic, fashion/glamour, historical/vintage, seasonal. Other specific photo needs: "We want local personalities in the Queen City of the Ozarks only." Reviews photos with accompanying manuscript only. Model release required. Photo captions required.

Specs Uses 4×6 or 5×7 glossy color prints. Accepts images in digital format. Send via Zip. "No e-mail submissions, please."

Making Contact & Terms Send query letter with résumé, prints, tearsheets. Provide résumé, business

card, self-promotion piece to be kept on file for possible future assignments. Responds in 3 weeks to queries; 6 weeks to portfolios. Responds only if interested; send nonreturnable samples. Pays $100 for color cover; $10 for b&w inside; $20 for color inside. Pays on publication. Credit line given. Buys first rights.

$□ ▣ STICKMAN REVIEW: An Online Literary Journal

2890 N. Fairview Dr., Flagstaff AZ 86004. (928)913-0869. E-mail: art@stickmanreview.com. Web site: www.stickmanreview.com. **Contact:** Anthony Brown, editor. Estab. 2001. Biannual literary magazine publishing fiction, poetry, essays and art for a literary audience. Sample copies available on Web site.

Needs Buys 2 photos from freelancers/issue; 4 photos/year. Interested in alternative process, avant garde, documentary, erotic, fine art. Reviews photos with or without a manuscript.

Specs Accepts images in digital format. Send via e-mail as JPEG, GIF, TIFF, PS D files at 72 dpi (500K maximum).

Making Contact & Terms Contact through e-mail only. Does not keep samples on file; cannot return material. Responds in 1 month to queries; 2 months to portfolios. Simultaneous submissions OK. Pays $25-50. **Pays on acceptance.** Credit line given. Buys electronic rights.

Tips "Please check out the magazine on our Web site. We are open to anything, so long as its intent is artistic expression."

$▨ SUB-TERRAIN MAGAZINE

P.O. Box 3008, MPO, Vancouver BC V6B 3X5 Canada. (604)876-8710. Fax: (604)879-2667. E-mail: subter @portal.ca. Web site: www.subterrain.ca. **Contact:** Brian Kaufman, editor-in-chief. Estab. 1988. Literary magazine published 3 times/year.

Needs Uses "many" unsolicited photos. Needs "artistic" photos. Photo captions preferred.

Specs Uses color and/or b&w prints.

Making Contact & Terms Submit portfolio for review. Send unsolicited photos by mail for consideration. Keeps samples on file "sometimes." Responds in 6 months. Simultaneous submissions OK. Pays $25-100/photo. Also pays in contributor's copies. Pays on publication. Credit line given. Buys one-time rights.

$ $▨ ▣ THE SUN

107 N. Roberson St., Chapel Hill NC 27516. (919)942-5282. Fax: (919)932-3101. E-mail: info@thesunmag azine.org. Web site: www.thesunmagazine.org. **Contact:** Art Director. Circ. 70,000. Estab. 1974. Monthly literary magazine featuring personal essays, interviews, poems, short stories, photos and photo essays. Sample copy available for $5. Photo guidelines free with SASE or on Web site.

Needs Buys 10-30 photos/issue; 200-300 photos/year. Needs "slice of life" photographs of people and environments. "We also need photographs that relate to political, spiritual and social themes. We consider documentary-style images. Most of our photos of people feature unrecognizable individuals, although we do run portraits in specific places, including the cover."
Model/property release strongly preferred.

Specs Uses 4×5 to 11×17 glossy or matte b&w prints. Slides are not accepted, and color photos are discouraged. "We cannot review images via e-mail or Web site. If you are submitting digital images, please send high-quality digital prints first. If we accept your images for publication, we will request the image files on CD or DVD media (Mac or PC) in uncompressed TIFF grayscale format at 300 dpi or greater."

Making Contact & Terms Send query letter with prints. Portfolio may be dropped off Monday-Friday. Does not keep samples on file; include SASE for return of material. Responds in 3 months. Simultaneous submissions and previously published work OK. "Submit no more than 30 of your best b&w prints. Please do not e-mail images." Pays $400 for b&w cover; $100-200 for b&w inside. Pays on publication. Credit line given. Buys one-time rights.

Tips "We're looking for artful and sensitive photographs that aren't overly sentimental. We're open to unusual work. Read the magazine to get a sense of what we're about. Send the best possible prints of your work. Our submission rate is extremely high; please be patient after sending us your work. Send return postage and secure return packaging."

$ $▨ ▣ TASTE FOR LIFE

86 Elm St., Peterborough NH 03458-1009. (603)924-7271. Fax: (603)924-7344. E-mail: tmackay@tasteforl ife.com. Web site: www.tasteforlife.com. **Contact:** Ellen Klempner Beguin, creative director. Circ.

250,000. Estab. 1998. Monthly consumer magazine. *"Taste for Life* is a national publication catering to the natural product and health food industry and its consumers. Our mission is to provide authoritative information on nutrition, fitness and choices for healthy living.'' Sample copies available.

Needs Buys 2-5 photos from freelancers/issue; 24-60 photos/year. Needs photos of gardening, food/drink, health/fitness. Specific photo needs include herbs, medicinal plants, organic farming, aromatherapy, alternative healthcare. Reviews photos with accompanying manuscript only. Model and property release required. Photo captions required; include plant species, in the case of herbs.

Specs Prefers images in digital format. Send via CD, DVD as TIFF, EPS files at 300 dpi minimum.

Making Contact & Terms Send query letter with résumé, photocopies, tearsheets, stock list. Provide résumé, business card, self-promotion piece to be kept on file for possible future assignments. Responds only if interested. Include SASE if samples need to be returned. Simultaneous submissions and previously published work OK. Pays $400-600 for color cover; $100-300 for color inside. Pays extra for electronic usage of photos. Pays on publication. Credit line given. Buys one-time rights. Will negotiate with a photographer unwilling to sell all rights.

Tips "Photos should portray healthy people doing healthy things everywhere, all the time. In the case of herbal photography, stunning detailed images showing fruit, leaves, flowers, etc., are preferred. All images should be good enough to be covers.''

$ ▣ TEXAS GARDENER MAGAZINE

P.O. Box 9005, Waco TX 76714-9005. (254)848-9393. Fax: (254)848-9779. E-mail: info@texasgardener.com. Web site: www.texasgardener.com. **Contact:** Chris S. Corby, editor/publisher. Circ. 25,000. Bimonthly. Emphasizes gardening. Readers are "51% male, 49% female, home gardeners, 98% Texas residents." Sample copy available for $4.

Needs Buys 18-27 photos from freelancers/issue; 108-162 photos/year. Needs "color photos of gardening activities in Texas." Special needs include "cover photos shot in vertical format. Must be taken in Texas." Photo captions required.

Specs Prefers high-resolution digital images. Send via e-mail as JPEG files at 300 dpi.

Making Contact & Terms Send query letter with samples, SASE. Responds in 3 weeks. Pays $100-200 for color cover; $25-100 for color inside. Pays on publication. Credit line given. Buys one-time rights.

Tips "Provide complete information on photos. For example, if you submit a photo of watermelons growing in a garden, we need to know what variety they are and when and where the picture was taken.''

$ $ ▣ TEXAS HIGHWAYS

P.O. Box 141009, Austin TX 78714. (512)486-5870. Fax: (512)486-5879. E-mail: mmurph1@dot.state.tx.us. Web site: www.texashighways.com. **Contact:** Michael A. Murphy, photo editor. New photo editor will start Aug. 1, 2007. Circ. 260,000. Monthly. *"Texas Highways* interprets scenic, recreational, historical, cultural and ethnic treasures of the state and preserves the best of Texas heritage. Its purpose is to educate and entertain, to encourage recreational travel to and within the state, and to tell the Texas story to readers around the world." Readers are ages 45 and over (majority); $24,000 to $60,000/year salary bracket with a college education. Photo guidelines available on Web site.

Needs Buys 30-60 photos from freelancers/issue; 360-420 photos/year. Needs "travel and scenic photos in Texas only." Special needs include "fall, winter, spring and summer scenic shots and wildflower shots (Texas only)." Photo captions required; include location, names, addresses and other useful information.

Specs "We take only color originals, 35mm or larger transparencies. No negatives or prints." Accepts images in digital format. Prefers camera RAW files with tweaks and captions in sidecar files. Consult guidelines before submitting.

Making Contact & Terms Send query letter with samples, SASE. Provide business card and tearsheets to be kept on file for possible future assignments. Responds in 1 month. Simultaneous submissions OK. Pays $400 for color cover; $60-170 for color inside. Pays $15 extra for electronic usage. Pays on publication. Credit line given. Buys one-time rights.

Tips "Look at our magazine and format. We accept only high-quality, professional-level work—no snapshots. Interested in a photographer's ability to edit own material and the breadth of a photographer's work. Look at 3-4 months of the magazine. Query not just for photos but with ideas for new/unusual topics.''

$ ◩ TEXAS MONTHLY

P.O. Box 1569, Austin TX 78767. (512)320-6936. Web site: www.texasmonthly.com. **Contact:** Leslie Baldwin, photo editor. *Texas Monthly* is edited for the urban Texas audience and covers the state's

politics, sports, business, culture and changing lifestyles. It contains lengthy feature articles, reviews and interviews, and presents critical analysis of popular books, movies and plays.

Needs Uses about 50 photos/issue. Needs photos of celebrities, sports, travel.

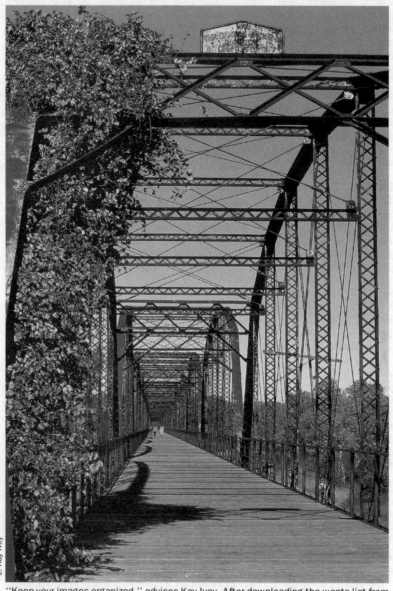

© L. Kay Ivey

''Keep your images organized,'' advises Kay Ivey. After downloading the wants list from the Web site of *Texas Highways*, she remembered this image she took during a fall foliage photo shoot at Canadian, Texas. *Texas Highways* published the photo with an article titled ''Bridging Texas, Spanning Time.''

Making Contact & Terms Send samples or tearsheets. No preference on printed material—b&w or color. Responds only if interested. Keeps samples on file.

Tips ''Check our Web site (www.texasmonthly.com/misc/artguide.php) for information on sending portfolios.''

$◻ 🖵 THEMA

THEMA Literary Society, P.O. Box 8747, Metairie LA 70011-8747. (504)940-7156. E-mail: thema@cox.net. Web site: http://members.cox.net/thema. **Contact:** Virginia Howard, manager/editor. Circ. 300. Estab. 1988. Literary magazine published 3 times/year emphasizing theme-related short stories, poetry and art. Sample copy available for $10.

Needs Photo must relate to one of *THEMA*'s upcoming themes (indicate the target theme on submission of photo). Upcoming themes (submissin deadlines in parenthesis); The Box Under The Bed (March 1, 2008); Unprepared For Adventure (July 1, 2008); In Kay's Kitchen (Novemer 1, 2008). Reviews photos with or without a manuscript. Model/property release preferred. Photo captions preferred.

Specs Uses 5×7 glossy color and/or b&w prints. Accepts images in digital format. Send via Zip as TIFF files at 200 dpi.

Making Contact & Terms Send query letter with prints, photocopies. Does not keep samples on file; include SASE for return of material. Responds in 1 week to queries; 3 months to portfolios. Simultaneous submissions and previously published work OK. Pays $25 for cover; $10 for b&w inside. **Pays on acceptance.** Credit line given. Buys one-time rights.

Tips "Submit only work that relates to one of *THEMA*'s upcoming themes. Contact by snail mail preferred."

THIN AIR MAGAZINE

Northern Arizona University, P.O. Box 23649, Flagstaff AZ 86002. (928)523-6743. Fax: (928)523-7074. Web site: www.thinairmagazine.com. **Contact:** Art Editor. Circ. 400. Estab. 1995. Biannual literary magazine. Emphasizes arts and literature—poetry, fiction and essays. Readers are collegiate, academic, writerly adult males and females interested in arts and literature. Sample copy available for $6.

Needs Buys 2-4 photos from freelancers/issue; 4-8 photos/year. Needs scenic/wildlife shots and b&w photos that portray a statement or tell a story. Looking for b&w cover shots. Model/property release preferred for nudes. Photo captions preferred; include name of photographer, date of photo.

Specs Uses 8×10 b&w prints.

Making Contact & Terms Send unsolicited photos by mail with SASE for consideration. Photos accepted August through May only. Keeps samples on file. Responds in 3 months. Simultaneous submissions and previously published work OK. Pays 2 contributor's copies. Credit line given. Buys one-time rights.

$◻ 🖵 🌐 TIMES OF THE ISLANDS: The International Magazine of the Turks & Caicos Islands

Times Publications Ltd., Southwinds Plaza, Box 234, Providenciales, Turks & Caicos Islands, British West Indies. (649)946-4788. E-mail: timespub@tciway.tc. Web site: www.timespub.tc. **Contact:** Kathy Borsuk, editor. Circ. 14,000. Estab. 1988. Quarterly magazine focusing on in-depth topics specifically related to Turks & Caicos Islands. Targeted beyond mass tourists to homeowners/investors/developers and others with strong interest in learning about these islands. Sample copy available for $6. Photo guidelines available on Web site.

Needs Buys 5 photos from freelancers/issue; 20 photos/year. Needs photos of environmental, landscapes/scenics, wildlife, architecture, adventure, travel. Interested in historical/vintage. Also scuba diving, islands in TCI beyond main island of Providenciales. Reviews photos with or without a manuscript. Photo captions required; include specific location, names of any people.

Specs Prefers images in high-resolution digital format. Send via CD or e-mail as JPEG files.

Making Contact & Terms Send query e-mail with photo samples. Provide business card, self-promotion piece to be kept on file for possible future assignments. Responds in 6 weeks to queries. Simultaneous submissions and previously published work OK. Pays $100-300 for color cover; $50-100 for inside. Pays on publication. Credit line given. Buys one-time rights; negotiable.

Tips "Make sure photo is specific to Turks & Caicos and location/subject accurately identified."

$☑ 🄰 🖵 🌐 TOTAL 911

9Publishing Limited, P.O. Box 6815, Matlock DE4 4WZ United Kingdom. (44)(845)450-6464. E-mail: editorial@total911.co.uk. Web site: www.total911.com. **Contact:** Philip Raby, publishing editor. Estab. 2005. Monthly consumer magazine. "A high-quality magazine for enthusiasts of the Porsche 911 in all its forms. Sold all around the world." Request photo guildelines via e-mail.

Needs Needs photos of automobiles, Porsche 911.

Specs Accepts images in digital format.

Making Contact & Terms E-mail query letter with link to photographer's Web site, JPEG samples at 72 dpi. Pays 30 days after publication. Credit line given. Buys one-time rights.

Tips "Do not contact us unless you are a professional photographer who can produce outstanding work using top-quality digital equipment. Especially keen to contact good photographers in the United States."

N 🖲 🖻 TRACE MAGAZINE

TRACE Inc., 476 Broome St., 2nd Flr., New York NY 10013. (212)625-1192. Fax: (212)625-1195. E-mail: editorial@trace212.com. Web site: www.trace212.com. **Contact:** Katie Constans, creative director. Circ. 100,000. Consumer publication published 10 times/year, focusing on international transcultural style, mixing music, fashion, lifestyle and art. "The magazine has offices in New York and London, which gather stories for our U.S. and U.K. editions."

Needs Wants photos of celebrities, music. Interested in fashion/glamour, lifestyle. Model release required.

Specs Accepts images in digital format. Send JPEG or GIF files. Reviews contact sheets, any size transparencies and negatives.

Making Contact & Terms E-mail query letter with link to photographer's Web site. Payment negotiated. Credit line given. Buys exclusive worldwide first-time periodical rights; worldwide rights to republish or cause the photographs to be republished in any book or periodical anthology, and/or any edition of TRACE Inc., and its affiliates; exclusive worldwide rights to use the photographs as part of any electronic and/or computer-based database, newsletter or Web site containing TRACE Inc., articles.

$ 🖊 🖻 TRACK & FIELD NEWS

2570 El Camino Real, Suite 606, Mountain View CA 94040. (650)948-8188. Fax: (650)948-9445. E-mail: editorial@trackandfieldnews.com. Web site: www.trackandfieldnews.com. **Contact:** Jon Hendershott, associate editor (features/photography). Circ. 25,000. Estab. 1948. Monthly magazine. Emphasizes national and world-class track and field competition and participants at those levels for athletes, coaches, administrators and fans. Sample copy free with 9×12 SASE. Photo guidelines free.

Needs Buys 10-15 photos from freelancers/issue; 120-180 photos/year. Wants, on a regular basis, photos of national-class athletes, men and women, preferably in action. "We are always looking for quality pictures of track and field action, as well as offbeat and different feature photos. We always prefer to hear from a photographer before he/she covers a specific meet. We also welcome shots from road and cross-country races for both men and women. Any photos may eventually be used to illustrate news stories in *T&FN*, feature stories in *T&FN*, or may be used in our other publications (books, technical journals, etc.). Any such editorial use will be paid for, regardless of whether material is used directly in *T&FN*. About all we don't want to see are pictures taken with someone's Instamatic or Polaroid. No shots of someone's child or grandparent running. Professional work only." Photo captions required; include subject name, meet date/name.

Specs Images must be in digital format. Send via CD, e-mail at 300 dpi.

Making Contact & Terms Send query letter with samples, SASE. Responds in 10-14 days. Pays $175 for color cover; $25 for b&w inside; $50 for color inside ($100 for interior color, full page; $175 for interior 2-page poster/spread). Payment is made monthly. Credit line given. Buys one-time rights.

Tips "No photographer is going to get rich via *T&FN*. We can offer a credit line, nominal payment and, in some cases, credentials to major track and field meets to enable on-the-field shooting. Also, we can offer the chance for competent photographers to shoot major competitions and competitors up close, as well as being the most highly regarded publication in the track world as a forum to display a photographer's talents."

$ $ 🖊 🖻 TRAILER BOATS MAGAZINE

Ehlert Publishing, Inc., 20700 Belshaw Ave., Carson CA 90746. (310)537-6322. Fax: (310)537-8735. Web site: www.trailerboats.com. **Contact:** Ron Eldridge, editor. Circ. 102,000. Estab. 1971. Monthly magazine. "We are the only magazine devoted exclusively to trailerable boats and related activities" for owners and prospective owners. Sample copy available for $1.25.

Needs Uses 15 photos/issue; 95-100% of freelance photography comes from assignment, 0-5% from stock. Needs how-to trailerable boat, travel (with manuscript). For accompanying manuscripts, needs articles related to trailer boat activities. Photos purchased with or without accompanying manuscript. "Photos must relate to trailer boat activities. No long list of stock photos or subject matter not related to editorial content." Photo captions preferred; include location of travel pictures.

Specs Uses transparencies. Accepts images in digital format. Send as JPEG files at 300 dpi.

Making Contact & Terms Query or send photos or contact sheet by mail with SASE for consideration. Responds in 1 month. Pays per text/photo package or on a per-photo basis. Pays $500 for cover; $25-200 for color inside. **Pays on acceptance.** Credit line given.

Tips "Shoot with imagination and a variety of angles. Don't be afraid to 'set up' a photo that looks natural. Think in terms of complete feature stories: photos and manuscripts."

$□ ▣ TRANSITIONS ABROAD

P.O. Box 745, Bennington VT 05201. (802)442-4827. E-mail: editor@transitionsabroad.com. Web site: www.transitionsabroad.com. **Contact:** Sherry Schwarz, editor. Circ. 12,000. Estab. 1977. Bimonthly magazine. Emphasizes educational and special interest travel abroad. Readers are people interested in cultural travel and learning, living, working or volunteering abroad; all ages, both sexes. Sample copy available for $6.95. Photo guidelines available on Web site.

Needs Buys 12 photos from freelancers/issue; 60 photos/year. Needs photos in international settings of people of other countries. Each issue has an area focus: January/February—Asia and the Pacific Rim; March/April—Western Europe; May/June—Latin America; July/August—worldwide; September/October—Eastern Europe, Middle East, newly independent states; November/December—Mediterranean Basin and Africa. Captions preferred. Articles can also be submitted with photos for a better chance of publication.

Specs Uses color for cover and inside, including for a few full-length photo pages and a featured photo in the Table of Contents. Covers must be vertical images. Prefers images in digital format. Send via CD, Zip, e-mail as TIFF files at 300 dpi. Prefers e-mail previews as JPEGs before sending high-res files.

Making Contact & Terms Send unsolicited color prints by mail with SASE for consideration. Responds in 6-8 weeks. Simultaneous submissions and previously published work OK. Pays $125-150 for color cover; $25-50 for stand-alone photos. Pays on publication. Credit line given. Buys one-time rights.

Tips In freelance photographer's samples, wants to see "mostly people in local activities, culture and environment (active shots)—people of other countries; close-ups preferred for cover. We use very few landscapes or abstract shots. Images of daily life and surroundings fit well into *Transitions*."

❷ TRAVEL + LEISURE

1120 Avenue of the Americas, 10th Floor, New York NY 10036. (212)382-5600. Fax: (212)382-5877. Web site: www.travelandleisure.com. **Contact:** Photo Department. Circ. 1.2 million. Monthly magazine. Emphasizes travel destinations, resorts, portraits, dining and entertainment.

Needs Does not accept unsolicited photos. Model release required. Photo captions required.

Making Contact & Terms "If mailing a portfolio, include a self-addressed stamped package for its safe return. You may also send it by messenger Monday through Friday between 11 a.m. and 5 p.m. We accept work in book form exclusively—no transparencies, loose prints, nor scans on CD, disk or e-mail. Send photocopies or photo prints, not originals, as we are not responsible for lost or damaged images in unsolicited portfolios. We do not meet with photographers if we haven't seen their book. However, please include a promo card in your portfolio with contact information, so we may get in touch with you if necessary."

$▣ ▦ TRAVELLER

45-49 Brompton Rd., London SW3 1DE United Kingdom. (44)(207)589-0500. Fax: (44)(207)581-8476. E-mail: traveller@wexas.com. Web site: www.traveller.org.uk. **Contact:** Amy Sohanpaul, editor. Circ. 25,000. Quarterly. Readers are predominantly male, professional, ages 35 and older. Sample copy available for £4.95.

Needs Uses 75-100 photos/issue; all supplied by freelancers. Needs photos of travel, wildlife, tribes. Reviews photos with or without a manuscript. Photo captions preferred.

Making Contact & Terms Send at least 20 original color slides or b&w prints. Or send at least 20 low-res scans by e-mail or CD (include printout of thumbnails); high-res (300 dpi) scans will be required for final publication. Does not keep samples on file; include SASE for return of material. Responds in 3 months. Pays £150 for color cover; £80 for full page; £50 for other sizes. Pays on publication. Buys one-time rights.

Tips Look at guidelines for contributors on Web site.

© Lawrence Morgan

Lawrence Morgan considers himself a "compulsive traveler," having visited 25 countries in the last decade. This image from Nepal was published on the cover of *Transitions Abroad*. "After selling them the image for a cover, I had my foot in the door and was able to also sell them an article about trekking in the Himalayas," he says.

$ ☑ ▣ TRAVELWORLD INTERNATIONAL MAGAZINE

NATJA, 531 Main St., #902, El Segundo CA 90245. (310)836-8712. Fax: (310)836-8769. E-mail: info@natja .org. Web site: www.natja.org and www.travelworldmagazine.com. **Contact:** Elizabeth BeShear, executive director. Circ. 75,000 unique visitors. Estab. 1992. Bimonthly online magazine of the North American Travel Journalists Association (NATJA). Emphasizes travel, food, wine and hospitality industries.
Needs Uses photos of food/drink, travel.
Specs Uses color and/or b&w. Prefers images in digital format.
Making Contact & Terms Send query via e-mail. Does not keep samples on file; cannot return material. Previously published work OK. Credit line given.

$ $☐ ▣ TRICYCLE: The Buddhist Review

The Buddhist Ray, Inc., 92 Vandam St., New York NY 10013. (212)645-1143. Fax: (212)645-1493. E-mail: editorial@tricycle.com. Web site: www.tricycle.com. **Contact:** Alexandra Kaloyanides, senior editor. Circ. 60,000. Estab. 1991. Quarterly nonprofit magazine devoted to the exploration of Buddhism, literature and the arts.
Needs Buys 10 photos from freelancers/issue; 40 photos/year. Reviews photos with or without a manuscript. Model/property release preferred. Photo captions preferred.
Specs Uses glossy b&w and color prints; 35mm transparencies. Accepts images in digital format. Send via CD, Zip, e-mail as TIFF, EPS, BMP, GIF, JPEG files at 300 dpi.
Making Contact & Terms Send query letter with tearsheets. Provide business card, self-promotion piece to be kept on file for possible future assignments. Responds in 3 months to queries. Simultaneous submissions OK. Pays $750 maximum for color cover; $250 maximum for b&w or color inside. Pays on publication. Credit line given. Buys one-time rights.
Tips "Read the magazine to get a sense of the kind of work we publish. We don't only use Buddhist art; we select artwork depending on the content of the piece."

$ $▣ TURKEY & TURKEY HUNTING

F+W Publications, 700 E. State St., Iola WI 54990-0001. (715)445-2214. Fax: (715)445-4087. E-mail: jim.schlender@fwpubs.com. Web site: www.turkeyandturkeyhunting.com. **Contact:** Jim Schlender, editor. Circ. 50,000. Estab. 1983. Magazine published 6 times/year. Provides features and news about wild turkeys and turkey hunting. Photo guidelines available on Web site.
Needs Buys 150 photos/year. Needs action photos of wild turkeys and hunter interaction scenes. Reviews photos with or without a manuscript.
Specs Uses 35mm transparencies and high-res digital images. "Do not send photos without first contacting the editor."
Making Contact & Terms Send query letter with samples; include SASE for return of material. Responds in 3 months to queries. Pays $300 minimum for color cover; $75-200 for color inside. Pays on publication. Credit line given. Buys one-time rights.

☐ ⑤ ▣ UP AND UNDER: The QND Review

P.O. Box 115, Hainesport, NJ 08036. E-mail: qndpoets@yahoo.com. Web site: www.quickanddirtypoets. com. **Contact:** Rachel Bunting, editor. Circ. 100. Estab. 2005. Annual literary magazine. "A literary journal with an eclectic mix of poetry: sex, death, politics, IKEA, Mars, food and jug handles, alongside a smorgasbord of other topics covered in such diverse forms as the sonnet, villanelle, haiku and free verse." Sample copy available for $7 and SAE.
Needs Acquires 8 photos from freelancers/issue; 8 photos/year. Interested in architecture, cities/urban, rural, landscapes/scenics, avant garde, fine art, historical/vintage. Reviews photos with or without a manuscript.
Specs Uses 8×10 or smaller b&w prints. Accepts digital images in Windows format. Send via e-mail as GIF or JPEG files.
Making Contact & Terms Send query letter with prints. Does not keep samples on file; include SASE for return of material. Responds in 2-3 months to queries. Simultaneous submissions OK. Pays 1 copy on publication. Credit line sometimes given, depending on space allowance in the journal. Acquires one-time rights.
Tips "This is predominantly a poetry journal, and we choose photographs to complement the poems, so we prefer unusual, artistic images whether they are landscapes, buildings or art. Include a short (3- to 5-line) bio."

$ $ ☑ ▣ ⬚ UP HERE

P.O. Box 1350, Yellowknife NT X1A 2N9 Canada. (867)766-6710. Fax: (867)873-9876. E-mail: jake@uphe re.ca. Web site: www.uphere.ca. **Contact:** Jake Kennedy, editor. Circ. 35,000. Estab. 1984. Magazine published 8 times/year. Emphasizes Canada's North. Readers are educated, affluent men and women ages 30 to 60. Sample copy available for $3.50 plus GST and 9×12 SAE. Photo guidelines free with SASE. If sending from U.S., include IRC instead of U.S. stamps (which cannot be used in Canada).

Needs Buys 18-27 photos from freelancers/issue; 144-216 photos/year. Needs photos of environmental, landscapes/scenics, wildlife, adventure, performing arts. Interested in documentary, seasonal. Purchases photos with or without accompanying manuscript. Photo captions required.

Specs Uses color transparencies, not prints, labeled with the photographer's name, address, phone number and caption. Occasionally accepts images in digital format. Send via CD, e-mail, Syquest, Zip.

Making Contact & Terms Provide résumé, business card, brochure, flier or tearsheets to be kept on file for possible future assignments. Include SASE for return of material. Responds in 2 months. Pays $250-350 for color cover; $40-150 for color inside. Pays on publication. Credit line given. Buys one-time rights.

Tips "We are a *people* magazine. We need stories that are uniquely Northern (people, places, etc.). Few scenics as such. We approach local freelancers for given subjects, but routinely complete commissioned photography with images from stock sources. Please let us know about Northern images you have." Wants to see "sharp, clear photos, good color and composition. We always need verticals to consider for the cover, but they usually tie in with an article inside."

☑ VANITY FAIR

Condé Nast Building, 4 Times Square, New York NY 10036. (212)286-2860. Fax: (212)286-7787 or (212)286-6787. Web site: www.vanityfair.com. **Contact:** Susan White, photography director. Monthly magazine.

Needs Freelancers supply 50% of photos. Needs portraits. Model/property release required for everyone. Photo captions required for photographer, styles, hair, makeup, etc.

Making Contact & Terms Contact through rep or submit portfolio for review. Provide résumé, business card, brochure, flier or tearsheets to be kept on file for possible future assignments. Responds in 2 weeks. Payment negotiable. Pays on publication.

Tips "We solicit material after a portfolio drop. So, really we don't want unsolicited material."

$ $ ☑ ▣ VERMONT LIFE

6 Baldwin St., Montpelier VT 05602. Web site: www.vermontlife.com. **Contact:** John Lazenby, managing editor. Circ. 75,000. Estab. 1946. Quarterly magazine. Emphasizes life in Vermont: its people, traditions, way of life, farming, industry, and the physical beauty of the landscape for "Vermonters, ex-Vermonters, and would-be Vermonters." Sample copy available for $6 with 9×12 SAE. Photo guidelines available for SASE, via e-mail or on Web site.

Needs Buys 27 photos from freelancers/issue; 108 photos/year. Wants (on a regular basis) scenic views of Vermont, seasonal (winter, spring, summer, autumn) submitted 6 months prior to the actual season, animal, human interest, humorous, nature, landscapes/scenics, wildlife, gardening, sports, photo essay/ photo feature, still life, travel. Interested in documentary. "We are using fewer, larger photos and are especially interested in good shots of wildlife, Vermont scenics." No photos in poor taste, clichés, or photos of places other than Vermont. No manipulated digital images. Model/property release preferred. Photo captions required.

Specs Uses 35mm, 2¼×2¼ color transparencies. Accepts images in digital format. See guidelines for specifications.

Making Contact & Terms Send query letter with SASE. Responds in 3 weeks. Simultaneous submissions OK. Pays $500 minimum for color cover; $75-250 for b&w or color inside; $250-800/job. Pays on publication. Credit line given. Buys one-time rights; negotiable.

Tips "Unusual angles and landscapes not shown in previous issues of *Vermont Life* are appreciated."

Ⓝ $ ☑ Ⓐ ▣ VIPER MAGAZINE, The Quarterly Magazine for Dodge Viper Enthusiasts

J.R. Thompson Company, 26970 Haggerty Rd., Farmington Hills MI 48331. (248)553-4566. Fax: (248)553-2138. E-mail: jrt@jrthompson.com. Web site: www.vipermagazine.com. **Contact:** Mark Gianotta, editor-in-chief. Circ. 15,000. Estab. 1992. Quarterly magazine published by and for the enthusiasts of the Dodge Viper sports car. Sample copy available for $6. Photo guidelines free.

Needs Buys 3-10 photos from freelancers/issue; 12-40 photos/year. Needs photos of "All Viper, only

Viper—unless the shot includes another car suffering indignity at the Viper's hands.'' Reviews photos with or without a manuscript. ''Can always use fresh pro outlooks on racing or pro/amateur series.'' Model release required; property release preferred for anything not shot in the public domain or in a ''news'' context. Photo captions required; include names and what's happening.

Specs 35mm slides preferred. Uses any size color prints; $2\frac{1}{4} \times 2\frac{1}{4}$, 4×5, 8×10 transparencies. Accepts images in digital format.

Making Contact & Terms Send query letter with samples, brochure, stock list or tearsheets. Provide résumé, business card, self-promotion piece or tearsheets to be kept on file for possible future assignments. Keeps samples on file; include SASE for return of material. Responds in 1 month to queries; 2-3 weeks to samples. Simultaneous submissions and previously published work OK. Payment varies. **Pays on acceptance.** Credit line given. Buys all rights; negotiable.

Tips ''Know what we want—we don't have time to train anyone. That said, unpublished pro-grade work will probably find a good home here. Send first-class work—not outtakes; have patience; and don't waste our time—or yours. Would like to see less 'buff-book' art and more of a 'fashion' edge.''

$⬛☑🖥 VISTA

1201 Brickell Ave., Suite 360, Miami FL 33131. (305)416-4644. Fax: (305)416-4344. E-mail: peterekstein@ vistamag.com. Web site: www.vistamagazine.com. **Contact:** Peter Ekstein, art director. Circ. 1 million. Estab. 1985. Monthly newspaper insert. Emphasizes Hispanic life in the U.S. Readers are Hispanic-Americans of all ages. Sample copies available.

Needs Buys 10-50 photos from freelancers/issue; 120-600 photos/year. Needs photos mostly of personalities (celebrities, multicultural, families, events). Reviews photos with accompanying manuscript only. Special photo needs include events in Hispanic-American communities. Model/property release preferred. Photo captions required.

Specs Accepts images in digital format. Send via CD, e-mail, Zip as TIFF, EPS files at 300 dpi.

Making Contact & Terms Provide résumé, business card, brochure, flier or tearsheets to be kept on file for possible future assignments. Keeps samples on file. Responds in 3 weeks. Previously published work OK. Pays $500 for color cover; $75 for b&w inside; $150 for color inside; day assignments are negotiated. Pays 25% extra for Web usage. Pays on publication. Credit line given. Buys one-time rights.

Tips ''Build a file of personalities and events. Hispanics are America's fastest-growing minority.''

🖥 WASHINGTON TRAILS

2019 3rd Ave., Suite 100, Seattle WA 98121-2430. (206)625-1367. E-mail: editor@wta.org. Web site: www.wta.org. **Contact:** Andrew Engelson, editor. Circ. 6,000. Estab. 1966. Magazine of the Washington Trails Association, published 10 times/year. Emphasizes ''backpacking, hiking, cross-country skiing, all nonmotorized trail use, outdoor equipment and minimum-impact camping techniques.'' Readers are ''people active in outdoor activities, primarily backpacking; residents of the Pacific Northwest, mostly Washington; age group: 9-90; family-oriented; interested in wilderness preservation, trail maintenance.'' Photo guidelines free with SASE or on Web site.

Needs Uses 10-15 photos from volunteers/issue; 100-150 photos/year. Needs ''wilderness/scenic; people involved in hiking, backpacking, skiing, wildlife; outdoor equipment photos, all with Pacific Northwest emphasis.'' Photo captions required.

Making Contact & Terms Send JPEGs by e-mail, or 5×7 or 8×10 glossy b&w prints by mail for consideration; include SASE for return of material. Responds in 1-2 months. Simultaneous submissions and previously published work OK. No payment for photos. A 1-year subscription offered for use of color cover shot. Credit line given.

Tips ''We are a black & white publication and prefer using black & white originals for the best reproduction. Photos must have a Pacific Northwest slant. Photos that meet our cover specifications are always of interest to us. Familiarity with our magazine would greatly aid the photographer in submitting material to us. Contributing to *Washington Trails* won't help pay your bills, but sharing your photos with other backpackers and skiers has its own rewards.''

$☑ Ⓐ THE WATER SKIER

1251 Holy Cow Rd., Polk City FL 33868-8200. (863)324-4341. Fax: (863)325-8259. E-mail: satkinson@usa waterski.org. Web site: www.usawaterski.org. **Contact:** Scott Atkinson, editor. Circ. 28,000. Estab. 1950. Magazine of USA Water Ski, published 9 times/year. Emphasizes water skiing. Readers are male and female professionals, ages 20-45. Sample copy available for $3.50. Photo guidelines available.

Needs Buys 1-5 photos from freelancers/issue; 9-45 photos/year. Needs photos of sports action. Model/property release required. Photo captions required.

Making Contact & Terms Call first. Pays $50-150 for color photos. Pays on publication. Credit line given. Buys all rights.

$⬚ ▣ WATERWAY GUIDE

326 First St., Suite 400, Annapolis MD 21403. (443)482-9377. Fax: (443)482-9422. Web site: www.waterwayguide.com. **Contact:** Jack Dozier, publisher. Circ. 30,000. Estab. 1947. Cruising guide with 4 annual regional editions. Emphasizes recreational boating. Readers are men and women ages 25-65, management or professional, with average income $138,000. Sample copy available for $39.95 and $3 shipping. Photo guidelines free with SASE.

Needs Buys 10-15 photos from freelancers/issue. Needs aerial photos of waterways. Expects to use more coastal shots from Maine to the Bahamas; also Hudson River, Great Lakes, Lake Champlain and Gulf of Mexico. Model release required. Photo captions required.

Specs Accepts images in digital format. Send as EPS, TIFF files at 300 dpi.

Making Contact & Terms Send unsolicited photos by mail with SASE for consideration. Responds in 4 months. Pay varies; negotiable. Pays on publication. Credit line given. Must sign contract for copyright purposes.

$⬚ ▣ ◪ WAVELENGTH MAGAZINE

1773 Verano Dr., Gabriola Island BC V0R 1X6 Canada. (250)247-8858. E-mail: diana@wavelengthmagazine.com. Web site: www.wavelengthmagazine.com. **Contact:** Diana Mumford, editor. Circ. 65,000. Estab. 1991. Quarterly magazine. Emphasizes safe, ecologically sensitive paddling. For sample copy, see downloadable PDF version on Web site.

Needs Buys 10 photos from freelancers/issue ("usually only from authors"); 60 photos/year. Needs kayaking shots. Photos should have sea kayak in them. Reviews photos with or without a manuscript. Model/property release preferred. Photo captions preferred.

Specs Prefers digital submissions, but only after query. Send as low-res for assessment.

Making Contact & Terms Send query letter. Provide business card or self-promotion piece to be kept on file for possible future assignments. Responds in 2 months to queries. Absolutely no simultaneous submissions or previously published work accepted. Pays $100-200 for color cover; $25-50 for inside. Pays on publication. Credit line given. Buys one-time print rights including electronic archive rights.

Tips "Look at free downloadable version on Web site and include kayak in picture wherever possible. Always need vertical shots for cover!"

$⬚ ▣ WEST SUBURBAN LIVING MAGAZINE

C2 Publishing, Inc., P.O. Box 111, Elmhurst IL 60126. (630)834-4994. Fax: (630)834-4996. Web site: www.westsuburbanliving.net. **Contact:** Chuck Cozette, editor. Circ. 25,000. Estab. 1995. Bimonthly regional magazine serving the western suburbs of Chicago. Sample copies available.

Needs Needs photos of babies/children/teens, couples, families, senior citizens, landscapes/scenics, architecture, gardening, interiors/decorating, entertainment, events, food/drink, health/fitness/beauty, performing arts, travel. Interested in seasonal. Model release required. Photo captions required. **Limited to Chicago-area freelance photographers.**

Specs Uses glossy color and/or b&w prints; 35mm, $2\frac{1}{4} \times 2\frac{1}{4}$, 4×5, 8×10 transparencies. Accepts images in digital format. Send via CD, Zip as TIFF files at 300 dpi.

Making Contact & Terms Responds only if interested; send nonreturnable samples. Simultaneous submissions and previously published work OK. Credit line given. Buys one-time rights, first rights, all rights; negotiable.

$ $▣ WESTERN HORSEMAN

P.O. Box 7980, Colorado Springs CO 80933. (719)633-5524. Fax: (719)633-1392. E-mail: edit@westernhorseman.com. Web site: www.westernhorseman.com. **Contact:** A.J. Mangum, editor. Circ. 211,000. Estab. 1936. Monthly magazine. Readers are active participants in Western horse activities, including pleasure riders, ranchers, breeders and riding club members.

Needs Articles and photos must have a strong horse angle, slanted towards the Western rider—rodeos, shows, ranching, stable plans, training. "We buy 35mm color slides for our annual cowboy calendar.

Slides must depict ranch cowboys/cowgirls at work.'' Model/property release preferred. Photo captions required; include name of subject, date, location.
Specs Prefers 35mm color slides or high-res digital images. Send digital images via CD, DVD as TIFF files at 300 dpi. ''We can sometimes use color prints if they are of excellent quality.''
Making Contact & Terms Submit material by mail for consideration. Pays $300-500 for color cover; $50-100 for color inside. For the calendar, pays $125-225/slide. Buys one-time rights; negotiable.
Tips ''In all prints, photos and slides, subjects must be dressed appropriately. Baseball caps, T-shirts, tank tops, shorts, tennis shoes, bare feet, etc., are unacceptable.''

$ $ ☑ ▣ WESTERN OUTDOORS, The Magazine of Western Sportfishing

Western Outdoors Publications, P.O. Box 73370, San Clemente CA 92673. (949)366-0030. Fax: (949)366-0804. E-mail: rich@wonews.com. **Contact:** Rich Holland, editor. Circ. 100,000. Estab. 1961. Magazine published 9 times/year. Emphasizes fishing and boating ''for Far West states.'' Sample copy free. Editorial and photo guidelines free with SASE.
Needs Uses 80-85 photos/issue; 70% supplied by freelancers; 80% comes from assignments, 25% from stock. Needs photos of fishing in California, Oregon, Washington, Baja. Most photos purchased with accompanying manuscript. Model/property release preferred for women and men in brief attire. Photo captions required.
Specs Prefers images in digital format.
Making Contact & Terms Query or send photos with SASE for consideration. Responds in 3 weeks. Pays $50-150 for color inside; $300-400 for color cover; $400-600 for text/photo package. **Pays on acceptance.** Buys one-time rights for photos only; first North American serial rights for articles; electronic rights are negotiable.
Tips ''Submissions should be of interest to Western fishermen, and should include a 1,120- to 1,500-word manuscript; a Trip Facts Box (where to stay, costs, special information); photos; captions; and a map of the area. Emphasis is on fishing how-to, somewhere-to-go. Submit seasonal material 6 months in advance. Query only; no unsolicited manuscripts. Make your photos tell the story, and don't depend on captions to explain what is pictured. Avoid 'photographic clichés' such as 'dead fish with man.' Get action shots, live fish. In fishing, we seek individual action or underwater shots. For cover photos, use vertical format composed with action entering picture from right; leave enough left-hand margin for cover blurbs, space at top of frame for magazine logo. Add human element to scenics to lend scale. Get to know the magazine and its editors. Ask for the year's editorial schedule (available through advertising department), and offer cover photos to match the theme of an issue. In samples, looks for color saturation, pleasing use of color components; originality, creativity; attractiveness of human subjects, as well as fish; above all—sharp, sharp, sharp focus!''

Ⓝ ☑ ▣ WHISKEY ISLAND MAGAZINE

Department of English, Cleveland State University, Cleveland OH 44115. (216)687-2056. Fax: (216)687-6943. E-mail: whiskeyisland@csuohio.edu. Web site: www.csuohio.edu/whiskey_island. **Contact:** Editor. Circ. 1,000. Estab. 1977. Biannual literary magazine publishing thoughtful, socially conscious, conversation-provoking work. Sample copy available for $6. Photo guidelines available for SASE.
Needs Uses 10 photos/issue; 20 photos/year. Needs photos of babies/children/teens, multicultural, disasters, environmental, landscapes/scenics, wildlife, cities/urban, pets, religious, rural, political, science, technology. Interested in alternative process, avant garde, documentary, fine art, seasonal. Looking for work ''with spirit and originality.'' Encourages images with a highly personal/intimate quality. Surreal and abstract are welcome. Reviews photos with or without ms. Model/property release preferred. Photo captions required; include title of work, photographer's name, address, phone number, e-mail, etc.
Specs Uses b&w prints. Accepts images in digital format. Send via e-mail attachment as low-resolution TIFF, JPEG files.
Making Contact & Terms E-mail or send query letter with slides, photocopies or disk. Does not keep samples on file; include SASE for return of material. Responds in 3 months. Pays 2 contributor's copies and a 1-year subscription. No credit line given.
Tips ''Label all material clearly. Include as much contact information as possible.''

$ ▢ Ⓢ ▣ WHISPER IN THE WOODS NATURE JOURNAL

Turning Leaf Productins, LLC, P.O. Box 1014, Traverse City MI 49685. (231)943-0153. Fax: (866)943-0153. E-mail: editor@whisperinthewoods.com. Web site: www.whisperinthewoods.com. **Contact:** Kimberli Bind-

schatel. Circ. 10,000. Quarterly. "For nature lovers interested in the appreciation of the beauty of nature." Sample copy available for $8 (includes shipping). Photo guidelines available on Web site.

Needs All nature.

Specs Uses slides. Accepts images in digital format. Send JPEGs for review; will require high-res files for publication. Photo captions required; include title of image with subject matter.

Making Contact & Terms "No e-mails, please. Send letter with samples in the mail." Pays $100 maximum for cover. Pays $20 minimum/$200 maximum for inside. Review fee: $10. Pays on publication. Buys one-time rights.

Tips "Please send bodies of work on a particular subject or theme."

$⬚ ▣ WHOLE LIFE TIMES

Conscious Enlightenment, LLC, 6464 W. Sunset Blvd., Suite 1080, Los Angeles CA 90028. (323)464-1285. Fax: (323)464-8838. E-mail: graphics@wholelifetimes.com. Web site: www.wholelifetimes.com. Circ. 58,000. Estab. 1979. Local southern California magazine emphasizing alternative health, personal growth, environment, progressive politics, spirituality, social justice, organic food. Readers are 65% female, educated and active, average age 25-54. "Our approach is option-oriented, holistic, entertaining." Sample copy available for $4 or on Web site.

Needs Buys 4-5 photos from freelancers/issue; 50 photos/year. Sometimes needs photos related to local environmental issues, food, celebrities in alignment with mission, progressive local politicians, social or political commentary cartoons, unusual beauty shots. Also seeking local photographers with unusual, edgy style. Reviews photos with or without a manuscript. Model release required; ownership release required. "Almost all photos are by local assignment."

Specs Prefers images in digital format. Send via e-mail, CD, DVD as TIFF, EPS, JPEG files at 300 dpi. Also uses 8×10 glossy or matte color prints; 35mm, $2\frac{1}{4} \times 2\frac{1}{4}$, 4×5, 8×10 transparencies.

Making Contact & Terms Send query letter with nonreturnable prints or digital files, photocopies, tearsheets, stock list. Provide business card to be kept on file for possible future assignments. Responds only if interested; send nonreturnable samples. Simultaneous submissions and previously published work OK. Fees are negotiated for assignments. Stock usage fees comparable to online fees. Pays 30 days after publication. Credit line given "with photo and in masthead." Buys one-time rights and one-time electronic rights.

Tips "Our readers are sophisticated but not trendy. For more info on our niche, see www.culturalcreatives .com. Prefer vertical images for cover and require space for cover lines and masthead. Payscale is moderate. Great opportunity for exposure and expanding portfolio through our well-established, nationally recognized niche publication in business for 28 years. Send only your best work!"

$ $▣ WINE & SPIRITS

2 W. 32nd St., Suite 601, New York NY 10001. (212)695-4660, ext. 15. Fax: (212)695-2920. E-mail: elenab@wineandspiritsmagazine.com. Web site: www.wineandspiritsmagazine.com. **Contact:** Elena Bessarabova, art director. Circ. 70,000. Estab. 1982. Bimonthly magazine. Emphasizes wine. Readers are male, ages 39-60, married, parents, $70,000-plus income, wine consumers. Sample copy available for $4.95; Special issues are $4.95-6.50 each.

Needs Buys 0-30 photos from freelancers/issue; 0-180 photos/year. Needs photos of food, wine, travel, people. Photo captions preferred; include date, location.

Specs Accepts images in digital format. Send via SyQuest, Zip at 300 dpi.

Making Contact & Terms Submit portfolio for review. Provide résumé, business card, brochure, flier or tearsheets to be kept on file for possible future assignments. Responds in 2 weeks, if interested. Simultaneous submissions OK. Pays $200-1,000/job. Pays on publication. Credit line given. Buys one-time rights.

Ⓝ $ $▣ WINE ENTHUSIAST

Wine Enthusiast Companies, 103 Fairview Park Dr., Elmsford NY 10523. E-mail: tmoriarty@wineenthusi ast.net. Web site: www.wineenthusiast.com/mag. **Contact:** Tim Moriarty, managing editor. Circ. 80,000. Bimonthly consumer magazine covering the lifestyle of wine. "In-depth, authoritative reviews of specific wines and stories on winemakers and regions are lightly accented with stories on food, travel, and other aspects of the good life revolving around wine. Our readers are upscale and educated, but not necessarily super-sophisticated about wine itself. Our informal, irreverent approach appeals to savvy enophiles and newbies alike."

Needs Needs photos of entertainment, food/drink, wine and spirits. Interested in lifestyle. Reviews photos with or without a manuscript.

Specs Accepts images in digital format. Send JPEG or GIF files.

Contact & Terms Pays $135- $400/photo. **Pays on acceptance.**

N $ WISCONSIN OUTDOOR JOURNAL

F + W Publications, 700 E. State St., Iola WI 54990-0001. (715)445-2214. Fax: (715)445-4087. E-mail: jacob.edson@fwpubs.com. Web site: www.wisoutdoorjournal.com. **Contact:** Jacob Edson, editor. Circ. 28,000. Estab. 1987. An in-state publication for hunters and anglers published 8 times/year. *WOJ* covers Wisconsin outdoors through how-to features, informational articles, regional field reports, historical features and features on Wisconsin flora, fauna and geography. Sample copy available for 9 × 12 SAE. Photo guidelines available on Web site or with SASE.

Needs Buys 20 photos from freelancers/issue; 160 photos/year. Needs photos of environmental, landscapes/scenics, wildlife. Reviews photos with or without a manuscript. Model/property release preferred. Photo captions preferred.

Making Contact & Terms Query before submitting samples. Keeps samples on file. Pays $25-150 for b&w inside; $40-200 for color inside. Pays on publication. Credit line given. Buys one-time rights.

Tips "Become familiar with the magazine. Because we're seasonal, emphasis is on fishing during warm weather, hunting in the fall, and ice fishing in the winter."

$ WISCONSIN SNOWMOBILE NEWS

P.O. Box 182, Rio WI 53960-0182. (920)992-6370. Fax: (920)992-6369. E-mail: wisnow@centurytel.net. Web site: www.reachsnowmobilers.com. **Contact:** Cathy Hanson, editor. Circ. 30,000. Estab. 1969. Magazine published 7 times/year. Official publication of the Association of Wisconsin Snowmobile Clubs. Emphasizes snowmobiling. Sample copy free with 9 × 12 SAE and 5 first-class stamps.

Needs Buys very few stand-alone photos from freelancers. "Most photos are purchased in conjunction with a story (photo/text) package. Photos need to be Midwest region only!" Needs photos of family-oriented snowmobile action, posed snowmobiles, travel. Model/property release preferred. Photo captions preferred; include where, what, when.

Specs Uses 8 × 10 glossy color and/or b&w prints; 35mm, 2¼ × 2¼, 4 × 5, 8 × 10 transparencies. Digital files accepted at 300 dpi.

Making Contact & Terms Submit portfolio for review. Send unsolicited photos by mail for consideration; include SASE for return of material. Provide résumé, business card, brochure, flier or tearsheets to be kept on file for possible future assignments. Responds in 2 weeks. Simultaneous submissions and previously published work OK. Pays $10-50 for color photos. Pays on publication. Credit line given. Buys one-time rights, all rights; negotiable.

$ $ WRITER'S DIGEST

F + W Publications, Inc., 4700 E. Galbraith Rd., Cincinnati OH 45236. (513)531-2690, ext. 1483. Fax: (513)891-7153. E-mail: kathy.dezarn@fwpubs.com. Web site: www.writersdigest.com. **Contact:** Kathleen DeZarn, art director. Editor: Maria Schneider. Circ. 120,000. Estab. 1920. Monthly consumer magazine. "Our readers write fiction, nonfiction, plays and scripts. They're interested in improving their writing skills and the ability to sell their work, and finding new outlets for their talents." Photo guidelines free with SASE or via e-mail.

Needs Occasionally buys photos from freelancers. Needs photos of education, hobbies, writing life, business concepts, product shots/still life. Other specific photo needs: photographers to shoot authors on location for magazine cover. Model/property release required. Photo captions required; include your copyright notice.

Specs Uses 8 × 10 color and/or digital (resizable) images. Accepts images in digital format if hired. Send via CD, Zip as TIFF, EPS, JPEG files at 300 dpi (at hire).

Making Contact & Terms Provide business card, self-promotion piece to be kept on file for possible future assignments. Keeps samples on file. Responds only if interested; send nonreturnable samples. Pays $0-1,000 for color cover; $0-600 for color inside. Pays when billed/invoiced. Credit line given. Buys one-time rights.

Tips "Please don't submit/re-submit frequently. We keep samples on file and will contact you if interested. Submissions are considered for other Writer's Digest publications as well. For stock photography, please include pricing/sizes of black & white usage if available."

◻ **THE WYOMING COMPANION MAGAZINE**

P.O. Box 1111, Laramie WY 82073-1111. (307)760-9649. E-mail: editor@wyomingcompanion.com. Web site: www.wyomingcompanion.com. **Contact:** Mick McLean, editor. Online magazine.

Needs Photos should be related to the state of Wyoming: scenics, recreation, people, Yellowstone and the Tetons, sunsets.

Making Contact & Terms Contact via e-mail. Photographers retain copyright.

Tips "Photographers should see Web site for more information, or query by e-mail."

YACHTING MAGAZINE

Bonnier Corporation, 18 Marshall St., Suite 114, South Norwalk CT 06854-2237. (203)299-5900. Fax: (203)299-5901. Web site: www.yachtingnet.com. **Contact:** David Pollard, art director. Circ. 132,000. Estab. 1907. Monthly magazine addressing the interests of both sail and powerboat owners, with the emphasis on high-end vessels. Includes boating events, boating-related products, gear and how-to.

Making Contact & Terms Send query letter with tearsheets. Provide self-promotion piece to be kept on file for possible future assignments. Responds only if interested; send nonreturnable samples. Pays on publication. Buys first rights.

Tips "Read the magazine, and have a presentable portfolio."

$◻ **YOUTH RUNNER MAGAZINE**

P.O. Box 1156, Lake Oswego OR 97035. (503)236-2524. Fax: (503)620-3800. E-mail: dank@youthrunner.com. Web site: www.youthrunner.com. **Contact:** Dan Kesterson, editor. Circ. 100,000. Estab. 1996. Quarterly magazine. Emphasizes track, cross country and road racing for young athletes, ages 8-18. Photo guidelines available on Web site.

Needs Uses 30-50 photos/issue. Also uses photos on Web site daily. Needs action shots from track, cross country and indoor meets. Model release preferred; property release required. Photo captions preferred.

Specs Accepts images in digital format only. Send via e-mail or CD.

Making Contact & Terms Send unsolicited photos by e-mail for consideration. Responds to e-mail submissions immediately. Simultaneous submissions OK. Pays $25 minimum. Credit line given. Buys electronic rights, all rights.

Newspapers & Newsletters

When working with newspapers, always remember that time is of the essence. Newspapers have various deadlines for each of their sections. An interesting feature or news photo has a better chance of getting in the next edition if the subject is timely and has local appeal. Most of the markets in this section are interested in regional coverage. Find publications near you and contact editors to get an understanding of their deadline schedules.

More and more newspapers are accepting submissions in digital format. In fact, most newspapers prefer digital images. However, if you submit to a newspaper that still uses film, ask the editors if they prefer certain types of film or if they want color slides or black & white prints. Many smaller newspapers do not have the capability to run color images, so black & white prints are preferred. However, color slides and prints can be converted to black & white. Editors who have the option of running color or black & white photos often prefer color film because of its versatility.

Although most newspapers rely on staff photographers, some hire freelancers as stringers for certain stories. Act professionally and build an editor's confidence in you by supplying innovative images. For example, don't get caught in the trap of shooting "grip-and-grin" photos when a corporation executive is handing over a check to a nonprofit organization. Turn the scene into an interesting portrait. Capture some spontaneous interaction between the recipient and the donor. By planning ahead you can be creative.

When you receive assignments, think about the image before you snap your first photo. If you are scheduled to meet someone at a specific location, arrive early and scout around. Find a proper setting or locate some props to use in the shoot. Do whatever you can to show the editor you are willing to make that extra effort.

Always try to retain resale rights to shots of major news events. High news value means high resale value, and strong news photos can be resold repeatedly. If you have an image with national appeal, search for larger markets, possibly through the wire services. You also may find buyers among national news magazines such as *Time* or *Newsweek*.

While most newspapers offer low payment for images, they are willing to negotiate if the image will have a major impact. Front-page artwork often sells newspapers, so don't underestimate the worth of your images.

$⬛ ARCHAEOLOGY

2660 Petersborough St., Herndon VA 20171. E-mail: shannonaswriter@yahoo.com. Estab. 1998. Quarterly magazine. Photo guidelines available via e-mail.

Needs Buys 12 photos from freelancers/issue; 48-72 photos/year. Needs photos of babies/children/teens, celebrities, couples, multicultural, families, parents, disasters, environmental, landscapes/scenics, wildlife, architecture, cities/urban, education, gardening, interiors/decorating, pets, religious, rural, adventure, events, food/drink, sports, travel, agriculture, medicine, military, political, product shots/still life, science, technology—as related to archaeology. Interested in alternative process, avant garde, documentary, fashion/glamour, fine art, historical/vintage, seasonal. Wants photos of archaeology sites and excavations in progress that are available for children and teens to visit. "Would like photographs of artifacts and Paleobiology." Reviews photos with or without a manuscript. Model/property release preferred.

Specs Uses glossy or matte color and/or b&w prints.

Making Contact & Terms Send query letter via e-mail. "If possible, please do not include photographs in files if they are sent through e-mail. A CD with your photographs sent to *Archaeology* is acceptable." Provide résumé, business card or self-promotion piece to be kept on file for possible future assignments. "A CD with your photographs is requested but not required. Illustrations and artwork are also accepted." Responds within 1 month to queries; 1 week to portfolios. Simultaneous submissions and previously published work OK. **Pays on acceptance**. Credit line given. Buys one-time rights, first rights; negotiable.

Ⓝ $◻ ▣ CALIFORNIA BUCKS

Outdoor News Service, P.O. Box 9007, San Bernardino CA 92427-0007. (909)887-3444. Fax: (909)887-8180. E-mail: cabucks@earthlink.net. Web site: www.outdoornewsservice.com. **Contact:** Rick Bean, managing editor. Circ. 500. Estab. 2005. Quarterly newsletter "covers the hunting of deer in California—when, where and how."

Needs Needs photos of deer and deer hunting. Reviews photos with or without a manuscript. Model release required; include identification of subjects.

Specs Accepts images in digital format. Send JPEG or TIFF files.

Making Contact & Terms Pays $25-$50/photo, depending on size. For photos submitted with a manuscript, pays $75/printed page. Pays on publication. Credit line given. Buys one-time rights.

Tips "Request a sample copy so you can see how the newsletter is set up. Virtually the whole newsletter is broken into 'departments.' "

Ⓝ $◻ ▣ CALIFORNIA HOG HUNTER, A Newsletter Dedicated to Hunting Wild Hogs

Outdoor News Service, P.O. Box 9007, San Bernardino CA 92427-0007. (909)887-3444. Fax: (909)887-8180. E-mail: cahoghunter@earthlink.net. Web site: www.outdoornewsservice.com. **Contact:** Rick Bean, managing editor. Circ. 1,000. Estab. 1998. Quarterly newsletter "covers the hunting of wild hogs in California—when, where and how."

Needs Needs photos of wild hogs and wild-hog hunting. Reviews photos with or without a manuscript. Model release required; include identification of subjects.

Specs Accepts images in digital format. Send JPEG or TIFF files.

Making Contact & Terms Pays $25-$50/photo, depending on size. For photos submitted with a manuscript, pays $75/printed page. Pays on publication. Credit line given. Buys one-time rights.

Tips "Request a sample copy so you can see how the newsletter is set up. Virtually the whole newsletter is broken into 'departments.' "

$◻ ▣ HARD HAT NEWS

Lee Publications, P.O. Box 121, Palatine Bridge NY 13428. (518)673-3237. Fax: (518)673-2381. E-mail: hrieser@leepub.com. Web site: www.hardhat.com. **Contact:** Holly Rieser, editor. Circ. 60,000. Estab. 1970. Biweekly trade newspaper for heavy construction. Readership includes owners, managers, senior construction trades. Photo guidelines available via e-mail only.

Needs Buys 12 photos from freelancers/issue; 280 photos/year. Specific photo needs: heavy construction in progress, construction people. Reviews photos with accompanying manuscripts only. Property release preferred. Photo captions required.

Specs "Only hi-res digital photographs accepted." Send via e-mail as JPEG files at 300 dpi.

Making Contact & Terms "E-mail only." Responds in 1 week to queries. Simultaneous submissions OK. Pays $60 minimum for color cover; $15 minimum for b&w inside. Pays on publication. Credit line given. Buys first rights.

Tips "Include caption and brief explanation of what picture is about."

$ 🌀 📧 ⬇ THE LAWYERS WEEKLY

123 Commerce Valley Dr. E., Suite 700, Markham ON L3T 7W8 Canada. (905)479-2665. Fax: (905)479-2826. E-mail: tim.wilbur@lexisnexis.ca. Web site: www.thelawyersweekly.ca. **Contact:** Tim Wilbur, managing editor. Circ. 20,300. Estab. 1983. Weekly newspaper. Emphasizes law. Readers are male and female lawyers and judges, ages 25-75. Sample copy available for $8. Photo guidelines free with SASE.

Needs Uses 12-20 photos/issue; 5 supplied by freelancers. Needs head shots of lawyers and judges mentioned in stories, as well as photos of legal events.

Specs Accepts images in digital format. Send as JPEG, TIFF files.

Making Contact & Terms Provide résumé, business card, brochure, flier or tearsheets to be kept on file for possible future assignments. Deadlines: 1- to 2-day turnaround time. Does not keep samples on file; include SASE for return of material. Responds only when interested. **Pays on acceptance.** Credit line not given.

Tips "We need photographers across Canada to shoot lawyers and judges on an as-needed basis. Send a résumé, and we will keep your name on file. Mostly black & white work."

$ PACKER REPORT

212 Crestview Ln., De Pere WI 54115. (920)366-4043. Fax: (920)347-9660. E-mail: packrepted@aol.com. Web site: www.packerreport.com. **Contact:** Todd Korth, managing editor. Circ. 30,000. Estab. 1973. Monthly magazine (published 10 times/year). Emphasizes Green Bay Packer football. Readers are 94% male, all occupations, all ages. Sample copy free with SASE and 3 first-class stamps.

Making Contact & Terms Send query letter with résumé of credits. Provide résumé, business card, brochure, flier or tearsheets to be kept on file for possible future assignments. Does not keep samples on file; include SASE for return of material. Responds in 1 month. Simultaneous submissions and previously published work OK. Pays $50 for color cover; $20 for b&w or color inside. Pays on publication. Credit line given. Buys one-time rights; negotiable.

$ 🌀 Ⓐ 📧 STREETPEOPLE'S WEEKLY NEWS (Homeless Editorial)

P.O. Box 270942, Dallas TX 75227-0942. E-mail: sw_n@yahoo.com. **Contact:** Lon G. Dorsey, Jr., publisher. Estab. 1990. Newspaper. Sample copy available by sending $35 to cover immediate handling (same day as received) and postage. Includes photo guidelines package now required. "Also contains information about our homeless television show and photo gallery."

● *SWN* wishes to establish relationships with professionals interested in homeless issues. "Photographers may be certified by *SWN* by submitting $35 check or money order and samples of work. Photographers needed in every metropolitan city in U.S."

Needs Wants photos of babies/children/teens, celebrities, couples, multicultural, families, parents, senior citizens, cities/urban, education, pets, religious, rural, events, food/drink, health/fitness, hobbies, humor, political, technology/computers. Interested in alternative process, documentary, fine art, historical/vintage, seasonal. Subjects include: photojournalism on homeless or street people. Model/property release required. "All photos *must* be accompanied by *signed* model releases." Photo captions required.

Specs Accepts images in digital format. Send via CD, e-mail as GIF, JPEG files.

Making Contact & Terms "Hundreds of photographers are needed to show national state of America's homeless." Send unsolicited photos by mail for consideration with SASE for return. Responds promptly. Pays $15-450 for cover; $15-150 for inside. Pays extra for electronic usage (negotiable). Pays on acceptance or publication. Credit line sometimes given. Buys all rights; negotiable.

Tips In freelancer's samples, wants to see "professionalism, clarity of purpose, without sex or negative atmosphere which could harm purpose of paper." The trend is toward "kinder, gentler situations, the 'let's help our fellows' attitude." To break in, "find out what we're about so we don't waste time with exhaustive explanations. We're interested in all homeless situations. Inquiries not answered without SASE. **All persons interested in providing photography should get registered with us.** Now using 'Registered photographers and Interns of *SWN*' for publishing and upcoming Internet worldwide awards competition. Info regarding competition is outlined in *SWN*'s photo guidelines package. Photographers not registered will not be considered due to the continuous sending of improper materials, inadequate

information, wasted hours of screening matter, etc. **If you don't wish to register with us, please don't send anything for consideration.** You'll find that many professional pubs are going this way to reduce the materials management pressures which have increased. We are trying something else new—salespeople who are also photographers. So, if you have a marketing/sales background with a photo kicker, contact us!"

$ ☑ ▣ SUN

1000 American Media Way, Boca Raton FL 33464-1000. (561)989-1154. Fax: (561)989-1395. **Contact:** Ann Charles, photo editor. Weekly tabloid. Readers are housewives, college students, middle Americans. Sample copy free with extra-large SAE and $1.70 postage.

Needs Buys 30 photos from freelancers/issue; 1,560 photos/year. Wants varied subjects: prophesies and predictions, amazing sightings (i.e., Jesus, Elvis, angels), stunts, unusual pets, health remedies, offbeat medical, human interest, inventions, spectacular sports action; offbeat pics and stories; and celebrity photos. "Also—we are always in need of interesting, offbeat, humorous stand-alone pix." Model release preferred. Photo captions preferred.

Specs Uses 8×10 b&w prints; 35mm transparencies. Accepts images in digital format.

Making Contact & Terms Send query letter with stock list and samples. Responds in 2 weeks. Simultaneous submissions and previously published work OK. Pays $75 for b&w cover; $125-200 for color cover; $50-125 for b&w inside; $125-200 for color inside. Pays on publication. Buys one-time rights.

Tips "We are specifically looking for the unusual, offbeat, freakish true stories and photos. *Nothing* is too far out for consideration. We suggest you send for a sample copy and take it from there."

$ ☑ ▣ ⊕ THE SUNDAY POST

D.C. Thomson & Co. Ltd., 2 Albert Square, Dundee DD1 9QJ Scotland. (44)(1382)223131. Fax: (44)(1382)201064. E-mail: mail@sundaypost.com. Web site: www.sundaypost.com. **Contact:** Alan Morrison, picture editor. Circ. 481,000. Estab. 1919. Weekly family newspaper.

Needs Needs photos of "UK news and news involving Scots," sports. Other specific needs: exclusive news pictures from the UK, especially Scotland. Reviews photos with accompanying manuscript only. Model/property release preferred. Photo captions required; include contact details, subjects, date. "Save in the caption field of the file info, so they can be viewed on our picture desk system. Mac users should ensure attachments are PC-compatible as we use PCs."

Specs Prefers images in digital format. Send via e-mail as JPEG files. "We need a minimum 5MB file saved at quality level 9 or above, ideally at 200 ppi/dpi ."

Making Contact & Terms Send query letter with tearsheets, stock list. Does not keep samples on file; include SASE for return of material. Responds in 2 weeks to queries. Simultaneous submissions OK. Pays $200 (USD) for b&w or color cover; $100-150 (USD) for b&w or color inside. Pays on publication. Credit line not given. Buys single use, all editions, one date, worldwide rights; negotiable.

Tips "Offer pictures by e-mail before sending: lo-res only, please—72 ppi, 800 pixels on the widest side; no more than 10 at a time. Make sure the daily papers aren't running the story first and that it's not being covered by the Press Association (PA). We get their pictures on our contracted feed."

$ $ ▣ ⊠ TORONTO SUN PUBLISHING

333 King St. E., Toronto ON M5A 3X5 Canada. (416)947-2399. E-mail: torsun.photoeditor@sunmedia.ca. Web site: www.torontosun.com. **Contact:** Jim Thomson, photo editor. Circ. 180,000. Estab. 1971. Daily newspaper. Emphasizes sports, news and entertainment. Readers are 60% male, 40% female, ages 25-60. Sample copy free with SASE.

Needs Uses 30-50 photos/issue; occasionally uses freelancers (spot news pics only). Needs photos of Toronto personalities making news out of town. Also disasters, beauty, sports, fashion/glamour. Reviews photos with or without a manuscript. Photo captions preferred.

Specs Accepts images in digital format. Send via CD or e-mail.

Making Contact & Terms Arrange a personal interview to show portfolio. Send any size color prints; 35mm transparencies; press link digital format. Deadline: 11 p.m. daily. Does not keep samples on file. Responds in 1-2 weeks. Simultaneous submissions and previously published work OK. Pays $125-500 for color cover; $50-500 for b&w inside. Pays on publication. Credit line given. Buys one-time and other negotiated rights.

Tips "The squeeky wheel gets the grease when it delivers the goods. Don't try to oversell a questionable photo. Return calls promptly."

$▣ VENTURA COUNTY REPORTER

Dept. PM, 700 E. Main St., Ventura CA 93001. (805)658-2244. Fax: (805)658-7803. E-mail: artdirector@vc reporter.com. Web site: www.vcreporter.com. **Contact:** Enrique Candioti, art director. Circ. 35,000. Estab. 1977. Weekly tabloid newspaper.

Needs Uses 12-14 photos/issue; 40-45% supplied by freelancers. "We require locally slanted photos (Ventura County, CA)." Model release required.

Specs Accepts images in digital format. Send via e-mail or CD.

Making Contact & Terms Send sample b&w or color original photos; include SASE for return of material. Responds in 2 weeks. Simultaneous submissions OK. Pays $150 for cover; $25-40 for inside. Pays on publication. Credit line given. Buys one-time rights.

$▣ ▣ ▣ THE WESTERN PRODUCER

P.O. Box 2500, Saskatoon SK S7K 2C4 Canada. (306)665-3544. Fax: (306)934-2401. E-mail: newsroom@p roducer.com. Web site: www.producer.com. **Contact:** Terry Fries, news editor. Editor: Barb Glen. Circ. 70,000. Estab. 1923. Weekly newspaper. Emphasizes agriculture and rural living in western Canada. Photo guidelines free with SASE.

Needs Buys 5-8 photos from freelancers/issue; 260-416 photos/year. Needs photos of farm families, environmental, gardening, science, livestock, nature, human interest, scenic, rural, agriculture, day-to-day rural life and small communities. Interested in documentary. Model/property release preferred. Photo captions required; include person's name, location, and description of activity.

Specs Accepts images in digital format. Send via CD, Zip, e-mail as TIFF, EPS, PICT files at 300 dpi.

Making Contact & Terms Send material for consideration by mail or e-mail to the attention of the news editor; include SASE for return of material if sending by mail. Previously published work OK, "but let

© Chuck Graham

Chuck Graham has been writing and photographing for the *Ventura County Reporter* since 1998. This photo was part of a photo/text package about foxes on the Channel Islands for which Graham was paid $300.

us know.'' Pays $75-150 for b&w or color cover; $60-80 for b&w or color inside; $50-250 for text/photo package. Pays on publication. Credit line given. Buys one-time rights.

Tips Needs current photos of farm and agricultural news. ''Don't waste postage on abandoned, derelict farm buildings or sunset photos. We want modern scenes with life in them—people or animals, preferably both.'' Also seeks items on agriculture, rural western Canada, history and contemporary life in rural western Canada.

Trade Publications

Most trade publications are directed toward the business community in an effort to keep readers abreast of the ever-changing trends and events in their specific professions. For photographers, shooting for these publications can be financially rewarding and can serve as a stepping stone toward acquiring future assignments.

As often happens with this category, the number of trade publications produced increases or decreases as professions develop or deteriorate. In recent years, for example, magazines involving new technology have flourished as the technology continues to grow and change.

Trade publication readers are usually very knowledgeable about their businesses or professions. The editors and photo editors, too, are often experts in their particular fields. So, with both the readers and the publications' staffs, you are dealing with a much more discriminating audience. To be taken seriously, your photos must not be merely technically good pictures, but also should communicate a solid understanding of the subject and reveal greater insights.

In particular, photographers who can communicate their knowledge in both verbal and visual form will often find their work more in demand. If you have such expertise, you may wish to query about submitting a photo/text package that highlights a unique aspect of working in a particular profession or that deals with a current issue of interest to that field.

Many photos purchased by these publications come from stock—both freelance inventories and stock photo agencies. Generally, these publications are more conservative with their freelance budgets and use stock as an economical alternative. For this reason, some listings in this section will advise sending a stock list as an initial method of contact. (See sample stock list on page 19.) Some of the more established publications with larger circulations and advertising bases will sometimes offer assignments as they become familiar with a particular photographer's work. For the most part, though, stock remains the primary means of breaking in and doing business with this market.

$⊘ ⑤ ▣ AAP NEWS

141 Northwest Point Blvd., Elk Grove Village IL 60007. (847)434-4755. Fax: (847)434-8000. Web site: www.aapnews.org. **Contact:** Michael Hayes, art director/production coordinator. Estab. 1985. Monthly tabloid newspaper. Publication of American Academy of Pediatrics.

Needs Uses 60 photos/year. Needs photos of babies/children/teens, families, health/fitness, sports, travel, medicine, pediatricians, health care providers—news magazine style. Interested in documentary. Model/property release required as needed. Photo captions required; include names, dates, locations and explanations of situations.

Specs Accepts images in digital format. Send via CD, floppy disk, Jaz, Zip, e-mail as TIFF, EPS, JPEG files at 300 dpi.

Making Contact & Terms Provide résumé, business card or tearsheets to be kept on file (for 1 year) for possible future assignments. Cannot return material. Simultaneous submissions and previously published work OK. Pays $50-150 for one-time use of photo. Pays on publication. Buys one-time or all rights; negotiable.

Tips ''We want great photos of 'real' children in 'real-life' situations; the more diverse the better.''

Ⓝ $ $ $⊘ ▣ ABA BANKING JOURNAL

345 Hudson St., New York NY 10014. **Contact:** Wendy Williams, creative director. Art Director: Phil Desiere. Circ. 30,000. Estab. 1909. Monthly magazine. Emphasizes ''how to manage a bank better. Bankers read it to find out how to keep up with changes in regulations, lending practices, investments, technology, marketing and what other bankers are doing to increase community standing.''

Needs Buys 6 photos/year; freelance photography is 20% assigned, 80% from stock. Personality, and occasionally photos of unusual bank displays or equipment. ''We need candid photos of various bankers who are subjects of articles.'' Photos purchased with accompanying manuscript or on assignment.

Specs Uses 35mm transparencies. Accepts images in digital format. Send via CD, e-mail as CMYK JPEG files at 300 dpi.

Making Contact & Terms Send query letter with samples, postcards; include SASE for return of material. Responds in 1 month. Pays $400-1,500/photo. **Pays on acceptance.** Credit line given. Buys one-time rights.

Tips ''Send postcard. We hire by location, city.''

$ $▣ ☑ ADVANCED MANUFACTURING

CLB Media Inc., 240 Edwards St., Aurora ON L4G 3S9 Canada. (905)727-0077. Fax: (905)727-0017. E-mail: jtenpenny@CLBmedia.ca. Web site: www.advancedmanufacturing.com. **Contact:** John Tenpenny, editor. Circ. 17,400. Estab. 1998. Bimonthly trade magazine providing a window on the world of advanced manufacturing. Sample copies available for SAE with first-class postage.

Needs Buys 2 photos from freelancers per issue. Subjects include industry, science and technology. Reviews photos with or without a manuscript. Model release required. Photo captions preferred.

Specs Uses 5×7 color prints; 4×5 transparencies. ''We prefer images in high-resolution digital format. Send as FTP files at a minimum of 300 dpi.''

Making Contact & Terms Send query letter with résumé, stock list. Provide self-promotion piece to be kept on file for possible future assignments. Responds only if interested. Simultaneous submissions and previously published work OK. Pays $200-1,000 for color cover; $150-1,000 for color inside. Pays 30-45 days after invoice date. Credit line given. Buys one-time rights, electronic rights; negotiable.

Tips ''Read our magazine. Put yourself in your clients' shoes. Meet their needs and you will excel. Understand your audience and the editors' needs. Meet deadlines, be reasonable and professional.''

$⊘ ⑤ ▣ AFTERMARKET BUSINESS

Advanstar Communications, 7500 Old Oak Blvd., Cleveland OH 44130. (440)891-2677. Fax: (440)891-2675. E-mail: sparker@advanstar.com. Web site: www.aftermarketbusiness.com. **Contact:** Stephanie Parker, art director. Circ. 41,821. Estab. 1936. ''*Aftermarket Business* is a monthly tabloid-sized magazine, written for corporate executives and key decision-makers responsible for buying automotive products (parts, accessories, chemicals) and other services sold at retail to consumers and professional installers. It's the oldest continuously published business magazine covering the retail automotive aftermarket and is the only publication dedicated to the specialized needs of this industry.'' Sample copies available; call (888)527-7008 for rates.

Needs Buys 0-1 photo from freelancers/issue; 12-15 photos/year. Needs photos of automobiles, product shots/still life. "Review our editorial calendar to see what articles are being written. We use lots of conceptual material." Model/property release preferred.

Specs Prefers images in digital format. Send via CD, Zip, e-mail as TIFF, JPEG files at 300 dpi. Also uses 35mm, $2^{1}/_{4} \times 2^{1}/_{4}$ transparencies.

Making Contact & Terms Send query letter with slides, transparencies, stock list. Provide business card or self-promotion piece to be kept on file for possible future assignments. Responds only if interested; send nonreturnable samples. Pay negotiable. Pays on publication. Credit line given. "Corporate policy requires all freelancers to sign a print and online usage contract for stories and photos." Usually buys one-time rights.

Tips "We can't stress enough the importance of knowing our audience. We are not a magazine aimed at car dealers. Our readers are auto parts distributors. Looking through sample copies will show you a lot about what we need. Show us a variety of stock and lots of it. Send only dupes."

$ ☐ Ⓢ ▣ AIR LINE PILOT

535 Herndon Pkwy., Box 20172, Herndon VA 22070. (703)481-4460. Fax: (703)464-2114. E-mail: magazine@alpa.org. Web site: www.alpa.org. **Contact:** Pete Janhunen, publications manager. Circ. 72,000. Estab. 1932. Publication of Air Line Pilots Association. 10 issues/year. Emphasizes news and feature stories for airline pilots. Photo guidelines available on Web site.

Needs Buys 3-4 photos from freelancers/issue; 18-24 photos/year. Needs dramatic 35mm transparencies, prints or high-resolution IBM-compatible images on disk or CD of commercial aircraft, pilots and co-pilots performing work-related activities in or near their aircraft. "Pilots must be ALPA members in good standing. Our editorial staff can verify status." Special needs include dramatic images technically and aesthetically suitable for full-page magazine covers. Especially needs vertical composition scenes. Model release required. Photo captions required; include aircraft type, airline, location of photo/scene, description of action, date, identification of people and which airline they work for.

Specs Accepts images in digital format. Uses original 35mm or larger slides; Fuji Velvia 50 film preferred.

Making Contact & Terms Send query letter with samples. Send unsolicited photos by mail with SASE for consideration. "Currently use two local outside vendors for assignment photography. Occasionally need professional 'news' photographer for location work. Most freelance work is on speculative basis only." No simultaneous submissions. Pays $350 for cover (buys all rights); Fees for inside are negotiable (buys one-time rights). **Pays on acceptance.**

Tips In photographer's samples, wants to see "strong composition, poster-like quality and high technical quality. Photos compete with text for space, so they need to be very interesting to be published. Be sure to provide brief but accurate caption information and send only professional-quality work. Cover images should show airline pilots at work or in the airport going to work. For covers, please shoot vertical images. Check Web site for criteria and requirements. Send samples of slides to be returned upon review. Make appointment to show portfolio."

$ AMERICAN BEE JOURNAL

51 S. Second St., Hamilton IL 62341. (217)847-3324. Fax: (217)847-3660. E-mail: abj@dadant.com. Web site: www.dadant.com/journal. **Contact:** Joe M. Graham, editor. Circ. 13,000. Estab. 1861. Monthly trade magazine. Emphasizes beekeeping for hobby and professional beekeepers. Sample copy free with SASE.

Needs Buys 1-2 photos from freelancers/issue; 12-24 photos/year. Needs photos of beekeeping and related topics, beehive products, honey and cooking with honey. Special needs include color photos of seasonal beekeeping scenes. Model release preferred. Photo captions preferred.

Making Contact & Terms Send query letter with samples. Send 5×7 or $8^{1}/_{2} \times 11$ color prints by mail for consideration; include SASE for return of material. Responds in 2 weeks. Pays $75 for color cover; $10 for color inside. Pays on publication. Credit line given. Buys all rights.

Ⓝ $ ☐ Ⓐ ▣ AMERICAN POWER BOAT ASSOCIATION

17640 E. Nine Mile Rd., Box 377, Eastpointe MI 48021-0377. (586)773-9700. Fax: (586)773-6490. E-mail: propeller@apba-racing.com. Web site: www.apba-racing.com. **Contact:** Tana Moore, publications editor. Estab. 1903. Sanctioning body for U.S. power boat racing; monthly magazine. Majority of assignments made on annual basis. Photos used in monthly magazine, brochures, audiovisual presentations, press releases, programs and Web site.

Needs Needs photos of adventure, events. Interested in documentary, historical/vintage. Power boat racing—action and candid. Photo captions required.

Specs Accepts images in digital format. Send via CD, e-mail as TIFF, EPS, JPEG files at 300 dpi.

Making Contact & Terms Initial personal contact preferred. Suggests initial contact by e-mail, letter or phone, possibly to be followed by evaluating samples. Provide business card to be kept on file for possible future assignments. Responds in 2 weeks when needed. Payment varies. Standard is $25 for color cover; $15 for interior pages. Credit line given. Buys one-time rights; negotiable. Photo usage must be invoiced by photographer within the month incurred.

Tips Prefers to see selection of shots of power boats in action or pit shots, candids, etc., (all identified). Must show ability to produce clear color action shots of racing events. "Send a few samples with introduction letter, especially if related to boat racing."

$⊘ ▣ ANIMAL SHELTERING

HSUS, 2100 L St. NW, Washington DC 20037. (202)452-1100. Fax: (301)258-3081. E-mail: asm@hsus.org. Web site: www.animalsheltering.org. **Contact:** Kate Antoniades, writer/copyeditor. Circ. 7,500. Estab. 1978. Bimonthly magazine of The Humane Society of the United States. Emphasizes animal protection. Readers are animal control workers, shelter workers, men and women, all ages. Sample copy free.

Needs Buys about 2-10 photos from freelancers/issue; 30 photos/year. Needs photos of domestic animals interacting with animal control and shelter workers; animals in shelters, including farm animals and wildlife; general public visiting shelters and adopting animals; humane society work, functions and equipment. Photo captions preferred.

Specs Accepts color images in digital or print format. Send via CD, Zip, e-mail as TIFF, JPEG files at 300 dpi.

Making Contact & Terms Provide samples of work to be kept on file for possible future use or assignments; include SASE for return of material. Responds in 1 month. Pays $150 for cover; $75 for inside. Pays on publication. Credit line given. Buys one-time and electronic rights.

Tips "We almost always need good photos of people working with animals in an animal shelter or in the field. We do not use photos of individual dogs, cats and other companion animals as often as we use photos of people working to protect, rescue or care for dogs, cats and other companion animals."

Ⓝ $ $▣ APA MONITOR

American Psychological Association, 750 First St. NE, Washington DC 20002. (202)336-5675. Fax: (202)336-6103. E-mail: monitor@apa.org. **Contact:** Sadie Dingfelder, senior editor. Circ. 150,000. Monthly magazine. Emphasizes "news and features of interest to psychologists and other behavioral scientists and professionals, including legislation and agency action affecting science and health, and major issues facing psychology both as a science and a mental health profession." Sample copy available for $3 and 9×12 envelope.

Needs Buys 60-90 photos/year. Photos purchased on assignment. Needs portraits, feature illustrations and spot news.

Specs Prefers images in digital format; send TIFF files at 300 dpi via e-mail. Uses 5×7 and 8×10 glossy prints.

Making Contact & Terms Arrange a personal interview to show portfolio or query with samples. Pays by the job; $100/hour; $175 minimum; $200 for stock. **Pays on receipt of invoice.** Credit line given. Buys first serial rights.

Tips "Become good at developing ideas for illustrating abstract concepts and innovative approaches to clichés such as meetings and speeches. We look for quality in technical reproduction and innovative approaches to subjects."

$⊘ APPALOOSA JOURNAL

Appaloosa Horse Club, 2720 W. Pullman Rd., Moscow ID 83843. (208)882-5578. Fax: (208)882-8150. E-mail: journal@appaloosa.com. Web site: www.appaloosajournal.com. **Contact:** Diane Rice, editor. Circ. 22,000. Estab. 1946. Monthly association magazine. "*Appaloosa Journal* is the official publication of the Appaloosa Horse Club. We are dedicated to educating and entertaining Appaloosa enthusiasts from around the world." Readers are Appaloosa owners, breeders and trainers, child through adult. Complimentary sample copies available. Photo guidelines free with SASE.

Needs Buys 3 photos from freelancers/issue; 36 photos/year. Needs photos for cover, and to accompany

features and articles. Specifically wants photographs of high-quality Appaloosa horses, especially in winter scenes. Model release required. Photo captions required.

Specs Uses glossy color prints; 35 mm transparencies.

Making Contact & Terms Send query letter with résumé, slides, prints. Keeps samples on file. Responds only if interested; send nonreturnable samples. Simultaneous submissions OK. Pays $200 for color cover; $25 minimum for color inside. **Pays on acceptance.** Credit line given. Buys first rights.

Tips "The Appaloosa Horse Club is a not-for-profit organization. Serious inquiries within specified budget only." In photographer's samples, wants to see "high-quality color photos of world-class, characteristic (coat patterned) Appaloosa horses with people in appropriate outdoor environments. Send a letter introducing yourself and briefly explaining your work. If you have inflexible preset fees, be upfront and include that information. Be patient. We are located at the headquarters; although an image might not work for the magazine, it might work for other printed materials. Work has a better chance of being used if allowed to keep on file. If work must be returned promptly, please specify. Otherwise, we will keep it for other departments' consideration."

$ $ AQUA MAGAZINE: The Business Publication for Spa & Pool Professionals

Athletic Business Publications, Inc., 4130 Lien Rd., Madison WI 53704-3602. (608)249-0186. Fax: (608)249-1153. E-mail: scott@aquamagazine.com. Web site: www.aquamagazine.com. **Contact:** Scott Maurer, art director. Circ. 15,000. Estab. 1976. Monthly magazine. "*AQUA* serves spa dealers, swimming pool dealers and/or builders, spa/swimming pool maintenance and service, casual furniture/patio dealers, landscape architects/designers and others allied to the spa/swimming pool market. Readers are qualified owners, GM, sales directors, titled personnel."

Needs Photos of swimming pools and/or spas (hot tubs) that show all or part of pool/spa. "The images may include grills, furniture, gazebos, ponds, water features." Photo captions preferred.

Making Contact & Terms "OK to send promotional literature, and to e-mail contact sheets/Web gallery or low-resolution samples, but do not send anything that has to be returned (i.e., slides, prints) unless asked for." Simultaneous submissions and previously published work OK, "but should be explained." Pays $400 for color cover (negotiable); $200 for color inside. Pays on publication. Credit line given. Buys all rights; negotiable.

Tips Wants to see "visually arresting images, high quality, multiple angles, day/night lighting situations. Photos including people are rarely published."

$ $ ☑ ⑤ ▣ ARCHITECTURAL LIGHTING

One Thomas Circle NW, Suite 600, Washington DC 2005. (202)729-3647. Fax: (202)785-1974. E-mail: edonoff@hanleywood.com. Web site: www.archlighting.com. **Contact:** Elizabeth Donoff, editor. Circ. 25,000. Estab. 1981. Published 7 times/year. Emphasizes architecture and architectural lighting. Readers are architects and lighting designers. Sample copy free.

Needs Buys 3-5 photos/feature story. Needs photos of architecture and architectural lighting.

Specs Prefers images in digital format. Send via e-mail as TIFF files at 300 dpi, minimum 4×6 inches.

Making Contact & Terms Query *first* by e-mail to obtain permission to e-mail digital samples. Keeps samples on file. Cannot return material. Responds in 1-2 weeks. Simultaneous submissions OK. Pays $300-400 for color cover; $50-125 for color inside. Pays net 40 days point of invoice submission. Credit line given. Buys all rights for all media, including electronic media.

Tips Looking for "a strong combination of architecture and architectural lighting."

ℕ $◻ ⑤ ▣ ASIAN ENTERPRISE

Asian Business Ventures, Inc., P.O. Box 2135, Walnut CA 91788-2135. (909)860-3316. Fax: (909)860-7054. E-mail: alma.asianent@gmail.com. Web site: www.asianenterprise.com. **Contact:** Alma Guiuan, office manager. Circ. 100,000. Estab. 1993. Monthly trade magazine. "Largest Asian American small business focus magazine in U.S." Sample copy available for SAE with first-class postage.

Needs Buys 3-5 photos from freelancers/issue; 36-60 photos/year. Needs photos of multicultural, business concepts, senior citizens, environmental, architecture, cities/urban, education, travel, military, political, technology/computers. Reviews photos with or without a manuscript. Model/property release required.

Specs Uses 4×6 matte b&w prints. Accepts images in digital format. Send via Zip as TIFF, JPEG files at 300-700 dpi.

Making Contact & Terms Send query letter with prints. Provide self-promotion piece to be kept on file

for possible future assignments. Responds only if interested; send nonreturnable samples. Simultaneous submissions OK. Pays $50-200 for color cover; $25-100 for b&w inside. Pays on publication. Credit line given. Buys one-time rights.

$ $ ATHLETIC BUSINESS: The Leading Resource for Athletic, Fitness & Recreation Professionals

Athletic Business Publications, Inc., 4130 Lien Rd., Madison WI 53704. (608)249-0186. Fax: (608)249-1153. E-mail: katy@athleticbusiness.com. Web site: www.athleticbusiness.com. **Contact:** Katy Williams, art director. Circ. 43,000. Estab. 1977. Monthly magazine. Emphasizes athletics, fitness and recreation. Readers are athletic, park and recreational directors and club managers, ages 30-65. Sample copy available for $8.

Needs Buys 2-3 photos from freelancers per issue; 24-26 photos/year. Needs photos of "individuals and teams playing sports, athletic equipment, recreational parks, and health club/multi-sport interiors." Model/property release preferred. Photo captions preferred.

Making Contact & Terms "Feel free to send promotional literature, but do not send anything that has to be returned (i.e., slides, prints) unless asked for." Simultaneous submissions and previously published work OK, "but should be explained." Pays $400 for color cover (negotiable); $200 for color inside. Pays on publication. Credit line given. Buys all rights; negotiable.

Tips Wants to see "visually arresting images, ability with subject, high quality and reasonable price." To break in, "shoot a quality and creative shot from more than one angle and at different depths."

Ⓝ $ $ ATHLETIC MANAGEMENT

31 Dutch Mill Rd., Ithaca NY 14850-9785. (607)257-6970. Fax: (607)257-7328. E-mail: art@momentummedia.com. **Contact:** Eleanor Frankel, editor-in-chief. Circ. 30,000. Estab. 1989. Bimonthly magazine. Emphasizes the management of athletics. Readers are managers of high school and college athletic programs.

Needs Uses 10-20 photos/issue; 50% supplied by freelancers. Needs photos of athletic events and athletic equipment/facility shots; college and high school sports action photos. Model release preferred.

Making Contact & Terms Call Pam Crawford, art director, at (413)253-4726. Previously published work OK. Pays $600-800 for color cover; $200-400 for color inside. Pays on publication. Credit line given. Buys first North American serial rights; negotiable.

Ⓝ $ Ⓢ ▯ AUTO GLASS

National Glass Association, 8200 Greensboro Dr., Suite 302, McLean VA 22102-3881. (866)442-4890. Fax: (703)442-0630. Email: mslovick@glass.org. Web site: www.glass.org. **Contact:** Matt Slovick, managing editor. Circ. 14,000. Estab. 1990. Trade magazine emphasizing automotive use of glass published 7 times/year. Sample copies available for 9×12 SAE with $1.25 first-class postage.

Needs Buys 1-3 photos from freelancers/issue; 7-21 photos/year. Needs photos of cities/urban, automobiles. All photos should feature glass prominently. Reviews photos with or without manuscript. Photo captions required.

Specs Uses 4×6 minimum, glossy color prints. Accepts images in digital format. Send via CD, Zip, e-mail, FTP upload as TIFF, EPS files at 300 dpi.

Making Contact & Terms Send query letter with tearsheets, stock list. Provide self-promotion piece to be kept on file for possible future assignments. Responds only if interested, send nonreturnable samples. Payment depends on freelancer and position of photo in the magazine. **Pays on acceptance.** Credit line given. Buys one-time rights.

$ AUTOMATED BUILDER

1445 Donlon St. #16, Ventura CA 93003. (800)344-2537, (805)642-9735. Fax: (805)642-8820, (800)799-8947. E-mail: info@automatedbuilder.com. Web site: www.automatedbuilder.com. **Contact:** Don Carlson, editor/publisher. Circ. 26,000. Estab. 1964. Monthly. Emphasizes home and apartment construction. Readers are "factory and site builders and dealers of all types of homes, apartments and commercial buildings." Sample copy free with SASE.

Needs Buys 4-8 photos from freelancers/issue; 48-96 photos/year. Needs in-plant and job site construction photos and photos of completed homes and apartments. Reviews photos purchased with accompanying manuscript only. Photo captions required.

Making Contact & Terms "Call to discuss story and photo ideas." Send 3×5 color prints; 35mm or 2¼×2¼ transparencies by mail with SASE for consideration. Will consider dramatic, preferably vertical

cover photos. Responds in 2 weeks. Pays $350 for text/photo package; $150 for cover. Credit line given "if desired." Buys first time reproduction rights.

Tips "Study sample copy. Query editor by phone on story ideas related to industrialized housing industry."

AUTOMOTIVE COOLING JOURNAL

15000 Commerce Pkwy., Suite C, Mount Laurel NJ 08054. (856)439-1575. Fax: (856)439-9596. Web site: www.narsa.org. **Contact:** Mike Dwyer, executive director/editor. Circ. 10,500. Estab. 1956. Monthly magazine of the National Automotive Radiator Service Association. Emphasizes cooling system repair, mobile air conditioning service. Readers are mostly male shop owners and employees.

Needs Buys 3-5 photos from freelancers/issue; 36-60 photos/year. Needs shots illustrating service techniques, general interest auto repair emphasizing cooling system and air conditioning service. Model/property release preferred. Photo captions required.

Specs Uses any size glossy prints; 35mm, $2^1/_4 \times 2^1/_4$, 4×5, 8×10 transparencies.

Making Contact & Terms Send unsolicited photos by mail with SASE for consideration. Provide résumé, business card, brochure, flier or tearsheets to be kept on file for possible future assignments. Responds in 1 month. Payment negotiable. Pays on publication. Credit line given. Buys one-time rights.

N ▣ AUTOMOTIVE NEWS

Crain Communications, 1155 Gratiot Ave., Detroit MI 48207. (313)446-6000. Fax: (313)446-0383. Web site: www.autonews.com. Circ. 77,000. Estab. 1926. Weekly tabloid. Emphasizes the global automotive industry. Readers are automotive industry executives, including people in manufacturing and retail. Sample copies available.

Needs Buys 5 photos from freelancers/issue; 260 photos/year. Needs photos of automotive executives (environmental portraits), auto plants, new vehicles, auto dealer features. Photo captions required; include identification of individuals and event details.

Specs Uses 8×10 color prints; 35mm, $2^1/_4 \times 2^1/_4$, 4×5 transparencies. Accepts images in digital format. Send as JPEG files at 300 dpi (at least 6" wide).

Making Contact & Terms Send unsolicited photos by mail with SASE for consideration. Provide résumé, business card, brochure, flier or tearsheets to be kept on file for possible future assignments. Keeps samples on file. Responds in 2 weeks. Simultaneous submissions and previously published work OK. Pays on publication. Credit line given. Buys one-time rights, possible secondary rights for other Crain publications.

$ $ ▣ ▣ AVIONICS MAGAZINE

PBI Media, 4 Choke Cherry Rd., 2nd floor, Rockville MD 20850. (301)354-2000. Fax: (301)340-8741. E-mail: bcarey@accessintel.com. Web site: www.avionicsmagazine.com. **Contact:** Bill Carey, editor-in-chief. Circ. 20,000. Estab. 1976. Monthly magazine. Emphasizes aviation electronics. Readers are avionics and air traffic management engineers, technicians, executives. Sample copy free with 9×12 SASE.

Needs Buys 1-2 photos from freelancers/issue; 12-24 photos/year. Needs photos of travel, business concepts, industry, technology, aviation. Interested in alternative process, avant garde. Reviews photos with or without a manuscript. Photo captions required.

Specs Prefers images in digital format. Send as JPEG files at 300 dpi minimum.

Making Contact & Terms Query by e-mail. Provide résumé, business card, brochure, flier or tearsheets to be kept on file for possible future assignments. Simultaneous submissions OK. Responds in 2 months. Pay varies; negotiable. **Pays on acceptance.**Credit line given. Rights negotiable.

$ ▣ BALLINGER PUBLISHING

P.O. Box 12665, Pensacola FL 32591-2665. (850)433-1166. Fax: (850)435-9174. E-mail: kelly@ballingerpu blishing.com. Web site: www.ballingerpublishing.com. **Contact:** Kelly Oden, executive editor. Circ. 15,000. Estab. 1990. Monthly magazines. Emphasize business, lifestyle. Readers are executives, ages 35-54, with average annual income of $80,000. Sample copy available for $1.

Needs Needs photos of Florida topics: technology, government, ecology, global trade, finance, travel, regional and life shots. Model/property release required. Photo captions preferred.

Specs Uses 5×7 b&w and/or color prints; 35mm. Prefers images in digital format. Send via CD, floppy disk, Zip as TIFF, EPS files at 300 dpi.

Making Contact & Terms Send unsolicited photos by mail or e-mail for consideration; include SASE for

Trade Publications

return of material sent by mail. Provide résumé, business card, brochure, flier or tearsheets to be kept on file for possible future assignments. Responds in 3 weeks. Pays $100-300 for color cover; $7 for b&w or color inside. Pays on publication. Buys one-time rights.

BARTENDER MAGAZINE

P.O. Box 158, Liberty Corner NJ 07938. (908)766-6006. Fax: (908)766-6607. E-mail: barmag@aol.com. Web site: www.bartender.com. **Contact:** Tim Williams, art director. Circ. 150,000. Estab. 1979. Magazine published 4 times/year. *Bartender Magazine* serves full-service drinking establishments (full-service means able to serve liquor, beer and wine). ''We serve single locations, including individual restaurants, hotels, motels, bars, taverns, lounges and all other full-service on-premises licensees.'' Sample copy available for $2.50.

Needs Number of photos/issue varies; number supplied by freelancers varies. Needs photos of liquor-related topics, drinks, bars/bartenders. Reviews photos with or without a manuscript. Model/property release required. Photo captions preferred.

Making Contact & Terms Provide résumé, business card, brochure, flier or tearsheets to be kept on file for possible future assignments; include SASE for return of material. Previously published work OK. Payment negotiable. Pays on publication. Credit line given. Buys all rights; negotiable.

$ $ $☑ ▣ BEDTIMES: The Business Journal for the Sleep Products Industries

501 Wythe St., Alexandria VA 22314. (703)683-8371. Fax: (703)683-4503. E-mail: jpalm@sleepproducts.org. Web site: www.sleepproducts.org. **Contact:** Julie Palm, editor. Estab. 1917. Monthly association magazine; 40% of readership is overseas. Readers are manufacturers and suppliers in bedding industry. Sample copies available.

Needs Needs head shots, events, product shots/still life, conventions, shows, annual meetings. Reviews photos with or without a manuscript. Photo captions required; include correct spelling of name, title, company, return address for photos.

Specs Prefers digital images sent as JPEGs via e-mail. Also accepts glossy prints.

Making Contact & Terms Send query letter with résumé, photocopies. Responds in 3 weeks to queries. Simultaneous submissions and previously published work may be OK—depends on type of assignment. Pays $1,000 minimum for color cover; $100-750 for b&w or color inside. Pays on publication. Credit line given. Buys one-time rights; negotiable.

Tips ''Like to see variations of standard 'mug shot' so they don't all look like something for a prison line-up. Identify people in the picture. Use interesting angles. We'd like to get contacts from all over the U.S. (near major cities) who are available for occasional assignments.''

$◻ Ⓐ ▣ BEE CULTURE: The Magazine of American Beekeeping

A.I. Root, 623 W. Liberty St., Medina OH 44256-6677. (800)289-7668, ext. 3214 or (330)725-6677, ext. 3214. E-mail: kim@beeculture.com. Web site: www.beeculture.com. **Contact:** Kim Flottum, editor. Circ. 12,000. Estab. 1873. Monthly trade magazine emphasizing beekeeping industry—how-to, politics, news and events. Sample copies available. Photo guidelines available on Web site.

Needs Buys 1-2 photos from freelancers/issue; 6-8 photos/year. Needs photos of wildlife, gardening, agriculture, science. Reviews photos with or without a manuscript. Model release required. Photo captions preferred.

Specs Uses 5×7 glossy or matte color prints; 35mm, 2¼×2¼, 4×5, 8×10 transparencies. Accepts images in digital format. Send via CD, e-mail as TIFF, EPS, JPEG files at 300 dpi.

Making Contact & Terms Send query letter with photocopies. Does not keep samples on file; include SASE for return of material. ''E-mail contact preferred. Send low-res samples electronically for examination.'' Responds in 2 weeks to queries. Payment negotiable. **Pays on acceptance.** Credit line given. Buys first rights.

Tips ''Read 2-3 issues for layout and topics. Think in vertical!''

▣ BEEF TODAY

FarmJournal Media, 222 S. Jefferson St., Mexico MO 65265. (573)581-9643. Fax: (573)581-9646. E-mail: beeftoday@farmjournal.com. Web site: www.agweb.com. **Contact:** Anna McBrayer, art director. Circ. 220,000. Monthly magazine. Emphasizes American agriculture. Readers are active farmers, ranchers or agribusiness people. Sample copy and photo guidelines free with SASE.

Needs Buys 5-10 photos from freelancers/issue; 180-240 photos/year. ''We use studio-type portraiture

(environmental portraits), technical, details, scenics.'' Wants photos of environmental, livestock (feeding transporting, worming cattle), landscapes/scenics (from different regions of the U.S.). Model release preferred. Photo captions required.

Specs Accepts images in digital format. Send via CD or e-mail as TIFF, EPS, JPEG files, color RGB only.

Making Contact & Terms Arrange a personal interview to show portfolio. Send query letter with résumé of credits along with business card, brochure, flier or tearsheets to be kept on file for possible future assignments. DO NOT SEND ORIGINALS. Responds in 2 weeks. Simultaneous submissions OK. Payment negotiable. ''We pay a cover bonus.'' **Pays on acceptance.** Credit line given. Buys one-time rights.

Tips In portfolio or samples, likes to see ''about 20 slides showing photographer's use of lighting and ability to work with people. Know your intended market. Familiarize yourself with the magazine and keep abreast of how photos are used in the general magazine field.''

$ $ $ BEVERAGE DYNAMICS

Adams Beverage Group, 17 High St., 2nd Floor, Norwalk CT 06851. (203)855-8499. Fax: (203)855-7605. Web site: www.adamsbevgroup.com. **Contact:** Richard Brandes, editor. Art Director: Adam Lane. Circ. 67,000. Quarterly. Emphasizes distilled spirits, wine and beer. Readers are retailers (liquor stores, supermarkets, etc.), wholesalers, distillers, vintners, brewers, ad agencies and media.

Needs Uses 5-10 photos/issue. Needs photos of retailers, products, concepts and profiles. Special needs include good retail environments, interesting store settings, special effect photos. Model/property release required. Photo captions required.

Making Contact & Terms Send query letter with samples and list of stock photo subjects. Provide business card to be kept on file for possible future assignments. Keeps samples on file; send nonreturnable samples, slides, tearsheets, etc. Responds in 2 weeks. Simultaneous submissions OK. Pays $550-750 for color cover; $450-950/job. Pays on publication. Credit line given. Buys one-time rights or all rights.

Tips ''We're looking for good location photographers who can style their own photo shoots or have staff stylists. It also helps if they are resourceful with props.''

$ ▨ ▣ BOXOFFICE

8981 Sunset Blvd., Suite 309, West Hollywood CA 90069. (310)858-4500. Fax: ((310)858-4503. E-mail: chadgl@boxoffice.com or annleee@boxoffice.com. Web site: www.boxoffice.com. **Contact:** Chad Greene, staff editor or AnnLee Ellingson, editor-at-large. Circ. 10,000. Estab. 1920. Monthly trade magazine; the official publication of the National Association of Theater Owners. Sample copy available for $10.

Needs Photo needs are very specific: ''All photos must be of movie theaters and management.'' Reviews photos with accompanying manuscript only. Photo captions required.

Specs Uses 4×5, 8×10 glossy color and/or b&w prints; 35mm, $2\frac{1}{4} \times 2\frac{1}{4}$, 4×5 transparencies. Accepts images in digital format. Send via CD, Zip as TIFF files at 300 dpi.

Making Contact & Terms Send query letter with résumé, tearsheets. Does not keep samples on file; cannot return material. Responds in 1 month to queries. Responds only if interested; send nonreturnable samples. Previously published work OK. Pays $10/printed photo. Pays on publication. Credit line sometimes given. Buys one-time print rights and all electronic rights.

ℕ BUILDINGS: The Source for Facilities Decision-Makers

615 Fifth St. SE, P.O. Box 1888, Cedar Rapids IA 52406. (319)364-6167. Fax: (319)364-4278. Web site: www.buildings.com. **Contact:** Elisa Geneser, art director. Circ. 72,000. Estab. 1906. Monthly magazine. Emphasizes commercial real estate. Readers are building owners and facilities managers. Sample copy available for $8.

Needs Buys 5 photos from freelancers/issue; 60 photos/year. Needs photos of concept, building interiors and exteriors, company personnel and products. Model/property release preferred. Photo captions preferred.

Specs Prefers images in digital format. Send TIFF files at 300 dpi minimum.

Making Contact & Terms Provide résumé, business card, brochure, flier or tearsheets to be kept on file for possible future assignments. Responds as needed. Simultaneous submissions OK. Payment is negotiable. Pays on publication. Credit line given. Rights negotiable.

ℕ $ $ ▣ BUSINESS NH MAGAZINE

670 N. Commercial St., Suite 110, Manchester NH 03101. (603)626-6354. Fax: (603)626-6359. E-mail: production@businessnhmagazine.com. Web site: www.businessnhmagazine.com. **Contact:** Jen Kear-

ney, graphic designer. Circ. 14,600. Estab. 1984. Monthly magazine. Emphasizes business. Readers are male and female top management, average age 45. Sample copy free with 9×12 SAE and 5 first-class stamps.

Needs Uses 3-6 photos/issue. Needs photos of couples, families, rural, entertainment, food/drink, health/fitness, performing arts, travel, business concepts, industry, science, technology/computers. Model/property release preferred. Photo captions required; include names, locations, contact phone number.

Specs Accepts images in digital format. Send via CD, Zip as TIFF, JPEG files at 300 dpi.

Making Contact & Terms Arrange personal interview to show portfolio. Provide résumé, business card, brochure, flier or tearsheets to be kept on file for possible future assignments. Responds in 3 weeks. Pays $450 for color cover; $100 for color or b&w inside. Pays on publication. Credit line given. Buys one-time rights. Offers internships for photographers.

Tips Looks for "people in environment shots, interesting lighting, lots of creative interpretations, a definite personal style. If you're just starting out and want excellent statewide exposure to the leading executives in New Hampshire, you should talk to us. Send letter and samples, then arrange for a portfolio showing."

$◨ CANADIAN GUERNSEY JOURNAL

RR 5, Guelph ON N1H 6J2 Canada. (519)836-2141. Fax: (519)763-6582. E-mail: guernsey@gencor.ca. Web site: www.guernseycanada.ca. **Contact:** Doris Curran, administration. Estab. 1927. Annual journal of the Canadian Guernsey Association. Emphasizes dairy cattle, purebred and grade guernseys. Readers are dairy farmers. Sample copy available for $15.

Needs Needs photos of guernsey cattle: posed, informal, scenes. Photo captions preferred.

Making Contact & Terms Contact through adminstration office. Keeps samples on file.

$ CASINO JOURNAL

Ascend Media Gaming Group, 505 E. Capovilla Ave., Suite 102, Las Vegas NV 89119. (702)794-0718. Fax: (702)794-0799. E-mail: aholtmann@ascendmedia.com. Web site: www.casinojournal.com. **Contact:** Andy Holtmann, editor. Circ. 35,000. Estab. 1985. Monthly journal. Emphasizes casino operations. Readers are casino executives, employees and vendors. Sample copy free with 11×14 SAE and 9 first-class stamps. Ascend Media Gaming Group also publishes *IGWB*, *Slot Manager*, and *Indian Gaming Business*. Each magazine has its own photo needs.

Needs Buys 0-2 photos from freelancers/issue; 12-24 photos/year. Needs photos of gaming tables and slot machines, casinos and portraits of executives. Model release required for gamblers, employees. Photo captions required.

Making Contact & Terms Send query letter with résumé of credits, stock list. Responds in 3 months. Pays $100 minimum for color cover; $10-25 for b&w inside; $10-35 for color inside. Pays on publication. Credit line given. Buys all rights; negotiable.

Tips "Read and study photos in current issues."

◨ CATHOLIC LIBRARY WORLD

100 North St., Suite 224, Pittsfield MA 01201-5109. (413)443-2CLA. Fax: (413)442-2252. E-mail: cla@cathla.org. Web site: www.cathla.org/cathlibworld.html. **Contact:** Jean R. Bostley, SSJ, executive director. Circ. 1,100. Estab. 1929. Quarterly magazine of the Catholic Library Association. Emphasizes libraries and librarians (community/school libraries; academic/research librarians; archivists). Readers are librarians who belong to the Catholic Library Association; other subscribers are generally employed in Catholic institutions or academic settings. Sample copy available for $15.

Needs Uses 2-5 photos/issue. Needs photos of authors of children's books, and librarians who have done something to contribute to the community at large. Special needs include photos of annual conferences. Model release preferred for photos of authors. Photo captions preferred.

Specs Uses 5×7 b&w prints. Accepts images in digital format. Send via e-mail, CD, Zip as PDF files at 1,200 dpi.

Making Contact & Terms Send b&w prints; include SASE for return of material. Deadlines: January 15, April 15, July 15, September 15. Responds in 2 weeks. Credit line given. Acquires one-time rights.

$ CEA ADVISOR

Connecticut Education Association, Capitol Place, Suite 500, 21 Oak St., Hartford CT 06106. (860)525-5641. Fax: (860)725-6356. Web site: www.cea.org. **Contact:** Michael Lydick, managing editor. Circ.

42,000. Monthly tabloid. Emphasizes education. Readers are public school teachers. Sample copy free with 6 first-class stamps.

Needs Buys 1-2 photos from freelancers/issue; 12-24 photos/year. Needs "classroom scenes, students, school buildings." Model release preferred. Photo captions preferred.

Making Contact & Terms Send b&w contact sheet by mail for consideration. Provide résumé, business card, brochure, flier or tearsheets to be kept on file for possible future assignments. Cannot return material. Responds in 1 month. Simultaneous submissions and previously published work OK. Pays $50 for b&w cover; $25 for b&w inside. Pays on publication. Credit line given. Buys all rights.

CHEF, The Professional Magazine for Chefs

Talcott Communications Corp., 20 W. Kinzie, Suite 1200, Chicago IL 60610. (312)849-2220. Fax: (312)849-2174. E-mail: rbenes@talcott.com. Web site: www.chefmagazine.com. **Contact:** Robert Benes, editor. Circ. 50,000. Estab. 1956. Trade magazine. "We are a food magazine for chefs. Our focus is to help chefs enhance the bottom lines of their businesses through food preparation, presentation, and marketing the menu."

Needs Buys 1-2 photos from freelancers/issue. Needs photos of food/drink. Other specific photo needs: chefs, establishments. Reviews photos with or without a manuscript. Model/property release preferred. Photo captions preferred.

Specs Prefers images in digital format. Send via CD, Jaz, Zip as TIFF, EPS, JPEG files at 300 dp minimum, 5×7.

Making Contact & Terms Send query letter with résumé, photocopies, tearsheets, stock list. Provide résumé, business card or self-promotion piece to be kept on file for possible future assignments. Responds in 1 month to queries; 3 months to portfolios. Previously published work OK. Pays on publication. Credit line given. Buys one-time rights (prefers one-time rights to include electronic).

CHILDHOOD EDUCATION

The Olney Professional Bldg., 17904 Georgia Ave., Suite 215, Olney MD 20832. (301)570-2111. E-mail: abauer@acei.org. Web site: www.acei.org. **Contact:** Anne Bauer, director of publications/editor. Assistant Editor: Bruce Herzig. Circ. 15,000. Estab. 1924. Bimonthly journal of the Association for Childhood Education International. Emphasizes the education of children from infancy through early adolescence. Readers include teachers, administrators, day-care workers, parents, psychologists, student teachers, etc. Sample copy free with 9×12 SAE and $1.44 postage. Photo guidelines free with SASE.

Needs Uses 1 photos/issue supplied by freelance photographers. Uses freelancers mostly for covers. Subject matter includes children, infancy-14 years, in groups or alone, in or out of the classroom, at play, in study groups; boys and girls of all races and in all cities and countries. Wants close-ups of children, unposed. Reviews photos with or without accompanying manuscript. Special needs include photos of minority children; photos of children from different ethnic groups together in one shot; boys and girls together. Model release required.

Specs Accepts images in digital format, 300 dpi.

Making Contact & Terms Send unsolicited photos by e-mail to abauer@acei.org and bherzig@acei.org. Responds in 1 month. Simultaneous submissions and previously published work are discouraged but negotiable. Pays $200 for color cover; $75-100 for b&w inside. Pays on publication. Credit line given. Buys one-time rights.

Tips "Send pictures of unposed children in educational settings, please."

THE CHRONICLE OF PHILANTHROPY

1255 23rd St. NW, Suite 700, Washington DC 20037. (202)466-1200. Fax: (202)466-1200. E-mail: frances.b orchardt@philanthropy.com. Web site: http://philanthropy.com. **Contact:** Frances Borchardt, photo editor. Circ. 50,000. Estab. 1988. Biweekly tabloid. Readers come from all aspects of the nonprofit world such as charities, foundations and relief agencies such as the Red Cross. Sample copy free.

Needs Buys 10-15 photos from freelancers/issue; 260-390 photos/year. Needs photos of people (profiles) making the news in philanthropy and environmental shots related to person(s)/organization. Most shots arranged with freelancers are specific. Model release required. Photo captions required.

Specs Accepts images in digital format. Send via CD, Zip, e-mail as TIFF, JPEG files at 200 dpi.

Making Contact & Terms Arrange a personal interview to show portfolio. Send 35mm, 2¼×2¼ transparencies and prints by mail for consideration. Provide résumé, business card, brochure, flier or tearsheets to be kept on file for possible future assignments. Responds in 2 days. Previously published work

OK. Pays (color and b&w) $275 plus expenses/half day; $450 plus expenses/full day; $100 for Web publication (2-week period). Pays on publication. Buys one-time rights.

$ ☑ Ⓢ ▣ CIVITAN MAGAZINE

P.O. Box 130744, Birmingham AL 35213-0744. (205)591-8910. Fax: (205)592-6307. E-mail: dorothy@civit an.org. Web site: www.civitan.org. **Contact:** Dorothy Wellborn, editor. Circ. 24,000. Estab. 1920. Quarterly publication of Civitan International. Emphasizes work with mental retardation/developmental disabilities. Readers are men and women, college age to retirement, usually managers or owners of businesses. Sample copy free with 9×12 SASE and 2 first-class stamps.

Needs Buys 1-2 photos from freelancers/issue; 6-12 photos/year. Always looking for good cover shots (multicultural, travel, scenic and how-to), babies/children/teens, families, religious, disasters, environmental, landscapes/scenics. Model release required. Photo captions preferred.

Specs Accepts images in digital format. Send via CD or e-mail at 300 dpi only.

Making Contact & Terms Send sample of unsolicited 2¼×2¼ or 4×5 transparencies by mail for consideration. Provide résumé, business card, brochure, flier or tearsheets to be kept on file for possible future assignments. Responds in 1 month. Simultaneous submissions and previously published work OK. Pays $50-200 for color cover; $20 for color inside. **Pays on acceptance.** Buys one-time rights.

$ ▣ CLASSICAL SINGER

P.O. Box 1710, Draper UT 84020. (801)254-1025. Fax: (801)254-3139. E-mail: layout@classicalsinger.c om. Web site: www.classicalsinger.com. **Contact:** Art Director. Circ. 9,000. Estab. 1988. Glossy monthly trade magazine for classical singers. Sample copy free.

Needs Looking for photos in opera or classical singing. E-mail for calendar and ideas. Photo captions preferred; include where, when, who.

Specs Uses b&w and color prints or high-res digital photos.

Making Contact & Terms Responds in 1 month to queries. Simultaneous submissions and previously published work OK. Pays honorarium plus 10 copies. Pays on publication. Credit line given. Buys one-time rights. Photo may be used in a reprint of an article on paper or Web site.

Tips "Our publication is expanding rapidly. We want to make insightful photographs a big part of that expansion."

$ ▣ CLAVIER

200 Northfield Rd., Northfield IL 60093. (847)446-5000. Fax: (847)446-6263. E-mail: clavier@instrumenta listmagazine.com. Web site: www.instrumentalistmagazine.com. **Contact:** Judy Nelson, editor. Circ. 13,000. Estab. 1962. Magazine published 10 times/year. Readers are piano and organ teachers. Sample copy available for $3.

Needs Human interest photos of keyboard instrument students and teachers. Special needs include synthesizer photos and children performing.

Specs Accepts images in digital format. Send via CD, e-mail as TIFF, JPEG, EPS files at 300 dpi minimum. Cover shots must be 6×10 at 300 dpi minimum. Uses glossy b&w and/or color prints. Kodachrome glossy color prints or 35mm transparencies. Vertical format preferred. Photos should enlarge to 8½×11 without grain.

Making Contact & Terms Send material by mail with SASE for consideration. Responds in 1 month. Pays $225 for color cover; $10-25 for b&w inside. Pays on publication. Credit line given. Buys all rights.

Tips "We look for sharply focused images that show action, and for clear color that is bright and true. We need photographs of children and teachers involved in learning music at the piano. We prefer shots that show them deeply involved in their work rather than posed shots. Very little is taken on specific assignment except for the cover. Authors usually include article photographs with their manuscripts. We purchase only one or two items from stock each year."

$ ☑ CLEANING & MAINTENANCE MANAGEMENT MAGAZINE

13 Century Hill Dr., Latham NY 12110. (518)783-1281. Fax: (518)783-1386. E-mail: rdipaolo@ntpmedia.c om. Web site: www.cmmonline.com. **Contact:** Rich Dipaolo, senior editor. Circ. 38,300. Estab. 1963. Monthly. Emphasizes management of cleaning/custodial/housekeeping operations for commercial buildings, schools, hospitals, shopping malls, airports, etc. Readers are middle- to upper-level managers of in-house cleaning/custodial departments, and managers/owners of contract cleaning companies. Sample copy free (limited) with SASE.

Needs Uses 10-15 photos/issue. Needs photos of cleaning personnel working on carpets, hardwood floors, tile, windows, restrooms, large buildings, etc. Model release preferred. Photo captions required.
Making Contact & Terms Provide résumé, business card, brochure, flier or tearsheets to be kept on file for possible future assignments. "Send query letter with specific ideas for photos related to our field." Responds in 1-2 weeks. Simultaneous submissions and previously published work OK. Pays $25 for b&w inside. Credit line given. Rights negotiable.
Tips "Query first and shoot what the publication needs."

▣ CONSTRUCTION BULLETIN

15524 Highwood Dr., Minnetonka MN 55345. (952)933-3386. Fax: (952)933-5063. E-mail: ivy.chang@ree dbusiness.com. Web site: www.acppubs.com. **Contact:** Ivy Chang, editor. Circ. 5,000. Estab. 1893. Weekly magazine. Emphasizes construction in Minnesota, North Dakota and South Dakota *only*. Readers are male and female executives, ages 23-70. Sample copy available for $4.
Needs Uses 15 photos/issue; digital images only. Needs photos of construction equipment in use on Minnesota, North Dakota, South Dakota job sites. Photo captions required; include who, what, where, when.
Making Contact & Terms Send high-resolution digital images (minimum 300 dpi) for consideration. Credit line given.
Tips "Be observant; keep camera at hand when approaching construction sites in Minnesota, North Dakota and South Dakota."

ℕ CONSTRUCTION EQUIPMENT GUIDE

470 Maryland Dr., Ft. Washington PA 19034. (215)885-2900 or (800)523-2200. Fax: (215)885-2910. E-mail: editorial@cegltd.com. Web site: www.cegltd.com. **Contact:** Craig Mongeau, editor-in-chief. Circ. 120,000. Estab. 1957. Biweekly trade newspaper. Emphasizes construction equipment industry, including projects ongoing throughout the country. Readers are males and females of all ages; many are construction executives, contractors, dealers and manufacturers. Free sample copy.
Needs Buys 35 photos from freelancers/issue; 910 photos/year. Needs photos of construction job sites and special event coverage illustrating new equipment applications and interesting projects. Call to inquire about special photo needs for coming year. Model/property release preferred. Photo captions required for subject identification.
Making Contact & Terms Send any size matte or glossy b&w prints by mail with SASE for consideration. Provide résumé, business card, brochure, flier or tearsheets to be kept on file for possible future assignments. Responds in 3 weeks. Payment negotiable. Pays on publication. Credit line given. Buys all rights; negotiable.

ℕ $ $ ▣ CONVENIENCE STORE DECISIONS

Penton Media, Two Greenwood Square, Suite 410, 3331 Street Rd., Bensalem PA 19020. (215)246-4555. Fax: (215)245-4060. E-mail: kquackenbush@penton.com. Web site: www.csdecisions.com. **Contact:** Kate Quackenbush, managing editor. Circ. 41,000. Estab. 1990. Monthly trade magazine. Sample copies available.
Needs Buys 24-36 photos from freelancers/year. Needs photos of food/drink, business concepts, product shots/still life, retail. Convenience stores—transactions, customers, employees. Gasoline/petroleum outlets—customers pumping gas, etc. Newsworthy photos dealing with convenience stores and gas stations. Reviews photos with or without a manuscript. Photo captions preferred.
Specs Uses any print format, but prefers digital images in TIFF, EPS or JPEG format via CD or e-mail at 300 dpi.
Making Contact & Terms Send query letter with photocopies, stock list. Provide business card or self-promotion piece to be kept on file for possible future assignments. Simultaneous submissions and previously published work OK. Pays $300-800 for color cover; $100-600 for color inside. Pays on publication. Credit line given. Buys one-time rights, electronic rights; negotiable.
Tips "We have numerous opportunities for spec jobs in various markets across the country. We also have a great need for spot photo/illustration that relates to our audience (convenience store operators and petroleum marketers). We will do a lot of volume with the right photographer. Consider our audience."

ℕ $ $ ▢ COTTON GROWER MAGAZINE

Meister Media Worlwide, 65 Germantown Court, Suite 202, Cordova TN 38018. (901)756-8822. Fax: (901)756-8879. E-mail: hgantz@meistermedia.com. Web site: www.meistermedia.com. (901)756-8822.

Fax: (901)756-8879. **Contact:** Henry Gantz, senior editor. Circ. 45,000. Estab. 1999. Monthly trade magazine. Emphasizes "cotton production; for cotton farmers." Sample copies and photo guidelines available.

Needs Buys 1 photo from freelancers/issue; 12 photos/year. Needs photos of agriculture. "Our main photo needs are cover shots of growers. We write cover stories on each issue."

Specs Prefers high-res digital images; send JPEGS at 300 dpi via e-mail or CD. Uses high-quality glossy prints from 35mm.

Making Contact & Terms Send query letter with slides, prints, tearsheets. Responds in 1 week. Pays $100-350 for color cover. **Pays on acceptance**. Credit line given. Buys all rights.

Tips "Most photography hired is for cover shots of cotton growers."

$ CROPLIFE

37733 Euclid Ave., Willoughby OH 44094. (440)602-9142. Fax: (440)942-0662. E-mail: paul@croplife.com. Web site: www.croplife.com. **Contact:** Paul Schrimpf, group editor. Circ. 24,500. Estab. 1894. Monthly magazine. Serves the agricultural distribution channel delivering fertilizer, chemicals and seed from manufacturer to farmer. Sample copy and photo guidelines free with 9×12 SASE.

Needs Buys 6-7 photos/year; 5-30% supplied by freelancers. Needs photos of agricultural chemical and fertilizer application scenes (of commercial—not farmer—applicators), people shots of distribution channel executives and managers. Model release preferred. Photo captions required.

Specs Uses 8×10 glossy b&w and color prints; 35mm slides, transparencies.

Making Contact & Terms Send query letter first with résumé of credits. Responds in 3 weeks. Simultaneous submissions and previously published work OK. Pays $150-300 for color cover; $150-250 for color inside. **Pays on acceptance.** Buys one-time rights.

Tips "E-mail is the best way to approach us with your work. Experience and expertise is best."

$ $ ▣ DAIRY TODAY

FarmJournal Media, P.O. Box 958, Mexico MO 65265. (573)581-9641. Fax: (573)581-9646. E-mail: mkowalski@farmjournal.com. Web site: www.agweb.com. **Contact:** Michelle Kowalski, associate editor. Circ. 50,000. Monthly magazine. Emphasizes American agriculture. Readers are active farmers, ranchers or agribusiness people. Sample copy and photo guidelines free with SASE.

Needs Buys 5-10 photos from freelancers/issue; 60-120 photos/year. "We use studio-type portraiture (environmental portraits), technical, details, scenics." Wants photos of environmental, landscapes/scenics, agriculture, business concepts. Model release preferred. Photo captions required.

Making Contact & Terms Arrange a personal interview to show portfolio. Send query letter with résumé of credits along with business card, brochure, flier or tearsheets to be kept on file for possible future assignments. "Portfolios may be submitted via CD-ROM." DO NOT SEND ORIGINALS. Responds in 2 weeks. Simultaneous submissions OK. Pays $75-400 for color photo; $200-400/day. "We pay a cover bonus." **Pays on acceptance.** Credit line given, except in advertorials. Buys one-time rights.

Tips In portfolio or samples, likes to see "about 40 slides showing photographer's use of lighting and ability to work with people. Know your intended market. Familiarize yourself with the magazine and keep abreast of how photos are used in the general magazine field."

$ $ ▢ ▣ EL RESTAURANTE MEXICANO

Maiden Name Press, P.O. Box 2249, Oak Park IL 60303. (708)488-0100. Fax: (708)488-0101. E-mail: kfurore@restmex.com. Web site: www.restmex.com. **Contact:** Kathy Furore, editor. Circ. 26,000. Estab. 1997. Bimonthly trade magazine for restaurants that serve Mexican, Tex-Mex, Southwestern and Latin cuisine. Sample copies available.

Needs Buys at least 1 photo from freelancers/issue; at least 6 photos/year. Needs photos of food/drink. Reviews photos with or without a manuscript.

Specs Uses 35mm transparencies. Accepts images in digital format. Send via e-mail as TIFF, JPEG files of at least 300 dpi.

Making Contact & Terms Send query letter with slides, prints, photocopies, tearsheets, transparencies or stock list. Provide résumé, business card, self-promotion piece to be kept on file for possible future assignments. Responds in 2 months to queries. Previously published work OK. Pays $450 maximum for color cover; $125 maximum for color inside. Pays on publication. Credit line given. Buys all rights; negotiable.

Tips "We look for outstanding food photography; the more creatively styled, the better."

$ Ⓐ ELECTRICAL APPARATUS

Barks Publications, Inc., 400 N. Michigan Ave., Chicago IL 60611-4198. (312)321-9440. E-mail: edickson @barks.com. Web site: www.barks.com/eacurr.html. **Contact:** Elsie Dickson, associate publisher. Circ. 16,000. Monthly trade magazine. Emphasizes industrial electrical machinery maintenance and repair for the electrical aftermarket. Readers are "persons engaged in the application, maintenance and servicing of industrial and commercial electrical and electronic equipment." Sample copies available.

Needs "Assigned materials only. We welcome innovative industrial photography, but most of our material is staff-prepared." Photos purchased with accompanying manuscript or on assignment. Model release required "when requested." Photo captions preferred.

Making Contact & Terms Send query letter with résumé of credits. Contact sheet or contact sheet with negatives OK; include SASE for return of material. Responds in 3 weeks. Pays $25-100 for b&w or color. Pays on publication. Credit line given. Buys all rights, but exceptions are occasionally made.

▣ ESL TEACHER TODAY

2660 Petersborough St., Herndon VA 20171. E-mail: shannonaswriter@yahoo.com. **Contact:** Shannon Murphy. Quarterly trade magazine. Photo guildelines available via e-mail.

Needs Buys 12-24 photos/year. Needs photos of babies/children/teens, multicultural, families, parents, disasters, environmental, landscapes/scenics, wildlife, cities/urban, education, religious, rural, adventure, events, food/drink, sports, travel, agriculture, medicine, military, political, product shots/still life, science, technology—as related to teaching ESL (English as a Second Language) around the globe. Interested in alternative process, avant garde, documentary, fashion/glamour, fine art, historical/vintage, seasonal. Reviews photos with or without a manuscript. Model/property release preferred.

Specs Uses glossy or matte color and/or b&w prints.

Making Contact & Terms Send query letter via e-mail. "If possible, please do not include photographs in files if they are sent through e-mail. A disk with your photographs sent to *ESL Teacher Today* is acceptable." Provide résumé, business card or self-promotion piece to be kept on file for possible future assignments. Responds within 1 month to queries; 1 week to portfolios. Simultaneous submissions and previously published work OK. **Pays on acceptance.** Credit line given. Buys one-time rights, first rights; negotiable.

$ $ $ ▣ FARM JOURNAL

FarmJournal Media, 222 S. Jefferson St., Mexico MO 65265. (573)581-9641. Fax: (573)581-9646. E-mail: farmjournal@farmjournal.com. Web site: www.agweb.com. **Contact:** Anna McBrayer, art director. Circ. 600,000. Estab. 1877. Monthly magazine. Emphasizes the business of agriculture: "Good farmers want to know what their peers are doing and how to make money marketing their products." Free sample copy upon request.

- *Farm Journal* has received the Best Use of Photos/Design from the American Agricultural Editors' Association (AAEA).

Needs Freelancers supply 60% of the photos. Photos having to do with the basics of raising, harvesting and marketing of all the farm commodities, farm animals and international farming. People-oriented shots are encouraged. Also uses human interest and interview photos. All photos must relate to agriculture. Photos purchased with or without accompanying manuscript. Model release required. Photo captions required.

Specs Uses glossy or semigloss color prints; 35mm, $2\frac{1}{4} \times 2\frac{1}{4}$ transparencies; all sizes for covers. Accepts images in digital format. Send via CD as TIFF, EPS, JPEG files at 300 dpi.

Making Contact & Terms Arrange a personal interview or send photos by mail. Provide calling card and samples to be kept on file for possible future assignments. Responds in 1 month. Simultaneous submissions OK. Pays per assignment or photo. Pays $200-400/job; $400-1,200 for color cover (plus cover bonus); $150-500 for color inside. **Pays on acceptance.** Credit line given. Buys one-time rights; negotiable.

Tips "Be original and take time to see with the camera. Be selective. Look at use of light—available or strobed—and use of color. I look for an easy rapport between photographer and subject. Take as many different angles of subject as possible. Use fill where needed. Send nonreturnable samples of agriculture-related photos only. We are always looking for photographers located in the midwest and other areas of the country where farming is a way of life. Don't forget to shoot vertical versions of everything to be used as possible cover shots."

$ Ⓐ ▣ FIRE CHIEF

330 N. Wabash Ave., Suite 2300, Chicago IL 60611. (312)595-1080. Fax: (312)595-0295. E-mail: sundee@f irechief.com. Web site: www.firechief.com. **Contact:** Sundee Koffarnus, art director. Circ. 53,000. Estab. 1956. Monthly magazine. Emphasizes fire department management and operations. Readers are primarily fire officers and predominantly chiefs of departments. Sample copy free. Photo guidelines free with SASE or on Web site.

Needs Uses photos of fire and emergency response.

Specs Prefers images in digital format. Send via e-mail, CD, Zip as TIFF, EPS files at highest possible resolution.

Making Contact & Terms Send any glossy color prints; 35mm, $2\frac{1}{4} \times 2\frac{1}{4}$ transparencies by mail for consideration. Keeps samples on file. Responds in 1 month. Pays on publication. Buys first serial rights; negotiable.

Tips "Most photographs are part of a feature story; however, we do buy some for other use. Cover photos must include an officer in the picture—white, yellow or red helmet—in an action scene, fire, accident, incident, etc."

$ Ⓒ ▣ FIRE ENGINEERING

21-00 Route 208 South, Fairlawn NJ 07410. (973)251-5040. Fax: (973)251-5065. E-mail: dianef@pennwell .com. Web site: www.fireengineering.com. **Contact:** Diane Feldman, executive editor. Estab. 1877. Training magazine for firefighters. Photo guidelines free.

Needs Uses 400 photos/year. Needs action photos of disasters, firefighting, EMS, public safety, fire investigation and prevention, rescue. Photo captions required; include date, what is happening, location and fire department contact.

Specs Accepts images in digital format. Send via CD as JPEG files at 300 dpi.

Making Contact & Terms Send unsolicited photos by mail for consideration. Responds in 3 months. Pays $300 for color cover; $35-150 for color inside. Pays on publication. Credit line given. Rights negotiable.

Tips "Firefighters must be doing something. Our focus is on training and learning lessons from photos."

$ $ Ⓒ Ⓢ ▣ FIREHOUSE MAGAZINE

3 Huntington Quadrangle, Suite 301N, Melville NY 11747. (631)845-2700. Fax: (631)845-7218. Web site: www.firehouse.com. **Contact:** Harvey Eisner, editor-in-chief. Circ. 110,000. Estab. 1976. Monthly. Emphasizes "firefighting—notable fires, techniques, dramatic fires and rescues, etc." Readers are "paid and volunteer firefighters, EMTs." Sample copy available for $5 with 9×12 SASE and 7 first-class stamps. Photo guidelines free with SASE or on Web site.

Needs Buys 20 photos from freelancers/issue; 240 photos/year. Needs photos of fires, terrorism, firefighter training, natural disasters, highway incidents, hazardous materials, dramatic rescues. Model release preferred.

Specs Uses 3×5, 5×7, 8×10 matte or glossy b&w or color prints; 35mm transparencies. Accepts images in digital format. Send via CD, e-mail as TIFF, EPS, JPEG files at 300 dpi.

Making Contact & Terms "Photos must not be more than 30 days old." Include SASE. "Photos cannot be returned without SASE." Responds ASAP. Pays up to $300 for color cover; $20-100 for b&w inside; $20-200 for color inside. Pays on publication. Credit line given. Buys one-time rights.

Tips "Mostly we are looking for action-packed photos—the more fire, the better the shot. Show firefighters in full gear; do not show spectators. Fire safety is a big concern. Much of our photo work is freelance. Try to be in the right place at the right time as the fire occurs. Be sure that photos are clear, in focus, and show firefighters/EMTs at work. *Firehouse* encourages submissions of high-quality action photos that relate to the firefighting/EMS field. Please understand that while we encourage first-time photographers, a minimum waiting period of 3-6 months is not unusual. Although we are capable of receiving photos over the Internet, please be advised that there are color variations. Include captions. Photographers must include a SASE, and we cannot guarantee the return of unsolicited photos. Mark name and address on the back of each photo."

$ Ⓒ ▣ FIRE-RESCUE MAGAZINE

Elsevier Public Safety, 525 B St., Suite 1900, San Diego CA 92101. (800)266-5367. Fax: (619)699-6396. E-mail: s.pieper@elsevier.com. Web site: www.firerescuemagazine.com. **Contact:** Shannon Pieper, managing editor. Circ. 50,000. Estab. 1997. Monthly. Emphasizes techniques, equipment, action stories of

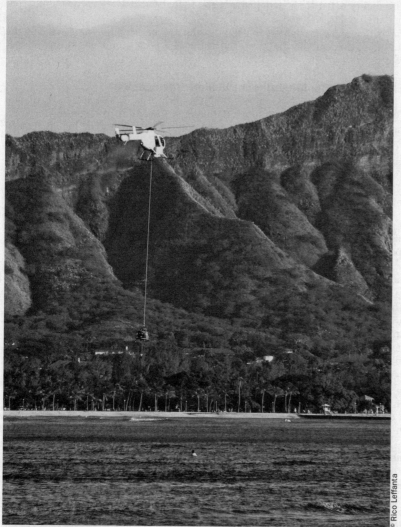

Rico Leffanta

While photographing yachts, Rico Leffanta spotted a rescue helicopter ferrying two people to the shore. Thinking quickly, he photographed the helicopter instead. He e-mailed the photo to the editor of *Firehouse Magazine*, who responded the same day, informing Leffanta that she wanted to use the photo for the cover of *Advance Resuce Technology*.

fire and rescue incidents. Editorial slant: ''Read it today, use it tomorrow.'' Sample copy free with 9×12 SAE and 7 first-class stamps. Photo guidelines free with SASE.

Needs Uses 20-25 photos/issue; most supplied by freelancers. Needs photos of fires, fire ground scenes, commanders operating at fires, company officers/crews fighting fires, disasters, emergency medical services, rescue scenes, transport, injured victims, equipment and personnel, training, earthquake rescue operations. Special photo needs include strong color shots showing newsworthy rescue operations, including a unique or difficult firefighting, rescue/extrication, treatment, transport, personnel, etc.; b&w showing same. Photo captions required.

Specs Accepts images in digital format. Prefers digital format submitted via e-mail or FTP (www.info.jems.com/fpt). Send via Zip, e-mail, Jaz, CD as TIFF, EPS, JPEG files at 300 dpi.

Making Contact & Terms Send query letter or e-mail with 5×7 or larger glossy color prints or color

contact sheets. Pays $200 for cover; $22-137 for color inside; $27-110 for b&w inside. Pays on publication. Credit line given. Buys one-time rights.

Tips Looks for "photographs that show firefighters in action, using proper techniques and wearing the proper equipment. Submit timely photographs that show the technical aspects of firefighting and rescue. Tight shots/close-ups preferred."

ⓝ $ $ ◨ ▣ FLEET EXECUTIVE, The Magazine for Vehicle Management

NAFA, 125 Village Blvd., Suite 200, Princeton NJ 08540. (609)720-0882. Fax: (609) 452-8004. E-mail: cmcloughlin@nafa.org. Web site: www.nafa.org. **Contact:** Carolann McCloughlin, managing editor. Circ. 4,500. Estab. 1957. Official magazine of the National Association of Fleet Administrators, Inc., published 8 times/year. Sample copy available for $4. Photo guidelines available.

Needs Needs photos of automobiles, business concepts, technology/computers. Interested in historical/ vintage. Assignments include photo coverage of association members' work environments and vehicle fleets. Reviews photos with or without a manuscript. Model/property release preferred. Photo captions preferred.

Specs Uses color prints. Accepts images in digital format. Send via CD, Zip, e-mail as TIFF files at 300 dpi.

Making Contact & Terms Provide business card or self-promotion piece to be kept on file for possible future assignments. Responds only if interested; send nonreturnable samples. **Pays on acceptance**. Buys all rights; negotiable.

Tips "Research publication so samples are on target with magazine's needs."

$ $ ◨ Ⓐ ▣ ◸ FLORAL MANAGEMENT MAGAZINE

Society of American Florists, 1601 Duke St., Alexandria VA 22314. (703)836-8700. Fax: (800)208-0078. E-mail: kpenn@safnow.org. Web site: www.safnow.org. **Contact:** Kate Penn, editor-in-chief. Estab. 1894. National trade association magazine representing growers, wholesalers and retailers of flowers and plants. Photos used in magazine and promotional materials.

Needs Offers 15-20 assignments/year. Needs photos of floral business owners, employees on location, and retail environmental portraits. Reviews stock photos. Model release required. Photo captions preferred.

Audiovisual Needs Uses slides (with graphics) for convention slide shows.

Specs Prefers images in digital format. Send via CD or e-mail as TIFF files at 300 dpi. Also uses b&w prints; transparencies.

Making Contact & Terms Send query letter with samples. Provide résumé, business card, brochure, flier or tearsheets to be kept on file for possible future assignments. Responds in 1 week. Pays $150-600 for color cover; $75-150/hour; $125-250/job; $75-500 for color inside. Credit line given. Buys one-time rights.

Tips "We shoot a lot of tightly composed, dramatic shots of people, so we look for these skills. We also welcome input from the photographer on the concept of the shot. Our readers, as business owners, like to see photos of other business owners. Therefore, people photography, on location, is particularly popular." Photographers should approach magazine "via letter of introduction and sample. We'll keep name in file and use if we have a shoot near photographer's location."

ⓝ $ ◻ Ⓢ ▣ FOREST LANDOWNER

900 Circle 75 Parkway SE, Suite. 205, Atlanta GA 30339-3075. (404)325-2954. Fax: (404)325-2955. E-mail: info@forestlandowners.com. Web site: www.forestlandowners.com. **Contact:** Sarah Sturm, editor. Circ. 10,000. Estab. 1942. Bimonthly magazine of the Forest Landowners Association. Emphasizes forest management and policy issues for private forest landowners. Readers are forest landowners and forest industry consultants; 94% male between the ages of 46 and 55. Sample copy available for $3 (magazine), $30 (manual).

Needs Uses 15-25 photos/issue; 3-4 supplied by freelancers. Needs photos of unique or interesting private southern forests. Other subjects: environmental, regional, wildlife, landscapes/scenics. Model/property release preferred. Photo captions preferred.

Specs Accepts images in digital format. Send via CD, Zip, e-mail as TIFF, EPS files at 300 dpi.

Making Contact & Terms Send Zip disk, color prints, negatives or transparencies by mail or e-mail for consideration. Send query letter with stock list. Keeps samples on file. SASE. Responds in 3 weeks. Simultaneous submissions and previously published work OK. Pays $100-150 for color cover; $25-50 for

b&w inside; $35-75 for color inside. Pays on publication. Credit line given. Buys one-time and all rights; negotiable.

Tips "We most often use photos of timber management, seedlings, aerial shots of forests, and unique southern forest landscapes. Mail Zip, CD or slides of sample images. Captions are important."

THE FRUIT GROWERS NEWS

Great American Publishing, P.O. Box 128, Sparta MI 49345. (616)887-9008. E-mail: editor@fruitgrowersnews.com. Web site: www.fruitgrowersnews.com. **Contact:** Kimberly Warren, editorial director. Circ.14,000. Monthly. Emphasizes all aspects of tree fruit and small fruit growing as well as farm marketing. Readers are growers but include anybody associated with the field. Sample copy available for $6.

Needs Buys 3 photos from freelancers/issue; 25 photos/year. Needs portraits of growers, harvesting, manufacturing, field shots for stock photography—anything associated with fruit growing. Photo captions required.

Specs Accepts images in digital format. Send via CD as JPEG, TIFF or EPS files at 300 dpi, at least 4×6.

Making Contact & Terms Query about prospective jobs. Simultaneous submissions and previously published work OK. Payment rates to be negotiated between editorial director and individual photographer. Pays on publication. Credit line given. Buys first North American rights.

Tips "Learn about the field. Great American Publishing also publishes *The Vegetable Growers News*, *Spudman*, *Fresh Cut*, *Museums & More* and *Party & Paper Retailer*. Contact the editorial director for information on these publications."

GEOSYNTHETICS

Industrial Fabrics Association International, 1801 County Road-B W., Roseville MN 55113. (651)222-2508 or (800)225-4324. Fax: (651)225-6966. E-mail: generalinfo@ifai.com. Web site: www.gfrmagazine.com and www.ifai.com. **Contact:** Ron Bygness, editor. Circ. 18,000. Estab. 1983. Assocation magazine published 6 times/year. Emphasizes geosynthetics in civil engineering applications. Readers are civil engineers, professors and consulting engineers. Sample copies available.

Needs Uses 10-15 photos/issue; various number supplied by freelancers. Needs photos of finished applications using geosynthetics; photos of the application process. Reviews photos with accompanying manuscript only. Model release required. Photo captions required; include project, type of geosynthetics used and location.

Specs Prefers images in high-res digital format.

Making Contact & Terms "Please call before submitting samples!" Keeps samples on file. Responds in 1 month. Simultaneous submissions OK. Credit line given. Buys all rights; negotiable.

Tips "There is no cash payment from our magazine."

[N] $[S] GLASS MAGAZINE

National Glass Association, 8200 Greensboro Dr., Suite 302, McClean VA 22102-3881. (703)442-4890, ext. 131. Fax: (703)442-0630. Email: mslovick@glass.org. Web site: www.glass.org. **Contact:** Matt Slovick, editor-in-chief. Circ. 23,000. Estab. 1948. Monthly trade magazine emphasizing architectural, commercial use of glass. Sample copies available for 9×12 SAE with $1.25 first-class postage.

Needs Buys 1-3 photos/year. Needs photos of architecture, cities/urban, interiors/decorating (doors and windows only), business concepts, industry. All photos should feature glass prominently. Architectural shots must be accompanied by names of companies that produced and installed the glass. Reviews photos with or without a manuscript. Photo caption required.

Specs Uses 4×6 or larger glossy color prints. Accepts images in digital format. Send via CD, Zip, e-mail, FTP upload as TIFF, EPS files at 300 dpi.

Making Contact & Terms Send query letter with tearsheets, stock list. Provide self-promotion piece to be kept on file for possible future assignments. Responds only if interested, send nonreturnable samples. Payment depends on freelancer and position of photo in the magazine. **Pays on acceptance**. Credit line given. Buys one-time rights.

$ [image] GOVERNMENT TECHNOLOGY

e.Republic, Inc., 100 Blue Ravine Rd., Folsom CA 95630. (916)932-1300. Fax: (916)932-1470. E-mail: kmartinelli@erepublic.com. Web site: www.govtech.net. **Contact:** Kelly Martinelli, creative director. Circ. 60,000. Estab. 2001. Monthly trade magazine. Emphasizes information technology as it applies to state and local government. Readers are government executives.

Needs Buys 2 photos from freelancers/issue; 20 photos/year. Needs photos of government officials, disasters, environmental, political, technology/computers. Reviews photos with accompanying manuscript only. Model release required; property release preferred. Photo captions required.

Specs Accepts images in digital format only. Send via DVD, CD, Zip, e-mail as TIFF, JPEG files at 300 dpi.

Making Contact & Terms Send query letter with résumé, prints, tearsheets. Provide business card, self-promotion piece to be kept on file for possible future assignments. Responds only if interested; send nonreturnable samples. Simultaneous submissions and previously published work OK. Payment is dependent upon pre-publication agreement between photographer and *Government Technology*. Pays on publication. Credit line given. Buys one-time rights, electronic rights.

Tips "See some of the layout of the magazine; read a little of it."

$▣ GRAIN JOURNAL

3065 Pershing Court, Decatur IL 62526. (217)877-9660. Fax: (217)877-6647. E-mail: ed@grainnet.com. Web site: www.grainnet.com. **Contact:** Ed Zdrojewski, editor. Circ. 10,752. Bimonthly trade magazine. Emphasizes grain industry. Readers are "elevator and feed mill managers primarily, as well as suppliers and others in the industry." Sample copy free with 10×12 SAE and 3 first-class stamps.

Needs Uses about 1-2 photos/issue. "We need photos concerning industry practices and activities. We look for clear, high-quality images without a lot of extraneous material." Photo captions preferred.

Specs Accepts images in digital format minimum 300 dpi resolution. Send via e-mail, floppy disk, Zip.

Making Contact & Terms Send query letter with samples and list of stock photo subjects. Responds in 1 week. Pays $100 for color cover; $30 for b&w inside. Pays on publication. Credit line given. Buys all rights; negotiable.

$ THE GREYHOUND REVIEW

NGA, P.O. Box 543, Abilene KS 67410. (785)263-4660. E-mail: nga@ngagreyhounds.com. Web site: www.ngagreyhounds.com. **Contact:** Tim Horan. Circ. 3,006. Monthly publication of The National Greyhound Association. Emphasizes Greyhound racing and breeding. Readers are Greyhound owners and breeders. Sample copy free with SAE and 11 first-class stamps.

Needs Buys 1 photo from freelancers/issue; 12 photos/year. Needs "anything pertinent to the Greyhound that would be of interest to Greyhound owners." Photo captions required.

Making Contact & Terms Query via e-mail first. After response, send b&w or color prints and contact sheets by mail for consideration. Provide résumé, business card, brochure, flier or tearsheets to be kept on file for possible future assignments. Can return unsolicited material if requested; include SASE for return of material. Responds in 1 month. Simultaneous submissions and previously published work OK. Pays $85 for color cover; $25-100 for color inside. **Pays on acceptance.** Credit line given. Buys one-time and North American rights.

Tips "We look for human-interest or action photos involving Greyhounds. No muzzles, please, unless the Greyhound is actually racing. When submitting photos for our cover, make sure there's plenty of cropping space on all margins around your photo's subject; full breeds on our cover are preferred."

Ⓝ $ $▣ HEARTH AND HOME

P.O. Box 1288, Laconia NH 03247. (603)528-4285. Fax: (603)527-3404. E-mail: production@villagewest.com. **Contact:** Production. Circ. 16,000. Monthly magazine. Emphasizes news and industry trends for specialty retailers and manufacturers of solid fuel and gas appliances, barbeque grills, hearth accessories and casual furnishings. Sample copy available for $5.

Needs Buys 3 photos from freelancers/issue; 36 photos/year. Needs "shots of fireplace and patio furnishings stores (preferably a combination store), retail displays, wood heat installations, fireplaces, wood stoves, lawn and outdoor room shots, garden shots (installation as well as final design), gas grills, gas fireplaces, indoor/outdoor gas installation, outdoor room shots emphasizing BBQs, furniture, and outdoor fireplaces. Assignments available for conferences." Model release required. Photo captions preferred.

Specs Accepts digital images with color proof; high-res, 300 dpi preferred.

Making Contact & Terms Contact before submitting material. Responds in 2 weeks. Simultaneous and photocopied submissions OK. Pays $50-300 for color photos; $250-1,200/job. Pays within 30 days after publication prints. Credit line given. Buys various rights.

Tips "Call first and ask what we need. We're *always* on the lookout for gorgeous outdoor room material."

$ $ ☑ ▣ ⬚ HEATING PLUMBING AIR CONDITIONING (HPAC) MAGAZINE

Rogers Media, Inc., 1 Mount Pleasant Rd., Toronto ON M4Y 2Y5 Canada. (416)764-2000. Fax: (416)764-1746. E-mail: bill.begin@hpacmag.rogers.com. Web site: www.bizlink.com/heatingandplumbing.html. **Contact:** Bill Begin, publisher. Circ. 17,000. Estab. 1927. Bimonthly magazine plus annual buyers guide. Emphasizes heating, plumbing, air conditioning, refrigeration. Readers are predominantly male mechanical contractors, ages 30-60. Sample copy available for $4.

Needs Buys 5-10 photos from freelancers/issue; 30-60 photos/year. Needs photos of mechanical contractors at work, site shots, product shots. Model/property release preferred. Photo captions preferred.

Specs Prefers images in digital format. Send via CD, e-mail as TIFF, JPEG files at 300 dpi minimum. Also uses 4×6 glossy/semi-matte color and/or b&w prints; 35mm transparencies.

Making Contact & Terms Send unsolicited photos by mail for consideration. Cannot return material. Responds in 1 month. Simultaneous submissions and previously published work OK. Pays $400 for b&w or color cover; $50-200 for b&w or color inside (payment in Canadian dollars). Pays on publication. Credit line given. Buys one-time rights; negotiable.

Ⓝ $ ☑ Ⓢ ▣ THE HORSE

P.O. Box 919003, Lexington KY 40591-9003. (859)276-6833. Fax: (859)276-4450. E-mail: marszman@thehorse.com. Web site: www.thehorse.com. **Contact:** Megan Arszman, photo/newsletter editor. Circ. 49,000. Estab. 1995. Monthly magazine. Emphasizes equine health. Readers are equine veterinarians, hands-on horse owners, trainers and barn managers. Sample copy free with large SASE. Photo guidelines free with SASE and on Web site at www.thehorse.com/ViewArticle.aspx?ID=4883&kw=4883.

Needs Buys 20-30 photos from freelancers/issue; 240-360 photos/year. Needs generic horse shots, horse health such as farrier and veterinary shots. "We use all breeds and all disciplines." Model/property release preferred. Photo captions preferred.

Specs Uses color transparencies. Accepts images in digital format. Send via CD, floppy disk, Zip, e-mail as TIFF, EPS, JPEG files at 300 dpi (4×6).

Making Contact & Terms Send unsolicited photos by mail for consideration. Keeps samples on file. Previously published work OK. Pays $350 for color cover; $40-120 for color inside. Pays on publication. Buys one-time rights.

Tips "Please include name, address and phone number of photographer; date images were sent; whether images may be kept on file or should be returned; date by which images should be returned; number of images sent. Usually 10-20 samples is adequate. Do not submit originals."

$ $ $ ☑ ▣ IEEE SPECTRUM

3 Park Ave., 17th Floor, New York NY 10016. (212)419-7569. Fax: (212)419-7570. E-mail: r.silberman@ieee.org. Web site: www.spectrum.ieee.org. **Contact:** Randi Silberman, photo editor. Circ. 370,000. Monthly magazine of the Institute of Electrical and Electronics Engineers, Inc. (IEEE). Emphasizes electrical and electronics field and high technology. Readers are males/females, educated, ages 20-70.

Needs Uses 20-30 photos/issue. Purchases stock photos in following areas: technology, energy, medicine, military, sciences and business concepts. Hires assignment photographers for location shots and portraiture, as well as product shots. Model/property release required. Photo captions required.

Specs Accepts images in digital format. Send via CD as TIFF, JPEG files at 300 dpi.

Making Contact & Terms Provide promos or tearsheets to be kept on file for possible future assignments. Pays $1,200 for color cover; $200-600 for inside. **Pays on acceptance.** Credit line given. Buys one-time rights.

Tips Wants photographers who are consistent, have an ability to shoot color and b&w, display a unique vision, and are receptive to their subjects. "As our subject matter is varied, *Spectrum* uses a variety of imagemakers."

☑ ▣ IGA GROCERGRAM

Pace Communications, 1301 Carolina St., Greensboro NC 27401. (336)383-5772. Fax: (336)383-5792. E-mail: chris.ferguson@paceco.com. **Contact:** Chris Ferguson, art director. Circ. 11,000. Estab. 1926. Monthly magazine of the Independent Grocers Alliance. Emphasizes food industry. Readers are IGA retailers. Sample copy available upon request.

Needs Needs in-store shots, food (appetite appeal). Prefers shots of IGA stores. Model/property release required. Photo captions required.

Specs Accepts images in digital format. Send as TIFF files at 300 dpi.

Making Contact & Terms Send samples by e-mail or link to Web site for consideration. Provide résumé, business card, brochure, flier or tearsheets to be kept on file for possible future assignments. Keeps samples on file. Responds in 3 weeks. Simultaneous submissions and previously published work OK. Pay negotiable. **Pays on acceptance.** Credit line given. Buys one-time rights.

$☑ ITE JOURNAL

1099 14th St. NW, Suite 300W, Washington DC 20005-3438. (202)289-0222. Fax: (202)289-7722. E-mail: ite_staff@ite.org. Web site: www.ite.org. **Contact:** Managing Editor. Circ. 17,000. Estab. 1930. Monthly journal of the Institute of Transportation Engineers. Emphasizes surface transportation, including streets, highways and transit. Readers are transportation engineers and professionals.

Needs One photo used for cover illustration per issue. Needs ''shots of streets, highways, traffic, transit systems. No airports, airplanes, or bridges.'' Also considers landscapes, cities, rural, automobiles, travel, industry, technology, historical/vintage. Model release required. Photo captions preferred; include location, name or number of road or highway, and details.

Making Contact & Terms Send query letter with list of stock photo subjects. Send 35mm slides or 2¼×2¼ transparencies by mail for consideration. Provide résumé, business card, brochure, flier or tearsheets to be kept on file for possible future assignments. ''Send originals; no dupes, please.'' Simultaneous submissions and previously published work OK. Pays $200 for color cover. Pays on publication. Credit line given. Buys multiple-use rights.

Tips ''Send a package to me in the mail; package should include samples in the form of slides and/or transparencies.''

$☑ 🖳 JOURNAL OF ADVENTIST EDUCATION

General Conference of Seventh-day Adventists, 12501 Old Columbia Pike, Silver Spring MD 20904-6600. (301)680-5075. Fax: (301)622-9627. E-mail: rumbleb@gc.adventist.org. Web site: http://education.gc.adventist.org/jae. **Contact:** Beverly J. Rumble, editor. Circ. 11,000. Estab. 1939. Published 5 times/year. Emphasizes procedures, philosophy and subject matter of Christian education. Official professional organ of the Department of Education covering elementary, secondary and higher education for all Seventh-day Adventist educational personnel (worldwide).

Needs Buys 5-15 photos from freelancers/issue; up to 75 photos/year. Needs photos of children/teens, multicultural, parents, education, religious, health/fitness, technology/computers with people, committees, offices, school photos of teachers, students, parents, activities at all levels, elementary through graduate school. Reviews photos with or without a manuscript. Model release preferred. Photo captions preferred.

Specs Uses mostly color prints; 35mm, 2¼×2¼, 4×5 transparencies. Accepts images in digital format. Send via Zip, CD-ROM (preferred), e-mail as TIFF, GIF, JPEG files at 300 dpi. Do not send large numbers of photos as e-mail attachments.

Making Contact & Terms Send query letter with prints, photocopies, transparencies. Provide self-promotion piece to be kept on file for possible future assignments. Responds in 1 month to queries. Simultaneous submissions and previously published work OK. Pays $100-350 for color cover; $50-100 for color inside. Willing to negotiate on electronic usage of photos. Pays on publication. Credit line given. Buys one-time rights for use in magazine and on Web site.

Tips ''Get good-quality people shots—close-ups, verticals especially; use interesting props in classroom shots; include teacher and students together, teachers in groups, parents and teachers, cooperative learning and multiage, multicultural children. Pay attention to backgrounds (not too busy) and understand the need for high-res photos!''

$ JOURNAL OF PSYCHOACTIVE DRUGS

Haight-Ashbury Publications, 856 Stanyan St., San Francisco CA 94117. (415)752-7601. Fax: (415)933-8674. **Contact:** Terry Chambers, managing editor. Circ. 1,400. Estab. 1967. Quarterly. Emphasizes ''psychoactive substances (both legal and illegal).'' Readers are ''professionals (primarily health) in the drug abuse treatment field.''

Needs Uses 1 photo/issue; supplied by freelancers. Needs ''full-color abstract, surreal, avant garde or computer graphics.''

Making Contact & Terms Send query letter with 4×6 color prints or 35mm slides. Include SASE for return of material. Responds in 2 weeks. Simultaneous submissions and previously published work OK. Pays $50 for color cover. Pays on publication. Credit line given. Buys one-time rights.

$ $☑ 🔲 JUDICATURE

2700 University Ave., Des Moines IA 50311. (773)973-0145. Fax: (773)338-9687. E-mail: drichert@ajs.org. Web site: www.ajs.org. **Contact:** David Richert, editor. Circ. 6,000. Estab. 1917. Bimonthly publication of the American Judicature Society. Emphasizes courts, administration of justice. Readers are judges, lawyers, professors, citizens interested in improving the administration of justice. Sample copy free with 9 × 12 SAE and 6 first-class stamps.

Needs Buys 1-2 photos from freelancers/issue; 6-12 photos/year. Needs photos relating to courts, the law. "Actual or posed courtroom shots are always needed." Interested in fine art, historical/vintage. Model/property release preferred. Photo captions preferred.

Specs Uses b&w and/or color prints. Accepts images in digital format. Send via CD, Zip, e-mail as JPEG files at 600 dpi.

Making Contact & Terms Send 5 × 7 glossy b&w prints or slides by mail for consideration; include SASE for return of material. Provide résumé, business card, brochure, flier or tearsheets to be kept on file for possible future assignments. Responds in 2 weeks. Simultaneous submissions and previously published work OK. Pays $250 for b&w cover; $350 for color cover; $125-250 for b&w inside; $125-300 for color inside. Pays on publication. Credit line given. Buys one-time rights.

$ LANDSCAPE ARCHITECTURE

636 Eye St. NW, Washington DC 20001. (202)898-2444. E-mail: jroth@asla.org. Web site: www.asla.org. **Contact:** Jeff Roth, art director. Circ. 22,000. Estab. 1910. Monthly magazine of the American Society of Landscape Architects. Emphasizes "landscape architecture, urban design, parks and recreation, architecture, sculpture" for professional planners and designers.

Needs Buys 5-10 photos from freelancers/issue; 50-120 photos/year. Needs photos of landscape- and architecture-related subjects as described above. Special needs include aerial photography and environmental portraits. Model release required. Credit, caption information required.

Making Contact & Terms Send query letter with samples or list of stock photo subjects. Provide brochure, flier or tearsheets to be kept on file for possible future assignments. Response time varies. Previously published work OK. Pays $300-600/day. Pays on publication. Credit line given. Buys one-time rights.

Tips "We take an editorial approach to photographing our subjects."

$ $☑ MARKETING & TECHNOLOGY GROUP

1415 N. Dayton, Chicago IL 60622. (312)274-2216. Fax: (312)266-3363. E-mail: qburns@meatingplace.com. Web site: www.meatingplace.com. **Contact:** Queenie Burns, vice president/design & production. Circ. 18,000. Estab. 1993. Publishes magazines that emphasize meat and poultry processing. Readers are predominantly male, ages 35-65, generally conservative. Sample copy available for $4.

Needs Buys 1-3 photos from freelancers/issue. Needs photos of food, processing plant tours, product shots, illustrative/conceptual. Model/property release preferred. Photo captions preferred.

Making Contact & Terms Provide résumé, business card, brochure, flier or tearsheets to be kept on file for possible future assignments. Submit portfolio for review. Keeps samples on file. Responds in 1 month. Simultaneous submissions and previously published work OK. Payment negotiable. Pays on publication. Credit line given.

Tips "Work quickly and meet deadlines. Follow directions when given; and when none are given, be creative while using your best judgment."

☑ 🔲 🔁 MEETINGS AND INCENTIVE TRAVEL

Rogers Media, 1 Mount Pleasant Rd., 7th Floor, Toronto ON M4Y 2Y5 Canada. (416)764-1634. Fax: (416)764-1419. E-mail: dave.curcio@mtg.rogers.com. Web site: www.meetingscanada.com. **Contact:** David Curcio, creative and design director. Circ. 10,500. Estab. 1970. Bimonthly trade magazine emphasizing meetings and travel.

Needs Buys 1-5 photos from freelancers/issue; 7-30 photos/year. Needs photos of environmental, landscapes/scenics, cities/urban, interiors/decorating, events, food/drink, travel, business concepts, technology/computers. Reviews photos with or without a manuscript. Model/property release required. Photo captions required; include location and date.

Specs Uses 8 × 12 prints depending on shoot and size of photo in magazine. Accepts images in digital format. Send via CD as TIFF files at 300 dpi.

Making Contact & Terms Contact through rep or send query letter with tearsheets. Portfolio may be dropped off every Tuesday. Provide résumé, business card, self-promotion piece to be kept on file for

possible future assignments. Responds only if interested; send nonreturnable samples. Simultaneous submissions and previously published work OK. "Payment depends on many factors." Credit line given. Buys one-time rights.

Tips "Send samples to keep on file."

Ⓝ ☑ ▣ MIDWEST FOOD NETWORK

(formerly *Midwest Foodservice News*), P.O. Box 917, Newark OH 43058. (740)345-5542. Fax: (740)345-5557. E-mail: carmen@midwestfoodnetwork.com. Web site: www.midwestfoodnework.com. Contact: Carmen Seward, editor. Circ. 27,000. Estab. 1976. Bi-monthly magazine. "Regional publication with a national interest and a local flair. Each edition contains state and national news, plus articles of local interest, to foster an informative dialogue between foodservice operators, their suppliers and associated businesses." Sample copy available for $3.95 with $2 first-class postage.

Needs Buys 5 or more photos from freelancers/issue; approximately 100 photos/year. Needs photos of celebrities, cities/urban, food/drink, travel, product shots/still life, photos from the restaurant and hospitality industry and foodservice companies (i.e., chefs, restaurant kitchens, dining areas, chef celebrities, etc.). Interested in historical/vintage. Reviews photos with or without a manuscript. Model/property release required. Photo captions preferred; include description of photo plus all the names, etc., and photo credit.

Specs Accepts images in digital format only. Send via CD, e-mail as TIFF, EPS, BMP, GIF, JPEG files at 300-800 dpi.

Making Contact & Terms Send query letter with slides, prints, transparencies. Provide self-promotion piece to be kept on file for possible future assignments. Responds only if interested; send nonreturnable samples. Simultaneous submissions OK. Pay is based on experience. Pays on publication. Credit line given. Buys first rights.

$ ▣ MILITARY OFFICER MAGAZINE

201 N. Washington St., Alexandria VA 22314. (800)234-6622. Fax: (703)838-8179. E-mail: editor@moaa.org. Web site: www.moaa.org. **Contact:** Jill Akers, photo editor. Circ. 400,000. Estab. 1945. Monthly publication of the Military Officers Association of America. Represents the interests of military officers from the 7 uniformed services: Army, Navy, Air Force, Marine Corps, Coast Guard, Public Health Service and National Oceanic and Atmospheric Administration. Emphasizes military history (particularly Vietnam and Korea), travel, health, second-career job opportunities, military family lifestyle and current military/political affairs. Readers are commisssioned officers or warrant officers and their families. Sample copy available on request with 9×12 SASE.

Needs Buys 8 photos from freelancers/issue; 96 photos/year. "We're always looking for good color images of active-duty military people and healthy, active mature adults with a young 50s look—our readers are 55-65."

Specs Uses digital images as well as 2¼×2¼ or 4×5 transparencies. Send digital images via e-mail as JPEG files at 300 dpi.

Making Contact & Terms Send query letter with list of stock photo subjects. Provide résumé, brochure, flier to be kept on file. "Do NOT send original photos unless requested to do so." Payment negotiated. "Photo rates vary with size and position." Pays on publication. Credit line given. Buys one-time rights.

Ⓝ $ $ ☑ ▣ NAILPRO

7628 Densmore Ave., Van Nuys CA 91406-2042. (818)782-7328. Fax: (818)782-7450. E-mail: syaggy@creativeage.com. Web site: www.nailpro.com. **Contact:** Stephanie Yaggy, executive editor. Circ. 65,000. Estab. 1990. Monthly magazine publishd by Creative Age Publications. Emphasizes topics for professional manicurists and nail salon owners. Readers are females of all ages. Sample copy available for $2 with 9×12 SASE.

Needs Buys 10-12 photos from freelancers/issue; 120-144 photos/year. Needs photos of beautiful nails illustrating all kinds of nail extensions and enhancements; photographs showing process of creating and decorating nails, both natural and artificial. Also needs salon interiors, health/fitness, fashion/glamour. Model release required. Photo captions required; identify people and process if applicable.

Specs Accepts images in digital format. Send via Zip, e-mail as TIFF, EPS files at 300 dpi or better.

Making Contact & Terms Send query letter; responds only if interested. Call for portfolio review. "Art directors are rarely available, but photographers can leave materials and pick up later (or leave nonreturnable samples)." Send color prints; 35mm, 2¼×2¼, 4×5 transparencies. Keeps samples on file. Responds

in 1 month. Previously published work OK. Pays $500 for color cover; $50-250 for color inside. **Pays on acceptance**. Credit line given. Buys one-time rights.

Tips "Talk to the person in charge of choosing art about photo needs for the next issue and try to satisfy that immediate need; that often leads to assignments. Submit samples and portfolios with letter stating specialties or strong points."

ℕ $🖾 NAILS MAGAZINE

Bobit Publishing, 3520 Challenger St., Torrance CA 90503. (310)533-2400. Fax: (310)533-2507. E-mail: danielle.parisi@bobit.com. Web site: www.nailsmag.com. **Contact:** Danielle Parisi, art director. Circ. 60,000. Estab. 1982. Monthly trade publication for nail technicians and beauty salon owners. Sample copies available.

Needs Buys up to 10 photos from freelancers/issue. Needs photos of celebrities, buildings, historical/vintage. Other specific photo needs: salon interiors, product shots, celebrity nail photos. Reviews photos with or without a manuscript. Model release required. Photo captions preferred.

Specs Uses 35mm transparencies. Accepts images in digital format. Send via CD, Zip as TIFF, EPS files at 266 dpi.

Making Contact & Terms Send query letter with résumé, slides, prints. Keep samples on file. Responds in 1 month on queries. **Pays on acceptance.** Credit line sometimes given if it's requested. Buys all rights.

$THE NATIONAL NOTARY

National Notary Association, 9350 De Soto Ave., P.O. Box 2402, Chatsworth CA 91313-2402. (818)739-4000. Web site: www.nationalnotary.org. **Contact:** Phillip Browne, managing editor. Circ. 300,000+. Bimonthly association magazine. Emphasizes "Notaries Public and notarization—goal is to impart knowledge, understanding and unity among notaries nationwide and internationally." Readers are employed primarily in the following areas: law, government, finance and real estate. Sample copy available for $5.

Needs Number of photos purchased varies with each issue. "Photo subject depends on accompanying story/theme; some product shots used." Reviews photos with accompanying manuscript only. Model release required.

Making Contact & Terms Send query letter with samples. Provide business card, tearsheets, résumé or samples to be kept on file for possible future assignments. Prefers to see prints as samples. Cannot return material. Responds in 6 weeks. Previously published work OK. Pays $25-300 depending on job. Pays on publication. Credit line given "with editor's approval of quality." Buys all rights.

Tips "Since photography is often the art of a story, the photographer must understand the story to be able to produce the most useful photographs."

$🖊 🆂 🖾 NAVAL HISTORY

U.S. Naval Institute, 291 Wood Rd., Annapolis MD 21402. (410)295-1071. Fax: (410)295-1049. E-mail: avoight@usni.org. Web site: www.usni.org. **Contact:** Amy Voight, photo editor. Circ. 50,000. Estab. 1873. Bimonthly association publication. Emphasizes Navy, Marine Corps, Coast Guard. Readers are male and female naval officers (enlisted, retirees), civilians. Photo guidelines free with SASE.

Needs Needs 40 photos from freelancers/issue; 240 photos/year. Needs photos of foreign and U.S. Naval, Coast Guard and Marine Corps vessels, industry, military, personnel and aircraft. Interested in historical/vintage. Photo captions required.

Specs Uses 8×10 glossy or matte b&w and/or color prints (color preferred); transparencies. Accepts images in digital format. Send via CD, Zip, e-mail as JPEG files at 300 dpi.

Making Contact & Terms Send unsolicited photos by mail for consideration; include SASE for return of material. Responds in 1 month. Simultaneous submissions and previously published work OK. Pays $200 for color cover; $50 for color inside. Pays on publication. Credit line given. Buys one-time and electronic rights.

$NEVADA FARM BUREAU AGRICULTURE AND LIVESTOCK JOURNAL

2165 Green Vista Dr., Suite 205, Sparks NV 89431. (775)674-4000. Web site: http://nvfb.fb.org. **Contact:** Doug Busselman, editor. Circ. 1,500. Monthly magazine. Emphasizes Nevada agriculture. Readers are primarily Nevada Farm Bureau members and their families; men, women and youth of various ages. Members are farmers and ranchers. Sample copy free with 10×13 SAE with 3 first-class stamps.

Needs Uses 5 photos/issue; 30% occasionally supplied by freelancers. Needs photos of Nevada agriculture—people, scenes and events. Model release preferred. Photo captions required.

Making Contact & Terms Send 3×5 and larger b&w or color prints, any format and finish, by mail with SASE for consideration. Responds in 1 week. Pays $10 for b&w cover, $50 for color cover; $5 for b&w inside. **Pays on acceptance.** Credit line given. Buys one-time rights.

Tips In portfolio or samples, wants to see "newsworthiness, 50%; good composition, 20%; interesting action, 20%; photo contrast/resolution, 10%. Try for new angles on stock shots: awards, speakers, etc. We like 'Great Basin' agricultural scenery such as cows on the rangelands and high desert cropping. We pay little, but we offer credits for your résumé."

$⬚ ▣ 9-1-1 MAGAZINE

18201 Weston Place, Tustin CA 92780. (714)544-7776. E-mail: editor@9-1-1magazine.com. Web site: www.9-1-1magazine.com. **Contact:** Randall Larson, editor. Circ. 18,000. Estab. 1988. Published 9 times/year. Emphasizes public safety communications for police, fire, paramedic, dispatch, medical, etc. Readers are ages 20-65. Sample copy free with 9×12 SASE and 7 first-class stamps. Photo guidelines free with SASE.

Needs Buys 20-30 photos from freelancers/issue; 270 photos/year. "Primary needs include dramatic photographs of incidents and unusual situations for covers; *From the Field*, our 2-page photo department included in each issue; and to illustrate articles. We especially need communications-related photos and law enforcement images. We have an overabundance of car-crash and structure-fire images, and are only looking for the more unusual or spectacular images in those categories. We rarely use stock photos, and we insist that all photography submitted to *9-1-1 Magazine* be for our exclusive use." Photo captions required; if possible, include incident location by city and state, agencies involved, incident details.

Specs Prefers digital images but also accepts color prints; 35mm, $2\frac{1}{4} \times 2\frac{1}{4}$, 4×5, 8×10 transparencies. "Digital picture submissions should be from a (minimum) 4-megapixel camera at highest setting (or minimum resolution of 1,500 pixels wide; or 5" wide at 300 dpi). Low-res samples acceptable with query."

Making Contact & Terms Send query letter with list of stock photo subjects. "Prefer original images versus stock content." Send unsolicited photos by post or e-mail for consideration; include SASE for return of material. Responds in 3 weeks. Pays $300 for color cover; $50 for color inside, $\frac{1}{4}$ page or less; $75 for color inside, $\frac{1}{2}$ page; $100 for color inside, full page. Pays on publication. Credit line given. Buys one-time rights.

Tips "We need photos for unillustrated cover stories and features appearing in each issue. See editorial calendar on Web site under 'Advertising' link. Assignments possible. Emphasis is on interesting composition, clarity and uniqueness of image."

▣ NORTHWEST TERRITORIES EXPLORER'S GUIDE

Northwest Territories Tourism, P.O. Box 610, Yellowknife NT X1A 2N5 Canada. (867)873-5007. Fax: (867)873-4059. E-mail: communications@spectacularnwt.com. Web site: www.spectacularnwt.com. **Contact:** Communications Manager. Circ. 90,000. Estab. 1996. Annual tourism publication for Northwest Territories. Sample copies available.

Needs Needs photos of babies/children/teens, couples, multicultural, families, senior citizens, landscapes/scenics, wildlife, adventure, automobiles, events, travel. Interested in historical/vintage, seasonal. Also needs photos of Northwest Territories, winter and road touring.

Specs Uses 35mm transparencies.

Making Contact & Terms Send query letter with résumé, slides, prints, photocopies, tearsheets, transparencies, stock list. Portfolio may be dropped off Monday through Saturday. Provide résumé, business card, self-promotion piece to be kept on file for possible future assignments. Responds in 1 week to queries. Simultaneous submissions OK. **Pays on acceptance.**

⬚ $▣ THE ONTARIO TECHNOLOGIST

10 Four Seasons Place, Suite 404, Toronto ON M9B 6H7 Canada. (416)621-9621. Fax: (416)621-8694. E-mail: cmellor@oacett.org. Web site: www.oacett.org. **Contact:** Colleen Mellor, editor-in-chief. Circ. 23,000. Bimonthly publication of the Ontario Association of Certified Engineering Technicians and Technologists. Emphasizes engineering and applied science technology. Sample copy free with SAE and IRC.

Needs Uses 10-12 photos/issue. Needs how-to photos—"building and installation of equipment; similar technical subjects." Model release preferred. Photo captions preferred.

Making Contact & Terms Prefers business card and brochure for files. Send 5×7 glossy color prints or high-res digital images at 300 dpi for consideration. Responds in 1 month. Previously published work OK. Payment varies; negotiable. Pays on publication. Credit line given. Buys one-time rights.

$ $ THE PARKING PROFESSIONAL

P.O. Box 7167, Fredericksburg VA 22404. (540)371-7535. Fax: (540)371-8022. E-mail: jackson@parking.org. Web site: www.parking.org. **Contact:** Kim Jackson, editor. Circ. 10,000. Estab. 1984. Monthly magazine of the International Parking Institute. Emphasizes parking and transportation: public, private, institutional, etc. Readers are male and female public parking and transportation managers, ages 30-60. Sample copy free.

Needs Buys 4-5 photos from freelancers/issue; 48-60 photos/year. Model release required. Photo captions preferred; include location, purpose, type of operation.

Specs Uses 5×7, 8×10 color and/or b&w prints; 35mm, 2¼×2¼, 4×5, 8×10 transparencies.

Making Contact & Terms Contact through rep. Arrange a personal interview to show portfolio for review. Send query letter with résumé of credits. Provide résumé, business card, brochure, flier or tearsheets to be kept on file for possible future assignments. Responds in 2 weeks. Previously published work OK. Pays $100-300 for color cover; $25-100 for b&w or color inside; $100-500 for photo/text package. Pays on publication. Credit line given. Buys one-time, all rights; negotiable.

$ $ ⑤ ▣ PEDIATRIC ANNALS

6900 Grove Rd., Thorofare NJ 08086. (856)848-1000. E-mail: pedann@slackinc.com. Web site: www.pediatricannalsonline.com. **Contact:** Mary Archer, executive editor. Circ. 58,000. Monthly journal. Readers are practicing pediatricians. Sample copy free with SASE.

Needs Uses 5-7 photos/issue; primarily stock. Occasionally uses original photos of children in medical settings.

Specs Color photos preferred. Accepts images in digital format. Send as EPS, JPEG files at 300 dpi.

Making Contact & Terms Request editorial calendar for topic suggestions. E-mail query with link(s) to samples. Simultaneous submissions and previously published work OK. Pays varies; negotiable. Pays on publication. Credit line given. Buys unlimited North American rights including any and all subsidiary forms of publication, such as electronic media and promotional pieces.

$ ▨ ▣ PET PRODUCT NEWS

P.O. Box 6050, Mission Viejo CA 92690. (949)855-8822. Fax: (949)855-3045. E-mail: ppneditor@bowtieinc.com. Web site: www.petproductnews.com. **Contact:** Photo Editor. Monthly tabloid. Emphasizes pets and the pet retail business. Readers are pet store owners and managers. Sample copy available for $5. Photo guidelines free with SASE or on Web site.

Needs Buys 16-50 photos from freelancers/issue; 192-600 photos/year. Needs photos of people interacting with pets, retailers interacting with customers and pets, pets doing "pet" things, pet stores and vets examining pets. Also needs wildlife, events, industry, product shots/still life. Interested in seasonal. Reviews photos with or without a manuscript. Model/property release preferred. "Enclose a shipment description with each set of photos detailing the type of animal, name of pet store, names of well-known subjects and any procedures being performed on an animal that are not self-explanatory."

Specs Accepts images in digital format. Send via CD, Zip, e-mail as TIFF, EPS, JPEG files at 300 dpi.

Making Contact & Terms "We cannot assume responsibility for submitted material, but care is taken with all work. Freelancers must include a self-addressed, stamped envelope for returned work." Send sharp 35mm color slides or prints by mail for consideration. Responds in 2 months. Previously published work OK. Pays $75 for color cover; $50 for color inside. Pays on publication. Photographer also receives 2 complimentary copies of issue in which their work appears. Credit line given; name and identification of subject must appear on each slide or photo. Buys one-time rights.

Tips Looks for "appropriate subjects, clarity and framing, sensitivity to the subject. No avant garde or special effects. We need clear, straight-forward photography. Definitely no 'staged' photos; keep it natural. Read the magazine before submission. We are a trade publication and need business-like, but not boring, photos that will add to our subjects."

$ $ ◯ ⑤ ▣ PI MAGAZINE, Professional Investigator Magazine

(formerly PI Magazine, Journal of Professional Investigators), 4400 Rt. 9 S., Suite 1000, P.O. Box 7198, Freehold NJ 07728 -7198. (732)308-3800. Fax: (732)308-3314. E-mail: jim@pimagazine.com. Web site:

www.pimagazine.com. **Contact:** Jimmie Mesis, publisher. Circ. 10,000. Estab. 1987. Bimonthly trade magazine. "Our audience is 80% private investigators with the balance law enforcement, insurance investigators, and people with interest in becoming a PI. The magazine features educational articles about the profession. Serious conservative format." Sample copy available for $6.95 and SAE with $1.75 first-class postage.

Needs Buys 10 photos from freelancers/issue; 60-100 photos/year. Needs photos of technology/computers, law/crime. Reviews photos with or without a manuscript. Model/property release required. Photo captions preferred.

Specs Accepts images in digital format. Send via CD, e-mail as TIFF, EPS files at highest dpi.

Making Contact & Terms Send query letter with tearsheets, stock list. Provide résumé, business card, self-promotion piece to be kept on file for possible future assignments. Responds only if interested; send nonreturnable samples. Simultaneous submissions OK. Pays $200-500 for color cover; $50-200 for color inside. Pays on publication. Credit line given. Buys all rights; negotiable.

$ ☑ Ⓐ ▣ PILOT GETAWAYS

Airventure Publishing LLC, P.O. Box 550, Glendale CA 91209. (818)241-1890. E-mail: editor@pilotgetaways.com. Web site: www.pilotgetaways.com. **Contact:** John Kounis, editor. Circ. 25,000. Estab. 1998. Bimonthly magazine focusing on travel by private aircraft. Includes sections on backcountry, bush and mountain flying. Emphasizes private pilot travel—weekend getaways, fly-in dining, bush flying, and complete flying vacations. Readers are mid-life males, affluent. Sample copy available for $4.95.

Needs Uses assignment photos. Needs photos of adventure, travel, product shots/still life. Model release required. Photo captions required.

Specs Accepts medium-format and 35mm slides. Accepts images in digital format. Send via CD as TIFF files at 300 dpi.

Making Contact & Terms Provide résumé, business card or tearsheets to be kept on file for possible future assignments; contact by e-mail. Responds in 1 month. Simultaneous submissions OK. Prefers previously unpublished work. Pays $135 for color cover, $25 for image inside magazine. Pays 30 days after publication. Credit line given. Buys all rights; negotiable.

Tips "Exciting, fresh and unusual photos of airplanes used for recreation. Aerial landscapes, fly-in destinations. Outdoor recreation: skiing, hiking, fishing and motor sports. Affluent backcountry lifestyles: homes, hangars and private airstrips. Query first. Don't send originals—color copies or low-resolution digital OK for evaluation."

$ $▣ PLANNING

American Planning Association, 122 S. Michigan Ave, Chicago IL 60603. (312)431-9100. E-mail: rsessions @planning.org. Web site: www.planning.org. **Contact:** Richard Sessions, art director. Editor: Sylvia Lewis. Circ. 35,000. Estab. 1972. Monthly magazine. "We focus on urban and regional planning, reaching most of the nation's professional planners and others interested in the topic." Sample copy and photo guidelines free with 10×13 SASE with 4 first-class stamps (do not send cash or checks).

Needs Buys 4-5 photos from freelancers/issue; 60 photos/year. Photos purchased with accompanying manuscript and on assignment. Photo essay/photo feature (architecture, neighborhoods, historic preservation, agriculture); scenic (mountains, wilderness, rivers, oceans, lakes); housing; transportation (cars, railroads, trolleys, highways). "No cheesecake; no sentimental shots of dogs, children, etc. High artistic quality is very important. We publish high-quality nonfiction stories on city planning and land use. Ours is an association magazine but not a house organ, and we use the standard journalistic techniques: interviews, anecdotes, quotes. Topics include energy, the environment, housing, transportation, land use, agriculture, neighborhoods and urban affairs." Photo captions required.

Specs Uses 4-color prints; 35mm, 4×5 transparencies. Accepts images in digital format. Send via Zip, CD as TIFF, EPS, JPEG files at 300 dpi and around 5×7 in physical size.

Making Contact & Terms Send query letter with samples; include SASE for return of material. Responds in 1 month. Previously published work OK. Pays $50-100 for b&w photos; $50-200 for color photos; $350 maximum for cover; $200-600 for manuscript. Pays $25-75 for electronic use of images. Pays on publication. Credit line given.

Tips "Just let us know you exist. Eventually, we may be able to use your services. Send tearsheets or photocopies of your work, or a little self-promo piece. Subject lists are only minimally useful, as are Web site addresses. How the work looks is of paramount importance. Please don't send original slides or prints with the expectation of them being returned. Send something we can keep in our files."

$PLASTICS NEWS

1725 Merriman Rd., Akron OH 44313. (330)836-9180. Fax: (330)836-2322. E-mail: editorial@plasticsnews.com. Web site: www.plasticsnews.com. **Contact:** Don Loepp, managing editor. Circ. 60,000. Estab. 1989. Weekly tabloid. Emphasizes plastics industry business news. Readers are male and female executives of companies that manufacture a broad range of plastics products; suppliers and customers of the plastics processing industry. Sample copy available for $1.95.

Needs Buys 1-3 photos from freelancers/issue; 52-156 photos/year. Needs photos of technology related to use and manufacturing of plastic products. Model/property release preferred. Photo captions required.

Making Contact & Terms Send unsolicited photos by mail for consideration. Provide résumé, business card, brochure, flier or tearsheets to be kept on file for possible future assignments. Send query letter with stock list. Keeps samples on file; include SASE for return of material. Responds in 2 weeks. Simultaneous submissions and previously published work OK. Pays $125-175 for color cover; $100-150 for b&w inside; $125-175 for color inside. Pays on publication. Credit line given. Buys one-time and all rights.

$ $ $ ☑ ▣ PLASTICS TECHNOLOGY

Gardner Publications, 6915 Valley Ave. Cincinnati OH 45244. (800)950-8020 or (513)527-8800. E-mail: sbriggs@gardnerweb.com. Web site: www.ptonline.com. **Contact:** Sheri Briggs, art director. Circ. 50,000. Estab. 1954. Monthly trade magazine. Sample copy available for first-class postage.

Needs Buys 1-3 photos from freelancers/issue. Needs photos of agriculture, business concepts, industry, science, technology. Model release required. Photo captions required.

Specs Uses 5×7 glossy color prints; 35mm, 2¼×2¼, 4×5 transparencies. Accepts images in digital format. Send via CD, Zip, e-mail as TIFF, EPS, JPEG files at 300 dpi.

Making Contact & Terms Send query letter with résumé, photocopies, tearsheets. Provide business card, self-promotion piece to be kept on file for possible future assignments. Responds only if interested; send nonreturnable samples. Simultaneous submissions OK. Pays $1,000-1,300 for color cover; $300 minimum for color inside. Pays on publication. Credit line given. Buys one-time rights, all rights; negotiable.

$POLICE AND SECURITY NEWS

DAYS Communications, Inc., 1208 Juniper St., Quakertown PA 18951. (215)538-1240. Fax: (215)538-1208. E-mail: amenear@policeandsecuritynews.com. Web site: www.policeandsecuritynews.com. **Contact:** Al Menear, associate publisher. Circ. 22,200. Estab. 1984. Bimonthly trade journal. *"Police and Security News* is edited for middle and upper management and top administration. Editorial content is a combination of articles and columns ranging from the latest in technology, innovative managerial concepts, training and industry news in the areas of both public law enforcement and private security."* Sample copy free with 9¾×10 SAE and $2.17 first-class postage.

Needs Buys 2 photos from freelancers/issue; 12 photos/year. Needs photos of law enforcement and security related. Reviews photos with or without a manuscript. Photo captions preferred.

Specs Uses color and b&w prints.

Making Contact & Terms Provide résumé, business card, self-promotion piece or tearsheets to be kept on file for possible future assignments. Art director will contact photographer for portfolio review if interested. Portfolio should include b&w and/or color prints or tearsheets. Keeps samples on file; include SASE for return of material. Simultaneous submissions and previously published work OK. Pays $20-40 for color inside. Pays on publication. Credit line given. Buys one-time rights; negotiable.

$◻ POLICE TIMES/CHIEF OF POLICE

6350 Horizon Dr., Titusville FL 32780. (321)264-0911. Fax: (321)264-0033. E-mail: policeinfo@aphf.org. Web site: www.aphf.org. **Contact:** Jim Gordon, executive editor. *Police Times:* quarterly trade magazine (circ. 155,000; *Chief of Police:* bimontly trade magazine (circ. 33,000). Readers are law enforcement officers at all levels. *Police Times* is the official journal of the American Federation of Police and Concerned Citizens. Sample copy available for $2.50. Photo guidelines free with SASE.

Needs Buys 60-90 photos/year. Needs photos of police officers in action, civilian volunteers working with the police, and group shots of police department personnel. Wants no photos that promote other associations. Police-oriented cartoons also accepted on spec. Model release preferred. Photo captions preferred.

Making Contact & Terms Send glossy b&w and color prints for consideration; include SASE for return of material. Responds in 3 weeks. Simultaneous submissions and previously published work OK. Pays $10-25 for b&w; $25-50 for color. **Pays on acceptance.** Credit line given if requested; editor's option.

Buys all rights, but may reassign to photographer after publication; includes Internet publication rights.
Tips "We are open to new and unknowns in small communities where police are not given publicity."

$◻ ⑤ ▣ PROCEEDINGS

U.S. Naval Institute, 291 Wood Rd., Annapolis MD 21402. (410)295-1071. Fax: (410)295-1049. E-mail: avoight@usni.org. Web site: www.usni.org. **Contact:** Amy Voight, photo editor. Circ. 80,000. Monthly trade magazine dedicated to providing an open forum for national defense. Sample copy available for $3.95. Photo guidelines free with SASE.
Needs Buys 10 photos from freelancers/issue; 120 photos/year. Needs photos of industry, military, political. Model release preferred. Photo captions required; include time, location, subject matter, service represented—if necessary.
Specs Uses glossy color prints. Accepts images in digital format. Send via CD, Zip as TIFF, JPEG files at 300 dpi.
Making Contact & Terms Send query letter with résumé, prints. Does not keep samples on file; include SASE for return of material. Responds only if interested; send nonreturnable samples. Simultaneous submissions and previously published work OK. Pays $200 for color cover; $25-75 for color inside. Pays on publication. Credit line given. Buys one-time and sometimes electronic rights.
Tips "We look for original work. The best place to get a feel for our imagery is to see our magazine or look at our Web site."

Ⓐ ▣ PUBLIC POWER

2301 M. St. NW, 3rd Floor, Washington DC 20037-1484. (202)467-2948. Fax: (202)467-2910. E-mail: jlabella@appanet.org. Web site: www.appanet.org. **Contact:** Jeanne LaBella, editor. Circ. 20,000. Bimonthly publication of the American Public Power Association. Emphasizes electric power provided by cities, towns and utility districts. Sample copy and photo guidelines free.
Needs "We buy photos on assignment only."
Specs Prefers digital images; call art director (Robert Thomas) at (202)467-2983 to discuss.
Making Contact & Terms Send query letter with samples. Provide résumé, business card, brochure, flier or tearsheets to be kept on file for possible future assignments. **Pays on acceptance.** Credit line given. Buys one-time rights.

Ⓝ $ $ $◩ PURCHASING MAGAZINE

225 Wyman St., Waltham MA 02451. (617)964-3030. Fax: (781)734-8076. E-mail: mroach@reedbusiness.com. Web site: www.purchasing.com. **Contact:** Michael Roach, senior art director. Circ. 93,000. Estab. 1915. Bimonthly. Readers are management and purchasing professionals.
Needs Uses 0-10 photos/issue, most on assignment. Needs corporate photos and people shots. Model/property release preferred. Photo captions required.
Making Contact & Terms Arrange a personal interview to show portfolio. Provide résumé, business card, brochure, flier or tearsheets to be kept on file for possible future assignments. Cannot return material. Simultaneous submissions and previously published work OK. Pays $500-800 for b&w; $300-500 for color; $50-100/hour; $800/day; $1,200 for cover and reprints. **Pays on acceptance.** Credit line given. Buys all rights for all media including electronic media.
Tips In photographer's portfolio, looks for informal business portraits, corporate atmosphere.

$ $◩ ▣ QSR, The Magazine of Quality and Speed for Restaurant Success

4905 Pine Cone Dr., Suite 2, Durham NC 27707. (919)489-1916. Fax: (919)489-4767. E-mail: mavery@journalistic.com. Web site: www.qsrmagazine.com. **Contact:** Mitch Avery, production manager. Estab. 1997. Trade magazine directed toward the business aspects of quick-service restaurants (fast food). "Our readership is primarily management level and above, usually franchisors and franchisees. Our goal is to cover the quick-service and fast, casual restaurant industries objectively, offering our readers the latest news and information pertinent to their business." Photo guidelines free.
Needs Buys 10-15 photos/year. Needs corporate identity portraits, images associated with fast food, general food images for feature illustration. Reviews photos with or without a manuscript. Model/property release preferred.
Specs Prefers images in digital format. Send via CD/DVD, Zip as TIFF, EPS files at 300 dpi. Uses $2\frac{1}{4} \times 2\frac{1}{4}$, transparencies.
Making Contact & Terms Send query letter with samples, brochure, stock list, tearsheets. Art director

will contact photographer for portfolio review if interested. Portfolio should include slides and digital sample files. Keeps samples on file. Responds only if interested; send nonreturnable samples. Simultaneous submissions and previously published work OK. Pays $250-500 for color cover; $250-500 for color inside. Pays on publication. Publisher only interested in acquiring all rights unless otherwise specified.

Tips "Willingness to work with subject and magazine deadlines essential. Willingness to follow artistic guidelines necessary but should be able to rely on one's own eye. Our covers always feature quick-service restaurant executives with some sort of name recognition (i.e., a location shot with signage in the background, use of product props which display company logo)."

$ ☑ ▣ QUICK FROZEN FOODS INTERNATIONAL

2125 Center Ave., Suite 305, Fort Lee NJ 07024-5898. (201)592-7007. Fax: (201)592-7171. Web site: www.qffintl.com. **Contact:** John M. Saulnier, chief editor/publisher. Circ. 15,000. Quarterly magazine. Emphasizes retailing, marketing, processing, packaging and distribution of frozen foods around the world. Readers are international executives involved in the frozen food industry: manufacturers, distributors, retailers, brokers, importers/exporters, warehousemen, etc. Sample copy available for $12.

Needs Buys 10-25 photos/year. Uses photos of agriculture, plant exterior shots, step-by-step in-plant processing shots, photos of retail store frozen food cases, head shots of industry executives, etc. Photo captions required.

Specs Uses 5×7 glossy b&w and/or color prints. Accepts digital images via CD at 300 dpi, CMYK.

Making Contact & Terms Send query letter with résumé of credits. Responds in 1 month. Payment negotiable. Pays on publication. Buys all rights but may reassign to photographer after publication.

Tips A file of photographers' names is maintained; if an assignment comes up in an area close to a particular photographer, she/he may be contacted. "When submitting your name, inform us if you are capable of writing a story if needed."

RANGEFINDER

1312 Lincoln Blvd., Santa Monica CA 90401. (310)451-8506. Fax: (310)395-9058. E-mail: ogettell@rfpublishing.com, aronck@rfpublishing.com. Web site: www.rangefindermag.com. **Contact:** Oliver Gettell, associate editor or Abigail Ronck, assistant editor. Circ. 50,000. Estab. 1952. Monthly magazine. Emphasizes topics, developments and products of interest to the professional photographer. Readers are professionals in all phases of photography. Sample copy free with 11×14 SAE and 2 first-class stamps. Photo guidelines free with SASE.

Needs Buys very few photos from freelancers/issue. Needs all kinds of photos; almost always run in conjunction with articles. "We prefer photos accompanying 'how-to' or special interest stories from the photographer." No pictorials. Special needs include seasonal cover shots (vertical format only). Model release required; property release preferred. Photo captions preferred.

Making Contact & Terms Send query letter with résumé of credits. Keeps samples on file; include SASE for return of material. Responds in 1 month. Previously published work occasionally OK; give details. Payment varies. Covers submitted gratis. Pays on publication. Credit line given. Buys first North American serial rights; negotiable.

$ ▣ READING TODAY

International Reading Association, 800 Barksdale Rd., P.O. Box 8139, Newark DE 19714-8139. (302)731-1600, ext. 250. Fax: (302)731-1057. E-mail: jmicklos@reading.org. Web site: www.reading.org. **Contact:** John Micklos, Jr., editor-in-chief. Circ. 85,000. Estab. 1983. Bimonthly newspaper of the International Reading Association. Emphasizes reading education. Readers are educators who belong to the International Reading Association. Sample copies available. Photo guidelines free with SASE.

Needs Buys 4 photos from freelancers/issue; 24 photos/year. Needs classroom shots and photos of people of all ages reading in various settings. Reviews photos with or without a manuscript. Model/property release preferred. Photo captions preferred; include names (if appropriate) and context of photo.

Specs Uses 3½×5 or larger color and b&w prints. Accepts images in digital format. Send via CD, e-mail as JPEG files.

Making Contact & Terms Send query letter with résumé of credits and stock list. Send unsolicited photos by mail for consideration; include SASE for return of material. Responds in 1 month. Simultaneous submissions and previously published work OK. Pays $100 for editorial use. **Pays on acceptance.** Credit line given. Buys one-time rights for print use and rights to post editorially on the IRA Web site.

$ ⊘ ▣ RECOMMEND MAGAZINE

Worth International Media Group, 5979 NW 151st St., Suite 120, Miami Lakes FL 33014. (305)828-0123. Fax: (305)826-6950. E-mail: janet@recommend.com. Web site: www.recommend.com or www.worthit.com. **Contact:** Janet Del Mastro, art director. Circ. 55,000. Estab. 1985. Monthly. Emphasizes travel. Readers are travel agents, meeting planners, hoteliers, ad agencies.

Needs Buys 16 photos from freelancers/issue; 192 photos/year. "Our publication divides the world into 7 regions. Every month we use travel destination-oriented photos of animals, cities, resorts and cruise lines; feature all types of travel photography from all over the world." Model/property release required. Photo captions preferred; identification required on every photo.

Specs Accepts images in digital format. Send via CD, Zip as TIFF, EPS files at 300 dpi minimum. "We do not accept 35mm slides or transparencies."

Making Contact & Terms "Contact via e-mail to view sample of photography." Simultaneous submissions and previously published work OK. Pays $75-150 for color cover; $50 for front cover less than 80 square inches; $25-50 for color inside. Pays 30 days after publication. Credit line given. Buys one-time rights.

Tips Prefers to see high-res digital files.

$ ⊘ Ⓢ ▣ REFEREE

P.O. Box 161, Franksville WI 53126. (262)632-8855. Fax: (262)632-5460. E-mail: jstern@referee.com. Web site: www.referee.com. **Contact:** Jeffrey Stern, senior editor. Circ. 40,000. Estab. 1976. Monthly magazine. Readers are mostly male, ages 30-50. Sample copy free with 9 × 12 SAE and 5 first-class stamps. Photo guidelines free with SASE.

Needs Buys 37 photos from freelancers/issue; 444 photos/year. Needs action officiating shots—all sports. Photo needs are ongoing. Photo captions required; include officials' names and hometowns.

Specs Prefers to use digital files (minimum 300 dpi submitted on CD only—no DVDs) and 35mm slides. Also uses color prints.

Making Contact & Terms Send unsolicited photos by mail for consideration. Responds in 2 weeks. Simultaneous submissions and previously published work OK. Pays $100 for color cover; $35 for color inside. Pays on publication. Credit line given. Rights purchased negotiable.

Tips "Prefer photos that bring out the uniqueness of being a sports official. Need photos primarily of officials at or above the high school level in baseball, football, basketball, softball, volleyball and soccer in action. Other sports acceptable, but used less frequently. When at sporting events, take a few shots with the officials in mind, even though you may be on assignment for another reason. Don't be afraid to give it a try. We're receptive, always looking for new freelance contributors. We are constantly looking for pictures of officials/umpires. Our needs in this area have increased. Names and hometowns of officials are required."

$ $ $ ⊘ Ⓐ ▣ REGISTERED REP.

Penton Media, 249 W. 17th St., New York NY 10011. (212)204-4200. E-mail: john.herr@penton.com. Web site: www.rrmag.com. **Contact:** John Herr, group design director. Circ. 115,000. Estab. 1976. Monthly magazine. Emphasizes stock brokerage and financial services industries. Magazine is "requested and read by 90% of the nation's top financial advisors."

Needs Uses about 8 photos/issue; 5 supplied by freelancers. Needs environmental portraits of financial and brokerage personalities, and conceptual shots of financial ideas—all by assignment only. Model/property release is photographer's responsibility. Photo captions required.

Specs Prefers 100 ISO film or better. Accepts images in digital format. Send via Zip, Jaz as TIFF at 300 dpi.

Making Contact & Terms Provide brochure, flier or tearsheets to be kept on file for possible future assignments. Cannot return material. Due to space limitations, please obtain permission *prior* to sending digital samples via e-mail. Simultaneous submissions and previously published work OK. Pays $500-1,500 for cover; $200-800 for inside. Pays 30 days after publication. Credit line given. Buys one-time rights. Publisher requires signed rights agreement.

Tips "We're always looking for young talent. The focus of our magazine is on design, so talent and professionalism are key."

▣ RELAY MAGAZINE

P.O. Box 10114, Tallahassee FL 32302-2114. (850)224-3314. Fax: (850)224-2831. E-mail: neasley@publicpower.com. **Contact:** Nicole Carlson Easley, director of marketing and communications. Circ. 5,000.

Estab. 1957. Quarterly industry magazine of the Florida Municipal Electric Association. Emphasizes energy, electric, utility and telecom industries in Florida. Readers are utility professionals, local elected officials, state and national legislators, and other state power associations.

Needs Number of photos/issue varies; various number supplied by freelancers. Needs photos of electric utilities in Florida (hurricane/storm damage to lines, utility workers, power plants, infrastructure, telecom, etc.); cityscapes of member utility cities. Model/property release preferred. Photo captions required.

Specs Uses 3×5, 4×6, 5×7, 8×10 b&w and/or color prints. Accepts images in digital format.

Making Contact & Terms Send query letter with description of photo or photocopy. Keeps samples on file. Simultaneous submissions and previously published work OK. Payment negotiable. Pays on use. Credit line given. Buys one-time rights, repeated use (stock); negotiable.

Tips "Must relate to our industry. Clarity and contrast important. Always query first."

$⬘▣ REMODELING

1 Thomas Circle NW, Suite 600, Washington DC 20005. (202)452-0800. E-mail: ibush@hanleywood.com. Web site: www.remodelingmagazine.com. **Contact:** Ingrid Bush, managing editor. Circ. 80,000. Published 13 times/year. "Business magazine for remodeling contractors." Readers are "small contractors involved in residential and commercial remodeling." Sample copy free with 8×11 SASE.

Needs Uses 10-15 photos/issue; number supplied by freelancers varies. Needs photos of remodeled residences, both before and after. Reviews photos with "short description of project, including architect's or contractor's name and phone number. We have one regular photo feature: *Before and After* describes a whole-house remodel. Request editorial calendar to see upcoming design features."

Specs Accepts images in digital format. Send via Zip as TIFF, GIF, JPEG files at 300 dpi.

Making Contact & Terms Provide résumé, business card, brochure, flier or tearsheets to be kept on file for possible future assignments. Responds in 1 month. **Pays on acceptance.** Credit line given. Buys one-time rights; Web rights.

Tips Wants "interior and exterior photos of residences that emphasize the architecture over the furnishings."

$ $▣ RENTAL MANAGEMENT

American Rental Association, 1900 19th St., Moline IL 61265. (309)764-2475. Fax: (309)764-2747. E-mail: wayne.walley@ararental.org. Web site: www.rentalmanagementmag.com. **Contact:** Wayne Walley, editor. Circ. 18,000. Estab. 1970. Monthly business management magazine for managers in the equipment rental industry—no appliances, furniture, cars, "rent to own" or real estate (property or apartments). Sample copies available; e-mail betsy.bucher@ararental.org.

Needs Buys 0-5 photos from freelancers/issue; 5-10 photos/year. Needs photos of business concepts, technology/computers. Projects: construction, landscaping, remodeling, parties, and events with rental companies invlolved. Business scenes: rental stores, communication, planning, training, financial management, HR issues, etc. Reviews photos with or without a manuscript. Model/property release preferred. Photo captions preferred; include identification of people.

Specs Digital format requested. Send via CD, FTP, e-mail, Zip as TIFF, EPS, JPEG files at 300 dpi/8×10 minimum (CMYK).

Making Contact & Terms Send query letter with résumé, samples, stock list. Provide résumé, business card or self-promotion piece to be kept on file for possible future assignments. Responds only if interested; send nonreturnable samples. Previously published work OK "if not in our industry." Usually pays $200-500 for color cover; $100-400 for color inside. Negotiates fee and rights prior to assignment or purchase of existing photos. **Pays on acceptance.** Credit line given. Buys one-time rights, first rights.

Tips "We occasionally use photographers to shoot pictures to accompany freelance articles. We also sometimes buy stock shots to help illustrate freelance and staff-written articles."

$ $⬘▣ RESTAURANT HOSPITALITY

Penton Media, 1300 E. Ninth St., Cleveland OH 44114. (216)931-9942. Fax: (216)696-0836. E-mail: croberto@penton.com. Web site: www.restaurant-hospitality.com. **Contact:** Christopher Roberto, group creative director. Editor-in-Chief: Michael Sanson. Circ. 123,000. Estab. 1919. Monthly magazine. Emphasizes "hands-on restaurant management ideas and strategies." Readers are restaurant owners, chefs, food service chain executives.

Needs Buys 15 photos from freelancers/issue; 180 photos/year. Needs "on-location portraits, restaurant

and food service interiors, and occasional food photos." Special needs include "subject-related photos; query first." Model release preferred. Photo captions preferred.

Specs Accepts images in digital format. Send via CD, FTP, e-mail as TIFF, EPS, JPEG files at 300 dpi.

Making Contact & Terms Send samples or list of stock photo subjects if available. Provide business card, samples or tearsheets to be kept on file for possible future assignments. Previously published work OK. Pay varies; negotiable. Cover fees on per project basis. **Pays on acceptance.** Credit line given. Buys one-time rights plus reprint rights in all media.

Tips "Send postcard samples including your Web address for online viewing of your work."

$ ⑤ ▣ THE SCHOOL ADMINISTRATOR

801 N. Quincy St., Arlington VA 22203. Web site: www.aasa.org. **Contact:** Liz Griffin, managing editor. Circ. 22,000. Monthly magazine of the American Association of School Administrators. Emphasizes K-12 education. Readers are school district administrators including superintendents, ages 50-60. Sample copy available for $10.

Needs Uses 8-10 photos/issue. Needs classroom photos (K-12), photos of school principals, superintendents and school board members interacting with parents and students. Model/property release preferred for physically handicapped students. Photo captions required; include name of school, city, state, grade level of students, and general description of classroom activity.

Specs Accepts images in digital format: TIFF, JPEG files at 300 dpi. Send via link to FTP site

Making Contact & Terms "Send a link to your FTP site with photos of children in public school settings, grades K-12. Do not send originals or e-mails of your work or Web site. Check our Web site for our editorial calendar. Familiarize yourself with topical nature and format of magazine before submitting work." Work assigned is 3-4 months prior to publication date. Keeps samples on file; include SASE for return of material. Simultaneous submissions and previously published work OK. Pays $50-75 for inside photos. Credit line given. Buys one-time rights.

Tips "Prefer photos with interesting, animated faces and hand gestures. Always looking for the unusual human connection where the photographer's presence has not made subjects stilted."

ℕ ▣ SCHOOL TRANSPORTATION NEWS

STN Media Group, 700 Torrance Blvd., Suite C, Redondo Beach CA 90277. (310)792-2226. Fax: (310)792-2231. E-mail: vince@stnonline.com. Web site: www.stnonline.com. **Contact:** Vince Rios, art director. Monthly trade magazine specializing in school bus and pupil transportation industries in North America.

Needs Needs photos of babies/children/teens, education, automobiles, humor, historical/vintage, photos related to the school transportation community. Reviews photos with or without an accompanying manuscript. Model release required. Photo captions required.

Specs Accepts images in digital format. Send TIFF, EPS or high-density JPEG files at 300 dpi via e-mail to the editors, or mail a disc. Photos should be unedited and uncompressed.

Making Contact & Terms Payment negotiated. Pays on publication. Credit line given. Buys all rights.

Tips "Think visual. STN is always seeking quality color photographs, regardless of whether they accompany a story or not. Photographs should be clear and depict a scene, event or individual of interest to the school transportation community."

$ $ $ ✐ ▣ SCRAP

1615 L St. NW, Suite 600, Washington DC 20036. (202)662-8547. E-mail: kentkiser@scrap.org. Web site: www.scrap.org. **Contact:** Kent Kiser, publisher and editor-in-chief. Circ. 13,000. Estab. 1988. Bimonthly magazine of the Institute of Scrap Recycling Industries. Emphasizes scrap recycling for owners and managers of recycling operations worldwide. Sample copy available for $8.

Needs Buys 0-15 photos from freelancers/issue; 15-70 photos/year. Needs operation shots of companies being profiled and studio concept shots. Model release required. Photo captions required.

Specs Accepts images in digital format. Send via CD, Zip, e-mail as TIFF files at 270 dpi.

Making Contact & Terms Provide résumé, business card, brochure, flier or tearsheets to be kept on file for possible future assignments. Responds in 1 month. Previously published work OK. Pays $800-1,500/ day; $100-400 for b&w inside; $200-600 for color inside. **Pays on delivery of images.** Credit line given. Rights negotiable.

Tips Photographers must possess "ability to photograph people in corporate atmosphere, as well as industrial operations; ability to work well with executives, as well as laborers. We are always looking for good color photographers to accompany our staff writers on visits to companies being profiled. We

try to keep travel costs to a minimum by hiring photographers located in the general vicinity of the profiled company. Other photography (primarily studio work) is usually assigned through freelance art director."

$SECURITY DEALER

3 Huntington Quadrangle, Suite 301N, Melville NY 11747. (631)845-2700. Fax: (631)845-7109. E-mail: susan.brady@secdealer.com. Web site: www.secdealer.com. **Contact:** Susan Brady, editor-in-chief. Circ. 28,000. Estab. 1967. Monthly magazine. Emphasizes security subjects. Readers are business owners who install alarm, security, CCTV, home automation and access control systems. Sample copy free with SASE.
Needs Uses 2-5 photos/issue; none at present supplied by freelance photographers. Needs photos of security-application equipment. Model release preferred. Photo captions required.
Making Contact & Terms Send b&w and color prints by mail for consideration; include SASE for return of material. Responds "immediately." Simultaneous submissions and/or previously published work OK.
Tips "Do not send originals; send dupes only, and only after discussion with editor."

$☐ ▣ SMALL BUSINESS TIMES

1123 N. Water St., Milwaukee WI 53202. (414)277-8181. (414)277-8191. Web site: www.biztimes.com. **Contact:** Shelly Paul, art director. Circ. 15,000. Estab. 1994. Biweekly business-to-business publication.
Needs Buys 2-3 photos from freelancers/issue; 200 photos/year. Needs photos of cities/urban, business men and women, business concepts. Interested in documentary.
Specs Uses various sizes of glossy color and b&w prints. Accepts images in digital format. Send via CD as TIFF files at 300 dpi.
Making Contact & Terms Provide résumé, business card, self-promotion piece to be kept on file for possible future assignments. Responds only if interested; send nonreturnable samples. Simultaneous submissions and previously published work OK. Pays $250 maximum for color cover; $80 maximum for b&w inside. **Pays on acceptance.** Credit line given.
Tips "Readers are owners/managers/CEOs. Cover stories and special reports often need conceptual images and portraits. Clean, modern and cutting edge with good composition. Covers have lots of possibility! Approximate one-week turnaround. Most assignments are for the Milwaukee area."

$Ⓢ▣ SPECIALTY TRAVEL INDEX

Alpine Hansen Publishing, P.O. Box 458, San Anselmo CA 94979. (415)455-1643. Fax: (415)455-1648. E-mail: info@specialtytravel.com. Web site: www.specialtytravel.com. **Contact:** Editor. Circ. 30,000. Estab. 1980. Biannual trade magazine. Directory of special interest travel. Readers are travel agents. Sample copy available for $6.
Needs Contact for want list. Buys photo/manuscript packages. Photo captions preferred.
Specs Uses digital images. Send via CD or photographer's Web site. "No e-mails for photo submissions!"
Making Contact & Terms Send query letter with résumé, stock list and Web site URL to view samples. Does not keep samples on file; include SASE for return of material. Responds in 2 months to queries. Simultaneous submissions and previously published work OK. Pays $25/photo. **Pays on acceptance.** Credit line given.
Tips "We like a combination of scenery and active people. Read our magazine for a sense of what we need."

$ $Ⓐ▣ STRATEGIC FINANCE

10 Paragon Dr., Montvale NJ 07645. (201)573-9000. Fax: (201)474-1603. E-mail: mzisk@imanet.org. Web site: www.imanet.org. **Contact:** Mary Zisk, art director. Circ. 66,000. Estab. 1919. Monthly publication of the Institute of Management Accountants, "the leading international trade association for corporate accounting and finance professionals." Emphasizes management accounting and financial management. Readers are financial executives.
Needs Needs environmental portraits of executives through assignment only.
Specs Uses digital images, prints and transparencies.
Making Contact & Terms Provide tearsheets to be kept on file for possible future assignments. Pays $1,000 flat fee (includes expenses). **Pays on acceptance.** Credit line given. Buys one-time rights.

$ $SUCCESSFUL MEETINGS

770 Broadway, New York NY 10003. (646)654-7348. Fax: (646)654-7367. **Contact:** Don Salkaln, art director. Circ. 70,000. Estab. 1955. Monthly. Emphasizes business group travel for all sorts of meetings.

Readers are business and association executives who plan meetings, exhibits, conventions and incentive travel. Sample copy available for $10.

Needs Special needs include high-quality corporate portraits; conceptual, out-of-state shoots.

Making Contact & Terms Arrange a personal interview to show portfolio. Send query letter with résumé of credits and list of stock photo subjects. Responds in 2 weeks. Simultaneous submissions and previously published work OK, "only if you let us know." Pays $500-750 for color cover; $50-150 for b&w inside; $75-200 for color inside; $150-250/b&w page; $200-300/color page; $50-100/hour; $175-350/³⁄₄ day. **Pays on acceptance.** Credit line given. Buys one-time rights.

▣ THE SURGICAL TECHNOLOGIST

AST, 6 W. Dry Creek Circle, Suite 200, Littleton CO 80120-8031. (303)694-9130 or (800)637-7433. E-mail: kludwig@ast.org. Web site: www.ast.org. **Contact:** Karen Ludwig, editor/publisher. Circ. 23,000. Monthly journal of the Association of Surgical Technologists. Emphasizes surgery. Readers are operating room professionals, well educated in surgical procedures, ages 20-60. Sample copy free with 9×12 SASE and 5 first-class stamps. Photo guidelines free with SASE.

Needs Needs "surgical, operating room photos that show members of the surgical team in action." Model release required.

Making Contact & Terms Send low-res JPEGS with query via e-mail. Responds in 4 weeks after review by editorial board. Simultaneous submissions and previously published work OK. Payment negotiable. **Pays on acceptance.** Credit line given. Buys all rights.

Ⓝ $ $Ⓩ TECHNIQUES

1410 King St., Alexandria VA 22314. (703)683-3111. Fax: (703)683-7424. Email: acte@acteonline.org. Web site: www.acteonline.org. Circ. 42,000. Estab. 1926. Monthly magazine of the Association for Career and Technical Education. Emphasizes education for work and on-the-job training. Readers are teachers and administrators in high schools and colleges. Sample copy free with 10×13 SASE.

• This publication is now outsourced and offers little opportunity for freelance photography.

Needs Buys 1-2 photos from freelancers/issue; 12-24 photos/year. Needs "students in classroom and job training settings; teachers; students in work situations." Model release preferred for children. Photo caption preferred; include location, explanation of situation.

Specs Uses 5×7 color prints; 35mm transparencies.

Making Contact & Terms Send query letter with list of stock photo subjects. Send unsolicited photos by mail for consideration. Provide résumé, business card, brochure, flier or tearsheets to be kept on file for possible future assignments. Responds as needed. Simultaneous submissions and previously published work OK. Pays $400 minimum for color cover; $30 minimum for b&w inside; $50 minimum for color inside; $500-1,000/job. Pays on publication. Credit line given. Buys one-time rights; sometimes buys all rights; negotiable.

$ Ⓐ TEXTILE RENTAL MAGAZINE

1800 Diagonal Rd., Suite 200, Alexandria VA 22314. (877)770-9274. Fax: (703)519-0026. E-mail: jmorgan @trsa.org. Web site: www.trsa.org. **Contact:** Jack Morgan, editor. Circ. 6,000. Monthly magazine of the Textile Rental Services Association of America. Emphasizes the linen supply, industrial and commercial textile rental and service industry. Readers are "heads of companies, general managers of facilities, predominantly male; national and international readers."

Needs Photos needed on assignment basis only. Model release preferred. Photo captions preferred or required "depending on subject."

Making Contact & Terms "We contact photographers on an as-needed basis from a directory. We also welcome inquiries and submissions." Cannot return material. Previously published work OK. Pays $350 for color cover plus processing; "depends on the job." **Pays on acceptance.** Credit line given if requested. Buys all rights.

$ THOROUGHBRED TIMES

P.O. Box 8237, Lexington KY 40533. (859)260-9800. E-mail: photos@thoroughbredtimes.com. Web site: www.thoroughbredtimes.com. **Contact:** Sarah Dorroh, photo editor. Circ. 19,000. Estab. 1985. Weekly tabloid news magazine. Emphasizes Thoroughbred breeding and racing. Readers are wide demographic range of industry professionals. Photo guidelines available upon request.

Needs Buys 10-15 photos from freelancers/issue; 520-780 photos/year. Looks for photos "only from

desired trade (Thoroughbred breeding and racing)." Needs photos of specific subject features (personality, farm or business). Model release preferred. Photo captions preferred. "File info required."

Making Contact & Terms Provide business card, brochure, flier or tearsheets to be kept on file for possible future assignments. Responds in 1 month. Previously published work OK. Pays $50 for b&w cover or inside; $50 for color; $250/day. Pays on publication. Credit line given. Buys one-time rights.

$TOBACCO INTERNATIONAL

Lockwood Publications, Inc., 26 Broadway, Floor 9M, New York NY 10004. (212)391-2060. Fax: (212)827-0945. E-mail: e.leonard@lockwoodpublications.com. Web site: www.tobaccointernational.com. **Contact:** Emerson Leonard, editor. Circ. 5,000. Estab. 1886. Monthly international business magazine. Emphasizes cigarettes, tobacco products, tobacco machinery, supplies and services. Readers are executives, ages 35-60. Sample copy free with SASE.

Needs Uses 20 photos/issue. "Prefer photos of people smoking, processing or growing tobacco products from all around the world, but any interesting newsworthy photos relevant to subject matter is considered." Model and/or property release preferred.

Making Contact & Terms Send query letter with photocopies, transparencies, slides or prints. Does not keep samples on file; include SASE for return of material. Responds in 3 weeks. Simultaneous submissions OK (not if competing journal). Pays $50/color photo. Pays on publication. Credit line may be given.

$ $⊡ TOP PRODUCER

FarmJournal Media, 1818 Market St., 31st Floor, Philadelphia PA 19103. (215)557-8900. Fax: (215)568-3989. E-mail: TopProducer@farmjournal.com. Web site: www.agweb.com. **Contact:** Dana Timmins, art director. Circ. 120,000. Monthly. Emphasizes American agriculture. Readers are active farmers, ranchers or agribusiness people. Sample copy and photo guidelines free with SASE.

Needs Buys 5-10 photos from freelancers/issue; 60-100 photos/year. "We use studio-type portraiture (environmental portraits), technical, details and scenics." Model release preferred. Photo captions required.

Making Contact & Terms Send query letter with résumé of credits along with business card, brochure, flier or tearsheets to be kept on file for possible future assignments. "DO NOT SEND ORIGINALS. Please send information for online portfolios/Web sites, as we often search for stock images on such sites. Digital files and/or portfolios may be sent via CD to the address noted above." Simultaneous submissions and previously published work OK. Pays $75-400 for color photos; $200-400/day, with additional bonus for cover usage. **Pays on acceptance.** Credit line given. Buys one-time rights.

Tips In portfolio or samples, likes to see "about 40 samples showing photographer's use of lighting and ability to work with people. Know your intended market. Familiarize yourself with the magazine and keep abreast of how photos are used in the general magazine field."

Ⓝ ⊡ TRANSPORT TOPICS

2200 Mill Rd., Alexandria VA 22314. (703)838-1735. Fax: (703)548-3662. Web site: www.ttnews.com. **Contact:** Kelvin Childs, debuty news editor. Circ. 31,000. Estab. 1935. Weekly tabloid. Publication of American Trucking Associations. Emphasizes the trucking industry and freight transportation. Readers are executives, ages 35-65.

Needs Uses approximately 12 photos/issue; amount supplied by freelancers "depends on need." Needs photos of truck transportation in all modes. Model/property release preferred. Photo captions preferred.

Making Contact & Terms Send unsolicited JPEGs by e-mail for consideration. Provide résumé, business card, brochure, flier or tearsheets to be kept on file for possible future assignments. Does not keep samples on file; include SASE for return of material. Responds in 1 month. Simultaneous submissions and previously published work OK. Payment negotiable. Pays standard "market rate" for color cover photo. **Pays on acceptance**. Credit line given. Buys one-time or permanent rights; negotiable.

Tips "Trucks/trucking must be dominant element in the photograph—not an incidental part of an environmental scene."

Ⓝ $ $⊡ TRANSPORTATION MANAGEMENT & ENGINEERING

3030 W. Salt Creek Lane, IL 60005-5025. (847)391-1000. Fax: (847)390-0408. E-mail: bwilson@sgcmail.com. Web site: www.roadsbridges.com. **Contact:** Bill Wilson, editor. Circ. 18,000. Estab. 1994. Quarterly supplement. "TM&E is a controlled publication targeted towards 18,000 traffic/transit system planners, designers, engineers and managers in North America." Sample copies available.

Needs Buys 1-2 photos from freelancers/issue; 5-10 photos/year. Needs photos of landscapes/scenics, transportation-related, traffic, transit. Reviews photos with or without manuscript. Property release preferred. Photo captions preferred.

Specs Uses 5×7 glossy prints; 35mm transparencies. Accepts images in digital format. Send via CD as TIFF, EPS files at 300 dpi.

Making Contact & Terms Send query letter with prints. Portfolio may be dropped off every Monday. Responds in 3 weeks to queries. Responds only if interested; send nonreturnable samples. Pays $100-1,000 for color cover; $50-500 for color inside. Pays on publication. Credit line sometimes given. Buys all rights; negotiable.

Tips "Read our magazine."

$ ⑤ ▣ TREE CARE INDUSTRY

TCIA, 3 Perimeter Rd., Unit 1, Manchester NH 03103. (603)314-5380. Fax: (603)314-5386. E-mail: tcia@tcia.org. Web site: www.tcia.org. **Contact:** Mark Garvin, editor. Circ. 28,500. Estab. 1990. Monthly trade magazine for arborists, landscapers and golf course superintendents interested in professional tree care practices. Published by the Tree Care Industry Association. Sample copy available for $5.

Needs Buys 3-6 photos/year. Needs photos of environment, landscapes/scenics, gardening. Reviews photos with or without a manuscript.

Specs Uses color prints; 35mm transparencies. Accepts images in digital format. Send via Zip, CD, e-mail as TIFF files at 300 dpi.

Making Contact & Terms Send query letter with stock list. Does not keep samples on file; include SASE for return of material. Pays $100 maximum for color cover; $100 minimum for color inside. Pays on publication. Credit line given. Buys one-time rights and online rights.

Tips Query by e-mail.

$ $ ◪ ▣ UNDERGROUND CONSTRUCTION

Oildom Publishing Co., P.O. Box 941669, Houston TX 77094-8669. (281)558-6930. Fax: (281)558-7029. E-mail: rcarpenter@oildom.com. Web site: www.uconline.com. **Contact:** Robert Carpenter, editor. Circ. 37,000. Estab. 1945. Monthly trade journal. Emphasizes construction and rehabilitation of sewer, water, gas, telecom, electric and oil underground pipelines/conduit. Readers are contractors, utilities and engineers. Sample copy available for $3.

Needs Uses photos of underground construction and rehabilitation.

Specs Uses high-resolution digital images (minimum 300 dpi); large-format negatives or transparencies.

Making Contact & Terms Query before sending photos. Generally responds within 30 days. Pays $100-400 for color cover; $50-250 for color inside. Buys one-time rights.

Tips "Freelancers are competing with staff as well as complimentary photos supplied by equipment manufacturers. Subject matter must be unique, striking and/or off the beaten track. Photos of people on the job are always desirable."

$ $ ◪ ▣ VETERINARY ECONOMICS

Advanstar Veterinary Healthcare Communications, 8033 Flint, Lenexa KS 66214. (913)492-4300. Fax: (913)492-4157. E-mail: afulton@advanstar.com. Web site: www.vetecon.com. **Contact:** Alison Fulton, associate design director. Circ. 58,000. Estab. 1960. Monthly trade magazine emphasizing practice management for veterinarians. Sample copies and photo guidelines available.

Needs Buys 1 photo from Internet and/or freelancers; 12 photos/year. Needs photos of business concepts and medicine. Reviews photos with or without a manuscript. Model release and license agreement required. Photo captions preferred.

Specs Prefers images in digital format. Send via CD, Zip, e-mail as TIFF, EPS, JPEG files at 300 dpi. Uses some matte color prints.

Making Contact & Terms Send 1 e-mail with sample image less than 2 MB; repeat e-mails are deleted. Does not keep samples on file. **Pays on acceptance.** Credit line given.

$ ▢ ▣ WATER WELL JOURNAL

National Ground Water Association, 601 Dempsey Rd., Westerville OH 43081. (800)551-7379. Fax: (614)898-7786. E-mail: tplumley@ngwa.org. Web site: www.ngwa.org. **Contact:** Thad Plumley, director of publications. Circ. 24,000. Estab. 1947. Monthly association publication. Emphasizes construction of water wells, development of ground water resources and ground water cleanup. Readers are water well

drilling contractors, manufacturers, suppliers, and ground water scientists. Sample copy available for $21 U.S., $36 foreign.

Needs Buys 1-3 freelance photos/issue plus cover photos; 12-36 photos/year. Needs photos of installations and how-to illustrations. Model release preferred. Photo captions required.

Specs Accepts images in digital format. Send via CD, Jaz, Zip as TIFF files at 300 dpi.

Making Contact & Terms Send query letter with samples. "We'll contact you." Pays $250 for color cover; $50 for b&w or color inside; "flat rate for assignment." Pays on publication. Credit line given. Buys all rights.

Tips "E-mail or send written inquiries; we'll reply if interested. Unsolicited materials will not be returned."

THE WHOLESALER

1838 Techny Court, Northbrook IL 60062. (847)564-1127. Fax: (847)564-1264. E-mail: editor@thewholesaler.com. Web site: www.thewholesaler.com. **Contact:** Mary Jo Martin, editor. Circ. 35,000. Estab. 1946. Monthly news tabloid. Emphasizes wholesaling/distribution in the plumbing, heating, air conditioning, piping (including valves), fire protection industry. Readers are owners and managers of wholesale distribution businesses; manufacturer representatives. Sample copy free with $11 \times 15\frac{3}{4}$ SAE and 5 first-class stamps.

Needs Buys 3 photos from freelancers/issue; 36 photos/year. Interested in field and action shots in the warehouse, on the loading dock, at the job site. Property release preferred. Photo captions preferred; "Just give us the facts."

Making Contact & Terms Send query letter with stock list. Send any size glossy color and/or b&w prints by mail with SASE for consideration. Responds in 2 weeks. Simultaneous submissions and previously published work OK. Pays on publication. Buys one-time rights.

Ⓝ $ $▣ WINES & VINES

1800 Lincoln Ave., San Rafael CA 94901. (415)453-9700. Fax: (415)453-2517. E-mail: edit@winesandvines.com. Web site: www.winesandvines.com. **Contact:** Jane Firstenfeld. Circ. 5,000. Estab. 1919. Monthly magazine. Emphasizes winemaking and marketing in the U.S. and internationally for wine industry professionals, including winemakers, wine merchants and suppliers.

Needs Wants color cover subjects on a regular basis.

Specs Accepts images in digital format. Send via CD, Zip, e-mail as TIFF, or JPEG files at 400 dpi.

Making Contact & Terms Prefers e-mail query with link to portfolio; or send material by mail for consideration. Will e-mail if interested in reviewing photographer's portfolio. Provide business card to be kept on file for possible future assignments. Responds in 3 months. Previously published work considered. Pays $100-300 for color cover, or negotiable ad trade out. Pays on publication. Credit line given. Buys one-time rights.

$ WISCONSIN ARCHITECT

321 S. Hamilton St., Madison WI 53703. (608)257-8477. E-mail: editor@aiaw.org. Web site: www.aiaw.org. **Contact:** Brenda Taylor, managing editor. Circ. 3,700. Estab. 1931. Annual magazine of the American Institute of Architects Wisconsin. Emphasizes architecture. Readers are design/construction professionals.

Needs Uses approximately 100 photos/issue. "Photos are almost exclusively supplied by architects who are submitting projects for publication. Of these, approximately 65% are professional photographers hired by the architect."

Making Contact & Terms "Contact us through architects." Keeps samples on file. Responds in 1-2 weeks when interested. Simultaneous submissions and previously published work OK. Pays $50-100 for color cover when photo is specifically requested. Pays on publication. Credit line given. Rights negotiable.

WOMAN ENGINEER

Equal Opportunity Publications, Inc., 445 Broad Hollow Rd., Suite 425, Melville NY 11747. (631)421-9421, ext. 12. Fax: (631)421-0359. E-mail: jschneider@eop.com. Web site: www.eop.com/we.html. **Contact:** Jim Schneider, editor. Circ. 16,000. Estab. 1979. Magazine published 3 times/year. Emphasizes career guidance for women engineers at the college and professional levels. Readers are college-age and professional women in engineering. Sample copy free with 9×12 SAE and 6 first-class stamps.

Needs Uses at least 1 photo/issue (cover); planning to use freelance work for covers and possibly editorial; most of the photos are submitted by freelance writers with their articles. Model release preferred. Photo captions required.

Making Contact & Terms Send query letter with list of stock photo subjects, or call to discuss current needs. Responds in 6 weeks. Simultaneous submissions OK. Credit line given. Buys one-time rights.

Tips "We are looking for strong, sharply focused photos or slides of women engineers. The photo should show a woman engineer at work, but the background should be uncluttered. The photo subject should be dressed and groomed in a professional manner. Cover photo should represent a professional woman engineer at work and convey a positive and professional image. Read our magazine, and find actual women engineers to photograph. We're not against using cover models, but we prefer cover subjects to be women engineers working in the field."

$ $ ▣ WOODSHOP NEWS, The News Magazine for Professional Woodworkers

Soundings Publications LLC, 10 Bokum Rd., Essex CT 06426. (860)767-8227. Fax: (860)767-0645. E-mail: editorial@woodshopnews.com. Web site: www.woodshopnews.com. **Contact:** Tod Riggio, editor. Circ. 60,000. Estab. 1986. Monthly trade magazine (tabloid format) covering all areas of professional woodworking. Sample copies available.

Needs Buys 12 sets of cover photos from freelancers/year. Needs photos of celebrities, architecture, interiors/decorating, industry, product shots/still life. Interested in documentary. "We assign our cover story, which is always a profile of a professional woodworker. These photo shoots are done in the subject's shop and feature working shots, portraits and photos of subject's finished work." Photo captions required; include description of activity contained in shots. "Photo captions will be written in-house based on this information."

Specs Prefers digital photos.

Making Contact & Terms Send query letter with résumé, photocopies, tearsheets. Provide self-promotion piece to be kept on file for possible future assignments. Responds only if interested; send nonreturnable samples. Previously published work OK occasionally. Pays $600-800 for color cover. Note: "We want a cover photo 'package'—one shot for the cover, others for use inside with the cover story." **Pays on acceptance.** Credit line given. Buys "perpetual" rights, but will pay a lower fee for one-time rights.

Tips "I need a list of photographers in every geographical region of the country—I never know where our next cover profile will be done, so I need to have options everywhere. Familiarity with woodworking is a definite plus. Listen to our instructions! We have very specific lighting and composition needs, but some photographers ignore instructions in favor of creating 'artsy' photos, which we do not use, or poorly lighted photos, which we cannot use."

$ ▣ ▣ ⊕ WORLD TOBACCO

dmg world media, Westgate House, 120/130 Station Rd., Redhill, Surrey RH1 1ET. (44)(1737)855573. E-mail: stephenwhite@dmgworldmedia.com; duncanmacowan@dmgworldmedia.com. Web site: www. worldtobacco.co.uk. **Contact**: Duncn MacOwan, editor. Circ. 4,300. Trade magazine. "Focuses on all aspects of the tobacco industry from international trends to national markets, offering news and views on the entire industry from leaf farming to primary and secondary manufacturing, to packaging, distribution and marketing." Sample copies available. Request photo guildelines via e-mail.

Needs Buys 5-10 photos from freelancers/issue; agriculture, product shots/still life. "Anything related to tobacco and smoking. Abstract smoking images considered, as well as international images."

Specs Accepts almost all formats. Minimum resolution of 300 dpi at the size to be printed. Prefers TIFFs to JPEGs, but can accept either.

Making Contact & Terms E-mail query letter with link to photographer's Web site, JPEG samples at 72 dpi. Provide self-promotion piece to be kept on file for possible future assignments. Pays $200 maximum for cover photo. **Pays on acceptance.** Credit line given.

Tips "Check the features list on our Web site."

$ ▢ ▣ WRITERS' JOURNAL, The Complete Writers' Magazine

Val-Tech Media, P.O. Box 394, Perham MN 56573. (218)346-7921. Fax: (218)346-7924. E-mail: writersjournal@writersjournal.com. Web site: www.writersjournal.com. **Contact:** John Ogroske, publisher. Circ. 26,000. Estab. 1980. Bimonthly trade magazine. Sample copy available for $6.

Needs Buys 1 photo from freelancers/issue; 6 photos/year. Needs photos of landscapes/scenics, wildlife,

rural, travel. *WRITERS' Journal* offers 2 photography contests yearly. Send SASE for contest guidelines or visit Web site. Model release required ("if applicable to photo"). Photo titles preferred.

Specs Uses 8×10 color prints; 35mm or larger transparencies or slides (preferred) for noncontest photos. "Digital images must be accompanied by a hardcopy printout."

Making Contact & Terms Send query letter with tearsheets, stock list. Does not keep samples on file; include SASE for return of material. Responds in 2 months. Pays $50-60 for color cover. Pays on publication. Credit line given. Buys first North American rights.

Book Publishers

There are diverse needs for photography in the book publishing industry. Publishers need photos for the obvious (covers, jackets, text illustrations and promotional materials), but they may also need them for use on CD-ROMs and Web sites. Generally, though, publishers either buy individual or groups of photos for text illustration, or they publish entire books of photography.

Those in need of text illustration use photos for cover art and interiors of textbooks, travel books and nonfiction books. For illustration, photographs may be purchased from a stock agency or from a photographer's stock, or the publisher may make assignments. Publishers usually pay for photography used in book illustration or on covers on a per-image or per-project basis. Some pay photographers hourly or day rates, if on an assignment basis. No matter how payment is made, however, the competitive publishing market requires freelancers to remain flexible.

To approach book publishers for illustration jobs, send a cover letter with photographs or slides and a stock photo list with prices, if available. (See sample stock list on page 19.) If you have a Web site, provide a link to it. If you have published work, tearsheets are very helpful in showing publishers how your work translates to the printed page.

PHOTO BOOKS

Publishers who produce photography books usually publish books with a theme, featuring the work of one or several photographers. It is not always necessary to be well-known to publish your photographs as a book. What you do need, however, is a unique perspective, a salable idea and quality work.

For entire books, publishers may pay in one lump sum or with an advance plus royalties (a percentage of the book sales). When approaching a publisher for your own book of photographs, query first with a brief letter describing the project, and include sample photographs. If the publisher is interested in seeing the complete proposal, you can send additional information in one of two ways depending on the complexity of the project.

Prints placed in sequence in a protective box, along with an outline, will do for easy-to-describe, straightforward book projects. For more complex projects, you may want to create a book dummy. A dummy is basically a book model with photographs and text arranged as they will appear in finished book form. Book dummies show exactly how a book will look, including the sequence, size, format and layout of photographs and accompanying text. The quality of the dummy is important, but keep in mind that the expense can be prohibitive.

To find the right publisher for your work, first check the Subject Index on page 503 to help narrow your search, then read the appropriate listings carefully. Send for catalogs and

guidelines for those publishers that interest you. You may find guidelines on publishers' Web sites as well. Also, become familiar with your local bookstore or visit the site of an online bookstore such as Amazon.com. By examining the books already published, you can find those publishers who produce your type of work. Check for both large and small publishers. While smaller firms may not have as much money to spend, they are often more willing to take risks, especially on the work of new photographers. Keep in mind that photo books are expensive to produce and may have a limited market.

$ ⊘ Ⓢ ▣ A&B PUBLISHERS GROUP

Imprint: Upstream Publications. A&B Distributors Inc., 223 Duffield St., Brooklyn NY 11238. (718)783-7808. Fax: (718)783-7267. E-mail: ericgist2002@yahoo.com. **Contact:** Eric Gist, production manager. Estab. 1992. Publishes hardcover; trade paperback and mass market paperback originals and reprints. Subjects include nutrition, cooking, health, healing. Photos used for text illustrations, promotional materials, book covers, dust jackets. Examples of recently published titles: *Master Teacher* (text illustrations); *A Taste of the Africa Table* (book cover).
Needs Buys 20-30 freelance photos/year. Needs photos of babies/children/teens, multicultural. Model release required. Photo captions preferred.
Specs Uses matte prints; 4×5 transparencies. Accepts images in digital format. Send via CD, Zip as TIFF, EPS files at 300 dpi.
Making Contact & Terms Send query letter with slides. Keeps samples on file. Responds in 2 months to queries; 1 month to portfolios. Simultaneous submissions and previously published work OK. Pays $250-750 for b&w cover; $350-900 for color cover; $125-750 for b&w inside; $250-900 for color inside.

$ $ ⊘ ▣ ABSEY AND CO. INC.

23011 Northcrest Dr., Spring TX 77389. (281)257-2340 or (888)412-2739. Fax: (281)251-4676. E-mail: AbseyandCo@aol.com. Web site: www.absey.com. **Contact:** Edward Wilson, editor-in-chief. Estab. 1997. Publishes hardcover, trade paperback and mass market paperback originals. Subjects include young adult, educational material. Photos used for text illustrations, promotional materials, book covers, dust jackets. Examples of recently published titles: *Authentic Strategies for High-Stakes Tests, Stealing a Million Kisses, Dr. JAC's Guide to Writing Depth*.
Needs Buys 5-50 freelance photos/year. Needs photos of babies/children/teens, multicultural, environmental, landscapes/scenics, wildlife, education, health/fitness, agriculture, product shots/still life. Interested in avant garde. Model/property release required. Photo captions required.
Specs Uses 3×5 glossy or matte color and/or b&w prints. Accepts images in digital format. Send as TIFF, EPS, GIF, JPEG files at 600 dpi.
Making Contact & Terms Send query letter with résumé, photocopies, tearsheets, stock list. Provide résumé or self-promotion piece to be kept on file for possible future assignments. Responds in 3 months if interested. Pays $50-1,000 for b&w or color cover; $25-100 for b&w inside; $25-150 for color inside. Pays on publication. Credit line given. Buys one-time rights; negotiable.
Tips Does not want "cutesy" photos.

Ⓝ ▣ ACTION PUBLISHING

P.O. Box 391, Glendale CA 91209. (323)478-1667. Fax: (323)478-1767. Web site: www.actionpublishing.com. **Contact:** Art Director. Estab. 1996. Subjects include children's books, fiction, nonfiction, art and photography.
Specs Uses all formats.
Making Contact & Terms Send promo piece. Pays by the project or per photo.
Tips "We use a small number of photos. Promo is kept on file for reference if potential interest. If book proposal, send query letter first with Web link to sample photos if available."

$ $ Ⓐ ALL ABOUT KIDS PUBLISHING

9333 Bendow Dr., Gilroy CA 95020. (408)846-1833. Fax: (408)846-1835. Web site: www.aakp.com. **Contact:** Linda L. Guevara, editor. Estab. 2000. Publishes children's books, including picture books and books for young readers. Subjects include fiction, activity books, animals, concepts, multicultural, nature/environment.

Needs Uses freelance photographers on assignment only. Model/property release required.

Specs Uses 35mm transparencies.

Making Contact & Terms Submit portfolio, color samples/copies. Include cover letter, résumé, contact info. Keeps samples on file for possible future assignments; include SASE for return of material. Pays by the project, $500 minimum or royalty of 5% based on wholesale price.

Tips "Check out our Web site for updates and submission guidelines."

$ $⊘ ▣ ALLYN & BACON PUBLISHERS

75 Arlington St., Suite 300, Boston MA 02116. (617)848-7328. E-mail: annie.pickert@ablongman.com. Web site: www.ablongman.com. **Contact:** Annie Pickert, photography director. Estab. 1868. Publishes college textbooks. Photos used for text illustrations, book covers. Examples of recently published titles: *Criminal Justice*; *Including Students with Special Needs*; *Social Psychology* (text illustrations and promotional materials).

Needs Offers 1 assignment plus 80 stock projects/year. Needs photos of babies/children/teens, celebrities, couples, multicultural, families, parents, senior citizens, disasters, education, special education, science, technology/computers. Interested in fine art, historical/vintage. Also uses multi-ethnic photos in education, health and fitness, people with disabilities, business, social sciences, and good abstracts. Reviews stock photos. Model/property release required.

Specs Uses b&w prints, any format; all transparencies. Accepts images in digital format. Send via CD, Zip, e-mail as TIFF, EPS, PICT, GIF, JPEG files at 72 dpi for review, 300 dpi for use.

Making Contact & Terms Provide self-promotion piece or tearsheets to be kept on file for possible future assignments. "Do not call or send stock lists." Cannot return samples. Responds in "24 hours to 4 months." Pays $100-250 for b&w cover; $100-600 for color cover; $100-200 for b&w inside; $100-250 for color inside. Pays on usage. Credit line given. Buys one-time rights; negotiable. Offers internships for photographers January-June.

Tips "Send tearsheets and promotion pieces. Need bright, strong, clean abstracts and unstaged, nicely lit people photos."

$⊘ ▣ AMERICAN PLANNING ASSOCIATION

122 S. Michigan, Suite 1600, Chicago IL 60603. (312)431-9100. Fax: (312)431-9985. Web site: www.planning.org. **Contact:** Richard Sessions, Susan Deegan or Jessica Campbell, art directors. Publishes planning and related subjects. Photos used for text illustrations, promotional materials, book covers, dust jackets. Examples of recently published titles: *Planning* (text illustrations, cover); *PAS Reports* (text illustrations, cover). Photo guidelines and sample (*Planning*) available for $1 postage.

Needs Buys 100 photos/year; offers 8-10 freelance assignments/year. Needs planning-related photos. Photo captions required; include what's in the photo and credit information.

Specs Uses 35mm color slides; 5×7, 8×10 b&w prints. Accepts images in digital format. Send via CD, floppy disk, Zip, e-mail as TIFF, EPS, JPEG files at 300 dpi minimum; maximum quality, lowest compression.

Making Contact & Terms Provide résumé, business card, brochure, flier, tearsheets, promo pages or good photocopies to be kept on file for possible future assignments. "Do not send original work—slides, prints, whatever—with the expectation of it being returned." Responds in 2 weeks. Simultaneous submissions and previously published work OK. Pays $350 maximum for cover; $100-150 for b&w or color inside. **Pays on receipt of invoice**. Credit line given. Buys one-time and electronic rights (CD-ROM and online).

Tips "Send a sample I can keep."

AMERICAN SCHOOL HEALTH ASSOCIATION

P.O. Box 708, Kent OH 44240. (330)678-1601. Fax: (330)678-4526. E-mail: treed@ashaweb.org. Web site: www.ashaweb.org. **Contact:** Thomas M. Reed, director of editorial services. Estab. 1927. Publishes professional journals. Photos used for book covers.

Needs Looking for photos of school-age children. Model/property release required. Photo captions preferred; include photographer's full name and address.

Specs Uses 35mm transparencies.

Making Contact & Terms Send query letter with samples. Does not keep samples on file; include SASE for return of material. Responds as soon as possible. Simultaneous submissions and previously published work OK. Payment negotiable. Pays on publication. Credit line given. Buys one-time rights.

AMHERST MEDIA®: PUBLISHER OF PHOTOGRAPHY BOOKS

175 Rano St., Suite 200, Buffalo NY 14207. (716)874-4450. Fax: (716)874-4508. E-mail: submissions@amherstmedia.com. Web site: www.amherstmedia.com. **Contact:** Craig Alesse, photo book publisher. Estab. 1974. Publishes trade paperback originals and reprints. Subjects include photography how-to. Photos used for text illustrations, book covers. Examples of recently published titles: *Portrait Photographer's Handbook*; *The Best of Professional Digital Photography*; *How to Create a High-Profit Photography Business in Any Market*. Catalog and submission guidelines free.

Needs Does not buy single photos, but accepts proposals for photography how-to books. "Looking for well-written and illustrated photo books." Reviews photos as part of a manuscript package only.

Making Contact & Terms Send query letter with book outline, 2 sample chapters and SASE. Responds in 2 months to queries. Simultaneous submissions OK. Pays 6-8% royalties on retail price; offers advance. Rights negotiable.

Tips "Our audience is made up of beginning to advanced photographers. If I were trying to market a photography book, I would fill the need of a specific audience and self-edit in a tight manner."

$ $🖉 Ⓐ 🖵 APPALACHIAN MOUNTAIN CLUB BOOKS

5 Joy St., Boston MA 02108. (617)523-0636. Fax: (617)523-0722. Web site: www.outdoors.org. **Contact:** Brian Davidson, production manager. Estab. 1876. Publishes hardcover originals, trade paperback originals and reprints. Subjects include nature, outdoors, recreation, paddlesports, hiking/backpacking, skiing. Photos used for text illustrations, book covers. Examples of recently published titles: *Discover the White Mountains*; *Best Day Hikes* series.

Needs Buys 10-15 freelance photos/year. Looking for photos of paddlesports, skiing and outdoor recreation. Model/property release required. Photo captions preferred; include location, description of subject, photographer's name and phone number.

Specs Uses 3×5 glossy color and/or b&w prints; 35mm, 2¼×2¼ transparencies. Accepts images in digital format; send via CD or FTP at 300 dpi.

Making Contact & Terms Send query letter with brochure, stock list or tearsheets. Art director will contact photographer for portfolio review if interested. Portfolio should include b&w or color prints, tearsheets. Works with local freelancers on assignment only. Keeps samples on file; include SASE for return of material. Responds only if interested; send nonreturnable samples. Considers previously published work. Pays by the project, $100-400 for color cover; $50 for b&w inside. **Pays on acceptance.** Credit line given. Buys first North American serial rights.

Ⓐ AUTONOMEDIA

P.O. Box 568, Brooklyn NY 11211. Phone/fax: (718)963-2603. E-mail: info@autonomedia.org. Web site: www.autonomedia.org. **Contact:** Jim Fleming, editor. Estab. 1974. Publishes books on radical culture and politics. Photos used for text illustrations, book covers. Examples of recently published titles: *TAZ* (cover illustration); *Cracking the Movement* (cover illustration); *Zapatistas* (cover and photo essay).

Needs "The number of photos bought annually varies, as does the number of assignments offered." Model/property release preferred. Photo captions preferred.

Making Contact & Terms Send query letter with samples. Does not keep samples on file; include SASE for return of material. Responds in 1 month. Works on assignment only. Payment negotiable. Pays on publication. Buys one-time and electronic rights.

$ $🖉 Ⓢ 🖵 BEDFORD/ST. MARTIN'S

75 Arlington St., Boston MA 02116. (617)399-4000. Web site: www.bedfordstmartins.com. **Contact:** Donna Lee Dennison, art director. Estab. 1981. Publishes college textbooks. Subjects include English, communications, philosophy, music, history. Photos used for text illustrations, promotional materials, book covers. Examples of recently published titles: *Stages of Drama, 5th Edition* (text illustration, book cover); *12 Plays* (book cover); *Campbell Media & Cultural 5*.

Needs Buys 12 + photos/year. "We use photographs editorially, tied to the subject matter of the book." Needs mostly historical photos. Also wants artistic, abstract, conceptual photos; people—predominantly American; multicultural, cities/urban, education, performing arts, political, product shots/still life, business concepts, technology/computers. Interested in documentary, fine art, historical/vintage. Not interested in photos of children or religous subjects. Also uses product shots for promotional material. Reviews stock photos. Model/property release required.

Specs Prefers images in digital format. Send via CD, Zip as TIFF, EPS, JPEG files at 300 dpi. Also uses 8×10 b&w and/or color prints; 35mm, 2¼×2¼, 4×5 transparencies.

Making Contact & Terms Send query letter with nonreturnable samples. Provide résumé, business card, brochure, flier or tearsheets to be kept on file for possible future assignments. Previously published work OK. Pays $50-1,000 for cover. Credit line always included for covers, never on promo. Buys one-time rights and all rights in every media; depends on project; negotiable.

Tips ''We want artistic, abstract, conceptual photos; computer-manipulated works, collages, etc., that are nonviolent and nonsexist. We like Web portfolios; we keep postcards, sample sheets on file if we like the style and/or subject matter.''

🅐 ▣ BENTLEY PUBLISHERS

1734 Massachusetts Ave., Cambridge MA 02138. (617)547-4170. Fax: (617)876-9235. E-mail: michael.bentley@rb.com and susan.lit@bentleypublishers.com. Web site: www.bentleypublishers.com. **Contact:** Michael Bentley, president. Estab. 1950. Publishes professional, technical, consumer how-to books. Photos used for text illustrations, promotional materials, book covers, dust jackets. Examples of published titles: *Corvette from the Inside* (cover, text illustration); *Corvette by the Numbers* (cover, text illustration); *Supercharged!* (cover, text illustration).

Needs Buys 70-100 photos/year; offers 5-10 freelance assignments/year. Looking for motorsport, automotive technical and engineering photos. Reviews stock photos. Model/property release required. Photo captions required; include date and subject matter.

Specs Uses 8×10 transparencies. Accepts images in digital format.

Making Contact & Terms Send query letter with samples. Provide résumé, business card, brochure, flier or tearsheets to be kept on file for possible future assignments. Keeps samples on file; cannot return material. Works on assignment only. Responds in 6 weeks. Simultaneous submissions and previously published work OK. Payment negotiable. Credit line given. Buys electronic and one-time rights.

$ ⑤ ▣ BONUS BOOKS, INC.

9255 Sunset Blvd., #711, Los Angeles CA 90069. (310)260-9400. Fax: (310)857-7812. E-mail: submissions@bonusbooks.com. Web site: www.bonusbooks.com. **Contact:** Acquisitions Editor. Estab. 1985. Publishes hardcover and trade paperback originals and reprints. Subjects include sports, gambling, self-help, how-to, biography, broadcasting, fundraising, medical. Photos used for text illustrations, book covers. Examples of recently published titles: *America's Right Turn*; *Baseball, Chicago Style*; *Quick Inspirations*.

Needs Buys 1 freelance photo/year; offers 1 assignment/year. Model release required; property release preferred. Photo captions required; include identification of location and objects or people.

Specs Uses 8×10 matte b&w prints; 35mm transparencies. Accepts images in digital format. Send via Zip, CD as TIFF, EPS files at 300 dpi.

Making Contact & Terms Send query letter with résumé of credits and samples. Provide résumé, business card, brochure, flier or tearsheets to be kept on file for possible future assignments. Buys stock photos only. Does not return unsolicited material. Responds in 1 month. Pays in contributor's copies, plus $150 maximum/color transparency. Credit line given if requested. Buys one-time rights.

Tips ''Don't call. Send written query. In reviewing a portfolio, we look for composition, detail, high-quality prints, well-lit studio work. We are not interested in nature photography or greeting card-type photography.''

▣ ♬ BOSTON MILLS PRESS

132 Main St., Erin ON N0B 1T0 Canada. (519)833-2407. Fax: (519)833-2195. Web site: www.bostonmillspress.com. **Contact:** John Denison, publisher. Estab. 1974. Publishes coffee table books, local guide books. Photos used for text illustrations, book covers and dust jackets. Examples of recently published titles: *Gift of Wings*; *Superior: Journey on an Inland Sea*.

Needs ''We're looking for book-length ideas, *not* stock. We pay a royalty on books sold, plus advance.''

Specs Prefers images in digital format, but will accept 35mm transparencies.

Making Contact & Terms Send query letter with résumé of credits. Does not keep samples on file; include SAE/IRC for return of material. Responds in 3 weeks. Simultaneous submissions OK. Payment negotiated with contract. Credit line given.

🖉 🅐 ▣ CENTERSTREAM PUBLICATION

P.O. Box 17878, Anaheim CA 92807. Phone/fax: (714)779-9390. E-mail: centerstrm@aol.com. **Contact:** Ron Middlebrook, owner. Estab. 1982. Publishes music history, biographies, DVDs, music instruction

(all instruments). Photos used for text illustrations, book covers. Examples of published titles: *Dobro Techniques*; *History of Leedy Drums*; *History of National Guitars*; *Blues Dobro*; *Jazz Guitar Christmas* (book covers).

Needs Reviews stock photos of music. Model release preferred. Photo captions preferred.

Specs Uses color and/or b&w prints; 35mm, $2^1/_4 \times 2^1/_4$, 4×5 transparencies. Accepts images in digital format. Send via Zip as TIFF files.

Making Contact & Terms Send query letter with samples and stock list. Send unsolicited photos by mail for consideration. Provide résumé, business card, brochure, flier or tearsheets to be kept on file for possible future assignments. Works on assignment only. Responds in 1 month. Simultaneous submissions and previously published work OK. Payment negotiable. **Pays on receipt of invoice.** Credit line given. Buys all rights.

$▢ CHATHAM PRESS

P.O. Box 677, Old Greenwich CT 06870. (203)622-1010. Fax: (718)359-8568. **Contact:** Roger Corbin, editor. Estab. 1971. Publishes New England- and ocean-related topics. Photos used for text illustrations, book covers, art, wall framing.

Needs Buys 25 photos/year; offers 5 freelance assignments/year. Needs photos of architecture, gardening, cities/urban, automobiles, food/drink, health/fitness/beauty, science. Interested in fashion/glamour, fine art, avant garde, documentary, historical/vintage. Model release preferred. Photo captions required.

Specs Uses b&w prints.

Making Contact & Terms Send query letter with samples; include SASE for return of material. Responds in 1 month. Payment negotiable. Credit line given. Buys all rights.

Tips To break in with this firm, ''produce superb black-and-white photos. There must be an Ansel Adams-type of appeal that is instantaneous to the viewer.''

$ $▣ CLEIS PRESS

P.O. Box 14697, San Francisco CA 94114. (415)575-4700. Fax: (415)575-4705. E-mail: fdelacoste@cleispress.com. Web site: www.cleispress.com. **Contact:** Frédérique Delacoste, art director. Estab. 1979. Publishes fiction, nonfiction, trade and gay/lesbian erotica. Photos used for book covers. Examples of recently published titles: *Best Gay Erotica 2006*; *Best Lesbian Erotica 2006*; *Best Women's Erotica 2006*.

Needs Buys 20 photos/year. Reviews stock photos.

Specs Uses color and/or b&w prints; 35mm transparencies.

Making Contact & Terms Query via e-mail only. Provide résumé, business card, brochure, flier or tearsheets to be kept on file for possible future assignments. Works with local freelancers on assignment only. Keeps samples on file. Responds in 1 week. Pays $350/photo for all uses in conjunction with book. Pays on publication.

$ $▣ CONARI PRESS

Red Wheel/Weiser, LLC, 65 Parker St., Suite 7, Newburyport MA 01950. (978)465-0504. Fax: (978)465-0243. E-mail: info@redwheelweiser.com. Web site: www.redwheelweiser.com. **Contact:** Art Director. Estab. 1987. Publishes hardcover and trade paperback originals and reprints. Subjects include women's studies, psychology, parenting, inspiration, home and relationships (all nonfiction titles). Photos used for text illustrations, book covers, dust jackets.

Needs Buys 5-10 freelance photos/year. Looking for artful photos; subject matter varies. Interested in reviewing stock photos of most anything except high-tech, corporate or industrial images. Model release required. Photo captions preferred; include photography copyright.

Specs Prefers images in digital format.

Making Contact & Terms Provide résumé, business card, self-promotion piece or tearsheets to be kept on file for possible future assignments. Art director will contact photographer for portfolio review if interested. Portfolio should include prints, tearsheets, slides, transparencies or thumbnails. Keeps samples on file. Simultaneous submissions and previously published work OK. Pays by the project: $400-1,000 for color cover; rates vary for color inside. Pays on publication. Credit line given on copyright page or back cover.

Tips ''Review our Web site to make sure your work is appropriate.''

$ $☑ ▣ THE COUNTRYMAN PRESS

W.W. Norton & Co., Inc., P.O. Box 748, Woodstock VT 05091. (802)457-4826. Fax: (802)457-1678. E-mail: kthompson@wwnorton.com. Web site: www.countrymanpress.com. **Contact:** Kelly Thompson, production coordinator. Estab. 1973. Publishes hardcover originals, trade paperback originals and reprints. Subjects include travel, nature, hiking, biking, paddling, cooking, Northeast history, gardening and fishing. Examples of recently published titles: *The King Arthur Flour Baker's Companion* (book cover); *Vermont: An Explorer's Guide* (text illustrations, book cover). Catalog available for $6^{3}/_{4} \times 10^{1}/_{2}$ envelope.

Needs Buys 25 freelance photos/year. Needs photos of environmental, landscapes/scenics, wildlife, architecture, gardening, rural, sports, travel. Interested in historical/vintage, seasonal. Model/property release preferred. Photo captions preferred; include location, state, season.

Specs Uses 4×6 glossy or matte color prints; 35mm, $2^{1}/_{4} \times 2^{1}/_{4}$, 4×5, 8×10 transparencies. Accepts images in digital format. Send via CD, floppy disk, Zip as TIFF files at 350 dpi.

Making Contact & Terms Send query letter with résumé, slides, tearsheets, stock list. Provide résumé, business card, self-promotion piece to be kept on file for possible future assignments. Responds in 2 months, only if interested. Simultaneous submissions and previously pubished work OK. Pays $100-600 for color cover. Pays on publication. Credit line given. Buys all rights for life of edition (normally 2-7 years); negotiable.

Tips "Our catalog demonstrates the range of our titles and shows our emphasis on travel and the outdoors. Crisp focus, good lighting, and strong contrast are goals worth striving for in each shot. We prefer images that invite rather than challenge the viewer, yet also look for eye-catching content and composition."

$ ▣ CRABTREE PUBLISHING COMPANY

PMB 16A, 350 Fifth Ave., Suite 3308, New York NY 10118. (800)387-7650. Fax: (800)355-7166. Web site: www.crabtreebooks.com. **Contact:** Crystal Foxton and Allison Napier, photo researchers. Estab. 1978. Publishes juvenile nonfiction, library and trade. Subjects include natural science, history, geography (including cultural geography), 18th- and 19th-century North America, sports. Photos used for text illustrations, book covers. Examples of recently published titles: *Insect Homes*; *Changing Weather: Storms*; *Extreme Mountain Biking*; *Inventing the Camera*; *Sir Walter Raleigh: Founding the Virginia Colony*; *Black Holes*.

Needs Buys 400-600 photos/year. Wants photos of cultural events around the world, animals (exotic and domestic) and historical reenactments. Model/property release required for children, photos of artwork, etc. Photo captions preferred; include place, name of subject, date photographed, animal behavior.

Specs Uses color prints; 35mm, 4×5, 8×10 transparencies; high-resolution digital files (no JPEG compressed files).

Making Contact & Terms Does NOT accept unsolicited photos. Provide résumé, business card, brochure, flier or tearsheets to be kept on file for possible future assignments. Simultaneous submissions and previously published work OK. Pays $75-100 for color photos. Pays on publication. Credit line given. Buys nonexclusive rights.

Tips "Since our books are for younger readers, lively photos of children and animals are always excellent." Portfolio should be "diverse and encompass several subjects rather than just 1 or 2; depth of coverage of subject should be intense so that any publishing company could, conceivably, use all or many of a photographer's photos in a book on a particular subject."

$○ ▣ THE CREATIVE COMPANY

Imprint: Creative Editions. 123 S. Broad St., Mankato MN 56001. (507)388-2024. Fax: (507)388-1364. E-mail: tammi.stoffel@thecreativecompany.us. Web site: www.thecreativecompany.us. **Contact:** Tammi Stoffel, photo researcher. Estab. 1933. Publishes hardcover originals, textbooks for children. Subjects include animals, nature, geography, history, sports (professional and college), science, technology, biographies. Photos used for text illustrations, book covers. Examples of recently published titles: *Let's Investigate Wildlife* series (text illustrations, book cover); *Ovations* (biography) series (text illustrations, book cover). Catalog available for 9×12 SAE with $2 first-class postage. Photo guidelines free with SASE.

Needs Buys 2,000 stock photos/year. Needs photos of celebrities, disasters, environmental, landscapes/scenics, wildlife, architecture, cities/urban, gardening, pets, rural, adventure, automobiles, entertainment, health/fitness, hobbies, sports, travel, agriculture, industry, medicine, military, science, technology/computers. Other specific photo needs: NFL, NHL, NBA, Major League Baseball. Photo captions required; include photographer's or agent's name.

Specs Accepts images in digital format for Mac only. Send via CD as JPEG files.

Making Contact & Terms Send query letter with photocopies, tearsheets, stock list. Provide self-promotion piece to be kept on file for possible future assignments. Responds in 1 month to queries. Simultaneous submissions and previously published work OK. Pays $100-150 for cover; $50-150 for inside. Projects with photos and text are considered as well. Pays on publication. Credit line given. Buys one-time rights and foreign publication rights as requested.

Tips "Inquiries must include nonreturnable samples. After establishing policies and terms, we keep photographers on file and contact as needed. All photographers who agree to our policies can be included on our e-mail list for specific, hard-to-find image needs. We rarely use black-and-white or photos of people unless the text requires it. Project proposals must be for a 4-, 6-, or 8-book series for children."

$□ ▣ CREATIVE EDITIONS

The Creative Company, 123 S. Broad St., Mankato MN 56001. (507)388-2024. Fax: (507)388-1364. E-mail: tammi.stoffel@thecreativecompany.us. Web site: www.thecreativecompany.us. **Contact:** Tammi Stoffel, photo researcher. Estab. 1989. Publishes hardcover originals. Subjects include photo essays, biography, poetry, stories designed for children. Photos used for text illustrations, book covers, dust jackets. Examples of recently published titles: *Little Red Riding Hood* (text illustrations, book cover, dust jacket); *Poe* (text illustrations, book cover, dust jacket). Catalog available.

Needs Looking for photo-illustrated documentaries or gift books. Must include some text. Publishes 5-10 books/year.

Specs Uses any size glossy or matte color and/or b&w prints. Accepts images in digital format for Mac only. Send via CD as JPEG files at 72 dpi minimum (high-res upon request only).

Making Contact & Terms Send query letter with publication credits and project proposal, prints, photocopies, tearsheets of previous publications, stock list for proposed project. Responds in 1 month to queries. Simultaneous submissions and previously published work OK. Advance to be negotiated. Credit line given. Buys world rights for the book; photos remain property of photographer.

Tips "Creative Editions publishes unique books for the book-lover. Emphasis is on aesthetics and quality. Completed manuscripts are more likely to be accepted than preliminary proposals. Please do not send slides or other valuable materials."

CREATIVE WITH WORDS PUBLICATIONS (CWW)

P.O. Box 223226, Carmel CA 93922. Fax: (831)655-8627. E-mail: geltrich@mbay.net. Web site: http://members.tripod.com/CreativeWithWords. **Contact:** Brigitta Geltrich, editor. Estab. 1975. Publishes poetry and prose anthologies according to set themes. Black & white photos used for text illustrations, book covers. Photo guidelines free with SASE.

Needs Looking for theme-related b&w photos. Model/property release preferred.

Specs Uses any size b&w photos. "We will reduce to fit the page."

Making Contact & Terms Request theme list, then query with photos. Does not keep samples on file; include SASE for return of material. Responds 3 weeks after deadline if submitted for a specific theme. Payment negotiable. Pays on publication. Credit line given. Buys one-time rights.

◑ Ⓐ ▣ ◩ CRUMB ELBOW PUBLISHING

P.O. Box 294, Rhododendron OR 97049. **Contact:** Michael P. Jones, publisher. Estab. 1979. Publishes juvenile, educational, environmental, nature, historical, multicultural, travel and guidebooks. Photos used for text illustrations, promotional materials, book covers, dust jackets, educational videos. "We are just beginning to use photos in books and videos." Examples of recently published titles: *A Few Short Miles* (text illustrations, dust jacket); *Poetry in Motion* (text illustrations, dust jacket). Photo guidelines free with SASE.

Needs Looking for nature, wildlife, historical, environmental, folklife, historical reenactments, ethnicity and natural landscapes. Also wants photos of multicultural, architecture, cities/urban, education, gardening, interiors/decorating, pets, religious, rural, adventure, automobiles, entertainment, events, food/drink, health/fitness/beauty, hobbies, humor, performing arts, sports, travel, agriculture, business concepts, industry, medicine, military, political, product shots/still life, science, technology/computers. Interested in alternative process, avant garde, documentary, erotic, fashion/glamour, fine art, historical/vintage, seasonal. Model/property release preferred for individuals posing for photos. Photo captions preferred.

Specs Uses 3×5, 5×7, 8×10 color and/or b&w prints; 35mm transparencies; videotape. Accepts images in digital format. Send via CD.

Making Contact & Terms Submit portfolio for review. Send query letter with résumé of credits, samples, stock list. Provide résumé, business card, brochure, flier or tearsheets to be kept on file for possible future assignments. Works on assignment only. Keeps samples on file; include SASE for return of material. Responds in 1 month depending on work load. Simultaneous submissions OK. Payment varies. Pays on publication. Credit line given. Offers internships for photographers year-round. Buys one-time rights.

Tips "Send enough samples so we have a good idea of what you can really do. Black & white photos are especially appealing. Also, remember that photography can be like an endless poem that continues to tell a never-ending story. Capture your images in a way that makes them become forever points in time."

[A] ▣ DOCKERY HOUSE PUBLISHING, INC.

1720 Regal Row, Suite 112, Dallas TX 75235. (214)630-4300. Fax: (214)638-4049. E-mail: ctradlec@docke rypublishing.com. Web site: www.dockerypublishing.com. **Contact:** Catrice Tradlec, director of photography. Publishes customized books and magazines. Subjects include food, travel, healthy living. Photos used for text illustrations, promotional materials, book covers, magazine covers and articles. Examples of recently published titles: *The Magical Taste of Grilling*; *Total Health and Wellness*.

Needs Looking for lifestyle trends, people, travel, food, luxury goods. Needs vary. Reviews stock photos. Model release preferred.

Specs Uses all sizes and finishes of color and b&w prints; 35mm and digital.

Making Contact & Terms Send query letter with samples. Provide résumé, business card, brochure, flier or tearsheets to be kept on file for possible future assignments. Works on assignment only. Keeps samples on file. Cannot return material. Payment negotiable. Pays net 30 days. Buys all rights; negotiable.

$ ▣ [S] ▣ DOWN THE SHORE PUBLISHING CORP.

P.O. Box 100, West Creek NJ 08092. Fax: (609)597-0422. E-mail: info@down-the-shore.com. Web site: www.down-the-shore.com. **Contact:** Raymond G. Fisk, publisher. Estab. 1984. Publishes regional calendars; seashore, coastal, and regional books (specific to the mid-Atlantic shore and New Jersey). Photos used for text illustrations, scenic calendars (New Jersey and mid-Atlantic only). Examples of recently published titles: *Great Storms of the Jersey Shore* (text illustrations); *NJ Lighthouse Calendar* (illustrations, cover); *Shore Stories* (text illustrations, dust jacket). Photo guidelines free with SASE or on Web site.

Needs Buys 30-50 photos/year. Needs scenic coastal shots, photos of beaches and New Jersey lighthouses (New Jersey and mid-Atlantic region). Interested in seasonal. Reviews stock photos. Model release required; property release preferred. Photo captions preferred; *specific location* identification essential.

Specs "We have a very limited use of prints." Prefers 35mm, $2\frac{1}{4} \times 2\frac{1}{4}$, 4×5 transparencies. Accepts digital submissions via high-resolution files on CD. Refer to guidelines before submitting.

Making Contact & Terms Send query letter with stock list. Provide résumé, business card, brochure, flier or tearsheets to be kept on file for possible future requests. Responds in 6 weeks. Previously published work OK. Pays $100-200 for b&w or color cover; $10-100 for b&w or color inside. Pays 90 days from publication. Credit line given. Buys one-time or book rights; negotiable.

Tips "We are looking for an honest depiction of familiar scenes from an unfamiliar and imaginative perspective. Images must be specific to our very regional needs. Limit your submissions to your best work. Edit your work very carefully."

$ ▢ EMPIRE PUBLISHING SERVICE

Imprints: Gaslight, Empire, Empire Music & Percussion. P.O. Box 1344, Studio City CA 91614-0344. (818)784-8918. **Contact:** J. Cohen, art director. Estab. 1960. Publishes hardcover and trade paperback originals and reprints, textbooks. Subjects include entertainment, plays, health, Sherlock Holmes, music. Photos used for text illustrations, book covers. Examples of recently published titles: *Men's Costume Cut and Fashion, 17th Century* (text illustrations); *Scenery* (text illustrations).

Needs Needs photos of celebrities, entertainment, events, food/drink, health/fitness, performing arts. Interested in fashion/glamour, historical/vintage. Model release required. Photo captions required.

Specs Uses 8×10 glossy prints.

Making Contact & Terms Send query letter with résumé, samples. Provide résumé, business card to be kept on file for possible future assignments. Responds only if interested; send nonreturnable samples. Simultaneous submissions considered depending on subject and need. Pays on publication. Credit line given. Buys all rights.

Tips "Send appropriate samples of high-quality work only. Submit samples that can be kept on file and are representative of your work."

☒ $ $F+W PUBLICATIONS

Imprints: Writer's Digest Books, TOW Books, Betterway Books, North Light Books, IMPACT Books, Popular Woodworking Books, Memory Makers Books, Adams Media, David & Charles, Krause Publications. 4700 E. Galbraith Rd., Cincinnati OH 45236. Web site: www.fwpublications.com. **Contact:** Art Directors: Grace Ring, Marissa Bowers, Wendy Dunning. Publishes 120 books/year for writers, artists, graphic designers and photographers, plus selected trade (humor, lifestyle, home improvement) titles.
Needs Tries to fill photo needs through stock first, before making assignments.
Making Contact & Terms Send nonreturnable photocopies of printed work to be kept on file. Art director will contact photographer for portfolio review if interested. "Pay rates usually depend on the scope of the project; $1,000 for a cover is pretty typical." Considers buying second rights (reprint rights) to previously published photos. "We like to know where art was previously published." Finds photographers through word of mouth, submissions, self-promotions.
Tips "Don't call. Send appropriate samples we can keep."

$ FARCOUNTRY PRESS

Lee Enterprises, P.O. Box 5630, Helena MT 59604 (physical address: 2222 Washington St., Helena MT 59602). (406)444-5122 or (800)821-3874. Fax: (406)443-5480. E-mail: theresa.rush@lee.net. Web site: www.farcountrypress.com. **Contact:** Theresa Rush, photo librarian. Estab. 1973. Montana's largest book publisher, specializing in photography (states, cities, geographical regions, national parks, wildlife, wildflowers), popular history, children's education (nature, history), guidebooks, cookbooks, Lewis and Clark history, regional essays. Photo guidelines available on Web site.
Needs Looking for color photography of landscapes/scenics, wildlife, people. Photo captions required; include name and address on mount. Package slides in individual protectors, then in sleeves.
Specs "We prefer working with medium- and large-format ($2\frac{1}{4}$, 4×5, etc.) for the large-format coffee table type books, but we will also work with high-quality 35mm. For digital photo submissions, please send 12-bit TIFF files (higher preferred), at least 350 dpi or higher, formatted for Macs. Use Adobe RGB (1998) color space. All images should be flattened—no channels or layers. Do not use compression; save at the highest-possible quality setting. Do not interpolate (upsizing) or sharpen images. Information, watermarks and/or type should never appear directly on the images. Include with your submission a 'quick view'—either a contact sheet(s) or a folder with low-resolution files for quick editing. Copyright and caption data entered in the appropriate IPTC fields. Image file names contain photographer's name, e.g., STSmith3945.tif. Use file names that include: 1) the name or initials of the photographer; 2) location; 3) a unique photo ID number (example: Jones_Beijing_004697.tif)."
Making Contact & Terms Send query letter with stock list. "Do not send unsolicited transparencies." Reporting time depends on project. Simultaneous submissions and previously published work OK. Buys one-time rights.
Tips "We seek bright, heavily saturated colors. Focus must be razor sharp. Include strong seasonal looks, scenic panoramas, intimate close-ups. Of special note to *wildlife* photographers, specify shots taken in a captive situation (zoo or game farm); we identify shots taken in a captive situation."

$ $☒ FIFTH HOUSE PUBLISHERS

1511-1800 Fourth St. SW, Calgary AB T2S 2S5 Canada. (403)571-5230. Fax: (403)571-5235. E-mail: meaghan@fifthhousepublishers.ca. Web site: www.fifthhousepublishers.ca. **Contact:** Meaghan Craven, managing editor. Estab. 1982. Publishes calendars, history, biography, western Canadiana. Photos used for text illustrations, book covers, dust jackets and calendars. Examples of recently published titles: *The Canadian Weather Trivia Calendar*; *Wild Alberta*; *A World Within*.
Needs Buys 15-20 photos/year. Looking for photos of Canadian weather. Model/property release preferred. Photo captions required; include location and identification.
Making Contact & Terms Send query letter with samples and stock list. Keeps samples on file. Pays $300 Canadian/calendar image. Pays on publication. Credit line given. Buys one-time rights.

☒ FOCAL PRESS

30 Corporate Dr., Suite 400, Burlington MA 01803. (781)313-4794. Fax: (781)313-4880. E-mail: d.heppner@elsevier.com. Web site: www.focalpress.com. **Contact:** Diane Heppner, acquisitions editor/photography. Estab. 1938.

Needs "We publish professional reference titles, practical guides and student textbooks in all areas of media and communications technology, including photography and digital imaging. We are always looking for new proposals for book ideas. Send e-mail for proposal guidelines."

Making Contact & Terms Simultaneous submissions and previously published work OK. Buys all rights; negotiable.

$ ☑ ▣ GRAPHIC ARTS CENTER PUBLISHING COMPANY

3019 NW Yeon, Portland OR 97210. (503)226-2402, ext. 306. Fax: (503)223-1410. E-mail: jeanb@gacpc.com. Web site: www.gacpc.com. **Contact:** Jean Bond-Slaughter, editorial assistant. Publishes adult trade photo-essay books and state, regional and recreational calendars. Examples of published titles: *Primal Forces*; *Cherokee*; *Oregon IV*; *Alaska's Native Ways*.

Needs Offers 5-10 photo-essay book contracts/year. Needs photos of environmental, landscapes/scenics, wildlife, gardening, adventure, food/drink, travel. Interested in fine art, historical/vintage, seasonal.

Specs Uses 35mm, 2¼×2¼ and 4×5 transparencies. Accepts images in digital format. Send via CD.

Making Contact & Terms "Contact the editorial assistant to receive permission to send in a submission. An unsolicited submission will be returned unopened with postage due." Once permission is granted, send bio, samples: 20-40 transparencies that are numbered, labeled with descriptions and verified in a delivery memo, and return postage or a completed Fed Ex form. Responds in up to 6 months. Payment varies based on project. Credit line given. Buys book rights.

Tips "Photographers must be previously published and have a minimum of 5 years full-time professional experience to be considered. Call to present your book or calendar proposal before you send in a submission. Topics proposed must have strong market potential."

☑ ▣ GRYPHON HOUSE

P.O. Box 207, Beltsville MD 20704. (301)595-9500. Fax: (301)595-0051. E-mail: rosanna@ghbooks.com. Web site: www.ghbooks.com. **Contact:** Rosanna Mollett, art director. Estab. 1970. Publishes educational resource materials for teachers and parents of young children. Examples of recently published titles: *Great Games for Young Children* (text illustrations); *Starting With Stories* (book cover).

Needs Looking for b&w and color photos of young children (from birth to 6 years.) Reviews stock photos. Model release required.

Specs Uses 5×7 glossy color (cover only) and b&w prints. Accepts images in digital format. Send via CD, Zip, e-mail as TIFF files at 300 dpi.

Making Contact & Terms Send query letter with samples and stock list. Keeps samples on file. Simultaneous submissions OK. Payment negotiable. **Pays on receipt of invoice**. Credit line given. Buys book rights.

▣ HANCOCK HOUSE PUBLISHERS

1431 Harrison Ave., Blaine WA 98230-5005. (800)938-1114. Fax: (800)983-2262. E-mail: david@hancockwildlife.org. Web site: www.hancockwildlife.org. **Contact:** David Hancock, president. Estab. 1968. Publishes trade books. Photos used for text illustrations, promotions, book covers. Examples of recently published titles: *Meet the Sasquatch* by Chris Murhydd (over 500 color images); *Alaska in the Wake of the North Star* by Loel Shuler; *Pheasants of the World* (350 color photos).

Needs Needs photos of birds/nature. Reviews stock photos. Model release preferred. Photo captions preferred.

Making Contact & Terms Send query letter with samples, SASE. Responds in 1 month. Simultaneous submissions and previously published work OK. Payment negotiable. Credit line given. Buys nonexclusive rights.

☐ ▣ HERALD PRESS

616 Walnut Ave., Scottdale PA 15683. (724)887-8500. Fax: (724)887-3111. E-mail: merrill@mph.org. Web site: www.mph.org. **Contact:** Design Director. Estab. 1908. Photos used for book covers, dust jackets. Examples of published titles: *Lord, Teach Us to Pray*; *Starting Over*; *Amish Cooking* (all cover shots).

Needs Buys 5 photos/year; offers occasional freelance assignments. Subject matter varies. Reviews stock photos of people and other subjects including religious, environmental. Model/property release required. Photo captions preferred; include identification information.

Specs Uses varied sizes of glossy color and/or b&w prints; 35mm transparencies. Prefers images in digital format. Send via CD or e-mail as JPEG files.

Making Contact & Terms Send query letter or e-mail with samples. Provide résumé, business card, brochure, flier or tearsheets to be kept on file for possible future assignments. Keeps samples on file. Works on assignment only or selects from file of samples. Responds in 1 month. Simultaneous submissions and previously published work OK. Payment negotiable. **Pays on acceptance.** Credit line given. Buys book rights; negotiable.

Tips "We put your résumé and samples on file. It is best to direct us to your Web site."

$ $☑ ▣ HOLT, RINEHART AND WINSTON

10801 N. Mopac Expressway, Bldg. 3, Austin TX 78759-5415. (512)721-7000. Fax: (800)269-5232. E-mail: HoltInfo@hrw.com. Web site: www.hrw.com. **Contact:** Curtis Riker, director of image acquisitions. Photo Research Manager: Jeannie Taylor. Publishes textbooks in multiple formats. "The Photo Research Department of the HRW School Division in Austin obtains photographs for textbooks in subject areas taught in secondary schools." Photos are used for text illustrations, promotional materials and book covers.

Needs Uses 6,500+ photos/year. Wants photos that illustrate content for mathematics, sciences, social studies, world languages, and language arts. Model/property release preferred. Photo captions required; include scientific explanation, location and/or other detailed information.

Specs Prefers images in digital format. Send via CD or broadband transmission.

Making Contact & Terms Send a query letter with a sample of work (nonreturnable photocopies, tearsheets, printed promos) and a list of subjects in stock. Self-promotion pieces kept on file for future reference. Include promotional Web site link if available. "Do not call!" Will respond only if interested. Payment negotiable depending on format and number of uses. Credit line given.

Tips "Our book image programs yield an emphasis on rights-managed stock imagery, with a focus on teens and a balanced ethnic mix. Though we commission assignment photography, we maintain an in-house studio with 2 full-time photographers. We are interested in natural-looking, uncluttered photographs labeled with exact descriptions, that are technically correct and include no evidence of liqor, drugs, cigarettes or brand names."

$ $▣ HUMAN KINETICS PUBLISHERS

1607 N. Market, Champaign IL 61820. (217)351-5076. E-mail: neilb@hkusa.com. Web site: www.hkusa.com. **Contact:** Neil Bernstein, photographer. Estab. 1979. Publishes hardcover originals, trade paperback originals, textbooks, online courses and CD-ROMs. Subjects include sports, fitness, physical therapy, sports medicine, nutrition, physical activity. Photos used for text illustrations, promotional materials, catalogs, magazines, Web content, book covers. Examples of recently published titles: *Serious Tennis* (text illustrations, book cover); *Beach Volleyball* (text illustrations, book cover). Photo guidelines available via e-mail only.

Needs Buys 2,000 freelance photos/year. Needs photos of babies/children/teens, multicultural, families, education, events, food/drink, health/fitness, performing arts, sports, medicine, military, product shots/still life. All photos purchased must show some sort of sport, physical activity, health and fitness. "Expect ethnic diversity in all content photos." Model release preferred.

Specs Prefers images in digital format. Send via CD, Zip as TIFF, JPEG files at 300 dpi at 9×12 inches; will accept 5×7 color prints, 35mm transparencies.

Making Contact & Terms Send query letter and URL via e-mail to view samples. Responds only if interested. Simultaneous submissions and previously pubished work OK. Pays $250-500 for b&w or color cover; $75-125 for b&w or color inside. Pays extra for electronic usage of photos. Pays on publication. Credit line given. Buys one-time rights. Prefers world rights, all languages, for one edition; negotiable.

Tips "Go to Borders or Barnes & Noble and look at our books in the sport and fitness section. We want and need peak action, emotion, and razor-sharp images for future projects. The pay is below average, but there is opportunity for exposure and steady income to those with patience and access to a variety of sports and physical education settings. We have a high demand for quality shots of youths engaged in physical education classes at all age groups. We place great emphasis on images that display diversity and technical quality. Do not contact us if you charge research or holding fees. Do not contact us for progress reports. Will call if selection is made or return images. Typically, we hold images 4 to 6 months. If you can't live without the images that long, don't contact us. Don't be discouraged if you don't make a sale in the first 6 months. We work with over 200 agencies and photographers. Photographers should check to see if techniques demonstrated in photos are correct with a local authority. Most technical photos and submitted work are rejected on content, not quality."

☑ Ⓐ HYPERION BOOKS FOR CHILDREN

114 Fifth Ave., New York NY 10011. (212)633-4400. Fax: (212)807-5880. Web site: www.hyperionchildre nsbooks.com. **Contact:** Susan Masry, design coordinator. Publishes children's books, including picture books and books for young readers. Subjects include adventure, animals, history, multicultural, sports. Catalog available for 9×12 SAE with 3 first-class stamps.

Needs Needs photos of multicultural subjects.

Making Contact & Terms Provide résumé, business card, self-promotion piece to be kept on file for possible future assignments. Pays royalties based on retail price of book, or a flat fee.

$ $☑ Ⓐ ▣ INNER TRADITIONS/BEAR & COMPANY

1 Park St., Rochester VT 05767. (802)767-3174. Fax: (802)767-3726. E-mail: peri@innertraditions.com. Web site: www.innertraditions.com. **Contact:** Peri Champine, art director. Estab. 1975. Publishes adult trade and teen self-help. Subjects include New Age, health, self-help, esoteric philosophy. Photos used for text illustrations, book covers. Examples of recently published titles: *Tibetan Sacred Dance* (cover, interior); *Tutankhamun Prophecies* (cover); *Animal Voices* (cover, interior).

Needs Buys 10-50 photos/year; offers 5-10 freelance assignments/year. Needs photos of babies/children/ teens, multicultural, families, parents, religious, alternative medicine, environmental, landscapes/sce nics. Interested in fine art, historical/vintage. Reviews stock photos. Model/property release required. Photo captions preferred.

Specs Uses 35mm, 4×5 transparencies. Accepts images in digital format. Send via CD, Zip as TIFF, EPS, JPEG files at 300 dpi.

Making Contact & Terms Provide résumé, business card, brochure, flier or tearsheets to be kept on file for possible future assignments. Works with freelancers on assignment only. Simultaneous submissions OK. Pays $150-600 for color cover; $50-200 for b&w and color inside. Pays on publication. Credit line given. Buys book rights; negotiable.

$ $☑ Ⓐ ▣ JUDICATURE

2700 University Ave., Des Moines IA 50311. (773)973-0145. Fax: (773)338-9687. E-mail: drichert@ajs.o rg. Web site: www.ajs.org. **Contact:** David Richert, editor. Estab. 1917. Publishes legal journal, court and legal books. Photos used for text illustrations, cover of bimonthly journal.

Needs Buys 10-12 photos/year; occasionally offers freelance assignments. Looking for photos relating to courts, the law. Reviews stock photos. Model/property release preferred. Photo captions preferred.

Specs Uses 5×7 color and/or b&w prints; 35mm transparencies. Prefers images in digital format.

Making Contact & Terms Send query letter with samples. Works on assignment only. Keeps samples on file. Responds in 2 weeks. Simultaneous submissions and previously published work OK. Pays $250-350 for cover; $125-300 for color inside; $125-250 for b&w inside. **Pays on receipt of invoice.** Credit line given. Buys one-time rights.

Ⓝ $ $☑ ▣ KEY CURRICULUM PRESS

1150 65th St., Emeryville CA 94608. (800)995-6284. Fax: (800)541-2442. Web site: www.keypress.com. **Contact:** Christine Osborne, production editor. Estab. 1971. Publishes textbooks, CD-ROMs, software. Subjects include mathematics. Photos used for text illustrations, promotional materials, book covers. Examples of recently published titles: *Discovering Algebra* (text illustrations, promotional materials, book cover); *The Heart of Mathematics* (text illustrations, promotional materials, book cover). Catalog available for first-class postage.

Needs Needs photos of babies/children/teens, couples, multicultural, families, environmental, land scapes/scenics, wildlife, architecture, cities/urban, education, rural, health/fitness/beauty, performing arts, sports, science, technology/computers. Interested in documentary, fine art. Also needs technology with female adults performing professional tasks. Female professionals, not just in office occupations. Model/property release required. Photo captions preferred; include type of technology pictured.

Specs Accepts images in digital format. Send via CD as TIFF, EPS files at 300 dpi (72 dpi for FPOs).

Making Contact & Terms Send query letter with résumé, photocopies, tearsheets, stock list. Provide business card, self-promotion piece to be kept on file for possible future assignments. Responds only if interested, send nonreturnable samples. Simultaneous submissions and previously published work OK. Pays $250-500 for b&w cover; $250-1,000 for color cover; by the project, $250-1,000 for cover shots; $150-200 for b&w inside; $150-300 for color inside; by the project, $100-900 for inside shots. **Pays on acceptance.** Credit line given. Buys all rights to assignment photography.

Tips "Provide Web site gallery. Call prior to dropping off portfolio."

$LAYLA PRODUCTION INC.

370 E. 76th St., New York NY 10021. (212)879-6984. Fax: (212)639-1723. E-mail: laylaprod@aol.com. **Contact:** Lori Stein, manager. Estab. 1980. Publishes adult trade and how-to gardening. Photos used for text illustrations, book covers. Examples of recently published titles: *Spiritual Gardening* and *American Garden Guides,* 12 volumes (commission or stock, over 4,000 editorial photos).

Needs Buys over 150 photos/year; offers 6 freelance assignments/year. Needs photos of gardening.

Making Contact & Terms Provide résumé, business card, brochure, flier or tearsheets to be kept on file for possible future assignments. Prefers no unsolicited material. Simultaneous submissions and previously published work OK. Pays $50-300 for color photos; $50-300 for b&w photos; $30-75/hour; $250-500/day. Other methods of pay depend on job, budget and quality needed. Buys all rights.

Tips "We're usually looking for a very specific subject. We do keep all résumés/brochures received on file—but our needs are small, and we don't often use unsolicited material."

$ $☑ ▣ LERNER PUBLISHING GROUP

241 First Ave. N., Minneapolis MN 55401. (612)332-3344. Fax: (612)332-7615. E-mail: dwallek@igigraphics.com. Web site: www.lernerbooks.com. **Contact:** Dan Wallek, director of photo research. Estab. 1959. Publishes educational books for young people. Subjects include animals, biography, history, geography, science and sports. Photos used for text illustrations, promotional materials, book covers. Examples of recently published titles: *Colorful Peacocks* (text illustrations, book cover); *Ethiopia in Pictures* (text illustrations, book cover).

Needs Buys more than 1,000 photos/year; occasionally offers assignments. Needs photos of children/teens, celebrities, multicultural, families, disasters, environmental, landscapes/scenics, wildlife, cities/urban, education, pets, rural, hobbies, sports, agriculture, industry, political, science, technology/computers. Model/property release preferred when photos are of social issues (e.g., the homeless). Photo captions required; include who, where, what and when.

Specs Uses any size glossy color prints; 35mm transparencies. Accepts images in digital format. Send via CD, e-mail, FTP link as TIFF, JPEG files at 300 dpi.

Making Contact & Terms Send query letter with detailed stock list by mail, fax or e-mail. Provide flier or tearsheets to be kept on file. "No calls, please." Cannot return material. Responds only if interested. Previously published work OK. Pays by the project: $200-500 for cover; $50-150 for inside. **Pays on receipt of invoice**. Credit line given. Buys one-time print rights, electronic rights, Spanish-language rights, worldwide territory rights.

Tips Prefers crisp, clear images that can be used editorially. "Send in as detailed a stock list as you can (including fees for clearing additional rights), and be willing to negotiate price."

$☑ ⑤ ▣ LUCENT BOOKS

27500 Drake Rd., Farmington Hills MI 48331. (248)699-4253. Fax: (248)699-8004. Web site: www.gale.com/lucent. **Contact:** Shelley Dickey, production manager. Estab. 1987. Publishes juvenile nonfiction. Subjects include social issues, science/environment, crime, health/medicine, black history, biographies and histories. Photos used for text illustrations and book covers. Examples of recently published titles: *The Death Penalty* (text illustrations); *Teen Smoking* (text illustrations).

Needs Buys hundreds of photos/year, including many historical and biographical images, as well as controversial topics such as euthanasia. Needs celebrities, teens, disasters, environmental, wildlife, education. Interested in documentary, historical/vintage. Reviews stock photos. Model/property release required; photo captions required.

Specs Uses 5×7, 8½×11 b&w prints. Accepts images in digital format. Send via CD, Zip, e-mail at 300 dpi.

Making Contact & Terms Send query letter with résumé of credits and samples. Provide résumé, business card, brochure, flier or tearsheets to be kept on file for possible future assignments. Keeps samples on file. Will contact if interested. Simultaneous submissions and previously published work OK. Pays $100-300 for color cover; $50-100 for inside. Credit lines given on request.

Ⓐ MBI PUBLISHING COMPANY

Imprints: Motorbooks, Zenith Press, Voyageur Press, MBI. 380 Jackson St., Suite 200, St. Paul MN 55101-3385. (651)287-5000. Fax: (651)287-5001. E-mail: mlabarre@mbipublishing.com. Web site: www.mbipublishing.com. **Contact:** Publishing Assistant. Estab. 1965. Publishes trade, specialist and how-to automotive, aviation and military, as well as regional U.S. travel, Americana, collectibles, nature/wildlife, coun-

try life, history. Photos used for text illustrations, book covers, dust jackets. Examples of recently published titles: *Organic Farming: Everything You Need to Know; The Surfboard: Art, Style, Stoke; Harley-Davidson; Jeep Offroad; Leave No Man Behind: The Saga of Combat Search and Rescue.*

Needs Anything to do with transportation, including tractors, motorcycles, bicycles, trains, aviation, automobiles, construction equipment. Also wants photos of Americana, regional U.S. travel, country life, nature. Model release preferred.

Making Contact & Terms "Present a résumé and cover letter first, and we'll follow up with a request to see samples." Unsolicited submissions of original work are discouraged. Works on assignment typically as part of a book project. Responds in 10 weeks. Simultaneous submissions and previously published work OK. Payment negotiable. Credit line given. Rights negotiable.

$ $ $ ☑ ▣ MCGRAW-HILL

1333 Burr Ridge Pkwy., Floors 2-5, Burr Ridge IL 60527. (630)789-4000. Fax: (630)789-6594. E-mail: gino_cieslik@mcgraw-hill.com. Web site: www.mhhe.com. Publishes hardcover originals, textbooks, CD-ROMs. Photos used for book covers.

Needs Buys 20 freelance photos/year. Needs photos of business concepts, industry, technology/computers.

Specs Uses 8×10 glossy prints; 35mm, 2¼×2¼, 4×5 transparencies. Accepts images in digital format. Send via CD.

Making Contact & Terms Contact through rep. Provide business card, self-promotion piece to be kept on file for possible future assignments. Responds only if interested. Previously published work OK. Pays $650-1,000 for b&w cover; $650-1,500 for color cover. Pays extra for electronic usage of photos. Pays on publication. Credit line given. Buys one-time rights.

$ $ ☑ ▣ MILKWEED EDITIONS

1011 Washington Ave. S., Suite 300, Minneapolis MN 55415. (612)332-3192. Fax: (612)215-2550. Web site: www.milkweed.org. Estab. 1980. Publishes hardcover originals and trade paperback originals. Subjects include literary fiction, literary nonfiction, poetry, children's fiction. Photos used for book covers and dust jackets. Examples of recently published titles: *Ordinary Wolves; Firekeeper.* Catalog available for $1.50. Photo guidelines available for first-class postage.

Needs Buys 6-8 freelance photos/year. Needs photos of environmental, landscapes/scenics, wildlife, people, stock, art, multicultural.

Specs Uses any size glossy or matte color and/or b&w prints; 2¼×2¼, 4×5 transparencies. Accepts images in digital format. Send via CD, Zip, e-mail as TIFF, EPS, JPEG files at 300 dpi.

Making Contact & Terms Send query letter with résumé, business card, self-promotion piece to be kept on file for possible future assignments. Responds only if interested; send nonreturnable samples. Simultaneous submissions OK. Pays $300-800 for b&w or color cover; by the project, $800 maximum for cover/inside shots. Credit line given. Buys one-time rights.

Ⓝ $ Ⓢ ▣ MITCHELL LANE PUBLISHERS, INC.

P.O. Box 196, Hockessin DE 19707. (302)234-9426. Fax: (302)234-4742. E-mail: mitchelllane@mitchellla ne.com. Web site: www.mitchelllane.com. **Contact:** Barbara Mitchell, publisher. Estab. 1993. Publishes hardcover originals for library market. Subjects include biography for children and young adults. Photos used for text illustrations, book covers. Examples of recently published titles: *Hurricane Katrina* (text illustrations and book cover); *Ride the Giant Waves with Garrett McNamara* (text illustrations, book cover).

Needs Photo captions required.

Specs Accepts images in digital format. Send via CD as TIFF, JPEG files at 300 dpi.

Making Contact & Terms Send query letter with stock list (stock photo agencies only). Does not keep samples on file; cannot return material. Responds only if interested. Pays on publication. Credit line given. Buys one-time rights.

$ $ MUSIC SALES GROUP

257 Park Ave. S., 20th Floor, New York NY 10010. (212)254-2100. Fax: (212)254-2013. E-mail: de@music sales.com. Web site: www.musicsales.com. **Contact:** Daniel Earley. Publishes instructional music books, song collections and books on music. Photos used for covers and/or interiors. Examples of recently published titles: *Bob Dylan: Time Out of Mind; Paul Simon: Songs from the Capeman; AC/DC: Bonfire.*

Needs Buys 200 photos/year. Model release required on acceptance of photo. Photo captions required.
Specs Uses 8×10 glossy prints; 35mm, 2×2, 5×7 transparencies.
Making Contact & Terms Send query letter first with résumé of credits. Provide business card, brochure, flier or tearsheets to be kept on file for possible future assignments. Responds in 2 months. Simultaneous submissions and previously published work OK. Pays $75-100 for b&w; $250-750 for color.
Tips In samples, wants to see ''the ability to capture the artist in motion with a sharp eye for framing the shot well. Portraits must reveal what makes the artist unique. We need rock, jazz, classical—onstage and impromptu shots. Please send us an inventory list of available stock photos of musicians. We rarely send photographers on assignment and buy mostly from material on hand.'' Send business card and tearsheets or prints stamped 'proof' across them. Due to the nature of record releases and concert events, we never know exactly when we may need a photo. We keep photos on permanent file for possible future use.''

$ ☑ Ⓢ ▣ NICOLAS-HAYS, INC.

P.O. Box 540206, Lake Worth, FL 33454-0206. (451)798-1040. Fax: (451)798-1042. E-mail: info@nicolash ays.com. Web site: www.nicolashays.com. **Contact:** Y. Paglia. Estab. 1976. Publishes trade paperback originals and reprints. Subjects include Eastern philosophy, Jungian psychology, New Age how-to. Photos used for book covers. Example of recently published title: *Dervish Yoga for Health and Longevity: Samadeva Gestural Euphony-The Seven Major Arkanas* (book cover). Catalog available upon request.
Needs Buys 1 freelance photo/year. Needs photos of landscapes/scenics.
Specs Uses color prints; 35mm, 2¼×2¼, 4×5 transparencies. Accepts images in digital format.
Making Contact & Terms Send query letter with photocopies, tearsheets. Provide self-promotion piece to be kept on file for possible future assignments. Responds only if interested; send nonreturnable samples. Simultaneous submissions and previously pubished work OK. Pays $100-200 for color cover. **Pays on acceptance**. Credit line given. Buys one-time rights.
Tips ''We are a small company and do not use many photos. We keep landscapes/seascapes/skyscapes on hand—images need to be inspirational.''

▣ NORTHLAND PUBLISHING

P.O. Box 1389, Flagstaff AZ 86001. (928)774-5251. Fax: (928)774-0592. E-mail: info@northlandbooks.c om. Web site: www.northlandbooks.com. **Contact:** David Jenney, publisher. Estab. 1958. Specializes in nonfiction titles with American West and Southwest themes, including Native American arts, crafts and culture; regional cookery; interior design and architecture; site-specific visual tour books. Photos used for text illustrations, promotional materials, book covers, dust jackets. Examples of recently published photography-driven titles: *The New Southwest Home* (cover/interior); *Seasonal Southwest Cooking* (cover/interior); *Lasting Light: 125 Years of Grand Canyon Photography* (cover/interior).
Needs Buys 300 stock photos/year. ''Occasional assignments for photographers in the region.'' Model/property release required. Photo captions required.
Specs ''Large-format transparencies preferred. Hi-res digital files on CD or DVD also accepted.''
Making Contact & Terms Send query letter with samples. Previously published work OK. Payment negotiable. Pays within 30 days of invoice. Credit line given. Buys non-exclusive lifetime and all rights.
Tips ''We look for site- or subject-specific images but occasionally publish a new book with an idea from a photographer. Point us to your Web site.''

$ Ⓢ ▣ W.W. NORTON AND COMPANY

500 Fifth Ave., New York NY 10110. (212)790-4362. Fax: (212)869-0856. Web site: www.wwnorton.com. **Contact:** Neil Ryder Hoos, manager, photo permissions. Estab. 1923. Photos used for text illustrations, book covers, dust jackets. Examples of recently published titles: *Inventing America*; *We the People*; *Earth: Portrait of a Planet*; *Enjoyment of Music*; *Psychological Science*.
Needs Variable. Photo captions preferred.
Specs Accepts images in all formats; digital images at a minimum of 300 dpi for reproduction and archival work.
Making Contact & Terms Send stock list. Do not enclose SASE. Simultaneous submissions and previously published work OK. Responds as needed. Payment negotiable. Credit line given. Buys one-time rights; many images are also used in print and Web-based ancillaries; negotiable.
Tips ''Competitive pricing and minimal charges for electronic rights are a must.''

Ⓝ $▣ PAULIST PRESS

997 Macarthur Blvd., Mahwah NJ 07430. (201)825-7300. Fax: (201)825-8345. E-mail: pmcmahon@paulis tpress.com. Web site: www.paulistpress.com. **Contact:** Paul McMahon, managing editor. Estab. 1869. Publishes hardcover and trade paperback originals, juvenile and textbooks. Types of books include religion, theology and spirituality including biography. Specializes in academic and pastoral theology. Recent titles include *How to Read a Church*, *Traveling with the Saints in Italy* and *Child's Guide to the Seven Sacraments*. Publishes 90 titles/year.

● Paulist Press recently began to distribute the general trade imprint HiddenSpring.

Needs Needs photos of religion. "Mainly images concerning religious pilgrimage—not limited to Catholic images. Cathedrals, artwork, world sites such as the Hagia Sophia, Benares, India, etc." Photo captions preferred.

Making Contact & Terms Send query letter with brochure, résumé and tearsheets. Samples are filed. Portfolio review not required. Negotiates rights purchased. Originals are returned at job's completion if requested.

$◯ ▣ PHOTOGRAPHER'S MARKET

4700 E. Galbraith Rd., Cincinnati OH 45236. (513)531-2690, ext. 1226. Fax: (513)531-2686. E-mail: photo market@fwpubs.com. **Contact:** Donna Poehner, editor. Photo guidelines free with SASE or via e-mail.

Needs Publishes 30-35 photos/year. Uses general subject matter. Photos must be work sold to markets listed in *Photographer's Market*. Photos are used to illustrate the various types of images being sold to photo buyers listed in *Photographer's Market*. Look through this book for examples.

Specs Prefers images in digital format. Send via e-mail or CD as TIFF or JPEG files, 5×7 at 300 dpi; saved as grayscale, not RGB. Uses color and b&w (b&w preferred) prints, any size and format (5×7 or 8×10 preferred). Also uses tearsheets and transparencies, all sizes, color and b&w.

Making Contact & Terms "Submit photos in fall and winter to ensure sufficient time to review them before our early-summer deadline. Be sure to include SASE for return of material. All photos are judged according to subject uniqueness as well as technical quality and composition. Photos are held and reviewed at close of deadline." Simultaneous submissions OK. *Work must be previously published.* Pays $75 plus complimentary copy of *Photographer's Market*. Pays when book goes to printer (September). Book forwarded in November upon arrival from printer. Credit line given. Buys second reprint rights.

Tips "Send photos with brief cover letter describing the background of the sale. If sending more than one photo, make sure that photos are clearly identified. Slides should be enclosed in plastic slide sleeves, and prints should be reinforced with cardboard. Cannot return material if SASE is not included. Tearsheets will be considered disposable unless SASE is provided and return is requested. Because photos are printed in black & white on newsprint stock, some photos (especially color shots) may not reproduce well. Photos should have strong contrast and not too much fine detail that might be lost when printed. Being able to communicate via e-mail (not just snail mail and phone) is a plus."

Ⓝ $◨ Ⓢ ▣ PLAYERS PRESS INC.

P.O. Box 1132, Studio City CA 91614. **Contact:** David Cole, vice president. Estab. 1965. Publishes entertainment books including theater, film and television. Photos used for text illustrations, promotional materials, book covers, dust jackets. Examples of recently published titles: *Women's Wear for the 1930s* (text illustrations); *Period Costume for Stage & Screen* (text illustrations).

Needs Buys 50-1,000 photos/year. Needs photos of entertainers, actors, directors, theaters, productions, actors in period costumes, scenic designs and clowns. Reviews stock photos. Model release required for actors, directors, productions/personalities. Photo captions preferred for names of principals and project/production.

Specs Uses 8×10 glossy or matte b&w prints; 5×7 glossy color prints; 35mm, 2¼×2¼ transparencies. Accepts images in digital format. Send via Zip as TIFF files at 600 dpi.

Making Contact & Terms Send query letter with list of stock photo subjects. Send unsolicited photos by mail for consideration; include SASE for return of material. Responds in 3 weeks. Simultaneous submissions and previously published work OK. Pays $1-100 for b&w cover; $1-500 for color cover; by the project, $10-100 for cover shots; $1-50 for b&w and color inside; by the project, $10-100 for inside shots. Credit line sometimes given, depending on book. Buys all rights; negotiable in "rare cases."

Tips Wants to see "photos relevant to the entertainment industry. Do not telephone; submit only what we ask for."

◨ ▣ PRAKKEN PUBLICATIONS, INC.

832 Phoenix Dr., P.O. Box 8623, Ann Arbor MI 48107. (734)975-2800. Fax: (734)975-2787. Web site: http://techdirections.com or http://eddigest.com. **Contact:** Sharon K. Miller, art/design/production manager. Estab. 1934. Publishes *The Education Digest* (magazine), *Tech Directions* (magazine for technology and career/technical educators), text and reference books for technology and career/technical education. Photos used for text illustrations, promotional materials, book covers, magazine covers and posters. No photo guidelines available.

Needs Wants photos of education "in action," especially technology and career/technical education; prominent historical figures, technology/computers, industry. Photo captions required; include scene location, activity.

Specs Uses all media; any size. Accepts images in digital format. Send via CD, Jaz, Zip as TIFF, EPS, JPEG files at 300 dpi.

Making Contact & Terms Send query letter with samples. Send unsolicited photos by mail for consideration. Keeps samples on file. Payment negotiable. Methods of payment to be arranged. Credit line given. Rights negotiable.

Tips Wants to see "high-quality action shots in tech/career tech-ed classrooms" when reviewing portfolios. Send inquiry with relevant samples to be kept on file. "We buy very few freelance photographs but would be delighted to see something relevant."

$ ◨ Ⓢ PROSTAR PUBLICATIONS INC.

3 Church Circle, Suite 109, Annapolis MD 21401. (800)481-6277. Fax: (800)487-6277. E-mail: editor@prostarpublications.com. Web site: www.prostarpublications.com. **Contact:** Diana Hunter, associate editor. Estab. 1991. Publishes trade paperback originals (how-to, nonfiction). Subjects include history, nature, travel, nautical. Photos used for book covers. Examples of recently published titles: *The Age of Cunard*; *California's Channel Islands*; *Pacific Seaweeds*. Photo guidelines free with SASE.

Needs Buys less than 100 photos/year; offers very few freelance assignments/year. Reviews stock photos of nautical (sport). Prefers to review photos as part of a manuscript package. Model/property release required. Photo captions required.

Specs Uses color and/or b&w prints.

Making Contact & Terms Send query letter with stock list. Does not keep samples on file; include SASE for return of material. Responds in 1 month. Simultaneous submissions and previously published work OK. Pays $10-50 for color or b&w photos. Pays on publication. Credit line given. Buys book rights; negotiable.

$ ◨ ▣ 🌐 QUARTO PUBLISHING PLC.

The Old Brewery, 6 Blundell St., London N7 9BH United Kingdom. (44)(20)7700-6700. Fax: (44)(20)7700-4191. E-mail: PennyC@quarto.com. Web site: www.quartobooks.com. **Contact:** Penny Cobb, deputy art director. Estab. 1976. Publishes nonfiction books on a wide variety of topics including arts, crafts, natural history, home and garden, reference. Photos used for text illustrations, book covers, dust jackets. Examples of recently published titles: *The Color Mixing Bible*; *Garden Birds*; *The Practical Geologist*. Contact for photo guidelines.

Needs Buys 1,000 photos/year. Subjects vary with current projects. Needs photos of multicultural, environmental, wildlife, architecture, gardening, interiors/decorating, pets, religious, adventure, food/drink, health/fitness, hobbies, performing arts, sports, travel, product shots/still life, science, technology/computers. Interested in fashion/glamour, fine art, historical/vintage. Special photo needs include arts, crafts, alternative therapies, New Age, natural history. Model/property release required. Photo captions required; include full details of subject and name of photographer.

Specs Uses all types of prints. Accepts images in digital format. Send via CD, floppy disk, Zip, e-mail as TIFF, EPS, JPEG files at 72 dpi for viewing, 300 dpi for reproduction.

Making Contact & Terms Provide résumé, business card, samples, brochure, flier or tearsheets to be kept on file for future reference. Arrange a personal interview to show portfolio. Simultaneous submissions and previously published work OK. Pays $30-60 for b&w photos; $60-100 for color photos. Pays on publication. Credit line given. Buys one-time rights; negotiable.

Tips "Be prepared to negotiate!"

$ $ ◨ Ⓢ ▣ REIMAN MEDIA GROUP, INC.

5400 S. 60th St., Greendale WI 53129. Fax: (414)423-8463. E-mail: tbellin@reimanpub.com. Web site: www.reimanpub.com. **Contact:** Trudi Bellin, photo coordinator. Estab. 1965. Publishes consumer-cook-

ing, people-interest, gardening, nostalgia and country themes. Examples of recently published titles: *The Taste of Home Cookbook*; *America's Best Church Supper Recipes*; *Annual-2007 Birds & Blooms*.

Needs Buys 150 photos/year. Looking for food-related images showing at-home entertaining for all seasons, family dinners, couples cooking and dining, pot lucks, table settings, food as gifts; people and backyard beauty shots. Reviews stock photos of families, senior citizens, couples (30s-60s age range), social groups, rural, rural lifestyle, scenics, birds, flowers and flower gardens. "Conservative audience means few photos published with wine, liquor or smoking elements." Model/property release required. Photo captions preferred; include season, location.

Specs Uses color transparencies, any size. Accepts images in digital format: TIFF or high-quality JPEG files at 300 dpi for up to 9×11 reproduction. Embedded metadata is recommended. Send via lightboxes or on removable media. Or send CD/DVD with printed thumbnails and caption sheet. E-mail if first review selection is small (12 images or less).

Making Contact & Terms Send query letter with résumé of credits and stock list. Send unsolicited photos by mail for consideration. Keeps samples on file ("tearsheets, no duplicates"); include SASE for return of material. Responds in 3 months for first review. Simultaneous submissions and previously published work OK. Pays $300 for color cover; $100-300 for color inside. Pays on publication. Credit line given. Buys one-time rights (reprint and Web rights reserved).

Tips "Study our publications first. Keep our target audience in mind. Send well-composed and well-framed photos that are sharp and colorful. All images received on spec."

$ ☑ ⑤ ▣ SCHOLASTIC LIBRARY PUBLISHING

Grolier, 568 Broadway, New York NY 10012. Web site: www.scholastic.com/librarypublishing. **Contact:** Caroline Anderson, director of photography. Estab. 1829. Publishes 7 encyclopedias plus specialty reference sets in print and online versions. Photos used for text illustrations. Examples of published titles: *The New Book of Knowledge*; *Encyclopedia Americana*.

Needs Buys 5,000 images/year. Needs excellent-quality editorial photographs of all subjects A-Z and current events worldwide. All images must have clear captions and specific dates and locations, and natural history subjects should carry Latin identification.

Specs Uses 8×10 glossy b&w and/or color prints; 35mm, 4×5, 8×10 (reproduction-quality dupes preferred) transparencies. Accepts images in digital format. Send via photo CD, floppy disk, Zip as JPEG files at requested resolution.

Making Contact & Terms Send query letter, stock lists and printed examples of work. Cannot return unsolicited material and does not send guidelines. Include SASE only if you want material returned. Pricing to be discussed if/when you are contacted to submit images for specific project. Please note, encyclopedias are printed every year, but rights are requested for continuous usage until a major revision of the article in which an image is used (including online images).

Tips "Send subject lists and small selection of samples. Printed samples *only*, please. In reviewing samples, we consider the quality of the photographs, range of subjects, and editorial approach. Keep in touch, but don't overdo it—quarterly e-mails are more than enough for updates on subject matter."

$ ⑤ ▣ SCHOOL GUIDE PUBLICATIONS

210 North Ave., New Rochelle NY 10801. (800)433-7771, ext. 27. Fax: (914)632-3412. E-mail: mridder@schoolguides.com. Web site: www.schoolguides.com. **Contact:** Myles Ridder, publisher. Estab. 1886. Publishes mass market paperback originals. Photos used for promotional materials, book covers.

Needs Needs photos of college students.

Specs Accepts images in digital format; send via CD, Zip, e-mail as TIFF or JPEG files.

Making Contact & Terms E-mail query letter. **Pays on acceptance.**

$ ◻ ▣ SENTIENT PUBLICATIONS, LLC

1113 Spruce St., Boulder CO 80302. (303)443-2188. Fax: (303)381-2538. E-mail: cshaw@sentientpublications.com. Web site: www.sentientpublications.com. **Contact:** Connie Shaw, editor. Estab. 2001. Publishes trade paperback originals and reprints. Subjects include education, ecology, spirituality, travel, publishing, self-help, health, parenting. Photos used for book covers. Examples of recently published titles: *Mysteries of the Life Force, Roadsigns*. Catalog free with #10 SASE.

Needs Buys 8 freelance photos/year. Needs photos of babies/children/teens, landscape/scenics, religious. Interested in avant garde.

Specs Accepts images in digital format. Send via e-mail as TIFF files at 300 dpi.

Making Contact & Terms Send query letter with résumé, prints, photocopies, stock list. Provide self-promotion piece to be kept on file for possible future assignments. Responds only if interested; send nonreturnable samples. Simultaneous submissions and previously published work OK. Pays $100 maximum for color cover. Pays on publication. Credit line given. Buys one-time rights.

Tips "Look at our Web site for the kind of cover art we need."

$ $ 🅰 ▣ STRANG COMMUNICATIONS COMPANY

600 Rinehart Rd., Lake Mary FL 32746. (407)333-0600. Fax: (407)333-7100. E-mail: bill.johnson@strang.com. Web site: www.strang.com. **Contact:** Bill Johnson, marketing design director. Estab. 1975. Publishes religious magazines and books for Sunday School and general readership as well as gift books and children's books. Photos used for text illustrations, promotional materials, book covers, dust jackets. Examples of recently published titles: *Charisma Magazine*; *New Man Magazine*; *Ministries Today Magazine*; *Vida Cristiana* (all editorial, cover).

Needs Buys 75-100 photos/year; offers 75-100 freelance assignments/year. Needs photos of people, environmental portraits, situations. Reviews stock photos. Model/property release preferred for all subjects. Photo captions preferred; include who, what, when, where.

Specs Uses 8×10 prints; 35mm, $2^1/_4 \times 2^1/_4$, 4×5 transparencies. Accepts images in digital format for Mac (Photoshop). Send via CD, e-mail.

Making Contact & Terms Arrange a personal interview to show portfolio or call and arrange to send portfolio. Send query letter with samples. Provide résumé, business card, brochure, flier or tearsheets to be kept on file for possible future assignments. Works with freelancers on assignment only. Keeps samples on file. Simultaneous submissions and previously published work OK. Pays $5-75 for b&w photos; $50-550 for color photos; negotiable with each photographer. Pays on publication and receipt of invoice. Credit line given. Buys one-time, first-time, book, electronic and all rights; negotiable.

🖱 🅰 TILBURY HOUSE PUBLISHERS

2 Mechanic St., Suite 3, Gardiner ME 04345. (207)582-1899 or (800)582-1899. Fax: (207)582-8227. E-mail: tilbury@tilburyhouse.com. Web site: www.tilburyhouse.com. **Contact:** Jennifer Bunting, publisher. Subjects include children's books; New England; ships, boats and canoes. Photos used for text illustrations, book covers. Example of recently published titles: *Just for Elephants* (text illustrations, book cover) by Carol Buckley; *The Rangeley and Its Region* (text illustrations, book cover) by Stephen A. Cole. Catalog available for 6×9 SAE with 55¢ first-class postage.

Making Contact & Terms Pays by the project, or royalties based on book's wholesale price.

🖱 🅰 ▣ TRICYCLE PRESS

Ten Speed Press, P.O. Box 7123, Berkeley CA 94707. (510)559-1600. Fax: (510)559-1629. Web site: www.tricyclepress.com. **Contact:** The Editors. Estab. 1993. Publishes children's books, including board books, picture books, and books for middle readers. Photos used for text illustrations and book covers. Example of recently published titles: *Busy Barnyard* (photography by Steven Holt).

Needs Needs photos of children, multicultural, wildlife, performing arts, science.

Specs Uses 35mm transparencies; also accepts images in digital format.

Making Contact & Terms Responds only if interested; send nonreturnable samples. Pays royalties of $7^3/_4$-$8^3/_4$%, based on net receipts.

Tips "Tricycle Press is looking for something outside the mainstream; books that encourage children to look at the world from a different angle. Like its parent company, Ten Speed Press, Tricycle Press is known for its quirky, offbeat books. We publish high-quality trade books."

$ $ $ 🖱 ▣ TYNDALE HOUSE PUBLISHERS

351 Executive Dr., Carol Stream IL 60188. Web site: www.tyndale.com. **Contact:** Talinda Iverson, art buyer. Estab. 1962. Publishes hardcover and trade paperback originals. Subjects include Christian content. Photos used for promotional materials, book covers, dust jackets. Examples of recently published titles: Left Behind Series (book cover); *Red Rock Mysteries*—Youth Fiction Series. Photo guidelines with #10 SASE.

Needs Buys 5-20 freelance photos/year. Needs photos of babies/children/teens, couples, multicultural families, parents, senior citizens, landscapes/scenics, cities/urban, gardening, religious, rural, adventure, entertainment. Model/property release required.

Specs Accepts images in digital format.

Making Contact & Terms Send query letter with prints, tearsheets. Provide self-promotion piece to be kept on file for possible future assignments. Responds only if interested; send nonreturnable samples. Simultaneous submissions OK. Pays by the project; $200-1,750 for cover; $100-500 for inside. **Pays on acceptance**. Credit line given.

Tips "We don't have portfolio viewings. Negotiations are different for every project. Have every piece submitted with legible contact information."

$ ⬛ Ⓐ ▣ VICTORY PRODUCTIONS

55 Linden St., Worcester MA 01609. (508)755-0051. Fax: (508)755-0025. E-mail: susan.littlewood@victor yprd.com. Web site: www.victoryprd.com. **Contact:** Susan Littlewood. Publishes children's books. Examples of recently published titles: *OPDCA Readers* (text illustrations); *Ecos del Pasado* (text illustrations); *Enciclopedia Puertorriquena* (text illustrations).

Needs Needs a wide variety of photographs. "We do a lot of production for library reference and educational companies." Model/property release required.

Specs Accepts images in digital format. Send via CD, e-mail, floppy disk, Jaz, SyQuest, Zip as TIFF, GIF, JPEG files.

Making Contact & Terms Provide résumé, business card, brochure, flier or tearsheets to be kept on file for possible future assignments. Works on assignment only. Keeps samples on file. Responds in 1-2 weeks. Payment negotiable; varies by project. Credit line usually given, depending upon project. Rights negotiable.

VINTAGE BOOKS

Random House, 1745 Broadway, 20-2, New York NY 10019. (212)572-2444. Fax: (212)572-2662. **Contact:** John Gall, art director. Publishes trade paperback reprints; fiction. Photos used for book covers. Examples of recently published titles: *Selected Stories* by Alice Munro (cover); *The Fight* by Norman Mailer (cover); *Bad Boy* by Thompson (cover).

Needs Buys 100 freelance photos/year. Model/property release required. Photo captions preferred.

Making Contact & Terms Send query letter with samples, stock list. Portfolios may be dropped off every Wednesday. Keeps samples on file. Responds only if interested; send nonreturnable samples. Pays by the project, per use negotiation. Pays on publication. Credit line given. Buys one-time and first North American serial rights.

Tips "Show what you love. Include samples with name, address and phone number."

▣ ⬛ VISITOR'S CHOICE MAGAZINE

102 E. Fourth St., Vancouver BC V5T 1G2 Canada. (604)608-5180. Fax: (604)608-5181. E-mail: editor@vis itorschoice.com. Web site: www.visitorschoice.com. **Contact:** Shelley Ackerman, art director. Estab. 1977. Publishes full-color visitor guides for 16 communities and areas of British Columbia. Photos used for text illustrations, book covers, Web sites. Photo guidelines available via e-mail upon request.

Needs Looking for photos of attractions, mountains, lakes, views, lifestyle, architecture, festivals, people, sports and recreation—specific to British Columbia region. Specifically looking for people/activity shots. Model release required; property release preferred. Photo captions required—"detailed but brief."

Specs Uses color prints; 35mm transparencies. Prefers images in digital format.

Making Contact & Terms Send query letter or e-mail with samples; include SASE for return of material. Works with Canadian photographers. Keeps digital images on file. Responds in 3 weeks. Previously ublished work OK. Payment varies with size of photo published. Pays in 30-60 days. Credit line given.

s "Please submit photos that are relevant to our needs only. Photos should be specific, clear, artistic, rful, with good lighting."

▣ VOYAGEUR PRESS

lishing Company, 380 Jackson St., Suite 200, St. Paul MN 5510-3885. (651)287-5000. Fax: 001. E-mail: mlabarre@mbipublishing.com. Web site: www.mbipublishing.com or www.voy om. **Contact:** Publishing Assistant. Estab. 1972. Publishes adult trade books, hardcover origi- nts. Subjects include regional history, nature, popular culture, travel, wildlife, Americana, thouses, quilts, tractors, barns and farms. Photos used for text illustrations, book covers, ndars. Examples of recently published titles: *Legendary Route 66: A Journey Through a's Mother Road; Illinois Central Railroad; Birds in Love: The Secret Courting & Mating ry Birds; Backroads of New York; How to Raise Cattle; Knitknacks; Much Ado About*

Knitting; Farmall: The Red Tractor that Revolutionzed Farming; Backroads of Ohio; Farmer's Wife Baking Cookbook; John Deere Two-Cylinder Tractor Encyclopedia (text illustrations, book covers, dust jackets). Photo guidelines free with SASE.

● Voyageur Press is an imprint of MBI Publishing Company (see separate listing in this section).

Needs Buys 500 photos/year. Wants photos of wildlife, Americana, environmental, landscapes/scenics, cities/urban, gardening, rural, hobbies, humor, travel, farm equipment, agricultural. Interested in fine art, historical/vintage, seasonal. "Artistic angle is crucial—books often emphasize high-quality photos." Model release required. Photo captions preferred; include location, species, "interesting nuggets," depending on situation.

Specs Uses 35mm and large-format transparencies. Accepts images in digital format for review only; prefers transparencies for production. Send via CD, Zip, e-mail as TIFF, BMP, GIF, JPEG files at 300 dpi.

Making Contact & Terms Provide résumé of credits, samples, brochure, detailed stock list or tearsheets. Cannot return material. Responds only if interested; send nonreturnable samples. Simultaneous submissions OK. Pays $300 for cover; $75-175 for inside. Pays on publication. Credit line given, "but photographer's Web site will not be listed." Buys all rights; negotiable.

Tips "We are often looking for specific material (crocodile in the Florida Keys; farm scenics in the Midwest; wolf research in Yellowstone), so subject matter is important. However, outstanding color and angles and interesting patterns and perspectives are strongly preferred whenever possible. If you have the capability and stock to put together an entire book, your chances with us are much better. Though we use some freelance material, we publish many more single-photographer works. Include detailed captioning info on the mounts."

$ $ WARNER BOOKS

1271 Avenue of the Americas, 9th Floor, New York NY 10020. (212)522-2842. Fax: (212)522-7993. **Contact:** Anne Twomey, creative director. Publishes "everything but textbooks." Photos used for book covers and dust jackets.

Needs Buys approximately 100 freelance photos/year; offers approximately 30 assignments/year. Needs photos of landscapes, people, food still life, women and couples. Reviews stock photos. Model release required. Photo captions preferred.

Specs Uses color prints/transparencies; also some b&w and hand-tinting.

Making Contact & Terms Provide brochure, flier or tearsheets to be kept on file for possible future assignments. Cannot return unsolicited material. Simultaneous submissions and previously published work OK. Pays $800 minimum for color photos; $1,200 minimum/job. Credit line given. Buys one-time rights.

Tips "Printed and published work (color copies are OK, too) are very helpful. Do not call; we do not remember names—we remember samples. Be persistent."

$ ☑ Ⓢ ▣ WAVELAND PRESS, INC.

4180 IL Rt. 83, Suite 101, Long Grove IL 60047-9580. (847)634-0081. Fax: (847)634-9501. E-mail: info@waveland.com. Web site: www.waveland.com. **Contact:** Jan Weissman, photo editor. Estab. 1975. Publishes college textbooks. Photos used for text illustrations, book covers. Examples of recently published titles: *Our Global Environment: A Health Perspective, 6th Edition*; *Juvenile Justice, 2nd Edition*.

Needs Number of photos purchased varies depending on type of project and subject matter. Subject matter should relate to college disciplines: criminal justice, anthropology, speech/communication, sociology, archaeology, etc. Needs photos of multicultural, disasters, environmental, cities/urban, education, religious, rural, health/fitness, agriculture, political, technology. Interested in fine art, historical/vintage. Model/property release required. Photo captions preferred.

Specs Accepts images in digital format. Send via CD, Zip, e-mail as TIFF, EPS, JPEG files at 300 dpi.

Making Contact & Terms Send query letter with stock list. Provide résumé, business card, brochure, flier or tearsheets to be kept on file for possible future assignments. Simultaneous submissions and previously published work OK. Pays $50-200 for cover; $25-100 for inside. Pays on publication. Credit line given. Buys one-time and book rights.

Tips "Mail stock list and price list."

Ⓝ $☐ Ⓢ ▣ ⬙ WEIGL EDUCATIONAL PUBLISHERS LIMITED

6325 10th St. SE, Calgary AB T2H 2Z9 Canada. (403)233-7747. Fax: (403)233-7769. E-mail: leia.tait@weigl.com. Web site: www.weigl.com. **Contact:** Photo Research Department. Estab. 1979. Publishes text-

books, library and multimedia resources. Subjects include social studies, biography, life skills, environment/science studies, multicultural, language arts, geography. Photos used for text illustrations, book covers. Examples of recently published titles: *Land Mammals* (text illustrations, book cover); *Fossils* (text illustrations, book cover), *Opossums* (text illustrations, book cover); *Eiffel Tower* (text illustrations, book cover).

Needs Buys 2,000 photos/year. Needs photos of social issues and events, politics, celebrities, technology, people gatherings, multicultural, architecture, cities/urban, religious, rural, agriculture, disasters, environment, science, performing arts, life skills, landscape, wildlife, industry, medicine, biography and people doing daily activities, Canadiana, famous landmarks, aboriginal people. Interested in historical/vintage, seasonal. Model/property release required. Photo captions required.

Specs Prefers images in digital format. Send via CD, e-mail, FTP as TIFF files at 300 dpi. Uses 5×7, 8×10 color prints (b&w for historical only); 35mm, $2\frac{1}{4} \times 2\frac{1}{4}$ transparencies.

Making Contact & Terms Send query letter with stock list. Provide tearsheets to be kept on file for possible future assignments. "Tearsheets or samples that don't have to be returned are best. We get in touch when we actually need photos." Simultaneous submissions and previously published work OK. Pays $0-250 for color cover; $0-100 for color inside. Credit line given upon request (photo credits are listed in appendix). Buys one-time, book and all rights; negotiable.

Tips Needs "clear, well-framed shots that don't look posed. Action, expression, multicultural representation are important, but above all, educational value is sought. People must know what they are looking at. Please keep notes on what is taking place, where and when. As an educational publisher, our books use specific examples as well as general illustrations."

ℕ $⊘ ▣ WILLOW CREEK PRESS

P.O. Box 147, Minocqua WI 54548. (715)358-7010. Fax: (715)358-2807. E-mail: joyr@willowcreekpress.com. Web site: www.willowcreekpress.com. **Contact:** Joy Rasmussen, art director. Estab. 1986. Publishes hardcover, paperback and trade paperback originals; hardcover and paperback reprints; calendars and greeting cards. Subjects include pets, outdoor sports, gardening, cooking, birding, wildlife. Photos used for text illustrations, promotional materials, book covers, dust jackets, calendars and greeting cards. Examples of recently published titles: *Pug Mugs, Horse Wisdom, How to Work Like a Cat.* Catalog free with #10 SASE. Photo guidelines free with #10 SASE or on Web site.

Needs Buys 2,000 freelance photos /year. Needs photos of gardening, pets, outdoors, recreation, landscapes/scenics, wildlife. Model/property release required. Photo caption s preferred.

Specs Uses 35mm transparencies. Accepts images in digital format. Send via CD.

Making Contact & Terms Send query letter with sample of work. Provide self-promotion piece to be kept on file. Responds only if interested. "If you send slides, we will return them if a SASE is included." Simultaneous submissions and previously published work OK. Pays by the project. Pays on publication. Credit line given. Buys one-time rights.

Tips "CDs are hard to browse as quickly as a slide sheet or prints. Slides or transparencies are best, as the quality can be assessed immediately. Be patient. Communicate through e-mail."

$⊘ Ⓢ ▣ WILSHIRE BOOK COMPANY

9731 Variel Ave., Chatsworth CA 91311-4315. (818)700-1522. Fax: (818)700-1527. E-mail: mpowers@mpowers.com. Web site: www.mpowers.com. **Contact:** Melvin Powers, president. Estab. 1947. Publishes trade paperback originals and reprints. Photos used for book covers.

Needs Needs photos of horses. Model release required.

Specs Uses 35mm, $2\frac{1}{4} \times 2\frac{1}{4}$, 4×5 transparencies. Accepts images in digital format. Send via floppy disk, e-mail.

Making Contact & Terms Send query letter with slides, prints, transparencies. Portfolio may be dropped off Monday through Friday. Does not keep samples on file; include SASE for return of material. Responds in 6 weeks. Simultaneous submissions and previously published work OK. Pays $100-150 for color cover. **Pays on acceptance.** Credit line given.

Greeting Cards, Posters

& Related Products

The greeting card industry takes in close to $7.5 billion per year—80 percent through the giants American Greetings and Hallmark Cards. Naturally, these big companies are difficult to break into, but there is plenty of opportunity to license your images to smaller companies.

There are more than 2,000 greeting card companies in the United States, many of which produce low-priced cards that fill a niche in the market, focusing on anything from the cute to the risqué to seasonal topics. A number of listings in this section produce items like calendars, mugs and posters, as well as greeting cards.

Before approaching greeting card, poster or calendar companies, it's important to research the industry to see what's being bought and sold. Start by checking out card, gift and specialty stores that carry greeting cards and posters. Pay attention to the selections of calendars, especially the large seasonal displays during December. Studying what you see on store shelves will give you an idea of what types of photos are marketable.

Greetings etc., published by Edgell Publications, is a trade publication for marketers, publishers, designers and retailers of greeting cards. The magazine offers industry news and information on trends, new products, and trade shows. Look for the magazine at your library; call (973)895-3300, ext. 234 to subscribe, or visit their Web site: www.edgellcommunications. com/Greetings/. Also, the National Stationery Show (www.nationalstationeryshow.com) is a large trade show held every year in New York City. It is the main event of the greeting card industry.

APPROACHING THE MARKET

After your initial research, query companies you are interested in working with and send a stock photo list. (See sample stock list on page 19.) You can help narrow your search by consulting the Subject Index on page 503. Check the index for companies interested in the subjects you shoot.

Since these companies receive large volumes of submissions, they often appreciate knowing what is available rather than actually receiving samples. This kind of query can lead to future sales even if your stock inventory doesn't meet their immediate needs. Buyers know they can request additional submissions as their needs change. Some listings in this section advise sending quality samples along with your query while others specifically request only a list. As you plan your queries, follow the instructions to establish a good rapport with companies from the start.

Some larger companies have staff photographers for routine assignments but also look for freelance images. Usually, this is in the form of stock, and images are especially desirable

if they are of unusual subject matter or remote scenic areas for which assignments—even to staff shooters—would be too costly. Freelancers are usually offered assignments once they have established track records and demonstrated a flair for certain techniques, subject matter or locations. Smaller companies are more receptive to working with freelancers, though they are less likely to assign work because of smaller budgets for photography.

The pay in this market can be quite lucrative if you provide the right image at the right time for a client in need of it, or if you develop a working relationship with one or a few of the better-paying markets. You should be aware, though, that one reason for higher rates of payment in this market is that these companies may want to buy all rights to images. But with changes in the copyright law, many companies are more willing to negotiate sales that specify all rights for limited time periods or exclusive product rights rather than complete surrender of copyright. Some companies pay royalties, which means you will earn the money over a period of time based on the sales of the product.

$ $☑ ▣ ADVANCED GRAPHICS

447 E. Channel Rd., Benicia CA 94510. (707)745-5062. Fax: (707)745-5320. E-mail: jtenpenny@clbmedia. ca. Web site: www.advancedgraphics.com. **Contact:** John Tenpenny, editor. Estab. 1984. Specializes in life-size standups and cardboard displays, decorations and party supplies.
Needs Buys 20 images/year; number supplied by freelancers varies. Needs photos of celebrities (movie and TV stars, entertainers), babies/children/teens, couples, multicultural, families, parents, senior citizens, wildlife. Interested in seasonal. Reviews stock photos.
Specs Uses 4×5, 8×10 transparencies. Accepts images in digital format. Send via CD, Jaz, Zip, e-mail.
Making Contact & Terms Send query letter with stock list. Keeps samples on file. Responds in 1 month. Pays $400 maximum/image; royalties of 7-10%. Simultaneous submissions and previously published work OK. **Pays on acceptance.** Credit line given. Buys exclusive product rights; negotiable.
Tips "We specialize in publishing life-size standups which are cardboard displays of celebrities. Any pictures we use must show the entire person, head to toe. We must also obtain a license for each image that we use from the celebrity pictured or from that celebrity's estate. The image should be vertical and not too wide."

▣ ◫ ART IN MOTION

2000 Brigantine Dr., Coquitlam BC V3K 7B5 Canada. (604)525-3900 or (800)663-1308. Fax: (604)525-6166 or (877)525-6166. E-mail: artistrelations@artinmotion.com. Web site: www.artinmotion.com. **Contact:** Artist Relations. Specializes in open edition reproductions, framing prints, wall decor and licensing.
Needs "We are publishers of fine art reproductions, specializing in the decorative and gallery market. In photography, we often look for alternative techniques such as hand coloring, polaroid transfer, or any process that gives the photograph a unique look."
Specs Accepts unzipped digital images sent via e-mail as JPEG files at 72 dpi.
Making Contact & Terms Submit portfolio for review. Pays royalties of 10%. Royalties paid monthly. "Art In Motion covers all associated costs to reproduce and promote your artwork."
Tips "Contact us via e-mail, or direct us to your Web site; also send slides or color copies of your work (all submissions will be returned)."

☑ ▣ ARTVISIONS™: FINE ART LICENSING

12117 SE 26th St., Bellevue WA 98005-4118. E-mail "see Web site." Web site: www.artvisions.com. Estab. 1993. Licenses "fashionable, decorative fine art photography and high-quality art to the commercial print, décor and puzzle/game markets."
Needs Handles fine art and photography licensing only. *"We're not currently seeking new talent. However, we are always willing to view the work of top-notch established artists."*
Making Contact & Terms "See Web site. Not currently seeking new talent. However, we are always willing to view the work of top-notch established artists and photographers. If you fit this category, please contact ArtVisions via e-mail and include a link to a Web site where your art can be seen. Or, you may include a few small samples attached to your e-mail as JPEG files." Royalties are split 50/50. Exclusive worldwide representation for licensing is required. Written contract provided.

Tips "To gain an idea of the type of art we license, please view our Web site. Animals, children, people and pretty places should be generic, rather than readily identifiable (this also prevents potential copyright issues and problems caused by not having personal releases for use of a 'likeness'). We prefer that your original work be 4×5, or no smaller than $2\frac{1}{4}$ square format; high-resolution TIFF files from a 'pro-quality' digital camera are acceptable—resolution is NOT to be interpolated nor files compressed in any way."

$ $ ☑ ▣ AVANTI PRESS INC.

6 W. 18 St., 6th Floor, New York NY 10011. (212)414-1025. E-mail: artsubmissions@avantipress.com. Web site: www.avantipress.com. **Contact:** Art Submissions. Estab. 1980. Specializes in photographic greeting cards. Photo guidelines free with SASE or on Web site.

Needs Buys approximately 200 images/year; all are supplied by freelancers. Interested in humorous, narrative, colorful, simple, to-the-point photos of babies, children (4 years old and younger), mature adults, animals (in humorous situations) and exceptional florals. Has specific deadlines for seasonal material. Does NOT want travel, sunsets, landscapes, nudes, high-tech. Reviews stock photos. Model/ property release required.

Specs Will work with all mediums and formats. Accepts images in digital format. Send via CD as TIFF, JPEG files.

Making Contact & Terms Request guidelines for submission with SASE or visit Web site. DO NOT submit original material. Pays on license. Credit line given. Buys 5-year worldwide, exclusive card rights.

☑ Ⓐ ▣ BON ART/ARTIQUE/ART RESOURCES INT., LTD.

129 Glover Ave., Norwalk CT 06850-1311. (800)228-2989. E-mail: sales@fineartpublishers.com. Web site: www.fineartpublishers.com and www.artiq.com. **Contact:** Robin Bonnist, creative director. Estab. 1980. Licensing and design studio specializing in posters and open edition fine art prints.

Needs Buys 50 images/year. Needs artistic/decorative photos (not stock photos) of landscapes/scenics, wildlife, architecture, cities/urban, gardening, interiors/decorating, rural, adventure, health/fitness, extreme sports. Interested in fine art, cutting edge b&w, sepia photography. Model release required. Photo captions preferred.

Specs Accepts images in digital format with color proof. E-mail as TIFF, JPEG files at 300 dpi, or send link to your Web site.

Making Contact & Terms Send unsolicited photos by mail with SASE for consideration. Works on assignment only. Responds in 1 month. Simultaneous submissions and previously published work OK. Pays advance against royalties—specific dollar amount is subjective to project. Pays on publication. Credit line given if required. Buys all rights; exclusive reproduction rights.

Tips "Send us new and exciting material; subject matter with universal appeal. Submit color copies, slides, transparencies, actual photos of your work; if we feel the subject matter is relevant to the projects we are currently working on, we'll contact you."

☑ ▣ THE BOREALIS PRESS

P.O. Box 230, Surry ME 04684. (207)667-3700 or (800)669-6845. Fax: (207)667-9649. E-mail: info@boreal ispress.net. Web site: www.borealispress.net. **Contact:** Mark Baldwin or David Williams. Estab. 1989. Specializes in greeting cards, magnets and "other products for thoughtful people." Photo guidelines available for SASE.

Needs Buys more than 100 images/year; 90% are supplied by freelancers. Needs photos of humor, babies/children/teens, couples, families, parents, senior citizens, adventure, events, hobbies. Interested in documentary, historical/vintage, seasonal. Photos must tell a story. Model/property release preferred.

Specs Uses 5×7 to 8×10 prints; 35mm, $2\frac{1}{4} \times 2\frac{1}{4}$, 4×5, 8×10 transparencies. Accepts images in digital format. Send via CD. Send low-resolution files if e-mailing.

Making Contact & Terms Send query letter with slides (if necessary), prints, photocopies, SASE. Send no originals on initital submissions. "Photographer's name must be on every image submitted." Responds in 2 weeks to queries; 3 weeks to portfolios. Previously published work OK. Pays by the project, royalties. **Pays on acceptance**, receipt of contract. Credit line given.

Tips "Photos should have some sort of story, in the loosest sense. They can be in any form. We do *not* want multiple submissions to other card companies. Include SASE, and put your name on every image you submit."

Greeting Cards

$ ☑ ⑤ ▣ BRISTOL GIFT CO., INC.

P.O. Box 425, Washingtonville NY 10992. (845)496-2821. Fax: (845)496-2859. E-mail: bristol6@frontiern et.net. Web site: http://bristolgift.net. **Contact:** Matthew Ropiecki, president. Estab. 1988. Specializes in gifts.

Needs Interested in religious, nature, still life. Submit seasonal material 6 months in advance. Reviews stock photos. Model/property release preferred.

Specs Uses 4×5, 8×10 color prints; 4×5 transparencies. Accepts images in digital format. Send via CD, floppy disk, Zip, e-mail as TIFF, JPEG files.

Making Contact & Terms Send query letter with samples. Keeps samples on file. Responds in 1 month. Previously published work OK. Pays $50-200/image. Buys exclusive product rights.

$ ☐ ▣ CENTRIC CORPORATION

6712 Melrose Ave., Los Angeles CA 90038. (323)936-2100. Fax: (323)936-2101. E-mail: centric@juno.c om. Web site: www.centriccorp.com. **Contact:** Sammy Okdot, president. Estab. 1986. Specializes in gift products: gifts, t-shirts, clocks, watches, pens, pillows, mugs, frames, wallets.

Needs Photos of celebrities, environmental, wildlife, humor. Interested in humor and thought-provoking images. Submit seasonal material 5 months in advance. Reviews stock photos.

Specs Uses 8×12 color and/or b&w prints; 35mm transparencies. Accepts images in digital format. Send via CD as JPEG files.

Making Contact & Terms Submit portfolio for review or query with résumé of credits. Provide résumé, business card, self-promotion piece or tearsheets to be kept on file for possible future assignments. Responds in 2 weeks. Works mainly with local freelancers. Pays by the job; negotiable. **Pays on acceptance.** Rights negotiable.

$ ▣ COMSTOCK CARDS

600 S. Rock Blvd., Suite 15, Reno NV 89502. (775)856-9400. Fax: (775)856-9406. E-mail: info@comstockc ards.com. Web site: www.comstockcards.com. **Contact:** Production Assistant. Estab. 1986. Specializes in greeting cards, invitations, notepads, games, gift wrap. Photo guidelines free with SASE.

Needs Buys/assigns 30-40 images/year; all are supplied by freelancers. Wants wild, outrageous and shocking adult humor; seductive images of men or women. Definitely does not want to see traditional, sweet, cute, animals or scenics. "If it's appropriate to show your mother, we don't want it!" Frontal nudity in both men and women is OK and now being accepted as long as it is professionally done—no snapshot from home. Submit seasonal material 10 months in advance. Model/property release required. Photo captions preferred.

Specs Uses 5×7 color prints; 35mm, 2¼×2¼ color transparencies. Accepts images in digital format.

Making Contact & Terms Send query letter with samples, tearsheets, SASE. Responds in 2 months. Pays $50-150 for color photos. Pays on publication. Buys all rights; negotiable.

Tips "Submit with SASE if you want material returned."

$ ☑ ⑤ ▣ CONCORD LITHO

92 Old Turnpike Rd., Concord NH 03301. (603)225-3328 or (800)258-3662. Fax: (603)225-5503. E-mail: info@concordlitho.com. Web site: www.concordlitho.com. **Contact:** Art Librarian. Estab. 1958. Specializes in bookmarks, greeting cards, calendars, postcards, stationery and gift wrap. Photo guidelines free with SASE.

Needs Buys 150 images/year; 50% are supplied by freelancers. Rarely offers assignments. Needs photos of nature, seasonal, domestic animals, dogs and cats, religious, inspirational, florals and scenics. Also considers babies/children, multicultural, families, gardening, rural, business concepts, fine art. Submit seasonal material minimum 6-8 months in advance. Does not want nudes, comedy or humorous—nothing wild or contemporary. Model/property release required for historical/nostalgia, homes and gardens, dogs and cats. Photo captions preferred; include accurate information pertaining to image (location, dates, species, etc.).

Specs Uses 8×10 satin color prints; 35mm, 2¼×2¼, 4×5, 8×10 transparencies. Accepts images in digital format. Send via CD, e-mail as TIFF, EPS, PICT, GIF, JPEG files at 300 dpi (TIFF, EPS, JPEG).

Making Contact & Terms Submit samples/dupes for review along with stock list. Keeps samples/dupes on file. Response time may be as long as 6 months. Simultaneous submissions and previously published work OK. Pays by the project, $50-800. Pays on usage. Credit line sometimes given depending upon client and/or product. Buys one-time rights.

Tips "Send nonreturnable samples/color copies demonstrating skill and creativity, along with a complete-as-possible stock list. No phone calls, please."

DELJOU ART GROUP

1616 Huber St., Atlanta GA 30318. (404)350-7190. Fax: (404)350-7195. E-mail: submit@deljouartgroup.com. Web site: www.deljou.com. **Contact:** Daniel Deljou, president. Estab. 1980. Specializes in wall decor, fine art.

Needs All images supplied by freelancers. Specializes in artistic images for reproduction for high-end art market. Work sold through art galleries as photos or prints. Needs nature photos. Reviews stock photos of graphics, b&w photos. No tourist photos: only high-quality, artistic photos.

Specs Uses color and/or b&w prints; 35mm, $2\frac{1}{4} \times 2\frac{1}{4}$, 4×5, 8×10 transparencies. Accepts images in digital format. Prefers initial digital submissions via e-mail, but will accept CDs. Final, accepted images must be high-resolution, of at least 300 dpi.

Making Contact & Terms Submit portfolio for review; include SASE for return of material. Also send portfolio via e-mail. Responds in 1 month. Simultaneous submissions and previously published work OK. Pays royalties on sales. Credit line sometimes given depending upon the product. Rights negotiable.

Tips "Abstract-looking photographs OK. Hand-colored black & white photographs needed."

▣ DESIGN DESIGN, INC.

P.O. Box 2266, Grand Rapids MI 49501. (616)771-8359. Fax: (616)774-4020. E-mail: susan.birnbaum@designdesign.us. Web site: www.designdesign.us. **Contact:** Susan Birnbaum, creative director. Estab. 1986. Specializes in greeting cards and paper-related product development.

Needs Licenses stock images from freelancers and assigns work. Specializes in humorous topics. Submit seasonal material 1 year in advance. Model/property release required.

Specs Uses 35mm transparencies. Accepts images in digital format. Send via Zip.

Making Contact & Terms Submit portfolio for review. Provide résumé, business card, self-promotion piece or tearsheets to be kept on file for possible future assignments. Do not send original work. Pays royalties. Pays upon sales. Credit line given.

Ⓝ Ⓐ ▣ DODO GRAPHICS INC.

P.O. Box 585, Plattsburgh NY 12901. (518)561-7294. Fax: (518)561-6720. **Contact:** Frank How, president. Estab. 1979. Specializes in posters and framing prints.

Needs Buys 50-100 images/year; 100% are supplied by freelancers. Offers 25-50 assignments/year. Needs all subjects. Submit seasonal material 3 months in advance. Reviews stock photos. Model/property release preferred. Photo captions preferred.

Specs Uses color and/or b&w prints; 35mm, 4×5 transparencies; CD-ROMs.

Making Contact & Terms Submit portfolio for review. Send query letter with samples and stock list or CD-ROMs. Works on assignment only. Keeps samples on file. Responds in 1 month. Simultaneous submissions OK. Payment negotiable. **Pays on acceptance.** Credit line given. Buys all rights; negotiable.

$ $$ ☑ Ⓢ ▣ GALLANT GREETINGS CORP.

4300 United Parkway, Schiller Park IL 60176. (847)671-6500. Fax: (847)233-2499. E-mail: joanlackouitz@gallantgreetings.com. Web site: www.gallantgreetings.com. **Contact:** Joan Lackouitz, vice president/product development. Estab. 1966. Specializes in greeting cards.

Needs Buys vertical images; all are supplied by freelancers. Needs photos of landscapes/scenics, wildlife, gardening, pets, religious, automobiles, humor, sports, travel, product shots/still life. Interested in alternative process, avant garde, fine art. Submit seasonal material 1 year in advance. Model release required. Photo captions preferred.

Specs Accepts images in digital format. Send via CD, e-mail as TIFF files at 300 dpi. No slides accepted.

Making Contact & Terms Send query letter with photocopies. Provide self-promotion piece to be kept on file for possible future assignments. Responds in 8 weeks. Send nonreturnable samples. Pays by the project, approximately $300/image. Pays 30 days from receipt of invoice. Buys U.S. greeting card and allied product rights; negotiable.

◐ Ⓐ GRAPHIC ARTS CENTER PUBLISHING COMPANY

P.O. Box 10306, Portland OR 97296-0306. (503)226-2402, ext. 306. Fax: (503)223-1410. Web site: www.gacpc.com. **Contact:** Jean Bond-Slaughter, editorial assistant. "We are an independent book packager/producer."

Needs Photos of environment, regional, landscapes/scenics. "We only publish regionally focused books and calendars." Photo captions required.

Specs Contact the editorial assistant at the phone number above to receive permission to send in a submission. Upon acceptance, send bio, samples, 20-40 transparencies that are numbered, labeled with descriptions and verified in a delivery memo, return postage or a filled-out FedEx form. Responds in up to 4 months. Uses transparencies of any format, 35mm, $2^{1}/_4 \times 2^{1}/_4$, 4×5, but must be tack sharp and possess high reproductive quality; or submit equivalent digital files. "Our books/calendars usually represent one photographer. We use only full-time, professional photographers and/or well-established photographic businesses. New calendar/book proposals must have large market appeal and/or have corporate sale possibilities as well as fit our company's present focus."

☑ Ⓢ ▣ IMAGE CONNECTION AMERICA, INC.

456 Penn St., Yeadon PA 19050. (610)626-7770. Fax: (610)626-2778. E-mail: sales@imageconnection.biz. **Contact:** Michael Markowicz, president. Estab. 1988. Specializes in postcards, posters, bookmarks, calendars, gift wrap, greeting cards.

Needs Wants contemporary photos of babies/children/teens, celebrities, families, pets, entertainment, humor. Interested in alternative process, avant garde, documentary, erotic, fashion/glamour, fine art, historical/vintage. Model release required. Photo captions preferred.

Specs Uses 8×10 b&w prints; 35mm transparencies. Accepts images in digital format. Send via floppy disk, Zip as TIFF, EPS, PICT files.

Making Contact & Terms Send query letter with samples and SASE. Payment negotiable. Pays quarterly or monthly on sales. Credit line given. Buys exclusive product rights; negotiable.

☑ Ⓢ ▣ IMPACT PHOTOGRAPHICS

4961 Windplay Dr., El Dorado Hills CA 95762. (916)939-9333. Fax: (916)939-9334. Web site: www.impact photographics.com. Estab. 1975. Specializes in calendars, postcards, magnets, bookmarks, mugs, CD-ROMs, posters, books for the tourist industry. Photo guidelines and fee schedule free with SASE.

- This company sells to specific tourist destinations; their products are not sold nationally. They need material that will be sold for at least a 5-year period.

Needs Buys stock. Buys 3,000 photos/year. Needs photos of wildlife, scenics, US travel destinations, national parks, theme parks and animals. Submit seasonal material 4-5 months in advance. Model/property release required. Photo captions preferred.

Specs Uses 35mm, $2^{1}/_4 \times 2^{1}/_4$, 4×5, 8×10 transparencies. Accepts images in digital format. Send via CD, Zip as TIFF, JPEG files at 300 dpi.

Making Contact & Terms "Must have submissions request before submitting samples. No unsolicited submissions." Send query letter with stock list. Provide business card, self-promotion piece or tearsheets to be kept on file for possible future assignments. Responds in 1 month. Simultaneous submissions and previously published work OK. Request fee schedule; rates vary by size. Pays on usage. Credit line and printed samples of work given. Buys one-time and nonexclusive product rights.

▣ INNOVATIVE ART

(formerly Portal Publications, Ltd.), 100 Smith Ranch Rd., Suite 210, San Rafael CA 94903. (415)884-6200 or (800)227-1720. Fax: (415)382-3377. Web site: www.portalpub.com. **Contact:** Andrea Smith, senior art director. Estab. 1954. Specializes in greeting cards, calendars, posters, wall decor, framed prints. Photo guidelines free with SASE.

Needs Offers up to 400 or more assignments/year. Contemporary photography (florals, landscapes, b&w and hand-tinted b&w); nostalgia, nature and wildlife, endangered species, humorous, animal photography, scenic, inspirational, tinted b&w children's photography, still life, garden themes and dance; sports, travel, food and youth-oriented popular icons such as celebrities, movie posters and cars. "Nothing too risqué." Reviews stock photos. Model release required. Photo captions preferred.

Making Contact & Terms "No submission will be considered without a signed guidelines form, available on our Web site at www.portalpub.com/contact/ArtistSubmissionForm.pdf, or contact Robin O'Conner at (415)526-6362."

Tips "Ours is an increasingly competitive business, so we look for the highest quality and most unique imagery that will appeal to our diverse market of customers."

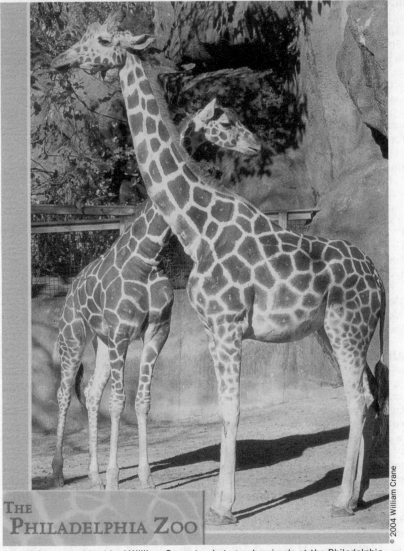

© 2004 William Crane

THE
PHILADELPHIA ZOO

Impact Photographics hired William Crane to photograph animals at the Philadelphia Zoo. This photo was one of 53 in a series.

$□ JILLSON & ROBERTS

3300 W. Castor St., Santa Anna CA 92704-3908. (714)424-0111. Fax: (714)424-0054. E-mail: shawn@jillso nroberts.com. Web site: www.jillsonroberts.com. **Contact:** Shawn K. Doll, creative director. Estab. 1974. Specializes in gift wrap, totes, printed tissues, accessories. Photo guidelines free with SASE.

Needs Needs vary. Specializes in everyday and holiday products. Themes include babies, sports, pets, seasonal, weddings. Submit seasonal material 3-6 months in advance.

Making Contact & Terms Submit portfolio for review or query with samples. Provide résumé, business card, self-promotion piece or tearsheets to be kept on file for possible future assignments. Responds in 3 weeks. Pays average flat fee of $250 or royalties.

Tips ''Please follow our guidelines!''

$ $🖰 ▣ BRUCE MCGAW GRAPHICS, INC.

389 W. Nyack Rd., West Nyack NY 10994. (845)353-8600. Fax: (845)353-8907 or (800)446-8230. E-mail: acquisitions@bmcgaw.com. Web site: www.bmcgaw.com. **Contact:** Katy Murphy, product development manager. Estab. 1979. Specializes in posters, framing prints, wall decor.

Needs Licenses 250-300 images/year in a variety of media; 10-15% in photography. Interested in b&w: still life, floral, figurative, landscape; color: landscape, still life, floral. Also considers celebrities, environmental, wildlife, architecture, rural, fine art, historical/vintage. Does not want images that are too esoteric or too commercial. Model/property release required for figures, personalities, images including logos or copyrighted symbols. Photo captions required; include artist's name, title of image, year taken. Not interested in stock photos.

Specs Uses color and/or b&w prints; 35mm, $2\frac{1}{4} \times 2\frac{1}{4}$, 4×5, 8×10 transparencies. Accepts images in digital format at 300 dpi.

Making Contact & Terms Submit portfolio for review. ''Review is typically 2 weeks on portfolio drop-offs. Be certain to leave phone number for pick up.'' Provide résumé, business card, self-promotion piece or tearsheets to be kept on file for possible future assignments. ''Do not send originals!'' Responds in 1 month. Simultaneous submissions and previously published work OK. Pays royalties on sales. Pays quarterly following first sale and production expenses. Credit line given. Buys exclusive product rights for all wall decor.

Tips ''Work must be accessible without being too commercial. Our posters/prints are sold to a mass audience worldwide who are buying art prints. Images that relate a story typically do well for us. The photographer should have some sort of unique style or look that separates him from the commercial market. It is important to take a look at our catalog or Web site before submitting work to get a sense of our aesthetic. You can view the catalog in any poster shop. We do not typically license traditional stock-type images—we are a decorative house appealing to a higher-end market. Send your best work (20-60 examples).''

$ $🖰 ▣ MODERNART EDITIONS

The Art Publishing Group, 165 Chubb Ave., Lyndhurst NJ 07071. (201)842-8500 or (800)760-3058. Fax: (201)842-8546. E-mail: modernarteditions@theartpublishinggroup.com. Web site: www.modernarteditions.com. **Contact:** Artist Submissions. Specializes in posters, wall decor, open edition fine art prints.

Needs Interested in b&w or sepia tone, seasonal, landscapes, seascapes, European scenes, floral still lifes, abstracts, cities, gardening, sports, fine art. Model/property release required.

Specs Uses 8×10 color and/or b&w prints; $2\frac{1}{4} \times 2\frac{1}{4}$, 4×5 transparencies. Accepts images in digital format. Send JPEG files for review via e-mail to submitart@theartpublishinggroup.com.

Making Contact & Terms Submit portfolio for review. Keeps samples on file. Include SASE for return of material. Simultaneous submissions OK. Responds within 2 months. Pays advance of $100-300 plus royalties of 10%. Pays on usage. Credit line given. Buys one-time, all, and exclusive product rights.

🖰 ▣ NEW YORK GRAPHIC SOCIETY PUBLISHING GROUP

129 Glover Ave., Norwalk CT 06850-1311. (800)677-6947. Fax: (203)846-2105. E-mail: donna@nygs.com. Web site: www.nygs.com. **Contact:** Donna Lavan, vice president of publishing. Estab. 1925. Specializes in fine art reproductions, prints, posters.

Needs Buys 150 images/year; 125 are supplied by freelancers. ''Looking for variety of images.''

Specs Uses 4×5 transparencies. Accepts images in digital format. Send via Zip, e-mail.

Making Contact & Terms Send query letter with samples to Attn: Artist Submissions. Does not keep samples on file; include SASE for return of material. Responds in 1 month. Payment negotiable. Pays on usage. Credit line given. Buys exclusive product rights.

Tips ''Submissions sent with cover letter, SASE, samples of work (prints, brochures, transparencies) are best. Images must be color correct.''

$ $🖰 ▣ NORS GRAPHICS

P.O. Box 143, Woolwich ME 04579. (207)442-7237. Fax: (207)442-8904. E-mail: norsman@care2.com. Web site: www.norsboat.com. **Contact:** Alexander Bridge, publisher. Estab. 1982. Specializes in limited edition prints, posters and stationery products.

Needs Buys 6 images/year; 50% are supplied by freelancers. Offers 6 assignments/year. Needs photos of sports. Interested in rowing/crew and sailing. Submit seasonal material 6-12 months in advance. Does

not want only rowing photos. Reviews stock photos of sports. Model release required. Photo captions preferred.

Specs Uses transparencies and digital files. Send via CD.

Making Contact & Terms Send query letter with samples. Keeps samples on file. Responds in 2 weeks. Pays by the project, $100-750/image plus royalties of 5-20%. Pays on usage. Credit line given. Buys all rights.

$ ◩ ▣ NOVA MEDIA INC.

1724 N. State St., Big Rapids MI 49307-9073. (231)796-4637. E-mail: trund@netonecom.net. Web site: www.novamediainc.com. **Contact:** Thomas J. Rundquist, president. Estab. 1981. Specializes in CD-ROMs, CDs/tapes, games, limited edition plates, posters, school supplies, T-shirts. Photo guidelines free with SASE.

Needs Buys 100 images/year; most are supplied by freelancers. Offers 20 assignments/year. Seeking art fantasy photos. Needs photos of children/teens, celebrities, multicultural, families, landscapes/scenics, education, religious, rural, entertainment, health/fitness/beauty, military, political, technology/computers. Interested in documentary, erotic, fashion/glamour, fine art, historical/vintage. Submit seasonal material 2 months in advance. Reviews stock photos. Model release required. Photo captions preferred.

Specs Uses color and/or b&w prints. Accepts images in digital format. Send via CD.

Making Contact & Terms Send query letter with samples. Accepts e-mail submissions. Responds in 1 month. Keeps samples on file; does not return material. Simultaneous submissions and previously published work OK. Payment negotiable. Pays extra for electronic usage of photos. Pays on usage. Credit line given. Buys electronic rights; negotiable.

Tips "The most effective way to contact us is by e-mail or regular mail. Visit our Web site."

▣ PALM PRESS, INC.

1442A Walnut St., Berkeley CA 94709. (510)486-0502. Fax: (510)486-1158. E-mail: theresa@palmpressinc.com. Web site: www.palmpressinc.com. **Contact:** Theresa McCormick, assistant art director. Estab. 1980. Specializes in greeting cards. Photo guidelines available on Web site.

Needs Buys only photographic images from freelancers. Buys 200 images/year. Wants photos of humor, nostalgia; unusual, interesting, original b&w or color images for all occasions including Christmas and Valentine's Day. Submit seasonal material 1 year in advance. Model/property release required.

Specs Uses prints, slides, transparencies. Accepts images in digital format. Send via e-mail as small JPEG, TIFF files.

Making Contact & Terms "SASE must be included for work to be returned." Responds in 3-4 weeks. Pays royalties on sales. Credit line given.

◩ ▣ PAPER PRODUCTS DESIGN

60 Galli Dr., Novato CA 94949. (415)883-1888. Fax: (415)883-1999. E-mail: carol@paperproductsdesign.com. Web site: www.paperproductsdesign.com. **Contact:** Carol Florsheim. Estab. 1992. Specializes in napkins, plates, candles, porcelain.

Needs Buys 500 images/year; all are supplied by freelancers. Needs photos of babies/children/teens, architecture, gardening, pets, food/drink, humor, travel. Interested in avant garde, fashion/glamour, fine art, historical/vintage, seasonal. Submit seasonal material 6 months in advance. Model release required. Photo captions preferred.

Specs Uses glossy color and/or b&w prints; 35mm, $2\frac{1}{4} \times 2\frac{1}{4}$, 4×5, 8×10 transparencies. Accepts images in digital format. Send via Zip, e-mail at 350 dpi.

Making Contact & Terms Send query letter with photocopies, tearsheets. Responds in 1 month to queries, only if interested. Simultaneous submissions and previously published work OK.

◩ Ⓢ ▣ PORTFOLIO GRAPHICS, INC.

P.O. Box 17437, Salt Lake City UT 84117. (801)424-2574. E-mail: info@portfoliographics.com. Web site: www.nygs.com. **Contact:** Kent Barton, creative director. Estab. 1986. Publishes and distributes open edition fine art prints and posters.

Needs Buys 100 images/year; nearly all are supplied by freelancers. Seeking creative, fashionable, and decorative art for commercial and designer markets. Clients include galleries, designers, poster distributors (worldwide) and framers. For posters, "keep in mind that we need decorative art that can be framed

and hung in home or office." Submit seasonal material on an ongoing basis. Reviews stock photos. Photo captions preferred.

Specs Uses prints, transparencies, digital files.

Making Contact & Terms Send photos, transparencies, tearsheets or gallery booklets with SASE. Does not keep samples on file; must include SASE for return of material. Art director will contact photographer for portfolio review if interested. Responds in 3 months. Pays royalties of 10% on sales. Semi-annual royalties paid per pieces sold. Credit line given. Buys exclusive product rights license per piece.

Tips "We find artists through galleries, magazines, art exhibits and submissions. We are looking for a variety of artists, styles and subjects that are fresh and unique."

$ $☑ ▣ ☒ POSTERS INTERNATIONAL

1180 Caledonia Rd., Toronto ON M6A 2W5 Canada. (416)789-7156. Fax: (416)789-7159. E-mail: dow@pif ineart.com. Web site: www.postersinternational.net. **Contact:** Dow Marcus, art director. Estab. 1976. Specializes in posters/prints. Photo guidelines available.

Needs Buys 200 images/year. Needs photos of landscapes/scenics, architecture, cities/urban, rural, hobbies, sports, travel. Interested in alternative process, avant garde, fine art, historical/vintage. Interesting effects, Polaroids, painterly or hand-tinted submissions welcome. Submit seasonal material 2 months in advance. Model/property release preferred. Photo captions preferred; include date, title, artist, location.

Specs Uses 8×10 prints; $2^{1}/_{4} \times 2^{1}/_{4}$, 4×5, 8×10 transparencies. Accepts images in digital format. Send via CD, Zip, e-mail as TIFF, JPEG files at 600 dipi.

Making Contact & Terms Send query letter with résumé, slides, prints, photocopies, tearsheets, transparencies, stock list. Provide business card, self-promotion piece to be kept on file for possible future assignments. Responds in 2 weeks to queries; 5 weeks to portfolios. Simultaneous submissions OK. Pays advance of $200 minimum/image plus royalties of 10% minimum. **Pays on acceptance** or publication. Buys worldwide rights for approximately 4-5 years to publish in poster form. Slides will be returned.

Tips "Keep all materials in contained unit. Provide easy access to contact information. Provide any information on previously published images. Submit a number of pieces. Develop a theme (we publish in series of 2, 4, 6, etc.). Black & white performs very well. Vintage is also a key genre; sepia great, too. Catalog is published with supplement 2 times/year. We show our images in our ads, supporting materials and Web site."

$ $☑ ⑤ ▣ REIMAN MEDIA GROUP, INC.

5400 S. 60th St., Greendale WI 53129. Fax: (414)423-8463. E-mail: tbellin@reimanpub.com. Web site: www.reimanpub.com. **Contact:** Trudi Bellin, photo coordinator. Estab. 1965. Specializes in calendars; also publishes books, cards and posters. Photo guidelines free with SASE.

• Also publishes magazines, several of which are listed in the Consumer Publications section of this book.

Needs Buys more than 350 images/year; all are supplied by freelancers. Interested in humorous cow and pig photos as well as scenic North American country images including barns, churches, cabins, waterfalls and lighthouses. Needs photos of landscapes/scenics, gardening, rural, travel, agriculture. Also needs backyard and flower gardens; wild birds, song birds (especially cardinals), hummingbirds; North American scenics by season; various cute baby animals plus kittens and puppies. All calendars reflect the seasons, even those that highlight animals. Interested in seasonal. Unsolicited calendar work must arrive September 1-15. All submissions must be limited to 40 images or less per calendar theme. No smoking, drinking, nudity. Reviews stock photos. Model/property release required. Photo captions required; include season, location; birds and flowers must include common and/or scientific names.

Specs Uses color transparencies, all sizes. Accepts images in digital format. Prefers you set up lightboxes for review, but accepts files on removable media, include files via CD or DVD with printed thumbnails and caption sheets. Embedded metadata is recommended. "Comp high-res files must be available." Published at 300 dpi for up to 11×13 reproduction.

Making Contact & Terms Send query letter with résumé of credits, stock list. Tearsheets are kept on file but not dupes. Responds in 3 months for first review. Simultaneous submissions and previously published work OK. Pays $25-400/image. Pays on publication. Credit line given. Buys one-time rights.

Tips "Most contributors have been published in our magazines first. Horizontal format is preferred for calendars. The subject of the calendar theme must be central to the photo composition. All projects look for technical quality. Focus has to be sharp (no soft focus), and colors must be vivid so they 'pop off the page.'"

$ $ [S] [■] RIGHTS INTERNATIONAL GROUP

500 Pateson Plank Road, Union City NJ 07087. (201)239-8118. Fax: (201)222-0694. E-mail: info@rightsint ernational.com. Web site: www.rightsinternational.com. **Contact:** Robert Hazaga, president. Estab. 1996. Licensing agency specializing in the representation of photographers and artists to manufacturers for licensing purposes. Manufacturers include greeting card, calendar, poster and home furnishing companies.

Needs Needs photos of architecture, entertainment, humor, travel, floral, coastal. "Globally influenced— not specific to one culture. Moody feel." See Web site for up-to-date needs. Reviews stock photos. Model/ property release required.

Specs Uses prints, slides, transparencies. Accepts images in digital format. Send via CD, e-mail as JPEG files.

Making Contact & Terms Submit portfolio for review. Keeps samples on file. Responds in 2 weeks. Simultaneous submissions and previously published work OK. Payment negotiable. Pays on license deal. Credit line given. Buys exclusive product rights.

$[] [S] [■] [⊕] SANGHAVI ENTERPRISES PVT. LTD.

D-24, M.I.D.C., Satpur, Nashik 422 007 India. (91)(253)235-0181. Fax: (91)(253)235-1381. E-mail: seplns k@sancharnet.in. **Contact:** H.L. Sanghavi, managing director. Estab. 1974. Specializes in greeting cards, calendars, school supplies, stationery.

Needs Buys approximately 30 images/year. Needs photos of babies/children/teens, couples, landscapes/ scenics, wildlife, gardening, pets. Interested in erotic. No graphic illustrations. Submit seasonal material any time throughout the year. Reviews stock photos.

Specs Uses any size color prints. Accepts images in digital format.

Making Contact & Terms Send query letter with samples. "Prefer nonreturnable copies; no originals, please. Send us duplicate photos, not more than 10 for selection." Responds in 1 month. Previously published work OK. Pays $30 maximum for color photos. Credit line given. Pays on publication.

[■] [⊕] SANTORO GRAPHICS LTD.

Rotunda Point, 11 Hartfield Crescent, Wimbledon, London SW19 3RL United Kingdom. (44)(208)781- 1100. Fax: (44)(208)781-1101. E-mail: fbostock@santorographics.com. Web site: www.santorographics. com. **Contact:** Faye Bostock, art director's assistant. Specializes in greeting cards, stationery, gift wrap, party supplies, school supplies.

Needs Wants "humorous, cute, retro, nostalgic and unusual pictures of animals, people and situations." Also interested in fine art imagery. "Do not submit seasonal material; we do not print it."

Specs Accepts images in digital format sent via CD or e-mail; glossy prints; 35mm transparencies.

Making Contact & Terms Send query letter/e-mail with CV, slides/prints/photocopies/digital files. Include SASE for return of material. **Pays on receipt of invoice.** Credit line not given. Rights and fees determined by negotiation.

$ $ [✐] [■] SPENCER GIFTS, LLC

6826 Black Horse Pike, Egg Harbor Twp. NJ 08234-4197. (609)645-5526. Fax: (609)645-5797. E-mail: james.stevenson@spencergifts.com. Web site: www.spencersonline.com. **Contact:** James Stevenson, senior graphic artist. Estab. 1965. Specializes in packaging design, full-color art, novelty gifts, brochure design, poster design, logo design, promotional P.O.P.

Needs Needs photos of babies/children/teens, couples, party scenes (must have releases), jewelry (gold, sterling silver, body jewelry—earrings, chains, etc.). Interested in fashion/glamour. Model/property release required. Photo captions preferred.

Specs Uses transparencies. Accepts images in digital format. Send via CD, DVD at 300 dpi.

Making Contact & Terms Send query letter with photocopies. Portfolio may be dropped off any weekday, 9-5. Provide self-promotion piece to be kept on file for possible future assignments. Responds only if interested; send *only* nonreturnable samples. Pays by the project, $250-850/image. **Pays on receipt of invoice.** Buys all rights; negotiable. Will respond upon need of services.

$[✐] [S] [✄] TELDON

Teldon Marketing Inc., 3500 Viking Way, Richmond BC V6V 1N6 Canada. (604)273-4500, ext. 266. Fax: (604)273-6100. E-mail: photo@teldon.com. Web site: www.teldon.com. **Contact:** Photo Editor. Estab. 1968. Publishes high-quality dated and nondated promotional products, including wall calendars, desk

calendars, magnets, newsletters, postcards, etc. Photo guidelines free with SAE (legal size)—waiting list applies.

Needs Buys over 1,000 images/year; 70% are supplied by freelancers. Needs photos of lifestyles (babies/children/teens, couples, multicultural, families, parents, senior citizens, wildlife (North American), architecture (exterior residential homes), gardening, interiors/decorating, adventure, sports, travel (world), motivational, inspirational, landscape/scenic. Reviews stock photos. Model/property release required for trademarked buildings, residential houses, people. Photo captions required; include complete detailed description of destination, i.e., Robson Square, Vancouver, British Columbia, Canada (month picture taken also helpful).

Specs Uses 35mm, medium- and large-format (horizontal only) transparencies. "We make duplicates of what we think is possible material and return the originals within a given time frame. Originals are recalled once final selection has been made. We do not accept digital submissions at this time."

Making Contact & Terms Send query letter or e-mail. "No submissions accepted unless guidelines have been received and reviewed." Include SAE and IRCs for return of material. Responds in 1 month, depending on workload. Simultaneous submissions and previously published work OK. Works with freelancers and stock agencies. Pays $150 for one-time use, non-negotiable. Pays in September of publication year. Credit line and complementary calendar copies given. Photos used for one-time use in dated products, North American rights, unlimited print runs.

Tips Send horizontal transparencies only; dramatic and colorful nature/scenic/wildlife shots. City shots should be no older than 1 year. "Examine our catalog on our Web site carefully, and you will see what we are looking for."

$ $ ⊘ Ⓢ ▣ TIDE-MARK PRESS

P.O. Box 20, Windsor CT 06095. (860)683-4499, ext. 107. Fax: (860)683-4055. E-mail: carol@tide-mark.com. Web site: www.tidemarkpress.com. **Contact:** Carol Powers, acquisitions editor. Estab. 1979. Specializes in calendars. Photo guidelines available on Web site or free with SASE.

Needs Buys 1,000 images/year; 800 are supplied by freelancers. Categories: landscapes/scenics, wildlife, architecture, gardening, interiors/decorating, pets, religious, adventure, automobiles, entertainment, events, food/drink, health/fitness, hobbies, humor, performing arts, sports, travel. Interested in fine art, historical/vintage; Native American; African American. Needs "complete calendar concepts that are unique but also have identifiable markets; groups of photos that could work as an entire calendar; ideas and approach must be visually appealing and innovative but also have a definable audience. No general nature or varied subjects without a single theme." Submit seasonal material 18 months in advance. Reviews stock photos. Model release preferred. Photo captions required.

Specs Uses 35mm transparencies. Accepts low-res images in EPS or JPEG format for initial review; send high-res only on selection.

Making Contact & Terms "Offer specific topic suggestions that reflect specific strengths of your stock." Send query letter with sample images; include SASE for return of material. Editor will contact photographer for portfolio review if interested. Responds in 3 months. Pays $150-350/color image for photos; royalties on net sales if entire calendar supplied. Pays on publication or per agreement. Credit line given. Buys one-time rights.

Tips "We tend to be a niche publisher and rely on niche photographers to supply our needs. Ask for a copy of our guidelines and a copy of our catalog so that you will be familiar with our products. Then send a query letter of specific concepts for a calendar."

$ $ ⊘ ▣ ZOLAN FINE ARTS, LLC

70 Blackman Rd., Ridgefield CT 06877. (203)431-1629. Fax: (203)431-2629. E-mail: donaldz798@aol.com. Web site: www.zolan.com. **Contact:** Jennifer Zolan, president/art director. Commercial and fine art business. Photos used for artist reference in oil paintings.

Needs Buys 16-24 images/year; assignments vary with need. Needs "candid, heartwarming and endearing photos of children (ages 1-3) with high emotional appeal, capturing the magical moments of early childhood." Interested in seasonal. "We are looking for Hispanic girls; Caucasion, Hispanic, Asian, and African-American kids in the following scenes: Hispanic kids in endearing scenes, ethnic children for inspirational themes, boys in country scenes with John Deere tractors, boys on the farm, boys fishing/hunting, girls at the beach, boys playing sports, children with pets, little girls in gardens and English garden scenes, little girls in farm scenes." Reviews stock photos. Model release preferred.

Specs Uses any size color and/or b&w prints. Prefers images in digital format. Send via e-mail, CD, Zip as TIFF, EPS, PICT, GIF, JPEG files at 72 dpi.

Making Contact & Terms Request photo guidelines by phone, mail, fax or e-mail. Does not keep samples on file; include SASE for return of material. Responds in 2 months to queries. Pays $300-1,000 "depending on the extent of photo shoot and if backgrounds are part of the assignment shoot." **Pays on acceptance**.

Tips "Photos should have high emotional appeal and tell a story. Photos should look candid and natural. Call or write for free photo guidelines before submitting your work. We are happy to work with amateur and professional photographers. We are always looking for human interest types of photographs on early childhood, ages 1-3. Photos should evoke pleasant and happy memories of early childhood. Photographers should write, e-mail or fax for guidelines before submitting their work. No submissions without receiving the guidelines."

© Werner Lobert

Werner Lobert contacted Tide-Mark Press to see if they were interested in his photos of riverboats. They used six of his images in a calendar, for which Lobert was paid $1,200. Lobert's advice to photographers: "Keep trying. If one door does not open, try another one. You will get your break."

Stock Photo Agencies

I f you are unfamiliar with how stock agencies work, the concept is easy to understand. Stock agencies house large files of images from contracted photographers and market the photos to potential clients. In exchange for licensing the images, agencies typically extract a 50-percent commission from each use. The photographer receives the other 50 percent.

In recent years, the stock industry has witnessed enormous growth, with agencies popping up worldwide. Many of these agencies, large and small, are listed in this section. However, as more and more agencies compete for sales, there has been a trend toward partnerships among some small to mid-size agencies. Other agencies have been acquired by larger agencies and essentially turned into subsidiaries. Often these subsidiaries are strategically located to cover different portions of the world. Typically, smaller agencies are bought if they have images that fill a need for the parent company. For example, a small agency might specialize in animal photographs and be purchased by a larger agency that needs those images but doesn't want to search for individual wildlife photographers.

The stock industry is extremely competitive, and if you intend to sell stock through an agency, you must know how they work. Below is a checklist that can help you land a contract with an agency.

- Build a solid base of quality images before contacting any agency. If you send an agency 50-100 images, they are going to want more if they're interested. You must have enough quality images in your files to withstand the initial review and get a contract.
- Be prepared to supply new images on a regular basis. Most contracts stipulate that photographers must send additional submissions periodically—perhaps quarterly, monthly or annually. Unless you are committed to shooting regularly, or unless you have amassed a gigantic collection of images, don't pursue a stock agency.
- Make sure all of your work is properly cataloged and identified with a file number. Start this process early so that you're prepared when agencies ask for this information. They'll need to know what is contained in each photograph so that the images can be properly keyworded on Web sites.
- Research those agencies that might be interested in your work. Smaller agencies tend to be more receptive to newcomers because they need to build their image files. When larger agencies seek new photographers, they usually want to see specific subjects in which photographers specialize. If you specialize in a certain subject area, be sure to check out our Subject Index on page 503, which lists companies according to the types of images they need.
- Conduct reference checks on any agencies you plan to approach to make sure they conduct business in a professional manner. Talk to current clients and other contracted

photographers to see if they are happy with the agency. Also, some stock agencies are run by photographers who market their own work through their own agencies. If you are interested in working with such an agency, be certain that your work will be given fair marketing treatment.

- Once you've selected a stock agency, contact them via e-mail or whatever means they have stipulated in their listing or on their Web site. Today, almost all stock agencies have Web sites and want images submitted in digital format. If the agency accepts slides, write a brief cover letter explaining that you are searching for an agency and that you would like to send some images for review. Wait to hear back from the agency before you send samples. Then send only duplicates for review so that important work won't get lost or damaged. Always include a SASE when sending samples by regular mail. It is best to send images in digital format; some agencies will only accept digital submissions.
- Finally, don't expect sales to roll in the minute a contract is signed. It usually takes a few years before initial sales are made.

SIGNING AN AGREEMENT

There are several points to consider when reviewing stock agency contracts. First, it's common practice among many agencies to charge photographers fees, such as catalog insertion rates or image duping fees. Don't be alarmed and think the agency is trying to cheat you when you see these clauses. Besides, it might be possible to reduce or eliminate these fees through negotiation.

Another important item in most contracts deals with exclusive rights to market your images. Some agencies require exclusivity to sales of images they are marketing for you. In other words, you can't market the same images they have on file. This prevents photographers from undercutting agencies on sales. Such clauses are fair to both sides as long as you can continue marketing images that are not in the agency's files.

An agency also may restrict your rights to sign with another stock agency. Usually such clauses are designed merely to keep you from signing with a competitor. Be certain your contract allows you to work with other agencies. This may mean limiting the area of distribution for each agency. For example, one agency may get to sell your work in the United States, while the other gets Europe. Or it could mean that one agency sells only to commercial clients, while the other handles editorial work. Before you sign any agency contract, make sure you can live with the conditions, including 40/60 fee splits favoring the agency.

Finally, be certain you understand the term limitations of your contract. Some agreements renew automatically with each submission of images. Others renew automatically after a period of time unless you terminate your contract in writing. This might be a problem if you and your agency are at odds for any reason. Make sure you understand the contractual language before signing anything.

REACHING CLIENTS

One thing to keep in mind when looking for a stock agent is how they plan to market your work. A combination of marketing methods seems the best way to attract buyers, and most large stock agencies are moving in that direction by offering catalogs, CDs and Web sites.

But don't discount small, specialized agencies. Even if they don't have the marketing muscle of big companies, they do know their clients well and often offer personalized service and deep image files that can't be matched by more general agencies. If you specialize in regional or scientific imagery, you may want to consider a specialized agency.

MICROSTOCK

A relatively new force in the stock photography business is microstock. The term microstock comes from the ''micro payments'' that these agencies charge their clients—often as little as

one dollar (the photographer gets only half of that), depending on the size of the image. Compare that to a traditional stock photo agency, where a rights-managed image could be licensed for hundreds of dollars, depending on the image and its use. Unlike the traditional stock agencies, microstock agencies are more willing to look at work from amateur photographers, and they consider their content "member generated." However, they do not accept all photos or all photographers; images must still be vetted by the microstock site before the photographer can upload his collection and begin selling. Microstock sites are looking for the lifestyle, people and business images that their traditional counterparts often seek. Unlike most traditional stock agencies, microstock sites offer no rights-managed images; all images are royalty free.

So if photographers stand to make only fifty cents from licensing an image, how are they supposed to make money from this arrangement? The idea is to sell a huge quantity of photos at these low prices. Microstock agencies have tapped into a budget-minded client that the traditional agencies have not normally attracted—the small business, nonprofit organization, and even the individual who could not afford to spend $300 for a photo for their newsletter or brochure. There is currently a debate in the photography community about the viability of microstock as a business model for stock photographers. Some say it is driving down the value of *all* photography and making it harder for all photographers to make a living selling their stock photos. While others might agree that it is driving down the value of photography, they say that microstock is here to stay and photographers should find a way to make it work for them or find other revenue streams to counteract any loss of income due to the effects of microstock. Still others feel no pinch from microstock: They feel their clients would never purchase from a microstock site and that they are secure in knowing they can offer their clients something unique. For more information on microstock, see the comments of stock photography consultant Paul H. Henning in the interview on page 37.

If you want to see how a microstock site works, see the following Web sites, which are some of the more prominent microstock sites. You'll find directions on how to open an account and start uploading photos.

www.shutterstock.com (http://submit.shutterstock.com/)

www.istockphoto.com (http://www.istockphoto.com/training_manuals.php)

www.bigstockphoto.com (http://bigstockphoto.com/core.php?predupload = 1)

www.fotolia.com (http://fotolia.com/Info/HowToSell)

www.dreamstime.com (http://www.dreamstime.com/sell)

DIGITAL IMAGING GUIDELINES AND SYSTEMS

The photography industry is in a state of flux as it grapples with the ongoing changes that digital imaging has brought. In an effort to identify and promote digital imaging standards, the Universal Photographic Digital Imaging Guidelines (UPDIG) were established. The objectives of UPDIG are to:

- make digital imaging practices more clear and reliable
- develop a Web resource for imaging professionals (including photo buyers, photographers and nonprofit organizations related to the photography industry)
- Demonstrate the creative and economic benefits of the guidelines to clients
- Develop industry guidelines and workflows for various types of image reproduction, including RAW file delivery, batch-converted files, color-managed master files, and CMYK with proofs.

To learn more about UPDIG, visit www.updig.org.

PLUS (Picture Licensing Universal System) is a cooperative, multi-industry initiative de-

Learn More About the Stock Industry

For More Info

There are numerous resources available for photographers who want to learn about the stock industry. Here are a few of the best.

- **PhotoSource International, (800)223-3860,** Web site: www.photosource.com. Owned by author/photographer Rohn Engh, this company produces several newsletters that can be extremely useful for stock photographers. A few of these include *PhotoStockNotes, PhotoDaily, PhotoLetter* and *PhotoBulletin.* Engh's *Sellphotos.com* (Writer's Digest Books) is a comprehensive guide to selling editorial stock photography online. Recently revised *Sell & Re-Sell Your Photos* (Writer's Digest Books) tells how to sell stock to book and magazine publishers.

- **Selling Stock, (301)251-0720,** Web site: www.pickphoto.com. This newsletter is published by one of the photo industry's leading insiders, Jim Pickerell. He gives plenty of behind-the-scenes information about agencies and is a huge advocate for stock photographers.

- *Negotiating Stock Photo Prices,* **5th edition,** by Jim Pickerell and Cheryl Pickerell DiFrank, 110 Frederick Avenue, Suite A, Rockville MD 20850, (301)251-0720. This is the most comprehensive and authoritative book on selling stock photography.

- **The Picture Archive Council of America, (800)457-7222,** Web site: www.pacaoffice.org. Anyone researching an American agency should check to see if the agency is a member of this organization. PACA members are required to practice certain standards of professionalism in order to maintain membership.

- **British Association of Picture Libraries and Agencies, (44)(171)713-1780,** Web site: www.bapla.org.uk. This is PACA's counterpart in the United Kingdom and is a quick way to examine the track record of many foreign agencies.

- *Photo District News,* Web site: www.pdn-pix.com. This monthly trade magazine for the photography industry frequently features articles on the latest trends in stock photography, and publishes an annual stock photography issue.

- *Stock Artists Alliance,* Web site: www.stockartistsalliance.org. This trade organization focuses on protecting the rights of independent stock photographers.

signed to define and categorize image usage around the world. It does not address pricing or negotiations, but deals solely with defining licensing language and managing license data so that photographers and those who license photography can work with the same systems and use the same language when licensing images. To learn more about PLUS, visit www.useplus.com.

MARKETING YOUR OWN STOCK

If you find the terms of traditional agencies unacceptable, there are alternatives available. Many photographers are turning to the Internet as a way to sell their stock images without an agent and are doing very well. Your other option is to join with other photographers sharing space on the Web. Check out PhotoSource International at www.photosource.com and www.agpix.com.

If you want to market your own stock, it is not absolutely necessary that you have your own Web site, but it will help tremendously. Photo buyers often "google" the keyword they're searching for—that is, they use an Internet search engine, keying in the keyword plus "photo." Many photo buyers, from advertising firms to magazines, at one time or another, either have found the big stock agencies too unwieldy to deal with, or they simply did not have exactly what the photo buyer was looking for. Googling can lead a photo buyer straight to your site; be sure you have adequate contact information on your Web site so the photo buyer can contact you and possibly negotiate the use of your photos.

One of the best ways to get into stock is to sell outtakes from assignments. The use of stock images in advertising, design and editorial work has risen in the last five years. As the quality of stock images continues to improve, even more creatives will embrace stock as an inexpensive and effective means of incorporating art into their designs. Retaining the rights to your assignment work will provide income even when you are no longer able to work as a photographer.

◪ ACCENT ALASKA/KEN GRAHAM AGENCY

P.O. Box 272, Girdwood AK 99587. (907)783-2796. Fax: (907)783-3247. E-mail: info@accentalaska.com. Web site: www.accentalaska.com. **Contact:** Ken Graham, owner. Estab. 1979. Stock agency. Has 300,000 photos in files. Clients include: advertising agencies, public relations firms, audiovisual firms, businesses, book publishers, magazine publishers, newspapers, calendar companies, greeting card companies, postcard publishers, CD-ROM encyclopedias.

Needs Wants modern stock images of Alaska, Antarctica, Hawaii and Pacific Northwest." Please do not submit material which we already have in our files."

Specs Uses images from digital cameras 6 megapixels or greater; 35mm, $2\frac{1}{4} \times 2\frac{1}{4}$, 4×5, 5×7, 617, 624, 4×10 transparencies. Send via CD, Zip, e-mail lightbox URL.

Payment & Terms Pays 50% commission for color photos. Negotiates fees at industry-standard prices. Works with photographers on contract basis only. Offers nonexclusive contract. Payment made quarterly.

Making Contact "See our Web site contact page. Any material must include SASE for returns." Expects minimum initial submission of 60 images. Prefers online Web gallery for initial review.

Tips "Realize we specialize in Alaska and the Northwest although we do accept images from Hawaii, Pacific, Antarctica and Europe. The bulk of our sales are Alaska-related. We are always interested in seeing submissions of sharp, colorful, and professional-quality images with model-released people when applicable. Do not want to see same material repeated in our library."

◪ ⊕ ACE STOCK LIMITED

Satellite House, 2 Salisbury Rd., Wimbledon, London SW19 4EZ United Kingdom. (44)(208)944-9944. Fax: (44)(208)944-9940. E-mail: info@acestock.com. Web site: www.acestock.com. **Contact:** John Panton, director. Estab. 1980. Stock photo agency. Has approximately 500,000 photos in files; over 65,000 online. Clients include: ad agencies, audiovisual firms, businesses, book/encyclopedia publishers, magazine publishers, postcard companies, calendar companies, greeting card companies, design companies, direct mail companies.

Needs Photos of babies/children/teens, couples, multicultural, families, parents, senior citizens, environmental, landscapes/scenics, wildlife, pets, adventure, automobiles, food/drink, health/fitness, hobbies, humor, sports, travel, business concepts, industry, medicine, product shots/still life, science, technology/computers. Interested in alternative process, avant garde, documentary, fashion/glamour, seasonal.

Specs "Under duress will accept 35mm, 6×6 cm, 4×5, 8×10 transparencies. Prefer digital submissions saved as RGB, JPEG, Photoshop 98 color space, Quality High. Scanning resolutions for low-res at 72 dpi and high-res at 300 dpi with 30MB minimum size. Send via CD-ROM, or e-mail low-res samples."

Payment & Terms Pays 50% commission on net receipts. Average price per image (to clients): $400.

Works with photographers on contract basis only. Offers limited regional exclusivity. Contracts renew automatically for 2 years with each submission. No charges for scanning. Charges $200/image for catalog insertion. Statements issued quarterly. Payment made quarterly. Photographers permitted to review sales records with 1-month written notice. Offers one-time rights, first rights or mostly nonexclusive rights. Informs photographers when client requests to buy all rights, but agency negotiates for photographer. Model/property release required for people and buildings. Photo captions required; include place, date and function. "Prefer data as IPTC-embedded within Photoshop File Info 'caption' for each scanned image."

Making Contact Send e-mail with low-res attachments or Web site link or FTP or send 50 sample transparencies. Alternatively, arrange a personal interview to show portfolio or post 50 sample transparencies. Responds within 1 month. Photo guidelines sheet free with SASE. Online tips sheet for contracted photographers.

Tips Prefers to see "definitive cross-section of your collection that typifies your style and prowess. Must show originality, command of color, composition and general rules of stock photography. All people must be mid-Atlantic to sell in UK. No dupes. Scanning and image manipulation is all done in-house. We market primarily online search engines and e-mail promos. In addition, we distribute printed catalogs and CD-ROMs."

AERIAL ARCHIVES

Hangar 23, Box 470455, San Francisco CA 94147-0455. (415)771-2555. Fax: (707)769-7277. E-mail: www.aerialarchives.com/contact.htm. Web site: www.aerialarchives.com. **Contact:** Herb Lingl. Estab. 1989. Has 100,000 photos in files, plus 500 gigabytes of digital aerial imagery. Has 2,000 hours of film, video footage. Clients include: advertising agencies, public relations firms, audiovisual firms, businesses, book publishers, magazine publishers, newspapers, calendar companies.

Needs Aerial photography only.

Specs Accepts images in digital format only, *unless they are historical*. Uses $2\frac{1}{4}\times2\frac{1}{4}$, 4×5, 9×9 transparencies; 70mm, 5" and 9×9 (aerial film). Other media also accepted.

Payment & Terms Buys photos, film, videotape outright only in special situations where requested by submitting party. Pays on commission basis. Average price per image (to clients): $325. Enforces minimum prices. Offers volume discounts to customers. Photographers can choose not to sell images on discount terms. Works with photographers on contract basis only. Statements issued quarterly. Payment made monthly. Photographers allowed to review account records in cases of discrepancies only. Offers one-time rights, electronic media rights, agency promotion rights. Informs photographers and allows them to negotiate when client requests all rights. Property release preferred. Photo captions required; include date and location, and altitude if available.

Making Contact Send query letter with stock list. Provide résumé, business card, self-promotion piece to be kept on file. Expects minimum initial submission of 100 images with quarterly submissions of at least 50 images. Responds only if interested; send nonreturnable samples. Photo guidelines sheet available via e-mail.

Tips "Supply complete captions with date and location; aerial photography only."

AGE FOTOSTOCK

Buenaventura Muñoz 16, 08018 Barcelona, Spain. (34)(93)300-2552. E-mail: agency@agefotostock.com (New York); age@agefotostock.com (Barcelona). Web site: www.agefotostock.com. Estab. 1973. Stock agency. There is a branch office in Madrid and a subsidiary company in New York City, age fotostock america, inc. Photographers may submitt their images to Barcelona directly or through the New York office at: age fotostock america, inc., 594 Broadway, Suite 707, New York NY 10012-3257. Clients include: advertising agencies, businesses, newspapers, postcard publishers, public relations firms, book publishers, calendar companies, audiovisual firms, magazine publishers, greeting card companies.

Needs "We are a general stock agency and are constantly uploading images onto our Web site. Therefore, we constantly require creative new photos from all categories."

Specs Accepts all formats. Details available upon request, or see Web site, "Photographers/submitting images."

Payment & Terms Pays 50% commission for all formats. Terms specified in photographer's contract. Works with photographers on contract basis only. Offers image exclusivity worldwide. Statements issued monthly. Payment made monthly. Photographers allowed to review account records. Model/property release required. Photo captions required.

Making Contact "Send query letter with résumé and 100 images for selection. Download the photographer's info pack from our Web site."

▣ AGSTOCKUSA INC.

25315 Arriba Del Mundo Dr., Carmel CA 93923. (831)624-8600. Fax: (831)626-3260. E-mail: info@agstockus.com. Web site: www.agstockusa.com. **Contact:** Ed Young, owner. Estab. 1996. Stock photo agency. Has 100,000 photos. Clients include: advertising agencies, graphic design firms, businesses, public relations firms, book/encyclopedia publishers, calendar companies, magazine publishers, greeting card companies.

Needs Photos should cover all aspects of agriculture worldwide: fruits, vegetables and grains in various growth stages; studio work, aerials; harvesting, processing, irrigation, insects, weeds, farm life, agricultural equipment, livestock, plant damage and plant disease.

Specs Uses 35mm, $2\frac{1}{4} \times 2\frac{1}{4}$, 4×5, 6×7, 6×17 transparencies. Accepts images in digital format. Send as high-res TIFF files.

Payment & Terms Pays 50% commission for color photos. Average price per image (to clients): $100-25,000 for color photos. Works with photographers on contract basis only. Offers nonexclusive contract. Contracts renew automatically with additional submissions for 2 years. Charges 50% Web site insertion fee. Statements issued monthly. Payment made monthly. Photographers allowed to review account records. Offers unlimited use and buyouts if photographer agrees to sale. Informs photographer when client requests all rights; final decision made by agency. Model/property release preferred. Photo captions required; include location of photo and all technical information (what, why, how, etc.).

Making Contact "Review our Web site to determine if work meets our standards and requirements." Submit low-res JPEGs on CD for review. Call first. Keeps samples on file; include SASE for return of material. Expects minimum initial submission of 250 images. Responds in 3 weeks. Photo guidelines available on Web site. Agency newsletter distributed yearly to contributors under contract.

Tips "Build up a good file (quantity and quality) of photos before approaching any agency. A portfolio of 16,000 images is currently displayed on our Web site. CD-ROM catalog with 7,600 images available to qualified photo buyers."

▣ AKM IMAGES, INC.

109 Bushnell Place, Mooresville, NC 28115. E-mail: um83@yahoo.com. Web site: www.akmimages.com. **Contact:** Annie-Ying Molander. Estab. 2002. Stock agency. Has over 30,000 photos in files. Clients include: advertising agencies, book publishers, magazine publishers, newspapers, calendar companies, greeting card companies, postcard publishers.

Needs Wants photos of agriculture, cities/urban, gardening, multicultural, religious, rural, landscapes/scenics, entertainment, wildlife, travel and underwater. "We also need landscape and culture from Asian countries, Nordic countries (Sweden, Norway, Finland), Alaska, Greenland, Iceland. Also need culture about Sami and Lapplander."

Specs Uses 4×6 glossy color prints; 35mm transperancies. Accepts images in digital format. Send via CD, DVD or slides with caption. We also accept slides/negatives.

Payment/Terms Pays 50% commission for color photos. Average price per image (to clients) varies for color photos. Terms specified in photographers' contracts. Works with photographers on contract basis only. Offers nonexclusive contract. Contracts renew automatically with each submission for 5 years from date of signed contract. When contracts ends photographer must renew within 60 days. To end contract photographer must give AKM Images, Inc. 60 days notice. Statements of photographers' sales issued quarterly. Payment made quarterly. Photographers allowed to review account records in cases of discrepancies only. Offers one-time rights. Model/property release required. Photo captions required.

Making Contact Send query letter by e-mail with images and stock list. Does not keep samples on file; include SASE for return of material. Expects minimum initial submissions of 100 images. Responds in 2 months to samples. Photo submission guidelines available free with SASE or via e-mail.

▣ ALASKA STOCK IMAGES

2505 Fairbanks St., Anchorage AK 99503. (907)276-1343. Fax: (907)258-7848. E-mail: info@alaskastock.com. Web site: www.alaskastock.com. **Contact:** Jeff Schultz, owner. Stock photo agency. Member of the Picture Archive Council of America (PACA) and ASMP. Has 350,000 photos in files. Clients include: international and national advertising agencies; businesses; magazines and newspapers; book/encyclopedia publishers; calendar, postcard and greeting card publishers.

Needs Wants photos of everything related to Alaska, including babies/children/teens, couples, multicultural, families, parents, senior citizens involved in winter activities and outdoor recreation, wildlife, environmental, landscapes/scenics, cities/urban, pets, adventure, travel, industry. Interested in alternative process, avant garde, documentary (images which were or could have been shot in Alaska), historical/vintage, seasonal, Christmas.

Specs Uses 35mm, 2×2, 4×5, 6×17 panoramic transparencies. Accepts images in digital format. Send via CD as JPEG files at 72 dpi for review purposes. "Put together a gallery of low-res images on your Web site and send us the URL, or send via PC-formatted CD as JPEG files no larger than 9×12 at 72 dpi for review purposes." Accepted images must be 50MB minimum shot as RAW originals.

Payment & Terms Pays 40% commission for color and b&w photos; minimum use fee $125. No charges for catalog, dupes, etc. Offers volume discounts to customers; inquire about specific terms. Photographers can choose not to sell images on discount terms. Works with photographers on contract basis only. Offers nonexclusive contract; exclusive contract for images in promotions. Contracts renew automatically with additional submissions; nonexclusive for 3 years. Statements issued monthly. Payment made monthly. Photographers allowed to review account records. Offers negotiable rights. Informs photographer and negotiates rights for photographer when client requests all rights. Model/property release preferred for any people and recognizable personal objects (boats, homes, etc.). Photo captions required; include who, what, when, where.

Making Contact Send query letter with samples. Does not keep samples on file; include SASE for return of material. Expects minimum initial submission of 200 images with periodic submissions of 100-200 images 1-4 times/year. Responds in 3 weeks. Photo guidelines free on request. Market tips sheet distributed 2 times/year to those with contracts. "View our guidelines online at www.alaskastock.com/prospect ivephotographers.asp."

Tips "E-mailed sample images should be sent in one file, not separate images. For photographers shooting digital images, Alaska Stock assumes that you are shooting RAW format and are able to properly process the RAW image to meet our 50MB minimum standards with acceptable color, contrast and density range."

⚙ ▣ ⊕ AMANA IMAGES INC.

(formerly Orian Press), 1-13 Kanda-Jimbocho, Chiyoda-ku, Tokyo 101 Japan. (81)(3)3295-1424. Fax: (81)(3)3295-1430. E-mail: info@amanaimages.com. **Contact:** Mr. Masa Takahashi. Estab. 1952. Stock photo agency. Member of the Picture Archive Council of America (PACA). Has 100,000 digital files and 700,000 photos in files. Has 3 branch offices in Osaka, Nagoya and Tokyo. Clients include: advertising agencies, public relations firms, businesses, book/encyclopedia publishers, magazine publishers, newspapers, postcard publishers, calendar companies, greeting card companies, and TV stations.

Needs Wants photos of babies/children/teens, celebrities, couples, multicultural, families, parents, senior citizens, disasters, environmental, landscapes/scenics, wildlife, architecture, cities/urban, education, gardening, interiors/decorating, pets, religious, rural, adventure, automobiles, entertainment, events, food/drink, health/fitness, hobbies, humor, performing arts, sports, travel, agriculture, business concepts, medicine, military, political, industry, product shots/still life, science, technology/computers. Interested in documentary, erotic, fashion/glamour, fine art, historical/vintage, seasonal.

Specs Uses 35mm, $2^{1}/_{4} \times 2^{1}/_{4}$ transparencies. Accepts images in digital format. Send via CD, FTP, e-mail as TIFF, JPEG files.

Payment & Terms Pays 60% commission for b&w and color photos. Average price per image (to clients): $120-500 for b&w photos; $200-800 for color photos. Enforces strict minimum prices. Offers volume discounts to customers; inquire about specific terms. Discount sales terms not negotiable. Works with photographers on contract basis only. Offers exclusive contract only. Contracts renew automatically with additional submissions for 2 years. Statements issued monthly. Payment made monthly. Photographers allowed to review account records. Offers one-time and electronic media rights. Model/property release required. Photo captions and keywords required.

Making Contact Send query letter with transparencies and SAE. Expects minimum initial submission of 100 images with periodic submissions of at least 200 images. Responds in 1 month. Photo guidelines and catalog free with SAE.

AMERICAN MUSEUM OF NATURAL HISTORY LIBRARY, PHOTOGRAPHIC COLLECTION

Library Services Department, Central Park West at 79th St., New York NY 10024. (212)769-5419. Fax: (212)769-5009. E-mail: speccol@amnh.org. Web site: www.amnh.org. **Contact:** Barbara Mathe, museum

archivist. Estab. 1869. Provides services for authors, film and TV producers, general public, government agencies, picture researchers, scholars, students, teachers and publishers.

Needs "We accept only donations with full rights (nonexclusive) to use; we offer visibility through credits." Model release required. Photo captions required.

Payment & Terms Credit line given. Buys all rights.

◻ ⊕ ANDES PRESS AGENCY

26 Padbury Ct., London E2 7EH United Kingdom. (44)(207)613-5417. Fax: (44)(207)739-3159. E-mail: apa@andespressagency.com. Web site: http://andespressagency.com. **Contact:** Val Baker. Picture library and news/feature syndicate. Has 300,000 photos in files. Clients include: magazine publishers, businesses, book publishers, nongovernmental charities, newspapers.

Needs Wants photos of multicultural, senior citizens, disasters, environmental, landscapes/scenics, architecture, cities/urban, education, religious, rural, travel, agriculture, business, industry, political. "We have color and black & white photographs on social, political and economic aspects of Latin America, Africa, Asia and Britain, specializing in contemporary world religions."

Specs Uses 35mm and digital files.

Payment & Terms Pays 50% commission for b&w and color photos. General price range (to clients): £60-300 for color photos. Works with photographers on contract basis only. Offers nonexclusive contract. Contracts renew with additional submissions. Statements issued bimonthly. Payment made bimonthly. Offers one-time rights. "We never sell all rights; photographer has to negotiate if interested." Model/property release preferred. Photo captions required.

Making Contact Send query via e-mail. Do not send unsolicited images.

Tips "We want to see that the photographer has mastered one subject in depth. Also, we have a market for photo features as well as stock photos. Please write to us first via e-mail."

◻ ANIMALS ANIMALS/EARTH SCENES

17 Railroad Ave., Chatham NY 12037. (800)392-5553 or (518)392-5500. Fax: (518)392-5503. E-mail: info@animalsanimals.com. Web site: www.animalsanimals.com. **Contact:** Nancy Carrizales. Member of Picture Archive Council of America (PACA). Has 1.5 million photos in files. Clients include: ad agencies, public relations firms, businesses, audiovisual firms, book publishers, magazine publishers, encyclopedia publishers, newspapers, postcard companies, calendar companies, greeting card companies.

Needs "We specialize in nature photography." Wants photos of disasters, environmental, landscapes/scenics, wildlife, pets, travel, agriculture.

Specs Uses 35mm, $2\frac{1}{4} \times 2\frac{1}{4}$, 4×5 transparencies. Accepts images in digital format.

Payment & Terms Pays 50% commission. Works with photographers on contract basis only. Offers exclusive contract. Charges catalog insertion fee. Photographers allowed to review account records to verify sales figures "if requested and with proper notice and cause." Statements issued quarterly. Payment made quarterly. Offers one-time rights; other uses negotiable. Informs photographers and allows them to negotiate when client requests all rights. Model release required if used for advertising. Photo captions required; include Latin names ("they must be correct!").

Making Contact Send query for guidelines by mail or e-mail. Expects minimum initial submission of 200 images with quarterly submissions of at least 200 images. Include SASE for return of material.

Tips "First, pre-edit your material. Second, know your subject."

◻ ⊕ ANT PHOTO LIBRARY

860 Derril Rd., Moorooduc, 3933 Australia. (61)(3)5978-8877. Fax: (61)(3)5978-8144. E-mail: images@antphoto.com.au. Web site: www.antphoto.com.au. **Contact:** Peter Crawley-Boevey. Estab. 1982. Has 170,000 photos in files, with 20,000 high-res files online. Clients include: advertising agencies, public relations firms, businesses, book publishers, magazine publishers, newspapers, calendar companies, greeting card companies, postcard publishers.

Needs Wants photos of "flora and fauna of Australia, Asia and Antarctica, and the environments in which they live."

Specs "Use digital camera files supplied as a minimum of 16-bit TIFF files from a minimun of 8-megapixel SLR digital camera. Full specs on our Web site."

Payment & Terms Pays 50% commission for color photos. Offers volume discounts to customers. Discount sales terms not negotiable. Works with photographers on contract basis only. Offers limited regional exclusivity. Statements issued quarterly. Payment made quarterly. Photographers allowed to review

account records in cases of discrepancies only. Model release required. Photo captions required; include species, common name and scientific name on supplied Excel spreadsheet.

Making Contact Send e-mail with 10 of your best images attached (images must be relevant to our needs). Expects minimum initial submission of 200 images with regular submissions of at least 100 images. Responds in 3 weeks to samples. Photo guidelines available on Web site. Market tips sheet "available to all photographers we represent."

Tips "Our clients come to us for images of all common and not-so-common wildlife species from around the world particularly. Good clean shots. Good lighting and very sharp."

ANTHRO-PHOTO FILE
33 Hurlbut St., Cambridge MA 02138. (617)868-4784. Fax: (617)497-7227. E-mail: ndevore@anthrophoto .com. Web site: www.anthrophoto.com. **Contact:** Nancy DeVore. Estab. 1969. Has 10,000 photos in files. Clients include: book publishers, magazine publishers.

Needs Wants photos of environmental, wildlife, social sciences.

Specs Uses b&w prints; 35mm transparencies. Accepts images in digital format.

Payment & Terms Pays 60% commission. Average price per image (to clients): $170 minimum for b&w photos; $200 minimum for color photos. Offers volume discounts to customers; discount terms negotiable. Works with photographers with contract. Contracts renew automatically. Statements issued annually. Payment made annually. Photographers allowed to review account records. Offers one-time rights. Informs photographers and allows them to negotiate when client requests all rights. Photo captions required.

Making Contact Send query letter with stock list. Keeps samples on file; include SASE for return of material.

Tips Photographers should call first.

▣ ⊕ A+E
9 Hochgernstr., Stein D-83371 Germany. Phone: (+49)8621-61833. Fax: (+49)8621-63875. E-mail: aplus e@aol.com. Web site: www.apluse.de. **Contact:** Elizabeth Pauli, director. Estab. 1987. Picture library. Has 30,000 photos in files. Clients include newspapers, postcard publishers, book publishers, calendar companies, magazine publishers.

Needs Wants photos of nature/landscapes/scenics, pets, "only your best material."

Specs Uses 35mm, 6×6 transparencies. Accepts images in digital format. Send via CD as JPEG files at 100 dpi for referencing purposes only.

Payment & Terms Pays 50% commission. Average price per image (to clients): $15-100 for b&w photos; $75-1,000 for color photos. Offers volume discounts to customers. Works with photographers on contract basis only. Offers nonexclusive contract. Subject exclusivity may be negotiated. Statements issued annually. Payment made annually. Photographers allowed to review account records in cases of discrepancies only. Offers one-time rights. Model/property release required. Photo captions preferred; include country, date, name of person, town, landmark, etc.

Making Contact Send query letter with your qualification, description of your equipment, transparencies or CD, stock list. Include SASE for return of material in Europe. Cannot return material outside Europe. Expects minimum initial submission of 100 images with annual submissions of at least 100 images. Responds in 1 month.

Tips "Judge your work critically. Technically perfect photos only—sharp focus, high colors, creative views—are likely to attract a photo editor's attention."

⊘ ▣ APPALIGHT
230 Griffith Run Rd., Spencer WV 25276. E-mail: wyro@appalight.com. Web site: www.appalight.com. **Contact:** Chuck Wyrostok, director. Estab. 1988. Stock photo agency. Has over 30,000 photos in files. Clients include advertising agencies, public relations firms, businesses, book/encyclopedia publishers, magazine publishers, calendar companies, greeting card companies, graphic designers.

• Currently not accepting submissions. This agency also markets images through the Photo Source Bank.

Needs General subject matter with emphasis on the people, natural history, culture, commerce, flora, fauna, and travel destinations of the Appalachian Mountain region and Eastern Shore of the United States. Wants photos of West Virginia, babies/children/teens, couples, multicultural, families, parents, senior citizens, disasters, environmental, landscapes, wildlife, cities/urban, education, gardening, pets, reli-

gious, rural, adventure, events, health/fitness, hobbies, humor, travel, agriculture, business concepts, industry, medicine, military, political, science, technology/computers. Interested in documentary, seasonal.

Specs Uses 8×10 glossy b&w prints; 35mm, $2\frac{1}{4} \times 2\frac{1}{4}$, 4×5 transparencies and digital images.

Payment & Terms Pays 50% commission for b&w or color photos. Works with photographers on nonexclusive contract basis only. Contracts renew automatically for 2-year period with additional submissions. Payment made quarterly. Photographers allowed to review account records during regular business hours or by appointment. Offers one-time rights, electronic media rights. Model release preferred. Photo captions required.

Making Contact AppaLight is not currently accepting submissions.

Tips ''We look for a solid blend of topnotch technical quality, style, content and impact. Images that portray metaphors applying to ideas, moods, business endeavors, risk-taking, teamwork and winning are especially desirable.''

ARCHIVO CRIOLLO

El comercio e8-113 y Shyris Building Andre, Main Floor, Quito, Ecuador. Phone/fax: (593)(2)2469-204. E-mail: info@archivocriollo.com. Web site: www.archivocriollo.com. **Contact:** Diana Santander, administrator. Estab. 1998. Picture library. Has 20,000 photos in files. Clients include: advertising agencies, businesses, newspapers, postcard publishers, calendar companies, magazine publishers, greeting card companies, travel agencies.

Needs Wants photos of multicultural, environmental, landscapes/scenics, wildlife, architecture, cities/urban, religious, rural, adventure, travel, art and culture, photo production, photo design, press photos. Interested in alternative process, documentary, fine art, historical/vintage.

Specs Uses 35mm transparencies. Accepts images in digital format. Send via CD, Zip, e-mail or FTP as JPEG files at 300 dpi, 11 inches.

Payment & Terms Pays 50% commission for color photos. Average price per image (to clients): $50-150 for color photos; $450-750 for videotape. Enforces minimum prices. Offers volume discounts to customers; terms specified in photographers' contracts. Photographers can choose not to sell images on discount terms. Works with photographers with or without a contract; negotiable. Offers nonexclusive contract. Charges 50% sales fee. Payment made quarterly. Photographers allowed to review account records. Informs photographers and allows them to negotiate when client requests all rights. Photo captions preferred.

Making Contact Send query letter with stock list. Responds only if interested. Catalog available.

ARGUS PHOTOLAND, LTD. (APL)

Room 2001-4 Progress Commercial Bldg., 9 Irving St., Causeway Bay, Hong Kong. (852)2890-6970. Fax: (852)2881-6979. E-mail: argus@argusphoto.com. Web site: www.argusphoto.com. **Contact:** Lydia Li, photo editor. Estab. 1992. Stock photo agency with branches in Beijing and Guangzhou. Has over 1 million searchable photos online. Clients include: advertising agencies, graphic houses, corporations, real estate developers, book and magazine publishers, postcard, greeting card, calendar and paper product manufacturers.

Needs ''We cover general subject matters with urgent needs of high-end lifestyle images, wellness, interior design, hospitality, garden design, Asian/Oriental people, and sports images. High quality feature stories welcome.''

Specs Accepts high-quality digital images only. Send 50MB JPEG files at 300 dpi via DVD/FTP for review. English captions and keywords required. Download with English captions and keywords.

Payment & Terms Pays 50% commission. Average price per image (to clients): $100-6,000. Offers volume discounts to customers. Works with photographers on contract basis only. Statements/payment made quarterly. Informs photographers and allows them to negotiate when client requests all rights. Model/property release may be required. Expects minimum initial submission of 200 images.

ARKRELIGION.COM

57 Burdon Lane, Cheam Surrey SM2 7BY United Kingdom. (44)(208)642-3593. Fax: (44)(208)395-7230. E-mail: images@artdirectors.co.uk. Web site: www.arkreligion.com. Estab. 2004. Stock agency. Has 100,000 photos in files. Clients include: advertising agencies, businesses, newspapers, postcard publishers, calendar companies, magazine publishers, greeting card companies.

Needs Wants photos of major, minor and alternative religions. This covers all aspects of religion from birth to death.

Specs Prefers digital submissions. Initial submission: 1MB JPEG. High-res requirement: 50MB TIFF. See contributors' page on Web site for full details. Uses 35mm, $2^{1}/_{4} \times 2^{1}/_{4}$, 4×5, 8×10 transparencies.

Payment & Terms Pays 50% commission for b&w or color photos when submitted digitally; pays 40% commission when film is submitted. Average price per image (to clients): $65-1,000 for b&w or color photos. Enforces strict minimum prices. Offers volume discounts to customers. Discount sales terms not negotiable. Works with photographers on contract basis only. Offers nonexclusive contract. Statements issued quarterly. Payment made quarterly. Photographers allowed to review account records in cases of discrepancies only. Offers one-time rights, electronic media rights. Model/property release preferred. Photo captions required; include as much relevant information as possible.

Making Contact Contact by e-mail. Does not keep samples on file. Expects minimum initial submission of 50 images with periodic submissions of at least 50 images. Responds in 6 weeks to queries. Photo guidelines available on Web site.

Tips "Fully caption material and follow the full requirements for digital submissions as detailed on the Web site. Will only accept slides/transparencies where these represent exceptional and/or difficult-to-obtain images."

ART DIRECTORS & TRIP PHOTO LIBRARY

57 Burdon Lane, Cheam Surrey SM2 7BY United Kingdom. (44)(208)642-3593. Fax: (44)(208)395-7230. E-mail: images@artdirectors.co.uk. Web site: www.artdirectors.co.uk. Estab. 1992. Stock agency. Has 1 million photos in files. Clients include: advertising agencies, businesses, newspapers, postcard publishers, public relations firms, book publishers, calendar companies, magazine publishers, greeting card companies.

Needs Wants photos of babies/children/teens, couples, multicultural, families, parents, senior citizens, disasters, environmental, landscapes/scenics, wildlife, architecture, cities/urban, education, gardening, interiors/decorating, pets, religious, rural, adventure, automobiles, entertainment, events, food/drink, health/fitness, hobbies, humor, performing arts, sports, travel, agriculture, business concepts, industry, medicine, military, political, product shots/still life, science, technology/computers. Interested in alternative process, avant garde, documentary, historical/vintage, seasonal.

Specs Prefers digital submissions. Initial submission: 1MB JPEG. High-res requirement: 50MB TIFF. See contributors' page on Web site for full details. Uses 35mm, $2^{1}/_{4} \times 2^{1}/_{4}$, 4×5, 8×10 transparencies.

Payment & Terms Pays 50% commission for b&w or color photos when submitted digitally; pays 40% commission when film is submitted. Average price per image (to clients): $65-1,000 for b&w or color photos. Enforces strict minimum prices. Offers volume discounts to customers. Discount sales terms not negotiable. Works with photographers on contract basis only. Offers nonexclusive contract. Statements issued quarterly. Payment made quarterly. Photographers allowed to review account records in cases of discrepancies only. Offers one-time rights, electronic media rights. Model/property release preferred. Photo captions required; include as much relevant information as possible.

Making Contact Contact by e-mail. Does not keep samples on file. Expects minimum initial submission of 50 images with periodic submissions of at least 50 images. Responds in 6 weeks to queries. Photo guidelines available on Web site.

Tips "Fully caption material and follow the full requirements for digital submissions as detailed on the Web site. Will only accept slides/transparencies where these represent exceptional and/or difficult-to-obtain images."

ART LICENSING INTERNATIONAL INC.

7350 S. Tamiami Trail, #227, Sarasota FL 34231. Estab. 1986. (941)966-8912. Fax: (941)966-8914. E-mail: artlicensing@comcast.net. Web site: www.artlicensinginc.com; www.licensingcourse.com; www.out-of-the-blue.us. **Contact:** Michael Woodward, president. Creative Director: Maureen May. Estab. 1986. "We represent artists, photographers and creators who wish to establish a licensing program for their work. We are particularly interested in photographic images that we can license internationally particularly for fine art posters, limited edition giclees for interior design projects and home and office decor."

Needs "We prefer concepts that have a unique look or theme and that are distinctive from the generic designs produced in-house by publishers and manufacturers. Images for prints and posters must be in pairs or sets of 4 or more with a regard for trends and color palettes related to the home décor and intererior design trends. Nature themes are of particular interest."

Payment & Terms "Our general commission rate is 50% with no expenses to the photographer as long as the photographer provides high-resolution scans."

Making Contact Send CD/photocopies, e-mail JPEGS or details of your Web site. Send SASE if you want material returned.

Tips "We require substantial portfolios of work that can generate good incomes, or concepts that have wide commerical appeal."

◾ ARTWERKS STOCK PHOTOGRAPHY

5045 Brennan Bend, Idaho Falls ID 83406. (208)523-1545. E-mail: photojournalistjerry@msn.com. **Contact:** Jerry Sinkovec, owner. Estab. 1984. News/feature syndicate. Has 100 million photos in files. Clients include: advertising agencies, public relations firms, businesses, book publishers, magazine publishers, calendar companies, postcard publishers.

Needs Wants photos of American Indians, ski action, ballooning, British Isles, Europe, Southwest scenery, disasters, environmental, landscapes/scenics, wildlife, adventure, events, food/drink, hobbies, performing arts, sports, travel, business concepts, industry, product shots/still life, science, technology/computers. Interested in documentary, fine art, historical/vintage, lifestyle.

Specs Uses 8×10 glossy color and/or b&w prints; 35mm, 2¼×2¼, 4×5 transparencies. Accepts images in digital format. Send via CD, Zip as JPEG files.

Payment & Terms Pays 50% commission. Average price per image (to clients): $125-800 for b&w photos; $150-2,000 for color photos; $250-5,000 for film and videotape. Negotiates fees below stated minimums depending on number of photos being used. Offers volume discounts to customers; terms not specified in photographers' contracts. Discount sales terms not negotiable. Works with photographers with or without a contract, negotiable. Offers nonexclusive contract. Charges 100% duping fee. Statements issued quarterly. Payment made quarterly. Offers one-time rights. Does not inform photographers or allow them to negotiate when a client requests all rights. Model/property release preferred. Photo captions preferred.

Making Contact Send query letter with brochure, stock list, tearsheets. Provide résumé, business card. Portfolios may be dropped off every Monday. Agency will contact photographer for portfolio review if interested. Portfolio should include slides, tearsheets, transparencies. Works with freelancers on assignment only. Does not keep samples on file; include SASE for return of material. Expects minimum initial submission of 20 images. Responds in 2 weeks. Catalog free with SASE.

◾ AURORA PHOTOS

20-36 Danforth St., Suite 216, Portland ME 04101. (207)828-8787. Fax: (207)828-5524. E-mail: info@auroraphotos.com. Web site: www.auroraphotos.com. **Contact:** José Azel, owner. Estab. 1993. Stock agency, news/feature syndicate. Member of the Picture Archive Council of America (PACA). Has 500,000 photos in files. Clients include: advertising agencies, businesses, book publishers, magazine publishers, newspapers, calendar companies, postcard publishers.

Needs Wants photos of babies/children/teens, celebrities, couples, multicultural, families, parents, senior citizens, disasters, environmental, landscapes/scenics, wildlife, architecture, cities/urban, education, rural, adventure, events, sports, travel, agriculture, industry, military, political, science, technology/computers.

Specs Accepts digital submissions only; contact for specs.

Payment & Terms Pays 50% commission for film. Average price per image (to clients): $225 minimum-$30,000 maximum. Offers volume discounts to customers. Works with photographers on image-exclusive contract basis only. Statements issued monthly. Payment made monthly. Photographers allowed to review account records once/year. Offers one-time rights, electronic media rights. Model/property release required. Photo captions required.

Making Contact Contact through Web site form. Does not keep samples on file; does not return material. Responds in 1 month. Photo guidelines available after initial contact.

Tips "Review our Web site closely. List area of photo expertise/interest and forward a personal Web site address where your photos can be found."

◾ THE BERGMAN COLLECTION

Division of Project Masters, Inc., P.O. Box AG, Princeton NJ 08542-0872. (609)921-0749. Fax: (609)921-6216. E-mail: information@pmiprinceton.com. Web site: http://pmiprinceton.com. **Contact:** Victoria B. Bergman, vice president. Estab. 1980 (Collection established in the 1930s.) Stock agency. Has 20,000

photos in files. Clients include: advertising agencies, book publishers, audiovisual firms, magazine publishers.

Needs "Specializes in medical, technical and scientific stock images of high quality and accuracy."

Specs Uses color and/or b&w prints; 35mm, $2\frac{1}{4} \times 2\frac{1}{4}$ transparencies. Accepts images in digital format. Send via CD, floppy disk, Zip, e-mail as TIFF, BMP, JPEG files.

Payment & Terms Pays on commission basis. Works with photographers on contract basis only. Offers one-time rights. Model/property release required. Photo captions required; must be medically, technically, scientifically accurate.

Making Contact "Do not send unsolicited images. Call, write, fax or e-mail to be added to our database of photographers able to supply, on an as-needed basis, specialized images not already in the collection. Include a description of the field of medicine, technology or science in which you have images. We contact photographers when a specific need arises."

Tips "Our needs are for very specific images that usually will have been taken by specialists in the field as part of their own research or professional practice. A good number of the images placed by The Bergman Collection have come from photographers in our database."

▣ BIOLOGICAL PHOTO SERVICE AND TERRAPHOTOGRAPHICS

P.O. Box 490, Moss Beach CA 94038. (650)359-6219. E-mail: bpsterra@pacbell.net. Web site: www.agpix. com/biologicalphoto. **Contact:** Carl W. May, photo agent. Stock photo agency. Estab. 1980. Has 80,000 photos in files. Clients include: ad agencies, businesses, book/encyclopedia publishers, magazine publishers.

Needs All subjects in the pure and applied life and earth sciences. Stock photographers must be scientists. Subject needs include: electron micrographs of all sorts; biotechnology; modern medical imaging; marine and freshwater biology; diverse invertebrates; organisms used in research; tropical biology; and land and water conservation. All aspects of general and pathogenic microbiology, normal human biology, petrology, volcanology, seismology, paleontology, mining, petroleum industry, alternative energy sources, meteorology and the basic medical sciences, including anatomy, histology, medical microbiology, human embryology and human genetics.

Specs Uses 4×5 through 11×14 glossy, high-contrast b&w prints for EM's; 35mm, $2\frac{1}{4} \times 2\frac{1}{4}$, 4×5, 8×10 transparencies. "Dupes acceptable for rare and unusual subjects, but we prefer originals." Welcomes images in digital format as 50-100MB TIFF files.

Payment & Terms Pays 50% commission for b&w and color photos. General price range (for clients): $75-500, sometimes higher for advertising uses. Works with photographers with or without a contract, but only as an exclusive agency. Photographers may market directly on their own, but not through other agencies or portals. Statements issued quarterly. Payment made quarterly; "one month after end of quarter." Photographers allowed to review account records to verify sales figures "by appointment at any time." Offers only rights-managed uses of all kinds; negotiable. Informs photographers and allows them veto authority when client requests a buyout. Model/property release required for photos used in advertising and other commercial areas. Thorough scientific photo captions required; include complete identification of subject and location.

Making Contact Interested in receiving work from newer, lesser-known scientific and medical photographers if they have the proper background. Send query letter with stock list, résumé of scientific and photographic background; include SASE for return of material. Responds in 2 weeks. Photo guidelines free with query, résumé and SASE. Tips sheet distributed intermittently to stock photographers only. "Nonscientists should not apply."

Tips "When samples are requested, we look for proper exposure, maximum depth of field, adequate visual information and composition, and adequate technical and general information in captions. Digital files should have image information in IPTC and EXIF fields. We avoid excessive overlap among our photographer/scientists. We are experiencing an ever-growing demand for photos covering environmental problems and solutions of all sorts—local to global, domestic and foreign. Our three greatest problems with potential photographers are: 1) inadequate captions; 2) inadequate quantities of *fresh* and *diverse* photos; 3) poor sharpness/depth of field/grain/composition in photos."

▣ ⊕ THE ANTHONY BLAKE PHOTO LIBRARY LTD.

20 Blades Court, Deodar Rd., London SW15 2NU United Kingdom. (44)(208)877-1123. Fax: (44)(208)877-9787. E-mail: anna@abpl.co.uk; info@abpl.co.uk. Web site: www.abpl.co.uk. **Contact:** Anna Weller.

Estab. 1980. Has 200,000 photos in files. Clients include: advertising agencies, businesses, book publishers, magazine publishers, newspapers, calendar companies, greeting card companies.

Needs Wants photos of food/drink. Other photo needs include people eating/drinking, vineyards (around the world).

Specs Accepts images in digital format. "Please contact us for the file type and size required."

Payment & Terms Pays 50% commission. Average price per image (to clients): $75-1,000 for film. Negotiates fees below standard minimum prices occasionally for bulk use. Offers volume discounts to customers. Discount sales terms not negotiable. Works with photographers on contract basis only. Guaranteed subject exclusivity (within files). Contracts renew automatically with additional submissions. Statements issued quarterly. Photographers allowed to review account records in cases of discrepancies only. Offers one-time rights. Informs photographers and allows them to negotiate when client requests all rights. Model release preferred. Photo captions preferred.

Making Contact Call first. Send slides, tearsheets, transparencies. Does not keep samples on file; include SASE for return of material. Expects minimum initial submission of 150 images. Responds in 1 month to samples. Photo guidelines available on Web site.

ⓝ ▣ BLEND IMAGES

1201 1st Ave. S., Suite 321B, Seattle WA 98134. (888)721-8810 or (206)621-8810. Fax: (206)749-9391. E-mail: creative@blendimages.com. Web site: www.blendimages.com. Estab. 2005. Stock agency. Clients include: advertising agencies, businesses, public relations firms, magazine publishers. Blend Images represents a "robust, high-quality collection of ethnically diverse lifesty and business imagery."

Needs Wants photos of babies/children/teens, couples, multicultural, families, parents, senior citizens, business concepts; interested in lifestyle. Photos must be ethnically diverse.

Specs Accepts images in digital format only. Images should be captured using professional-level DSLRs of 11+ megapixels, pro digital backs, or high-end scanners that can deliver the required quality. Final media should be 48-52 MB, 24-bit RGB (8 bits per channel), uncompressed TIFF files at 300 ppi. Images should be fully retouched, color corrected, and free from dust, dirt, posterization, artifacting or other flaws. Files should be produced in a color-managed environment with Adobe RGB 1998 as the desired color space.

Making Contact E-mail your photographic background and professional experience, along with 30-50 tightly edited, low-resolution PJEGs in one of the following ways: 1. URL with your personal Web site. 2. Web photo gallery. (Web galleries can be created using your imaging software. Reference your owner's manual for instructions.) 3. Spring-loaded hot link—a clickable link that provides downloadable JPEGs.

▣ THE BRIDGEMAN ART LIBRARY

65 E. 93rd St., New York NY 10128. (212)828-1238. Fax: (212)828-1255. E-mail: newyork@bridgemanart.com. Web site: www.bridgemanart.com. Estab. 1972. Member of the Picture Archive Council of America (PACA). Has 250,000 photos in files. Has branch offices in London, Paris and Berlin. Clients include: advertising agencies, public relations firms, audiovisual firms, businesses, book publishers, magazine publishers, newspapers, calendar companies, greeting card companies, postcard publishers.

Needs Interested in fine art.

Specs Uses 4×5, 8×10 transparencies and 50MB+ digital files.

Payment & Terms Pays 50% commission for color photos. Enforces minimum prices. Offers volume discounts to customers; terms specified in photographers' contracts. Discount sales terms not negotiable. Works with photographers on contract basis only. Charges 100% duping fee. Statements issued quarterly. Photographers allowed to review account records. Offers one-time rights, electronic media rights, agency promotion rights.

Making Contact Send query letter with photocopies, stock list. Does not keep samples on file; include SASE for return of material. Expects minimum initial submission of 20 images. Responds only if interested; send nonreturnable samples. Catalog available.

▣ ⊕ BSIP

34 Rue Villiers-de-l'Isle-Adam, Paris 75020 France. (33)(143)58-6987. Fax: (33)(143)58-6214. E-mail: international@bsip.com. Web site: www.bsip.com. **Contact:** Barbara Labous. Estab. 1990. Member of Coordination of European Picture Agencies Press Stock Heritage (CEPIC). Has 80,000 downloadable high-res images online. Clients include: advertising agencies, book publishers, magazine publishers, newspapers.

Needs Wants photos of environmental, food/drink, health/fitness, medicine, science, nature and animals.

Specs Accepts images in digital format only. Send via CD or DVD as TIFF files at 330 dpi, 11×7.33 inches.

Payment & Terms Pays 50% commission for color photos. Offers volume discounts to customers; terms specified in photographers' contracts. Discount sales terms not negotiable. Works with photographers with or without a contract; negotiable. Offers guaranteed subject exclusivity. Contracts renew automatically with additional submissions for 5 years. Statements issued monthly. Payment made monthly. Photographers allowed to review account records. Offers one-time rights, electronic media rights, agency promotion rights. Model release required. Photo captions required.

Making Contact Send query letter. Portfolio may be dropped off every Monday through Friday. Keeps samples on file. Expects minimum initial submission of 50 images with monthly submissions of at least 20 images. Responds in 1 week to samples; 2 weeks to portfolios. Photo guidelines sheet available on Web site. Catalog free with SASE. Market tips sheet available.

CALIFORNIA VIEWS/MR. PAT HATHAWAY HISTORICAL PHOTO COLLECTION

469 Pacific St., Monterey CA 93940-2702. (831)373-3811. E-mail: hathaway@caviews.com. Web site: www.caviews.com. **Contact:** Mr. Pat Hathaway, photo archivist. Estab. 1970. Picture library; historical collection. Has 80,000 b&w images; 10,000 35mm color images in files. Clients include: advertising agencies, public relations firms, audiovisual firms, book/encyclopedia publishers, magazine publishers, museums, postcard companies, calendar companies, television companies, interior decorators, film companies.

Needs Historical photos of California from 1855 to today, including disasters, landscapes/scenics, rural, agricultural, automobiles, travel, military, portraits, John Steinbeck and Edward F. Rickets.

Payment & Terms Payment negotiable. Offers volume discounts to customers.

Making Contact ''We accept donations of California photographic material in order to maintain our position as one of California's largest archives. Please do not send unsolicited images.'' Does not keep samples on file; cannot return material.

▣ ⊕ ⊡ CAPITAL PICTURES

85 Randolph Ave., London W9 1DL United Kingdom. (44)(207)286-2212. Fax: (44)(207)286-1218. E-mail: sales@capitalpictures.com. Web site: www.capitalpictures.com. Picture library. Has 800,000 photos in files. Clients include: advertising agencies, book publishers, magazine publishers, newspapers. Specializes in high-quality photographs of famous people (politics, royalty, music, fashion, film and television).

Needs ''We have a lot of clients looking for 'picture of the capital.' We need very high-quality images of London—postcard-type images for international sales. Not just large files, but great content—famous landmarks photographed at the best time, from the best angle, creating interesting and evocative images. Try looking on the Internet for pictures of London for some inspiration.''

Specs High-quality digital format only. Send via CD, e-mail as JPEG files.

Payment & Terms Pays 50% commission for b&w and color photos, film, videotape. ''We have our own price guide but will negotiate competitive fees for large quantity usage or supply agreements.'' Offers volume discounts to customers. Discount sales terms negotiable. Works with photographers with or without a contract; negotiable, whatever is most appropriate. No charges—only 50% commission for sales. Statements issued monthly. Payment made monthly. Photographers allowed to review account records. Offers any rights they wish to purchase. Informs photographers and allows them to negotiate when client requests all rights ''if we think it is appropriate.'' Photo captions preferred; include date, place, event, name of subject(s).

Making Contact Send query letter with samples. Agency will contact photographer for portfolio review if interested. Keeps samples on file. Expects minimum initial submission of 24 images with monthly submissions of at least 24 images. Responds in 1 month to queries.

▣ ⊡ CHARLTON PHOTOS, INC.

3605 Mountain Dr., Brookfield WI 53045. (262)781-9328. Fax: (262)781-9390. E-mail: jim@charltonphotos.com. Web site: www.charltonphotos.com. **Contact:** James Charlton, director of research. Estab. 1981. Stock photo agency. Has 475,000 photos; 200 hours of video. Clients include: ad agencies, public relations firms, audiovisual firms, businesses, book/encyclopedia publishers, magazine publishers, newspapers, calendar companies.

Needs "We handle photos of agriculture and pets."

Specs Uses color photos; 35mm, 2 ¼ transparencies, as well as digital. Also uses video.

Payment & Terms Pays 60/40% commission. Average price per image (to clients): $500-650 for color photos. Offers volume discounts to customers; terms specified in photographers' contracts. Works with photographers on contract basis only. Prefers exclusive contract, but negotiable based on subject matter submitted. Contracts renew automatically with additional submisions for 3 years minimum. Charges duping fee, 50% catalog insertion fee and materials fee. Statements issued monthly. Payment made monthly. Photographers allowed to review account records that relate to their work. Model/property release required for identifiable people and places. Photo captions required; include who, what, when, where.

Making Contact Query by phone before sending any material. Expects initial submission of 1,000 images. Responds in 2 weeks. Photo guidelines free with SASE. Market tips sheet distributed quarterly to contract freelance photographers; free with SASE.

Tips "Provide our agency with images we request by shooting a self-directed assignment each month. Visit our Web site."

■ CHINASTOCK

2506 Country Village, Ann Arbor MI 48103-6500. (734)996-1440. Fax: call for number. E-mail: decoxphoto @aol.com. Web site: www.denniscox.com. **Contact:** Dennis Cox, director. Estab. 1993. Stock photo agency. Has 60,000 photos in files. Has branch office in Beijing, China. Clients include: advertising agencies, public relations firms, book/encyclopedia publishers, magazine publishers, newspapers, calendar companies.

Needs Handles only photos of China (including Hong Kong and Taiwan), including tourism. Wants photos of babies/children/teens, celebrities, couples, multicultural, families, parents, senior citizens, disasters, environmental, landscapes/scenics, wildlife, architecture, cities/urban, education, gardening, pets, religious, rural, automobiles, entertainment, events, food/drink, health/fitness/beauty, performing arts, sports, travel, agriculture, industry, medicine, military, political, science, technology/computers, cultural relics. Interested in documentary, historical/vintage. Needs hard-to-locate photos and exceptional images of tourism subjects.

Specs Uses 35mm, 2×2 transparencies, high-res digital files.

Payment & Terms Pays 50% commission for b&w and color photos. Average price per image (to clients): $125 minimum for b&w and color photos. Occasionally negotiates fees below standard minimum prices. "Prices are based on usage and take into consideration budget of client." Offers volume discounts to customers. Costs are deducted from resulting sales. Photographers can choose not to sell images on discount terms. Works with photographers with or without a signed contract. "Will negotiate contract to fit photographer's and agency's mutual needs." Payment made quarterly. Photographers allowed to review account records. Offers one-time rights and electronic media rights. Informs photographers and allows them to negotiate when client requests all rights. Model/property release preferred. Photo captions required; include where image was shot and what is taking place.

Making Contact Send query letter with stock list. "Let me know if you have unusual material." Keeps samples on file; include SASE for return of material. Agency is willing to accept 1 great photo and has no minimum submission requirements. Responds in 2 weeks. Market tips sheet available upon request.

Tips Agency "represents mostly veteran Chinese photographers and some special coverage by Americans. We're not interested in usual photos of major tourist sites. We have most of those covered. We need more photos of festivals, modern family life, joint ventures, and all aspects of Hong Kong and Taiwan."

■ BRUCE COLEMAN PHOTO LIBRARY

Bruce Coleman, Inc., 111 Brook St., 2nd Floor, Scarsdale NY 10583. (914)713-4821. Fax: (914)722-8347. E-mail: library@bciusa.com. Web site: www.bciusa.com. **Contact:** Norman Owen Tomalin, photo director. Estab. 1970. Stock photo agency. Has more than 1.75 million photos on file. Clients include: advertising agencies, public relations firms, audiovisual firms, businesses, book/encyclopedia publishers, magazine publishers, newspapers, postcard publishers, calendar companies, greeting card companies, zoos (installations), TV.

Needs Wants photos of babies/children/teens, couples, multicultural, families, parents, senior citizens, disasters, environmental, landscapes/scenics, wildlife, architecture, cities/urban, pets, rural, adventure, hobbies, sports, travel, agricultural, business concepts, industry, product shots/still life, science, technology/computers.

Specs Accepts images in digital format.

Payment & Terms Pays 50% commission for color transparencies, digital files and b&w photos. Average price per image (to clients): $125 minimum for color and b&w photos. Contracts renew automatically for 5 years. Statements issued quarterly. Payment made quarterly. Does not allow photographer to review account records; any deductions are itemized. Offers one-time rights. Model/property release preferred for people, private property. Photo captions required; include location, species, genus name, Latin name, points of interest.

Making Contact Send e-mail query with résumé and URL link or a CD portfolio. "A portfolio can be uploaded to our FTP server." Photo guidelines and technical specs available online.

Tips "We look for strong dramatic angles, beautiful light, sharpness. We like photos that express moods/feelings and show us a unique eye/style. We like work to be properly captioned; the digital file should contain all vital information regarding the photograph. We are asking for natural settings, dramatic use of light and/or angles. Photographs should not be contrived and should express strong feelings toward the subject. We advise photographers to shoot a lot and edit carefully, photograph what they really love, and follow our want lists."

CORBIS

902 Broadway, 3rd Floor, New York NY 10010. (212)777-6200. Fax: (212)533-4034. Web site: www.corbis .com. Estab. 1991. Stock agency, picture library, news/feature syndicate. Member of the Picture Archive Council of America (PACA). Corbis also has offices in London, Paris, Dusseldorf, Tokyo, Seattle, Chicago and Los Angeles. Clients include: advertising agencies, businesses, newspapers, public relations firms, book publishers, calendar companies, audiovisual firms, magazine publishers, greeting card companies, businesses/corporations, media companies.

Making Contact "Please check "About Corbis" on our Web site for current submission information."

◪ ⊕ SYLVIA CORDAIY LIBRARY LTD.

45 Rotherstone, Devizes, Wilshire SN10 2DD United Kingdom. (44)01380728327. Fax: (44)01380728328. E-mail: info@sylvia-cordaiy.com. Web site: www.sylvia-cordaiy.com. Estab. 1990. Stock photo agency. Has 800,000 images in files. Clients include: advertising agencies, public relations firms, audiovisual firms, businesses, book publishers, magazine publishers, newspapers, calendar companies, greeting card companies, postcard publishers.

Needs Wants photos of worldwide travel, wildlife, disasters, environmental issues. Specialist files include architecture, the polar regions, ancient civilizations, natural history, flora and fauna, livestock, domestic pets, veterinary, equestrian and marine biology, London and UK, transport railways, shipping, aircraft, aerial photography. Also interested in babies/children/teens, couples, multicultural, families, parents, senior citizens, architecture, cities/urban, education, gardening, pets, religious, rural, adventure, sports, travel, agriculture, industry, military, product shots/still life, science, technology/computers. Interested in documentary, historical/vintage, seasonal. Handles the Paul Kaye archive of 20,000 b&w prints.

Specs Uses 35mm, medium- and large-format transparencies. Accepts images in digital format. Send via CD/DVD.

Payment & Terms Pays 50% commission for b&w and color images. Pay "varies widely according to publisher and usage." Offers volume discounts to customers. Works with photographers with or without a contract, negotiable. Offers nonexclusive contract, limited regional exclusivity. Charges for return postage. Payment made monthly. Statements only issued with payments. Photographers allowed to review account records. Offers one-time rights, electronic media rights. Model release preferred. Photo captions required; include location and content of image.

Making Contact Send query letter with samples, stock list. Provide CV (curriculum vitae), business card, self-promotion piece or tearsheets to be kept on file. Agency will contact photographer for portfolio review if interested. Keeps samples on file; include SAE for return of material. Expects minimum initial submission of 100 images. Responds in 2 weeks. Photo guidelines sheet free with SAE.

Tips "Send SAE, location of images list, and brief details of previous experience."

◪ ⊕ CREATIVE STOCK IMAGES

Storgata 11, Postbox 1184, Bodø 8001 Norway. (+47)975-23-895. E-mail: info@crestock.com. Web site: www.crestock.com. **Contact:** Geir Are Jensen, CEO. Estab. 2005. Stock agency. "Crestock is a community-based, royalty-free microstock agency. We maintain a growing, high-quality image archive." Has

150,000 photos in files. Clients include advertising agencies, businesses, newspapers, public relations firms, book publishers, calendar companies, audiovisual firms, magazine publishers.

Needs Wants photos of babies/children/teens, celebrities, couples, multicultural, families, parents, senior citizens, architecture, cities/urban, education, gardening, interiors/decorating, pets, religious, rural, agriculture, business concepts, industry, medicine, military, political, product shots/still life, science, technology/computers, disasters, environmental, landscapes/scenics, wildlife, adventure, automobiles, entertainment, events, food/drink, health/fitness/beauty, hobbies, humor, performing arts, sports, travel. Interested in alternative process, avant garde, documentary, erotic, fashion/glamour, fine art, historical/vintage, seasonal, lifestyle.

Specs Accepts images in digital format. Upload via Web site as JPEG, EPS, AI, Flash animations.

Payment/Terms Pays 20-30% commission for "credit" sales or fixed sums for "subscription" sales. Enforces strict minimum prices. Works with photographers on contract basis only. Nonexclusive contract. Statements issued continually. Payments made on request. Photographers allowed to review account records in cases of discrepancies only. Offers one-time rights, electronic media rights, agency promotion rights. Model/property release required. Captions required.

Making Contact Register at Web site and submit photos for approval. Responds in 1 week. Catalog available online.

Tips "Crestock is among the most selective microstock agencies, so be prepared for strict quality standards. Make sure your captioning and keywording is well thought through."

■ CUSTOM MEDICAL STOCK PHOTO

The Custom Medical Bldg., 3660 W. Irving Park Rd., Chicago IL 60618-4132. (773)267-3100. Fax: (773)267-6071. E-mail: sales@cmsp.com. Web site: www.cmsp.com. **Contact:** Mike Fisher and Henry Schleichkorn, medical archivists. Member of Picture Archive Council of America (PACA). Clients include: advertising agencies, magazines, journals, textbook publishers, design firms, audiovisual firms, hospitals, Web designers—all commercial and editorial markets that express interest in medical and scientific subject area.

Needs Wants photos of biomedical, scientific, healthcare environmentals and general biology for advertising illustrations, textbook and journal articles, annual reports, editorial use and patient education.

Specs "Accepting only digital submissions. Go online to www.cmsp.com/cmspweb/images for information about contacting us before submitting images, and image specifications."

Payment & Terms Pays per shot or commission. Per-shot rate depends on usage. Commission: 30-40% on domestic leases; 30% on foreign leases. Works with photographers on contract basis only. Offers guaranteed subject exclusivity contract. Contracts of 5-7 years. Royalty-free contract available. Administrative costs charged based on commission structure. Statements issued bimonthly. Payment made bimonthly. Credit line given if applicable, at client's discretion. Offers one-time, electronic media and agency promotion rights; other rights negotiable. Informs photographers but does not permit them to negotiate when a client requests all rights.

Making Contact Send query letter with list of stock photo subjects or check contributor Web site. Call for address and submission packet. "Do not send uncaptioned, unsolicited photos by mail." Responds in 1 month on average. Photo guidelines available on Web site. Monthly want list available to contributors only. Model/property release required.

Tips "Our past want lists are a valuable guide to the types of images requested by our clients. Past want lists are available on the Web site. Environmentals of researchers, hi-tech biomedicine, physicians, nurses and patients of all ages in situations from neonatal care to mature adults are requested frequently. Almost any image can qualify to be medical if it touches an area of life: breakfast, sports, etc. Trends also follow newsworthy events found on newswires. Photos should be good, clean images that portray a single idea, whether it is biological, medical, scientific or conceptual. Photographers should possess the ability to recognize the newsworthiness of subjects. Put together a minimum of 10 images for submission. Contributing to our agency can be very profitable if a solid commitment can exist."

■ DDB STOCK PHOTOGRAPHY, LLC

P.O. Box 80155, Baton Rouge LA 70898. (225)763-6235. Fax: (225)763-6894. E-mail: info@ddbstock.com. Web site: www.ddbstock.com. **Contact:** Douglas D. Bryant, president. Estab. 1970. Stock photo agency. Member of American Society of Picture Professionals. Rights managed stock only, no RF. Currently represents 103 professional photographers. Has 550,000 transparencies in files and 20,000 high-resolution digital images available for download on Web site. Clients include: text-trade book/encyclopedia publish-

ers, travel industry, museums, ad agencies, audiovisual firms, magazine publishers, CD-ROM publishers and many foreign publishers.

Needs Specializes in picture coverage of Latin America with emphasis on Mexico, Central America, South America, and the Caribbean. Needs photos of anthropology/archeology, art, commerce, crafts, secondary and university education, festivals and ritual, geography, history, indigenous people and culture, museums, parks, political figures, religion. Also uses babies/children/teens, couples, multicultural, families, parents, senior citizens, architecture, rural, adventure, entertainment, events, food/drink, health/fitness, performing arts, business concepts, industry, military, science, technology/computers.

Specs Prefers images in TIFF digital format on DVD at 8 megapixels or higher. Prepare digital submissions per http://www.ddbstock.com/submissionguidelines.html. Accepts original 35mm transparencies.

Payment & Terms Pays 40% commission for color photos; 25% on foreign sales through foreign agents. Payment rates: $50-$20,000. Average price per image (to clients): $275. Offers volume discount to customers; terms specified in photographers' contracts. 4-year initial minimum holding period for original transparencies. Payment made quarterly. Does not allow independent audits. "We are a small agency and do not have staff to oversee audits." Offers one-time, print/electronic media, world and all language rights. Model/property release preferred for ad set-up shots. Photo captions required; include location and detailed description. "We have a geographic focus and need specific location info on captions (Geocode latitude/longitude if you carry a GPS unit, and include latitude/longitude in captions)."

Making Contact Interested in receiving work from professional photographers who regularly visit Latin America. Send query letter with brochure, tearsheets, stock list. Expects minimum initial submission of 300 digital images/original transparencies and yearly submissions of at least 500 images. Responds in 6 weeks. Photo guidelines available on Web site.

Tips "Speak Spanish and spend one to six months shooting in Latin America and the Caribbean every year. Follow our needs list closely. Call before leaving on assignment. Shoot digital TIFFs at 8 megapixels or larger. Shoot Fuji professional transparency film if you have not converted to digital. Edit carefully. Eliminate images with focus, framing, excessive grain/noise, or exposure problems. The market is far too competitive for average pictures and amateur photographers. Review guidelines for photographers on our Web site. Include coverage from at least three Latin American countries or five Caribbean Islands. No one-time vacation shots! Shoot subjects in demand listed on Web site."

▤ ⊕ DINODIA PHOTO LIBRARY

13-15 Vithoba Lane, Vithalwadi, Kalbadevi, Bombay 400 002 India. (91)(22)2240-4126. Fax: (91)(22)2240-1675. E-mail: jagdish@dinodia.com. Web site: www.dinodia.com. **Contact:** Jagdish Agarwal, founder. Estab. 1987. Stock photo agency. Has 500,000 photos in files. Clients include: advertising agencies, public relations firms, audiovisual firms, businesses, book/encyclopedia publishers, magazine publishers, newspapers, postcard companies, calendar companies, greeting card companies.

Needs Wants photos of babies/children/teens, celebrities, couples, multicultural, families, parents, senior citizens, disasters, environment, landscapes/scenics, wildlife, architecture, cities/urban, education, gardening, interiors/decorating, pets, religious, rural, adventure, automobiles, entertainment, events, food/drink, health/fitness/beauty, hobbies, humor, performing arts, sports, travel, agriculture, business concepts, industry, medicine, military, political, product shots/still life, science, technology/computers. Interested in alternative process, avant garde, documentary, erotic, fashion/glamour, fine art, historical/vintage, seasonal.

Specs "At the moment we are only accepting digital. Initially it is better to send a few nonreturnable printed samples for our review."

Payment & Terms Pays 50% commission for b&w and color photos. General price range (to clients): U.S. $50-600. Negotiates fees below stated minimum prices. Offers volume discounts to customers; inquire about specific terms. Discount sales terms not negotiable. Works with photographers on contract basis only. Offers limited regional exclusivity; "Prefer exclusive for India." Contracts renew automatically with additional submissions for 5 years. Statement issued monthly. Payment made monthly. Photographers permitted to review sales figures. Informs photographers and allows them to negotiate when client requests all rights. Offers one-time rights. Model release preferred. Photo captions required.

Making Contact Send query letter with résumé of credits, nonreturnable samples, stock list and SASE. Responds in 1 month. Photo guidelines free with SASE. Dinodia news distributed monthly to contracted photographers.

Tips "We look for style—maybe in color, composition, mood, subject matter, whatever—but the photos

should have above-average appeal." Sees trend that "market is saturated with standard documentary-type photos. Buyers are looking more often for stock that appears to have been shot on assignment."

▣ DK STOCK, INC.

75 Maiden Lane, Suite 319, New York NY 10038. (212)405-1891. Fax: (212)405-1890. E-mail: david@dkstock.com. Web site: www.dkstock.com. **Contact:** David Deas, photo editor. Estab. 2000. "A multicultural stock photo company based in New York City, and the first company to launch a fully searchable multiethnic Web site and publish an African-American stock photography catalog. Prior to launching DK Stock, its founders worked for years in the advertising industry as a creative team specializing in connecting clients to the $1.6 trillion ethnic market. This market is growing, and DK Stock's goal is to service it with model-released, well composed, professional imagery." Member of the Picture Archive Council of America (PACA). Has 10,000 photos in files. Clients include: advertising agencies, public relations firms, buisinesses, book publishers, magazine publishers, newspapers, calendar companies, greeting card companies.

Needs "Looking for contemporary lifestyle images that reflect the black and Hispanic diaspora." Wants photos of babies/children/teens, celebrities, couples, multicultural, families, parents, senior citizens, education, adventure, entertainment, health/fitness/beauty, hobbies, humor, performing arts, sports, travel, agriculture, business concepts, industry, medicine, military, political, science, technology/computers. Interested in historical/vintage, lifestyle. "Images should include models of Hispanics and/or people of African descent. Images of Caucasian models interacting with black and/or Hispanic people can also be submitted. Be creative, selective and current. Visit Web site to get an idea of the style and range of representative work. E-mail for a current copy of 'needs list.'"

Specs Uses 35mm, $2\frac{1}{4} \times 2\frac{1}{4}$, 4×5, 8×10 transparencies. Accepts images in digital format. Send via CD as TIFF files at 300 dpi, 50MB.

Payment & Terms Pays 50% commission for b&w or color photos. Average price per image (to clients): $100-15,000 for b&w photos or color photos. Enforces minimum prices. Offers volume discounts to customers; terms specified in photographers' contracts. Photographers can choose not to sell images on discount terms. Works with photographers on contract basis only. Offers nonexclusive contract. Contracts renew automatically with additional submissions for 5 years. Statements issued monthly. Payment made monthly. Photographers allowed to review account records. Model/property release required. Photo captions optional.

Making Contact Send query letter with slides, prints, photocopies, tearsheets, transparencies. Portfolio may be dropped off every Monday-Friday. Does not keep samples on file; include SASE for return of material. Expects minimum initial submission of 50 images with 5 times/year submissions of at least 25 images. Responds in 2 weeks to samples, portfolios. Photo guidelines free with SASE. Catalog free with SASE.

Tips "We love working with talented people. If you have 10 incredible images, let's begin a relationship. Also, we're always looking for new and upcoming talent as well as photographers who can contribute often. There is an increasing demand for lifestyle photos of multicultural people. Our clients are based in the Americas, Europe, Asia and Africa. Be creative, original and technically proficient."

◖ ▣ DRK PHOTO

100 Starlight Way, Sedona AZ 86351. (928)284-9808. Fax: (928)284-9096. Web site: www.drkphoto.com. **Contact:** Daniel R. Krasemann, president. "We handle only the personal best of a select few photographers—not hundreds. This allows us to do a better job aggressively marketing the work of these photographers." Member of Picture Archive Council of America (PACA) and American Society of Picture Professionals (ASPP). Clients include: ad agencies; PR and AV firms; businesses; book, magazine, textbook and encyclopedia publishers; newspapers; postcard, calendar and greeting card companies; branches of the government; and nearly every facet of the publishing industry, both domestic and foreign.

Needs "Especially need marine and underwater coverage." Also interested in S.E.M.'s, African, European and Far East wildlife, and good rainforest coverage.

Specs Prefers digital capture. Uses 35mm, $2\frac{1}{4} \times 2\frac{1}{4}$, 4×5 transparencies; hi-res digital scans.

Payment & Terms Pays 50% commission for color photos. General price range (to clients): $100-" into thousands." Works with photographers on contract basis only. Contracts renew automatically. Statements issued quarterly. Payment made quarterly. Offers one-time rights; "other rights negotiable between agency/photographer and client." Model release preferred. Photo captions required.

Making Contact "With the exception of established professional photographers shooting enough volume

to support an agency relationship, we are not soliciting open submissions at this time. Those professionals wishing to contact us in regards to representation should query with a brief letter of introduction.''

▣ ⊕ DW STOCK PICTURE LIBRARY (DWSPL)

108 Beecroft Rd., Beecroft, New South Wales 2119 Australia. (61)(02)9869-0717. E-mail: info@dwpicture .com.au. Web site: www.dwpicture.com.au. Estab. 1997. Has more than 200,000 photos on file and 30,000 online. ''Strengths include African wildlife, Australia, travel, horticulture, agriculture, people and lifestyles.'' Clients include: advertising agencies, designers, printers, book publishers, magazine publishers, calendar companies.

Needs Wants photos of babies/children/teens, families, parents, senior citizens, disasters, gardening, pets, rural, health/fitness, travel, industry. Interested in lifestyle.

Specs Accepts images in digital format. Send as low-res JPEG files via CD.

Payment & Terms Pays 50% commission. Average price per image (to clients): $200 for color photos. Enforces minimum prices. Offers volume discounts to customers. Works with photographers on contract basis only. Statements issued quarterly. Photographers allowed to review account records in cases of discrepancies only. Offers one-time rights. Model release preferred. Photo captions required.

Making Contact Send query letter with images; include SASE if sending by mail. Expects minimum initial submission of 200 images. Responds in 2 weeks to samples.

▣ ⊕ E & E PICTURE LIBRARY

Beggars Roost, Woolpack Hill, Brabourne Lees, Ashford, Kent TN25 6RR United Kingdom. E-mail: isobel @picture-library.freeserve.co.uk. Web site: www.heritage-images.com (go to E & E Image Library); www .eeimages.co.uk; www.eeimages.com; http://picture-library.mysite.wanadoo-members.co.uk. **Contact:** Isobel Sinden. Estab. 1998. Member of BAPLA (British Association of Picture Libraries and Agencies). Has 130,000 images on file. Clients include: advertisers/designers, businesses, book publishers, magazine publishers, newspapers, calendar/card companies, merchandising, TV.

Needs Faith/religious/spiritual images worldwide, buildings, heritage, clergy, festivals, ceremony, objects, places, food, ritual, monks, nuns, stained glass, carvings. Mormons, Shakers, all groups/sects, large or small. Biblelands. Death, saints, ancient, heritage, burial, funerals, graves, gravediggers, green burial, eccentricities. Festivals. Curiosities, unusual oddities like follies, signs, symbols. Architecture, religious or secular, commemmorative, i.e., VIPs. Manuscripts and illustrations, old and new, linked with any of the subjects above. Interested in documentary, fine art, historical/vintage, seasonal.

Specs Accepts images in digital format. Send via CD, JPEG files in medium-high resolution. Uses 35mm, $2\frac{1}{4} \times 2\frac{1}{4}$, 4×5 transparencies.

Payment & Terms Average price per image (to clients): $140-200 for color photos. Offers volume discounts to customers. Works with photographers on contract basis for 5 years, offering exclusive/nonexclusive contract renewable automatically with additional submissions. Offers one-time rights. Model release where necessary. Photo captions very important and must be accurate. Include what, where, any special features or connections, name, date (if possible), and religion.

Making Contact Send query letter with slides, tearsheets, transparencies/CD. Expects minimum initial submission of 40 images. Responds in 2 weeks. Photo guidelines sheet and ''wants list'' available via e-mail.

Tips ''Decide on exact subject of image. *Get in close and then closer*. Exclude all extraneous matter. Fill the frame. Dynamic shots. Interesting angles, light. No shadows or miniscule subject matter far away. Tell us what is important about the picture. No people in shot unless they have a role in the proceedings as in a festival or service, etc.''

▣ ⊕ ECOSCENE

Empire Farm, Throop Rd., Templecombe Somerset BA8 0HR United Kingdom. (44)(196)337-1700. E-mail: sally@ecoscene.com. Web site: www.ecoscene.com. **Contact:** Sally Morgan, director. Estab. 1988. Picture library. Has 80,000 photos in files. Clients include: advertising agencies, businesses, book/encyclopedia publishers, magazine publishers, newspapers, Internet, multimedia.

Needs Wants photos of disasters, environmental, energy issues, sustainable development, wildlife, gardening, rural, health/fitness, agriculture, medicine, science, pollution, industry, energy, indigenous peoples.

Specs Accepts digital submissions only. Send via CD as 48MB (minimum) TIFF files at 300 dpi.

Payment & Terms Pays 55% commission for color photos. Average price per image (to clients): $90

minimum for color photos. Negotiates fees below stated minimum prices, depending on quantity reproduced by a single client. Offers volume discounts to customers. Discount sales terms not negotiable. Works with photographers on contract basis only. Offers nonexclusive contract. Contracts renew automatically with additional submissions, 4 years minimum. Statements issued quarterly. Payment made quarterly. Offers one-time and electronic media rights. Informs photographers and allows them to negotiate when client requests all rights. Model/property release preferred. Photo captions required; include location, subject matter, and common and Latin names of wildlife and any behavior shown in pictures.

Making Contact Send query letter with résumé of credits. Digital submissions only. Keeps samples on file; include SASE for return of material. Expects minimum initial submission of 100 images with annual submissions of at least 100 images. Responds in 3 weeks. Photo guidelines free with SASE. Market tips sheets distributed quarterly to anybody who requests, and to all contributors.

Tips Photographers should have a "neat presentation and accurate, informative captions. Images must be tightly edited with no fillers. Photographers must be critical of their own work and check out the Web site to see the type of image required. Substandard work is never accepted, whatever the subject matter. Enclose return postage."

▣ ENVISION

27 Hoppin Rd., Newport RI 02840. (401)619-1500 or (800)524-8238. E-mail: envision@att.net. Web site: www.envision-stock.com. **Contact:** Sue Pashko, director. Estab. 1987. Stock photo agency. Member of the Picture Archive Council of America (PACA). Has 200,000 photos in files. Clients include: advertising agencies, public relations firms, businesses, book/encyclopedia publishers, magazine publishers, newspapers, calendar and greeting card companies, graphic design firms.

Needs Professional-quality photos of food, commercial food processing, fine dining, crops. Model-released images of people interactig with food and produce in any way.

Specs Accepts images in digital format: 50MB files, Adobe 1998 RGB, 300 dpi.

Payment & Terms Pays 50% commission for b&w and color photos and film. General price range (to clients): $200-25,000 for b&w photos; $200-25,000 for color photos. Works with photographers on contract basis only. Statements issued monthly. Payment made monthly. Offers one-time rights; "each sale individually negotiated—usually one-time rights." Model/property release required. Photo captions required.

Making Contact Present portfolio online or arrange for low-res scans to be reviewed on disk. Regular submissions are mandatory. Responds in 1 month.

Tips "Clients expect the very best in professional-quality material. Photos that are unique, taken with a very individual style. Demands for traditional subjects *but* with a different point of view; African- and Hispanic-American lifestyle photos are in great demand. We have a need for model-released, professional-quality photos of people with food—eating, cooking, growing, processing, etc."

▣ ▣ ESTOCK PHOTO, LLC

1170 Broadway, 9th Floor, New York NY 10001. (800)284-3399. Fax: (212)545-1185. E-mail: sales@estockphoto.com. Web site: www.estockphoto.com. **Contact:** Laura Diez, president. Member of Picture Archive Council of America (PACA). Has over 1 million photos in files. Clients include: ad agencies, public relations and AV firms; businesses; book, magazine and encyclopedia publishers; newspapers, calendar and greeting card companies; textile firms; travel agencies and poster companies.

Needs Wants photos of travel, destination, people, lifestyles, business.

Specs Uses 35mm, medium-format, 4×5 transparencies. Accepts images in digital format.

Payment & Terms Price depends on quality and quantity. Usually pays 50% commission. General price range (to clients): $125-6,500. Works with photographers on contract basis only. Offers exclusive and limited regional exclusive contracts. Contracts renew automatically for 3 years. Offers to clients "any rights they want to have; payment is calculated accordingly." Statements issued bimonthly and quarterly. **Payment made bimonthly and quarterly.** Photographers allowed to review account records to verify their sales figures. Offers one-time and electronic media rights. Informs photographers and allows them to negotiate when client requests all rights; some conditions. Model release required; "depends on subject matter." Photo captions preferred.

Making Contact Send query letter with samples—"about 100 is the best way." Send query letter with list of stock photo subjects or submit portfolio for review. Response time depends; often the same day. Photo guidelines free with SASE.

Tips "Photos should show what the photographer is all about. They should show technical competence—photos that are sharp, well-composed, have impact; if color, they should show color."

▣ ETHNO IMAGES, INC.

189 Third St., Suite A112, Oakland CA 94607. (510)433-0766. E-mail: admin@mail.ethnoimages.com. Web site: www.ethnoimages.com. **Contact:** Troy A. Jones, CEO/president; T. Lynn Jones, COO. Estab. 1999. Since its inception, Ethno Images has become the resource of choice for multicultural imagery. The Ethno collection contains lifestyle-driven images spanning traditional to contemporary to cutting edge. Clients are marketing professionals in advertising agencies, book and magazine publishers, in-house marketing departments and design shops.

Needs Wants multicultural images representing lifestyles, families, teenagers, children, couples, celebrities, sports and business. "All multicultural groups accepted; African-American images are requested frequently."

Specs Digital submissions only. Send digital images via CD, Zip as TIFF, JPEG files at 300 dpi (at least 48MB).

Payment & Terms Pays 50% commission for b&w or color photos. Average price per image (to clients): $300. Enforces minimum prices. Offers volume discounts to customers. Works with photographers on contract and freelance basis. Offers nonexclusive contract. Payment made monthly. Model release required; property release preferred. Photo captions required.

Making Contact E-mail us and send low-resolution files or a Web address for review. Photo guidelines and a current needs list provided upon request.

Tips "Caption each image and provide contact information. Prefer initial submissions on CD-ROM in JPEG format or TIFF format. Call or e-mail for more information."

▣ ⊕ EUREKA-SLIDE

3 av Th. Frissen, Brussels B-1160 Belgium. (32)(02)372-2702. Fax: (32)(02)372-2707. E-mail: info@eurek aslide.com. Web site: www.eurekaslide.com. **Contact:** Sylvie De Leu, director. Estab. 1985. Has 300,000 photos in files. Clients include: advertising agencies, businesses, newspapers, postcard publishers, public relations firms, book publishers, calendar companies, audiovisual firms, magazine publishers, greeting card companies.

Needs Wants photos of babies, children, couples, multicultural, families, parents, senior citizens, teens, disasters, environmental, landscapes/scenics, wildlife, architecture, beauty, cities/urban, education, gardening, interiors/decorating, pets, religious, rural, adventure, automobiles, entertainment, events, food/drink, health/fitness, hobbies, humor, performing arts, sports, travel, agriculture, buildings, business concepts, computers, industry, medicine, military, political product shots/still life, science, technology/computers. Interested in alternative process, avant garde, documentary.

Specs Uses 35mm, $2^{1}/_{4} \times 2^{1}/_{4}$, 4×5 transparencies. Accepts images in digital format. Send via CD, Jaz as JPEG files at 300 dpi.

Payment & Terms Pays 50% commission for color photos. Average price per image (to clients): $150 minimum-$200 maximum for color photos. Enforces minimum prices. Offers volume discounts to customers; terms specified in photographer's contracts. Works with photographers on contract basis only. Offers limited regional exclusivity. Statements issued semiannually. Payment made semiannually. Photographers allowed to review account records in cases of discrepancies only. Model/property release required. Photo captions required.

Making Contact Contact through rep. Send query letter with résumé. Expects minimum initial submission of 50 images.

Tips "Before sending, call us."

⊕ EYE UBIQUITOUS/HUTCHINSON

(formerly Eye Ubiquitous), 65 Brighton Rd., Shoreham, West Sussex BN43 6RE United Kingdom. (440)(127)344-0113. Fax: (440)(127)344-0116. E-mail: library@eyeubiquitous.com. Web site: www.eye ubiquitous.com. **Contact:** Stephen Rafferty, library manager. Estab. 1988. Picture library. Has 300,000 photos in files. Clients include: ad agencies, public relations firms, businesses, book/encyclopedia publishers, magazine publishers, newspapers, television companies.

Needs Wants photos of worldwide social documentary and general stock.

Specs Transparencies and 50 MB files at 300 DPI, color corrected Adobe 1998.

Payment & Terms Pays commission exclusive 40% and 35% non exclusive. Offers volume discounts to

customers; inquire about specific terms. Discount sales terms not negotiable. Works with photographers on contract basis only. Offers exclusive, limited regional exclusivity and nonexclusive contracts. Contracts renew automatically with additional submissions. Charges to photographers "discussed on an individual basis." Payment made quarterly. Photographers allowed to review account records. Buys one-time, electronic media and agency promotion rights; negotiable. Does not inform photographers or allow them to negotiate when client requests all rights. Model/property release preferred for people, "particularly Americans." Photo captions required; include where, what, why, who.

Making Contact Submit portfolio for review. Works with freelancers only. Keeps samples on file. Include SASE for return. No minimum number of images expected in initial submission, but "the more the better." Responds as time allows. Photo guidelines free with SASE. Catalog free with SASE. Market tips sheet distributed to contributors "when we can"; free with SASE.

Tips "Find out how picture libraries operate. This is the same for all libraries worldwide. Amateurs can be very good photographers but very bad at understanding the industry after reading some irresponsible and misleading articles. Research the library requirements."

N ▢ ⊕ FAMOUS PICTURES & FEATURES AGENCY

13 Harwood Rd., London SW6 4QP United Kingdom. (44)(207)731-9333. Fax: (44)(207)731-9330. E-mail: info@famous.uk.com. Web site: www.famous.uk.com. **Contact:** Rob Howard. Estab. 1985. Picture library, news/feature syndicate. Has more than 500,000 photos on database. Clients include: advertising agencies, book publishers, magazine publishers, newspapers, calendar companies, postcard publishers and poster publishers.

Needs Wants photos of music, film, TV personalities; international celebrities; live, studio, party shots (paparazzi) with stars of all types.

Specs Prefers images in digital format. Send via FTP or e-mail as JPEG files at 300 dpi or higher.

Payment & Terms Pays 50% commission for color photos. Offers volume discounts to customers. Photographers can choose not to sell images on discount terms. Works with photographers with or without a contract; contracts available for all photographers. Offers limited regional exclusivity. Statements issued monthly. Payment made monthly. Photographers allowed to review account records. Offers one-time rights. Photo captions preferred.

Making Contact E-mail, phone or write, provide samples. Provide résumé, business card, self-promotion piece or tearsheets to be kept on file. Agency will contact photographer for portfolio review if interested. Keeps samples in online database. Will return material with SAE/IRC.

Tips "We are solely marketing images via computer networks. Our fully searchable archive of new and old pictures is online. Send details via e-mail for more information. When submitting work, please caption pictures correctly."

N ◪ ▨ FIRST LIGHT ASSOCIATED PHOTOGRAPHERS

333 Adelaide St. W., 6th Floor, Toronto ON M5V 1R5 Canada. (416)597-8625. Fax: (416)597-2035. E-mail: info@firstlight.com. Web site: www.firstlight.com. **Contact:** Shelley Smith, artist manager. Estab. 1984. Stock agency, represents 40 international agencies and over 250 photographers. One million images available online. Clients include: advertising agencies, public relations firms, audiovisual firms, businesses, book/encyclopedia publishers, magazine publishers, newspapers, calendar companies.

Needs Wants commercial imagery in all categories. Special emphasis on model-released people, lifestyle, conceptual photography and business and Canadian images. "Our broad files require variety of subjects."

Specs "For initial review submissions we prefer low-res JPEG files on CD. Can also send preview-sized files via e-mail. For final submissions we require clean 50MB (minimum) high-res files."

Payment & Terms Pays 45% commmission. Works on contract basis only, nonexclusive. Minimal scanning fee per image for images supplied as film. Statements issued monthly. Payment made monthly. Offers one-time rights. Informs photographers and allows them to negotiate when client requests all rights. Model release required. Photo captions required.

Making Contact Send query letter via e-mail.

Tips Wants to see "tight, quality editing and description of goals and shooting plans."

▢ ⊕ FOCUS NEW ZEALAND PHOTO LIBRARY LTD.

Box 84-153, Westgate, Auckland 1250 New Zealand. (64)(9)4115416. Fax: (64)(9)4115417. E-mail: photos@focusnzphoto.co.nz. Web site: www.focusnzphoto.co.nz. **Contact:** Brian Moorhead, director. Estab. 1985. Stock agency. Has 40,000 photos in files. Clients include: advertising agencies, businesses, news-

papers, postcard publishers, public relations firms, book publishers, calendar companies, magazine publishers, greeting card companies, electronic graphics.

Needs Wants photos of babies/children/teens, couples, multicultural, families, parents, senior citizens, environmental, landscapes/scenics, architecture, cities/urban, education, rural, adventure, events, health/fitness/beauty, hobbies, performing arts, sports, travel, agriculture, business concepts, industry, science, technology/computers. Interested in seasonal. Also needs New Zealand, Australian and South Pacific images.

Specs Uses 35mm, medium-format and up to full-frame panoramic 6×17 transparencies. Accepts images in digital format, RGB, TIFF, 300 dpi, A4 minimum.

Payment & Terms Pays 50% commission. Offers volume discounts to customers. Discount sales terms not negotiable. Works with photographers on contract basis only. Offers nonexclusive contract. Statements issued quarterly. Payment made quarterly. Photographers allowed to review account records. Offers one-time, electronic media and agency promotion rights. Model/property release preferred. Photo captions required; include exact location, content, details, releases, date taken.

Making Contact Send query letter. Does not keep samples on file; include SASE for return of material. Expects minimum initial submission of 100 images with yearly submissions of at least 100-200 images. Responds in 3 weeks to samples. Photo guidelines sheet free with SASE or by e-mail. Catalog free on Web site. Market tips sheet available by mail or e-mail to contributors only.

Tips "Only submit original, well-composed, well-constructed, technically excellent work, fully captioned."

▣ FOODPIX

Jupiter Images, 99 Pasadena Ave., South Pasadena CA 91030. (800)764-7427. E-mail: etherbert@jupiterimages.com. Web site: www.jupiterimages.com. **Contact:** Ellen Herbert, collection director. Estab. 1994. Stock agency. Member of the Picture Archive Council of America (PACA). Has 40,000 photos in files. Clients include: advertising agencies, businesses, newspapers, book publishers, calendar companies, design firms, magazine publishers.

Needs Wants food, beverage and food/lifestyle images.

Specs Accepts analog and digital images. Review and complete the Online Submission Questionnaire on the Web site before submitting work.

Payment & Terms Enforces minimum prices. Offers volume discounts to customers; terms specified in photographers' contracts. Works with photographers on contract basis only. Offers exclusive contract only. Statements issued monthly. Payment made quarterly. Offers one-time rights. Model/property release required. Photo captions required.

Making Contact Send query e-mail with samples. Expects maximum initial submission of 50 images. Responds in 1 month. Catalog available.

▣ ◉ FOTO-PRESS TIMMERMANN

Speckweg 34A, D-91096 Moehrendorf, Germany. (49)(9131)42801. Fax: (49)(9131)450528. E-mail: info@f-pt.com. Web site: www.f-pt.com. **Contact:** Wolfgang Timmermann. Stock photo agency. Has 750,000 photos in files. Clients include: advertising agencies, audiovisual firms, businesses, book/encyclopedia publishers, magazine publishers, newspapers, calendar companies.

Needs Wants landscapes, countries, travel, tourism, towns, people, business, nature, babies/children/teens, couples, families, parents, senior citizens, adventure, entertainment, health/fitness/beauty, hobbies, industry, medicine, technology/computers. Interested in erotic, fine art, seasonal, lifestyle.

Specs Uses $2\frac{1}{4} \times 2\frac{1}{4}$, 4×5, 8×10 transparencies (no prints). Accepts images in digital format. Send via CD, Zip as TIFF files.

Payment & Terms Pays 50% commission for color photos. Works on nonexclusive contract basis (limited regional exclusivity). First period: 3 years; contract automatically renewed for 1 year. Photographers allowed to review account records. Statements issued quarterly. Payment made quarterly. Offers one-time rights. Informs photographers and allows them to negotiate when a client requests to buy all rights. Model/property release preferred. Photo captions required; include state, country, city, subject, etc.

Making Contact Send query letter with stock list. Send unsolicited photos by mail for consideration; include SAE/IRC for return of material. Responds in 1 month.

FOTOCONCEPT INC.

18020 SW 66th St., Ft. Lauderdale FL 33331. (954)680-1771. Fax: (954)680-8996. **Contact:** Aida Bertsch, vice president. Estab. 1985. Stock photo agency. Has 400,000 photos in files. Clients include: magazines, advertising agencies, newspapers, publishers.

Needs Wants general worldwide travel, medical and industrial.

Specs Uses 35mm, $2\frac{1}{4} \times 2\frac{1}{4}$, 4×5 transparencies.

Payment & Terms Pays 50% commission for b&w or color photos. Average price per image (to clients): $175 minimum for b&w or color photos. Works with photographers on contract basis only. Offers nonexclusive contract. Contracts renew automatically with each submission for 1 year. Statements issued quarterly. Payment made quarterly. Photographers allowed to review account records to verify sales figures. Offers one-time rights. Model release required. Photo captions required.

Making Contact Send query letter with stock list. Responds in 1 month.

Tips Wants to see "clear, bright colors and graphic style. Looking for photographs with people of all ages with good composition, lighting and color in any material for stock use."

🖵 🌐 FOTOSCOPIO

Jaramillo 3894 8°; "18" , C1430AGJ Capital Federal, Buenos Aires, Argentina. Phone/fax: (54)(114)542-3512. E-mail: info@fotoscopio.com. Web site: www.fotoscopio.com. **Contact:** Gustavo Di Pace, director. Estab. 1999. Fotoscopio is a Latin American stock photo agency. Has 50,000 photos in files. Clients include: advertising agencies, businesses, postcard publishers, book publishers, calendar companies, magazine publishers, greeting card companies.

Needs Wants photos of Hispanic people, Latin American countries, babies/children/teens, celebrities, couples, multicultural, families, senior citizens, disasters, environmental, landscapes/scenics, wildlife, architecture, cities/urban, interiors/decorating, pets, religious, adventure, automobiles, entertainment, health/fitness/beauty, hobbies, sports, travel, agriculture, business concepts, industry, product shots/still life, technology/computers. Interested in documentary, fine art, historical/vintage.

Specs Uses 35mm, $2\frac{1}{4} \times 2\frac{1}{4}$, 4×5, 8×10 transparencies. Accepts images in digital format. Send via CD, Zip, e-mail as JPEG files at 72 dpi.

Payment & Terms Average price per image (to clients): $50-300 for b&w photos; $50-800 for color photos. Negotiates fees below stated minimums. Offers volume discounts to customers; terms specified in photographer's contracts. Discount sales terms not negotiable. Works with photographers on contract basis only. Offers nonexclusive contract. Contracts renew automatically with additional submissions for 1 year. Statements issued and payment made whenever one yields rights of reproduction of his photography. Photographers allowed to review account records in cases of discrepancies only. Offers one-time and electronic media rights. Model release required; property release preferred. Photo captions preferred.

Making Contact Send query letter with résumé, slides, prints, photocopies, tearsheets, transparencies, stock list. Provide résumé, business card, self-promotion piece to be kept on file. Expects minimum initial submission of 100 images. Responds in 1 month to samples. Photo guidelines sheet free with SASE.

🖵 FUNDAMENTAL PHOTOGRAPHS

210 Forsyth St., Suite 2, New York NY 10002. (212)473-5770. Fax: (212)228-5059. E-mail: mail@fphoto.com. Web site: www.fphoto.com. **Contact:** Kip Peticolas, partner. Estab. 1979. Stock photo agency. Applied for membership into the Picture Archive Council of America (PACA). Has 100,000 photos in files. Clients include: textbook/encyclopedia publishers, advertising agencies, corporate industrial.

Needs Wants photos of medicine, biology, microbiology, environmental, industry, weather, disasters, science-related business concepts, agriculture, technology/computers.

Specs Uses 35mm and all large-format transparencies. Accepts images in digital format. Send as RAW or TIFF files at 300 dpi, 11×14 size.

Payment & Terms Pays 50% commission for b&w or color photos. General price range (to clients): $100-500 for b&w photos; $150-1,200 for color photos; depends on rights needed. Enforces strict minimum prices. Offers volume discount to customers. Works with photographers on contract basis only. Offers guaranteed subject exclusivity. Contracts renew automatically with additional submissions for 2 or 3 years. Charges $5/image scanning fee; can increase to $15 if corrective Photoshop work required. Statements issued and payment made quarterly for any sales during previous quarter. Photographers allowed to review account records with written request submitted 2 months in advance. Offers one-time and electronic media rights. Gets photographer's approval when client requests all rights; negotiation conducted by the agency. Model release required. Photo captions required; include date and location.

Making Contact Arrange a personal interview to show portfolio or make contact by e-mail and arrange for digital submission. Submit portfolio for review. Send query letter with résumé of credits, samples or list of stock photo subjects. Keeps samples on file; include SASE for return of material. Expects minimum initial submission of 100 images. Photo guidelines free with SASE. Tips sheet distributed. E-mail crucial for communicating current photo needs.

Tips ''Our primary market is science textbooks. Photographers should research the type of illustration used and tailor submissions to show awareness of saleable material. We are looking for science subjects ranging from nature and rocks to industrials, medicine, chemistry and physics; macro photography, photomicrography, stroboscopic; well-lit still life shots are desirable. The biggest trend that affects us is the need for images that document new discoveries in sciences and ecology.''

[N] [符号] GEOSLIDES & GEO AERIAL PHOTOGRAPHY

4 Christian Fields, London SW16 3JZ United Kingdom. (44)(208)764-6292. Fax: (44)(115)981-9418. E-mail: geoslides@geo-group.co.uk. Web site: www.geo-group.co.uk. **Contact:** John Douglas, marketing director. Estab. 1968. Picture library. Has approximately 100,000 photos in files. Clients include: advertising agencies, public relations firms, audiovisual firms, businesses, book/encyclopedia publishers, magazine publishers, newspapers, calendar companies, television.

Needs Accent on travel/geography and aerial (oblique) shots. Wants photos of disasters, environmental, landscapes/scenics, wildlife, architecture, rural, adventure, travel, agriculture, industry, medicine, military, political, product shots/still life, science, technology/computers. Interested in documentary, historical/vintage.

Specs Uses 35mm, $2\frac{1}{4} \times 2\frac{1}{4}$, 4×5 transparencies.

Payment & Terms Pays 50% commission for b&w or color photos. General price range (to clients) $75-750. Works with photographers with or without a contract; negotiable. Offers nonexclusive contract. Charges mailing costs. Statements issued monthly. Payment made upon receipt of client's fees. Offers one-time rights and first rights. Does not inform photographers or allow them to negotiate when clients request all rights. Model release required. Photo captions required; include description of location, subject matter and sometimes the date.

Making Contact Send query letter or e-mail with résumé of credits, stock list; include SAE/IRC for return of material. Photo guidelines available for SAE/IRC. No samples until called for.

Tips Looks for ''technical perfection, detailed captions, must fit our needs, especially location needs. Increasingly competitive on an international scale. Quality is important. Needs large stocks with frequent renewals.'' To break in, ''build up a comprehensive (i.e., in subject or geographical area) collection of photographs which are well documented.''

[符号] GETTY IMAGES

601 N. 34th St., Seattle WA 98103. (206)925-5000. Fax: (206)925-5001. Web site: www.gettyimages.com. ''Getty Images is the world's leading imagery company, creating and distributing the largest and most relevant collection of still and moving images to communication professionals around the globe and supporting their work with asset management services. From news and sports photography to contemporary and archival imagery, Getty Images' products are found each day in newspapers, magazines, advertising, films, television, books and Web sites. Gettyimages.com is the first place customers turn to search, purchase, download and manage powerful imagery. Seattle-headquartered Getty Images is a global company with customers in more than 100 countries.''

• Getty owns the microstock agency iStockphoto.

Making Contact Please visit www.gettyimages.com/contributors and select the link ''Interested in marketing your imagery through Getty Images?''

[符号] JOEL GORDON PHOTOGRAPHY

112 Fourth Ave., New York NY 10003. (212)254-1688. E-mail: joel.gordon@verizon.net. **Contact:** Joel Gordon, picture agent. Stock photo agency. Clients include: ad agencies, designers, textbook/encyclopedia publishers.

Specs ''We now accept digital files only. Call for information. Will review low-res files only if they have IPTC or metadata info.''

Payment & Terms Pays 50%. Works with photographers with or without a contract. Offers nonexclusive contract. Payment made after client's check clears. Photographers allowed to review account records to verify sales figures. Informs photographers and allows them to negotiate when client requests all rights.

Offers one-time, electronic media and agency promotion rights. Model/property release preferred. Photo captions preferred.

▣ GRANT HEILMAN PHOTOGRAPHY, INC.

P.O. Box 317, Lititz PA 17543. (717)626-0296. Fax: (717)626-0971. E-mail: info@heilmanphoto.com. Web site: www.heilmanphoto.com. **Contact:** Sonia Wasco, president. Estab. 1948. Member of the Picture Archive Council of America (PACA). Has 1 million photos in files. Now representing Photo Network Stock. Sub agents in Canada, Europe, England, Japan. Clients include: advertising agencies, public relations firms, businesses, book/textbook publishers, magazine publishers, calendar companies, greeting card companies, postcard publishers.

Needs Wants photos of environmental, landscapes/scenics, wildlife, gardening, pets, rural, agriculture, science, technology/computers. Interested in seasonal.

Specs Uses 35mm, $2\frac{1}{4} \times 2\frac{1}{4}$, 4×5 transparencies. Accepts images in digital format. Send via CD, floppy disk, Jaz, Zip, e-mail as TIFF, EPS, PICT, JPEG files.

Payment & Terms Pays on commission basis. Enforces minimum prices. Offers volume discounts to customers. Works with photographers on contract basis only. Offers guaranteed subject exclusivity (within files). Contracts renew automatically with additional submissions per contract definition. Charges determined by contract. Statements issued quarterly. Payment made quarterly. Photographers allowed to review account records. Offers one-time rights, electronic media rights, agency promotion rights. Model/property release required. Photo captions required; include all known information.

Making Contact Send query letter with résumé, slides, prints, photocopies, tearsheets, transparencies, stock list. Provide résumé, business card, self-promotion piece to be kept on file. Expects minimum initial submission of 200 images.

Tips "Make a professional presentation."

▣ ⊕ HORIZON INTERNATIONAL IMAGES LIMITED

Horizon House, Route de Picaterre, Alderney, Guernsey GY9 3UP British Channel Islands. (44)(1481)822587. Fax: (44)(1481)823880. E-mail: mail@hrzn.com. Web site: www.hrzn.com; www.e-picturelibrary.net. UK registered. Estab. 1978. Stock photo agency. Horizon sells stock image use rights (in UK and worldwide), both rights managed and royalty free, via its Web site and international agents.

Needs Wants photos of Lifestyle (sports, couples, multicultural, families, parents, seniors, adventure, entertainment, food/drink, health/fitness, babies/children/teens, humor); Business (meetings, small business, big business); Industry (construction, energy, manufacturing, mining, medicine, science, technology/computers). Environment (landscapes/scenics, plants, rural); Animals (farm, horses, wildlife, pets); Travel (architecture, natural landmarks, festivals/traditional costume). Particular requirements for model-released people.

Specs Accepts images in digital format. Drum-scanned from transparencies or 12-megapixel camera and above interpolated to minimum 50MB file before JPEG compression. Use factor 10 JPEG compression in current versions of Adobe Photoshop. All submitted image files must be carefully cropped to mask out rebate and retouched with clone or repair tools (do not use dust filter software). Submit via Horizon's Web site or send by post on CD or DVD (media nonreturnable). Transparency scanning service available—please enquire.

Payment & Terms Considering new photographers of high technical and artistic standard on 50% sales commission. See full Terms and Conditions on Web site.

Making Contact Register first on www.e-picturelibrary.net (click "Join Now" on the task bar). Then submit sample selection via online submission system. Horizon sometimes purchases and commissions stock (is prepared to review assignment portfolios from photographers interested in producing images of model-released people on an assigned basis).

Tips "Horizon's terms and conditions apply."

▣ HORTICULTURAL PHOTOGRAPHY™

337 Bedal Lane, Campbell CA 95008. (408)364-2015. Fax: (408)364-2016. E-mail: requests@horticultural photo.com. Web site: www.horticulturalphoto.com. **Contact:** Robin M. Orans, owner. Estab. 1974. Picture library. Has 200,000 photos in files. Clients include: advertising agencies, public relations firms, businesses, book publishers, magazine publishers.

Needs Wants photos of flowers, plants with botanical identification, gardens, landscapes.

Specs Uses color slides; 35mm transparencies. Accepts images in digital format. Contact prior to sending images.

Payment & Terms Pays commission for images. Average price per image (to clients): $25-1,000 for color photos. Negotiates fees below stated minimums; depends on quantity. Offers volume discounts to customers. Discount sales terms not negotiable. Works with photographers on contract basis only; negotiable. Statements issued semiannually. Payment made semiannually. Photographers allowed to review account records in cases of discrepancies only. Offers one-time rights, electronic media rights and language rights. Photo captions required; include common and botanical names of plants, date taken, location.

Making Contact Contact through rep. Send e-mail with résumé, stock list. Does not keep samples on file. Expects minimum initial submission of 40 images with quarterly submissions of at least 100 images. Responds in 1 month to samples and portfolios. Photo guidelines available by e-mail or on Web site.

Tips "Send e-mail for guidelines."

▣ ⊕ HUTCHISON PICTURE LIBRARY

65 Brighton Rd., Shoreham-by-Sea, West Sussex BN43 6RE United Kingdom. E-mail: library@hutchisonpictures.co.uk. Web site: www.hutchisonpictures.co.uk. **Contact:** Stephen Rafferty, manager. Stock photo agency, picture library. Has around 500,000 photos in files. Clients include: ad agencies, public relations firms, audiovisual firms, businesses, book/encyclopedia publishers, magazine publishers, newspapers, postcard companies, calendar companies, television and film companies.

Needs "We are a general, documentary library (no news or personalities). We file mainly by country and aim to have coverage of every country in the world. Within each country we cover such subjects as industry, agriculture, people, customs, urban, landscapes, etc. We have special files on many subjects such as medical (traditional, alternative, hospital, etc.), energy, environmental issues, human relations (relationships, childbirth, young children, etc., but all *real people*, not models)." We constantly require images of Spain and Spanish-speaking countries. Also interested in babies/children/teens, couples, multicultural, families, parents, senior citizens, disasters, architecture, education, gardening, interiors/decorating, religious, rural, health/fitness, travel, military, political, science, technology/computers. Interested in documentary, seasonal. "We are a color library."

Specs Uses 35mm transparencies. Accepts images in digital format: 50MB at 300 dpi, cleaned of dust and scratches at 100%, color corrected.

Payment & Terms Pays 40% commission for exclusive; 35% for nonexclusive. Statements issued semiannually. Payment made semiannually. Sends statement with check in June and January. Offers one-time rights. Model release preferred. Photo captions required.

Making Contact Always willing to look at new material or collections. Arrange a personal interview to show portfolio. Send letter with brief description of collection and photographic intentions. Responds in about 2 weeks, depends on backlog of material to be reviewed. "We have letters outlining working practices and lists of particular needs (they change)." Distributes tips sheets to photographers who already have a relationship with the library.

Tips Looks for "collections of reasonable size (rarely less than 1,000 transparencies) and variety; well captioned (or at least well indicated picture subjects; captions can be added to mounts later); sharp pictures, good color, composition; and informative pictures. Prettiness is rarely enough. Our clients want information, whether it is about what a landscape looks like or how people live, etc. The general rule of thumb is that we would consider a collection which has a subject we do not already have coverage of or a detailed and thorough specialist collection. Please do not send *any* photographs without prior agreement."

▣ ⊕ ▣ I.C.P. INTERNATIONAL COLOUR PRESS

Piazza Vesuvio 19, Milano 20144 Italy. (39)(024)801-3106. Fax: (39)(024)819-5625. E-mail: icp@icponline.it. Web site: www.icponline.it. **Contact:** Mr. Alessandro Marosa, CEO. Estab. 1970. Stock photo agency. Clients include: advertising agencies, public relations firms, audiovisual firms, businesses, book/encyclopedia publishers, magazine publishers, postcard publishers, calendar companies and greeting card companies.

Specs High-res digital (A3-A4, 300 dpi), keyworded (English and, if possible, Italian).

Payment & Terms Pays 50% commission for color photos. Offers volume discounts to customers; terms specified in photographer's contract. Discount sales terms not negotiable. Contracts renew automatically with additional submissions, for 3 years. Statements issued monthly. Payment made monthly. Photogra-

phers permitted to review account records to verify sales figures or deductions. Offers one-time, first and sectorial exclusive rights. Model/property release required. Photo captions required.

Making Contact Arrange a personal interview to show portfolio. Send query letter with samples and stock list. Works on assignment only. No fixed minimum for initial submission. Responds in 3 weeks, if interested.

◻ THE IMAGE FINDERS

2570 Superior Ave., 2nd Floor, Cleveland OH 44114. (216)781-7729. Fax: (216)443-1080. E-mail: imagefinders@sbcglobal.net. Web site: www.theimagefinders.com. **Contact:** Jim Baron, owner. Estab. 1988. Stock photo agency. Has 500,000 photos in files. Clients include: advertising agencies, public relations firms, businesses, book/encyclopedia publishers, magazine publishers, calendar companies, greeting card companies.

Needs General stock agency. Always interested in good Ohio images. Also needs babies/children/teens, couples, multicultural, families, senior citizens, landscapes/scenics, wildlife, architecture, gardening, pets, automobiles, food/drink, sports, travel, agriculture, business concepts, industry, medicine, political, technology/computers. Interested in fashion/glamour, fine art, seasonal.

Specs Uses 35mm, $2\frac{1}{4} \times 2\frac{1}{4}$, 4×5, 6×7, 6×9 transparencies. Accepts digital images; see guidelines before submitting. Send via CD.

Payment & Terms Pays 50% commission for b&w and color photos. Average price per image (to clients): $50-500 for b&w photos; $50-2,000 for color photos. "This is a small agency and we will, on occasion, go below stated minimum prices." Offers volume discounts to customers; terms specified in photographers' contracts. Works with photographers on contract basis only. Contracts renew automatically with additional submissions for 2 years. Statements issued monthly if requested. Payment made monthly. Photographers allowed to review account records. Offers one-time rights; negotiable depending on what the client needs and will pay for. Informs photographers and allows them to negotiate when client requests all rights. "This is rare for us. I would inform photographer of what the client wants and work with photographer to strike the best deal." Model/property release preferred. Photo captions required; include location, city, state, country, type of plant or animal, etc.

Making Contact Send query letter with stock list or send e-mail with link to your Web site. Call before you send anything that you want returned. Expects minimum initial submission of 100 images with periodic submission of at least 100-500 images. Responds in 2 weeks. Photo guidelines free with SASE. Market tips sheet distributed 2-4 times/year to photographers under contract.

Tips Photographers must be willing to build their file of images. "We need more people images, industry, lifestyles, wildlife, travel, etc. Scenics and landscapes must be outstanding to be considered. Call first or e-mail. Submit at least 100 good images. Must have ability to produce more than 100-200 images per year."

◻ THE IMAGE WORKS

P.O. Box 443, Woodstock NY 12498. (845)679-8500. Fax: (845)679-0606. E-mail: info@theimageworks.com. Web site: www.theimageworks.com. **Contact:** Mark Antman, president. Estab. 1983. Stock photo agency. Member of Picture Archive Council of America (PACA). Has 1 million photos in files. Clients include: ad agencies, book/encyclopedia publishers, magazine publishers, newspapers, postcard publishers, greeting card companies.

Needs "We are always looking for excellent documentary photography. Our prime subjects are people-related subjects like family, education, health care, workplace issues, worldwide historical, technology, fine arts. In the past year we began building an extensive environmental issues file including nature, wildlife and pollution."

Specs Prefers images in digital format; contact for digital guidelines. Rarely accepts 35mm, $2\frac{1}{4} \times 2\frac{1}{4}$ transparencies and prints.

Payment & Terms Pays 50% commission for b&w and color photos. Average price per image (to clients): $200 for b&w and color photos. Works with photographers on contract basis only. Offers nonexclusive contract. Statements issued monthly. Payment made monthly. Photographers allowed to review account records to verify sales figures by appointment. Offers one-time, agency promotion and electronic media rights. Informs photographers and allows them to negotiate when clients request all rights. Model release preferred. Photo captions required.

Making Contact Send e-mail with description of stock photo archives. Responds in 1 month. Expects minimum initial submission of 500 images.

Tips "The Image Works was one of the first agencies to market images digitally. We continue to do so through our Web site and CD-ROMs. We encourage our photographers to submit digital images. Technology continues to transform the stock photo industry and is an essential part of the way we operate. All digital images from photographers must be reproduction-quality. When making a new submission to us, be sure to include a variety of images that show your range as a photographer. We also want to see some depth in specialized subject areas. Thorough captions are a must. We will not look at uncaptioned images. Write or call first."

▣ INDEX STOCK IMAGERY, INC.

23 W. 18th St., 3rd Floor, New York NY 10011. (212)929-4644 or (800)690-6979. Fax: (212)633-1914. E-mail: editing@indexstock.com. Web site: www.indexstock.com; corporate www.indexstockimagery.com. **Contact:** New Artist Inquiries. Estab. 1981. Stock photo agency. Member of Picture Archive Council of America (PACA). "Representation in over 70 countries worldwide, with 100,000 + images; represent 1,700 artists and smaller agencies, including the Stock Imagery and Picture Cube collections. Manage several corporate and not-for-profit archives. Offers two royalty-free subscription products—Index Open and Photos to Go Unlimited. Markets images to small business and consumers via Photos to Go."

Needs Alternative processes and stylistically creative imagery of the highest quality.

Specs Prefers images in digital format from a 10-megapixel or higher camera (no point-and-shoots: must use a professional camera with interchangeable lenes). Files must be captured in RAW, converted to TIFF (no JPEG files accepted). See the Web site under "For Artists Only" for more information.

Payment & Terms Pays 40% commission for image sales. "We have competitive prices, but under special circumstances we contact photographer prior to negotiations." Works on material exclusive contract basis only. Statements and payments issued monthly. Photographers allowed to review account records. Offers one-time and electronic media rights. Informs photographer and allows them to negotiate when client requests all rights. Model/property release required for all images. Photo captions required.

Making Contact "We are always willing to review new photographers' work. However, we prefer to see that the individual has a subject specialty or a stylistic signature that sets them apart in this highly competitive industry. Therefore, we ask that an initial submission be properly edited to demonstrate that they have a high degree of vision, creativity and style that can be relied upon on a regular basis. Quite simply, we are looking for technically superior, highly creative images."

Ⓐ ▣ INTERNATIONAL PHOTO NEWS

Dept. PM, 2902 29th Way, West Palm Beach FL 33407. (561)683-9090. E-mail: jkravetz1@earthlink.net. **Contact:** Jay Kravetz, photo editor. News/feature syndicate. Has 50,000 photos in files. Clients include: newspapers, magazines, book publishers. Previous/current clients include: newspapers that need celebrity photos with story.

Needs Wants photos of celebrities, entertainment, events, health/fitness/beauty, performing arts, travel, politics, movies, music and television, at work or play. Interested in avant garde, fashion/glamour.

Specs Accepts images in digital format. Send via CD, Zip, e-mail as TIFF, JPEG files at 300 dpi. Uses 5×7, 8×10 glossy b&w prints.

Payment & Terms Pays $10 for b&w photos; $25 for color photos; 5-10% commission. Average price per image (to clients): $25-100 for b&w photos; $50-500 for color photos. Works with photographers on contract basis only. Offers nonexclusive contract. Contracts renew automatically with additional submissions; 1-year renewal. Photographers allowed to review account records. Statements issued monthly. Payment made monthly. Offers one-time rights. Model/property release preferred. Photo captions required.

Making Contact Send query letter with résumé of credits. Solicits photos by assignment only. Responds in 1 week.

Tips "We use celebrity photographs to coincide with our syndicated columns. Must be approved by the celebrity."

Ⓝ ▣ ⊕ THE IRISH PICTURE LIBRARY

Davison & Associates Ltd., 69b Heather Rd., Sandyford Industrial Estate, Dublin 18 Ireland. (353)1295 0799. Fax: (353)1295 0705. E-mail: info@fatherbrowne.com. Web site: www.fatherbrowne.com/ipl. **Contact:** David Davison. Estab. 1990. Picture library. Has 60,000 photos in files. Clients include: advertising agencies, businesses, book publishers, magazine publishers, newspapers, calendar companies.

Needs Wants photos of historic Irish material. Interested in alternative process, fine art, historical/vintage.

Specs Uses any prints. Accepts images in digital format. Send via CD as TIFF, JPEG files at 400 dpi.

Payment & Terms Pays 50% commission for b&w and color photos. Average price per image (to clients): $100-1,000 for b&w and color photos. Enforces minimum prices. Offers volume discounts to customers. Photographers can choose not to sell images on discount terms. Works with photographers on contract basis only. Statements issued quarterly. Payment made quarterly. Photographers allowed to review account records. Offers one-time rights, electronic media rights. Property release required. Photo captions required.

Making Contact Send query letter with photocopies. Does not keep samples on file; include SAE/IRC for return of material.

ISRAELIMAGES.COM

POB 60 Kammon 20112, Israel. (972)(4)908-2023. Fax: (972)(4)990-5783. E-mail: israel@israelimages.com. Web site: www.israelimages.com. **Contact:** Israel Talby, managing director. Estab. 1991. Has 450,000 photos in files. Clients include: advertising agencies, web designers, businesses, book publishers, magazine publishers, newspapers, calendar companies, greeting card and postcard publishers, multimedia producers, schools and universities, etc.

Needs "We are interested in everything about Israel, Judaism (worldwide) and The Holy Land."

Specs Uses digital material only, minimum accepted size 2000×3000 pixels. Send CD with low-res samples for review. "When accepted, we need TIFF or JPEG files at 300 dpi, RGB, saved at quality '11' in Photoshop."

Payment & Terms Average price per image (to clients): $50-3,000/picture. Negotiates fees below standard minimum against considerable volume that justifies it. Offers volume discounts to customers. Works with photographers on contract basis only. Offers limited regional exclusivity, nonexclusive contract. Contracts renew automatically with additional submissions. Statements issued quarterly. Payment made quarterly. Photographers allowed to review account records. Offers one-time rights, electronic media rights, agency promotion rights. Informs photographers and allows them to negotiate when a client requests all rights. Model/property release preferred. Photo captions required (what, who, when, where).

Making Contact Send query letter with CD or send low-res by e-mail. Expects minimum initial submission of 100 images. Responds in 2 weeks.

Tips "We strongly encourage everyone to send us images to review. When sending material, a strong edit is a must. We don't like to get 100 pictures with 50 similars. Last, don't overload our e-mail with submissions. Make an e-mail query, or better yet, view our submission guidelines on the Web site. Good luck and welcome!"

IVERSON SCIENCE PHOTOS

31 Boss Ave., Portsmouth NH 03801. (603)433-8484. Fax: (603)433-8484. E-mail: bruce.iverson@verizon.net. **Contact:** Bruce Iverson, owner. Estab. 1981. Stock photo agency. Clients include: advertising agencies, book/encyclopedia publishers, museums.

Needs Currently only interested in submissions of scanning electron micrographs and transmission electron micrographs—all subjects.

Specs Uses all photographic formats and digital imagery.

Payment & Terms Pays 50% commission for b&w and color photos. Offers nonexclusive contract. Photographer paid within 1 month of agency's receipt of payment. Offers one-time rights. Photo captions required; include magnification and subject matter.

Making Contact "Give us a call or e-mail first. Our subject matter is very specialized." Responds in 2 weeks.

Tips "We are a specialist agency for science photos and technical images."

JAYAWARDENE TRAVEL PHOTO LIBRARY

7A Napier Road, Wembley, Middlesex HA0 UA United Kingdom. (44)(20)8795-3581. Fax: (44)(20)8795-4083. E-mail: jaytravelphotos@aol.com. Web site: www.jaytravelphotos.com. **Contact:** Rohith or Franco, partners. Estab. 1992. Stock photo agency and picture library. Has 150,000 photos in files. Clients include: advertising agencies, businesses, book/encyclopedia publishers, magazine publishers, newspapers, postcard publishers, tour operators/travel companies.

Needs Travel and tourism-related images worldwide.

Specs Uses 35mm up to 6×7cm original transparencies and digital images (see Web site for guidelines).
Payment & Terms Pays 50% commission. Average price per image (to clients): $125-1,000. Enforces minimum prices of $125, "but negotiable on quantity purchases." Offers volume discounts to customers; inquire about specific terms. Discount sales terms not negotiable. Works with photographers on contract basis only. Offers limited regional exclusivity contract. Statements issued semiannually. Payment made semiannually, within 30 days of payment received from client. Offers one-time and exclusive rights for fixed periods. Does not inform photographers or allow them to negotiate when client requests all rights. Model/property release preferred. Photo captions required; include country, city/location, subject description.
Making Contact Send e-mail with stock list, or call. Expects a minimum initial submission of 300 images with quarterly submissions of at least 100 images. Responds in 3 weeks.
Tips "Study our guidelines on our Web site on what to submit. If you're planning a photo shoot anywhere, you need to give us an itinerary, with as much detail as possible, so we can brief you on what kind of pictures the library may need."

JEROBOAM

120 27th St., San Francisco CA 94110. (415)821-7098. Fax: (415)824-8085 (call before faxing). E-mail: jeroboamster@gmail.com. **Contact:** Ellen Bunning, owner. Estab. 1972. Has 200,000 b&w photos, 200,000 color slides in files. Clients include: text and trade book, magazine and encyclopedia publishers, editorial (mostly textbooks).
Needs "We want people interacting, relating photos, artistic/documentary/photojournalistic images, especially ethnic and handicapped. Images must have excellent print quality—contextually interesting and exciting and artistically stimulating." Wants photos of babies/children/teens, couples, multicultural, families, parents, senior citizens, disasters, environmental, cities/urban, education, gardening, pets, religious, rural, adventure, health/fitness, humor, performing arts, sports, travel, agriculture, industry, medicine, military, political, science, technology/computers. Interested in documentary, historical/vintage, seasonal. Needs shots of school, family, career and other living situations. Child development, growth and therapy, medical situations. No nature or studio shots.
Specs Uses 35mm transparencies.
Payment & Terms Works on consignment only; pays 50% commission. Average price per image (to clients): $150 minimum for b&w and color photos. Works with photographers without a signed contract. Statements issued monthly. Payment made monthly. Photographers allowed to review account records to verify sales figures. Offers one-time and electronic media rights. Informs photographers and allows them to negotiate when client requests all rights. Model/property release preferred for people in contexts of special education, sexuality, etc. Photo captions preferred; include "age of subject, location, etc."
Making Contact Call if in the Bay area; if not, query with samples and list of stock photo subjects; send material by mail for consideration or submit portfolio for review. "Let us know how long you've been shooting." Responds in 2 weeks.
Tips "The Jeroboam photographers have shot professionally a minimum of 5 years, have experienced some success in marketing their talent, and care about their craft excellence and their own creative vision. New trends are toward more intimate, action shots; more ethnic images needed."

▣ KIEFFER NATURE STOCK

4548 Beachcomber Court, Boulder CO 80301. (303)530-3357. Fax: (303)530-0274. E-mail: John@KiefferNatureStock.com. Web site: www.KiefferNatureStock.com. **Contact:** John Kieffer, president. Estab. 1986. Stock agency. Has 150,000 images on file. Clients include: advertising agencies, businesses, multimedia, greeting card and postcard publishers, book publishers, calendar companies, graphic design firms, magazine publishers.
Needs "Our photos show people of all ages participating in an active and healthy lifestyle." Wants photos of babies/children/teens, couples, multicultural, families, senior citizens, recreation, environmental, landscapes/scenics, wildlife, rural, adventure, health/fitness, sports, travel, agriculture.
Specs Prefers images in high-resolution digital format. Also accepts large-format film (6×7-cm and 4×5-inch); 35mm transparencies. Send low-resolution files via CD or e-mail in JPEG format at 72 dpi.
Payment & Terms Pays 50% commission for all imagery. Average price per image (to clients): $150-3,500 for all imagery. "I try to work with a buyer's budget." Offers volume discounts to customers. Offers nonexclusive contract. Payment made quarterly. Model release required; property release preferred. Photo captions required; include location, description.

Making Contact "First review our Web site. Then send a query letter via e-mail, and include a stock list or an active link to your Web site." Keeps samples on file. Responds in 3 weeks.

Tips "Call and speak with John Kieffer before submitting film, and include a FedEx account number for its safe return."

■ KIMBALL STOCK

(formerly Ron Kimball Stock), 1960 Colony St., Mountain View CA 94043. (888)562-5522 or (650)969-0682. Fax: (650)969-0485. E-mail: submissions@kimballstock.com. Web site: www.kimballstock.com. **Contact:** Jeff Kimball. Estab. 1970. Has 1 million photos in files. Clients include: advertising agencies, businesses, newspapers, postcard publishers, public relations firms, book publishers, calendar companies, magazine publishers, greeting card companies.

Needs Wants photos of dogs, cats, lifestyle with cars and domestic animals, landscapes/scenics, wildlife (outside of North America). Interested in seasonal.

Specs Prefers images in digital format, minimum of 10-megapixel digital camera, although 16-megapixel is preferred. Send via e-mail as JPEG files or send CD to mailing address. Uses 35mm, 120mm, 4×5 transparencies.

Payment & Terms Pays 50% commission for color photos. Offers volume discounts to customers. Works with photographers with or without a contract; negotiable. Offers nonexclusive contract. Statements issued quarterly. Payment made quarterly. Photographers allowed to review account records. Offers one-time rights, electronic media rights. Model/property release required. Photo captions required.

Making Contact Send query letter with transparencies, digital files, stock list. Provide self-promotion piece to be kept on file. Expects minimum initial submission of 250 images with quarterly submissions of at least 200 images. Responds only if interested; send nonreturnable samples. Photo guidelines available on Web site.

■ JOAN KRAMER AND ASSOCIATES, INC.

10490 Wilshire Blvd., Suite 1701, Los Angeles CA 90024. (310)446-1866. Fax: (310)446-1856. E-mail: ekeeeek@earthlink.net. Web site: www.home.earthlink.net/~ekeeeek. **Contact:** Joan Kramer, president. Member of Picture Archive Council of America (PACA). Has 1 million photos in files. Clients include: ad agencies, magazines, recording companies, photo researchers, book publishers, greeting card companies, promotional companies, AV producers.

Needs "We use any and all subjects! Stock slides must be of professional quality." Subjects on file include travel, cities, personalities, animals, flowers, lifestyles, underwater, scenics, sports and couples.

Specs Uses 8×10 glossy b&w prints; any size transparencies.

Payment & Terms Pays 50% commission. Offers all rights. Model release required.

Making Contact Send query letter or call to arrange an appointment. Do not send photos before calling.

■ ● LAND OF THE BIBLE PHOTO ARCHIVE

P.O. Box 8441, Jerusalem 91084 Israel. (972)(2)566-2167. Fax: (972)(2)566-3451. E-mail: radovan@netvision.net.il. Web site: www.biblelandpictures.com. **Contact:** Zev Radovan. Estab. 1975. Picture library. Has 50,000 photos in files. Clients include: book publishers, magazine publishers, newspapers, calendar companies, postcard publishers.

Needs Wants photos of museum objects, archaeological sites. Also multicultural, landscapes/scenics, architecture, religious, travel. Interested in documentary, fine art, historical/vintage.

Specs Uses high-resolution digital system.

Payment & Terms Average price per image (to clients): $80-700 for b&w, color photos. Offers volume discounts to customers; terms specified in photographers' contracts.

Tips "Our archives contain tens of thousands of color slides covering a wide range of subjects: historical and archaeological sites, aerial and close-up views, museum objects, mosaics, coins, inscriptions, the myriad ethnic and religious groups individually portrayed in their daily activities, colorful ceremonies, etc. Upon request, we accept assignments for in-field photography."

■ ● LEBRECHT MUSIC & ARTS PHOTO LIBRARY

58-B Carlton Hill, London NW8 0ES United Kingdom. E-mail: pictures@lebrecht.co.uk. Web site: www.lebrecht.co.uk. **Contact:** Ms. E. Lebrecht. Estab. 1992. Has 50,000 high-res images online; thousands more not yet scanned. Clients include: book publishers, magazine publishers, newspapers, calendar companies, film production companies, greeting card companies, public relations firms, advertising agencies.

Needs Wants photos of arts personalities, performing arts, instruments, musicians, dance (ballet, contemporary and folk), orchestras, opera, concert halls, jazz, blues, rock, authors, artists, theatre, comedy, art and artists. Interested in historical/vintage.

Specs Accepts images in digital format only.

Payment & Terms Pays 50% commission for b&w or color photos. Offers volume discounts to customers. Works with photographers on contract basis only. Offers limited regional exclusivity. Statements issued quarterly. Offers one-time rights. Informs photographers and allows them to negotiate when a client requests all rights. Model release required. Photo captions required; include who is in photo, location, date.

Making Contact Send e-mail.

LIGHTWAVE

170 Lowell St., Arlington MA 02174. (781)646-1747. E-mail: paul@lightwavephoto.com. Web site: www.lightwavephoto.com. **Contact:** Paul Light. Has 250,000 photos in files. Clients include: advertising agencies, textbook publishers.

Needs Wants candid photos of people in school, work and leisure activities, lifestyle.

Specs Uses color transparencies.

Payment & Terms Pays $210/photo; 50% commission. Works with photographers on contract basis only. Offers nonexclusive contract. Contracts renew automatically each year. Statements issued annually. Payment made "after each usage." Offers one-time rights. Informs photographers and allows them to negotiate when client requests all rights. Model/property release preferred. Photo captions preferred.

Making Contact "Create a small Web site and send us the URL."

Tips "Photographers should enjoy photographing people in everyday activities. Work should be carefully edited before submission. Shoot constantly and watch what is being published. We are looking for photographers who can photograph daily life with compassion and originality."

☐ ⊕ LINEAIR FOTOARCHIEF, B.V.

van der Helllaan 6, Arnhem 6824 HT Netherlands. (31)(26)4456713. Fax: (31)(26)3511123. E-mail: info@lineairfoto.nl. Web site: www.lineairfoto.nl. **Contact:** Ron Giling, manager. Estab. 1990. Stock photo agency. Has 750,000 analog photos in files and more than 300,00 downloadable images available through the Web site. Clients include advertising agencies, public relations firms, book/encyclopedia publishers, magazine publishers. Library specializes in images from Asia, Africa, Latin America, Eastern Europe and nature in all forms on all continents. Member of WEA, a group of international libraries that use the same server to market each other's images, uploading only once.

Needs Wants photos of disasters, environmental, landscapes/scenics, wildlife, cities/urban, education, religious, adventure, travel, agriculture, business concepts, industry, political, science, technology/computers. Interested in everything that has to do with the development of countries all over the world, especially in Asia, Africa and Latin America.

Specs Accepts images in digital format only. Send via CD as TIFF or high-quality JPEG files at 300 dpi, A4 or rather bigger size. "Photo files need to have IPTC information!"

Payments & Terms Pays 50% commission. Average price per image (to clients): $100-500. Enforces minimum prices. Offers volume discounts to customers; inquire about specific terms. Photographers can choose not to sell images on discount terms. Works with or without a signed contract; negotiable. Offers limited regional exclusivity. Statements issued quarterly. Payment made quarterly. Photographers allowed to review account records. "They can review bills to clients involved." Offers one-time rights. Informs photographers and allows them to negotiate when client requests all rights. Photo captions required; include country, city or region, description of the image.

Making Contact Submit portfolio or e-mail thumbnails (20KB files) for review. There is no minimum for initial submissions. Responds in 3 weeks. Market tips sheet available upon request. View Web site to subject matter and quality.

Tips "We like to see high-quality pictures in all aspects of photography. So we'd rather see 50 good ones than 500 for us to select the 50 out of. Send contact sheets. We will mark the selected pictures for you to send as high-res, including the very important IPTC (caption and keywords)."

☐ ⊕ LINK PICTURE LIBRARY

41A The Downs, London SW20 8HG United Kingdom. (44)(208)944-6933. E-mail: library@linkpicturelibrary.com. Web site: www.linkpicturelibrary.com. **Contact:** Orde Eliason. Has 100,000 photos in files.

Clients include: businesses, book publishers, magazine publishers, newspapers. Specializes in images of Southern and Central Africa, Southeast Asia, China and India.

Needs Wants photos of children and teens, multicultural, cities/urban, religious, adventure, travel, business concepts, industry, military, political. Interested in documentary, historical/vintage. Especially interested in India and Africa.

Specs Accepts images in digital format. Send via CD, e-mail as TIFF, JPEG files at 300 dpi.

Payment & Terms Pays 50% commission for color photos. Average price per image (to clients): $120 minimum for b&w, color photos. Enforces minimum prices. Offers volume discounts to customers. Offers nonexclusive contract. Contracts renew automatically with additional submissions for 3 years. Statements issued semiannually. Payment made semiannually. Photographers allowed to review account records. Offers one-time rights. Photo captions required; include country, city location, subject detail.

Making Contact Provide résumé, business card, self-promotion piece to be kept on file. Expects minimum initial submission of 100 images with quarterly submissions of at least 100 images. Responds in 2 weeks to samples. Responds only if interested; send nonreturnable samples.

Tips "Arrange your work in categories to view. Embed metadata in all images. Provide contact details and supply SASE for returns."

▣ LUCKYPIX

1658 N. Milwaukee, #324, Chicago IL 60647. (773)235-2000. Fax: (773)235-2030. E-mail: info@luckypix.com. Web site: www.luckypix.com. **Contact:** Director of Photography. Estab. 2001. Stock agency. Has 9,000 photos in files (adding constantly). Clients include: advertising agencies, businesses, book publishers, design companies, magazine publishers.

Needs Wants photos of babies/children/teens, multicultural, families, cities/urban, humor, travel, business concepts. Also needs unstaged, serendipitous photos.

Specs Accepts images in digital format. Send final/accepted images via CD/DVD as 8-bit TIFF files at 300 dpi, 50MB or more. Photos for review: upload to Web site or e-mail info@luckypix.com.

Payment & Terms Pays 50% commission for b&w photos; 50% for color photos; 50% for film. Enforces minimum prices. Offers exclusivity by image and similars. Contracts renew automatically annually. Charges $10 if photographers want Luckypix to scan. Statements issued quarterly. Payment made quarterly. Photographers allowed to review account records. Offers one-time rights. Model/property release required.

Making Contact Call or upload sample from Web site (preferred). Responds in 1 week. See Web site for guidelines.

Tips "Have fun shooting. Search the archives before deciding what pictures to send."

▣ ⬛ MASTERFILE

175 Bloor St. E., South Tower, 2nd Floor, Toronto ON M4W 3R8 Canada. (800)387-9010. E-mail: portfolio @masterfile.com. Web site: www.masterfile.com. General stock agency offering rights-managed and royalty-free images. The combined collection exceeds 1 million images online. Clients include: major advertising agencies, broadcasters, graphic designers, public relations firms, book and magazine publishers, producers of greeting cards, calendars and packaging.

Specs Accepts images in digital format only, in accordance with submission guidelines.

Payment & Terms Pays photographers 40% royalties of amounts received by Masterfile. Contributor terms outlined in photographer's contract, which is image-exclusive. Photographer sales statements and royalty payments issued monthly.

Making Contact Refer to www.masterfile.com/info/artists/submissions.html for submission guidelines.

▣ ⬛ ⬛ MAXX IMAGES, INC.

711 W. 15th St., North Vancouver BC V7M 1T2 Canada. (604)985-2560. Fax: (604)985-2590. E-mail: newsubmissions@maxximages.com. Web site: www.maxximages.com. **Contact:** Dave Maquignaz, president. Estab. 1994. Stock agency. Member of the Picture Archive Council of America (PACA). Has 2.1 million images online. Has 350 hours of video footage. Clients include: advertising agencies, public relation firms, audiovisual firms, businesses, book publishers, magazine publishers, newspapers, calendar companies, postcard publishers, video production, graphic design studios.

Needs Wants photos of people, lifestyle, business, recreation, leisure.

Specs Uses all formats.

Making Contact Send e-mail. Review submission guidelines on Web site prior to contact.

Scott Higdon chose LuckyPix to represent his stock photography because of their willingness to work with new photographers and review a small selection of images rather than the 100-200 required by other agencies. Higdon believes this is a good stock image because "the image is of a minority teen female using technology, so it opens up consideration to a wide audience. This image should appeal to advertisers, who might want to place text to the left half of the image."

▣ THE MEDICAL FILE INC.

279 E. 44th St., 21st Floor, New York NY 10017. (212)883-0820 or (917)215-6301. E-mail: themedicalfile@gmail.com. Web site: www.peterarnold.com. **Contact:** Barbara Gottlieb, president. Estab. 2005. Clients include: advertising agencies, public relations firms, businesses, book/encyclopedia publishers, magazine publishers, postcard companies, calendar companies and greeting card companies.

Needs Wants photos of any medically related imagery including fitness and food in relation to healthcare.

Specs Accepts digital format images only on CD or DVD. Images can be downloaded to FTP site.

Payment & Terms Average price per image (for clients): $250 and up. Works on exclusive and nonexclusive contract basis. Contracts renew automatically with each submission for length of original contract.

Payment made quarterly. Offers one-time rights. Informs photographers when clients request all rights or exclusivity. Model release required. Photo captions required.

Making Contact Arrange a personal interview to show portfolio. Submit portfolio for review. Tips sheet distributed as needed to contract photographers only.

Tips Wants to see a cross-section of images for style and subject. "Photographers should not photograph people *before* getting a model release. The day of the 'grab shot' is over."

MEDICAL ON LINE LTD.

2nd Floor, Patman House, 23-27 Electric Parade, George Lane, South Woodford, London E18 2LS United Kingdom. (44)(208)530-7589. Fax: (44)(208)989-7795. E-mail: info@mediscan.co.uk. Web site: www.mediscan.co.uk. **Contact:** Tony Bright or Paula Willett. Estab. 2001. Picture library. Has over 1 million photos and over 2,000 hours of film/video footage on file. Subject matter includes medical personnel and environment, diseases and medical conditions, surgical procedures, microscopic, scientific, ultrasound/CT/MRI scans and x-rays. Online catalog on Web site. Clients include: advertising and design agencies, business-to-business, newspapers, public relations, book and magazine publishers in the healthcare, medical and science arenas.

Needs Photos of babies/children/teens/senior citizens; health/lifestyle/fitness/beauty; medicine, especially plastic surgery, rare medical conditions; model-released images; science, including microscopic imagery, botanical and natural history.

Specs Accepts negatives; 35mm and medium format transparencies; digital images (make contact before submitting samples).

Payment & Terms Pays up to 50% commission. Statements issued quarterly. Payment made quarterly. Model/property release required, where necessary.

Making Contact E-mail or call.

MEGAPRESS IMAGES

1751 Richardson, Suite 2205, Montreal QC H3K 1G6 Canada. (514)279-9859. E-mail: info@megapress.ca. Web site: www.megapress.ca. Estab. 1992. Stock photo agency. Has 500,000 photos in files. Has 2 branch offices. Clients include: book/encyclopedia publishers, magazine publishers, postcard publishers, calendar companies, greeting card companies, advertising agencies.

Needs Wants photos of people (babies/children/teens, couples, people at work, medical); animals including puppies in studio; industries; celebrities and general stock. Also needs families, parents, senior citizens, disasters, environmental, landscapes/scenics, wildlife, gardening, pets, religious, adventure, automobile, food/drink, health/fitness/beauty, sports, travel, business concepts, still life, science. "Looking only for the latest trends in photography and very high-quality images. A part of our market is Quebec's local French market."

Specs Accepts images in digital format only. Send via CD, floppy disk, Zip as JPEG files at 300 dpi.

Payment & Terms Pays 50% commission for color photos. Average price per image (to client): $100. Enforces minimum prices. Will not negotiate below $60. Works with photographers with or without a contract. Statements issued semiannually. Payment made semiannually. Offers one-time rights. Model release required for people and controversial news.

Making Contact Submit link first by e-mail. "If interested, we'll get back to you." Does not keep samples on file; include SAE/IRC for return of material. Expects minimum initial submission of 250 images with periodic submission of at least 1,000 digital pictures per year. Make first contact by e-mail. Accepts digital submissions only.

Tips "Pictures must be very sharp. Work must be consistent. We also like photographers who are specialized in particular subjects. We are always interested in Canadian content. Lots of our clients are based in Canada."

NATURAL SELECTION STOCK PHOTOGRAPHY L.L.C.

1603 Golf Course Rd., Suite A, Rio Rancho NM 87124. (505)896-4362. Fax: (505)896-4367. E-mail: mail@nssp.com. Web site: www.nssp.com. **Contact:** David L. Brown, manager. Estab. 1987. Stock photo agency. Has over 750,000 photos in files. Clients include: advertising agencies, public relations firms, businesses, book/encyclopedia publishers, magazine publishers, newspapers, postcard publishers, calendar companies, greeting card companies.

Needs Interested in photos of nature in all its diversity. Wants photos of disasters, environmental, landscapes/scenics, wildlife, pets, rural, adventure, travel, agriculture.

Specs Uses all formats.

Payment & Terms Pays 50% commission for color and b&w photos. Average price per image (to clients): $300-50,000 for b&w and color photos. Works with photographers on contract basis only. Offers nonexclusive contracts with image exclusivity. Contracts renew automatically with additional submissions for 3 years. Payment made monthly on fees collected. Offers one-time rights. "Informs photographer when client requests all rights." Model/property release required when appropriate. Photo captions required; include photographer's name, where image was taken and specific information as to what is in the picture.

Making Contact Send query letter with résumé of credits; include types of images on file, number of images, etc. Expects minimum initial submission of 200 images. Responds in 1 month.

Tips "All images must be completely captioned, properly sleeved, and of the utmost quality. High-quality digital images from Canon 1Ds or Nikon D2x cameras are welcomed."

911 PICTURES

63 Gardiners Lane., East Hampton NY 11937. (631)324-2061. Fax: (631)329-9264. E-mail: 911pix@optonl ine.net. Web site: www.911pictures.com. **Contact:** Michael Heller, president. Estab. 1996. Stock agency. Has 3,200 photos in files. Clients include: advertising agencies, public relations firms, audiovisual firms, businesses, book publishers, magazine publishers, calendar companies, insurance companies, public safety training facilities.

Needs Wants photos of disaster services, public safety/emergency services, fire, police, EMS, rescue, hazmat. Interested in documentary.

Specs Accepts images in digital format on CD at minimum 300 dpi, 8″ minimum short dimension. Images for review may be sent via e-mail, CD as BMP, GIF, JPEG files at 72 dpi.

Payment & Terms Pays 50% commission for b&w and color photos; 75% for film and videotape. Enforces minimum prices. Offers volume discounts to customers. Works with photographers on contract basis only. Offers nonexclusive contract. Charges any print fee (from negative or slide) or dupe fee (from slide). Statements issued/sale. Payment made/sale. Photographers allowed to review account records in cases of discrepancies only. Offers one-time rights. Informs photographers and allows them to negotiate when client requests all rights. Model release preferred. Photo captions preferred; include photographer's name, and a short caption as to what is occurring in photo.

Making Contact Send query letter with résumé, slides, prints, photocopies, tearsheets. "Photographers can also send e-mail with thumbnail (low-resolution) attachments." Does not keep samples on file; include SASE for return of material. Responds only if interested; send nonreturnable samples. Photo guidelines sheet free with SASE.

Tips "Keep in mind that there are hundreds of photographers shooting hundreds of fires, car accidents, rescues, etc., every day. Take the time to edit your own material, so that you are only sending in your best work. We are especially in need of hazmat, police and natural disaster images. At this time 911 Pictures is only soliciting work from those photographers who shoot professionally or who shoot public safety on a regular basis. We are not interested in occasional submissions of one or two images."

NOVASTOCK

1306 Matthews Plantation Dr., Matthews NC 28105-2463. (888)894-8622. Fax: (704)841-8181. E-mail: Novastock@aol.com. Web site: www.portfolios.com/novastock. **Contact:** Anne Clark, submission department. Estab. 1993. Stock agency. Clients include: advertising agencies, businesses, postcard publishers, public relations firms, book publishers, calendar companies, magazine publishers, greeting card companies, and large international network of subagents.

Needs "We need commercial stock subjects such as lifestyles, fitness, business, science, medical, family, etc. We also are looking for unique and unusual imagery. We have one photographer who burns, scratches and paints on his film." Wants photos of babies/children/teens, couples, multicultural, families, parents, senior citizens, disasters, environmental, wildlife, rural, adventure, health/fitness, travel, business concepts, military, science, technology/computers.

Specs Prefers images in digital format as follows: (1) Original digital camera files. (2) Scanned images in the 30-50MB range. "When sending files for editing, please send small files only. Once we make our picks, you can supply larger files. Final large files should be uncompressed TIFF or JPEG saved at best-quality compression. NEVER sharpen or use contrast and saturation filters. Always flatten layers. Files and disks must be readable on Windows PC."

Payment & Terms Pays 50% commission for b&w and color photos. Price range per image: $100-50,000

for b&w and color photos. "We never charge the photographer for any expenses whatsoever." Works with photographers on contract basis only. "We need exclusivity only for images accepted, and similars." Photographer is allowed to market work not represented by Novastock. Statements and payments are made in the month following receipt of income from sales. Informs photographers and discusses with photographer when client requests all rights. Model/property release required. Photo captions required; include who, what and where. "Science and technology need detailed and accurate captions. Model releases must be cross-referenced with the appropriate images."

Making Contact Contact by e-mail or send query letter with digital files, slides, tearsheets, transparencies. Does not keep samples on file; include SASE for return of material or personal check to cover return costs. Expects minimum initial submission of 100 images. Responds in 1 week to submissions.

Tips "Digital files on CD/DVD are preferred. All images must be labeled with caption (if necessary) and marked with model release information and your name and copyright. We market agency material through more than 50 agencies in our international subagency network. The photographer is permitted to freely market nonsimilar work any way he/she wishes. If you are unsure if your work meets the highest level of professionalism as used in current advertising, please do not contact."

▣ ⊕ OKAPIA K.G.

Michael Grzimek & Co., Postfach 645, Röderbergweg 168, Frankfurt 60385 Germany. E-mail: okapia@t-online.de. Web site: www.okapia.com. **Contact:** President. Stock photo agency and picture library. Has 700,000 photos in files. Clients include: ad agencies, book/encyclopedia publishers, magazine publishers, newspapers, postcard companies, calendar companies, greeting card companies, school book publishers.

Needs Wants photos of natural history, babies/children/teens, couples, families, parents, senior citizens, gardening, pets, adventure, health/fitness, travel, agriculture, industry, medical, science, technology/computers, general interest.

Specs Uses 35mm, $2\frac{1}{4} \times 2\frac{1}{4}$, 4×5 transparencies. Accepts digital images. Send via DVD, CD, floppy disk as JPEG files at 355 dpi.

Payment & Terms Pays 50% commission for color photos. Average price per image (to clients): $60-120 for color photos. Enforces strict minimum prices. Offers volume discounts to customers. Discount sales terms not negotiable. Works with photographers on contract basis only. Offers nonexclusive contract, limited regional exclusivity and guaranteed subject exclusivity (within files). Contracts renew automatically for 1 year with additional submissions. Charges catalog insertion fee. Statements issued quarterly, semiannually or annually, depending on money photographers earn. Payment made quarterly, semiannually or annually with statement. Photographers allowed to review account records in cases of discrepancies only. Offers one-time, electronic media and agency promotion rights. Does not permit photographers to negotiate when client requests all rights. Model/property release preferred. Photo captions required.

Making Contact Send query letter with slides. Does not keep samples on file; include SASE for return of material. Expects minimum initial submission of 300 slides. Responds in 5 weeks. Photo guidelines free with SASE. Distributes tips sheets on request semiannually to photographers with statements.

Tips "We need every theme which can be photographed." For best results, "send pictures continuously."

▣ OMNI-PHOTO COMMUNICATIONS

10 E. 23rd St., New York NY 10010. Phone/fax: (212)995-0895. E-mail: info@omniphoto.com or david@omniphoto.com. Web site: www.omniphoto.com. **Contact:** Mary Fran Loftus, president. Estab. 1979. Stock photo and art agency. Has 100,000 photos in files. Clients include: advertising agencies, public relations firms, businesses, book/encyclopedia/magazines/calendar/greeting card companies.

Needs Wants photos of babies/children/teens, couples, multicultural, families, senior citizens, environmental, wildlife, architecture, cities/urban, religious, rural, entertainment, food/drink, health/fitness, sports, travel, agriculture, industry, medicine.

Specs Accepts images in digital format. High-resolution 30-50MB JPEGs required for accepted digital images.

Payment & Terms Pays 50% commission. Works with photographers on contract basis only. Offers limited regional exclusivity. Contracts renew automatically with additional submissions for 4 years. Charges catalog insertion fee. Statements issued with payment on a quarterly basis. Offers one-time rights. Informs photographers and allows them to negotiate when client requests all rights. Model/property release required. Photo captions required.

Making Contact Send low-res sample JPEGs (approximately 3×5 inches) on DVD, CD, or point us to your Web site portfolio. Only discs with SASE are returned. No e-mail attachments."

Tips "We want spontaneous-looking, professional-quality photos of people interacting with each other. Have carefully-thought-out backgrounds, props and composition, commanding use of color. Stock photographers must produce high-quality work at an abundant rate. Self-assignment is very important, as is a willingness to obtain model releases; caption thoroughly and make submissions regularly."

⊡ ⊕ ONASIA

30 Cecil Street, Prudential Tower Level 15, Singapore 049712. + (662) 655-4680. Fax: + (662) 655-4682. E-mail: sales@onasia.com. Web site: www.onasia.com. Contact: Peter Charlesworth or Yvan Cohen, directors. An Asia-specialized agency offering rights-managed stock, features and assignment services. Represents over 130 photographers and has over 140,000 high-resolution images available online and 400,000 photos in files. Offices in Singapore and Bangkok. Represented co-exclusively by Jupiter Images for commercial imagery. Clients include: advertising and graphic design agencies, newspapers, magazines, book publishers, calendar and gift card companies.

Needs Wants model-released Asia-related conceptual, lifestyle and business imagery as well as a broad range of nonreleased editorial imagery including current affairs, historical collections, travel and leisure, economics as well as social and political trends. Please note: We only accept images from or relating to Asia.

Specs Accepts images in digital format. Send via CD or to our FTP site as 12×18-inch JPEG files at 300 dpi. All files must be retouched to remove dust and dirt. Photo captions required; include dates, location, country and a detailed description of image, including names where possible.

Payment/Terms Pays 50% commission to photographers. Terms specified in photographer contracts. Photographers are required to submit on an image-exclusive basis. Statements issued monthly.

Making Contact E-mail queries to info@onasia.com with lo-res JPEG samples or a link to photographer's Web site. Does not keep samples on file; cannot return material. Expects minimum initial submission of 150 images. Photo guidelines available via e-mail.

Tips "Provide a well-edited low-res portfolio for initial evaluation. Ensure that subsequent submissions are tightly edited, sized to Onasia's specs, retouched and submitted with full captions."

⊡ ONREQUEST IMAGES

1415 Western Ave., Suite 300, Seattle WA 98101. (877)202-5025. Fax: (206)774-1291. E-mail: photographer.manager@onrequestimages.com. Web site: www.onrequestimages.com. **Contact:** Barb Ferderer, director of photographer relations. Estab. 2003. Custom image services. Headquartered in Seattle, the company has offices in New York, Chicago, Los Angeles, Denver, Dallas, Philadelphia and San Francisco. Clients include Fortune 1000 corporations.

Needs Wants photos of babies, multicultural, families, parents, senior citizens, environmental, landscapes/scenics, architecture, education, interiors/decorating, pets, rural, adventure, food/drink, health/fitness/beauty, travel, agriculture, business concepts, science, technology/computers. Interested in lifestyle, seasonal.

Specs Accepts images in digital format as TIFF files at 300 dpi. Send via e-mail or upload.

Payment/Terms Offers volume discounts to customers; terms specified in photographers' contracts. Photographers can choose not to sell images on discount terms. Works with photographers on contract basis only. Offers nonexclusive contract; guaranteed subject exclusivity (within files). Statements issued quarterly. Payments made within 45 days. Rights offered depend on contract. Informs photographers and allows them to negotiate when a client requests all rights. Model release/property release required. Captions required.

Making Contact E-mail query letter with link to photographer's Web site. Provide self-promtion piece to be kept on file. Expects minimum initial submission of 15 images. Responds in 2 weeks. Photo guidelines sheet available.

Tips "Be honest about what you specialize in."

⊡ OUT OF THE BLUE

7350 S. Tamiami Trail, #227, Sarasota FL 34231. (941)966-4042. Fax: (941)966-8914. E-mail: outoftheblue.us@mac.com. Web site: www.out-of-the-blue.us. Estab. 2003. **Contact:** Michael Woodward, president. Creative Director: Maureen May. "Where serendipity, creativity and commerce merge. We specializes in creating 'Art Brands.' We are looking for fine art photographic collections that we can license for product categories such as fine art posters, giclees on paper and canvas for interior design projects, home and office decor."

Needs ''We require collections or groups of photographic images which are either decorative or have a more sophisiticated fine art look. CD presentations preferred, but photocopies/flyers are acceptable.''

Making Contact & Terms Send examples on CD (JPEG files), color photocopies with SASE. E-mail presentations also accepted. Fine artists should send short bio. ''Our general commision rate is 50% with no expenses to photographer as long as photographer can provide high-resolution scans if we agree to representation.''

Tips ''Our agency specializes in aiming to create full licensing programs so we can license art/photographs across a varied product range. We are therefore only interested in collections or groups of images or concepts that have commercial appeal. Photographers need to consider actual products for the market when creating new art.''

▣ ⊕ ▨ OXFORD SCIENTIFIC (OSF)

Oxford Scientific Films, Network House, Station Yard, Thame OX9 3UH United Kingdom. (44)(184)426-2370. Fax: (44)(184)426-2380. E-mail: creative@osf.co.uk. Web site: www.osf.co.uk. **Contact:** Creative Director. Estab. 1968. Stock agency. Stills and footage libraries. Has 350,000 photos, over 2,000 feet of HD, film and video originated footage. Clients include: advertising agencies, design companies, audiovisual firms, book/encyclopedia publishers, magazine and newspaper publishers, merchandising companies, multimedia publishers, film production companies.

Needs Wants photos and footage of natural history: animals, plants, behavior, close-ups, life-histories, histology, embryology, electron microscopy, scenics, geology, weather, conservation, country practices, ecological techniques, pollution, special-effects, high- speed, time-lapse, landscapes, environmental, travel, sports, pets, domestic animals, wildlife, disasters, gardening, rural, agriculture, industry, medicine, science, technology/computers. Interested in seasonal.

Specs Uses 35mm and larger transparencies; 16 and 35mm film and video. Accepts images in digital format. Send via CD, e-mail at 72 dpi for initial review; 300 dpi (RGB TIFF files) for final submission. Review guidelines for details.

Payment & Terms Pays 50% commission. Negotiates fees below stated minimums on bulk deals. Average price per image (to clients) $100-2,000 for b&w and color photos; $300-4,000 for film or videotape. Offers volume discounts to regular customers; inquire about specific terms. Discount sale terms not negotiable. Works with photographers on contract basis only; needs image exclusivity. Offers image-exclusive contract, limited regional exclusivity, guaranteed subject exclusivity. Contracts renew automatically every 2 years. There is a charge for handling footage. Offers one-time, electronic media and agency promotion rights. Informs photographers and allows them to negotiate when client requests all rights. Model/property release required. Photo captions required; include common name, Latin name, behavior, location and country, magnification where appropriate, if captive, if digitally manipulated. Contact OSF for footage terms.

Making Contact Submission guidelines available on Web site. Expects minimum initial submission of 100 images with quarterly submissions of at least 100 images. Interested in receiving high-quality, creative, inspiring work from both amateur and professional photographers. Responds in 1 month.

Tips ''Contact via e-mail, phone or fax, or visit our Web site to obtain submission guidelines.'' Prefers to see ''good focus, composition, exposure, rare or unusual natural history subjects and behavioral and action shots, inspiring photography, strong images as well as creative shots. Read photographer's pack from Web site or e-mail/write to request a pack, giving brief outline of areas covered and specialties and size.''

▣ PACIFIC STOCK

Koko Marina Center, 7192 Kalanianaole Hwy., Suite G-230, Honolulu HI 96825. (808)394-5100. Fax: (808)394-5200. E-mail: pics@pacificstock.com. Web site: www.pacificstock.com. **Contact:** Barbara Brundage, owner/president. Member of Picture Archive Council of America (PACA). Has 100,000 photos in files; 20,000 digital images online. ''Pacific Stock specializes exclusively in rights-managed imagery from throughout Hawaii, Pacific and Asia and the *new* royalty-free Wiki Shots (www.wikishots.com).'' Clients include advertising agencies, public relations firms, audiovisual firms, businesses, book/encyclopedia publishers, magazine publishers, postcard companies, calendar companies, greeting card companies.

Needs Needs photos of North American West Coast, Hawaii, Pacific Islands, Australia, New Zealand, Far East, etc. Subjects include: people (women, babies/children/teens, couples, multicultural, families, parents, senior citizens), culture, marine science, industrial, environmental, landscapes, wildlife, adven-

ture, food/drink, health/fitness, sports, travel, agriculture, business concepts. "We also have an extensive vintage Hawaii file."

Specs Accepts images in digital format only. Send via CD or DVD as 16-bit TIFF files (guidelines on Web site at http://www.pacificstock.com/photographer_guidelines.asp).

Payment & Terms Pays 40% commission for color photos. Average price per image (to clients): $650. Works with photographers on contract basis only. Statements and payments issued monthly. Photographers allowed to review account records to verify sales figures. Offers one-time or first rights; additional rights with photographer's permission. Informs photographers and allows them to negotiate when client requests all rights. Model/property release required for all people and certain properties, i.e., homes and boats. Photo captions required; include: "who, what, where." See submission guidelines for more details.

Making Contact "E-mail or call us after reviewing our Web site and our photo guidelines. Want lists distributed regularly to represented photograpehrs; free via e-mail to interested photographers."

Tips Photographer must be able to supply minimum of 500 image files (must be model-released) for initial entry and must make quarterly submissions of fresh material from Hawaii, Pacific and Asia area destinations. Image files must be captioned in File Info (i.e., IPTC headers) according to our submission guidelines. Please contact us to discuss the types of imagery that sell well for us. We are interested in working with photographers who work with us and enjoy supplying imagery requested by our valued clients."

▣ PAINET INC.

20 Eighth St. S., P.O. Box 431, New Rockford ND 58356. (701)947-5932 or (888)966-5932. Fax: (701)947-5933. E-mail: photogs@painetworks.com. Web site: www.painetworks.com. **Contact:** S. Corporation, owner. Estab. 1985. Picture library. Has 589,000 digital photos in files. Clients include: advertising agencies, magazine publishers.

Needs "Anything and everything."

Specs "Refer to www.painetworks.com/helppages/submit.htm for information on how to scan and submit images to Painet. The standard contract is also available from this page."

Payment & Terms Pays 60% commission (see contract). Works with photographers with or without a contract. Offers nonexclusive contract. Payment made immediately after a sale. Informs photographers and allows them to negotiate when client requests all rights. Provides buyer contact information to photographer by sending photographer copies of the original invoices on all orders of photographer's images.

Making Contact "Occasionally receives a list of current photo requests."

Tips "We have added an online search engine with 532,000 images. We welcome submissions from new photographers, since we add approximately 60,000 images quarterly. Painet markets color and black & white images electronically or by contact with the photographer. Because images and image descriptions are entered into a database from which searches are made, we encourage our photographers to include lengthy descriptions that improve the chances of finding their images during a database search. We prefer descriptions be included in the IPTC (File Info area of Photoshop). Photographers who provide us their e-mail address will receive a biweekly list of current photo requests from buyers. Photographers can then send matching images via e-mail or FTP, and we forward them to the buyer. Painet also hosts Photographer's and Photo Agency Web sites. See details at http://www.painetworks.com/helppages/setupPT.htm ."

▣ PANORAMIC IMAGES

2302 Main St., Evanston IL 60202. (847)324-7000. Fax: (847)324-7004. E-mail: images@panoramicimages.com, michelle@panoramicimages.com. Web site: www.panoramicimages.com. **Contact:** Michelle Alvardo, director of photography. Estab. 1987. Stock photo agency. Member of ASPP, NANPA and IAPP. Clients include: advertising agencies, magazine publishers, newspapers, design firms, graphic designers, corporate art consultants, postcard companies, calendar companies.

Needs Wants photos of lifestyles, environmental, landscapes/scenics, wildlife, architecture, cities/urban, gardening, interiors/decorating, rural, adventure, automobiles, health/fitness, sports, travel, business concepts, industry, medicine, military, science, technology/computers. Interested in alternative process, avant garde, documentary, fine art, historical/vintage, seasonal. Works only with *panoramic formats* (2:1 aspect ratio or greater). Subjects include: cityscapes/skylines, international travel, nature, tabletop, backgrounds, conceptual.

Specs Uses 2¼×5, 2¼×7 (6×12cm, 6×17cm). "Transparencies preferred for initial submission. Call for digital submission guidelines or see Web site."

Payment & Terms Pays 40% commission for photos. Average price per image (to clients): $600. No charge for scanning, metadata or inclusion on Web site. Statements issued quarterly. Payment made quarterly. Offers one-time, electronic rights and limited exclusive usage. Model release preferred "and/or property release, if necessary." Photo captions required. Call or see Web site for submission guidelines before submitting.

Making Contact Send e-mail with stock list or low-res scans/lightbox. Responds in 1-3 months. Specific want lists created for contributing photographers. Photographer's work is represented on full e-commerce Web site and distributed worldwide through image distribution partnerships with Getty Images, National Geographic Society Image Collection, Amana, Digital Vision, etc.

Tips Wants to see "well-exposed chromes or very high-res stitched pans. Panoramic views of well-known locations nationwide and worldwide. Also, generic beauty panoramics."

▣ ⊕ PAPILIO NATURAL HISTORY LIBRARY

155 Station Rd., Herne Bay, Kent CT6 5QA United Kingdom. (44)(122)736-0996. E-mail: library@papiliophotos.com. Web site: www.papiliophotos.com. **Contact:** Justine Pickett. Estab. 1984. Has 65,000 photos in files. Clients include: advertising agencies, book publishers, magazine publishers, newspapers, calendar companies, greeting card companies, postcard publishers.

Needs Wants photos of wildlife.

Specs Prefers digital submissions. Uses digital shot in-camera as RAW and converted to TIFF for submission, minimum file size 17MB. See Web page for further details or contact for a full information sheet about shooting and supplying digital photos.

Payment & Terms Works with photographers on contract basis only. Offers nonexclusive contract. Statements issued quarterly. Payment made quarterly. Offers one-time rights, electronic media rights. Photo captions required; include Latin names and behavioral information and keywords.

Making Contact Send query letter with résumé. Does not keep samples on file. Expects minimum initial submission of 150 images. Responds in 1 month to samples. Returns all unsuitable material with letter. Photo guidelines sheet free with SASE.

Tips "Contact first for information about digital. Send digitial submissions on either CD or DVD. Supply full caption listing for all images. Wildlife photography is very competitive. Photographers are advised to send only top-quality images."

▣ PHOTO AGORA

3711 Hidden Meadow Lane, Keezletown VA 22832. (540)269-8283. E-mail: robert@photoagora.com. Web site: www.photoagora.com. **Contact:** Robert Maust. Estab. 1972. Stock photo agency. Has over 50,000 photos in files. Clients include: businesses, book/encyclopedia and textbook publishers, magazine publishers, calendar companies.

Needs Wants photos of families, children, students, Virginia, Africa and other third world areas, work situations, etc. Also needs babies/children/teens, couples, multicultural, parents, senior citizens, disasters, environmental, landscapes/scenics, wildlife, cities/urban, education, gardening, pets, religious, rural, health/fitness, travel, agriculture, industry, medicine, science, technology/computers.

Specs Prefers high-resolution digital images. Ask for password to download agreement and submission guidelines from Web site.

Payment & Terms Pays 50% commission for b&w and color photos. Average price per image (to clients): $40 minimum for b&w photos; $100 minimum for color photos. Negotiates fees below standard minimum prices. Offers volume discounts to customers; inquire about specific terms. Photographers can choose not to sell images on discount terms. Works with photographers with or without a contract. Offers nonexclusive contract. Statements issued quarterly. Payment made quarterly. Photographers allowed to review account records. Offers one-time rights. Informs photographers and allows them to negotiate when client requests all rights. Model/property release preferred. Photo captions required; include location, important dates, scientific names, etc.

Making Contact Call, write or e-mail. No minimum number of images required in initial submission. Responds in 3 weeks. Photo guidelines free with SASE or download from Web site.

▣ PHOTO EDIT

235 E. Broadway St., Suite 1020, Long Beach CA 90802. (800)860-2098. Fax: (800)804-3707. E-mail: sales@photoeditinc.com. Web site: www.photoeditinc.com. **Contact:** Leslye Borden or Liz Ely. Estab.

1987. Stock agency. 100% digital. 200,000 images online. Clients include: advertising agencies, businesses, public relations firms, book/textbook publishers, calendar companies, magazine/newspaper publishers.

Needs Digital images of babies/children/teens, couples, multicultural, families, parents, senior citizens, disasters, environment, cities/urban, education, religious, food/drink, health/fitness, hobbies, sports, travel, agriculture, business concepts, industry, medicine, political, science, technology/computers.

Specs Uses images in digital format (RAW, unmanipulated). Send via CD as TIFF or JPEG files at 300 dpi.

Payment & Terms Pays 50% commission for color images. Average price per image (to clients): $175 for color images. Enforces minimum prices. Enjoys preferred vendor status with many clients. Works with photographers on contract basis only. Offers nonexclusive contract. Contracts renew automatically with continuous submissions. Offers one-time rights. Informs photographers and allows them to negotiate when a client requests all rights. Model/property release preferred. Photo captions required.

Making Contact Send query letter by e-mail with images. Does not keep samples on file. Expects minimum initial submission of 1,000 edited images with quarterly submissions of new images. Responds immediately only if interested. Photo guidelines sheet available via e-mail.

Tips "Call to discuss interests, equipment, specialties, availability, etc."

N ▣ PHOTO NETWORK

P.O. Box 317, Lititz PA 17543. (717)626-0296 or (800)622-2046. Fax: (717)626-0971. E-mail: info@heilmanphoto.com. Web site: www.photonetworkstock.com or www.heilmanphoto.com. **Contact:** Sonia Wasco, president. Stock photo agency/library. Member of Picture Archive Council of America (PACA). Has more than 1 million photos in files. Clients include: agribusiness companies, ad agencies, textbook companies, graphic artists, public relations firms, newspapers, corporations, magazines, calendar companies, greeting card companies.

- Photo Network is now owned by Grant Heilman Photography.

Needs Wants photos of agriculture, families, couples, ethnics (all ages), animals, travel and lifestyles. Also wants photos of babies/children/teens, parents, senior citizens, disasters, environmental, wildlife, architecture, cities/urban, education, gardening, interiors/decorating, pets, religious, rural, adventure, automobiles, food/drink, health/fitness/beauty, hobbies, humor, sports, business concepts, industry, medicine, military, political, science, technology/computers. Special subject needs include people over age 55 enjoying life; medical shots (patients and professionals); children and domestic animals.

Specs Uses transparencies and digital format. Send via CD as JPEG files.

Payment & Terms Information available upon request.

Making Contact Send query letter with stock list. Send a sample of 200 images for review; include SASE for return of material. Responds in 1 month.

Tips Wants to see a portfolio "neat and well-organized and including a sampling of photographer's favorite photos." Looks for "clear, sharp focus, strong colors and good composition. We'd rather have many very good photos rather than one great piece of art. Would like to see photographers with a specialty or specialties and have it/them covered thoroughly. You need to supply new photos on a regular basis and be responsive to current trends in photo needs. Contract photographers are supplied with quarterly 'want' lists and information about current trends."

▣ PHOTO RESEARCHERS, INC.

60 E. 56th St., New York NY 10022. (212)758-3420. Fax: (212)355-0731. E-mail: portfolio@photoresearchers.com. Web site: www.photoresearchers.com. Stock agency. Has over 1 million photos and illustrations in files, with 150,000 images in a searchable online database. Clients include: advertising agencies; graphic designers; publishers of textbooks, encyclopedias, trade books, magazines, newspapers, calendars, greeting cards; foreign markets.

Needs Wants images of all aspects of science, astronomy, medicine, people (especially contemporary shots of teens, couples and seniors). Particularly needs model-released people, European wildlife, up-to-date travel and scientific subjects. Lifestyle images must be no older than 2 years; travel images must be no older than 5 years.

Specs Prefers images in digital format. Accepts any size transparencies.

Payment & Terms Rarely buys outright; pays 50% commision on stock sales. General price range (to clients): $150-7,500. Works with photographers on contract basis only. Offers limited regional exclusivity. Contracts renew automatically with additional submissions for 5 years (initial term; 1 year thereafter).

Charges $15 for Web placement for transparencies. Photographers allowed to review account records upon reasonable notice during normal business hours. Statements issued monthly, bimonthly or quarterly, depending on volume. Informs photographers and allows them to negotiate when a client requests to buy all rights, but does not allow direct negotiation with customer. Model/property release required for advertising; preferred for editorial. Photo captions required; include who, what, where, when. Indicate model release.

Making Contact See "About Representation and Submission Guidelines" on Web site.

Tips "We seek the photographer who is highly imaginative or into a specialty (particularly in the scientific or medical fields) and who is dedicated to technical accuracy. We are looking for serious contributors who have many hundreds of images to offer for a first submission and who are able to contribute often."

PHOTO RESOURCE HAWAII

111 Hekili St., #41, Kailua HI 96734. (808)599-7773. Fax: (808)235-5477. E-mail: prh@photoresourcehaw aii.com. Web site: www.PhotoResourceHawaii.com. **Contact:** Tami Kauakea Winston, owner. Estab. 1983. Stock photo agency. Has Web site with electronic delivery of over 12,000 images. Clients include: ad agencies, audiovisual firms, businesses, book/encyclopedia publishers, magazine publishers, calendar companies, greeting card companies, postcard publishers.

Needs Photos of Hawaii and the South Pacific.

Specs Accepts images in digital format only; 48MB or larger; TIFF files from RAW files preferred.

Payment & Terms Pays 50% commission. Enforces minimum prices. Offers volume discounts to customers. Discount sales terms not negotiable. Works with photographers on contract basis only. Offers nonexclusive contract. Contracts renew automatically with additional submissions. Statements issued bimonthly. Payment made bimonthly. "Rights-managed licensing only, no royalty-free." Model/property release preferred. Photo captions and keywording online required.

Making Contact Send query e-mail with samples. Expects minimum initial submission of 100 images with periodic submissions at least 5 times/year. Responds in 2 weeks.

PHOTO STOCK/GRANATAIMAGES.COM

19/5 Via Wildt, Milan 20131 Italy. (39)(022)668-0702. Fax: (39)(022)668-1126. E-mail: paolo.granata@gr anataimages.com. Web site: www.granataimages.com. **Contact:** Paolo Granata, manager. Estab. 1985. Stock and press agency. Member of CEPIC. Has 2 million photos in files and 800,000 images online. Clients include: advertising agencies, newspapers, book publishers, calendar companies, audiovisual firms, magazine publishers, production houses.

Needs Wants photos of celebrities, people.

Specs Uses high-resolution digital files. Send via Zip, FTP, e-mail as TIFF, JPEG files.

Payment & Terms Pays 60% commission for color photos. Negotiates fees below stated minimums in cases of volume deals. Offers volume discounts to customers. Photographers can choose not to sell images on discount terms. Works with photographers on contract basis only. Offers exclusive contract only. Contracts renew automatically with additional submissions for 1 year. Statements issued monthly. Photographers allowed to review account records in cases of discrepancies only. Offers one-time rights. Model/property release preferred. Photo captions required; include location, country and any other relevant information.

Making Contact Send query letter with digital files.

PHOTOBANK-BANGKOK

Photobank-Singapore, 58/18 Soi Promsri 2, (Soi 49-19) Sukhumvit Rd., Klongton Nue, Wattana 10110 Bangkok. (66)(02)391-8185. Fax: (66)(02)391-4498. E-mail: cassio@loxinfo.co.th. Web site: www.photo bangkok.com. **Contact:** Alberto Cassio. Estab. 1975. Picture library. Has 550,000 photos in files. Clients include: advertising agencies, businesses, book publishers, audiovisual firms.

Needs Wants photos of babies/children/teens, couples, families, disasters, environmental, landscapes/scenics, wildlife, cities/urban, education, interiors/decorating, pets, adventure, food/drink, health/fitness/beauty, hobbies, sports, agriculture, business concepts, industry, medicine, product shots/still life, science, technology/computers. Interested in historical/vintage.

Specs Uses 35mm, $2^{1}/_{4} \times 2^{1}/_{4}$ transparencies; B copy videos.

Payment & Terms Pays 50% commission for color photos; 40% for videotape. Average price per image (to clients): $100-2,000 for photos; $200-3,000 for videotape. Enforces minimum prices. Offers volume discounts to customers. Works with photographers on contract basis only. Offers limited regional exclu-

sivity. Contracts renew automatically with additional submissions. Statements issued quarterly. Photographers allowed to review account records in cases of discrepancies only. Offers one-time rights. Model release preferred. Photo captions required.

Making Contact Contact through rep. Expects minimum initial submission of 500 images with 6-month submissions of at least 200 images.

Tips "Set up an appointment and meet personally."

◼ PHOTOEDIT

235 Broadway, Suite 1020, Long Beach CA 90802. (800)860-2098. Fax: (800)804-3707. E-mail: sales@phot oeditinc.com. Web site: www.photoeditinc.com. **Contact:** Leslye Borden, president. Vice President: Elizabeth Ely. Estab. 1987. Stock photo agency. Member of Picture Archive Council of America (PACA). Has 500,000 photos. Clients include: textbook/encyclopedia publishers, magazine publishers.

Needs Photos of people—seniors, babies, couples, adults, teens, children, families, minorities, handicapped—ethnic a plus.

Specs Uses digital images only.

Payment & Terms Pays 50% commission for color photos. Average price per image (to clients): $200/ quarter page, textbook only; other sales higher. Works on contract basis only. Offers nonexclusive contract. Payments and statements issued quarterly; monthly if earnings over $1,000/month. Photographers are allowed to review account records. Offers one-time rights; limited time use. Consults photographer when client requests all rights. Model release preferred.

Making Contact Submit digital portfolio for review. Once accepted into agency, expects minimum initial submission of 1,000 images with additional submission of 1,000 images/year. Responds in 1 month. Photo guidelines available on Web site.

Tips In samples, looks for "drama, color, social relevance, inter-relationships, current (*not* dated) material, tight editing. We want photographers who have easy access to models of every ethnicity (not professional models) and who will shoot actively and on spec."

◼ ⊕ PHOTOLIBRARY.COM

Level 11, 54 Miller St., North Sydney 2090 NSW Australia. (61)(2)9929-8511. Fax: (61)(2)9923-2319. E-mail: creative@photolibrary.com. Web site: www.photolibrary.com. Estab. 1967. Stock agency. Has more than 1 million high-res images on the Web. Clients include: advertising agencies, graphic designers, corporate, newspapers, postcard publishers, public relations firms, book publishers, calendar companies, magazine publishers, greeting card companies.

• This agency also has an office in the UK at 83-84 Long Acre, London WC2E 9NG. Phone: (44)(207)836-5591. Fax: (44)(207)379-4650; other offices in New Zealand, Singapore, Malaysia, Thailand, Phillipines. Other companies in The Photolibrary Group include OSF in Oxfordshire (UK), specializing in the natural world, and Garden Picture Library in London.

Needs "Contemporary imagery covering all subjects, especially model-released people in business and real life."

Specs Prefers images in digital format. Digital specifications: 50-70MB; use only professional cameras of not less than 10 megapixels (see details on Web site under "Contributors").

Payment & Terms Pays 50% commission. Offers volume discounts to customers. Discount sales terms not negotiable. Offers guaranteed subject exclusivity. Statements issued quarterly. Photographers allowed to review account records. Offers one-time rights, electronic media rights, agency promotion rights. Model/property release required. Photo captions required; include date of skylines.

Making Contact See Web site for information on how to make initial submissions.

◼ ⊕ PHOTOLIFE CORPORATION LTD.

2012 C C Wu Building, 302 Hennessy Rd., Wanchai, Hong Kong. (852)2808 0012. Fax: (852)2808 0072. E-mail: edit@photolife.com.hk. Web site: www.photolife.com.hk. **Contact:** Sarin Li, director of business development. Estab. 1994. Stock photo library. Has over 1.6 million photos in files. Clients include: advertising agencies, newspapers, book publishers, calendar companies, magazine publishers, greeting card companies, corporations, production houses, graphic design firms.

Needs Wants contemporary images of sports, travel, business concepts, food, nature, wildlife, medicine. Interested in lifestyle.

Specs Accepts images in digital format only. "Use only professional digital cameras (capable of producing

24 MB + images) with high-quality interchangeable lenses; or images from high-end scanners producing a file up to 50MB.''

Payment & Terms Pays 50% commission for b&w and color photos. Average price per image (to clients): $105-1,550 for b&w photos; $105-10,000 for color photos. Offers volume discounts to customers; terms specified in photographers' contracts. Works with photographers on contract basis only. Contract can be initiated with minimum 300 selected images. Quarterly submissions needed. Informs photographers and allows them to negotiate when client requests all rights. Model release required; property release preferred. Photo captions required; include destination and country.

Making Contact E-mail 50 low-res images (1,000 pixels or less), or send CD with 50 images.

Tips ''Visit our Web site. Edit your work tightly. Send images that can keep up with current trends in advertising and print photography.''

▣ PHOTOPHILE STOCK PHOTOGRAPHY

501 Silverside Road, Suite 105 Wilmington, DE 19809. (800)619-4PHOTO. E-mail: info@PhotophileStock. com. Web site: www.PhotophileStock.com. **Contact:** Orville Morrison. Clients include: advertising agencies, audiovisual firms, businesses, postcard and calendar producers, greeting card companies, textbook and travel book publishers, editorial.

Needs Wants photos of lifestyle, vocations, sports, industry, business, medical, babies/children/teens, couples, multicultural/international, wildlife, architecture, cities/urban, education, interiors/decorating, animals/pets, religious, rural, events, food/drink, health/fitness, hobbies, humor, travel, agriculture, still life, science, sea life, digital illustrations.

Specs Uses digital formats only.

Payment & Terms Pays 50% commission. Works with photographers on contract basis only. Statements issued quarterly. Payment made quarterly. Informs photographers and allows them to negotiate when client requests all rights. Model/property release preferred. Photo captions required and preferrably embedded in metatags of image. Include location or description of obscure subjects; travel photos should be captioned with complete destination information.

Making Contact E-mail Web site link or send CD/DVD for review. May also request FTP information to upload images for review. ''Professionals only, please.'' Photographer must be continuously shooting to add new images to files.

Tips ''Specialize, and shoot for the broadest possible sales potential. Get proper captions. Manage digital files for highest quality; sharp focus and good composition are important.''

ℕ ⊕ PHOTOSOURCE NEW ZEALAND LTD.

Stock Image Group, Suite 6, Clarence House, 18 Clarence St., Devonport, Auckland New Zealand. 64 9 445 7536. Fax: 64 9 445 7537. E-mail: psi2@photosource.com. Web site: www.photosource.com. Estab. 1998. Picture library. Has 80,000 photos in files. Clients include: advertising agencies, businesses, postcard publishers, public relations firms, book publishers, calendar companies, government departments, magazine publishers, greeting card companies.

Needs Wants photos of babies/children/teens, celebrities, couples, multicultural, families (New Zealand only), parents, senior citizens, wildlife, disasters, environmental, landscapes/scenics, architecture, cities/urban, education, gardening, interiors/decorating, adventure, entertainment, food/drink, hobbies, performing arts, sports, travel, business concepts, industry, medicine, product shots/still life, science, technology/computers. Interested in seasonal.

Specs Uses 35mm, 2¼×2¼, 4×5, 8×10 transparencies.

Payment & Terms Pays 50% commission for photos, film. Average price per image (to clients): $200-2,500 for photos. Offers volume discounts. Discount sales terms not negotiable. Works with photographers on contract basis only. Offers nonexclusive contract with guaranteed subject exclusivity in New Zealand. Statements issued quarterly. Payment made quarterly. Offers one-time rights. Informs photographers and allows them to negotiate when client requests all rights. Model/property release required. Photo captions preferred; include full description of location or subject.

Making Contact Contact via e-mail.

Tips ''All 35mm should be mounted with description and other relevant information on a list. Check all work thoroughly for technical faults and leave 'faulty' material out of submission. Keep subjects in order. Present slides in sleeves, not boxes. 120 format and larger, if mounted, should be labelled, too. 120 format, if unmounted, should be numbered to correspond easily with a description list.''

▣ ◉ SYLVIA PITCHER PHOTO LIBRARY

75 Bristol Rd., Forest Gate, London E7 8HG United Kingdom. E-mail: SPphotolibrary@aol.com. Web site: www.sylviapitcherphotos.com. **Contact:** Sylvia Pitcher. Estab. 1965. Picture library. Has 70,000 photos in files. Clients include: book publishers, magazine publishers, design consultants, record and TV companies.

Needs Wants photos of musicians—blues, country, bluegrass, old time and jazz with views of America that could be used as background to this music. Also, other relevant subject matter such as recording studios, musicians' birth places, clubs etc. Please see Web site for a good indication of the library's contents.

Specs Accepts images in digital format.

Payment & Terms Pays 50% commission for b&w and color photos. Average price per image (to clients): $105-1,000. Negotiates fees below stated minimum for budget CDs or multiple sale. Offers volume discounts to customers; terms specified in photographers' contracts. Photographers can choose not to sell images on discount terms, if specified at time of depositing work in library. Works with photographers with or without contract; negotiable. Offers nonexclusive contract. Contracts renew automatically with additional submissions for 3 years. Statements issued quarterly. Payment made when client's check has cleared. Offers one-time rights. Model/property release preferred. Photo captions required; include artist, place/venue, date taken.

Making Contact Send query letter with CD of approximately 10 low-res sample images and stock list. Provide self-promotion piece to be kept on file. Expects minimum initial submission of 50 high-res images on CD with further submissions when available.

▣ PIX INTERNATIONAL

3600 N. Lake Shore Dr., Unit 612 Floor, Chicago IL 60613. (773)472-7457. E-mail: pixintl@yahoo.com. Web site: www.pixintl.com. **Contact:** Linda Matlow, president. Estab. 1978. Stock agency, news/feature syndicate. Has 200,000 photos in files. Clients include: advertising agencies, public relations firms, businesses, book publishers, magazine publishers, newspapers.

Needs Wants photos of celebrities, entertainment, performing arts.

Specs Accepts images in digital format only. E-mail link to Web site. "Do not e-mail any images. Do not send any unsolicited digital files. Make contact first to see if we're interested."

Payment & Terms Pays 50% commission for b&w or color photos, film. Average price per image (to clients): $35 minimum for b&w or color photos; $75-3,000 for film. Enforces minimum prices. Offers volume discounts to customers; terms specified in photographers' contracts. Discount sales terms not negotiable. Works with photographers with or without a contract; negotiable. Statements issued monthly. Payment made monthly. Photographers allowed to review account records in cases of discrepancies only. Offers one-time rights. Informs photographers and allows them to negotiate when client requests all rights. Model release not required for general editorial. Photo captions required; include who, what, when, where, why.

Making Contact "E-mail us your URL with thumbnail examples of your work that can be clicked for a larger viewable image." Responds in 2 weeks to samples, only if interested.

Tips "We are looking for razor-sharp images that stand up on their own without needing a long caption. Let us know by e-mail what types of photos you have, your experience, and cameras used. We do not take images from the lower-end consumer cameras—digital or film. They just don't look very good in publications. For photographers we do accept, we would only consider high-res 300 dpi at 6×9 or higher scans submitted on CDR. Please direct us to samples on your Web site."

▣ ◉ PLANS, LTD. (Photo Libraries and News Services)

#201 Kamako Bldg., 1-8-9 Ohgi-gaya, Kamakura 248-0011 Japan. (81)(46)723-2350. Fax: (81)(46)723-2351. E-mail: yoshida@plans.jp. Web site: www.plans.jp. **Contact:** Takashi Yoshida, president. Estab. 1982. Stock agency. Has 100,000 photos in files. Clients include: photo agencies, newspapers, book publishers, magazine publishers, advertising agencies.

Needs "We do consulting for photo agencies for the Japanese market."

Specs Accepts images in digital format, high resolution.

Payment & Terms Pays 40-50% commission for digital data. Average price per image (to clients): $120-1,000 for b&w or color photos. Negotiates fees below standard minimum prices. Offers volume discounts to customers. Discount sales terms not negotiable. Works with photographers with or without contract; negotiable. Offers nonexclusive contract. Contracts renew automatically with additional submissions.

Statements issued monthly or every 6 months. Payment made monthly or every 6 months. Photographers allowed to review account records. Offers one-time rights, electronic media rights, agency promotion rights. Model release preferred. Photo captions and keywords required; include year, states, city.

Making Contact Send query e-mail with résumé, stock list. Does not keep samples on file. Responds only if interested; send digital data samples.

Tips "We need all kinds of photographs of the world. Photographers and archival photo owners should submit stock list including subjects, themes, when, where, color or black & white, format, total amount of stock, brief profile."

▣ 🔁 PONKAWONKA INC.

20 Midvale Ave., Toronto ON M3H 3H9 Canada. (416)638-2475. E-mail: contact@ponkawonka.com. Web site: www.ponkawonka.com. **Contact:** Stephen Epstein. Estab. 2002. Stock agency. Has 60,000 photos in files. Clients include: advertising agencies, businesses, newspapers, public relations firms, book publishers, calendar companies, magazine publishers.

Needs Wants photos of religious events and holy places. Interested in avant garde, documentary, historical/vintage. "Interested in images of a religious or spiritual nature. Looking for photos of ritual, places of worship, families, religious leaders, ritual objects, historical, archaeological, anything religious, especially in North America."

Specs Accepts images in digital format. Send via CD or DVD as TIFF or JPEG files.

Payment & Terms Pays 50% commission for any images. Offers volume discounts to customers. Works with photographers on contract basis only. Charges only apply if negatives or transparencies have to be scanned. Statements issued quarterly. Payment made quarterly. Offers one-time rights. Informs photographers and allows them to negotiate when client requests all rights. Model/property release preferred. Photo captions required; include complete description and cutline for editorial images.

Making Contact Send query e-mail. Does not keep samples on file; cannot return material. Expects minimum initial submission of 200 images with annual submissions of at least 100 images. Responds only if interested; send 30-40 low-res samples by e-mail. Photo guidelines available on Web bsite.

Tips "We are always looking for good, quality images of religions of the world. We are also looking for photos of people, scenics and holy places of all religions. Send us sample images. First send us an e-mail introducing yourself, and tell us about your work. Let us know how many images you have that fit our niche and what cameras you are using. If it looks promising, we will ask you to e-mail us 30-40 low-res images (72 dpi, no larger than 6 inches on the long side). We will review them and decide if a contract will be offered. Make sure the images are technically and esthetically salable. Images must be well-exposed and a large file size. We are an all-digital agency and expect scans to be high-quality files. Tell us if you are shooting digitally with a professional DSLR or if scanning from negatives with a professional slide scanner."

▣ POSITIVE IMAGES (Stock Photography & Gallery 61)

(formerly Positive Images), 61 Wingate St., Haverhill MA 01832. (978)556-9366. Fax: (978)556-9448. E-mail: pat@positiveimagesphoto.com. Web site: www.agpix.com/positiveimages. **Contact:** Pat Bruno, owner. Stock photo agency and fine art gallery. Member of ASPP, GWAA. Clients include advertising agencies, public relations firms, book/encyclopedia publishers, magazine publishers, greeting card and calendar companies, sales/promotion firms, design firms.

Needs Wants horticultural images showing technique and lifestyle, photo essays on property-released homes and gardens, travel images from around the globe, classy and funky pet photography, health & nutrition, sensitive and thought-provoking images suitable for high-end greeting cards, calendar-quality landscapes, castles, lighthouses, country churches. Model/property releases preferred.

Payment & Terms Pays 50% commission for stock photos; 60% commision for fine art. Average price per image (to clients): $250. Works with photographers on contract basis only. Offers limited regional exclusivity. Payment made quarterly. Offers one-time and electronic media rights. "We never sell all rights."

Making Contact "Positive Images Stock is accepting limited new collections; however, if your images are unique and well organized digitally, we will be happy to review online after making e-mail contact. Our Gallery 61 will review fine art photography portfolios online as well and will consider exhibiting nonmembers' work."

Tips "Positive Images has taken on more of a boutique approach, limiting our number of photographers so that we can better service them and offer a more in-depth and unique collection to our clients. Our

brand-new Gallery 61 is a storefront in a small historic arts district. Our plan is to evolve this into an online gallery as well. We are always in search of new talent, so we welcome anyone with a fresh approach to contact us!''

▣ PURESTOCK

7660 Centurion Pkwy., Jacksonville FL 32256. (904)680-1990. E-mail: photoeditor@purestock.com. Web site: www.purestock.com. The Purestock royalty-free brand is designed to provide the professional creative community with high-quality images at high resolution and very competitve pricing. Purestock offers CDs and single-image downloads in a wide range of categories including lifestyle, business, education and sports to distributors in over 100 countries.

Needs ''A variety of categories including lifestyle, business, education, medical, industry, etc.''

Specs ''Digital files which are capable of being output at 80MB with minimal interpolation. File must be 300 dpi, RGB, TIFF at 8-bit color.''

Payment & Terms Statements issued monthly to contracted image providers. Model release required. Photo captions required.

Making Contact Submit a portfolio including a subject-focused collection of 300+ images. Photo guidelines available on Web site at www.purestock.com/submissions.asp.

Tips ''Please review our Web site to see the style and quality of our imagery before submitting.''

▨ ▣ ⊕ RAILPHOTOLIBRARY.COM

Newton Harcourt, Leicester, Leicestershire LE8 9FH United Kingdom. (44)(116)259-2068. Fax: (44)(116)259-3001. E-mail: studio@railphotolibrary.com. Web site: www.railphotolibrary.com. **Contact:** Colin Nash, picture library manager. Estab. 1969. Has 400,000 photos in files relating to railways worldwide. Clients include: advertising agencies, businesses, newspapers, postcard publishers, public relations firms, book publishers, calendar companies, audiovisual firms, magazine publishers, greeting card companies.

Needs Wants photos of railways.

Specs Uses digital images; glossy b&w prints; 35mm, $2^{1}/_{4} \times 2^{1}/_{4}$ transparencies.

Payment & Terms Buys photos, film or videotape outright depending on subject; negotiable. Pays 50% commission for b&w or color photos. Average price per image (to clients): $125 maximum for b&w or color photos. Works with photographers with or without a contract; negotiable. Statements issued quarterly. Photographers allowed to review account records in cases of discrepancies only. Photo captions preferred.

Making Contact Send query letter with slides, prints. Portfolio may be dropped off Monday through Saturday. Does not keep samples on file; include SAE/IRC for return of material. Unlimited initial submission. Responds in 2 weeks.

Tips ''Submit well-composed pictures of all aspects of railways worldwide: past, present and future; captioned digital files, prints or slides. We are the world's leading railway picture library, and photographers to the railway industry.''

▣ RAINBOW

61 Entrada, Santa Fe NM 87505. (505)820-3434. E-mail: rainbow@cybermesa.com. Web site: www.rainbowimages.com. **Contact:** Coco McCoy, director. Estab. 1976. Fine art print gallery and stock photo agency. Member of American Society of Picture Professionals (ASPP). Clients include: galleries, educational publishers, advertising agencies, public relations firms, design agencies, book publishers, magazine publishers, calendar and notecard companies; 20% of sales come from overseas.

Needs ''Rainbow is known for its high-quality imagery and is now happy to open its doors to its fine arts division, Sky Gallery. In that spirit, we are looking for outstanding images such as wonders of nature, from micro-organisms and insects to dramatic shots of large mammals; botanica; landscapes; ancient temples; colorful Mexico and Guatemala; museum-quality artifacts; and well-known jazz musicians.''

Specs Accepts images in digital format only. Images must be high-res scans or shot with at least an 8-megapixel camera. Send at least 30 images as JPEGs on a CD with captions.

Payment & Terms Pays 50% commission. Contracts renew automatically with each submission; no time limit. Statements issued quarterly. Payment made quarterly. Photographers allowed to review account records to verify sales figures. Offers one-time rights. Informs photographers and allows them to negotiate when client requests all rights. Photo captions required for scientific photos or geographic locations, etc.;

include simple description if not evident from photo; prefers both Latin and common names for plants and insects to make photos more valuable.

Making Contact Interested in receiving work from published photographers. "Photographers may e-mail or call us for photo guidelines or information. Arrange a personal interview to show portfolio, or send query letter with samples; include SASE for return of material. Responds in 1 month.

Tips "E-mail us describing your work with 3 copies of published samples, or send a CD or DVD with captions. Edit your work carefully before sending. We look for luminous images with either a concept illustrated or a mood conveyed by beauty or light. Clear captions help our researchers choose images and ultimately improve sales."

N ▣ RETNA LTD.

24 W. 25th St., 12th Floor, New York NY 10010. (212)255-0622. Fax: (212)255-1224. E-mail: info@retna.com. Web site: www.retna.com. **Contact:** Jessica Daly or Walter McBride. Estab. 1978. Member of the Picture Archive Council of America (PACA). Stock photo agency, assignment agency. Has more than 2 million photos in files. Clients include advertising agencies, public relations firms, book/encyclopedia publishers, magazine publishers, newspapers, record companies.

● Retna handles shoots and assignments for clients and pulls from their talented pool of photographers.

Needs Handles photos of musicians (pop, country, rock, jazz, contemporary, rap, R&B) and celebrities (movie, film, television and politicians). Covers New York, Milan and Paris fashion shows; has file on royals. Also uses events, sports. Interested in fashion/glamour, historical/vintage.

Specs Original material required. All formats accepted. Send digital images via CD, Zip, e-mail as TIFF, JPEG files at 300 dpi.

Payment & Terms Commission varies. General price range (to clients): $200 and up. Works with photographers on contract basis only. Contracts renew automatically with additional submissions for 3 years. Statements issued monthly. Payment made monthly. Offers one-time rights; negotiable. When client requests all rights photographer will be consulted, but Retna will negotiate. Model/property release required. Photo captions required.

Making Contact Arrange a personal interview to show portfolio. Primarily concentrating on selling stock, but does assign on occasion. Does not publish "tips" sheets, but makes regular phone calls to photographers.

Tips "Wants to see strong celebrity studio shooters, some music photograhy. We are also always seeking event photographers who have great access. Photography must be creative, innovative and of the highest aesthetic quality possible."

▣ REX USA LTD

160 Monmouth St., Red Bank NJ 07701. (732)576-1919. Fax: (732)576-1909. E-mail: chuck@rexusa.com. Web site: www.rexusa.com. **Contact:** Charles Musse, manager. Estab. 1935. Stock photo agency, news/feature syndicate. Affiliated with Rex Features in London. Member of Picture Archive Council of America (PACA). Has 1.5 million photos. Clients include: advertising agencies, public relations firms, audiovisual firms, businesses, book/encyclopedia publishers, magazine publishers, newspapers, postcard companies, calendar companies, greeting card companies and TV, film and record companies.

Needs Wants primarily editorial material: celebrities, personalities (studio portraits, candid, paparazzi), human interest, news features, movie stills, glamour, historical, geographic, general stock, sports and scientific.

Specs Prefers digital; Uses 35mm; b&w and color negatives.

Payment & Terms Pays 50-65% commission; payment varies depending on quality of subject matter and exclusivity. "We obtain highest possible prices, starting at $100-100,000 for one-time sale." Pays 50% commission for b&w and color photos. Works with or without contract. Offers nonexclusive contract. Statements issued monthly. Payment made monthly. Photographers allowed to review account records. Offers one-time, first and all rights. Informs photographers and allows them to negotiate when client requests all rights. Model release required. Photo captions required.

Making Contact E-mail query letter with samples and list of stock photo subjects.

▣ ROBERTSTOCK

4203 Locust St., Philadelphia PA 19104. (800)786-6300. Fax: (800)786-1920. E-mail: sales@robertstock.com. Web site: www.robertstock.com, www.classicstock.com. **Contact:** Bob Roberts, president. Estab.

1920. Stock photo agency. Member of the Picture Archive Council of America (PACA). Has 2 different Web sites: Robertstock offers contemporary rights-managed and royalty-free images; ClassicStock offers retro and vintage images. Clients include: advertising agencies, public relations firms, audiovisual firms, businesses, book/encyclopedia publishers, magazine publishers, newspapers, postcard publishers, calendar companies, greeting card companies.

Needs Uses images on all subjects in depth.

Specs Accepts images in digital format. Send via CD, Zip at 300 dpi, 50MB or higher.

Payment & Terms Pays 45-50% commission. Works with photographers with or without a contract; negotiable. Offers various contracts. Statements issued monthly. Payment made monthly. Payment sent with statement. Photographers allowed to review account records to verify sales figures ''upon advance notice.'' Offers one-time rights. Informs photographers when client requests all rights. Model release required. Photo captions required.

Making Contact Send query letter. Does not keep samples on file. Expects minimum initial submission of 250 images with quarterly submissions of 250 images. Responds in 1 month. Photo guidelines available.

▨ ▣ ⊕ SCIENCE PHOTO LIBRARY, LTD.

327-329 Harrow Rd., London W9 3RB United Kingdom. (44)(207)432-1100. Fax: (44)(207)286-8668. E-mail: picture.editing@sciencephoto.com. Web site: www.sciencephoto.com. **Contact:** Research Director. Stock photo agency. Clients include: advertising agencies, public relations firms, audiovisual firms, businesses, book/encyclopedia publishers, magazine publishers, newspapers, electronic media.

Needs SPL specializes in all aspects of science, medicine and technology/computers. ''Our interpretation of these areas is broad. We include earth sciences, landscape and sky pictures, and animals. We have a major and continuing need for high-quality photographs showing science, technology and medicine *at work* : laboratories, high-technology equipment, computers, lasers, robots, surgery, hospitals, etc.''

Specs Uses color prints and 35mm, $2\frac{1}{4} \times 2\frac{1}{4}$, 4×5, 6×7, 5×6 and 6×9 transparencies. Accepts images in digital format. Send via CD. File sizes should be at least 50MB with no interpolation.

Payment & Terms Pays 50% commission. Average price per image (to clients): $80-1,000; varies according to use. Only discounts below minimum for volume or education. Offers volume discounts to customers; inquire about specific terms. Discount sales terms not negotiable. Works on contract basis only. Offers exclusivity; exceptions are made; subject to negotiation. Agreement made for 5 years; general continuation is assured unless otherwise advised. Statements issued quarterly. Payment made quarterly. Photographers allowed to review account records to verify sales figures; fully computerized accounts/commission handling system. Offers one-time and electronic media rights. Model release required. Photo captions required.

Making Contact Send query letter with samples or query with list of stock photo subjects. Send unsolicited photos by mail for consideration. Returns material submitted for review. Responds in 1 month. Photo guidelines available on Web site.

▣ SILVER IMAGE PHOTO AGENCY, INC.

4104 NW 70th Terrace, Gainesville FL 32606. (352)373-5771. E-mail: floridalink@aol.com. Web site: www.silver-image.com. **Contact:** Carla Hotvedt, president/owner. Estab. 1988. Stock photo agency. Assignments in Florida/southern Georgia. Has 150,000 photos in files. Clients include: public relations firms, book/encyclopedia publishers, magazine publishers, newspapers.

Needs Wants photos from Florida only: nature, travel, tourism, news, people.

Specs Accepts images in digital format only. Send via CD, FTP, e-mail as JPEG files *upon request only*.

Payment & Terms Pays 50% commission for image licensing fees. Average price per image (to clients): $150-600. Works with photographers on contract basis only. Offers nonexclusive contract. Payment made monthly. Statements provided when payment is made. Photographers allowed to review account records. Offers one-time rights. Informs photographer and allows them to be involved when client requests all rights. Model release preferred. Photo captions required; include name, year shot, city, state, etc.

Making Contact Send query letter via e-mail only. Do not submit material unless first requested.

Tips ''I will review a photographer's work to see if it rounds out our current inventory. Photographers should review our Web site to get a feel for our needs. We will gladly add a photographer's e-mail address to our online photo requests list.''

▨ ▨ ▣ ⊕ SKISHOOT-OFFSHOOT

Hall Place, Upper Woodcott, Whitchurch, Hants RG28 7PY United Kingdom. (44)(1635)255527. Fax: (44)(1635)255528. E-mail: info@skishoot.co.uk. Web site: www.skishoot.co.uk. Estab. 1986. Stock

photo agency. Member of British Association of Picture Libraries and Agencies (BAPLA). Has over 400,000 photos in files. Clients include: advertising agencies, book publishers, magazine publishers, newspapers, greeting card companies, postcard publishers. Specializes in winter sports but also has photos from around the world (France, in particular) taken all year-round.

Needs Wants photos of skiing, snowboarding and other winter sports. Also photos of children/teens, families, landscapes/scenics, cities/urban, rural, adventure, sports.

Specs Prefers CDs with high-resolution images.

Payment & Terms Pays 50% commission for color photos. Average price per image (to clients): $100-5,000 for color. Enforces strict minimum prices. BAPLA recommended rates are used. Offers volume discounts to customers. Photographers can choose not to sell images on discount terms. Works with photographers with or without a contract; negotiable. Offers limited regional exclusivity. Contracts renew automatically with additional submissions within originally agreed time period. Payments made to photographers through PayPal. Statements issued quarterly. Photographers allowed to review account records in cases of discrepancies only. Offers one-time rights. Informs photographers when a client requests all rights. Model release preferred. Photo captions required; include location details.

Making Contact Send query letter with samples, stock list. Include SAE for return of material. Portfolio should include color. Works on assignment only. Expects minimum initial submission of 50 images. Responds in 1 month to samples.

SKYSCAN PHOTOLIBRARY

Oak House, Toddington, Cheltenham, Gloucestershire GL54 5BY United Kingdom. (44)(124)262-1357. Fax: (44)(124)262-1343. E-mail: info@skyscan.co.uk. Web site: www.skyscan.co.uk. **Contact:** Brenda Marks, library manager. Estab. 1984. Picture library. Member of the British Association of Picture Libraries and Agencies (BAPLA) and the National Association of Aerial Photographic Libraries (NAPLIB). Has more than 130,000 photos in files. Clients include: advertising agencies, public relations firms, businesses, book publishers, magazine publishers, newspapers, calendar companies, postcard publishers.

Needs Wants "anything aerial! Air-to-ground; aviation; aerial sports. As well as holding images ourselves, we also wish to make contact with holders of other aerial collections worldwide to exchange information."

Specs Uses color and/or b&w prints; any format transparencies. Accepts images in digital format. Send via CD, e-mail.

Payment & Terms Pays 50% commission for b&w and color photos. Average price per image (to clients): $100 minimum. Enforces strict minimum prices. Offers volume discounts to customers. Photographers can choose not to sell images on discount terms. Works with photographers with or without a contract; negotiable. Offers guaranteed subject exclusivity (within files); negotiable to suit both parties. Statements issued quarterly. Payment made quarterly. Photographers allowed to review account records in cases of discrepancies only. Offers one-time, electronic media and agency promotion rights. Informs photographers and allows them to negotiate when a client requests all rights. Will inform photographers and act with photographer's agreement. Model/property release preferred for "air-to-ground of famous buildings (some now insist they have copyright to their building)." Photo captions required; include subject matter, date of photography, location, interesting features/notes.

Making Contact Send query letter or e-mail. Provide résumé, business card, self-promotion piece or tearsheets to be kept on file. Agency will contact photographer for portfolio review if interested. Portfolio should include color slides and transparencies. Does not keep samples on file; include SAE for return of material. No minimum submissions. Photo guidelines sheet free with SAE. Catalog free with SAE. Market tips sheet free quarterly to contributors only.

Tips "We see digital transfer of low-resolution images for layout purposes as essential to the future of stock libraries, and we have invested heavily in suitable technology. Contact first by letter or e-mail with résumé of material held and subjects covered."

SOVFOTO/EASTFOTO, INC.

263 West 20th Street #2, New York NY 10001. (212)727-8170. Fax: (212)727-8228. E-mail: research@sovfoto.com. Web site: www.sovfoto.com. **Contact:** Mr. Vanya Edwards, director; Meredith Brosnan, researcher. Estab. 1935. Stock photo agency. Has 500,000 photos in files. Clients include: advertising firms, audiovisual firms, book/encyclopedia publishers, magazine publishers, newspapers.

Needs All subjects acceptable as long as they pertain to Russia, Eastern European countries, Central Asian countries or China.

Specs Uses b&w historical; color prints; 35mm transparencies. Accepts images in digital format. Send via CD or DVD as TIFF files.

Payment & Terms Pays 50% commission. Average price per image (to clients): $150-500 for b&w or color photos for editorial use. Statements issued quarterly. Payment made quarterly. Photographers allowed to review account records to verify sales figures or account for various deductions. Offers one-time print, electronic media, and nonexclusive rights. Model/property release preferred. Photo captions required.

Making Contact Arrange personal interview to show portfolio. Send query letter with samples, stock list. Keeps samples on file. Expects minimum initial submission of 50-100 images. Responds in 2 weeks.

Tips Looks for "news and general interest photos (color) with human element."

🖥 🌐 SPECTRUM PICTURES

Ostrovni 16, 11000, Prague 1, Czech Republic. (42)(060)823-5416. E-mail: spectrum@spectrumpictures.com. Web site: www.spectrumpictures.com. **Contact:** Martin Mraz, executive director. Estab. 1992. Stock agency and news/feature syndicate. Has 35,000 photos in files. Clients include: advertising agencies, audiovisual firms, businesses, book publishers, magazine publishers, newspapers, calendar companies.

Needs "We work mainly with pictures from Central and Eastern Europe and Eurasia. "Wants photos of celebrities, children/teens, multicultural, families, parents, senior citizens, disasters, environmental, landscapes/scenics, wildlife, architecture/buildings, cities/urban, education, religious, rural, adventure, entertainment, events, health/fitness/beauty, humor, performing arts, travel, agriculture, business concepts, industry, medicine, military, political, science, technology/computers. Interested in alternative process, avant garde, documentary, fashion/glamour, fine art, historical/vintage, regional, seasonal.

Specs Uses digital images. Send via CD, e-mail, FTP as JPEG files.

Payment & Terms Pays 50% commission for b&w and color photos. Average price per image (to clients): $175-5,000 for individual photos and features. Negotiates fees below standard minimum prices. Offers volume discounts to customers. Photographers can choose not to sell images on discount terms. Works with photographers with or without contract; negotiable. Offers nonexclusive contract. Contracts renew automatically with additional submissions. Payment made upon payment from client. Photographers allowed to review account records in cases of discrepancies only. Offers one-time, electronic media, and agency promotion rights. Informs photographers and allows them to negotiate when client requests all rights. Photo captions in English required.

Making Contact Send query letter via e-mail before sending pictures. Send only a few low-res images. Responds only if interested; send nonreturnable samples on CD or via e-mail.

Tips "Please e-mail before sending samples. We prefer that no one send original slides via mail. Send scanned low-resolution images on CD-ROM or via e-mail. Remember that we specialize in Eastern Europe, Central Europe and Eurasia (Russia, Georgia, former Soviet countries). We are primarily a photojournalist agency, but we work with other clients as well."

🖥 SPORTSLIGHT PHOTO

6 Berkshire Circle, Gt. Barrington MA 01230. (413)528-8457. E-mail: stock@sportslightphoto.com. Web site: www.sportslightphoto.com. **Contact:** Roderick Beebe, director. Stock photo agency. Has 500,000 photos in files. Clients include: advertising agencies, public relations firms, corporations, book publishers, magazine publishers, newspapers, postcard companies, calendar companies, greeting card companies, design firms.

Needs "We specialize in every sport in the world. We deal primarily in the recreational sports such as skiing, golf, tennis, running, canoeing, etc., but are expanding into pro sports, and have needs for all pro sports, action and candid close-ups of top athletes. We also handle adventure-travel photos, e.g., rafting in Chile, trekking in Nepal, dogsledding in the Arctic, etc."

Specs Uses 35mm transparencies. Accepts images in digital format. Send via CD. Contact us prior to shipment.

Payment & Terms Pays 50% commission. Average price per image (to clients): $100-6,000. Contract negotiable. Offers limited regional exclusivity. Contract is of indefinite length until either party (agency or photographer) seeks termination. Charges $5/image for duping fee; $3 for catalog and digital CD-ROM insertion promotions. Statements issued quarterly. Payment made quarterly. Photographers allowed to review account records to verify sales figures "when discrepancy occurs." Offers one-time rights; sometimes exclusive rights for a period of time; and other rights, depending on client. Informs photographers and consults with them when client requests all rights. Model release required for corporate and advertis-

ing usage. (Obtain releases whenever possible.) Strong need for model-released "pro-type" sports. Photo captions required; include who, what, when, where, why.

Making Contact Interested in receiving work from newer and known photographers. Cannot return unsolicited material. Responds in 2-4 weeks. Photo guidelines free with SASE. See Web site for more information regarding digital transmission. For review, send JPEG files at 72 dpi via e-mail or CD; or "direct us to your Web site to review images for consideration."

Tips "We look for a range of sports subjects that shows photographer's grasp of the action, drama, color and intensity of sports, as well as capability of capturing great shots under all conditions in all sports. Want well-edited, perfect exposure and sharpness, good composition and lighting in all photos. Seeking photographers with strong interests in particular sports. Shoot variety of action, singles and groups, youths, male/female—all combinations; plus leisure, relaxing after tennis, lunch on the ski slope, golf's 19th hole, etc. Sports fashions change rapidly, so that is a factor. Art direction of photo shoots is important. Avoid brand names and minor flaws in the look of clothing. Attention to detail is very important. Shoot with concepts/ideas such as teamwork, determination, success, lifestyle, leisure, cooperation in mind. Clients look not only for individual sports but for photos to illustrate a mood or idea. There is a trend toward use of real-life action photos in advertising as opposed to the set-up slick ad look. More unusual shots are being used to express feelings, attitude, etc."

▣ TOM STACK & ASSOCIATES, INC.

154 Tequesta Street, Tavernier FL 33070. (305)852-5520. Fax: (305)852-5570. E-mail: tomstack@earthlink.net. **Contact:** Therisa Stack. Has 500,000 photos in files. Clients include: advertising agencies, public relations firms, businesses, audiovisual firms, book publishers, magazine publishers, encyclopedia publishers, postcard companies, calendar companies, greeting card companies.

Needs Wants photos of wildlife, endangered species, marine life, landscapes; foreign geography; photomicrogfaphy; scientific research; whales; solar heating; mammals such as weasels, moles, shrews, fisher, marten, etc.; extremely rare endangered wildlife; wildlife behavior photos; lightning and tornadoes; hurricane damage; dramatic and unusual angles and approaches to composition, creative and original photography with impact. Especially needs photos on life science, flora and fauna and photomicrography. No run-of-the-mill travel or vacation shots. Special needs include photos of energy-related topics—solar and wind generators, recycling, nuclear power and coal burning plants, waste disposal and landfills, oil and gas drilling, supertankers, electric cars, geo-thermal energy.

Specs Only accepts images in digital format. Send via CD or e-mail sample JPEGs.

Payment & Terms Pays 50-60% commission. Average price per image (to clients): $150-200 for color photos; as high as $7,000. Works with photographers on contract basis only. Contracts renew automatically with additional submissions for 3 years. Statements issued quarterly. Payment made quarterly. Offers one-time and electronic media rights. Informs photographers and allows them to negotiate when client requests all rights. Model release preferred. Photo captions preferred.

Making Contact E-mail tomstack@earthlink.net

Tips "Strive to be original, creative and take an unusual approach to the commonplace; do it in a different and fresh way. We take on only the best so we can continue to give more effective service."

▣ STILL MEDIA

2012 Anacapa St., Santa Barbara CA 93108. (805)682-2868. E-mail: images@stillmedia.com. Web site: www.stillmedia.com. **Contact:** Jeffrey Aaronson, founder/owner. Director: Becky Green Aaronson. Photojournalism and stock photography agency. Has 500,000 photos in files. Clients include: advertising agencies, public relations firms, businesses, book/encyclopedia publishers, magazine publishers, newspapers, calendar companies.

Needs Reportage, world events, travel, cultures, business, the environment, sports, people, industry.

Specs Accepts images in digital format only. Contact via e-mail.

Payment & Terms Pays 50% commission for color photos. Works with photographers on contract basis only. Offers nonexclusive and guaranteed subject exclusivity contracts. Statements issued quarterly. Payment made quarterly. Photographers allowed to review account records. Offers one-time and electronic media rights. Model/property release preferred. Photo captions required.

Making Contact "We are currently accepting new photographers."

▣ ▣ ▣ STOCK FOUNDRY IMAGES

An incorporated affiliate of Artzooks Multimedia Inc., P.O. Box 78089, Nepean ON K2E 1B1 Canada. (613)258-1551. Fax: (613)258-1551. E-mail: info@stockfoundry.com. Web site: www.stockfoundry.com.

Contact: Tom Barradas, vice president/creative development. Estab. 2006. Stock agency. Clients include: advertising agencies, businesses, newspapers, public relations firms, book publishers, audiovisual firms, magazine publishers.

Needs Wants photos of babies/children/teens, celebrities, couples, multicultural, families, parents, senior citizens, architecture, cities/urban, education, gardening, interiors/decorating, pets, religious, rural, agriculture, business concepts, industry, medicine, military, political, product shots/still life, science, technology/computers, disasters, environmental, landscapes/scenics, wildlife, adventure, automobiles, entertainment, events, food/drink, health/fitness/beauty, hobbies, humor, performing arts, sports, travel. Interested in alternative process, avant garde, documentary, erotic, fashion/glamour, fine art, historical/vintage, lifestyle, seasonal.

Specs Accepts images in digital format. Send via CD. Save as EPS, JPEG files at 300 dpi. For film and video: MOV

Payment & Terms Buys photos/film/video outright. Pays $25 minimum for all photos, film and videotape. Pays $250 maximum for all photos, film and videotape. Pays 50% commission. Average price per image (to clients): $60 minimum for all photos, film and videotape; $600 maximum for all photos, film and videotape. Negotiates fees below stated minimums. Offers volume discounts to customers. Terms specified in photographer's contracts. Works with photographers on contract basis only. Offers guaranteed subject exclusivity (within files). Contracts renew automatically with additional submissions. "Term lengths are set on each submission from the time new image submissions are received and accepted. There is no formal obligation for photographers to pay for inclusion into catalogs, advertising, etc.; however, we do plan to make this an optional item." Statements issued monthly or real time online. Payment made monthly. Photographers allowed to review account records in cases of discrepancies only. Informs photographers and allows them to negotiate when a client requests all rights. Negotiates fees below stated minimums. "Volume discounts sometimes apply for preferred customers." Model/property release required. Captions preferred: include actions, location, event, and date (if relevant to the images, such as in the case of vintage collections).

Making Contact E-mail query letter with link to photographer's Web site. Send query letter with tearsheets, stocklist. Portfolio may be dropped off Monday through Friday. Expects initial submission of 100 images with monthly submission of at least 25 images. Responds only if interested; send nonreturnable samples. Provide resume to be kept on file. Photo guidelines sheet available online. Market tips sheet is free annually via e-mail to all contributors.

Tips "Submit to us contemporary work that is at once compelling and suitable for advertising. We prefer sets of images that are linked stylistically and by subject matter (better for campaigns). It is acceptable to shoot variations of the same scene (orientation, different angles, with copy space and without, etc.), and, in fact, we encourage it. Please try to provide us with accurate descriptions, especially as they pertain to specific locations, places, dates, etc. Our wish list for the submission process would be to receive a PDF tearsheet containing small thumbnails of all the high-res images. This would save us time, and speed up the evaluation process."

STOCK OPTIONS®

P.O. Box 1048, Fort Davis TX 79734. (432)426-2777. Fax: (432)426-2779. E-mail: kh@stockoptionsphoto. com. **Contact:** Karen Hughes, owner. Estab. 1985. Stock photo agency. Member of Picture Archive Council of America (PACA). Has 200,000 photos in files. Clients include: advertising agencies, public relations firms, audiovisual firms, corporations, book/encyclopedia and magazine publishers, newspapers, postcard companies, calendar companies, greeting card companies.

Needs Emphasizes the southern U.S. Files include Gulf Coast scenics, wildlife, fishing, festivals, food, industry, business, people, etc. Also western folklore and the Southwest.

Specs Uses 35mm, $2^{1}/_{4} \times 2^{1}/_{4}$, 4×5 transparencies.

Payment & Terms Pays 50% commission for color photos. Average price per image (to client): $300-3,000. Works with photographers on contract basis only. Offers nonexclusive contract. Contracts renew automatically with each submission for 5 years from expiration date. When contract ends photographer must renew within 60 days. Charges catalog insertion fee of $300/image and marketing fee of $10/hour. Statements issued upon receipt of payment from client. Payment made immediately. Photographers allowed to review account records to verify sales figures. Offers one-time and electronic media rights. "We will inform photographers for their consent only when a client requests all rights, but we will handle all negotiations." Model/property release preferred for people, some properties, all models. Photo captions required; include subject and location.

Making Contact Interested in receiving work from full-time commercial photographers. Arrange a personal interview to show portfolio. Send query letter with stock list. Contact by phone and submit 200 sample photos. Tips sheet distributed annually to all photographers.

Tips Wants to see "clean, in-focus, relevant and current materials." Current stock requests include industry, environmental subjects, people in up-beat situations, minorities, food, cityscapes and rural scenics.

▣ STOCK PIPE LINE

Stock Media, 1123 Broadway, Suite 1006, New York NY 10010. (212) 463-8300. E-mail: sales@stockpipeli ne.com. Web site: www.stockpipeline.com. **Contact**: Christopher Babler. Estab. 2005; parent Company established in 2000. Stock agency. "We are an e-commerce, licensing, hi-res fulfuillment platform that provides back-end support to stock photographers' existing Web sites. Eight language search capabilities, 100% royalties, online sales tracking, price controls for the photographer, drag-and-drop image uploading, automatic e-mail notification upon sale. Automatic IPTC extraction of metadata, and easy-to-use keywording software."

Specs Accepts images in digital format. "The essential requirement is to have good, quality images that are naturally sharp with good shadow detail. On upload, every image is automatically converted for storage to be 18 inches on the longest side at 300 dpi, about a 56MB file."

Payment & Terms Offers volume discounts to customers. Photographers can choose not to sell images on discount terms.

Making Contact E-mail query letter with link to photographer's Web site.

Tips "Stock Pipe Line, along with the marketing of Stock Photo Finder (image search engine), makes for the perfect direct photographer-to-client contact."

▣ ▣ ▣ STOCK TRANSPARENCY SERVICES/STSIMAGES

225, Neha Industrial Estate, Off Dattapada Rd., Borivali (East), Mumbai 400 066 India. (91)(222)870-1586. Fax: (91)(222)870-1609. E-mail: info@stsimages.com. Web site: www.stsimages.com. **Contact:** Mr. Pawan Tikku. Estab. 1993. Has over 200,000 photos in files. Has minimal reels of film/video footage. Clients include: advertising agencies, businesses, postcard publishers, public relations firms, book publishers, calendar companies, freelance Web designers, audiovisual firms, magazine publishers, greeting card companies.

Needs Wants photos of babies/children/teens, celebrities, couples, multicultural, families, parents, senior citizens, disasters, environmental, landscapes/scenics, wildlife, architecture, cities/urban, education, gardening, interiors/decorating, pets, religious, rural, adventure, automobiles, entertainment, events, food/drink, health/fitness, hobbies, humor, performing arts, sports, travel, agriculture, business concepts, industry, medicine, military, political, product shots/still life, science, technology/computers. Interested in alternative process, avant garde, documentary, fashion/glamour, fine art, historical/vintage, seasonal. Also needs underwater images.

Specs Uses 10×12 glossy color prints; 35mm, $2\frac{1}{4} \times 2\frac{1}{4}$, 4×5, 8×10 transparencies; 35mm film; Digi-Beta or Beta video. Accepts images in digital format. Send via DVD, CD, e-mail as TIFF, JPEG files at 300 dpi. Minimum file size 25MB, preferred 50MB or more.

Payment & Terms Pays 50% commission. Average price per image (to clients): $20 minimum for b&w or color photos, $50 minimum for film or videotape. Enforces minimum prices. Offers volume discounts to customers. Works with photographers on contract basis only. Offers exclusive contract, limited regional exclusivity. Contracts renew automatically with additional submissions for 3 years. No duping fee. No charges for catalog insertion. Statements issued quarterly. Payment made monthly. Photographers allowed to review account records. Offers royalty-free images as well as one-time rights, electronic media rights. Model release required; property release preferred. Photo captions required; include name, description, location.

Making Contact Send query letter with slides, prints. Portfolio may be dropped off every Saturday. Provide résumé, business card to be kept on file. Expects minimum initial submission of 200 images with regular submissions of at least some images. Responds in 1 month to queries. Photo guidelines sheet free with SASE. Catalog free with SASE. Market tips sheet available to regular contributors only; free with SASE.

Tips 1) Strict self-editing of images for technical faults. 2) Proper cataloging. 3) All images should have the photographer's name on them. 4) Digital images are welcome, should be minimum A4 size in 300

dpi. 5) All digital images must contain necessary keyword and caption information within the "file info" section of the image file. 6) Do not send duplicate images.

🖥 🌐 STOCKFOOD GMBH (THE FOOD IMAGE AGENCY)

Tumblingerstr. 32, 80337 Munich Germany. (49)(89)747-20222. Fax: (49)(89)721-1020. E-mail: petra.thierry@stockfood.com. Web site: www.stockfood.com. **Contact:** Petra Thierry, manager, Photographers and Art Dept. Estab. 1979. Stock agency, picture library. Member of the Picture Archive Council of America (PACA). Has over 200,000 photos in files. Clients include: advertising agencies, businesses, newspapers, postcard publishers, public relations firms, book publishers, calendar companies, magazine publishers, greeting card companies.

Needs Wants photos of food/drink, health/fitness/food, wellness/spa, people eating and drinking, nice flowers and garden images, eating and drinking outside, table settings.

Specs Uses $2^1/_4 \times 2^1/_4$, 4×5, 8×10 transparencies. Accepts images in digital format. Send via CD/DVD as TIFF files at 300 dpi, 20MB minimum (8.5 mio pixels).

Payment & Terms Pays 40% commission for rights managed images. Enforces minimum prices. Works with photographers on contract basis only. Offers limited regional exclusivity, guaranteed subject exclusivity (within files). Contracts renew automatically. Statements issued quarterly. Photographers allowed to review account records. Offers one-time rights. Model release required; photo captions required.

Making Contact Send e-mail with new examples of your work as JPEG files.

🖥 STOCKYARD PHOTOS

1410 Hutchins St., Houston TX 77003. (713)236-8157. Fax: (713)227-0399. E-mail: jim@stockyard.com. Web site: www.stockyard.com. **Contact:** Jim Olive. Estab. 1992. Stock agency. Has tens of thousands of photos in files. Clients include: advertising agencies, businesses, newspapers, postcard publishers, public relations firms, book publishers, calendar companies, audiovisual firms, magazine publishers, greeting card companies, real estate firms, interior designers, retail catalogs.

Needs Needs photos relating to Houston, Texas, and the Gulf Coast.

Specs Accepts images in digital format only. To be considered, e-mail URL to photographer's Web site, showing a sample of 20 images for review.

Payment & Terms Average price per image (to clients): $250-1,500 for color photos. Offers volume discounts to customers. Photographers can choose not to sell images on discount terms.

🖥 SUPERSTOCK INC.

7660 Centurion Pkwy., Jacksonville FL 32256. (904) 565-0066. E-mail: creativeassociate@superstock.com. Web site: www.superstock.com. International stock photo agency represented in 192 countries. Extensive rights-managed and royalty-free content within 3 unique collections—contemporary, vintage and fine art. Clients include: advertising agencies, businesses, book and magazine publishers, newspapers, greeting card and calendar companies.

Needs "SuperStock is looking for dynamic lifestyle, travel, sports and business imagery, as well as fine art content and vintage images with releases."

Specs Accepts images in digital format only. Digital files must be a minimum of 50MB (up-sized), 300 dpi, 8-bit color, RGB, JPEG format.

Payment & Terms Statements issued monthly to contracted contributors. "Rights offered vary, depending on image quality, type of content, and experience." Informs photographers when client requests all rights. Model release required. Photo captions required.

Making Contact Complete SuperStock's online questionnaire at www.superstock.com/expose. Photo guidelines available on at www.superstock.com/paperwork.

Tips "Please review our Web site to see the style and quality of our imagery before submitting."

🖥 📷 TAKE STOCK INC.

2343 Uxbridge Dr. NW, Calgary AB T2N 3Z8 Canada. (403)261-5815. E-mail: takestock@telusplanet.net. Estab. 1987. Stock photo agency. Clients include: advertising agencies, public relations firms, audiovisual firms, corporate, book/encyclopedia publishers, magazine publishers, newspapers, postcard publishers, calendar and greeting card companies, graphic designers, trade show display companies.

Needs Wants model-released people, lifestyle images (all ages), Asian people, Canadian images, arts/recreation, industry/occupation, business, high-tech, illustrations. Wants photos of couples, multicultural, families, senior citizens, gardening, rural, adventure, agriculture, technology/computers.

Specs Uses 35mm, medium- to large-format transparencies. Accepts digital images for review only.

Payment & Terms Pays 50% commission for b&w or color photos. General price range (to clients): $300-1,000 for b&w photos; $300-1,500 for color photos. Works with photographers on contract basis only. Offers limited regional exclusivity. Contracts renew automatically with additional submissions for 3 year terms. Charges 100% duping and catalog insertion fees. Statements issued every 2 months depending on sales. Payment made every 2 months depending on sales. Photographers allowed to review account records to verify sales figures, "with written notice and at their expense." Offers one-time, exclusive and some multi-use rights; some buy-outs with photographer's permission. Model/property release required. Photo captions required.

Making Contact Send query letter with stock list. Responds in 3 weeks. Photo guidelines free with SAE/IRC. Tips sheet distributed every 2 months to photographers on file.

TIMECAST PRODUCTIONS

2801 Poole Way, Carson City NV 89706. (775)883-6427. Fax: (775)883-6427. E-mail: info@timecastproductions.com. Web site: http://timecast.productions.com. **Contact:** Edward Salas, owner. Estab. 1995. Stock photo and video agency. Has 5,000 photos, 150 hours of video footage. "Timecast Productions is the leading Internet-based producer and supplier of factual and event-based stock footage for television advertising and corporate presentation." Clients include: television program content producers, advertising agencies, corporate, and multimedia producers.

Needs "We offer a wide selection of high-quality stock footage from the wild West and its infamous characters to contemporary lifestyle and culture from around the world—people, places, news, events, business, industry cities, transportation, medicine, nature, historical and more."

Specs Accepts footage in all broadcast-quality formats.

Payment & Terms Based on usage, negotiable with client. Offers royalty-free and rights-managed terms. Offers volume discounts to customers. Filmmakers can choose not to sell photos or video on discount terms. Works with filmmakers on contract basis only. Offers nonexclusive contract. Statements issued monthly. Payment made monthly. Filmmakers allowed to review account records. Offers one-time and electronic media rights. Informs filmmakers and allows them to negotiate when client requests all rights. Model, talent and property releases required. Captions and time code logs required.

Making Contact Contact us first by e-mail, through our Web site, or by telephone. Let our representative know the category and format of your material. If we are interested, we will request you send compressed samples in Quicktime format via high-speed Internet, or send material on optical disc for our review. Following our review, consideration will be given for representaion.

TOP STOCK

33855 LaPlata Lane, Pine CO 80470. (303)838-2203 or (800)333-5961. E-mail: info@all-digit-all.com. Web site: http://all-digit-all.com/stock_images.htm. **Contact:** Tony Oswald, owner. Estab. 1985. Stock agency. Has 36,000 photos in files. Clients include: advertising agencies, public relations firms, book publishers, magazine publishers, calendar companies.

Needs Wants photos of sport fishing only.

Specs Uses color prints; 35mm, $2^1/_4 \times 2^1/_4$, 4×5, 8×10 transparencies. Accepts images in digital format. Send via CD, DVD, Jaz, Zip as TIFF files at 350 dpi.

Payment & Terms Pays 50% commission for b&w or color photos. Average price per image (to clients): $100 minimum for b&w or color photos. Enforces minimum prices. Offers volume discounts to customers; terms specified in photographers' contracts. Photographers can choose not to sell images on discount terms. Works with photographers with or without a contract; negotiable. Contracts renew automatically with additional submissions for 2 years. Charges 50% filing fee. Statements issued quarterly. Payment made quarterly. Photographers allowed to review account records in cases of discrepancies only. Offers one-time rights. Informs photographers and allows them to negotiate when client requests all rights. Model release required; property release preferred. Photo captions required; include names of people, places.

Making Contact Send query letter with tearsheets. Does not keep samples on file; include SASE for return of material. Expects minimum initial submission of 100 images with monthly submissions of at least 25 images. Responds in 1 month. Photo guidelines free with SASE.

Tips "Do not send images unless they are of sport fishing!"

🌐 TRAVEL INK PHOTO LIBRARY

The Old Coach House, Goring-on-Thames, Reading, Berkshire RG8 9AR United Kingdom. (44)(149)187-3011. Fax: (44)(149)187-5558. E-mail: info@travel-ink.co.uk. Web site: www.travel-ink.co.uk. Has over 115,000 photos in files. Clients include: advertising agencies, businesses, newspapers, public relations firms, book publishers, calendar companies, audiovisual firms, magazine publishers, greeting card companies.

Needs Wants photos of multicultural, environmental, landscapes/scenics, wildlife, architecture, cities/urban, gardening, religious, rural, adventure, events, food/drink, health/fitness/beauty, hobbies, sports, travel.

Specs Uses 35mm and medium-format transparencies. Accepts images in digital format. See Web site for details.

Payment & Terms Pays on a commission basis. Enforces minimum prices. Offers volume discounts to customers. Works with photographers on contract basis only. Offers exclusive contract only. Statements issued quarterly. Payment made quarterly. Photographers allowed to review account records. Offers one-time rights. Model/property release required. Photo captions required.

Making Contact ''Currently accepting submissions from new photographers. Please e-mail first.''

▣ 🌐 TRH PICTURES/CODY IMAGES

2 Reform St., Beith, Scotland, KA15 2AE United Kingdom. (08)(45)223-5451. Fax: (08)(45)223—5452. E-mail: sam@codyimages.com. Web site: www.codyimages.com. **Contact:** Ted Nevill. Estab. 1982. Picture library. Has 100,000 photos in files. Clients include: advertising agencies, newspapers, book publishers, calendar companies, audiovisual firms, magazine publishers.

Needs Wants photos of historical/modern aviation, warfare, transport on land and sea, space.

Specs Uses color and/or b&w prints; 35mm, $2\frac{1}{4}\times2\frac{1}{4}$, 4×5, 8×10 transparencies. Accepts images in ditigal format.

Payment & Terms Pays commission. Average price per image (to clients): $80 minimum. Offers volume discounts to customers. Discount sales terms not negotiable. Works with photographers with or without a contract; negotiable. Offers nonexclusive contract. Contracts renew automatically with additional submissions. Statements issued quarterly. Payment made quarterly. Photographers allowed to review account records. Offers one-time rights, electronic media rights. Informs photographers and allows them to negotiate when a client requests all rights. Model/property release preferred. Photo captions preferred.

Making Contact Send query letter with résumé, slides, prints, photocopies, transparencies, stock list. Provide résumé, business card, self-promotion piece to be kept on file. Expects minimum initial submission of 1,000 images. Responds in 1 month.

▣ 🌐 TROPIX PHOTO LIBRARY

44 Woodbines Ave., Kingston-Upon-Thames, Surrey KT1 2AY United Kingdom. (44)(208)8546-0823. E-mail: photographers@tropix.co.uk. Web site: www.tropix.co.uk. **Contact:** Veronica Birley, proprietor. Picture library specialist. Has 100,000 photos in files. Clients include: advertising agencies, book/encyclopedia publishers, magazine publishers, newspapers, government departments, design groups, travel companies, calendar/card companies.

Needs ''Stunning images of the developing world, especially positive, upbeat and modern aspects: all people images to be accompanied by full model release. Full pictorial detail of cultures, societies, economies and destinations, as well as medicine, health, education, commerce, etc. But every picture must be in brilliant color and imaginatively shot. Tropix only accepts stock shot in past 2 years. Please e-mail Tropix first to inquire if your own collection is of interest, as many subjects are currently closed to new stock.''

Specs Uses large digital files only, minimum 25MB when sent as TIFF files.

Payment & Terms Pays 40% commission for color photos. Average price per image (to clients): $145 for b&w and color photos. Offers guaranteed subject exclusivity. Charges cost of returning photographs by insured post, if required. Statements made quarterly with payment. Photographers allowed to have qualified auditor review account records to verify sales figures in the event of a dispute but not as routine procedure. Offers one-time, electronic media and agency promotion rights. Informs photographers when a client requests all rights, but agency handles negotiation. Model release always required. Photo captions required; accurate, detailed data to be supplied in IPTC, electronically, and on paper. ''It is essential to follow captioning guidelines available from agency.''

Making Contact ''E-mail Tropix with a detailed list of your photo subjects for each destination. Name

the destination in the subject line. Send no unsolicited photos or JPEGs, please. When submitting images, only include those that are bright, exciting and technically perfect.''

Tips Looks for ''special interest topics, accurate and informative captioning, strong images and an understanding of and involvement with specific subject matters. Not less than 20 salable images per country photographed should be available.'' Digital images supplied to clients by e-mail or FTP.

🄽 🖻 🌐 ULLSTEIN BILD

Ullstein GmbH, Axel-Springer-Str. 65, 10888 Berlin Germany. E-mail: kontakt@ullsteinbild.de. Web site: www.ullsteinbild.de. Estab. 1900. Stock agency, picture library and news/feature syndicate. Has approximately 12 million photos in files. Clients include: advertising agencies, public relations firms, audiovisual firms, businesses, book publishers, magazine publishers, newspapers, calendar companies, greeting card companies, postcard publishers, TV companies.

Needs Wants photos of celebrities, couples, multicultural, families, parents, senior citizens, wildlife, disasters, environmental, landscapes/scenics, architecture, cities/urban, education, pets, religious, rural, adventure, automobiles, entertainment, events, health/fitness, hobbies, humor, performing arts, sports, travel, agriculture, buildings, computers, industry, medicine, military, political, portraits, science, technology/computers. Interested in digital, documentary, fashion/glamour, historical/vintage, regional, seasonal. Other specific photo needs: German history.

Specs Accepts images in digital format *only*. Send via FTP, CD, e-mail, LEONARDO as TIFF, JPEG files at minimum 15MB decompressed.

Payment & Terms Pays on commission basis. Works with photographers on contract basis only. Offers nonexclusive contract for 5 years minimum. Statements issued monthly, quarterly, annually. Payment made monthly, quarterly, annually. Photographers allowed to review account records in cases of discrepancies only. Offers one-time rights. Photo captions required; include date, names, events, place.

Making Contact ''Please contact Mr. Ulrich Ramershoven (ramersoven@ullsteinbild.de) before sending pictures!''

UNICORN STOCK PHOTOS

524 Second Ave., Holdrege NE 68949. (308)995-4100. Fax: (308)995-4581. E-mail: info@unicorn-photos.com. Web site: www.unicorn-photos.com. **Contact:** Larry Durfee, owner. Has over 500,000 photos in files. Clients include: advertising agencies, corporate accounts, textbooks, magazines, calendar companies, religious publishers.

Needs Wants photos of ordinary people of all ages and races doing everyday things at home, school, work and play. Current skylines of all major cities, tourist attractions, historical, wildlife, seasonal/holiday and religious subjects. ''We particularly need images showing two or more races represented in one photo and family scenes with BOTH parents. There is a need for more minority shots including Hispanics, Asians and African-Americans.'' Also wants babies/children/teens, couples, senior citizens, disasters, landscapes, gardening, pets, rural, adventure, automobiles, events, food/drink, health/fitness, hobbies, sports, travel, agriculture.

Specs Uses 35mm color slides.

Payment & Terms Pays 50% commission for color photos. Average price per image (to clients): $200 minimum for color photos. Works with photographers on contract basis only. Offers nonexclusive contract. Contracts renew automatically with additional submissions for 4 years. Statements issued quarterly. Payment made quarterly. Informs photographers and allows them to negotiate when client requests all rights. Model release preferred; increases sales potential considerably. Photo captions required; include location, ages of people, dates on skylines.

Making Contact Write first for guidelines. ''We are looking for professionals who understand this business and will provide a steady supply of top-quality images. At least 500 images are generally required to open a file. Contact us by e-mail.''

Tips ''We keep in close, personal contact with all our photographers. Our monthly newsletter is a very popular medium for doing this.''

🖻 VIEWFINDERS

Bruce Forster Photography, Inc., 1325 NW Flanders St., Portland OR 97209. (503)417-1545. Fax: (503)274-7995. E-mail: studio@viewfindersnw.com. Web site: www.viewfindersnw.com. **Contact:** Bruce Forster, owner. Estab. 1996. Stock agency. Member of the Picture Archive Council of America

(PACA). Has 70,000 photos in files. Clients include: advertising agencies, public relations firms, businesses, book publishers, magazine publishers, design agencies.

• Viewfinders is currently not accepting new submissions as they overhaul and streamline their archive. They will begin accepting work as soon as the review of the archive is complete. Please check their Web site in the future for updated information regarding changes in the submission process.

Needs All images should come from the Pacific Northwest—Oregon, Washington, northern California, British Columbia and Idaho. Wants photos of babies/children/teens, couples, multicultural, families, senior citizens, environmental, landscapes/scenics, architecture, cities/urban, education, gardening, adventure, entertainment, events, health/fitness, performing arts, sports, travel, agriculture, industry, medicine, science, technology/computers. Interested in alternative process, avant garde, documentary, lifestyle.

Specs Prefers to review samples of photographers' work electronically, via photographer's Web site or online portfolio.

Payment & Terms Pays 50% commission for b&w and color photos. Works with photographers on contract basis only. Offers limited regional exclusivity. Statements issued monthly. Payment made monthly. Photographers allowed to review account records. Model/property release preferred. Photo captions required.

▣ VIREO (VISUAL RESOURCES FOR ORNITHOLOGY)

The Academy of Natural Sciences, 1900 Benjamin Franklin Pkwy., Philadelphia PA 19103-1195. (215)299-1069. Fax: (215)299-1182. E-mail: vireo@ansp.org. Web site: www.acnatsci.org/vireo. **Contact:** Doug Wechsler, director. Estab. 1979. Picture library. "We specialize in birds only." Has 135,000 photos in files. Clients include: advertising agencies, businesses, book publishers, magazine publishers, newspapers, calendar companies, CD-ROM publishers.

Needs "Wants high-quality photographs of birds from around the world with special emphasis on behavior. All photos must be related to birds or ornithology."

Specs Uses 35mm, $2\frac{1}{4} \times 2\frac{1}{4}$ transparencies. Accepts images in digital format. See Web site for specs.

Payment & Terms Pays 50% commission for b&w and color photos. Average price per image (to clients): $125. Negotiates fees below stated minimums; "we deal with many small nonprofits as well as commercial clients." Offers volume discounts to customers. Discount sales terms negotiable. Works with photographers on contract basis only. Offers nonexclusive contract. Statements issued semiannually. Payment made semiannually. Offers one-time rights. Model release preferred. Photo captions preferred; include date, location.

Making Contact Read guidelines on Web site. To show portfolio, photographer should send 10 JPEGs. Follow up with a call. Responds in 1 month to queries.

Tips "Write to us describing the types of bird photographs you have, the type of equipment you use, and where you do most of your bird photography. You may also send us a Web link to a portfolio of your work. Edit work carefully."

▣ ● VISUAL & WRITTEN

Luis Bermejo 8, 7-B, 50009 Zaragoza, Spain. (718)715-0372 (U.S. number). E-mail: info@visual-and-written.com and kike@visual-and-written.com. Web site: www.vwpics.com. Contact: Kike Calvo, director. Estab. 1997. Digital stock agency and news agency. Has 500,000 photos in files. Has branch office in New York: 35-36 76th St., Suite 628, New York NY 11372. Clients include: advertising agencies, businesses, newspapers, postcard publishers, public relations firms, book publishers, calendar companies, audiovisual firms, magazine publishers, greeting card companies, zoos, aquariums.

Needs Wants photos of babies/children/teens, celebrities, couples, multicultural, families, parents, senior citizens, disasters, environmental, landscapes/scenics, wildlife, architecture, cities/urban, education, pets, religious, rural, adventure, travel, agriculture, business concepts, industry, science, technology/computers. Interested in documentary, erotic, fashion/glamour, fine art. Also needs underwater imagery: reefs, sharks, whales, dolphins and colorful creatures, divers and anything related to oceans. Images that show the human impact on the environment.

Specs Accepts images in digital format only. Send via CD or DVD, e-mail at 300 dpi, 55MB minimum, largest size: 5400 pixels; from a high-end digital camera, or scanned with a Nikon 4000 or similar scanner.

Payment & Terms Pays 50% commission for b&w photos; 50% for color photos. Enforces minimum prices. Works with photographers with or without contract; negotiable. Offers nonexclusive contract. Statements issued quarterly. Payment made quarterly. Any deductions are itemized. Offers one-time

rights. Informs photographers and allows them to negotiate when client requests all rights. Model release required. Photo captions required. "Photo essays should include location, Latin name, what, why, when, how, who. Please make sure IPTC is filled correctly. It's the only way to include photo captions."

Making Contact "The best way is to send an email with some low-res images." Send an email with résumé, tearsheets, stock list. Provide self-promotion piece to be kept on file. Expects minimum initial submission of 100 images with periodic submissions of at least 50 images. Responds in 1 week to samples. "Photo guidelines available in our New Photographers link on Web site. Photographers can find all technical data there, along with contract information."

Tips "We have opened a new press division, so we are interested in daily news and event photography. Nature and animals are still a strong portion of our sales. We have a large distribution network, with partners all around the world."

▣ ⊕ WILDLIGHT PHOTO AGENCY

16 Charles St., Suite 14, Redfern NSW 2016 Australia. (61)(2)9698-8077. Fax: (61)(2)9698-2067. E-mail: images@wildlight.net. Web site: www.wildlight.net. **Contact:** Manager. Estab. 1985. Picture library. Has 300,000 photos in files. Clients include: advertising agencies, public relations firms, audiovisual firms, businesses, book/encyclopedia publishers, magazine publishers, newspapers, postcard publishers, calendar companies, greeting card companies.

Needs Wants Australian photos of babies/children/teens, couples, multicultural, families, parents, senior citizens, disasters, environmental, landscapes/scenics, wildlife, architecture, cities/urban, education, gardening, interiors/decorating, pets, religious, rural, adventure, entertainment, events, food/drink, health/fitness, hobbies, humor, performing arts, sports, travel, agriculture, business concepts, industry, medicine, military, political, product shots/still life, science, technology/computers. Interested in documentary, seasonal.

Specs Accepts images in digital format only.

Payment & Terms Pays 45% commission for color photos. Works with photographers on contract basis only. Offers image exclusive contract within Australia. Statements issued quarterly. Payment made quarterly. Offers one-time rights. Model/property release required. Photo captions required.

Making Contact Send CD to show portfolio. Expects minimum initial submission of 500 images with periodic submissions of at least 100 images/quarter. Responds in 2-3 weeks. Photo guidelines available on Web site.

▣ WINDIGO IMAGES

Kezar, Inc., 11812 Wayzata Blvd., #122, Minnetonka MN 55305. (952)540-0606. Fax: (952)540-1018. E-mail: info@windigoimages.com. Web site: www.windigoimages.com. **Contact:** Mitch Kezar, president/owner or Ellen Becker, general manager. Estab. 1982. Stock agency. Has 260,000 photos in files. Also sells fine art prints. Represents 126 photographers. Clients include: advertising agencies, businesses, newspapers, postcard publishers, public relations firms, book publishers, calendar companies, audiovisual firms, magazine publishers, greeting card companies.

Needs "We have a constant need for modern hunting, fishing, camping, hiking and mountain biking images. We seek high-quality images."

Specs Accepts images in digital format. Send via CD, e-mail as JPEG files at 72 dpi for initial consultation.

Payment & Terms Pays 50% commission for color photos. Offers volume discounts to customers; terms specified in photographers' contracts. Works with photographers on contract basis only. Offers nonexclusive contract. Statements issued monthly. Photographers allowed to review account records. Offers one-time, electronic media and agency promotion rights.

Making Contact Send query letter with résumé, stock list. Provide résumé, business card, self-promotion piece to be kept on file. Expects minimum initial submission of 100 images. Responds in 1 week.

Tips "Study the market and offer images that can compete in originality, composition, style and quality. Our clients are the best in the business, and we expect no less of our photographers."

▣ ⊕ WORLD RELIGIONS PHOTO LIBRARY

53A Crimsworth Rd., London SW8 4RJ United Kingdom. E-mail: co@worldreligions.co.uk. Web site: www.worldreligions.co.uk. **Contact:** Christine Osborne. Has 10,000 photos online. Clients include: book publishers, magazine publishers, newspapers.

Needs Religious images from anywhere in the world showing worship, rites of passage, sacred sites,

shrines, food and places of pilgrimage. Especially Hispanic/Mexico and from South America. Also Kabbalah, Mormon, Jehovah's Witnesses, Moonies, Aum, cults and Shamans.

Specs Still accepts transparencies but prefers images in digital format. Send submissions on a CD as JPEGs, 500×300 pixels at 72 dpi.

Payment & Terms Pays 50% commission. Offers volume discounts to good clients. Works with photographers with or without a contract. Offers one-time rights. Model release preferred where possible. Photo captions required; it is essential to include subject, place, date (if historic); descriptions are essential; no images will be considered without.

Making Contact Send query letter or e-mail. Include SAE for return of material. Expects minimum initial submission of 50 images. Responds in 2 weeks to samples. Photo guidelines free with SASE. Catalog available. Market tips sheet available to contract photographers.

Tips ''Supply excellent captions and edit your submission very carefully.''

Advertising, Design

& Related Markets

Advertising photography is always "commercial" in the sense that it is used to sell a product or service. Assignments from ad agencies and graphic design firms can be some of the most creative, exciting and lucrative that you'll ever receive.

Prospective clients want to see your most creative work—not necessarily your advertising work. Mary Virginia Swanson, an expert in the field of licensing and marketing fine art photography, says that the portfolio you take to the Museum of Modern Art is also the portfolio that Nike would like to see. Your clients in advertising and design will certainly expect your work to show, at the least, your technical proficiency. They may also expect you to be able to develop a concept or to execute one of their concepts to their satisfaction. Of course, it depends on the client and their needs: Read the tips given in many of the listings on the following pages to learn what a particular client expects.

When you're beginning your career in advertising photography, it is usually best to start close to home. That way, you can make appointments to show your portfolio to art directors.

Regions

Important

- **Northeast & Midatlantic:** Connecticut, Delaware, Maine, Maryland, Massachusetts, New Hampshire, New Jersey, New York, Pennsylvania, Rhode Island, Vermont, Washington DC.

- **Midsouth & Southeast:** Alabama, Arkansas, Florida, Georgia, Louisiana, Mississippi, North Carolina, South Carolina, Tennessee, Virginia, West Virginia.

- **Midwest & North Central:** Illinois, Indiana, Iowa, Kentucky, Michigan, Minnesota, Nebraska, North Dakota, Ohio, South Dakota, Wisconsin.

- **South Central & West:** Arizona, California, Colorado, Hawaii, Kansas, Missouri, Nevada, New Mexico, Oklahoma, Texas, Utah.

- **Northwest & Canada:** Alaska, Canada, Idaho, Montana, Oregon, Washington, Wyoming.

Meeting the photo buyers in person can show them that you are not only a great photographer but that you'll be easy to work with as well. This section is organized by region to make it easy to find agencies close to home.

When you're just starting out, you should also look closely at the agency descriptions at the beginning of each listing. Agencies with smaller annual billings and fewer employees are more likely to work with newcomers. On the flip side, if you have a sizable list of ad and design credits, larger firms may be more receptive to your work and be able to pay what you're worth.

Trade magazines such as *HOW*, *Print*, *Communication Arts* and *Graphis* are good places to start when learning about design firms. These magazines not only provide information about how designers operate, but they also explain how creatives use photography. For ad agencies, try *Adweek* and *Advertising Age*. These magazines are more business oriented, but they reveal facts about the top agencies and about specific successful campaigns. (See Publications on page 465 for ordering information.) The Web site of Advertising Photographers of America (APA) contains information on business practices and standards for advertising photographers (www.apanational.org).

NORTHEAST & MIDATLANTIC

■ A.T. ASSOCIATES
63 Old Rutherford Ave., Charlestown MA 02129. (617)242-8595. Fax: (617)242-0697. **Contact:** Dan Kovacevic. Estab. 1980. Member of IDSA. Design firm. Approximate annual billing: $200,000. Number of employees: 3. Firm specializes in publication design, display design, packaging, signage and product. Types of clients: industrial, financial and retail. Examples of recent clients: real estate brochures (city scapes); and sales brochure (bikes/bikers).
Needs Works with 1 photographer/month. Uses photos for catalogs, packaging and signage. Reviews stock photos as needed. Model/property release preferred. Photo captions preferred.
Specs Accepts images in digital format only.
Making Contact & Terms Works with local freelancers only. Provide résumé, business card, brochure, flier or tearsheets to be kept on file. Keeps samples on file. Cannot return material. Responds only if interested. Payment negotiable. Pays on receipt of invoice. Credit line sometimes given. Buys all rights; negotiable.

■ ○ ■ ■ ADVERTEL, INC.
P.O. Box 18053, Pittsburgh PA 15236-0053. (412)344-4700, ext. 104. Fax: (412)344-4712. E-mail: info@advertel.com. Web site: www.advertel.com. **Contact:** Dorota Grajewska. Estab. 1994. Member of MMTA (Multimedia Telecommunications Association). Specialized production house. Approximate annual billing: $500,000-1 million. Types of clients: all, including airlines, utility companies, manufacturers, distributors and retailers.
Needs Uses photos for direct mail, P-O-P displays, catalogs, signage and audiovisual. Subjects include: communications, telecommunications and business. Reviews stock photos. Model release preferred; property release required.
Audiovisual Needs Uses slides and printing and computer files.
Specs Uses 4×5 matte color and/or b&w prints; PCX, TIFF, JPEG files.
Making Contact & Terms Send query letter with stock list or with samples. Provide résumé, business card, brochure, flier or tearsheets to be kept on file. Works with local freelancers only. Keeps samples on file. Cannot return material. Response time varies; "I travel a lot." Payment negotiable. **Pays on receipt of invoice**, net 30 days. Rights negotiable.
Tips Looks for ability to mix media—video, print, color, b&w.

■ ■ AMERICA HOUSE COMMUNICATIONS
44 Catherine St., Newport RI 02840. (401)849-9600. Fax: (401)846-1379. E-mail: nmilici@americahouse.com. Web site: www.americahouse.com. **Contact:** Nicole C. Milici, co-creative director. Estab. 1992. Design, advertising, marketing and PR firm. Firm specializes in publication design, Web design, interactive media, public relations and advertising. Types of clients: catalogue, tourism, industrial, financial,

retail, publishers, health care. Examples of recent clients: Tennis Hall of Fame Championship; Tall Ships 2007.

Needs Works with 1 photographer/month. Uses photos for direct mail, P-O-P displays, catalogs and destination guides. Reviews stock photos of New England scenics, people and medical/health care. Model/property release preferred. Photo captions preferred.

Specs Prefers digital images.

Making Contact & Terms Submit portfolio for review. Provide résumé, business card, brochure, flier or tearsheets to be kept on file. Cannot return material. Response time varies depending on project. Pays $1,200/day. Pays on receipt of invoice, net 30 days. Credit line given depending on usage. Buys one-time rights unless client photo shoot.

Tips Looks for composition and impact.

N ▣ CARLA SCHROEDER BURCHETT DESIGN CONCEPT

137 Main St., Unadilla NY 13849. (607)369-4709. **Contact:** Carla Burchett, owner. Estab. 1972. Member of Packaging Designers Council. Design firm. Number of employees: 2. Firm specializes in packaging. Types of clients: manufacturers, houses, parks. Example of recent project: Footlets (direct on package).

Needs Works with "very few" freelancers. Uses photos for posters, packaging and signage. Subjects include: environmental, landscapes/scenics, wildlife, pets, adventure, entertainment, events, health/fitness, hobbies, performing arts, travel, agriculture, business concepts, product shots/still life, technology/computers. Interested in reviewing stock photos of children and animals, as well as alternative process, avant garde, documentary, fine art, historical vintage. Model release required.

Specs Uses 35mm, 4×5 transparencies. Accepts images in digital format.

Making Contact & Terms Send unsolicited photos by mail for consideration. Works with local freelancers only. Keeps samples on file; include SASE for return of material. Responds same week if not interested. Payment negotiable. Credit line given. Buys first rights; negotiable.

N $⊘▣⊠ BYNUMS MARKETING AND COMMUNICATIONS, INC.

(formerly Bynums Advertising Service), 401 Wood St., Suite 1805, Pittsburgh PA 15222. (412)471-4332. Fax: (412)471-1383. Web site: www.bynums.com. **Contact:** Russell Bynum, president. Estab. 1985. Ad agency. Number of employees: 8. Firm specializes in annual reports, collateral, direct mail, magazine ads, packaging, publication design, signage. Types of clients: financial, healthcare, consumer goods, nonprofit.

Needs Works with 1 photographer/month. Uses photos for billboards, brochures, direct mail, newspapers, posters. Subjects include: babies/children/teens, couples, multicultural, families, parents, senior citizens, environmental, wildlife, cities/urban, education, religious, adventure, automobiles, events, food/drink, health/fitness, performing arts, sports, medicine, product shots/still life, science, technology/computers. Interested in fine art, seasonal. Model/property release required. Photo captions preferred.

Audiovisual Needs Works with 1 videographer and 1 filmmaker/year. Uses slides, film, videotape.

Specs Uses 8×10 glossy or matte color and/or b&w prints; 35mm, 4×5 transparencies. Accepts images in digital format. Send via Zip, e-mail as TIFF files.

Making Contact and Terms Send query letter with résumé, prints, tearsheets, stock list. Provide business card, self-promotion piece to be kept on file. Responds only if interested, send nonreturnable samples. Pays $150-300 for b&w and color photos. "Payment may depend on quote and assignment requirements." Buys electronic rights.

$ $ $⊘▣ HAMPTONDESIGN GROUP

417 Haines Mill Rd., Allentown PA 18104. (610)821-0963. Fax: (610)821-3008. E-mail: wendy@hamptondesigngroup.com. Web site: www.hamptondesigngroup.com. **Contact:** Wendy Ronga, creative director. Estab. 1997. Member of Type Director Club, Society of Illustrators, Art Directors Club, Society for Publication Designers. Design firm. Approximate annual billing: $450,000. Number of employees: 3. Firm specializes in annual reports, magazine ads, publication design, collateral, direct mail. Types of clients: financial, publishing, nonprofit. Examples of recent clients: Conference for the Aging, Duke University/Templton Foundation (photo shoot/5 images); Religion and Science, UCSB University (9 images for conference brochure).

Needs Works with 2 photographers/month. Uses photos for billboards, brochures, catalogs, consumer magazines, direct mail, newspapers, posters, trade magazines. Subjects include: babies/children/teens, multicultural, senior citizens, environmental, landscapes/scenics, wildlife, pets, religious, health/fitness/

beauty, business concepts, medicine, science. Interested in alternative process, avant garde, fine art, historical/vintage, seasonal. Model/property release required. Photo captions preferred.

Specs Prefers images in digital format. Send via CD as TIFF, EPS, JPEG files at 300 dpi.

Making Contact and Terms Send query letter. Keeps samples on file. Responds only if interested; send nonreturnable samples. Pays $150-1,500 for color photos; $75-1,000 for b&w photos. Pays extra for electronic usage of photos, varies depending on usage. Price is determined by size, how long the image is used and if it is on the home page. **Pays on receipt of invoice.** Credit line given. Buys one-time rights, all rights, electronic rights; negotiable.

Tips "Use different angles and perspectives, a new way to view the same old boring subject. Try different films and processes."

$ $ 🙂 Ⓐ 🖥 📷 MARSHAD TECHNOLOGY GROUP

76 Laight St., New York NY 10013. E-mail: neal@marshad.com. Web site: www.marshad.com. **Contact:** Neal Marshad, owner. Estab. 1983. Video, motion picture and multimedia production house. Approximate annual billing: $9 million. Number of employees: 15. Types of clients: industrial, financial, retail.

Needs Buys 20-50 photos/year; offers 5-10 assignments/year. Freelancers used for cosmetics, food, travel. Subjects include: beauty, tabletop, architectural, landscapes/scenics, wildlife, entertainment, events, food/drink, performing arts, sports, travel, business concepts, product shots/still life. Interested in avant garde, documentary, fashion/glamour, fine art. Model release required; property release preferred. Photo captions preferred.

Audiovisual Needs Uses film, video, CD for multimedia DVDs.

Specs Uses DV. Accepts images in digital format. Send via CD as TIFF, JPEG files at 300 dpi.

Making Contact & Terms Works with local freelancers on assignment only. Provide résumé, business card, self-promotion piece or tearsheets to be kept on file. "No calls!" Pays $125-250 for b&w photos; $125-450 for color photos; $125-1,000 for videotape. Pays on usage. Credit line depends on client. Buys all rights; negotiable.

$🖥 MITCHELL STUDIOS DESIGN CONSULTANTS

1810-7 Front St., East Meadow NY 11554. (516)832-6230. Fax: (516)832-6232. E-mail: msdcdesign@aol.com. **Contact:** Steven E. Mitchell, principal. Estab. 1922. Design firm. Number of employees: 6. Firm specializes in packaging, display design. Types of clients: industrial and retail. Examples of projects: Lipton Cup-A-Soup, Thomas J. Lipton, Inc.; Colgate Toothpaste, Colgate Palmolive Co.; Chef Boy-Ar-Dee, American Home Foods (all 3 involved package design).

Needs Works with varying number of photographers/month. Uses photographs for direct mail, P-O-P displays, catalogs, posters, signage and package design. Subjects include: products/still life. Reviews stock photos of still life/people. Model release required; property release preferred. Photo captions preferred.

Specs Uses all sizes and finishes of color and b&w prints; 35mm, 2¼×2¼, 4×5, 8×10 transparencies. Accepts images in digital format. Send via CD, SyQuest, floppy disk, Jaz, Zip as EPS files.

Making Contact & Terms Submit portfolio for review. Provide résumé, business card, brochure, flier or tearsheets to be kept on file. Cannot return material. Responds as needed. Pays $35-75/hour; $350-1,500/day; $500 and up/job. **Pays on receipt of invoice.** Credit line sometimes given depending on client approval. Buys all rights.

Tips In portfolio, looks for "ability to complete assignment." Sees a trend toward "tighter budgets." To break in with this firm, keep in touch regularly.

$ $🗓 🖥 MIZEREK ADVERTISING, INC.

333 E. 14th St., Suite 7J, New York NY 10003. (212)777-3344. Fax: (212)777-8181. Web site: www.mizerek.net. **Contact:** Leonard Mizerek, president. Estab. 1974. Firm specializes in collateral, direct mail. Types of clients: fashion, jewelry, industrial.

Needs Works with 2 photographers/month. Uses photos for trade magazines. Subjects include: interiors/decorating, business concepts, jewelry. Interested in avant garde, fashion/glamour. Reviews stock photos of creative images showing fashion/style. Model release required; property release preferred.

Specs Uses 8×10 glossy b&w prints; 4×5, 8×10 transparencies. Accepts images in digital format. Send via CD as TIFF files at 300 dpi.

Making Contact & Terms Mailing samples of portfolio for review. Provide Web site contact and/or

brochure, flier or tearsheets to be kept on file. Pays $1,000-5,000/job; $1,500-2,500/day; **Pays on acceptance.** Credit line sometimes given.

Tips Looks for "clear product visualization. Must show detail and have good color balance." Sees trend toward "more use of photography and expanded creativity."

☑ 🖵 MONDERER DESIGN

2067 Massachusetts Ave., Cambridge MA 02140. (617)661-6125. Fax: (617)661-6126. E-mail: stewart@m onderer.com. Web site: www.monderer.com. **Contact:** Stewart Monderer, president. Estab. 1981. Member of AIGA. Design firm. Approximate annual billing: $1 million. Number of employees: 4. Firm specializes in annual reports, branding, print and collateral, direct response, publication design and packaging, Web site and interactive design. Types of clients: technology, life science, industrial, financial and educational. Examples of recent clients: Brochure, Northeastern University (faces, portraits, classroom); Brochure, Makepeace (real estate, nature, landscape); ads, thermo scientific (metaphorical, conceptual).

Needs Works with 2 photographers/month. Uses photos for adverstising, annual reports, catalogs, posters and brochures. Subjects include: environmental, architecture, cities/urban, education, adventure, automobiles, entertainment, events, performing arts, sports, travel, business concepts, industry, medicine, product shots/still life, science, technology/computers, conceptual, site specific, people on location. Interested in alternative process, avant garde, documentary, historical/vintage, seasonal. Model release preferred; property release sometimes required.

Specs Accepts images in digital format. Send via CD as TIFF, EPS files at 300 dpi.

Making Contact & Terms Send unsolicited photos by mail for consideration. Keeps samples on file. Follow up from photographers recommended. Payment negotiable. **Pays on receipt of invoice.** Credit line sometimes given depending upon client. Rights always negotiated depending on use.

$ $ ☑ 🖵 🖼 MULLIN/ASHLEY ASSOCIATE

860 High St., Chestertown MD 21620. (410)778-2184. Fax: (410)778-6640. E-mail: mar@mullinashley.c om. Web site: www.mullinashley.com. **Contact:** Marlayn King, creative director. Estab. 1978. Approximate annual billing: $2 million. Number of employees: 13. Firm specializes in collateral and interactive media. Types of clients: industrial, business to business, healthcare. Examples of recent clients: W.L. Gore & Associates, Nevamar of International Paper, Community Hospitals.

Needs Works with 3 photographers/month. Uses photos for brochures. Subjects include: business concepts, industry, product shots/still life, technology. Also needs industrial, business to business, healthcare on location. Model release required; property release preferred. Photo captions preferred.

Audiovisual Needs Works with 1 videographer/year. Uses for corporate capabilities, brochure, training and videos.

Specs Prefers images in digital format; also uses $2^1/4 \times 2^1/4$, 4×5 transparencies; high-8 video.

Making Contact & Terms Send query letter or e-mail with résumé, digital files or tearsheets. Provide résumé, business card, self-promotion piece to be kept on file. Responds only if interested; send nonreturnable samples. Pays $500-8,000 for b&w or color photos; depends on the project or assignment. Pays on receipt of invoice. Credit line sometimes given depending upon assignment.

$ 🖵 NATIONAL BLACK CHILD DEVELOPMENT INSTITUTE

1313 L St., NW, Suite 110, Washington DC 20005. (202)833-2220. Fax: (202)833-8222. Web site: www.nb cdi.org. **Contact:** Vicki L. Davis, vice president. Estab. 1970.

Needs Uses photos in brochures, newsletters, annual reports and annual calendar. Candid action photos of black children and youth. Reviews stock photos. Model release required.

Specs Uses 5×7, 8×10 color and/or glossy b&w prints; color slides; b&w contact sheets. Accepts images in digital format. Send via CD.

Making Contact & Terms Send query letter with samples; include SASE for return of material. Pays $70 for cover; $20 for inside. Credit line given. Buys one-time rights.

Tips "Candid action photographs of one black child or youth or a small group of children or youths. Color photos selected are used in annual calendar and are placed beside an appropriate poem selected by organization. Therefore, photograph should communicate a message in an indirect way. Black & white photographs are used in quarterly newsletter and reports. Obtain sample of publications published by organization to see the type of photographs selected."

$ $ ◐ A ▣ ▨ NOVUS

121 E. 24th St., 12th Floor, New York NY 10010. (212)473-1377. Fax: (212)505-3300. E-mail: novuscom@ aol.com. Web site: www.novuscommunications.com. **Contact:** Robert Antonik, owner/president. Estab. 1988. Creative marketing and communications firm. Number of employees: 5. Firm specializes in advertising, annual reports, publication design, display design, multimedia, packaging, direct mail, signage and Web site, Internet and DVD development. Types of clients: industrial, financial, retail, health care, telecommunications, entertainment, nonprofit.

Needs Works with 1 photographer/month. Uses photos for annual reports, billboards, consumer and trade magazines, direct mail, P-O-P displays, catalogs, posters, packaging and signage. Subjects include: babies/children/teens, couples, multicultural, families, parents, senior citizens, environmental, landscapes/scenics, wildlife, architecture, cities/urban, education, gardening, interiors/decorating, pets, religious, rural, adventure, automobiles, entertainment, events, food/drink, health/fitness, hobbies, humor, performing arts, sports, travel, agriculture, business concepts, industry, medicine, military, political, product shots/still life, science, technology/computers. Interested in alternative process, avant garde, documentary, fashion/glamour, fine art, historical/vintage, seasonal. Reviews stock photos. Model/property release required. Photo captions preferred.

Audiovisual Needs Uses film, videotape, DVD.

Specs Uses color and/or b&w prints; 35mm, $2\frac{1}{4} \times 2\frac{1}{4}$, 4×5, 8×10 transparencies. Accepts images in digital format. Send via Zip, CD as TIFF, JPEG files.

Making Contact & Terms Arrange a personal interview to show portfolio. Works on assignment only. Keeps samples on file. Cannot return material. Responds in 1-2 weeks. Pays $75-150 for b&w photos; $150-750 for color photos; $300-1,000 for film; $150-750 for videotape. Pays upon client's payment. Credit line given. Rights negotiable.

Tips "The marriage of photos with illustrations continues to be trendy. More illustrators and photographers are adding stock usage as part of their business. Send sample postcard; follow up with phone call."

$ ◐ ▣ POSEY SCHOOL

P.O. Box 254, Northport NY 11768. (631)757-2700. E-mail: EPosey@optonline.net. Web site: www.posey school.com. **Contact:** Elsa Posey, president. Estab. 1953. Sponsors a school of dance, art, music, drama; regional dance company and acting company. Uses photos for brochures, news releases and newspapers.

Needs Buys 12-15 photos/year; offers 4 assignments/year. Special subject needs include children dancing, ballet, modern dance, jazz/tap (theater dance) and "photos showing class situations in any subjects we offer. Photos must include girls and boys, women and men." Interested in documentary, fine art, historical/vintage. Reviews stock photos. Model release required.

Specs Uses 8×10 glossy b&w prints. Accepts images in digital format. Send via CD, e-mail.

Making Contact & Terms "Call us." Responds in 1 week. Pays $35 for most photos, b&w or color. Credit line given if requested. Buys one-time rights; negotiable.

Tips "We are small but interested in quality (professional) work. Capture the joy of dance in a photo of children or adults. Show artists, actors or musicians at work. We prefer informal action photos, not posed pictures. We need photos of *real* dancers dancing. Call first. Be prepared to send photos on request."

N ◐ ▣ MIKE QUON/DESIGNATION INC.

543 River Rd., Fair Haven NJ 07704-3227. (732)212-9200. Fax: (732)212-9217. Web site: www.quondesig n.com. **Contact:** Mike Quon, president/creative director. Design firm. Firm specializes in corporate identity/logos, collateral, event promotion, advertising, illustration. Types of clients: industrial, financial, retail, publishers, nonprofit.

Needs Works with 1-3 photographers/year. Uses photos for direct mail, P-O-P displays, packaging, signage. Model/property release preferred. Photo captions required; include company name.

Specs Uses color and/or b&w digital images.

Making Contact & Terms Submit portfolio for review by mail only. No drop-offs. "Please, do not call office. Contact through mail only." Keeps samples on file. Responds only if interested; send nonreturnable samples. Pays net 30 days. Credit line given when possible. Buys first rights, one-time rights; negotiable.

Tips Mike Quon says he is using more stock photography and less assignment work.

◐ ▣ ARNOLD SAKS ASSOCIATES

350 E. 81st St., 4th Floor, New York NY 10028. (212)861-4300. Fax: (212)535-2590. E-mail: afiorillo@saks design.com. Web site: www.saksdesign.com. **Contact:** Anita Fiorillo, vice president. Estab. 1968. Graphic

design firm. Number of employees: 10. Approximate annual billing: $2 million. Types of clients: industrial, financial, legal, pharmaceutical, hospitals. Examples of recent clients: Alcoa; McKinsey; UBS; Wyeth; Xerox; Hospital for Special Surgery.

Needs Works with approximately 15 photographers during busy season. Uses photos for annual reports and corporate brochures. Subjects include corporate situations and portraits. Wants photos of babies/children/teens, couples, multicultural, families, parents, senior citizens, automobiles, health/fitness/beauty, performing arts, sports, business concepts, industry, medicine, product shots/still life, science, technology/computers. Reviews stock photos; subjects vary according to the nature of the annual report. Model release required. Photo captions preferred.

Specs Uses b&w prints. Accepts images in digital format. Send via e-mail as TIFF, EPS, JPEG files.

Making Contact & Terms ''Appointments are set up during the spring for summer review on a first-come only basis. We have a limit of approximately 30 portfolios each season.'' Call to arrange an appointment. Responds as needed. Payment negotiable, ''based on project budgets. Generally we pay $1,500-2,500/day.'' **Pays on receipt of invoice** and payment by client; advances provided. Credit line sometimes given depending upon client specifications. Buys one-time and all rights; negotiable.

Tips ''Ideally a photographer should show a corporate book indicating his success with difficult working conditions and establishing an attractive and vital final product. Our company is well known in the design community for doing classic graphic design. We look for solid, conservative, straightforward corporate photography that will enhance these ideals.''

JACK SCHECTERSON ASSOCIATES

5316 251 Place, Little Neck NY 11362. (718)225-3536. Fax: (718)423-3478. **Contact:** Jack Schecterson, principal. Estab. 1962. Design firm. Firm specializes in 2D and 3D visual marketing communications via product, package, collateral and graphic design for large and small industrial and consumer product manufacturers. Types of clients: industrial, retail, publishing, consumer product manufacturers.

Needs ''Depends on work in-house.'' Uses photos for packaging, P-O-P displays and corporate graphics, collateral. Reviews stock photos. Model/property release required. Photo captions preferred.

Specs Uses color and/or b&w prints; 35mm, 2¼×2¼, 4×5, 8×10 transparencies. Accepts images in digital format.

Making Contact & Terms Works with local freelancers on assignment. Responds in 3 weeks. Payment negotiable, ''depends upon job.'' Credit line sometimes given. Buys all rights.

Tips Wants to see creative and unique images. ''Contact by mail only. Send SASE for return of samples or leave samples for our files.''

TOBOL GROUP, INC.

14 Vanderventer Ave., Suite 250, Port Washington NY 11050. (516)767-8182. Fax: (516)767-8185. E-mail: mt@tobolgroup.com. Web site: www.tobolgroup.com. **Contact:** Mitch Tobol, president. Estab. 1981. Ad agency/design studio. Types of clients: high-tech, industrial, business-to-business, consumer. Examples of recent clients: Weight Watchers (in-store promotion); Eutectic & Castolin; Mainco (trade ad); Light Alarms.

Needs Works with up to 2 photographers and videographers/month. Uses photos for billboards, consumer and trade magazines, direct mail, P-O-P displays, catalogs, posters, newspapers, audiovisual. Subjects are varied; mostly still-life photography. Reviews business-to-business and commercial video footage. Model release required.

Audiovisual Needs Uses videotape, DVD, CD.

Specs ''Digital photos in all formats, BetaSP, digital video.'' Uses 4×5, 8×10, 11×14 b&w prints; 35mm, 2¼×2¼, 4×5 transparencies; ½'' videotape. Accepts images in digital format. Send via e-mail or link to Web site.

Making Contact & Terms Send query letter with samples; include SASE for return of material. Provide résumé, business card, brochure, flier or tearsheets to be kept on file; follow up with phone call. Works on assignment only. Responds in 3 weeks. Pays $100-10,000/job. Pays net 30 days. Credit line sometimes given, depending on client and price. Rights purchased depend on client.

Tips In freelancer's samples or demos, wants to see ''the best—any style or subject as long as it is done well. Trend is photos or videos to be multi-functional. Show me your *best* and what you enjoy shooting. Get experience with existing company to make the transition from still photography to audiovisual.''

▢ ▣ WORCESTER POLYTECHNIC INSTITUTE

100 Institute Rd., Worcester MA 01609. (508)831-6715. Fax: (508)831-5820. E-mail: charna@wpi.edu. Web site: www.wpi.edu. **Contact:** Charna Westervelt, editorial director. Estab. 1865. Publishes periodicals; promotional, recruiting and fund-raising printed materials. Photos used in brochures, newsletters, posters, audiovisual presentations, annual reports, catalogs, magazines, press releases and Web site.

Needs On-campus, comprehensive and specific views of all elements of the WPI experience.

Specs Prefers images in digital format, but will use 5×7 (minimum) glossy b&w and color prints; 35mm, $2^{1}\!/\!_4\times2^{1}\!/\!_4$, 4×5 transparencies; b&w contact sheets.

Making Contact & Terms Arrange a personal interview to show portfolio or query with Web site link. Provide résumé, business card, brochure, flier or tearsheets to be kept on file. "No phone calls." Responds in 6 weeks. Payment negotiable. Credit line given in some publications. Buys one-time or all rights; negotiable.

$ $ $▢ ▣ SPENCER ZAHN & ASSOCIATES

2015 Sansom St., Philadelphia PA 19103. (215)564-5979. Fax: (215)564-6285. **Contact:** Spencer Zahn, president. Estab. 1970. Member of GPCC. Marketing, advertising and design firm. Approximate annual billing: $5 million. Number of employees: 7. Firm specializes in direct mail, electronic collateral, print ads. Types of clients: financial and retail, automotive.

Needs Works with 1-3 photographers/month. Uses photos for billboards, consumer and trade magazines, direct mail, P-O-P displays, posters and signage. Subjects include: people, still life. Reviews stock photos. Model/property release required.

Specs Uses b&w and/or color prints and transparencies. Accepts images in digital format. Send via Zip, CD.

Making Contact & Terms Send query letter with résumé of credits, stock list, samples. Submit portfolio for review. Provide résumé, business card, brochure, flier or tearsheets to be kept on file. Keeps samples on file. Responds in 1 month. Pays on publication. Credit line sometimes given. Buys one time and/or all rights; negotiable.

MIDSOUTH & SOUTHEAST

$ $▢ ▣ BOB BOEBERITZ DESIGN

247 Charlotte St., Asheville NC 28801. (828)258-0316. E-mail: bobb@main.nc.us. Web site: www.bobboe beritzdesign.com. **Contact:** Bob Boeberitz, owner. Estab. 1984. Member of American Advertising Federation, Asheville Freelance Network, Asheville Creative Services Group, National Academy of Recording Arts & Sciences, Public Relations Association of Western North Carolina. Graphic design studio. Approximate annual billing: $100,000. Number of employees: 1. Firm specializes in annual reports, collateral, direct mail, magazine ads, packaging, publication design, signage, Web sites. Types of clients: management consultants, retail, recording artists, mail-order firms, industrial, nonprofit, restaurants, hotels, book publishers.

Needs Works with 1 freelance photographer "every 6 months or so." Uses photos for consumer and trade magazines, direct mail, brochures, catalogs, posters. Subjects include: babies/children/teens, couples, multicultural, families, parents, senior citizens, environmental, landscapes/scenics, wildlife, architecture, cities/urban, education, pets, rural, adventure, entertainment, events, food/drink, health/fitness/beauty, hobbies, performing arts, sports, travel, business concepts, industry, medicine, product shots/still life, science, technology/computers; some location, some stock photos. Interested in fashion/glamour, seasonal. Model/property release required.

Specs Uses 8×10 glossy b&w prints; 35mm, 4×5 transparencies. Accepts images in digital format. Send via CD, Zip, floppy disk, e-mail as TIFF, BMP, JPEG, GIF files at 300 dpi.

Making Contact & Terms Provide résumé, business card, brochure, flier or tearsheets to be kept on file. Cannot return unsolicited material. Responds "when there is a need." Pays $75-200 for b&w photos; $100-500 for color photos; $75-150/hour; $500-1,500/day. Pays on per-job basis. Buys all rights; negotiable.

Tips "Send promotional piece to keep on file. Do not send anything that has to be returned. I usually look for a specific specialty; no photographer is good at everything. I also consider studio space and equipment. Show me something different, unusual, something that sets you apart from any average local photographer. If I'm going out of town for something, it has to be for something I can't get done locally.

I keep and file direct mail pieces (especially postcards). I do not keep anything sent by e-mail. If you want me to remember your Web site, send a postcard."

$ $⊙ Ⓐ HACKMEISTER ADVERTISING & PUBLIC RELATIONS COMPANY

2631 E. Oakland Park Blvd., Suite 204, Ft. Lauderdale FL 33306. (954)568-2511. E-mail: hackmeisterad@a ol.com. **Contact:** Richard Hackmeister, president. Estab. 1979. Ad agency and PR firm. Serves industrial, electronics manufacturers who sell to other businesses.

Needs Works with 1 photographer/month. Uses photos for trade magazines, direct mail, catalogs. Subjects include: electronic products. Model release required. Photo captions required.

Specs Uses 8×10 glossy color prints; 4×5 transparencies.

Making Contact & Terms "Call on telephone first." Does not return unsolicited material. Pays by the day; $200-2,000/job. Buys all rights.

Tips Looks for "good lighting on highly technical electronic products—creativity."

Ⓝ $⊘ ▣ HOWARD, MERRELL AND PARTNERS, INC.

8521 Six Forks Rd., Raleigh NC 27613. (919)848-2400. Fax: (919)845-9845. **Contact:** Jennifer McFarland, art buyer/broadcast manager. Estab. 1976. Member of AAAA, American Advertising Federation, Advertising Research Foundation, Direct Marketing Association, Interpublic Group of Companies—IPG. Approximate annual billing: $72 million. Number of employees: 45.

Needs Works with 10-20 photographers/month. Uses photos for consumer and trade magazines, direct mail, catalogs and newspapers. Subjects include: people, landscapes/scenics. Reviews stock photos. Model/property release required.

Specs Uses b&w prints; 2¼×2¼, 4×5 transparencies. Accepts images in digital format.

Making Contact & Terms Provide tearsheets to be kept on file. Works on assignment and buys stock photos. Payment individually negotiated. **Pays on receipt of invoice.** Buys one-time and all rights (1-year or 2-year unlimited use); negotiable.

⊘ Ⓐ ▣ MYRIAD PRODUCTIONS

P.O. Box 888886, Atlanta GA 30356. (678)417-0041. E-mail: myriad@mindspring.com. **Contact:** Ed Harris, president. Estab. 1965. Primarily involved with sports productions and events. Types of clients: publishing, nonprofit.

Needs Works with photographers on assignment-only basis. Uses photos for portraits, live-action and studio shots, special effects, advertising, illustrations, brochures, TV and film graphics, theatrical and production stills. Subjects include: celebrities, entertainment, sports. Model/property release required. Photo captions preferred; include name(s), location, date, description.

Specs Uses 8×10 b&w and/or color prints; 2¼×2¼ transparancies. Accepts images in digital format. Send via "Mac-compatible CD or DVD. No floppy disks or Zips!"

Making Contact & Terms Provide brochure, résumé or samples to be kept on file. Send material by mail for consideration. "No telephone or fax inquiries, please!" Cannot return material. Response time "depends on urgency of job or production." Payment negotiable. Credit line sometimes given. Buys all rights.

Tips "We look for an imaginative photographer—one who captures all the subtle nuances. Working with us depends almost entirely on the photographer's skill and creative sensitivity with the subject. All materials submitted will be placed on file and not returned, pending future assignments. Photographers should not send us their only prints, transparencies, etc., for this reason."

$▨ SIDES & ASSOCIATES

404 Eraste Landry Rd., Lafayette LA 70506. (337)233-6473. Fax: (337)233-6485. E-mail: larry@sides.com. **Contact:** Larry Sides, agency president. Estab. 1976. Member of AAAA, PRSA, Chamber of Commerce, Better Business Bureau. Ad agency. Number of employees: 13. Firm specializes in publication design, display design, signage, video and radio production. Types of clients: industrial, financial, retail, nonprofit. Examples of recent clients: Iberia Bank (brochures and newspaper); Episcopal School of Acadia VA (brochure, newspaper); Lafayette Consolicated Government (brochure).

Needs Works with 2 photographers/month. Uses photos for billboards, brochures, newspapers, P-O-P displays, posters, signage. Subjects include: setup shots of people. Reviews stock photos of everything. Model/property release required.

Audiovisual Needs Works with 2 filmmakers and 2 videographers/month. Uses slides and/or film or video for broadcast, TV, newspaper.

Specs Uses 35mm, $2\frac{1}{4} \times 2\frac{1}{4}$, 4×5 transparencies.

Making Contact & Terms Provide résumé, business card, self-promotion piece or tearsheets to be kept on file. Works with local freelancers only. Responds only if interested; send nonreturnable samples. Payment determined by client and usage. Pays "when paid by our client." Rights negotiable.

$☐ ▣ 🖼 SOUNDLIGHT

5438 Tennessee Ave., New Port Richey FL 34652. (727)842-6788. E-mail: keth@awakening-healing.com. Web site: www.SoundLight.org. **Contact:** Keth Luke. Estab. 1972. Approximate annual billing: $150,000. Number of employees: 2. Firm specializes in Web sites, direct mail, magazine ads, publication design. Types of clients: businesses, astrological and spiritual workshops, books, calendars, fashion, magazines, nonprofit, Web pages. Examples of recent clients: Sensual Women of Hawaii (calendars, post cards).

Needs Works with 1 freelance photographer every 7 months. Subjects include: women, celebrities, couples, people in activities, landscapes/scenics, animals, religious, adventure, health/fitness/beauty, humor, alternative medicine, spiritual, travel sites and activities, exotic dance and models (art, glamour, lingerie and nude). Interested in alternative process, avant garde, erotic, fine art. Reviews stock photos, slides, computer images. Model release preferred for models and advertising people. Photo captions preferred; include who, what, where.

Audiovisual Needs Uses freelance photographers for slide sets, multimedia productions, videotapes, Web sites.

Specs Uses 4×6 to 8×10 glossy color prints; 35mm color slides. Accepts images in digital format. Send via CD, floppy disk, e-mail as TIFF, GIF, JPEG files at 70-100 dpi.

Making Contact & Terms Send query letter with résumé, stock list. Provide prints, slides, business card, computer disk, CD, contact sheets, self-promotion piece or tearsheets to be kept on file. Works on assignment; sometimes buys stock nude model photos. May not return unsolicited material. Responds in 3 weeks. Pays $100 maximum for b&w and color photos; $10-1,800 for videotape; $10-100/hour; $50-750/day; $2,000 maximum/job; sometimes also pays in "trades." Pays on publication. Credit line sometimes given. Buys one-time, all rights; various negotiable rights depending on use.

Tips In portfolios or demos, looks for "unique lighting, style, emotional involvement; beautiful, artistic, sensual, erotic viewpoints." Sees trend toward "manipulated computer images. Send query about what you have to show, to see what we can use at that time."

Ⓝ Ⓐ ▣ 🖼 SOUTH CAROLINA FILM COMMISSION

1201 Main St., Suite 1600, Columbia SC 29201. (803)737-0490. Fax: (803)737-3104. Web site: www.filmsc .com. **Contact:** Jeff Monks. Types of clients: motion picture and television producers.

Needs Works with 8 photographers/month. Uses photos of South Carolina landscapes/architecture to recruit feature films/TV productions. Subjects include: location photos for feature films, TV projects, national commercials, print ads and catalogs.

Specs Accepts images in digital format. Send via CD as JPEG files. Recommended resolution and sizes for digital files: 144-150 dpi; file size: 200 DB-1 MB; JPEG compression = 10 maximum quality; 1280×1024 resolution (for single photos).

Making Contact & Terms Submit portfolio by mail. Provide résumé, business card, self-promotion piece or tearsheets to be kept on file. Works with local freelancers on assignment only. Does not return unsolicited material. Payment negotiable. Pays per yearly contract, upon completion of assignment. Buys all rights.

Tips "Experience working in the film/video industry is essential. Ability needed to identify and photograph suitable structures or settings to work as a movie location."

MIDWEST & NORTH CENTRAL

$ Ⓐ BRAGAW PUBLIC RELATIONS SERVICES

800 E. Northwest Hwy., Suite 1040, Palatine IL 60074. (847)934-5580. Fax: (847)934-5596. Web site: http://bragawpr.com. **Contact:** Richard S. Bragaw, president. Estab. 1981. Member of Publicity Club of Chicago. PR firm. Number of employees: 3. Types of clients: professional service firms, high-tech entrepreneurs.

Needs Uses photos for trade magazines, direct mail, brochures, newspapers, newsletters/news releases. Subjects include: "products and people." Model release preferred. Photo captions preferred.

Specs Uses 3×5, 5×7, 8×10 glossy prints.

Making Contact & Terms Provide résumé, business card, brochure, flier or tearsheets to be kept on file. Works with freelance photographers on assignment basis only. Payment is negotiated at the time of the assignment. **Pays on receipt of invoice.** Credit line "possible." Buys all rights; negotiable.

Tips "Execute an assignment well, at reasonable costs, with speedy delivery."

[A] BRIGHT LIGHT VISUAL COMMUNICATIONS

602 Main St., Suite 810, Cincinnati OH 45202. (513)721-2574. Fax: (513)721-3329. Web site: www.brightlightusa.com. **Contact:** Linda Spalazzi, CEO. Visual communication company. Types of clients: national, regional and local companies in the governmental, educational, industrial and commercial categories. Examples of recent clients: Procter & Gamble; U.S. Grains Council; Convergys.

Needs Model/property release required. Photo captions preferred.

Audiovisual Needs "Hire crews around the world using variety of formats."

Making Contact & Terms Provide résumé, flier and brochure to be kept on file. Call to arrange appointment or send query letter with résumé of credits. Works on assignment only. Pays $100 minimum/day for grip; payment negotiable based on photographer's previous experience/reputation and day rate (10 hours). Pays within 30 days of completion of job. Buys all rights.

Tips Sample assignments include camera assistant, gaffer or grip. Wants to see sample reels or samples of still work. Looking for sensitivity to subject matter and lighting. "Show a willingness to work hard. Every client wants us to work smarter and provide quality at a good value."

DESIGN & MORE

336 Rivershire Court, Lincolnshire IL 60069. (847)821-8868. Fax: (847)821-8886. E-mail: burtdesignmore @sbcglobal.net. **Contact:** Burt Bentkover, principal creative director. Estab. 1989. Design and marketing firm. Approximate annual billing: $300,000. Number of employees: 2. Firm specializes in marketing communications, annual reports, collateral, display design, magazine ads, publication design, signage. Types of clients: foodservice, business-to-business, industrial, retail.

Needs Works with 1 freelancer/month. Uses photos for annual reports, sales brochures, consumer and trade magazines. Subjects include abstracts, food/drink. Interested in alternative process, avant garde. Reviews stock photos. Property release required.

Specs Uses 35mm, 2¼×2¼, 5×7 transparencies. Accepts images in digital format.

Making Contact & Terms Provide résumé, business card, brochure, flier or tearsheets to be kept on file. "Never send originals." Responds in 2 weeks. Pays $500-2,000/day. Pays in 45 days. Cannot offer photo credit. Buys negotiable rights.

Tips "Submit nonreturnable photos."

[N] $ FLINT COMMUNICATIONS

101 10th St. N., Fargo ND 58102. (701)237-4850. Fax: (701)234-9680. Email: gerriL@flintcom.com or dawnk@flintcom.com. Web site: www.flintcom.com. **Contact:** Gerri Lien, creative director or Dawn Koranda, art director. Estab. 1946. Ad agency. Approximate annual billing: $9 million. Number of employees: 30. Firm specializes in display design, direct mail, magazine ads, publication design, signage, annual reports. Types of clients: industrial, financial, agriculture, health care and tourism.

Needs Works with 2-3 photographers/month. Uses photos for direct mail, P-O-P displays, posters and audiovisual. Subjects include: babies/children/teens, couples, parents, senior citizens, architecture, rural, adventure, automobiles, events, food/drink, health/fitness, sports, travel, agriculture, industry, medicine, political, product shots/still life, science, technology, manufacturing, finance, health care, business. Interested in documentary, historical/vintage, seasonal. Reviews stock photos. Model release preferred.

Audiovisual Needs Works with 1-2 filmmakers and 1-2 videographers/month. Uses slides and film.

Specs Uses 35mm, 2¼×2¼, 4×5 transparencies. Accepts images in digital format. Send via CD, Zip as TIFF, EPS, JPEG files.

Making Contact & Terms Send query letter with stock list. Submit portfolio for review. Provide résumé, business card, brochure, flier or tearsheets to be kept on file. Responds in 1-2 weeks. Pays $50-150 for b&w photos; $50-1,500 for color photos; $50-130/hour; $400-1,200/day; $100-2,000/job. **Pays on receipt of invoice.** Buys one-time rights.

$ $ $ ☑ ▣ HUTCHINSON ASSOCIATES, INC.

1147 W. Ohio St., Suite 305, Chicago IL 60622-5874. (312)455-9191. Fax: (312)455-9190. E-mail: hutch@hutchinson.com. Web site: www.hutchinson.com. **Contact:** Jerry Hutchinson. Estab. 1988. Member of American Institute of Graphic Arts. Design firm. Number of employees: 3. Firm specializes in identity development, Web site development, annual reports, collateral, magazine ads, publication design, marketing brochures. Types of clients: industrial, financial, real estate, retail, publishing, nonprofit and medical. Example of recent client: Cardinal Growth.

Needs Works with 1 photographer/month. Uses photographs for annual reports, brochures, consumer and trade magazines, direct mail, catalogs, Web sites and posters. Subjects include: still life, real estate. Reviews stock photos.

Specs Accepts images in digital format.

Making Contact & Terms Send query letter with samples. Keeps samples on file. Responds ''when the right project comes along.'' Payment rates depend on the client. Pays within 30-45 days. Credit line sometimes given. Buys one-time, exclusive product and all rights; negotiable.

Tips In samples, ''print quality and composition count.''

$ ▣ ▣ ▣ IDEA BANK MARKETING

P.O. Box 2117, Hastings NE 68902. (402)463-0588. Fax: (402)463-2187. E-mail: sherma@ideabankmarketing.com, mail@ideabankmarketing.com. Web site: www.ideabankmarketing.com. **Contact:** Sherma Jones, vice president/creative director. Estab. 1982. Member of Lincoln Ad Federation. Ad agency. Approximate annual billing: $1.5 million. Number of employees: 11. Types of clients: industrial, financial, tourism and retail.

Needs Works with 1-2 photographers/quarter. Uses photos for direct mail, catalogs, posters and newspapers. Subjects include people and products. Reviews stock photos. Model release required; property release preferred.

Audiovisual Needs Works with 1 videographer/quarter. Uses slides and videotape for presentations.

Specs Uses digital images.

Making Contact & Terms Provide résumé, business card, brochure, flier or tearsheets to be kept on file. Works with freelancers on assignment only. Responds in 2 weeks. Pays $75-125/hour; $650-1,000/day. **Pays on acceptance with receipt of invoice**. Credit line sometimes given depending on client and project. Buys all rights; negotiable.

☑ ▣ ▣ KINETIC CORPORATION

200 Distillery Commons, Suite 200, Louisville KY 40206. (502)719-9500. Fax: (502)719-9509. E-mail: info@theTechnologyAgency.com. Web site: www.theTechnologyAgency.com. **Contact:** Digital services manager. Estab. 1968. Types of clients: industrial, financial, fashion, retail and food.

Needs Works with freelance photographers and/or videographers as needed. Uses photos for audiovisual and print. Model and/or property release required.

Specs Prefers images in digital format. Send via CD, Jaz, Zip as TIFF files.

Making Contact & Terms Provide résumé, business card, brochure, flier or tearsheets to be kept on file. Works with local freelancers only. Responds only when interested. Payment negotiable. Pays within 30 days. Buys all rights.

▣ ▣ LIGGETT STASHOWER, INC.

(formerly Liggett Stashower Advertising, Inc.), 1228 Euclid Ave., Cleveland OH 44115. (216)348-8500. Fax: (216)736-8118. Web site: www.liggett.com. **Contact:** Tom Federico. Estab. 1932. Ad and PR agency. Examples of recent clients: Forest City Management; Ritz-Carlton; Crane Performance Siding; Henkel Consumer Adhesives; TimberTech.

Needs Works with 10 photographers, filmmakers and/or videographers/month. Uses photos for billboards, Web sites, consumer and trade magazines, direct mail, P-O-P displays, catalogs, posters, newspapers, signage and audiovisual. Interested in reviewing stock photos/film or video footage. Model/property release required.

Audiovisual Needs Uses film and videotape for commercials.

Specs Uses b&w and/or color prints (size and finish varies); $2\frac{1}{4} \times 2\frac{1}{4}$, 4×5, 8×10 transparencies; 16mm film; $\frac{1}{4}$-$\frac{3}{4}''$ videotape. Accepts images in digital format.

Making Contact & Terms Send query letter with samples. Provide résumé, business card, brochure, flier

or tearsheets to be kept on file. Responds only if interested. Pays according to project. Buys one-time, exclusive product, all rights; negotiable.

$ $ 🖳 LOHRE & ASSOCIATES INC.

2330 Victory Pkwy., Suite 701, Cincinnati OH 45206. (513)961-1174. E-mail: chuck@lohre.com. Web site: www.lohre.com. **Contact:** Charles R. Lohre, president. Ad agency. Types of clients: industrial.

Needs Uses photos for trade magazines, direct mail, catalogs and prints. Subjects include: machine-industrial themes and various eye-catchers.

Specs Uses high-res digital images.

Making Contact & Terms Send query letter with résumé of credits. Provide business card, brochure, flier or tearsheets to be kept on file.

$ ○ 🖳 MCGUIRE ASSOCIATES

1234 Sherman Ave., Evanston IL 60202. (847)328-4433. Fax: (847)328-4425. Email: jmcguire@ameritech. net. **Contact:** James McGuire, owner. Estab. 1979. Design firm. Specializes in annual reports, publication design, direct mail, corporate materials. Types of clients: industrial, retail, nonprofit.

Needs Uses photos for annual reports, consumer and trade magazines, direct mail, catalogs, brochures. Reviews stock photos. Model release required.

Specs Prefers high-res digital images. Uses color and/or b&w prints; 35mm, $2^{1}/_{4} \times 2^{1}/_{4}$, 4×5, 8×10 transparencies.

Making Contact & Terms Provide résumé, business card, brochure, flier or tearsheets to be kept on file. Cannot return material. Pays $600-1,800/day. **Pays on receipt of invoice.** Credit line sometimes given depending upon client or project. Buys all rights; negotiable.

🅐 🖳 🎞 OMNI PRODUCTIONS

P.O. Box 302, Carmel IN 46082-0302. (317)846-6664. Fax: (317)864-2345. E-mail: omni@omniproduction s.com. Web site: www.omniproductions.com. **Contact:** Winston Long, president. AV firm. Types of clients: industrial, corporate, educational, government, medical.

Needs Works with 6-12 photographers/month. Uses photos for AV presentations. Subject matter varies. Also works with freelance filmmakers to produce training films and commercials. Model release required.

Specs Uses b&w and/or color prints; 35mm transparencies; 16mm and 35mm film and videotape. Accepts images in digital format.

Making Contact & Terms Provide complete contact info, rates, business card, brochure, flier, digital samples or tearsheets to be kept on file. Works with freelance photographers on assignment basis only. Cannot return unsolicited material. Payment negotiable. **Pays on acceptance.** Credit line given ''sometimes, as specified in production agreement with client.'' Buys all rights ''on most work; will purchase one-time use on some projects.''

🅐 🖳 🎞 PHOTO COMMUNICATION SERVICES, INC.

P.O. Box 9, Traverse City MI 49685-0009. (231)943-5050. E-mail: photomarket@photocomm.net. Web site: www.photocomm.net. **Contact:** M'Lynn Hartwell, president. Estab. 1970. Commercial/illustrative and multimedia firm. Types of clients: commercial/industrial, fashion, food, general, human interest.

- This firm also has an office in Hawaii: P.O. Box 458, Kapa'a HI 96746-0458. ''Also see our advertising agency at www.UtopianEmpire.com.''

Needs Works with varying number of photographers/month. Uses photos for catalogs, P-O-P displays, AV presentations, trade magazines and brochures, and a ''large variety of subjects.'' Sometimes works with freelance filmmakers. Model release required.

Audiovisual Needs ''Primarily industrial or training video.''

Specs Uses digital, ''plus some older technology'' such as 8×10 (or larger) glossy (or semi-glossy) b&w and/or color prints, 35mm film, transparencies, most current formats of digital videotape.

Making Contact & Terms Send query letter with résumé of credits, samples, stock list; include SASE for return of material. Works with freelance photographers on assignment basis only. Payment determined by private negotiation. Pays 30 days from acceptance. Credit line given ''whenever possible.''

Tips ''Be professional and to the point. If I see something I can use, I will make an appointment to discuss the project in detail.''

◖ Ⓐ ▣ QUALLY & COMPANY, INC.

2 E. Oak St., Suite 2903, Chicago IL 60611. **Contact:** Mike Iva, creative director. Ad agency. Types of clients: new product development and launches.

Needs Uses photos for every media. "Subject matter varies, but it must always be a 'quality image' regardless of what it portrays." Model/property release required. Photo captions preferred.

Specs Uses b&w and color prints; 35mm, 4×5, 8×10 transparencies. Accepts images in digital format.

Making Contact & Terms Send query letter with photocopies, tearsheets. Provide résumé, business card, brochure, flier or tearsheets to be kept on file. Responds only if interested; send nonreturnable samples. Payment negotiable. Pays net 30 days from receipt of invoice. Credit line sometimes given, depending on client's cooperation. Rights purchased depend on circumstances.

◖ Ⓐ ▣ PATRICK REDMOND DESIGN

P.O. Box 75430-PM, St. Paul MN 55175-0430. E-mail: redmond@patrickredmonddesign.com. Web site: www.patrickredmonddesign.com. **Contact:** Patrick Redmond, M.A., designer/owner/president. Estab. 1966. Design firm. Number of employees: 1. Firm specializes in publication design, book covers, books, packaging, direct mail, posters, branding, logos, trademarks, annual reports, Web sites, collateral. Types of clients: publishers, financial, retail, advertising, marketing, education, nonprofit, industrial, arts. Examples of recent clients: *White, Poems by Jennifer O'Grady*, Mid-List Press (book cover); Hauser Artists World Music & Dance Promotional Material, Hauser Artists (promotional material); *The Traditional Irish Wedding* by Bridget Haggerty, Irish Books and Media and Wolfhound Press (book cover). See "portfolio" section of Web site for examples. Member: AIGA (American Institute of Graphic Arts), AdFed (Advertising Federation of Minnesota), AAR (American Advertising Federation).

● Books designed by Redmond have won awards from Midwest Independent Publishers Association, Midwest Book Achievement Awards, Publishers Marketing Association Benjamin Franklin Awards.

Needs Uses photos for books and book covers, direct mail, P-O-P displays, catalogs, posters, packaging, annual reports. Subject varies with client—may be editorial, product, how-to, etc. May need custom b&w photos of authors (for books/covers designed by PRD). "Poetry book covers provide unique opportunities for unusual images (but typically have miniscule budgets)." Reviews stock photos; subject matter varies with need. Model/property release required; varies with assignment/project. Photo captions required; include correct spelling and identification of all factual matters regarding images; names, locations, etc. to be used optionally if needed.

Specs Accepts images in digital format; type varies with need, production requirements, budgets.

Making Contact & Terms Contact through rep. Arrange a personal interview to show portfolio if requested. "Send query letter with your Web site address only via brief e-mail text message. Patrick Redmond Design will not reply unless specific photographer may be needed." Works with local freelancers on assignment only. Cannot return material. Payment negotiable. "Client typically pays photographer directly even though PRD may be involved in photo/photographer selection and photo direction." Payment depends on client. Credit line sometimes given depending upon publication style/individual projects. Rights purchased by clients vary with project; negotiable. "Clients typically involved with negotiation of rights directly with photographer. Please include note 'Photographer's Market' in any correspondence."

Tips Needs are "open—vary with project; location work, studio, table-top, product, portraits, travel, etc." Seeing "use of existing stock images when image/price are right for project, and use of black & white photos in low- to mid-budget/price books. Provide URLs and e-mail addresses. Freelance photographers need Web presence in today's market in addition to exposure via direct mail, catalogs, brochures, etc. Do not send any images/files attached to your e-mails. Briefly state/describe your work in e-mail. Do not send unsolicited print samples or digital files in any format via e-mail, traditional mail or other delivery."

Ⓐ ▣ ▨ VIDEO I-D, INC.

105 Muller Rd., Washington IL 61571. (309)444-4323. Fax: (309)444-4333. E-mail: videoid@videoid.com. Web site: www.videoid.com. **Contact:** Sam B. Wagner, president. Number of employees: 10. Types of clients: health, education, industry, service, cable and broadcast.

Needs Works with 2 photographers/month to shoot digital stills, multimedia backgrounds and materials, films and videotapes. Subjects "vary from commercial to industrial—always high quality." Somewhat interested in stock photos/footage. Model release required.

Audiovisual Needs Uses digital stills, videotape, DVD, DVD-ROM, CD-ROM.

Specs Uses digital still extension, Beta SP, HDV and HD. Accepts images in digital format. Send via DVD, CD, e-mail, FTP.

Making Contact & Terms Provide résumé, business card, self-promotion piece or tearsheets to be kept on file. "Also send video sample reel." Include SASE for return of material. Works with freelancers on assignment only. Responds in 3 weeks. Pays $10-65/hour; $160-650/day. Usually pays by the job; negotiable. **Pays on acceptance.** Credit line sometimes given. Buys all rights; negotiable.

Tips "Sample reel—indicate goal for specific pieces. Show good lighting and visualization skills. Show me you can communicate what I need to see, and have a willingness to put out effort to get top quality."

SOUTH CENTRAL & WEST

N $ ◨ ▨ THE ADVERTISING CONSORTIUM

10536 Culver Blvd., Suite D., Culver City, CA 90232. (310)287-2222. Fax: (310)287-2227. theadco@pacbell.net. **Contact:** Kim Miyade, president. Estab. 1985. Full-service ad agency. Approximate annual billing: $1.2 million. Number of employees: 2. Firm specializes in magazine ads, direct mail. Types of clients: industrial, retail. Current clients include Bernini, Davante, Westime, Modular Communication Systems, Luxury Optical Holdings.

Needs Number of photographers used on a monthly basis varies. Uses photos for billboards, consumer and trade magazines, direct mail, posters, newspapers and signage. Subjects include: babies/children/teens, couples, families, wildlife, product shots/still life, technology/computers. Interested in fashion/glamour. Reviews stock photos. Model release required; property release preferred.

Audiovisual Needs Uses slides, film and high-res scans on disk.

Specs Uses color and b&w prints. Accepts images in digital format. Send via CD, Zip.

Making Contact & Terms Send unsolicited photos by mail for consideration. Works with local freelancers only. Provide résumé, business card, brochure, flier or tearsheets to be kept on file. Notification dependent upon opportunity. Payment negotiable. Credit line sometimes given. Buys all rights.

$ ◨ BEAR ENTHUSIAST MARKETING GROUP

32121 Lindero Canyon Rd., Suite 200, Westlake Village CA 91361. (818)865-6464. Fax: (818)865-6499. E-mail: info@bearemg.com. Web site: www.bearemg.com. **Contact:** Bruce Bear, president. Estab. 1961. Ad agency. Number of employees: 15. Firm specializes in display design, magazine ads, collateral, direct mail, packaging.

Needs Works with 3 photographers/month. Uses photos for brochures, catalogs, consumer magazines, direct mail, P-O-P displays, posters, trade magazines. Subjects include: fishing, hunting and outdoor scenes, wildlife, active lifestyle scenes. Model release preferred.

Specs Uses 35mm transparencies. Accepts images in digital format.

Making Contact & Terms Send query letter with stock list. Pays $151-300. **Pays on receipt of invoice.** Credit line sometimes given.

$ ▢ Ⓐ ◨ BERSON, DEAN, STEVENS

P.O. Box 3997, Thousand Oaks CA 91359-3997. (818)713-0134. Fax: (818)713-0417. Web site: www.BersonDeanStevens.com. **Contact:** Lori Berson, owner. Estab. 1981. Design firm. Number of employees: 3. Firm specializes in annual reports, display design, collateral, packaging, direct mail and video production. Types of clients: industrial, financial, food and retail. Examples of recent clients: Dole Food Company; Charles Schwab & Co., Inc.

Needs Works with 4 photographers/month. Uses photos for billboards, trade magazines, direct mail, P-O-P displays, catalogs, posters, packaging, signage and Web. Subjects include: product shots and food. Reviews stock photos. Model/property release required.

Specs Accepts images in digital format only. Send via CD, DVD as TIFF, EPS, JPEG files at 300 dpi.

Making Contact & Terms Provide résumé, business card, brochure, flier or tearsheets to be kept on file. Works on assignment only. Responds in 1-2 weeks. Payment negotiable. Pays within 30 days after receipt of invoice. Credit line not given. Rights negotiable.

$ $ ▢ Ⓐ ◨ BRAINWORKS DESIGN GROUP

5 Harris Court, Bldg. T, Suite A, Monterey CA 93940. (831)657-0650. Fax: (831)657-0750. E-mail: design@brainwks.com. Web site: www.brainwks.com. **Contact:** Alfred Kahn, president. Estab. 1986. Design firm.

Approximate annual billing: $2 million. Number of employees: 8. Firm specializes in publication design and collateral. Types of clients: higher education, technology, science

Needs Works with 4 photographers/month. Uses photographs for direct mail, catalogs and posters. Subjects include: couples, environmental, education, entertainment, performing arts, sports, business concepts, science, technology/computers. Interested in avant garde, documentary. Wants conceptual images. Model release required.

Specs Uses 35mm, 4×5 transparencies. Accepts images in digital format. Send via CD.

Making Contact & Terms Arrange a personal interview to show portfolio. Send unsolicited photos by mail for consideration. Works with freelancers on assignment only. Keeps samples on file. Cannot return material. Responds in 1 month. Pay negotiable. **Pays on receipt of invoice.** Credit line sometimes given, depending on client. Buys first, one-time and all rights; negotiable.

[A] [▣] [▩] BRAMSON + ASSOCIATES

7400 Beverly Blvd., Los Angeles CA 90036. (323)938-3595. Fax: (323)938-0852. E-mail: gbramson@aol.com. **Contact:** Gene Bramson, principal. Estab. 1970. Ad agency. Approximate annual billing: $2 million. Number of employees: 7. Types of clients: industrial, financial, food, retail, health care. Examples of recent clients: Hypo Tears; 10 Lab Corporation; Chiron Vision.

Needs Works with 2-5 photographers/month. Uses photos for trade magazines, direct mail, catalogs, posters, newspapers, signage. Subject matter varies; includes babies/children/teens, couples, multicultural, families, architecture, cities/urban, gardening, interiors/decorating, pets, automobiles, food/drink, health/fitness/beauty, business concepts, medicine, science. Interested in avant garde, documentary, erotic, fashion/glamour, historical/vintage. Reviews stock photos. Model/property release required. Photo captions preferred.

Audiovisual Needs Works with 1 videographer/month. Uses slides and/or videotape for industrial, product.

Specs Uses 11×15 color and/or b&w prints; 35mm, 2¼×2¼, 4×5, 8×10 transparencies. Accepts images in digital format. Send via CD.

Making Contact & Terms Submit portfolio for review. Send unsolicited photos by mail for consideration; include SASE for return of material. Works with local freelancers on assignment only. Provide résumé, business card, brochure, flier or tearsheet to be kept on file. Responds in 3 weeks. Payment negotiable, depending on budget for each project. **Pays on receipt of invoice.** Credit line not given. Buys one-time and all rights.

Tips "Innovative, crisp, dynamic, unique style—otherwise we'll stick with our photographers. If it's not great work, don't bother."

$ $[▨][▣] DESIGN2MARKET

1973 O'Toole Way, San Jose CA 95131. (408)232-0440. Fax: (408)232-0443. E-mail: info@design2marketinc.com. Web site: www.design2marketinc.com. **Contact:** Lior Taylor, senior designer. Design firm. Number of employees: 5. Firm specializes in publication design, display design, magazine ads, collateral, packaging, direct mail and advertising. Types of clients: industrial, retail, nonprofit and technology. Examples of recent clients: NEC (Tradeshow, promotions), Metropolis Retail (Web),California Insurance Careers Program (Web, promotions), Silicon Valley Charity Ball (invitation and posters); IDEC Corporation (advertising); City College of San Francisco (advertising); Polycom (packaging).

Needs Works with 6 photographers/month. Uses photos for trade magazines, direct mail, P-O-P displays, catalogs, posters, packaging and advertising. Subjects include: people, computers, equipment. Reviews stock photos. Model/property release required.

Specs Accepts images in digital format. Send via CD as TIFF, EPS, PICT, JPEG files at 300 dpi minimum.

Making Contact & Terms Send unsolicited photos by mail for consideration. Include SASE for return of material. Provide résumé, business card, brochure, flier or tearsheets to be kept on file. Works on assignment and buys stock photos. Payment negotiable. Credit line sometimes given. Buys all rights.

[A] [▩] DYKEMAN ASSOCIATES, INC.

4115 Rawlins St., Dallas TX 75219. (214)528-2991. Fax: (214)528-0241. E-mail: adykeman@airmail.net. Web site: www.dykemanassociates.com. **Contact:** Alice Dykeman, APR, Fellow-PRSA. Estab. 1974. Member of Public Relations Society of America. PR, marketing, video production firm. Firm specializes in Web site creation and promotion, communication plans, media training, collateral, direct marketing. Types of clients: industrial, financial, sports, technology.

Needs Works with 4-5 photographers and/or videographers. Uses photos for publicity, consumer and trade magazines, direct mail, catalogs, posters, newspapers, signage, Web sites.

Audiovisual Needs "We produce and direct video. Just need crew with good equipment and people and ability to do their part."

Making Contact & Terms Arrange a personal interview to show portfolio. Provide business card, brochure, flier or tearsheets to be kept on file. Works on assignment only. Cannot return material. Pays $800-1,200/day; $250-400/1-2 days. "Currently we work only with photographers who are willing to be part of our trade dollar network. Call if you don't understand this term." Pays 30 days after receipt of invoice.

Tips Reviews portfolios with current needs in mind. "If video, we would want to see examples. If for news story, we would need to see photojournalism capabilities."

$⬙⬛⬖⬕ FRIEDENTAG PHOTOGRAPHICS

314 S. Niagara St., Denver CO 80224-1324. (303)333-0570. **Contact:** Harvey Friedentag, manager. Estab. 1957. AV firm. Approximate annual billing: $500,000. Number of employees: 3. Firm specializes in direct mail, annual reports, publication design, magazine ads. Types of clients: business, industry, financial, publishing, government, trade and union organizations. Produces slide sets, motion pictures and videotape. Examples of recent clients: Perry Realtors annual report (advertising, mailing); Lighting Unlimited catalog (illustrations).

Needs Works with 5-10 photographers/month on assignment only. Buys 1,000 photos and 25 films/year. Reviews stock photos of business, training, public relations, and industrial plants showing people and equipment or products in use. Other subjects include agriculture, business concepts, industry, medicine, military, political, science, technology/computers. Interested in avant garde, documentary, erotic, fashion/glamour. Model release required.

Audiovisual Needs Uses freelance photos in color slide sets and motion pictures. "No posed looks." Also produces mostly 16mm Ektachrome and some 16mm b&w; ³/₄" and VHS videotape. Length requirement: 3-30 minutes. Interested in stock footage on business, industry, education and unusual information. "No scenics, please!"

Specs Uses 8×10 glossy b&w and/or color prints; 35mm, 2¼×2¼, 4×5 color transparencies. Accepts images in digital format. Send via CD as JPEG files.

Making Contact & Terms Send material by mail for consideration. Provide flier, business card, brochure and nonreturnable samples to show clients. Responds in 3 weeks. Pays $500/day for still; $700/day for motion picture plus expenses; $100 maximum for b&w photos; $200 maximum for color photos; $700 maximum for film; $700 maximum for videotape. **Pays on acceptance.** Buys rights as required by clients.

Tips "More imagination needed—be different; *no scenics, pets or portraits*, and above all, technical quality is a must. There are more opportunities now than ever, especially for new people. We are looking to strengthen our file of talent across the nation."

⬙⬗⬛⬕ GRAPHIC DESIGN CONCEPTS

15329 Yukon Ave., El Camino Village CA 90260-2452. (310)978-8922. **Contact:** C. Weinstein, president. Estab. 1980. Design firm. Number of employees: 10. Firm specializes in annual reports, collateral, publication design, display design, packaging, direct mail, signage. Types of clients: industrial, financial, retail, publishers, nonprofit. Examples of recent clients: Sign of Dove (brochures); Trust Financial (marketing materials).

Needs Works with 10 photographers/month. Uses photos for annual reports, billboards, consumer and trade magazines, direct mail, P-O-P displays, catalogs, posters, packaging, signage. Subjects include babies/children/teens, celebrities, couples, multicultural, families, parents, senior citizens, disasters, environmental, landscapes/scenics, wildlife, architecture, cities/urban, gardening, interiors/decorating, pets, religious, rural, adventure, automobiles, entertainment, events, food/drink, health/fitness, hobbies, humor, performing arts, travel, sports, agriculture, business concepts, industry, medicine, military, political, product shots/still life, science, technology/computers, pictorial. Interested in alternative process, avant garde, documentary, erotic, fashion/glamour, fine art, historical/vintage, seasonal. Model/property release required for people, places, art. Photo captions required; include who, what, when, where.

Audiovisual Needs Uses film and videotape.

Specs Uses 8×10 glossy color and/or b&w prints; 35mm, 2¼×2¼, 4×5, 8×10 transparencies. Accepts images in digital format. Send via CD, floppy disk as TIFF, JPEG files at 300 dpi.

Making Contact & Terms Provide résumé, business card, brochure, flier or tearsheets to be kept on

file. Works with freelancers on assignment only. Responds as needed. Pays $15 minimum/hour; $100 minimum/day; $100 minimum/job; $50 minimum for color photos; $25 minimum for b&w photos; $200 minimum for film; $200 minimum for videotape. **Pays on receipt of invoice.** Credit line sometimes given depending upon usage. Buys rights according to usage.
Tips In samples, looks for "composition, lighting and styling." Sees trend toward "photos being digitized and manipulated by computer."

◪ HALLOWES PRODUCTIONS & ADVERTISING

11260 Regent St., Los Angeles CA 90066-3414. (310)390-4767. Fax: (310)745-1107. Miracle Mile Office: Hallowes Productions, 5670 Wilshire Blvd., Suite 1590, Los Angeles CA 90036-5679. E-mail: adjim@aol.com. Web site: www.jimhallowes.com and www.hallowesproductions.com. **Contact:** Jim Hallowes, creative director/producer-director. Estab. 1984. Creates and produces TV commercials, corporate films and videos, and print and electronic advertising.
Needs Buys 8-10 photos/year. Uses photos for magazines, posters, newspapers and brochures. Reviews stock photos; subjects vary.
Audiovisual Needs Uses film and video for TV commercials and corporate films.
Specs Uses 35mm, 4×5 transparencies; 35mm/16mm film; Beta SP videotape; all digital formats.
Making Contact & Terms Send query letter with résumé of credits. "Do not fax unless requested." Keeps samples on file. Responds if interested. Payment negotiable. Pays on usage. Credit line sometimes given, depending upon usage, usually not. Buys first and all rights; rights vary depending on client.

Ⓐ ▣ THE HITCHINS COMPANY

22756 Hartland St., Canoga Park CA 91307. (818)715-0510. Fax: (775)806-2687. E-mail: whitchins@socal. rr.com. **Contact:** W.E. Hitchins, president. Estab. 1985. Ad agency. Approximate annual billing: $300,000. Number of employees: 2. Firm specializes in collateral, direct mail, magazine ads. Types of clients: industrial, retail (food), auctioneers. Examples of recent clients: Electronic Expediters (brochure showing products); Allan-Davis Enterprises (magazine ads).
Needs Uses photos for trade and consumer magazines, direct mail, newspapers. Model release required.
Specs Uses b&w and/or color prints. "Copy should be flexible for scanning." Accepts images in digital format. Send via CD, floppy disk, e-mail.
Making Contact & Terms Provide résumé, business card, brochure, flier or tearsheets to be kept on file. Works on assignment only. Cannot return material. Payment negotiable depending on job. **Pays on receipt of invoice** (30 days). Rights purchased negotiable; "varies as to project."
Tips Wants to see shots of people and products in samples.

Ⓝ $◪ ▣ ◪ BERNARD HODES GROUP

333 Twin Dolphin Dr., Suite 400, Redwood City CA 94065. (650)264-1100. Fax: (650)593-3672. Email: info@hodes.com. Web site: www.hodes.com. **Contact:** Ray Chancellor, creative director. Estab. 1970. Member of Western Art Directors Club, San Francisco Ad Club. Ad agency, design firm. Has over 90 offices and affiliates worldwide; approximately 700 employees. Firm specializes in annual reports, collateral, direct mail, magazine ads, packaging, publication design. Types of clients: industrial, retail, non-profit.
Needs Works with 1 or more photographers/month. Uses photos for brochures, catalogs, consumer and trade magazines, direct mail. Model release preferred.
Audiovisual Needs Uses slides.
Specs Uses 35mm, 2¼×2¼, 4×5 transparencies. Accepts images in digital format. Send via CD, SyQuest, Zip, e-mail as TIFF, EPS, JPEG files.
Making Contact & Terms Send query letter with résumé. Works with local freelancers only. Provide résumé, business card, self-promotion piece to be kept on file. Pays net 30 days. Buys all rights.

▣ ◪ IMAGE INTEGRATION

2619 Benvenue Ave., #A, Berkeley CA 94704. (510)841-8524. E-mail: vincesail@aol.com. **Contact:** Vince Casalaina, owner. Estab. 1971. Firm specializes in material for TV productions and Internet sites. Approximate annual billing: $100,000. Examples of recent clients: "Ultimate Subscription," *Sailing World* (30-second spot); "Road to America's Cup," ESPN (stock footage); "Sail with the Best," U.S. Sailing (promotional video).

Needs Works with 1 photographer/month. Reviews stock photos of sailing only. Property release preferred. Photo captions required; include regatta name, regatta location, date.

Audiovisual Needs Works with 1 videographer/month. Uses videotape. Subjects include: sailing only.

Specs Uses 4×5 or larger matte color and/or b&w prints; 35mm transparencies; 16mm film and Betacam videotape. Prefers images in digital format. Send via e-mail, Zip, CD-ROM (preferred).

Making Contact & Terms Send unsolicited photos of sailing by mail with SASE for consideration. Keeps samples on file. Responds in 2 weeks. Payment depends on distribution. Pays on publication. Credit line sometimes given, depending upon whether any credits included. Buys nonexclusive rights; negotiable.

☑ ▣ JUDE STUDIOS

8000 Research Forest, Suite 115-266, The Woodlands TX 77382. (281)364-9366. Fax: (281)364-9529. E-mail: jdollar@judestudios.com. Web site: www.judestudios.com. **Contact:** Judith Dollar, art director. Estab. 1994. Member of Houston Art Directors Club, American Advertising Federation. Number of employees: 2. Firm specializes in collateral, direct mail, packaging. Types of clients: industrial, high tech, medical, event marketing, service. Examples of recent clients: home builder; festivals and events; corporate collateral; various logos; banking.

Needs Works with 1 photographer/month. Uses photos for brochures, catalogs, direct mail, trade and trade show graphics. Needs photos of families, senior citizens, education, pets, business concepts, industry, product shots/still life, technology/computers. Model release required; property release preferred. Photo captions preferred.

Specs Uses 5×7, 8×10 glossy prints; 35mm, 2¼×2¼, 4×5 transparencies. Accepts images in digital format. Send via CD as TIFF, EPS, JPEG files at 350 dpi. "Do not e-mail attachments."

Making Contact & Terms Send query letter with prints, photocopies, tearsheets. Provide business card, self-promotion piece to be kept on file. Responds only if interested; send nonreturnable samples. Pays by the project. **Pays on receipt of invoice.**

Ⓐ KOCHAN & COMPANY

800 Geyer Ave., St Louis MO 63104. (314)621-4455. Fax: (314)621-1777. Web site: www.kochanandcompany.com. **Contact:** Tracy Tucker, creative director/vice president. Estab. 1987. Member of AAAA. Ad agency. Number of employees: 15. Firm specializes in display design, magazine ads, packaging, direct mail, signage. Types of clients: attractions, retail, nonprofit. Example of recent clients: Argosy Casino (billboards/duratrans); Pasta House Co. (menu inserts); HealthLink (billboards); Remington Park Racetrack/Casino (billboards/print ads).

Needs Uses photos for billboards, brochures, catalogs, direct mail, newspapers, posters, signage. Reviews stock photos. Model/property release required. Photo captions required.

Making Contact & Terms Send query letter with samples, brochure, stock list, tearsheets. To show portfolio, photographer should follow up with call and/or letter after initial query. Portfolio should include b&w, color, prints, tearsheets, slides, transparencies. Works with freelancers on assignment only. Keeps samples on file. Responds only if interested; send nonreturnable samples. **Pays on receipt of invoice.** Credit line given. Buys all rights.

$ $ $ $ Ⓐ ▣ POINTBLANK AGENCY

100 N. Brand Blvd., Suite 211, Glendale CA 91203. (818)551-9181. Fax: (818)551-9681. E-mail: valn@pointblankagency.com. Web site: www.pointblankagency.com. **Contact:** Valod Nazarian. Ad and design agency. Serves travel, high-technology and consumer-technology clients.

Needs Uses photos for trade show graphics, Web sites, consumer and trade magazines, direct mail, P-O-P displays, newspapers. Subject matter of photography purchased includes: conceptual shots of people and table top (tight shots of electronics products). Model release required. Photo captions preferred.

Specs Uses 8×10 matte b&w and/or color prints; 35mm, 2¼×2¼, 4×5, 8×10 transparencies. Accepts images in ditigal format. Send via CD.

Making Contact & Terms Arrange a personal interview to show portfolio. Provide résumé, business card, brochure, flier or tearsheets to be kept on file. Works on assignment basis only. Does not return unsolicited material. Responds in 3 weeks. Pay is negotiable. **Pays on receipt of invoice.** Buys one-time, exclusive product, electronic, buy-outs, and all rights (work-for-hire); negotiable.

Tips Prefers to see "originality, creativity, uniqueness, technical expertise" in work submitted. There is more use of "photo composites, dramatic lighting and more attention to detail" in photography.

☻ ▣ RED HOTS ENTERTAINMENT

67885 Foothill Rd., Cathedral City CA 92234-2436. **Contact:** Chip Miller and Daniel Pomeroy, creative directors. Estab. 1987. Motion picture, music video, commercial and promotional trailer film production company. Number of employees: 10. Types of clients: fashion, entertainment, publishing, motion picture, TV and music. Examples of recent clients: "History of Vegas," Player's Network (broadcast); "Making of First Love," JWP/USA (MTV Broadcast); "The Sun Show," SSTV; "The Belly Twins Show;" "Old Sand Mill Lost Years" (MTV).

Needs Works with 1 photographer/month. Uses freelancers for TV, music video, motion picture stills and production. Model release required; property release preferred. Photo captions preferred.

Audiovisual Needs Uses film and video.

Making Contact & Terms Provide business card, résumé, references, samples or tearsheets to be kept on file. Payment negotiable "based on project's budget." Rights negotiable.

Tips Wants to see a minimum of 2 pieces "expressing range of studio, location, style and model-oriented work. Must include samples of work published or commissioned for production."

$ $ ▣ TED ROGGEN ADVERTISING AND PUBLIC RELATIONS

101 Westcott St., Unit 306, Houston TX 77007. (713)426-2314. Fax: (713)869-3563. E-mail: sroggen@aol.com. **Contact:** Ted Roggen. Estab. 1945. Ad agency and PR firm. Number of employees: 3. Firm specializes in magazine ads, direct mail. Types of clients: construction, entertainment, food, finance, publishing, travel.

Needs Buys 25-50 photos/year; offers 50-75 assignments/year. Uses photos for billboards, direct mail, radio, TV, P-O-P displays, brochures, annual reports, PR releases, sales literature and trade magazines. Subjects include adventure, health/fitness, sports, travel. Interested in erotic, fashion/glamour. Model release required. Photo captions required.

Specs Uses 5×7 glossy or matte b&w and/or color prints; 4×5 transparencies. "Contact sheet OK."

Making Contact & Terms Provide résumé to be kept on file. Pays $75-250 for b&w photos; $125-300 for color photos; $150/hour. **Pays on acceptance.** Rights negotiable.

$ ▣ ▣ ▣ DANA WHITE PRODUCTIONS

2623 29th St., Santa Monica CA 90405. (310)450-9101. E-mail: dwprods@aol.com. **Contact:** Dr. Dana White, president. Estab. 1977. Full-service audiovisual, multi-image, digital photography and design, video/film production studio. Types of clients: schools and community-based nonprofit institutions, corporate, government, publishing, marketing/advertising, and art galleries. Examples of recent clients: Toyota Hybrid Synergy: Mobile Experience Tour (video production); Los Angeles County (annual report); Back Forty Feature Films; Southern California Gas Company/South Coast AQMD (Clean Air Environmental Film Trailers in 300 LA-based motion picture theaters); Glencoe/McGraw-Hill (textbook photography and illustrations, slide shows); Pepperdine University (awards banquet presentations, fundraising, biographical tribute programs); U.S. Forest Service (training programs); Venice Family Clinic (newsletter photography); Johnson & Higgins (brochure photography). "Stock photography is available through PhotoEdit: www.photoeditinc.com; locate Dana White in list of photographers."

Needs Works with 2-3 photographers/month. Uses photos for catalogs, audiovisual, books. Subjects include: people, products, still life, event documentation, architecture. Interested in reviewing 35mm stock photos by appointment. Model release required for people and companies.

Audiovisual Needs Uses all AV formats including scanned and digital images for computer-based multimedia; 35mm slides for multi-image presentations; and medium-format as needed.

Specs Uses color and/or b&w prints; 35mm, 2¼×2¼ transparencies; digital images (minimum 6mp files).

Making Contact & Terms Arrange a personal interview to show portfolio and samples. "Please do not send originals." Works with freelancers on assignment only. Will assign certain work on spec. Do not submit unsolicited material. Cannot return material. **Pays when images are shot to White's satisfaction**—never delays until acceptance by client. Pays according to job: $25-100/hour, up to $750/day; $20-50/shot; or fixed fee based upon job complexity and priority of exposure. Hires according to work-for-hire and will share photo credit when possible.

Tips In freelancer's portfolio or demo, Dr. White wants to see "quality of composition, lighting, saturation, degree of difficulty, and importance of assignment. The trend seems to be toward more video, less AV. Clients are paying less and expecting more. To break in, freelancers should diversify, negotiate, be personable and flexible, go the distance to get and keep the job. Freelancers need to see themselves as

Advertising

hunters who are dependent upon their hunting skills for their livelihood. Don't get stuck in one-dimensional thinking. Think and perform as a team—service that benefits all sectors of the community and process.''

NORTHWEST & CANADA

$ $☺ ▣ AUGUSTUS BARNETT ADVERTISING/DESIGN

P.O. Box 197, Fox Island WA 98333. (253)549-2396. Web site: www.augustusbarnett.com. **Contact:** Charlie Barnett, president. Estab. 1981. Ad agency, design firm. Firm specializes in print ads, collateral, direct mail, business to business, retail, food, package design and identities. Types of clients: industrial, financial, retail, nonprofit.

Needs Works with 1-2 photographers/month. Uses photos for consumer and trade magazines, direct mail, P-O-P displays, newspapers. Subjects include: industrial, food-related product photography. Model release required; property release preferred for fine art, vintage cars, boats and documents. Photo captions preferred. **Specs** Uses 4×5, 8×10 glossy b&w prints; 35mm, 2¼×2¼, 4×5 transparencies. Accepts images in digital format. Send via CD, Jaz, Zip, e-mail, FTP as TIFF, EPS, GIF files at 300 dpi minimum.

Making Contact & Terms Call for interview or drop off portfolio. Keeps samples on file. Responds in 2 weeks. Pays $600-1,500/day; negotiable. **Pays on receipt of invoice**. Credit line sometimes given "if the photography is partially donated for a nonprofit organization." Buys one-time and exclusive product rights; negotiable.

$ $☑ ▣ CREATIVE COMPANY

726 NE Fourth St., McMinnville OR 97128. (503)883-4433 or (866)363-4433. Fax: (503)883-6817. E-mail: jlmorrow@creativeco.com. Web site: www.creativeco.com. **Contact:** Jennifer L. Morrow, president, or Steve Donatelli, Creative Director. Estab. 1978. Member of American Institute of Graphic Artists. Strategic branding and communications firm. Approximate annual billing: $1.5 million. Number of employees: 12. Firm specializes in branding, collateral, direct mail, magazine ads, packaging, publication design. Types of clients: service, industrial, financial, manufacturing, food and wine, education, non-profit, business-to-business.

Needs Works with 1-2 photographers/month. Uses photos for direct mail, P-O-P displays, catalogs, posters, packaging and sales promotion packages. Subjects include: babies/children/teens, multicultural, senior citizens, gardening, food/drink, health/fitness/beauty, agriculture, business concepts, industry, product shots/still life, technology/computers. Model release preferred.

Specs Prefers high-resolution digital files. "We would like to view samples online or via e-mail."

Making Contact & Terms Arrange a personal interview to show portfolio. Works with local freelancers only. Provide resume, business card, brochure, flier or tearsheets to be kept on file. Responds "when needed." Pays $150-300 for b&w photos; $300-1,000 for color photos; $50-100/hour; $700-2,000/day; $200-15,000/job. Credit line not given. Buys one-time, one-year and all rights; negotiable.

Tips In freelancers' portfolios looks for "product shots, lighting, creative approach, understanding of sales message and reproduction." Sees trend toward "more special effect photography and manipulation of photos in computers." To break in with this firm, "do good work, be responsive, and understand how to maximize color and effect on the press."

$ ▣ ▣ ▣ GIBSON ADVERTISING & DESIGN

P.O. Box 80407, Billings MT 59104. (406)248-3555. Fax: (406)839-9006. E-mail: mike@gibsonad.com. Web site: www.gibsonad.com. **Contact:** Mike Curtis, president. Estab. 1984. Ad agency. Number of employees: 2. Types of clients: industrial, financial, retail, food, medical.

Needs Works with 1-3 freelance photographers and 1-2 videographers/month. Uses photos for direct mail, P-O-P displays, catalogs, posters, newspapers, signage and audiovisual. Subjects vary with job. Reviews stock photos. "We would like to see more Western photos." Model release required. Property release preferred.

Audiovisual Needs Uses slides and videotape.

Specs Uses color and b&w prints; 35mm, 2¼×2¼, 4×5, 8×10 transparencies; 16mm, VHS, Betacam videotape; and digital formats.

Making Contact & Terms Send query letter with résumé of credits or samples. Provide résumé, business card, brochure, flier or tearsheets to be kept on file. Works with local freelancers on assignment only.

Keeps samples on file. Cannot return material. Responds in 2 weeks. Pays $75-150/job; $150-250 for color photo; $75-150 for b&w photo; $100-150/hour for video. **Pays on receipt of invoice**, net 30 days. Credit line sometimes given. Buys one-time and electronic rights. Rights negotiable.

$ $⊘ ▣ HENRY SCHMIDT DESIGN

14710 SE Lee Ave., Portland OR 97267-2631. (503)652-1114. E-mail: hank@hankink.com. Web site: www.hankink.com. **Contact:** Hank Schmidt, president. Estab. 1976. Design firm. Approximate annual billing: $250,000. Number of employees: 2. Firm specializes in branding, packaging, P-O-P displays, catalog/sales literature.

Needs Works with 1-2 photographers/month. Uses photos for catalogs and packaging. Subjects include product shots/still life. Interested in fashion/glamour. Model/property release required.

Specs Uses digital photography for almost all projects. Send digital images via CD, e-mail as TIFF, JPEG files.

Making Contact & Terms Interested in receiving work from newer, lesser-known photographers. Send query letter with samples; include SASE for return of material. Provide résumé, business card, brochure, flier or tearsheets to be kept on file. Payment negotiable. **Pays on receipt of invoice**, net 30 days. Credit line sometimes given. Buys all rights.

Tips "I shoot with digital photographers almost exclusively." Expects photographer to provide image processing; "I never buy 'raw' images."

$▣ ⧗ ▨ SUN.ERGOS: A Company of Theatre and Dance

130 Sunset Way, Priddis AB T0L 1W0 Canada. (403)931-1527. Fax: (403)931-1534. E-mail: waltermoke@ sunergos.com. Web site: www.sunergos.com. **Contact:** Robert Greenwood, artistic and managing director. Estab. 1977. "A unique, professional, two-man company of theatre and dance, touring nationally and internationally as cultural ambassadors to urban and rural communities."

Needs Buys 10-30 photos/year; offers 3-5 assignments/year. Uses photos for brochures, newsletters, posters, newspapers, annual reports, magazines, press releases, audiovisual uses and catalogs. Reviews theater and dance stock photos. Property release required for performance photos for media use. Photo captions required; include subject, date, city, performance title.

Audiovisual Needs Uses slides, film and videotape for media usage, showcases and international conferences. Subjects include performance pieces/showcase materials.

Specs Uses 8×10, 8½×11 color and/or b&w prints; 35mm, 2¼×2¼ transparencies; 16mm film; NTSC/PAL/SECAM videotape.

Making Contact & Terms Arrange a personal interview to show portfolio. Send query letter with résumé of credits. Provide résumé, business card, self-promotion piece or tearsheets to be kept on file. Works on assignment only. Response time depends on project. Pays $100-150/day; $150-300/job; $2.50-10 for color or b&w photos. Pays on usage. Credit line given. Buys all rights.

Tips "You must have experience shooting dance and *live* theater performances."

◔ ▣ ▣ ⧗ ▨ WARNE MARKETING & COMMUNICATIONS

65 Overlea Blvd., Suite 112, Toronto ON M4H 1P1 Canada. (416)927-0881. Fax: (416)927-1676. E-mail: scott@warne.com. Web site: www.warne.com. **Contact:** Scott Warne, president. Estab. 1979. Ad agency. Types of clients: business-to-business.

Needs Works with 4 photographers/month. Uses photos for trade magazines, direct mail, Internet, P-O-P displays, catalogs and posters. Subjects include: business concepts, science, technology/computers, in-plant photography and studio set-ups. Special subject needs include in-plant shots. Model release required.

Audiovisual Needs Uses PowerPoint and videotape.

Specs Uses digital images or transparencies.

Making Contact & Terms Send letter citing related experience plus 2 or 3 samples. Works on assignment only. Cannot return material. Responds in 2 weeks. Pays $1,000-1,500/day. Pays within 30 days. Buys all rights.

Tips In portfolio/samples, prefers to see industrial subjects and creative styles. "We look for lighting knowledge, composition and imagination."

Galleries

The popularity of photography as a collectible art form has improved the market for fine art photographs over the last decade. Collectors now recognize the investment value of prints by Ansel Adams, Irving Penn and Henri Cartier-Bresson, and therefore frequently turn to galleries for photographs to place in their private collections.

The gallery/fine art market can make money for many photographers. However, unlike commercial and editorial markets, galleries seldom generate quick income for artists. Galleries should be considered venues for important, thought-provoking imagery, rather than markets through which you can make a substantial living.

More than any other market, this area is filled with photographers who are interested in delivering a message. Many photography exhibits focus on one theme by a single artist. Group exhibits feature the work of several artists, and they often explore a theme from many perspectives, though not always. These group exhibits may be juried (i.e., the photographs in the exhibit are selected by a committee of judges who are knowledgeable about photography). Some group exhibits also may include other mediums such as painting, drawing or sculpture. In any case, galleries want artists who can excite viewers and make them think about important subjects. They, of course, also hope that viewers will buy the photographs shown in their galleries.

As with picture buyers and art directors, gallery directors love to see strong, well-organized portfolios. Limit your portfolio to 20 top-notch images. When putting together your portfolio, focus on one overriding theme. A director wants to be certain you have enough quality work to carry an entire show. After the portfolio review, if the director likes your style, then you might discuss future projects or past work that you've done. Directors who see promise in your work, but don't think you're ready for a solo exhibition, may place your photographs in a group exhibition.

HOW GALLERIES OPERATE

In exchange for brokering images, a gallery often receives a commission of 40-50 percent. They usually exhibit work for a month, sometimes longer, and hold openings to kick off new shows. And they frequently provide pre-exhibition publicity. Some smaller galleries require exhibiting photographers to help with opening night reception expenses. Galleries also may require photographers to appear during the show or opening. Be certain that such policies are put in writing before you allow them to show your work.

Gallery directors who foresee a bright future for you might want exclusive rights to represent your work. This type of arrangement forces buyers to get your images directly from the gallery that represents you. Such contracts are quite common, usually limiting the exclusive

rights to specified distances. For example, a gallery in Tulsa, Oklahoma, may have exclusive rights to distribute your work within a 200-mile radius of the gallery. This would allow you to sign similar contracts with galleries outside the 200-mile range.

FIND THE RIGHT FIT

As you search for the perfect gallery, it's important to understand the different types of exhibition spaces and how they operate. The route you choose depends on your needs, the type of work you do, your long-term goals, and the audience you're trying to reach. (The following descriptions were provided by the editor of *Artist's & Graphic Designer's Market*.)

- **Retail or commercial galleries.** The goal of the retail gallery is to sell and promote artists while turning a profit. Retail galleries take a commission of 40-50 percent of all sales.
- **Co-op galleries.** Co-ops exist to sell and promote artists' work, but they are run by artists. Members exhibit their own work in exchange for a fee, which covers the gallery's overhead. Some co-ops also take a commission of 20-30 percent to cover expenses. Members share the responsibilities of gallery-sitting, sales, housekeeping and maintenance.
- **Rental galleries.** The rental gallery makes its profit primarily through renting space to artists and consequently may not take a commission on sales (or will take only a very small commission). Some rental spaces provide publicity for artists, while others do not. Showing in this type of gallery is risky. Rental galleries are sometimes thought of as "vanity galleries" and, consequently, they do not have the credibility other galleries enjoy.
- **Nonprofit galleries.** Nonprofit spaces will provide you with an opportunity to sell work and gain publicity, but will not market your work agressively, because their goals are not necessarily sales-oriented. Nonprofits normally take a commission of 20-30 percent.
- **Museums.** Don't approach museums unless you have already exhibited in galleries. The work in museums is by established artists and is usually donated by collectors or purchased through art dealers.
- **Art consultancies.** Generally, art consultants act as liaisons between fine artists and buyers. Most take a commission on sales (as would a gallery). Some maintain small gallery spaces and show work to clients by appointment.

If you've never exhibited your work in a traditional gallery space before, you may want to start with a less traditional kind of show. Alternative spaces are becoming a viable way to help the public see your work. Try bookstores (even large chains), restaurants, coffee shops, upscale home furnishings stores and boutiques. The art will help give their business a more pleasant, interesting environment at no cost to them, and you may generate a few fans or even a few sales.

Think carefully about what you take pictures of and what kinds of businesses might benefit from displaying them. If you shoot flowers and other plant life, perhaps you could approach a nursery about hanging your work in their sales office. If you shoot landscapes of exotic locations, maybe a travel agent would like to take you on. Think creatively and don't be afraid to approach a business person with a proposal. Just make sure the final agreement is spelled out in writing so there will be no misunderstandings, especially about who gets what money from sales.

COMPOSING AN ARTIST'S STATEMENT

When you approach a gallery about a solo exhibition, they will usually expect your body of work to be organized around a theme. To present your work and its theme to the public, the

gallery will expect you to write an artist's statement, a brief essay about how and why you make photographic images. There are several things to keep in mind when writing your statement:

1. **Be brief.** Most statements should be 100-300 words long. You shouldn't try to tell your life's story leading up to this moment.
2. **Write as you speak.** There is no reason to make up complicated motivations for your work if there aren't any. Just be honest about why you shoot the way you do.
3. **Stay focused.** Limit your thoughts to those that deal directly with the specific exhibit for which you're preparing.

Before you start writing your statement, consider your answers to the following questions:

1. Why do you make photographs (as opposed to using some other medium)?
2. What are your photographs about?
3. What are the subjects in your photographs?
4. What are you trying to communicate through your work?

A.R.C. GALLERY

832 W. Superior St., #204., Chicago IL 60622. (312)733-2787. E-mail: arcgallery@yahoo.com. Web site: www.arcgallery.org. **Contact:** Pat Oho, executive director. Estab. 1973. Sponsors 5-8 exhibits/year. Average display time 1 month. Overall price range $100-1,200.
Exhibits All styles considered. Contemporary fine art photography, documentary and journalism.
Making Contact & Terms Charges no commission, but there is a space rental fee.
Submissions Must send slides, résumé and statement to gallery for review; include SASE. Reviews transparencies. Responds in 1 month.
Tips Photographers "should have a consistent body of work. Show emerging and experimental work."

ADDISON/RIPLEY FINE ART

1670 Wisconsin Ave. NW, Washington DC 20007. (202)338-5180. Fax: (202)338-2341. E-mail: addisonrip @aol.com. Web site: www.addisonripleyfineart.com. **Contact:** Christopher Addison, owner. Art consultancy, for-profit gallery. Estab. 1981. Approached by 100 artists/year; represents or exhibits 25 artists. Average display time 6 weeks. Gallery open Tuesday through Saturday from 11 to 6. Closed end of summer. Located in Georgetown in a large, open, light-filled gallery space. Overall price range $500-80,000. Most work sold at $2,500-10,000.
Exhibits Exhibits works of all media.
Making Contact & Terms Gallery provides insurance, promotion, contract. Accepted work should be framed, mounted, matted.
Submissions Mail portfolio for review. Send query letter with artist's statement, bio, photocopies, résumé, SASE. Responds in 1 month.
Tips "Submit organized, professional-looking materials."

ADIRONDACK LAKES CENTER FOR THE ARTS

Rt. 28, P.O. Box 205, Blue Mt. Lake NY 12812. (518)352-7715. Fax: (518)352-7333. E-mail: alca@frontiern et.net. Web site: www.adk-arts.org. **Contact:** Program Director. Estab. 1967. Sponsors 15-20 exhibits/ year. Average display time 1 month. Overall price range $100-2,000. Most work sold at $250.
Exhibits Exhibits photos of babies/children/teens, celebrities, couples, multicultural, families, parents, senior citizens, disasters, environmental, landscapes/scenics, wildlife, architecture, education, gardening, interiors/decorating, pets, religious, rural, adventure, automobiles, entertainment, events, food/ drink, health/fitness, hobbies, humor, performing arts, sports, travel. Interested in contemporary Adirondack, nature photography, alternative process, avant garde, documentary, fashion/glamour, fine art, historical/vintage, seasonal.
Making Contact & Terms Charges 30% commission. "Pricing is determined by photographer. Payment made to photographer at end of exhibit." Accepted work should be framed, matted.
Submissions Send résumé, artist's statement, slides/photos. Deadline is first Monday in November.
Tips "Our gallery is open during all events taking place at the Arts Center, including concerts, films,

workshops and theater productions. Guests for these events are often customers seeking images from our gallery for their own collections or their places of business. Customers are often vacationers who have come to enjoy the natural beauty of the Adirondacks. For this reason, landscape and nature art sells well here.''

Ⓝ Ⓞ AKRON ART MUSEUM

1 S.High St., Akron OH 44308. (330)376-9185. Fax: (330)376-1180. E-mail: mail@akronartmuseum.org. Web site: www.akronartmuseum.org. **Contact:** Barbara Tannenbaum, chief curator. The Akron Art Museum re-opened in July 2007 after expanding into a new, larger building.

- This museum annually awards the Knight Purchase Award to a living artist working with photographic media.

Exhibits To exhibit, photographers must possess ''a notable record of exhibitions, inclusion in publications, and/or a role in the historical development of photography. We also feature area photographers (northeast Ohio).'' Interested in innovative works by contemporary photographers; any subject matter. Interested in alternative process, documentary, fine art, historical/vintage.

Making Contact & Terms Payment negotiable. Buys photography outright.

Submissions Will review Web sites and CDs. Send material via e-mail or by mail with SASE if you want materials returned. Responds in 2 months, ''depending on our workload.''

Tips ''Send professional-looking materials wth high-quality images, a résumé and an artist's statement. Never send original prints.''

ALASKA STATE MUSEUM

395 Whittier St., Juneau AK 99801-1718. (907)465-2901. Fax: (907)465-2976. E-mail: bruce_kato@eed.state.ak.us. Web site: www.museums.state.ak.us. **Contact:** Bruce Kato, chief curator. Museum. Estab. 1900. Approached by 40 artists/year. Sponsors 1 photography exhibit every 2 years. Average display time 10 weeks. Downtown location—3 galleries.

Exhibits Interested in historical and fine art.

Submissions Finds artists through portfolio reviews.

THE ALBUQUERQUE MUSEUM OF ART & HISTORY

2000 Mountain Rd. NW, Albuquerque NM 87104. (505)243-7255. Fax: (505)764-6546. Web site: www.cabq.gov/museum. **Contact:** Douglas Fairfield, curator of art or Glenn Fye, photo archivist. Estab. 1967. Sponsors 7-10 exhibits/year. Average display time 3-4 months. Gallery open Tuesday through Sunday from 9 to 5. Closed Monday and city holidays.

Exhibits Considers art, historical and documentary photography for exhibition and purchase. Art related to Albuquerque, the state of New Mexico, and the Southwest.

Submissions Submit portfolio of slides, photos, or disk for review. Responds in 2 months.

Ⓝ AMERICAN PRINT ALLIANCE

302 Larkspur Turn, Peachtree City GA 30269-2210. E-mail: director@printalliance.org. Web site: www.printalliance.org. **Contact:** Carol Pulin, director. Nonprofit arts organization with online gallery and exhibitions, travelling exhibitions, and journal publication; Print Bin: a place on Web site that is like the unframed, shrink-wrapped prints in a bricks-and-mortar gallery's ''print bin.'' Estab. 1992. Approached by hundreds of artists/year; represents dozens of artists/year. ''We only exhibit original prints, artists' books and paperworks.'' Usually sponsors 2 travelling exhibits/year—all prints, paperworks and artists' books; photography within printmaking processes but not as a separate medium. Most exhibits travel for 2 years. Hours depend on the host gallery/museum/arts center. ''We travel exhibits throughout the U.S. and occasionally to Canada.'' Overall price range for Print Bin: $150-3,200; most work sold at $300-500.

Exhibits ''We accept all styles, genres and subjects; the decisions are made on quality of work.''

Making Contact & Terms Individual subscription: $30-37. Print Bin is free with subscription. ''Subscribers have free entry to juried travelling exhibitions but must pay for framing, shipping to and from our office.'' Gallery provides promotion.

Submissions Subscribe to journal, *Contemporary Impressions* (www.printalliance.org/alliance/al_subform.html), send one slide and signed permission form (www.printalliance.org/gallery/printbin_info.html). Returns slide if requested with SASE. Usually does not respond to queries from non-subscribers. Files slides and permission forms. Finds artists through submissions to the gallery or Print Bin, and especially

portfolio reviews at printmakers conferences. "Unfortunately, we don't have the staff for individual portfolio reviews, though we may—and often do—request additional images after seeing one work, often for journal articles. Generally about 100 images are reproduced per year in the journal."

Tips "See the Standard Forms area of our Web site (www.printalliance.org/library/li_forms.html) for correct labels on slides and much, much more about professional presentation."

AMERICAN SOCIETY OF ARTISTS, INC.

P.O. Box 1326, Palatine IL 60078. (847)991-4748 or (312)751-2500. E-mail: asoa@webtv.net. Web site: www.americansocietyofartists.org. **Contact:** Helen Del Valle, membership chairman.

Exhibits Members and nonmembers may exhibit. "Our members range from internationally known artists to unknown artists—quality of work is the important factor. We have about 25 shows throughout the year that accept photographic art."

Making Contact & Terms Accepted work should be framed, mounted or matted.

Submissions Send SASE and 5 slides/photos representative of your work, and request membership information and application. Responds in 2 weeks. Accepted members may participate in lecture and demonstration service. Member publication: *ASA Artisan*.

ARIZONA STATE UNIVERSITY ART MUSEUM

P.O. Box 872911, Tempe AZ 85287-2911. (480)965-2787. Fax: (480)965-5254. E-mail: asuartmusem@asu. edu. Web site: http://asuartmuseum.asu.edu. **Contact:** Marilyn Zeitlin, director. Estab. 1950. The ASU Art Museum has 2 facilities and approximately 8 galleries of 2,500 square feet each; mounts approximately 15 exhibitions/year. Average display time 3-4 months.

Exhibits Only a small number of solo shows are presented, but all proposals are reviewed by curatorial staff.

Making Contact & Terms Accepted work should be framed, mounted, matted.

Submissions Send query letter with résumé, reviews, images of current work and SASE. "Allow several months for a response since we receive many proposals and review monthly."

N ARNOLD ART

210 Thames St., Newport RI 02840. E-mail: info@arnoldart.com. Web site: www.arnoldart.com. **Contact:** William Rommel, owner. For-profit gallery. Estab. 1870. Represents or exhibits 40 artists. Average display time 1 month. Gallery open Monday through Saturday from 9:30 to 5:30; Sunday from 12 to 5. Closed Christmas, Thanksgiving, Easter. Art gallery is 17 ft.×50 ft., open gallery space (3rd floor). Overall price range $100-35,000. Most work sold at $300.

Exhibits Marine (sailing), classic yachts, America's Cup, wooden boats, sailing/racing.

Making Contact & Terms Artwork is accepted on consignment, and there is a 45% commission. Gallery provides promotion. Accepted work should be framed.

Submissions E-mail to arrange personal interview to show portfolio.

THE ART DIRECTORS CLUB

106 W. 29th St., New York NY 10001. (212)643-1440. Fax: (212)643-4266. E-mail: info@adcglobal.org. Web site: www.adcglobal.org. **Contact:** Myrna Davis, executive director. Estab. 1920. Sponsors 8-10 exhibits/year. Average display time 1 month.

Exhibits Exhibits photos of babies/children/teens, celebrities, couples, multicultural, families, parents, senior citizens, disasters, environmental, landscapes/scenics, wildlife, architecture, cities/urban, education, gardening, interiors/decorating, pets, religious, rural, adventure, automobiles, entertainment, events, food/drink, health/fitness/beauty, hobbies, humor, performing arts, sports, travel, agriculture, business concepts, industry, medicine, military, political, product shots/still life, science, technology/ computers. Interested in alternative process, avant garde, documentary, erotic, fashion, glamour, fine art, historical/vintage, seasonal. Must be a group show with theme and sponsorship. Interested in work for advertising, publication design, graphic design, new media.

Submissions Send query letter with samples. Cannot return material. Responds depending on review committee's schedule.

ART FORMS

16 Monmouth St., Red Bank NJ 07701. (732)530-4330. Fax: (732)530-9791. E-mail: artforms99@aol.com. **Contact:** Charlotte T. Scherer, director. Estab. 1985. Photography is exhibited all year long. Average display time 6 weeks. Overall price range $250-25,000.

Exhibits Work must be original. Interested in alternative process, avant garde, erotic, fine art.
Making Contact & Terms Charges 50% commission. Accepted work can be framed or unframed, mounted or unmounted, matted or unmatted. Requires exclusive representation locally.
Submissions Send query letter with samples, SASE. Responds in 1 month.

■ ART SOURCE L.A., INC.

West Coast office: 2801 Ocean Park Blvd., PMB 7, Santa Monica CA 90405. (310)452-4411. Fax: (310)452-0300. E-mail: info@artsourcela.com. Web site: www.artsourcela.com. East Coast office: 12001 Montrose Park Place, North Bethesda MD 20852. (301)230-0023. Fax: (301)230-0025. E-mail: bonniek@artsourcela.com. **Contact:** Francine Ellman, president. Estab. 1980. Overall price range $300-15,000. Most work sold at $1,000.
Exhibits Exhibits photos of multiculturual, environmental, landscapes/scenics, wildlife, architecture, cities/urban, gardening, interiors/decorating, rural, automobiles, food/drink, travel, technology/computers. Interested in alternative process, avant garde, fine art, historical/vintage, seasonal. "We do projects worldwide, putting together fine art for corporations, healthcare, hospitality, government and public space. We use a lot of photography."
Making Contact & Terms Interested in receiving work from emerging and established photographers. Charges 50% commission. Accepted work should be mounted or matted.
Submissions Prefers digital submissions via e-mail. Send a minimum of 20 slides, photographs or inkjet prints (laser copies not acceptable), clearly labeled with name, title and date of work; plus catalogs, brochures, résumé, price list, SASE. Responds in 2 months maximum.
Tips "Show a consistent body of work, well marked and presented so it may be viewed to see its merits."

ART WITHOUT WALLS, INC.

P.O. Box 341, Sayville NY 11782. (631)567-9418. Fax: (631)567-9418. E-mail: artwithoutwalls@webtv.net. **Contact:** Sharon Lippman, executive director. Nonprofit gallery. Estab. 1985. Approached by 300 artists/year; represents or exhibits 100 artists. Sponsors 3 photography exhibits/year. Average display time 1 month. Gallery open daily from 9 to 5. Closed December 22 to January 5 and Easter week. Traveling exhibits in various public spaces. Overall price range $1,000-25,000. Most work sold at $3,000-5,000. "Price varies—especially if student work."
Exhibits Exhibits photos of celebrities, multicultural, families, parents, senior citizens, disasters, environmental, landscapes/scenics, wildlife, architecture, cities/urban, education, gardening, interiors/decorating, pets, rural, adventure, automobiles, entertainment, events, food/drink, health/fitness/beauty, hobbies, humor, performing arts, sports, travel, agriculture, medicine, political, product shots/still life, science, technology/computers. Interested in alternative process, avant garde, documentary, fashion/glamour, fine art, historical/vintage, seasonal.
Making Contact & Terms Artwork is accepted on consignment, and there is a 20% commission. Gallery provides promotion, contract. Accepted work should be framed, mounted, matted.
Submissions Mail portfolio for review. Send query letter with artist's statement, brochure, photographs, résumé, reviews, SASE, slides. Responds in 1 month. Finds artists through submissions, portfolio reviews, art exhibits.
Tips "Work should be properly framed with name, year, medium, title, size."

■ ▦ ART@NET INTERNATIONAL GALLERY

(617)495-7451 or (359)898-448132. Fax: (359)(2)851-2838. E-mail: artnetg@yahoo.com. Web site: www.designbg.com. **Contact:** Yavor Shopov, director. For-profit Internet gallery. Estab. 1998. Approached by 100 artists/year; represents or exhibits 20 artists. Sponsors 5 photography exhibits/year. Display time permanent. "Our gallery exists only on the Internet. Each artist has individual 'exhibition space' divided into separate thematic exhibitions along with bio and statement." Overall price range $150-55,000.
Exhibits Exhibits photos of multicultural, landscapes/scenics, wildlife, architecture, cities/urban, education, adventure, beauty, sports, travel, science, buildings. Interested in avant garde, erotic, fashion/glamour, fine art, seasonal.
Making Contact & Terms Artwork is accepted on consignment; there is a 10% commission and a rental fee for space of $1/image per month or $5/image per year. First 6 images are displayed free of rental fee. Gallery provides promotion. Accepted work should be matted.
Submission "We accept computer scans only; no slides, please. E-mail us attached scans, 900×1200 px (300 dpi for prints or 900 dpi for 36mm slides), as JPEG files for IBM computers." E-mail query letter

with artist's statement, bio, résumé. Responds in 6 weeks. Finds artists through submissions, portfolio reviews, art exhibits, art fairs, referrals by other artists.

Tips "E-mail us a tightly edited selection of less than 20 scans of your best work. All work must force any person to look over it again and again. Main usage of all works exhibited in our gallery is for limited edition (photos) or original (paintings) wall decoration of offices and homes, so photos must have quality of paintings. We like to see strong artistic sense of mood, composition, light, color and strong graphic impact or expression of emotions. For us, only quality of work is important, so newer, lesser-known artists are welcome."

N ▣ ARTISTS LAIR

2766 Janitell Rd., Colorado Springs CO 80906. (719)576-5247. Fax: (719)576-5247 (call first). E-mail: pagiartistslair@aol.com. **Contact:** Ernie Ferguson, gallery consultant. For-profit gallery. Estab. 2006. Open Monday through Saturday from 10 to 5:30. Closed some holidays. Located in an emerging retail area, 12×16 sq. ft. with an additional 10×14 sq. ft. Overall price range $60-3,000. Most work sold at $100-200.

Exhibits Exhibits photos of babies/children/teens, couples, multicultural, families, parents, senior citizens, architecture, cities/urban, education, gardening, interiors/decorating, pets, religious, rural, agriculture, business concepts, industry, medicine, military, political, product shots/still life, science, technology/computers, disasters, environmental, landscapes/scenics, wildlife, adventure, automobiles, entertainment, events, food/drink, health/fitness/beauty, hobbies, humor, performing arts, sports, travel. Interested in alternative process, avant garde, documentary, erotic, fashion/glamour, fine art, historical/vintage, seasonal.

Making Contact & Terms Artwork is accepted on consignment, and there is a 35% commission. Gallery provides promotion, contract. Accepted work should be framed, mounted, matted.

Submissions Call or write to arrange personal interview to show portfolio of photographs, transparencies, slides. E-mail query letter with link to artist's Web site, JPEG samples at 72 dpi. Send query letter with artist's statement, bio, brochure, business card, photocopies, photographs, résumé, reviews, SASE, slides. Returns materials with SASE. Responds in 2 weeks. Finds artists through word of mouth, art exhibits, submissions, portfolio reviews, art fairs, referrals by other artists.

ARTISTS' COOPERATIVE GALLERY

405 S. 11th St., Omaha NE 68102. (402)342-9617. Web site: www.artistsco-opgallery.com. Estab. 1974. Sponsors 11 exhibits/year. Average display time 1 month. Gallery sponsors all-member exhibits and outreach exhibits; individual artists sponsor their own small group exhibits throughout the year. Overall price range $100-500.

Exhibits Fine art photography only. Interested in all types, styles and subject matter.

Making Contact & Terms Charges no commission. Reviews transparencies. Accepted work should be framed work only. "Artist must be willing to work 13 days per year at the gallery. We are a member-owned-and-operated cooperative. Artist must also serve on one committee."

Submissions Send query letter with résumé, SASE. Responds in 2 months.

Tips "Write for membership application. Membership committee screens applicants August 1-15 each year. Responds by September 1. New membership year begins October 1. Members must pay annual fee of $325. Our community outreach exhibits include local high school photographers and art from local elementary schools."

ARTLINK

437 E. Berry St., Suite 202, Fort Wayne IN 46802. (260)424-7195. Fax: (260)424-8453. E-mail: deb@artlink fw.com. Web site: http://artlinkfw.com. **Contact:** Deb Washler, executive director. Nonprofit gallery. Estab. 1979. Sponsors 1 photography exhibit every other year. Average display time 6 weeks. Gallery open Tuesday through Saturday from 12 to 5; Friday and Saturday evenings from 6 to 9; Sundays from 1 to 5. Located 2 blocks from downtown Fort Wayne. Overall price range $100-2,000. Most work sold at $250.

Making Contact & Terms Artwork of Artlink members is accepted on consignment, and there is a 35% commission. Gallery provides insurance. Accepted work should be framed.

Submissions "The art panel reviews portfolios in May only. If an artist sends a portfolio in any other month, it will be held until the May review. Artists should send slides or a CD of images, artist's statement, and SASE, if they would like to have their material returned."

N ▣ THE ARTS COMPANY

215 5th Ave., Nashville TN 37219.(615)254-2040. Fax: (615)254-9289. E-mail: art@theartscompany.com. Web site: www.theartscompany.com. **Contact:** Anne Brown, owner. Art consultancy, for-profit gallery. Estab. 1996. Sponsors 2-3 photography exhibits/year. Average display time 1 month. Open Monday through Saturday from 10 to 5. Located in downtown Nashville, the gallery has 6,000 sq. ft. of contemporary space in a historic building. Overall price range $10-35,000. Most work sold at $300-3,000.

Exhibits Exhibits photos of celebrities, architecture, cities/urban, rural, environmental, landscapes/scenics, entertainment, performing arts. Interested in documentary, fine art, historical/vintage.

Making Contact & Terms Artwork is accepted on consignment. Gallery provides insurance, contract. Accepted work should be framed. Requires exclusive representation locally.

Submissions "We prefer an initial info packet via e-mail." Send query letter with artist's statement, bio, brochure, business card, photocopies, résumé, reviews, SASE, CD. Returns material with SASE. Finds artists through word of mouth, art fairs, art exhibits, submissions, referrals by other artists.

Tips "Provide professional images on a CD along with a professional bio, résumé.

N ▣ ARTWORKS GALLERY

811 Race St., Cincinnati OH 45202. (513)333-0388. Fax: (513)333-0799. E-mail: allen@artworkscincinnati .com. Web site: www.artworkscincinnati.org. **Contact:** Allen Cochran, gallery coordinator. Alternative space, cooperative gallery, nonprofit gallery, rental gallery. Estab. 2003. Average display time 1.5 months. Open Monday through Friday from 9 to 5. Closed January. Has 1,500 sq. ft. of exhibition space in downtown Cincinnati. Overall price range $200-15,000. Most work sold at $1,200.

Exhibits Exhibits photos of multicultural, architecture, cities/urban, education, gardening, interiors/decorating, rural, environmental, adventure, performing arts. Interested in alternative process, avant garde, documentary, fashion/glamour, fine art, lifestyle.

Making Contact & Terms Artwork is accepted on consignment, and there is a 30% commission. Gallery provides promotion, contract.

Submissions Call; send images via e-mail; mail portfolio for review; send query letter with résumé, slides, artist's statement, digital slides. Send nonreturnable samples. "We hold on to materials for future exhibition opportunities." Responds to queries in 1 month. Finds artists through word of mouth, art fairs, portfolio reviews, exhibitions, submissions, referrals by other artists.

Tips "ArtWorks is looking for strong artists who are not only talented in terms of their ability to make and create, but who can also professionally present themselves and show a genuine interest in the exhibition of their artwork. We're looking for concise statements that the artists themselves have written about their work as well as a résumé of exhibitions to help back up their written statements. Artists should continue to communicate with us beyond exhibitions and further down the line just to let us know what they're up to and how they've grown."

ARTWORKS GALLERY

233 Pearl St., Hartford CT 06103. (860)247-3522. Fax: (860)548-0779. E-mail: artworks.gallery@snet. Web site: www.artworksgallery.org. **Contact:** Diane Legere, executive director. Estab. 1976. Average display time 1 month. Overall price range $100-5,000. Most work sold at $500-800.

Exhibits Exhibits photos of disasters, environmental, landscapes/scenics, wildlife. Interested in contemporary work, alternative process, avant garde, documentary, erotic, fine art. "We have juried shows; members must be voted in after interview."

Making Contact & Terms There is a co-op membership fee plus a donation of time. There is a 30% commission.

Submissions Send for membership application. Include SASE. Responds in 1 month.

Tips "The more energy and equipment you put into the gallery, the more you get out of it. It's a great place to network and establish yourself."

ASHLAND ARTS/ICON STUDIOS

1205 W. Pierce St., Phoenix AZ 85007. (602)257-8543 or (602)253-8888. Fax: (602)257-8543. **Contact:** David Cook, director. Estab. 1986. Sponsors 6 exhibits/year. Average display time 2 months. One juried show in spring and fall of each year "for adults only." Annual anniversary exhibition in spring (call for information—$25 fee, 3 slides, SASE). Overall price range $100-500. Most work sold at $150.

Exhibits Exhibits photos of landscapes/scenics, architecture, rural, travel. "Contemporary only (portrait, landscape, genre, mixed media in b&w, color, nonsilver, etc.); photographers must represent themselves,

have complete exhibition proposal form and be responsible for own announcements.'' Interested in ''all subjects in the contemporary vein—manipulated, straight and non-silver processes.'' Interested in alternative process, avant garde, fine art.

Making Contact & Terms Charges 25% commission. There is a rental fee for space; covers 2 months. Accepted work can be framed or unframed, mounted or unmounted, matted or unmatted. Shows are limited to material able to fit through the front door. Installations acceptable.

Submissions Send query letter with résumé, samples, SASE. Responds in 2 weeks.

Tips ''Sincerely look for a venue for your art and follow through. Search for traditional and nontraditional spaces. Treat your work with care and make slides if possible for easy presentation.''

▣ AXIS GALLERY

(212)741-2582. E-mail: info@axisgallery.com. Web site: www.axisgallery.com. **Contact:** Lisa Brittan, director. For-profit gallery. Estab. 1997. Approached by 40 African artists/year; represents or exhibits 30 artists. Open Tuesday through Saturday from 11 to 6. Closed during summer. Located in Chelsea, 1,600 sq. ft. Overall price range $500-3,000.

• At the time of this printing, the gallery was in the process of relocating.

Exhibits Interested in alternative process, avant garde, documentary, erotic, fine art, historical/vintage. Also interested in photojournalism, resistance.

Making Contact & Terms Artwork is accepted on consignment, and there is a 50% commission. Gallery provides insurance, promotion, contract. *Accepts only artists from Africa.*

Submissions Send query letter with résumé, reviews, SASE, slides, photographs or CD-ROM. Responds in 3 months. Finds artists through research, recommendations, submissions, portfolio reviews, art exhibits, referrals by other artists.

Tips ''Send letter with SASE and materials listed above. Photographers should research galleries first to check if their work fits the gallery program. Avoid bulk mailings.''

BELL STUDIO

3428 N. Southport Ave., Chicago IL 60657. Web site: www.bellstudio.net. **Contact:** Paul Therieau, director. For-profit gallery. Estab. 2001. Approached by 60 artists/year; represents or exhibits 10 artists. Sponsors 3 photography exhibits/year. Average display time 6 weeks. Open all year; Monday through Friday from 12 to 7; weekends from 12 to 5. Located in brick storefront; 750 sq. ft. of exhibition space; high traffic. Overall price range: $150-3,500. Most work sold at $600.

Exhibits Interested in alternative process, avant garde, fine art.

Making Contact & Terms Artwork is accepted on consignment, and there is a 50% commission. Gallery provides insurance, promotion, contract. Accepted work should be framed. Requires exclusive representation locally.

Submissions Write to arrange personal interview to show portfolio; include bio and résumé. Responds to queries within 3 months, only if interested. Finds artists through referrals by other artists, submissions, word of mouth.

Tips ''Send SASE; type submission letter; include show history, résumé.''

▣ BENHAM STUDIO GALLERY

1216 First Ave., Seattle WA 98101. (206)622-2480. Fax: (206)622-6383. E-mail: queries@benhamgallery.com. Web site: www.benhamgallery.com. **Contact:** Marita Holdaway, owner. Estab. 1987. Sponsors 9 exhibits/year. Average display time 6 weeks. Overall price range $250-9,750. Most work sold at $650.

Exhibits Exhibits photos of multicultural, environmental, landscapes/scenics, architecture, cities/urban, religious, rural, humor. Interested in alternative process, avant garde, documentary, fine art.

Making Contact & Terms Charges 50% commission.

Submissions See Web site for submission guidelines. ''If you have a Web site with a portfolio, you can send the URL via e-mail. We will not return any unsolicited submissions. We will not be responsible for any lost or damaged materials you send us.''

▣ MONA BERMAN FINE ARTS

78 Lyon St., New Haven CT 06511. (203)562-4720. E-mail: info@MonaBermanFineArts.com. Web site: www.MonaBermanFineArts.com. **Contact:** Mona Berman, director. Estab. 1979. Sponsors 0-1 exhibit/year. Average display time 1 month. Overall price range $500-5,000.

• '' We are art consultants serving corporations, architects and designers. We also have private clients.

We hold very few exhibits; we mainly show work to our clients for consideration and sell a lot of photographs.''

Exhibits ''Photographers must have been represented by us for over 2 years. Interested in all except figurative, although we do use some portrait work.''

Making Contact & Terms Charges 50% commission. ''Payment to artist 30 days after receipt of payment from client.'' Interested in seeing unframed, unmounted, unmatted work only.

Submissions ''E-mail digital images or Web links, or send CDs. Inquire by e-mail; no calls, please. Always include retail prices.'' Materials returned with SASE only. Responds in 1 month.

Tips ''Looking for new perspectives, new images, new ideas, excellent print quality, ability to print in *very* large sizes, consistency of vision. Digital prints must be archival.''

BLOSSOM STREET GALLERY & SCULPTURE GARDEN

4809 Blossom St., Houston TX 77007. (713)869-1921. E-mail: blossomcontact@blossomstreetgallery.com. Web site: www.blossomstreetgallery.com. **Contact:** Laurie, director. For-profit gallery. Estab. 1997. Sponsors 2 photography exhibits/year. Average display time 1 month. Gallery open Tuesday through Sunday from 11 to 6. Located in inner city; 3 exhibit spaces with 1-acre sculpture park and garden area. Overall price range $200-20,000. Most work sold at $1,000.

Exhibits Exhibits photos of babies/children/teens, celebrities, couples, multicultural, families, environmental, landscapes/scenics, architecture, cities/urban, interiors/decorating, religious, rural, adventure, health/fitness, humor, performing arts, travel, industry, medicine, technology/computers. Interested in erotic, fashion/glamour, fine art.

Making Contact & Terms Artwork is accepted on consignment, and there is a 50% commission. Gallery provides insurance, promotion, contract. Accepted work should be ready to hang. Requires exclusive representation locally if a one-person exhibit.

Submissions Send query letter with artist's statement, bio, brochure, business card, photocopies, photographs, résumé, reviews, slides, SASE; or send URL for Web site. Responds within 1 month, only if interested. Finds artists through word of mouth, submissions, portfolio reviews, art exhibits, referrals by other artists.

BOOK BEAT GALLERY

26010 Greenfield, Oak Park MI 48237. (248)968-1190. Fax: (248)968-3102. E-mail: cary@thebookbeat.com. Web site: www.thebookbeat.com. **Contact:** Cary Loren, director. Estab. 1982. Sponsors 6 exhibits/year. Average display time 6-8 weeks. Overall price range $300-5,000. Most work sold at $600.

Exhibits ''Book Beat is a fine art and photography bookstore with a back-room gallery. Our inventory includes vintage work from 19th- to 20th-century rare books, issues of *Camerawork*, and artist books. Book Beat Gallery is looking for couragous and astonishing image makers. Artists with no boundries and an open mind are welcome to submit one slide sheet with statement, résumé and return postage. We are especially interested in photographers who have published book works or work with originals in the artist book format, and also those who work in 'dead media' and extinct processes.''

Submissions Responds in 6 weeks.

RENA BRANSTEN GALLERY

77 Geary St., San Francisco CA 94108. (415)982-3292. Fax: (415)982-1807. E-mail: info@renabranstengallery.com. Web site: www.renabranstengallery.com. For-profit gallery. Estab. 1974. Approached by 200 artists/year; represents or exhibits 12-15 artists. Average display time 4-5 weeks. Open Tuesday through Friday from 10:30 to 5:30; Saturday from 11 to 5. ''We usually close the last week of August and the first week of September.''

Submissions E-mail JPEG samples at 72 dpi. Finds artists through word of mouth, art exhibits, submissions, art fairs, portfolio reviews, referrals by other artists.

BREW HOUSE SPACE 101

2100 Mary St., Pittsburgh PA 15203. (412)381-7767. Fax: (412)390-1977. E-mail: thebrewhouse@gmail.com. Web site: www.brew-house.org. Alternative space; cooperative, nonprofit, rental gallery. Estab. 1993. Average display time 1 month. Gallery open Wednesday and Thursday from 6 to 9; Saturday from 12 to 6. Located in Pittsburgh's historic south side; 1,360 sq. ft. with 23-ft.-high ceilings.

Exhibits Exhibits photos of environmental. Interested in fine art.

Making Contact & Terms Artwork is accepted through juried selection. Gallery provides insurance, promotion, contract. Accepted work should be framed.

Submissions Mail portfolio for review. Responds in 3 months. Finds artists through submissions.

J.J. BROOKINGS GALLERY

330 Commercial St., San Jose CA 95112. (408)287-3311. Fax: (408)287-6075. E-mail: info@jjbrookings.com. Web site: www.jjbrookings.com. **Contact:** Timothy C. Duran, director. Sponsors rotating group exhibits. Sponsors openings. Overall price range $500-30,000.

Exhibits Interested in photography created with a "painterly eye."

Making Contact & Terms Charges 50% commission.

Submissions Send material by mail for consideration. Responds in 3-5 weeks if interested; immediately if not acceptable.

Tips Wants to see "professional presentation, realistic pricing, numerous quality images. We're interested in whatever the artist thinks will impress us the most. 'Painterly' work is best. No documentary or politically oriented work."

BUNNELL STREET GALLERY

106 W. Bunnell, Suite A, Homer AK 99603. (907)235-2662. Fax: (907)235-9427. E-mail: bunnell@xyz.net. Web site: www.bunnellstreetgallery.org. **Contact:** Asia Freeman, director. Nonprofit gallery. Estab. 1990. Approached by 50 artists/year; represents or exhibits 35 artists. Sponsors 1 photography exhibit/year. Average display time 1 month. Gallery open Monday through Saturday from 10 to 6; Sunday from 12 to 4, summer only. Closed January. Located in 30 ft. × 25 ft. exhibition space; good lighting, hardwood floors. Overall price range $50-2,500. Most work sold at $500.

Exhibits Exhibits photos of families, gardening, food/drink. Interested in alternative process, fine art.

Making Contact & Terms Artwork is accepted on consignment, and there is a 40% commission. A donation of time is requested. Gallery provides insurance, promotion, contract. Accepted work should be framed.

Submissions Call or write to arrange a personal interview to show portfolio of slides. Mail portfolio for review. Responds in 1 month. Finds artists through word of mouth, submissions, art exhibits, referrals by other artists.

THE CAMERA OBSCURA GALLERY

1309 Bannock St., Denver CO 80204. (303)623-4059. Fax: (303)893-4195. E-mail: info@CameraObscuraGallery.com. Web site: www.CameraObscuraGallery.com. **Contact:** Hal Gould, owner/director. Estab. 1980. Approached by 350 artists/year; represents or exhibits 20 artists. Sponsors 7 photography exhibits/year. Open Tuesday through Saturday from 10 to 6; Sunday from 1 to 5. Overall price range $400-20,000. Most work sold at $600-3,500.

Exhibits Exhibits photos of environmental, landscapes/scenics, wildlife. Interested in fine art.

Making Contact & Terms Charges 50% commission. Write to arrange a personal interview to show portfolio of photographs. Send bio, brochure, résumé, reviews. Responds in 1 month. Finds artists by word of mouth, submissions, portfolio reviews, art exhibits, art fairs, referrals by other artists, reputation.

Tips "To make a professional gallery submission, provide a good representation of your finished work that is of exhibition quality. Slowly but surely we are experiencing a more sophisticated audience. The last few years have shown a tremendous increase in media reporting on photography-related events and personalities, exhibitions, artist profiles and market news."

WILLIAM CAMPBELL CONTEMPORARY ART

4935 Byers Ave., Ft. Worth TX 76107. (817)737-9566. E-mail: wcca@flash.net. Web site: www.WilliamCampbellContemporaryArt.com. **Contact:** William Campbell, owner/director. Estab. 1974. Sponsors 8-10 exhibits/year. Average display time 5 weeks. Sponsors openings; provides announcements, press releases, installation of work, insurance, cost of exhibition. Overall price range $300-8,000.

Exhibits "Primarily interested in photography which has been altered or manipulated in some form."

Making Contact & Terms Charges 50% commission. Reviews transparencies. Accepted work should be mounted. Requires exclusive representation within metropolitan area.

Submissions Send CD (preferred) or slides and résumé by mail with SASE. Responds in 1 month.

SANDY CARSON GALLERY

760 Santa Fe Dr., Denver CO 80204. (303)573-8585. Fax: (303)573-8587. E-mail: scarson@ecentral.com. Web site: www.sandycarsongallery.com. Estab. 1975. Average display time 7 weeks. Open Tuesday through Friday from 10 to 6; Saturday from 12 to 4. Gallery is available for special events.

Exhibits "We include all mediums and represent artists who are professional and committed, with an extensive body of work and continually producing more."

Submissions "We are not presently seeking new artists. Please contact us by e-mail or call the gallery."

CENTER FOR CREATIVE PHOTOGRAPHY

University of Arizona, 1030 N. Olive Rd., P.O. Box 210103, Tucson AZ 85721-0103. (520)621-7968. Fax: (520)621-9444. E-mail: oncenter@ccp.library.arizona.edu. Web site: www.creativephotography.org. Museum/archive, research center, print study, library, museum retail shop. Estab. 1975. Sponsors 6-8 photography exhibits/year. Average display time 3-4 months. Gallery open Monday through Friday from 9 to 5; weekends from 12 to 5. Closed most holidays. 5,500 sq. ft.

◾ THE CENTER FOR FINE ART PHOTOGRAPHY

The MOCA Building, 201 S. College Ave., Fort Collins CO 80524. (970)224-1010. E-mail: contact@c4fap.org. Web site: www.c4fap.org. **Contact:** Grace Norman, curator. Nonprofit gallery. Estab. 2005. Approached by 60 artists/year; represents or exhibits about 300 artists. Average display time 4-5 weeks. Open Tuesday through Friday from 12 to 5; Saturday from 1 to 5. Closed between exhibitions. Located on the 3rd floor of the Fort Collins MOCA Building, consisting of an 850-sq.-ft. main (group exhibit) gallery and a 440-sq.-ft. solo gallery. Both galleries are used for an annual international exhibition. Overall price range $180-3,000. Most work sold at $150-500. "The Center publishes work of selected exhibitors in its bimonthly *Artists' ShowCase*—the feature section in *CameraArts Magazine*. It also provides and markets to buyers its online gallery of artists' portfolios—*Artists' ShowCase Online*, available to all members of the Center." Workshops and forums are also offered.

Exhibits Exhibits photos of babies/children/teens, celebrities, couples, multicultural, families, parents, senior citizens, architecture, cities/urban, interiors/decorating, rural, political, environmental, landscapes/scenics, wildlife, performing arts; abstract, experimental work. Interested in alternative process, avant garde, documentary, erotic, fine art. "The Center features fine art photography that incorporates all processes, many styles and subjects."

Making Contact & Terms Art is accepted through either juried calls for entry or from portfolio review. Gallery provides insurance. Accepts only fine art photographic work.

Submissions Write to arrange a personal interview to show portfolio of photographs or CD. Send query letter with artist's statement, bio, photographs or CD, reviews. Responds within 1 month, only if interested. Finds artists through word of mouth, art exhibits, submissions, art fairs, portfolio reviews, referrals by other artists.

Tips "Only signed archival-quality work is seriously considered by art collectors. This includes both traditional and digital prints. A certificate of archival processing should accompany the work. Signing the print rather than the mat is appropriate."

◾ CENTER FOR MAINE CONTEMPORARY ART

162 Russell Ave., Rockport ME 04856. (207)236-2875. Fax: (207)236-2490. E-mail: info@cmcanow.org. Web site: www.cmcanow.org. **Contact:** Curatorial Department. Estab. 1952. Average exhibition duration 2 months.

Exhibits Work should be recent and not previously exhibited in the area.

Making Contact & Terms Charges 40% commission.

Submissions Accepts images in digital format. See guidelines on Web site.

N ◾ CENTER FOR NEW DISCIPLINES

929 Julia St., New Orleans LA 70113. E-mail: michoola@gmail.com. Web site: www._nueveau.net/newdisciplines. **Main Contact:** Michelle O'Reagan, gallery director. Alternative space, art consultancy, for-profit gallery. Estab. 2007. Approached by 100 artists/year; represents or exhibits 20 artists/year. Average display time 1 month. Open Monday through Sunday from 11 to 6. Closed 1 month in summer. Located in the warehouse/arts district of New Orleans with 1,600 sq. ft. of space for performance and visual arts classes and approximately 500 sq. ft. of gallery space. Overall price range $45-5,000. Most work sold at $400.

Exhibits Wants photos of multicultural, architecture, cities/urban, industry, political, disasters, environmental. Interested in alternative process, avant garde, documentary, erotic, fine art, historical/vintage. "We welcome alternative process photography, international/multicultural focused work, and subject matter that deals with the local cultural and political struggles and triumphs of New Orleans."

Making Contact & Terms Artwork is accepted on consignment; there is a 40% commission. Gallery provides insurance, promotion, contract. Accepted work should be matted.

Submissions Call, write to arrange a personal interview to show portfolio of photographs, slides. E-mail query letter with link to artist's Web site, PDF at 150-300 dpi. Send query letter with artist's statement, bio, brochure, résumé, reviews, SASE, slides. Returns material with SASE. Responds in 3 weeks. Finds artists through word of mouth, art exhibits, submissions, portfolio reviews, referrals by other artists.

Tips "Our gallery desires to further your journey in the art field, so adding elements that speak to your previous efforts and accomplishments, such as a bio and résumé, are encouraged."

CENTER FOR PHOTOGRAPHIC ART

Sunset Cultural Center, P.O. Box 1100, Carmel CA 93921. (831)625-5181. Fax: (831)625-5199. E-mail: info@photography.org. Web site: www.photography.org. Estab. 1988. Nonprofit gallery. Sponsors 7-8 exhibits/year. Average display time 5-7 weeks.

Exhibits Interested in fine art photography.

Submissions Send query letter with slides, résumé, artist's statement, SASE.

Tips "Submit for exhibition consideration slides or transparencies accompanied by a concise bio and artist's statement."

THE CENTRAL BANK GALLERY

P.O. Box 1360, Lexington KY 40588. Fax: (606)253-6432. **Contact:** John G. Irvin, curator. Estab. 1987. Sponsors 12 exhibits/year. Average display time 3 weeks. Overall price range $75-1,500.

Exhibits Interested in all types of photos. No nudes. *Kentucky photographers only.*

Making Contact & Terms Charges no commission. "We pay for everything—invitations, receptions, and hanging. We give the photographer 100 percent of the proceeds."

Submissions Send query letter with telephone call. Responds same day.

Tips "We enjoy encouraging artists."

▣ CEPA GALLERY

617 Main St., Suite 201, Buffalo NY 14203. (716)856-2717. Fax: (716)270-0184. E-mail: sean@cepagallery. com. Web site: www.cepagallery.com. **Contact:** Sean Donaher, artistic director. Alternative space, nonprofit gallery. Estab. 1974. Sponsors 15 photography exhibits/year. Average display time 6-8 weeks. Open Monday through Friday from 10 to 5; Saturday from 12 to 4. Located in the heart of downtown Buffalo's theater district in the historic Market Arcade complex—8 galleries on 3 floors of the building plus public art sites and state-of-the-art Imaging Facility. Overall price range varies depending on artist and exhibition—all prices set by artist.

Exhibits Exhibits photos of multicultural. Interested in alternative process, avant garde, fine art.

Making Contact & Terms Artwork is accepted on consignment, and there is a 25% commission. Gallery provides insurance, promotion.

Submissions E-mail proposal and digital images or send query letter with artist's statement, bio, résumé, reviews, slides, slide script, SASE. Responds in 3 months. Finds artists through word of mouth, submissions, art exhibits, referrals by other artists.

Tips Prefers only photo-related materials. (See additional information in the Center for Exploratory and Perceptual Art listing in this section.)

THE CHAIT GALLERIES DOWNTOWN

218 E. Washington St., Iowa City IA 52240. (319)338-4442. Fax: (319)338-3380. E-mail: info@thegalleries downtown.com. Web site: www.thegalleriesdowntown.com. **Contact:** Benjamin Chait, director. For-profit gallery. Estab. 2003. Approached by 300 artists/year; represents or exhibits 50 artists. Open Monday through Friday from 11 to 6; Saturday from 11 to 5; Sunday by appointment or by chance. Located in a downtown building renovated to its original look of 1882 with 14-ft.-high molded ceiling and original 9-ft. front door. Professional museum lighting and Scamozzi-capped columns complete the elegant gallery. Overall price range: $50-4,000.

Exhibits Exhibits landscapes, oil and acrylic paintings, sculpture, fused glass wall pieces, jewelry.

Making Contact & Terms Artwork is accepted on consignment, and there is a 50% commission. Gallery provides insurance, promotion and contract. Accepted work should be framed. Requires exclusive representation locally.

Submissions Call; mail portfolio for review. Responds to queries in 2 weeks. Finds artists through art fairs, art exhibits, portfolio reviews and referrals by other artists.

CHAPMAN FRIEDMAN GALLERY

624 W. Main St., Louisville KY 40202. E-mail: friedman@imagesol.com. Web site: www.chapmanfriedmangallery.com or www.imagesol.com. **Contact:** Julius Friedman, owner. For-profit gallery. Estab. 1992. Approached by 100 or more artists/year; represents or exhibits 25 artists. Sponsors 1 photography exhibit/year. Average display time 1 month. Open Wednesday through Saturday from 10 to 5. Closed August. Located downtown; approximately 3,500 sq. ft. with 15-foot ceilings and white walls. Overall price range: $75-10,000. Most work sold at more than $1,000.

Exhibits Exhibits photos of landscapes/scenics, architecture. Interested in alternative process, avant garde, erotic, fine art.

Making Contact & Terms Artwork is accepted on consignment, and there is a 50% commission. Gallery provides insurance, promotion and contract. Accepted work should be framed. Requires exclusive representation locally.

Submissions Send query letter with artist's statement, bio, brochure, photographs, résumé, slides and SASE. Responds to queries within 1 month, only if interested. Finds artists through portfolio reviews and referrals by other artists.

CLAMPART

531 W. 25th Street, New York NY 10001. E-mail: info@clampart.com. Web site: www.clampart.com. **Contact:** Brian Clamp, director. For-profit gallery. Estab. 2000. Approached by 1,200 artists/year; represents or exhibits 15 artists. Sponsors 6 photography exhibits/year. Average display time 2 months. Open Tuesday through Saturday from 11 to 6; closed last 2 weeks of August. Located on the ground floor on Main Street in Chelsea. Small exhibition space. Overall price range: $300-50,000. Most work sold at $2,000.

Exhibits Exhibits photos of couples, disasters, environmental, landscapes/scenics, architecture, cities/urban, humor, performing arts, travel, science, technology/computers. Interested in alternative process, avant garde, documentary, erotic, fashion/glamour, fine art, historical/vintage.

Making Contact & Terms Artwork is accepted on consignment, and there is a 50% commission. Gallery provides insurance, promotion and contract. Accepted work should be framed, mounted and matted.

Submissions E-mail query letter with artist's statement, bio and JPEGs. Responds to queries in 2 weeks. Finds artists through portfolio reviews, submissions and referrals by other artists.

Tips "Include a bio and well-written artist's statement. Do not submit work to a gallery that does not handle the general kind of work you produce."

THE CONTEMPORARY ART WORKSHOP

542 W. Grant Place, Chicago IL 60614. (773)472-4004. Fax: (773)472-4505. E-mail: info@contemporaryartworkshop.org. Web site: www.contemporaryartworkshop.org. **Contact:** Lynn Kearney, director. Nonprofit gallery. Estab. 1949. Average display time 1 month. Gallery open Tuesday through Friday from 12:30 to 5:30; Saturday from 12 to 5. Closed holidays. "The CAW is located in Chicago's Lincoln Park neighborhood. It is housed in a converted dairy that was built in the 1800s." The CAW includes over 21 artists' studios as well as 2 galleries that show (exclusively) emerging Chicago-area artists.

Exhibits Interested in fine art.

Making Contact & Terms Artwork is accepted on consignment, and there is a 30% commission. Gallery provides promotion. *Accepts artists from Chicago area only.*

Submissions Send query letter with artist's statement, bio, résumé, reviews, samples (slides, photos or JPEGs on CD), SASE. Responds in 2 months. Finds artists through word of mouth, submissions, art exhibits, referrals by other artists.

CONTEMPORARY ARTS COLLECTIVE

231 W. Charleston Blvd., Suite 110, Las Vegas NV 89102. (702)382-3886. Fax: (702)598-3886. E-mail: info@lasvegascac.org. Web site: www.lasvegascac.org. **Contact:** Natalia Ortiz. Nonprofit gallery. Estab. 1989. Sponsors more than 9 exhibits/year. Average display time 1 month. Gallery open Tuesday through

Saturday from 12 to 4. Closed Thanksgiving, Christmas, New Year's Day. 1,200 sq. ft. Overall price range $200-4,000. Most work sold at $400.

Exhibits Interested in alternative process, avant garde, documentary, fine art.

Making Contact & Terms Artwork is accepted through annual call for proposals of self-curated group shows, and there is a 30% requested donation. Gallery provides insurance, promotion, contract.

Submissions Finds artists through annual call for proposals, membership, word of mouth, submissions, portfolio reviews, art exhibits, art fairs, referrals by other artists and walk-ins. Check Web site for dates and submission guidelines.

Tips Submitted slides should be "well labeled and properly exposed with correct color balance."

CORPORATE ART SOURCE/CAS GALLERY

2960-F Zelda Rd., Montgomery AL 36106. (334)271-3772. Fax: (334)271-3772. Web site: www.casgallery. com. Art consultancy, for-profit gallery. Estab. 1990. Approached by 100 artists/year; represents or exhibits 50 artists. Sponsors 1 photography exhibit/year. Average display time 6 weeks. Gallery open Monday through Friday from 10 to 5:30; weekends from 11 to 3. Overall price range $200-20,000. Most work sold at $1,000.

Exhibits Exhibits photos of landscapes/scenics, architecture, rural. Interested in alternative process, avant garde, fine art, historical/vintage.

Making Contact & Terms Artwork is accepted on consignment, and there is a 50% commission. Gallery provides contract.

Submissions E-mail from the Web site, or mail portfolio for review. Send query letter. Responds within 6 weeks, only if interested. Finds artists through submissions, portfolio reviews, art exhibits, art fairs, referrals by other artists.

▣ CROSSMAN GALLERY

University of Wisconsin-Whitewater, 950 W. Main St., Whitewater WI 53190. (262)472-5708. E-mail: flanagam@uww.edu. Web site: www.uww.edu. **Contact:** Michael Flanagan, director. Estab. 1971. Photography is frequently featured in thematic exhibits at the gallery. Average display time 1 month. Overall price range $250-3,000.

Exhibits "We primarily exhibit artists from the Midwest but do include some from national and international venues. Works by Latino artists are also featured in a regular series at ongoing exhibits." Interested in all types of innovative approach to photography.

Making Contact & Terms Sponsors openings; provides food, beverage, show announcement, mailing, shipping (partial) and possible visiting artist lecture/demo.

Submissions Submit 10-20 slides or CD, artist's statement, résumé, SASE.

Tips "The Crossman Gallery operates within a university environment. The focus is on exhibits that have the potential to educate viewers about processes and techniques and have interesting thematic content."

ELLEN CURLEE GALLERY

1308-A Washington Ave., St. Louis MO 63122. E-mail: ellen@ellencurleegallery.com. Web site: www.elle ncurleegallery.com. **Contact:** Ellen Curlee, owner. For-profit gallery. Estab. 2005. Approached by 50 artists/year; represents or exhibits 7artists. Exhibits photography only. Average display time 6-8 weeks. Located in newly renovated downtown loft district; 900 sq. ft.

Exhibits Exhibits contemporary fine art photography: all procesesses, a variety of subject matters and points of view.

Making Contact & Terms Requires exclusive representation locally.

Submissions Send query letter with artist's statement, bio. Finds artists through art exhibits, submissions, portfolio reviews, referrals by other artists.

▣ THE DALLAS CENTER FOR CONTEMPORARY ART

2801 Swiss Ave., Dallas TX 75204. (214)821-2522. Fax: (214)821-9103. E-mail: info@thecontemporary.n et. Web site: www.thecontemporary.net. **Contact:** Joan Davidow, director. Nonprofit gallery. Estab. 1981. Sponsors 1-2 photography exhibits/year. Other exhibits may include photography as well as other mediums. Average display time 6-8 weeks. Gallery open Tuesday through Saturday from 10 to 5.

Exhibits Exhibits a variety of subject matter and styles.

Making Contact & Terms Charges no commission. "Because we are nonprofit, we do not sell artwork.

If someone is interested in buying art in the gallery, they get in touch with the artist. The transaction is between the artist and the buyer.''

Submissions Reviews slides/CDs. Send material by mail for consideration; include SASE. Responds October 1 annually.

Tips ''Memberships available starting at $50. See our Web site for info and membership levels.''

DELAWARE CENTER FOR THE CONTEMPORARY ARTS

200 S. Madison St., Wilmington DE 19801. (302)656-6466. Fax: (302)656-6944. E-mail: info@thedcca.org. Web site: www.thedcca.org. **Contact:** Neil Watson, executive director. Alternative space, museum retail shop, nonprofit gallery. Estab. 1979. Approached by more than 800 artists/year; exhibits 50 artists. Sponsors 30 total exhibits/year. Average display time 6 weeks. Gallery open Tuesday, Thursday and Friday from 10 to 6; Wednesday from 12 to 5; Saturday from 10 to 5; Sunday from 12 to 5. Closed on major holidays. Seven galleries located along rejuvenated Wilmington riverfront. State-of-the-art, under one-year-old, very versatile. Overall price range $500-50,000.

Exhibits Interested in alternative process, avant garde.

Making Contact & Terms Gallery provides PR and contract. Accepted work should be framed, mounted, matted. Prefers only contemporary art.

Submissions Send query letter with artist's statement, bio, SASE, 10 slides. Returns material with SASE. Responds within 6 months. Finds artists through word of mouth, submissions, portfolio reviews, art exhibits, referrals by other artists.

DETROIT FOCUS

P.O. Box 843, Royal Oak MI 48068-0843. (248)541-2210. Fax: (248)541-3403. E-mail: michael@sarnacki.n et. Web site: www.detroitfocus.org. **Contact:** Michael Sarnacki, director. Artist alliance. Estab. 1978. Approached by 100 artists/year; represents or exhibits 100 artists. Sponsors 1 or more photography exhibit/year.

Exhibits Interested in photojournalism, avant garde, documentary, erotic, fashion/glamour, fine art.

Making Contact & Terms No charge or commission.

Submissions Call or e-mail. Responds in 1 week. Finds artists through word of mouth, submissions, art exhibits, referrals by other artists.

▣ DOT FIFTYONE GALLERY

51 NW 36 St., Miami FL 33127. (305)573-3754. Fax: (305)573-3754. E-mail: dot@dotfiftyone.com. Web site: www.dotfiftyone.com. **Contact:** Isaac Perelman and Alfredo Guzman, directors. For-profit gallery. Estab. 2004. Approached by 40+ artists/year; represents or exhibits 10 artists. Sponsors 2 photography exhibits/year. Average display time 40 days. Open Monday through Friday from 12 to 7; Saturdays and private viewings available by appointment. Located in the Wynwood Art District; approximately 7,000 sq. ft.; 2 floors. Overall price range $600-30,000. Most work sold at $6,000.

Exhibits Exhibits photos of couples, architecture, cities/urban, interiors/decorating, landscapes/scenics. Interested in avant garde, erotic, fashion/glamour, fine art.

Making Contact & Terms Artwork is accepted on consignment, and there is a 50% commission. Requires exclusive representation locally.

Submissions E-mail with a link to photographer's Web site. Write to arrange a personal interview to show portfolio. Mail portfolio for review. Finds artists through art fairs, portfolio reviews, referrals by other artists.

Tips ''Have a good presentation. Contact the gallery first by e-mail. Never try to show work during an opening, and never show up at the gallery without an appointment.''

▣ CATHERINE EDELMAN GALLERY

300 W. Superior St., Lower Level, Chicago IL 60610. (312)266-2350. Fax: (312)266-1967. Web site: www.e delmangallery.com. **Contact:** Catherine Edelman, director. Estab. 1987. Sponsors 6 exhibits/year. Average display time 8 weeks. Open Tuesday through Saturday from 10 to 5:30. Overall price range $1,000-15,000.

Exhibits ''We exhibit works ranging from traditional photography to mixed media photo-based work.''

Making Contact & Terms Charges 50% commission. Accepted work should be matted. Requires exclusive representation within metropolitan area.

Submissions Query first. Will review unsolicited work with SASE or CD-ROM.

Tips Looks for "consistency, dedication and honesty. Try to not be overly eager and realize that the process of arranging an exhibition takes a long time. The relationship between gallery and photographer is a partnership."

PAUL EDELSTEIN GALLERY

P.O. Box 80012, Memphis TN 38108-0012. (901)454-7105, (888)454-7105. E-mail: henrygrove@yahoo.com. Web site: www.askart.com. **Contact:** Paul R. Edelstein, director/owner. Estab. 1985. "Shows are presented continually throughout the year." Overall price range: $300-10,000. Most work sold at $1,000.
Exhibits Exhibits photos of celebrities, children, multicultural, families. Interested in avant garde, historical/vintage, C-print, dye transfer, ever color, fine art and 20th-century photography "that intrigues the viewer"—figurative still life, landscape, abstract—by upcoming and established photographers.
Making Contact & Terms Charges 50% commission. Buys photos outright. Reviews transparencies. Accepted work should be framed or unframed, mounted or unmounted, matted or unmatted work. There are no size limitations. Submit portfolio for review. Send query letter with samples. Cannot return material. Responds in 3 months.
Tips "Looking for figurative and abstract figurative work."

ENVOY

535 W. 22nd St., 6th Floor, New York NY 10011. (212)242-7524. E-mail: office@envoygallery.com. Web site: www.envoygallery.com. **Contact:** Director. Art consultancy and for-profit gallery. Estab. 2005. Approached by 120 artists/year; represents or exhibits 14 artists. Average display time 5 weeks. Open Tuesday through Saturday from 11 to 6. Closed December 23 through January 4, and July 4. Located in Chelsea. Overall price range $1,000-35,000. Most work sold at $8.000.
Exhibits Exhibits photos of babies/children/teens, celebrities, couples, multicultural, cities/urban, pets, political, landscapes/scenics. Interested in fine art.
Making Contact & Terms Artwork is accepted on consignment, and there is a 50% commission. Requires exclusive representation locally.
Submissions Finds artists through referrals by other artists.
Tips "Check out the gallery first to see if your work is appropriate for the gallery. Then, strictly follow the guidelines for submission of work."

THOMAS ERBEN GALLERY

526 W. 26th St., 4th Floor., New York NY 10001. (212)645-8701. Fax: (212)941-9630. E-mail: info@thomaserben.com. Web site: www.thomaserben.com. For-profit gallery. Estab. 1996. Approached by 100 artists/year; represents or exhibits 15 artists. Average display time 5-6 weeks. Gallery open Tuesday through Saturday from 10 to 6 (Monday through Friday in July). Closed Christmas/New Year's Day and August.
Submissions Mail portfolio for review. Responds in 1 month.

▣ FAHEY/KLEIN GALLERY

148 N. La Brea Ave., Los Angeles CA 90036. (323)934-2250. Fax: (323)934-4243. E-mail: fkg@earthlink.net. Web site: www.faheykleingallery.com. **Contact:** David Fahey or Ken Devlin, co-owners. Estab. 1986. For-profit gallery. Approached by 200 artists/year; represents or exhibits 60 artists. Sponsors 10 exhibits/year. Average display time 5-6 weeks. Gallery open Tuesday through Saturday from 10 to 6. Closed on all major holidays. Sponsors openings; provides announcements and beverages served at reception. Overall price range $500-500,000. Most work sold at $2,500. Located in Hollywood; gallery features 2 exhibition spaces with extensive work in back presentation room.
Exhibits Interested in established work; photos of celebrities, landscapes/scenics, wildlife, architecture, entertainment, humor, performing arts, sports. Interested in alternative process, avant garde, documentary, erotic, fashion/glamour, fine art, historical/vintage. Specific photo needs include iconic photographs, Hollywood celebrities, photojournalism, music-related, reportage and still life.
Making Contact & Terms Artwork is accepted on consignment, and the commission is negotiated. Gallery provides insurance, promotion, contract. Accepted work should be unframed, unmounted and unmatted. Requires exclusive representation within metropolitan area. Photographer must be established for a minimum of 5 years; preferably published.
Submissions Prefers Web site URLs for initial contact, or send material (CD, reproductions, no originals) by mail with SASE for consideration. Responds in 2 months. Finds artists through art fairs, exhibits, portfolio reviews, submissions, word of mouth, referrals by other artists.

Tips "Please be professional and organized. Have a comprehensive sample of innovative work. Interested in seeing mature work with resolved photographic ideas and viewing complete portfolios addressing one idea."

FALKIRK CULTURAL CENTER

P.O. Box 151560, San Rafael CA 94915-1560. (415)485-3328. Fax: (415)485-3404. **Contact:** Beth Goldberg, curator. Web site: www.falkirkculturalcenter.org. Nonprofit gallery and national historic place (1888 Victorian) converted to multi-use cultural center. Approached by 500 artists /year; exhibits 300 artists. Sponsors 2 photography exhibits/year. Average display time 2 months. Gallery open Monday through Friday from 1 to 5 (Thursday til 9); Saturday from 10 to 1.

Making Contact & Terms Gallery provides insurance. *Accepts only artists from San Francisco Bay area*, "especially Marin County since we are a community center."

Submissions Send query letter with artist's statement, bio, slides, résumé. Returns material with SASE. Finds artists through word of mouth, submissions, portfolio reviews, art exhibits, art fairs, referrals by other artists.

◼ FINE ARTS CENTER GALLERIES/UNIVERSITY OF RHODE ISLAND

105 Upper College Rd., Kingston RI 02881-0820. (401)874-2627. Fax: (401)874-2007. E-mail: jtolnick@uri. edu. Web site: www.uri.edu/artgalleries. **Contact:** Judith Tolnick Champa, director. Nonprofit galleries. Estab. 1968. Sponsors 4-6 photography exhibits/year. Average display time 1-3 months. There are 3 exhibition spaces: The Main and Photography Galleries, open Tuesday through Friday from 12 to 4 and weekends from 1 to 4; and The Corridor Gallery, open daily from 9 to 9. Exhibitions are curated from a national palette and regularly reviewed in the local press. Unsolicited proposals (slides or CD with SASE are reviewed as needed).

FOCAL POINT GALLERY

321 City Island Ave., New York NY 10464. (718)885-1403. Fax: (718)885-1451. Web site: www.focalpoint gallery.com. **Contact:** Ron Terner, photographer/director. Estab. 1974. Overall price range $75-1,500. Most work sold at $175.

Exhibits Open to all subjects, styles and capabilities. "I'm looking for the artist to show me a way of seeing I haven't seen before." Nudes and landscapes sell best. Interested in alternative process, avant garde, documentary, erotic, fine art.

Making Contact & Terms Charges 40% commission. Artist should call for information about exhibition policies.

Tips Sees trend toward more use of alternative processes. "The gallery is geared toward exposure— letting the public know what contemporary artists are doing—and is not concerned with whether it will sell. If the photographer is only interested in selling, this is not the gallery for him/her, but if the artist is concerned with people seeing the work and gaining feedback, this is the place. Most of the work shown at Focal Point Gallery is of lesser-known artists. Don't be discouraged if not accepted the first time. Continue to come back with new work when ready." Call for an appointment.

◼ THE FRASER GALLERY

7700 Wisconsin Ave., Suite E, Bethesda MD 20814. (301)718-9651. E-mail: info@thefrasergallery.com. Web site: www.thefrasergallery.com. **Contact:** Catriona Fraser, director. Estab. 1996. Approached by 500 artists/year; represents 25 artists and sells the work of an additional 75 artists. Sponsors 4 photography exhibits/year. Average display time 1 month. Gallery open Tuesday through Saturday from 11:30 to 6. Closed Sunday and Monday except by appointment. Overall price range $200-20,000. Most work sold at under $5,000.

Exhibits Exhibits landscapes/scenics.

Making Contact & Terms Artwork is accepted on consignment, and there is a 50% commission. Gallery provides insurance, promotion, contract. Accepted work should be framed, matted to full conservation standards. Requires exclusive representation locally.

Submissions Send query letter with bio, reviews, slides or CD-ROM, SASE. Responds in 1 month. Finds artists through submissions, portfolio reviews, art exhibits, art fairs.

Tips "Research the background of the gallery, and apply to galleries that show your style of work. All work should be framed or matted to full museum standards."

N ▣ GALLERY AT 910

910 Santa Fe Dr., Denver CO 80204. (303)815-7113. Fax: (303)333-9762. E-mail: info@thegalleryat910.com. Web site: www.thegalleryat910.com. **Contact:** Michele Renee Ledoux, curator. Estab. 2007. Community outreach gallery whose mission is to create an open dialogue between artists and the community by raising awareness of social and environmental issues through creation of art. Average display time 2 months. Located in Denver's art district with 1,200 sq. ft./105 linear ft./optional additional 76 linear ft. of marble walls.

Exhibits Interested in fine art.

Making Contact & Terms Artwork is accepted on consignment; there is a 35% commission, or there is a rental fee for space. Gallery provides insurance, promotion, contract. Artwork must be professionally displayed. See Web site for submission guidelines. Responds to queries as soon as possible. Finds artists through word of mouth, art fairs, portfolio reviews, submissions, referrals by other artists.

▣ GALLERY 400

College of Architecture and the Arts, University of Illinois at Chicago, 400 S. Peoria St. (MC 034), Chicago IL 60607. (312)996-6114. Fax: (312)355-3444. E-mail: lorelei@uic.edu. Web site: http://gallery400.aa.uic.edu. **Contact:** Lorelei Stewart, director. Nonprofit gallery. Estab. 1983. Approached by 500 artists/year; exhibits 80 artists. Sponsors 1 photography exhibit/year. Average display time 4-6 weeks. Gallery open Tuesday through Friday from 10 to 6; Saturday from 12 to 6.

Making Contact & Terms Gallery provides insurance, promotion.

Submissions Send query letter with SASE for guidelines. Responds in 5 months. Finds artists through word of mouth, art exhibits, referrals by other artists.

Tips "Check our Web site for guidelines for proposing an exhibition and follow those proposal guidelines. Please do not e-mail, as we do not respond to e-mails."

GALLERY M

2830 E. Third Ave., Denver CO 80206. (303)331-8400. Fax: (303)331-8522. Web site: www.gallerym.com. **Contact:** Managing Partner. For-profit gallery. Estab. 1996. Sponsors 2 photography exhibits/year. Average display time 6-12 weeks for featured artist. Overall price range $1,000-75,000.

Exhibits Primarily interested in social documentation and photojournalism.

Making Contact & Terms Gallery provides promotion. Requires exclusive regional representation.

Submissions "Artists interested in showing at the gallery should visit the Artist Submissions section of our Web site (under Site Resources). The gallery provides additional services for both collectors and artists, including our quarterly newsletter, *The Art Quarterly*."

GALLERY NAGA

67 Newbury St., Boston MA 02116. (617)267-9060. Fax: (617)267-9040. E-mail: mail@gallerynaga.com. Web site: www.gallerynaga.com. **Contact:** Arthur Dion, director. For-profit gallery. Estab. 1976. Approached by 150 artists/year; represents or exhibits 40 artists. Sponsors 2 photography exhibits/year. Average display time 1 month. Gallery open Tuesday through Saturday from 10 to 5:30. Overall price range $850-35,000. Most work sold at $2,000-3,000.

Exhibits Exhibits photos of landscapes/scenics, architecture, cities/urban.

Making Contact & Terms Charges 50% commission. Gallery provides insurance. Requires exclusive representation locally. *Accepts only artists from New England/Boston.*

Submissions Send query letter with artist's statement, résumé, bio, photocopies, slides, SASE. Responds in 6 months. Finds artists through submissions, portfolio reviews, art exhibits.

N ▣ GALLERY 110 COLLECTIVE

110 S. Washington St., Seattle WA 98104. E-mail: director@gallery110.com. Web site: www.gallery110.com. **Contact:** Molly Norris, director. Cooperative gallery. Estab. 2003. Sponsors 6 photo exhibits/year. Average display time 1 month. Open Wednesday through Saturday from 12 to 5. Located in the historic gallery district of Pioneer Square, the gallery has 2 side-by-side storefront spaces. Overall price range $125-3,000. Most work sold at $500-800.

Exhibits Exhibits photos of rural, disasters, landscapes/scenics, sports (rodeos). Interested in alternative process, documentary, fine art.

Making Contact & Terms Artwork is accepted on consignment, and there is a 50% commission. Artwork

is bought outright for 50% commission; net 60 days. Gallery provides insurance, promotion, contract (nonexclusive).

Submissions Call or write to arrange personal interview to show portfolio of slides or CD. Send query letter with artist's statement, bio, résumé, SASE, and "the reasons they've chosen us." Finds artists through word of mouth, art exhibits, submissions, referrals by other artists.

Tips "I want to know that the artist has researched us. I want to see art I've never seen before that shows that the artist is aware of other art/history."

▣ GALLERY 72

2709 Leavenworth, Omaha NE 68105-2399. (402)345-3347. Fax: (402)348-1203. E-mail: gallery72@novia .net. **Contact:** Robert D. Rogers, director. Estab. 1972. Represents or exhibits 6 artists. Sponsors 2 photography exhibits/year. Average display time 3-4 weeks. Gallery open Monday through Saturday from 10 to 5; Sunday from 12 to 5. One large room, one small room.

Exhibits Exhibits photos of senior citizens, landscapes/scenics, cities/urban, interiors/decorating, rural, performing arts, travel.

Making Contact & Terms Artwork is accepted on consignment, and there is a 50% commission. Gallery provides insurance, promotion. Requires exclusive representation locally. "No Western art."

Submissions Call or write to arrange personal interview to show portfolio. Send query letter with artist's statement, brochure, photocopies, résumé. Accepts digital images. Finds artists through word of mouth, submissions, art exhibits.

Ⓝ GALLERY 218

207 E. Buffalo St., Suite 218, Milwaukee WI 53202. (414)643-1732. E-mail: info@gallery218.com. Web site: www.gallery218.com. **Contact:** Judith Hooks, president. Estab. 1990. Sponsors 12 exhibits/year. Average display time 1 month. Sponsors openings. "If a group show, we make arrangements and all artists contribute. If a solo show, artist provides everything." Overall price range $150-5,000. Most work sold at $350.

Exhibits Interested in alternative process, avant garde, abstract, fine art. Membership dues: $55/year plus $55/month rent. Artists help run the gallery. Group and solo shows. Photography is shown alongside fine arts painting, printmaking, sculpture, etc.

Making Contact & Terms Charges 25% commission. There is an entry fee for each month. Fee covers the rent for 1 month. Accepted work must be framed.

Submissions Send SASE for an application. "This is a cooperative space. A fee is required."

Tips "Get involved in the process if the gallery will let you. We require artists to help promote their show so that they learn what and why certain things are required. Have inventory ready. Read and follow instructions on entry forms; be aware of deadlines. Attend openings for shows you are accepted into locally."

HALLWALLS CONTEMPORARY ARTS CENTER

341 Delaware Ave., Buffalo NY 14202. (716)854-1694. Fax: (716)854-1696. E-mail: john@hallwalls.org. Web site: www.hallwalls.org. **Contact:** John Massier, visual arts curator. Nonprofit multimedia organization. Estab. 1974. Sponsors 10 exhibits/year. Average display time 6 weeks.

Exhibits Interested in work that expands the boundaries of traditional photography. No limitations on type, style or subject matter.

Making Contact & Terms "Sales are not our focus. If a work does sell, we suggest a donation of 15% of the purchase price."

Submissions Send material by mail for consideration. Work may be kept on file for additional review for 1 year.

Tips "We're looking for photographers with innovative work that challenges the boundaries of the medium. While we do not focus on the presentation of photography alone, we present innovative work by contemporary photographers in the context of contemporary art as a whole."

THE HALSTED GALLERY INC.

P.O. Box 130, Bloomfield Hills MI 48303. (248)745-0062. Fax: (248)332-0227. E-mail: thalsted@halstedgal lery.com. Web site: www.halstedgallery.com. **Contact:** Wendy or Thomas Halsted. Estab. 1969. Sponsors 3 exhibits/year. Average display time 2 months. Sponsors openings. Overall price range $500-25,000.

Exhibits Interested in 19th- and 20th-century photographs.

Submissions Call to arrange a personal interview to show portfolio only. Prefers to see scans. Send no slides or samples. Unframed work only.

Tips This gallery has no limitations on subjects. Wants to see creativity, consistency, depth and emotional work.

THE HARWOOD MUSEUM OF ART

238 Ledoux St., Taos NM 87571-6004. (505)758-9826. Fax: (505)758-1475. E-mail: harwood@unm.edu. Web site: www.harwoodmuseum.org. **Contact:** Margaret Bullock, curator. Estab. 1923. Approached by 100 artists/year; represents or exhibits more than 200 artists. Sponsors "at least" 1 photography exhibit/ year. Average display time 3 months. Gallery open Tuesday through Saturday from 10 to 5; Sunday from 12 to 5. Overall price range $1,000-5,000. Most work sold at $2,000.

Exhibits Interested in alternative process, avant garde, documentary, fine art.

Making Contact & Terms Artwork is accepted on consignment, and there is a 40% commission. Gallery provides insurance, contract. Accepted work should be framed, mounted, matted. "The museum exhibits work by Taos, New Mexico, artists as well as major artists from outside our region."

Submissions Mail portfolio for review. Send query letter with artist's statement, bio, brochure, résumé, reviews, SASE, slides. Responds in 3 months. Finds artists through word of mouth, submissions, art exhibits, referrals by other artists.

Tips "The gift shops accepts some art on consignment, but the museum itself does not."

HENRY STREET SETTLEMENT/ABRONS ART CENTER

466 Grand St., New York NY 10002. (212)598-0400. Fax: (212)505-8329. E-mail: mdust@henrystreet.org. Web site: www.henrystreet.org. **Contact:** Martin Dust, visual arts coordinator. Alternative space, non-profit gallery, community center. Holds 9 solo photography exhibits/year. Gallery open Monday through Friday from 9 to 6; Saturday and Sunday from 12 to 6. Closed major holidays.

Exhibits Exhibits photos of multicultural, environmental, landscapes/scenics, architecture, cities/urban, rural. Interested in alternative process, avant garde, documentary, fine art, historical/vintage.

Making Contact & Terms Artwork is accepted on consignment, and there is a 20% commission. Gallery provides insurance, space, contract.

Submissions Send query letter with artist's statement, SASE. Finds artists through word of mouth, submissions, referrals by other artists.

HERA EDUCATIONAL FOUNDATION AND ART GALLERY

P.O. Box 336, Wakefield RI 02880. (401)789-1488. E-mail: info@heragallery.org. Web site: www.heragall ery.org. **Contact:** Chelsea Heffner, director. Cooperative gallery. Estab. 1974. The number of photo exhib-its varies each year. Average display time 6 weeks. Gallery open Wednesday through Friday from 1 to 5; Saturday from 10-4. Closed during the month of January. Sponsors openings; provides refreshments and entertainment or lectures, demonstrations and symposia for some exhibits. Call for information on exhibitions. Overall price range: $100-10,000.

Exhibits Interested in all types of innovative contemporary art that explores social and artistic issues. Exhibits photos of disasters, environmental, landscapes/scenics. Interested in fine art.

Making Contact & Terms Charges 25% commission. Works must fit inside a 6'6"×2'6" door. Photogra-pher must show a portfolio before attaining membership.

Submissions Inquire about membership and shows. Responds in 6 weeks. Membership guidelines and application available on Web site or mailed on request.

Tip "Hera exhibits a culturally diverse range of visual and emerging artists. Please follow the application procedure listed in the Membership Guidelines. Applications are welcome at any time of the year."

GERTRUDE HERBERT INSTITUTE OF ART

506 Telfair St., Augusta GA 30901-2310. (706)722-5495. Fax: (706)722-3670. E-mail: ghia@ghia.org. Web site: www.ghia.org. **Contact:** Kim Overstreet, executive director. Nonprofit gallery. Estab. 1937. Has 5 solo or group shows annually; exhibits approximately 40 artists annually. Average display time 6-8 weeks. Open Tuesday through Friday from 10 to 5; weekends by appointment only. Closed 1st week in August, and December 20-31. Located in historic 1818 Ware's Folly mansion.

Making Contact & Terms Artwork is accepted on consignment, and there is a 35% commission.

Submissions Send query letter with artist's statement, bio, brochure, résumé, reviews, slides or CD of

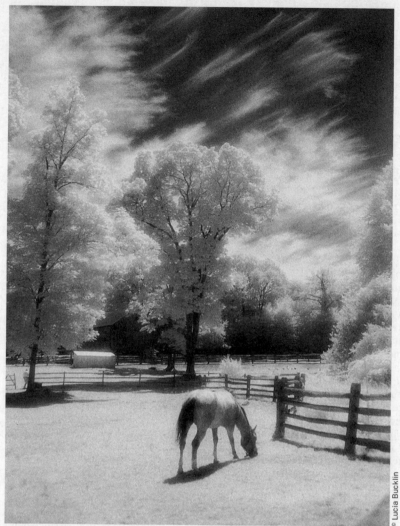

Lucia Bucklin uses Kodak black & white infrared film and scans it into her computer. She prints on either watercolor paper or canvas, using an Epson 2400 printer. This infrared image was part of an exhibition at Henry Street Settlement/Abrons Art Center. Bucklin has had more than 55 exhibitions, including 12 solo exhibitions. She says: "A typical submission to a gallery will include a CD of my images, my awards, references, previous exhibitions, press clippings, and marketing postcards, along with a SASE for their return."

work, SASE. Responds to queries in 1-3 months. Finds artists through art exhibits, submissions, referrals by other artists.

ICEBOX QUALITY FRAMING & GALLERY

1500 Jackson St. NE, Suite 443, Minneapolis MN 55413. (612)788-1790. Fax: (612)788-6947. E-mail: icebox@bitstream.net. Web site: www.iceboxminnesota.com. **Contact:** Howard M. Christopherson, owner. Exhibition, promotion and sales gallery. Estab. 1988. Represents photographers and fine artists in all media, predominantly photography. "A sole proprietorship gallery, Icebox sponsors installations and exhibits in the gallery's 1,700-sq.-ft. space in the Minneapolis Arts District." Overall price range $200-1,500. Most work sold at $200-800.

Exhibits Exhibits photos of multicultural, environmental, landscapes/scenics, rural, adventure, travel. Interested in alternative process, documentary, erotic, fine art, historical/vintage. Specifically wants "fine art photographs from artists with serious, thought-provoking work."

Making Contact & Terms Charges 50% commission.

Submissions "Send letter of interest telling why and what you would like to exhibit at Icebox. Include only materials that can be kept at the gallery and updated as needed. Check Web site for more details about entry and gallery history."

Tips "We are experienced with the out-of-town artist's needs."

ILLINOIS STATE MUSEUM CHICAGO GALLERY

100 W. Randolph, Suite 2-100, Chicago IL 60601. (312)814-5322. Fax: (312)814-3471. Web site: www.museum.state.il.us. **Contact:** Kent Smith, director. Assistant Administrator: Jane Stevens. Estab. 1985. Sponsors 2-3 exhibits/year. Average display time 4 months. Sponsors openings; provides refreshments at reception and sends out announcement cards for exhibitions.

Exhibits *Must be an Illinois photographer.* Interested in contemporary and historical/vintage, alternative process, fine art.

Submissions Send résumé, artist's statement, 10 slides, SASE. Responds in 6 months.

INDIANAPOLIS ART CENTER

820 E. 67th St., Indianapolis IN 46220. (317)255-2464. Fax: (317)254-0486. E-mail: exhibs@indplsartcenter.org. Web site: www.indplsartcenter.org. **Contact:** David Kwasigroh, director of exhibitions. Estab. 1934. Sponsors 1-2 photography exhibits/year. Average display time 8 weeks. Overall price range $50-5,000. Most work sold at $500.

Exhibits Interested in alternative process, avant garde, documentary, fine art and "very contemporary work, preferably unusual processes." Prefers artists who live within 250 miles of Indianapolis.

Making Contact & Terms Charges 35% commission. One-person show: $300 honorarium; 2-person show: $200 honorarium; 3-person show: $100 honorarium; plus $0.32/mile travel stipend (one way). Accepted work should be framed (or other finished-presentation formatted).

Submissions Send minimum of 20 digital images with résumé, reviews, artist's statement and SASE between July 1 and December 31. No wildlife or landscape photography. Interesting color and mixed media work is appreciated.

Tips "We like photography with a very contemporary look that incorporates unusual processes and/or photography with mixed media. Submit excellent images with a full résumé, a recent artist's statement, and reviews of past exhibitions or projects. Please, no glass-mounted slides. Always include a SASE for notification and return of materials, ensuring that correct return postage is on the envelope. Exhibition materials will not be returned. Currently book 2010-11."

INSLEY QUARTER GALLERY

830 Royal St., New Orleans LA 70116. (504)529-3334. E-mail: InsleyArtGallery@aol.com. Web site: www.InsleyArt.com or www.neworleansinsleyart.com. **Contact:** Charlene Insley, owner. Retail gallery. Estab. 2004. Approached by 52 artists/year; represents or exhibits 5-8 artists. Sponsors 1 photography exhibit/year. Average display time 2 months. Open Tuesday through Saturday from 10 to 6. Located in the French Quarter. Overall price range $300-22,500. Most work sold at $2,000.

Making Contact & Terms Artwork is accepted on consignment, and there is a 30-50% commission. Accepted work should be framed. *Represents only New Orleans artists.* Requires exclusive representation locally.

Submissions Send query letter with bio, brochure or business card. Cannot return material. Responds within 2 months, only if interested. Finds artists through referrals by other artists, submissions and portfolio reviews.

INTERNATIONAL CENTER OF PHOTOGRAPHY

1133 Avenue of the Americas, New York NY 10036. (212)857-0000. Fax: (212)768-4688. E-mail: exhibitions@icp.org. Web site: www.icp.org. **Contact:** Department of Exhibitions & Collections. Estab. 1974.

Submissions "Due to the volume of work submitted, we are only able to accept portfolios in the form of 35mm slides or CDs. All slides must be labeled on the front with a name, address, and a mark indicating the top of the slide. Slides should also be accompanied by a list of titles and dates. CDs must be labeled with a name and address. Submissions must be limited to one page of up to 20 slides or a CD of no more

than 20 images. Portfolios of prints or of more than 20 images will not be accepted. Photographers may also wish to include the following information: cover letter, resume or curriculum vitae, artist's statement and/or project description. ICP can only accept portfolio submissions via mail (or FedEx, etc.). Please include a SASE for the return of materials. ICP cannot return portfolios submitted without return postage.''

INTERNATIONAL VISIONS GALLERY

2629 Connecticut Ave. NW, Washington DC 20008. (202)234-5112. Fax: (202)234-4206. E-mail: intvisions @aol.com. Web site: www.inter-visions.com. **Contact:** Timothy Davis, owner/director. For-profit gallery. Estab. 1997. Approached by 60 artists/year; represents or exhibits 50 artists. Sponsors 1 photography exhibit/year. Average display time 4-6 weeks. Gallery open Wednesday through Saturday from 11 to 6. Located in the heart of Washington, DC; features 1,000 sq. ft. of exhibition space. Overall price range $1,000-8,000. Most work sold at $2,500.

Exhibits Exhibits photos of babies/children/teens, multicultural.

Making Contact & Terms Artwork is accepted on consignment, and there is a 50% commission. Gallery provides insurance, promotion, contract. Accepted work should be framed. Requires exclusive representation locally.

Submissions Call. Send query letter with artist's statement, bio, photocopies, résumé, SASE. Responds in 2 months. Finds artists through word of mouth, art exhibits, referrals by other artists.

STELLA JONES GALLERY

Bank One Center, 201 St. Charles, New Orleans LA 70170. (504)568-9050. Fax: (504)568-0840. E-mail: jones6941@aol.com. Web site: www.stellajones.com. **Contact:** Stella Jones. For-profit gallery. Estab. 1996. Approached by 40 artists/year; represents or exhibits 45 artists. Sponsors 1 photography exhibit/year. Average display time 6-8 weeks. Gallery open Monday through Friday from 11 to 6; Saturday from 12 to 5. Located on 1st floor of corporate 53-story office building downtown, 1 block from French Quarter. Overall price range $500-150,000. Most work sold at $5,000.

Exhibits Exhibits photos of babies/children/teens, multicultural, families, cities/urban, education, religious, rural.

Making Contact & Terms Artwork is accepted on consignment, and there is a 50% commission. Gallery provides insurance, promotion, contract. Accepted work should be framed. Requires exclusive representation locally.

Submissions Call to show portfolio of photographs, slides, transparencies. Mail portfolio for review. Send query letter with artist's statement, bio, brochure, business card, photocopies, photographs, résumé, reviews, slides, SASE. Responds in 1 month. Finds artists through word of mouth, submissions, portfolio reviews, art exhibits, referrals by other artists.

Tips ''Photographers should be organized with good visuals.''

KEARON-HEMPENSTALL GALLERY

536 Bergen Ave., Jersey City NJ 07304. (201)333-8855. Fax: (201)333-8488. E-mail: suzann@khgallery.com. Web site: www.khgallery.com. **Contact:** Suzann McKiernan Anderson, director. Estab. 1980. Sponsors 1 exhibit/year. Average display time 1 month. Overall price range $150-400.

Exhibits Interested in color and b&w prints.

Making Contact & Terms Charges 50% commission. Reviews transparencies. Accepted work should be mounted, matted work only. Requires exclusive representation locally. Send material by mail for consideration. Include SASE, résumé, exhibition listing, artist's statement and price of sold work. Responds in 1 month.

Tips ''Be professional: have a full portfolio; be energetic and willing to assist with sales of your work.''

◫ KIRCHMAN GALLERY

P.O. Box 115, 213 N. Nuget St., Johnson City TX 78636. 830-868-9290. E-mail: info@kirchmangallery.com. Web site: www.kirchmangallery.com. **Contact:** Susan Kirchman, owner/director. Art consultancy and for-profit gallery. Estab. 2005. Represents or exhibits 25 artists. Average display time 1 month. Sponsors 4 photography exhibits/year. Open Wednesday through Sunday from 11 to 6; any time by appointment. Located across from Johnson City's historic Courthouse Square in the heart of Texas hill country. Overall price range $250-25,000. Most work sold at $500-1,000.

Exhibits Exhibits photos of landscapes/scenics. Interested in alternative process, avant garde, fine art.

Making Contact & Terms Artwork is accepted on consignment, and there is a 50% commision.

Submissions "Send 20 digital-format examples of your work, along with a resume and artist's statement."

◼ ROBERT KLEIN GALLERY

38 Newbury St., Boston MA 02116. (617)267-7997. Fax: (617)267-5567. E-mail: inquiry@robertkleingallery.com. Web site: www.robertkleingallery.com. **Contact:** Robert L. Klein, owner or Eunice Hurd, director. Estab. 1978. Sponsors 10 exhibits/year. Average display time 5 weeks. Overall price range $1,000-200,000.

Exhibits Interested in fashion, documentary, nudes, portraiture, and work that has been fabricated to be photographs.

Making Contact & Terms Charges 50% commission. Buys photos outright. Accepted work should be unframed, unmatted, unmounted. Requires exclusive representation locally. Must be established a minimum of 5 years; preferably published.

Submissions "Send materials by e-mail or mail with SASE for consideration."

ROBERT KOCH GALLERY

49 Geary St., San Francisco CA 94108. (415)421-0122. Fax: (415)421-6306. E-mail: info@kochgallery.com. Web site: www.kochgallery.com. For-profit gallery. Estab. 1979. Sponsors 6-8 photography exhibits/year. Average display time 2 months. Gallery open Tuesday through Saturday from 10:30 to 5:30.

Making Contact & Terms Artwork is accepted on consignment. Gallery provides insurance, promotion, contract. Requires West Coast or national representation.

Submissions Finds artists through publicatons, art exhibits, art fairs, referrals by other artists and curators, collectors, critics.

MARGEAUX KURTIE MODERN ART AT THE ART HOTEL

39 Yerba Buena, P.O. Box 39, Cerrillos NM 87010. (505)473-2250. E-mail: mkmamadrid@att.net. Web site: www.mkmamadrid.com. **Contact:** Jill Alikas, director. For-profit gallery and art consultancy. Estab. 1996. Approached by 200 artists/year; represents or exhibits 13 artists. Sponsors 2 photography exhibits/year. Average display time 5 weeks. Gallery open Thursday through Tuesday from 11 to 5. Closed February. Located within a historic frontier village 35 miles outside of Santa Fe, 1,020 sq. ft. Overall price range $350-15,000. Most work sold at $2,800.

Exhibits Interested in avant garde, erotic, fine art.

Making Contact & Terms Artwork is accepted on consignment, and there is a 50% commission. Requires exclusive representation locally.

Submissions Web site lists criteria for review process. Mail portfolio for review. Send query letter with artist's statement, bio, résumé, reviews, SASE, slides, $25 review fee (check payable to gallery). Finds artists through art fairs, art exhibits, portfolio reviews, referrals by other artists, submissions, word of mouth.

LA ART ASSOCIATION/GALLERY 825

825 N. La Cienega Blvd., Los Angeles CA 90069. (310)652-8272. Fax: (310)652-9251. E-mail: gallery825@laaa.org. Web site: www.laaa.org. **Contact:** Peter Mays, executive director. Artistic Director: Sinead Finnerty-Pyne. Estab. 1925. Sponsors 16 exhibits/year. Average display time 4-5 weeks. Sponsors openings. Overall price range $200-5,000. Most work sold at $600.

 • Also displays exhibitions at LAAA South, The Mike Napoliello Gallery, 936 Hermosa Beach Ave., #105, Hermosa Beach CA 90254.

Exhibits Exhibits photography and work of all media. New artists membership screenings conducted twice/year; contact the gallery for dates. Gallery offers group and solo shows." Interested in southern Californian artists—all media and avant garde, alternative process, fine art. Has annual "open" juried show open to all southern California artists. Call for prospectus.

Making Contact & Terms Charges 40% commission. Works are limited to 100 lbs.

Submissions Submit 2 pieces during screening date. Responds immediately following screening. Call for screening dates.

Tips "Bring work produced in the last 3 years."

N LA MAMA'S LA GALLERIA

6 E. First St., New York NY 10003. (212)505-2476. Estab. 1982. La Galleria is located in the downtown East Village section of Manhattan; close to various transportation; street level access. Open Thursday through Sunday from 1 to 6.

Exhibits Exhibits new works.

LEHIGH UNIVERSITY ART GALLERIES

420 E. Packer Ave., Bethlehem PA 18015. (610)758-3619. Fax: (610)758-4580. E-mail: rv02@lehigh.edu. Web site: www.luag.org. **Contact:** Ricardo Viera, director/curator. Sponsors 5-8 exhibits/year. Average display time 6-12 weeks. Sponsors openings.

Exhibits Exhibits fine art/multicultural, Latin American. Interested in all types of works. The photographer should "preferably be an established professional."

Making Contact & Terms Reviews transparencies. Arrange a personal interview to show portfolio. Send query letter with SASE. Responds in 1 month.

Tips "Don't send more than 10 (top) slides, or CD."

LEWIS LEHR INC.

444 E. 86th St., New York NY 10028. (212)288-6765. **Contact:** Lewis Lehr, director. Estab. 1984. Private dealer. Overall price range $50-30,000 .

Exhibits Exhibits FSA, Civil War camera work and European vintage.

Making Contact & Terms Buys vintage photos. No submissions accepted.

Tips Vintage American sells best. Sees trend toward "more color and larger" print sizes. To break in, "knock on doors."

N LEOPOLD GALLERY

324 W. 63rd St., Kansas City KS 64113. E-mail: email@leopoldgallery.com. Web site: www.leoppoldgaller y.com. **Contact:** Robin Elliott, assistant director. For-profit gallery. Estab. 1991. Approached by 100+ artists/year; represents or exhibits 50 artists/year. Sponsors 1 photography exhibit/year. Average display time 3 weeks. Open Sunday through Saturday from 10 to 6; weekends from 10 to 5. Closed holidays. "We are located in Brookside, a charming retail district built in 1920 with more than 70 shops, restaurants and offices. The gallery has two levels of exhibition space, with the upper level dedicated to artist openings/exhibitions." Overall price range $50-25,000. Most work sold at $1,000.

Exhibits Exhibits photos of architecture, cities/urban, rural, environmental, landscapes/scenics, wildlife, entertainment, performing arts. Interested in alternative process, avant garde, documentary, fine art.

Making Contact & Terms Artwork is accepted on consignment; there is a 50% commission. Gallery provides insurance, promotion, contract. Accepted work should be framed, mounted, matted. **Accepts artists from Kansas City area only.**

Submissions E-mail query letter with link to artist's Web site, JPEG samples at 72 dpi. Send query letter with artist's statement, bio, brochure, business card, résumé, reviews, SASE, disc with images. Responds in 2 weeks. Finds artists through word of mouth, art exhibitions, submissions, art fairs, portfolio reviews, referrals by other artists.

LIMITED EDITIONS & COLLECTIBLES

697 Haddon, Collingswood NJ 08108. (856)869-5228. E-mail: jdl697ltd@juno.com. Web site: www.ltdedi tions.net. **Contact:** John Daniel Lynch, Sr., owner. For-profit online gallery. Estab. 1997. Approached by 24 artists/year; represents or exhibits 70 artists. Sponsors 20 photography exhibits/year. Overall price range $100-3,000. Most work sold at $450.

Exhibits Exhibits photos of landscapes/scenics, wildlife, adventure, automobiles, entertainment, events, food/drink, health/fitness/beauty, hobbies, humor, performing arts, sports, travel. Interested in alternative process, documentary, erotic, fashion/glamour, historical/vintage, seasonal.

Making Contact & Terms Artwork is accepted on consignment, and there is a 30% commission. Gallery provides insurance, promotion, contract.

Submissions Call or write to show portfolio. Send query letter with bio, business card, résumé. Responds in 1 month. Finds artists through word of mouth, portfolio reviews, art exhibits, referrals by other artists.

LIZARDI/HARP GALLERY

P.O. Box 91895, Pasadena CA 91109. (626)791-8123. Fax: (626)791-8887. E-mail: lizardiharp@earthlink. net. **Contact:** Grady Harp, director. Estab. 1981. Sponsors 3-4 exhibits/year. Average display time 4-6 weeks. Overall price range $250-1,500. Most work sold at $500.

Exhibits Primarily interested in the figure. Also exhibits photos of celebrities, couples, religious, performing arts. "Must have more than one portfolio of subject, unique slant and professional manner." Interested in avant garde, erotic, fine art, figurative, nudes, "maybe" manipulated work, documentary and mood landscapes, both b&w and color.

Making Contact & Terms Charges 50% commission. Accepted work should be unframed, unmounted; matted or unmatted.

Submissions Submit portfolio for review. Send query letter by mail résumé, samples, SASE. Responds in 1 month.

Tips Include 20 labeled slides, résumé and artist's statement with submission. "Submit at least 20 images that represent bodies of work. I mix photography of figures, especially nudes, with shows on painting."

LUX CENTER FOR THE ARTS

2601 N. 48th St., Lincoln NE 68504-3632. **Contact:** Stephanie Leach, exhibition/education director. Nonprofit gallery. Estab. 1978. represents or exhibits 60+ artists. Sponsors 3-4 photography exhibits/year. Average display time 1 month. Open Tuesday through Friday from 11 to 5; Saturday from 10 to 5.

Exhibits Exhibits photos of landscapes/scenics. Interested in alternative process, avant garde, fine art.

Making Contact & Terms Artwork is accepted on consignment, and there is a 50% commission.

Submissions Mail portfolio for review. Send query letter with artist's statement, bio, slides or digital images on CD, SASE. Finds artists through referrals by other artists and through research.

Tips "To make your submission professional, you should have high-quality images (either slides or high-res digital images), cover letter, bio, résumé, artist's statement and SASE."

MACALESTER GALLERY

Janet Wallace Fine Arts Center, Macalester College, 1600 Grand Ave., St. Paul MN 55105. (651)696-6416. Fax: (651)696-6266. E-mail: fitz@macalester.edu. Web site: www.macalester.edu/gallery. **Contact:** Greg Fitz, curator. Nonprofit gallery. Estab. 1964. Approached by 15 artists/year; represents or exhibits 3 artists. Sponsors 1 photography exhibit/year. Average display time 4-5 weeks. Gallery open Monday through Friday from 10 to 4; weekends from 12 to 4. Closed major holidays, summer and school holidays. Located in the core of the Janet Wallace Fine Arts Center on the campus of Macalester College. Gallery is approx. 1,100 sq. ft. and newly renovated. Overall price range: $200-1,000. Most work sold at $350.

Exhibits Exhibits photos of multicultural, environmental, landscapes/scenics, architecure, rural. Interested in avant garde, documentary, fine art, historical/vintage.

Making Contact & Terms Gallery provides insurance. Accepted work should be framed, mounted, matted.

Submissions Send query letter with artist's statement, bio, brochure, business card, photocopies, photographs, résumé, reviews, SASE, slides. Responds in 3 weeks. Finds artists through word of mouth, portfolio reviews, referrals by other artists.

Tips "Photographers should present quality slides which are clearly labeled. Include a concise artist's statement. Always include a SASE. No form letters or mass mailings."

■ THE MAIN STREET GALLERY

105 Main St., P.O. Box 161, Groton NY 13073. (607)898-9010. Web site: www.mainstreetgal.com. **Contact:** Adrienne Bea Smith, director. For-profit gallery and art consultancy. Estab. 2003. Exhibits 15 artists. Sponsors 1 photography exhibit/year. Average display time 5-6 weeks. Open Thursday through Saturday from 12 to 6; Sunday from 1 to 5. Closed January and February. Located in the village of Groton in the Finger Lakes Region of New York, 20 minutes from Ithaca; 900 sq. ft. Overall price range: $120-5,000.

Exhibits Interested in fine art.

Terms Artwork is accepted on consignment, and there is a 40% commission. Gallery provides insurance, promotion and contract. Accepted work should be framed, mounted and matted. Requires exclusive representation locally.

Submissions Write to arrange a personal interview to show portfolio of photographs, slides. Send query letter with artist's statement, bio, brochure, photographs, résumé, reviews, slides/CD images, SASE.

Responds to queries in 1 month, only if interested. Finds artists through art exhibits, portfolio reviews, referrals by other artists, submissions, word of mouth.

Tips After submitting materials, the artist will set an appointment to talk over work. Artists should send in up-to-date résumé and artist's statement.

MARKEIM ART CENTER

Lincoln Avenue and Walnut Street, Haddonfield NJ 08033. (856)429-8585. Fax: (856)429-8585. E-mail: markeim@verizon.net. Web site: www.markeimartcenter.org. **Contact:** Elizabeth Madden, executive director. Estab. 1956. Sponsors 10-11 exhibits/year. Average display time 4 weeks. "The exhibiting artist is responsible for all details of the opening." Overall price range $75-1,000. Most work sold at $350.

Exhibits Interested in all types work. Exhibits photos of babies/children/teens, celebrities, couples, multi-cultural, families, parents, senior citizens, environmental, landscapes/scenics, wildlife, architecture, cities/urban, education, rural, adventure, automobiles, entertainment, performing arts, sports, travel, agriculture, product shots/still life. Interested in alternative process, avant garde, documentary, fine art, historical/vintage, seasonal.

Making Contact & Terms Charges 30% commission. Accepted work should be framed, mounted or unmounted, matted or unmatted. "Artists from New Jersey and Delaware Valley region are preferred. Work must be professional and high quality."

Submissions Send slides by mail for consideration. Include SASE, résumé and letter of intent. Responds in 1 month.

Tips "Be patient and flexible with scheduling. Look not only for one-time shows, but for opportunities to develop working relationships with a gallery. Establish yourself locally and market yourself outward."

THE MAYANS GALLERY LTD.

601 Canyon Rd., Santa Fe NM 87501. (505)983-8068. E-mail: arte2@aol.com. Web site: www.artnet.com/mayans.html. **Contact:** Ernesto Mayans, director. Estab. 1977. Publishes books, catalogs and portfolios. Overall price range $200-5,000.

Making Contact & Terms Charges 50% commission. Consigns. Requires exclusive representation within area.

Submissions Size limited to 11×20 maximum. Arrange a personal interview to show portfolio. Send query by mail with SASE for consideration. Responds in 2 weeks.

Tips "Please call before submitting."

MILL BROOK GALLERY & SCULPTURE GARDEN

236 Hopkinton Rd., Concord NH 03301. (603)226-2046. E-mail: artsculpt@mindspring.com. Web site: www.themillbrookgallery.com. For-profit gallery. Estab. 1996. Exhibits 70 artists. Sponsors 1 photography exhibit/year. Average display time 6 weeks. Gallery open Tuesday through Saturday from 11 to 5, April 1 to December 24; open by appointment December 25 to March 31. Outdoor juried sculpture exhibit. Three rooms inside for exhibitions, 1,800 sq. ft. Overall price range $8-30,000. Most work sold at $500-1,000.

Making Contact & Terms Artwork is accepted on consignment, and there is a 50% commission. Gallery provides insurance, promotion, contract. Accepted work should be framed, matted.

Submissions Write to arrange a personal interview to show portfolio of photographs, slides. Send query letter with artist's statement, bio, photocopies, photographs, résumé, slides, SASE. Responds within 1 month, only if interested. Finds artists through word of mouth, submissions, art exhibits, referrals by other artists.

MULTIPLE EXPOSURES GALLERY

105 N. Union St., #312, Alexandria VA 22314-3217. (703)683-2205. E-mail: multipleexposuresgallery@verizon.net. Web site: www.torpedofactory.org. **Contact:** Alan Sislen, president. Cooperative gallery. Estab. 1986. Represents or exhibits 14 artists. Sponsors 12 photography exhibits/year. Average display time 1 month. Open daily from 11 to 5. Closed on 5 major holidays throughout the year. Located in Torpedo Factory Art Center; 10-ft. walls with about 40 ft. of running wall space; 1 bin for each artist's matted photos, up to 20×24 in size with space for 25 pieces.

Exhibits Exhibits photos of landscapes/scenics, architecture, beauty, cities/urban, religious, rural, adventure, automobiles, events, travel, buildings. Interested in alternative process, documentary, fine art. Other

specific subjects/processes: "We have on display roughly 300 images that run the gamut from platinum and older alternative processes through digital capture and output."

Making Contact & Terms There is a co-op membership fee, a time requirement, a rental fee and a 15% commission. Accepted work should be matted. *Accepts only artists from Washington, DC, region.* Accepts only photography. "Membership is by jury of active current members. Membership is limited to 14. Jurying for membership is only done when a space becomes available; on average, 1 member is brought in about every 2 years."

Submissions Send query letter with SASE to arrange a personal interview to show portfolio of photographs, slides. Responds in 2 months. Finds artists through word of mouth, referrals by other artists, ads in local art/photography publications.

Tips "Have a unified portfolio of images mounted and matted to archival standards."

MUSEO DE ARTE DE PONCE

P.O. Box 9027, Ponce PR 00732-9027. (787)848-0505. Fax: (787)841-7309. E-mail: map@museoarteponce .org. Web site: www.museoarteponce.org. **Contact:** Curatorial department. Museum. Estab. 1961. Approached by 50 artists/year; mounts 3 exhibitions/year. Gallery open Monday through Sunday from 10 to 5. Closed New Year's Day, January 6, Good Friday, Thanksgiving and Christmas day.

Exhibits Interested in avant garde, fine art.

Submissions Send query letter with artist's statement, résumé, images, reviews, publications. Responds in 3 months. Finds artists through research, art exhibits, studio and gallery visits, word of mouth, referrals by other artists.

MUSEO ITALOAMERICANO

Fort Mason Center, Bldg. C, San Francisco CA 94123. (415)673-2200. Fax: (415)673-2292. E-mail: sfmuseo @sbcglobal.net. Web site: www.museoitaloamericano.org. **Contact:** Susan Filippo, administrator. Museum. Estab. 1978. Approached by 80 artists/year; exhibits 15 artists. Sponsors 1 photography exhibit/year (depending on the year). Average display time 2-3 months. Gallery open Tuesday through Sunday from 12 to 4; Monday by appointment. Closed major holidays. Gallery is located in the San Francisco Marina District, with a beautiful view of the Golden Gate Bridge, Sausalito, Tiburon and Alcatraz; 3,500 sq. ft. of exhibition space.

Exhibits Exhibits photos of babies/children/teens, celebrities, couples, multicultural, families, parents, senior citizens, environmental, landscapes/scenics, architecture, cities/urban, education, religious, rural, entertainment, events, food/drink, hobbies, humor, performing arts, sports, travel, product shots/still life. Interested in alternative process, avant garde, documentary, fine art, historical/vintage.

Making Contact & Terms "The museum rarely sells pieces. If it does, it takes 20% of the sale." Museum provides insurance, promotion. Accepted work should be framed, mounted, matted. *Accepts only Italian or Italian-American artists.*

Submissions Call or write to arrange a personal interview to show portfolio of photographs, slides, catalogs. Send query letter with artist's statement, bio, brochure, photographs, résumé, reviews, slides, SASE. Responds in 2 months. Finds artists through word of mouth, submissions.

Tips "Photographers should have good, quality reproduction of their work with slides, and clarity in writing their statements and résumés. Be concise."

◼ MUSEUM OF CONTEMPORARY PHOTOGRAPHY, COLUMBIA COLLEGE CHICAGO

600 S. Michigan Ave., Chicago IL 60605-1996. (312)663-5554. Fax: (312)344-8067. E-mail: mocp@colum. edu. Web site: www.mocp.org. **Contact:** Rod Slemmons, director or Natasha Egan, associate director: Estab. 1984. "We offer our audience a wide range of provocative exhibitions in recognition of photography's roles within the expanded field of imagemaking." Sponsors 6 main exhibits and 4-6 smaller exhibits/year. Average display time 2 months.

Exhibits Exhibits photos of babies/children/teens, celebrities, couples, multicultural, families, parents, senior citizens, environmental, landscapes/scenics, architecture, cities/urban, rural, humor, performing arts, agriculture, medicine, political, science, technology/computers. Interested in alternative process, avant garde, documentary, fashion/glamour, fine art, photojournalism, commercial, technical/scientific, video. "All high-quality work considered."

Submissions Reviews portfolios, transparencies, images on CD. Interested in reviewing unframed work only, matted or unmatted. Submit portfolio for review; inlcude SASE. Responds in 2-3 months. No critical review offered.

Tips "Professional standards apply; only very high-quality work considered."

◧ MUSEUM OF PHOTOGRAPHIC ARTS

1649 El Prado, Balboa Park, San Diego CA 92101. (619)238-7559. Fax: (619)238-8777. E-mail: info@mopa .org. Web site: www.mopa.org. **Contact:** Deborah Klochko, director. Curator of Photography: Carol Mc-Cusker. Estab. 1983. Sponsors 12 exhibits/year. Average display time 3 months.

Exhibits Interested in 19th-century to contemporary photography.

Making Contact & Terms ''The criteria is simply that the photography be of advanced artistic caliber, relative to other fine art photography. MoPA is a museum and therefore does not sell works in exhibitions.'' Exhibition schedules planned 2-3 years in advance. Holds a private Members' Opening Reception for each exhibition.

Submissions ''For space, time and curatorial reasons, there are few opportunities to present the work of newer, lesser-known photographers.'' Send an artist's statement and a résumé with a portfolio (unframed photographs), or a CD with JPEGs, or a link to Web site. Files are kept on contemporary artists for future reference. Send return address and postage if you wish your work returned. Responds in 2 months.

Tips ''Exhibitions presented by the museum represent the full range of artistic and journalistic photographic works. There are no specific requirements. The executive director and curator make all decisions on works that will be included in exhibitions. There is an enormous stylistic diversity in the photographic arts. The museum does not place an emphasis on one style or technique over another.''

NEVADA MUSEUM OF ART

160 W. Liberty St., Reno NV 89501. (775)329-3333. Fax: (775)329-1541. Web site: www.nevadaart.org. **Contact:** Ann Wolfe, curator. Estab. 1931. Sponsors 12-15 exhibits/year in various media. Average display time 2-3 months.

Submissions Send portfolio with slides via mail. ''No phone calls, please.''

Tips ''The Nevada Museum of Art is a private, nonprofit institution dedicated to providing a forum for the presentation of creative ideas through its collections, educational programs, exhibitions and community outreach. We specialize in art addressing the environment and teh altered landscape.''

NEW GALLERY/THOM ANDRIOLA

2627 Colquitt, Houston TX 77098-2117. (713)520-7053. Fax: (713)520-1145. E-mail: newgallery@sprynet. com. Web site: www.newgallery.net. **Contact:** Thom Andriola, director. For-profit gallery. Estab. 1979. Represents or exhibits 22 artists/year. Sponsors 1 photography exhibit/year. Average display time 1 month. Open Tuesday through Saturday from 11 to 5.

Making Contact & Terms Artwork is accepted on consignment, and there is a 50% commission. Requires exclusive representation locally.

NEW MEXICO STATE UNIVERSITY ART GALLERY

MSC 3572, NMSU, P.O. Box 30001, Las Cruces NM 88001-8003. (505)646-2545. Fax: (506)646-8036. E-mail: artglry@nmsu.edu. Web site: www.nmsu.edu/~artgal. **Contact:** John Lawson, director. Museum. Estab. 1969. Average display time 2-3 months. Gallery open Tuesday through Saturday from 11 to 4; Saturday and Sunday from 1 to 5. Closed Christmas through New Year's Day and university holidays. See Web site for summer hours. Located on university campus, 3,900 sq. ft. of exhibit space.

Making Contact & Terms Artwork is accepted on consignment, and there is a 30% commission. Gallery provides insurance, promotion, contract. Accepted work should arrive ready to install.

Submissions Send query letter with artist's statement, bio, brochure, résumé, slides, SASE. Responds in 6 months.

◧ NEXUS/FOUNDATION FOR TODAY'S ART

1400 N. American St., Suite 102, Philadelphia PA 19122. E-mail: info@nexusphiladelphia.org. Web site: nexusphiladelphia.org **Contact:** Nick Cassway, executive director. Alternative space; cooperative, non-profit gallery. Estab. 1975. Approached by 40 artists/year; represents or exhibits 20 artists. Sponsors 2 photography exhibits/year. Average display time 1 month. Open Wednesday through Sunday from 12 to 6; closed July and August. Located in Fishtown, Philadelphia; 2 gallery spaces, approximately 750 sq. ft. each. Overall price range: $75-1,200. Most work sold at $200-400.

Exhibits Exhibits photos of multicultural, families, environmental, architecture, rural, entertainment, humor, performing arts, industry, political. Interested in alternative process, documentary, fine art.

Submissions Send query letter with artist's statement, bio, photocopies, photographs, slides, SASE. Finds

artists through portfolio reviews, referrals by other artists, submissions, and juried reviews 2 times/year. "Please visit our Web site for submission dates."

Tips "Learn how to write a cohesive artist's statement."

▣ NORTHWEST ART CENTER

500 University Ave. W., Minot ND 58707. (701)858-3264. Fax: (701)858-3894. E-mail: nac@minotstateu.edu. Web site: www.minotstateu.edu/nac. **Contact:** Avis Veikley, director. Estab. 1976. Sponsors 18-20 exhibits/year, including 2 national juried shows. Average display time 1 month. Northwest Art Center consists of 2 galleries: Hartnett Hall Gallery and the Library Gallery. Overall price range $50-2,000. Most work sold at $800 or less.

Exhibits Interested in alternative process, avant garde, documentary, fine art, historical/vintage.

Making Contact & Terms Charges 30% commission. Accepted work must be framed.

Submissions Send material by mail with SASE or e-mail for consideration. Responds within 3 months. Prospectus for juried shows available online.

ⓝ ▣ ⊕ NUDOPIA GALLERY

15 Thermopilon St., 542 48 Analipsi, Thessaloniki, Greece. (30) (231)085-5950. E-mail: info@nudopiagallery.com, info@nudopia.com. Web site: www.nudopiagallery.com. **Contact:** Mary Diangelo, art director. Giannis Angelous, owner. Estab. 2007. Online commercial fine art gallery.

Exhibits Artistic and contemporary nudes exclusively.

Making Contact & Terms Charges commission for fine art prints. Other uses, such as printed media (coffee table books, limited edition posters, calendars, etc.) are negotiable. See Web site for details. Responds within 6 weeks only if interested.

Submissions Initial contact by e-mail. Provide query letter, Web site portfolio link. Ground mail submission guidelines available on Web site. Accepts digital submissions only.

▣ OAKLAND UNIVERSITY ART GALLERY

208 Wilson Hall, Oakland University, Rochester MI 48309-4401. (248)370-3005. Fax: (248)370-4208. E-mail: goody@oakland.edu. Web site: www.oakland.edu/ouag. **Contact:** Dick Goody, director. Nonprofit gallery. Estab. 1962. Represents 10-25 artists/year. Sponsors 6 exhibits/year. Average display time 4-5 weeks. Open September-May: Tuesday through Sunday from 12 to 5; evenings during special events and theater performances (Wednesday through Friday from 7 through 1st intermission, weekends from 5 through 1st intermission). Closed Monday, holidays and June-August. Located on the campus of Oakland University; exhibition space is approximately 2,350 sq. ft. of floor space, 301-ft. linear wall space, with 10-ft. 7-in. ceiling. The gallery is situated across the hall from the Meadow Brook Theatre. "We do not sell work, but do make available price lists for visitors with contact information noted for inquiries."

Exhibits Considers all styles and all types of prints and media.

Making Contact & Terms Charges no commission. Gallery provides insurance, promotion and contract. Accepted work should be framed, mounted, matted. No restrictions on representation; however, prefers emerging Detroit artists.

Submissions E-mail bio, education, artist's statement and JPEG images. Mail portfolio for review. Send query letter with artist's statement, bio, photocopies, résumé, slides. Returns material with SASE. Responds to queries in 1-2 months. Finds artists through referrals by other artists, word of mouth, art community, advisory board and other arts organizations.

OPALKA GALLERY

The Sage Colleges, Opalka Gallery, 140 New Scotland Ave., Albany NY 12208. (518)292-7742. Fax: (518)292-1903. E-mail: opalka@sage.edu. Web site: www.sage.edu/sca/opalkagallery.com. **Contact:** Jim Richard Wilson, director. Nonprofit gallery. Estab. 2002. "The Opalka Gallery replaced Rathbone Gallery, which served The Sage Colleges for 25 years." Approached by 90-120 artists/year; represents or exhibits approximately 24 artists. Average display time 5 weeks. Open Monday through Frday from 10 to 4:30 (10-4 and by appointment during July); Monday through Thursday evenings from 6 to 8; Sunday from 12 to 4. Open by appointment only between exhibitions and when classes are not in session. Closed July 4. "Located on the Sage Albany campus, The Opalka's primary concentration is on work by professional artists from outside the region. The gallery frequently features multidisciplinary projects and hosts poetry readings, recitals and symposia, often in conjunction with its exhibitions. The 7,400-sq.-ft. facility in-

cludes a vaulted gallery and a 75-seat lecture/presentation hall with Internet connectivity." Overall price range $50-260,000.

Exhibits Interested in fine art.

Making Contact & Terms Artwork is accepted on consignment; there is no commision. "We primarily accept artists from outside our region and those who have ties to The Sage Colleges. We host the local 'Photography Regional' every three years." Requires exclusive representation locally.

Submissions Send query letter with artist's statement, bio, brochure, business card, photocopies, photographs, reviews, slides, SASE; or e-mail pertinent information. Finds artists through word of mouth, art exhibits, submissions, portfolio reviews, referrals by other artists.

Tips "Submit all correspondence in a professional manner. Include an artist's statement, bio, reviews, and any pertinent information with visuals of your work (slides, CD, etc.)."

OPENING NIGHT GALLERY

2836 Lyndale Ave. S., Minneapolis MN 55408-2108. (612)872-2325. Fax: (612)872-2385. E-mail: deen@onframe-art.com. Web site: www.onframe-art.com. **Contact:**Deen Braathen. Rental gallery. Estab. 1975. Approached by 40 artists/year; represents or exhibits 15 artists. Sponsors 1 photography exhibit/year. Average display time 6-10 weeks. Gallery open Monday through Friday from 8:30 to 5; Saturday from 10:30 to 4. Overall price range $300-12,000. Most work sold at $2,500.

Exhibits Exhibits photos of landscapes/scenics, architecture, cities/urban.

Making Contact & Terms Artwork is accepted on consignment, and there is a 50% commission. Gallery provides insurance, promotion, contract. Accepted work should be framed "by our frame shop." Requires exclusive representation locally.

Submissions Mail slides for review. Send query letter with artist's statement, bio, résumé, slides, SASE. Responds in 2 months. Finds artists through word of mouth, submissions, portfolio reviews.

🖥 ORGANIZATION OF INDEPENDENT ARTISTS

45 West 21 St., #504, New York NY 10010. (347)405-2422. E-mail: oiaonline@surfbest.net. Web site: www.oiaonline.org. **Contact:** Geraldine Cosentino, director. Estab. 1976. Sponsors several exhibits/year. Average display time 4-6 weeks.

- OIA is a nonprofit organization that provides exhibition opportunities for unaffiliated and underserved artists at alternative public spaces in NYC and on their Web site.

Exhibits Interested in fine art.

Making Contact & Terms Membership is $75/year.

Submissions Submit slides or CD with proposal. "Write, e-mail or visit Web site for information on membership. If request is by mail, please include a SASE."

Tips "It is not required to be a member to submit a proposal, but interested photographers may want to become OIA members to be included in OIA's active artists registry that is used regularly by curators and artists. You must be a member to have your work in the registry but *not* to be considered for exhibits at OIA's Gallery 402 or public spaces."

🖥 🌐 OXYGEN GALLERY

P.O. Box 50797, Thessaloniki 54014 Greece. (30)(694)425-7125. E-mail: info@oxygengallery.com. Web site: www.oxygengallery.com. **Contact:** Giannis Angelou, owner. Online commercial gallery. Estab. 2004.

Exhibits Interested in concept and unusual images. Opportunities for additional portfolio showcases.

Making Contact & Terms Charges 50% commission.

Submissions Send query letter with résumé, credits, samples in digital media plus printed index. Submission guidelines provided on Web site. Accepts digital submissions only.

Tips "Study the images on the Web site and the information provided. We opt for a few very unique images rather than large numbers of images. Follow your most creative spirit."

🖥 PALO ALTO ART CENTER

1313 Newell Rd., Palo Alto CA 94303. (650)329-2366. Fax: (650)326-6165. E-mail: artcenter@cityofpaloalto.org. Web site: www.cityofpaloalto.org/artcenter. **Contact:** Exhibitions Dept. Estab. 1971. Average display time 1-3 months. Open Tuesday through Saturday from 10 to 5; Sunday from 1 to 5. Sponsors openings.

Exhibits "Exhibit needs vary according to curatorial context." Seeks "imagery unique to individual artist.

No standard policy. Photography may be integrated in group exhibits." Interested in alternative process, avant garde, fine art; emphasis on art of the Bay Area.
Submissions Send slides/CD, bio, artist's statement, SASE.

N ROBERT PARDO GALLERY

121 E. 31st St., PH12C, New York NY 10016. (917)256-1282. Fax: (646)935-0009. Email: robertpardogallery@yahoo.com. Web site: www.robertpardogallery.com. **Contact:** Dr. Giovanna Federico. For-profit gallery. Estab. 1986. Approached by 500 artists/year; represents or exhibits 18 artists. Sponsors 3 photography exhibits/year. Average display time 4-5 weeks. Gallery open Tuesday through Saturday from 10 to 6. Closed August.
Exhibits Interested in avant garde, fashion/glamour, fine art.
Submissions Arrange personal interview to show portfolio of slides, transparencies. Responds in 1 month.

PARKLAND ART GALLERY

2400 W. Bradley Ave., Champaign IL 61821. (217)351-2485. Fax: (217)373-3899. E-mail: artgallery@parkland.edu. Web site: www.parkland.edu/gallery. **Contact:** Art Gallery Director. Nonprofit gallery. Estab. 1980. Approached by 130 artists/year; represents or exhibits 8 artists. Average display time 4-6 weeks. Open Monday through Friday from 10 to 3; Saturday from 12 to 2. Closed college and official holidays. Overall price range $100-5,000. Most work sold at $300.
Exhibits Interested in alternative process, avant garde, documentary, fine art, historical/vintage.
Making Contact & Terms Gallery provides insurance, promotion. Accepted work should be framed.
Submissions Mail portfolio for review. Send query letter with artist's statement, bio, brochure, résumé, reviews, slides, SASE. Responds in 4 months. Finds artists through word of mouth, portfolio reviews, art exhibits, referrals by other artists, call for entry.

PENTIMENTI GALLERY

145 N. Second St., Philadelphia PA 19106. (215)625-9990. Fax: (215)625-8488. E-mail: mail@pentimenti.com. Web site: www.pentimenti.com. Commercial gallery. Estab. 1992. Average display time 6 weeks. Gallery open Tuesday by appointment; Wednesday through Friday from 11 to 5; Saturday from 12 to 5. Closed August, Christmas and New Year's Day. Located in the heart of Old City Cultural District in Philadelphia. Overall price range $500-10,000. Most work sold at $3,000.
Exhibits Exhibits photos of multicultural, families, environmental, landscapes/scenics, wildlife, architecture, cities/urban, gardening, entertainment, events. Interested in avant garde, documentary, fashion/glamour, fine art, historical/vintage.
Making Contact & Terms Artwork is accepted on consignment, and there is a 50% commission. Gallery provides insurance, promotion, contract. Accepted work should be framed, mounted, matted.
Submissions Send query letter with artist's statement, bio, brochure, photocopies, photographs, résumé, reviews, slides, SASE. Responds in 3 months. Finds artists through word of mouth, portfolio reviews, art fairs, referrals by other artists, curators, etc.

■ PETERS VALLEY CRAFT CENTER

19 Kuhn Rd., Layton NJ 07851. (973)948-5202. Fax: (973)948-0011. E-mail: pvstore@warwick.net. Web site: www.petersvalley.org. **Contact:** Mikal Brutzman, gallery manager. Nonprofit gallery and store. Estab. 1970. Approached by about 100 artists/year; represents about 350 artists. Average display time 1 month in gallery; varies for store items. Open year round; call for hours. Located in northwestern New Jersey in Delaware Water Gap National Recreation Area; 2 floors, approximately 3,000 sq. ft. Overall price range $5-3,000. Most work sold at $100-300.
Exhibits Considers all media and all types of prints. Also exhibits non-referential, mixed media, collage and sculpture.
Making Contact & Terms Artwork is accepted on consignment, and there is a 60% commission to artist. "Retail price set by the gallery in conjunction with artist." Gallery provides insurance and promotion. Accepted work should be framed, mounted and matted. ***Accepts only artists from North America.***
Submissions Call or write to arrange a personal interview to show portfolio. Send query letter with artist's statement, bio, résumé and images (slides or CD of JPEGs). Returns material with SASE. Responds in 2 months. Finds artists through submissions, art exhibits, art fairs, referrals by other artists.
Tips "Submissions must be neat and well-organized throughout."

PHOENIX GALLERY

210 11th Ave. at 25th St., Suite 902, New York NY 10001. (212)226-8711. Fax: (212)343-7303. E-mail: info@phoenix-gallery.com. Web site: www.phoenix-gallery.com. **Contact:** Linda Handler, director. Estab. 1958. Sponsors 10-12 exhibits/year. Average display time 1 month. Overall price range $100-10,000. Most work sold at $3,000-8,000.

Exhibits "The gallery is an artist-run nonprofit organization; an artist has to be a member in order to exhibit in the gallery. There are 3 types of membership: active, inactive, and associate." Interested in all media; alternative process, documentary, fine art.

Making Contact & Terms Charges 25% commission.

Submissions Artists wishing to be considered for membership must submit an application form, slides and résumé. Call, e-mail or download membership application from Web site.

Tips "The gallery has a special exhibition space, The Project Room, where nonmembers can exhibit their work. If an artist is interested, he/she may send a proposal with art to the gallery. The space is free; the artist shares only in the cost of the reception with the other artists showing at that time."

▣ PHOTO-EYE GALLERY

376 Garcia St., Suite A, Santa Fe NM 87501. E-mail: elizabethavedon@photoeye.com. Web site: www.photoeye.com. **Contact:** Elizabeth Avedon, gallery director. For-profit gallery. Average display time 2 months. Open Tuesday through Saturday from 11 to 5. "We have a physical gallery, Photo-Eye Gallery, Santa Fe, located off historic Canyon Road, plus 2 online galleries—The Photographer's Showcase and Photo Bistro." Overall price range $600-4,500. Most work sold at $1,200.

Exhibits Exhibits photos of babies/children/teens, architecture, cities/urban, political, wildlife, adventure. Interested in alternative process, avant garde, documentary, fine art. Exhibits contemporary photography only, all photographic processes.

Making Contact & Terms Gallery provides insurance, promotion, contract. Accepted work should be matted. Requires exclusive representation locally.

Submissions "We only accept digital files. All work should be submitted to the Photographer's Showcase." Responds in 2-4 weeks. Finds artists through art exhibits, word of mouth, art fairs, portfolio reviews, referrals by other artists.

Tips "Approach gallery in a professional, non-pushy way. Keep it short—in the end the work will speak for itself."

PHOTOGRAPHIC RESOURCE CENTER

832 Commonwealth Ave., Boston MA 02215. (617)975-0600. Fax: (617)975-0606. E-mail: prc@bu.edu. Web site: www.prcboston.org. **Contact:** Leslie K. Brown, curator. "The PRC is a nonprofit arts organization founded in 1976 to facilitate the study and dissemination of information relating to photography." Average display time 6 weeks. Open Tuesday, Wednesday and Friday from 10 to 6; Saturday and Sunday from 12 to 5; Thursday from 10 to 8. Closed major holidays. Located in the heart of Boston University. Gallery brings in nationally recognized artists to lecture to large audiences and host workshops on photography.

Exhibits Interested in contemporary and historical photography and mixed-media work incorporating photography.

Submissions Send query letter with artist's statement, bio, slides, résumé, reviews, SASE. Responds in 3-6 months. Finds artists through word of mouth, art exhibits, portfolio reviews.

Tips "Present a cohesive body of work."

▣ PHOTOGRAPHY ART

107 Myers Ave., Beckley WV 25801. (304)252-4060 or (304)575-6491. Fax: (304)252-4060 (call before faxing). E-mail: bruceburgin@photographyart.com. Web site: www.photographyart.com. **Contact:** Bruce Burgin, owner. Internet rental gallery. Estab. 2003. "Each artist deals directly with his/her customers. I do not charge commissions and do not keep records of sales."

Exhibits Exhibits photos of landscapes/scenics, wildlife. Interested in fine art.

Making Contact & Terms There is a rental fee for space. The rental fee covers 1 year. The standard gallery is $360 to exhibit 40 images with biographical and contact info for 1 year. No commission charged for sales. Artist deals directly with customers and receives 100% of any sale. Gallery provides promotion.

Submissions Internet sign-up. No portfolio required.

Tips "An artist should have high-quality digital scans. The digital images should be cropped to remove

any unnecessary background or frames, and sized according to the instructions provided with their Internet gallery. I recommend the artist add captions and anecdotes to the images in their gallery. This will give a visitor to your gallery a personal connection to you and your work.''

THE PHOTOMEDIA CENTER

P.O. Box 8518, Erie PA 16505. (617)990-7867. E-mail: info@photomediacenter.org. Web site: www.photo mediacenter.org. **Contact:** Eric Grignol, executive director. Nonprofit gallery. Estab. 2004. Sponsors 12 ''new'' photography exhibits/year. ''Previously featured exhibits are archived online. We offer many opportunities for artists, including sales, networking, creative collaboration and promotional resources; maintain an information board and slide registry for members; and hold an open annual juried show in the summer.''

Exhibits Interested in alternative process, avant garde, documentary, fine art.

Making Contact & Terms Artwork is accepted on consignment, and there is a 25% commission. Gallery provides promotion. Prefers only artists working in photographic, digital and new media.

Submissions ''We have a general portfolio review call in the fall for the following year's exhibition schedule. If after December 31, send query letter with artist's statement, bio, résumé, slides, SASE.'' Responds in 2-6 months. Finds artists through word of mouth, submissions, portfolio reviews, art exhibits, referrals by other artists.

Tips ''We are looking for artists who have excellent technical skills, a strong sense of voice and cohesive body of work. Pay careful attention to our guidelines for submissions on our Web site. Label everything. Must include a SASE for reply.''

PIERRO GALLERY OF SOUTH ORANGE

Baird Center, 5 Mead St., South Orange NJ 07079. (973)378-7755, ext. 3. Fax: (973)378-7833. E-mail: pierrogallery@southorange.org. Web site: www.pierrogallery.org. **Contact:** Judy Wukitsch, gallery director. Nonprofit gallery. Estab. 1994. Approached by 75-185 artists/year; represents or exhibits 25-50 artists. Average display time 7 weeks. Open Friday through Sunday from 1 to 4; by appointment. Closed mid-December through mid-January and during August. Overall price range $100-10,000. Most work sold at $800.

Exhibits Interested in fine art, ''which can be inclusive of any subject matter.''

Making Contact & Terms Artwork is accepted on consignment, and there is a 15% commission. Gallery provides insurance, promotion, contract. Accepted work should be framed.

Submissions Mail portfolio for review; 3 portfolio reviews/year: January, June, October. Send query letter with artist's statement, résumé, slides. Responds in 2 months from review date. Finds artists through word of mouth, submissions, portfolio reviews, referrals by other artists.

POLK MUSEUM OF ART

800 E. Palmetto St., Lakeland FL 33801-5529. (863)688-7743. Fax: (863)688-2611. E-mail: info@polkmuse umofart.org. Web site: www.polkmuseumofart.org. **Contact:** Todd Behrens, curator of art. Museum. Estab. 1966. Approached by 75 artists/year; represents or exhibits 3 artists. Sponsors 1-3 photography exhibits/year. Galleries open Tuesday through Saturday from 10 to 5; Sunday from 1 to 5. Closed major holidays. Four different galleries of various sizes and configurations.

Exhibits Interested in alternative process, avant garde, documentary, fine art, historical/vintage.

Making Contact & Terms Museum provides insurance, promotion, contract. Accepted work should be framed.

Submissions Mail portfolio for review. Send query letter with artist's statement, bio, résumé, slides, SASE.

THE PRINT CENTER

1614 Latimer St., Philadelphia PA 19103. (215)735-6090. Fax: (215)735-5511. E-mail: info@printcenter.o rg. Web site: www.printcenter.org. **Contact:** Ashley Peel Pinkham, assistant director. Nonprofit gallery and Gallery Store. Estab. 1915. Represents over 100 artists from around the world in Gallery Store. Sponsors 5 photography exhibits/year. Average display time 8-10 weeks. Gallery open Tuesday through Saturday from 11 to 5:30. Closed December 22 through January 3. Three galleries. Overall price range $45-4,000. Average price is $500.

Exhibits Exhibits contemporary prints and photographs of all processes.

Making Contact & Terms Charges 50% commission. Gallery provides insurance, promotion, contract. Artists must be printmakers or photographers.

Submissions Returns material with SASE. Responds in 3 months. Finds artists through membership in the organization, word of mouth, submissions, portfolio reviews, art exhibits, art fairs and referrals by other artists (sumbissions are sent by our artist members for review by curator and gallery store manager).

PUMP HOUSE CENTER FOR THE ARTS

P.O. Box 1613, Chillicothe OH 45601. Phone/fax: (740)772-5783. E-mail: pumpart@bright.net. Web site: www.pumphouseartgallery.com. **Contact:** Priscilla V. Smith, director. Nonprofit gallery. Estab. 1991. Approached by 6 artists/year; represents or exhibits more than 50 artists. Average display time 6 weeks. Gallery open Tuesday through Friday from 11 to 4; weekends from 1 to 4. Closed Monday and major holidays. Overall price range $150-600. Most work sold at $300. Facility is also available for rent (business, meetings, reunions, weddings, wedding receptions or rehearsals, etc.).

Exhibits Exhibits photos of landscapes/scenics, wildlife, architecture, gardening, travel, agriculture. Interested in fine art, historical/vintage.

Making Contact & Terms Artwork is accepted on consignment, and there is a 30% commission. Gallery provides insurance, promotion. Accepted work should be framed, matted, wired for hanging. Call or stop in to show portfolio of photographs, slides. Send query letter with bio, photographs, slides, SASE. Responds in 1 month. Finds artists through word of mouth, submissions, portfolio reviews, art exhibits, art fairs, referrals by other artists.

Tips "All artwork must be original designs, framed, ready to hang (wired—no sawtooth hangers)."

QUEENS COLLEGE ART CENTER

Benjamin S. Rosenthal Library, Queens College, Flushing NY 11367-1597. (718)997-3770. Fax: (718)997-3753. E-mail: suzanna.simor@qc.cuny.edu. Web site: www.qc.cuny.edu. **Contact:** Suzanna Simor, director. Curator: Alexandra de Luise. Estab. 1955. Average display time approximately 6 weeks. Overall price range $200-600.

Exhibits Open to all types, styles, subject matter; decisive factor is quality.

Making Contact & Terms Charges 40% commission. Accepted work can be framed or unframed, mounted or unmounted, matted or unmatted. Sponsors openings. Photographer is responsible for providing/arranging refreshments and cleanup.

Submissions Send query letter with résumé, samples and SASE. Responds in 1 month.

▣ ◪ MARCIA RAFELMAN FINE ARTS

10 Clarendon Ave., Toronto ON M4V 1H9 Canada. (416)920-4468. Fax: (416)968-6715. E-mail: info@mrfinearts.com. Web site: www.mrfinearts.com. **Contact:** Marcia Rafelman, president. Gallery Director: Meghan Richardson. Semi-private gallery. Estab. 1984. Average display time 1 month. Gallery is centrally located in Toronto; 2,000 sq. ft. on 2 floors. Overall price range $800-25,000. Most work sold at $1,500.

Exhibits Exhibits photos of environmental, landscapes. Interested in alternative process, documentary, fine art, historical/vintage.

Making Contact & Terms Charges 50% commission. Gallery provides insurance, promotion, contract. Requires exclusive representation locally.

Submissions Mail or e-mail portfolio for review; include bio, photographs, reviews. Responds within 2 weeks, only if interested. Finds artists through word of mouth, submissions, art fairs, referrals by other artists.

Tips "We only accept work that is archival."

THE RALLS COLLECTION INC.

1516 31st St. NW, Washington DC 20007. (202)342-1754. Fax: (202)342-0141. E-mail: maralls@aol.com. Web site: www.rallscollection.com. For-profit gallery. Estab. 1991. Approached by 125 artists/year; represents or exhibits 60 artists. Sponsors 7 photography exhibits/year. Average display time 1 month. Gallery open Tuesday through Saturday from 11 to 4 and by appointment. Closed Thanksgiving, Christmas. Overall price range $1,500-50,000. Most work sold at $2,500-5,000.

Exhibits Exhibits photos of babies/children/teens, celebrities, parents, landscapes/scenics, architecture, cities/urban, gardening, interiors/decorating, pets, rural, entertainment, health/fitness, hobbies, performing arts, sports, travel, product shots/still life. Interested in alternative process, avant garde, documentary, fashion/glamour, fine art, historical/vintage.

Making Contact & Terms Artwork is accepted on consignment, and there is a 50% commission. Gallery provides insurance, promotion, contract. Accepted work should be framed, matted. Requires exclusive representation locally. Accepts only artists from America.

Submissions Mail portfolio for review. Send query letter with artist's statement, bio, brochure, business card, photocopies, photographs, résumé, reviews, slides, SASE. Responds in 2 months. Finds artists through word of mouth, submissions, portfolio reviews, art exhibits, art fairs, referrals by other artists.

▣ ROCHESTER CONTEMPORARY

137 East Ave., Rochester NY 14604. (585)461-2222. Fax: (585)461-2223. E-mail: info@rochestercontemp orary.org. Web site: www.rochestercontemporary.org. **Contact:** Elizabeth Switzer, programming director. Estab. 1977. Sponsors 10-12 exhibits/year. Average display time 4-6 weeks. Gallery open Wednesday through Friday from 1 to 6; weekends from 1 to 5. Overall price range $100-500.

Making Contact & Terms Charges 25% commission.

Submissions Send slides/CD, letter of inquiry, résumé and statement. Responds in 3 months.

SAN DIEGO ART INSTITUTE'S MUSEUM OF THE LIVING ARTIST

1439 El Prado, San Diego CA 92101. (619)236-0011. Fax: (619)236-1974. E-mail: admin@sandiego-art.o rg. Web site: www.sandiego-art.org. **Contact:** Kerstin Robers, member associate. Art Director: K.D. Benton. Nonprofit gallery. Estab. 1941. Represents or exhibits 500 member artists. Overall price range $50-3,000. Most work sold at $700.

Exhibits Photos of babies/children/teens, couples, multicultural, families, parents, senior citizens, disasters, environmental, landscapes/scenics, wildlife, architecture, cities/urban, education, gardening, pets, rural, adventure, entertainment, events, food/drink, health/fitness/beauty, hobbies, humor, performing arts, sports, travel, agriculture, political, product shots/still life, science, technology. Interested in alternative process, avant garde, documentary, erotic, fine art, historical/vintage, seasonal.

Making Contact & Terms Artwork is accepted on consignment, and there is a 40% commission. Membership fee: $125. Accepted work should be framed. Work must be carried in by hand for each monthly show except for annual international show, juried by slides.

Submissions Membership not required for submission in monthly juried shows, but fee required. Artists interested in membership should request membership packet. Finds artists through referrals by other artists.

Tips "All work submitted must go through jury process for each monthly exhibition. Work must be framed in professional manner. No glass; plexiglass or acrylic only."

▣ SCHMIDT/DEAN SPRUCE

1710 Samson St., Philadelphia PA 19103. (215)569-9433. Fax: (215)569-9434. Web site: www.schmidtdea n.com. **Contact:** Christopher Schmidt, director. For-profit gallery. Estab. 1988. Sponsors 4 photography exhibits/year. Average display time 6 weeks. Gallery open Tuesday through Saturday from 10:30 to 6. August hours are Tuesday through Friday from 10:30 to 6. Overall price range $500-12,000.

Exhibits Interested in alternative process, documentary, fine art.

Making Contact & Terms Charges 50% commission. Gallery provides insurance, promotion. Accepted work should be framed, mounted, matted. Requires exclusive representation locally.

Submissions Call/write to arrange a personal interview to show portfolio of slides or CD. Send query letter with SASE. "Send 10 to 15 slides or digital images on CD and a résumé that gives a sense of your working history. Include a SASE."

▣ SECOND STREET GALLERY

115 Second St. SE, Charlottesville VA 22902. (434)977-7284. Fax: (434)979-9793. E-mail: director@secon dstreetgallery.org. Web site: www.secondstreetgallery.org. **Contact:** Leah Stoddard, director. Estab. 1973. Sponsors approximately 2 photography exhibits/year. Average display time 1 month. Open Tuesday through Saturday from 11 to 6; 1st Friday of every month from 6 to 8, with Artist Talk at 6:30. Overall price range $300-2,000.

Making Contact & Terms Charges 30% commission.

Submissions Reviews slides/CDs in fall; $10 processing fee. Submit 10 slides or a CD for review; include artist statement, cover letter, bio/résumé, and most importantly, a SASE. Responds in 2 months.

Tips Looks for work that is "cutting edge, innovative, unexpected."

SELECT ART

1025 E. Levee St., Dallas TX 75207. E-mail: selart@swbell.net. **Contact:** Paul Adelson, owner. Estab. 1986. Overall price range $250-900.

- This market deals fine art photography to corporations and sells to collectors.

Exhibits Wants photos of architectural pieces, landscapes, automobiles and buildings. Interested in fine art.

Making Contact & Terms Charges 50% commission. Accepted work should be unframed and matted.

Submissions Send slides by mail with SASE for consideration. Responds in 1 month.

Tips "Make sure the work you submit is fine art photography, not documentary/photojournalistic or commercial photography. No nudes. Label all slides. Include biographical information, pricing (state whether retail or wholesale). Photographers must be service oriented and send out slides or artwork when they say they will."

SOUTH DAKOTA ART MUSEUM

South Dakota State University, Box 2250, Brookings SD 57007. (605)688-5423 or (866)805-7590. Fax: (605)688-4445. Web site: www.SouthDakotaArtMuseum.com. **Contact:** John Rychtarik, curator of exhibits. Museum. Estab. 1970. Sponsors 1-2 photography exhibits/year. Average display time 4 months. Gallery open Monday through Friday from 10 to 5; Saturday from 10 to 4; Sunday from 12 to 4. Closed state holidays. Six galleries offer 26,000 sq. ft. of exhibition space. Overall price range $200-6,000. Most work sold at $500.

Exhibits Interested in alternative process, documentary, fine art.

Making Contact & Terms Artwork is accepted on consignment, and there is a 30% commission. Gallery provides insurance, promotion. Accepted work should be framed.

Submissions Send query letter with artist's statement, bio, résumé, slides, SASE. Responds within 3 months, only if interested. Finds artists through word of mouth, portfolio reviews, art exhibits, referrals by other artists.

▣ SOUTHSIDE GALLERY

150 Courthouse Square, Oxford MS 38655. (662)234-9090. E-mail: southside@southsideartgallery.com. Web site: www.southsideartgallery.com. **Contact:** Wil Cook, director. For-profit gallery. Estab. 1993. Average display time 4 weeks. Gallery open Monday through Saturday from 10 to 6; Sunday from 12 to 5. Overall price range $300-20,000. Most work sold at $425.

Exhibits Exhibits photos of landscapes/scenics, architecture, cities/urban, rural, entertainment, events, performing arts, sports, travel, agriculture, political. Interested in avant garde, fine art.

Making Contact & Terms Artwork is accepted on consignment, and there is a 55% commission. Gallery provides promotion. Accepted work should be framed.

Submissions Mail portfolio for review. Responds within 4-6 weeks, only if interested. Finds artists through submissions.

B.J. SPOKE GALLERY

299 Main St., Huntington NY 11743. (631)549-5106. E-mail: mgr@bjspokegallery.com. Web site: www.bj spokegallery.com. **Contact:** Manager. Member-owned cooperative gallery. Average display time 1 month. Sponsors openings. Overall price range $300-2,500.

Exhibits Holds national/international juried competitions. Visit Web site for details. Interested in "all styles and genres, photography as essay, as well as 'beyond' photography."

Making Contact & Terms Charges 30% commission. Photographer sets price.

Submissions Arrange a personal interview to show portfolio. Send query letter with SASE.

THE STATE MUSEUM OF PENNSYLVANIA

300 North St., Harrisburg PA 17120-0024. (717)783-9904. Fax: (717)783-4558. E-mail: nstevens@state.pa. us. Web site: www.statemuseumpa.org. **Contact:** N. Lee Stevens, senior curator of art collections. Museum established in 1905; current Fine Arts Gallery opened in 1993. Number of exhibits varies. Average display time 2 months. Overall price range $50-3,000.

Exhibits Fine art photography is a new area of endeavor for The State Museum, both collecting and exhibiting. Interested in works produced with experimental techniques.

Making Contact & Terms Work is sold in gallery, but not actively. Connects artists with interested

buyers. No commission. Accepted work should be framed. *Photography must be created by a native or resident of Pennsylvania, or contain subject matter relevant to Pennsylvania.*

Submissions Send material by mail for consideration; include SASE. Responds in 1 month.

◪ STATE OF THE ART

120 W. State St., Ithaca NY 14850. (607)277-1626 or (607)277-4950. E-mail: gallery@soag.org. Web site: www.soag.org. Cooperative gallery. Estab. 1989. Sponsors 1 photography exhibit/year. Average display time 1 month. Gallery open Wednesday through Friday from 12 to 6; weekends from 12 to 5. Located in downtown Ithaca, 2 rooms about 1,100 sq. ft. Overall price range $100-6,000. Most work sold at $200-500.

Exhibits Exhibits photos in all media and subjects. Interested in alternative process, avant garde, fine art, computer-assisted photographic processes.

Making Contact & Terms There is a co-op membership fee plus a donation of time. There is a 10% commission for members, 30% for nonmembers. Gallery provides promotion, contract. Accepted work must be ready to hang. Write for membership application.

Tips Other exhibit opportunity: Annual Juried Photo Show in March. Application available on Web site in January.

STATE STREET GALLERY

1804 State St., La Crosse WI 54601. (608)782-0101. E-mail: ssg1804@yahoo.com. Web site: www.statestr eetartgallery.com. **Contact:** Ellen Kallies, president. Wholesale, retail and trade gallery. Estab. 2000. Approached by 15 artists/year; exhibits 12-14 artists/quarter in gallery. Average display time 4-6 months. Gallery open Tuesday through Saturday from 10 to 3. Located across from the University of Wisconsin/La Crosse. Overall price range $50-12,000. Most work sold at $500-1,200 and above.

Exhibits Exhibits photos of environmental, landscapes/scenics, architecture, cities/urban, gardening, rural, travel, medicine.

Making Contact & Terms Artwork is accepted on consignment, and there is a 40% commission. Gallery provides insurance, promotion, contract. Accepted work should be framed, matted.

Submissions Call or mail portfolio for review. Send query letter with artist's statement, photographs, slides, SASE. Responds in 1 month. Finds artists through word of mouth, art exhibits, art fairs, referrals by other artists.

Tips "Be organized, professional in presentation, flexible."

THE STUDIO: AN ALTERNATIVE SPACE FOR CONTEMPORARY ART

2 Maryland Ave., Armonk NY 10504-2029. (914)273-1452. Fax: (914)219-5030. E-mail: thestudiony@opt online.net. Web site: www.thestudiony-alternative.org. **Contact:** Katie Stratis, director. Alternative space and nonprofit gallery. Estab. 1998. Located in Westchester County in the hamlet of Armonk, New York; approximately 500 sq. ft.; sculpture garden. "The Studio Annex in New York City is a satellite gallery of The Studio, and it also shows up to three exhibits a year."

Exhibits Exhibits photos of multicultural, architecture, gardening, rural, environmental, landscapes/scenics, entertainment, events, performing arts. Interested in alternative process, avant garde, documentary. "The subject matter is left up to the artists chosen to be in the curated exhibitions."

Making Contact & Terms Artwork is accepted on consignment, and there is a 30% commission.

Submissions "Curated exhibitions only; no open submission policy. Once a year there is a juried exhibition, but review Juried Prospectus before sending any submissions."

JILL THAYER GALLERIES AT THE FOX

1700 20th St., Bakersfield CA 93301-4329. (661)631-9711. E-mail: jill@jillthayer.com. Web site: www.jillt hayer.com. **Contact:** Jill Thayer, director. For-profit gallery. Estab. 1994. Represents more than 25 "emerging, mid-career and established artists of regional and international recognition." Features 6-8 exhibits/year. Average installation: 6 weeks. Open Friday and Saturday from 1 to 4 or by appointment. Closed holidays. Located at the historic Fox Theater, built in 1930. Thayer renovated the 400-sq.-ft. space in 1994. "The gallery features large windows, high ceilings, wood floor and bare-wire halogen lighting system. Clients include southern California upscale; 25% of sales are to corporate collectors." Overall price range $250-10,000. Most work sold at $2,500.

Exhibits Considers all media. Exhibits "contemporary, abstract and representational work."

Making Contact & Terms Artwork is accepted on consignment "for duration of exhibit with 50% commis-

sion. Artist pays all shipping and must provide insurance. Retail price set by the gallery and the artist. Gallery provides marketing, mailer design and partial printing. Artist shares cost of printing, mailings and receptions."

Submissions Send query letter with artist's statement, bio, résumé, exhibition list, reviews, 12 slides, SASE. Responds in 1 month if interested. Finds artists through submissions and portfolio reviews.

Tips "When submitting to galleries, be concise, professional, send up-to-date package (art and info) and slide sheet of professionally documented work. Frame professionally if selected for exhibition. No colored mats or color laser prints. All works on paper must be archival and of museum quality."

NATALIE AND JAMES THOMPSON ART GALLERY

School of Art & Design, San José State University, San José CA 95192-0089. (408)924-4723. Fax: (408)924-4326. E-mail: jfh@cruzio.com. Web site: www.sjsu.edu. **Contact:** Jo Farb Hernandez, director. Nonprofit gallery. Approached by 100 artists/year. Sponsors 1-2 photography exhibits/year. Average display time 1 month. Gallery open Tuesday through Friday from 11 to 4; Tuesday evenings from 6 to 7:30.

Exhibits "We are open to all genres, aesthetics and techniques."

Making Contact & Terms "Works are not generally for sale." Gallery provides insurance, promotion. Accepted work should be framed and/or ready to hang.

Submissions Send query letter with artist's statement, bio, résumé, reviews, slides, SASE. Responds as soon as possible. Finds artists through word of mouth, submissions, portfolio reviews, art exhibits, art fairs, referrals by other artists.

▣ THROCKMORTON FINE ART

145 E. 57th St., 3rd Floor, New York NY 10022. (212)223-1059. Fax: (212)223-1937. E-mail: kraige@throckmorton-nyc.com. Web site: www.throckmorton-nyc.com. **Contact:** Kraige Block, director. For-profit gallery. Estab. 1993. Approached by 50 artists/year; represents or exhibits 20 artists. Sponsors 5 photography exhibits/year. Average display time 2 months. Overall price range $1,000-10,000. Most work sold at $1,500.

Exhibits Exhibits photos of babies/children/teens, landscapes/scenics, architecture, cities/urban, rural. Interested in erotic, fine art, historical/vintage, Latin American photography.

Making Contact & Terms Charges 50% commission. Gallery provides insurance, promotion.

Submissions Write to arrange a personal interview to show portfolio of photographs/slides/CD, or send query letter with artist's statement, bio, photocopies, slides, CD, SASE. Responds in 3 weeks. Finds artists through word of mouth, portfolio reviews.

Tips "Present your work nice and clean."

UNI GALLERY OF ART

University of Northern Iowa, 104 Kamerick Art Bldg., Cedar Falls IA 50614-0362. (319)273-6134. E-mail: galleryofart@uni.edu. Web site: www.uni.edu/artdept/gallery. **Contact:**Darrell Taylor, director. Estab. 1976. Sponsors 9 exhibits/year. Average display time 1 month. Approximately 5,000 sq. ft. of space and 424 ft. of usable wall space.

Exhibits Interested in all styles of high-quality contemporary art works.

Making Contact & Terms "We do not often sell work; no commission is charged."

Submissions Arrange a personal interview to show portfolio, CV (curriculum vitae) and samples. Send material by mail for consideration or submit portfolio for review; include SASE for return of material. Response time varies.

UNIVERSITY ART GALLERY IN THE D.W. WILLIAMS ART CENTER

New Mexico State University, MSC 3572, P.O. Box 30001, Las Cruces NM 88003-8001. (505)646-2545. Fax: (505)646-5207. E-mail: artglry@nmsu.edu. Web site: www.nmsu.edu/~ artgal. **Contact:** John Lawson, interim director. Estab. 1973. Sponsors 1 exhibit/year. Average display time 2 months. Overall price range $300-2,500.

Making Contact & Terms Buys photos outright.

Submissions Arrange a personal interview to show portfolio. Submit portfolio for review. Send query letter with samples. Send material by mail with SASE by end of October for consideration. Responds in 3 months.

Tips Looks for "quality fine art photography. The gallery does mostly curated, thematic exhibitions. Very few one-person exhibitions."

UNIVERSITY OF RICHMOND MUSEUMS

Richmond VA 23173. (804)289-8276. Fax: (804)287-1894. E-mail: rwaller@richmond.edu. Web site: http://museums.richmond.edu. **Contact:** Richard Waller, director. Estab. 1968. "University Museums comprises Joel and Lila Harnett Museum of Art, Joel and Lila Harnett Print Study Center, and Lora Robins Gallery of Design from Nature." Sponsors 18-20 exhibits/year. Average display time 8-10 weeks.
Exhibits Interested in all subjects.
Making Contact & Terms Charges 10% commission. Work must be framed for exhibition.
Submissions Send query letter with résumé, samples. Send material by mail for consideration. Responds in 1 month.
Tips "If possible, submit material that can be left on file and fits standard letter file. We are a nonprofit university museum interested in presenting contemporary art as well as historical exhibitions."

◼ UNTITLED [ARTSPACE]

1 NE Third St., Oklahoma City OK 73103. E-mail: untitledartspace@1ne3.org. Web site: www.1ne3.org. **Contact:** Lori Deemer, operations director. Alternative space, nonprofit gallery. Estab. 2003. Average display time 6-8 weeks. Open Tuesday, Wednesday, Thursday from 11 to 6; Friday from 11 to 8; Saturday from 11 to 4. "Located in a reclaimed industrial space abandoned by decades of urban flight. Damaged in the 1995 Murrah Federal Building bombing, Untitled [ArtSpace] has emerged as a force for creative thought. As part of the Deep Deuce historic district in downtown Oklahoma City, Untitled [ArtSpace] brings together visual arts, performance, music, film, design and architecture. Our mission is to stimulate creative thought and new ideas through contemporary art. We are committed to providing access to quality exhibitions, educational programs, performances, publications, and to engaging the community in collaborative outreach efforts." Most work sold at $750.
Making Contact & Terms Artwork is accepted on consignment, and there is a 50% commission.
Submissions Mail portfolio for review. Send query letter with artist's statement, bio, résumé, slides, or CD of images. Prefers 10-15 images on a CD. Include SASE for return of materials or permission to file the portfolio. Reviews occur twice annually, in January and July. Finds artists through submissions, portfolio reviews. Responds to queries within 1 week, only if interested.
Tips "Review our previous programming to evaluate if your work is along the lines of our mission. Take the time to type and proof all written submissions. Make sure your best work is represented in the images you choose to show. Nothing takes away from the review like poorly scanned or photographed work."

UPSTREAM PEOPLE GALLERY

5607 Howard St., Omaha NE 68106. (402)991-4741. E-mail: shows@upstreampeoplegallery.com. Web site: www.upstreampeoplegallery.com. **Contact:** Larry Bradshaw, curator. For-profit Internet gallery. Estab. 1998. Approached by 13,000 artists/year; represents or exhibits 1,300 artists. Sponsors 4 photography exhibits/year. Average display time 1 or more years online. Virtual gallery open 24 hours daily. Overall price range $100-125,000. Most work sold at over $300.
Exhibits Exhibits photos of babies/children/teens, couples, multicultural, families, parents, senior citizens, disasters, environmental, landscapes/scenics, wildlife, gardening, interiors/decorating, pets, religious, adventure, automobiles, events, health/fitness/beauty, humor, performing arts, sports, travel, agriculture, military, political, product shots/still life, technology/computers. Interested in alternative process, avant garde, documentary, fine art, historical/vintage, seasonal.
Making Contact & Terms Artwork is accepted on consignment, and there is no commission if the artists sells; there is a 20% commission if the gallery sells. There is an entry fee for space; covers 1 or more years.
Submissions Mail portfolio of slides for review. Send query letter with artist's statement, bio, brochure (optional), résumé, reviews, slides, personal photo. Responds to queries in 1 week. Finds artists through art exhibits, portfolio reviews, referrals by other artists, submissions, word of mouth, Internet.

URBAN INSTITUTE FOR CONTEMPORARY ARTS

41 Sheldon Blvd. SE, Grand Rapids MI 49503. (616)454-7000. Fax: (616)459-9395. E-mail: jteunis@uica.org. Web site: www.uica.org. **Contact:** Janet Teunis, managing director. Alternative space and nonprofit gallery. Estab. 1977. Approached by 250 artists/year; represents or exhibits 20 artists. Sponsors 3-4 photography exhibits/year. Average display time 6 weeks. Gallery open Tuesday through Saturday from 12 to 10; Sunday from 12 to 7. Closed Monday, the month of August, and the week of Christmas and New Year's.

Exhibits Interested in avant garde, fine art.

Submissions Send query letter with artist's statement, bio, résumé, reviews, slides, SASE. Finds artists through submissions.

Tips ''Get submission requirements at www.uica.org/visualArts.html under 'Apply for a Show.' ''

VILLA JULIE COLLEGE GALLERY

1525 Greenspring Valley Rd., Stevenson MD 21153. (443)334-2163. Fax: (410)486-3552. Web site: www.v jc.edu. **Contact:** Diane DiSalvo, director of cultural programs. College/university gallery. Estab. 1997. Sponsors at least 2 photography exhibits/year. Average display time 6 weeks. Gallery open Monday, Tuesday, Thursday, Friday from 11 to 5; Wednesday from 11 to 8; Saturday from 1 to 4. ''Two beautiful spaces.''

Exhibits Interested in alternative process, avant garde, documentary, fine art, historical/vintage. ''We are looking for artwork of substance by artists from the mid-Atlantic region.''

Making Contact & Terms ''We facilitate inquiries directly to the artist.'' Gallery provides insurance. *Accepts artists from mid-Atlantic states only; emphasis on Baltimore artists.*

Submissions Write to show portfolio of slides. Send artist's statement, bio, résumé, reviews, slides, SASE. Responds in 3 months. Finds artists through word of mouth, submissions, portfolio reviews, referrals by other artists.

Tips ''Be clear, concise. Have good representation of your images.''

VIRIDIAN ARTISTS, INC.

530 W. 25th St., #407, New York NY 10001. (212)414-4040. Fax: (212)414-4040. E-mail: info@viridianarti sts.com. Web site: www.viridianartists.com. **Contact:** Barbara Neski, director. Estab. 1968. Sponsors 11 exhibits/year. Average display time 4 weeks. Overall price range $175-10,000. Most work sold at $1,500.

Exhibits Interested in eclectic work in all fine art media including photography, installation, painting, mixed media and sculpture. Interested in alternative process, avant garde, fine art.

Making Contact & Terms Charges 30% commission.

Submissions Will review transparencies and cds only if submitted as part of membership application for representation with SASE. Request information for representation via phone or e-mail or check Web site.

Tips ''Opportunities for photographers in galleries are improving. Broad range of styles being shown in galleries. Photography is getting a large audience that is seemingly appreciative of technical and aesthetic abilities of the individual artists. Present a portfolio (regardless of format) that expresses a clear artistic and aesthetic focus that is unique, individual, and technically outstanding.''

VISUAL ARTS GALLERY

University of Alabama at Birmingham, 1530 Third Ave. S., Birmingham AL 35294-1260. (205)934-0815. Fax: (205)975-2836. E-mail: blevine@uab.edu. Web site: www.uab.edu/art/gallery/vag.html. **Contact:** Brett M. Levine, director/curator. Nonprofit university gallery. Sponsors 1-3 photography exhibits/year. Average display time 3-4 weeks. Gallery open Monday through Thursday from 11 to 6; Friday from 11 to 5; Saturday from 1-5. Closed major holidays and last 2 weeks of December. Located on 1st floor of Humanities Building: 2 rooms with a total of 2,000 sq. ft. and 222 running ft.

Exhibits Exhibits photos of multicultural. Interested in alternative process, avant garde, fine art, historical/vintage.

Making Contact & Terms Gallery provides insurance, promotion. Accepted work should be framed.

Submissions Does not accept unsolicited exhibition proposals. Write to arrange a personal interview to show portfolio of slides. Send query letter with artist's statement, bio, brochure, photographs, résumé, reviews, slides, SASE.

THE WAILOA CENTER GALLERY

P.O. Box 936, Hilo HI 96721. (808)933-0416. Fax: (808)933-0417. E-mail: wailoa@yahoo.com. **Contact:** Ms. Codie King, director. Estab. 1967. Sponsors 24 exhibits/year. Average display time 1 month.

Exhibits Photos must be submitted to director for approval. ''All entries accepted must meet professional standards outlined in our pre-entry forms.''

Making Contact & Terms Gallery receives 10% ''donation'' on works sold. No fee for exhibiting. Accepted work should be framed. ''Photos must also be fully fitted for hanging. Expenses involved in shipping, insurance, invitations and reception, etc., are the responsibility of the exhibitor.''

Submissions Submit portfolio for review. Send query letter with résumé of credits, samples, SASE. Responds in 3 weeks.

Tips "The Wailoa Center Gallery is operated by the State of Hawaii, Department of Land and Natural Resources. We are unique in that there are no costs to the artist to exhibit here as far as rental or commissions are concerned. We welcome artists from anywhere in the world who would like to show their works in Hawaii. Wailoa Center is booked 2-3 years in advance. The gallery is also a visitor information center with thousands of people from all over the world visiting."

WASHINGTON COUNTY MUSEUM OF FINE ARTS

P.O. Box 423, Hagerstown MD 21741. (301)739-5727. Fax: (301)745-3741. E-mail: info@wcmfa.org. Web site: www.wcmfa.org. **Contact:** Curator. Estab. 1929. Approached by 30 artists/year. Sponsors 1 juried photography exhibit/year. Average display time 6-8 weeks. Museum open Tuesday through Friday from 9 to 5; Saturday from 9 to 4; Sunday from 1 to 5. Closed legal holidays. Overall price range $50-7,000.

Exhibits Exhibits photos of babies/children/teens, celebrities, couples, multicultural, families, parents, senior citizens, disasters, environmental, landscapes/scenics, wildlife, architecture, cities/urban, education, gardening, interiors/decorating, pets, religious, rural, adventure, automobiles, entertainment, events, food/drink, health/fitness/beauty, hobbies, humor, performing arts, sports, travel, agriculture, business concepts, industry, medicine, military, political, product shots/still life, science, technology/computers. Interested in alternative process, avant garde, documentary, fashion/glamour, fine art, historical/vintage, seasonal.

Making Contact & Terms Museum provides artist's contact information to potential buyers. Accepted work should not be framed.

Submissions Write to show portfolio of photographs, slides. Mail portfolio for review. Responds in 1 month. Finds artists through word of mouth, portfolio reviews, art exhibits, referrals by other artists.

Tips "We sponsor an annual juried competition in photography. Entry forms are available in October each year. Send name and address to be placed on list."

EDWARD WESTON FINE ART AND PHOTOGRAPHY

(formerly Edward Weston Fine Art), P.O. Box 3098, Chatsworth CA 91313. (818)885-1044. Fax: (818)885-1021. **Contact:** Rachel or Anne. Estab. 1960. Approached by 50 artists/year; represents or exhibits 100 artists. Sponsors 10 photography exhibits/year. Average display time 4-6 weeks. Gallery open Monday through Friday. Overall price range $100-50,000. Most work sold at $1,000.

Exhibits Exhibits photos of celebrities, Hollywood glamour and contemporary photography.

Making Contact & Terms Artwork is accepted on consignment, and there is a 50% commission. Gallery provides contract. Accepted work should be framed, matted. Requires exclusive representation locally.

Submissions Write to arrange a personal interview to show portfolio of photographs, transparencies. Mail slides for review. Send query letter with bio, brochure, business card, photocopies, photographs, reviews.

Tips "Be thorough and complete."

WHITE CANVAS GALLERY

111 S. 14th St., Richmond VA 23219-4127. E-mail: info@whitecanvasgallery.com. Web site: www.whitecanvasgallery.com. **Contact:** Kat Hurst, director. For-profit gallery. Estab. 2004 (formerly Cudahy's Gallery, 1981-2003). Approached by 75 artists/year; represents or exhibits 50 artists. Sponsors 1 photography exhibit/year. Average display time 5 weeks. Open Tuesday through Saturday from 10 to 6; Sunday from 12 to 5. Located on a busy downtown street; free parking for customers.

Exhibits Exhibits photos of architecture, cities/urban, gardening, interiors/decorating, rural, environmental, landscapes/scenics. Interested in fine art and pinhole photography

Making Contact & Terms Artwork is accepted on consignment, and there is a 50% commission. Requires exclusive representation locally. Accepts only artists from the US.

Submissions Write to arrange a personal interview to show portfolio of photographs, slides, CDs. Mail portfolio for review. Send query letter with artist's statement, bio, brochure, business card, photocopies, photographs, résumé, slides, CD, SASE. Finds artists through word of mouth, art exhibits, submissions, art fairs, referrals by other artists. Responds to queries in 4-6 weeks.

Tips "Include list with titles, dimensions, media, price points, résumé/bio, artist's statement. Label slides and photos with title, dimensions, artist's name, media. Include SASE for return of your materials."

WISCONSIN UNION GALLERIES

800 Langdon St., Room 507, Madison WI 53706-1495. (608)262-7592. Fax: (608)262-8862. E-mail: art@union.wisc.edu. Web site: www.union.wisc.edu/art. **Contact:** Christie Wilmot, art committee director. Nonprofit gallery. Estab. 1928. Approached by 100 artists/year; represents or exhibits 20 artists. Average display time 6 weeks. Open Monday through Sunday from 10 to 8. Closed during winter break and when gallery exhibitions turn over. "See our Web site at http://www.union.wisc.edu/art/submit.html to find out more about the galleries' features."

Exhibits Exhibits photos of education. Interested in fine art. "Photography exhibitions vary based on the artist proposals submitted."

Making Contact & Terms All sales through gallery during exhibition only.

Submissions Current submission guidelines available at http://www.union.wisc.edu/art/submit.html. Finds artists through art fairs, art exhibits, referrals by other artists, submissions, word of mouth.

WOMEN & THEIR WORK ART SPACE

1710 Lavaca St., Austin TX 78701. (512)477-1064. Fax: (512)477-1090. E-mail: info@womenandtheirwork.org. Web site: www.womenandtheirwork.org. **Contact:** Katherine McQueen, associate director. Alternative space, nonprofit gallery. Estab. 1978. Approached by more than 400 artists/year; represents or exhibits 8-9 solo and several juried shows. Sponsors 1-2 photography exhibits/year. Average display time 5 weeks. Gallery open Monday through Friday from 9 to 6; Saturday from 12 to 5. Closed December 24 through January 2, and other major holidays. Exhibition space is 2,000 sq. ft. Overall price range $500-5,000. Most work sold at $800-1,000.

Exhibits Interested in contemporary, alternative process, avant garde, fine art.

Making Contact & Terms "We select artists through a juried process and pay them to exhibit. We take 25% commission if something is sold." Gallery provides insurance, promotion, contract. Accepted work should be framed, mounted, matted. ***Texas women in solo shows only.*** "All other artists, male or female, in curated show. Online Artist Slide Registry on Web site."

Submissions Finds artists through annual juried process.

Tips "Provide quality slides, typed résumé and a clear statement of artistic intent."

WOMEN'S CENTER ART GALLERY

UCSB, Student Resource Building 1220, Santa Barbara CA 93106-7190. (805)893-3778. Fax: (805)893-3289. E-mail: sharon.hoshida@sa.ucsb.edu. Web site: ww.sa.ucsb.edu/women'scenter. **Contact:** Sharon Hoshida, program director. Nonprofit gallery. Estab. 1973. Approached by 200 artists/year; represents or exhibits 50 artists. Sponsors 1 photography exhibit/year. Average display time 11 weeks. Open Monday through Thursday from 10 to 9; Friday from 10 to 5. Closed UCSB campus holidays. Exhibition space is roughly 750 sq. ft. Overall price range $10-1,000. Most work sold at $300.

Exhibits Exhibits photos of babies/children/teens, couples, multicultural, families, parents, senior citizens, disasters, environmental, landscapes/scenics, wildlife, architecture, cities/urban, education, interiors/decorating, religious, rural, adventure, entertainment, events, hobbies, humor, performing arts, sports, travel. Interested in alternative process, avant garde, documentary, erotic, fashion/glamour, fine art, historical/vintage, seasonal.

Making Contact & Terms Artwork is accepted on consignment, and there is no commission. Gallery provides insurance, promotion. Accepted work should be framed. Preference given to residents of Santa Barbara County.

Submissions Mail portfolio for review. Send query letter with artist's statement, bio, photocopies, photographs, resume, slides, SASE. Responds within 3 months, only if interested. Finds artists through word of mouth, portfolio reviews, art exhibits, e-mail and promotional calls to artists.

Tips "Complete your submission thoroughly and include a relevent statement pertaining to the specific exhibit."

▣ WORLD FINE ART GALLERY

511 W. 25th St., #803, New York NY 10001-5501. (646)336-1677. Fax: (646)336-6090. E-mail: info@worldfineart.com. Web site: www.worldfineart.com. **Contact:** O'Delle Abney, director. Cooperative gallery. Estab. 1992. Approached by 1,500 artists/year; represents or exhibits 50 artists. Average display time 1 month. Open Tuesday through Saturday from 12 to 6. Closed August. Located in Chelsea, NY; 1,000 sq. ft. Overall price range: $500-5,000. Most work sold at $1,500.

Exhibits Exhibits photos of landscapes/scenics, gardening. Interested in fine art.

Making Contact & Terms There is a rental fee for space. The rental fee covers 1 month or 1 year. Gallery provides insurance, promotion and contract. Accepted work should be framed; must be considered suitable for exhibition.

Submissions Write to arrange a personal interview to show portfolio, or e-mail JPEG images. Responds to queries in 1 week. Finds artists through the Internet.

Tips "Have a Web site available for review."

YESHIVA UNIVERSITY MUSEUM

15 W. 16th St., New York NY 10011. (212)294-8330. Fax: (212)294-8335. E-mail: rwulkan@yum.cjh.org. Web site: www.yumuseum.org. **Contact:** Sylvia A. Herskowitz, director. Estab. 1973. Sponsors 6-8 exhibits/year; at least 1 photography exhibit/year. Average display time 4-6 months. The museum occupies 4 galleries and several exhibition arcades. All galleries are handicapped accessible.

Exhibits Seeks "individual or group exhibits focusing on Jewish themes and interests; exhibition-ready work essential."

Making Contact & Terms Accepts images in digital format. Send CD and accompanying text with SASE for return. Send color slide portfolio of 10-12 slides or photos, exhibition proposal, résumé with SASE for consideration. Reviews take place 3 times/year.

Tips "We exhibit contemporary art and photography based on Jewish themes. We look for excellent quality, individuality, and work that reveals a connection to Jewish identity and/or spirituality."

Art Fairs

Art fairs (also called art festivals or art shows) can provide photographers with a good source of income. If you like to travel and enjoy making prints, matting and framing, you might want to consider this outlet for selling your work. Art fairs are located all over the United States. Many outdoor fairs occur during the spring, summer and fall months to take advantage of warmer temperatures. However, depending on the region, temperatures could be hot and humid, and not all that pleasant! And, of course, there is always the chance of rain. Indoor art fairs held in November and December are popular because they capitalize on the holiday buying season.

To start selling your photographs at art fairs, you will need an inventory of prints. Some should be framed: Even if customers do not buy the framed pieces, at least they can get an idea of how your work looks framed, which could spur sales of your unframed prints. Ideally, all photos should be matted and stored in protective wraps or bags so that customers can look through your inventory without damaging prints and mats. You will also need a canopy or tent to protect yourself and your wares from the elements, as well as some bins in which to store the prints. A display wall will allow you to show off your best, framed prints. Generally, artists will have a 10-ft. by 10-ft. space in which to set up their tents and canopies. Most listings will specify the dimensions of the exhibition space for each artist.

If you see the "loving cup" icon ♥ before a listing, it means that this art fair is a juried event. In other words, there is a selection process artists must go through to be admitted into the fair. Many art fairs have quotas for the categories of exhibitors. For example, one art fair may accept the mediums of photography, sculpture, painting, metal work and jewelry. Once each category fills with qualified exhibitors, no more will be admitted to the show that year. The jurying process also ensures that the artists who sell their work at the fair meet the sponsor's criteria for quality. So, overall, if an art fair is juried, that is a good thing for the artists because it signals that they will be exhibiting their work with artists of equal caliber.

There are fees associated with entering art fairs. Most fairs have an application fee or a space fee, or sometimes both. The space fee is essentially a rental fee for the space your booth will occupy during the art fair's duration. These fees can vary greatly from show to show, so be sure to check this information in each listing before you apply to any art fair.

Most art fair sponsors want to exhibit only work that is handmade by the artist, no matter what medium. Unfortunately, some people try to sell work that they purchased elsewhere as their own original artwork. In the art fair trade, this is known as "buy/sell." It is an undesirable situation since it tends to bring down the quality of the whole show. Some listings will make a point to say "no buy/sell" or "no manufactured work."

Some photographers travel extensively around the United States to participate in art fairs. That can become very expensive, and those photographers want to be sure they will make enough profit to offset their travel expenses. For photographers just starting to sell at art fairs, however, it is probably best for them to stay in their own state or region. For that reason, the art fair listings on the following pages are divided into geographic regions.

Regions

Important

- **Northeast & Midatlantic:** Connecticut, Delaware, Maine, Maryland, Massachusetts, New Hampshire, New Jersey, New York, Pennsylvania, Rhode Island, Vermont, Washington DC.

- **Midsouth & Southeast:** Alabama, Arkansas, Florida, Georgia, Louisiana, Mississippi, North Carolina, South Carolina, Tennessee, Virginia, West Virginia.

- **Midwest & North Central:** Illinois, Indiana, Iowa, Kentucky, Michigan, Minnesota, Nebraska, North Dakota, Ohio, South Dakota, Wisconsin.

- **South Central & West:** Arizona, California, Colorado, Hawaii, Kansas, Missouri, Nevada, New Mexico, Oklahoma, Texas, Utah.

- **Northwest & Canada:** Alaska, Canada, Idaho, Montana, Oregon, Washington, Wyoming.

Art Fairs

NORTHEAST & MIDATLANTIC

☑ ALLENTOWN ART FESTIVAL

P.O. Box 1566, Ellicott Station, Buffalo NY 14205-1566. (716)881-4269. E-mail: allentownartfestival@veri zon.net. Web site: www.allentownartfestival.com. **Contact:** Mary Myszkiewicz, president. Estab. 1958. Fine arts & crafts show held annually 2nd full weekend in June. Outdoors. Accepts photography, painting, watercolor, drawing, graphics, sculpture, mixed media, clay, glass, acrylic, jewelry, creative craft (hard/ soft). Slides juried by hired professionals that change yearly. Awards/prizes: $17,925 in 40 cash prizes; Best of Show. Number of exhibitors: 450. Public attendance: 300,000. Free to public. Artists should apply by downloading application from Web site. Deadline for entry: January 31. Application fee: $15. Space fee: $250. Exhibition space: 13×10 ft. For more information artists should e-mail, visit Web site, call or send SASE.

Tips "Artists must have attractive booth and interact with the public."

☑ ART IN THE HEART OF THE CITY

171 East State St., Ithaca NY 14850. (607)277-8679. Fax: (607)277-8691. E-mail: phil@downtownithaca.c om. Web site: www.downtownithaca.com. **Contact:** Phil White, office manager/event coordinator. Estab. 1999. Sculpture exhibition held annually in early June. Primarily outdoors; limited indoor pieces. Accepts photography, wood, ceramic, metal, stone. Juried by our Public Arts Commission. Number of exhibitors: 28-35. Public attendance: 100,000+. Free to public. Artists should apply by submitting application, artist statement, slides/photos. Deadline for entry: May. Exhibitions space depends on placement. For more information artists should e-mail.

Tips "Be sure there is a market and interest for your work, and advertise early."

☑ ART IN THE PARK SUMMER AND FALL FOLIAGE FESTIVALS

(formerly Art in the Park Fall Foliage Festival), sponsored by the Chaffee Center for the Visual Arts. 16 S. Main St., Rutland VT 05701. (802)775-0356. Fax: (802)773-4401. E-mail: beyondmarketing@yahoo.c om. Web site: www.chaffeeartcenter.org. **Contact:** Sherri Birkheimer, event coordinator. Estab. 1961. Fine arts & crafts show held biannually: Art in the Park Summer Festival held 2nd weekend in August (Saturday and Sunday); Art in the Park Fall Foliage Festival held on Columbus Day weekend (Saturday and Sunday). Outdoors. Accepts photography, clay, fiber, floral, glass, wood, jewelry, soaps and baskets. Juried by a panel of 10-15 judges. Submit 3 slides (2 of artwork and 1 of booth display). Number of exhibitors: 130. Public attendance: 7,000-9,000. Public admission: voluntary donation. Artists should apply by visiting Web site for application. Deadline for entry: "Ongoing jurying, but to receive discount for doing both shows, March 31." Space fee: $135-310. Exhibition space: 10×12 ft. and 20×12 ft. For more information, artists should e-mail, visit Web site, call.

Tips "Have a good presentation and variety, if possible (in pricing also), to appeal to a large group of people."

ART'S ALIVE

200-125th St. & the Bay, Ocean City MD 21842-2247. (410)250-0125. Fax: (410)250-5409. E-mail: Bmoore @ococean.com. Web site: www.ococean.com. **Contact:** Brenda Moore, event coordinator. Estab. 2000. Fine art show held annually in mid-June. Outdoors. Accepts photography, ceramics, drawing, fiber, furniture, glass, printmaking, jewelry, mixed media, painting, sculpture, fine wood. Juried. Awards/ prizes: $5,000 in cash prizes. Number of exhibitors: 110. Public attendance: 10,000. Free to pubic. Artists should apply by downloading application from Web site or call. Deadline for entry: February 28. Space fee: $75. Exhibition space: 12×12 ft. For more information, artists should e-mail, visit Web site, call or send SASE.

Tips "Apply early."

Ⓝ ☑ ARTS ON FOOT

Downtown DC BID, 1250 H St., NW, Suite 1000, Washington DC 20005. (202)661-7592. E-mail: ashley@d owntowndc.org. Web site: www.artsonfoot.org. **Contact:** Ashley Neeley. Fine arts & crafts show held annually in September. Outdoors. Accepts photography, painting, sculpture, fiber art, furniture, glass, jewelry, leather. Juried by 5 color images of the artwork. Send images as 35mm slides, TIFF or JPEG files on CD or DVD. Also include artist's résumé and SASE for return of materials. Free to the public. Deadline for entry: July. Exhibition space: 10×10 ft. "Arts on Foot will pay participating artists a $25 gratuity to

help cover out-of-pocket expenses (such as transportation and food) each artist may incur during Arts on Foot.'' For more information, artists should call, e-mail, visit Web site.

⚑ CHATSWORTH CRANBERRY FESTIVAL

P.O. Box 286, Chatsworth NJ 08019-0286. (609)726-9237. Fax: (609)726-1459. E-mail: lgiamalis@aol.com. Web site: www.cranfest.org. **Contact:** Lynn Giamalis, chairperson. Estab. 1983. Arts & crafts show held annually in October. Outdoors. Accepts photography. Juried. Number of exhibitors: 200. Public attendance: 75,000-100,000. Free to public. Artists should apply by sending SASE to above address. Deadline for entry: September 1. Space fee: $200. Exhibition space: 15×15 ft. For more information, artists should visit Web site.

CHRISTMAS CRAFT SHOW

5989 Susquehanna Plaza Dr., York PA 17406. (717)764-1155, ext.1243. Fax: (717)252-4708. E-mail: joe.alfano@cumulus.com. Web site: www.warm103.com. **Contact:** Joe Alfano, director of special events. Estab. 1985. Arts & crafts show held annually in early December. Indoors. Accepts photography and all hand crafts. Number of exhibitors: 250. Public attendance: 3,000. Public admission: $3. Artists should apply by visiting Web site or calling or mailing for an entry form. Space fee: $95. Exhibition space: 10×10 ft. Average gross sales/exhibitor: $1,000-$2,000. For more information, artists should e-mail, visit Web site or call.

- York Craft Shows also sponsors the Codorus Summer Blast in late June. See listing for this event in this section.

Ⓝ ⚑ CHRISTMAS CRAFTS EXPOS I & II

P.O Box 227, North Granby CT 06060. (860)653-6671. Fax: (860)653-6858. E-mail: acf@handmadeinamerica.com. Web site: www.handmadeinamerica.com. **Contact:** Joanne McAulay, president. Estab. 1971. Fine arts & crafts holiday show held annually 1st 2 weekends in December. Indoors. Accepts photography, metal, fiber, pottery, glass, wood, jewelry, pen & ink. Juried by 6 product slides or photos, 1 booth photo, and 1 studio or shop photo (where the art is made). Number of exhibitors: 200. Public attendance: 10,000. Public admission: $7. Artists should apply by calling for an application or by downloading one from Web site. Deadline for entry: Applications are juried and space sold until sold out. Space fee: $420-$650. Exhibition space: 10×10 ft.; 10×15 ft.; 10×20 ft. For more information, artists should e-mail, visit Web site, send SASE.

Tips ''Look at current market trends and economics. Have a unique and presentable booth. Be personable and friendly to customers.''

CODORUS SUMMER BLAST

Codorus State Park, Hanover PA 17313. (717)764-1155, ext.1243. Fax: (717)252-4708. E-mail: joe.alfano@cumulus.com. Web site: www.warm103.com. **Contact:** Joe Alfano, marketing/promotions. Estab. 2000. Arts & crafts show held annually in late June. Accepts photography and all crafts. Number of exhibitors: 50. Public attendance: 15,000. Free to the public. Artists should apply on Web site or through the mail. Space fee: $85. Exhibition space: 20×20 ft. Average gross sales/exhibitor: $1,000-2,000. For more information, artists should e-mail, visit Web site or call.

- York Craft Shows also sponsors Christmas Craft Show in mid-December. See listing for this event in this section.

⚑ COLORSCAPE CHENANGO ARTS FESTIVAL

P.O. Box 624, Norwich NY 13815. (607)336-3378. E-mail: info@colorscape.org. Web site: www.colorscape.org. **Contact:** Peggy Finnegan, festival director. Estab. 1995. Fine arts & crafts show held annually the weekend after Labor Day. Outdoors. Accepts photography and all types of mediums. Juried. Awards/prizes: $5,000. Number of exhibitors: 80-85. Public attendance: 14,000-16,000. Free to public. Deadline for entry: March. Application fee: $15/jury fee. Space fee: $150. Exhibition space: 12×12 ft. For more information, artists should e-mail, visit Web site, call or send SASE.

Tips ''Interact with your audience. Talk to them about your work and how it is created. Don't sit grumpily at the rear of your booth reading a book. People like to be involved in the art they buy and are more likely to buy if you involve them.''

⚏ ⚏ CRAFT FAIR AT THE BAY

Castleberry Fairs & Festivals, 38 Charles St., Rochester NH 03867. (603)332-2616. E-mail: info@castleberr yfairs.com. Web site: www.castleberryfairs.com. **Contact:** Terry Mullen, event coordinator. Estab. 1988. Arts & crafts show held annually 3rd weekend in July in Alton, New Hampshire. Outdoors. Accepts photography and all other mediums. Juried by photo, slide or sample. Number of exhibitors: 85. Public attendance: 7,500. Free to the public. Artists should apply by downloading application from Web site. Deadline for entry: until full. Space fee: $250. Exhibition space: 100 sq. ft. Average gross sales/exhibitor: "Generally, this is considered an 'excellent' show, so I would guess most exhibitors sell ten times their booth fee, or in this case, at least $2,500 in sales." For more information, artists should visit Web site. **Tips** "Do not bring a book; do not bring a chair. Smile and make eye contact with everyone who enters your booth. Have them sign your guest book; get their e-mail address so you can let them know when you are in the area again. And, finally, make the sale—they are at the fair to shop, after all."

⚏ CRAFTS AT RHINEBECK

6550 Springbrook Ave., Rhinebeck NY 12572. (845)876-4001. Fax: (845)876-4003. E-mail: vimperati@dut chessfair.com. Web site: www.craftsatrhinebeck.com. **Contact:** Vicki Imperati, event coordinator. Estab. 1981. Fine arts & crafts show held biannually in late June and early October. Indoors and outdoors. Accepts photography, fine art, ceramics, wood, mixed media, leather, glass, metal, fiber, jewelry. Juried by 3 slides of work and 1 of booth display. Number of exhibitors: 350. Public attendance: 25,000. Public admission: $7. Artists should apply by calling for application or downloading application from Web site. Deadline for entry: February 1. Application fee: $20. Space fee: $300-730. Exhibition space: inside: 10×10 ft. and 10×20 ft.; outside: 15×15 ft. For more information, artists should e-mail, visit Web site or call. **Tips** "Presentation of work within your booth is very important. Be approachable and inviting."

⚏ ⚏ ELMWOOD AVENUE FESTIVAL OF THE ARTS, INC.

P.O. Box 786, Buffalo NY 14213. (716)830-2484. Fax: (716)885-2197. E-mail: directoreafa@aol.com. Web site: www.elmwoodartfest.org. **Contact:** Joe DePasquale. Estab. 2000. Arts & crafts show held annually in late-August, the weekend before Labor Day weekend. Outdoors. Accepts photography, metal, fiber, ceramics, glass, wood, jewelry, basketry, 2D media. Juried. Awards/prizes: to be determined. Number of exhibitors: 170. Public attendance: 80,000-120,000. Free to the public. Artists should apply by e-mailing their contact information or by downloading application from Web site. Deadline for entry: April. Application fee: $20. Space fee: $200. Exhibition space: 150 sq. ft. Average gross sales/exhibitor: $2,700. For more information, artists should e-mail, visit Web site, call, send SASE. **Tips** "Make sure your display is well designed, with clean lines that highlight your work. Have a variety of price points—even wealthy people don't always want to spend $500 at a booth where they may like the work."

⚏ A FAIR IN THE PARK

Box Heart Gallery, 4523 Liberty Ave., Pittsburgh PA 15224. (412)687-8858. Fax: (412)687-6338. E-mail: boxheartexpress@earthlink.net. Web site: www.craftsmensguild.org. **Contact:** Nicole Capozzi, director. Estab. 1969. Contemporary fine arts & crafts show held annually the weekend after Labor Day. Outdoors. Accepts photography, clay, fiber, jewelry, metal, mixed media, wood, glass, 2D visual arts. Juried. Awards/prizes: 1 Best of Show and 4 Craftsmen's Guild Awards. Number of exhibitors: 115. Public attendance: 25,000+. Free to public. Artists should apply by sending application with jury fee, booth fee and 5 slides. Deadline for entry: May 1. Application fee: $20. Space fee: $250-300. Exhibition space: 11×12 ft. Average gross sales/exhibitor: $900-3,000. For more information artists should e-mail, visit Web site or call. **Tips** "It is very important for artists to present their work to the public, to concentrate on the business aspect of their artist career. They will find that they can build a strong customer/collector base by exhibiting their work and by educating the public about their artistic process and passion for creativity."

⚏ ⚏ FALL CRAFTS AT LYNDHURST

P.O. Box 28, Woodstock NY 12498. (845)331-7900. Fax: (845)331-7484. E-mail: crafts@artrider.com. Web site: www.craftsatlyndhurst.com; www.artrider.com. **Contact:** Laura Kandel. Estab. 1984. Fine arts & crafts show held annually in mid-September. Outdoors. Accepts photography, wearable and nonwear-able fiber, metal and nonmetal jewelry, clay, leather, wood, glass, painting, drawing, prints, mixed media. Juried by 5 images of work and 1 of booth, viewed sequentially. Number of exhibitors: 325. Public

attendance: 20,000. Public admission: $10. Artists should apply by downloading application from www.ar trider.com or can apply online at www.zapplication.org. Deadline for entry: January. Application fee: $45. Space fee: $750. Exhibition space: 10×10. For more information, artists should e-mail, visit Web site, call.

N ⬛ FALL FINE ART & CRAFTS AT BROOKDALE PARK

Watchung Ave., Montclair NJ. (908)874-5247. Fax: (908)874-7098. E-mail: rosesquared@patmedia.com. Web site: www.rosesquared.com. **Contact:** Janet Rose, president. Estab.1997. Fine arts & craft show held annually in mid-October. Outdoors. Accepts photography and all other mediums. Juried. Number of exhibitors: 180. Public attendance: 14,000. Free to the public. Artists should apply by downloading application from Web site or call for application. Deadline: 1 month before show date. Application fee: $15. Space fee: $310. Exhibition space: 120 sq. ft. For more information, artists should e-mail, visit Web site, call.

Tips "Create a professional booth that is comfortable for the customer to enter. Be informative, friendly and outgoing. People come to meet the artist."

N ⬛ FALL FINE ART & CRAFTS AT NOMAHEGAN PARK

Springfield Ave, Cranford NJ. (908)874-5247. Fax: (908)874-7098. E-mail: rosesquared@patmedia.com. Web site: www.rosesquared.com. **Contact:** Janet Rose, president. Estab.1986. Fine arts & craft show held annually in October. Outdoors. Accepts photography and all other mediums. Juried. Number of exhibitors: 110. Public attendance: 12,000. Free to the public. Artists should apply by downloading application from Web site or call for application. Deadline: 1 month before show date. Application fee: $15. Space fee: $310. Exhibition space: 120 sq. ft. For more information, artists should e-mail, visit Web site, call.

Tips "Create a professional booth that is comfortable for the customer to enter. Be informative, friendly and outgoing. People come to meet the artist."

N ⬛ FINE ART & CRAFTS AT ANDERSON PARK

N. Mountain Ave., Upper Montclair NJ. (908)874-5247. Fax: (908)874-7098. E-mail: rosesquared@patmedia.net. Web site: www.rosesquared.com. **Contact:** Janet Rose, president. Estab.1984. Fine arts & craft show held annually in mid-September. Outdoors. Accepts photography and all other mediums. Juried. Number of exhibitors: 190. Public attendance: 16,000. Free to the public. Artists should apply by downloading application from Web site or call for application. Deadline: 1 month before show date. Application fee: $15. Space fee: $310. Exhibition space: 120 sq. ft. For more information, artists should e-mail, visit Web site, call.

Tips "Create a professional booth that is comfortable for the customer to enter. Be informative, friendly and outgoing. People come to meet the artist."

N ⬛ FINE ART & CRAFTS AT NOMAHEGAN PARK

Springfield Ave., Cranford NJ. (908)874-5247. Fax: (908)874-7098. E-mail: rosesquared@patmedia.com. Web site: www.rosesquared.com. **Contact:** Janet Rose, president. Estab. 1987. (908)874-5247. Fax: (908)874-7098. E-mail: rosesquared@patmedia.net. Web site: www.rosesquared.com. Fine arts & craft show held annually in early June. Outdoors. Accepts photography and all other mediums. Juried. Number of exhibitors: 110. Public attendance: 12,000. Free to the public. Artists should apply by downloading application from Web site or call for application. Deadline: 1 month before show date. Application fee: $15. Space fee: $310. Exhibition space: 120 sq. ft. For more information, artists should e-mail, visit Web site, call.

Tips "Create a professional booth that is comfortable for the customer to enter. Be informative, friendly and outgoing. People come to meet the artist."

N ⬛ FINE ART & CRAFTS FAIR AT VERONA PARK

Verona Park NJ. (908)874-5247. Fax: (908)874-7098. E-mail: rosesquared@patmedia.net. Web site: www.rosesquared.com. **Contact:** Janet Rose, president. Estab.1986. Fine arts & craft show held annually in May. Outdoors. Accepts photography and all other mediums. Juried. Number of exhibitors: 140. Public attendance: 14,000. Free to the public. Artists should apply by downloading application from Web site or call for application. Deadline: 1 month before show date. Application fee: $15. Space fee: $310. Exhibition space: 120 sq. ft. For more information, artists should e-mail, visit Web site, call.

Tips "Create a professional booth that is comfortable for the customer to enter. Be informative, friendly and outgoing. People come to meet the artist."

⬛ GARRISON ART CENTER FINE ART & CRAFT FAIR

P.O. Box 4, 23 Camison's Landing, Garrison NY 10524. (845)424-3960. Fax: (845)424-3960. E-mail: gac@ highlands.com. Web site: www.garrisonartcenter.org. Estab. 1969. **Contact:** Libby Turnock, executive director. Fine arts & crafts show held annually 3rd weekend in August. Outdoors. Accepts all mediums. Juried by a committee of artists and community members. Number of exhibitors: 75. Public attendance: 10,000. Public admission: suggested donation of $5. Artists should call for application form or download from Web site. Deadline for entry: April. Application fee: $15. Space fee: $245; covered corner booth: $265. Exhibition space: 10×10 ft. For more information, artists should e-mail, visit Web site, call, send SASE.

Tips "Have an inviting booth and be pleasant and accessible. Don't hide behind your product—engage the audience."

ⓝ ⬛ GLOUCESTER WATERFRONT FESTIVAL

Castleberry Fairs & Festivals, 38 Charles St., Rochester NH 03867. (603)332-2616. E-mail: info@castelberr yfairs.com. Web site: www.castelberryfairs.com. **Contact:** Terry Mullen, events coordinator. Estab. 1971. Arts & crafts show held 3rd weekend in August in Gloucester, Massachusettes. Outdoors. Accepts photography and all other mediums. Juried by photo, slide or sample. Number of exhibitors: 300. Public attendance: 50,000. Free to the public. Artists should apply by downloading application from Web site. Deadline for entry: until full. Space fee: $350. Exhibition space: 100 sq. ft. Average gross sales/exhibitor: "Generally, this is considered an 'excellent' show, so I would guess most exhibitors sell ten times their booth fee, or in this case, at least $3,500 in sales." For more information, artists should visit Web site.

Tips "Do not bring a book; do not bring a chair. Smile and make eye contact with everyone who enters your booth. Have them sign your guest book; get their e-mail address so you can let them know when you are in the area again. And, finally, make the sale—they are at the fair to shop, after all."

ⓝ ⬛ GUNSTOCK SUMMER FESTIVAL

Castleberry Fairs & Festivals, 38 Charles St., Rochester NH 03867. (603)332-2616. E-mail: info@castelberr yfairs.com. Web site: www.astelberryfairs.com. **Contact:** Terry Mullen, events coordinator. Estab. 1971. Arts & crafts show held annually the weekend before the Fourth of July in Gilford, New Hampshire. Indoors and outdoors. Accepts photography and all other mediums. Juried by photo, slide or sample. Number of exhibitors: 100. Public attendance: 10,000. Free to the public. Artists should apply by downloading application from Web site. Deadline for entry: until full. Space fee: $200. Exhibition space: 100 sq. ft. For more information, artists should visit Web site.

Tips "Do not bring a book; do not bring a chair. Smile and make eye contact with everyone who enters your booth. Have them sign your guest book; get their e-mail address so you can let them know when you are in the area again. And, finally, make the sale—they are at the fair to shop, after all."

ⓝ ⬛ HOLIDAY CRAFTS AT MORRISTOWN

P.O. Box 28, Woodstock NY 12498. (845)331-7900. Fax: (845)331-7484. E-mail: crafts@artrider.com. Web site: www.craftsatmorristown.com; www.artrider.com. **Contact:** Laura Kandel. Estab. 1990. Fine arts & crafts show held annually in early December. Indoors. Accepts photography, wearable and non-wearable fiber, metal and nonmetal jewelry, clay, leather, wood, glass, painting, drawing, prints, mixed media. Juried by 5 images of work and 1 of booth, viewed sequentially. Number of exhibitors: 165. Public attendance: 5,000. Public admission: $7. Artists should apply by downloading application from www.artrider.com or can apply online at www.zapplication.org. Deadline for entry: January. Application fee: $45. Space fee: $475. Exhibition space: 10×10. For more information, artists should e-mail, visit Web site, call.

HOME, CONDO AND GARDEN ART & CRAFT FAIR

P.O. Box 486, Ocean City MD 21843. (410)524-7020. Fax: (410)524-0051. E-mail: oceanpromotions@beac hin.net. Web site: www.oceanpromotions.info. **Contact:** Mike, promoter; Starr, assistant. Estab. 1984. Fine arts & crafts show held annually in March. Indoors. Accepts photography, carvings, pottery, ceramics, glass work, floral, watercolor, sculpture, prints, oils, pen & ink. Number of exhibitors: 125. Public attendance: 18,000. Public admission: $7/adults; $6/seniors & students; 13 and under free. Artists should

apply by e-mailing request for info and aplication. Deadline for entry: Until full. Space fee: $250. Exhibition space: 10×8 ft. For more information, artists should e-mail, visit Web site or call.

N M MEMORIAL WEEKEND ARTS & CRAFTS FESTIVAL

Castleberry Fairs & Festivals. 38 Charles St., Rochester NH 03867. (603)332-2616. E-mail: info@castleberryfairs.com. Web site: www.castleberryfairs.com. **Contact:** Terry Mullen, event coordinator. Estab. 1989. Arts & crafts show held annually on Memorial Day weekend in Meredith, New Hampshire. Outdoors. Accepts photography and all other mediums. Juried by photo, slide or sample. Number of exhibitors: 85. Public attendance: 7,500. Free to the public. Artists should apply by downloading application from Web site. Deadline for entry: until full. Space fee: $300. Exhibition space: 100 sq. ft. Average gross sales/exhibitor: "Generally, this is considered an 'excellent' show, so I would guess most exhibitors sell ten times their booth fee, or in this case, at least $3,000 in sales." For more information, artists should visit Web site.

Tips "Do not bring a book; do not bring a chair. Smile and make eye contact with everyone who enters your booth. Have them sign your guest book; get their e-mail address so you can let them know when you are in the area again. And, finally, make the sale—they are at the fair to shop, after all."

MONTAUK POINT LIONS CLUB

P.O. Box 683, Montauk NY 11954. (631)668-5300. Fax: (631)668-1214. **Contact:** John McDonald, chairman. Estab. 1970. Arts & crafts show held annually Labor Day weekend. Outdoors. Accepts photography, arts & crafts. Number of exhibitors: 100. Public attendance: 1,000. Free to public. Artists should apply by mail. Deadline for entry: Labor Day Saturday. Application fee: $125. Exhibition space: 100 sq. ft. For more information, artists should send SASE.

N M MOUNT GRETNA OUTDOOR ART SHOW

P.O. Box 637, Mount Gretna PA 17064. (717)964-3270. Fax: (717)964-3054. E-mail: mtgretnaart@comcast.net. Web site: www.mtgretnaarts.com. **Contact:** Linda Bell, show committee chairperson. Estab. 1974. Fine arts & crafts show held annually 3rd full weekend in August. Outdoors. Accepts photography, oils, acrylics, watercolors, mixed media, jewelry, wood, paper, graphics, sculpture, leather, clay/porcelain. Juried by 4 professional artists who assign each applicant a numeric score. The highest scores in each medium are accepted. Awards/prizes: Judges' Choice Awards: 30 artists are invited to return the following year, jury exempt; the top 10 are given a monetary award of $200. Number of exhibitors: 260. Public attendance: 15,000-19,000. Public admission: $7; children under 12: free. Artists should apply via www.zapplication.org. Deadline for entry: April. Application fee: $15 jury fee. Space fee: $275. Exhibition space: 10×10 ft. For more information, artists should e-mail, visit Web site, call.

N M NEW ENGLAND CRAFT & SPECIALTY FOOD FAIR

Castleberry Fairs & Festivals, 38 Charles Rd., Rochester NH 03867. (603)332-2616. E-mail: info@castleberryfairs.com. Web site: www.castleberryfairs.com. **Contact:** Terry Mullen, event coordinator. Estab. 1995. Arts & crafts show held annually on Veteran's Day weekend in Salem, New Hampshire. Indoors. Accepts photography and all other mediums. Juried by photo, slide or sample. Number of exhibitors: 200. Public attendance: 15,000. Free to the public. Artists should apply by downloading application from Web site. Deadline for entry: until full. Space fee: $300. Exhibition space: 100 sq. ft. Average gross sales/exhibitor: "Generally, this is considered an 'excellent' show, so I would guess most exhibitors sell ten times their booth fee, or in this case, at least $3,000 in sales." For more information, artists should visit Web site.

Tips "Do not bring a book; do not bring a chair. Smile and make eye contact with everyone who enters your booth. Have them sign your guest book; get their e-mail address so you can let them know when you are in the area again. And, finally, make the sale—they are at the fair to shop, after all."

NORTH CONGREGATIONAL PEACH FAIR

17 Church St., New Hartford CT 06057. (860)379-2466. Estab. 1996. Arts & crafts show held annually in mid-August. Outdoors. Accepts photography, most arts and crafts. Number of exhibitors: 50. Public attendence: 500-2,000. Free to public. Artists should call for application form. Deadline for entry: August. Application fee: $60. Exhibition space: 11×11 ft.

Tips "Be prepared for all kinds of weather."

◪ PARADISE CITY ARTS FESTIVALS

30 Industrial Dr. E., Northampton MA 01060-2351. (800)511-9725. Fax: (413)587-0966. E-mail: artist@pa radisecityarts.com. Web site: www.paradisecityarts.com. **Contact:** Katherine Sanderson. Estab. 1995. Five fine arts & crafts shows held annually in March, April, May, October and November. Indoors. Accepts photography, all original art and fine craft media. Juried by 5 slides or digital images of work and an independent board of jury advisors. Number of exhibitors: 150-275. Public attendance: 5,000-20,000. Public admission: $12. Artists should apply by submitting name and address to be added to mailing list or print application from Web site. Deadline for entry: September 20th and April 1. Application fee: $30. Space fee: $650-1,500. Exhibition space: 10×10 ft.-10×20 ft. For more information, artists should e-mail, visit Web site or call.

◪ PAWLING ARTS & CRAFTS FESTIVAL

115 Chas. Colman Blvd., Pawling NY 12564-1120. (845)855-5626. Fax: (845)855-1798. **Contact:** Verna Carey, chairman. Estab. 1991. Arts & crafts show held annually in late September. Accepts photography, handcrafts. No kit work. Juried.

◪ PETERS VALLEY CRAFT FAIR

19 Kuhn Rd., Layton NJ 07851.(973)948-5200. Fax: (973)948-0011. E-mail: pv@warwick.net. Web site: www.petersvalley.org. **Contact:** Mikal Brutzman, craft fair coordinator. Estab. 1970. Arts & crafts show held annually in late September at the Sussex County Fair Grounds in Augusta, New Jersey. Indoors. Accepts photography, ceramics, fiber, glass, basketry, metal, jewelry, sculpture, printmaking, paper book art, drawing, painting. Juried. Awards/prizes: cash awards. Number of exhibitors: 160. Public attendance: 7,000-10,000. Public admission: $7. Artists should apply by downloading application from Web site. Deadline for entry: May 30. Jury fee: $25. Space fee: $350. Exhibition space: 10×10 ft. Average gross sales/exhibitor: $2,000-3,000. For more information artists should e-mail, visit Web site, call or send SASE.

Tips ''Have fun, have an attractive booth design and a diverse price range.''

◪ QUAKER ARTS FESTIVAL

P.O. Box 202, Orchard Park NY 14127. (716)677-2787. **Contact:** Randy Kroll, chairman. Estab. 1961. Fine arts & crafts show held annually in September. Outdoors. Accepts photography, painting, graphics, sculpture, crafts. Juried by 4 panelists during event. Awards/prizes: over $10,000 total cash prizes. Number of exhibitors: 330. Public attendance: 75,000. Free to the public. Artists should apply by sending SASE. Deadline for entry: August. Space fee: $175. Exhibition space: 10×12 ft. For more information, artists should call, send SASE.

Tips ''Have an inviting booth and be pleasant and accessible. Don't hide behind your product—engage the audience.''

◪ ◪ SPRING CRAFTS AT LYNDHURST

P.O. Box 28, Woodstock NY 12498. (845)331-7900. Fax: (845)331-7484. E-mail: crafts@artrider.com. Web site: www.craftsatlyndhurst.com; www.artrider.com. **Contact:** Laura Kandel. Estab. 1984. Fine arts & crafts show held annually in mid-May. Outdoors. Accepts photography, wearable and nonwearable fiber, metal and nonmetal jewelry, clay, leather, wood, glass, painting, drawing, prints, mixed media. Juried by 5 images of work and 1 of booth, viewed sequentially. Number of exhibitors: 300. Public attendance: 20,000. Public admission: $10. Artists should apply by downloading application from www.ar trider.com or can apply online. Deadline for entry: January 4. Application fee: $45. Space fee: $750. Exhibition space: 10×10. For more information, artists should e-mail, visit Web site, call.

◪ ◪ SPRING CRAFTS AT MORRISTOWN

P.O. Box 28, Woodstock NY 12498. (845)331-7900. Fax: (845)331-7484. E-mail: crafts@artrider.com. Web site: www.craftsatmorristown.com; www.artrider.com. **Contact:** Laura Kandel. Estab. 1990. Fine arts & crafts show held annually in mid-March. Indoors. Accepts photography, wearable and nonwearable fiber, metal and nonmetal jewelry, clay, leather, wood, glass, painting, drawing, prints, mixed media. Juried by 5 images of work and 1 of booth, viewed sequentially. Number of exhibitors: 165. Public attendance: 5,000. Public admission: $7. Artists should apply by downloading application from www.artri der.com or apply online at www.zapplication.org. Deadline for entry: January 4. Application fee: $45. Space fee: $475. Exhibition space: 10×10 ft. For more information, artists should e-mail, visit Web site, call.

Ⓝ Ⓜ SPRING FINE ART & CRAFTS AT BROOKDALE PARK

Watchung Ave., Montclair NJ. (908)874-5247. Fax: (908)874-7098. E-mail: rosesquared@patmedia.net. Web site: www.rosesquared.com. **Contact:** Janet Rose, president. **Contact:** Estab.1988. Fine arts & craft show held annually in mid-June. Outdoors. Accepts photography and all other mediums. Juried. Number of exhibitors: 180. Public attendance: 16,000. Free to the public. Artists should apply by downloading application from Web site or call for application. Deadline: 1 month before show date. Application fee: $15. Space fee: $310. Exhibition space: 120 sq. ft. For more information, artists should e-mail, visit Web site, call.

Tips "Create a professional booth that is comfortable for the customer to enter. Be informative, friendly and outgoing. People come to meet the artist."

SPRINGFEST AND SEPTEMBERFEST

P.O. Box 677, Nyack NY 10960-0677. (845)353-2221. Fax: (845)353-4204. Web site: www.nyack-ny.com. **Contact:** Lorie Reynolds, executive director. Estab. 1980. Arts & crafts show held annually in April and September. Outdoors. Accepts photography, pottery, jewelry, leather, clothing. Number of exhibitors: 220. Public attendance: 30,000. Free to public. Artists should apply by submitting application, fees, permits, photos of product and display. Deadline for entry: 15 days before show. Space fee: $175. Exhibition space: 10×10 ft. For more information, artists should visit Web site, call or send SASE.

Ⓝ Ⓜ SUMMER ARTS & CRAFTS FESTIVAL

Castleberry Fairs & Festivals, 38 Charles St., Rochester NH 03867. (603)332-2616. E-mail: info@castleberr yfairs.com. Web site: www.castleberryfairs.com. **Contact:** Terry Mullen, events coordinator. Estab. 1992. Arts & crafts show held annually 2nd weekend in August in Lincoln, New Hampshire. Outdoors. Accepts photography and all other mediums. Juried by photo, slide or sample. Number of exhibitors: 100. Public attendance: 7,500. Free to the public. Artists should apply by downloading application from Web site. Deadline for entry: until full. Space fee: $200. Exhibition space: 100 sq. ft. For more information, artists should visit Web site.

Tips "Do not bring a book; do not bring a chair. Smile and make eye contact with everyone who enters your booth. Have them sign your guest book; get their e-mail address so you can let them know when you are in the area again. And, finally, make the sale—they are at the fair to shop, after all."

Ⓜ SYRACUSE ARTS & CRAFTS FESTIVAL

109 S. Warren St. #1900, Syracuse NY 13202. (315)422-8284. Fax: (315)471-4503. E-mail: mail@downtow nsyracuse.com. Web site: www.syracuseartsandcraftsfestival.com. **Contact:** Laurie Reed, festival director. Estab. 1970. Fine arts & crafts show held annually in July. Outdoors. Accepts photography, ceramics, fabric/fiber, glass, jewelry, leather, metal, wood, computer art, drawing, printmaking, painting. Juried by 4 independent jurors. Jurors review 4 slides of work and 1 slide of booth display. Awards/prizes: $5,000, Award of Distinction/Medium, Best of Show, Best of Display and Honorable Mentions. Number of exhibitors: 170. Public attendance: 50,000. Free to public. Artists should apply by calling for application or downloading from Web site. Deadline for entry: March 16. Application fee: $225. Space fee: $15. Exhibition space: 10×10 ft. For more information, artists should e-mail, visit Web site or call.

Ⓜ WASHINGTON SQUARE OUTDOOR ART EXHIBIT

115 East 9th St., #7C, New York NY 10003. (212)982-6255. Fax: (212)982-6256. Web site: www.washingto nsquareoutdoorartexhibit.org. **Contact:** Margot J. Lufitg, executive director. Estab. 1931. Fine arts & crafts show held semiannually Memorial Day weekend and the following weekend in May/early June, and Labor Day weekend and following weekend in September. Outdoors. Accepts photography, oil, water-color, graphics, mixed media, sculpture, crafts. Juried by submitting 5 slides of work and 1 of booth. Awards/prizes: certificates, ribbons and cash prizes. Number of exhibitors: 200. Public attendance: 200,000. Free to public. Artists should apply by sending a SASE or downloading application from Web site. Deadline for entry: March, Spring Show; July, Fall Show. Application fee: $20. Exhibition space: 10×5 ft. For more information, artists should call or send SASE.

Tips "Price work sensibly."

Ⓜ WESTMORELAND ART NATIONALS

252 Twin Lakes Rd., Latrobe PA 15650-3554. (724)834-7474. E-mail: info@artsandheritage.com. Web site: www.artsandheritage.com. **Contact:** Donnie Gutherie, executive director. Estab. 1975. Fine arts &

crafts show held annually in July. Indoors. Accepts photography, all mediums. Juried: 2 jurors review slides. Awards/prizes: $5,000+ in prizes. Number of exhibitors: 200. Public attendance: 100,000. Free to public. Artists should apply by downloading application from Web site. Application fee: $35/craft show; $25/fine art exhibit. Space fee: $325. Exhibition space: 10×10 ft. For more information, artists should visit Web site.

Tips: "Sell the product; don't let the product sell itself."

⚓ WILD WIND FOLK ART & CRAFT FESTIVAL

719 Long Lake, New York NY 12847. (814)723-0707 or (518)624-6404. E-mail: wildwindcraftshow@yahoo.com. Web site: www.wildwindfestival.com. **Contact:** Liz Allen or Carol Jilk, promoters. Estab. 1979. Fine arts & traditional crafts show held annually the weekend after Labor Day at the Warren County Fairgrounds in Pittsfield, Pennsylvania. Barn locations and outdoors. Accepts photography, paintings, pottery, jewelry, traditional crafts, prints, stained glass. Juried by promoters. Three photos or slides of work plus one of booth, if available. Number of exhibitors: 140. Public attendance: 8,000. Public admission: $6/adult; $4/seniors; 12 & under free. Artists should apply by visiting Web site and filling out application request, calling or sending a written request.

MIDSOUTH & SOUTHEAST

⚓ APPLE ANNIE CRAFTS & ARTS SHOW

4905 Roswell Rd. NE, Marietta GA 30062. (770)552-6400, ext. 6110. Fax: (770)552-6420. E-mail: appleannie@st-ann.org. Web site: www.st-ann.org/appleannie. **Contact:** Show Manager. Estab.1981. Arts & crafts show held annually 1st weekend in December. Indoors. Accepts photography, woodworking, ceramics, pottery, painting, fabrics, glass. Juried. Number of exhibitors: 135. Public attendance: 5,000. Public admission: $2. Artists should apply by visiting Web site to print an application form, or call to have one sent to them. Deadline: March 31. Application fee: $10 nonrefundable. Space fee: $120. Exhibition space: 72 sq. ft. For more information, artists should e-mail, visit Web site, call.

Tips "Have an open, welcoming booth and be accessible and friendly to customers."

⚓ APPLE CHILL & FESTIFALL

200 Plant Rd., Chapel Hill NC 27514. (919)968-2784. Fax: (919)932-2923. E-mail: lradson@townofchapelhill.org. Web site: www.applechill.com and www.festifall.com. **Contact:** Lauren Rodson, lead event coordinator. Estab. 1972. Apple Chill street fair held annually 3rd full weekend in April; Festifall street fair held annually 1st weekend in October. Estab. 1972. Outdoors. Accepts photography, pottery, painting, fabric, woodwork, glass, jewelry, leather, sculpture, tile. Juried by application process; actual event is not juried.

⚓ ART FESTIVAL BETH-EL

400 S. Pasadena Ave., St. Petersburg FL 33707. (727)347-6136. Fax: (727)343-8982. **Contact:** Sonya Miller, chairwoman. Estab. 1972. Fine arts & crafts show held annually the last weekend in January. Indoors. Accepts photography, painting, jewelry, sculpture, woodworking. Juried by special committee on-site or through slides. Awards/prizes: $7,500 prize money; $100,000 Purchase Award. Number of exhibitors: 150-175. Public attendance: 8,000-10,000. Free to the public. Artists should apply by application with photos or slides; show is invitational. Deadline for entry: September. Space fee: $25. Exhibition space: 4×8 ft. panels or wall space. For more information, artists should call.

Tips "Don't crowd display panels with artwork. Make sure your prices are on your pictures. Speak to customers about your work."

⚓ ART IN THE PARK

P.O. Box 1540, Thomasville GA 31799. (229)227-7020. Fax: (229)227-3320. E-mail: roseshowfest@rose.net. Web site: www.downtownthomasville.com. **Contact:** Felicia Brannen, festival coordinator. Estab. 1998-1999. Arts & crafts show held annually in April. Outdoors. Accepts photography, handcrafted items, oils, acrylics, woodworking, stained glass, other varieties. Juried by a selection committee. Number of exhibitors: 60. Public attendance: 2,500. Free to public. Artists should apply by application. Deadline for entry: March 1. Space fee: $75, varies by year. Exhibition space: 20×20 ft. For more information, artists should e-mail or call.

Tips "Most important, be friendly to the public and have an attractive booth display."

☘ BIG ARTS ART FAIR

900 Dunlop Rd., Sanibel FL 33957. (239)395-0900. Fax: (239)395-0330. E-mail: ncunnigham@bigarts.org. Web site: www.bigarts.org. **Contact:** Natalie Cunningham, programs assistant. Estab. 1979. Fine arts & crafts show held annually the Friday and Saturday after Thanksgiving. Outdoors. Accepts photography, ceramics, graphics, painting, original wearable art, glass, jewelry, fiber, mixed media, sculpture, garden art. Juried by 1 judge, who changes annually. Awards/prizes: cash. Number of exhibitors: 80-90. Public attendance: 3,000-5,000. Public admission: $3. Artists should apply by visiting Web site or calling after June 1 for application. Deadline for entry: late September. Application/space fee: $150. Exhibition space: 10×10 ft. For more information, artists should e-mail, visit Web site or call.

☘ CHERRY BLOSSOM FESTIVAL OF CONYERS

1996 Centennial Olympic Parkway, Conyers GA 30013. (770)860-4190. Fax: (770)602-2500. E-mail: rebecca.hill@conyersga.com. **Contact:** Rebecca Hill, event manager. Estab. 1981. Arts & crafts show held annually in late March. Outdoors. Accepts photography, paintings. Juried. Number of exhibitors: 300. Public attendance: 40,000. Free to public; $5 parking fee. Deadline for entry: January. Space fee: $125/booth. Exhibition space: 10×10 ft. For more information, artists should e-mail, visit Web site or call.

☘ CHURCH STREET ART & CRAFT SHOW

P.O. Box 1409, Waynesville NC 28786. (828)456-3517. Fax: (828)456-2001. E-mail: downtownwaynesville@charter.net. Web site: www.downtownwaynesville.com. **Contact:** Ronald Huelster, executive director. Estab. 1983. Fine arts & crafts show held annually 2nd Saturday in October. Outdoors. Accepts photography, paintings, fiber, pottery, wood, jewelry. Juried by committee: submit 4 slides or photos of work and 1 of booth display. Awards/prizes: $1,000 cash prizes in 1st, 2nd, 3rd and Honorable Mentions. Number of exhibitors: 100. Public attendance: 15,000-18,000. Free to public. Deadline for entry: August 15. Application/space fee: $95-165. Exhibition space: 10×12 ft.-12×20 ft. For more information artists should e-mail, call or send SASE.

Tips Recommends "quality in work and display."

ⓝ ☘ CITY OF FAIRFAX FALL FESTIVAL

4401 Sideburn Rd., Fairfax VA 22030. (703)385-7949. Fax: (703)246-6321. E-mail: lherman@fairfaxva.gov. Web site: www.fairfaxva.gov. **Contact:** Leslie Herman, special events coordinator. Estab. 1975. Arts & crafts show held annually 2nd Saturday in October. Outdoors. Accepts photography, jewelry, glass, pottery, clay, wood, mixed media. Juried by a panel of 5 independent jurors. Number of exhibitors: 400. Public attendance: 25,000. Public admission: $3 for age 18 and older. Artists should apply by contacting Leslie Herman for an application. Deadline for entry: March. Application fee: $5. Space fee: $125. Exhibition space: 10×10 ft. For more information, artists should e-mail.

Tips "Be on-site during the event. Smile. Price according to what the market will bear."

ⓝ ☘ CITY OF FAIRFAX HOLIDAY CRAFT SHOW

4401 Sideburn Rd., Fairfax VA 22030. (703)385-7949. Fax: (703)246-6321. E-mail: lherman@fairfaxva.gov. Web site: www.fairfaxva.gov. **Contact:** Leslie Herman, special events coordinator. Estab. 1985. Arts & crafts show held annually 3rd weekend in November. Indoors. Accepts photography, jewelry, glass, pottery, clay, wood, mixed media. Juried by a panel of 5 independent jurors. Number of exhibitors: 247. Public attendance: 10,000. Public admission: $3 for age 18 an older. Artists should apply by contacting Leslie Herman for an application. Deadline for entry: March. Application fee: $5. Space fee: 10×6 ft.: $175; 11×9 ft.: $250; 10×10 ft.: $250. For more information, artists should e-mail.

Tips "Be on-site during the event. Smile. Price according to what the market will bear."

DOWNTOWN FESTIVAL & ART SHOW

P.O. Box 490, Gainesville FL 32602. (352)334-5064. Fax: (352)334-2249. E-mail: piperlr@cityofgainesville.org. Web site: www.gvlculturalaffairs.org. **Contact:** Linda Piper, festival director. Estab. 1981. Fine arts & crafts show held annually in November. Outdoors. Accepts photography, wood, ceramic, fiber, glass, and all mediums. Juried by 3 slides of artwork and 1 slide of booth. Awards/prizes: $14,000 in Cash Awards; $5,000 in Purchase Awards. Number of exhibitors: 250. Public attendance: 115,000. Free to the public. Artists should apply by mailing 4 slides. Deadline for entry: May. Space fee: $175. Exhibition space: 12 ft.×12 ft. Average gross sales/exhibitor: $6,000. For more information, artists should e-mail, visit Web site, call, send SASE.

Tips "Submit the highest-quality slides possible. A proper booth slide is so important."

Florida photographer John Hartung has found his home state to be a good market for him, yielding two thirds of his sales over the year. He says, "Selling at art fairs can be very difficult at times. There is much work involved and much uncertainty. However, it's great for the soul to see people react to the work you've created. To succeed, be creative, be different, and find what you do best and wow the people. Most importantly, have fun along the way! Your attitude will be reflected in your work and in your sales."

FESTIVAL IN THE PARK

1409 East Blvd., Charlotte NC 28203. (704)338-1060. Fax: (704)338-1061. E-mail: festival@festivalinthep ark.org. Web site: www.festivalinthepark.org. **Contact:** Julie Whitney Austin, executive director. Estab. 1964. Fine arts & crafts/arts & crafts show held annually 3rd Thursday after Labor Day. Outdoors. Accepts photography, decorative and wearable crafts, drawing and graphics, fiber and leather, jewelry, mixed media, painting, metal, sculpture, wood. Juried by slides or photographs. Awards/prizes: $4,000 in cash awards. Number of exhibitors: 150. Public attendance: 85,000. Free to the public. Artists should apply by visiting Web site for application. Application fee: $20. Space fee: $350. Exhibition space: 10×10 ft. For more information, artists should e-mail, visit Web site, call.

FOOTHILLS CRAFTS FAIR

2753 Lynn Rd. #A, Tryon NC 28782-7870. (828)859-7427. E-mail: bbqfestival@azztez.net. Web site: www.BlueRidgeBBQFestival.com. **Contact:** Julie McIntyre. Estab. 1993. Fine arts & crafts show and Blue Ridge BBQ Festival/Championship held annually 2nd Friday and Saturday in June. Outdoors. Accepts photography, handcrafts; nothing manufactured or imported. Juried. Number of exhibitors: 50. Public attendance: 25,000+. Public admission: $6; under 12 free. Artists should apply by downloading application from Web site or sending personal information to e-mail or mailing address. Deadline for entry: March 30. Jury fee: $25. Space fee: $150. Exhibition space: 10×10 ft. For more information, artists should visit Web site.

Tips "Have an attractive booth, unique items, and reasonable prices."

GERMANTOWN FESTIVAL

P.O. Box 381741, Germantown TN 38183. (901)757-9212. E-mail: gtownfestival@aol.com. **Contact:** Melba Fristick, coordinator. Estab. 1971. Arts & crafts show held annually the weekend after Labor Day. Outdoors. Accepts photography, all arts and crafts mediums. Number of exhibitors: 400+. Public attendance: 65,000. Free to public. Artists should apply by sending applications by mail. Deadline for entry: until filled. Application/space fee: $190-240. Exhibition space: 10×10 ft. For more information, artists should e-mail, call or send SASE.

Tips "Display and promote to the public. Price attractively."

☙ HIGHLANDS ART LEAGUE'S ANNUAL FINE ARTS & CRAFTS FESTIVAL

1989 Lakeview Dr., Sebring FL 33870. (863)385-5312. Fax: (863)385-5336. E-mail: info@highlandsartleague.com. Web site: www.highlandsartleague.com. **Contact:** Show Coordinator. Estab. 1966. Fine arts & crafts show held annually 2nd weekend in November. Outdoors. Accepts photography, pottery, painting, jewelery, fabric. Juried based on quality of work. Awards/prizes: monetary awards up to $1,500 and Purchase Awards. Number of exhibitors: more than 100. Public attendance: more than 15,000. Free to the public. Artists should apply by calling or visiting Web site for application form after May 1. Deadline for entry: October. Application fee: $60 plus $15 jury fee. Exhibtion space: 10×14 ft. Artists should e-mail for more information.

☙ HOLIDAY ARTS & CRAFTS SHOW

60 Ida Lee Dr., Leesburg VA 20176. (703)777-1368. Fax: (703)737-7165. E-mail: lfountain@leesburgva.gov. Web site: www.idalee.org. **Contact:** Linda Fountain, program supervisor. Estab. 1990. Arts & crafts show held annually 1st weekend in December. Indoors. Accepts photography, jewelry, pottery, baskets, clothing, accessories. Juried. Number of exhibitors: 100. Public attendance: 4,000. Free to public. Artists should apply by downloading application from Web site. Deadline for entry: August 31. Space fee: $100-150. Exhibition space: 10×7 ft. For more information, artists should e-mail or visit Web site.

☙ HOLLY ARTS & CRAFTS FESTIVAL

P.O. Box 2122, Pinehurst NC 28370. (910)295-7462. E-mail: sbharrison@earthlink.net, pbguild@pinehurst.net. Web site: www.pinehurstbusinessguild.com. **Contact:** Susan Harrison, Holly Arts & Crafts committee. Estab. 1978. Arts & crafts show held annually 3rd Saturday in October. Outdoors. Accepts photography and crafts. Juried based on uniqueness, quality of product, and overall display. Awards/prizes: plaque given to Best in Show; 2 Honorable Mentions receive ribbons. Number of exhibitors: 200. Public attendance: 7,000. Free to the public. Artists should apply by filling out application form. Deadline for entry: March 15, 2007. Space fee: $65. Exhibition space: 10×10 ft. For more information, artists should e-mail, visit Web site, call, send SASE.

☙ INTERNATIONAL FOLK FESTIVAL

P.O. Box 318, Fayetteville NC 28302-0318. (910)323-1776. Fax: (910)323-1727. E-mail: kelvinc@theartscouncil.com. Web site: www.theartscouncil.com. **Contact:** Kelvin Culbreth, director of special events. Estab. 1978. Fine arts & crafts show held annually in late September. Outdoors. Accepts photography, painting of all mediums, pottery, woodworking, sculptures of all mediums. "Work must be original." Juried. Awards/prizes: $2,000 in cash prizes in several categories. Number of exhibitors: 120+. Public attendance: 70,000. Free to public. Artists should apply on the Web site. Deadline for entry: September 1. Application fee: $60; includes space fee. Exhibition space: 10×10 ft. Average gross sales/exhibitor: $500. For more information, artists should e-mail or visit Web site.

Tips "Have reasonable prices."

JUBILEE FESTIVAL

P.O. Drawer 310, Daphne AL 36526. (251)621-8222. Fax: (251)621. E-mail: office@eschamber.com. Web site: www.eschamber.com. **Contact:** Angela Kimsey, event coordinator. Estab. 1952. Fine arts & crafts show held in September in Olde Towne of Daphne, Alabama. Outdoors. Accepts photography and fine arts and crafts. Juried. Awards/prizes: ribbons and cash prizes. Number of exhibitors: 258. Public attendance: 200,000. Free to the public. Application fee: $25. Space fee: $265. Exhibition space: 10 ft. × 10 ft. For more information, artists should e-mail, call, see Web site.

NEW SMYRNA BEACH FIESTA

210 Sams Ave., New Smyrna Beach FL 32168. (386)424-2175. Fax: (386)424-2177. Web site: www.cityofn sb.com. **Contact:** Kimla Shelton, program coordinator. Estab. 1952. Arts & crafts show held annually the last full weekend in February. Outdoors. Accepts photography, oil, acrylics, pastel, drawings, graphics, sculpture, crafts, watercolor. Awards/prizes: $10,800 prize money; $1,000/category; Honorable Mentions. Number of exhibitors: 250. Public attendance: 14,000. Free to public. Artists should apply by calling to get on mailing list. Applications are always mailed out the day before Thanksgiving. Deadline for entry: until full. Application/space fee: $133.13. Exhibition space: 10×10 ft. For more information, artists should send SASE.

PANOPLY ARTS FESTIVAL, PRESENTED BY THE ARTS COUNCIL, INC.

700 Monroe St. SW, Suite 2, Huntsville AL 35801. (256)519-2787. Fax: (256)533-3811. E-mail: tac@panop ly.org. Web site: www.panoply.org; www.artshuntsville.org. Estab. 1982. Fine arts show held annually the last weekend in April. Also features music and dance. Outdoors. Accepts photography, painting, sculpture, drawing, printmaking, mixed media, glass, fiber. Juried by a panel of judges chosen for their in-depth knowledge and experience in multiple mediums, and who jury from slides or disks in January. During the festival 1 judge awards the various prizes. Awards/prizes: Best of Show: $1,000; Award of Distinction: $500; Merit Awards: 5 awards, $200 each. Number of exhibitors: 60-80. Public attendance: 140,000 +. Public admission: weekend pass: $10; 1-day pass: $5; children 12 and under: free. Artists should e-mail, call or write for an application form, or check online through November 1. Deadline for entry: January 2008. Application fee: $30. Space fee: $175 for space only; $375 including tent rental. Exhibition space: 10×10 ft. Average gross sales/exhibitor: $2,500. For more information, artists should e-mail.

PUNGO STRAWBERRY FESTIVAL

P.O. Box 6158, Virginia Beach VA 23456. (757)721-6001. Fax: (757)721-9335. E-mail: pungofestival@aol. com. Web site: www.PungoStrawberryFestival.info. **Contact:** Janet Dowdy, secretary of board. Estab. 1983. Arts & crafts show held annually on Memorial Day Weekend. Outdoors. Accepts photography and all media. Number of exhibitors: 60. Public attendance: 120,000. Free to Public; $5 parking fee. Artists should apply by calling for application or downloading a copy from the Web site and mail in. Deadline for entry: March 1; applications accepted from that point until all spaces are full. Application fee: $50 refundable deposit. Space fee: $175. Exhibition space: 10×10 ft. For more information, artists should e-mail, visit Web site or call.

RIVERSIDE ART FESTIVAL

2623 Herschel St., Jacksonville FL 32204. (904)389-2449. Fax: (904)389-0431. E-mail: rap@fdn.com. Web site: www.Riverside-Avondale.com. **Contact:** Bonnie Grissett, executive director. Estab. 1972. Fine arts & crafts show held annually the weekend after Labor Day. Outdoors. Accepts photography and all fine art. Juried. Awards/prizes: $10,000/cash. Number of exhibitors: 150. Public attendance: 25,000. Free to public. Artists should apply by sending name and address or by e-mailing for an application. Deadline for entry: June 15. Jury fee: $25 (nonrefundable). Space fee: $175. Exhibition space: 10×10 ft. For more information, artists should call or e-mail.

SANDY SPRINGS FESTIVAL

135 Hilderbrand Dr., Sandy Springs GA 30328-3805. (404)851-9111. Fax: (404)851-9807. E-mail: info@sa ndyspringsfestival.com. Web site: www.sandyspringsfestival.com. **Contact:** Christy Nickles, special events director. Estab. 1985. Fine arts & crafts show held annually in mid-September. Outdoors. Accepts photography, painting, sculpture, jewelry, furniture, clothing. Juried by area professionals and nonprofessionals who are passionate about art. Awards/prizes: change annually; usually cash with additional prizes. Number of exhibitors: 100 +. Public attendance: 20,000. Public admission: $5. Artists should apply via application on Web site. Application fee: $10 ($35 for late registration). Space fee: $125. Exhibition space: 10×10 ft. Average gross sales/exhibitor: $1,000. For more information, artists should visit Web site.

Tips "Most of the purchases made at Sandy Springs Festival are priced under $100. The look of the booth and its general attractiveness are very important, especially to those who might not 'know' art."

SPRINGFEST

P.O. Box 831, Southern Pines NC 28388. (910)315-6508. E-mail: spba@earthlink.net. Web site: www.sout hernpines.biz. **Contact:** Susan Harrison, booth coordinator. Estab. 1979. Arts & crafts show held annually last Saturday in April. Outdoors. Accepts photography and crafts. Number of exhibitors: 200. Public attendance: 8,000. Free to the public. Artists should apply by filling out application form. Deadline for entry: March 15, 2007. Space fee: $60. Exhibition space: 10×12 ft. For more information, artists should e-mail, visit Web site, call, send SASE.

STEPPIN'OUT

P.O. Box 233, Blacksburg VA 24063. (540)951-0454. E-mail: dmob@downtownblacksburg.com. Web site: www.downtownblacksburg.com. **Contact:** Gwynn Hamilton, director. Estab. 1981. Arts & crafts show held annually 1st Friday and Saturday in August. Outdoors. Accepts photography, pottery, painting, drawing, fiber arts, jewelry, general crafts. Number of exhibitors: 170. Public attendance: 30,000. Free to public. Artists should apply by e-mailing, calling or by downloading application on Web site. Space fee: $135. For more information, artists should e-mail, visit Web site or call.

Tips "Visit shows and consider the booth aesthetic—what appeals to you. Put the time, thought, energy and money into your booth to draw people in to see your work."

N 🖾 STOCKLEY GARDENS FALL ARTS FESTIVAL

801 Boush St., Norfolk VA 23510.(757)625-6161. Fax: (757)625-7775. E-mail: jlong@hope-house.org. Web site: www.hope-house.org. **Contact:** Jenny Long, development coordinator. Estab. 1984. Fine arts & crafts show held annually 3rd weekend in October. Outdoors. Accepts photography and all major fine art mediums. Juried. Number of exhibitors: 150. Public attendance: 30,000. Free to the public. Artists should apply by submitting application, jury and booth fees, 5 slides. Deadline for entry: July. Application fee: $15. Space fee: $225. Exhibition space: 10×10 ft. For more information, artists should e-mail, visit Web site, call.

SUBIACO ABBEY ART FAIR

405 Subiaco Ave., Subiaco AR 72865. (479)934-1000. Fax: (479)934-1033. E-mail: aaronpirrera@yahoo.c om. Web site: www.subi.org. **Contact:** Fr. Aaron Pirrera, director. Estab. 1998. Fine arts & crafts show held annually in early September. Indoors and outdoors. Accepts photography and all other mediums. Number of exhibitors: 25-30. Public attendance: 250-400. Free to the public. Artists should apply by calling Fr. Aaron or sending a letter with a photo of the art/craft. Deadline: June/July. Space fee: 10% of sales. Exhibition space: 10×10 ft. Artists should e-mail or call for more information

Tips "Keep prices low. Fine arts new to the area."

N 🖾 VIRGINIA CHRISTMAS SHOW

P.O. Box 305, Chase City VA 23924. (434)372-3996. Fax: (434)372-3410. E-mail: vashowsinc@aol.com. **Contact:** Patricia Wagstaff, coordinator. Estab. 1986. Holiday arts & crafts show held annually 1st week in November in Richmond, Virginia. Indoors. Accepts photography and other arts and crafts. Juried by 3 slides of artwork and 1 of display. Awards/prizes: Best Display. Number of exhibitors: 350. Public attendance: 25,000. Public admission: $7. Artists should apply by writing or e-mailing for an application. Space fee: $400. Exhibition space: 10×10 ft. For more information, artists should e-mail, send SASE.

Tips "If possible, attend the show before you apply."

N 🖾 VIRGINIA SPRING SHOW

P.O. Box 305, Chase City VA 23924. (434)372-3996. Fax: (434)372-3410. E-mail: vashowsinc.@aol.com. **Contact:** Patricia Wagstaff, coordinator. Estab. 1986. Arts & crafts show held annually 2nd weekend in March in Richmond, Virginia. Accepts photography and other arts and crafts. Juried by 3 slides of artwork and 1 of display. Awards/prizes: Best Display. Number of exhibitors: 350. Public attendance: 25,000. Public admission: $7. Artists should apply by writing or e-mailing for an application. Space fee: $400. Exhibition space: 10×10 ft. For more information, artists should e-mail, send SASE.

Tips "If possible, attend the show before you apply."

🖾 WELCOME TO MY WORLD PHOTOGRAPHY COMPETITION

319 Mallery St., St. Simons Island GA 31522.(912)638-8770. E-mail: glynnart@bellsouth.net. Web site: www.glynnart.org. **Contact:** Pat Weaver, executive director. Estab. 1991. Seasonal photography competi-

tion annually held in July. Indoors. Accepts only photography. Juried. Awards/prizes: 1st, 2nd, 3rd in each category. Number of exhibitors: 50. Artists should apply by visiting Web site. Deadline for entry: June. Application fee: $35. For more information artists should e-mail, visit Web site or call.

MIDWEST & NORTH CENTRAL

☑ AKRON ARTS EXPO

220 S. Balch St., Akron OH 44302. (330)375-2835. Fax: (330)375-2883. E-mail: recreation@ci.akron.oh. us. Web site: www.ci.akron.oh.us. **Contact:** Yvette Davidson, community events coordinator. Estab. 1979. Fine art & craft show held annually in late July. Outdoors. Accepts photography, 2D art, functional craft, ornamental. Juried by 4 slides of work and 1 slide of display. Awards/prizes: $1,600 in cash awards and ribbons. Number of exhibitors: 165. Public attendance: 3,000+. Free to public. Deadline for entry: March 31. Space fee: $150-180. Exhibition space: 15×15 ft. For more information, artists should e-mail or call.

☑ ALLEN PARK ARTS & CRAFTS STREET FAIR

16850 Southfield, Allen Park MI 48101. (313)928-1370. Fax: (313)382-7946. Contact: Allen Park Festivities Commission. Estab. 1981. Arts & crafts show held annually 1st Friday and Saturday in August. Outdoors. Accepts photography, sculpture, ceramics, jewelry, glass, wood, prints, drawings, paintings. Juried by 3 photos of work. Number of exhibitors: 400. Free to the public. Artists should apply by requesting an application form by December 31 of the previous year. Application fee: $5. Space fee: $100. Exhibition space: 10×10 ft. For more information, artists should call.

☑ AMISH ACRES ARTS & CRAFTS FESTIVAL

1600 W Market St., Nappanee IN 46550. (574)773-4188. Fax: (574)773-4180. E-mail: jenniwysong@amis hacres.com. Web site: www.amishacres.com. **Contact:** Jenni Wysong, marketplace coordinator. Estab. 1962. Arts & crafts show held annually 1st full weekend in August. Outdoors. Accepts photography, crafts, floral, folk, jewelry, oil, acrylic, sculpture, textiles, watercolors, wearable, wood. Juried by 5 images, either 35mm slides or digital images e-mailed. Awards/prizes: $10,000 cash including Best of Show and $1,500 Purchase Prizes. Number of exhibitors: 350. Public attendance: 70,000. Public admission: $6; children under 12 free. Artists should apply by sending SASE or printing application from Web site. Deadline for entry: April 1. Space fee: 10×10 ft.: $485; 15×12 ft.: $675; 20×12 ft.: $1,095; 30×12 ft.: $1,695. Exhibition space: from 120-300 sq. ft. Average gross sales/exhibitor: $7,000. For more information, artists should e-mail, visit Web site, call or send SASE.

Tips "Create a vibrant, open display that beckons to passing customers. Interact with potential buyers. Sell the romance of the purchase."

☒ ☑ ANN ARBOR STREET ART FAIR

P.O. Box 1352, Ann Arbor MI 48106. (734)994-5260. Fax: (734)994-0504. E-mail: production@artfair.org. Web site: www.artfair.org. **Contact:** Jeannie Uh, production coordinator. Estab. 1958. Fine arts & crafts show held annually 3rd Saturday in July. Outdoors. Accepts photography, fiber, glass, digital art, jewelry, metals, 2D and 3D mixed media, sculpture, clay, painting, drawing, printmaking, pastels, wood. Juried based on originality, creativity, technique, craftsmanship and production. Awards/prizes: cash prizes for outstanding work in any media. Number of exhibitors: 175. Public attendance: 500,000. Free to the public. Artists should apply through www.zapplication.org. Deadline for entry: January. Application fee: $30. Space fee: $595. Exhibition space: 10×20 ft. or 10×12 ft. Average gross sales/exhibitor: $7,000. For more information, artists should e-mail, visit Web site, call.

☑ ANNUAL ARTS & CRAFTS ADVENTURE AND ANNUAL ARTS & CRAFTS ADVENTURE II

P.O. Box 1326, Palatine IL 60078. (847)991-4748 or (312)751-2500. E-mail: asoa@webtv.net. Web site: www.americansocietyofartists.org. **Contact:** American Society of Artists—"anyone in the office can help." Estab. 1991. Fine arts & crafts show held biannually in May and September. Outdoors. Accepts photography, pottery, paintings, sculpture, glass, wood, woodcarving. Juried by 4 slides or photos of work and 1 slide or photo of display; SASE (No. 10); a résumé or show listing is helpful. Number of exhibitors: 75. Free to the public. Artists should apply by submitting jury materials. If juried in, you will receive a jury/approval number. Deadline for entry: 2 months prior to show or earlier if spaces fill. Space

fee: $80. Exhibition space: approximately 100 sq. ft. for single space; other sizes available. For more information, artists should send SASE, submit jury material.

- Event held in Park Ridge, Illinois.

Tips "Remember that when you are at work in your studio, you are an artist. But when you are at a show, you are selling your work."

☒ ANNUAL ARTS & CRAFTS EXPRESSIONS

P.O. Box 1326, Palatine IL 60078. (847)991-4748 or (312)751-2500. E-mail: asoa@webtv.net. Web site: www.americansocietyofartists.org. **Contact:** American Society of Artists—"anyone in the office can help." Estab. 1998. Fine arts & crafts show held annually in late July. Outdoors. Accepts photography, sculpture, jewelry, glass works, woodworking and more. Juried by 4 slides or photos of work and 1 slide or photo of display; SASE (No. 10); a résumé or show listing is helpful. Number of exhibitors: 50. Free to the public. Artists should apply by submitting jury materials. If juried in, you will receive a jury/ approval number. Deadline for entry: 2 months prior to show or earlier if spaces fill. Space fee: $155. Exhibition space: approximately 100 sq. ft. for single space; other sizes available. For more information, artists should send SASE, submit jury material.

- Event held in Chicago, Illinois.

Tips "Remember that when you are at work in your studio, you are an artist. But when you are at a show, you are selling your work."

☒ ANNUAL ARTS ADVENTURE

P.O. Box 1326, Palatine IL 60078. (847)991-4748 or (312)571-2500. E-mail: asoa@webtv.net. Web site: www.americansocietyofartists.org. **Contact:** American Society of Artists—"anyone in the office can help." Estab. 2001. Fine arts & crafts show held annually the end of July. Event held in Chicago, Illinois. Outdoors. Accepts photography, paintings, pottery, sculpture, jewelry and more. Juried by 4 slides or photos of work and 1 slide or photo of display; SASE (No. 10); a résumé or show listing is helpful. Number of exhibitors: 50. Free to the public. Artists should apply by submitting jury materials. If juried in, you will receive a jury/approval number. Deadline for entry: 2 months prior to show or earlier if spaces fill. Space fee: $125. Exhibition space: approximately 100 sq. ft. for single space; other sizes available. For more information, artsits should send SASE, submit jury material.

- Event held in Chicago, Illinois.

Tips "Remember that when you are at work in your studio, you are an artist. But when you are at a show, you are selling your work."

☒ ANNUAL CRESTWOOD ARTS & CRAFTS ADVENTURE

P.O. Box 1326, Palatine IL 60078. (847)991-4748 or (312)751-2500. E-mail: asoa@webtv.net. Web site: www.americansocietyofartists.org. **Contact:** American Society of Artists—"anyone in the office can help." Estab. 1979. Arts & crafts show held annually in June and August. Outdoors. Accepts photography, paintings, jewelry, glassworks, quilting, graphics, woodworking, paperworks and more. Juried by 4 slides or photos of work and 1 slide or photo of display; SASE (No. 10); a résumé or show listing is helpful. Number of exhibitors: 150. Free to the public. Artists should apply by submitting jury materials. If juried in, you will receive a jury/approval number. Deadline for entry: 2 months prior to show or earlier if spaces fill. Space fee: $160. Exhibition space: approximately 100 sq. ft. for single space; other sizes available. For more information, artsits should send SASE, submit jury material.

- Event held in St. Louis, Missouri.

Tips "Remember that when you are at work in your studio, you are an artist. But when you are at a show, you are selling your work."

☒ ANNUAL EDENS ART FAIR

P.O. Box 1326, Palatine IL 60078. (847)991-4748 or (312)2500. E-mail: asoa@webtv.net. Web site: www.a mericansocietyofartists.com. **Contact:** American Society of Artists—"anyone in the office can help." stab. 1995 (after renovation of location; held many years prior to renovation). Fine arts & fine selected crafts show held annually in mid-July. Outdoors. Accepts photography, paintings, sculpture, glass works, jewelry. Juried by 4 slides or photos of work and 1 slide or photo of display; SASE (No. 10); a résumé or show listing is helpful. Number of exhibitors: 50. Free to the public. Artists should apply by submitting jury materials. If juried in, you will receive a jury/approval number. Deadline for entry: 2 months prior to show or earlier if spaces fill. Space fee: $130. Exhibition space: approximately 100 sq. ft. for single

space; other sizes available. For more information, artists should send SASE, submit jury material.

- Event held in Willamette, Illinois.

Tips "Remember that when you are at work in your studio, you are an artist. But when you are at a show, you are selling your work."

☙ ANNUAL HYDE PARK ARTS & CRAFTS ADVENTURE

(formerly Annual White Oaks Arts & Crafts Adventure), P.O. Box 1326, Palatine IL 60078. (847)991-4748 or (312)751-2500. E-mail: asoa@webtv.net. Web site: www.americansocietyofartists.org. **Contact:** American Society of Artists—"anyone in the office can help." Estab. 2001. Arts & crafts show held twice a year in late May/early June and September. Outdoors. Accepts photography, paintings, glass, wood, fiber arts, hand-crafted candles, quilts, sculpture and more. Juried by 4 slides or photos of work and 1 slide or photo of display; SASE (No. 10); a résumé or show listing is helpful. Number of exhibitors: 50. Free to the public. Artists should apply by submitting jury materials. If juried in, you will receive a jury/approval number. Deadline for entry: 2 months prior to show or earlier if spaces fill. Space fee: $135. Exhibition space: approximately 100 sq. ft. for single space; other sizes are available. For more information, artists should send SASE, submit jury material.

- Event held in Chicago, Illinois.

Tips "Remember that when you are at work in your studio, you are an artist. But when you are at a show, you are selling your work."

☙ ANNUAL OAK PARK AVENUE-LAKE ARTS & CRAFTS SHOW

P.O. Box 1326, Palatine IL 60078. (847)991-4748 or (312)751-2500. E-mail: asoa@webtv.net. Web site: www.americansocietyofartists.org. **Contact:** American Society of Artists—"anyone in the office can help." Estab. 1974. Fine arts & crafts show held annually in mid-August. Outdoors. Accepts photography, paintings, graphics, sculpture, glass, wood, paper, fiber arts, mosaics. Juried by 4 slides or photos of work and 1 slide or photo of display; SASE (No. 10); a résumé or show listing is helpful. Number of exhibitors: 150. Free to the public. Artists should apply by submitting jury materials. If juried in, you will receive a jury/approval number. Deadline for entry: 2 months prior to show or earlier if spaces fill. Space fee: $160. Exhibition space: approximately 100 sq. ft. for single space; other sizes available. For more information, artists should send SASE, submit jury material.

- Event held in Oak Park, Illinois.

Tips "Remember that when you are at work in your studio, you are an artist. But when you are at a show, you are selling your work."

☙ ART IN THE PARK

8707 Forest Ct., Warren MI 48093. (586)795-5471. E-mail: wildart@wowway.com. Web site: www.warrenfinearts.org. **Contact:** Paula Wild, chairperson. Estab. 1990. Fine arts & crafts show held annually 2nd weekend in July. Indoors and outdoors. Accepts photography, sculpture, basketry, pottery, stained glass. Juried. Awards/prizes: 2D & 3D monetary awards. Number of exhibitors: 115. Public attendance: 7,500. Free to public. Deadline for entry: May 16. Jury fee: $10. Space fee: $100/outdoor; $150/indoor. Exhibition space: 12×12 ft./tent; 10×10 ft./pavilion. For more information, artists should e-mail, visit Web site or send SASE.

☙ AN ARTS & CRAFTS AFFAIR, AUTUMN & SPRING TOURS

P.O. Box 184, Boys Town NE 68010. (402)331-2889. Fax: (402)445-9177. E-mail: hpifestivals@cox.net. Web site: www.hpifestivals.com. **Contact:** Huffman Productions. Estab. 1983. An arts & crafts show that tours different cities and states. The Autumn Festival tours annually October-November; Spring Festival tours annually March-April. Artists should visit Web site to see list of states and schedule. Indoors. Accepts photography, pottery, stained glass, jewelry, clothing, wood, baskets. All artwork must be hand-crafted by the actual artist exhibiting at the show. Juried by sending in 2 photos of work and 1 of display. Awards/prizes: 4 $30 show gift certificates; $50, $100 and $150 certificates off future booth fees. Number of exhibitors: 200-430 depending on location. Public attendance: 12,000-40,000. Public admission: $6-7/adults; $5-6/seniors; 10 & under, free. Artists should apply by calling to request an application. Deadline for entry: varies for date and location. Space fee: $220-550. Exhibition space: 8×11 ft. up to 8×22 ft. For more information, artists should e-mail, visit Web site, call or send SASE.

Tips "Have a nice display, make sure business name is visible, dress professionally, have different price points, and be willing to talk to your customers."

☙ ARTS EXPRESSIONS

(formerly Annual Northwoods Arts & Crafts Expressions), P.O. Box 1326, Palatine IL 60078. (847)991-4748 or (312)751-2500. E-mail: asoa@webtv.net. Web site: www.americansocietyofartists.org. Estab. 2003. Fine arts & crafts show held in summer. Outdoors. Accepts photography, paintings, graphics, sculpture, quilting, woodworking, fiber art, hand-crafted candles, glass works, jewelry, etc. Juried by 4 slides/photos representative of work being exhibited; 1 photo of display set-up, #10 SASE, résumé with 7 show listings helpful. Number of exhibitors: 50. Free to public. Artists should apply by submitting jury material and indicate you are interested in this particular show. When you pass the jury, you will receive jury approval number and application you requested. Deadline for entry: 2 months prior to show or earlier if space is filled. Space fee: to be announced. Exhibition space: 100 sq. ft. for single space; other sizes are available. For more information, artists should send SASE to submit jury material.

 • Event held in Chicago, Illinois.

Tips "Remember that at work in your studio, you are an artist. When you are at a show, you are selling your work."

☙ ARTS ON THE GREEN

P.O. Box 752, KY 40031. 502-222-3822. Fax: 502-222-3823. E-mail: judyanded2@peoplepc.com. Web site: www.oldhamcountyarts.org. **Contact:** Judy Wegenast, show coordinator. Estab. 2001. Fine arts & crafts show held annually 1st weekend in June. Outdoors. Accepts photography, painting, clay, sculpture, metal, wood, fabric, glass, jewelry. Juried by a panel. Awards/prizes: cash prizes for Best of Show and category awards. Number of exhibitors: 100. Public attendance: 7,500. Free to the public. Artists should apply online or call. Deadline for entry: March 15, 2008. Jury fee: $15. Space fee: $125. Electricity fee: $15. Exhibition space: 12×12 ft. For more information, artists should e-mail, visit Web site, call.

Tips "Make potential customers feel welcome in your space. Don't overcrowd your work. Smile!"

Ⓝ ☙ AUTUMN FESTIVAL, AN ARTS & CRAFTS AFFAIR

P.O. Box 184, Boys Town NE 68010.(402)331-2889. Fax: (402)445-9177. E-mail: hpifestivals@cox.net. Web site: www.hpifestivals.com. **Contact:** Huffman Productions. Estab. 1986. Fine arts & craft show held annually in October. Indoors. Accepts photography, pottery, jewelry, wood. All must be handcrafted by the exhibitor. Juried by 2 photos of work and 1 of display. Awards/prizes: $420 total cash awards. Number of exhibitors: 300. Public attendance: 16,000. Public admission: $6. Artists should apply by calling for an application. Deadline: when full or by the end of September. Space fee: $400. Exhibition space: 8×11 ft. ("We provide pipe and drape plus 500 watts of power." For more information, artists should e-mail, visit Web site, call, send SASE.

Tips "Have a nice display; dress professionally; have various price points; be willing to talk to your customers; display your business name."

☙ BLACK SWAMP ARTS FESTIVAL

P.O. Box 532, Bowling Green OH 43402. (419)354-2723. E-mail: info@blackswamparts.org. Web site: www.blackswamparts.org. **Contact:** Tim White, visual arts committee. Estab. 1993. Fine arts & crafts show held annually the weekend after Labor Day. Outdoors. Accepts photography, ceramics, drawing, enamel, fiber, glass, jewelry, leather, metal, mixed media, painting, paper, prints, sculpture, wood. Juried by unaffiliated, hired jurors. Awards/prizes: Best in Show, 2nd Place, 3rd Place, Honorable Mention, Painting Prize. Number of exhibitors: Juried: 110. Invitational: 40. Public attendance: 60,000. Free to the public. Artists should apply by visiting Web site. Deadline for entry: Juried: April; Invitational: June or until filled. Application fee: Juried: $225; Invitational: $120. Exhibition space: 10×10 ft. For more information, artists should visit Web site, call (voice mail only) or e-mail.

Tips "Offer a range of prices, from $5 to $500."

☙ CAIN PARK ARTS FESTIVAL

40 Severance Circle, Cleveland Heights OH 44118-9988. (216)291-3669. Fax: (216)3705. E-mail: jhoffman @clvhts.com. Web site: www.cainpark.com. **Contact:** Janet Hoffman, administrative assistant. Estab. 1976. Fine arts & crafts show held annually 2nd full week in July. Outdoors. Accepts photography, painting, clay, sculpture, wood, jewelry, leather, glass, ceramics, clothes and other fiber, paper, block printing. Juried by a panel of professional artists; submit 5 slides. Awards/prizes: cash prizes of $750, $500 and $250; also Judges' Selection, Director's Choice and Artists' Award. Number of exhibitors: 155. Public attendance: 60,000. Free to the public. Artists should apply by requesting an application by mail,

visiting Web site to download application or by calling. Deadline for entry: March 1, 2007. Application fee: $25. Space fee: $350. Exhibition space: 10×10 ft. Average gross sales/exhibitor: $4,000. For more information, artists should e-mail, visit Web site, call.

Tips "Have an attractive booth to display your work. Have a variety of prices. Be available to answer questions about your work."

ⓃⓎ CEDARHURST CRAFT FAIR
P.O. Box 923, Mt. Vernon IL 62864. (618)242-1236. Fax: (618)242-9530. E-mail: linda@cedarhurst.org. Web site: www.cedarhurst.org. **Contact:** Linda Wheeler, coordinator. Estab. 1977. Arts & crafts show held annually in September. Outdoors. Accepts photography, paper, glass, metal, clay, wood, leather, jewelry, fiber, baskets, 2D art. Juried. Awards/prizes: Best of each category. Number of exhibitors: 125. Public attendance: 14,000. Public admission: $3. Artists should apply by filling out application form. Deadline for entry: March. Application fee: $25. Space fee: $275. Exhibition space: 10×15 ft. For more information, artists should e-mail, visit Web site.

CENTERVILLE/WASHINGTON TOWNSHIP AMERICANA FESTIVAL
P.O. Box 41794, Centerville OH 45441-0794. (937)433-5898. Fax: (937)433-5898. E-mail: americanafestival@sbcglobal.net. Web site: www.americanafestival.org. **Contact:** Patricia Fleissner, arts & crafts chair. Estab. 1972. Arts & crafts show held annually on the Fourth of July. Festival includes entertainment, parade, food, car show and other activities. Accepts photography and all mediums. "No factory-made items accepted." Awards/prizes: 1st Place; 2nd Place; 3rd Place; certificates and ribbons for most attractive displays. Number of exhibitors: 275-300. Public attendance: 70,000. Free to the public. Artists should send SASE for application form or apply online. Deadline for entry: June 27, 2007. "Main Street is usually full by early June." Space fee: $45. Exhibition space: 12×10 ft. For more information, artists should e-mail, visit Web site, call.

Tips "Artists should have moderately priced items; bring business cards; and have an eye-catching display."

COUNTRY ARTS & CRAFTS FAIR
N104 W14181 Donges Bay Rd., Germantown WI 53022. (262)251-0604. E-mail: stjohnucc53022@sbcglobal.net. **Contact:** Mary Ann Toth, booth chairperson. Estab. 1975. Arts & crafts show held annually in September. Indoors and outdoors. Limited indoor space; unlimited outdoor booths. Accepts photography, jewelry, clothing, country crafts. Number of exhibitors: 70. Public attendance: 500-600. Free to the public. Artists should e-mail for an application and state permit. Space fee: $10 for youth; $30 for outdoor; $40 for indoor. Exhibition space: 10×10 ft. and 15×15 ft. For more information, artists should e-mail or call Mary Ann Toth or Amy Green, or send SASE.

Ⓨ CUNEO GARDENS ART FESTIVAL
3417 R.F.D., Long Grove IL 60047. Phone/Fax: (847)726-8669. E-mail: dwevents@comcast.net. Web site: www.dwevents.org. **Contact:** D & W Events, Inc. Estab. 2005. Fine arts & crafts show. Outdoors. Accepts photography, fiber, oil, acrylic, watercolor, mixed media, jewelry, sculpture, metal, paper, painting. Juried by 3 jurors. Awards/prizes: Best of Show; 1st and 2nd Places; and Honorable Mentions. Number of exhibitors: 100. Public attendance: 10,000. Free to public. Artists should apply by downloading application from Web site, e-mail or call. Deadline for entry: March 1. Application fee: $25. Space fee: $250. Exhibition space: 100 sq. ft. For more information, artists should e-mail, visit Web site, call.

Tips "Artists should display professionally and attractively, and interact positively with everyone."

Ⓨ DEERFIELD FINE ARTS FESTIVAL
3417 R.F.D., Long Grove IL 60047. Phone/Fax: (847)726-8669. E-mail: dwevents@comcast.net. Web site: www.dwevents.org. **Contact:** D & W Events, Inc. Estab. 2000. Fine arts & crafts show held annually in early June. Outdoors. Accepts photography, fiber, oil, acrylic, watercolor, mixed media, jewelry, sculpture, metal, paper, painting. Juried by 3 jurors. Awards/prizes: Best of Show; 1st and 2ndPlaces; and Honorable Mentions. Number of exhibitors: 120. Public attendance: 35,000. Free to public. Artists should apply by downloading application from Web site, e-mail or call. Deadline for entry: March 1. Application fee: $25. Space fee: $275. Exhibition space: 100 sq. ft. For more information artists should e-mail, visit Web site, call.

Tips "Artists should display professionally and attractively, and interact positively with everyone."

N ☑ DELAWARE ARTS FESTIVAL

P.O. Box 589, Delaware OH 43015. (740-)363-2695. E-mail: info@delawareartsfestival.org. Web site: www.delawareartsfestival.org. **Contact:** Tom King. Estab. 1973. Fine arts & crafts show held annually the Saturday and Sunday after Mother's Day. Outdoors. Accepts photography; all mediums, but no buy/sell. Juried by committee members who are also artists. Awards/prizes: Ribbons, cash awards, free booth for the following year. Number of exhibitors: 160. Public attendance: 25,000. Free to the public. Artists should apply by visiting Web site for application. Application fee: $10. Space fee: $125. Exhibition fee: 120 sq. ft. For more information, artists should e-mail or visit Web site.

Tips "Have high-quality stuff. Engage the public. Set up a good booth."

N ☑ FERNDALE ART SHOW

Integrity Shows, 2102 Roosevelt, Ypsilanti MI 48197. (734)216-3958. Fax: (734)482-2070. E-mail: mark@integrityshows.com. Web site: www.downtownferndale.com. **Contact:** Mark Loeb, president. Estab. 2004. Fine arts & crafts show held annually in September. Outdoors. Accepts photography and all fine art and craft mediums; emphasis on fun, funky work. Juried by 3 independent jurors. Awards/prizes: Purchase Awards and Merit Awards. Number of exhibitors: 90. Public attendance: 30,000. Free to the public. Application is available in March. Deadline for entry: July. Application fee: $15. Space fee: $250. Exhibition space: 10×12 ft. For more information, artists should e-mail or call.

Tips "Enthusiasm. Keep a mailing list. Develop collectors."

N ☑ FLORA AND FAUNA ART SHOW

Integrity Shows, 2102 Roosevelt, Ypsilanti MI 48197. (734)216-3958. Fax: (734)482-2070. E-mail: mark@integrityshows.com. Web site: www.integrityshows.com. **Contact:** Mark Loeb, president. Estab. 2006. Fine arts & crafts show held annually in September. Outdoors. Accepts photography and all fine art and craft mediums; 75% of each artist's work must be related to flora or fauna. Juried by 3 independent jurors. Awards/prizes: Purchase Awards and Merit Awards. Number of exhibitors: 50. Public attendance: 10,000. Public admission: suggested donation: $5. Application is available in March. Deadline for entry: July. Application fee: $15. Space fee: $200. Exhibition space: 12×15 ft. For more information, artists should e-mail or call.

Tips "Enthusiasm. Keep a mailing list. Develop collectors."

☑ FOUR RIVERS ARTS & CRAFTS HARVEST HOME FESTIVAL

112 S. Lakeview Dr., Petersburg IN 47567. (812)354-6808, ext. 112. Fax: (812)354-2785. E-mail: rivers4@sigecom.net. **Contact:** Denise Tuggle, program assistant. Estab. 1976. Arts & crafts show held annually 3rd weekend in October. Indoors. Juried. Board of Directors are assigned certain buildings to check for any manufactured items. Crafts are not judged. Awards/prizes: $30-50; 3 display awards based on display uniqueness and the correlation of the harvest theme. Number of exhibitors: 200. Public attendance: 5,000. Free to public; $2 parking fee. Artists should apply by calling with information. Application will be mailed along with additional information. Deadline for entry: July 30. Space fee: $55, 2 per applicant. Exhibition space: 10×10 ft. For more information, artists should call.

N ☑ FRANKFORT ART FAIR

P.O. Box 566, Frankfort MI 49635.(231)352-7251. Fax: (231)352-6750. E-mail: fcofc@frankfort-elberta.com. Web site: www.frankfort-elberta.com. **Contact:** Alice Fewins, art fair director. Estab. 1976. Arts & crafts show held annually in August. Outdoors. Accepts photography, clay, glass, jewelry, textiles, wood, drawing/graphic arts, painting, sculpture, baskets, mixed media. Juried by 3 photos of work and one photo of booth display. Prior exhibitors are not automatically accepted. No buy/sell allowed. Artists should apply by downloading application from Web site, e-mailing or calling. Deadline for entry: May 1. Jury fee: $15. Space fee: $85 for Saturday; $20 for optional Friday night sales. Exhibition space: 12×12 ft. For more information, artists should e-mail, see Web site.

☑ GOOD OLD SUMMERTIME ART FAIR

P.O. Box 1753, Kenosha WI 53141-1753. (262)654-0065. E-mail: kaaartfairs@yahoo.com. Web site: www.KenoshaArtAssoc.org. **Contact:** Karen Gulbransen, art fair coordinator. Estab. 1975. Fine arts show held annually 1st Sunday in June. Outdoors. Accepts photography, paintings, drawings, mosaics, ceramics, pottery, sculpture, wood, stained glass. Juried by a panel. Photos or slides required with application. Awards/prizes: Best of Show, 1st, 2nd and 3rd Places, plus Purchase Awards. Number of exhibitors:

100. Public attendance: 3,000. Free to public. Artists should apply by completing application form, and including fees and SASE. Deadline for entry: April 1. Application/space fee: $60-65. Exhibition space: 12 × 12 ft. For more information, artists should e-mail, visit Web site or send SASE.
Tips "Have a professional display, and be friendly."

☙ GREENWICH VILLAGE ART FAIR

711 N. Main St., Rockford IL 61103. (815)968-2787. Fax: (815)316-2179. E-mail: gvaf@rockfordartmuseum.org. Web site: www.rockfordartmuseum.org. **Contact:** Scott Prine, chairman. Estab. 1948. Fine arts & crafts show held annually in September. Outdoors. Accepts photography and all mediums. Juried by a panel of artists and committee. Awards/prizes: Best of Show and Best of Categories. Number of exhibitors: 120. Public attendance: 7,000. Public admission: $4. Artists should apply by mail or locating prospectus on the Web site. Deadline for entry: April 30. Application fee: $20. Space fee: $195. Exhibition space: 10 × 10 ft. For more information, artists should e-mail, visit Web site or call.

Ⓝ ☙ HIGHWOOD FINE ART FESTIVAL

3417 R.F.D., Long Grove IL 60047. Phone/Fax: (847)726-8669. E-mail: dwevents@comcast.net. Web site: www.dwevents.org. **Contact:** D&W Events. Inc. Estab. 2007. Fine arts & crafts show. Outdoors. Accepts photography, fiber, oil, acrylic, watercolor, mixed media, jewelry, sculpture, metal, paper, painting. Juried by 3 jurors. Awards/prizes: Best of Show; 1st and 2nd Places; and Honorable Mentions. Number of exhibitors: 75. Public attendance: 15,000. Free to public. Artists should apply by downloading application from Web site, e-mail or call. Deadline for entry: March 1. Application fee: $25. Space fee: $250. Exhibition space: 100 sq. ft. For more information, artists should e-mail, visit Web site, call.
Tips "Artists should display professionally and attractively, and interact positively with everyone."

☙ HINSDALE FINE ARTS FESTIVAL

22 E. First St., Hinsdale IL 60521. (630)323-3952. Fax: (630)323-3953. E-mail: janet@hindsdalechamber.com. Web site: www.hinsdalechamber.com. **Contact:** Jan Anderson, executive director. Fine arts show held annually in mid-June. Outdoors. Accepts photography, ceramics, painting, sculpture, fiber arts, mixed media, jewelry. Juried by 3 slides. Awards/prizes: Best in Show, Presidents Award and 1st, 2nd and 3rd Place in 7 categories. Number of exhibitors: 150. Public attendance: 2,000-3,000. Free to public. Artists should apply by mailing or downloading application from Web site. Deadline for entry: March 2. Application fee: $25. Space fee: $250. Exhibition space: 10 × 10 ft. For more information, artists should e-mail or visit Web site.
Tips "Original artwork sold by artist. Artwork should be appropriately and reasonably priced."

☙ KIA ART FAIR (KALAMAZOO INSTITUTE OF ARTS)

314 S. Park St., Kalamazoo MI 49007-5102. (269)349-7775. Fax: (269)349-9313. E-mail: sjrodia@yahoo.com. Web site: www.kiarts.org. **Contact:** Steve Rodia, artist coordinator. Estab. 1951. Fine arts & crafts show held annually 1st Saturday in June. Outdoors. Accepts photography, prints, pastels, drawings, paintings, mixed media, ceramics (functional and nonfunctional), sculpture/metalsmithing, wood, fiber, jewelry, glass, leather. Juried by no fewer than 3 and no more than 5 art professionals chosen for their experience and expertise. See prospectus for more details. Awards/prizes: 1st prize: $500; 2nd prize: 2 at $300 each; 3rd prize: 3 at $200 each. Number of exhibitors: 200. Public attendance: 40,000-50,000. Free to the public. Artists should apply by filling out application form and submitting 4 35mm color slides of their art and 1 color slide of their booth display. Deadline for entry: March 1. Application fee: $20, nonrefundable. Space fee: $110. Exhibition space: 10 × 12 ft. Height should not exceed 10 ft. in order to clear the trees in the park. For more information, artists should e-mail, visit Web site, call.

☙ LES CHENEAUX FESTIVAL OF ARTS

P.O. Box 30, Cedarville MI 49719. (906)484-2821. Fax: (906)484-6107. E-mail: lcha@cedarville.net. **Contact:** A. Goehring, curator. Estab. 1976. Fine arts & crafts show held annually 2nd Saturday in August. Outdoors. Accepts photography and all other media; original work and design only; no kits or commercially manufactured goods. Juried by a committee of 10. Submit 4 slides (3 of the artwork; 1 of booth display). Awards/prizes: monetary prizes for excellent and original work. Number of exhibitors: 70. Public attendance: 8,000. Public admission: $7. Artists should fill out application form to apply. Deadline for entry: April 1. Application fee: $65. Exhibition space: 10 × 10 ft. Average gross sales/exhibitor: $5-$500. For more information, artists should call, send SASE.

MASON ARTS FESTIVAL

P.O. Box 381, Mason OH 45040. ((513)573-9376. E-mail: pgast@cinci.rr.com for Inside City Gallery; mraffel@cinci.rr.com for outdoor art festival. Web site: www.masonarts.org. **Contact:** Pat Gastreich, City Gallery Chairperson. Fine arts and crafts show held annually in September. Indoors and outdoors. Accepts photography, graphics, printmaking, mixed media, painting and drawing, ceramics, metal sculpture, fiber, glass, jewelry, wood, leather. Juried. Awards/prizes: $3,000+. Number of exhibitors: 75-100. Public attendance: 3,000-5,000. Free to the public. Artists should apply by visiting Web site for application, e-mailing mraffel@cinci.rr.com, or calling (513)573-0007. Deadline for entry: June. Application fee: $25. Space fee: $75 for single space; $135 for adjoinging spaces. Exhibition space: 12×12 ft.; artist must provide 10×10 ft. pop-up tent.

- City Gallery show is held indoors; these artists are not permitted to participate outdoors and vice versa. City Gallery is a juried show featuring approximately 30-50 artists who may show up to 2 pieces.

Tips ''Photographers are required to disclose both their creative and printing processes. If digital manipulation is part of the composition, please indicate.''

MICHIGAN STATE UNIVERSITY HOLIDAY ARTS & CRAFTS SHOW

322 MSU Union, East Lansing MI 48824. (517)355-3354. Fax: (517)432-2448. E-mail: uab@hfs.msu.edu. Web site: www.uabevents.com. **Contact:** Kate Lake, assistant manager. Estab. 1963. Arts & crafts show held annually 1st weekend in December. Indoors. Accepts photography, basketry, candles, ceramics, clothing, sculpture, soaps, drawings, floral, fibers, glass, jewelry, metals, painting, graphics, pottery, wood. Juried by a panel of judges using the photographs submitted by each vendor to eliminate commercial products. They will evaluate on quality, creativity and crowd appeal. Number of exhibitors: 220. Public attendance: 15,000. Free to public. Artists should apply online. Application will be available in July. Application fee: $240. Exhibition space: 8×5 ft. For more information, artists should visit Web site or call.

MICHIGAN STATE UNIVERSITY SPRING ARTS & CRAFTS SHOW

322 MSU Union, East Lansing MI 48824. (517)355-3354. Fax: (517)432-2448. E-mail: artsandcrafts@uabevents.com. Web site: www.uabevents.com Contact: Kate Lake, assistant manager. Estab. 1963. Arts & crafts show held annually in mid-May. Outdoors. Accepts photography, basketry, candles, ceramics, clothing, sculpture, soaps, drawings, floral, fibers, glass, jewelry, metals, painting, graphics, pottery, wood. Juried by a panel of judges using the photographs submitted by each vendor to eliminate commercial products. They will evaluate on quality, creativity and crowd appeal. Number of exhibitors: 329. Public attendance: 60,000. Free to public. Artists can apply online beginning in February. Online applications will be accepted until show is filled. Application fee: $240. Exhibition space: 10x10 ft. For more information, artists should visit Web site or call.

NEW ENGLAND ARTS & CRAFTS FESTIVAL

Castleberry Fairs & Festivals, 38 Charles St., Rochester NE 03867. (603)322-2616. E-mail: info@castleberryfairs.com. Web site: www.castleberryfairs.com. **Contact:** Terry Mullen, event coordinator. Estab. 1988. Arts & crafts show held annually on Labor Day weekend in Topsfield, Massachusettes. Indoors and outdoors. Accepts photography and all other mediums. Juried by photo, slide or sample. Number of exhibitors: 250. Public attendance: 25,000. Public admission: $5.00 for adults: free for 13 and under. Artists should apply by downloading application from Web site. Deadline for entry: until full. Space fee: $350. Exhibition space: 100 sq. ft. Average gross sales/exhibitor: ''Generally, this is considered an 'excellent' show, so I would guess most exhibitors sell ten times their booth fee, or in this case, at least $3,500 in sales.'' For more information, artists should visit Web site.

Tips ''Do not bring a book; do not bring a chair. Smile and make eye contact with everyone who enters your booth. Have them sign your guest book; get their e-mail address so you can let them know when you are in the area again. And, finally, make the sale—they are at the fair to shop, after all.''

ORCHARD LAKE FINE ART SHOW

P.O. Box 79, Milford MI 48381-0079. (248)684-2613. Fax: (248)684-0195. E-mail: patty@hotworks.org. Web site: www.hotworks.org. **Contact:** Patty Narozny, show director. Estab. 2002. Fine arts & crafts show held annually 1st weekend in August. Outdoors. Accepts photography, clay, glass, fiber, wood, jewelry, painting, prints, drawing, sculpture, metal, multimedia. Juried by 3 art professionals who view

3 slides of work and 1 of booth. Awards/prizes: $2,500 in awards: 1 Best of Show: $1,000; 2 Purchase Awards: $500 each; 5 Awards of Excellence: $100 each. Free to the public; parking: $5. Artists can obtain an application on the Web site, or they can call the show director who will mail them an application. Deadline for entry: March. Application fee: $25. Space fee: starts at $300. Exhibition space: 12×3 ft. "We allow room on either side of the tent, and some space behind the tent." For more information, artists should e-mail, visit Web site, call, send SASE.

Tips "Be attentive to your customers. Do not ignore anyone."

☑ RILEY FESTIVAL

312 E. Main St. #C, Greenfield IN 46140. (317)462-2141. Fax: (317)467-1449. E-mail: info@rileyfestival.com. Web site: www.rileyfestival.com. **Contact:** Sarah Kesterson, office manager. Estab. 1975. Fine arts & crafts show held annually in October. Outdoors. Accepts photography, fine arts, home arts, quilts. Juried. Awards/prizes: small monetary awards and ribbons. Number of exhibitors: 450. Public attendance: 75,000. Free to public. Artists should apply by downloading application on Web site. Deadline for entry: September 15. Space fee: $160. Exhibition space: 10×10 ft. For more information, artists should visit Web site.

Tips "Keep arts priced for middle-class viewers."

ⓝ ☑ SPRING FESTIVAL, AN ARTS & CRAFTS AFFAIR

P.O. Box 184, Boys Town NE 68010. (402)331-2889. Fax: (402)445-9177. E-mail: hpifestivals@cox.net. Web site: www.hpifestivals.com. **Contact:** Huffman Productions. Estab. 2007. Fine arts & craft show held annually in March. Indoors. Accepts photography, pottery, jewelry, wood. All must be handcrafted by the exhibitor. Juried by 2 photos of work and 1 of disply. Awards/prizes: $420 total cash awards. Number of exhibitors: 180. Public attendance: 6,000-8,000. Public admission: $5. Artists should apply by calling for an application. Deadline: when full or by mid-March. Space fee: $220. Exhibition space: 10×10 ft. "We provide pipe and drape." For more information, artists should e-mail, visit Web site, call, send SASE.

Tips "Have a nice display; dress professionally; have various price points; be willing to talk to your customers; display your business name."

ⓝ ☑ ST. CHARLES FINE ART SHOW

213 Walnut St., St. Charles IL 60174. (630)513-5386. Fax: (630)513-6310. E-mail: bethany@dtown.org. Web site: www.stcharlesfineartshow.com. **Contact:** Bethany McFarland, marketing coordinator. Estab. 1999. Fine art fair held annually in late May. Outdoors. Accepts photography, painting, sculpture, glass, ceramics, jewelry, nonwearable fiber art. Juried by committee: submit 4 slides of art and 1 slide of booth/display. Awards/prizes: Cash awards of $2,500+ awarded in several categories. Purchase Award Program: $14,000 of art has been purchased through this program since its inception in 2005. Number of exhibitors: 100. Free to the public. Artists should apply by downloading application from Web site or call for application. Deadline for entry: February. Jury fee: $25. Space fee: $200. Exhibition space: 12×12 ft. For more information, artists should e-mail, visit Web site, call.

☑ ST. JAMES COURT ART SHOW

P.O. Box 3804, Louisville KY 40201. (502)635-1842. Fax: (502)635-1296. E-mail: mesrock@stjamescourtartshow.com. Web site: www.stjamescourtartshow.com. **Contact:** Marguerite Esrock, executive director. Estab. 1957. Annual fine arts & crafts show held the first full weekend in October. Accepts photography; has 16 medium categories. Juried in March; there is also a street jury held during the art show. Awards/prizes: Best of Show-3 places; $7,500 total prize money. Number of exhibitors: 340. Public attendance: 275,000. Free to the public. Artists should apply by visiting Web site and printing out an application or via www.zapplication.org. Deadline for entry: March 1, 2007. Application fee: $30. Space fee: $400-500. Exhibition space: 10×12 ft. For more information, artists should e-mail or visit Web site.

Tips "Have a variety of price points. Don't sit in the back of the booth and expect sales."

☑ STONE ARCH FESTIVAL OF THE ARTS

219 Main St. SE, Suite 304, Minneapolis MN 55414. (612)378-1226. E-mail: mplsriverfront@msn.com. Web site: www.stonearchfestival.com. **Contact:** Sara Collins, manager. Estab. 1994. Fine arts & crafts show and culinary arts show held annually Father's Day weekend. Outdoors. Accepts photography, painting, ceramics, jewelry, fiber, printmaking, wood, metal. Juried by committee. Awards/prizes: free

booth the following year; $100 cash prize. Number of exhibitors: 230. Public attendance: 80,000. Free to public. Artists should apply by application found on Web site or through www.zapplication.org. Deadline for entry: March 15. Application fee: $20 jury. Space fee: $250-300. Exhibition space: 10×10 ft. For more information, artists should e-mail, visit Web site, call or send SASE.

Tips "Have an attractive display and variety of prices."

◩ STREET FAIRE AT THE LAKES

P.O. Box 348, Detroit Lakes MN 56502. (800)542-3992. Fax: (218)847-9082. E-mail: dlchamber@visitdetr oitlakes.com. Web site: www.visitdetroitlakes.com. **Contact:** Sue Brown, artist coordinator. Estab. 2001. Fine arts & crafts show held annually 1st weekend after Memorial Day. Outdoors. Accepts photography, handmade/original artwork, wood, metal, glass, painting, fiber. Juried by anonymous scoring. Submit 5 slides, 4 of work and 1 of booth display. Top scores are accepted. Number of exhibitors: 125. Public attendance: 15,000. Free to public. Artists should apply by downloading application from Web site. Deadline for entry: January 15. Application fee: $150-175. Exhibition space: 11×11 ft. For more information, artists should e-mail or call.

SUMMER ARTS AND CRAFTS FESTIVAL

UW-Parkside, 900 Wood Rd., Box 2000, Kenosha WI 53141. (262)595-2457. E-mail: eichner@uwp.edu. **Contact:** Mark Eichner, coordinator. Estab. 1990. Arts & crafts show held annually 3rd week in June. Outdoors. Accepts photography, painting, glass, sculpture, woodwork, metal, jewelry, leather, quilts. Number of exhibitors: 200. Public attendance: 4,000. Free to the public. Artists should apply by calling or e-mailing for an application form. Deadline for entry: May. Space fee: $100. Exhibition space: 10×10 ft. For more information, artists should e-mail, call.

Tips "Items priced less than $100 are excellent sellers."

◩ SUMMERFAIR

2515 Essex Place, Studio 243, Cincinnati OH 45206. (513)531-0050. Fax:(513)531-0377. E-mail: exhibitors @summerfair.org. Web site: www.summerfair.org. **Contact:** Christina Waddle. Estab. 1968. Fine arts & crafts show held annually the weekend after Memorial Day. Outdoors. Accepts photography, ceramics, drawing/printmaking, fiber/leather, glass, jewelry, painting, sculpture/metal, wood. Juried by a panel of judges selected by Summerfair, including artists and art educators with expertise in the categories offered at Summerfair. Submit 5 slides of artwork, including artist's name, demensions of work, and arrow indicating top of work. "Do not submit a booth slide." Awards/prizes: $10,000 in cash awards. Number of exhibitors: 300. Public attendance: 35,000. Public admission: $9. Artists should apply by downloading application from Web site (available in December) or by e-mailing for an application. Deadline: February. Application fee: $25. Space fee: $325, single single; $650, double space; $75 canopy fee (optional—exhibitors can rent a canopy for all days of the fair.). Exhibition space: 10×10 ft. for single space; 10×20 for double space. For more information, artists should e-mail, visit Web site, call.

ℕ ◩ UPTOWN ART FAIR

1406 West Lake St., Suite 202, Minneapolis MN 55408. (612)823-4581. Fax: (612)823-3158. E-mail: info@ uptownminneapolis.com. Web site: www.uptownminneapolis.com. **Contact:** Cindy Fitzpatrick. Estab. 1963. Fine arts & crafts show held annually 1st full weekend in August. Outdoors. Accepts photography, painting, printmaking, drawing, 2D and 3D mixed media, ceramics, fiber, sculpture, jewelry, wood. Juried by 4 images of artwork and 1 of booth display. Awards/prizes: Best in Show in each category; Best Artist. Number of exhibitors: 350. Public attendance: 350,000. Free to the public. Artists should apply by visiting www.zapplication.com. Deadline for entry: March. Application fee: $30. Space fee: $450 for 10×10 space; $900 for 10×20 space. For more information, artists should call or visit Web site.

◩ A VICTORIAN CHAUTAUQUA

1101 E Market St., P.O. Box 606, Jeffersonville IN 47131-0606. (812)283-3728. Fax: (812)283-6049. E-mail: hsmsteam@aol.com. Web site: www.steamboatmuseum.org. **Contact:** Yvonne Knight, administrator. Estab. 1993. Fine arts & crafts show held annually 3rd weekend in May. Outdoors. Accepts photography, all mediums. Juried by a committee of 5. Awards/prizes: $100, 1st Place; $75, 2nd Place; $50, 3rd Place. Number of exhibitors: 80. Public attendance: 3,000. Public admission: $3. Deadline for entry: March 31. Space fee: $40-60. Exhibition space: 12×12 ft. For more information, artists should e-mail or call.

N ✦ WILMETTE FESTIVAL OF FINE ARTS

P.O. Box 902, Wilmette IL 60091-0902. Phone/fax: (847)256-2080. E-mail: wilmetteartsguild@aol.com. Web site: www.wilmetteartsguild.org. **Contact:** Marge Graham, president. Estab. 1992. Fine arts & crafts show held annually in September. Outdoors. Accepts photography, paintings, prints, jewelry, sculpture, ceramics, and any other appropriate media; no wearable. Juried by a committee of 6-8 artists and art teachers. Awards/prizes: 1st Place: $1,000; 2nd Place: $750; 3rd Place: $500; People's Choice: $50; local merchants offer purchase awards. Number of exhibitors: 100. Public attendance: 4,000. Free to the public. Deadline for entry: April. Application fee: $120. Space fee: $195. Exhibition space: 12 × 12 ft. For more information, artists should e-mail, visit Web site, call, send SASE.

Tips "Maintain a well-planned, professional appearance in booth and person. Greet viewers when they visit the booth. Offer printed bio with photos of your work. Invite family, friends and acquaintances."

✦ WINNEBAGOLAND ART FAIR

South Park Avenue/South Park, Oshkosh WI 54902. (920)303-1503. E-mail: shelling1230@charter.net. Estab. 1957. Fine arts show held annually. Outdoors. Accepts photography, watercolor, oils & acrylics, 3D large, 3D small, drawing, pastels. Juried. Applicants send in slides to be reviewed. Awards/prizes: monetary awards, Purchase, Merit and Best of Show awards. Number of exhibitors: 125-160. Public attendance: 5,000-7,000. Free to public. Deadline for entry: April 30. Application fee: $60, but may increase next year. Exhibition space: 20 × 20 ft. For more information, artists should e-mail or call.

Tips "Have a nice-looking exhibit booth."

N ✦ WYANDOTTE STREET ART FAIR

3131 Biddle Ave., Wyandotte MI 48192. (734)324-4505. Fax: (734)324-4505. E-mail: info@wyan.org. Web site: www.wyandottestreetartfair.net. **Contact:** Lisa Hooper, executive director, Wyandotte Downtown Development Authority. Estab. 1961. Fine arts & crafts show held annually 2nd week in July. Outdoors. Accepts photography, 2D mixed media, 3D mixed media, painting, pottery, basketry, sculpture, fiber, leather, digital cartoons, clothing, stitchery, metal, glass, wood, toys, prints, drawing. Juried. Awards/prizes: Best New Artist: $500; Best Booth Design Award: $500; Best of Show: $1,200. Number of exhibitors: 300. Public attendance: 200,000. Free to the public. Artists should apply online. Deadline for entry: February. Application fee: $10 jury fee. Space fee: $250/single space; $500/double space. Exhibition space: 10 × 10 ft. Average gross sales/exhibitor: $2,000-$4,000. For more information, artists should e-mail, visit Web site, call, send SASE.

SOUTH CENTRAL & WEST

✦ AFFAIRE IN THE GARDENS ART SHOW

Greystone Park, 501 Doheny Rd., Beverly Hills CA 90210-2921. (310)550-4796. Fax: (310)858-9238. E-mail: kmclean@beverlyhills.org. Web site: www.beverlyhills.org. **Contact:** Karen Fitch McLean, art show coordinator. Estab. 1973. Fine arts & crafts show held biannually 3rd weekend in May and 3rd weekend in October. Outdoors. Accepts photography, painting, sculpture, ceramics, jewelry, digital media. Juried. Awards/prizes: 1st Place in category, cash awards, Best in Show cash award; Mayor's Purchase Award in October show. Number of exhibitors: 225. Public attendance: 30,000-40,000. Free to public. Deadline for entry: end of February, May show; end of July, October show. Application fee: $30. Space fee: $300. Exhibition space: 10 × 12 ft. For more information, artists should e-mail, visit Web site, call or send SASE.

Tips "Art fairs tend to be commercially oriented. It usually pays off to think in somewhat commercial terms—what does the public usually buy? Personally, I like risky and unusual art, but the artists who produce esoteric art sometimes go hungry! Be nice and have a clean presentation."

✦ ART IN THE PARK

P.O. Box 247, Sierra Vista AZ 85636-0247. (520) 378-1763. E-mail: artinthepark@cox.net. Web site: www.huachuco-art.com. **Contact:** Vendor Committee. Estab. 1972. Fine arts & crafts show held annually 1st full weekend in October. Outdoors. Accepts photography, all fine arts and crafts created by vendor. Juried by 3-6 typical customers. Artists submit 6 photos. Number of exhibitors: 222. Public attendance: 20,000. Free to public. Artists should apply by calling, e-mailing or sending SASE between February and

May. Deadline for entry: postmarked by May 30. Application fee: $10 included in space fee. Space fee: $175, includes jury fee. Exhibition space: 15×35 ft. For more information, artists should e-mail, call or send SASE.

AVON FINE ART & WINE AFFAIRE

15648 N. Eagles Nest Dr., Fountain Hills AZ 85268-1418. (480)837-5637. Fax: (480)837-2355. E-mail: info@thunderbirdartists.com. Web site: www.thunderbirdsartists.com. **Contact:** Denise Colter, vice president. Estab. 1993. Fine arts & crafts show and wine tasting held annually in mid-July. Outdoors. Accepts photography, painting, mixed media, bronze, metal, copper, stone, stained glass, clay, wood, paper, baskets, jewelry, scratchboard. Juried by 4 slides of work and 1 slide of booth. Number of exhibitors: 150. Public attendance: 3,000-6,000. Free to public. Artists should apply by sending application, fees, 4 slides of work, 1 slide of booth and 2 SASEs. Deadline for entry: March 27. Application fee: $20. Space fee: $360-1,080. Exhibition space: 10×10 ft.-10×30 ft. For more information, artists should visit Web site.

CALABASAS FINE ARTS FESTIVAL

26135 Mureau Rd., Calabasas CA 91302. (818)878-4225, ext. 270. E-mail: artcouncil@cityofcalabasas.com. Web site: www.cityofcalabasas.com. Estab. 1997. Fine arts & crafts show held annually in late April/early May. Outdoors. Accepts photography, painting, sculpture, jewelry, mixed media. Juried. Number of exhibitors: 250. Public attendance: 10,000+. Free to public; parking: $5. For more information, artists should visit Web site or e-mail.

CHUN CAPITOL HILL PEOPLE'S FAIR

1290 Williams St., Denver CO 80218. (303)830-1651. Fax: (303)830-1782. E-mail: chun@chundenver.org. Web site: www.peoplesfair.com; www.chundenver.org. Estab. 1971. Arts & crafts show held annually 1st weekend in June. Outdoors. Accepts photography, ceramics, jewelry, paintings, wearable art, glass, sculpture, wood, paper, fiber. Juried by professional artisans representing a variety of mediums and selected members of fair management. The jury process is based on originality, quality and expression. Awards/prizes: Best of Show. Number of exhibitors: 300. Public attendance: 250,000. Free to public. Artists should apply by downloading application from Web site. Deadline for entry: March. Application fee: $35. Space fee: $300. Exhibition space: 10×10 ft. For more information, artists should e-mail, visit Web site or call.

EDWARDS FINE ART & SCULPTURE FESTIVAL

15648 N. Eagles Nest Dr., Fountain Hills AZ 85268-1418. (480)837-5637. Fax: (480)837-2355. E-mail: info@thunderbirdartists.com. Web site: www.thunderbirdsartists.com. **Contact:** Denise Colter, vice president. Estab. 1999. Fine arts & sculpture show held annually in late July. Outdoors. Accepts photography, painting, drawing, graphics, fiber sculpture, mixed media, bronze, metal, copper, stone, stained glass, clay, wood, baskets, jewelry. Juried by 4 slides of work and 1 slide of booth presentation. Number of exhibitors: 115. Public attendance: 3,000-6,000. Free to public. Artists should apply by sending application, fees, 4 slides of work, 1 slide of booth labeled and 2 SASE. Deadline for entry: March 29. Application fee: $20. Space fee: $360-1,080. Exhibition space: 10×10 ft.-10×30 ft. For more information, artists should visit Web site.

EVERGREEN ARTS FESTIVAL

P.O. Box 3931, Evergreen CO 80437-3931. (303)679-1609, opt. 1. E-mail: info@evergreenartists.org. Web site: http://www.evergreenartists.org/Shows_Festivals.htm. **Contact:** EAA Arts Festival Coordinator. Estab. 1966. Fine arts & crafts show held annually last weekend in August. Outdoors. Accepts photography, fiber, oil, acrylic, pottery, jewelry, mixed media, ceramics, wood, watercolor. Juried by 5 jurors that change yearly. Artists should submit 4 slides of work and 1 of booth display. Awards/prizes: Best of Show; 1st, 2nd, 3rd Places in each category. Number of exhibitors: 96. Public attendance: 3,000-6,000. Free to public. Deadline for entry: April 15. Application fee: $25. Space fee: $275-325. Exhibition space: 10×10 ft. For more information, artists should call or send SASE.

Tips "Have a variety of work. It is difficult to sell only high-ticket items."

FILLMORE JAZZ FESTIVAL

P.O. Box 15107, San Rafael CA 94915. (800)310-6563. Fax: (414)456-6436. E-mail: art@fillmorejazzfestival.com. Web site: www.fillmorejazzfestival.com. Estab. 1984. Fine arts & crafts show and jazz festival

held annually 1st weekend of July in San Franciso, between Jackson & Eddy Streets. Outdoors. Accepts photography, ceramics, glass, jewelry, paintings, sculpture, metal clay, wood, clothing. Juried by pres-creened panel. Number of exhibitors: 250. Public attendance: 90,000. Free to public. Deadline for entry: ongoing. Space fee: $350-600. Exhibition space: 8×10 ft. or 10×10 ft. Average gross sales/exhibitor: $800-11,000. For more information, artists should e-mail, visit Web site or call.

N Y FOURTH AVENUE SPRING STREET FAIR

329 E. 7th St., Tucson AZ 85705.(520)624-5004. Fax: (520)624-5933. E-mail: www.kurt@fourthavenue.org. Web site: www.fourthavenue.org. **Contact:** Kurt Tallis, event director. Estab. 1970. Arts & crafts fair held annually in March. Outdoors. Accepts photography, drawing, painting, sculpture, arts and crafts. Juried by 5 jurors. Awards/prizes: Best of Show. Number of exhibitors: 400. Public attendance: 300,000. Free to the public. Artists should apply by completing the online application. Deadline for entry: December. Application fee: $35. Space fee: $425. Exhibition space: 10×10 ft. Average gross sales/exhibitor: $3,000. For more information, artists should e-mail, visit Web site, call, send SASE.

N Y FOURTH AVENUE WINTER STREET FAIR

329 E. 7th St., Tucson AZ 85705. (520)624-5004. Fax: (520)624-5933. E-mail: www.kurt@fourthavenue.org. Web site: www.fourthavenue.com. **Contact:** Kurt Tallis, event director. Estab. 1970. Arts & crafts fair held annually in December. Outdoors. Accepts photography, drawing, painting, sculpture, arts and crafts. Juried by 5 jurors. Awards/prizes: Best of Show. Number of exhibitors: 400. Public attendance: 300,000. Free to the public. Artists should apply by completing the online application. Deadline for entry: September. Application fee: $35. Space fee: $425. Exhibition space: 10×10 ft. Average gross sales/exhibitor: $3,000. For more information, artists should e-mail, visit Web site, call, send SASE.

Y FOURTH OF JULY STREET FAIR, AUTUMN FEST IN THE PARK AND HOLIDAY STREET FESTIVAL

501 Poli St. #226, Ventura CA 93002. (805)654-7830. Fax: (805)648-1030. E-mail: mgoody@ci.ventura.ca.us. Web site: www.venturastreetfair.com. **Contact:** Michelle Goody, cultural affairs coordinator. Estab. 1976. Fine arts & crafts show held annually in July, September and December. Outdoors. Accepts photography. Juried by a panel of 3 artists who specialize in various mediums; photos of work required. Number of exhibitors: 75-300. Public attendance: 1,000-50,000. Free to public. Artists should apply by downloading application from Web site or call to request application. Space fee: $100-175. Exhibition space: 10×10 ft. For more information, artists should e-mail, visit Web site or call.
Tips "Be friendly, outgoing; know the area for pricing."

HOME DECORATING & REMODELING SHOW

P.O. Box 230699, Las Vegas NV 89105-0699. (702)450-7984 or (800)343-8344. Fax: (702)451-7305. E-mail: spvandy@cox.net. Web site: www.nashvillehomeshow.com. **Contact:** Vandy Richards, manager member. Estab. 1983. Home show held annually in September. Indoors. Accepts photography, sculpture, watercolor, oils, mixed media, pottery. Awards/prizes: Outstanding Booth Award. Number of exhibitors: 300-350. Public attendance: 25,000. Public admission: $8. Artists should apply by calling. Marketing is directed to middle and above income brackets. Deadline for entry: open until filled. Space fee: $850+. Exhibition space: 9×10 ft. or complement of 9×10 ft. For more information, artists should call.

Y KINGS MOUNTAIN ART FAIR

13106 Skyline Blvd., Woodside CA 94062. (650)851-2710. E-mail: kmafsecty@aol.com. **Contact:** Carrie German, administrative assistant. Web site: www.kingsmountainartfair.org. Estab. 1963. Fine arts & crafts show held annually Labor Day weekend. Accepts photography, ceramics, clothing, 2D, painting, glass, jewelry, leather, sculpture, textile/fiber, wood. Juried. Number of exhibitors: 135. Public attendance: 10,000. Free to public. Deadline for entry: January 30. Application fee: $10. Space fee: $100 plus 15%. Exhibition space: 10×10 ft. Average gross sales/exhibitor: $3,000. For more information, artists should e-mail, visit Web site, call or send SASE.

Y LAKE CITY ARTS & CRAFTS FESTIVAL

P.O.Box 1147, Lake City CO 81235. (970)944-2706. E-mail: jlsharpe@centurytel.net. Web site: www.lakecityarts.org. **Contact:** Laura Sharpe, festival director. Estab. 1975. Fine arts/arts & craft show held annually 3rd Tuesday in July. One-day event. Outdoors. Accepts photography, jewelry, metal work, wood-

working, painting, handmade items. Juried by 3-5 undisclosed jurors. Prize: Winners are entered in a drawing for a free both space in the following year's show. Number of Exhibitors: 85. Public Attendance: 500. Free to the public. Deadline for entry: entries must be postmarked April 25. Application fee: $75; nonrefundable jury fee: $10. Exhibition space: 12×12 ft. Average gross sales/exhibitor: $500-$1,000. For more information, artists should visit Web site .

Tips "Repeat vendors draw repeat customers. People like to see their favorite vendors each year or every other year. If you come every year, have new things as well as your best-selling products."

☑ LITCHFIELD LIBRARY ARTS & CRAFTS FESTIVAL

101 W Wigwam Blvd., Litchfield Park AZ 85340. (623)935-5053. E-mail: tinalibrary@qwest.net. **Contact:** Tina Norwalk, administrator. Estab. 1970. Fine arts & crafts show held annually 1st weekend in November. Outdoors. Accepts photography and all mediums. Juried. Number of exhibitors: 300. Public attendance: 125,000. Free to public. Artists should apply by calling for application. Deadline for entry: April. Space fee: $300. Exhibition space: 10×15 ft. For more information, artists should call.

Tips "Professional display and original art."

☑ MID-MISSOURI ARTISTS CHRISTMAS ARTS & CRAFTS SALE

P.O. Box 116, Warrensburg MO 64093. (660)747-6092. E-mail: bjsmith@iland.net or rlimback@iland.net. **Contact:** Beverly Smith. Estab. 1970. Holiday arts & crafts show held annually in November. Indoors. Accepts photography and all original arts and crafts. Juried by 3 good-quality color photos (2 of the artwork, 1 of the display). Number of exhibitors: 50. Public attendance: 1,000. Free to the public. Artists should apply by e-mailing or calling for an application form. Deadline for entry: November. Space fee: $50. Exhibition space: 10×10 ft. For more information, artists should e-mail or call.

Tips "Items under $100 are most popular."

N ☑ NEW MEXICO ARTS & CRAFTS FAIR

5500 San Mateo NE, Suite 106, Albuquerque NM 87109. (505)884-9043. Fax: (505)884-9084. E-mail: info@nmartsandcraftsfair.org. Web site: www.nmartsandcraftsfair.org. **Contact:** Kristin Schuetz, office manager. Estab. 1962. Fine arts & craft show held annually in June. Indoors and outdoors. Accepts photography, ceramics, fiber, digital art, drawing, precious jewelry and nonprecious, printmaking, sculpture, wood, mixed media. **Only New Mexico residents 18 years and older are eligible.** Juried by submitting 5 slides; 5 New Mexico artists are chosen each year to jury. Awards/prizes: Total cash awards exceed $4,500. Best of Show: $1,500; First Lady's Choice; Jury Awards; Artist's Choice Award; Creativity Award; First-Time Exhibitor Award. Number of exhibitors: 220. Public admission: $10 for 3-day adult & senior pass; $5 for adult & senior daily admission; free to youth 12 and under. Artists should apply by downloading application from Web site or e-mail for application. Deadline: January. Application fee: Jury fee of $25 per category entered. Space fee: 10×10 ft. (outdoor-1 exhibitor): $25; 10×10 ft. (indoor-1 exhibitor): $375; 10×10 ft. (outdoor, 2 exhibitors): $400; 10×10 ft. (indoor, 2 exhibitors): $450. For more information, artists should e-mail, visit Web site, call.

N ☑ OFFICIAL TEXAS STATE ARTS & CRAFTS FAIR

4000 Riverside Dr., Kerrville TX 78028. (830)896-5711. Fax: (830)896-5569. E-mail: fair@tacef.org. Web site: www.tacef.org. **Contact:** Penni Carr. Estab.1972. Fine arts & crafts show held annually on Memorial Day weekend. Outdoors. Accepts photography, ceramics, fiber, glass, graphics/drawing, jewelry, leather, metal, mixed media, painting, sculpture, wood. Juried by a panel of professional artists and college art professors. Number of exhibitors: 160+. Public attendance: 16,000. Public admission: $10 for a 4-day pass. Artists should apply by downloading application from Web site. Deadline: December. Application fee: $20. Space fee: $300-600. Exhibition space: 10×10. ft. and 10×20 ft. For more information, artists should visit Web site.

Tips "Market and advertise."

☑ PASEO ARTS FESTIVAL

3022 Paseo, Oklahoma City OK 73103. (405)525-2688. Web site: www.ThePaseo.com. **Contact:** Lori Oden, executive director. Estab. 1976. Fine arts & crafts show held annually Memorial Day weekend. Outdoors. Accepts photography and all fine art mediums. Juried by submitting 3 slides or CD. Awards/prizes: $1,000, Best of Show; $350, 2D; $350, 3D; $350, Best New Artist. Number of exhibitors: 75. Public attendance: 50,000-60,000. Free to public. Artists should apply by calling for application form. Deadline

for entry: March 1. Application fee: $25. Space fee: $250. Exhibition space: 10×10 ft. For more informa-tion, artists should visit Web site, call or send SASE.

◪ SANTA CALI GON DAYS FESTIVAL

P.O. Box 1077, Independence MO 64051. (816)252-4745. Fax: (816)252-4917. E-mail: tfreeland@indepen dencechamber.org. Web site: www.santacaligon.com. **Contact:** Teresa Freeland, special projects assis-tant. Estab. 1940. Market vendors show held annually Labor Day weekend. Outdoors. Accepts photogra-phy, all other mediums. Juried by committee. Number of exhibitors: 240. Public attendance: 225,000. Free to public. Artists should apply by requesting application. Application requirements include completed application, application fee, 4 photos of product/art and 1 photo of display. Deadline for entry: March 6-April 7. Application fee: $20. Space fee: $330-430. Exhibition space: 8×8 ft.-10×10 ft. For more infor-mation, artists should e-mail, visit Web site or call.

📄 ◪ SAUSALITO ART FESTIVAL

P.O. Box 10, Sausalito CA 94966. (415)332-3555. Fax: (415)331-1340. E-mail: artfestonel@aol.com. Web site: www.sausalitoartfestival.org. **Contact:** Joseph Lillis, executive director. Estab. 1952. Fine arts & crafts show held annually Labor Day weekend. Outdoors. Accepts photography, 2D and 3D mixed media, ceramics, drawing, fiber, functional art, glass, jewelry, printmaking, sculpture, woodwork. Juried. Jurors are elected by their peers from the previous year's show (1 from each category). They meet the 1st weekend in April and give scores of 1, 2, 3, 4 or 5 to each applicant (5 being the highest). Awards/prizes: $500 for each 1st and 2nd Place in each category; optional $1,000 for Best in Show. Number of exhibitors: 270. Public attendance: 40,000. Public admission: $20; seniors (age 62+): $10; children (under 6): $5. Artists should apply by visiting Web site for instructions and application (http://www.sausalitoartfestival .org/artists.html). Deadline for entry: March. Application fee: $50. Space fee: $950-2,600. Exhibition space: 100 or 200 sq. ft. Average gross sales/exhibitor: $14,000. For more information, artists should visit Web site.

📄 ◪ SCOTTSDALE ARTS FESTIVAL

7380 E. 2nd St., Scottsdale AZ 85251. (480)874-4686. Fax: (480)874-4699. E-mail: festival@sccarts.org. Web site: www.scottsdaleartsfestival.org. **Contact:** Debbie Rauch, artist coordinator. Estab. 1970. Fine arts & crafts show held annually in March. Outdoors. Accepts photography, jewelry, ceramics, sculpture, metal, glass, drawings, fiber, paintings, printmaking, mixed media, wood. Juried. Awards/prizes: 1st, 2nd, 3rd Places in each category and Best of Show. Number of exhibitors: 200. Public attendance: 40,000. Public admission: $7. Artists should apply through www.zapplication.org. Deadline for entry: October. Application fee: $25. Space fee: $415. Exhibition space: 100 sq. ft. For more information, artists should visit Web site.

◪ SIERRA MADRE WISTORIA FESTIVAL

37 Auburn Ave., Suite 1, Sierra Madre CA 91024.(626)355-5111. Fax: (626)306-1150. E-mail: info@sierra madrechamber.com. Web site: www.SierraMadrechamber.com. Estab. 100 years ago. Fine arts, crafts and garden show held annually in March. Outdoors. Accepts photography, anything handcrafted. Juried. Craft vendors send in application and photos to be juried. Most appropriate are selected. Awards/prizes: Number of exhibitors: 175. Public attendance: 12,000. Free to public. Artists should apply by sending completed and signed application, 3-5 photographs of their work, application fee, license application, space fee and 2 SASEs. Deadline for entry: November 30. Application fee: $25. Space fee: $185. Exhibition space: 10×10 ft. For more information, artists should e-mail, visit Web site or call.
Tips ''Have a clear and simple application. Be nice.''

◪ SOLANO AVENUE STROLL

1563 Solano Ave. #PMB 101, Berkeley CA 94707. (510)527-5358. E-mail: saa@solanoave.org. Web site: www.solanoave.org. **Contact:** Allen Cain, executive director. Estab. 1974. Fine arts & crafts show held annually 2nd Sunday in September. Outdoors. Accepts photography and all other mediums. Juried by board of directors. Jury fee: $10. Number of exhibitors: 140 spaces for crafts; 600 spaces total. Public attendance: 300,000. Free to the public. Artists should apply online after April 1, or send SASE. Deadline for entry: June 1. Space fee: $10. Exhibition space: 10×10 ft. For more information, artists should e-mail, visit Web site, send SASE.

Tips "Artists should have a clean presentation; small-ticket items as well as large-ticket items; great customer service; enjoy themselves."

ST. GEORGE ART FESTIVAL

86 S. Main St., St. George UT 84770. (435)634-5850. Fax: (435)634-0709. E-mail: leisure@sgcity.org. Web site: www.sgcity.org. **Contact:** Carlene Garrick, administrator assistant. Estab. 1979. Fine arts & crafts show held annually Easter weekend in either March or April. Outdoors. Accepts photography, painting, wood, jewelry, ceramics, sculpture, drawing, 3D mixed media, glass. Juried from slides. Awards/prizes: $5,000 Purchase Awards. Art pieces selected will be placed in the city's permanent collections. Number of exhibitors: 110. Public attendance: 20,000/day. Free to public. Artists should apply by completing application form, nonrefundable application fee, slides or digital format of 4 current works in each category and 1 of booth, and SASE. Deadline for entry: January 6. Application fee $20. Space fee: $125. Exhibition space: 10×11 ft. For more information, artists should e-mail.

Tips "Artists should have more than 50% originals. Have quality booths and set-up to display art in best possible manner. Be outgoing and friendly with buyers."

STRAWBERRY JUNCTION ARTS & CRAFTS SHOW

13858 N. Pumpkin Hollow, Proctoe OK 74457-3236. (918)456-0113. **Contact:** Cleva Smith, coordinator. Estab. 1985. Arts & crafts show held annually at various times throughout the year. Indoors. Accepts handmade arts & crafts and some photography. Juried by 3 photos. Number of exhibitors: 30-80. Free to public. Artists should apply by contacting the coordinator. Deadline for entry: until full. Application fee: $60. Space fee: $160 per 10×10 ft. Exhibition space: 10×10 ft.-10×20 ft. Average gross sales/exhibitor: $800-1,500. For more information, artists should call or send SASE.

SUN FEST, INC.

P.O. Box 2404, Bartlesville OK 74005. (918)914-2826. Fax: (918)331-3351. E-mail: lhigbee@tctc.org. **Contact:** Laura Higbee, chair of board. Estab. 1982. Fine arts & crafts show held annually in early June. Outdoors. Accepts photography, painting and other arts and crafts. Juried. Awards/prizes: $2,000; Best of Show receives free booth rental for the following year. Number of exhibitors: 95-100. Number of attendees: 25,000-30,000. Free to the public. Artists should apply by e-mailing or calling for an entry form, or visit Web site. Application fee: $125 ($150 for late application). Exhibition space: 10×10 ft. For more information, artists should e-mail, call or visit Web site.

TILLES ARTS & CRAFT FESTIVAL

9551 Litzsinger Rd., St. Louis MO 63124. (636)391-0922, ext.12. Fax: (636)527-2259. E-mail: toconnell@stlouisco.com. Web site: www.stlouisco.com/parks. **Contact:** Tonya O'Connell, recreation supervisor. Fine arts & crafts show held biannually in May and September. Outdoors. Accepts photography, oil, acrylic, clay, fiber, sculpture, watercolor, jewelry, wood, floral, baskets, prints, drawing, mixed media. Juried by a committee. Awards/prizes: $100. Number of exhibitors: 90-100. Public attendance: 5,000. Public admission: $1. Deadline for entry: March, spring show; May, fall show. Application fee: $15. Space fee: $75. Exhibition space: 10×10 ft. For more information, artists should call.

TUBAC FESTIVAL OF THE ARTS

P.O. Box 1866, Tubac AZ 85646. (520)398-2704. Fax: (520)398-1704. E-mail: artfestival@tubacaz.com. Web site: www.tubacaz.com. Estab. 1960. Fine arts & crafts show held annually in early February. Outdoors. Accepts photography and considers all fine arts and crafts. Juried. A 7-member panel reviews applicants' slides and artist's statements. Jury process is blind—applicants' names are withheld from the jurists. Number of exhibitors: 170. Public attendance: 50,000. Free to the public; parking: $5. Applications for the 2008 festival will be available and posted on Web site mid-summer 2007. Deadline for entry: mid-October. Application fee: $25. Space fee: $575 for 10×10 ft. space. For more information, artists should e-mail, visit Web site, call, send SASE.

TULSA INTERNATIONAL MAYFEST

321 S. Boston, #101, Tulsa OK 74103. (918)582-6435. Fax: (918)587-7721. E-mail: comments@tulsamayfest.org. Web site: www.tulsamayfest.org. Estab. 1972. Fine arts & crafts show held annually in May. Outdoors. Accepts photography, clay, leather/fiber, mixed media, drawing, pastels, graphics, printmaking, jewelry, glass, metal, wood, painting. Juried by a blind jurying process. Artists should submit 4

slides of work and 1 of booth set-up. Awards/prizes: Best in Category and Best in Show. Number of exhibitors: 120. Public attendance: 350,000. Free to public. Artists should apply by downloading application in late November. Deadline for entry: January 16. Application fee: $35. Space fee: $300. Exhibition space: 10 × 10 ft. For more information, artists should e-mail or visit Web site.

NORTHWEST & CANADA

ANACORTES ARTS FESTIVAL

505 O Ave., Anacortes WA 98221. (360)293-6211. Fax: 360-299-0722 . E-mail: info@anacortesartsfestival. com. Web site: www.anacortesartsfestival.com. **Contact:** Mary Leone. Fine arts & crafts show held annually 1st full weekend in August. Accepts photography, painting, drawings, prints, ceramics, fiber art, paper art, glass, jewelry, sculpture, yard art, woodworking. Juried by projecting 3 images on a large screen. Works are evaluated on originality, quality and marketability. Each applicant must provide 3 high-quality digital images or slides—2 of the product and 1 of the booth display. Awards/prizes: over $4,000 in prizes. Number of exhibitors: 250. Artists should apply by visiting Web site for online submission or by mail (there is a $25 processing fee for application by mail). Deadline for entry: early March. Booth fee: $300. For more information, artists should see Web site.

ANNUAL ARTS & CRAFTS FAIR

Pend Oreille Arts Council, P.O. Box 1694, Sandpoint ID 83864. (208)263-6139. E-mail: art@sandpoint.net. Web site: www.ArtinSandpoint.org. Estab. 1962. Arts & crafts show held annually in August. Outdoors. Accepts photography and all handmade, noncommercial works. Juried by 8-member jury. Number of exhibitors: 100. Public attendance: 5,000. Free to public. Artists should apply by sending in application. Deadline for entry: May 1. Application fee: $15. Space fee: $150-230, no commission. Exhibition space: 10 × 10 ft. or 10 × 15 ft. For more information, artists should e-mail, visit Web site, call or send SASE.

ART & JAZZ ON BROADWAY

P.O. Box 583, Philipsburg MT 59858. **Contact:** Sherry Armstrong at hitchinpost@blackfoot.net or (406)859-0366, or Liz Willett at kokopellilane@mac.com or (406)859-3189. Estab. 2000. Fine arts/jazz show held annually in August. Outdoors. Accepts photography and handcrafted, original, gallery-quality fine arts and crafts made by selling artist. Juried by Flint Creek Valley Arts Council. Number of exhibitors: 75. Public attendance: 1,500-2,000. Admission fee: donation to Flint Creek Valley Arts Council. Artists should e-mail or call for an entry form. Application fee: $45. Exhibtion space: 10 × 10 ft. For more information, artists should e-mail or call.
Tips "Be prepared for temperatures of 100 degrees or rain. Display in a professional manner. Friendliness is crucial; fair pricing is essential."

THE CRAFTSMEN'S CHRISTMAS ARTS & CRAFTS SHOW

P.O. Box 494, Black Eagle MT. 59414-0494. (406)453-3120. E-mail: giskaasent@bresnan.net. **Contact:** Sue Giskaas, owner/promoter. Estab. 2005. Arts & crafts show held annually 1st Friday and Saturday in November. Indoors. Accepts photography, anything handmade, no resale. Juried by management selects. Number of exhibitors: 85. Public attendance: 5,000. Public admission: $2. Artists should apply by sending SASE to above address. Deadline for entry: October 1. Space fee: $125. Exhibition space: 10 × 10 ft. For more information, artists should e-mail, call or send SASE.

STRAWBERRY FESTIVAL

2815 2nd Ave. N., Billings MT 59101. (406)259-5454. Fax: (406)294-5061. E-mail: lisaw@downtownbillin gs.com. Web site: www.strawberryfun.com. **Contact:** Lisa Woods, executive director. Estab. 1991. Fine arts & crafts show held annually 2nd Saturday in June. Outdoors. Accepts photography. Juried. Number of exhibitors: 76. Public attendance: 15,000. Free to public. Artists should apply by application available on the Web site. Deadline for entry: April 14. Exhibition space: 12 × 12 ft. For more information, artists should visit Web site.

TULIP FESTIVAL STREET FAIR

P.O. Box 1801, Mt. Vernon WA 98273. (360)226-9277. E-mail: dwntwnmv@cnw.com. Web site: www.do wntownmountvernon.com. **Contact:** Executive Director. Estab. 1984. Arts & crafts show held annually

3rd weekend in April. Outdoors. Accepts photography and original artists' work only. No manufactured work. Juried by a board. Jury fee: $10 with application and prospectus. Number of exhibitors: 215-220. Public attendance: 20,000-25,000. Free to public. Artists should apply by calling or e-mailing. Deadline for entry: January 30. Application fee: $10. Flat fee: $300. Exhibition space: 10×10 ft. Average gross sales/exhibitor: $2,500-4,000. For more information, artists should e-mail, visit Web site, call or send SASE.

Tips "Keep records of your street fair attendance and sales for your résumé. Network with other artists about which street fairs are better to return to or apply for."

WHITEFISH ARTS FESTIVAL

P.O. Box 131, Whitefish MT 59937. (406)862-5875. Fax: (406)862-3515. Web site: www.whitefishartsfestival.org. **Contact:** Rachael Knox, coordinator. Estab. 1979. Fine arts & crafts show held annually 1st full weekend in July. Outdoors. Accepts photography, pottery, jewelry, sculpture, paintings, woodworking. Juried. Art must be original and handcrafted. Work is evaluated for creativity, quality and originality. Awards/prizes: Best of Show awarded half-price booth fee for following year with no application fee. Number of exhibitors: 100. Public attendance: 3,000. Free to public. Deadline for entry: April 14. Application fee: $20. Space fee: $195. Exhibition space: 10×10 ft. For more information, artists should e-mail, visit Web site or call.

Tips Recommends "variety of price range, professional display, early application for special requests."

Contests

W hether you're a seasoned veteran or a newcomer still cutting your teeth, you should consider entering contests to see how your work compares to that of other photographers. The contests in this section range in scope from tiny juried county fairs to massive international competitions. When possible, we've included entry fees and other pertinent information in our limited space. Contact sponsors for entry forms and more details.

Once you receive rules and entry forms, pay particular attention to the sections describing rights. Some sponsors retain all rights to winning entries or even *submitted* images. Be wary of these. While you can benefit from the publicity and awards connected with winning prestigious competitions, you shouldn't unknowingly forfeit copyright. Granting limited rights for publicity is reasonable, but you should never assign rights of any kind without adequate financial compensation or a written agreement. If such terms are not stated in contest rules, ask sponsors for clarification.

If you're satisfied with the contest's copyright rules, check with contest officials to see what types of images won in previous years. By scrutinizing former winners, you might notice a trend in judging that could help when choosing your entries. If you can't view the images, ask what styles and subject matters have been popular.

N AFI FEST

2021 N. Western Ave., Los Angeles CA 90027-1657. (323)856-7600 or (866)AFI-FEST. Fax: (323)467-4578. E-mail: AFIfest@AFI.com. Web site: www.afifest.com. **Contact:** Director, festivals. Cost: $40 shorts; $50 features. "LA's most prominent annual film festival." Various cash and product prizes are awarded. Open to filmmakers of all skill levels. **Annual July deadline.** Photographers should write, call or e-mail for more information.

ALEXIA COMPETITION

Syracuse University Newhouse School, Syracuse NY 13244-2100. (315)443-2304. E-mail: dcsuther@syr.edu. Web site: www.alexiafoundation.org. **Contact:** David Sutherland. Annual contest. Provides financial ability for students to study photojournalism in England, and for professionals to produce a photo project promoting world peace and cultural understanding. Students win cash grants plus scholarships to study photojournalism at Syracuse University in London. A professional wins $15,000 cash grant. **February 1 student deadline**. **January 16 professional deadline**. Photographers should e-mail or see Web site for more information.

ANNUAL COLLEGE PHOTOGRAPHY CONTEST

Serbin Communications, 813 Reddick St., Santa Barbara CA 93103. (805)963-0439 or (800)876-6425. Fax: (805)965-0496. E-mail: admin@serbin.com. Web site: www.serbin.com. Annual student contest. Sponsored by *Photographer's Forum Magazine* (see separate listing in the Consumer Publications section) and Nikon. Winners and finalists have their photos published in *The Best of College Photography Annual*. See Web site for entry form.

ANNUAL EXHIBITION OF PHOTOGRAPHY

San Diego County Fair Entry Office, 2260 Jimmy Durante Blvd., Del Mar CA 92014. (858)792-4207. E-mail: entry@sdfair.com. Web site: www.sdfair.com/entry. Sponsor: San Diego County Fair (22nd District Agricultural Association). Annual event for still photos/prints. **Pre-registration deadline:** April/May. Access the dates and specifications for entry on Web site. There are 3 divisions: Photography, Digital Arts, and Photojournalism. Entry form can be submitted online.

ANNUAL INTERNATIONAL PHOTOGRAPHY COMPETITION

(formerly Bethesda International Photography Exhibition), Fraser Gallery, 7700 Wisconsin Ave., Suite E, Bethesda MD 20814. (301)718-9651. Fax: (301)718-9652. E-mail: info@thefrasergallery.com. Web site: www.thefrasergallery.com. **Contact:** Catriona Fraser, director. Cost: $25. Annual contest. Provides an exhibition opportunity in the greater Washington, D.C., area in a highly respected independent commercial fine arts gallery. Nearly $1,000 in cash awards and inclusion in group shows for all award winners. **December deadline.** Photographers should send SASE for more information or print the prospectus and entry form from the Web site, www.thefrasergallery.com/photocomp.html.

ANNUAL JURIED PHOTOGRAPHY EXHIBITION

Perkins Center for the Arts, 395 Kings Hwy., Moorestown NJ 08057. (856)235-6488 or (800)387-5226. Fax: (856)235-6624. E-mail: create@perkinscenter.org. Web site: www.perkinscenter.org. Cost: $8/entry; up to 3 entries. Regional juried photography exhibition. Works from the exhibition are considered for inclusion in the permanent collection of the Philadelphia Museum of Art, the Woodmere Art Museum, and the Johnson & Johnson Corporate Art Collection. Past jurors include Merry Foresta, former curator of photography at the Smithsonian American Art Museum; Katherine Ware, curator of photographs at the Philadelphia Museum of Art; and photographers Emmett Gowin, Ruth Thorne-Thomsen, Matthew Pillsbury and Vik Muniz. All work must be framed with wiring in back and hand-delivered to Perkins Center. Photographers should call, e-mail or see Web site for prospectus in November.

☐ ANNUAL SPRING PHOTOGRAPHY CONTEST

(formerly Best Of Photography Annual), Serbin Communications, 813 Reddick St., Santa Barbara CA 93103. (805)963-0439 or (800)876-6425. Fax: (805)965-0496. E-mail: admin@serbin.com. Web site: www.serbin.com. Annual amateur contest. Sponsored by *Photographer's Forum Magazine* (see separate listing in the Consumer Publications section) and Canon. Winners and finalists have their photos published in *Best of Photography Annual*. See Web site for entry form.

APOGEE PHOTO MAGAZINE BIMONTHLY PHOTO CONTEST

11749 Zenobia Loop, Westminster CO 80031. (303)838-4848. Fax: (303)463-2885. E-mail: mfulks@apoge ephoto.com. Web site: www.apogeephoto.com. **Contact:** Michael Fulks, publisher. Bimonthly contest. Themes and prizes change with each contest. Photographers should see Web site (www.apogeephoto. com/contest.shtml) for more information.

APOGEE PHOTO MAGAZINE MONTHLY COVER PHOTO CONTEST

11749 Zenobia Loop, Westminster CO 80031. (303)838-4848. Fax: (303)463-2885. E-mail: mfulks@apoge ephoto.com. Web site: www.apogeephoto.com. **Contact:** Michael Fulks, publisher. Monthly contest. No theme; ''We choose the best from all images received the previous month.'' Prizes change month-to-month. Photographers should see Web site (www.apogeephoto.com/POM_details.shtml) for more information.

ARC AWARDS

500 Executive Blvd., Ossining-on-Hudson NY 10562. (914)923-9400. Fax: (914)923-9484. E-mail: info@m ercommawards.com. Web site: www.mercommawards.com. Cost: $165-270. Annual contest. The purpose of the contest is to honor outstanding achievement in annual reports. Major category for annual report photography—covers and interiors. ''Best of Show'' receives a personalized trophy. Grand Award winners receive personalized award plaques. Gold, silver, bronze and finalists receive a personalized award certificate. Every entrant receives complete judge score sheets and comments. **May deadline.** Photographers should see Web site, write, call or e-mail for more information.

⒩ THE ART OF DIGITAL SHOW

3830 Valley Centre Dr., Suite 705-833, San Diego CA 92130. (858)793-0900. E-mail: steven@artofdigitalsh ow.com. Web site: www.artofdigitalshow.com. **Contact:** Steven Churchill, curator. Cost: $25 for 1st entry; $10 for each additional entry; $45 for video art. This competition accepts art created or manipulated via any form of digital technology, including digital painting, computer-based illustration, digitally manipulated photography, digital video art, etc. It does not include photographic images that are simply made with a digital camera or printed with a digital printer. Upload via Web site (preferred), e-mail to entries@artofdigitalshow.com, or mail CD. Award/prize: 1st Place: $1,000; 2nd Place: $750; 3rd Place: $500; 4th Place: $250; Honorable Mention: $100. Photographers should e-mail, visit Web site for more information.

ARTIST FELLOWSHIPS/VIRGINIA COMMISSION FOR THE ARTS

223 Governor St., Richmond VA 23219-2010. (804)225-3132. Fax: (804)225-4327. E-mail: arts@arts.virgin ia.gov. Web site: www.arts.virginia.gov. Applications accepted in alternating years. The purpose of the Artist Fellowship program is to encourage significant development in the work of individual artists, to support the realization of specific artistic ideas, and to recognize the central contribution professional artists make to the creative environment of Virginia. Grant amounts: $5,000. Emerging and established artists are eligible. Open only to photographers who are legal residents of Virginia and at least 18 years of age. Applications are available in June. See *Guidelines for Funding* and application forms on the Web site or write for more information.

⒩ ARTISTS ALPINE HOLIDAY

P.O. Box 167, Ouray CO 81427. **Contact:** Gary Wade, business director, (970)252-9095; Registration: DeAnn McDaniel, (970)626-3212. Cost: $20 1st entry; $5 2nd entry; $5 3rd entry. Annual fine arts show. Juried. Cash awards for 1st, 2nd and 3rd prizes in all categories total $4,300. Best of Show: $500; People's Choice Award: $300. Open to all skill levels. Photographers should write or call for more information.

ARTSLINK PROJECTS

435 Hudson Street, New York NY 10014. (212)643-1985, ext. 22. Fax: (212)643-1996. E-mail: al@cecartsli nk.org. Web site: www.cecartslink.org. **Contact:** Tamalyn Miller. Cost: free. Annual travel grants. ArtsLink Projects accepts applications from individual artists, curators and nonprofit arts organizations who intend to undertake projects in Central Europe, Russia and Eurasia. Grants range from $2,500-10,000. Open to advanced photographers. **January deadline.** Photographers should e-mail or call for more information.

ASTRID AWARDS

500 Executive Blvd., Ossining-on-Hudson NY 10562. (914)923-9400. Fax: (914)923-9484. E-mail: info@mercommawards.com. Web site: www.mercommawards.com. Annual contest. The purpose of the contest is to honor outstanding achievement in design communications. Major category for photography, including books, brochures and publications. "Best of Show" receives a personalized trophy. Grand Award winners receive personalized award plaques. Gold, silver, bronze and finalists receive a personalized award certificate. Every entrant receives complete judge score sheets and comments. **January/February deadline.** Photographers should see Web site, write, call or e-mail for more information.

◼ ATLANTA PHOTOJOURNALISM SEMINAR CONTEST

PMB 301, 541 Tenth St. NW, Atlanta GA 30318-5713. (404)982-9359. Email: contest@photojournalism.org. Web site: www.photojournalism.org. Annual contest. This is an all-digital contest with several different categories (all related to news and photojournalism). Photographs may have been originally shot on film or with a digital camera, but the entries must be submitted in digital form. Photographs do not have to be published to qualify. No slide or print entries are accepted. Video frame grabs are not eligible. Rules are very specific. See Web site for official rules. More than $5,000 in prizes, including $1,000 and Nikon camera gear for Best Portfolio. Open to all skill levels. **November deadline.**

◖ BANFF MOUNTAIN PHOTOGRAPHY COMPETITION

Box 1020, 107 Tunnel Mountain Dr., Banff AB T1L 1H5 Canada. (403)762-6347. Fax: (403)762-6277. E-mail: BanffMountainPhotos@banffcentre.ca. Web site: www.BanffMountainFestivals.ca. **Contact:** Competition Coordinator. Annual contest. Up to 5 images (prints or slides) in each of 5 categories: Mountain Landscape, Mountain Adventure, Mountain Flora/Fauna, Mountain Culture, and Mountain Environment. Entry form available on Web site. Approximately $6,000 in cash and prizes to be awarded. Open to all skill levels. Photographers should write, e-mail or fax for more information.

◼ THE CENTER FOR FINE ART PHOTOGRAPHY

201 S. College Ave., Fort Collins CO 80524. (907)224-1010. E-mail: exhibitions@c4fap.org. Web site: www.c4fap.org. **Contact:** Grace Norman, exhibitions director. Cost: typically $35 for first 3 entries; $10 for each additional entry. Competitions held 10 times/year. "The Center's competitions are designed to attract and exhibit quality fine art photography created by emerging and established artists working in traditional, digital and mixed-media photography. The themes for each exhibition vary greatly. The themes, rules, details and entry forms for each call for entry are posted on the Center's Web site." All accepted work is exhibited in the Center gallery. Additionally, the Center offers monetary awards, scholarships, solo exhibitions and other awards. Awards are stated with each call for entry. Open to all skill levels and to all domestic and international photographers working with digital or traditional photography or combinations of both. Photographers should see Web site for deadlines and more information.

COLLEGE PHOTOGRAPHER OF THE YEAR

109 Lee Hills Hall, Columbia MO 65211-1370. (573)882-4882. Fax: (573)884-4999. E-mail: info@cpoy.org. Web site: www.cpoy.org. **Contact:** Angel Anderson, coordinator. Annual contest to recognize excellent photography by currently enrolled college students. Portfolio winner receives a plaque, cash and camera products. Other category winners receive cash and camera products. Open to beginning and intermediate photographers. **Fall deadline.** Photographers should see Web site for more information.

COMMUNICATION ARTS ANNUAL PHOTOGRAPHY COMPETITION

110 Constitution Dr., Menlo Park CA 94025-1107. (650)326-6040. Fax: (650)326-1648. E-mail: competition@commarts.com. Web site: www.commarts.com. Entries must be accompanied by a completed entry form. "Entries may originate from any country. Explanation of the function in English is very important to the judges. The work will be chosen on the basis of its creative excellence by a nationally representative jury of designers, art directors and photographers." Categories include interactive design, illustration, photography, design, advertising. "For furtuer information regarding our competitions, please visit our Web site."

◼ ◖ ENERGY GALLERY ART CALL

E-mail: info@energygallery.com. Web site: www.energygallery.com. Cost: $30 for 5 images; additional images $5/each. A jury selects artworks for the online exhibition at Energy Gallery's Web site for a period

of 3 months and archived in Energy Gallery's Web site permanently. Selected artists also qualify to participate in Energy Gallery's annual exhibit. Photographers should visit Web site for submission form and more information.

FIFTYCROWS INTERNATIONAL FUND FOR DOCUMENTARY PHOTOGRAPHY

FiftyCrows, 49 Geary St., Suite 225, San Francisco CA 94108. Web site: www.fiftycrows.org. Grants, career and distribution assistance to emerging and mid-career documentary photographers to help complete a long-term documentary project of social, political, ethical, environmental or economic importance. FiftyCrows maintains a by-appointment gallery and reference library, and creates short films about documentary photographers. To receive call-for-entry notification and updates, enter e-mail address in the sign-up area on the home page of the Web site.

FIRELANDS ASSOCIATION FOR THE VISUAL ARTS

39 S. Main St., Oberlin OH 44074. (440)774-7158. E-mail: favagallery@oberlin.net. Web site: www.favagallery.org. **Contact:** Betsy Manderen, executive director. Cost: $15/photographer; $12 for FAVA members. Annual juried photography contest for residents of Ohio, Kentucky, Indiana, Michigan, Pennsylvania and West Virginia. Both traditional and experimental techniques welcome. Photographers may submit up to 3 works completed in the last 3 years. **Annual entry deadline: March-April (date varies).** Photographers should call or e-mail for entry form.

Ⓝ LAKE CHAMPLAIN MARITIME MUSEUM'S SPRING JURIED PHOTOGRAPHY EXHIBIT

4472 Basin Harbor Rd., Vergennes VT 05491. (802)475-2022, ext. 107. E-mail: eloiseb@lcmm.org. Web site: www.lcmm.org. **Contact:** Eloise Beil. Annual competition has a different theme each year. "Amateur and professional photographers are invited to submit framed prints in color or black & white. Professional photographers will judge and comment on the work." Call for entries begins in March. Photographers should call or email for a registration form.

Ⓝ LAKE CHAMPLAIN THROUGH THE LENS: JURIED PHOTOGRAPHY EXHIBIT

4472 Basin Harbor Rd., Vergenes VT 05491. (802)475-2022, ext. 107. E-mail: eloiseb@lcmm.org. Web site: www.lcmm.org. **Contact:** Eloise Beil. Annual juried competition for amateur and professional photographers. "While sharing a common theme, the photographs capture many different facets of life in the Champlain Valley—scenic views; nature and wildlife; boats; still-life details; and the activity of people and pets." Photographers outside of the Lake Champlain area are welcome to submit, but are responsible for safe packing and shipping, and must provide return postage. Visitors to the exhibition cast their votes for the People's Choice Award. Call for entries begins in June. Photographers should call, see Web site for more information.

Ⓝ ▣ LAKE SUPERIOR MAGAZINE AMATEUR PHOTO CONTEST

P.O. Box 16417, Duluth MN 55816-0417. (218)722-5002. Fax: (218)722-4096. E-mail: edit@lakesuperior.com. Web site: www.lakesuperior.com. **Contact:** Konnie LeMay, editor. Annual contest. Photos must be taken in the Lake Superior region. "Categories have changed, and those who wish to enter should find them on the Web site." Accepts up to 10 b&w and/or color images—prints no larger than $8\frac{1}{2} \times 10$, and transparencies. Digital images can be submitted as prints with accompanying CD. Grand Prize: $200 prize package to select Lake Superior region hotels and restaurants, plus a 1-year subscription and calendar. 1st Prize: $50 merchandise gift certificate plus 1-year subscription and calendar. 2nd Prize: 1-year subscription and calendar. **October deadline.** Photographers should write, e-mail or see Web site for more information.

LARSON GALLERY JURIED PHOTOGRAPHY EXHIBITION

Yakima Valley Community College, P.O. Box 22520, Yakima WA 98907. (509)574-4875. Fax: (509)574-6826. E-mail: gallery@yvcc.edu. Web site: www.larsongallery.org. **Contact:** Denise Olsen, assistant gallery director. Cost: $12/entry (limit 4 entries). National juried competition with approximately $3,500 in prize money. Held annually in April. **First jurying held in February.** Photographers should write, fax, e-mail or visit the Web site for prospectus.

Ⓝ LOS ANGELES CENTER FOR DIGITAL JURIED COMPETITION

107 W. Fifth St., Los Angeles CA 90013. (323)646-9427. E-mail: lacda@lacda.com, rexbruce@lacda.com. Web site: www.lacda.com. **Contact:** Rex Bruce, gallery director and principal curator. LACDA is dedicated

Richard Ennis entered this photo of a Royal Lipizzan stallion (a horse that summers on the shores of Vermont's Lake Champlain) in the Lake Chaplain Maritime Museum's juried photo exhibition. The photo won first place in the people and pets category for professionals and also won the People's Choice award. In addition, he sold several matted prints of the photograph during the exhibition.

to the propagation of all forms of digital art, supporting local, international, emerging and established artists in our gallery. Its Juried Competition is open to digital artists around the world. It also sponsors other competitions throughout the year. Photographers should visit Web site, e-mail, call for more information.

MERCURY AWARDS

500 Executive Blvd., Ossining-on-Hudson NY 10562. (914)923-9400. Fax: (914)923-9484. E-mail: rwitt@ mercommawards.com. Web site: www.mercommawards.com. **Contact:** Ms. Reni L. Witt, president. Cost: $190-250/entry (depending on category). Annual contest. The purpose of the contest is to honor outstanding achievement in public relations and corporate communications. Major category for photography, including ads, brochures, magazines, etc. ''Best of Show'' receives a personalized trophy. Grand Award winners receive award plaques (personalized). Gold, silver, bronze and finalists receive a personalized award certificate. All nominators receive complete judge score sheets and evaluation comments. **November 11 deadline.** Photographers should write, call or e-mail for more information.

MYRON THE CAMERA BUG, ''Photography's Official Mascot'' ™

(featuring Digital Shutterbugs & The Foto Critters Family), % Educational Dept., 2106 Hoffnagle St., Philadelphia PA 19152-2409. E-mail: cambug8480@aol.com. **Contact:** Len Friedman, director. Sponsored by Luvable Characters EduTainment Workshop. Open to all photography students and educators. Photographers should e-mail for details.

N NEW YORK STATE FAIR PHOTOGRAPHY COMPETITION AND SHOW

581 State Fair Blvd., Syracuse NY 13209. (315)487-7711, ext. 1264 or 1265. E-mail: art&home@agmkt.stat e.ny.us. **Contact:** Mary Lou Sobon, program manager. Cost: $6/entrant for 1 or 2 works. Two prints may be entered per person. Prints only, no transparencies. Youth competition also featured. Open to amateurs and professionals in both b&w and color. **Open to New York State residents only. July deadline.**

THE GORDON PARKS PHOTOGRAPHY COMPETITION

Fort Scott Community College, 2108 S. Horton, Fort Scott KS 66701-3140. (620)223-2700. Fax: (620)223-6530. E-mail: photocontest@fortscott.edu. Web site: www.fortscott.edu. **Contact:** Jill Warford. Cost: $15 for each photo—maximum of 4 entries. Annual contest. Photos that reflect important themes in the life and works of Gordon Parks. Awards: $1,000 1st Place, $500 2nd Place, $250 3rd Place. Open to all skill levels. Winners will be announced during the Gordon Parks Celebration of Culture & Diversity on the Fort Scott Community College campus in October. Photographers should send e-mail or write for more information.

◼ THE PHOTO REVIEW ANNUAL PHOTOGRAPHY COMPETITION

140 E. Richardson Ave., Suite 301, Langhorne PA 19047. (215)891-0214. E-mail: info@photoreview.org. Web site: www.photoreview.org. **Contact:** Stephen Perloff, editor. Cost: $30 for up to 3 images; $5 each for up to 2 additional images. National annual contest. All types of photographs are eligible—b&w, color, nonsilver, computer-manipulated, etc. Submit slides or prints (unmatted, unframed, 16×20 or smaller), or images on CD. All entries must be labeled. Awards include a Microtek i800 scanner; $350 in gift certificates from Calumet Photographic; 2 Lensbaby 2.0 SLR selective focus lenses with macro kits; 2 $100 gift certificates from Sprint Systems; a professional-level membership in Women in Photography International (worth $235) and $250 in cash prizes. All winners reproduced in summer issue of *Photo Review* magazine and exhibited at photography gallery of the University of Arts/Philadelphia. Open to all skill levels. **May 15 deadline.** Photographers should send SASE or see Web site for more information.

PHOTOGRAPHY NOW

% The Center for Photography at Woodstock, 59 Tinker St., Woodstock NY 12498. (845)679-9957. Fax: (845)679-6337. E-mail: info@cpw.org. Web site: www.cpw.org. **Contact:** CPW program associate. Two annual contests: 1 for exhibitions, 1 for publication. Juried annually by renowned photographers, critics, museum and gallery curators. **Deadlines vary**. General submission is ongoing. Photographers must call or write for guidelines.

◼ PHOTOSPIVA

Spiva Center for the Arts, 222 W. Third St., Joplin MO 64801. (417)623-0183. E-mail: spiva@spivaarts.org. Web site: www.spivaarts.org. **Contact:** Executive director. Annual, national fine art photography compe-

tition. $2,000 in awards. Open to all photographers in the U.S. and its territories; any photographic process welcome; digital entry. Juror: TBA. Prospectus available after December 1, 2007. Send business-size SASE or download from Web site. **Deadline:** February 15, 2008. Exhibition: April 19-June 1, 2008.

N PICTURE.COM FREE PHOTO CONTEST
The International Library of Photography, 3600 Crondall Lane, Suite 101-3111, Owings Mills MD 21117. Web site: www.picture.com. Prize/award: $67,000 in prizes. Apply online or by mail. Send 1 photo in only 1 of the following categories: action, children, humor, nature, people, animals/pets, portraiture, sports, travel or other. Photographers retain all rights to their photographs. Photographers should visit Web site for more information.

PICTURES OF THE YEAR INTERNATIONAL
109 Lee Hills Hall, Columbia MO 65211-1370. (573)882-4882. Fax: (573)884-4999. E-mail: shawrf@missouri.edu. Web site: www.poyi.org. **Contact:** Rick Shaw, director. Cost: $50/entrant. Annual contest to reward and recognize excellence in photojournalism, sponsored by the Missouri School of Journalism. Over $20,000 in cash and product awards. Open to all skill levels. **January deadline.** Photographers should write, call or e-mail for more information.
- The Missouri School of Journalism also sponsors College Photographer of the Year. See Web site for details.

THE PROJECT COMPETITION
Center, P.O. Box 2483, Santa Fe NM 87504. E-mail: info@visitcenter.org. Web site: www.visitcenter.org. **Contact:** Laura Wzorek, programs director. Cost: $35. Annual contest. The Project Competition honors committed photographers working on long-term documentary projects and fine-art series. Three jurors reach a consensus on the 1st Prize and 3 Honorable Mentions. Each individual juror also selects a project to receive 1 of the 3 Juror's Choice awards: $5,000 cash award; full-tuition scholarship for a weeklong workshop of winner's choice at the Santa Fe Workshops; and complimentary participation in Review Santa Fe. Open to all skill levels. **Deadline:** September, 2008. Photographers should see Web site for more information.
- Center, the organization that sponsors this competition, was formerly known as The Santa Fe Center for Photography.

RHODE ISLAND STATE COUNCIL ON THE ARTS FELLOWSHIPS
One Capitol Hill, 3rd Floor, Providence RI 02908. (401)222-3880. Fax: (401)222-3018. E-mail: Cristina@arts.ri.gov. Web site: www.arts.ri.gov. **RI residents only.** Cost: free. Annual contest "to encourage the creative development of Rhode Island artists by enabling them to set aside time to pursue their work and achieve specific career goals." Awards $5,000 fellowship; $1,000 merit award. Open to advanced photographers. **April 1 deadline.** Photographers should send SASE, e-mail or see Web site for more information.

THE SINGULAR IMAGE
Center, P.O. Box 2483, Santa Fe NM 87504. (505)984-8353. E-mail: info@visitcenter.org. Web site: www.visitcenter.org. **Contact:** Laura Wzorek, programs director. Cost: $35. Annual contest. Recognizes outstanding individual photographs in color and b&w. Photographers are invited to submit their most compelling images. Open to all skill levels. **Deadline:** September 2008. Photographers should see Web site for more information.
- Center, the organization that sponsors this competition, was formerly known as The Santa Fe Center for Photography.

TAYLOR COUNTY FAIR PHOTO CONTEST
P.O. Box 613, Grafton WV 26354-0613. E-mail: hsw1@adelphia.net. **Contact:** Harry S. White, Jr., club president. Cost: $3/print (maximum of 10). Annual juried contest held in July/August. Color and b&w, all subject matter. All prints must be mounted or matted, with a minimum overall size of 8×10 and maximum overall size of 16×20. No framed prints or slides. No signed prints or mats. All prints must be identified on the back as follows: NAME, ADDRESS, PHONE NUMBER, TITLE, and entry number of print (e.g., 1 of 6). All entries must be delivered in a reusable container. Entrant's name, address and number of prints must appear on the outside of the container. Open to amateur photographers only.

TEXAS PHOTOGRAPHIC SOCIETY, THE NATIONAL COMPETITION

6338 N. New Braunfels #174, San Antonio TX 78209. (210)824-4123. E-mail: clarke@texasphoto.org. Web site: www.texasphoto.org. **Contact:** Clarke Evans, TPS president. Cost: $35 for 5 images, plus $5 for each image over 5, and membership fee if joining Texas Photographic Society. You do not have to be a member to enter. See Web site or call for information on membership fees. TPS has a membership of 1,300 from 49 states and 12 countries. Contest held annually. Cash awards: 1st Place: $1,000; 2nd Place: $650; 3rd Place: $350; 5 honorable mentions at $150 each. TPS 16: The National Competition will be juried by Michelled Dunn Marsh, Director of Aperture West. The exhibition will open at St. Edward's University Art Gallery and be exhibited at galleries in Odessa, Houston (as part of FotoFest International); New York and San Francisco. Open to all skill levels. See Web site or call Clarke for more information.

UNLIMITED EDITIONS INTERNATIONAL JURIED PHOTOGRAPHY COMPETITIONS

% Competition Chairman, 319 E. Shay Circle, Hendersonville NC 28791. (828)489-9609. E-mail: UltdEditionsIntl@aol.com. **Contact:** Gregory Hugh Leng, president/owner. Sponsors juried photography contests offering cash and prizes. Also offers opportunity to sell work to Unlimited Editions International. Photographers must send SASE for entry forms and information.

WRITERS' JOURNAL PHOTO CONTEST

Val-Tech Media, P.O. Box 394, Perham MN 56573. (218)346-7921. Fax: (218)346-7924. E-mail: writersjournal@writersjournal.com. Web site: www.writersjournal.com. **Contact:** Leon Ogroske. Cost: $3/entry. No limit on number of entries. Photos can be of any subject matter, with or without people. Model releases must accompany all photos of people. 1st Prize: $25; 2nd Prize: $15; 3rd Prize: $10; winners will be published in *WRITERS' Journal* magazine. **May 30/November 30 deadlines**. Photographers should send SASE for guidelines.

YOUR BEST SHOT

Popular Photography & Imaging, 1633 Broadway, New York NY 10019. E-mail: yourbestshot@hfmus.com. Web site: www.PopPhoto.com. Monthly contest; submit up to 5 entries/month. Cash awards: 1st Place: $300; 2nd Place: $200; 3rd Place: $100; Honorable Mentions: $50. Photographers should see Web site for more information on how to enter.

Photo Representatives

Many photographers are good at promoting themselves and seeking out new clients, and they actually enjoy that part of the business. Other photographers are not comfortable promoting themselves and would rather dedicate their time and energy solely to producing their photographs. Regardless of which camp you're in, you may need a photo rep.

Finding the rep who is right for you is vitally important. Think of your relationship with a rep as a partnership. Your goals should mesh. Treat your search for a rep much as you would your search for a client. Try to understand the rep's business, who they already represent, etc., before you approach them. Show you've done your homework.

When you sign with a photo rep, you basically hire someone to get your portfolio in front of art directors, make cold calls in search of new clients, and develop promotional ideas to market your talents. The main goal is to find assignment work for you with corporations, advertising firms, or design studios. And, unlike stock agencies or galleries, a photo rep is interested in marketing your talents rather than your images.

Most reps charge a 20-to 30-percent commission. They handle more than one photographer at a time, usually making certain that each shooter specializes in a different area. For example, a rep may have contracts to promote three different photographers—one who handles product shots, another who shoots interiors, and a third who photographs food.

DO YOU NEED A REP?

Before you decide to seek out a photo representative, consider these questions:

- Do you already have enough work, but want to expand your client base?
- Are you motivated to maximize your profits? Remember that a rep is interested in working with photographers who can do what is necessary to expand their businesses.
- Do you have a tightly edited portfolio with pieces showing the kind of work you want to do?
- Are you willing to do what it takes to help the rep promote you, including having a budget to help pay for self-promotional materials?
- Do you have a clear idea of where you want your career to go, but need assistance in getting there?
- Do you have a specialty or a unique style that makes you stand out?

If you answered yes to most of these questions, perhaps you would profit from the expertise of a rep. If you feel you are not ready for a rep or that you don't need one, but you still want some help, you might consider a consultation with an expert in marketing and/or self-promotion.

As you search for a rep, there are numerous points to consider. First, how established is the rep you plan to approach? Established reps have an edge over newcomers in that they know the territory. They've built up contacts in ad agencies, magazines and elsewhere. This is essential since most art directors and picture editors do not stay in their positions for long periods of time. Therefore, established reps will have an easier time helping you penetrate new markets.

If you decide to go with a new rep, consider paying an advance against commission in order to help the rep financially during an equitable trial period. Usually it takes a year to see returns on portfolio reviews and other marketing efforts, and a rep who is relying on income from sales might go hungry if he doesn't have a base income from which to live.

Whatever you agree upon, always have a written contract. Handshake deals won't cut it. You must know the tasks that each of you is required to complete, and having your roles discussed in a contract will guarantee there are no misunderstandings. For example, spell out in your contract what happens with clients that you had before hiring the rep. Most photographers refuse to pay commissions for these "house" accounts, unless the rep handles them completely and continues to bring in new clients.

Also, it's likely that some costs, such as promotional fees, will be shared. For example, photographers often pay 75 percent of any advertising fees (such as sourcebook ads and direct mail pieces).

If you want to know more about a specific rep, or how reps operate, contact the Society of Photographers and Artists Representatives, 60 E. 42nd St., Suite 1166, New York NY 10165, (212)779-7464, www.spar.org. SPAR sponsors educational programs and maintains a code of ethics to which all members must adhere.

ACHARD & ASSOCIATES
611 Broadway, Suite 803, New York NY 10012. (212)614-0962. Fax: (212)254-9751. E-mail: philippe@p-achard.com. Web site: www.p-achard.com. **Contact:** Philippe Achard, Malado Baldwin or Suzie Mellring, art directors. Commercial photography representative. Estab. 1990. Represents 12 photographers. Staff includes Philippe Achard, Malado Baldwin and Suzie Mellring. Agency specializes in fashion, portraiture, interiors and still life. Markets include advertising agencies, editorial/magazines, direct mail firms, corporate/client direct, design firms, publishing/books.
Handles Photography only.
Terms Rep receives 25% commission. Exclusive area representation required. For promotional purposes, talent must provide images and money. Advertises in *Le Book*.
How to Contact Send portfolio. Responds only if interested within 1 week. Portfolios may be dropped off every day. To show portfolio, photographer should follow up with a call.
Tips Finds new talent through recommendations from other artists, magazines. "Be original."

ROBERT BACALL REPRESENTATIVES INC.
16 Penn Plaza, Suite 731, New York NY 10001. (212)695-1729. E-mail: rob@bacall.com. Web site: www.bacall.com. **Contact:** Robert Bacall. Commercial photography and artist representative. Estab. 1988. Represents 12 photographers. Agency specializes in digital, food, still life, fashion, beauty, kids, corporate, environmental, portrait, lifestyle, location, landscape. Markets include advertising agencies, corporations/clients direct, design firms, editorial/magazines, publishing/books, sales/promotion firms.
Terms Rep receives 30% commission. Exclusive area representation required. For promotional purposes, talent must provide portfolios, cases, tearsheets, prints, etc. Advertises in *Creative Black Book*, *Workbook*, *Le Book*, *Alternative Pick*, *PDN-Photoserve*.
How to Contact Send query letter, direct mail flier/brochure. Responds only if interested. After initial contact, drop off or mail materials for review.
Tips "Seek representation when you feel your portfolio is unique and can bring in new business."

MARGE CASEY & ASSOCIATES
20 W. 22nd St., #1605, New York NY 10010. (212)929-3757. Fax: (212)929-8611. E-mail: info@margecasey.com. Web site: www.margecasey.com. **Contact:** Patrick Casey, partner. Represents photographers. Staff includes Elliot Abelson, production coordinator/partner; Patrick Casey, sales associate/photo agent/

partner; Marge Casey, sales associate/photo agent/partner. Agency specializes in representing commercial photographers. Markets include advertising agencies, corporate/client direct, design firms, editorial/ magazines, direct mail firms.

Handles Photography.

How to Contact Send brochure, promo cards. Responds only if interested. Portfolios may be dropped off every Monday through Friday. To show portfolio, photographer should follow up with call. Rep will contact photographer for portfolio review if interested.

Tips Finds new talent through submission, recommendations from other artists.

RANDY COLE REPRESENTS, LLC

115 West 30th St. Ste. 404, New York NY 10001. (212)760-1212. Fax: (212)760-1199. E-mail: randy@rand ycole.com. Web site: www.randycole.com. Commercial photography representative. Estab. 1989. Member of SPAR. Represents 8 photographers. Staff includes an assistant. Markets include advertising agencies, editorial/magazines, direct mail firms, corporate/client direct, design firms, publishing/books.

Handles Photography.

Terms Rep receives commission on the creative fees; dependent upon specific negotiation. Advertises in *Creative Black Book*, *Workbook*, *Le Book* and other sourcebooks.

How to Contact Send e-mail or promo piece and follow up with call. Portfolios may be dropped off; set up appointment.

Tips Finds new talent through submissions and referrals.

LINDA DE MORETA REPRESENTS

1511 Union St., Alameda CA 94501. (510)769-1421. Fax: (510)892-2955. E-mail: linda@lindareps.com. Web site: www.lindareps.com. **Contact:** Linda de Moreta. Commercial photography and illustration representative. Estab. 1988. Member of Graphic Artists Guild. Represents 1 photographer, 9 illustrators, 1 lettering artist and 1 comp/storyboard artists. Markets include advertising agencies, design firms, corporations/client direct, editorial/magazines, paper products/greeting cards, publishing/books, sales/promotion firms.

Handles Photography, illustration, lettering/storyboards.

Terms Exclusive representation requirements and commission arrangements vary. Advertising costs are handled by individual agreement. Materials for promotional purposes vary with each artist. Advertises in *Workbook*, *Directory of Illustration*.

How to Contact E-mail or send direct mail flier/brochure. "Please do *not* send original art. Include SASE for any items you wish returned." Responds to any inquiry in which there is an interest. Portfolios are individually developed for each artist.

Tips Obtains new talent primarily through client and artist referrals, some solicitation. "I look for a personal vision and style of photography, and exceptional creativity combined with professionalism, maturity, and commitment to career advancement."

FRANÇOISE DUBOIS/DUBOIS REPRESENTS

305 Newbury Lane, Newbury Park CA 91320. (805)376-9738. Fax: (805)376-9729. E-mail: fdubois@franc oisedubois.com. Web site: www.francoisedubois.com. **Contact:** Françoise Dubois, owner. Commercial photography representative and creative and marketing consultant. Represents 3 photographers. Staff includes Andrew Bernstein (sports and sports celebrities), Pam Francis (people, portraiture), Michael Dubois (still life/people) and Michael Baciu (photo impressionism). Agency specializes in commercial photography for advertising, editorial, creative, marketing consulting. Markets include advertising agencies, corporations/clients direct, design firms, editorial/magazines, publishing/books, sales/promotion firms.

Handles Photography.

Terms Rep receives 25% commission. Charges FedEx expenses (if not paid by advertising agency or other potential client). Exclusive area representation required. Advertising costs are paid by talent. For promotional purposes, talent must provide "3 portfolios, advertising in national sourcebook, and 3 or 4 direct mail pieces per year. All must carry my name and number." Advertises in *Creative Black Book*, *Workbook*, *The Alternative Pick* and *Le Book*.

How to Contact Send tearsheets, bio and interesting direct mail promos. Responds in 2 months, only if interested. Rep will contact photographer for portfolio review if interested. Portfolio should include "whatever format as long as it is consistent."

Tips "Do not look for a rep if your target market is too small a niche. Do not look for a rep if you're not somewhat established. Hire a consultant to help you design a consistent and unique portfolio and marketing strategy, and to make sure your strengths are made evident and you remain focused."

TOM GOODMAN INC.

2061 Lombard St., Philadelphia PA 19146. (610)649-1514. Fax: (610)649-1630. E-mail: tom@tomgoodman.com. Web site: www.tomgoodman.com. **Contact:** Tom Goodman. Commercial photography and commercial illustration representative. Estab. 1986. Represents 4 photographers. Agency specializes in commercial photography, electronic imaging. Markets include advertising agencies, corporations/client direct, design firms, editorial/magazines, publishing/books, direct mail firms, sales/promotion firms.
Handles Photography, electronic imaging.
Terms Rep receives 25% commission. Advertising costs are split: 75% paid by talent; 25% paid by representative. For promotional purposes, talent must provide original film, files or tearsheets. Requires direct mail campaigns. Optional: sourcebooks. Advertises in *Creative Black Book*.
How to Contact Send query letter with direct mail flier/brochure.

BARBARA GORDON

165 E. 32nd St., New York NY 10016. (212)686-3514. Fax: (212)532-4302. **Contact:** Barbara Gordon. Commercial illustration and photography representative. Estab. 1969. Member of SPAR, Society of Illustrators, Graphic Artists Guild. Represents illustrators and photographers. "I represent only a small select group of people and therefore give a great deal of personal time and attention to each." Also does coaching and consulting.
Terms Rep receives 25% commission. No geographic restrictions in continental US.
How to Contact Send direct mail flier/brochure. Responds in 2 weeks. After initial contact, drop off or mail appropriate materials for review. Portfolio should include tearsheets, slides, photographs; "if you want materials or promotion piece returned, include SASE."
Tips Obtains new talent through recommendations from others, solicitation, art conferences, etc. "I have obtained talent from all of the above. I do not care if an artist or photographer has been published or is experienced. I am essentially interested in people with a good, commercial style. Don't send résumés and don't call to give me a verbal description of your work. Send promotion pieces. *Never* send original art. If you want something back, include a SASE. Always label your slides in case they get separated from your cover letter. And always include a phone number where you can be reached."

CAROL GUENZI AGENTS, INC.

865 Delaware, Denver CO 80204-4533. (303)820-2599 or (800)417-5120. Fax: (303)820-2598. E-mail: art@artagent.com. Web site: www.artagent.com. **Contact:** Carol Guenzi. Commercial illustration, photography, new media, film/animation representative. Estab. 1984. Member of Art Directors Club of Denver, AIGA and ASMP. Represents 30 illustrators, 8 photographers, 6 computer multimedia designers. Agency specializes in a "worldwide selection of talent in all areas of visual communications." Markets include advertising agencies, corporations/clients direct, design firms, editorial/magazine, paper products/greeting cards, sales/promotions firms.
Handles Illustration, photography, new media, film and animation. Looking for unique styles and applications and digital imaging.
Terms Rep receives 25-30% commission. Exclusive area representation required. Advertising costs are split: 70-75% paid by talent; 25-30% paid by representative. For promotional purposes, talent must provide "promotional material after 6 months, some restrictions on portfolios." Advertises in *Directory of Illustration*, *Black Book* and *Workbook*.
How to Contact E-mail JPEGs or send direct mail piece, tearsheets. Responds in 2-3 weeks, only if interested. After initial contact, call or e-mail for appointment or to drop off or ship materials for review. Portfolio should include tearsheets, prints, samples and a list of current clients.
Tips Obtains new talent through solicitation, art directors' referrals and active pursuit by individual. "Show your strongest style and have at least 12 samples of that style before introducing all your capabilities. Be prepared to add additional work to your portfolio to help round out your style. We do a large percentage of computer manipulation and accessing on network. All our portfolios are both electronic and prints."

PAT HACKETT/ARTIST REPRESENTATIVE

7014 N. Mercer Way, Mercer Island WA 98040. (206)447-1600. Fax: (206)447-0739. E-mail: pat@pathack ett.com. Web site: www.pathackett.com. **Contact:** Pat Hackett. Commercial illustration and photography representative. Estab. 1979. Member of Graphic Artists Guild. Represents 12 illustrators and 1 photographer. Markets include advertising agencies, corporations/client direct, design firms, editorial/magazines. **Handles** Illustration, photography.

Terms Rep receives 25-33% commission. Exclusive area representation required. No geographic restrictions. Advertising costs are split: 75% paid by talent; 25% paid by representative. For promotional purposes, talent must provide "standardized portfolio, i.e., all pieces within the book are the same format." Advertises in *Showcase* and *Workbook*.

How to Contact Send direct mail flier/brochure or e-mail. Responds within 3 weeks if interested.

JG + A

(formerly Jean Gardner & Associates), 444 N. Larchmont Blvd., Suite 207, Los Angeles CA 90004. (323)464-2492. Fax: (323)465-7013. 177 Prince St., 4th Floor, New York NY 10012. (212)353-3591. Web site: www.jgaonline.com. **Contact:** Jean Gardner. Commercial photography representative. Estab. 1985. Member of APA. Represents 12 photographers. Staff includes Dominique Cole (sales rep) and Sherwin Taghdiri (sales rep). Agency specializes in photography. Markets include advertising agencies, design firms.

Handles Photography.

Terms Rep receives 25% commission. Charges shipping expenses. Exclusive representation required. No geographic restrictions. Advertising costs are paid by talent. For promotional purposes, talent must provide promos, advertising and a quality portfolio. Advertises in various source books.

How to Contact Send direct mail flier/brochure.

TRICIA JOYCE INC.

79 Chambers St., New York NY 10007. (212)962-0728. E-mail: tricia@triciajoyce.com. Web site: www.tric iajoyce.com. **Contact:** Tricia Joyce or Leah Siegel-Picus. Commercial photography representative. Estab. 1988. Represents photographers and stylists. Agency specializes in fashion, advertising, cosmetics/ beauty, interiors, portraiture. Markets include advertising agencies, corporations/clients direct, design firms, editorial/magazines and sales/promotion firms.

Handles Photography and fine art.

Terms Agent receives 25% commission for photography; 20% for stylists.

How to Contact Send query letter, résumé, direct mail flier/brochure and photocopies. Responds only if interested. After initial contact, "wait to hear—please don't call."

⁣𝗡 KORMAN + COMPANY

(212)402-2450. Fax: (212)504-9588. Web site: www.kormanandcompany.com. **Contact:** Alison Korman. Commercial photography representative. Estab. 1984. Markets include advertising agencies, corporations/clients direct, editorial/magazines, publishing/books, music, celebrities.

Handles Photography.

Terms Rep receives 25-30% commission or hourly consultation.

How to Contact Send promo by e-mail with link to Web site. *Do not attach large files*. Responds in 1 month if interested.

Tips "Research before seeking." Obtains new talent through "recommendations, seeing somebody's work out in the market and liking it. Be prepared to discuss your short-term and long-term goals and how you think a rep can help you achieve them."

CAROYL LABARGE REPRESENTING

5601 Santa Cruz Ave., Richmond CA 94804. E-mail: lyorac@earthlinknet.com. Web site: caroyllabargeny. com. Commercial and fine art photography. Estab. 1991. Represents 2 photographers and 1 fine artist. Agency specializes in still life, interiors, food and fine art. Markets include advertising agencies, corporations/clients direct, design firms, editorial/magazines, publishing/books, sales/promotion firms.

Handles Photography.

Terms Rep receives 25% commission. Photographer pays all expenses. For promotional purposes, talent must provide promo pieces.

How to Contact Send query letter, tearsheets. Responds within 1 week, only if interested. Rep will contact photographer for portfolio review if interested.

Tips Obtains new talent through references and magazines. "Contact me by direct mail only."

LEE + LOU PRODUCTIONS INC.

8522 National Blvd., #104, Culver City CA 90232. (310)287-1542. Fax: (310)287-1814. E-mail: leelou@earthlink.net. Web site: www.leelou.com. Commercial illustration and photography representative, digital and traditional photo retouching. Estab. 1981. Represents 5 illustrators, 5 photographers, 3 film directors. Specializes in automotive. Markets include advertising agencies.

Handles Photography, commercial film, illustration.

Terms Rep receives 25% commission. Charges for shipping, entertainment. Exclusive area representation required. Advertising costs are paid by talent. For promotional purposes, talent must provide direct mail advertising material. Advertises in *Creative Black Book*, *Workbook* and *Single Image*.

How to Contact Send direct mail flier/brochure, tearsheets. Responds in 1 week. After initial contact, call for appointment to show portfolio of photographs.

Tips Obtains new talent through recommendations from others, some solicitation.

THE BRUCE LEVIN GROUP

305 Seventh Ave., Suite 1101, New York NY 10001. (212)627-2281. Fax: (212)627-0095. E-mail: brucelevin @mac.com. Web site: www.brucelevingroup.com. **Contact:** Bruce Levin, president. Commercial photography representative. Estab. 1983. Member of SPAR and ASMP. Represents 10 photographers. Agency specializes in advertising, editorial and catalog; heavy emphasis on fashion, lifestyle and computer graphics.

Handles Photography. Looking for photographers who are "young and college-educated."

Terms Rep receives 25% commission. Exclusive area representation required. Advertising costs are split: 75% paid by talent; 25% paid by representative. Advertises in *Workbook* and other sourcebooks.

How to Contact Send brochure, photos; call. Portfolios may be dropped off every Monday through Friday.

Tips Obtains new talent through recommendations, research, word of mouth, solicitation.

JUDITH MCGRATH

P.O. Box 133, 32W040 Army Trail Rd., Wayne IL 60184. (630)762-8451. Fax: (630)762-8452. E-mail: judy@judymcgrath.net. Web site: www.judymcgrath.net. Commercial photography representative. Estab. 1980. Represents photographers. Markets include advertising agencies, corporate/client direct, design firms, editorial/magazines, paper products/greeting cards, publishing/books, direct mail firms.

Handles Photography.

Terms Rep receives 25% commission. Exclusive area representation required. Advertising costs paid by talent. Advertises in *Workbook*.

How to Contact Send query letter, bio, tearsheets, photocopies. Rep will contact photographer for portfolio review if interested.

MUNRO GOODMAN ARTISTS REPRESENTATIVES

630 N. State St., #2109, Chicago IL 60610. (312)335-8925. E-mail: steve@munrocampagna.com. Web site: www.munrocampagna.com. **Contact:** Steve Munro, president. Commercial photography and illustration representative. Estab. 1987. Member of SPAR, CAR (Chicago Artist Representatives). Represents 4 photographers, 30 illustrators. Markets include advertising agencies, corporations/clients direct, design firms, publishing/books.

Handles Illustration, photography.

Terms Rep receives 25% commission. Exclusive area representation required. Advertising costs are split: 75% paid by talent; 25% paid by representative. For promotional purposes, talent must provide 2 portfolios, leave-behinds, several promos. Advertises in *Creative Black Book*, *Workbook*, other sourcebooks.

How to Contact Send query letter, bio, tearsheets, SASE. Responds within 2 weeks, only if interested. After initial contact, write to schedule an appointment.

Tips Obtains new talent through recommendations, periodicals. "Do a little homework and target appropriate rep. Try to get a referral from an art buyer or art director."

NPN WORLDWIDE

The Roland Group, Inc., 4948 St. Elmo Ave., Suite 201, Bethesda MD 20814. (301)718-7955. Fax: (301)718-7958. E-mail: info@npnworldwide.com. Web site: www.npnworldwide.com. Photography bro-

ker. Member of SPAR. Markets include advertising agencies, corporate/client direct, design firms.
Handles Photography.
Terms Rep receives 35% commission.
How to Contact "Go to our Web site. The 'contact us' section has a special talent recruitment form with further instructions on how to submit your work." Rep will contact photographer for portfolio review if interested.
Tips Finds new talent through submissions. "Go to our Web site and take a look around to see what we are all about."

PHOTOKUNST

725 Argyle Ave., Friday Harbor WA 98250. (360)378-1028. Fax: (360)370-5061. E-mail: info@photokunst. com. Web site: www.photokunst.com. **Contact:** Barbara Cox, principal. Consulting and marketing of photography archives and fine art photography, nationally and internationally. Estab. 1998. "Accepting select number of photographers on our new Web site. Works with artists on Lecensing, Photo Sales, Curating and traveling exhibitions, book projects."
Handles Emphasis on photojournalism, documentary and ethnographic photography. Vintage and contemporary photography.
Terms Charges for consultation, hourly/daily rate; for representation, Web site fee and percentage of sales.
How to Contact Send query letter, bio, slides, photocopies, SASE, reviews, book, other published materials. Responds in 2 months.
Tips Finds new talent through submissions, recommendations from other artists, publications, art fairs, portfolio reviews. "In order to be placed in major galleries, a book or catalog must be either in place or in serious planning stage."

PHOTOTHERAPY: RHONI EPSTEIN + SUSAN BARAZ

(formerly Rhoni Epstein Associates), 913 24th St., Santa Monica CA 90403. E-mail: rhoni@phototherapist s.com. Web site: www.phototherapists.com. **Contact:** Rhoni Epstein. Commercial and fine art photography consultants. Estab. 2007. "We show you how to differentiate yourself from the myriad of other photographers. Customized portfolios, marketing programs, branding materials and Web site design are developed to be compatible with you and your photography. Your imagery will be focused and tell memorable stories that will last in the viewer's mind long after your portfolio has been seen. We'll guide you to recognize and embrace your own personal style, which will fulfill you and your market." Rhoni Epstein is a photographer's representative and an assistant professor in the photography department at Art Center College of Design. Susan Baraz is an internationally known creative consultant for commercial and fine art photography.
How to Contact Via e-mail.

MARIA PISCOPO

2973 Harbor Blvd., #341, Costa Mesa CA 92626-3912. Phone/fax: (888)713-0705. E-mail: maria@mpiscop o.com. Web site: www.mpiscopo.com. **Contact:** Maria Piscopo. Commercial photography representative. Estab. 1978. Member of SPAR, Women in Photography, Society of Illustrative Photographers. Markets include advertising agencies, design firms, corporations.
Handles Photography. Looking for "unique, unusual styles; established photographers only."
Terms Rep receives 25% commission. Exclusive area representation required. No geographic restrictions. Advertising costs are split: 50% paid by talent; 50% paid by representative. For promotional purposes, talent must have a Web site and provide 3 traveling portfolios, leave-behinds and at least 6 new promo pieces per year. Plans Web, advertising and direct mail campaigns.
How to Contact Send query letter, bio, promo piece and SASE. Responds within 2 weeks, only if interested.
Tips Obtains new talent through personal referral and photo magazine articles. "Do lots of research. Be very businesslike, organized, professional and follow the above instructions!"

ALYSSA PIZER

13121 Garden Land Rd., Los Angeles CA 90049. (310)440-3930. Fax: (310)440-3830. E-mail: alyssapizer@ earthlink.net. Web site: www.alyssapizer.com. **Contact:** Alyssa Pizer. Commercial photography representative. Estab. 1990. Member of APCA. Represents 10 photographers. Agency specializes in fashion,

beauty and lifestyle (catalog, image campaign, department store, beauty and lifestyle awards). Markets include advertising agencies, corporations/clients direct, design firms, editorial/magazines.

Handles Photography. Established photographers only.

Terms Rep receives 25% commission. Photographer pays for FedEx and messenger charges. Talent pays 100% of advertising costs. For promotional purposes, talent must provide 10 portfolios, leave-behinds and quarterly promotional pieces.

How to Contact Send query letter or direct mail flier/brochure or e-mail Web site address. Responds in a couple of days. After initial contact, call to schedule an appointment or drop off or mail materials for review.

Tips Obtains new talent through recommendations from clients.

THE ROLAND GROUP, INC.

4948 St. Elmo Ave., Suite 201, Bethesda MD 20814. (301)718-7955. Fax: (301)718-7958. E-mail: info@therolandgroup.com. Web site: www.therolandgroup.com. **Contact:** Rochel Roland. Commercial photography and illustration representatives and brokers. Estab. 1988. Member of SPAR, Art Directors Club and Ad Club. Represents 300 photographers, 10 illustrators. Markets include advertising agencies, corporations/clients direct, design firms and sales/promotion firms.

Handles Illustration, photography.

Terms Agent receives 35% commission. For promotional purposes, talent must provide transparencies, slides, tearsheets and a digital portfolio.

How to Contact Go to www.npnworldwide.com and complete talent recruitment form on contact page. Responds only if interested.

Tips "The Roland Group provides the NPN Worldwide Service, a global network of advertising and corporate photographers." (See separate listing in this section.)

ⓝ WALTER SCHUPFER MANAGEMENT CORPORATION

413 W. 14th St., 4th Floor, New York NY 10014. (212)366-4675. Fax: (212)255-9726. E-mail: mail@wschupfer.com. Web site: www.wschupfer.com. **Contact:** Walter Schupfer, president. Commercial photography representative. Estab. 1996. Represents photographers, stylists, designers. Staff includes producers, art department, syndication. Agency specializes in photography. Markets include advertising agencies, corporate/client direct, design firms, editorial/magazines, record labels, galleries.

Handles Photography, design, stylists, make-up artists, specializing in complete creative management.

Terms Charges for messenger service. Exclusive area representation required. For promotional purposes, talent must provide several commercial and editorial portfolios. Advertises in *Le Book*.

How to Contact Send promo cards, "then give us a call." To show portfolio, photographer should follow up with call.

Tips Finds new talent through submissions, recommendations from other artists. "Do research to see if your work fits our agency."

TM ENTERPRISES

P.O. Box 18644, Beverly Hills CA 90209. E-mail: tmarquesusa@yahoo.com. **Contact:** Tony Marques. Commercial photography representative and photography broker. Estab. 1985. Member of Beverly Hills Chamber of Commerce. Represents 50 photographers. Agency specializes in photography of women only: high fashion, swimsuit, lingerie, glamour and fine (good taste) *Playboy*-style pictures, erotic. Markets include advertising agencies, corporations/clients direct, editorial/magazines, paper products/greeting cards, publishing/books, sales/promotion firms, medical magazines.

Handles Photography.

Terms Rep receives 50% commission. Advertising costs are paid by representative. "We promote the standard material the photographer has available, unless our clients request something else." Advertises in Europe, South and Central America, and magazines not known in the U.S.

How to Contact Send everything available. Responds in 2 days. After initial contact, drop off or mail appropriate materials for review. Portfolio should include slides, photographs, transparencies, printed work.

Tips Obtains new talent through worldwide famous fashion shows in Paris, Rome, London and Tokyo; by participating in well-known international beauty contests; recommendations from others. "Send your material clean and organized (neat). Do not borrow other photographers' work in order to get representa-

tion. Always protect yourself by copyrighting your material. Get releases from everybody who is in the picture (or who owns something in the picture).''

DOUG TRUPPE

121 E. 31st St., New York NY 10016. (212)685-1223. E-mail: doug@dougtruppe.com. Web site: www.dougtruppe.com. **Contact:** Doug Truppe, president. Commercial photography representative. Estab. 1998. Member of SPAR, Art Directors Club. Represents 8 photographers. Agency specializes in lifestyle, food, still life, portrait and children's photography. Markets include advertising agencies, corporate, design firms, editorial/magazines, publishing/books, direct mail firms.

Handles Photography. ''Always looking for great commercial work.'' Established, working photographers only.

Terms Rep receives 25% commission. Exclusive area representation required. Advertising costs are paid by talent. For promotional purposes, talent must provide directory ad (at least 1 directory per year), direct mail promo cards every 3 months, Web site. Advertises in *Workbook*.

How to Contact Send e-mail with Web site address. Responds within 1 month, only if interested. To show portfolio, photographer should follow up with call.

Tips Finds artists through recommendations from other artists, source books, art buyers. ''Please be willing to show some new work every 6 months. Have 4-6 portfolios available for representative. Have Web site and be willing to do direct mail every 3 months. Be professional and organized.''

THE WILEY GROUP

1535 Green St., Suite 301, San Francisco CA 94123. (415)441-3055. Fax: (415)441-6200. E-mail: office@thewileygroup.com. Web site: www.thewileygroup.com. **Contact:** David Wiley. Commercial and fine art illustration and photography representative. Estab. 1984. Member of AIP (Artists in Print), Society of Illustrators, Bay Area Lawyers for the Arts, and Graphic Artists Guild (GAG). Represents 12 illustrators. Clients include Coke, Pepsi, Robert Mondavi, Disney Co., Microsoft, Forbes and National Geographic.

Terms Rep receives 25% commission. No geographical restriction. Artist pays 75% of online agencies (Workbook.com or Theispot.com), postcards. Agent will reimburse artist for 25% of costs. Each year the artists are promoted using online agencies, bimonthly postcard mailings, and weekly eMailers from Adbase.com.

How to Contact For first contact, e-mail URL and one visual image representing your style. If interested, agent will call back to discuss representation.

Tips ''The bottom line is that a good agent will get you more work at better rates of pay.''

Workshops & Photo Tours

Taking a photography workshop or photo tour is one of the best ways to improve your photographic skills. There is no substitute for the hands-on experience and one-on-one instruction you can receive at a workshop. Besides, where else can you go and spend several days with people who share your passion for photography?

Photography is headed in a new direction. Digital imaging is here to stay and is becoming part of every photographer's life. Even if you haven't invested a lot of money into digital cameras, computers or software, you should understand what you're up against if you plan to succeed as a professional photographer. Taking a digital imaging workshop can help you on your way.

Outdoor and nature photography are perennial workshop favorites. Creativity is another popular workshop topic. You'll also find highly specialized workshops, such as underwater photography. Many photo tours specialize in a specific location and the great photo opportunities that location affords.

As you peruse these pages, take a good look at the quality of workshops and the skill level of photographers the sponsors want to attract. It is important to know if a workshop is for beginners, advanced amateurs or professionals. Information from a workshop organizer can help you make that determination.

These workshop listings contain only the basic information needed to make contact with sponsors, and a brief description of the styles or media covered in the programs. We also include information on costs when possible. Write, call or e-mail the workshop/photo tour sponsors for complete information. Most have Web sites with extensive information about their programs, when they're offered, and how much they cost.

A workshop or photo tour can be whatever the photographer wishes—a holiday from the normal working routine, or an exciting introduction to new skills and perspectives on the craft. Whatever you desire, you're sure to find in these pages a workshop or tour that fulfills your expectations.

AERIAL AND CREATIVE PHOTOGRAPHY WORKSHOPS

Hangar 23, Box 470455, San Francisco CA 94147. (415)771-2555. Fax: (707)769-7277. E-mail: See www.ae rialarchives/contact.htm. Web site: www.aerialarchives.com. **Contact:** Herb Lingl, director. Aerial and creative photography workshops in unique locations from helicopters, light planes and balloons.

N̄ ALASKA'S SEAWOLF ADVENTURES

P.Ö. Box 97, Gustavus AK 99826. (907)723-9440. E-mail: seawolfadventures@earthlink.net. Web site: www.seawolfadventures.net. **Contact:** Kimber Owen. Cost: $3,180/6 days. "Photograph glaciers, whales, bears, wolves, incredible scenics, etc., while using the Seawolf, a 97-foot, 12-passenger expedition ship, as your base camp in the Glacier Bay area."

ALDERMAN'S SLICKROCK ADVENTURES

19 W. Center St., Kanab UT 84741. (435)644-5981. E-mail: fotomd@xpressweb.com. Web site: www.utah cameras.com. **Contact:** Terry G. Alderman, master photographer. Cost: $85/day; 2-person minimum. Covers landscape photography of ghost towns, arches, petroglyphs and narrow canyons in the back country of Southern Utah and the Arizona Strip.

ANCHELL PHOTOGRAPHY WORKSHOPS

879 Cottage Street NE, Salem OR 97301. (503)275-2163. Fax: (503)588-4003. E-mail: info@anchellworksh ops.com. Web site: www.anchellworkshops.com. **Contact:** Steve Anchell. Cost: $250-2,500. Film or digital, group or private workshops held throughout the year, including large-format, 35mm, studio lighting, figure, darkroom, both color and b&w, travel. Open to all skill levels. Photographers should write, call or e-mail for more information.

ANDERSON RANCH ARTS CENTER

P.O. Box 5598, Snowmass Village CO 81615. (970)923-3181. Fax: (970)923-3871. E-mail: reg@andersonra nch.org. Web site: www.andersonranch.org. Digital media and photography workshops, June through September, feature distinguished artists and educators from around the world. Classes range from traditional silver and alternative photographic processes to digital formats and use of the computer as a tool for time-based and interactive works of art. Program is diversifying into video, animation, sound and installations.

ARIZONA HIGHWAYS PHOTO WORKSHOPS

Friends of Arizona Highways, P.O. Box 6106, Phoenix AZ 85005-6106. (888)790-7042. E-mail: Rnoll@azd ot.gov. Web site: www.friendsofazhighways.com. **Contact:** Robyn Noll, director. Offers photo adventures to the American West's most spectacular locations with top professional photographers whose work routinely appears in *Arizona Highways* magazine.

ARROWMONT SCHOOL OF ARTS AND CRAFTS

556 Parkway, Gatlinburg TN 37738. (865)436-5860. E-mail: info@arrowmont.org. Web site: www.arrow mont.org. Tuition ranges from $365-435 per week. Housing and meal packages begin at $285 (1 week) and $608 (2 weeks). Offers weekend, 1- and 2-week spring, summer and fall workshops in photography, drawing, painting, clay, metals/enamels, kiln glass, fibers, surface design, wood turning and furniture. Residencies, studio assistantships, work study, and scholarships are available.

ART WORKSHOPS IN GUATEMALA

4758 Lyndale Ave. S., Minneapolis MN 55419-5304. (612)825-0747. Fax: (612)825-6637. E-mail: info@art guat.org. Web site: www.artguat.org. **Contact:** Liza Fourre, director. Cost: $1,745; includes tuition, lodging, breakfast, ground transport. Annual workshops held in Antigua, Guatemala. Workshops include Adventure Travel Photo with Steve Northup, Portraiture/Photographing the Soul of Indigenous Guatemala with Nance Ackerman, Photography/Capturing Guatemala's Light and Contrasts with David Wells, Travel Photography/Indigenous Peoples, and Spirit of Place with Doug Beasley.

N̄ BACHMANN TOUR OVERDRIVE

P.O. Box 950833, Lake Mary FL 32746. (407)333-9988. E-mail: bill@billbachmann.com. Web site: www.bill bachmann.com. **Contact:** Bill Bachmann, owner. Cost varies; see Web site for prices. Bill Bachmann shares

his knowledge and adventures with small groups several times a year. Past trips have been to China, Tibet, South Africa, Antarctica, Inida, Nepal, Australia, New Zealand, New Guinea, Guatemala and Honduras. Future trips will be to Cuba, Italy, Greece, Peru, Brazil, Argentina and other destinations. Programs are designed for adventure travelers who love photography and want to learn stock photography from a top stock photographer. Open to all skill levels. Photographers should write, call or e-mail after seeing Web site for information, times and prices.

NOELLA BALLENGER & ASSOCIATES PHOTO WORKSHOPS

P.O. Box 457, La Canada CA 91012. (818)954-0933. Fax: (818)954-0910. E-mail: Noella1B@aol.com. Web site: www.noellaballenger.com. **Contact:** Noella Ballenger. Travel and nature workshops/tours, West Coast locations. Individual instruction in small groups emphasizes visual awareness, composition, and problem-solving in the field. All formats and levels of expertise welcome. Call or write for information.

FRANK BALTHIS PHOTOGRAPHY WORKSHOPS

P.O. Box 255, Davenport CA 95017. (831)426-8205. E-mail: frankbalthis@yahoo.com. **Contact:** Frank S. Balthis, photographer/owner. Cost depends on the length of program and travel costs. "Workshops emphasize natural history, wildlife and travel photography, often providing opportunities to photograph marine mammals." Worldwide locations range from Baja California to Alaska. Frank Balthis runs a stock photo business and is the publisher of the Nature's Design line of cards and other publications.

BETTERPHOTO.COM ONLINE PHOTOGRAPHY COURSES

16544 NE 79th St., Redmond WA 98052. (888)586-7337. Fax: (425)881-0309. E-mail: bsupport@betterphoto.com. Web site: www.betterphoto.com. **Contact:** Heather Young, director of operations. Cost: Online courses including personal critiques cost $198-366 for 4- and 8-week sessions. BetterPhoto.com is the worldwide leader in online photography education, offering an approachable resource for photographers who want to improve their skills, share their photos, and learn more about the art and technique of photography. BetterPhoto offers over 100 photography courses that are taught by today's top professional photographers. Eight-week courses are held every quarter, starting in January, April and July and October. Four-week courses begin the 1st Wednesday of every month. Courses range in skill level from beginner to advanced and consist of inspiring weekly lessons and personal feedback on students' photos from the instructors. "We provide free online newsletters, lively Q&A and photo discussions, a free monthly contest, helpful articles and online photography courses." Open to all skill levels.

BIRDS AS ART/INSTRUCTIONAL PHOTO-TOURS

P.O. Box 7245, 4041 Granada Dr., Indian Lake Estates FL 33855. (863)692-0906. E-mail: birdsasart@verizon.net. Web site: www.birdsasart.com. **Contact:** Arthur Morris, instructor. Cost: varies, approximately $300/day. The tours, which visit the top bird photography hot spots in North America, feature evening in-classroom lectures, breakfast and lunch, in-the-field instruction, 6 or more hours of photography, and most importantly, easily approachable yet free and wild subjects.

BLACK AND WHITE PHOTOGRAPHIC WORKSHOPS

P.O. Box 27555, Seattle WA 98165. (206)367-6864. Fax: (206)367-8102. E-mail: mark@bwphotoworkshops.com. Web site: www.bwphotoworkshops.com. **Contact:** Mark Griffith, director. Cost: $250-695. Lodging and food are not included in any workshop fee. Workshops on b&w photography, including the zone system, b&w print, and photographing in various locations. Open to all formats. Call, e-mail or see Web site for information.

BLUE PLANET PHOTOGRAPHY WORKSHOPS AND TOURS

1526 W. Charlotte Ct., Suite 107, Nampa ID 83687. (208)466-9340. E-mail: inquire@blueplanetphoto.com. Web site: www.blueplanetphoto.com. **Contact:** Mike Shipman, owner/photographer. Cost: varies depending on type and length of workshop ($250-5,000; average: $1,900). Award-winning professional photographer and former wildlife biologist Mike Shipman conducts small group workshops/tours emphasizing individual expression and "vision-finding" by Breaking the Barriers to Creative Vision™. Workshops held in beautiful locations away from crowds and the more-often-photographed sites. Some workshops are semi-adventure-travel style, using alternative transportation such as hot air balloons, horseback, llama, and camping in remote areas. Group feedback sessions, digital presentations and film

processing whenever possible. Workshops and tours held in western U.S., Alaska, Canada and overseas. Onsite transportation and lodging during workshop usually included; meals included on some trips. Specific fees, optional activities and gear list outlined in tour materials. Digital photographers welcome. Workshops and tours range from 2 to 12 days, sometimes longer; average is 9 days. Custom tours and workshops available upon request. Open to all skill levels. Photographers should write, call, e-mail or see Web site for more information.

NANCY BROWN HANDS-ON WORKSHOPS
381 Mohawk Lane, Boca Raton FL 33487. (561)988-8992. Fax: (561)988-1791. E-mail: nbrown50@bellsou th.net. Web site: www.nancybrown.com. **Contact:** Nancy. Cost: $2,000. Offers one-on-one intensive workshops all year long in studio and on location in Florida. You work with Nancy, the models and the crew to create your images. Photographers should call, fax, e-mail or see Web site for more information.

⊕ BURREN COLLEGE OF ART WORKSHOPS
Burren College of Art, Newton Castle, Ballyvaughan, County Clare, Ireland. (353)(65)707-7200. Fax: (353)(65)707-7201. E-mail: anna@burrencollege.ie. Web site: www.burrencollege.ie. **Contact:** Admissions Officer. ''These workshops present unique opportunities to capture the qualities of Ireland's western landscape. The flora, prehistoric tombs, ancient abbeys and castles that abound in the Burren provide an unending wealth of subjects in an ever-changing light.'' Photographers should e-mail for more information.

CALIFORNIA PHOTOGRAPHIC WORKSHOPS
2500 N. Texas St., Fairfield CA 94533. (888)422-6606. E-mail: cpwschool@sbcglobal.net. Web site: www. CPWschool.com. **Contact:** James Inks. Five-day workshops on professional, digital, portrait, wedding and commercial photography in the northern California redwoods near San Francisco.

⊕ CAMARGO FOUNDATION VISUAL ARTS FELLOWSHIP
1, Avenue Jermini, 13260 Cassis, France. E-mail: apply@camargofoundation.org. Web site: www.camarg ofoundation.org. **Contact.** Applications Coordinator. Semester-long residencies awarded to visual artists and academics. Artists may work on a specific project, develop a body of work, etc. Fellows must live on-site at foundation headquarters for the duration of the term. One-semester residential grants (September-December or January-May). Each fellow receives a $3,500 stipend. Open to advanced photographers. **January 12 deadline.** Photographers should visit Web site to apply.

JOHN C. CAMPBELL FOLK SCHOOL
One Folk School Rd., Brasstown NC 28902. (800)365-5724 or (828)837-2775. Fax: (828)837-8637 Web site: www.folkschool.org. Cost: $250-442 tuition; room and board available for additional fee. The Folk School offers weekend and weeklong courses in photography year-round. ''Please call for free catalog.''

ℕ THE CENTER FOR FINE ART PHOTOGRAPHY
201 S. College Ave., Fort Collins CO 80524. (907)224-1010. Web site: www.c4fap.org/workshops_intro.a sp. Cost: varies depending on workshop, $10-195 Offers worshops and forums by photographers who have skills in the subject they present, including Photoshop; photography basics with film and digital; studio lighting. Open to all skill levels. Photographers should write, call, see Web site for more information.

CENTER FOR PHOTOGRAPHY AT WOODSTOCK
59 Tinker St., Woodstock NY 12498. (845)679-9957. Fax: (845)679-6337. E-mail: info@cpw.org. Web site: www.cpw.org. **Contact:** Ariel Shanberg, executive director. A not-for-profit arts and education organization dedicated to contemporary creative photography, founded in 1977. Programs in education, exhibition, publication, and services for artists. This includes year-round exhibitions, summer/fall Woodstock Photography Workshop and Lecture Series, artist residencies, *PHOTOGRAPHY Quarterly* magazine, annual call for entries, permanent print collection, slide registry, library, darkroom, fellowship, membership, portfolio review, film/video screenings, internships, gallery talks and more.

⊕ CATHY CHURCH PERSONAL UNDERWATER PHOTOGRAPHY COURSES
P.O. Box 479, GT, Grand Cayman, Cayman Islands. (345)949-7415. Fax: (345)949-9770. E-mail: cathy@ca thychurch.com. Web site: www.cathychurch.com. **Contact:** Cathy Church. Cost: $125/hour. Hotel/dive

package available at Sunset House Hotel. Private and group lessons available for all levels throughout the year; classroom and shore diving can be arranged. Lessons available for professional photographers expanding to underwater work. Photographers should e-mail for more information.

CLICKERS & FLICKERS PHOTOGRAPHY NETWORK—LECTURES & WORKSHOPS

P.O. Box 6094, Malibu CA 90264-6094 and P.O. Box 60508, Pasadena CA 91116-6508. (626)794-7447. E-mail: photographer@ClickersAndFlickers.com. Web site: www.ClickersAndFlickers.com. **Contact:** Dawn Stevens, organizer. Cost: depends on particular workshop. Monthly lectures, events and free activities for members. "Clickers & Flickers Photography Network, Inc., was created to provide people with an interest and passion for photography (cinematography, filmmaking, image making) the opportunity to meet others with similar interests for networking and camaraderie. It provides an environment in which photography issues, styles, techniques, enjoyment and appreciation can be discussed as well as experienced with people from many fields and levels of expertise (beginners, students, amateur, hobbyist, or professionals, gallery owners and museum curators). We publish a bimonthly color magazine listing thousands of activities for photographers and lovers of images." Clickers & Flickers Photography Network, Inc., is a 21-year-old professional photography network association that promotes information and offers promotional marketing opportunities for photographers, cinematographers, individuals, organizations, businesses, events, publishers (including advertising or PR agencies). "C&F also provides referrals for photographers and cinematographers. If you are looking for the services of a photographer, we can help you. Our membership includes photographers and cinematographers who are skilled in the following types of photography: wedding, headshots, fine art, sports, events, products, news, glamour, fashion, macro, commercial, landscape, advertising, architectural, wildlife, candid, photojournalism, marquis gothic—fetish, aerial and underwater; using the following types of equipment: motion picture cameras (Imax, 70mm, 65mm, 35mm, 16mm, 8mm), steadicam systems, video, high-definition, digital, still photography—large format, medium format and 35mm." Open to all skill levels. Photographers should call or e-mail for more information.

COMMUNITY DARKROOM

713 Monroe Ave., Rochester NY 14607. (585)271-5920. E-mail: darkroom@geneseearts.org. Web site: www.geneseearts.org. **Contact:** Sharon Turner, director. Associate Director: Marianne Pojman. Costs $65-200, depending on type and length of class. "We offer 30 different photography and digital classes for all ages on a quarterly basis. Classes include 35mm camera techniques; black & white darkroom techniques; composition; studio lighting; digital camera techniques; Photoshop; Web design; InDesign; the business of photography; matting and framing; hand coloring; alternative processes; night, sports and nature photography; and much, much more! Call for a free brochure."

CONE EDITIONS WORKSHOPS

Powder Spring Rd., East Topsham VT 05076. (802)439-5751, ext. 101. Fax: (802)439-6501. E-mail: cathy @cone-editions.com. Web site: www.coneeditions.com. **Contact:** Cathy Cone. Cost: varies per workshop. See Web site for details on workshop dates and prices. Workshops in Piezography b&w digital printing, digital cameras, various workshops with Jon Cone, George DeWolfe, Larry Danque, Tyler Boley, Amaduo Diallo, Phil Bard, Clyde Butcher. Open to all skill levels. Photographers should call, e-mail, see Web site for more information.

THE CORPORATION OF YADDO RESIDENCIES

P.O. Box 395, Saratoga Springs NY 12866-0395. (518)584-0746. Fax: (518)584-1312. E-mail: yaddo@yadd o.org. Web site: www.yaddo.org. **Contact:** Candace Wait, program director. No fee; room, board, and studio space are provided. Deadlines to apply are January 1 and August 1—residencies are offered year round. Yaddo is a working artists' community on a 400-acre estate in Saratoga Springs, New York. It offers residencies of 2 weeks to 2 months to creative artists in a variety of fields. The mission of Yaddo is to encourage artists to challenge themselves by offering a supportive environment and good working conditions. Open to advanced photographers. Photographers should write, send SASE (63¢ postage), call or e-mail for more information.

⊕ THE CORTONA CENTER OF PHOTOGRAPHY, ITALY

P.O. Box 550894, Atlanta GA 30355. (404)872-3264. E-mail: allen@cortonacenter.com. Web site: www.co rtonacenter.com. **Contact:** Allen Matthews, director. Robin Davis and Allen Matthews lead a personal,

small-group photography workshop in the ancient city of Cortona, Italy, centrally located in Tuscany, once the heart of the Renaissance. Dramatic landscapes; Etruscan relics; Roman, Medieval and Renaissance architecture; and the wonderful and photogenic people of Tuscany await. Photographers should write, e-mail or see Web site for more information.

CORY PHOTOGRAPHY WORKSHOPS

P.O. Box 42, Signal Mountain TN 37377. (423)886-1004. E-mail: tompatcory@aol.com. Web site: www.tomandpatcory.com. **Contact:** Tom or Pat Cory. Small workshops/field trips (8-12 maximum participants) with some formal instruction, but mostly one-on-one instruction in the field. ''Since we tailor this instruction to each individual's interests, our workshops are suitable for all experience levels. Participants are welcome to use film or digital cameras or even video. Our emphasis is on nature and travel photography. We spend the majority of our time in the field, exploring our location. Cost and length vary by workshop. Many of our workshop fees include single-occupancy lodging, and some also include home-cooked meals and snacks. We offer special prices for 2 people sharing the same room, and, in some cases, special non-participant prices. Workshop locations vary from year to year but include the Eastern Sierra of California, Colorado and Arches National Park, Olympic National Park, Acadia National Park, the Upper Peninsula of Michigan, Death Valley National Park, Smoky Mountain National Park, and Glacier National Park. We offer international workshops in Ireland, Scotland, Provence, Brittany, Tuscany, New Zealand, New Foundland, Wales, Costa Rica and Panama. We also offer a number of short workshops throughout the year in and around Chattanooga, Tennessee—individual instruction and custom-designed workshops for groups.'' Photographers should write, call, e-mail or see Web site for more information.

COUPEVILLE ARTS CENTER/PHOTOGRAPHY

15 NW Birch St., Coupeville WA 98239. (360)678-3396. Tollfree: (877)678-3396. E-mail: info@coupevillearts.org. Web site: www.coupevillearts.org. **Contact:** Registrar. Cost: varies. Workshops are held on Whidbey Island and at various other locations. Topics are new and varied every year.

CREALDÉ SCHOOL OF ART

600 St. Andrews Blvd., Winter Park FL 32792. (407)671-1886. Web site: www.crealde.org. **Contact:** Peter Schreyer, executive director. Director of Photography: Rick Lang. Cost: Membership fee begins at $35/individual. Offers classes covering traditional and digital photography; b&w darkroom techniques; landscape, portrait, documentary, travel, wildlife and abstract photography; and educational tours.

CREATIVE ARTS WORKSHOP

80 Audubon St., New Haven CT 06511. (203)562-4927. E-mail: hshapiro8@aol.com. Web site: www.creativeartsworkshop.org. **Contact:** Harold Shapiro, photography department head. Offers advanced workshops and exciting courses for beginning and serious photographers. Traditional darkroom and digital classes.

BRUCE DALE PHOTOGRAPHIC WORKSHOPS

Bruce Dale Photography. Web site: www.brucedale.com. Bruce teaches throughout the world. Visit his Web site for current information on his workshops and lectures.

◼◼ DAWSON COLLEGE CENTRE FOR TRAINING AND DEVELOPMENT

4001 de Maisonneuve Blvd. W., Suite 2G.1, Montreal QC H3Z 3G4 Canada. (514)933-0047. Fax: (514)937-3832. E-mail: ctd@dawsoncollege.qc.ca. Web site: www.dawsoncollege.qc.ca/ciait. **Contact:** Roula Koutsoumbas. Cost: $90-595. Workshop subjects include imaging arts and technologies, computer animation, photography, digital imaging, desktop publishing, multimedia, and Web publishing and design.

THE JULIA DEAN PHOTO WORKSHOPS

801 Ocean Front Walk, Studio 8, Venice CA 90291. (310)392-0909. Fax: (310)664-0809. E-mail: workshops@juliadean.com. Web site: www.juliadean.com. **Contact:** Natalie Gamble, director of operations. Photography workshops of all kinds held throughout the year, including alternative and fine art, photography fundamentals, digital photography and travel workshops. Now offering workshops in Los Angeles, Santa Ana, Oceanside, Escondido and San Diego. Open to all skill levels. Photographers should call, e-mail or see Web site for more information.

ⓃCYNTHIA DELANEY PHOTO WORKSHOPS

168 Maple St., Elko NV 89801. (775)753-5833. E-mail: cynthia@cynthiadelaney.com. Web site: www.cyn thiadelaney.com. **Contact:** Cynthia Delaney, owner/photographer. Cost: $250-4,000. Held in January, March, April, May, June, July and August. Workshops focus on outdoor, travel and creative photography. Destinations include several locations in the western U.S. and tours abroad, including Galapagos Islands, Ireland, Iceland and Guatemala. "We are continuing to add new itineraries to the schedule. We welcome both film and digital shooters. The group size is kept small so that each participant will have plenty of one-on-one instruction." Open to all skill levels. Photographers should see Web site for more information.

DIGITAL WILDLIFE PHOTOGRAPHY FIELD SCHOOL

P.O. Box 236, South Wellfleet MA 02663. (508)349-2615. E-mail: mlowe@massaudubon.org. **Contact:** Melissa Lowe, program coordinator. Cost: $325-350. Four-day course on Cape Cod focusing on wildlife photography using digital technology. Course covers fundamentals of shooting wildlife in a natural setting and an introduction to editing images using photoshop. Taught by Shawn Carey and Eric Smith. Sponsored by Massachusetts Audubon Society.

JOE ENGLANDER PHOTOGRAPHY WORKSHOPS & TOURS

P.O. Box 1261, Manchaca TX 78652. (512)922-8686. E-mail: info@englander-workshops.com. Web site: www.englander-workshops.com. **Contact:** Joe Englander. Cost: $275-8,000. Instruction in beautiful locations throughout the world, all formats and media, color/b&w/digital, photoshop instruction. Locations include Europe, Asia and the US. See Web site for more information.

EUROPA PHOTOGENICA PHOTO TOURS TO EUROPE

(formerly France Photogenique/Europa Photogenica Photo Tours to Europe), 3920 W. 231st Place, Torrance CA 90505. Phone/fax: (310)378-2821. E-mail: FraPhoto@aol.com. Web site: www.europaphotogen ica.com. **Contact:** Barbara Van Zanten-Stolarski, owner. Cost: $2,700-3,600; includes meals, transportation, hotel accommodation. Tuition provided for beginners/intermediate and advanced level. Workshops held in spring (3-5) and fall (1-3). Five- to 11-day photo tours of the most beautiful regions of Europe. Shoot landscapes, villages, churches, cathedrals, vineyards, outdoor markets, cafes and people in Paris, Provence, southwest France, England, Italy, Greece, etc. Open to all skill levels. Photographers should call or e-mail for more information.

ⓃEXPOSURE36 PHOTOGRAPHY

805 SE 17th Place, Portland OR 97233. (866)368-6736. E-mail: info@exposure36.com. Web site: www.exp osure36.com. Cost: varies, depending on workshop. Open to all skill levels. Workshops offered at prime locations in the U.S. and Canada, including Yosemite, Smoky Mountains, Bryce Canyon, the Oregon coast. Also offers classes on the basics of photography in Portland, Oregon (through the Experimental College or Mt. Hood Community College) and Seattle, Washington (through the Experimental College of the University of Washington). Photographers should write, call, e-mail, see Web site for more information.

FINDING & KEEPING CLIENTS

2973 Harbor Blvd., Suite 341, Costa Mesa CA 92626-3912. Phone/fax: (888)713-0705. E-mail: maria@mpi scopo.com. Web site: www.mpiscopo.com. **Contact:** Maria Piscopo, instructor. "How to find new photo assignment clients and get paid what you're worth! See Web site for schedule or send query via e-mail." Maria Piscopo is the author of *The Photographer's Guide to Marketing & Self Promotion*, 3rd edition (Allworth Press).

FINE ARTS WORK CENTER

24 Pearl St., Provincetown MA 02657. (508)487-9960, ext. 103. Fax: (508)487-8873. E-mail: workshops@f awc.org. Web site: www.fawc.org. **Contact:** Dorothy Antczak, summer program director. Cost: $700/week, $625/week (housing). Faculty includes Constantine Manos, Arno Minkkinen, Amy Arbus, Marian Roth, Gabe Greenburg, Deborah Bright, David Hilliard, and Stella Johnson. Write, call or e-mail for more information.

FIRST LIGHT PHOTOGRAPHIC WORKSHOPS AND SAFARIS

P.O. Box 240, East Moriches NY 11940. (631)581-0400. Web site: www.firstlightphotography.com. **Contact:** Bill Rudock, president. Photo workshops and photo safaris for all skill levels held on Long Island,

NY, and specializing in national parks, domestic and international; also presents workshops for portrait and wedding photographers.

FIRST LIGHT PHOTOGRAPHY WORKSHOP TOURS
P.O. Box 36201, Lakewood CO 80227. (720)962-5929. E-mail: andy@firstlighttours.com. Web site: www.firstlighttours.com. **Contact:** Andy Long, owner. Cost: $1,095-4,395, depending on tour; hotels, meals and ground transportaion included. Tours are held in a variety of locations, including Penguins of Falkland Islands, Tasmania, Oregon coast, southwest Alaska, Alaskan northern lights, Florida, south Texas birds, Glacier National Park, historic Taos and Santa Fe, Bosque del Apache Wildlife Preserve, and more. See Web site for more information on locations, dates and prices. Open to all skill levels. Photographers should call, e-mail, see Web site for more information.

FLORENCE PHOTOGRAPHY WORKSHOP
Washington University, College of Art, Campus P.O. Box 1031, St. Louis MO 63130. (314)935-6500. E-mail: sjstremb@art.wustl.edu. Web site: www.artsci.wustl.edu/~photo/florenc.html. **Contact:** Stan Strembicki, professor. "Four-week intensive photographic study of urban and rural landscape of Florence and Tuscany. Digital darkroom, field trips within Florence, housing available."

FOCUS ADVENTURES
P.O. Box 771640, Steamboat Springs CO 80477. Phone/fax: (970)879-2244. E-mail: karen@focusadventures.com. Web site: www.focusadventures.com. **Contact:** Karen Gordon Schulman, owner. Photo workshops and tours emphasize the art of seeing and personal photographic vision. Summer digital photo workshops in Steamboat Springs, Colorado. Field trips to working ranches, the rodeo and wilderness areas. New fall digital workshop offered at Focus Ranch, a private guest ranch in NW Colorado. Customized private and small-group lessons available year-round. International photo tours and workshops to various destinations including Ecuador, the Galapagos Islands, Morocco and western Ireland.

FOTOFUSION
55 NE Second Ave., Delray Beach FL 33444. (561)276-9797. Fax: (561)276-9132. E-mail: info@fotofusion.org. Web site: www.fotofusion.org. **Contact:** Fatima NeJame, executive director. America's foremost festival of photography and digital imaging is held each January. Learn from more than 90 master photographers, picture editors, picture agencies, gallery directors, and technical experts, over 5 days of field trips, seminars, lectures and Adobe Photoshop CS workshops. January 15-19, 2008. Open to all skill levels. Photographers should write, call or e-mail for more information.

Ⓝ GALÁPAGOS TRAVEL
783 Rio Del Mar Blvd., Suite 49, Aptos CA 95003. (800)969-9014. E-mail: info@galapagostravel.com. Web site: www.galapagostravel.com. Cost: $4,300; includes lodging and most meals. Landscape and wildlife photography tour of the islands with an emphasis on natural history. Three nights in a first-class hotel in Quito, Ecuador, and 11 or 14 nights aboard a yacht in the Galápagos. See Web site for more information.

Ⓝ GERLACH NATURE PHOTOGRAPHY WORKSHOPS & TOURS
P.O. Box 642, Ashton, ID 83420. (208)652-4444. E-mail: michele@gerlachnaturephoto.com. Web site: www.gerlachnaturephoto.com. **Contact:** Michele Smith, office manager. Costs vary. Professional nature photographers John and Barbara Gerlach conduct intensive field workshops in the beautiful Upper Peninsula of Michigan in August and during October's fall color period. They lead a photo safari to the best game parks in Kenya during late-August/early-September every year. They also lead winter, summer and fall photo tours of Yellowstone National Park and conduct high-speed flash hummingbird photo workshops in British Columbia in late May. Barbara and John work for an outfitter a couple weeks a year leading photo tours into Yellowstone Back Country with the use of horses. This is a wonderful way to experience Yellowstone. Photographers should see Web site for more information.

GLOBAL PRESERVATION PROJECTS
P.O. Box 30866, Santa Barbara CA 93130. (805)682-3398 or (805)455-2790. E-mail: TIMorse@aol.com. Web site: www.GlobalPreservationProjects.com. **Contact:** Thomas I. Morse, director. Offers photographic workshops and expeditions promoting the preservation of environmental and historic treasures.

Produces international photographic exhibitions and publications. GPP workshops include the ghost town of Bodie, CA; Digital Basics for Photographers held in Santa Barbara; expeditions to Arches and Canyonlands; Durango Fall and Winter Train; Big Sur; Slot Canyons; White Sands; Death Valley. GPP has added a 34-ft. motor home with state-of-the art digital imaging and printer systems for participant use. Photographers should call, e-mail or see Web site for more information.

GOLDEN GATE SCHOOL OF PROFESSIONAL PHOTOGRAPHY

P.O. Box F, San Mateo CA 94402-0018. (650)548-0889. E-mail: goldengateschool@yahoo.com. Web site: www.goldengateschool.org. **Contact:** Julie Olson, director. Offers 1- to 4-day workshops in traditional and digital photography for professional and aspiring photographers in the San Francisco Bay Area.

ROB GOLDMAN CREATIVE WORKSHOPS

16 Glenveiw Place, Huntington NY 11743. (631)424-1650. Fax: (631)424-1650. E-mail: rob@rgoldman.com. Web site: www.rgoldman.com. **Contact:** Rob Goldman, photographer. Cost varies depending on type and length of workshop. 1-on-1 customized photography lessons for all levels, plus intensive workshops held 3-4 times/year. Purpose is artistic and personal growth for photographers. Open to all skill levels. Photographers should call or e-mail for more information.

HALLMARK INSTITUTE OF PHOTOGRAPHY

P.O. Box 308, Turners Falls MA 01376. (413)863-2478. E-mail: info@hallmark.edu. Web site: www.hallmark.edu. **Contact:** George J. Rosa III, president. Director of Enrollment Services: Shelley Nicholson. Tuition: $31,250. Offers an intensive 10-month resident program teaching the technical, artistic and business aspects of traditional and digital professional photography for the career-minded individual.

HAWAII PHOTO SEMINARS

Changing Image Workshops, P.O. Box 280, Kualapuu, Molokai HI 96757. (808)567-6430. E-mail: hui@aloha.net. Web site: www.huiho.org. **Contact:** Rik Cooke. Cost: $1,795; includes lodging, meals and ground transportation. Seven-day landscape photography workshop for beginners to advanced photographers. Workshops taught by 2 *National Geographic* photographers and a multimedia producer.

HEART OF NATURE PHOTOGRAPHY WORKSHOPS

P.O. Box 1645, Honokaa HI 96727. (808)345-7179. E-mail: info@heartofnature.net. Web site: www.heartofnature.net. **Contact:** Robert Frutos or Jenny Thompson. Cost: $345-2,695, depending on workshop/tours. "Will greatly increase your ability to capture dynamic images and convey the wonder, beauty and spirit of your experience in nature." Photographers should call or see Web site for more information.

HORIZONS TO GO

P.O. Box 634, Leverett MA 01054. (413)367-9200. Fax: (413)367-9522. E-mail: horizons@horizons-art.com. Web site: www.horizons-art.com. **Contact:** Jane Sinauer, director. Artistic vacations and small-group travel: 1- and 2-week programs in the American Southwest, Italy, France, Prague, Scandinavia, Mexico, Ecuador, Thailand, Vietnam, Cambodia, Myanmar and Bali.

IN FOCUS WITH MICHELE BURGESS

20741 Catamaran Lane, Huntington Beach CA 92646. (714)536-6104. E-mail: maburg5820@aol.com. Web site: www.infocustravel.com. **Contact:** Michele Burgess, president. Cost: $4,000-7,000. Offers overseas tours to photogenic areas with expert photography consultation at a leisurely pace and in small groups (maximum group size: 20).

INTERNATIONAL CENTER OF PHOTOGRAPHY

1114 Avenue of the Americas, New York NY 10036. (212)857-0001. E-mail: education@icp.org. Web site: www.icp.org. **Contact:** Donna Ruskin, education associate. "The cost of our weekend workshops range from $255 to $720 plus registration and lab fees. Our 5- and 10-week courses range from $360 to $770 plus registration and lab fees." ICP offers photography courses, lectures and workshops for all levels of experience—from intensive beginner classes to rigorous professional workshops.

INTERNATIONAL EXPEDITIONS

One Environs Park, Helena AL 35080. (800)633-4734 (US/Canada); (205)428-1700 (worldwide). Fax: (205)428-1714. E-mail: nature@ietravel.com. Web site: www.ietravel.com. **Contact:** Ralph Hammel-

bacher, president. Cost: $1,800-$4,898; includes scheduled transportation during expeditions unless otherwise specified; services of experienced English-speaking local guides; all accommodations; meals as specified in the respective itineraries; transfer and luggage handling when taking group flights. Guided nature expeditions all over the world: Costa Rica, Machu Picchu, Galapagos, Kenya, Patagonia and many more. Open to all skill levels. Photographers should write, call, e-mail, see Web site for more information.

JIVIDEN'S "NATURALLY WILD" PHOTO ADVENTURES
P.O. Box 333, Chillicothe OH 45601. (800)866-8655 or (740)774-6243. E-mail: mail@imagesunique.com. Web site: www.naturallywild.net. **Contact:** Jerry or Barbara Jividen. Cost: $149 and up depending on length and location. Workshops held throughout the year; please inquire. All workshops and photo tours feature comprehensive instruction, technical advice, pro tips and hands-on photography. Many workshops include lodging, meals, ground transportation, special permits and special "guest rates." Group sizes are small for more personal assistance and are normally led by 2 photography guides/certified instructors. Subject emphasis is on photographing nature, wildlife and natural history. Supporting emphasis is on proper techniques, composition, exposure, lens and accessory use. Workshops range from 1-7 days in a variety of diverse North American locations. Open to all skill levels. Free information available upon request. Free quarterly journal by e-mail upon request. Photographers should write, call or e-mail for more information.

N JORDAHL PHOTO WORKSHOPS
P.O. Box 3998, Hayward CA 94540. (510)785-7707. E-mail: kate@jordahlphoto.com. Web site: www.jordahlphoto.com. **Contact:** Kate or Geir Jordahl, directors. Cost: $150-700. Intensive 1- to 5-day workshops dedicated to inspiring creativity and community among artists through critique, field sessions and exhibitions.

ART KETCHUM HANDS-ON MODEL WORKSHOPS
2215 S. Michigan Ave., Chicago IL 60616. (773)866-2803. E-mail: ketch22@ix.netcom.com. Web site: www.artketchum.com. **Contact:** Art Ketchum, owner. Cost: $160 for 1-day workshops in Chicago studio; $125 for repeaters; and a special price of $100 fro participants that attend at least 6 workshops. Photographers should call, e-mail or visit Web site for more information.

WELDON LEE'S ROCKY MOUNTAIN PHOTO ADVENTURES
P.O. Box 487, Allenspark CO 80510-0487. Phone/fax: (303)747-2074. E-mail: wlee@RockyMountainPhotoAdventures.com. Web site: www.RockyMountainPhotoAdventures.com. **Contact:** Weldon Lee. Cost: $695-5,995; includes transportation and lodging. Workshops held monthly year round. Wildlife and landscape photography workshops featuring hands-on instruction with an emphasis on exposure, composition, and digital imaging. Participants are invited to bring a selection of images to be critiqued during the workshops. Photographers should write, call or e-mail for more information.

LEPP INSTITUTE OF DIGITAL IMAGING
P.O. Box 6240, Los Osos CA 93412. (805)528-7385. Fax: (805)528-7387. E-mail: info@LeppPhoto.com. Web site: www.LeppPhoto.com. **Contact:** Mary Sylvester, registrar. Offers small groups. "New focus on digital tools to optimize photography, make the most of your images and improve your photography skills at the premier digital imaging school on the West Coast."

◾ THE LIGHT FACTORY
Spirit Square, Suite 211, 345 N. College St., Charlotte NC 28202. (704)333-9755. E-mail: info@lightfactory.org. Web site: www.lightfactory.org. **Contact:** Marcie Kelso, executive director. The Light Factory is "a nonprofit arts center dedicated to exhibition and education programs promoting the power of photography and film." Classes are offered throughout the year in SLR and digital photography and filmmaking.

C.C. LOCKWOOD WILDLIFE PHOTOGRAPHY WORKSHOP
P.O. Box 14876, Baton Rouge LA 70898. (225)769-4766. Fax: (225)767-3726. E-mail: cactusclyd@aol.com. Web site: www.cclockwood.com. **Contact:** C.C. Lockwood, photographer. Cost: Lake Martin Spoonbill Rookery, $800; Atchafalaya Swamp, $290; Yellowstone, $ 3,775; Grand Canyon, $2,450. Workshop at Lake Martin is 3 days plus side trip into Atchafalaya, February and April. Each April and October, C.C. conducts a 2-day Atchafalaya Basin Swamp Wildlife Workshop. It includes lecture, canoe trip into the

swamp, and critique session. Every other year, C.C. does a 7-day winter wildlife workshop in Yellowstone National Park. C.C. also leads an 8-day Grand Canyon raft trip photo workshop in May.

LONG ISLAND PHOTO WORKSHOP

(516)221-4058. E-mail: jerry@jsmallphoto.com. Web site: www.liphotoworkshop.com. **Contact:** Jerry Small, director. Annual 4-day workshop covering professional wedding, portrait, and digital photography and photographic skills. Open to all skill levels.

HELEN LONGEST-SACCONE AND MARTY SACCONE

P.O. Box 220, Lubec ME 04652. (207)733-4201. Fax: (207)733-4202. E-mail: helen_marty@yahoo.com. Private creative vision photo workshops offered in Maine. Private digital imaging workshops, covering Photoshop and digital cameras.

THE MACDOWELL COLONY

100 High St., Peterborough NH 03458. (603)924-3886. Fax: (603)924-9142. E-mail: admissions@macdow ellcolony.org. Web site: www.macdowellcolony.org. Founded in 1907 to provide creative artists with uninterrupted time and seclusion to work and enjoy the experience of living in a community of gifted artists. Residencies of up to 8 weeks for writers, playwrights, composers, film/video makers, visual artists, architects and interdisciplinary artists. Artists in residence receive room, board and exclusive use of a studio. Average length of residency is 5 weeks. Ability to pay for residency is not a factor. There are no residency fees. Limited funds available for travel reimbursement. Application deadlines: January 15: summer (June-September); April 15: fall/winter (October-January); September 15: winter/spring (February-May). Photographers should write, call or see Web site for application and guidelines. Questions should be directed to the admissions director.

THE MAINE PHOTOGRAPHIC WORKSHOPS

(877)577-7700 or (207)236-8581. Fax: (207)236-2558. E-mail: info@TheWorkshops.com. Web site: www .TheWorkshops.com. For 34 years, the world's leading photography and film workshop center. More than 250 1-, 2- and 4-week workshops and master classes for working pros, serious amateurs, artists and college and high school students, in all areas of photography, filmmaking, video, television and digital media. Master Classes with renowned faculty including Eugene Richards, Joyce Tenneson, and photographers from Magnum and *National Geographic*. Film faculty includes Academy Award-winning directors and cinematographers. Destination workshops in Venice and Tuscany, Italy; Paris and Venice, France; Oaxaca, Mexico; San Lucar, Spain; Rio de Janeiro, Brazil; and other locations. Rockport College (www.roc kportcollege.edu) offers an Associate of Arts Degree, a Master of Fine Arts Degree, and a 1-year Professional Certificate in film, photography and new media. Request current catalog by phone, fax or e-mail. See complete course listing on Web site.

N WILLIAM MANNING PHOTOGRAPHY

6396 Birchdale Court, Cincinnati OH 45230. (513)624-8148. E-mail: william@williammanning.com. Web site: www.williammanning.com. **Contact:** William Manning, director. Cost: $1,200-4,000. Offers small group tours. Four programs worldwide, with emphasis on landscapes, wildlife and culture.

JOE & MARY ANN MCDONALD WILDLIFE PHOTOGRAPHY WORKSHOPS AND TOURS

73 Loht Rd., McClure PA 17841-9340. (717)543-6423. Fax: (717)543-6423. E-mail: hoothollow@acsworld. com. Web site: www.hoothollow.com. **Contact:** Joe McDonald, owner. Cost: $1,200-8,500. Offers small groups, quality instruction with emphasis on nature and wildlife photography.

MEXICO PHOTOGRAPHY WORKSHOPS

Otter Creek Photography, Hendricks WV 26271. (304)478-3586. E-mail: OtterCreekPhotography@yahoo. com. **Contact:** John Warner, instructor. Cost: $1,400. Intensive weeklong, hands-on workshops held throughout the year in the most visually rich regions of Mexico. Photograph snow-capped volcanoes, thundering waterfalls, pre-Columbian ruins, botanical gardens, fascinating people, markets and colonial churches in jungle, mountain, desert and alpine environments.

MID-ATLANTIC REGIONAL SCHOOL OF PHOTOGRAPHY

666 Franklin Ave., Nutley NJ 07110. (888)267-MARS (6277). Web site: www.photoschools.com. **Contact:** Jim Bastinck, director. Cost: $985; includes lodging and most meals. Annual 5-day workshop covering many aspects of professional photography from digital to portrait to wedding. Open to photographers of all skill levels.

MISSOURI PHOTOJOURNALISM WORKSHOP

109 Lee Hills Hall, Columbia MO 65211. (573)882-4882. Fax: (573)884-4999. E-mail: info@mophotowork shop.org. Web site: www.mophotoworkshop.org. **Contact:** Angel Anderson, coordinator. Cost: $600. Workshop for photojournalists. Participants learn the fundamentals of documentary photo research, shooting, editing and layout.

MOUNTAIN WORKSHOPS

Western Kentucky University, 1906 College Heights Blvd., 11070, Bowling Green KY 42101-1070. (270)745-8927. E-mail: mountainworkshops@wku.edu. Web Site:www.mountainworkshops.org. **Cont act:** Kurt Fattic, workshops coordinator. Cost: $595 plus expenses. Annual weeklong documentary photoj ournalism workshop held in October. Open to intermediate and advanced shooters.

NATURAL TAPESTRIES

1208 State Rt. 18, Aliquippa PA 15001. (724)495-7493. E-mail: nancyrotenberg@aol.com. Web site: www. naturaltapestries.com. **Contact:** Nancy Rotenberg and Michael Lustbader, owners. Cost: varies by work-shop; $500-600 for weekend workshops in Pennsylvania. "We offer small groups with quality instruction and an emphasis on nature. Garden and macro workshops are held on our farm in Pennsylvania, and others are held in various locations in North America." Open to all skill levels. Photographers should call or e-mail for more information.

NATURE PHOTOGRAPHY WORKSHOPS, GREAT SMOKY MOUNTAINS INSTITUTE AT TREMONT

Great Smoky Mountains National Park, 9275 Tremont Rd., Townsend TN 37882. (865)448-6709. E-mail: mail@gsmit.org. Web site: www.gsmit.org. **Contact:** Registrar. Workshop instructors: Bill Lea, Will Clay and others. Cost: $540. Offers workshops in April and October emphasizing the use of natural light in creating quality scenic, wildflower and wildlife images.

Ⓝ NEVERSINK PHOTO WORKSHOP

P.O. Box 641, Woodbourne NY 12788. (212)929-0008 or (845)434-0575. E-mail: lou@loujawitz.com. Web site: www.loujawitz.com/neversink.html. **Contact:** Louis Jawitz, owner. Offers weekend workshops in digital and film, teaching scenic, travel, location and stock photography during the last 2 weeks of August in the Catskill Mountains. See Web site for more information.

Ⓝ NEW ENGLAND SCHOOL OF PHOTOGRAPHY

537 Commonwealth Ave., Boston MA 02215. (617)437-1868 or (800)676-3767. Fax: (617)437-0261. E-mail: info@nesop.com. Web site: www.nesop.com. **Contact:** Academic Director. Instruction in profes-sional and creative photography.

NEW JERSEY HERITAGE PHOTOGRAPHY WORKSHOPS

124 Diamond Hill Rd., Berkeley Heights NJ 07922. (908)790-8820. Fax: (908)790-0074. E-mail: nancyori@ comcast.net. Web site: www.nancyoriphotography.com. **Contact:** Nancy Ori, director. Estab. 1990. Cost: $195-400. Workshops held every spring. Nancy Ori, well-known instructor, freelance photographer and fine art exhibitor of landscape and architecture photography, teaches how to use available light and proper metering techniques to document the man-made and natural environments of Cape May. A variety of film and digital workshops taught by guest instructors are available each year and are open to all skill levels, especially beginners. Topics include hand coloring of photographs, creative camera techniques with Polaroid materials, intermediate and advanced digital, landscape and architecture with alternative cameras, environmental portraits with lighting techniques, street photography; as well as pastel, water-color and oil painting workshops. All workshops include an historic walking tour of town, location shooting or painting, demonstrations and critiques. Scholarships available annually.

NEW JERSEY MEDIA CENTER LLC WORKSHOPS AND PRIVATE TUTORING

124 Diamond Hill Rd., Berkeley Heights NJ 07922. (908)790-8820. Fax: (908)790-0074. E-mail: nancyori@comcast.net. Web site: www.nancyoriworkshops.com. **Contact:** Nancy Ori, director. **1. Tuscany Photography Workshop** by Nancy Ori. Explore the Tuscan countryside, cities and small villages, with emphasis on architecture, documentary, portrait and landscape photography. The group will venture in non-tourist areas. Cost: $2,600; includes tuition, accommodations at a private estate, breakfasts and some dinners. Open to all skill levels. Held September 13-20, 2008. **2. Private Photography and Darkroom Tutoring** with Nancy Ori in Berkeley Heights, New Jersey. This unique and personalized approach to learning photography is designed for the beginning or intermediate student who wants to expand his/her understanding of the craft and work more creatively with the camera, develop a portfolio, create an exhibit or learn darkroom techniques. The goal is to refine individual style while exploring the skills necessary to make expressive photographs. The content will be tailored to individual needs and interests. Cost: $350 for a total of 8 hours; $450 for the darkroom sessions. **3. Capturing the Light of the Southwest**, a painting, sketching and photography workshop with Nancy Ori and Stan Sperlak, held every other year in October, will focus on the natural landscape and man-made structures of the area around Santa Fe and Taos. Participants can be at any level in their media. Stan Sperlak is a professional pastel painter and instructor. All will be encouraged to produce a substantial body of work worthy of portfolio or gallery presentation. Features special evening guest lecturers from the photography and painting community in the Santa Fe area. Artists should e-mail for more information. **4. Cape May Photography Workshops** are held annually in April and May. Also, a variety of subjects such as photojournalism, environmental portraiture, landscape, alternative cameras, Polaroid techniques, creative digital techniques, on-location wedding photography, large-format, and how to photograph birds in the landscape are offered by several well-known East-Coast instructors. Open to all skill levels. Includes critiques, demonstrations, location shooting of Victorian architecture, gardens, seascapes, and, in some cases, models in either film or digital. E-mail for dates, fees and more information. Workshops are either 3 or 4 days.

NEW MEXICO PHOTOGRAPHY FIELD SCHOOL

7505 Mallard Way, Suite F, Santa Fe NM 87507. (505)983-2934. E-mail: info@photofieldschool.com. Web site: www.photofieldschool.com. **Contact:** Cindy Lane, associate director. "Since 1986, the New Mexico Photography Field School has been unique in its offerings: hands-on photography workshops in the Southwest's canyons, hills and villages; based in Santa Fe. Participants capture the light, color and texture that is the West. Workshops are for the novice to the experienced photographer; for anyone who wants to master photographic technique while exploring the enchanted land that is New Mexico. Field School director and instructor Craig Varjabedian has been teaching photography for 25 years. His photographs are known for their interpretations of light and place in the Southwest. His works are widely exhibited and collected. Joining the Field School as digital advisor is William Plunkett, landscape and nature photographer. Canon USA has made available digital cameras for students to try out. A catalog with workshop descriptions, and instructors' bios is available upon request."

NIKON SCHOOL OF PHOTOGRAPHY

1300 Walt Whitman Rd., Melville NY 11747. (631)547-8666. Fax: (631)547-0309. Web site: www.nikonschool.com. Weekend seminars traveling to 28 major cities in the U.S. **Intro to Digital SLR Photography**—Cost: $119; covers composition, exposure, downloading, viewing, basic editing and printing. **Next Steps in Digital Photography: Streamlined Workflow Technique**—Cost: $159; covers the benefits of RAW files, color management, advanced editing and printing techniques, and archiving of image files.

NORTHERN EXPOSURES

4917 Evergreen Way #383, Everett WA 98203. (425)347-7650. E-mail: abenteuerbc@yahoo.com. **Contact:** Linda Moore, director. Cost: $300-750 for 3- to 5-day workshops (U.S. and Canada); $175-400/day for tours in Canada. Offers 3- to 5-day intermediate to advanced nature photography workshops in several locations in Pacific Northwest and western Canada; spectacular settings including coast, alpine, badlands, desert and rain forest. Also, 1- to 2-week Canadian Wildlife and Wildlands Photo Adventures and nature photo tours to extraordinary remote wildlands of British Columbia, Alberta, Saskatchewan, Yukon and Northwest Territories.

NYU TISCH SCHOOL OF THE ARTS

721 Broadway, 8th Floor, New York NY 10003. (212)998-1930. E-mail: photo.tsoa@nyu.edu. Web site: www.photo.tisch.nyu.edu. **Contact:** Department of Photography and Imaging. Summer classes offered

for credit and noncredit covering digital imaging, career development, basic to advanced photography, and darkroom techniques. Open to all skill levels.

OREGON COLLEGE OF ART AND CRAFT

8245 SW Barnes Rd., Portland OR 97225. (503)297-5544 or (800)390-0632. Web site: www.ocac.edu. Offers workshops and classes in photography throughout the year: b&w, color, alternative processes, studio lighting, digital imaging. Also offers MFA in photography. For schedule information, call or visit Web site.

⊕ STEVE OUTRAM'S TRAVEL PHOTOGRAPHY WORKSHOPS

D. Katsifarakis St., Galatas, Chania 73100 Crete, Greece. E-mail: mail@steveoutram.com. Web site: www.steveoutram.com. **Contact:** Steve Outram, workshop photographer. **Western Crete:** 9 days in the Venetian town of Chania, every May and October. **Lesvos:** 14 days on Greece's 3rd-largest island, every October. **Slovenia:** 11 days exploring the charming towns of Ljubjana and Piran, every June. **Zanzibar:** 14 days on this fascinating Indian Ocean island, every February and September. Learn how to take more than just picture postcard-type images on your travels. Workshops are limited to 8 people.

PALM BEACH PHOTOGRAPHIC CENTRE

55 NE Second Ave., Delray Beach FL 33444. (561)276-9797. Fax: (561)276-9132. E-mail: cs@workshop.org. Web site: www.workshop.org. **Contact:** Fatima NeJame, executive director. Cost: $75-1,300 depending on class. The center is an innovative learning facility offering 1- to 5-day seminars in photography and digital imaging year round. Also offered are travel workshops to cultural destinations such as South Africa, Bhutan, Cambodia, Peru, and India. Emphasis is on photographing the indigenous cultures of each country. Also hosts the annual Fotofusion event (see separate listing in this section). Photographers should call for details.

⊕ PAN HORAMA

Puskurinkatu 2, FIN-33730, Tampere Finland. Fax: 011-358-3-364-5382. E-mail: info@panhorama.net. Web site: www.panhorama.net. **Contact:** Rainer K. Lampinen, chairman. Annual panorama photography workshops. International Panorama Photo Exhibition held annually in autumn in Finland and retrospective exhibitions abroad. Awards: Master of Panorama Art, opportunity to exhibit at Underground Photo Gallery (http://www.iisalmi.fi/?deptid+12149), other awards.

PETERS VALLEY CRAFT CENTER

19 Kuhn Rd., Layton NJ 07851. (973)948-5200. Fax: (973)948-0011. E-mail: pv@warwick.net. Web site: www.petersvalley.org. Offers workshops May, June, July, August and September; 3-6 days long. Offers instruction by talented photographers in a wide range of photographic disciplines—from daguerrotypes to digital and everything in between. Also offers classes in blacksmithing/metals, ceramics, fibers, fine metals, weaving and woodworking. Located in northwest New Jersey in the Delaware Water Gap National Recreation Area, 70 miles west of New York City. Photographers should call for catalog or visit Web site or more information.

PHOTO EXPLORER TOURS

2506 Country Village, Ann Arbor MI 48103-6500. (800)315-4462 or (734)996-1440. E-mail: decoxphoto@aol.com. Web site: www.PhotoExplorerTours.com. **Contact:** Dennis Cox, director. Cost: $3,195; all-inclusive. Photographic explorations of China, southern Africa, India, Turkey, Burma and Vietnam. "Founded in 1981 as China Photo Workshop Tours by award-winning travel photographer and China specialist Dennis Cox, Photo Explorer Tours has expanded its tours program since 1996. Working directly with carefully selected tour companies at each destination who understand the special needs of photographers, we keep our groups small, usually from 5 to 16 photographers, to ensure maximum flexibility for both planned and spontaneous photo opportunities." On most tours, individual instruction is available from professional photographer leading tour. Open to all skill levels. Photographers should write, call or e-mail for more information.

PHOTO WORKSHOPS BY COMMERCIAL PHOTOGRAPHER SEAN ARBABI

San Francisco Bay Area, California. Phone/fax: (925)855-8060. E-mail: workshops@seanarbabi.com. Web site: www.seanarbabi.com/workshops.html. **Contact:** Sean Arbabi, photographer/instructor. Cost:

$85-3,000 for workshops only; meals, lodging, airfare and other services may be included, depending on workshop. Seasonal workshops held in spring, summer, fall, winter. Taught at California locations including Point Reyes National Seashore, wine country, the San Francisco Bay Area, and northern California. Sean Arbabi teaches through computer presentations and slide shows, field instruction and hands-on demonstrations. All levels of workshops are offered from beginner to advanced; subjects include digital photography, technical elements of exposure to composition, how to fine-tune your personal vision, equipment to pack and use, a philosophical approach to the art, as well as how to run a photography business.

PHOTOGRAPHERS' FORMULARY

P.O. Box 950, 7079 Hwy. 83 N, Condon MT 59826-0950. (800)922-5255. Fax: (406)754-2896. E-mail: lynnw@blackfoot.net; formulary@blackfoot.net. Web site: www.photoformulary.com. **Contact:** Lynn Wilson, workshops program director. Photographers' Formulary workshops include a wide variety of alternative processes, and many focus on the traditional darkroom. Located in Montana's Swan Valley, some of the best wilderness lands in the Rocky Mountains. See Web site for details on costs and lodging. Open to all skill levels.

PHOTOGRAPHIC ARTS CENTER

Fresh Meadows, Queens NY. Phone/Fax: (718)969-7924. E-mail: photocenter48@yahoo.com. **Contact:** Beatriz Arenas, president. Offers workshops on basics to advanced, b&w and color; Mac computers, Photoshop, Pagemaker, Canvas, CD recording and digital photography. Gives lessons in English and Spanish.

PHOTOGRAPHIC ARTS WORKSHOPS

P.O. Box 1791, Granite Falls WA 98252. (360)691-4105. E-mail: photoartswkshps@aol.com. Web site: www.barnbaum.com. **Contact:** Bruce Barnbaum, director. Offers a wide range of workshops across the U.S., Mexico, Europe and Canada. Instructors include masters of digital images. Workshops feature instruction in composition, exposure, development, printing, photographic goals and philosophy. Includes reviews of student portfolios. Sessions are intense, held in field, darkroom and classroom with various instructors. Ratio of students to instructors is always 8:1 or fewer, with detailed attention to problems students want solved. All camera formats, color and b&w.

PHOTOGRAPHIC CENTER NORTHWEST

900 12th Ave., Seattle WA 98122. (206)720-7222. E-mail: pcnw@pcnw.org. Web site: www.pcnw.org. **Contact:** Damian Murphy, executive director. Day and evening classes and workshops in fine art photography (b&w, color, digital) for photographers of all skill levels; accredited certificate program.

PHOTOGRAPHS II

P.O. Box 4376, Carmel CA 93921. (831)624-6870. E-mail: rfremier@redshift.com. Web site: www.starrsite s.com/photos2 or www.photographsII.com. **Contact:** Roger Fremier. Cost: Starts at $2,945 for International Photography Retreats. Offers 4 programs/year. Previous locations include France, England, Spain and Japan.

PHOTOGRAPHY AT THE SUMMIT: JACKSON HOLE

Rich Clarkson & Associates LLC, 1099 18th St., Suite 1840, Denver CO 80202. (303)295-7770 or (800)745-3211. E-mail: info@richclarkson.com. Web site: www.photographyatthesummit.com. **Contact:** Brett Wilhelm, administrator. Annual workshops held in spring (May) and fall (October). Weeklong workshops with top journalistic, nature and illustrative photographers and editors. See Web site for more information.

⊕ PHOTOGRAPHY IN PROVENCE

La Chambre Claire, Rue du Petit Portail, Ansouis 84240 France. E-mail: andrew.squires@wanadoo.fr. Web site: www.photographie.net/andrew/. **Contact:** Mr. Andrew Squires, M.A. Cost: $700; accommodations between $255-380. Annual workshop held from April to October. Theme: What to Photograph and Why? Designed for people who are looking for a subject and an approach they can call their own. Explore photography of the real world, the universe of human imagination, or simply let yourself discover what

touches you. Explore Provence and photograph on location. Possibility to extend your stay and explore Provence if arranged in advance. Open to all skill levels. Photographers should send SASE, call or e-mail for more information.

POLAROID & DIGITAL TRANSFERS, DIGITAL INFRARED & PHOTOSHOP WORKSHOPS
P.O. Box 335, Honaunau HI 96726. (808)328-2162. E-mail: kcarr@kathleencarr.com. Web site: www.kath leencarr.com. **Contact:** Kathleen T. Carr. Cost: $85-100/day plus $30 for materials. Carr, author of *Polaroid Transfers* and *Polaroid Manipulations: A Complete Visual Guide to Creating SX-70, Transfer and Digital Prints* (Amphoto Books, 1997 and 2002), offers her expertise on the subjects for photographers of all skill levels. Includes hand coloring. Programs last 1-7 days in various locations in California, Hawaii, Montana and other locales.

PRAGUE SUMMER SEMINARS
Metropolitan College, ED 118, University of New Orleans, 2000 Lakeshore Dr., New Orleans LA 70148. (504)280-7318. E-mail: prauge@uno.edu. Web site: http://inst.uno.edu/prauge. **Contact:** Irene Ziegler, program coordinator. Cost: $3,395; includes lodging. Challenging seminars, studio visits, excursions within Prague; field trips to Vienna, Austria and Brno, Moravia; film and lecture series. Open to beginners and intermediate photographers. Photographers should call, e-mail or see Web site for more information.

PROFESSIONAL PHOTOGRAPHER'S SOCIETY OF NEW YORK STATE PHOTO WORKSHOPS
2175 Stuyvesant St., Niskayuna NY 12309. (518)377-5935. E-mail: tmack1@nycap.rr.com. Web site: www.ppsnysworkshop.com. **Contact:** Tom Mack, director. Cost: $675 or $775. Weeklong, specialized, hands-on workshops for professional photographers in July.

PROFESSIONAL PHOTOGRAPHY AT DAYTONA BEACH COMMUNITY COLLEGE
(formerly Photographic Technology at Daytona Beach Community College), DBCC-Photography Dept., P.O. Box 2811, Daytona Beach FL 32120-2811. (386)506-3581. Fax: (386)506-3112. E-mail: biferid@dbcc.edu. Web site: http://go.dbcc.edu/photography. **Contact:** Dan Biferie, chair. Full-range professional photography coursework and periodic workshops available. Skills: commercial, editorial, fine art. Open to all. E-mail or call for more information.

⊕ PYRENEES EXPOSURES
19, rue Jean Bart, 66190 Collioure, France. E-mail: explorerimages@yahoo.com. Web site: www.exploreri mages.com. **Contact:** Martin N. Johansen, director. Cost: varies by workshop; starts at $250 for tuition; housing and meals extra. Workshops held year round. Offers 3- to 5-day workshops and photo expeditions in the French and Spanish Pyrenees, including the Côte Vermeille, with emphasis on landscapes, wildlife and culture. Workshops and tours are limited to small groups. Open to all skill levels. Photographers should e-mail or see Web site for more information.

▨ QUETICO PHOTO TOURS
P.O. Box 593, Atikokan ON P0T 1C0 Canada. (807)597-2621(summer), (807)737-8196 (winter). E-mail: jdstradiotto@canoemail.com. Web site: www.nwconx.net/~jdstradi. **Contact:** John Stradiotto, owner/operator/instructor. Cost: $750 U.S.; food and accommodation provided. Annual workshop/conference. Tours depart every Monday morning, May to October. "Nature photography skills, portrait photography, and telephoto work will be undertaken during a gentle wilderness tour. Guests additionally enjoy the benefits of fine outdoor food. We provide the support necessary for photographers to focus on observing nature and developing their abilities."

JEFFREY RICH WILDLIFE PHOTOGRAPHY TOURS
P.O. Box 66, Millville CA 96062. (530)547-3480. E-mail: jrich@jeffrichphoto.com. Web site: www.jeffrich photo.com. **Contact:** Jeffrey Rich, owner. Leading wildlife photo tours in Alaska and western U.S. since 1990: bald eagles, whales, birds, Montana babies and predators, Brazil's Pantanal, Borneo, and Japan's winter wildlife. Photographers should call or e-mail for brochure.

ROCKY MOUNTAIN FIELD SEMINARS
1895 Fall River Rd., Estes Park CO 80517. (970)586-3262 or (800)748-7002. E-mail: fieldseminars@rmna.o rg. Web site: www.rmna.org. **Contact:** Seminar coordinator. Cost: $75-175. Daylong and weekend semi-

nars covering photographic techniques for wildlife and scenics in Rocky Mountain National Park. Professional instructors include David Halpern, W. Perry Conway, Don Mammoser, Glenn Randall, Allan Northcutt and Lee Kline. Call or e-mail for a free seminar catalog listing over 50 seminars.

[N] ROCKY MOUNTAIN SCHOOL OF PHOTOGRAPHY
210 N. Higgins, Suite 101, Missoula MT 59802. (800)394-7677. Fax: (406) 721-9133. E-mail: rmsp@rmsp.com. Web site: www.rmsp.com. **Contact:** Jeanne Chaput de Saintonge, co-director. Cost: $90-6,000. ''RMSP offers professional career training in an 11-week 'Summer Intensive' program held each year in Missoula, Montana.'' Program courses include: basic and advanced color and b&w, studio and natural lighting, portraiture, marketing, stock, landscape, portfolio and others. Offers 7-day advanced training programs in nature, commercial, wedding, portraiture and documentary photography. ''We also offer over 40 workshops year round, including field workshops and digital and b&w darkroom printing. Instructors include David Muench, David Middleton, Brenda Tharp, Alison Shaw, George DeWolfe, John Paul Caponigro and others.''

SANTA FE WORKSHOPS
P.O. Box 9916, Santa Fe NM 87504-5916. (505)983-1400. E-mail: info@santafeworkshops.com. Web site: www.santafeworkshops.com. **Contact:** Registrar. Cost: $750-1,150 for tuition; lab fees, housing and meals extra; package prices for workshops in Mexico start at $2,250 and include ground transportation, most meals and accommodations. Over 120 weeklong workshops encompassing all levels of photography and more than 35 5-day digital lab workshops and 12 weeklong workshops in Mexico—all led by top professional photographers. The Workshops campus is located near the historic center of Santa Fe. Call or e-mail to request a free catalog.

SELLING YOUR PHOTOGRAPHY
2973 Harbor Blvd., #341, Costa Mesa CA 92626-3912. (888)713-0705. E-mail: maria@mpiscopo.com. Web site: www.mpiscopo.com. **Contact:** Maria Piscopo. Cost: $25-100. One-day workshops cover techniques for marketing and selling photography services. Open to photographers of all skill levels. See Web site for dates and locations. Maria Piscopo is the author of *Photographer's Guide to Marketing & Self-Promotion*, 3rd edition (Allworth Press).

SELLPHOTOS.COM
Pine Lake Farm, 1910 35th Rd., Osceola WI 54020. (715)248-3800, ext. 21. Fax: (715)248-7394. E-mail: info@photosource.com. Web site: www.sellphotos.com. **Contact:** Rohn Engh. Offers half-day workshops in major cities. Marketing critique of attendees' slides follows seminar.

JOHN SEXTON PHOTOGRAPHY WORKSHOPS
P.O. Box 30, Carmel Valley CA 93924. (831)659-3130. Fax: (831)659-5509. E-mail: info@johnsexton.com. Web site: www.johnsexton.com. **Contact:** Laura Bayless, administrative assistant. Director: John Sexton. Cost: $800-900. Offers a selection of intensive workshops with master photographers in scenic locations throughout the US. All workshops offer a combination of instruction in the aesthetic and technical considerations involved in making expressive prints.

BOB SHELL PHOTO WORKSHOPS
P.O. Box 808, Radford VA 24141. (540)639-4393. E-mail: bob@bobshell.com. Web site: www.bobshell.com. **Contact:** Bob Shell, owner. Cost: $750 and up. Glamour and nude photography workshops in exciting locations with top models. Taught by Bob Shell, one of the world's top glamour/nude photographers and technical editor of *Digital Camera* magazine. Full details on Web site.

SHENANDOAH PHOTOGRAPHIC WORKSHOPS
P.O. Box 54, Sperryville VA 22740. (540)937-5555. **Contact:** Frederick Figall, director. Three-day to 1-week photo workshops in the Virginia Blue Ridge foothills, held in summer and fall. Weekend workshops held year round in Washington, D.C., area.

[S] SINGING SANDS WORKSHOPS
156 Patillo Rd., Tecumseh ON N8N 2L9 Canada. (519)979-8662. E-mail: martel@wincom.net. Web site: www.singingsandsworkshops.com. **Contact:** Don Martel. Cost: $1,190; includes lodging/meals; film

shooters welcome. Semiannual workshops held in June and October. Creative photo techniques in the rugged coastline of Georgian Bay and the flats of Lake Huron, taught by Don Martel and James Sidney. Open to all skill levels. Photographers should send SASE, call, e-mail or see Web site for more information.

ℕ SMOKY MOUNTAIN LEARNING CENTER
414 Whittier School Rd., Whittier NC 28789.(877)951-6614. E-mail: info@mountainlearning.com. Web site: www.mountainlearning.com. Cost: $595; includes breakfast, lunch and dinner. Offers workshops on portraiture and wedding photography, Photoshop and Painter. Open to all skill levels. Photographers should write, call, see Web site for more information.

ℕ SOUTH SHORE ART CENTER
119 Ripley Rd., Cohasset MA 02025. (781)383-2787. Fax: (781)383-2964. E-mail: info@ssac.org. Web site: www/ssac.org Cost: $50-175. Offers workshops and classes in introductory and advanced digital photography, landscape photography, travel photography, portrait photography, and darkroom. Photographers should call, e-mail, or visit Web site for more information.

SOUTHEAST MUSEUM OF PHOTOGRAPHY AT DAYTONA COLLEGE
1200 W. International Speedway Blvd., Daytona Beach FL 32114. (386)506-4475. Fax: (386)506-4487. E-mail: museum@dpcc.edu. Web site: www.smponline.org. **Contact:** Kevin Miller, director. Photographic exhibitions, workshops and lecture series.

ℕ SOUTHWIND ADVENTURES
P.O. Box 621057, LIttleton CO 80162. (800)377-9463. Fax: (303)972-0708. E-mail: info@southwindadventures.com. Web site: www.southwindadventures.com. **Contact:** Tom Damon, president and adventure travel specialist. Cost: $1825-4595. Distinctive, personalized journeys to the Amazon, Andes and Galápagos.

SPORTS PHOTOGRAPHY WORKSHOP: COLORADO SPRINGS, CO
Rich Clarkson & Associates LLC, 1099 18th St., Suite 1840, Denver CO 80202. (303)295-7770 or (800)745-3211. E-mail: info@richclarkson.com. Web site: www.sportsphotographyworkshop.com. **Contact:** Brett Wilhelm, administrator. Annual workshop held in June. Weeklong workshop in sports photography at the U.S. Olympic Training Center with *Sports Illustrated* and Getty Images photographers and editors. See Web site for more information.

SUMMIT PHOTOGRAPHIC WORKSHOPS
P.O. Box 67459, Scotts Valley CA 95067. (831)440-0124. E-mail: b-and-k@pacbell.net. Web site: www.summitphotographic.com. **Contact:** Barbara Brundege, owner. Cost: $99-200 for workshops; $1,500-6,000 for tours. Offers several workshops per year, including nature and landscape photography; wildlife photography classes; photo tours from 5 days to 3 weeks; annual tour to Alaska. Open to all skill levels. Photographers should see Web site for more information.

ℕ SUPERIOR/GUNFLINT PHOTOGRAPHY WORKSHOPS
P.O. Box 19286, Minneapolis MN 55419. E-mail: photoworkshop@laynekennedy.com. **Contact:** Layne Kennedy, director. Cost: $300-1,300; includes meals/lodging for all adventure-related workshops; lodging and meals for North Shore session are paid for by participants. Offers wilderness adventure photo workshops 3 times/year. Winter session includes driving your own dogsled team in northeastern Minnesota. Summer sessions include kayaking/camping trip in the Apostle Islands with first and last nights in lodges, and a new session along Minnesota's North Shore, at the famed North House Folk School, covering Lake Superior's north shore. All trips professionally guided. Workshops stress how to shoot effective and marketable magazine photos in a story-telling format. Write for details on session dates.

SYNERGISTIC VISIONS WORKSHOPS
P.O. Box 2585, Grand Junction CO 81502. Phone/fax: (970)245-6700. E-mail: steve@synvis.com. Web site: www.synvis.com. **Contact:** Steve Traudt, director. Offers a variety of digital photography and photoshop classes at Western Colorado Community College, and 13 photography workshops and photo trips including Slot Canyons, Colorado Wildflowers, Bosque del Apache, Rock Art, Arches, Canyonlands and

more. Customized private field trips in Colorado, New Mexico, Utah and Arizona. Steve is also available to present day-long photo seminars to your group. Visit Web site for more information.

TAKE A PHOTOGRAPHIC JOURNEY OF A LIFETIME

(888)676-6468. E-mail: mcast@hfmus.com. Web site: www.mentorseries.com. **Contact:** Michelle Cast. Workshops that build not only your skill as a photographer but your sense of the world around you. Enjoy many days of photo activities led by world-renown professional shooters, all experienced and charismatic photographers who will offer in-the-field advice, lectures, slide shows and reviews. ''The chance of getting good photos is high because we have invested in getting great teachers and permits for private access to some cool places. Some of our upcoming destinations include Kansas, North Carolina, Montana,Vancouver, Morocco and Sweden.'' Open to all skill levels. Photographers should call, e-mail or see Web site for more information.

⟨N⟩ TEXAS SCHOOL OF PROFESSIONAL PHOTOGRAPHY

1501 W. Fifth St., Plainview TX 79072. (806)296-2276. E-mail: ddickson@lonestarbbs.com. **Contact:** Don Dickson, director. Cost: $395-420. Twenty-five different classes offered, including portrait, wedding, marketing, background painting and video.

⟨N⟩ TOUCH OF SUCCESS SEMINARS

P.O. Box 164, Hodgenville KY 42748. (270)769-1823. Web site: www.touchofsuccess.com. **Contact:** Bill Thomas, director. Costs vary from $295-895 to $5,000 for safaris. Offers workshops on nature scenics, plants, wildlife, stalking, building rapport and communication, composition, subject selection, lighting, marketing and business management. Workshops held at various locations in the U.S. Photo safaris led into upper Amazon, Andes, Arctic, Alaska, Africa and Australia. Writer's workshops for photographers who wish to learn how to write are also available. All workshops are conducted by author/photojournalist Bill Thomas. Photographers should see Web site for more information.

TRAVEL IMAGES

P.O. Box 2434, Eagle ID 83616. (800)325-8320. E-mail: phototours@travelimages.com. Web site: www.travelimages.com. **Contact:** John Baker, owner/guide. Small-group photo tours. Locations include U.S., Canada, Wales, Scotland, Ireland, England, New Zealand, Galapagos Islands, Provence, Tuscany, Cinque Terre, Venice, Austria and Switzerland.

⟨N⟩ TRIP TO SOUTHERN INDIA

108 Madeira Blvd., Melville NY 11747. (631)367-8082. E-mail: nelbur@juno.com. **Contact:** Nelson Burack. Cost: $4,900. Annual workshop held in October. Concentrates on photographing all the exciting areas of southern India as well as Vanansi and the Taj Mahal. Open to all skill levels. Photographers should write with SASE, call or e-mail for more information.

JOSEPH VAN OS PHOTO SAFARIS, INC.

P.O. Box 655, Vashon Island WA 98070. (206)463-5383. Fax: (206)463-5484. E-mail: info@photosafaris.com. Web site: www.photosafaris.com. **Contact:** Joseph Van Os, director. Offers over 50 different photo tours and workshops worldwide.

VIRGINIA CENTER FOR THE CREATIVE ARTS

154 San Angelo Dr., Amherst VA 24521. (434)946-7236. Fax: (434)946-7239. E-mail: vcca@vcca.com. Web site: www.vcca.com. **Contact:** Sheila Gulley Pleasants, artists services director. The Virginia Center for the Creative Arts (VCCA) is an international working retreat for writers, visual artists and composers. Located on 450 acres in the foothills of the Blue Ridge Mountains in central Virginia, the VCCA provides residential fellowships ranging from 2 weeks to 2 months. The VCCA can accommodate 22 fellows at a time and provides separate working and living quarters and all meals. There is 1 fully equipped black & white darkroom at the VCCA. Artists provide their own materials. Cost: $30/day suggested contribution. VCCA application and work samples required. Photographers should call or see Web site for more information.

VISION QUEST PHOTO WORKSHOP CENTER

2370 Hendon Ave., St. Paul MN 55108-1453. (651)644-1400. Fax: (651)644-2122. E-mail: info@dougbeasley.com. Web site: www.dougbeasley.com. **Contact:** Doug Beasley, director. Cost: $295-1,995; includes

food and lodging. Annual workshops held March through November. Hands-on photo workshops that emphasize content, vision and creativity over technique or gimmicks. Workshops are held in a variety of locations such as The Badlands of South Dakota, Oregon, Hawaii, Ireland, Norway and Guatemala. Open to all skill levels. Photographers should call or e-mail for more information.

VISUAL ARTISTRY & FIELD MENTORSHIP PHOTOGRAPHY WORKSHOP SERIES

P.O. Box 963, Eldersburg MD 21784. (410)552-4664. Fax: (410)552-3332. E-mail: tony@tonysweet.com. Web site: http://tonysweet.com. **Contact:** Tony Sweet or Susan Milestone, susan@tonysweet.com. Cost: $795-$1,000 for instruction; all other costs are the responsibility of participant. Five-day workshops, limit 8-10 participants. Formats: 35mm film; digital; xpan. Extensive personal attention and instructional slide shows. Post-workshop support and image critiques for 6 months after the workshop (for an additional fee). Frequent attendees discounts and inclement weather discounts on subsequent workshops. Dealer discounts available from major vendors. "The emphasis is to create in the participant a greater awareness of composition, subject selection, and artistic rendering of the natural world using the raw materials of nature: color, form and line." Open to intermediate and advanced photographers.

WILD WINGS PHOTO ADVENTURES

2035 Buchanan Rd. Manning SC 29102. (803)473-3414. E-mail: doug@totallyoutdoorspublishing.com. Web site: www.douggardner.com. **Contact:** Doug Gardner, founder/instructor. Cost: $200-$450; includes meals, lodging, guide/instructor fees. Annual workshops held various times throughout the year in North and South Carolinas: Waterfowl (Ducks, Snow Geese, Tundra Swan), Eastern Wood Ducks, Eastern Wild Turkey, and Osprey & Swamp Critters. "The purpose of Wild Wings Photo Adventures is to offer an action-packed, all-inclusive weekend of fun, fellowship, basic-to-advanced instruction on photography, as well as great opportunities to photograph 'wild' animals up close. Students will learn valuable techniques in the field with internationally recognized wildlife photographer Doug Gardner. Some adventures include meals and lodging."

WILDERNESS ALASKA

P.O. Box 113063, Anchorage AK 99511. (907)345-3567. Fax: (907)345-3967. E-mail: macgill@alaska.net. Web site: www.wildernessalaska.com. **Contact:** MacGill Adams. Offers custom photography trips featuring natural history and wildlife to small groups.

WILDERNESS PHOTOGRAPHY EXPEDITIONS

402 S. Fifth, Livingston MT 59047. (406)222-2302. Web site: tmurphywild.com. **Contact:** Tom Murphy, president. Offers programs in wildlife and landscape photography in Yellowstone National Park and special destinations.

WILDLIFE PHOTOGRAPHY SEMINAR

Leonard Rue Enterprises, 138 Millbrook Rd., Blairstown NJ 07825. (908)362-6616. E-mail: rue@rue.com. Web site: www.rue.com. **Contact:** Barbara, program support. This is an in-depth day-long seminar covering all major aspects of wildlife photography, based on a slide presentation format with question-and-answer periods. Taught by Leonard Lee Rue III and/or Len Rue, Jr.

ROBERT WINSLOW PHOTO, INC.

P.O. Box 334, Durango CO 81302-0334. (970)259-4143. Fax: (970)259-7748. E-mail: rwinslow@myduran go.net. Web site: www.robertwinslowphoto.com. **Contact:** Robert Winslow, president. Cost: varies depending on workshop or tour. "We conduct wildlife model workshops in totally natural settings. We also arrange and lead custom wildlife and natural history photo tours to most destinations around the world."

WOODSTOCK PHOTOGRAPHY WORKSHOPS

The Center for Photography at Woodstock, 59 Tinker St., Woodstock NY 12498. (845)679-9957. E-mail: info@cpw.org. Web site: www.cpw.org. **Contact:** Liz Unterman, CPW Education Coordinator. Cost: $120-625. Offers annual lectures and workshops in all topics in photography from June through October. Faculty includes numerous top professionals in fine art, documentary and commercial photography. Topics include still life, landscape, portraiture, lighting, alternative processes and digital. Offers 1-, 2- and 4-day events. Free catalog available by request.

N WORKING WITH ARTISTS

445 S. Saulsbury, Studio A-C/Main Gallery, Lakewood CO 80226. (303)837-1341. E-mail: info@workingwithartists.org. Web site: www.workingwithartists.org. Cost: varies, depending on workshop, $95-696; travel workshops: $2,295-3,950. Offers workshops on Photoshop, digital, alternative process, portraiture, landscape, creativity, studio lighting and more. Travels with Artists Workshops are held in Bali; Tuscany, Italy; San Miquel de Allende, Mexico; Spain. Open to all skill levels. Photographers should call, e-mail, see Web site for more information.

THE HELENE WURLITZER FOUNDATION OF NEW MEXICO

218 Los Pandos, P.O. Box 1891, Taos NM 87571. (505)758-2413. E-mail: hwf@taosnet.com. **Contact:** Michael A. Knight, executive director. Offers residencies to creative, *not* interpretive, artists in all media for varying periods of time, usually 3 months, from April 1 through September 30 annually, and on a limited basis from October 1 through March 31. Deadline: January 18 for following year. Send SASE for application, or request by e-mail.

YELLOWSTONE ASSOCIATION INSTITUTE

P.O. Box 117, Yellowstone National Park WY 82190. (307)344-2294. Fax: (307)344-2485. E-mail: registrar@YellowstoneAssociation.org. Web site: www.YellowstoneAssociation.org. **Contact:** Registrar. Offers workshops in nature and wildlife photography during the summer, fall and winter. Custom courses can be arranged. Photographers should see Web site for more information.

YOSEMITE OUTDOOR ADVENTURES

P.O. Box 230, El Portal CA 95318. (209)379-2321. E-mail: pdevine@yosemite.org. Web site: www.yosemite.org. **Contact:** Pete Devine, educational programs director. Cost: more than $200. Offers small (8-15 people) workshops in Yosemite National Park in outdoor field photography and natural history year-round. Photographers should see Web site for more information.

Stock Photography Portals

These sites market and distribute images from multiple agencies and photographers.

AGPix www.agpix.com

Alamy www.alamy.com

Digital Railroad www.digitalrailroad.net

Find a Photographer www.asmp.org/findaphotographer

Independent Photography Network (IPNStock) www.ipnstock.com

PhotoServe www.photoserve.com

PhotoSource International www.photosource.com

Portfolios.com www.portfolios.com

Shutterpoint Photography www.shutterpoint.com

Veer www.veer.com

Workbook Stock www.workbook.com

Portfolio Review Events

Portfolio review events provide photographers the opportunity to show their work to a variety of photo buyers including photo editors, publishers, art directors, gallery representatives, curators and collectors.

Art Director's Club, International Annual Awards Exhibition, New York City, www.adcglobal.org

Atlanta Celebrates Photography, held annually in October, Atlanta GA, www.acpinfo.org

Center for Photography at Woodstock, New York City, www.cpw.org

Festival of Light International Directory of Photography Festivals, an international collaboration of 16 countries and 22 photography festivals, www.festivaloflight.net

Fotofest, March, Houston TX, www.fotofest.org. Biennial—held in even-numbered years.

Fotofusion, January, Delray Beach FL, www.fotofusion.org

North American Nature Photographers Association, annual summit held in January. Location varies. www.nanpa.org

Photo LA, January, Los Angeles CA, www.photola.com.

Photo Miami, held annually in December, Miami FL, http://artfairsinc.com

Photo San Francisco, July, San Francisco CA, www.photosanfrancisco.net

Photolucida, March, Portland OR, www.photolucida.org. Biennial—held in odd-numbered years.

The Print Center, events held throughout the year, Philadelphia PA, www.printcenter.org

Review Santa Fe, July, Santa Fe NM, www.sfcp.org. The only juried portfolio review event.

Rhubarb-Rhubarb, July, Birmingham UK, www.rhubarb-rhubarb.net

Society for Photographic Education National Conference, March, different location each year, www.spenational.org

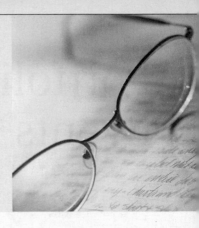

RESOURCES

Grants

State, Provincial & Regional

A rts councils in the United States and Canada provide assistance to artists (including poets) in the form of fellowships or grants. These grants can be substantial and confer prestige upon recipients; however, **only state or province residents are eligible**. Because deadlines and available support vary annually, query first (with a SASE) or check Web sites for guidelines.

UNITED STATES ARTS AGENCIES

Alabama State Council on the Arts, 201 Monroe St., Montgomery AL 36130-1800. (334)242-4076. E-mail: staff@arts.alabama.gov. Web site: www.arts.state.al.us.

Alaska State Council on the Arts, 411 W. Fourth Ave., Suite 1-E, Anchorage AK 99501-2343. (907)269-6610 or (888)278-7424. E-mail: aksca_info@eed.state.ak.us. Web site: www.eed.state.ak.us/aksca.

Arizona Commission on the Arts, 417 W. Roosevelt St., Phoenix AZ 85003-1326. (602)771-6501. E-mail: info@azarts.gov. Web site: www.azarts.gov.

Arkansas Arts Council, 1500 Tower Bldg., 323 Center St., Little Rock AR 72201. (501)324-9766. E-mail: info@arkansasarts.com. Web site: www.arkansasarts.com.

California Arts Council, 1300 I St., Suite 930, Sacramento CA 95814. (916)322-6555. E-mail: info@caartscouncil.com. Web site: www.cac.ca.gov.

Colorado Council on the Arts, 1625 Broadway, Suite 2700, Denver CO 80202. (303)892-3802. E-mail: online form. Web site: www.coloarts.state.co.us.

Connecticut Commission on Culture & Tourism, Arts Division, One Financial Plaza, 755 Main St., Hartford CT 06103. (860)256-2800. Web site: www.cultureandtourism.org.

Delaware Division of the Arts, Carvel State Office Bldg., 4th Floor, 820 N. French St., Wilmington DE 19801. (302)577-8278 (New Castle Co.) or (302)739-5304 (Kent or Sussex Counties). E-mail: delarts@state.de.us. Web site: www.artsdel.org.

District of Columbia Commission on the Arts & Humanities, 410 Eighth St. NW, 5th Floor, Washington DC 20004. (202)724-5613. E-mail: cah@dc.gov. Web site: http://dcarts.dc.gov.

Florida Arts Council, Division of Cultural Affairs, R.A. Gray Building, Third Floor, 500 S. Bronough St., Tallahassee FL 32399-0250. (850)245-6470. E-mail: info@florida-arts.org. Web site: www.florida-arts.org.

Georgia Council for the Arts, 260 14th St., Suite 401, Atlanta GA 30318. (404)685-2787. E-mail: gaarts@gaarts.org. Web site: www.gaarts.org.

Guam Council on the Arts & Humanities Agency, P.O. Box 2950, Hagatna GU 96932. (671)646-2781. Web site: www.guam.net.

Hawaii State Foundation on Culture & the Arts, 2500 S. Hotel St., 2nd Floor, Honolulu HI 96813. (808)586-0300. E-mail: ken.hamilton@hawaii.gov. Web site: www.state.hi.us/sfca.

Idaho Commission on the Arts, 2410 N. Old Penitentiary Rd., Boise ID 83712. (208)334-2119 or (800)278-3863. E-mail: info@arts.idaho.gov. Web site: www.arts.idaho.gov.

Illinois Arts Council, James R. Thompson Center, 100 W. Randolph, Suite 10-500, Chicago IL 60601. (312)814-6750. E-mail: iac.info@illinois.gov. Web site: www.state.il.us/agency/iac.

Indiana Arts Commission, 150 W. Market St., Suite 618, Indianapolis IN 46204. (317)232-1268. E-mail: IndianaArtsCommission@iac.in.gov. Web site: www.in.gov/arts.

Iowa Arts Council, 600 E. Locust, Des Moines IA 50319-0290. (515)281-6412. Web site: www.iowaartscouncil.org.

Kansas Arts Commission, 700 SW Jackson, Suite 1004, Topeka KS 66603-3761. (785)296-3335. E-mail: KAC@arts.state.ks.us. Web site: http://arts.state.ks.us.

Kentucky Arts Council, 21st Floor, Capital Plaza Tower, 500 Mero St., Frankfort KY 40601-1987. (502)564-3757 or (888)833-2787. E-mail: kyarts@ky.gov. Web site: http://artscouncil.ky.gov.

Louisiana Division of the Arts, Capitol Annex Bldg., 1051 N. 3rd St., 4th Floor, Room #420, Baton Rouge LA 70804. (225)342-8180. Web site: www.crt.state.la.us/arts.

Maine Arts Commission, 193 State St., 25 State House Station, Augusta ME 04333-0025. (207)287-2724. E-mail: MaineArts.info@maine.gov. Web site: www.mainearts.com.

Maryland State Arts Council, 175 W. Ostend St., Suite E, Baltimore MD 21230. (410)767-6555. E-mail: msac@msac.org. Web site: www.msac.org.

Massachusetts Cultural Council, 10 St. James Ave., 3rd Floor, Boston MA 02116-3803. (617)727-3668. E-mail: mcc@art.state.ma.us. Web site: www.massculturalcouncil.org.

Michigan Council for Arts & Cultural Affairs, 702 W. Kalamazoo St., P.O. Box 30705, Lansing MI 48909-8205. (517)241-4011. E-mail: artsinfo@michigan.gov. Web site: www.michigan.gov/hal/0,1607,7-160-17445_19272---,00.html.

Minnesota State Arts Board, Park Square Court, 400 Sibley St., Suite 200, St. Paul MN 55101-1928. (651)215-1600 or (800)866-2787. E-mail: msab@arts.state.mn.us. Web site: www.arts.state.mn.us.

Mississippi Arts Commission, 501 N. West St., Suite 701B, Woolfolk Bldg., Jackson MS 39201. (601)359-6030. Web site: www.arts.state.ms.us.

Missouri Arts Council, 815 Olive St., Suite 16, St. Louis MO 63101-1503. (314)340-6845 or (866)407-4752. E-mail: moarts@ded.mo.gov. Web site: www.missouriartscouncil.org.

Montana Arts Council, 316 N. Park Ave., Suite 252, Helena MT 59620-2201. (406)444-6430. E-mail: mac@mt.gov. Web site: www.art.state.mt.us.

National Assembly of State Arts Agencies, 1029 Vermont Ave. NW, 2nd Floor, Washington DC 20005. (202)347-6352. E-mail: nasaa@nasaa-arts.org. Web site: www.nasaa-arts.org.

Nebraska Arts Council, 1004 Farnam St., Plaza Level, Omaha NE 68102. (402)595-2122 or (800)341-4067. Web site: www.nebraskaartscouncil.org.

Nevada Arts Council, 716 N. Carson St., Suite A, Carson City NV 89701. (775)687-6680. E-mail: online form. Web site: http://dmla.clan.lib.nv.us/docs/arts.

New Hampshire State Council on the Arts, 2½ Beacon St., 2nd Floor, Concord NH 03301-4974. (603)271-2789. Web site: www.nh.gov/nharts.

New Jersey State Council on the Arts, 225 W. State St., P.O. Box 306, Trenton NJ 08625. (609)292-6130. Web site: www.njartscouncil.org.

New Mexico Arts, Dept. of Cultural Affairs, P.O. Box 1450, Santa Fe NM 87504-1450. (505)827-6490 or (800)879-4278. Web site: www.nmarts.org.

New York State Council on the Arts, 175 Varick St., New York NY 10014. (212)627-4455. Web site: www.nysca.org.

North Carolina Arts Council, 109 East Jones St., Cultural Resources Building, Raleigh NC 27601. (919)807-6500. E-mail: ncarts@ncmail.net. Web site: www.ncarts.org.

North Dakota Council on the Arts, 1600 E. Century Ave., Suite 6, Bismarck ND 58503. (701)328-7590. E-mail: comserv@state.nd.us. Web site: www.state.nd.us/arts.

Commonwealth Council for Arts and Culture (Northern Mariana Islands), P.O. Box 5553, CHRB, Saipan MP 96950. (670)322-9982 or (670)322-9983. E-mail: galaidi@vzpacifica.net. Web site: www.geocities.com/ccacarts/ccacwebsite.html.

Ohio Arts Council, 727 E. Main St., Columbus OH 43205-1796. (614)466-2613. Web site: www.oac.state.oh.us.

Oklahoma Arts Council, Jim Thorpe Building, 2101 N. Lincoln Blvd., Suite 640, Oklahoma City OK 73105. (405)521-2931. E-mail: okarts@arts.ok.gov. Web site: www.arts.state.ok.us.

Oregon Arts Commission, 775 Summer St. NE, Suite 200, Salem OR 97301-1280. (503)986-0082. E-mail: oregon.artscomm@state.or.us. Web site: www.oregonartscommission.org.

Pennsylvania Council on the Arts, 216 Finance Bldg., Harrisburg PA 17120. (717)787-6883. Web site: www.pacouncilonthearts.org.

Institute of Puerto Rican Culture, P.O. Box 9024184, San Juan PR 00902-4184. (787)724-0700. E-mail: www@icp.gobierno.pr. Web site: www.icp.gobierno.pr.

Rhode Island State Council on the Arts, One Capitol Hill, Third Floor, Providence RI 02908. (401)222-3880. E-mail: info@arts.ri.gov. Web site: www.arts.ri.gov.

American Samoa Council on Culture, Arts and Humanities, P.O. Box 1540, Office of the Governor, Pago Pago AS 96799. (684)633-4347. Web site: www.prel.org/programs/pcahe/PTG/terr-asamoa1.html.

South Carolina Arts Commission, 1800 Gervais St., Columbia SC 29201. (803)734-8696. E-mail: info@arts.state.sc.us. Web site: www.southcarolinaarts.com.

South Dakota Arts Council, 711 E. Wells Ave., Pierre SD 57501-3369. (605)773-3301. E-mail: sdac@state.sd.us. Web site: www.artscouncil.sd.gov.

Resources

Tennessee Arts Commission, 401 Charlotte Ave., Nashville TN 37243-0780. (615)741-1701. Web site: www.arts.state.tn.us.

Texas Commission on the Arts, E.O. Thompson Office Building, 920 Colorado, Suite 501, Austin TX 78701. (512)463-5535. E-mail: front.desk@arts.state.tx.us. Web site: www.arts. state.tx.us.

Utah Arts Council, 617 E. South Temple, Salt Lake City UT 84102-1177. (801)236-7555. Web site: http://arts.utah.gov.

Vermont Arts Council, 136 State St., Drawer 33, Montpelier VT 05633-6001. (802)828-3291. E-mail: online form. Web site: www.vermontartscouncil.org.

Virgin Islands Council on the Arts, 5070 Norre Gade, St. Thomas VI 00802-6872. (340)774-5984. Web site: http://vicouncilonarts.org.

Virginia Commission for the Arts, Lewis House, 223 Governor St., 2nd Floor, Richmond VA 23219. (804)225-3132. E-mail: arts@arts.virginia.gov. Web site: www.arts.state.va.us.

Washington State Arts Commission, 711 Capitol Way S., Suite 600, P.O. Box 42675, Olympia WA 98504-2675. (360)753-3860. E-mail: info@arts.wa.gov. Web site: www.arts.wa.gov.

West Virginia Commission on the Arts, The Cultural Center, Capitol Complex, 1900 Kanawha Blvd. E., Charleston WV 25305-0300. (304)558-0220. Web site: www.wvculture. org/arts.

Wisconsin Arts Board, 101 E. Wilson St., 1st Floor, Madison WI 53702. (608)266-0190. E-mail: artsboard@arts.state.wi.us. Web site: www.arts.state.wi.us.

Wyoming Arts Council, 2320 Capitol Ave., Cheyenne WY 82002. (307)777-7742. E-mail: ebratt@state.wy.us. Web site: http://wyoarts.state.wy.us.

CANADIAN PROVINCES ARTS AGENCIES

Alberta Foundation for the Arts, 10708 - 105 Ave., Edmonton AB T5H 0A1. (780)427-9968. Web site: www.cd.gov.ab.ca/all_about_us/commissions/arts.

British Columbia Arts Council, P.O. Box 9819, Stn. Prov. Govt., Victoria BC V8W 9W3. (250)356-1718. E-mail: BCArtsCouncil@gov.bc.ca. Web site: www.bcartscouncil.ca.

The Canada Council for the Arts, 350 Albert St., P.O. Box 1047, Ottawa ON K1P 5V8. (613)566-4414 or (800)263-5588 (within Canada). Web site: www.canadacouncil.ca.

Manitoba Arts Council, 525-93 Lombard Ave., Winnipeg MB R3B 3B1. (204)945-2237 or (866)994-2787 (in Manitoba). E-mail: info@artscouncil.mb.ca. Web site: www.artscouncil.mb.ca.

New Brunswick Arts Board (NBAB), 634 Queen St., Suite 300, Fredericton NB E3B 1C2. (506)444-4444 or (866)460-2787. Web site: www.artsnb.ca.

Newfoundland & Labrador Arts Council, P.O. Box 98, St. John's NL A1C 5H5. (709)726-2212 or (866)726-2212. E-mail: nlacmail@nfld.net. Web site: www.nlac.nf.ca.

Nova Scotia Department of Tourism, Culture, and Heritage, Culture Division, 1800 Argyle St., Suite 601, P.O. Box 456, Halifax NS B3J 2R5. (902)424-4510. E-mail: cultaffs@gov.ns.ca. Web site: www.gov.ns.ca/dtc/culture.

Ontario Arts Council, 151 Bloor St. W., 5th Floor, Toronto ON M5S 1T6. (416)961-1660 or (800)387-0058 (in Ontario). E-mail: info@arts.on.ca. Web site: www.arts.on.ca.

Prince Edward Island Council of the Arts, 115 Richmond St., Charlottetown PE C1A 1H7. (902)368-4410 or (888)734-2784. E-mail: info@peiartscouncil.com. Web site: www.peiart scouncil.com.

Québec Council for Arts & Literature, 79 boul. René-Lévesque Est, 3e étage, Québec QC G1R 5N5. (418)643-1707 or (800)897-1707. E-mail: info@calq.gouv.qc.ca. Web site: www.calq. gouv.qc.ca.

The Saskatchewan Arts Board, 2135 Broad St., Regina SK S4P 1Y6. (306)787-4056 or (800)667-7526 (Saskatchewan only). E-mail: sab@artsboard.sk.ca. Web site: www.artsbo ard.sk.ca.

Yukon Arts Section, Cultural Services Branch, Dept. of Tourism & Culture, Government of Yukon, Box 2703 (L-3), Whitehorse YT Y1A 2C6. (867)667-8589 or (800)661-0408 (in Yukon). E-mail: arts@gov.yk.ca. Web site: www.btc.gov.yk.ca/cultural/arts.

STATE AND REGIONAL GRANTS AND AWARDS

The following opportunities are arranged by state since most of them grant money to artists in a particular geographic region. Because deadlines vary annually, check Web sites or call for the most up-to-date information. Note: not all states are listed; see the list of state and provincial arts agencies on page 456 for state-sponsored arts councils.

California

Flintridge Foundation Awards for Visual Artists, 1040 Lincoln Ave., Suite 100, Pasadena CA 91103. (626)449-0839 or (800)303-2139. Fax: (626)585-0011. Web site: www.flintridge foundation.org. *For artists in California, Oregon and Washington only.*

James D. Phelan Award in Photography, Kala Art Institute, Don Porcella, 1060 Heinz Ave., Berkeley CA 94710. (510)549-6914. Web site: www.kala.org. *For artists born in California only.*

Connecticut

Martha Boschen Porter Fund, Inc., 145 White Hallow Rd., Sharon CT 06064. *For artists in northwestern Connecticut, western Massachusetts and adjacent areas of New York (except New York City).*

Idaho

Betty Bowen Memorial Award, % Seattle Art Museum, 100 University St., Seattle WA 98101. (206)654-3131. Web site: www.seattleartmuseum.org/bettybowen/. *For artists in Washington, Oregon and Idaho only.*

Illinois

Illinois Arts Council, Artists Fellowship Program, James R. Thompson Center, 100 W. Randolph, Suite 10-500, Chicago IL 60601. (312)814-6750. Web site: www.state.il.us/agency/iac/Guidelines/guidelines.htm. *For Illinois artists only.*

Kentucky

Kentucky Foundation for Women Grants Program, 1215 Heyburn Bldg., 332 W. Broadway, Louisville KY 40202. (502)562-0045. Web site: www.kfw.org/grants.html. *For female artists living in Kentucky only.*

Massachusetts

See Martha Boschen Porter Fund, Inc., under Connecticut.

Minnesota

McKnight Photography Fellowships Program, University of Minnesota Dept. of Art, Regis Center for Art, E-201, 405 21st Ave. S., Minneapolis MN 55455. (612)626-9640. Web site: www.mcknightphoto.umn.edu. *For Minnesota artists only.*

New York

A.I.R. Gallery Fellowship Program, 511 W. 25th St., Suite 301, New York NY 10001. (212)255-6651. E-mail: info@airnyc.org. Web site: www.airnyc.org. *For female artists from New York City metro area only.*

Arts & Cultural Council for Greater Rochester, 277 N. Goodman St., Rochester NY 14607. (585)473-4000. Web site: www.artsrochester.org.

Constance Saltonstall Foundation for the Arts Grants and Fellowships, P.O. Box 6607, Ithaca NY 14851 (include SASE). (607)277-4933. E-mail: info@saltonstall.org. Web site: www.saltonstall.org. *For artists in the central and western counties of New York.*

New York Foundation for the Arts: Artists' Fellowships, 155 Avenue of the Americas, 14th Floor, New York NY 10013-1507. (212)366-6900, ext. 217. E-mail: nyfaafp@nyfa.org. Web site: www.nyfa.org. *For New York artists only.*

Oregon

See Flintridge Foundation Awards for Visual Artists, under California.

Pennsylvania

Leeway Foundation—Philadelphia, Pennsylvania Region, 123 S. Broad St., Suite 2040, Philadelphia PA 19109. (215)545-4078. E-mail: info@leeway.org. Web site: www.leeway.org. *For female artists in Philadelphia only.*

Texas

Individual Artist Grant Program—Houston, Texas, Cultural Arts Council of Houston and Harris County, 3201 Allen Pkwy., Suite 250, Houston TX 77019-1800. (713)527-9330. E-mail: info@cachh.org. Web site: www.cachh.org. *For Houston artists only.*

Washington

See Flintridge Foundation Awards for Visual Artists, under California.

Resources

Professional Organizations

Advertising Photographers of America, National, 28 E. Jackson, Bldg. #10-A855, Chicago IL 60604-2263. (800)272-6264. E-mail: office@apanational.com. Web site: www.apanational.com.

Advertising Photographers of America, Atlanta, P.O. Box 20471, Atlanta GA 30325. (888)889-7190, ext. 50. E-mail: info@apaatlanta.com. Web site: www.apaatlanta.com.

Advertising Photographers of America, Los Angeles, 5455 Wilshire Blvd., Suite 1709, Los Angeles CA 90036. (323)933-1631. Fax: (323)933-9209. E-mail: office@apa-la.org. Web site: www.apa-la.org.

Advertising Photographers of America, Midwest, 28 E. Jackson, Bldg. #10-A855, Chicago IL 60604. (877)890-7375. E-mail: ceo@apa-m.com. Web site: www.apamidwest.com.

Advertising Photographers of America, New York, 27 W. 20th St., Suite 601, New York NY 10011. (212)807-0399. Fax: (212)727-8120. E-mail: info@apany.com. Web site: www.apany.com.

Advertising Photographers of America, San Diego, P.O. Box 84241, San Diego CA 92138. (619)417-2150. E-mail: membership@apasd.org. Web site: www.apasd.org.

Advertising Photographers of America, San Francisco, 560 Fourth St., San Francisco CA 94107. (415)882-9780. Fax: (415)882-9781. E-mail: info@apasf.com. Web site: www.apasf.com.

American Society of Media Photographers (ASMP), 150 N. Second St., Philadelphia PA 19106. (215)451-2767. Fax: (215)451-0880. Web site: www.asmp.org.

American Society of Picture Professionals (ASPP), 117 S. St. Asaph St., Alexandria VA 22314. Phone/fax: (703)299-0219. Web site: www.aspp.com.

The Association of Photographers, 81 Leonard St., London EC2A 4QS United Kingdom. (44)(207)739-6669. Fax: (44)(207)739-8707. E-mail: general@aophoto.co.uk. Web site: www.the-aop.org.

British Association of Picture Libraries and Agencies, 18 Vine Hill, London EC1R 5DZ United Kingdom. (44)(207)713-1780. Fax: (44)(207)713-1211. E-mail: enquiries@bapla.org.uk. Web site: www.bapla.org.uk.

British Institute of Professional Photography (BIPP), Fox Talbot House, Amwell End, Ware, Hertsfordshire SG12 9HN United Kingdom. (44)(192)046-4011. Fax: (44)(192)0487056. E-mail: info@bipp.com. Web site: www.bipp.com.

Canadian Association of Journalists, Algonquin College, 1385 Woodroffe Ave., B224, Ottawa ON K2G 1V8 Canada. (613)526-8061. Fax: (613)521-3904. E-mail: caj@igs.net. Web site: www.caj.ca.

Canadian Association of Photographers & Illustrators in Communications, The Case Goods Building, Suite 302, 55 Mill St., Toronto ON M5A 3C4 Canada. (416)462-3677. Fax: (416)462-9570. E-mail: info@capic.org. Web site: www.capic.org.

Canadian Association for Photographic Art, 31858 Hopedale Ave., Clearbrook BC V2T 2G7 Canada. (604)855-4848. Fax: (604)855-4824. E-mail: capa@capacanada.ca. Web site: www.capacanada.ca.

The Center for Photography at Woodstock (CPW), 59 Tinker St., Woodstock NY 12498. (845)679-9957. Fax: (845)679-6337. E-mail: info@cpw.org. Web site: www.cpw.org.

Evidence Photographers International Council (EPIC), 229 Peachtree St. NE, Suite 2200, Atlanta GA 30303. (886)868-3742. E-mail: EPICheadquarters@verizon.net. Web site: www.epic-photo.org.

International Association of Panoramic Photographers, 8855 Redwood St., Las Vegas NV 89139. (702)260-4608. E-mail: iappsecretary@aol.com. Web site: www.panoramicassociation.org.

International Center of Photography (ICP), 1133 Avenue of the Americas at 43rd St., New York NY 10036. (212)857-0000. E-mail: info@icp.org. Web site: www.icp.org.

The Light Factory (TLF), Spirit Square, Suite 211, 345 N. College St., Charlotte NC 28202. (704)333-9755. E-mail: info@lightfactory.org. Web site: www.lightfactory.org.

National Association of Photoshop Professionals (NAPP), 333 Douglas Rd. E., Oldsmar FL 34677. (813)433-5006. Fax: (813)433-5015. Web site: www.photoshopuser.com.

National Press Photographers Association (NPPA), 3200 Croasdaile Dr., Suite 306, Durham NC 27705. (919)383-7246. Fax: (919)383-7261. E-mail: info@nppa.org. Web site: www.nppa.org.

North American Nature Photography Association (NANPA), 10200 W. 44th Ave., Suite 304, Wheat Ridge CO 80033-2840. (303)422-8527. Fax: (303)422-8894. E-mail: info@nanpa.org. Web site: www.nanpa.org.

Photo Marketing Association International, 3000 Picture Place, Jackson MI 49201. (517)788-8100. Fax: (517)788-8371. E-mail: PMA_Information_Central@pmai.org. Web site: www.pmai.org.

Photographic Society of America (PSA), 3000 United Founders Blvd., Suite 103, Oklahoma City OK 73112-3940. (405)843-1437. Fax: (405)843-1438. E-mail: hq@psa-photo.org. Web site: www.psa-photo.org.

Picture Archive Council of America (PACA). (949)460-4531. Fax: (949)460-4532. E-mail: pacnews@pacoffice.org. Web site: www.stockindustry.org.

Professional Photographers of America (PPA), 229 Peachtree St. NE, Suite 2200, Atlanta GA 30303. (404)522-8600. Fax: (404)614-6400. E-mail: csc@ppa.com. Web site: www.ppa.com.

Professional Photographers of Canada (PPOC), 371 Dundas St., Woodstock ON N4S 1B6 Canada. (519)537-2555. Fax: (519)537-5573. E-mail: ppoc@rogers.com. Web site: www.ppoc.ca.

The Royal Photographic Society, Fenton House, 122 Wells Rd., Bath BA2 3AH United Kingdom. (44)(122)546-2841. Fax: (44)(122)544-8688. E-mail: reception@rps.org. Web site: www.rps.org.

Society for Photographic Education, 126 Peabody, The School of Interdisciplinary Studies, Miami University, Oxford OH 45056. (513)529-8328. Fax: (513)529-9301. E-mail: speoffice @spenational.org. Web site: www.spenational.org.

Society of Photographers and Artists Representatives (SPAR), 60 E. 42nd St., Suite 1166, New York NY 10165. E-mail: info@spar.org. Web site: www.spar.org.

Volunteer Lawyers for the Arts, 1 E. 53rd St., 6th Floor, New York NY 10022. (212)319-2787, ext. 1. Fax: (212)752-6575. Web site: www.vlany.org.

Wedding & Portrait Photographers International (WPPI), P.O. Box 2003, 1312 Lincoln Blvd., Santa Monica CA 90406. (310)451-0090. Fax: (310)395-9058. Web site: www.wppionline.com.

White House News Photographers' Association (WHNPA), 7119 Ben Franklin Station, Washington DC 20044-7119. Web site: www.whnpa.org.

Publications

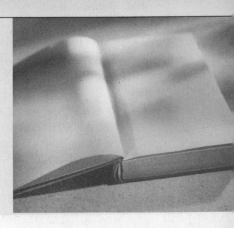

PERIODICALS

Advertising Age, Crain Communications, 711 Third Ave., New York NY 10017-4036. (212)210-0100. Web site: www.adage.com. Weekly magazine covering marketing, media and advertising.

Adweek, VNU Business Publications, 770 Broadway, New York NY 10003. (646)654-5421. Fax: (646)654-5365. E-mail: info@adweek.com. Web site: www.adweek.com. Weekly magazine covering advertising agencies.

American Photo, 1633 Broadway, 43rd Floor, New York NY 10019. (212)767-6000. Web site: www.americanphotomag.com. Monthly magazine emphasizing the craft and philosophy of photography.

Art Calendar, 1500 Park Center Dr., Orlando FL 32835. (877)415-3955. Fax: (407)563-7099. E-mail: info@ArtCalendar.com. Web site: www.artcalendar.com. Monthly magazine listing galleries reviewing portfolios, juried shows, percent-for-art programs, scholarships and art colonies.

ASMP Bulletin, 150 N. Second St., Philadelphia PA 19106. (215)451-2767. Fax: (215)451-0880. Web site: www.asmp.org. Newsletter of the American Society of Media Photographers published 5 times/year. Subscription with membership.

Communication Arts, 110 Constitution Dr., Menlo Park CA 94025. (650)326-6040. Fax: (650)326-1648. Web site: www.commarts.com. Trade journal for visual communications.

Editor & Publisher, VNU Business Publications, 770 Broadway, New York NY 10003-9595. (800)336-4380 or (646)654-5270. Fax: (646)654-5370. Web site: www.editorandpublisher. com. Monthly magazine covering latest developments in journalism and newspaper production. Publishes an annual directory issue listing syndicates and another directory listing newspapers.

Folio, Red 7 Media, LLC, 33 S. Main St., Norwalk CT 06854. (203)854-6730. Fax: (203)854-6735. Web site: www.foliomag.com. Monthly magazine featuring trends in magazine circulation, production and editorial.

Graphis, 307 Fifth Ave., 10th Floor, New York NY 10016. (212)532-9387. Fax: (212)213-3229. E-mail: info@graphis.com. Web site: www.graphis.com. Magazine for the visual arts.

HOW, F + W Publications, 4700 E. Galbraith Rd., Cincinnati OH 45236. (513)531-2690. Web site: www.howdesign.com. Bimonthly magazine for the design industry.

News Photographer, 6677 Whitemarsh Valley Walk, Austin TX 78746-6367. (919)383-7246. Fax: (919)383-7261. E-mail: magazine@nppa.org. Web site: www.nppa.org. Monthly news tabloid published by the National Press Photographers Association. Subscription with membership.

Outdoor Photographer, Werner Publishing, 12121 Wilshire Blvd., 12th Floor, Los Angeles CA 90025-1176. (310)820-1500. Fax: (310)826-5008. Web site: www.outdoorphotographe r.com. Monthly magazine emphasizing equipment and techniques for shooting in outdoor conditions.

Photo District News, VNU Business Publications, 770 Broadway, 7th Floor, New York NY 10003. (646)654-5780. Fax: (646)654-5813. Web site: www.pdn-pix.com. Monthly magazine for the professional photographer.

Photosource International, Pine Lake Farm, 1910 35th Rd., Osceola WI 54020-5602. (800)624-0266, ext. 21. E-mail: info@photosource.com. Web site: www.photosource.c om. This company publishes several helpful newsletters, including *PhotoLetter*, *PhotoDaily* and *PhotoStockNotes*.

Popular Photography & Imaging, 1633 Broadway, New York NY 10019. (212)767-6000. Fax: (212)767-5602. Web site: www.popphoto.com. Monthly magazine specializing in technical information for photography.

Print, F+W Publications, 4700 E. Galbraith Rd., Cincinnati OH 45236. (513)531-2690. E-mail: info@printmag.com. Web site: www.printmag.com. Bimonthly magazine focusing on creative trends and technological advances in illustration, design, photography and printing.

Professional Photographer, Professional Photographers of America (PPA), 229 Peachtree St. NE, Suite 2200, Atlanta GA 30303. (404)522-8600. Fax: (404)614-6400. Web site: www. ppa.com. Monthly magazine emphasizing technique and equipment for working photographers.

Publishers Weekly, 360 Park Ave. S., New York NY 10010. (646)746-6758. Fax: (646)746-6631. Web site: www.publishersweekly.com. Weekly magazine covering industry trends and news in book publishing; includes book reviews and interviews.

Rangefinder, P.O. Box 1703, 1312 Lincoln Blvd., Santa Monica CA 90406. (310)451-8506. Fax: (310)395-9058. Web site: www.rangefindermag.com. Monthly magazine covering photography technique, products and business practices.

Selling Stock, 110 Frederick Ave., Suite A, Rockville MD 20850. (301)251-0720. Fax: (301)309-0941. E-mail: sellingstock@chd.com. Web site: www.pickphoto.com. Newsletter for stock photographers; includes coverage of trends in business practices such as pricing and contract terms.

Shutterbug, Primedia, 1419 Chaffee Dr., Suite 1, Titusville FL 32780. (321)269-3212. Fax: (321)225-3149. Web site: www.shutterbug.net. Monthly magazine of photography news and equipment reviews.

Studio Photography, Cygnus Business Media, 3 Huntington Quadrangle, Suite 301N, Melville NY 11747. (631)845-2700. Fax: (631)845-7109. Web site: www.imaginginfo.com/ spd/. Monthly magazine showcasing professional photographers. Also provides guides, tips and tutorials.

BOOKS & DIRECTORIES

Adweek Agency Directory, VNU Business Publications, 770 Broadway, New York NY 10003. (646)654-5421. E-mail: info@adweek.com. Web site: www.adweek.com. Annual directory of advertising agencies in the U.S.

Adweek Brand Directory, VNU Business Publications, 770 Broadway, New York NY 10003. (646)654-5421. E-mail: info@adweek.com. Web site: www.adweek.com. Directory listing top 2,000 brands, ranked by media spending.

ASMP Copyright Guide for Photographers, American Society of Media Photographers, 150 N. Second St., Philadelphia PA 19106. (215)451-2767. Fax: (215)451-0880. Web site: www.asmp.org.

ASMP Professional Business Practices in Photography, 6th Edition, American Society of Media Photographers, 150 N. Second St., Philadelphia PA 19106. (215)451-2767. Fax: (215)451-0880. Web site: www.asmp.org. Handbook covering all aspects of running a photography business.

Bacon's Media Directories, Cision, 332 S. Michigan Ave., Suite 900, Chicago IL 60604. (866)639-5087. Web site: www.cision.com/media-directories.asp.

The Big Picture: The Professional Photographer's Guide to Rights, Rates & Negotiation, by Lou Jacobs, Writer's Digest Books, F + W Publications, 4700 E. Galbraith Rd., Cincinnati OH 45236. (513)531-2690. Web site: www.writersdigest.com. Essential information on understanding contracts, copyrights, pricing, licensing and negotiation.

Business and Legal Forms for Photographers, 3rd Edition, by Tad Crawford, Allworth Press, 10 E. 23 St., Suite 510, New York NY 10010. (212)777-8395. Fax: (212)777-8261. E-mail: PUB@allworth.com. Web site: www.allworth.com. Negotiation book with 28 forms for photographers.

The Business of Commercial Photography, by Ira Wexler, Amphoto Books, Watson-Guptill Publications, 770 Broadway, New York NY 10003. (800)278-8477. E-mail: info@watsonguptill.com. Web site: http://amphotobooks.com. Comprehensive career guide including interviews with 30 leading commercial photographers.

The Business of Photography: Principles and Practices, by Mary Virginia Swanson, available through her Web site (www.mvswanson.com) or by calling (520)742-6311.

The Business of Studio Photography, Revised Edition, by Edward R. Lilley, Allworth Press, 10 E. 23 St., Suite 510, New York NY 10010. (212)777-8395. Fax: (212)777-8261. E-mail: PUB@allworth.com. Web site: www.allworth.com. A complete guide to starting and running a successful photography studio.

Children's Writers & Illustrator's Market, Writer's Digest Books, F + W Publications, 4700 E. Galbraith Rd., Cincinnati OH 45236. (513)531-2690. Web site: www.writersdigest.com. Annual directory including photo needs of book publishers, magazines and multimedia producers in the children's publishing industry.

Color Confidence: The Digital Photographer's Guide to Color Management, by Tim Grey, Sybex, 10475 Crosspoint Blvd., Indianapolis IN 46256. Web site: www.sybex.com.

Color Management for Photographers: Hands-On Techniques for Photoshop Users, by Andrew Rodney, Focal Press. Web site: www.focalpress.com.

Creative Black Book, 740 Broadway, 2nd Floor, New York NY 10003. (800)841-1246. Fax: (212)673-4321. Web site: www.blackbook.com. Sourcebook used by photo buyers to find photographers.

How to Shoot Stock Photos That Sell, 3rd Edition, by Michal Heron, Allworth Press, 10 E. 23 St., Suite 510, New York NY 10010. (212)777-8395. Fax: (212)777-8261. E-mail: PUB@allworth.com. Web site: www.allworth.com. Comprehensive guide to producing, marketing and selling sock photos.

How You Can Make $25,000 a Year With Your Camera, by Larry Cribb, Writer's Digest Books, F + W Publications, 4700 E. Galbraith Rd., Cincinnati OH 45236. (513)531-2690. Web site: www.writersdigest.com. Newly revised edition of the popular book on finding photo opportunities in your own hometown.

LA 411, 411 Publishing, 5700 Wilshire Blvd., Suite 120, Los Angeles CA 90036. (800)545-2411. Fax: (323)965-2052. Web site: www.la411.com. Music industry guide, including record labels.

Legal Guide for the Visual Artist, 4th Edition, by Tad Crawford, Allworth Press, 10 E. 23 St., Suite 510, New York NY 10010. (212)777-8395. Fax: (212)777-8261. E-mail: PUB@allworth.com. Web site: www.allworth.com. The author, an attorney, offers legal advice for artists and includes forms dealing with copyright, sales, taxes, etc.

Literary Market Place, Information Today, 143 Old Marlton Pike, Medford NJ 08055-8750. (800)300-9868. Fax: (609)654-4309. E-mail: custserv@infotoday.com. Web site: www.infotoday.com or www.literarymarketplace.com. Directory that lists book publishers and other book publishing industry contacts.

Negotiating Stock Photo Prices, by Jim Pickerell and Cheryl Pickerell DiFrank, 110 Frederick Ave., Suite A, Rockville MD 20850. (301)251-0720. Fax: (301)309-0941. E-mail: sellingstock@chd.com. Web site: www.pickphoto.com. Hardbound book that offers pricing guidelines for selling photos through stock photo agencies.

Newsletters in Print, Thomson Gale, 27500 Drake Rd., Farmington Hills MI 48331. (248)699-4253 or (800)877-GALE. Fax: (800)414-5043. E-mail: gale.galeord@thomson.com. Web site: www.gale.com. Annual directory listing newsletters.

O'Dwyer's Directory of Public Relations Firms, J.R. O'Dwyer Company, 271 Madison Ave., #600, New York NY 10016. (212)679-2471. Fax: (212)683-2750. E-mail: john@odwyerpr.com. Web site: www.odwyerpr.com. Annual directory listing public relations firms, indexed by specialties.

Photo Portfolio Success, by John Kaplan, Writer's Digest Books, F + W Publications, 4700 E. Galbraith Rd., Cincinnati OH 45236. (513)531-2690. Web site: www.writersdigest.com.

The Photographer's Guide to Marketing & Self-Promotion, 3rd Edition, by Maria Piscopo, Allworth Press, 10 E. 23 St., Suite 510, New York NY 10010. (212)777-8395. Fax: (212)777-8261. E-mail: PUB@allworth.com. Web site: www.allworth.com. Marketing guide for photographers.

The Photographer's Internet Handbook, Revised Edition, by Joe Farace, Allworth Press, 10 E. 23 St., Suite 510, New York NY 10010. (212)777-8395. Fax: (212)777-8261. E-mail: PUB@allworth.com. Web site: www.allworth.com. Covers the many ways photographers can use the Internet as a marketing and informational resource.

Resources

Photographer's Market Guide to Building Your Photography Business, by Vic Orenstein, Writer's Digest Books, F + W Publications, 4700 E. Galbraith Rd., Cincinnati OH 45236. (513)531-2690. Web site: www.writersdigest.com. Practical advice for running a profitable photography business.

Pricing Photography: The Complete Guide to Assignment & Stock Prices, 3rd Edition, by Michal Heron and David MacTavish, Allworth Press, 10 E. 23 St., Suite 510, New York NY 10010. (212)777-8395. Fax: (212)777-8261. E-mail: PUB@allworth.com. Web site: www.allworth.com.

Real World Color Management: Industrial-Strength Production Techniques, by Bruce Fraser, Chris Murphy and Fred Bunting, Peachpit Press, 1248 8th St., Berkeley CA 94710. Web site: www.peachpit.com.

Sell & Resell Your Photos, 5th Edition, by Rohn Engh, Writer's Digest Books, F + W Publications, 4700 E. Galbraith Rd., Cincinnati OH 45236. (513)531-2690. Web site: www.writersdigest.com. Revised edition of the classic volume on marketing your own stock.

SellPhotos.com, by Rohn Engh, Writer's Digest Books, F + W Publications, 4700 E. Galbraith Rd., Cincinnati OH 45236. (513)531-2690. Web site: www.writersdigest.com. A guide to establishing a stock photography business on the Internet.

Shooting & Selling Your Photos, by Jim Zuckerman, Writer's Digest Books, F + W Publications, 4700 E. Galbraith Rd., Cincinnati OH 45236. (513)531-2690. Web site: www.writersdigest.com.

Songwriter's Market, Writer's Digest Books, F + W Publications, 4700 E. Galbraith Rd., Cincinnati OH 45236. (513)531-2690. Web site: www.writersdigest.com. Annual directory listing record labels.

Standard Rate and Data Service (SRDS), 1700 Higgins Rd., Des Plains IL 60018-5605. (847)375-5000. Fax: (847)375-5001. Web site: www.srds.com. Directory listing magazines and their advertising rates.

Workbook, Scott & Daughter Publishing, 940 N. Highland Ave., Los Angeles CA 90038. (800)547-2688. Fax: (323)856-4368. E-mail: press@workbook.com. Web site: www.workbook.com. Numerous resources for the graphic arts industry.

Writer's Market, Writer's Digest Books, F + W Publications, 4700 E. Galbraith Rd., Cincinnati OH 45236. (513)531-2690. Web site: www.writersmarket.com. Annual directory listing markets for freelance writers. Many listings include photo needs and payment rates.

Resources

Web Sites

PHOTOGRAPHY BUSINESS

The Alternative Pick www.altpick.com

Black Book www.blackbook.com

Copyright Web site www.benedict.com

EP: Editorial Photographers www.editorialphoto.com

MacTribe www.mactribe.com

ShootSMARTER.com www.shootsmarter.com

Small Business Administration www.sba.gov

MAGAZINE AND BOOK PUBLISHING

American Journalism Review's News Links http://newslink.org

Bookwire www.bookwire.com

STOCK PHOTOGRAPHY

Global Photographers Search www.photographers.com

PhotoSource International www.photosource.com

Stock Photo Price Calculator www.photographersindex.com/stockprice.htm

Selling Stock www.pickphoto.com

Stock Artists Alliance www.stockartistsalliance.org

The STOCKPHOTO Network www.stockphoto.net

ADVERTISING PHOTOGRAPHY

Advertising Age www.adage.com

Adweek, Mediaweek and Brandweek www.adweek.com

Communication Arts Magazine www.commarts.com

FINE ART PHOTOGRAPHY

The Art List www.theartlist.com

Art Support www.art-support.com

Art DEADLINES List www.artdeadlineslist.com

Photography in New York International www.photography-guide.com

Mary Virginia Swanson www.mvswanson.com

PHOTOJOURNALISM

The Digital Journalist www.digitaljournalist.org

Foto8 www.foto8.com

National Press Photographers Association www.nppa.org

MAGAZINES

Afterimage www.vsw.org

Aperture www.aperture.org

Art Calendar www.artcalendar.com

Art on Paper www.artonpaper.com

Black and White Photography www.bandwmag.com

Blind Spot www.blindspot.com

British Journal of Photography www.bjphoto.co.uk

Camera Arts www.cameraarts.com

Lens Work www.lenswork.com

Photo District News www.pdnonline.com

Photograph Magazine www.photography-guide.com

Photo Insider www.photoinsider.com

The Photo Review, The Photography Collector, and The Photographic Art Market Magazines www.photoreview.org

Shots Magazine www.shotsmag.com

View Camera www.viewcamera.com

Resources

E-ZINES

The following publications exist online only. Some offer opportunities for photographers to post their personal work.

Apogee Photo www.apogeephoto.com

American Photo Magazine www.americanphotomag.com

American Photography Museum www.photographymuseum.com

Art in Context www.artincontext.org

Art Business News www.artbusinessnews.com

Art Support www.art-support.com

Artist Register http://artistsregister.com

Digital Journalist www.digitaljournalist.org

En Foco www.enfoco.org

Fotophile www.fotophile.com

Handheld Magazine www.handheldmagazine.com/index.html

Musarium www.musarium.com

Fabfotos www.fabfotos.com

Foto8 www.foto8.com

One World Journeys www.oneworldjourneys.com

PhotoArts www.photoarts.com

Pixel Press www.pixelpress.org

Photo Imaging Information Council www.takegreatpictures.com

Photo Links www.photolinks.com

Online Photo Workshops www.photoworkshop.com

Picture Projects www.pictureprojects.com

Sight Photo www.sightphoto.com

Zone Zero www.zonezero.com

TECHNICAL

About.com www.photography.about.com

FocalFix.com www.focalfix.com

Photo.net www.photo.net

The Pixel Foundry www.thepixelfoundry.com

Shoot Smarter www.shootsmarter.com

Wilhelm Imaging Research www.wilhelm-research.com

HOW TO

Adobe Tutorials www.adobe.com.designcenter/tutorials/

Digital Photographers www.digitalphotographers.net

Digital Photography Review www.dpreview.com

Fred Miranda www.fredmiranda.com/forum/index.php

Imaging Resource www.imaging-resource.com

Lone Star Digital www.lonestardigital.com

The National Association of Photoshop Professionals www.photoshopuser.com

PC Photo Review www.pcphotoreview.com

Steve's Digicams www.steves-digicams.com

Glossary

Absolute-released images. Any images for which signed model or property releases are on file and immediately available. For working with stock photo agencies that deal with advertising agencies, corporations and other commercial clients, such images are absolutely necessary to sell usage of images. Also see Model release, Property release.

Acceptance (payment on). The buyer pays for certain rights to publish a picture at the time it is accepted, prior to its publication.

Agency promotion rights. Stock agencies request these rights in order to reproduce a photographer's images in promotional materials such as catalogs, brochures and advertising.

Agent. A person who calls on potential buyers to present and sell existing work or obtain assignments for a client. A commission is usually charged. Such a person may also be called a *photographer's rep*.

All rights. A form of rights often confused with work for hire. Identical to a buyout, this typically applies when the client buys all rights or claim to ownership of copyright, usually for a lump sum payment. This entitles the client to unlimited, exclusive usage and usually with no further compensation to the creator. Unlike work for hire, the transfer of copyright is not permanent. A time limit can be negotiated, or the copyright ownership can run to the maximum of 35 years.

Alternative Processes. Printing processes that do not depend on the sensitivity of silver to form an image. These processes include cyanotype and platinum printing.

Archival. The storage and display of photographic negatives and prints in materials that are harmless to them and prevent fading and deterioration.

Artist's statement. A short essay, no more than a paragraph or two, describing a photographer's mission and creative process. Most galleries require photographers to provide an artist's statement.

Assign (designated recipient). A third-party person or business to which a client assigns or designates ownership of copyrights that the client purchased originally from a creator such as a photographer. This term commonly appears on model and property releases.

Assignment. A definite OK to take photos for a specific client with mutual understanding as to the provisions and terms involved.

Assignment of copyright, rights. The photographer transfers claim to ownership of copyright over to another party in a written contract signed by both parties.

Audiovisual (AV). Materials such as filmstrips, motion pictures and overhead transparencies which use audio backup for visual material.

Automatic renewal clause. In contracts with stock photo agencies, this clause works on the concept that every time the photographer delivers an image, the contract is automatically

renewed for a specified number of years. The drawback is that a photographer can be bound by the contract terms beyond the contract's termination and be blocked from marketing the same images to other clients for an extended period of time.

Avant garde. Photography that is innovative in form, style or subject matter.

Biannual. Occurring twice a year. Also see Semiannual.

Biennial. Occurring once every two years.

Bimonthly. Occurring once every two months.

Bio. A sentence or brief paragraph about a photographer's life and work, sometimes published along with photos.

Biweekly. Occurring once every two weeks.

Blurb. Written material appearing on a magazine's cover describing its contents.

Buyout. A form of work for hire where the client buys all rights or claim to ownership of copyright, usually for a lump sum payment. Also see All rights, Work for hire.

Caption. The words printed with a photo (usually directly beneath it), describing the scene or action.

CCD. Charged Coupled Device. A type of light detection device, made up of pixels, that generates an electrical signal in direct relation to how much light strikes the sensor.

CD-ROM. Compact disc read-only memory; non-erasable electronic medium used for digitized image and document storage and retrieval on computers.

Chrome. A color transparency, usually called a slide.

Cibachrome. A photo printing process that produces fade-resistant color prints directly from color slides.

Clips. See Tearsheet.

CMYK. Cyan, magenta, yellow and black—refers to four-color process printing.

Color Correction. Adjusting an image to compensate for digital input and output characteristics.

Commission. The fee (usually a percentage of the total price received for a picture) charged by a photo agency, agent or gallery for finding a buyer and attending to the details of billing, collecting, etc.

Composition. The visual arrangement of all elements in a photograph.

Compression. The process of reducing the size of a digital file, usually through software. This speeds processing, transmission times and reduces storage requirements.

Consumer publications. Magazines sold on newsstands and by subscription that cover information of general interest to the public, as opposed to trade magazines, which cover information specific to a particular trade or profession. See Trade magazine.

Contact Sheet. A sheet of negative-size images made by placing negatives in direct contact with the printing paper during exposure. They are used to view an entire roll of film on one piece of paper.

Contributor's copies. Copies of the issue of a magazine sent to photographers in which their work appears.

Copyright. The exclusive legal right to reproduce, publish and sell the matter and form of an artistic work.

Cover letter. A brief business letter introducing a photographer to a potential buyer. A cover letter may be used to sell stock images or solicit a portfolio review. Do not confuse cover letter with query letter.

C-print. Any enlargement printed from a negative.

Credit line. The byline of a photographer or organization that appears below or beside a published photo.

Cutline. See Caption.

Day rate. A minimum fee that many photographers charge for a day's work, whether a full day is spent on a shoot or not. Some photographers offer a half-day rate for projects involving up to a half-day of work.

Demo(s). A sample reel of film or sample videocassette that includes excerpts of a filmmaker's or videographer's production work for clients.

Density. The blackness of an image area on a negative or print. On a negative, the denser the black, the less light that can pass through.

Digital Camera. A filmless camera system that converts an image into a digital signal or file.

DPI. Dots per inch. The unit of measure used to describe the resolution of image files, scanners and output devices. How many pixels a device can produce in one inch.

Electronic Submission. A submission made by modem or on computer disk, CD-ROM or other removable media.

Emulsion. The light-sensitive layer of film or photographic paper.

Enlargement. An image that is larger than its negative, made by projecting the image of the negative onto sensitized paper.

Exclusive property rights. A type of exclusive rights in which the client owns the physical image, such as a print, slide, film reel or videotape. A good example is when a portrait is shot for a person to keep, while the photographer retains the copyright.

Exclusive rights. A type of rights in which the client purchases exclusive usage of the image for a negotiated time period, such as one, three or five years. May also be permanent. Also see All rights, Work for hire.

Fee-plus basis. An arrangement whereby a photographer is given a certain fee for an assignment—plus reimbursement for travel costs, model fees, props and other related expenses incurred in completing the assignment.

File Format. The particular way digital information is recorded. Common formats are TIFF and JPEG.

First rights. The photographer gives the purchaser the right to reproduce the work for the first time. The photographer agrees not to permit any publication of the work for a specified amount of time.

Format. The size or shape of a negative or print.

Four-color printing, four-color process. A printing process in which four primary printing inks are run in four separate passes on the press to create the visual effect of a full-color photo, as in magazines, posters and various other print media. Four separate negatives of the color photo—shot through filters—are placed indentically (stripped) and exposed onto printing plates, and the images are printed from the plates in four ink colors.

GIF. Graphics Interchange Format. A graphics file format common to the Internet.

Glossy. Printing paper with a great deal of surface sheen. The opposite of matte.

Hard Copy. Any kind of printed output, as opposed to display on a monitor.

Honorarium. Token payment—small amount of money and/or a credit line and copies of the publication.

Image Resolution. An indication of the amount of detail an image holds. Usually expressed as the dimension of the image in pixels and the color depth each pixel has. Example: a 640×480, 24-bit image has higher resolution than a 640×480, 16-bit image.

IRC. International Reply Coupon. IRCs are used with self-addressed envelopes instead of stamps when submitting material to buyers located outside a photographer's home country.

JPEG. Joint Photographic Experts Group. One of the more common digital compression methods that reduces file size without a great loss of detail.

Licensing/Leasing. A term used in reference to the repeated selling of one-time rights to a photo.

Manuscript. A typewritten document to be published in a magazine or book.

Matte. Printing paper with a dull, nonreflective surface. The opposite of glossy.

Model release. Written permission to use a person's photo in publications or for commercial use.

Multi-image. A type of slide show that uses more than one projector to create greater visual impact with the subject. In more sophisticated multi-image shows, the projectors can be programmed to run by computer for split-second timing and animated effects.

Multimedia. A generic term used by advertising, public relations and audiovisual firms to describe productions using more than one medium together—such as slides and full-motion, color video—to create a variety of visual effects.

News release. See Press release.

No right of reversion. A term in business contracts that specifies once a photographer sells the copyright to an image, a claim of ownership is surrendered. This may be unenforceable, though, in light of the 1989 Supreme Court decision on copyright law. Also see All rights, Work for hire.

On spec. Abbreviation for "on speculation." Also see Speculation.

One-time rights. The photographer sells the right to use a photo one time only in any medium. The rights transfer back to the photographer on request after the photo's use.

Page rate. An arrangement in which a photographer is paid at a standard rate per page in a publication.

Photo CD. A trademarked, Eastman Kodak-designed digital storage system for photographic images on a CD.

PICT. The saving format for bit-mapped and object-oriented images.

Picture Library. See Stock photo agency.

Pixels. The individual light-sensitive elements that make up a CCD array. Pixels respond in a linear fashion. Doubling the light intensity doubles the electrical output of the pixel.

Point-of-purchase, point-of-sale (P-O-P, P-O-S). A term used in the advertising industry to describe in-store marketing displays that promote a product. Typically, these highly-illustrated displays are placed near checkout lanes or counters, and offer tear-off discount coupons or trial samples of the product.

Portfolio. A group of photographs assembled to demonstrate a photographer's talent and abilities, often presented to buyers.

PPI. Pixels per inch. Often used interchangeably with DPI, PPI refers to the number of pixels per inch in an image. See DPI.

Press release. A form of publicity announcement that public relations agencies and corporate communications staff people send out to newspapers and TV stations to generate news coverage. Usually this is sent with accompanying photos or videotape materials.

Property release. Written permission to use a photo of private property or public or government facilities in publications or for commercial use.

Public domain. A photograph whose copyright term has expired is considered to be "in the public domain" and can be used for any purpose without payment.

Publication (payment on). The buyer does not pay for rights to publish a photo until it is actually published, as opposed to payment on acceptance.

Query. A letter of inquiry to a potential buyer soliciting interest in a possible photo assignment.

Rep. Trade jargon for sales representative. Also see Agent.

Resolution. The particular pixel density of an image, or the number of dots per inch a device is capable of recognizing or reproducing.

Résumé. A short written account of one's career, qualifications and accomplishments.

Royalty. A percentage payment made to a photographer/filmmaker for each copy of work sold.

R-print. Any enlargement made from a transparency.

SAE. Self-addressed envelope.

SASE. Self-addressed, stamped envelope. (Most buyers require a SASE if a photographer wishes unused photos returned to him, especially unsolicited materials.)

Self-assignment. Any project photographers shoot to show their abilities to prospective clients. This can be used by beginning photographers who want to build a portfolio or by photographers wanting to make a transition into a new market.

Self-promotion piece. A printed piece photographers use for advertising and promoting their businesses. These pieces generally use one or more examples of the photographer's best work, and are professionally designed and printed to make the best impression.

Semiannual. Occurring twice a year. Also see Biannual.

Semigloss. A paper surface with a texture between glossy and matte, but closer to glossy.

Semimonthly. Occurring twice a month.

Serial rights. The photographer sells the right to use a photo in a periodical. Rights usually transfer back to the photographer on request after the photo's use.

Simultaneous submissions. Submission of the same photo or group of photos to more than one potential buyer at the same time.

Speculation. The photographer takes photos with no assurance that the buyer will either purchase them or reimburse expenses in any way, as opposed to taking photos on assignment.

Stock photo agency. A business that maintains a large collection of photos it makes available to a variety of clients such as advertising agencies, calendar firms and periodicals. Agencies usually retain 40-60 percent of the sales price they collect, and remit the balance to the photographers whose photo rights they've sold.

Stock photography. Primarily the selling of reprint rights to existing photographs rather than shooting on assignment for a client. Some stock photos are sold outright, but most are rented for a limited time period. Individuals can market and sell stock images to individual clients from their personal inventory, or stock photo agencies can market photographers' work for them. Many stock agencies hire photographers to shoot new work on assignment, which then becomes the inventory of the stock agency.

Subsidiary agent. In stock photography, this is a stock photo agency that handles marketing of stock images for a primary stock agency in certain US or foreign markets. These are usually affiliated with the primary agency by a contractual agreement rather than by direct ownership, as in the case of an agency that has its own branch offices.

SVHS. Abbreviation for Super VHS. Videotape that is a step above regular VHS tape. The number of lines of resolution in a SVHS picture is greater, thereby producing a sharper picture.

Tabloid. A newspaper about half the page size of an ordinary newspaper that contains many photos and news in condensed form.

Tearsheet. An actual sample of a published work from a publication.

TIFF. Tagged Image File Format. A common bitmap image format developed by Aldus.

Trade magazine. A publication devoted strictly to the interests of readers involved in a specific trade or profession, such as beekeepers, pilots or manicurists, and generally available only by subscription.

Transparency. Color film with a positive image, also referred to as a slide.

Unlimited use. A type of rights in which the client has total control over both how and how many times an image will be used. Also see All rights, Exclusive rights, Work for hire.

Unsolicited submission. A photograph or photographs sent through the mail that a buyer did not specifically ask to see.

Work for hire. Any work that is assigned by an employer who becomes the owner of the copyright. Stock images cannot be purchased under work-for-hire terms.

World rights. A type of rights in which the client buys usage of an image in the international marketplace. Also see All rights.

Worldwide exclusive rights. A form of world rights in which the client buys exclusive usage of an image in the international marketplace. Also see All rights.

Geographic Index

This index lists photo markets by the state in which they are located. It is often easier to begin marketing your work to companies close to home. You can also determine with which companies you can make appointments to show your portfolio, near home or when traveling.

INDIANA

NEW MEXICO

NEW YORK

International Index

This index lists photo markets outside the United States. Most of the markets are located in Canada and the United Kingdom. To work with markets located outside your home country, you will have to be especially professional and patient.

Subject Index

This index can help you find buyers who are searching for the kinds of images you are producing. Consisting of markets from the Publications, Book Publishers, Greeting Cards, Posters & Related Products, Stock Photo Agencies, Advertising, Design & Related Markets, and Galleries sections, this index is broken down into 48 different subjects. If, for example, you shoot outdoor scenes and want to find out which markets purchase this material, turn to the categories Landscapes/Scenics and Environmental.

Agriculture

Alternative Process

Architecture

Avant Garde

Cities/Urban

Couples

Documentary

Entertainment

Environmental

Fashion/Glamour

Fine Art

Health/Fitness/Beauty

Historical/Vintage

Hobbies

Humor

Industry

Interiors/Decorating

Landscapes/Scenics

Lifestyle

Medicine

Multicultural

Parents

Pets

Product Shots/Still Life

Religious

Science

Seasonal

Senior Citizens

Sports

Technology/Computers

Wildlife

Subject Index

General Index

This index lists every market appearing in the book; use it to find specific companies you wish to approach.

General Index

N

NOTES

NOTES

NOTES

NOTES

NOTES

NOTES

NOTES

NOTES

NOTES

NOTES